Manuscript Catalogues of the Early Museum Collections 1683-1886

(Part I)

Arthur MacGregor

with

Melanie Mendonça and Julia White

with contributions by

Penny Bayer, Justin Brooke, Jeremy Coote, Peter Gathercole, Abigail Headon, Moira Hook,
Nicolette Meister, Gloria Moss, Alison Petch, Philippa Walton, David Wilson

BAR International Series 907
2000

This title published by

Archaeopress
Publishers of British Archaeological Reports
PO Box 920
Oxford
OX2 7YH
England
www.archaeopress.com

BAR S907

Manuscript Catalogues of the Early Museum Collections 1683-1886 (Part I)

Published in association with the Ashmolean Museum Oxford

Printed in England by The Basingstoke Press

ISBN 1 84171 206 X

All BAR titles are available from:

Hadrian Books Ltd
122 Banbury Road
Oxford
OX2 7BP
England

The current BAR catalogue with details of all titles in print, prices and means of payment is available free from Hadrian Books

CONTENTS

ASHMOLEAN MUSEUM OXFORD

MANUSCRIPT CATALOGUES OF THE EARLY MUSEUM COLLECTIONS 1683-1886

Part I

The original intention of this volume was to publish all the surviving manuscript sources relating to the history of the Ashmolean collections. During the entire period of our researches one key volume – AMS 11, the Vice-Chancellor's consolidated catalogue of 1695-6 (see p. i, below) – was unavailable to us, having been mis-shelved at some time in the past within the Ashmolean Library and its whereabouts being unknown to our present-day colleagues there. The rediscovery of this valuable document in September 2000 was warmly welcomed, but it occurred just as the present volume was going to press. Given the importance of this primary source for the early history of the Ashmolean's collections, its considerable size and the years of work that will be involved in transcribing and translating its Latin texts, a decision was taken that it should form a separate companion volume to that offered here. This further volume, designated Part II, will be published as soon as resources allow.

PREFACE

Arthur MacGregor

For more than three centuries the collections of the Ashmolean Museum have occupied a position of primary importance in the history of collecting in Great Britain and an honourable position in the development of museums on a European scale.

In the course of its tercentenary celebrations in 1983, the Museum published a celebratory volume titled *Tradescant's Rarities*, in which the events that led to the founding of the Museum were described while a descriptive catalogue gave details of surviving specimens from the seventeenth-century collections. In reality, these fortunate survivors represented only a tiny and unrepresentative fraction of the exhibits that greeted visitors on the opening day: furthermore, from the beginning the collection was a dynamic one and in a continuous state of evolution.

During the years that intervened until the transfer of the institution at the turn of the twentieth century to new premises and with a redefined programme focusing on art and archaeology, the combined forces of decay, loss, theft, breakage and institutional reorganization made serious inroads into Ashmole's benefaction. Over the same period, new acquisitions attracted to the Museum from those who supported its evolving aims, gradually overlay and altered the original character and content of the collections.

The confusing picture generated by this ebb and flow of specimens is to some degree mitigated by the series of inventories compiled in manuscript by successive curators and (at least in the early years of the Museum's history) used by the board of Visitors in the exercise of their allotted duty of control of the collections. Despite early interest in reproducing them in printed form (documented in both the seventeenth and eighteenth century), the greater part of these catalogues has until the present remained unpublished and ‑ at least in recent years ‑ largely unconsulted. R.T. Gunther made creditable use of them in his *Early Science in Oxford* vol. III (1925) and R.F. Ovenell repeatedly demonstrated his familiarity with them in his institutional history, *The Ashmolean Museum, 1683‑1894* (1986), though needless to say, neither author had any opportunity to quote from them at length. Their independent importance, however, is very considerable, for they provide not only a record through time of the fluctuating content of the Museum but also an index of the changing preoccupations of the collectors and donors who progressively enriched the Ashmolean, of the curators who tended it, and of the wider community of scholars for whom the collections represented a fundamental resource.

During the earliest years of the Museum's existence, interest in the natural sciences predominated, still grounded to some extent in perceptions that were rooted in the age of Aristotle and Pliny. The founding of the Ashmolean itself, however, was an expression of a more pragmatic and empirical approach to natural philosophy that emerged in the course of the seventeenth century and under Robert Plot and Edward Lhwyd, its earliest keepers, the Museum occupied a leading place in the movement that was to shape the outlines of modern science. The following texts reveal evidence of both the backward-looking aspects of seventeenth-century science, in its preoccupation with the quasi-magical properties of substances, and of the new spirit of inquiry enshrined, for example, in Martin Lister's instructions for the experimental investigation of specimens submitted to the Museum.

By the time the present survey closes, towards the end of the nineteenth century, all involvement with the natural sciences at the Ashmolean had ceased and the scientific collections had been transferred elsewhere. The final catalogue reproduced here, indeed, records another major efflux ‑ that of the anthropological specimens removed to the Pitt Rivers Museum in 1886. Although several of the earlier lists included in the following pages record donations of ethnological material, the sheer scale of the Ashmolean's holdings at this date is striking: undoubtedly it must represent one of the greatest yet least acknowledged collections of the nineteenth century, with a history stretching back 250 years or more and including amongst other important items the most closely documented specimens to survive from Captain Cook's second historic voyage to the South Pacific and others from a number of exploratory voyages to the Canadian Arctic.

The texts bracketed by these earliest and latest catalogues, annotated as they are with periodic references to the published sources on which their compilers relied for identifications and comparisons, document a large part of the history of the Ashmolean in its earliest manifestation. They are presented here not as an exercise in museum bureaucracy (although some internal benefit may be expected to flow from improved accessibility to the data recorded) but rather as documents in the progress of scholarship through the wide range of fields in which the Ashmolean Museum has, from its earliest days, played a creditable part.

ACKNOWLEDGEMENTS

Arthur MacGregor

The Ashmolean Museum's principal debt in respect of this work is to my two co-authors. Over a period of two years of regular voluntary work Julia White transcribed into electronic form the majority of the catalogues forming the basis of the following texts. Without her commitment and her consistently careful work, the project would not have been brought to a conclusion. Melanie Mendonça wrought extensive improvements on all the Latin transcriptions and on their respective translations, to the extent of rendering some of the formal attributions of authorship largely historical. Her scholarly input and her industry were crucial to the successful completion of the project in its current form. In the preparation of the texts she was much aided by Anne Bowtell.

Gloria Moss's transcription and translation of two of the primary catalogues was undertaken in preparation for the Museum's tercentenary volume, *Tradescant's Rarities*, published in 1983, her work appearing in the form of microfiches accompanying the printed volume. Attempts to re-establish contact with Miss Moss prior to the present publication failed; such amendments to her original text as have proved necessary have been incorporated without her knowledge, but in the confident belief that nothing has been done of which she would have disapproved.

Two colleagues at the Pitt Rivers Museum have each contributed important sections dealing with ethnographic material formerly in the Ashmolean collections but now in their care. Jeremy Coote's work on the 1776 benefaction by Reinhold and George Forster of material from Captain Cook's second Pacific voyage was undertaken as part of a long-term research project on material from that expedition; the contributions of his co-authors, Peter Gathercole and Nicolette Meister, are also gratefully acknowledged. The work of all three authors on the manuscript and related materials has been made possible by grants from the Hulme University Fund, the South-Eastern Museum Service, and the Jerwood / Museums and Galleries Commission Cataloguing Grants Scheme. Tim Rogers of the Bodleian Library and Frieda Midgley of the University Archives respectively transcribed and translated the Latin text of the Forsters' letter to the Vice-Chancellor, as quoted in the introduction. Alison Petch's transcription of the very detailed 1886 'Anthropological Catalogue' was undertaken with the aid of a grant from the Pilgrim Trust as part of the Pitt Rivers Museum's project to computerize the records of all its collections. The ready agreement to our reproduction of these two texts by the Director of the Pitt Rivers Museum, Dr Mike O'Hanlon, and by the authors, is warmly acknowledged.

The shorter contribution by Abigail Headon on the list of nineteenth-century benefactions forms a complement to earlier work which she and I carried out on the archives. Philippa Walton's work on the 'Catalogue of Shells' was undertaken at first on a voluntary basis and later during a placement as part of a Diploma course in Professional Archaeology undertaken at the Department of Continuing Education in the University of Oxford. Justin Brooke's specialist knowledge of Cornish tin-mining enabled him to produce a valuable commentary to the catalogue of specimens given by Johan Angerstein.

David Wilson earned his place amongst the contributors from careful reading and editing of some of early versions of the Latin translations, while Penny Bayer and Moira Hook jointly undertook the checking of the extensive Anthropological Catalogue text, as re-created from the Pitt Rivers Museum's database, against the manuscript original.

In dealing with items outside my own area of knowledge I have benefited from the advice of colleagues working in other disciplines who have helped illuminate many obscurities in the early texts. Particular debts are owed to P.F. Clark (crustacea), Alwyne Wheeler (fish), Richard Sabin (mammals), Jan Bondeson, Sue Minter and Brian Moffat (materia medica), Barrie Cook, Andrew Burnett, Thomas Mannak and Luke Syson (numismatics), Colin McCarthy (reptiles and amphibia), Peter Dance, Sammy de Grave and Kathie Way (shells).

Gina Douglas, librarian at the Linnean Society, cheerfully responded to numerous requests for advice on bibliographical matters, while Neil Chambers advised on the Cook voyage references. Christer Nordlund kindly provided information on Johan Angerstein and his collection.

A number of colleagues within the Ashmolean also deserve mention. Alison Roberts electronically scanned some of the texts reproduced in microfiche in 1983, allowing them to be integrated more easily into the present catalogue; this work was completed by Zsuzanna Dákai. Jonathan Moffett solved many problems arising from shortcomings in the compatibility of the several forms of computer software which had been used in preparing the various texts; he also imposed the formatting on the camera-ready copy. Keith Bennett prepared the artwork for the cover and executed with scissors and paste certain refinements in the layout which proved beyond the capacity of the Museum's software. With her customary good grace, Julie Clements repeatedly came to the rescue over all manner of organizational difficulties. In the final stages of preparation of the text and index, Moira Hook returned to the project as a much-valued source of aid on various fronts. David Davison and his colleagues at Archaeopress were models of patience and support during the final stages of preparation of the text.

HISTORICAL INTRODUCTION
Arthur MacGregor

Seventeenth-century beginnings

... whereas the Repository consists of a collection of many particulars, wh[i]ch may by dilligence be preserved, & receive daily Improuvements: but are lyable to be imbezelled, & utterly dwarf'd from growth by negligence & ill Treatment, I have thought it therefore adviseable, that as the publique Library has a yearely Visitation, the Musaeum may likewise have one; & I presume that it may be comodiously fix'd, upon the Tuesday preceding the first weeke in Michaelmas Terme, the Persons to whome that Trust is recomended, being the Vicechancellor for the tyme being, the Deane of Christchurch, the Principall of Brazenose, the Kings Professor in Phisick, & the two Procters of the University...

With these words the eponymous founder of the Ashmolean Museum, on 1 September 1684, spelled out to the Vice-Chancellor of the University of Oxford the framework of governance that he wished to see established at the institution he had caused to be founded in the previous year.[1] Like many collectors, Elias Ashmole (1617-92) had an obsession with the means by which the integrity of his collection might be maintained after has death, but he was exceptionally effective in the elaborate mechanisms he erected in order to ensure that his wishes were observed. Two years earlier, in a memorandum to the University setting out the conditions applying to his donation, he had specifically stipulated:

...That a Catalogue of the Rarities shalbe made by the Professor[2] within two years after they shalbe placed in the Musaeum, & that an addition be made theretoo every yeare, of what shalbe placed therein, & by whome bestowed.

By virtue of his declared intention to endow the said professorship, Ashmole had been allowed to nominate its first incumbent. His choice had fallen upon Dr Robert Plot (1640-96), who, in the decade or so following the official opening of the 'Musaeum' on 21 May 1683, applied himself diligently to the task of drawing up a catalogue, appointing as his assistant in this task a talented young Welshman from Jesus College named Edward Lhwyd (1660-1709). By 1684, when Ashmole first visited his foundation and communicated his thoughts on its organization to the Vice-Chancellor, work on the catalogue was already in hand: Lhwyd's catalogue of shells (AMS 7: see pp. **-**) was completed in that year. By 1686 the initial task of cataloguing was complete; thereafter, new acquisitions were added to whichever section was appropriate. Ultimately, in the mid 1690s, a consolidated version of this multi-volume catalogue was compiled (see below).

The inventory so produced formed no passive record of the collection but acted specifically as a check-list against which the Visitors were to compare the holdings during their annual stock-check:

The said catalogue shall be divided into Parts, according to the Number of the Visitors; that so the Visitation may be expedited: each Visitor comparing his Part, and seeing that all Particulars be Safe, and Well-condition'd, and answering to the Catalogue.[3]

Accordingly, responsibility for the collections was shared out among the Visitors: 'artificials' (mostly coins and medals) to the Vice-Chancellor, precious stones and curiosities to the Dean of Christ Church, animals to the Principal of Brasenose, materia medica to the Regius Professor of Medicine, and shells to the Senior Proctor; the sixth catalogue, mainly ethnological in content, would have been assigned to the Junior Proctor.[4]

One further catalogue had been specified in Ashmole's 1686 statutes, namely a consolidated copy of all the foregoing, to be held by the Vice-Chancellor 'for the prevention of fraude or embezelment'. In the event it was to be 1695 or 1696 before this summation was completed: the Vice-Chancellor's accounts for 1696-7 record the payment of £3 to a scrivenor for work on the transcription. None the less, this volume holds some independent interest for, as Ovenell (1986, pp. 46, 48) observes, its contents vary to some degree from those of the earlier catalogues: in particular, the entire text of the Junior Proctor's catalogue was replaced with a new list of the fossils, shells, minerals and ores added to the Museum since its inception through the fieldwork undertaken during that period by Plot and Lhwyd. The temporary misplacement of this volume prevented its inclusion here, a situation to be rectified in Part II of this publication.[5]

These detailed working documents were complemented by a more generalized record of gifts to the Museum in the form of the Book of Benefactors, an illuminated, vellum-bound volume that opens with Ashmole's founding benefaction and continues with the gifts of others up to 1766 (see pp. 1-13). Its text adds little in the way of detail to our knowledge of the specimens, although it contains some information on the collectors and

[1] AMS 1 (4). For the founding of the Ashmolean Museum see Josten 1966, vol. I, *passim*; M. Welch in MacGregor 1983; Ovenell 1986; MacGregor and Turner 1986.

[2] That is to say, the Professor of Natural History and Chemistry, Robert Plot, who was also appointed first keeper of the Museum.

[3] *The Orders and Statutes of the Ashmolean Museum*, as approved by the Visitors on 29 April 1697.

[4] The detailed history of these catalogues, so far as it can be recovered, is discussed by Ovenell (1986, pp. 40-47).

[5] Apart from the volumes recorded as being presently in the Pitt Rivers Museum (see pp. 255-413), the archives listed here were transferred on a permanent basis in 1998 from the Ashmolean Library to the Museum's Department of Antiquities. The Consolidated Catalogue was rediscovered in the Library in September 2000.

their collections which finds no place in the catalogues.

The primary catalogues of the Ashmolean Museum are amongst the earliest examples in this country of such a genre. The Tradescants' own *Musœum Tradescantianum* had been published in 1656 and was followed by an account of a somewhat similar cabinet of rarities, exhibited to the public in London in the 1660s and belonging to one Robert Hubert (Hubert 1684).[6] A more ambitious project had followed in 1681 with the publication of the catalogue of the 'Repository' of the Royal Society, compiled by the botanist Nehemiah Grew (1681).[7] As well as these English sources, Plot and Lhwyd would have had before them a number of influential Continental models. Ovenell (1986, p. 39) makes the pertinent observation that among the printed volumes sent to the Museum by Ashmole in 1683 were two which may have been included specifically to assist with this process: Ceruti and Chiocco's *Musaeum Francisci Calceolari Veronensis* (1622) and Lodovico Moscardo's *Note overo Memorie de Museo di Lodovico Moscardo nobile veronese* (1656). Another museological tract of fundamental importance that receives mention in the text of one catalogue (AMS 13) is Ole Worm's *Museum Wormianum seu Historia Rerum Rariorum* (1655); other sources mentioned in this volume are of more general natural-historical interest, although some of the authors (notably Ulisse Aldrovandi) were also collectors in their own right.

Amongst the authorities most frequently cited, some – notably Conrad Gessner's *Historiae Animalium* (1551-8) and Guillaume Rondelet's *Libri de Piscibus Marinis* (1554) – were already of some antiquity, while others represented the very latest sources available. Extensive use is made, for example, of the series of volumes (1650-65) by Joannes Jonston (Jonstonus), a Polish naturalist of Scottish descent; of Martin Lister's *Historiœ Animalium Angliœ* (1678), the type-specimens for which were presented to the Ashmolean by the author (see pp. 153-8); of Francis Willughby's *Ornithology* (1678) and *De Historia Piscium* (1686); while Philippo Buonanni's influential *Recreatio...* (1684) appeared just in time to be of extensive use in the catalogue of shells (pp. 125-51).

Plot himself already had experience of organizing information of this kind in another context, for he was a considerable collector of natural rarities in his own right: on a visit to

Oxford in 1675, John Evelyn (*Diary*, 9-14 July 1675) admired Plot's 'rare Collection of natural Curiosities' and found it 'indeede extraordinary, that in one County, there should be found such varietie of Plants, Shells, Stones, Minerals, Marcasites, foul, Insects, Models of works &C: Chrystals, Achates, Marbles'. These items (some of which, at least, were ultimately to join the Ashmolean collections) were to be used in the production of Plot's *Natural History of Oxfordshire* (1677), other data for which were gathered by way of printed questionnaires which he circulated to selected contributors. Lhwyd's career as a collector had yet to develop, but from his later work, notably the *Lithophylacii* of 1699 and the ambitious encyclopaedic project for a compendious *Archaeologia Britannica* which remained only partly realized at his premature death, we may surmise that he was exceptionally gifted in this sphere. Surely there could scarcely have been two better-qualified persons in Oxford for the task in hand.

For the most part, the level of recording in the catalogues is fairly rudimentary, such details as are recorded being singled out, it seems, primarily to facilitate recognition of one exhibit from another during the annual stock-check. In some instances information is given on the geographical origins of a particular specimen, while the name of the donor is commonly attached to material arriving after the initial foundation, sometimes together with the date. Only in the case of the catalogues of shells (AMS 7: pp. 125-51) and zoological specimens (AMS 13: pp. 203-15) can any serious attempt be traced to expand the references in a coherent way to the extent that they might form the basis of a systematic work of reference. In the coin catalogue (AMS 9: pp. 67-123) two of the standard sixteenth-century works are cited extensively in the relevant sections: Hubert Goltz's *Sicilia et Magna Graecia...* (1576) and Fulvio Orsini's *Familiœ Romanœ...* (1577). Occasional reference is also made to the Duc de Croy's *Regum et Imperatorum Romanorum Numismata* (1654), but no authority is cited for the other issues that account for the bulk of the catalogue

Eighteenth-century revisions

The handiwork of the first keeper and his assistant was to stand the test of time in a respectable manner, but by the mid eighteenth century a need for radical revision became evident, fuelled by two opposing forces. On the one hand, the primary collection had become depleted (witness the number of entries annotated *'d'* or *'deest'* –

[6] See the chapters by MacGregor (pp. 147-58) and Hunter (pp. 159-68) in Impey and MacGregor 1985.

[7] For an account of the cataloguing project at the Royal Society see Simpson 1984.

'missing'), partly through losses[8] and partly by the natural processes of decay. The zoological collections had proved particularly at risk here: amassed in an era when the techniques of taxidermy were yet in their infancy, the more vulnerable specimens fell victim to rot and, no doubt, to the ravages of pests for which no adequate counter-measures yet existed. Ashmole himself had foreseen such an inevitability and had catered for it in his statutes, where it was decreed:

...That as any particular growes old & perishing, the Keeper may remove it into one of the Closets, or other repository; & some other to be substituted.[9]

The most spectacular casualty of this process was the renowned specimen of the Dodo: contrary, however, to the assertions of earlier writers (see especially Gunther (1925), pp. 361-2, followed by Whitehead (1970), p. 50, MacGregor and Turner (1986), p. 656, and others), the demise of this specimen should be attributed not to indifference and neglect but rather to inexorable processes beyond the control of the Visitors and keepers, who had to content themselves with recording its disintegration, as required by statute (on this episode see Ovenell 1992).

On the other hand, benefactions to the collection had been arriving since the earliest years of the Museum's existence. In addition to the broad accounts of these gifts contained in the Book of Benefactors, more detailed records were added (perhaps at the annual visitation) to the catalogues maintained by the individual Visitors. In addition, some keepers clearly became aware of certain areas that required special treatment: the list of pictures hanging in the Museum, added to AMS 9 by the industrious John Whiteside (keeper 1714-29), is a case in point (see pp. 59-65); the addition of English terms to the catalogue of materia medica is also credited to Whiteside (see p. 159), but ultimately, the point was reached at which some rationalization became necessary.

While serving to simplify the task of the Visitors, the new series of catalogues drawn up in the mid eighteenth century (see AMS 10, 13) reveals no conceptual advance on the originals compiled by Plot and Lhwyd. In most cases the entries are simply transcribed directly from the primary catalogues, with little or no attempt to amend the original information. By this means, for example, the text of a piece of paper accompanying a specimen of wood and recording that it had been 'given to Sr. Thomas Row by on Apothicary in the Great Maguls Court' who had in turn given it to the author, is faithfully preserved to demonstrate that the original was almost certainly written by John Tradescant the Elder (see p. 161). Credit for these revised catalogues goes to William Huddesford (keeper 1755-72), undoubtedly the most effective curator of the second half of the eighteenth century (see MacGregor and Turner 1986, pp. 652-5).

A few references to up-to-date sources not available to the original compilers were inserted in the revised catalogue of the zoological specimens (AMS13). Linnæus's *Systema Naturæ* receives brief mention in its 'augmented' or revised form (perhaps the edition of Gmelin, published in Leipzig in 1788); two volumes (12 and 15, both dated 1764) of the Comte de Buffon's multi-volume *Histoire naturelle* are alluded to amongst the marginalia, and Thomas Pennant's *Synopsis of Quadrupeds* (1771) is also mentioned, giving *termini post quem* for these insertions. They can scarcely be said, however, to indicate a concerted effort to keep the catalogues abreast of the latest publications. References to earlier, seventeenth-century sources are presumed to have been transcribed from the primary catalogues, but the loss of some of the relevant texts makes certainty on this point impossible.

The primary catalogues, together with their later recensions and additions through the eighteenth century, form the basis of much of the following text. A number of other lists are also included, however, which fill-out certain gaps that become evident in the catalogues when they are compared with other sources. Noteworthy are the lists of natural specimens supplied by William Borlase and referenced to his own *Natural History of Cornwall* (1758) (pp. 217-21) and that given by Joshua Platt in 1765 to accompany his benefaction of natural history specimens (pp. 229-38). From 1757 the systematic recording of donations was revived but in 1769 it lapsed again (pp.239-47). During the ensuing hiatus the most significant of all these additions arrived in the form of the anthropological specimens from Captain Cook's 1773-4 voyage to the South Pacific, given to the Museum in 1776 by Johann Reinhold Forster and his son George Forster, who together had accompanied Cook's second expedition to the South Seas in the capacity of naturalists.[10] This collection was never formally entered into the Ashmolean catalogues, but instead the keeper of the day, William Sheffield (1772-95) and the

[8] Many of these losses no doubt happened casually, but there were also more serious robberies from time to time: see Ovenell 1986, pp. 65-8, 133, 142, 147.

[9] Another statute declared: 'That whatsoever naturall Body that is very rare, whether Birds, Insects, Fishes or the like, apt to putrifie & decay with tyme, shalbe painted in a faire Velome Folio Booke, either with water colors, or at least design'd in black & white, by some good Master, with reference to the description of the Body it selfe...' Had such a book survived, it would have been of the greatest interest, but no such record exists.

[10] See '*From the Islands of the South Seas 1773-4*', exh. cat. Pitt Rivers Museum, n.d.

Visitors (to the extent that the latter continued at all to perform their detailed supervisory role of the collections) seem to have used as a check-list the manuscript inventory that accompanied the specimens and which survives today in the Pitt Rivers Museum: this forms a valuable addition to the following texts (see pp. 249-52).

Nineteenth-century reforms

Ultimately the role of the primary inventories was to some extent rendered redundant by the enterprising brothers J.S. Duncan (1769-1844) and P.B. Duncan (1772-1864), who successively held the keepership between 1823 and 1854, and to whose joint initiative the compiling of the Museum's first printed catalogue, published in 1836, can be attributed.[11] Between them, the Duncan brothers transformed the entire Museum, extensively refurbishing the building, clearing out many of the aged and decayed natural history exhibits and replacing them with large numbers of new specimens in an ambitious exposition of the tenets of 'natural theology', as expounded particularly by William Paley (1743-1805) (see MacGregor and Headon 2000). The flood of specimens attracted to the Museum during their joint keepership can be gauged from the extensive numbers of donors recorded in the 1836 catalogue and from the manuscript lists of acquisitions that supplemented them, reproduced here on pp. 241-7. The heavy bias of the 1836 catalogue towards natural history specimens, while it accurately reflected the Duncans' personal preoccupations, meant that the relevance of large parts of it was to be short-lived (see below).

A second printed catalogue published in 1868[12] records in summary form donations made to the Museum in the intervening years since 1836. Like the Book of Benefactors this is primarily a list of donors to the museum, giving scant information on the specimens themselves. From 1868 onwards were instituted the accessions registers which continue in unbroken sequence to the present day.

Needless to say, other manuscript inventories continued to play an important role in the Museum's day-to-day running. They record some of the fundamental changes that took place in the composition of the Ashmolean's collections in the later nineteenth century, as it lost control of significant parts of its holdings. The first of these major losses occurred with the founding of the new

Natural Science Museum (today the Oxford University Museum of Natural History) in the 1850s: all the natural history collections were formally transferred at this time, although many of the mineral and geological specimens had already been removed to the neighbouring Clarendon Building some years earlier and had been placed in the care of the relevant professors. Detailed records of exactly what survived to be transferred to the Natural Science Museum either were never compiled or have perished in the meantime. The coin collections similarly were transferred to the Bodleian Library at this time, but detailed records of the transfer are again lacking.

We are more fortunate in the case of the anthropological collections, removed to the Pitt Rivers Museum in 1886 and recorded before their departure in an exceptionally useful inventory (AMS 25). This detailed text, largely the work of the under-keeper of the day, Edward Evans, is also included here (pp. 255-413)

In a sense this latter document sounds the death-knell of the universal programme that characterized the institution devised by Ashmole. The transfer of this enormously important body of material, however, also formed the prelude to the rebirth of the Museum in its twentieth-century form.

Conclusion

The early catalogues have a continuing value beyond the obvious sense in which they form a record of the founding collection of the Museum (and indeed continue to form the primary records of a number of surviving specimens). More generally, they provide an index of the fluctuating levels of scholarship and the changing emphases in scholarly interest in the course of the succeeding centuries during which they remained in daily use. The supplementary lists included here extend the scope of the early catalogues, illustrating the growing tendency to specialization that ultimately was to deprive the Ashmolean of all but the rump of its original, universal collection.

The vacuum left behind by these transfers was filled by new collections of archaeological material and by specimens of decorative art from various sources (see MacGregor 1997, pp. 605-8), crowned by the huge gift of the Fortnum collection of fine metalwork, ceramics etc, which arrived in 1899 (Thomas and Wilson 1999). Ultimately, these moves were to define the character of the Ashmolean at the end of the nineteenth century, when it migrated from Broad Street to premises newly built behind the University Picture Galleries in Beaumont Street. In 1908 these two institutions were merged and their collections combined to form the foundation of the present-day Ashmolean Museum of Art and Archaeology.

[11] Ashmolean 1836. A little-known *Introduction* to this catalogue had been published in 1826 by John Duncan in which the principles of the arrangement were laid out but which contained no lists of specimens (see MacGregor and Headon, 2000).

[12] Ashmolean 1868. The catalogue is largely the work of G.A. Rowell, underkeeper at the Museum, who had also compiled the antiquarian section of the 1836 catalogue over half a century earlier.

THE BOOK OF BENEFACTORS

Transcribed and translated by Gloria Moss, annotated by Arthur MacGregor

Ashmolean Museum, AMS 2, compiled 1683-1766. Folio volume with modern board covers, quarter-bound in morocco and with reinforced corners, gold-lettered on the spine 'ASHMOLEAN MUSEUM, BOOK OF BENEFACTORS, 1683-1766'. 82 vellum leaves, 55 of them blank. 395 by 300 mm.

As implied by its title, the Book of Benefactors is not so much a record of material acquired by the Museum in its early years as a memorial to those who enriched the collections with their benefactions. Following Ashmole's founding gift to the University, comprising natural and man-made rarities, coins and medals, books and manuscripts, our attention is attracted first by a close-knit triumvirate of natural scientists who can claim an importance for the early history of the Museum in almost equal measure. A strong place for primacy in this group is made elsewhere (p. 153) for Martin Lister, who subscribed not only shells and fossils but also Roman antiquities from his native Yorkshire. Robert Plot, the first keeper, was similarly generous with donations of natural specimens (some of which had formed the raw materials for his *Natural History* of Oxfordshire) and Roman antiquities from his home territory in Kent. Edward Lhwyd, Plot's under-keeper and ultimately his successor, deposited many of the fossils or 'figured stones' on which much of his own reputation, as well as that of the Museum, was built before his early death in 1709.

The names of several important private collectors of the day appear in the lists, although major benefactions from any of them proved elusive. William Charleton and John Woodward both contributed modest numbers of specimens, but despite the expectations of the curators that they might look forward to 'many others of the same kind', they waited in vain. (Other collectors who were courted for contributions ‒ Sir Hans Sloane and Ralph Thoresby, for example, both received overtures ‒ were to resist those advances).

A number of specialist coin collectors were more forthcoming. Thomas Braithwait of Ambleside in Westmorland proved particularly generous and was encouraged in his philanthropy by Sir Daniel Fleming. John Sowter, a merchant of London, made several smaller benefactions over a decade or more, as well as sending occasional gifts of other material. The Revd James Ivie gave a useful series of Roman coins from Wiltshire while Richard Dyer contributed more recent numismatic specimens and several donors gave commemorative medals.

Amongst the additions to the early collections of antiquities, special interest attaches to the gift recorded in 1696 from Charles Hopkins. Not only does the 'gold plate' from Ballyshannon ‒ in fact a discoid ornament or 'sun-disk' of Bronze Age date (see Case 1977) ‒ represent the earliest documented discovery of a prehistoric artefact from the British Isles, but its documentation already extended to publication, in Gibson's edition of Camden's *Britannia*, which appeared in 1695. To the Roman antiquities from Kent contributed by Plot were added others from Reculver and Canterbury, given in 1686 by William Kingsley, but the most spectacular piece recorded here is of Anglo-Saxon date: the record of Thomas [*recte* Nathaniel] Palmer's gift in 1718 of 'a picture of an old man ... in a gold and crystal frame' is a surprisingly laconic acknowledgement of the acquisition of what remains today one of the Museum's most prized possessions ‒ the Alfred Jewel (see Hinton 1974, no. 23). Scarcely less remarkable are the two rune-stones sent from Sweden by John Robinson (chaplain to the English embassy to the Swedish court) in 1689 with the declared intention of ensuring that epigraphy of this nature was represented in Oxford (see MacGregor 1997, nos. 31.1-2).

Other inscriptions, noteworthy for the history of Egyptology, include the inscribed coffin lid acquired personally in Egypt and donated to the Museum in the year of its foundation by Robert Huntington (see Málek 1983) and the mummy contained in an inscribed coffin and given in the same year by Aaron Goodyear. The record of a further mummy, given in 1766 by Isaac Hughes, forms the final entry in the volume.

Ethnographic specimens, as yet classified with little more rigour than the 'artificial rarities' that had been received from the Tradescant collection, arrived from the furthest-flung colonies, though in small numbers. Sir William Hedges gave an 'idol' named Gonga or Ganga, brought back from India, where he had acquired it from an island temple at the mouth of the Ganges (see Harle 1983), while Roger Burrough gave a small marble figure of an Indian god. Edward Pococke, Regius Professor of Oriental Languages, enhanced the collections with Jewish as well as Turkish items acquired in the course of his travels, and another Oxford man, the Revd Thomas Hues, bequeathed what was evidently taken to be an inscription of some importance for the history of the 'Turkish church' in North Africa, where Hues had served in the Anglican ministry. A small collection of runic calendars arrived from Sweden in 1683, it seems in fulfilment of a pledge made during an earlier visit to England by their donor, John Heysig, when, evidently, he had learned of the newly founded Museum. From the Americas, Nathaniel Crynes gave a Mexican feather picture (a much sought-after commodity in Continental *Kunstkammern* of the period and one which was said to have been brought to England by Mary of Modena (Ovenell 1986, p. 137), Justinian Shepherd contributed a wampum belt and John Yeomans, a ship's captain from Bristol, was the donor of a canoe ‒ perhaps a model rather than full-sized, to judge from the fact that it came complete with a native occupant. Undoubted models followed also in the eighteenth century, contributed respectively by Dr George Clarke in 1719 (a warship) and by Dr Richard Rawlinson in 1757 (two types of Venetian boats).

More prominent, and doubtless considered of greater relevance to the new institution, were numerous gifts of natural history specimens. Edward Morgan, the celebrated plantsman, effectively founded the collection of plants with his donation in 1689 of some 2,000 specimens (almost all grown by himself) preserved in a three-volume *hortus siccus*. A further collection of plants as well as animals collected in India by James Pound, a physician, evidently included a number of specimens preserved in spirits, displayed for visual effect in glass jars in the windows of the Museum; a further sixteen specimens in jars, contributed by Smart Lethieullier, previously had formed part of the Woodward collection. Others came in the form of skins – a zebra from Charles Harris, an Angora goat from Timothy Lannoy and a lizard from Henry Johnson – or perhaps as stuffed specimens, as in the case of William Perrot's bat or 'flying fox'. Two significant donations of bird specimens – twenty-four of them from Edward Ent and what was evidently an interesting collection of northerly sea-birds from Nicholas Roberts, are also likely to have been stuffed specimens, while the only fish specimen recorded here, a 'Setang' from the Indian Ocean given by William Gibbons, may have been dried or in spirits.

Thomas Shaw's donation in 1716 of an extensive collection of insects caught in the Oxford neighbourhood forms a valuable indicator that the Ashmolean's sphere of interest encompassed entomology from at least this date.

The early importance of mineral and fossil specimens in the collections is more firmly founded. The interests of Lister, Plot and Lhwyd all converged in this subject-area and combined to establish the Ashmolean's reputation in this field by an early date. Woodward's tentative contribution was also in material of nature and there is evidence elsewhere in the archives that others were more forthcoming. Later in the eighteenth century, interest in the earth sciences enjoyed a brief revival under the enlightened keepership of William Huddesford, when further contributions to the collections were made by William Borlase, Thomas Pennant and Joshua Platt.

The experimental dimensions of the Ashmolean's role are alluded to only belatedly in the gift from Edward Seymour in 1756 of specimens of the chemical dyes which he had developed and, perhaps, in the huge lodestone sent in the same year by the Countess of Westmorland, which survives today in the Museum of the History of Science.

The Countess is one of three women recorded amongst the benefactors. Dorothy Long's ivory crozier-head remains in the collections, still prized although now recognized as twelfth-century work and as having no possible connection with the saint posited as its owner by the donor. Anne Mary Woodford's contribution of a paper collar ornamented in openwork by her own hand, has long since vanished.

Finally, it may be noted that two of the benefactors listed here, Ashmole's father-in-law Sir William Dugdale and the writer John Aubrey, contributed to the Museum's library with generous gifts of books and manuscripts rather than enriching its collections of exhibits. Here their volumes joined not only Ashmole's own extensive library but also the equally valuable manuscript collection of Anthony Wood, bequeathed together with over 1,000 printed books in 1695. The failure of Wood's bequest to register any impact in the Book of Benefactors underscores the very partial nature of the volume, while Ovenell (1986, p. 137) notes the presence in the text of several retrospective interpolations, indicating that even its present imperfect state resulted from intermittent rather than sustained attention. While the Book of Benefactors forms an interesting complement to the manuscript catalogues of the various Visitors, as reproduced below, its significance as a record of the collections themselves remains secondary.

[1r]

Munificentissimis optimisque cujuscunque
Conditionis Dignitatis aut Sexûs, qui Museum
Ashmoleanum Cimelijs quibuscunque, sive
Naturalibus sive Artificialibus, usque Locupletare
satagunt; Robertus Plott LL.D. Coll: Universitatis
Socio-Commensalis; istius Musæi Custos primarius
ac primus; et Regiæ Societatis Lond. Secretarius;
Hoc Volumen, Benefactorum tum nominibus, tum
donationibus inserendis accomodum, piæ, memoriæ,
virtutisque causâ, D.D.D. Anno Domini
MDCLXXXIII.°

Robert Plot LLD, Fellow-Commoner of University College, the first curator of this Museum and a first-rate one, and Secretary of the Royal Society in London, established this Book of Benefactors in the year of our Lord 1683 in order to keep a record of peoples' names and donations, and to bear witness to their piety and virtue. It contains the names of the most generous and excellent of persons who, whatever their means, sex or status, took pains to enrich the Ashmolean Museum with every conceivable kind of treasure, whether natural or artificial.

[3r -4r]

ELIAS ASHMOLE Aȓ: Lichfeldiæ natus, in Collegio Ænei Nasi apud Oxõn: educatus; Medicinæ Doctoratu, a Se non quæsito, sed totius Universitatis spontaneo motu et applausu insignitus. Nec in rebus gerendis minores honores meruit. Fecialis primum Windlesoriensis, postea vero ob celebratissimam in Aspidologia peritiam, quam Volumine satis magno de Honoratissimo Periscelidis Ordine propalavit; in summam istius Collegij dignitatem, nisi ipse nimis modestè restitisset, evehendus.

Quantum in rerum Antiquarum cognitione excelluerit, locupletissima accedunt Testimonia: REX ipse Serenissimus, et Universitas: Qui Ipsorum penu rei antiquariæ componendum Ipsi commiserunt: Et quid Notis præstitit, tria Volumina propria manu conscripta et in Bibliothecâ Bodleyanâ reposita, testantur; industriæ et Eruditionis illustre Posteris monumentum. Ejus demum diligentiæ et fidelitatis REX probe conscius, Vectigalium suorum

a Parliamento A°. Reg: 12° institutorum inspectionem (quod Contra rotulatoris vel Correctoris officium nominamus) Ipsi demandavit, Laborum et Fidei suæ præmium et argumentum.

Quinetiam Philosophiæ Naturalis, Chymiæ, ac totius politioris Literaturæ scientia celeberrimus: Is erat qui hoc Musæum, Naturæ Ærarium, Historiæ Physicæ compendium, Cæli, Aeris, Aquæ, Terræ incolis; nec non Monstrorum varietate; in usum communem (cum Ipse satis ea cognovisset) uberrime instruxit. Quicquid mare Ligusticum Coralliorum, quicquid Erythræum Margaritarum, quicquid item Indiæ Gemmarum produxere, Huc Ipsius operâ confluxerunt. Metalla insuper, Metallica, Mineralia, et quicquid Terra sinu suo interiori fovit, huic contribuit. Aromata, Medicamque materiam universam hactenus cognitam, Vir nunquam pro merito laudandus, hic reposuit.

Ac Mantissæ loco, Romanorum, aliorumque fere totius Orbis Gentium, Arma, Vestes, Ornamenta, Deos, Sacrificandi Vasa, Mortuorum Urnas et Lachrymatoria, addidit. Numismata insuper, Simulacra, Imagines, Picturas, reliquis rarioris notæ Cimelijs, accumulavit. Solus inquam nobilissimus ASHMOLUS hoc Musæum non magis totius Mundi universâ suppellectile, quam suo Nomine decoravit. Quibus omnibus quoniam Volumen istud sigillatim recensendis vix suffecerit, Eorum Catalogus tempore opportuno seorsim Typis mandabitur.

Idem Clarissimus Vir Elias Ashmole Armiger, Numismata Romana, Anglica, Scotica &c. quingenta quinquaginta sex, omnia argentea, Musæo suo secundâ vice donavit.

Idem insignissimus Vir Elias Ashmole Armiger, Effigies item Serenissimorum Principum Caroli et Jacobi fratrum Regum Angliæ, Limbis eleganter cælatis ac deauratis, adornatas contulit.

Idem Ornatissimus Vir D: ELIAS ASHMOLE Armiger, Numisma archetypum aureum, tum magnitudine tum formâ prostantissimũ, a Carolo Gustavo Suecorum Rege, Gulielmo Lilio Anglo Astrologorum principi, ob prognosticationes Sibi fælices, ac eventu comprobatus, gratè missum, suo Musæo donavit.

ANNO SUPRA MILLESIMUM ET SEXCENTESIMUM NONAGESIMO SECUNDO, Vir ille maximus Rem literariam promovere, et MUSÆUM istud artis et nature cimilijs adornare desijt: Ad extremum Vitæ Articulum, omnimodam Eruditionem stabiliendi tanto flagrans ardore; ut Librorum mille et septingenta volumina, quorum sexcenta ad minimũ MSS. sunt, Bibliothecæ quam idcircò suo nomini meritò inscripsimus, legaverit. Porrò quæ à maximis Principibus, Invictissimo Danorum Rege et Duce Brandenb. alijsque acceperat invicti laboris et virtutum Præmia honoraria; Catenas nempè aureas cum adjunctis numismatibus;

in hoc Gazophylacio post obitum conservari voluit: ut juniores (salivam eis movendo) ad Studia acrius prosequenda, proprio exemplo hortaretur.

Elias Ashmole Esq. was born in Lichfield and educated at Brasenose College, Oxford. He did not himself supplicate for a Doctorate in medicine, but was singled out for this honour by the spontaneous acclamation of the whole University. Nor in his active life did he deserve any less honour. He was first Windsor Herald and, on account of his celebrated expertise in the field of heraldry, which he displayed to the full in a large book he wrote on the most noble Order of the Garter, would subsequently have been raised to the highest honour in the College, had he not modestly declined the offer.

His knowledge and excellence in the field of antiquities is abundantly confirmed by reliable sources, including His Majesty the King and the University which entrusted to him the task of arranging the antiquities [*i.e., the Bodleian coin cabinet*]. His more outstanding achievements are testified to by three volumes written in his own hand and kept in the Bodleian Library. They serve as a conspicuous reminder to future generations, of his hard work and erudition. Finally, the King, very much aware of his industry and fidelity, appointed him in the twelfth year of his reign, to inspect the taxes instituted by Parliament (a post we nowadays term comptroller general of excise) as a proof of, and reward for, his diligence and faith. Indeed, he was famous for his knowledge of Natural Philosophy, chemistry and the whole body of literature. It was he who most fully equipped this Museum for public use, as a treasure-house of Nature and the history of Natural Science, with its collection of whatever inhabits the sky, air, water and earth, and also of various curiosities, after he himself had learned enough about these things. Whatever corals might come from the Ligurian Sea; whatever pearls from Erythrea; whatever gemstones were found in India - these things were brought together here by him. Then he added metals, minerals and whatever the earth produces in its interior. And this man whose merit is beyond praise, collected spices and materia medica.

And he gave objects, both Roman and of people from almost every part of the world - arms, clothing, jewels, statues of gods, sacrificial vessels, burial urns and lachrymatories, and furthermore, to the rarer and more notable treasures of the museum, he added coins, statues, pictures and paintings. The most noble Ashmole graced this museum as much with his own name as with artefacts from all over the world. And since this volume would scarcely be large enough to record all these objects individually, another catalogue will be ordered, at a suitable time, in which they will be listed separately by type. In his second series of gifts, the most illustrious Elias Ashmole gave 556 silver coins - Roman, English and Scottish ones among them. The same distinguished Ashmole also brought portraits of King Charles and King James of England, in elegantly carved and gilded frames.

This most excellent of men, Elias Ashmole Esq., bestowed upon his Museum an original gold medal remarkable for both its size and its form, which King Karl Gustav of Sweden had gratefully sent to his chief astrologer, William Lilly, for certain favourable prognostications he had received and which, in the event, proved to be true. In the year 1692 this great man ceased to promote literary activities and to add to the Museum's collection of the treasures of nature and art. To the end of his life he was eager to establish learning of all kinds and, to that end, he bequeathed 1,700 books, at least 600 of which are in manuscript, to the library, which for this reason we have provided with an inscription of his name. In addition, he wanted his *Praemia Honoraria*, the golden chains and medals, which he had received from those best of princes, the King of Denmark and the Duke of Brandenburg, and others, in recognition of his indefatigable work and achievements, to be preserved in this Museum after his death, so that, by stirring their ambition, he might, by his own example, encourage young men to pursue their studies with greater enthusiasm.

[6r]

A.D. MDCLXXIII.

AARON GOODYEAR Civis Londinensis ad
emporia Ottomanica mercaturam exercens,
succedentibus benefactoribus, post ASHMOLUM,
exemplar optimum: ex innato generositatis instinctu
in ipsis Cimeliarchii hujus natalitiis, donavit
integrum corpus humanum, quod vocant Mummi, ab
Alexandria advectum; exterius characteribus, et
figuris aliquot hieroglyphicis inscriptum et ornatum;
interius bitumine, et aromatibus, more Aegyptiaco,
conditum; cerotis, et fasciis involutum, et hoc modo
à putredine vindicatum.

A.D. 1683
Aaron Goodyear, citizen of London and a merchant trading with
Turkey, was, after Ashmole, a most worthy model for later
benefactors. From a natural impulse of nobility, and at the
opening of this museum, he donated an entire human body,
known as a mummy, which was brought from Alexandria. The
outside is inscribed and decorated with characters and several
hieroglyphic figures; the inside is preserved with bitumen and
spices in the Egyptian manner; it is covered with plaster and
bandages to protect it from decay.

A.D. MDCLXXXIII.

ROBERTUS HUNTINGTON S.T. Professor,
Collegiorū Mertonensis hic Oxonii Socius, ac SS. et
Individuæ Trinitatis prope Eblanam in Hibernia
Præpositus: Mercatoribus Anglis in urbe Halebensi
haud ita pridem a Sacris; in Aegyptum peregrè
profectus, duos lapides satis magnos, characteribus,
ac imaginibus hierogliphicis notatos, summo sudore
ac sumptu sibi comparavit, nec minori affectu, amici
sui Goodyeari æmulus, huic Musæo contribuit.

A.D. 1683
Robert Huntington was Professor of Theology, Fellow of
Merton College, Oxford, and Provost of Trinity College, Dublin,
in Ireland. Once a chaplain to the English traders in Aleppo, he
left for Egypt and obtained, at great expense and effort, two
moderately large stone reliefs with hieroglyphic characters and
pictures, and with as much enthusiasm to rival his friend
Goodyear, gave them to this Museum.

[6v]

A.D. MDCLXXIII.

JOHANNES ELIOT, olim e Collegio Exon,
utriusque Academiæ Medicinæ Doctor, facultatem
suam apud Cantuarienses Felicissime exercens,
Calculum eximiæ, quidem magnitudinis e vesica
puellæ octennis sua manu excisum, una cum duobus
lapidibus ad Ammonis cornu similitudinem
naturaliter formatis, quorum alter armatura ænea
obductus, huic Musæo lubens donavit.

A.D. 1683
John Eliot, formerly at Exeter College and a Doctor of Medicine
of both Universities, practised successfully in Canterbury and
removed an exceptionally large urinary stone from the bladder
of an eight-year-old girl with his own hands. He gave it to the
Museum together with two naturally formed stones, one of them
mounted in bronze, which resemble the horn of Ammon.

Præclarissima Heroina DOROTHEA conjux
generosissimi simul ac eruditissimi viri Domini
Iacobi Long de Draycot Cern in Comit. Wilts
Baronetti; Domus et sexus sui decus et ornamentum;
primitivæ Religionis, et venerandæ antiquitatis
cultrix optima: ex pietate sua, et summa in hanc
Universitatem benevolentia, Pastorale pedum Sancti
AUGUSTINI Hipponensis Episcopi ex ebore
cælatum, inter Cimelia hujus Musæi reponendum
dedit.

The most noble of ladies, Dorothy wife of that most generous
and learned of men, Sir James Long, Bart., of Draycot Cerne in
the county of Wiltshire, was the pride and joy of her family and
her sex, and showed a deep interest in primitive religions and
antiquities. Her piety and great good will to this University led
her to give a carved ivory crozier which had belonged to Saint
Augustine, Bishop of Hippo, to this museum to be placed with
the other treasures.

[7r]

A.D. MDCLXXXIII.

JOANNES COLVIL de Kelling in Comitatu
Norwicensi Generosus ad Scientiam tum naturalem
tum artificialem promovendam, huic Musæo dono
dedit Calculum adeo magnum e vesica cujusdam
Beatricis Shreve de Tunsted in eodem Comitatu sine
ulla aut sectione, aut dilaceratione extractum,
admirando sane artificio Iohannis Hubberti Civitatis
Norwicensis Chirurgi peritissimi; ut Prætor,
Eirenarchæ, Aldermanni, totusque ejusdem Civitatis
in Curia Municipali consessus, rei veritatem
instrumento ad id facto, Sigillo communi, et ipso
lapide munito, ne incredibile videretur, posteris
transmittere par esse duxerint.

A.D. 1683
John Colvil of Kelling in Norfolk, in his concern to promote the
study of science, natural as well as artificial, gave this Museum
a very large stone which was removed with admirable skill by
the highly experienced surgeon, John Hubbert of Norwich, from
the bladder of a certain Beatrice Shreve of Tunstead in the
same county, without either any incision or tearing. To dispel all
disbelief, the mayor, justices of the peace, aldermen and
members of the city's council, all gathered together in the town
hall thought it only fitting to pass down to posterity the truth of
the event by drawing up a document to this effect, sealed with
the city seal, and by mounting the stone itself.

A.D. MDCLXIII.

GERVASIUS WILCOX Civis et Piscarius
Londinensis in augmentum hujus Armarii, et
perpetuum id genus hominum dedecus, et
opprobrium, dono dedit Pseudo-protestantium
flagellum, quo nefarii quidam ardeliones, e quibus
Stephanus Colledge hic Oxonii laqueo plexus,
Monarchiæ, Ecclesiæ, ac Universitatibus, minus
prospere (laus Deo) ruinam intentabant.

A.D. 1683
Gervase Wilcox, citizen of London and fishmonger, gave the
Museum a so-called protestant flail, a weapon with which
certain unlawful zealots attempted unsuccessfully, thank God,
to subvert the Monarchy, the Church and the Universities. From
their ranks Stephen College was hanged at Oxford. Gervase
Wilcox added it to the Museum's collection as a perpetual
cause of shame and a reproach to men of that kind.

[7v]

A.D. MDCLXXXIII.

JOANNES HEYSIG Sueco-Holmensis, vir sane
morum candore, ac omni eruditionis genere
spectatissimus, benevolentiæ suæ arrham, plura
daturus, in hoc Musæo tabulam Antiquitatum

Runicarum, ac tria Kalendaria e ligno Runica,
Agricolis passim in Borealioribus Sueciæ et
Lapponiæ partibus etiamnum usitata; unà cum
duobus Numismatibus, CAROLI sc. IX. Suecorum
Regis, nec non Iohannis Schefferi Arg. Prof. Upsal.
in patriam rediens, grato animo reliquit.

A.D. 1683

John Heysig, of Holmen in Sweden, a man renowned for his
integrity and knowledge in many fields, on his return home, left
to this museum, as a pledge of his good will and with the
intention of giving more, an ancient runic tablet and three
wooden runic almanacs of the kind still used today by farmers
in the northern parts of Sweden and Lapland, together with two
medals, one of King Charles IX of Sweden, the other of
Johannes Scheffer Esq., Professor of Uppsala.

[8r-8v]

A.D. MDCLXI11.

MARTINUS LISTER Armiger, Equitis Aurati filius,
Medicinæ Doctoratu, gradu à se non quæsito, sed ab
Academia, ipso inscio, bene merenti tamen, sponte
delato, hic Oxonii insignitus; Vir praxi et scriptis
clarus: ut scientiam naturalem usque promoveret,
istud Musæum omne genus Cochleis; marinis,
fluviatilibus, ac terrestribus; Mytilis item
fluviatilibus; lapidibus formatis; fluoribus; variisque
selenitum, micarum, talcorum, omniumque
metallorum, speciebus; maximam in partem
Anglicanis, ditavit. Atque ut prisca posteris
vindicaret, multa tum Romanorum tum Britannorum
monumenta, sc. Altaria, numismata, annulos, sigilla,
ac idgenus alia; in plura superstes, benevolus
addidit.

Idem ornatissimus VIR, ut benefactionem suam
magis absolutam redderet, varios Libros, varijs
rerum Naturalium historijs refertos, Catalogo suo
recensitos; eidem Musæo addidit.

A.D. 1683

Martin Lister Esq., the son of a Knight, was awarded a
Doctorate in Medicine for which he had not himself supplicated
but which was spontaneously conferred on him by the
University of Oxford; he had no foreknowledge of this, but
amply deserved it. He was famous for his deeds and his
writings; and in order to further the study of Natural History, he
enriched this museum collection with shells of all kinds, from
the sea, from the rivers and from the land; also freshwater
mussels; formed stones and fluors, and various types of
gypsum, mica, talc and metals of all kinds, most of which come
from England. Furthermore, to preserve the past for posterity,
he generously gave the Museum a large number of antiquities,
Roman as well as British, which included altars, medals, rings
and seals.

This most excellent of men, to make complete his generous
gift, also gave the Museum a variety of books, listed in his own
catalogue, illustrating different aspects of Natural History.

[9r]

A.D. MDCLXXXIV.

IOHANNES YEOMANS Civis et Navarchus
Bristolliensis in partibus Americæ Boreazephyris
Mercaturâ faciens, Cymbam istis regionibus
propriam vulgò Canoe dictam (unicum Remigem
vehentem tunicâ hirsutâ indutum) Remis, fuscinâ,
Deoque tutelari instructam, pretio conquisivit, ac in
hâc fidissimâ statione anchoram ponere statuit.

A.D. 1684

John Yeomans, citizen of Bristol and ship's captain, trading in
north-western America, bought a boat peculiar to these parts
commonly known as a canoe, which carries a single oarsman
dressed up in rough clothing, is equipped with paddles and a
harpoon, and is guided by a tutelary god. He decided to anchor
it in this most beautiful of places.

A.D. MDCLXXXIV.

GULIELMUS GIBBONS Medicinæ Doctor et
Collegij S.ti Johannis Baptistæ socius, Vir in facultate
suâ peritissimus, ad Scientiam Naturalem
promovendam, et ut piscium numerum usque
adimpleret, Pisciculum cornutum, Indis Ican. Setang
(plurium arrham) benevolus addidit.

A.D. 1684

William Gibbons, Doctor of Medicine and Fellow of St. John's
College, a great expert in his field, generously offered the
Museum a little horned fish from the Indian ocean, known as a
Setang, in order to promote the study of Natural History and to
add to the Museum's collection of fishes. (We hope for more).

[9v]

A.D. MDCLXXXIV.

EDVARDUS ENT, Honoratissimi viri Dñi Georgij
Ent Militis, Collegij Medicorum Londinens. Præsidis
moderni filius, è Collegio Baliolensi, in Jure Civili
studiosus, ac Arcanorum Naturæ indagator
solertissimus, ut hujus Musæi maxime hiantem
Lacunam aliquo usque suppleret, illud 24 Avibus
(cujusque ferè speciei nonnullis) lubens instruxit.

A.D. 1684

Edward Ent, son of the most celebrated Sir George Ent,
President of the Royal College of Physicians, was a student of
Civil Law at Balliol College, and also took a very keen interest in
the mysteries of Nature. He was happy to be able to give the
Museum twenty-four birds (some of them wild) in order to fill a
major gap in the Museum's collection.

A.D. MDCLXXXIV.

THOMAS BRATHWAIT de Ambleside in Com.
Westmorlandiæ Armiger, venerandæ Antiquitatis
cultor maximus, ut istud Musæum in unoquoque
genere Cimeliorum absolutissimum redderet, Ei
trecenta ac amplius Numismata antiqua (quorum 6
ex auro, 66 ex argento, cætera ex ære) moriens
legavit.

NB. Dignissimo huic Viro D. Braithwait ut
Numismata hæc Universitati legaret, primum
persuasit; dein[de], ut ad nos mitterentur curavit
Nobilis, et Eruditissimus Vir D.D. Daniel Fleming
Eques Auratus, de Rydal-Hall in Comitatu
Westmoriæ, olim è Collegio Reginæ Oxoñ.
Commensalis, pro summo in Literas reconditiores
Amore, et singulari in hanc Universitatem
Benevolentia.

A.D. 1684

Thomas Braithwait Esq., of Ambleside in Westmorland, who
was a great antiquary, gave this museum at his death more
than 300 ancient coins, six of which are of gold, sixty-six of
silver and the rest of bronze, in order to make the Museum
unrivalled in one of the areas of its collection.
N.B. The person who first persuaded the noble Mr Braithwait to
leave his coins to the Museum, and who then saw to their
delivery, was the great and learned Sir Daniel Fleming, from
Rydal Hall in Westmorland. He was formerly a commoner of
Queen's College, Oxford, and he did these things out of a deep

love for scholarship and singular generosity to this University.

[10r]

A.D. MDCLXXXV.

Reverendus admodum in Christo Pater ac Dominus D. Johañes permissione divinâ Oxõn Epũs, ac Ædis Christi Decanus duo Numismata archetypa, unum ex auro, alterum ex argento, ad inaugurationem serenissimi IACOBI secundi, et MARIÆ BEATRICIS Regis et Regine Angliæ &c. Apr. 23.°An.1685° percussa; una cum Africæ Periplo; ac duabus Chartis Chorographicis antiquis, Universitatum tum Oxoniensis tũ Cantabrigiensis; in suæ erga Musæum Ashmoleanum benevolentiæ τεκμήριον (plurium spem faciens) Eidem contulit.

A.D. 1685
The very Reverend Father in Christ, John [Fell], by the Grace of God Bishop of Oxford and Dean of Christ Church, gave the collection, as a token of his good will to the Ashmolean Museum, two original medals, one of them gold and the other silver, struck to commemorate the coronation of their Royal Highnesses King James II and Queen Mary Beatrice of England on 23 April 1685; also an outline map of Africa and two ancient maps of the Universities of Oxford and Cambridge. (One hopes that there may be more.)

[10v]

A.D. MDCLXXXVI.

GULIELMUS KINGSLEY Armiger Ecclesiæ Metropoliticæ, Cantuariensis accola, rei antiquariæ peritissimus, ex integerrimo suo in hanc Academiam affectu; Musæum istud, non tantum Libris M.S. sed multis item alijs Antiquitatum ruderibus, Regulbij ac Durarvenni repertis (in plura superstes) gratabundus ditavit.

A.D. 1686
William Kingsley Esq., resident near the cathedral at Canterbury and a notable antiquary, out of regard for the University, was happy to enrich this museum not only with manuscript volumes but also with ancient remains of Reculver and Canterbury.

A.D. MDCLXXXVI.

GVLIELMVS CHARLETON è medio Templo London: Armiger rerum naturalium, domi, forisque ubique Gentiũ, explorator sagacissimus; hujus Musæi instructissimi quasi consummationem intentaret; eidem, è penu suo cumulatissimo, Zygænam piscem integram, varias tum Coralliorum tum Conchyliorum species, Numismata item nonnulla (plurium pignora) piè sacravit.

A.D. 1686
William Charleton Esq. of Middle Temple in London, was a keen observer of nature and of peoples everywhere, at home and abroad. As if to perfect this already well-equipped Museum, he supplied it, from his own abundant collection, with a complete hammer-headed shark, as well as various species of corals and shells, and a large number of coins.

[11r]

A.D. MDCLXXXVII

GULIELMUS DUGDALE de Blithe Hall in parœcià de Shustoke in Comitatu Cornaviorum Warwicensi Miles, Garterij nomine Armorum Anglicorum Rex, Vir in re antiquariâ consultissimus, pro summo suo in Generum suum meritissimum D. Eliam Ashmole favore, ac gratitudine; ac in augmentum famæ hujus Musæi, Ashmoleano nomine insigniti; quadraginta octo Libros M.S. (quorum 43 in folio, 5 in quarto) Antiquitatum Britannicarum ineffabili varietate refertos, in adjunctâ Bibliothecâ Ashmoleanâ reponendos legavit.

A.D. 1687
Sir William Dugdale, Garter King-of-Arms, of Blyth Hall in Shustoke in Warwickshire, a most learned antiquary, bequeathed forty-eight volumes in manuscript (forty-three folios and five quartos) on a wide range of British antiquities to be placed in the adjoining Ashmolean library. He gave them out of gratitude to and the deepest appreciation of his estimable son-in-law, Elias Ashmole, and to add to the reputation of this Museum which carries the distinguished name of Ashmole.

[11v]

A.D. MDCLXXXVIII.

ORNATISSIMUS Vir D. Samuel Butler generosâ apud Danmonios ortus prosapiâ, et in Civitate apud eosdem Exoniensi, Mercaturam felicissimè impræsentiarum exercens; pro summâ suâ in hanc Academiam benevolentiâ, Ramentum pretiosissimum Sacrosanctissimæ Crucis in quà olim pendebat JESUS Salvator mundi, capsulâ aureâ cruciformi inclusum, in isto Musæo, (tanquam in Hierophylacio) piè reponi curavit.

A.D. 1688
The excellent Samuel Butler was born into a noble family in Devon and lived near them in the city of Exeter as a successful merchant. Out of his deep affection for this University, he devoutly deposited within this Museum (as within a shrine) a precious fragment of the Holy Cross, contained in a gold cruciform box, on which Jesus, the Saviour of the World, was crucified.

A.D. MDCLXXXVIII.

CLARISSIMUS Vir D. Theophilus Leigh de Longborough in Comitatu Dobunorum Glocestrensi Armiger, ne plæclari facinoris memoria, aut quid Rari in isto Cimeliarchio, deesset; Eidem Numisma quoddam tum magnitudine tum cælaturâ præstantissimum, ex ipsissimo Argento cusũ, quod Angli e navi Hispanorum (propè Jamaicam) naufragâ expiscati sunt, lubens contulit.

A.D. 1688
The most illustrious Theophilus Leigh Esq. of Longborough in Gloucestershire, willingly brought to the Museum a medal, remarkable for its size and engraving, struck from the very same silver which the English recovered from the wreck of a Spanish ship (near Jamaica), in order to ensure that this notable feat was not forgotten, and that the museum did not lack such a rare object in its collection.

[12r]

A.D. MDCLXXXIX.

NICHOLAUS ROBERTS Menevensis, A:M. é Collegio Jesu, Historiæ naturalis studiosus, rerumq; naturalium in solo Patrio indagator sagacissimus; ut Musæum istud usq; locupletaret, Aves aliquot marinas plagis Septentrionalibus peculiares, Anatem sc. Arcticam Clusij; Lomwiam et Alcam Norvegiensium Hoieri; aliasque insuper nonnullas in Dimetiam migratorias; plurium spem faciens, Eidem beneficus addidit.

A.D. 1689

Nicholas Roberts MA, from St. Davids and of Jesus College, was deeply interested in Natural History and a keen student of the natural history of his own country. In order to add to the riches of the Museum, he kindly donated several sea-birds found only in the northern regions. These included an arctic duck of Clusius, a guillemot and a Norwegian auk of Hoier and several other migratory birds, which makes one hope that there may be more.

A.D. MDCLXXIX.

EDVARDUS MORGANIUS Glamorganensis, Horti Botanici qui Westmonasterij olim floruit Cultor celeberrimus, Vir de re Herbariâ optimè meritus; ab Edvardo Lloydo (hujus Musæi Procustode) certior factus, Hortum siccum, seu stirpium rariorum collectionem in Eo desiderari: tria ingentia volumina, duo circiter millia Plantarum specimina continentia (quas Ipse fere omnes in præfato Horto enutrierat) Eidem moriens ex animo legavit.

A.D. 1689

Edward Morgan from Glamorgan, the celebrated former keeper of the botanical gardens at Westminster, and a man extremely knowledgeable about plants. When he heard from Edward Lhwyd (under-keeper of this Museum) that the collection lacked a hortus siccus or a collection of [dried] plants, he bequeathed to the Museum three large folio volumes containing some 2,000 specimens of plants (almost all of which he had grown himself in the aforementioned garden).

[12v]

A.D. MDCLXXXIX.

INSIGNISSIMUS Vir D. JOHANNES AUBREY de Easton-Piers in Agro Belgarum Wiltonensi, Armiger; Collegij SS. Trinitatis Oxon. olim Alumnus, præter Libellos, tum MSS. tum impressos, plus minus Octaginta; diversas illustrium virorũ Effigies; Numismata Romana, Eorumque matrices lateritias; Operis item Musivi sive Tessellati specimen (quæ omnia suis Catalogis respectivè recensentur)ex Amore suo in D. Ashmolum, Musæumq;suum propensissimo, eidem ex mero motu contribuit.

A.D. 1689

The most distinguished John Aubrey Esq., from Easton Piercy in Wiltshire, formerly a scholar at Trinity College, Oxford, out of regard for Ashmole and his Museum, gave some eighty small books (some of them printed, some in manuscript), and in addition, several portraits of famous men, Roman coins and their clay matrices, and also a fragment of a mosaic or pavement (all of which are carefully listed in the catalogues).

A.D. MDCLXXXIX.

EGREGRIUS Vir D: JOHANNES ROBINSON AM: et Collegij Orielensis olim Socius, JACOBI Secundi apud Regem Sueciæ Minister ordinarius; ne Inscriptiones cujuscunque Gentis aut Linguæ hic Oxonij deessent, duos Lapides satis magnos Runis inscriptos, summo sudore ac sumptu ibidem comparavit, in Angliam benevolus transmisit, ac in Atrio hujus Musæi (pro honestate loci) lubens erigi voluit.

A.D. 1689

The distinguished John Robinson MA, former Fellow of Oriel College and King James II's Envoy-Extraordinary to Sweden, concerned that inscriptions of any people or language should be lacking from Oxford, obtained, at great trouble and expense,

two monumental runic stones, and generously sent them to England to be set up in the forecourt of the Museum (to grace their surroundings).

[13r]

A.D. MDCXC.

Clarissimus Vir D. GULIELMUS HEDGES Miles, Civis et Mercator Londinensis, in Indiã Orientalem peregrè profectus, Idolum Gongam, e Pagodâ Insulæ Sagur in ostio Gangis, post Benharum et Jagernotum, dignitate proximâ, summâ sagacitate procuravit; ac pro impenso suo, quo Academiam hanc prosequitur affectu, in isto Musæo, tanquam in Sacrario magè congruo (plurium Arrham) reponendum transmisit.

A.D. 1690

The famous Sir William Hedges, citizen and merchant of London, showed great discernment in procuring, on his travels in India, an idol of (the goddess) Gonga from a pagoda on the Island of Sagur at the mouth of the Ganges, a temple second in importance only to that of Benares or Juggernaut. He sent it at his own expense to this Museum, as if to a fitting shrine, and in this way honoured the University. (There may be more to come).

[14r-14v]

A.D. MDCXCI.

ROBERTUS PLOT LL: D. Collegij Magnæ Aulæ, (Universitatis vulgò dicti) olim Sociocommensalis; Regi JACOBO II.° Historiographus; Illustrissimo Principi HENRICO Norfolciæ Duci, Summo Angliæ (Comitis titulo) Mareschallo, in Curiâ suâ Militari, Registrarius; Primus in hâc celeberrimâ Academiâ Professor Chymicus; hujusque MUSÆI Custos primus ac primarius. Vir ob ingenij præstantiam et omnimodam eruditionem quam meritò celebris:

quod etiã facilè agnoscent quotquot Agri Oxoniensis et Staffordiensis (ut alia jam præteream) Historias Naturales ab ipso editas, æquo animo pensitaverint. Is postquam Gazophylaceum hocce Ashmoleanum, per septem Annos summâ fide ac diligentiâ procurasset, Londini tandem ad majora provectus, ideoque officio cedens, succedentibus Cimeliarchis industriæ juxta ac munificentiæ exemplar maximum (utinam et non impar humeris) reliquit. Omnia siquidem donavit cujuscunque generis Fossilia quæ in Agro Oxoniensi et Staffordiensi nata, ipse primus feliciter detexerat, quorumque Icones non minus elegantes quã descriptiones accuratas, earundem Provinciarũ Historijs dudum exhibuerat. Multa insuper Mineralia, et antiqua Romanæ in hanc Insulam Potestatis monumenta, cum in patrio solo Cantiano effossa, tum alibi locorum per Britanniam undique quæsita; Quin et exotica non pauca, Conchylia, Mineras, Metalla; Terras, Salia, Lapides; Alcyonia, Poros, Corallia, aliaque id genus multa, (quamvis et plura adhuc sperare jussit) quæ à naturæ operum studiosis spectentur dignissima, huic Musæo lubens contulit; communi Physiologorum commodo benevolus dicavit.

A.D. 1691

Robert Plot LLD, Fellow-Commoner of University College; Historiographer-Royal to King James II; military secretary to the most illustrious Duke Henry of Norfolk, Earl Marshal of

England; first professor of Chemistry in this great University, first and best curator of this Museum. He was deservedly celebrated for his superior talents and universal erudition, which anyone who has impartially read the Natural Histories of Oxfordshire and Staffordshire which he has published will acknowledge (as well as other works which I pass over). After he had directed the Ashmolean Museum with great commitment and diligence for seven years, he finally gave up that post and moved to London, leaving to future keepers a great example of hard work and of generosity (we hope not a burdensome one). He donated to the museum the great variety of material which he was luckily the first to uncover in Oxfordshire and Staffordshire, and he published fine illustrations and careful descriptions of them a short while ago in his histories of these counties. He also gave many minerals, and ancient objects from the period of the Roman occupation of this island, which he had both excavated in his native county of Kent and acquired elsewhere from all over Britain; and also a fair number of exotic items such as shells, minerals, metals, earths, salts, stones, tufa, sponges, corals and many other things of that kind (he told us to expect more) which are considered to be of great value by students of Natural History. These he willingly donated to the museum and generously dedicated them to advance the cause of the natural sciences.

[16r]

A.D. MDCXCII.

Reverendus admodum et celeberrimus Vir, D. EDVARDUS POCOCKIUS SS. Th:D. et Lingua. Orient: Professor Regius; nonnulla ad Religionem Judaicam spectantia, huic etiam Cimeliarchio dicari voluit: Nempe 1.° Librum Estheræ quē in festo Purim (quod incidit in 14 et 15 Februarij) legunt Judæi in Synagogis. 2.° Tubam Judaicā ex cornu Arietis, quam a primo Augusti ad vicesimum octavum, singulis diebus manè et vesperi inflare solent; uti et ipso etiam die Expiationis. 3.° Phylacteria capitis; quæ sunt quasi memorialia præceptorum Dei. 4.° Phylacteria manus, quæ sinistro nudo brachio alligantur, ut sint quasi é regione cordis. 5.° Flagellum castigatorium quo utuntur Judi, ex triplici corio, asinino scil. ovillo et bovino contextum. Quin et post mortem ejusdem insignissimi Viri, Vestem quandam Turcicam honorariam accepimus quâ olim, Vir a moribus et eruditione, Barbaris etiam colendus; dum per Imperia Ottomannica peregrinaretur, donatus est.

A.D. 1692
The Very Reverend and celebrated Edward Pococke, Doctor of Divinity and Regius Professor of Oriental Languages, decided to give the Museum various objects pertaining to the Jewish religion, namely: 1, The Book of Esther which is read by the Jews in Synagogue at the Festival of Purim (which falls on 14 and 15 of February). 2, A Jewish trumpet made of a ram's horn which is blown every day, both morning and evening, between 1 and 28 of August, and also on the day of Atonement. 3, Philacteries worn on the forehead to be a reminder of God's laws. 4, Philacteries worn on the arms which are tied to the bare left arm to be close to the heart. 5, A Jewish whip with a triple thong made from the skin of the ass, sheep and ox. In addition we received, after this very distinguished man's death, a Turkish robe of honour which he, respected even by a foreign people for his character and learning, was presented with during his travels in the Ottoman Empire.

[16v]

A.D. MDCXCII.

Reverendus Vir D. THOMAS HUES, Vicarius Ecclesiæ, Laycokiensis in Comitatu Wiltoniæ, olim

Exercitui Anglicano in Mauritaniâ à Sacris. Is dum Antiquitates Tingitanas curioisus lustraret, Lapidem characteribus Arabicis luculenter exaratum nactus, qui ejusdem loci Ecclesiæ Turcicæ Fundationem et annuos Reditus doceret; in patriam redux secum abduxit et Academiæ Oxoniensi, cujus Alumnus olim fuerat, moriens legavit.

A. D. 1692
The Reverend Thomas Hues, vicar of Lacock in Wiltshire, formerly served with the English military forces in Mauritania. While examining some ancient objects in Tangiers, he happened upon a stone clearly inscribed with Arabic characters, which recorded the foundation of the local Turkish church and its annual revenues. He took it back with him on his return home, and at his death, bequeathed it to the University of Oxford, where he had once been a student.

A.D. MDCXCII.

IOANNES SOWTER Mercator Londinensis; Vir singulari ingenio et suavissimis moribus insignitus: donavit æneos aliquot SUECORUM nummos ob singularem formam et magnitudinem notatu dignissimos: quem et plura adhuc daturum aliquando speramus.

A.D. 1692
John Sowter, London merchant, a man distinguished by his singular talent and charming manners, gave this museum several Swedish bronze coins notable for their unique shape and size: we hope that even more will be given to us in the future.

A.° MDCXCIII. Idem addidit Stragula equestria Turcica in obsidione illa Viennæ urbis celeberrimâ A.° MDCLXXXIII rapta.

In 1693, the same man gave the museum some Turkish horse-blankets which were seized in the famous siege of the city of Vienna in 1683.

Item. **A.° MDCXCIV** varia minerarum stanni et cupri specimina é Fodinis Cornubiæ et Devoniæ; in quibus unum et alterum cupri nativi, é puteis Polgouth et Trevascus.

In the year 1694, he gave various specimens of tin and copper from the mines of Devon and Cornwall. Both contain native copper from the mines at Polgooth and Trevascus.

Item. **A.° MDCCI.** nonnullos Victorini Postumi et Tetrici utriusque nummos areos.

In the year 1701, he gave some bronze coins from the reigns of Victorinus, Postumus and Tetricus.

[17r]

A.D. MDCXCIII.

ORNATISSIMUS Vir D. HARRIES de [] in Agro Wigorniensi Armiger, donavit elegantissimam Tabellarn Plasticam, in quâ felici manu exhibetur JOVIS Historia in Cretâ Insulâ enutriti. Amalthæa scilicet. nutrix sub elatâ quadam arbore, in eremo conspicitur; lacte repleturn Cornu Copiæ ad os Infantuli admovens: tum Capræ adstantes cum Satyro, et Canem in altâ rupe eviscerans Aquila. Quin et in summâ arbore pulli Aquilini in nido delitescunt, quibus Serpens arborem ascendens, exitium denunciat.

A.D. 1693
The very distinguished Mr Harries, from Worcestershire, gave a small, very beautiful relief, skilfully executed, showing the story of the early childhood of Jove on the island of Crete. In the

wilderness his nurse, Amalthea, is shown under a tall tree holding a cornucopia, filled with milk, to the child's lips; there are goats around together with a satyr, and at the top of a cliff, an eagle disembowels a dog. Hiding in a nest on top of a tree are eaglets, threatened with death by a serpent which climbs it.

A.D. MDCXCIIII

PRÆCLARISSIMUS DOMINUS, D. JOHANNES AUBREY, de Lhan-Trydhyd in Glamorganiâ, Baronettus; Vir nequicquam minus generosus, quàm Illustri Familia natus: Bibliothecæ Ashmoleanæ donavit Viri Celeberrimi D. Joannis Vaillant, Galliarum Regis Antiquarij, Historiam veterum Numismatum, duobus Tomis Parisijs nuper editâ.

A.D. 1694
The celebrated Sir John Aubrey, Bart. from Lhantrithyd in Glamorgan, a noble man born to an illustrious family, gave the Ashmolean library the *History of Ancient Coins* by the celebrated Jean Vaillant, antiquary to the French king, which was recently published in two volumes in Paris.

[17v]

A.D. MDCXCIII.

Dnũs MATTHIAS BIRD, Navarchus Kaer-Leonensis in Agro Monemuthensi; donavit Loricatam quandam Statuam, ex Lapide Alabastrite efformatam atque Auro foliato olim obductam, Gladium adhuc integra, gestabat dextrâ: et in sinistrâ bilancem: in dextrâ lance quæ gravior erat, Puellæ facies eminebat; in sinistrâ verò Globus terrestris. Effossa est prope Urbem Kaer-Lheion sive Iscam Legionum (ubi Legio secunda Augusta aliquandiu egit) ad locum Porth Sini Krân dictum, circa Annum MDCLX.

A.D. 1693
Matthew Bird, a ship's master from Caerleon in Monmouthshire, gave the Museum a figure in a coat of mail, sculpted from alabaster, which was once covered in gold leaf, holding a sword, still fully preserved, in its right hand and, in its left, a pair of scales. The right pan of the scales, which is the heavier, shows a girl's face, the left one shows the globe of the Earth. It was dug up in about 1660 near the town of Caerleon or, in Latin, Isca Legionum (where the Second Augustan legion used to be stationed) near the spot known as Porth Siny Kran.

A.D. MDCXCIII.

REVERENDUS Vir D. JACOBUS JVIE Wiltoniensis A.M. triginta circiter Romanorum nummos donavit ex ære minore. Ii autem omnes Sorbioduni inventi; titulos Crispi, Constantis, Constantij et Magnentij præferentes; adeoque integri ut nullam fere primariæ formæ jacturâ fecisse videantur.

A.D. 1693
The Reverend James Ivie MA, from Wiltshire, gave about thirty bronze Roman coins. All of them were found in Sorviodunum [Salisbury] and bear the names of Crispus, Constans, Constantius and Magnentius. There seems to be no damage to their original appearnce.

[18r]

A.D. MDCXCIV.

BENIAMIN BROWN S. T. B. collegij Ænei nasi socius, dedit ANNVLVM ARGENTEUM ANTIQVVM; a fossore quodam inter rudera ejusdem collegij casu repertum; ex parte alterâ antiquo opere tortuosum; alterâ verò sigillo et

symbolo nescio quibus insculptum. vide cat.D. Æd.ch.n.5j2.b.

A.D. 1694
Benjamin Brown, Bachelor of Theology and Fellow of Brasenose College, gave an ancient silver ring, found by chance by someone digging in excavations in the College. It is both a ring, in an antique twisted style, and is engraved with an unknown seal and symbol. See the Catalogue of the Dean of Christ Church, no. 512(b).

A.D. MDCXCV.

CAROLUS KING A.M. Ædis christi Alumnus, donavit IASPIDES ORIENTALES duas, formâ octogonâ, in quibus Imago cujusdam aquam haurientis &c. et CHALCEDONIVM in quo quatuor figuræ; Martis scilicet, Mercurij, Cereris, et Cupidinis, faberrimè sculptæ. Ibid. j54. 5j9.

A.D. 1695
Charles King MA, once a Student of Christ Church, gave the Museum three gems, two oriental jaspers, octagonal in shape, with the image of a water carrier; and one chalcedony with four skillfully carved figures of Mars, Mercury, Ceres and Cupid. Ibid, nos. 154, 519.

[18v]

A.D. MDCXCVI.

Dnũs. CAROLVS HOPKINS dedit orbiculatam quandam LAMINAM AVREAM prope Bali-Shani apud Hibernos nuper effossam; ad monitum vetustæ cujusdam Citharædi Hibernici, cantilenæ, in quâ virum aliquem fortem prædicabat locum sepulturæ designans, de duabus laminis totidemque annulis, aureis, cum ipso terræ mandatis, verba faciens. Narrationem fusius exaratam, vide apud Camdenum edit. Gibs.p.j022. cat.VC.954.

A.D. 1696
Charles Hopkins gave the Museum a circular gold plate which was recently dug up near Ballyshannon in Ireland. He found it with the help of an ancient dirge chanted by an old Irish harpist, in which he sang of a strong man and his place of burial, and told of two gold plates and as many gold rings, commited to the earth with him. For the narrative in full, see Camden, [*Britannia*], ed. Gibson, p. 1022. Vice-Chancellor's Catalogue, no. 959.

A.D. MDCXCVII.

ANNVLVS ARGENTEVS, in quo lapis Corneolus Arabice inscriptus. Donavit GEORGIVS WALKER. [C.D. Æd.Ch.512a]

A.D. 1697
A silver ring with an Arabic inscription on a carnelian was given by George Walker (Catalogue of the Dean of Christ Church, no. 512a).

A.D. MDCXCVIII.

Dnũs. IVSTINIAN SHEPHERD, a Barfordia majore, in agro Oxoniensi; dedit Cingulum quoddam Americanum ex monetâ testaceâ apud Novæ Angliæ Indigenas receptâ (tubulorum nicotianæ fragmina referente) confectum. cat. V.C.955.

A.D. 1698
Justinian Shepherd, from Great Barford in Oxfordshire, gave the Museum an American belt made from the shell money used by the native people of New England (resembling fragments of tobacco pipes). See the Vice-Chancellor's Catalogue, no. 955.

A.D. MDCXCIX.

Dnũs. THOMAS CREECH S.T.B. et collegij

omnium Anim. socius, dedit NVMISMA HISPANICVM ARGENTEVM, PSEVDO-CORALLIO QVODAM ADNATO COOPERATVM; ex thesauro isto quem e navi Hispanicâ, regnante Elizabethâ alto oceano submersâ, expiscati sunt Angli A.° 1687. C. V-C. 956.

A.D. 1699
Thomas Creech, Bachelor of Theology and Fellow of All Souls, gave a silver Spanish medal, encrusted with pseudo-coral, found in the treasure of a Spanish ship sunk on the high seas in Queen Elizabeth's reign, and fished up from it by Englishmen in 1687. See the Vice-Chancellor's Catalogue, no. 956.

[19r]

A.D. MDCC.

Dnūs RICARDVS DYER A.M. et collegij Orielensis socius, dedit QVATVOR NVMMOS AVREOS, & DECEM ARGENTEOS; additis insuper in perpetuam rei memoriam SEMICORONÂ ÆREÂ argento obductâ, aliâque (uti & solido & semisolido) circumquaque accisâ; quæ legalis Angliæ monetæ locum usurparunt, anno j695.C.V.C.252.a.&c.et 5.ad finem.

A.D. 1700
Richard Dyer MA, Fellow of Oriel College, gave the Museum four gold coins and ten silver ones and also added, as a perpetual memorial a silver-plated brass half crown, and other clipped coins (both shillings and sixpences) which took the place of the legal English currency. Given in 1695. See the Vice-Chancellor's Catalogue, no. 252a et seq. and 5 at the end.

A.D. MDCCI.

Dnūs IOANNES GOSCH apud Chalybonenses ripublicæ Batavorum consul, dedit SIGILLVM ÆNEVM MACARII Patriarchæ Antiocheni; a rustico quodam juxta Antiochiā ad Taurum montem, nuper repertum. Epigraphe sic se habet.

+ΜΑΚΑΡΙΟΣελεω θεον ΠΑΤΡΙΑΡΧΗΣ ΤΗΣ ΜΕΓΑΛΗΣ ΘΥ ΠΟΛΕΩΣ ΑΝΤΙΟΧΕΙΑΣ ΚΑΙ ΠΑΣΗΣ ΑΝΑΤΟΛΗΣ. C.V.C. 894.b.

A.D. 1701
John Gosch, the Dutch consul in Turkey, gave a brass seal belonging to Makarios, the Patriarch of Antioch, recently discovered by a peasant in the Taurus mountains near Antioch. It's inscription runs: 'Makarios by the mercy of God patriarch of the great city Antioch and of all Anatolia'. See the Vice-Chancellor's Catalogue, no. 894b.

[19v]

A.D. MDCCII.

Dnūs. ROGERVS BVRROVGH civis Londinensis dedit ICVNCVLAM MARMOREAM BRACHMANNI INDICI, faberrime sculptam. C.D.Æ.CH.646.b.

A.D. 1702
Roger Burrough, citizen of London, gave a skilfully sculpted, small marble image of an Indian Brahmin. Catalogue of the Dean of Christ Church, no. 646(b).

A.D. MDCCII.

GVILELMVS BROMLEY Arm. in comitijs regni, Academiæ Oxoniensis Advocatus; dedit Numisma archetypum aureum, ad inaugurationem serenissimæ Annæ Reginæ Angliæ &c. Apr.23.° An. 1702.

percussum. C. V-C.341.

A.D. 1702
William Bromley, Esquire of the Royal Court and one of the Burgesses of the University of Oxford, gave an original gold medal struck to commemorate the coronation of Her Majesty Queen Anne on 23 April 1702. See the Vice-Chancellor's Catalogue, no. 341.

A.D. MDCCVI

IACOBUS POUND M.B. pro singulari suo in Musæum Ashmoleanum studio et benevolentia, omnia ea Vegetabilia et Animalia ex India Orientali advecta, quæ cylindraceis vitris inclusa in fenestrarum capsulis reponuntur, munificè contulit.

A.D. 1706
James Pound, Bachelor of Medicine, out of his singular devotion and generosity to the Ashmolean Museum, donated to it all the vegetable and animal specimens he had brought home from the East Indies, which can be seen in cylindrical glass jars in the windows of the museum.

A.D. MDCCVII.

CAROLUS HARRIS Armiger, Oxoniensis, dedit corium cujusdam asini Africani ZEBRA dicti, coloris eleganter variegati.

A.D. 1707
Charles Harris Esq., of Oxford, made a gift of the skin of an African ass called a zebra, which is of beautifully variegated colours.

[20r]

A.D. MDCCVIII.

TIMOTHEUS LANNOY Armiger, ad Emporia Ottomannica mercaturam exercens, dedit capræ Turcicæ ex Angora juxta Constantinopolim, alutariam pellem sericeis pilis cincinnatis eleganter vestitam.

A.D. 1708
Timothy Lannoy Esq., a merchant trading to the Ottoman Empire, gave the museum the soft skin of a Turkish goat, with curly silken hair, from Angora, near Constantinople.

[MDCCXIV]

EDVARDUS LHUYD è Cambro-britannis oriundus: Coll: JESU apud Oxon: A.M. in eadem Academiâ S: Theologiæ Bedellus Superior; Plotioque ut in hoc Museo Successor, ita benevolentiâ et eruditione non impar. Vir enim hic pereruditus, postquam per plures annos Cimeliarchæ provinciam summâ curâ et fidelitate procurasset, et in rebus Naturalibus colligendis et ordinandis operam feliciter navasset, tandem Lithophylacium Suum Britannicum rarioribus omne genus figuratis lapidibus uberrime instructum inter κειμήλα Asmoleana conservari voluit.

Quantum autem Scientia, et Naturali, et antiquaria excelluerit LHUYDIUS, Scripta, quibus de posteris omnibus optime meritus est, abunde testantur, viz. Lithophylacij Britannici Ichnographia cum Epistolis una annexis; et Archæologia Britannica. Quam diu meditatus fuerat Gentis suæ Naturalem Historiam perficere vetuit Mors immatura Anno 1709.

In locum cl: LHUYDII suffectus fuit DAVID PARRY e Coll: JESU A.M. cui datum erat ad exitum

penè Anni 1714 Museum hocce custodire.

A.D. 1714

Edward Lhwyd, a Welshman by origin, of Jesus College, Oxford, was the Senior Bedel of Divinity at Oxford. He succeed Plot in this Museum and was entirely his equal in generosity and learning, for he was a very erudite man. After administering the Museum for many years with the greatest care and diligence, and after completing his work on building and arranging the Natural History collection, he wanted his collection of British stones, full of all types of figured stones, to be preserved among the treasures of the Ashmolean. The extent of his learning as both a naturalist and an antiquary can be clearly gauged from his writings. He left many good works to posterity including the *Lithophylacii Britannici Ichnographia*, together with his letters, and his *Archaeologia Britannica*. An untimely death in 1709 prevented him from completing his long meditated project of writing the natural history of his people. David Parry MA, of Jesus College, was appointed in his place and was designated Keeper of the Museum to the end of the year 1714.

[20v]

A.D. MDCCXV

IOHANNES WILKES Birminghamensis, Artium ferrariarum peritissimus, Securitati hujusce Musei prospiciens, Valvas Scholæ Historiæ Naturalis boreales, Serâ varijs obicibus et ferramentis elaborata firmiter Satis munivit.

A.D. 1715

John Wilkes, of Birmingham, a very expert locksmith, attending to the security of this Museum, satisfactorily strengthened the northern doors of the Natural History school with an elaborate bolt, bars and other ironwork.

A.D. MDCCXVI

IOHANNES WOODWARD celeberrimus in Collegio Greshamensi Medicinæ Professor, è copiosâ Suâ reliquiarum Diluvianarum Supellectile varias rariorum Fossilium Species huic Muséo benevolus contribuit: Quem et plura aliquando daturum Speramus.

A.D. 1716

John Woodward, celebrated Professor of Medicine at Gresham College, generously offered this museum various specimens of rare fossils from his abundant collection of remains from the period of the Flood. We hope that one day he will give more.

[21r]

A.D. MDCCXV1

THOMAS SHAW é Coll. Reginensi A:B: Historiæ Naturalis Studiosissimus, quam plurima Insecta circa Oxonium capta, et in suas Classes et Familias elegantissime disposita huic Museo D.D.

A.D. 1716

Thomas Shaw BA, from Queen's College, who was much devoted to Natural History, gave this Museum a large collection of insects caught around Oxford, elegantly arranged into their various classes and families.

A.D. MDCCXVII

Ornatissimus Juvenis HENRICUS JOHNSON ex Æde Christi Superioris Ordinis Commensalis cutem ingentis Lacerti Squamosi, Asraw vulgo dicti, huic Museo donavit.

A.D. 1717

The excellent young Henry Johnson, Gentleman-Commoner of Christ Church, gave this Museum the skin of a giant scaly lizard commonly known as an Asraw.

A.D. MDCCXVII.

JOSEPHUS DISNEY ex Æde Christi Commensalis, venerandæ Antiquitatis amantissimus, Typum Arcis, Pontefractensis Anno 1648, quo eam obsidione premebant Perduelles, delineatum, in hoc Museo conservandum D.

A.D. 1717

Joseph Disney, Commoner of Christ Church and a devoted antiquary, gave the museum a drawing of Pontefract Castle from the time when it was under enemy siege in 1648.

A.D. MDCCXVIII.

THOMAS PALMER de Fairfield in Agro Somerset Arm: Vir doctrinâ et Virtutum Comitatu Spectatissimus, Picturam Senis cujusdam (Sancti forsan Cuthberti) auro crystalloque munitam, inter Cimelia hujusce Musei reponendam transmisit. Perantiquum hoc Opus, magni quondam Ælfredi peculium Academiæ Oxon: legavit Thomas Palmer in eodem pago Militum Tribunus.

A.D. 1718

Thomas Palmer[1] of Fairfield in Somerset, a learned man and renowned throughout the county for his virtue, sent to this Museum a picture of an old man (possibly St. Cuthbert) set in a gold and crystal frame. Palmer, military commander in the same district, bequeathed this most ancient object, once a possession of King Alfred, to the University of Oxford.

[21v]

A.D. MDCCXIX.

GEORGIUS CLARKE L.L.D. Coll. Omn: Anim: Socius, hujus Academiæ sæpius Burgensis et regnante Anna e Dominis Comissionarijs pro Officio D.^{mi} magni Admiralli Unus; cum sit omnium bonarum Artium amantissimus, Bellicæ Navis effigiem omni suo malorum, Antennarum, Funiumque apparatu eleganter instructam conquisivit et in hac tutissimâ Statione Ancoram ponere decrevit. Jure optime hic memorandus est Gulielmus Lee Armiger, qui Naviculam tantâ pulchritudinis fabricavit.

A.D. 1719

George Clarke LLD, Fellow of All Souls College and several times Member of Parliament for this University had, in Queen Anne's reign, the post of Lord Commissioner of the Admiralty. Being deeply appreciative of beautifully made objects, he commissioned a model of a warship with all its masts, sails and rigging, and resolved that it should be anchored in this safe harbour. Here it is only right to remember William Lee Esq. who made the little ship so beautifully.

SMARTIUS LETHIULLIER, Armiger, de Aldersbrook in Com: Essex varias Animalium Species quas è Supellectili Woodwardiano redemerat vitris Cylindraceis 16 repositas in Museum contulit. An: 1756.

Smart Lethiullier Esq., of Aldersbrook in Essex, in 1756, gave this Museum various species of animals which he had purchased from the Woodward collection. They are enclosed in sixteen cylindrical glass jars.

[1] The Alfred Jewel, to which this entry refers, was presented to the Museum by Colonel Nathaniel Palmer; his son, Thomas Palmer, merely transmitted it to the Museum (although it had been intended for the Bodleian Library).

[22r]

A.D. MDCCLVII.

RICARDUS RAWLINSON, Arm: L.L.D. Soc:
Antiq: Soc: Exemplaria duarum Venetorum
Navicularum unum Pæota, alterum Gondola dict:
unaque Vulpem albi Coloris Moscoviæ Incolam
Museo Moriens legavit.

Queis insuper addidit Lecticæ gestatoriæ Indicæ,
Palanquin, dict: Exemplar.

A.D. 1757
Richard Rawlinson Esq. LLD, Fellow of the Society of
Antiquaries, left the Museum models of two kinds of small
Venetian boat, one known as a Paeota, the other a Gondola. He
also gave a white Moscovy fox. To these he added an Indian
litter called a palanquin.

A.D. MDCCXLV.

THOMAS NELSON, A.M. Coll: Univ. Soc:
Nuɱmulum aureum Reg: Annæ, Legalem Monetam
valoris quinque Minarum totidemque Solidorum
D.D.

A.D. 1745
Thomas Nelson MA, Fellow of University College, gave a gold
coin from the reign of Queen Anne which is worth five guineas.

NATHAN: CRYNES A.M. in Facultate Artium
Superior Bedellus Tabulam Mexicanam ex Avium
Plumis miro Artificio confictam Museo D.D.

A.D. 1745
Nathaniel Crynes MA, Senior Bedel in the Faculty of Arts, gave
the Museum a small Mexican picture which is ingeniously
composed of birds' feathers.

A.D. MDCCLVI.

EDVARDUS SEYMOUR de Wanatinǧa in Com:
Bercheriensi Pharmacopola, Artis ChymicoTinctoria
à se inventæ quâ cujuscunque generis Ligno
Juglandis Pectines impressit Museo Ashmoleano
Primitias consecravit.

A.D. 1756
Edward Seymour, from Wantage in Berkshire, was a
pharmacist and dedicated to the museum the first fruits of his
work on chemical dyes. He discovered this art, and struck
permanent tints through a plank of wood from a type of walnut
tree.

[23r]

A.D. MDCCLVI.

Illustrissima Dom: Dom: MARIA Comitissa de
WESTMORLAND Magnetem rarissimæ
magnitudinis cui vix ullam Regionem parem jactare
credimus, Academiæ OXON, nequid ibidem Arte vel
Natura pretiosum deesset, contulit, et in Museo
Ashmoleano reponendum esse voluit. Quadraginta et
Octo Uncias ambitu complectitur Lapis, centum et
quinquaginta Librarum Pondus attollit, plus indies
(ut Usu compertum est) attracturus.

Honoratissimus Dom: Dom: JOANNES Comes
de WESTMORLAND Almæ Universitatis OXON
Seneschallus Egregium hoc Uxoris suæ Munus
elegantissimo instrui Apparatu, Domicilioque suis
Impensis affabre jacto, conservari jussit.

A.D. 1756
That most noble Lady Mary, Countess of Westmorland, gave
the University of Oxford a lodestone which she wanted placed

in the Ashmolean Museum, so that it should not be lacking in
any precious work of art or nature. It is of an unusually large
size and we can hardly believe that anywhere else can boast of
having one like it. The stone is 48 inches in circumference and
is able to raise a weight of 150lbs or more (as we know from
experience).

The most celebrated Lord John, Earl of Westmorland,
Steward of the fair University of Oxford, arranged for this
exceptional gift of his wife's to be provided with a very elegant
case made, with great craftsmanship, at his own expense.

[22v]

A.D. MDCCXLIII.

ANNA MARIA WOODFORD, Filia Ricardi
Woodford M.D. Med: Reǧ: Prof.: in hâc Academiâ,
Collare chartaceum propriis Manibus Acûs puncturis
elaboratum. D.D.

A.D. 1743
Anne Mary Woodford, daughter of Richard Woodford MD,
Regius Professor of Medicine in this University,[2] gave the
Museum a paper collar, elaborately worked, by her own hand,
with the point of a needle.

[23v]

A.D. MDCCLVIII.

GULIELMUS BORLASE de LUDGVAN in Coɱ:
CORNUBIENSIUM Rector. A.M.R.S.S. omnibus
quæ dum Soli natalis Historiam molitus est
collegerat Corporibus Crystallinis Mineralibus et
Metallicis Repositorium hoc Rerum Naturalium,
Plurium Arrham auxit et ornavit; Addidit insuper
Speciminum aliorumque in Libro impresso
descriptorum Figuras calamo suo eleganter
delineatas, Codicemque MSS. una reconditum
Posterorumque Usui dicatum fecit.

A.D. 1758
William Borlase, Rector of Ludgvan in Cornwall, MA and FRS,
furnished this treasure-house of natural objects with all the
crystalline, mineral and metallic specimens which he had
collected while working on the History of his native land, and
may give more. He also added some pictures of other
specimens, elegantly drawn with his own pen, which have been
reproduced in the book. To all of this he added a manuscript
catalogue to be stored away for the use of future generations.

[24r]

A.D. MDCCLVII.

JARED LEIGH Junr. de (DOCTORS COMMONS)
in Civitate LONDON. Effigiem Salvatoris nostri
JESU CHRISTI defuncti, Hannibalis Carrache arte
graphica feliciter Expressam, insigne celeberrimi
Pictoris Ingenii, suæque erga nos Benevolentiæ
Monumentum, inter rarioris Notæ Cimelia reponi
voluit.

A.D. 1757
Jared Leigh the younger, of Doctors Commons in the City of
London, wanted to have a painting of the dead Jesus Christ,
our Saviour, masterfully and beautifully depicted by Annibale
Caracci, that outstanding painter of genius, placed among the
treasures of rare note as a token of his goodwill towards us.

A.D. MDCCLVIII.

THO[S]: PENNANT de Bychton in Com: FLINT Arm:
variis Rerum Naturalium Speciminibus, Metallorum

[2] The Regius Professor was, in fact, William Woodford.

sc. Mineralium Chrystallorum &c hoc Museum benigne locupletavit.

A.D. 1758

Thomas Pennant Esq., from Bychton in Flintshire, kindly enriched the Museum with various natural, metallic, mineral and crystalline specimens.

[24v]

A.D. MDCCLXI.

Gul: Perrot de North-Leigh in Com Oxon Arm: Vespertilionem ingentem Asiæ Incolam, Canem volantem dictum, huic Museo lautè favens contulit. Cujus Animalis Naturam ex Edvardi Historia Avium Tab.180. plenius investiget Lector.

A.D. 1761

William Perrot Esq., of North Leigh in Oxfordshire, generously gave a giant Asian bat, known as a flying dog [fox], to this Museum. The reader may study this animal more fully in Edwards's *History of Birds*, pl. 180.

[25v]

A.D. MDCCLXVI

ISAACUS Hughes de Crutched Fryers in Civitate London Cadaver Infantis Balsamo conditum, Variisque, Ægyptiaco More, notis characteribusque insignitum. D.D.

A.D. 1766

Isaac Hughes, from Crutched Friars in the City of London, gave the body of a child preserved in balsam and marked, in the Egyptian manner, with letters and characters.

LIBER PROCURATORIS JUNIORIS
The Book of the Junior Proctor
Transcribed and translated by Gloria Moss, annotated by Arthur MacGregor

Ashmolean Museum, AMS 18 [1685B], compiled c.1685. Quarto volume with modern brown leather binding; on the spine in gold on a green panel, 'ASHMOLEAN MUSEUM. CATALOGUE OF "ARTIFICIAL WORKS". c.1685'. 33 folios c.237 by 180 mm, mostly individually interleaved on guards.

The original title of this volume was lost, perhaps in the course of rebinding, but there seems every reason to endorse the identity given to it by Ovenell (1986, p. 46) and duly adopted here. Ovenell notes that at some time in the eighteenth century the text was bound up with a number of Museum documents to form part of Ashmole MS 1821. In that context it was listed by Black (1845, col. 1518) with the title (evidently not the original) 'Catalogus instrumentorum bellicorum atque civilium, et omnis generis supellectilis antiquariæ, quæ in Museo Ashmoliano (ut videtur) olim erat reposita; Lhuydii manu, ff 1a-5a, 8a-31a' (Catalogue of equipment of war and of civil use, and of all kinds of ancient utensils, which (it appears) were once housed in the Ashmolean Museum; fols.1a-5a and 8a-31a in Lhwyd's hand). No trace of this title appears on the surviving sheets, perhaps having been discarded in the early part of the twentieth century when the leaves were remounted, page by page, in the present morocco-bound volume.

Ovenell also tells us that this original text was excluded from the Vice-Cancellor's consolidated catalogue of 1695 (now missing), where Lhwyd substituted instead the text of his catalogue of fossils, adding later the list of natural specimens given by Martin Lister.

In its temporary location among the Ashmole manuscripts, Lhwyd's text seems to have dropped from the collective consciousness of the keepers and the board of Visitors. In the Museum's first printed catalogue of 1836 most of the North American material (including 'Powhatan's Mantle' and other important objects listed here) is conspicuous by its absence, indicating the degree of reliance placed on available documentary records by the compiler of that section, George Rowell. Evidently it returned to prominence later in the century, for in 1884 Arthur Evans was to make extensive use of it in his attempts to re-identify material from the founding collection. It was at that time that it acquired its alternative designation - 1685B - which now forms a prefix to the catalogue numbers by which surviving items are identified.

The catalogue therefore remains of fundamental importance in identifying the existing man-made curiosities from the founding collection, as well as in establishing the much greater range of such material embodied in Ashmole's original donation. Entries relating to surviving artefacts include references to the Museum's tercentenary catalogue (MacGregor 1983), where full descriptions and discussions will be found.

Later interpolations in this catalogue are comparatively rare. The donor of a 'Danish spur and stirrup' (p. 25), Christopher White (1651-96), was employed as the Museum's 'skilful and industrious Operator' or laboratory technician under Robert Plot. An intriguing entry for a 'beehive with glass windows through which one can see the bees making their honey' (p. 31) brings to mind the 'transparent apiaries' kept at Wadham College by John Wilkins and remarked upon in 1654 by Evelyn (*Diary*, 13 July 1654). Two items (p. 31) are attributed to John Aubrey, while the latest acquisition is a pair of silk-lined sandals given by Mrs Anne Rummer in 1739 (p. 23).

[1r]
Scutorum varia genera
Various types of shields

1 Scutum An Japonnicum? ex tribus ligneis conflatum tabulis, Quarum media in parte superiore angustior quam inferiore. duae exteriores inferius angustiores quam superius. parte convexa panno firmiter agglutinato obducitur, rosis ramisque ejusdem plantae depicte.
A shield: could it be Japanese? Composed of three wooden boards of which the middle one has a narrower upper than lower part; the two outer boards have narrower lower than upper parts. The convex part is covered with a piece of cloth firmly stuck down and decorated with roses and branches of the same plant.

2 Scutum Indicum Ligneum; 4 pedes longum, unicum tantum Latum. media parte paululum gracilescit, ad extremitates aliquantulum est Latius. parte convexa conchis venereis albis ossibusque undique exornatur. circumferentiam totam ambit vimen.
An Indian shield of wood. Four ft long, and only 1 ft wide. The central section is slightly narrower, and the ends somewhat wider. The convex part is decorated all over with white Venus shells and with bones. The edges are encloseded with osier.
MacGregor 1983, no. 46.

3 Scutum ligneum, tres pedes cum semisse longum, unum cum 7 uncijs latum. Parte tum convexa tum concava corio tegitur.
Wooden shield, 3½ ft long, and 1 ft 7 in wide. It is covered with leather both on the convex and on the concave side.

4 Scutum fere triangulare, quo equites templi erant muniti.
An almost triangular shield, with which the Knights Templar were armed.

5 Scutum an Japonicum? figurâ quadratâ, pedem & 10 uncias longum, pedem cum 4 uncijs latum, in acumen ephippij instar surgit: corio vario eleganterque depicto obducitur, ansam habet, quâ cingulo suspendi potest.
A shield. Could it be Japanese? Square in shape, and 1 ft 10 in long, 1 ft 4 in wide. It rises to a point like a saddle. Covered in variegated, beautifully painted leather. It has a

handle, by which it may be suspended with a strap.

6 Scutum alterum ligneum, figurâ superius imitatur, sed corio tegitur subalbido, ad duas circumferentiae uncias formâ laciniâ succinctum.

Another wooden shield, similar in shape to the above but covered with off-white leather; the two sides of the circumference each have a flap.

[2r]

Clypeorum varia Specimina
Various types of round shield

7 Clypeus indicus, rotundus; a centro ad ambitum unum metitur pedem. In parte convexa corio rufo vestitur.

Round, Indian shield, 1 ft in radius. The convex side is covered with red leather.
MacGregor 1983, no. 43.

8 Clypeus indicus, ligneus & rotundus, a centro ad ambitum 11 metitur uncias. panno tegitur, variè ornateque depicto.

Round Indian wooden shield, 11 ins in radius. It is covered with cloth, and painted with various colours and ornament.

9 Clypeus indicus, figurâ rotundâ, a centro ad circumferentiam undecim haud excedit uncias: in convexa parte quatuor habet bullas æreas. An ligneus cori[-o]aceus /sit\ non planè constat. Sed flexibilis est corij instar.

Round, Indian shield, no more than 11 ins in radius: it has four bronze studs on the convex side. There is no clear agreement whether it is wood or leather. But it is flexible like leather.

10 Clypeus Indicus ligneus, rotundus, corio in totum subalbido tegitur in centro umbillicum habet.

Round, wooden Indian shield, entirely covered in off-white leather. In the centre there is a projection.

11 Clypeus Indicus Orientalis, ligneus, rotundus, cute subrufâ. obducitur.

Round shield from the East Indies, covered with a reddish hide.

12 Clypeus indicus orientalis rotundus, ex arundinibus implexus.[1]

Round shield from the East Indies, woven from reeds.
MacGregor 1983, no. 45.

13 Clypeus ligneus rotundus: in convexa parte duo sunt circuli quorum inter maximum sunt varij flores avesque eleganter depicta; inter alterum verò insigne est pernobile. An galleus sit ?

Round wooden shield. There are two circles on the convex side, the larger of which contains various beautifully painted flowers and birds; the other depicts a coat-of-arms of high nobility. Could it be French?
See MacGregor 1983, no. 42.

14 Clypeus alter parvus, rotundus. in convexa

parte magna est ansa lignea. totam circumferentiam ambit lamina ferrea; pars concava aereis clavis munita.

Another small round shield. The convex side has a large wooden handle, and an iron band runs around the entire circumference: the concave side is reinforced with bronze nails.
MacGregor 1983, no. 99.

Tormenta bellica & sclo/p\pet[-ae/a]
Military catapults and muskets

15-16 Duo parva tormenta bellica ex ære conflata, suis vehiculis imposita.

Two small canons made of bronze, standing on their carriages.
MacGregor 1983, no. 86.

17 Scloppetum ferreum, Cujus truncus varijs Imperatorum capitibus ex conchis argenteis elaboratis splendidè exornatur. \\N°. 167 videtur [-ad]huic /sustinendo\ inserviisse.//[2]

Iron musket, its body splendidly decorated with the heads of different emperors in silver shell. No. 167 seems to have been used to support this.
MacGregor 1983, no. 87.

18 Sclopus parvus ferreus, tribus dotatus tubis.

Small iron musket with three barrels.
MacGregor 1983, no. 89.

[3r]

19 Cestra bellica cum bombarda, manubrium æreum habet, eleganter operatum.

Poleaxe with a firearm. It has a bronze handle elegantly worked.
See MacGregor 1983, no. 90.

20 Cestra altera tota ferrea, manubrium ære neto circumdatur.

Another poleaxe made entirely of iron, with a handle covered with braided bronze.

Arcus varij
Various bows

21 Arcus ex India orientali, longitudine 8 pedes metitur, ligno constans teriti, recto, incrustatione rubicundâ obducto; nervo dotatus est.

Bow from East India 8 ft long, with a smooth straight wooden stave with a reddish coating. It is fitted with a bow-string.
MacGregor 1983, no. 34.

22-3 Duo arcus ex ligno brasiliano confecti, longi 6 pedes cum semisse, figurâ triquetrâ.

Two bows made of Brazil wood, 6½ ft long, and triangular in section.

24-6 Tres alij arcus ex ligno brasiliano elaborati, eâdem cum prioribus figurâ, sed breviores.

Three more bows made of Brazil wood, similar in shape to the last, but shorter.
MacGregor 1983, no. 9.

27 Arcus magnus, parte mediâ panno aureo circundatus, 6 pedes longitudinehabet, ambæ

[1] **[f.1v]** 12.A Alter ex Arundinibus capis in Centro Stella nigri coloris depictus est.
One other bowl-shaped shield made of reeds; a black star is painted in the centre.

B-C. Duo lignei Clypei Argenteo, rubro, etc. Color[-e] splendide depicti.
Two wooden shields, splendidly painted with silver, red and other colours.

[2] **[f.1v]** 17.A. Sclopetrum minus, cujus pars quo humero applocatur cum emitantur globuli, eburneis lamellis quadrangularibus & triangularibus ornatus.
A smaller musket, part of which is held against the upper arm when it is fired; decorated with rectangular and triangular plates of ivory.

extremitates cornibus armantur.
Large bow, the central section of which is covered in golden cloth, with horn splints at either end; 6 ft in length.

28-30 Tres arcus admodum compressi, quorum unus 6 pedes longus, alteri duo 5 pedes & 4 uncias metitur.
Three very flat bows, one 6 ft long, the other two 5 ft 4 in long .
MacGregor 1983, no. 37-9.

31 Arcus alter paululum compressus; nervo vel ex ligno vel arundine jacto præditus; 5 pedes cum semisse longus.
Another somewhat flat bow, with a string made either of wood or reed: 5½ ft long.
MacGregor 1983, no. 40.

32 Arcus 4 pedes cum 4 uncijs longus, duobus in locis in media ejus parte viridi serico circumcinctus.
Bow, 4 ft 4 in long, with two separate strips of green silk wrapped around it in the middle.

33-4 Duo Arcus viminibus hîc illîc circumligati,
Two bows, wrapped around here and there with osier.
MacGregor 1983, no. 41.

35-41 Septem arcus turcici, ad figuram semicircularem tenduntur, & varijs coloribus picti. \\unus fract: et alter amissus.//
Seven Turkish bows, almost semicircular in shape, painted different colours. One is broken, and another is lost.

42a Balista chalybea, ex qua tam globulos quàm tela jaculari possunt.
Steel crossbow which can be used for shooting balls as well as arrows.
MacGregor 1983, no.97.

42b Arcus ex ebore eleganter elaboratus, ab utraque extremitate, cui nervus alligatur, duo leonis spectant capita.
Beautifully worked ivory bow, the ends of which, where the string is attached, are decorated with two lions' heads.

[4r]

Gladij varij, pugiones & cultri
Various swords, daggers and knives

104 Romphæa Anglicana, anceps, quâ Henricus 5.^tus Anglorum Rex contra Gallos pugnavit.
Double-edged English sword, with which King Henry V of England fought against the French.
MacGregor 1983, no. 93.

105 Gladius Scoticus, anceps; in vaginam reconditur, hocque juxta manubrium habet inscriptum; Jacobus Rex quintus Scotorum. 1542
Double-edged Scottish sword housed in a scabbard, and on it, next to the hilt, is the inscription [in Latin]: James V King of the Scots, 1542 .
MacGregor 1983, no. 94.

106-7 Duo acinaces turcic[-/i] falcati, versus dorsum incurvat[-o/i], manubriis [-/nigris]. \\Unus saltem deesse videtur.//
Two sickle-shaped Turkish scimitars, curving towards the back, with black handles. One at least appears to be missing.

108 Gladius ferreus, ad mucronem multò latior est quàm ad manubrium, dorsum obtusum habet ac crassum, manubrium ligneum vitro ornatum &

nigro capillo. \\...non referio//
Iron sword, much wider at the tip than at the hilt. The back is blunt and obtusely angled and the handle is wooden, decorated with glass and black hair.
MacGregor 1983, no. 31.

109 Falx fœniseca turcica. ligneo manubrio prædita.
Turkish or Phoenician sickle, with a wooden handle.
MacGregor 1983, no. 102.

111 Duæ aliæ falces fœnisecæ .
Two more Phoenician sickles.

112 Pugio totusferreus est, latus, compressus, in mucronem desinit quadratum; in vaginulam ex cute Piscis canis [-/carcharis] confectam reconditur.
Short dagger made completely of iron, broad and flat, with a squared end; it is kept in a small scabbard made from the skin of a shark.

113 Pugio indicus ferreus, anceps, sensim ita gracilescit, ut in mucronem desinit tandem valde acutum. manubrium eleganter ex argento ac concha argenteâ elaboratum.
Two-edged Indian dagger, made of iron, which tapers gradually and ends in a very sharp point. The handle is beautifully decorated with silver and silver shell.
MacGregor 1983, no. 95.

114 Pugio manubrium habet osseum ære [-] excuso circumdatum. /in\ vaginam ligneam reconditur, ære itidem excuso circumligatam.
Dagger which has a bone handle covered with beaten brass. It is kept in a wooden scabbard similarly covered with beaten brass.

115 Pugio anceps, sensim gracilescit, & in mucronem desinit, manubrio ex ebore seu osse facto dotatus.
Two-edged dagger tapering gradually and ending in a point; it has an ivory or bone handle.
MacGregor 1983, no. 96.

116 Pugio in mucronem acutissimum exit. Dorsum obtusum crassumque manubrium ligneum, ætate paenè exesum; /in\ vag/i\nam reconditur ligneam.
Dagger ending in a very sharp point. The back is blunt and obtusely angled, and the wooden handle has almost completely decayed with the years: it is kept in a wooden scabbard.

117 Pugio anceps in mucronem exit. manubrium simiæ imaginem exprimit. Vagina lignea.
Double-edged dagger ending in a point. The handle is carved in the form of a monkey. It has a wooden scabbard.
MacGregor 1983, no. 28.

118 Pugio parvus anceps, in mucronem exit acutum; Manubrium et vagina ex ære eleganter conflata.
Small double-edged dagger, ending in a sharp point; the handle and the scabbard are beautifully fashioned in bronze.
MacGregor 1983, no. 98.

119 Pugio parvus paululum curvatus, in mucronem abit acutisssimum manubrium corio obducitur. Vagina etiam corio rubro confecta.
Small, slightly curved dagger with an extremely sharp point and a handle covered in leather. The scabbard is also made of red leather.

[5r]

120 Cultor paululum falcatus, in mucronem desinit acutum. manubrium ligneum.
Knife, shaped a little like a sickle, with a sharp point. Wooden handle.

121-2 Duo pugiones venenati, rubigine forè exesi, carent tum manubrijs tum vaginis, quorum minimus undulatus est.
Two poisoned daggers, eaten up by rust on the outside, and without handles or scabbards. The smaller one is undulated.

123 Cultor multum est latior ad extremitatum quàm ad manubrium.juxta acumen tribus foraminibus dotatus [-ligneum/manubrium] ligneum.
Knife, much wider at the tip than at the handle; with three holes near the tip. Wooden handle.

124 Cultor osseus.
Knife made of bone.

125 Vagina pro pugione, ære munita, in quam quoddam ferrum reconditur, sed cui usui inserviat nondum constat.
Scabbard for a dagger, encased in bronze, into which some sort of iron weapon is kept, but it is not yet known what purpose it served.

126 Cultor magnus, cujus ebiculum crassum est et obtusum; manubrium totum corneum est.
Large knife, the blade of which is thick and blunt. The handle is made entirely of horn.

127 Cultor ansorio nostratium non dissimilis. manubrium Ligneum.
Cobbler's knife not unlike our own. Wooden handle.

128-32 Quinque intrumenta /ex India occidentali\ bellica, ex ligno brasiliano confecta, quae vulgò Tamahack appellantur.[3]
Five weapons, from the West Indies, made of Brazil wood, commonly known as tomahawks.
MacGregor 1983, nos. 5-8.

133-7 Quinque alia instrumenta bellica ex India occidentali, Lignea, eæ extremitates quae ictus dant globulis capitis infantis magnitudinis armantur. Haec /etiam\ Tamahacks dicuntur.
\\unum d://
Five other wooden weapons from the West Indies. The ends which strike the victim are formed into balls, each the size of a child's head. These again are also called tomahawks. One is missing.
See MacGregor 1983, Nos. 2-4.

138-9 Duo alia instrumenta bellica ex India occidentali, ex ligno brasiliano confecta, Tamahacks vulgò dicta.
Two more weapons from the West Indies, made of Brazil wood and commonly called tomahawks.

140-2 Tria alia instrumenta bellica ex India occidentali, ex silice facta. Manubria sunt ex ligno brasiliano. tamahacks appellata.
Three more weapons from the West Indies, made of flint. The handles are of Brazil wood. They are called tomahawks.

[3] [f.4v] 127A-130A. Quatuor Vaginæ, quarum duæ acinacibus aptantur.
Four scabbards, of which two are suitable for scimitars.

143 Alterum instrumentum bellicum ex India occidentali tamahack dictum, cujus manubrium xilo eleganter complicato & implexo obducitur.
Another weapon, called tomahawk, from the West Indies whose handle is elegantly covered with a complicated woven cotton.

144 Securis Saxonica, characteribus notata saxonicis; manubrium ligneum, ebore perbelle insertum.
Axe from Saxony, marked with Saxon characters; it has a wooden handle, prettily inlaid with ivory.
MacGregor 1983, no. 91.

[8r]

Baculi varij & fustes
Various staves and clubs

145-8 Quatuor baculi ex ligno brasileano facti.
\\duo desunt.//
Four staves made of Brazil wood. Two are missing.

149-51 Tres baculi tornati, quorum unus viridis est coloris, alteri duo nigri, maculis flavis aspersi.
\\d.1.//
Three staves, made on the lathe, one of which is green in colour, the other two black, with scattered yellow spots. One is missing.

152 Baculus Padre ga/u\rdiani hierosolymani; ex unâ septuaginta palmarum Elamnersium comparatus, quinque ferè pedes longitudine metitur, utrinque acuminatus, colore nigro, micis albis undique asperso, geniculatus.
Staff belonging to the Guardian Father of Jerusalem, made from one of the seventy palms of Elam; it is almost 5 ft in length, pointed at both ends, black with white dots all over it, and has nodes.

153 Fustis ligneus, cui usui inserviat minimè patet; sed ad unam extremitatem plumbeo candelabri scapo veluti armatur.
Wooden club; it is not at all clear what purpose it serves, but it is fitted with a piece of lead at one end, like the shank of a candlestick.

154 Fustis ligneus, vermibus ecesus.
Wooden club, destroyed by woodworm.

155 Fustis alter, duobus locis juxta utrasque extremitates ære circundatus.
Another club, which is wrapped in bronze in two places near each end.

156-7 Cannæ duæ geniculatæ.
Two canes, with nodes.
MacGregor 1983, no. 32.

158 Fustis alter ex arbore palma comparatus.
Another club made from the palm tree.

159-60 [-Duae] /Iuncus Indicus magnus.\ virga[-e] alba[-e].
Large Indian reed. A white staff.

161 Fustis ligneus, uni extremitati præfigitur haustrum ferreum.
Wooden club, with an iron 'haustrum' attached to one end.

162 Virga ex quâdam arbore mazor dicta comparatur. capitulum habet ex cornu nigro tornatum.
Staff made from a tree known as mazer. It has a small head of black horn turned on a lathe.

163-4 Tubi duo ex ligno brasiliano elaborati, Sempitans dicti, quibus venenato telo paratis homines perditi ad mortem usque adacti erant.
Two blow-pipes made from Brazil wood, known as sempitans, which were prepared with poisoned darts and used to execute condemned men.

165 Tubus vitreus, quo reges uncti fuerunt, 7 pedes cum semisse longitudine metitur, colore nigerrimo, politoque.
Glass tube with which kings were anointed; measuring 7½ ft in length, deep black in colour and polished.

166 Tubus nicotianus ligneus, quâdam laccâ coloris rubri, viridis, nigri, cærulei, flavi & albidi incrustatus utraque extremitas argento armatur. 6 pedes longus
Wooden tobacco pipe, covered with red, green, black, blue, yellow and white lacquer, and mounted with silver at both ends. 6 ft long.

167 Instrumentum, quo sclopetræ dum exonerantur, sustinentur, undique conchâ argenteâ splendidè ornatū, pars inferior ære armatur acuto, superior autem ære forcipato:quo aptum sit ad sclopetram sustinendam.
Apparatus on which muskets are supported while they are being fired. It is splendidly decorated all over with silver shell; the lower part is provided with a sharp metal spike, and the upper with a bronze fork to make it suitable to support a musket.
MacGregor 1983, no. 88.

[9r]

168 Pyxis pro pulvere pyrio ex [-corio/cornu] confecta.
Container for gunpowder; made of horn.
MacGregor 1983, no. 100.

169 Tympanum pyramidale ex uno ligni frustro conflatum. utraque extremitas corio tegitur varijs nervis constricto.
Pyramidal drum made from a single piece of wood with both ends covered with leather, bound together with various thongs.
MacGregor 1983, no. 25.

170 Manica ferrea anno 88 ab hispanica classe abrepta erat.
Iron manacle which was captured from the Spanish fleet in the year 1588.
MacGregor 1983, no. 101.

171 Pectorale ex ossibus Balaenæ nigris compositum.
Corslet made from black whale bones.

[10r]

Pilei & Coronæ
Caps and Crowns

172-4 Tres pilei Indici ex arundinibus /seu Cannis\ implexi.
Three Indian caps woven out of reed or cane.

175-6 Duo Pilei ex rubro serico complicati, auro argentoque notis pernobili/ter\ acupicti.[4]

Two caps made from red silk, embroidered with very fine gold and silver markings.

177 Pileus indicus a capilis contextus nigris.
Indian cap, woven with black hairs.

178 Pileus nigro panno factus.
Cap made from black cloth.

179 Pileus indicus holoserico rubro confectus & culcitratus.
Indian cap made entirely from red silk and quilted.

181 Duo Pilei ex nigrâ lana compositi
Two caps made of black wool.

182 Galerum H. 8.ᵗⁱ ex panno nigro factum, varijs bracteis nigris ornatum.
Cap belonging to Henry VIII, made from black cloth and decorated with various kinds of black plates.

183 Pileus Ann Bull. gramine indico ingeniose intextus.
Cap belonging to Anne Boleyn, ingeniously woven from Indian grass.

188 Quinque coronæ indicæ plumis psittacorum complicatæ.
Five Indian crowns made of parrot's feathers.

190 Duæ coronæ indicæ plumis psittacorum implexæ.
Two Indian crowns woven from parrots' feathers.

200 Decem alia ornamenta Indica pro collo, manibus, lumbo, & cruribus ex plumis psittacorum implexa.
Ten other Indian ornaments for the neck and hands, loins and legs, woven from parrot's feathers.

204 Quatuor flabella indica ex plumis, stramine, cute, /&\ arundinibus confecta
Four small Indian fans made from feathers, straw, skin and reeds.

[-178/A\ Pileus purpureo panno confectus.]
Cap made from purple cloth.

Vestes variæ
Various garments

205 Basilica Pohatan Regis virginiani vestis, duabus cervorum cutibus consuta, & nummis indicis vulgò [-Roanoke/coris] dictis splendidè exornata.
Royal robe of the Virginian King Powhatan, sewn together from two deer skins and splendidly adorned with Indian [shell] money known commonly as roanoke .
MacGregor 1983, no. 12.

206 Vestis virginiana manicarum expers, plumis complicata.
Sleeveless Virginian garment elaborately constructed with feathers.

207 Vestis indica manicarum expers, & jubis equinis ut videtur implexa.
Sleeveless Indian garment, apparently woven with horse hair.

208 Vestis virginiana manicarum expers, an pellibus animalis Racoun dicti consuta.
Sleeveless Virginian garment sewn together perhaps with skins of an animal known as the racoon.

[4] **[f.9v]** 175 /A\. Deus aut Idolum indicum pae God vulgò dictum.
Indian god or idol commonly called a Pae god.

176A. Pileus Indicus nigro panno confectus.
Indian cap made of black cloth.

209 Vestis Indica nostratis subuculae formam exprimens, manicata
Indian garment resembling one of our own shirts, with sleeves.
MacGregor 1983, no. 11.

210 Vestis pellicia ex unâ pelle confecta.
Furry garment, made from a single skin.

211 Vestis indica haud manicata, exterior pars pellicia est, interior verò ita elaborata, ut institis albis videatur exornari.
Indian garment without sleeves, the outer part being covered in fur, and the inner part made so that it appears to have white borders.

[11r]

212 Vestis arabica nigro panno Lineis albis hîc illîc notato implexa.
Arab garment woven in black cloth, marked with white lines here and there.

213 Vestis qualis sit nondum constat, viridi albo serico implexa, linteo [-viridi/flavo] duplicata.
Garment of a type not yet identified, woven in green and white silk, and lined with yellow linen.

215 Duæ vestes indicæ pellibus consutæ, quarum ope dum naviculis canows dictis navigant, ab undis tuti sunt.
Two Indian garments, sewn together from skins, with the aid of which those travelling in small boats, known as canoes, are protected from the waves.

216 Altera hujus modi vestis vesica cujusdam animalis consuta.
Another garment of this kind, sewn together from the bladder of an animal.

217 Vestis cujusdam Cænobiarchæ, linteo texta, serico vario polymita, insignibus eorum exornata, qui suam benevolentiam ad cænobium instruendum dotandumque tribuerunt. varij est coloris.
Cloak of the abbot of a monastery woven in linen and mixed with a variety of silk threads. It is decorated with the insignia of those who gave generous gifts for the building and endowment of the monastery. It is in various colours.

218 Vestis Galfridi Caroli primi homunculi personata, tota ex cæruleo serico confecta, ex thorace & femini cruralibus integra conficitur vestis.
The costume worn by Charles I's dwarf, Geoffrey, made entirely of blue silk. It is in one piece from the chest to the thigh.

219 Basilica vestis Ducis Muscov/i\ensis. thorax & brachia auro neto splendidè acupicta; tota est serico cinere nisi quod manicæ rubro serico fimbriatæ sint.
Royal robe belonging to the Duke of Muscovy. The chest and neck are splendidly embroidered with braided gold; the whole is made of ash-coloured silk, with the exception of the sleeves which may be fringed with red silk.

220 Velamentum pro vestalis virginis capite, telâ arachnis acuratè calamistratum.
Veil for the head of a vestal virgin, carefully designed to resemble a spider's web.

221 Vestis cujus thorax est ex panno zylino, femoralia ex corio subacto; tibialia ex panno rubro.
Garment, of which the chest is made from cotton material. The part covering the thighs is worked in leather, and the covering the lower leg is of a red material.

[12r]

Chirothecæ
Gloves

222 Chirotheca Edw. Confessoris gossipio neto, albo attexta, panno holoserico coloris purpurei fimbriata.
Glove belonging to Edward the Confessor. It is made from braided cotton, woven in white and fringed with purple silk.

223 Chirothecæ Annæ Bull. Reginæ serico cæruleo attextæ, auro neto fimbriata.
Gloves belonging to Queen Anne Boleyn, woven in blue silk and fringed with braided gold.

228 Chirothecæ Henrici 8.ti Accipitrariæ, ex corio confectæ, cum quatuor cucullis accipitrarijs.
Henry VIII's hawking gloves, made of leather, and four hawk's hoods.
MacGregor 1983, nos. 103–4.

230 Duo paria chirothecarum corio confecta, corio etiam perbelle fimbriata.
Two pairs of gloves made from leather and prettily fringed, also with leather.
MacGregor 1983, nos. 105, 161.

232 Duo cutis cujusdam frustra crinibus setarum instar hispidis obsita; sed cuinam usui inserviant aut cujus animalis sint nondum constat.
Two fragments of some type of hide, covered with prickly hairs like bristles. But what purpose they serve, or from what animal they come is not yet known.

Sudariola
Cloths

234 Duo sudariola, quorum unum ex serico subalbido implexum est, auro, argento & serico netis acupictum, auro neto fimbriatum. Alterum linteo textum, auro itidem argento & serico polymitum. Serico neto fimbriatum. \\Hoc omnino deperiit; & sequens valde exesum est.//
Two cloths, one of which is woven entirely in whitish silk, embroidered with braided gold, silver and silk, and is fringed with braided gold. The other is woven in linen and likewise embroidered with gold, silver and silk; it has a braided silk fringe. The first has perished completely, the second is very much damaged.

235 Il vero Ritratto del Santissimo sudario Del nostro Salvatore Giesu Christo.
A true relic of the most sacred shroud of our Saviour, Jesus Christ.

237 Duo manupiaria cortice cujusdam arboris texta.
Two napkins made from the bark of a tree.

238 Manupiarium aliud cujusdam arbore cortice implexum.
Another napkin made from the bark of a tree.

[13r]

Cingula et Armillæ
Belts and bracelets

244 Sex cingula quibus fratres sancti ordinis franciscani sese circumdant, ex Lino neto omnia perbelle implexa sunt.

Six belts with which the holy brethren of the Franciscan order gird themselves, all finely made from braided linen.

245 Alterum cingulum quibus fratres Sancti ordinis fran/ci\scani accinguntur, serico nigro, albo, & cæruleo pereleganter implexum, /geniculatim\. margaritis parvis splendidè ornatur.
Another belt worn by the holy brethren of the Franciscan order, very elegantly woven in black, white and dark blue silk, and splendidly decorated with clusters of small pearls.

246 Alterum cingulum franciscanum stramine comptè complicatum.[5]
Another Franciscan belt, finely woven with straw.

248 Cingula duo colore rubicundo, albo nigroque tranversim distincta, /ex\ pennis histricis corioque inter se implexis confecta.
Two belts decorated with stripes of red, white and black, made out of the quills of a porcupine and leather, woven together.

249 Cingulum, quo monachæ ad pænitentiam usque castigantur, setis apprimè hispidis complicatum.
Belt with which nuns chastise themselves as penance. It is made from very stiff bristles.

250 Zona Hierosolymana rubro texta serico, cæruleo vermiculata colore, flavo & nigro fimbriata.
Sash from Jerusalem made of red silk, with wavy blue lines running along it, and a yellow and black fringe.

251 Zona hierosolymana argento & serico rubro splendidè textilis; flavo cæruleoque mixtis fimbriata.
Sash from Jerusalem splendidly woven in silver and red silk; it has a fringe of yellow and blue.

252 Zona altera, hierosolymana auro neto sericoque fusco locupletissimè implexa.
Another sash from Jerusalem. It is richly woven from braided gold and dark silk.

253 Zona altera viridi serico texta, albo, rubro, & flavo fimbriata; longitudine matris Sanctæ Mariæ cingulum exacte æqual.
Another sash woven from green silk, with a white, red and yellow fringe; it is exactly equal in length to the belt of the Blessed Virgin Mary.

265 Armillæ /indicæ\ 12. ex serpentum ferarumque aliarum dentibus compositæ.
Twelve Indian bracelets made from the teeth of wild serpents and other wild animals.
MacGregor 1983, nos. 14-15.

266 Armillæ /compositæ\ ex ungulis cujusdam volucris confectæ.
Bracelets made from a bird's claws.

267 Putamina fructuum arboris Ahoaij-guacu dictæ, quæ tintinnabulorum vice usurpantur a Brasiliensibus, brachijs pedibusque circa talos in Saltationibus potissimum, circumdantur ornatus gratiâ.

Husks from the fruit of a tree known as Ahoaij-guacu which are used by the Brazilians, instead of bells, and are tied to their arms and feet and around their ankles, as ornament, mainly in their dances.
[14r]

268 Tintinnabula /Brasilica\ ex conchis pyramidalibus confecta.
Brazilian bells made from conical shells.

269 Armilla ex operculis cujusdam cochleæ facta.
Bracelet made from the shells of snails.

270 Armillæ indicæ nigræ ex wampampeek compositæ.
Black Indian bracelets made from wampumpeake.
MacGregor 1983, no. 10.

271 Armilla Indica alba ex wampampeek facta.
White Indian bracelets made from wampumpeake.
MacGregor 1983, no. 10.

272 Spira galeri ex corio composita, geniculata.
A hat-band made of leather, knotted.

273 Spira galeri ex serico neto confecta; argento geniculata.
A hat-band made of braided silk, knotted with silver.

274 Spira galeri ex vitro neto conflata.
A hat-band made of latticed glass.

276 Duæ fasciolæ, argento sericoque cæruleo netis complicatæ.
Two small ribands made of braided blue silk and silver.

277 Periscelis Ducis glocestrensis, cæruleo serico texta.
Garter belonging to the Duke of Gloucester, woven from blue silk.

278 Zona armillaris, qua Canis H.. 8.[ti] accinctus erat, splendide argento acupicto, auro fimbriata, ære fibulata.[6]
Collar worn by Henry VIII's dog. It is a splendid object, embroidered in silver, with a gold border and a bronze clasp.

279 Catena quædam auro neto facta; colore rubro, albo cæruleo, aureo [-colore].
A chain made of gold braid, with red, white, blue and gold colours.

280 Catena ex viridi serico facta. an Rosarium sit? [-] cruce enim dotata est.
Chain made of green silk. Can it be a rosary? For it is provided with a cross.
[15r]

Ocrearum calceorumque varia genera
Various kinds of boots and footwear

281 Ocreæ Ostiarij Regis caroli 1.[mi]
Boots belonging to the usher of King Charles I.

282 Ocreæ Gilfiridi Regis Caroli 1.[mi] homunculi.
Boots belonging to Geoffrey, dwarf of King Charles I.

283 Ocræ muliebris Venetæ, spiris confibulatæ.
Venetian boots, worn by women, tied with straps.

284 Ocreæ turcicæ seu persicæ, quarum calces

[5] **[f.12v]** 247 A. Cingulum alterum ex gossipio /albo\ confectum cui usui destinatum sit nondum constat.
Another belt made from white cotton. It is not yet known for what purpose it was intended.

[6] **[f.13v]** 278A. Zona armillaris, quâ canis Henrici 8ti accinctus erat; /ex\ corio rubicundo confecta, argentoque splendidè exornata.
Collar worn by Henry VIII's dog; it is made of red leather, and has splendid silver decorations.

ferreâ Laminâ armantur.[7]
Turkish or Persian boots, the heels of which are reinforced with iron strips.
MacGregor 1983, no. 107.

285 Ocreæ turcicæ ex corio argentei coloris confectæ a genu ad calcem usque astrigmentis consutæ.
Turkish boots made from silver-coloured leather, laced from the knee down to the foot.

286-7 Tibialia tota ex corio confectæ. An Russicæ sint ?
Leggings made entirely from leather. Are they Russian ?

288 Tibiale aliud Russicum valdè amplum, soleas habet, sed non item calces.
Another Russian legging, very large, with soles but no heels.

289-90 Suræ Laponnicæ pilosa cute compositæ.
Lappish knee-boots made of hairy skin.

291 Sura Persica parva, cujus calx ferro munitur
Little Persian knee-boot, the heel of which is strengthened with iron.

292 Tibiale Russicum ex corio consutum
Russian legging made of leather.

293 Calcei veneti muliebres cum baxeis, holoserico deteguntur, argento neto egregiè acupicto.
Venetian shoes, worn by women, together with socks of woven silk, beautifully embroidered with silver braid.
MacGregor 1983, no. 111.

294 Calapedia ex Malta, panno viridi obducta, cristisque vittæ rubræ ornantur.
Pattens from Malta, covered with a green cloth and decorated with tufts of red ribbons.
MacGregor 1983, no. 112.

295-300 Calapediorum turcicorum 5 paria.
Five pairs of Turkish pattens.

301-3 Calceorum /Turcicorum\ 3 paria: quod pedis superiorem ambit partem holoserico rubri coloris obductum.
Three pairs of Turkish shoes; the part which extends over the top of the foot is covered with red silk.
MacGregor 1983, no. 54.

304 Calcei viridi holoserico composit[-a/i], loricâ æreis annulis concatenatâ obducti. ea pars quæ extremos pedis digitos tegit ferreâ laminâ munitur
Shoes made of green silk, covered in chain-mail of bronze rings; the part which covers the ends of the toes is reinforced with an iron plate.
MacGregor 1983, no. 48.

305-6 Calceorum duo paria, serico auroque neto sunt acupicta, Pars extrema, qua pedes teguntur, cristis sericis exornantur.
Two pairs of shoes, embroidered with silk and gold braid. The part covering the feet, is decorated with silken tufts.
MacGregor 1983, no. 53.

[7] **[f.14v]** Unius tantum pars inferior pedi destinata restat; altera integra est - 284.
Of one, only the lower part, which fits the foot, remains; the other is complete - 284.

289. Suræ aliæ Laponicæ.
Another pair of Lappish knee-boots.

308-9 Calapediorum duo paria ex Moorlandia, quorum unum rubro corio conflatum, aureo fimbriatum, cæruleo duplicatum. Alterum ejusdem ferè est figuræ, sed corio cæruleo, aureo rubro viridi obductum.
Two pairs of shoes from Moor-land, one of which is made of red leather, with a gold border, lined in blue; the other is almost identical in shape, except that it is made of blue leather, and covered in gold, red and green.
MacGregor 1983, no. 51.

310 Calceorum 2 paria ex albo corio foraminato confecta. An sint ex China.
Two pairs of shoes made of white leather pierced with holes. Could they be from China?
MacGregor 1983, no. 108.

311 Calceus alter ex albo corio foraminato confectus, forsan ejusdem cum supra dictis sit regionis.
Another shoe made of white leather pierced with holes, said to be possibly from the same part of the world as the previous one.

[16r]

312 Calceorum par. quod superiorem pedis tegit partem serico viridi flavoque acupictum est.
Pair of shoes; the part which covers the top of the foot is embroidered with green and yellow silk.

313 Calcei ex unico corij frustro facti.
Shoes made from a single piece of leather.

314 Calcei ex unico corij frustro compositi, sericam /spiram\ per utrasque corrigias traductam habent, quâ circum pedes arctè constringi possent.
Shoes made from a single piece of leather, with a twisted piece of silk running through each of the latchets, enabling the shoe to be bound close to the feet.

315 Sandalia ex viminibus implexa.
Sandals woven from reeds.

316 Calceus rubro holoserico obductus, corio aurei coloris fimbriatus.
Shoe covered with red silk, with a fringe of gold leather.

317 Calapedium albo panno holoserico tectum vittisque cæruleis undique fimbriatum.
Patten, covered in whitish silk, and fringed all round with blue ribbons.

318 Calapedia quorum superiores partes & circumferentiæ solearum nigro holoserico obducuntur.
Boots, of which the upper parts and the edges of the soles, are covered with black silk.
MacGregor 1983, no. 47.

319-21 Tres calcei muliebres persic/i\, corio rubro confecti, calces inferiores ligneae nostratium more sunt, & ferreâ laminâ muniuntur.
Three Persian shoes of red leather, worn by women; the heels are of wood made in the way ours are, and are reinforced with iron plates.

322 Calcei flavo corio confecti, foraminati, corrigias calces corriaceas habent & omnes partes quas nostrates.
Shoes made of yellow leather and pierced with holes. They have leather heels and laces, and are like our own in every respect.

323 Calcei nigro corio confecti, omnes nostrorum

calceorum habent partes. sed sunt breves admodum. An sint a Scotiâ ?
Shoes made of black leather, and like our own in every respect, except that they are much shorter. Are they from Scotland?
MacGregor 1983, no. 110.

324 Calceus indicus ex uno corij frustro confectus.
Indian shoe made from a single piece of leather.

325 Calceus holoserico subflavo obductus, vittâ cæruleâ hîc illîc fimbriatus.
Shoe covered with yellowish silk, fringed here and there with blue ribbons.

326 Calceus viridi holoserico tectus, auro neto splendide polymitus, vittâ rubrâ fimbriata.
Shoe covered with green silk, sumptuously woven with gold braid, and fringed with red ribbon.

327 Calcei rubro corio confecti, corrigijs carent & calcibus.[8]
Shoes made of red leather; the laces and heels are missing.

328-35 Calceorum 8 paria.
Eight pairs of shoes.
MacGregor 1983, nos. 21, 50, 52, 55-7, 109.

337 Calceorum 2 paria, lino neto complicata.
Two pairs of shoes made of braided linen.

338 Calcei viminibus implexi.
Shoes woven from reeds.
MacGregor 1983, no. 49.

339 Calcei gallici ex uno ligni frustro elaborati.
French shoes worked from a single piece of wood.

342 Calapediorum tres species, totæ ex ligno elaboratæ.
Three kinds of clogs, all made of wood.
MacGregor 1983, nos. 20, 59.

343 Calapedium /Laponnicum\ humani cruris longitudinem æquans, corio albo obductum; superiori extremitati præfigitur calceus.
Lappish pattens covered with white leather, equal in length to a human leg; the shoe is pointed at the very end.
[17r]

344 Calapedium laponnicum longitudine 12 pedes superat paululum, duabus ligneis Laminis confectum.
A Lappish patten [ski?], a little over 12 ft in length, made from two flattened pieces of wood.

347 Tres calcei a septentrionali Americæ plaga allati, quorum ope Incolæ hujus eo regionis super altissimas nives tutum iter conficere queunt. Loris ex pelle cujusdam animalis factis ita sunt complicati, ut opus cancellatum apprimè imitentur, ligneo orbiculo totus circundatur ambitus. In mediâ parte ansis coriaceis dotati sunt, quibus possent pedibus aptari.
Three shoes from the northern part of America, with which the inhabitants of this region are able to travel safely over the deepest snow. They are woven with thongs from the skin of a certain animal, in such a way that they look very like lattice-work, and the whole is contained within a circular wooden surround. In the middle they have leather loops with which

they can be fastened to the feet.

348 Calceus alter ex septentrionali Americae Mexicanæ plagâ /trans\portatus. Superiores omnibus imitantur, nisi quod longior sit & angustior, ac loris gracilioribus implexus.
Another shoe, brought from the northern part of Mexican America. It is like the above examples in all respects except that it is longer and slimmer, and woven with narrower leather thongs.

349 Calapedia Holandica Skads vulgò dicta, quorum ope per glaciei superficiem rapido cursu transferuntur.
Dutch pattens known commonly as skads [skates] with the aid of which the surface of the ice can be rapidly crossed.

350 Sandalia. pars soleæ superior cujusdam forsan arboris pelle complicata; inferior corio confecta. Ansam habent, qua pedibus astringuntur.[9]
Sandals. The upper part of the shoe is woven from what is possibly the bark of a tree; the lower part is made of leather. They have a loop with which they can be fastened to the feet.
MacGregor 1983, no. 58.

[18r]

Crumenæ variæ peræque
Various money-bags and pouches

351 Crumena interiore pedis anserini cute reticulatâ confecta intus rubro serico ornatè duplicata.
Bag made from the reticulated skin of a goose's foot, and richly lined with red silk.

352 Crumena ab exuvijs bufonis confecta.
Bag made from the skin of a toad.

354 Sunt duæ aves, quarum terga crumenulis exornantur
Two birds, whose backs are embellished with little pouches.

355 Crumena tota ex argento neto implexa.
Bag woven out of braided silver.

356 Crumenula alter ex argento & auro netis complicata, margaritis bracteisque aureis passim splendidè coruscans.
Another little bag made of braided silver and gold, glittering brightly all over with gold sequins and pearls.

357 Entheca literaria ab magno Mogol. ad Carolum 1^mum missa, serico auroque pereleganter implexa; varijs coloribus fulgens. rubro serico duplicata.
Letter-case sent to Charles I by the Great Mogul, most elegantly decorated with silk and gold, gleaming with different colours, and lined with red silk.

358 Pera coriacea ex Canada, cujus aliqua pars

[8] [f.15v] 327. Turcicos esse, mercatores qidam referebant.
Certain merchants reckoned them to be Turkish.

[9] [f.16v] 350A. Sandalia, quorum soleæ ex lino [-complexa] complicato confectæ, intusque serico rubro obductæ; pars superior [-ex] serico flavo, rubro, et cæruleo etc. acupicta: cum hac inscriptione: Given by M.ͭˢ Anne Rummer, sent to her from Rome, 1739.
Sandals, of which the sole is made from woven linen and the inside is lined with red silk; the upper is embroidered with silk - yellow, red, blue, etc. Inscribed thus: Given by Mrs Anne Rummer, sent to her from Rome, 1739.

Histricis calamis rubro colore tinctis complicata.
Leather pouch from Canada, one part of which is made from the quills of a porcupine, tinted red.

359 Pera Itineraria turcica.
Turkish travelling pouch.

362 Tres peræ /indicæ\ stramine implexæ.
Three Indian pouches, woven with straw.

364 Duæ peræ coriaceæ chinenes forsan, serico varij colorris acupictæ.
Two leather pouches, perhaps Chinese, embroidered with silk of various colours.

365 Pera indica coriacea angulo annulis aereis fixo dotata.
Indian leather pouch, which has one corner fastened with copper rings.

366 Pera indica coriacea ejusdem cum priore formae, cingulum autem habet rubro colore.
Indian leather pouch, similar to the previous one in form, but has a red belt.

370 Quatuor peræ coriaceæ indicæ, nummo Roanoak dicto exornatæ. .
Four Indian leather bags, decorated with [shell] money called roanoke .
MacGregor 1983, no. 13.

371 Crumenula coriacæ, rubro colore, utrinque viridi corio fimbriata.
Small leather purse, red in colour, with a green fringe on both sides.

372 Pera altera ex Canada, utrinque auriculam habet Histricis calamis complicatam.
Another wallet from Canada which has an 'ear' on both sides made from the quills of a porcupine.

373 Pera ex linteo facta, serico rubro acupicta & fimbriata.
Wallet made from linen, embroidered and fringed in red silk.

393 Viginti Peræ & marsupia indica corticibus cujusdam arboris texta.
Twenty money-bags and Indian pouches woven from the bark of a certain tree.

395 Duæ peræ ex indici nuclearij cortice compositæ.
Two money-bags made from the bark of an Indian nut tree.

396 Theca pro pectinibus ex corio conflata.
A comb-case, made of leather.

[19r]

397 Pera turica [sic] itineraria nigra obserata, ansa prædita, qua a cingulo suspendi potest.
Black travelling Turkish pouch, fastened, and provided with a loop with which it can be suspended from a belt.

398 Crumena eadem quâ, num: 365.
A purse identical to no. 365.

Flagella varia
Various whips

398-9 Flagella 2. Tartarica, nervis coriaceis implexa, quorum unum capulum ex ebore eleganter elaboratum habet, alterum autem ex ligno.
Two Tartar whips, woven with leather strips, one of which has a handle elegantly worked in ivory; the handle of the other, however, is wooden.

400 Flagellum Tartaricum coriaceum, vario colore; manubrium ex cervi pede confectum, rubroque corio obductum.
A Tartar leather whip in various colours; the handle is made from a stag's foot, and covered with red leather.

401 Flagellum Tartaricum duabus chordis coriaceis confectum. Manubrium ligneum, corio obductum.
Tartar whip with two leather thongs. The handle is wooden and covered in leather.

402 Flagellum ex tauri priapo factum.
A whip made of a bull's pizzle.

403 Flagellum cujus manubrium ex arundine factum.
Whip with a handle made from a reed.

404 Flagellum rubro xylo intextum.
Whip woven from red cotton.

405 Flagellum tartarium tribus constans chordis.
Tartar whip consisting of three lashes of the same length.

410 Quinque flagella, quibus monachæ cædantur, quorum unum ex ferro neto confectum, alterum ex gossipios, reliqua tria ex lino neto.
Five scourges with which nuns are whipped, one of which is made from braided iron, another from cotton, the remaining three from braided linen.

412 Duæ scopæ ex Lusitania ex /equinis\ jubis complicatæ, quibus muscæ ab equis jugantur.
Two switches from Lusitania, elaborately made from a horse's mane, with which flies are driven away from horses.

414 Duæ aliæ scopæ e Lusitania crinibus rubris implexæ, quibus muscæ ab equis abisque jumentis arceuntur.
Two other switches from Lusitania, of interwoven red hair, with which flies are kept away from horses and mules.

[20r]

Utensilla varia
Various objects

416 Laternæ Duæ, quarum una ex [-ferro\ære] christallis hîc illîc oculato conflata; altera ex cornu.
Two lanterns, one of which is made of bronze, set here and there with oval-shaped crystal; the other is made of horn.
MacGregor 1983, no. 209.

417 Ignitabulum ex ferro conflatum.
Tinder box made of iron.

422 Quinque lectulæ indicæ Hamaccoes vulgo dictæ, quarum duæ ex corticibus arboris cujusdam complicatæ, duæ ex Lino, altera ex Xylino implexæ.
Five little Indian beds, known commonly as hammocks, two of which are constructed from the bark of a certain tree, two are made of linen, and the last of cotton.
MacGregor 1983, no. 16.

423 Umbrella indica.
Indian umbrella.

443 Viginti Sportularum Indicarum specimina.
Twenty examples of small Indian baskets.

444 Pluteus ex Balænae ossibus confectus
Bookcase [?] made of whale bone.

445 Custos pudicitiæ ab Italia transmissus.
Chastity belt from Italy.

447 Duo sedilia: unum Indicum, alterum Turcicum.
Two stools, one from India and the other from Turkey.

448 Ephippium Tartaricum, ligneis Staticulis dotatum.[10]
Tartar saddle, with wooden stirrups.
MacGregor 1983, no. 27.

449-50 Duo Henrici 8.ti staticula.[11]
Two stirrups belonging to Henry VIII.
MacGregor 1983, no. 84.

451 Atramentarium Turcicum ex ære elaboratum. \\Duo reperio Atramentaria aerea forme inusitate.//
Turkish inkwell worked in bronze. I can find two bronze inkwells of this unusual form.

452 Candelabrum ferreum.[12]
Iron lamp-stand.

454 Vascula duo indica, Bubali pelle obducta, /in\ qua butyrum oleumque recondere solent.
Two small Indian vessels, covered with ox hide, in which butter and oil are stored.
MacGregor 1983, nos. 72-3.

456 Duo canthari Indici duro corio consuti, orificia habent cornea.
Two Indian tankards, made of hard leather stitched together; they have openings made of horn.

457 Calix ex cedri ligno elaboratus, foras habei sculptas, hoc circa marginem inscriptum: Such as have tasted the true drink indeed, doe in this life grow sure of their salvation; God's word and spirit.
Cup made of cedar-wood, with carvings on the outside, and with this inscription around the edge: Such as have tasted the true drink indeed, doe in this life grow sure of their salvation: God's word and spirit.

459 Calices Duo ex lapide Serpentino confecti, quorum unus [-/operculum] habet argenteum & ansam. Alter vero ex Stanno.[13]
Two cups made from serpentine, one of which has a silver lid and handle; those of the other are, in fact, of tin.

464 Calices quinque ex conchis argentarijs elaborati.
Five cups, worked in silver shell.

465 Poculum ex [-Rhinose] Rhinocerotis cornu conflatum.
Drinking cup made from a Rhinoceros horn.
MacGregor 1983, no. 74.

513 Quadraginta octo calices in uno nidulo tornati.[14]
Forty-eight cups turned to form a single little nest.
[21r]

517 Costulæ 4. quarum una ebore eleganter obducta, altera conchæ argenteriæ frustulis quadratis splendidè facta, alteræ duæ concha argentariâ insertæ.
Four small costrels, one of which is elegantly covered with ivory; another is beautifully made of small square pieces of silver shell; the other two are inlaid with silver shell.

518 Calix ligneus, qui manubrio ex Rangiferorum crure facto præfigitur.
Wooden cup, with a handle made from the leg of a reindeer.

521 Pollubra tria indica rotunda & compressa, ex cucurbitarum putaminibus confecta.
Three round, thin-walled Indian basins, made from the shells of gourds.

523 Duæ ampullæ indicæ ex cucurbitarum putaminibus elaboratæ, rotundæ & compressæ, in ambitu orificia habent.
Two Indian bottles, made from gourd shells; rounded and thin-walled, with an opening at the rim.

526 Tria pollubra indica ex cucurbitarum putaminibus confecta, figurâ ovali.
Three Indian basins made from gourd shells; oval in shape.

536 Decem ampullæ indicæ ex cucurbitarum putaminibus, figurâ orbiculari.
Ten Indian vessels made from gourd shells; round in shape.
MacGregor 1983, no. 71.

539 Spattulæ tres indicæ ex ligno confectæ.
Three Indian spatulae made of wood.

542 Disci duo indici ex ligno elaborati.
Two Indian dishes, made from wood.

543 Mulctra Japonnica ligno polito extrinsecus obducta; extrinsecus vero viminibus implexa.
Japanese milk-pail, covered on the outside with polished wood; the outside is also covered with woven osier.
MacGregor 1983, no. 75.

544 Vas indicum totum ex ligno laboratum. An sit mulctra ?
Indian vase, made entirely of wood. Could it be a milk-pail?

545 Cochlear totum ex argento conflatum.
A spoon made entirely of silver.

546 Cochlear argenteo manubrio præditum. Sed ea pars quæ ori aptatur, ex buxo tornata.
A spoon with a silver handle. But the part intended for the mouth is of boxwood, turned on a lathe.

547 Cochlear argenteum deauratum manubrium habet; ea pars quæ cibum recipitex concha argenteâ conflata.\\fract://
A silver spoon with a gilded handle. The part which holds the food is made of silver shell. Broken.

548 Cochlear ex Jaspide orientali /seu heliotropio\ elaboratum. manubrium spathulæ argento deaurato præfigitur.
A spoon made of oriental jasper or bloodstone; the handle is

[10] **[f.19v]** Deest unum Staticulum
One stirrup missing.

[11] **[f.19v]** 450. Stapes æreus nuper in navi Hispanorum (juxta Jamaicam) naufragâ repertus.
Bronze stirrup recently found in the wreck of a Spanish ship (near Jamaica).

[12] **[f.19v]** 453. Calcar et stapes Danicus ex dono. Christoph. White.
Danish spur and stirrup. Given by Christopher White.

[13] **[f.19v]** unus fract:
One broken.

[14] **[f.19v]** desunt tres.
Three missing.

fixed to the spatula with gilded silver.

549 Cochlear ex concha venerea factum.
manubrium spathulae argento deaurato annectitur.
A spoon made from a Venus shell. The handle is attached to
the spatula with gilded silver.

550 Cochlear sine manubrio ex concha argentaria
elaboratum.
A spoon without a handle, made of silver shell.

554 Cochlearia 4. indica ex ossibus conflata. 2.°
fracta.
Four Indian spoons made of bone. Two are broken.
MacGregor 1983, nos. 22-3.

568 Cochlearia 14. ex ligno facta: n.° 565 exes. &
fract.
Fourteen Indian spoons made from wood. No. 565 is rotten
and broken.
MacGregor 1983, nos. 69,197-9.

[22r]

569 Patina magna chiñitica alba cæruleo colore
tincta.
A large white Chinese dish, with blue paint.

572 Tres aliæ patinæ chiniticæ albæ col. caeruleo
tinctæ.
Three other white Chinese dishes, painted with blue.

573 Patina altera chinnitica alba colore rubro,
aureo et viridi splendide nitet.
Another white Chinese dish, which gleams brightly with red,
gold and green.

575 Scutellæ duæ albæ colore cæruleo tinctæ. An
chiñiticæ sint ?
Two white saucers with blue colouring. Could they be
Chinese ?

576 Scutella ex testudine elaborata.
A saucer made of tortoise shell.

577 Scutella /ex\ plumbo aurato seu staño /facta\
circa marginem deaurata.
A saucer made of gold-plated lead or tin, gilded around the
edge.

580 Tres scutellæ Japonnicæ ligneæ, parte
convexa egregie politæ, concava varijs coloribus
fulget.
Three Japanese wooden saucers, the convex side is highly
polished, the concave side gleams with different colours.

582 Duæ aliæ scutellæ ligneæ; parte convexâ
politâ incrustatione obducuntur; concavâ verò
aureo rubro, viridi, nigroque colore tinctæ. An
Japonnicæ sint ?
Two more wooden saucers: the convex side has a polished
coating; the concave side, however, is painted with gold, red,
green and black. Could they be Japanese?

583 Scutella ex charta composita, rubro aureoque
colore eleganter depicta.
A saucer made of paper, elegantly painted in red and gold.

587 Disci 4. chin[-n]itici oblongi; in unâ parte
fæminas nudas prostratas habent sua pudenda
manibus tegentes.
Four elongated Chinese dishes which, on one side, have
recumbent naked women each covering her pudenda with
her hands .
MacGregor 1983, nos. 214-6.

596 Scutellæ 9. chinniticæ.

Nine Chinese saucers.

601 Salina quinque chin[-n]itica quinquangula.
Five five-cornered Chinese salt-cellars.

602 Discus chiñiticus albus, cæruleo colore tinctus
fractusque.
A white Chinese dish, with blue painting. Broken.

603 Discus alter gramine implexus, in concava
parte auro foliaceo obductus.
Another dish, woven from grass; the concave side is covered
in gold leaf.

606 Tres alij disci lignei, figura quadratâ.
Three other wooden dishes, square in shape.

613 Vitrea septem. ea pars cui vinum infunditur,
patinarum figuram quammodo exprimit. manubria
habent longa, artificiose admodum conflat. \\unum
fract.//
Seven glasses. The part into which the wine is poured is
essentially dish-shaped. They have long stems ('handles'),
very skilfully made. One broken.

617 Quatuor vitrea minora. ea pars quæ vinum
recipit, scutellas figurâ aliquomodo imitatur.
Four smaller glasses. The part which holds the wine is
somewhat like a saucer in shape.

620 Tria alia vitrea, quorum duo ansis sunt
prædita poculorum instar.
Three other glasses, two of which have handles like goblets.

623 Tria vitrea, quorum duo volucrum effigie
notantur, alterum hominis.
Three glasses, two of which are decorated with the figures of
birds, the third with that of a man.

[23r]

626 Tria vitrea, quorum unum Johannis
Tradescanti effigie insigne. Alterum Regis
anglicani insignibus splendide ornatur, ac hoc
inscriptum /auro\ habet. Vivat Rex Angliæ.[15]
Three glasses, one of which is distinguished by a likeness of
John Tradescant; another is decorated with the insignia of
the King of England and has this inscription [in Latin] in gold:
Long live the King of England.

636 Decem vitrea quædam varia parva orificia
habent, alia unicum tantum.
Ten glasses, some of which have a variety of small
openings: others have only one.

637 Pes vitrei.
Foot of a glass.

638 Aliud vitreum fractum.
Another broken glass.

640 Duo utres vitrei, quorum unus stramine
obductus, alter serico.
Two glass bottles, one of which is covered in straw, the other
in silk.

643 Tres alii utres.
Three more bottles.

644 Piscis imago ex vitro conflata.
The image of a fish made of glass.

645 Avis cujusdamfigura ex vitro conflata.

[15] **[f.22v]** Septem aliæ res ex vitro conflatæ.
Seven other items made of glass.

The image of a bird made of glass.

646 Vitreum aliud figuram cornu exhibet.
Another glass showing a figure with a horn.

647 Poculum ex cornu confectum, in artificiosum arietis caput collocatum cornibus naturalibus præditum, quorum extremitates argento ornantur et tintinnabulis. \\Deest poculum.//
A cup made of horn which is attached to an artificial ram's head with real horns, the tips of which are decorated with silver and hung with bells. The cup is missing.

648 Quoddam instrumentum ex lino neto implexum, An sit fiænicapistrum, ad indomitos equos compescendos paratum.
An object woven from braided linen. Could it be a halter to restrain untamed horses.

6[55+49] Pixis lignea, rotunda, in qua sex quadræ ligneæ continentur.
A round wooden pyxis, containing six wooden squares.

650 Speculum /ustorium\ ex chalybe conflatum; quodquidpiam flamabile longe dissitum igne concipit.
A burning mirror, made of steel, which sets fire to anything flammable over a long distance.

[24r]

Tubulorum, quibus tabaci fumus hauritur, ligneorum & fictilium varia specimina
Various examples of wooden and clay pipes, used for inhaling tobacco smoke

656 Tubuli sex Indici [-] lignei. Primus receptaculum habet peramplum, cujus ad summitatem perfigitur homo deformis, ac monstrosus, genibus recumbens, quasi futurum, ut alvum exoneraret. Secundus receptaculo dotatus, minori, cujus in summitatem collocatur homunculus deformis, cujus tergum pedibus ac ore hiante quoddam saevè apprehendit animal. tertius receptaculum habet, cujus summatati imponuntur volucres duæ. Quartus receptaculum habet magnum, cujus summitati rectus ad dexteram foraminis partem insidet Leo. Alteri duo receptacula habent magna, nullo animali ornata.
Six Indian wooden pipes. The first one has a very large bowl, to the very top of which is attached the image of a deformed and monstrous man, resting on his knees, as if he were about to empty his bowels. The second has a smaller bowl, on the top of which is a deformed dwarf whose back a savage animal seizes with its paws and its open jaws. The third has a bowl on the top of which are placed two birds. The fourth has a large bowl at the top of which, to the right of the opening, is a lion rampant. The remaining two have large bowls, not decorated with any animals.

657 Tubulus nicotianus, cujus tam fistula quàm receptaculum ex luto indurato fabrefacta sunt colore ad aes proxime accedit. receptaculum sustentatur ab animali quodam, Lupo simili.
Tobacco pipe, the stem and bowl of which are both skilfully modelled out of hardened clay, almost bronze in colour. The bowl is supported by an animal of some kind, similar to a wolf.

658 Tubulus nicotianus indicus; fistula ex ligno cortice vestito confecta; receptaculum /ex\ cornu cervi factum.

Indian tobacco pipe, with a wooden stem, covered with bark; the bowl is made from a deer's antler.

659 Tubulus nicotianus indicus; fistula in partes duas dividi potest, nigro colore receptaculum ex cornu coloris nigri elaboratum, laminâ ferreâ fimbriatum.
Indian tobacco pipe, the stem of which can be divided into two parts; the bowl is black, made from black-coloured horn, and bordered with an iron plate.

660 Tubulus nicotianus, 3 pedes longitudine metitur, tenuis, sed incrustatione quadam pulcrâ ex frustulis matris Perlarum & laccâ coloris nigri flavique nitet. Receptaculum ex ære argentato confectum glandium capsulas magnitudine haud excedens.
Tobacco pipe, measuring 3 ft in length, thin but with a beautiful covering of small pieces of mother-of-pearl and with a shining lacquer of black and yellow. The bowl is made from silver-plated bronze, and the inside of the bowl is hardly larger than the cup of an acorn.

663 Tres tubuli nicotiani, quorum fistulæ sunt ex arundine, receptacula ex luto indurato.
Three tobacco pipes, the stems of which are made of cane, and the bowls of hardened clay.

664 Tubulus indicus, fistulam habet arundineam, receptaculum ligneum.
Indian pipe, with a cane stem, and a wooden bowl.

[25r]

665 Tubulus indicus, fistula lignea, quadrata præditus, receptaculum naviculæ speciem ostendit.
Indian pipe, with a squared wooden stem, and a bowl which looks like a small boat.

666 Tubuli duo nicotiani, quorum fistulæ sunt ligneæ, & in duas partes dividi possunt, vaccâ rubri nigrique coloris pictâ; pars media & extremitates sunt viridis coloris, /cum\ circulo aureo. receptula ex luto indurato conflata. An Chiñenses sint?
Two tobacco pipes, with wooden stems which can be divided into two parts, decorated with a cow in red and black; the middle and ends are green in colour, with a golden circle. The bowl is made from hardened clay. Could they be Chinese?

667 Tubulus indicus, fistula lignea præditus, in duas partes dividi potest, vaccâ rubicundâ, viridi, fuscâ et albâ illinitus: receptaculum tabaci ex luto indurato confectum. An sit chiñenses.
Indian pipe, with a wooden stem, which can be divided into two parts, and is decorated with a cow in red, green, black and white: the bowl for the tobacco is made from hardened clay. Could it be Chinese ?

668 Tubulus alter chiñenses, fistulâ longâ, ligneâ præditus, plumbo hîc illîc circundatâ. receptaculum ex luto cinerei coloris indurato elaboratum.
Another Chinese pipe, with a long stem made of wood, wrapped around here and there with lead. The bowl is made from ash-coloured hardened clay.

669 Tubulus nicotianus, fistulam ex nigro ligno factam habet. Receptaculum ex luto indurato quibusdam chracteribus notato confectum.
Tobacco pipe with a stem made of black wood. The bowl is made from hardened clay which is decorated with certain

characters.

670 Tubulus nicotianus, fistula lignea dotatus. receptaculum ex luto indurato confectum.
Tobacco pipe with a wooden stem. The bowl is made of hardened clay.

671 Tubulus indicus nicotianus fistulam habens vaccâ nigrâ & rubrâ illinitam. Receptaculum ex luto indurato.
Indian tobacco pipe, with a stem decorated with a cow in black and red. The bowl is made from hardened clay.

674 Tres tubuli nicotiani toti ex terra induratâ terram lemniam rubram aliquomodo imitante confecti. figuram nostratium ferè exhibent.
Three tobacco pipes all from hardened earth which looks somewhat like red Lemnian clay; they look almost like our own pipes.

676 Duo alij tubuli [-ex luto] ex luto nigro indurato confecti: ejusdem cum superioribus figuram habent.
Two other pipes made from hardened black clay: they have the same shape as those above.

677 Tubulus ex uno ligno frustro elaboratus.
Pipe made out of a single piece of wood.

678 Duo receptacula tubulorum.
Two pipe bowls.

679A Tubulus nicotianus an Japonnicus? fistulâ donatus ligneâ, vaccâ nigri, rubri,flavique coloris illinitâ, ære neto multis in locis circundatâ, in quinque partes divisibili: receptaculum habet ex luto indurato coloris cinerei conflatum & ære neto itidem circundatum,
Tobacco pipe, possibly Japanese? It has a wooden stem painted with a cow in black, red and yellow; it is wrapped around in several places with braided bronze, and can be divided into five parts. The bowl is made of ash-coloured hardened clay similarly encircled with braided bronze.

[26r]

Res antquæ ex terris elaboratæ
Ancient earthenware objects

680 Urna Romana magna et capacissima, in quam totius domus cineres reconditi fuerunt, colore rubro; ventre amplissimo; collo brevi et angusto prædita, quod utrinque ansâ magnâ dotatum.
Large and capacious Roman urn, in which the ashes of a whole family were stored. It is red in colour, has a wide body, and a short and narrow neck with a large handle on either side.

681-3 Tres aliæ urnæ Romanæ, magnae, ventres habent protuberantes, quarum una in collum terminatur, viminibus circundatur; alteræ duæ collis carent.
Three other large Roman urns with swelling bodies, one of which ends at the neck and is covered with osier; the other two have lost their necks.
MacGregor 1983, nos. 211-13.

684 Frustra quædam urnæ Romanæ.
Remains of a Roman urn.

685 Vas quoddam Romanum pro floribus hurnanam ex scapulis figuram exhibens.
A Roman vase for flowers, showing a human figure from the shoulders up.

687 Duæ ollæ chi[-]nenses, quarum una viridis ē

coloris, ramis aurei coloris notata: altera alba cæruleo colore perbelle picta.
Two Chinese pots one of which is green in colour and decorated with golden branches; the other is white and beautifully painted in blue.
MacGregor 1983, nos. 76-7.

Res antiquæ ex vitro confectæ
Ancient glass objects

689 Duæ urnæ Romanæ lachrymales ex vitro confectæ.
Two Roman lachrymatory urns made from glass.

Res recentiores ex terris conflatae
More recent earthenware objects

692 Tria vasa fictilia, ventres habent protuberantes, colla longa quæ e ventribus sensim adaugentur, An sint ex Portugalia?
Three earthenware vessels with swelling bodies and long necks, which extend gradually from the vessel. Could they be from Portugal?

694 Lagenæ duæ rubicundæ, ansis præditæ, ventres habent protuberantes, quarum una hîc illîc deaurata, a ventre tubus deauratus ad collum usque exurgit.
Two red flasks with handles and swelling bodies, one of which is gilded in places and has a gilded pipe rising from the body all the way up to the neck.

695 Discus oblongus /indicus\, colore rubicundo, in quo continetur serpentium [-] nidus.
Elongated Indian dish, red in colour, enclosing a serpent's nest.

701 Sex alij disci, colore rubicundo, quorum quatuor ansas habent. An sint ex Portugalia.
Six other dishes, red in colour, four of which have handles. Could they be from Portugal?

[27r]

702 Vas quoddam plumbo ferè colore, utrinque ansis dotatum.
A vessel roughly the colour of lead, which has handles on both sides.

703 [-Lagena/Poculum] ex terra coloris cinerei factum.
Drinking cup made of ash-coloured earth.

Res antiquæ ex figno et lapide elaboratæ
Ancient wooden and stone objects

705 Calendar/i\a duo runicis characteribus notata, longa, gladij lignei figuram exhibentia.
Two calendars marked with runic characters; they are long and take the form of a wooden sword.

706 Figura cujusdam munimenti antiqui ex ligno facta.
Model of an ancient fortification made of wood.

706A Historia filii prodigalis ex ligno cælata.
The Parable of the Prodigal Son carved in wood.

708 Duæ columnæ cujusdam monumenti antiqui.
Two columns belonging to some ancient monument.

709 Effigies nostri Salvatoris crucifixi; ex albastro confecta, cujus ad utramque manum duo fures cruci alligantur.
Effigy of Our Saviour on the Cross, made of alabaster, with the two thieves crucified on either side of him .
MacGregor 1983, no. 223.

710 Caput S.^ti Johannis & Jesu Christi in pixidem reconditum ex alabastro elaboratum.
The head of St. John and of Jesus Christ worked in alabaster, stored in a small box.
MacGregor 1983, no. 224.

711 Martyrium Episcopi Amphipolis ex alabastro caelatum.
The martyrdom of the Bishop of Amphipolis carved in alabaster.
MacGregor 1983, no. 222.

718 Septem capita Lapidea.
Seven stone heads.

719 Vas lapideus
Stone vessel

720 Characteres ligno inscripti, speciemque libri aperti ostendunt.[16]
Letters inscribed in wood, looking like an open book.

721-2 Duo lapides magni ex Egypto allati, characteribus hieroglyphicus notati.
Two large stones brought from Egypt and marked with hieroglyphs.

722A Idolum Indicum Gonga appellatus ex Insula Seagur in ostio Gangis a Cl. viro Dño Gul. Hedges Milite huc delatum.[17]
Indian idol known as Gonga, brought from the island of Sagur at the mouth of the river Ganges, by the celebrated Sir William Hedges

[28r]

Artificiosa varia
Various works of art

723 Tabula opere musivo /eximiè tessellata\ [-exquisitissime confecta].
Mosaic table, finely tessellated [exquisitely made].

724 C[-o/i]sta opere etiam musivo pereleganter composita.
Box, also in mosaic, most elegantly composed.

726 Duæ figuræ Sepulchri nostri salvatoris; una lignea altera Saxea
Two models representing tomb of Our Saviour; one in wood the other in stone.

727 C[-o/i]sta ex [-] ligno elaborata, quam si per

foramen oculis collustres, cernere liceat splendidum palatium. an opus Japonnicum?
Wooden box which, if you look through the hole, allows you the view of a splendid palace. Could it be from Japan?

728 Solarium ligneum figurâ cylindriceâ, pedem altitudine aliquantulum excedit; stylo præditum longo, ex ferreâ Laminâ conflatum.
Cylindrically-shaped sundial, made of wood, slightly more than 1 ft high; it is fitted with a long pin, made of a thin sheet of metal.

731 Pectinarium an Japonnicum sit. colore nigro, politum est, humanis figuris auro pictis exornatur. Continet in se duos pectines amplissmos ex buxo elaboratos, radijs densis ac rarioribus dotatos.
Comb-case, possibly Japanese. It is black in colour, polished and decorated with human figures painted in gold. It contains within it two very large combs made from boxwood, which have both coarse and fine teeth.
MacGregor 1983, nos. 195-6.

732 C[-o/i]sta indica gramine facta. An Japonnica sit
Indian box made from grass. Could it be Japanese?

[-733 Crepitacula indica conchis fructibusque composita, quæ gestunt dum Ludum Pyrrhichum agunti.]
Indian rattles made from shells and husks which they wave during the Pyrrhic Games.

734 Fidicula indica lignea, varijs regibus alijsque hominibus ac fæminis, nec non varijs alijs animalibus exornata; colore viridi, rubro, aureo, nigro, alboque nervis caret.
Small Indian lute, made of wood, decorated with various kings and other men and women, and also with various animals; it is green, red, gold, black and white in colour, and lacks its strings.

735 Instrumentum musicum e[-] Lusitaniâ provectum, est figuræ circularis, in ambitu habet varias æneas laminas polis affixas rotarum instar.
Musical instrument from Lusitania, circular in shape; and all around it has various flat strips of bronze attached to poles like wheels.

738 Tres naviculæ indicæ vulgò canoes /a Lusitanis\ appellatæ, ferarum pellibus consutæ.
Three small Indian boats commonly called canoes by the Lusitanians. They are sewn from the skins of wild animals.[18]

742 Quatuor Remi qui supra dictis naviculis aptantur.
Four oars which belong to the small boats described above.
MacGregor 1983, no. 1.

746 [-/Quatuor] hastæ piscatoriæ cuspidibus Lamatis ex ossibus factis armatæ; harum etiam duæ media parte cuspidibus hamatis tribus ex ossibus confectis munitæ.
Four fishing spears with hooked points made of bone; two of these have, in the centre, three hooks made of bone.

748 Duæ aliæ hastæ piscatoriæ, quarum una

[16] **[f.26v]** Quare annon Idem cum 646 in Libro D.^ni Decani Æd. X.^ti.
For this reason it is perhaps not the same as No. 646 in the Book of the Dean of Christ Church.

[17] **[f.26v]** 722.B. Lignea Tabula, paulo plus quam tres pedes longa, prope unum lata; characteribus Hieroglyphicis notata. In Fenestrâ Musei suspensa.
Wooden board, a little more than 3 ft long, almost 1 ft wide, inscribed with hieroglyphic characters. Hung in the window of the Museum.

722.C. Pars Sarcophagi (vel forsan vasis in quo Mumiae condiebantur) In Angliam Allata, et Universitati oppignerata per Perry, M.D. ~ vide Perry's Travels, ubi egregii cimelii picturam quoque de eo tradit ipse Author cernere est.
Part of a sarcophagus (or perhaps of a container in which mummies are preserved) brought to England and bequeathed to the University by Perry, Doctor of Medicine. See Perry 1743, pp. 470-73, pl. 18, where a picture of this outstanding treasure is to be seen and where the author himself writes about it.

[18] **[f.27v]** Idem credo cum 728 in Libro D.^ni Decani Æd. X.^ti.
The same, I believe, as 728 in the Book of the Dean of Christ Church.

duabus cuspidibus munitur; altera verò inermus.
Two other fishing spears, of which one is fitted with two points. The other, in fact, has no point.

[29r]

749 Cunabula Henrici Sexti Anglorum Regis, tota ex ferro conflata.
Cradle of King Henry VI of England, made entirely from iron.
MacGregor 1983, no. 210.

750 Crepundia indica, quibus dæmones excitantur. Pars ea, quæ sonum edit, figurâ est sphærica, cujusdam nucis putamine confecta, frustulis ossium seu concharum ad bractearum speciem redactis undique obducta: hisce etiam frustulis manubrium tegitur.
Indian rattle with which demons are roused. The part which makes a noise is spherical in shape and is made from the shell of a nut; it is covered all over with fragments of bone or shell made to look like gold-plate: the handle is also covered with these fragments.

752 Trochleæ duæ ferreæ, quarum una hamo armatur forcipato, quo commodius aliquid apprehendere queat; altera annulum habet affixum, quo alicui alligari possit.
Two iron block-and-tackles, one of which is equipped with a forked hook with which things can be more easily picked up; the other is fitted with a ring with which it can be fastened to an object.

754 Duo calcaria Barbarica ferrea.
Two iron spurs from Barbary.
MacGregor 1983, nos. 17-19.

755 Lituus indicus eburneus, curvatus; una extremitas humanæ manus speciem exhibet. In mediâ parte foramen habet ad canendum aptatum.
Curved Indian trumpet, made of ivory: one end takes the form of a human hand. In the middle, it has an opening for blowing.
MacGregor 1983, no. 26.

756 Traha Laponnica, quâ ope Rangiferorum ei altigatorum hyeme per nives ferri solent lapon-nienses.
Lappish sledge to which reindeer are tied, and on which the Lapps are customarily carried across the snow in winter.

758 Duæ naves prostratæ exactè structæ; varijsque tormentis bellicis ex ligno elaboratis exoneratæ.
Two wrecked ships, precisely modelled, equipped with various canons which are made out of wood.
MacGregor 1983, no. 85.

[-756 Octo hominum aliorumque animalium picturæ in tabulis ita obscurè delineatæ ut vix quidem nisi vitrij cujusdam sylindrici ope quod sint esse appareant.]
Eight pictures of men and other animals depicted on tablets so faintly that is it scarcely possible to make out what they are without the aid of a lens.

7[-59/60] Arboris paradiseæ prohibitæ /species\ ex ligno elaborata, sub qua Adamus & Eva collocantur, ex ligno itidem confecti; inter ramos contorquetur serpens, ad Evam pomum aureum ore ex arbore porrigens.
Wooden model showing the forbidden tree of the Garden of Eden, under which Adam and Eve, also in wood, are placed; the serpent winds itself around the branches and, from the tree, holds the golden apple out to Eve in its mouth.

76[-8/1] Hercules & Antæus ex gypso elaborati, Athletarum instar colluctantes.
Hercules and Antaeus made from gypsum, wrestling like athletes.

76[-9/2] Figura Herculis /ex gypso facta &\ tergo [-/cen]tauri imposita; unam manum habet /ita\ porrectum, ut magnâ vi videatur hujus monstri capiti colaphum impacturus; alterâ verò manu ejus caput torquet.
Figure of Hercules on the back of a centaur, made from gypsum; he holds one hand outstretched in such a way that he seems about to deal a blow of great force to the head of this monster; he twists its head back with the other hand.

7[-70/63] Imago hominis ex ligno elaborata; vultum habet furtim spectantem unam manum porrigit, alterâ se sublevat, ut sine molestia columnæ insideat.
Figure of a man made out of wood; he has a furtive look on his face; he is stretching out one hand, with the other he raises himself, so that he may sit on a pillar without trouble.
MacGregor 1983, no. 227.

[30r]

7[-71/64] S.^tus Franciscus ex cerâ confectus, & in pixide colocatus.
Figure of St. Francis made out of wax and kept in a box.

7[-72/65] S.^tus Hieronimus ex cera confectus, & in pixide positus.
Figure of St. Jerome made out of wax and placed in a box.

7[-73/66] Hominis altera im/a\go ex cera elaborata
Another image of a man made of wax.

7[-74/67] Imago fæminæ ex cera facta.
Figure of a woman made out of wax

77[-5/1] Quatuor equi ex cerâ conflati
Four horses made out of wax.

7[-80/73] Duæ aliæ hominum imagines ex ceri fabre factæ, fractæ.
Two other figures of men made out of wax. These are broken.

7[-81/74] Fructus varij ex cera compositi.
Various fruits made of wax.

7[-82/75] Hydra artificialis septem capitibus cornulis prædita.
Model of a hydra with seven heads, each with little horns.

7[-83/76] Effigies cujusdam hominis ex ligno elaborata, manus habet erectes conjunctasque.
Figure of a man made from wood; he has his hands raised and joined.

7[-84/77] Idolum indicum ex plumis compositum, figurâ canem seu leonem imitatur.
Indian idol made of feathers in the shape of a dog or a lion.

7[-86/78] Duæ molæ pneumaticæ ex ebore opere valde dædaleo elaboratæ.
Two windmills, carved in ivory with great artistry.

7[-88/80] Pocula Duo ex ebore confecta.
Two drinking cups made of ivory.

7[-89/81] Pixis unguentaria ex ebore operata, rotunda, quatuor pedibus eburnis sustentata; cujus summitati alia parva affigitur pixis; quæ si ejus operculum dimoveatur multis foraminulis perforatur, e quibus egrediuntur suffimenta.

Round, ivory censer standing on four ivory feet; attached to the very top is another small container, which, if its lid is removed, is seen to be pierced with many small holes, from which the incense rises.

[-/786] Quinque Res ex ebore adeo tenniter tornatæ, ut tennitate /filorum\ ferè æmulæ videantur; geniculatæ sunt.
Five ivory objects, so skilfully turned on a lathe that, in their fineness, they seem almost to rival string; they have nodes.

[-/788] Pocula duo parva, quorum unum ex quodam ligno, alterum vero ex nuce muscata confectum. Pedibus eburnis et operimentis dotata.
Two small drinking cups, one of which is made of some wood, the other made from a muscat nut. They have ivory feet and lids.

[-/789] Decem Sportularum nidus, ex ligno compositus, qui in pixidem reconditur, corio turcico deaurato obductam.
A nest of ten little baskets, made of wood and kept in a box which is covered in gilded Turkish leather.

[-/799] Rheda ex ligno curiosè conflata.
A four-wheeled carriage carefully made of wood.

[-807 Octo imagines caloptricæ juxta leges opticas elaboratæ, et speculis cylindricis destinatae, quamvis nil nisi confusum chaos primo aspectu exhibeant, adhibito tamen specula ostentant eleganter satis elaboratas imagines.]
Eight catoptric images, made according to the laws of optics and intended for cylindrical mirrors. Although at first sight they seem to depict nothing but confused chaos, by using the mirrors they show images which are both elegant and of appropriate detail.

808 Alvearium vitreis fenestris præditū, per quas liceat apes videre farvos suos conficientes.
A beehive with glass windows through which one can see the bees making their honey.

[31r]

809 Corpus integrum humanum, quod mumi vocant more Ægyptiaco conditum.
A complete human body, which they call a mummy, preserved in the Egyptian manner.

810. Bajulum, Pallancheen dictum.
Travelling litter called a palanquin.

811 Pyxis nicotianæ ænea, stramineo opere eleganter variegata. Ex dono Joh. Aubrey Armig. e Soc. Regiâ.
Bronze tobacco jar elegantly decorated with basketwork. Given by John Aubrey Esq., of the Royal Society.

812 Quadrans omni latiduclini inserviens: auctore Francisco Potter. [-] Id.m D.s Aubrey don.vit.
A quadrant that can be used at every latitude, made by Francis Potter. Again given by John Aubrey.

LIBER DOMINI DECANI ÆDIS CHRISTI
The Book of the Dean of Christ Church
Transcribed and translated by Gloria Moss, annotated by Arthur MacGregor

Ashmolean Museum, AMS 8 [1685a], compiled *c*. 1684-90, with later additions. Leather-bound, quarto volume; black leather labels on spine and cover, `LIBER DÑI DECANI ÆDIS CHRISTI', all within tooled borders, 54 folios, 230 by 175 mm.

Many of the items listed here can be shown to derive directly from the Tradescant collection and many more, amounting to the majority of the natural specimens, are likely to have come from the same source. Those which currently survive in the collections are referred to the catalogue published to mark the tercentenary of the Museum (MacGregor 1983). Others long-since lost can yet be identified with entries in the Tradescant catalogue of 1656. For example, many of the 'micro-carvings' and other tiny (and all too vulnerable) objects fall into this category, including several flea-chains (p. 45: cf. Tradescant 1656, p. 39, where they are characterized as having '300 links a piece and yet but an inch long'), various nuts and cherry-stones which once housed minutely carved objects (p. 45; ibid., pp. 37, 39) and surgical instruments wrought on the points of needles (p. 45; ibid., p. 37). Other Tradescant curiosities now lost that can be identified here include the 'Blood that rained on the Isle of Wight, attested by Sir Jo: Oglander' (p. 46; ibid., p. 44) and 'An Orange gathered from a Tree that grew over Zebulon's Tombe' (p. 46; ibid., p. 43); many further links can be made with the Tradescant catalogue, with varying degrees of certainty. Other rarities certainly came from alternative sources, such as the horn that grew on the head of Mary Davis (p. 48), which was 'sent by Mr. Ashmole to be laid up in his Repository' in 1685 (see MacGregor 1983a). Together these typify the mixture of natural rarities and man-made *Kunstkammerstücke* ⁻ virtuoso productions in a variety of materials ⁻ that were the common currency of the sixteenth- and seventeenth-century cabinet of curiosities (see Impey and MacGregor 1985, *passim*).

Amongst the minerals and fossils, as well as those that would find a place in any comprehensive mineralogical collection there are others which owe their presence specifically to the quasi-magical properties attributed to them by classical tradition, transmitted largely through the works of Pliny and much prized by early collectors (for some discussion of this topic see Kunz 1915). Amongst the stones, eagle-stones (*aetites*) (p. 43) ⁻ hollow geodes with a loose element that rattled within ⁻ were prized as charms to aid problem-free childbirth while swallow-stones (*lapis chelidonius*) (p. 38), supposedly extracted from the heads of swallow nestlings, were a popular form of talisman for 'strengthening the brain' and for commercial success. *Asteriae* and *astroites* (pp. 41, 43) were fossil corals with millefiore-like star patterns on their surfaces, prized as 'victory stones', while *ombriae* (p. 39), believed by some to originate in rain and thunder-storms, had a reputation as antidotes against poison. Other popular talismanic pieces such as *glossopetrae* (p. 40) and toad-stones (pp. 40-41, 43) are here confidently identified as fossil fish teeth (from the shark and ray families respectively) while other 'sports of Nature' such as the naturally occurring tesserae or dice known as *Ludus Paracelsus* or *Ludus Helmontii* are similarly correctly explained. While the catalogue acknowledges the true nature of many of these and other pieces, the collection itself exemplifies the strong measure of Hermetic tradition that pervaded the benefaction with which Ashmole founded his new, proto-scientific institution. The monument which he erected to the 'new science', with its Baconian amalgamation of 'elaboratory', teaching facilities and 'museum' proper, remained firmly rooted in the alchemical tradition to which Ashmole was an enthusiastic subscriber and to which his first appointee as keeper, Robert Plot, for all his pioneering work in natural science, was not immune.

[7r]

Catalogus Lapidum tum pretiosorum, tum viliorum, nec non rerum minutiorum arte Thaumaturgicâ fabrefactarum, quæ Cl. vir Elias Ashmole suo Musæo donavit, ac in Scrinio præstantissimo reponi curavit An. Dñi 1683*[1]

[1][f.6v] NB. Quibus Hæc Notula [‡] affixa est, [-Anno] amissa sunt 21 Sept. Aº 1691.
Those items against which this sign [‡] appears, were lost on 21 September 1691.

[No no.]
Oculus Catti formâ ovali
Oval shaped cat's eye
Oculus Catti minor, forma conica
Small, conically shaped cat's eye
Oculus Catti ovalis, rufescens.
Oval-shaped cat's eye, with a red glint

A catalogue of stones both precious and semi-precious and some other small, miraculously formed objects which the celebrated Elias Ashmole gave to his museum in the year of Our Lord 1683, and which are preserved in the principal cabinet

1 Sapphirus una naturalis impolita.\\saphirs//
A natural, unpolished sapphire.

2 Duæ sapphiri politæ Plinio Cyani.
Two polished sapphires known to Pliny as bluestones.

3 Smaragdi seu Prasini duo naturales impoliti opaciores \\emerau..//
Two natural, opaque, unpolished emeralds or prase.

4 Cyathus e Smaragdo opaciori.
Ladle in cloudy emerald.

5 Prasini duo naturales pellucidiores.
Two natural, translucent prase.

6 Smaragdus magnus politus.
Large polished emerald.

7 Duo smaragdi minores, politi.
Two smaller polished emeralds.

8 Smaragdi quatuor minimi politi. \\3.8, emerauld//
Four smaller polished emeralds.

9 Topasius, vel Topasium Orientale, politum \\Topaz//
Polished topaz or oriental topaz.

10 Chrysolithi, Chrysopatij duo politi.\\Plinio Chrysolampides.//
Two polished chrysolites, or chrysopatii, known to Pliny as chrysolampis.

11 Hyacinthus magnus, spurius vereor.
A large jacinth, not genuine I fear.

12 Hyacinthi duo minores, ejusdem generis. \\11.13.//
Two smaller jacinths, of the same kind.

12 [-Hyacinthi duo veri, politi.]
Two polished genuine jacinths.

13 Berillus sive Beryllus major, politus. \\13.4//
Larger polished beryl.

14 Berillus minor, item politus.
Smaller beryl, likewise polished.

[on insert]

15 [-[-]palus [-] Pæderos, Italis girasole verus politus]
Opalis, seu Opalis alii Padrios, Italis, Girasole verus politus.
Highly polished opal, known to Italians as *girasole*, and to others as *opalis padrios*

16 [-Opalus alius (ut opinor) spurius] Opalus alius, ut opinor, spurius.
Another opal, in my opinion, a fake.

17 [-Calcedonij, aliâs Carchedonij, 4 pellucidi majores] [-A/C]alcedonii, alias, Carchedonii 4 pellucidi majores.
Four large and transparent chalcedonies, otherwise known as carbuncles.

18 [-Calcedonij /*\quinque Opaci[-] minores. \\a kind of onyx// [-]²] Calcedonii quinque opaciores minores. a kind of onyx.
Five smaller opaque chalcedonies. A kind of onyx.

19 [-Calcedonius grandimosus.Ferrando Imperato Ingemmamentum grandinosum] Calcedonius grandi[-m/n]osus Ferrando Imperato, Ingemma grandi[-m/n]osum.
Hailstone (lit: full of hail) chalcedony; the hailstone gem of Ferrante Imperato.

20 [Amethissti duo magni n[-]s, impoliti] Amathysti duo magni naturales, impoliti
Two large, unpolished, natural amethysts.

21 [-[-] ...les, impoliti.³] Amathysti duo minores naturales, impoliti
Two smaller, unpolished, natural amethysts.

[8r]

22 Amethystus magnus quadratus politus.
Large, square, polished amethyst.

23 Amethystus item magnus figuræ mixtæ, politus.

A similarly large, polished amethyst of irregular form.

24 Amethysti tres majores, item politi.
Three rather large amethysts, similarly polished.

25 Amethysti quatuor /3x\ minores, item politi.⁴
Four smaller amethysts, similarly polished.

26 Amethysti quatuor minimi, item politi.⁵
Four very small amethysts, similarly polished.

27 Granati duo Bohemici maximi, politi. \\20.25//
Two extremely large polished Bohemian garnets.

28 Granati item duo Bohemici magni, politi.
Another two large polished Bohemian garnets.

29 Granat[-i/us] [-duo] Bohemic[-i/us] minor[-es], polit[-i/us]
Smaller, polished Bohemian garnet.

30 Granati quatuor Bohemici superiorib⁶ paulo minores.⁶
Four Bohemian garnets, a little smaller than the above.

31 Granati quatuor Bohemici, adhuc minores politi.
Four polished Bohemian garnets, still smaller in size.

32 Granati quatuor Bohemici minimi politi.
Four very small, polished Bohemian garnets.

33 Granat[-i/us] polit[-i/ us], pal[-is/â] imposit[-is/a], formâ rosaceâ.
Polished, rose-shaped garnet, set in a bezel.

34 Granati communes majores, numero .22.
Twenty-two larger common garnets.

35 Granati cõmunes paulo minores, numero itẽ 22.
Twenty-two slightly smaller, common garnets.

36 Granati communes adhuc minores, numero.26./*\ \\d[-9]9//⁷
Twenty-six still smaller common garnets.

37 Granati cõmunes paulo dilutiores, numero.18. \\[-24.34]//⁸
Eighteen slightly less impressive common garnets.

38 Leucachates forma rotunda.
Round white agate.

39 Annulus ex Leucachate quo utuntur Turci in sagittando.
White agate ring used by the Turks in archery.
MacGregor 1983, no. 60.

40 Idem iterum.
Another of the same.
MacGregor 1983, no. 61.

41 Mucro sagittæ, ex Leucachate.
Arrow-head, of white agate.

42 Cyathus ex Leucachate.
Ladle of white agate.

[on insert]

43 [-Globus ex Leucachate paucis intercurrentib⁶ venulis tum citri[-]is sive ravis, tum molochinis.]
Globus ex Leuchachate [-quodammodo] paucis

⁴[f.7v] [-*d.1.]

⁵[f.7v] [+d.1.]

⁶[f.7v] [-]

⁷[f.7v] [*d.4]

⁸[f.7v] [+d19] [d9+d‖9 Des. 8]

²[f.6v] [-*d.q.] + d.1.

³[f.6v] 21. Amethysti duo minores naturales, impoliti.
Two small, unpolished, natural amethysts.

intercurrentibus venulis tum citrinis sive ravis, tum
molochinus.
Sphere of white agate, with a few intermingled veins both yellow
or greyish-yellow and mallow-coloured.

44 [-Globus ex Leucachate quodammodo flavescente.]
Globus ex Leuc[-h]achate [-quo/d\m] quodammodo
flavescente.
Sphere of white agate, with a hint of yellow.

45 [-Idem iterum.] Idem iterum.
Another of the same.

46 [-Leucachates paululum rufescens.] Deest.
Missing.

47 [-Mucro sagittæ ex Leucachate paululū rufescente.]
Mucro sagitta ex Leucachate paululū rufescente.
Arrow-head of white agate, slightly reddish.

48 [-Mucro sagittæ ex Achate coloris insuasi.] Mucro
sagitta ex Achate coloris insuasi.
Arrow-head of a dark, orange-coloured agate.

[7v]

[-In hoc loco substituitur mucro sagittæ ex Leu[-]te
pululum [-] all[-] distinctur]
In its place, an arrow-head of white agate, a little [*illeg.*].

[9r]

49 Cyathus ovalis ex Achate magno ejusdem coloris,
paucis venulis subcæruleis distincto.
Oval ladle made from a large agate of the same colour, marked
with a few small bluish veins.
MacGregor 1983, no. 217.

50 Achates longus utroque fine mucronatus,
subcæruleus et paululum flavescens.
Long, bluish and slightly yellowish agate, pointed at both ends.

51 Globus ex Achate maximā in partē subcæruleo,
aliquantulū cæsio, nonnullis lineis albis insignito.
Sphere of white agate, for the most part bluish in colour, also
somewhat bluish-grey, and marked with some white lines.

52 /*\Achates oblongus sulcatus ex subcæruleo
rufessens.[9]
Elongated agate, grooved and bluish shading to red.

53 Globus ex Achate livido subrubente, quibusdā
lineis ex cæruleo albescentibus et miniatis notato.
Sphere of blue-black agate, with a reddish tinge, and with some
whitish and reddish lines emerging from the blue.

54 Annulus ex Achate e cæruleo rufescente quo
utuntur Turci in sagittis emittendis. \\fract.1692.//[10]
Agate ring, blue shading to red, used by the Turks in archery.
Broken 1692.

55 Annulus ex Achate coloris luridi, venis albis
distincto.
Agate ring of blue-black colour, marked with white veins.

56 Achates ovalis coloris Bætici seu subnigri, duobis
notis ex albo flavescentibus, ex adverso signatus.
Ovoid agate, Bætic or blackish in colour, with two white markings
shading to yellow, on the back.

57 Achates pullus lineis albis in subcæruleo
discriminatus.
Dark grey agate, with white lines standing out against a blue

background.

58 Achates chrystallinus octogonus, lineis tum albis
tum rubris, notatus.
Crystalline, octagonal agate, marked with variegated red and white
lines.

59 Achates chrystallinus [-ovalis\quadratus] colore
insuaso tinctus.[11]
Square, crystalline agate, dark orange in colour.

60 Achates chrystallinᵘˢ ovalis lineis citrinis insignitus.
Crystalline, oval agate, marked with yellow lines.

[9r]

61 Achates chrystallinus itē ovalis lineis albis et citrinis
discriminatus.
Crystalline agate, again oval in shape, marked with white and
citrine coloured lines.

62 Achates chrystallinus item ovalis, maculis tum
insuasis, tum bæticis, vitiatus.
Chrystalline agate, again oval in shape, spoilt by dark orange and
Bætic spots.

63 Achates chrystallinus rufescens.
Reddish, crystalline agate.

64 Achates chrystallinus in pila annuli argentei,
maculis nigris fœdatus.
Crystalline agate mounted on a silver ring, stained with black
spots.

65 Achates item chrystallinus ovalis, maculis
nigerrimis inquinatus.
Another crystalline, oval agate, stained with very black spots.

66 Achates chrystallinus cylindraceus, tertia parte,
Leucachate et prasio, compositus.
Cylindrical, crystalline stone, consisting of agate, mixed in a two-to-
one ratio with white agate and prase.

67 Leucachates, maculis flavescentibus et miniatis
distinctus.
White agate, distinguished by its yellowish and red spots.

68 Achates [-cæsius \leucophæus] ovalis, lineis tum
albis tum subcæruleis insignitus.
Oval, ash-coloured agate, marked with white and bluish lines.

[10r]

69 Achates cæsius cordiformis, quibusdam maculis
insuasi coloris fœdatus.
Bluish-grey, heart-shaped agate, stained with certain spots of a
dark orange colour.

70 Achates luteus sive insuasus, cordiformis, lineis
albis ornatᵘˢ.
Heart-shaped agate, golden-yellow or dark, orange-coloured,
embellished with white lines.

71 Achates luteus cylindraceus lineis etiam albis
signatus.
Cylindrical, golden-yellow agate, also distinguished by white lines.

72 Achates /*\10 oval[-i/e]s, eisdē colore et lineis,
tincti.[12]
Ten oval agates, of the same colour and marked with similar lines.

73 Achates duo quadrati, eisdem colore et lineis,
distincti.
Two square agates, of the same colour and marked with similar

[9][f.8v] *[-]
[10][f.8v] f/

[11][f.8v] [-]
[12][f.8v] [-*d.[-]]

lines.

74 Achates unus rotundus, maculâ molochinâ insignitus.
A single round agate, notable for its mallow-coloured spots.

75 Achates ovalis coloris citrini, lineis et maculis albis notat*ᵉ*.
Yellow, ovoid agate, marked with white spots and lines.

76 Achates ovalis ejusdē coloris, maculis albis signatus.
Ovoid agate, of the same colour, marked with white spots.

77 Achates figura conicâ ejusdē coloris, lineis tum albis, tum subcæruleis ornatus.
Conical-shaped agate of the same colour, decorated with both white and bluish lines.

78 Achates tres quadrati, coloris luridi, lineis albis distincti.
Three square agates of pale yellow colour, marked with white lines.

79 Achates duo rotundi, eisdem colore et lineis insigniti.
Two round agates of the same colour and with similar lines.

80 Achates octogonus, eisdē colore et lineis notatus.
Octagonal shaped agate, of the same colour and with similar lines.

81 Achates cordiformis, eisdē etiam colore et lineis ornat*ᵉ*.
Heart-shaped agate, decorated in the same colour and with white lines.

82 Achates ovalis ejusdē coloris, duabus maculis albis signat*ᵉ*.
Ovoid agate of the same colour, marked with two white spots.

83 Achates duo ejusdē coloris, maculis albescentib*ᵉ* tincti.
Two agates of the same colour, with whitish spots.

84 /*\Achates tres cylindracei ejusdē coloris, lineis albis notati.¹³
Three cylindrical agates of the same colour, marked with white spots.

85 Achates duo ovales subcærulei, lineis albis distincti.
Two bluish ovoid agates, marked with white lines.

86 Achates /*\quinque ovales Cærulei, lineis albis ornati.¹⁴
Five blue, ovoid agates, decorated with white lines.

87 Hæmachates ovalis, punctis sanguineis, passim conspersus.
Ovoid, blood-coloured agate, spattered with blood-coloured spots.

88 Hæmachates ovalis, venis sanguineis, et quasi tabo fœdatus.
Ovoid, blood-coloured agate, with blood-coloured veins and discoloured as if with plague.

89 Hæmachates rotundus, lineis abis insignitus.
Round, blood-coloured agate, marked with white lines.

90 Hæmachates rotundus, lineis tum albis tum nigris notatus.
Round, blood-coloured agate, with both white and black lines.

91 Hæmachates /duo\ oval[-i/ e]s, venis albis distincti.¹⁵
Two ovoid, blood-coloured agates, marked with white lines.

92 Hæmachates ovalis, maculis albis ornatus.
Ovoid, blood-coloured agate, embellished with white spots.

93 Hæmachates quadratus parte minori albescens.
Square, blood-coloured agate with a small whitish area.

94 Hæmachates conicus lineis albis signatus.
Conical, blood-coloured agate, marked white lines.

95 Hæmachates ovalis nubeculâ infectus.
Ovoid, blood-coloured agate, somewhat clouded.

[llr]

96 Hæmachates lividus. /pene cordiformis\
Bluish, blood-coloured agate, almost heart-shaped.

97 Hæmachates /*\duo ovales venis cæruleis insigniti.¹⁶
Two ovoid, blood-coloured agates, marked with dark blue veins.

98 Hæmachates subcæruleus.
Bluish, blood-coloured agate.

99 Hæmachates venis quibusdam nigris notatus.
Blood-coloured agate, marked with black veins.

100 Hæmachates duo ovales quasi tabo conspurcati.
\\34.101//
Two oval, blood-coloured agates, defaced as if by the plague.

101 Oculus Beli.
Cat's eye.

102 Oculus Beli minor, formâ depressiori.
Smaller cat's eye, more flattened in form.

102/b Oculus Beli quasi Cataractâ aut suffusione obvolutus.
Cat's eye, obscured as if by a cataract or suffusion.

103 Lycophthalmi sex Gesneri. \\d 2//
Six wolf's eyes of Gessner.

104 Argus Lapis, multis quasi oculis conspersus, forma ovali.
Ovoid Argus stone, looking as though sprinkled with many eyes.

105 Argus lapis minor rotundus.
Smaller, round Argus stone.

106 Gladii manubrium ex Achate subcæruleo paululū flavessente.
Sword-handle made of bluish agate, a little yellow.

107 Gladii manubriū, ex Achate subcæruleo, venis quibusdam ex albo flavescentibus, distinctum.
Sword-handle made of bluish agate, distinguished by yellowish-white veins.

108 Cultri manubrium ex Achate subcæruleo, venis quibusdā albis ac rufescentibus, ornatum.
Knife-handle made of bluish agate, embellished with white and reddish veins.

109 Gladii manubrium ex Hæmachate, lineis ac venis albescentibus insignitū.

¹³ *d. [-] [f.9v] In hoc loco substituitus Achates penè cordiformis.
These objects have been replaced by an almost heart-shaped agate.

¹⁴ *d1. [f.9v] In unius locum substituitur globulus Achatis.
In place of one of these a small sphere of agate has been substituted.

¹⁵ [f.9v] *
¹⁶ [f.10v] *d.1.

Sword-handle of blood-coloured agate, marked with whitish lines. MacGregor 1983, no. 200.

110 [-Cultri manubrium ex Hæmatite, venis tum cæruleis tum albis notatum].
Knife-handle of blood-coloured agate, marked with blue and white veins.

/Polypodium vulgare in lapide scissilio carbonario delineatum. E puteis carbonarijs Dñi E. Evans de Eagles Bush in Glamorgania. Vide Figur. et descript. apud Camd. p. 693 Fig 2...[17]
Common fern, figured in laminar coal. Found in coal-pits by E. Evans of Eagles Bush in Glamorgan. See the illustration and description given in Camden 1695, p.[695], fig. [29].

110/b Cultri manubrium [-] dimidiatum &c. Ex dono J. Aubrey arm. R.S.S.
Half a knife-handle etc., marked with white. Given by J. Aubrey Esq., FRS.

111 Torques ex Achatibus Jaspidibusque variorum generū. \\13//
Necklaces of agate and jasper of various kinds. MacGregor 1983, nos. 65-6.

112 Armilla plerumque ex Leucachatib⁰ ac Sardachatibus. \\18//
Bracelet mainly of white and carnelian agates.

113 Monilia tria ex Leucachatibus. \\129//
Three necklaces made from white agates. MacGregor 1983, no. 67.

114 Torquis ex Leucachatibus aliquantulū rufessentibus. \\[-84] 81//
Necklace of reddish-white agates. MacGregor 1983, no. 65.

115 Torques duo ex Achatibus coloris Leucophæi. \\128//
Two necklaces of ash-coloured agates.

116 Torquis ex Leucachatibus, et achatibus citrinis, alternatim positis. \\circiter 172//
Necklace of alternating white and yellow agates. MacGregor 1983, no. 68.

117 Torquis ex Leucachatibus colore citrino tinctis, cum globulis floribusque deauratis, alternatim positis.[18]
Necklace of white agates tinged with yellow, arranged alternately with gilt flowers and spheres.

118 Cultri manubrium ex Sardachate.
Knife-handle of carnelian agate. MacGregor 1983, no. 202.

[12r]

[17][10v] Vid. Lithoph. Britan.
see [E. Lhwyd] *Lithophylacii Britannici Ichnographia*.
[No. no.*]
a.b.c.d.e Quinque Achates nitidiiss: forma ovali vel prope ad eam accedente.
f. Cyathus amplus ovalis ex Achate magno.
g. Pars Armillæ vel istiusmodi cujusdam, ex quinque Achatibus rotundis, fulvi metalli palis infixis, et inter se concatenatis.
a,b,c,d,e. Five polished agates, ovoid, or near ovoid in shape.
f. Large oval ladle made from a large agate.
g. Part of a bracelet made of five round agates, fastened on to bars of brown metal and linked together in a chain.
[18][f.10v] circiter 73

119 Sardachates formâ quadrangulâ oblongâ.
\\119.126.//
Rectangular carnelian agate.

120 Sardachates cordiformis.
Heart-shaped carnelian agate. MacGregor 1983, no. 191.

121 Sardachates cordiformis minor.
Smaller heart-shaped carnelian agate.

122 Sardachates octogonus.
Octagonal, carnelian agate.

123 Sardachates duo forma triquetra.
Two triangular carnelian agates.

124 Sardachates forma ovali.
Ovoid carnelian agate.

125 Sardachates multiformis.
Irregular carnelian agate.

126 Corallachates forma octogona. \\126.129.//
Octagonal coral-agate.

127 Corallachates cuspidem sagittæ referens.
Coral-agate shaped like the tip of an arrow.

128 Cultri manubrium ex Corallachate.
Knife-handle of coral-agate.

129 Corallachates forma ovali.
Ovoid coral-agate.

130 Corneolus, vel potius Carneolus, forma ovali.
\\130.140.//
Ovoid cornelian, or rather carnelian.

131 Corneolus ovalis convexior.
Ovoid carnelian, more convex in outline.

132 Corneolus formâ ovali adhuc convexiori.
Ovoid carnelian, still more convex in outline.

133 Corneolus cylindraceus.
Cylindrical carnelian.

134 Corneolus hemisphæricus.
Hemispherical carnelian.

135 Annulus e Corneolo quo utuntur Turc[-i\æ] in sagittis emittendis.
Carnelian ring, used by the Turks in archery. MacGregor 1983, no. 62.

136 Corneolus crucifõrmis.
Cruciform carnelian.

137 Annulus e Corneolo.
Carnelian ring. MacGregor 1983, no. 63.

138 Annulus e Corneolo minor.
Smaller carnelian ring.

139 Annulus e Corneolo minimus.
Very small carnelian ring.

140 Sigillum e corneolo capite humano insculpto, palâ aureâ incluso, encausto picta.[19]
Carnelian seal engraved with a human head, enclosed in a golden bezel and painted encaustically.

141 Jaspis orientalis punctis sanguineis conspersa, forma Rhõboidali. \\141.155//
Rhomboid oriental jasper, spattered with blood-coloured spots.

[19][f.11v] ‡ fract. et amiss
Broken and repaired.

142 Jaspis orientalis forma ovali.
Ovoid, oriental jasper.

143 Jaspis orientalis formâ item ovali.
Another ovoid oriental jasper.

144 Jaspis orientalis cylindracea.
Cylindrical, oriental jasper.

[12v]

☞Cochleare ex Jaspide (ut opinor) maxima ex parte diaphano olim fracto, jam vero conglutinato, manubrio argenteo deaurato infixum.

A spoon made, I think, of jasper, largely transparent. It was once broken but has now been stuck together. It has a gilt silver handle.

[13r]

145 Annulus parvus e Jaspide orientali. \\d.// \\1721//
Small ring of oriental jasper.

146 Jaspis viridis paucis venulis sanguineis intercurrentibus distincta, forma ovali.
Ovoid, green jasper with a few blood-coloured veins running through.

147 Jaspis item viridis forma quadrata, angulis perforata.[20]
Another green jasper, rectangular in shape and pierced with holes.

148 Cultri manubrium e Jaspide viridi.
Knife-handle of green jasper.
MacGregor 1983, no. 201.

149 Cultelli manubrium item e Jaspide viridi.
Handle from a small knife, also of green jasper.

150 Jaspis viridis forma ovali.
Ovoid, green jasper.

151 Jaspis viridis forma ovali paululum flavescens.
Ovoid, green jasper, slightly yellowing.

152 Jaspis item viridis forma ovali magis flavescens.
Another ovoid, green jasper, but more yellow.

153 [-Jaspis purpurea cordiformis.][21]
Deep red, heart-shaped jasper.

154 /Jaspides orientales duæ forma octagona, in quibus imago cujusdam aquam haurientis &c. Ex donis Rever. Viri D.Caroli King, Æd. Christi Alumni\
Two octagonal, oriental jaspers with the image of a water-carrier etc. Given by the Revd Charles King, Student of Christ Church.
MacGregor 1983, no. 131.

[-Jaspis purpurea cordiformis, pala aurei insita].
Deep red, heart-shaped jasper, in a bezel of gold.

155 Globus e Jaspide purpureâ.
Sphere of deep red jasper.
See MacGregor 1983, no. 115.

156 Grammatias forma ovali.
Ovoid jasper striped with white lines.

157 Grammatias forma ovali depressiori.[22]
Ovoid jasper striped with white lines, flatter in form.

158 Terebinthizusa Dioscoridis paululum rufessens.[23]

Turpentine stone [?] of Dioscorides, slightly reddish.

159 [-Prasius formâ ovali]. \\Prasius formâ ovali.//[24]
Ovoid prase.

160 Prasius cordiformis.
Heart-shaped prase.

161 Prasius octogonus.
Octagonal prase.

162 Onyx niger, seu onyx proprie sic dictus, forma ovali.\\162.168//
Ovoid, black onyx, i.e. onyx in the strict sense.

163 Onyx cornea forma ovali.
Hard, ovoid onyx.

164 Onyx luteus eâdem formâ.
Similarly shaped golden-yellow onyx.

165 Onyx aureus eâdem formâ.
Golden onyx of the same shape.

166 Onyx viridescens.
Greenish onyx.

167 Sardonyx multiformis. \\Ovalis//
Irregular, ovoid sard.

168 Sardonyx cordiformis.
Heart-shaped sard.

169 Turcois, Turcosa, sive Turchesia /magna\, forma conicâ. \\169.175//
Large, conical turquoise.

170 Turchosa magna forma /conicâ\ depressiori.
Large, conical turquoise, flatter in form.

171 Turchesia sive Turchina cuneoformis.
Wedge-shaped turquoise.

172 Turchosæ tres depressiores, forma ovali.
Three smaller ovoid turquoises, flatter in form.

173 Turchesiæ tres minores.
Three smaller turquoises.

[14r]

174 Turchosæ duæ minimæ.
Two tiny turquoises.

175 Turchosæ tres viridescentes, atque hoc pacto viliores. * \\1 d//[25]
Three greenish turquoises, and for this reason less valuable.

176 Corallij rubri specimina tria. \\176.182//[26]
Three specimens of red coral.

177 Corallij rubri fragmenta duo.
Two fragments of red coral.

178 Corallij rubri fragmenta decem perforata.
Ten perforated fragments of red coral.

179 Corallij albi specimen.
A specimen of white coral.

180 [-Corallium album rubro unitum, in forma fungi, pileolo inverso.]
White and red coral, mushroom-shaped, like an inverted cap.

[20] [f.12v] f.

[21] [f.12v] ‡

[22] [f.12v] 148 d

[23] [f.12v] d

[24] [f.12v] ‡

[25] [f.31v] Forte Malachites 4ᵗⁱ generis Wormij vid. Mus. p. 95
Possibly malachite of the fourth type described by Worm 1655, p. 95.

[26] [f.13v] 176 Chelidonius lapis
Celidony [swallow stone].

[181] Specimen Corallij albi et rubri unitorum.
A specimen of combined red and white coral.

182 [-Specimen Corallij albi et rubri unitorum.]
A specimen of combined red and white coral.

183 Chrystallus oblonga hexagona viz.ᵗ forma sua naturali. \\183.200//
Oblong, six-sided crystal in its natural state.

184 Chrystallus hexagona ut e matrice sua crescit.
Six-sided crystal in the form in which it grew from its matrix.

185 Chrystallus hexagone obtusa.
Blunt, six-sided crystal.

186 Chrystalli hexagonæ quatuor oblongæ impolitæ.[27]
Four elongated, six-sided crystals, unpolished.

187 Chrystalli tres multiformes politæ.
Three irregular crystals, polished.

188 Chrystalli tres pyriformes multifariam politæ.
Three conical crystals, polished at various points.

189 Chrystallus oblonga, utroque fine mucronata, multifariam polita.[28]
Elongated crystal, pointed at both ends and polished at various points.

190 Chrystallus multiformis subfusci coloris.
Irregular, dark-coloured crystal.

191 Chrystallus pyriformis multifariam polit[-us\a] ejusdẽ coloris.
Conical crystal of the same colour, polished at various points.

192 Chrystalli quadrangulæ decaëdræ 14 /majores et \ elatiores.
Fourteen fairly large and impressive ten-sided crystals, with quadrangular faces.

193 Chrystalli quadrangulæ decaëdræ 14 paulo minores et depressiores. \\[-d]//
Fourteen rather smaller and flatter ten-sided crystals with quadrangular faces.

194 Chrystalli quadrangulæ decaëdræ 14 ejusdẽ magnitud. \\[-d:2//[29]
Fourteen ten-sided crystals, of the same size, with quadrangular faces.

195 Chrystalli quadrangulæ decaëdræ 14 ejusdẽ fere magnitud.[30]
Fourteen ten-sided crystals with quadrangular faces, of almost the same size.

196 Chrystalli quadrangulæ decædræ 16 paulo minores.
Sixteen rather smaller ten-sided crystals with quadrangular faces.

197 Crystalli quadrangulæ decædræ 18. multo minores.[31]
Eighteen much smaller, ten-sided crystals with quadrangular faces.

198 Chrystalli quadrangulæ decædræ 12 minimæ. \\des:8//

Twelve very small, ten-sided crystals with quadrangular faces. Eight are missing.

199 Chrystallus figura conicâ multifariam polita.[32]
Conical crystal, polished at various points.

200 Chrystalli tres multifariam politæ forma triquetrâ.
Three triangular crystals, polished at various points.

201 Chrystallus magna oblonga multifariam polita.
Large, elongated crystal, polished at various points.

[15r]

202 Annulus e Chrystallo politâ.
Ring of polished crystal.
MacGregor 1983, no. 128.

203 [-Forma Crucis Dñi nr̃i Jesu Christi e Chrystallo politâ, auro in extremitatibus munita, tribusque insuper margaritis orientalibus ornata.][33]
Cross of Our Lord Jesus Christ, made of polished crystal, with gold mounts at the extremities, decorated on top with three oriental pearls.

204 Crux alia Dñi e Chrystallo politâ.
Another Cross of Our Lord made from polished crystal.

205 Chrystallus polita musco prægnans.
Polished crystal, full of moss.

206 Calculus globosus transparens naturaliter sic formatus.
Transparent, spherical pebble, naturally formed.
MacGregor 1983, no. 192.

207 Ombria triangularis palâ argenteâ munita, e Calculo transparenti naturaliter formata.
Triangular ombria mounted in a silver bezel, naturally formed from a transparent pebble.

208 Ombria triangularis, superiori multo minor, palâ non munita, e Calculo item transparenti naturaliter formata.
Triangular ombria, much smaller than the above, not mounted in a bezel, again naturally formed from a transparent pebble.

209 Ombria similis, superiori paulo minor.
A similar ombria, a little smaller than the above.

210 Ombria similis, superiori paulo depressior.
A similar ombria, a little flatter than the above.

211 Ombria similis, superioribus omnibus multo minor et rotundior, a triãgulo propemodũ recedens.
A similar ombria, much smaller than all the above and more rounded, less markedly triangular.

212 Ombria triangularis oblonga, superioribus figurâ similis, sed coloris subfusci. \\℈// \\307.212//[34]

[27] **[f13v]** [-...purascens, e ferrifodiinis Bristoliensibus]
... purplish, from the iron mines at Bristol ...

[28] **[f.13v]** 1754 deest 189 fract:

[29] **[f.13v]** [-d.2]

[30] **[f.13v]** [-d.]

[31] **[f.13v]** d. [-] 5 [-d/1/2]

[32] **[f.13v]** de:

[33] **[f.14v]** * d *Selenitœ Hoddingtonensis
Crystalline gypsum from Headington
203. Margarita decem.
Ten pearls.

[34] **[f.14v]** ℈ Ombria Elliptica ex dono Joh. Wills S. Th. Prof. de Bishops Itchington Com. Warw.
Elliptical ombria given by John Wills, Professor of Sacred Theology, of Bishops Itchington, Warwickshire.
✛ Alia ejusdem figure et magnitudinis ex dono Joannis Aubrey Armiger R.S.S.
Another of the same shape and size given by John Aubrey Esq., FRS.
✳ Calculus flavescens multiformis. [in another hand] Achates potius.
A yellowish pebble, irregular in shape. Probably an agate.

Elongated, triangular ombria, similar in shape to the above, but darkish in colour.

213 Ostreæ margari/ti\feræ frustulum nitidissimum.
Shining piece of a pearl-bearing oyster.

214 Margarita sordida, palæ annuli argentei insita. \\calculus flavescens..//[35]
Spoilt pearl, incorporated into the bezel of a silver ring.

215 Margarit[-æ] tres, vel forte quatuor, naturaliter unitæ, et Leucachati appensæ, intercedente ornamento quodam ovali, ex auro fabrifacto.
Three, or rather four naturally joined pearls and hanging white agates mounted on an oval ornament worked in gold.

216 Margaritæ sive Perlæ 12 nobiliores sive orientales.
Twelve splendid pearls, perhaps oriental.

217 Margaritæ 9, flavedine quodam̃odo inquinatæ.
Nine pearls, with a yellowish stain.

218 Margarita oblonga conica, sive Belemnitis formâ.
Elongated, conical pearl, shaped like a belemnite.

219 Margaritæ septẽ sordidiores.
Seven spoilt pearls.

220 Margaritæ /12 \ /[-6 d] \ fœdissimæ perforatæ, forsan igne deformatæ.[36]
Twelve pearls, badly damaged, possibly spoiled by fire.

221 Lapis Lazuli magnus oblongus octogonus. \\221.220//
Large, elongated, octagonal lapis lazuli.

222 Lapis Lazuli ovalis, ex uno latere, tribus figuris insculptus; ex alio, 14 foraminibus aliquo usque terebratus.
Ovoid lapis lazuli, incised with three figures on one face; on another, fourteen small scattered holes have been drilled through.
MacGregor 1983, no. 132.

223 Lapis Lazuli cylindraceus.
Cylindrical lapis lazuli.

[15v]

a. \\ -ᵹ// Bufonites seu Ichthyodontes scutellati quatuordecim è lapidicinâ Garfordiensi.
Fourteen plate-like toad-stones or fish teeth from the quarry at Garford.

b. Bufonites sex è lapidicina Sanfordiensi, ubi diligentius inqirenib. passim in arena occurrunt.
Six toad-stones from the quarry at Sandford, where the careful seeker will find them here and there in the sand.

c. Ichthyodos sagittatus, s. Glossopetra minima purpurascens. nũ [-6\-]cũ priore invenimus.
A tiny, purplish, barbed fish-tooth or glossopetra, found recently with the previous one.

d. Siliquastrum nigrum majusculum. E lapidicinâ Witneyense. Piscis cujusd. exotici dentem s. areolam molarem imitari suspicor. n.l.
Biggish, black fish-tooth, from the quarry at Witney. It looks to me like a grinder or the tooth of some exotic fish.

e. Siliquastro congener Punctularius [-marmoreus\ majusculus] Garford in Berksh. n.2.

Biggish punctularius similar to a fish-tooth, from Garford in Berkshire.

f. Punctularius exiguus perelegans. Marcham stone pits. n. 1.
Small, very fine punctularius, from the Marcham stone pits.

g. Ichthyodos maximus rostratus atrorubens, strijs rariorib. donatus. Faringdon Gravelpit. n4. Fragm.
Very large, hooked fish-tooth, dark red, marked with occasional grooves. Faringdon gravel pit.

h. Ichthyodos striatus plectrum gallinaceum referens. Marcham n.[-] I.
Grooved fish-tooth resembling the tail-feather of a domestic fowl. Marcham.

i. Clavellarius triquetrus. An piscis cujusd. marini mandibula? Marcham. n.1.
Triangular clavellarius. Is it the mandible of some marine fish? Marcham.

k. Porpites Plotij, Hist N. Ox. In sabuletis prope Stanton Harcourt copiosè invenitur. num. [-4] 1.
Button coral of Plot (1677, pl. VIII, fig. 9). Found in large numbers in the sandpits near Stanton Harcourt.

l. Porpites compressus. Ibid. invenimus. Num 2.
Flattened button coral. Ibid. We find two of them.

[-m/d] Gammaropodium bullatum. Sic libuit appellare lapidem bracchij cujusdam cancri aut Locustæ marinæ articulum exprimentem, Chawley draw-well. num. 1.
Studded gammaropod; so they used to call the stone resembling the 'arm' of a crab or the limb of a sea-lobster. Chawley draw-well.

n. [d] Porus minimus fossilis ramulis bifurcis. At Witney n.3. Singulos hosce lapides literis alphabeticis notatos in locis natalibus collegi, uti et alios quamplurimos non minoris elgantiæ. E. Lh. Hos omnes ad cæteros suæ sortis [-] bene multos retulimus, qui in alijs scrinijs seorsim collocantur.]
A small fossil poros, with forked branches, found at Witney. I found these stones marked with letters of the alphabet near my home, and also a large number of others of equal elegance. Edward Lhwyd. We placed all these with a large number of others of the same kind which are stored separately in other cases.

[16r]

224 Lapis Lazuli formâ quadrata.
Square lapis lazuli

225 Lapis Lazuli hexagonus spurius.
False, six-sided lapis lazuli.

226 Armilla ex lapidibus Lazuli oblongis spurijs, et baccis Indicis rubris quadam̃odo depressis, alternatim positis.
Bracelet made of false, elongated lapis lazuli, arranged alternately with slightly flattened Indian pearls, reddish in colour.

227 Lapis Nephriticus longus et rotundus, secundum longitudinem perforatus, ex viriditate albescens. \\227, 232.//*[37]
Nephrite, long and rounded, perforated along its length, green shading to white.

228 Lapis Nephriticus planus crenatus ejusdẽ coloris. \\[-d]//
Flat nephrite, of the same colour.

[35] **[f.14v]** Fract [-d]
[36] **[f.14v]** 3d

[37] **[f.15v]** * Italis Ischiada; Gallis Pierre de Jade.
In Italian *ischiada*; in French *pierre de jade*.

229 [-Lapis Nephriticus cordiformis magis pallescens. \\d//
Heart-shaped nephrite, large and pale.

230 Idem iterum. \\d//
Another of the same.

231 Lapis Nephriticus cylindraceus viridis pediculo transverso. \\[-]//
Cylindrical, green nephrite, on a small, transverse base.

232 Idem iterum, sed minor. \\[-]//
Another of the same, but smaller.

233 Lapis Bufonius magnus grisei coloris. \\[-d]//
Large grey toad-stone.

234 Lapis Bufonius minor ejusdẽ coloris. \\[-d]//
Smaller toad-stone of the same colour.

235 Lapis Bufonius adhuc minor quodaṁodo flavescens. \\Hic lapis perperam Bufonius dicitur, cum achates planè sit.// \\[-d]//
Yellowish toad-stone, smaller still. This stone is incorrectly termed a toad-stone since it is clearly an agate.

236 Lapis Bufonius flavus, vel potius citrinus, ejusdẽ magnitud. \\[-d]//
Golden-yellow, or rather citrine-coloured toad-stone, of the same size.

237 Lapis Bufonius subfuscus ejusdẽ magnitudinis. \\[-d]//
Darkish toad-stone of the same size.

238 Lapis Bufonius fuscus, maculâ alba notatus, fig. ovali. \\[-эϵ**]// \\[-d]//
Dark, ovoid toad-stone, with a white spot.

239 Lapis Bufonius fuscus, ejusdẽ magnitudinis cũ penultimo. \\ ӕ// \\[-d]//
(relates to text on [f.15v])
Dark toad-stone of the same size as the last but one.

240 Torquis e Gagatibus magnis oblongis, vereor adulterinis.
Necklace made of large, elongated, and I fear, false jet [beads].

241 Armilla e Gagatibus genuinis oblongis et rotundis.
Bracelet of genuine jet [beads], rounded and elongated.

242 Armilla e Gagatibus cylindraceis veris.
Bracelet of genuine cylindrical jet [beads].

243 Armilla e Gagatibus Decædris forte spurijs, filis aurichalcicis invicem conmexis [-cum cruce Sᵗⁱ Jōhis Hierosolymitani e matrice Perlarum appendentẽ.]
Bracelet made of ten-sided jet [beads], possibly false, alternately linked with golden-brass wires, with a pendant cross of St. John of Jerusalem in mother-of-pearl.

244 Astroites formosissimus formâ ovali.
Very beautiful, ovoid astroites.

245 Lapis Serpentinus /spissius virens\ forma quadrata. Ophites etiã dictus. [38]
Square dull green serpentine; also known as ophites.

246 Silex formosissimus coloris sanguinei quodaṁodo transparens.
Very beautiful, blood-coloured flint, almost transparent.

247 Marmor rubrum punctis albis interstrictũ, forte Porphyrites, forma rotunda.
Rounded red marble, spotted with white, possibly porphyry.

248 Porphyrites alius formã quadrangulâ oblonga.
Another porphyry, in the form of an elongated rectangle.

249 Marmor rubrũ venis flavis intermixtum formâ ovali.
Ovoid red marble, threaded with yellow veins.

250 Marmor rubrũ formosissimũ venis glast/inis\ & /quibusdã\ flavescentib° conspersũ.
Very beautiful red marble scattered with blue and a few yellowish veins.

[17r]

251 Marmor rubrum et album æquis partibus commixtũ, forma quadrangula oblonga.
Elongated rectangle of marble, with red and white intermixed in equal parts.

252 Marmor rubrum (ut opinor) factitium venis albis et viridescentibus conspersum, forma quadratâ.
Square of red marble (false, I suspect) scattered with white and greenish veins.

253 Marmor griseum (uti auguror) item factitium venulis albis rubris et nigris interstinctum, eade formâ.
Grey marble of the same shape and also (I suspect) false, with scattered little veins in red, white and black.

254 Marmor album paulo flavescens. [-\Isabella].
White marble, a little yellowish.

255 Marmor flavescens venis albis notatum.
Yellowish marble marked with white veins.

256 Idem iterum.
Another of the same.

257 Marmor flavescens notis citrinis conspersum.
Yellowish marble, spattered with yellow spots.

258 Marmor flavescens venulis albis et fuscis.
Yellowish marble with little white and dark veins.

259 Marmor flavescens venis subnigris maculatum.
Yellowish marble marked with darkish veins.

260 Marmor citrinum venis rufescentibus.
Yellow marble with reddish veins.

261 Marmor citrinum venis sanguineis.
Yellow marble with blood-coloured veins.

262 Marmor citrinum venis albis et rubentibus.
Yellow marble with white and reddish veins.

263 Ma/r\mor venis citrinis, albis, et [-purp..] robeis æqualite. conspersũ.
Marble veined equally with yellow, white and red.

264 Marmor ex citrino purpurascens.
Yellow marble shading to purple.

265 Marmor ex fusco viridescens.
Dark-coloured marble shading to green.

266 Marmor ex albo viridescens.
White marble shading to green.

267 Marmor rufescens lineis albis distinctum.
Reddish marble distinguished with white lines.

268 Marmor rufescens venis albis, vulgo Rance marble.
Reddish marble with white veins, commonly known as Rance marble.

269 Marmor coloris ravi vel Xerampelini, venulis albis.

[38] **[f.15v]** Marmor Lacædemonium, Augustum et Tiberiũ etiam dictum. Charleton sed. vid Worm. p.43.
Lacædemonian marble, also called Augustan and Tiberian [according to] Charleton, but see Worm 1655, p.43.

Greyish or dark-red marble, with small white veins.

270 Marmor coloris robei venis albis.
Red marble with white veins.

271 Idem iterum.
Another of the same:

272 Idem iterum.
Another of the same.

273 Idem iterum.
Another of the same.

274 Marmor coloris hiberi venis albis ornati.
Iberian-coloured marble embellished with white veins.

275 Idem iterum. atque hæc omnia formâ quadrangula oblongâ.
Another of the same. All of these are elongated rectangles.

276 /∋∈ Marmor Obsidianum sive Numidianū, venis albis.[39]
Obsidian or Numidian marble, with white veins.

277 Globulus e marmore gruino.
Small sphere of speckled marble.
MacGregor 1983, no. 64.

278 Globuli tres e marmore ferreo.[40]
Three small globes made of ferrous marble.

279 Globulus e marmore citrino rufescente.[41]
Small sphere of reddish yellow marble.
MacGregor 1983, no. 116.

280 Lapillus ovalis coloris insuasi, macula albescente signatus.[42]
Ovoid gem, dark orange in colour, with a whitish spot.

[18r]

281 Marmor Florentinum variegatum Tabulam Chorographicā. referens i.e. a Landskip marble. forma quadrangula oblongâ.
Elongated rectangle of variegated Florentine marble, with a topographical view, i.e. a landscape marble.

[on insert]

***b** Granite from Malvern Hills in Worcestershire. Given to y Museum By Dr Lyttleton of University College, Feb. 23, 1744/5.

282 Idem iterum, eadem formâ.
Another, of the same shape.

283 Marmor Florentinum Civitatis prospectū quodamodo referens, forma etiam quadrangulâ oblonga.[43]
Elongated rectangle of Florentine marble, in some way

representing a view of a city.

284 Marmor Florentinum, montium precipitia exhibens, eadem forma.
Florentine marble of the same shape, showing mountain precipices.

285 Marmor Florentinum, ædium et ecclesiarum ruinas referens, eadem formâ.
Florentine marble of the same shape, depicting the ruins of houses and churches.

286 Tria alia /minora\ ejusdē formæ, eadē exhibentia. \\quorum unum diu /desideravimus\//[44]
Three other smaller [marbles], of the same shape, showing the same scene; one of which we have long desired.

287 /[-d] [desidera-]\ Marmor Florentinum /magnum\ ejusdē formæ, ædificiorū ruinas referens, et Ecclesiæ pyramidem altissimam.[45]
A large Florentine marble of the same shape, showing the ruins of buildings and the tall spire of a church.

288 Embuscatum, forma ovali.
Ovoid embuscatum [?].

289 Embuscatum, forma quadrangulâ oblonga.
Elongated rectangular embuscatum [?].

290 Embuscatum, forma octogonâ.
Eight-sided embuscatum [?].

291 Embuscatum, forma quadrangulâ oblonga, Ebeno munitâ. \\ex dono Mrs Whitrig e Coll. Wadham.//[46]
Elongated rectangular embuscatum [?], framed in ebony. Given by Mrs Whitrig of Wadham College.

292 Marmor Florentinum pedale, magnæ Civitatis ruinas referens, forma ovali.[47]
Florentine marble, a foot long and ovoid, depicting the ruins of a great city.

293 Marmor Florentinum paulo minus, idem referens.
Florentine marble, slightly smaller, with the same scene.[48]

294 Marmor Florentinum multo minus, idem referens, marmoribus quadrangulis variegatis circumseptum.
Florentine marble, much smaller, with the same scene, and surrounded with various pieces of rectangular marble.

295 Marmor Florentinum præcedente paulo majus, Civitatem referens /quasi\ sub monte Teneriffâ, basano munitū.
Florentine marble, a little larger than the above, showing a city below what looks like the mountain of Tenerife, framed in basanite.

[39] d. 277 d [f.16v] ∋∈ Achates subrufescens venis albis distinct.

[in another hand] juxta quam ∋∈ b. altera achates valde obfusca. anglice 2 Gun flints.
Reddish agate distinguished with white veins, next to which there is another very dark agate. 2 gun-flints.

[40] d [- 2] d.

[41] d d d

[42] [f.16v] Marmor calcarium melanoleucon ex agro Penbrochiano. Don.vit Alex. Ford AM. et So ... Coll. Jesu
Black and white limestone marble from Pembrokeshire. Given by Alexander Ford, MA and Fellow of Jesus College.

[43] [f.17v] a Q

[44] [f.17v] unum deest. [-fract]
One is missing.

[45] [f.17v] 287.b. aliud multo adhuc majus; suspensū juxta Scrinium.
Another is much larger still: hung up next to the safe.

[46] [f.17v] 291b. Pictura ex avium Plumis conficta &c
Picture made of birds' feathers.

291c. Collare miro artificio ex charta acus Puncturis confict. opera. A.M. Woodford.
Collar marvellously made of paper, by piercing with a needle. A.M. Woodford.

291d. Equi Imago forficibus scissoribus confict:
Picture of a horse made using scissors.

[47] [f.17v] Hæc suspensa sunt in fenestra.
These are displayed in the window.

[48] æ [-d]

296 Embuscatum pedale, forma ovali. \\Fract. 1700//
Ovoid embuscatum [?], one foot in length. Broken in 1700.

297 Lapis magnus cuneoformis coloris thalassini, rupe solidâ repertus, in fodina Virginiæ 40 orgyias altâ.[49]
Large wedge-shaped stone, sea-blue in colour, found in solid rock in Virginia, in a pit cut 40 fathoms deep.

298 Phengites sive marmor Parium translucens, forma quadrangulâ oblongâ.[50]
Elongated rectangle of crystallized gypsum or Parian marble.

299 Basaltes forma globosâ.
Sphere of basalt.

300 Thyites Italis Verdello, lapis viridis cuneoformis.[51]
Thyites, called *verdello* in Italian; a green wedge-shaped stone.
[19r]

301 Marmor leucophæum forma ovali. \\[-d]//
Ovoid, ash-coloured marble.

302 Marmor cinereum Seravitanum maculis cinereis insigne, formâ quadrangula oblonga. [52]
Ovoid rectangle of ash-coloured marble, with grey markings.

303 Ophites, sive marmor Serpentinum Zeiblicium formâ quadr.
Square ophite or serpentine-marble of Zeiblicium.

304 Marmor hiberum venis luteis interstinctum, forma quadrangula oblongâ. \\Fract: 1700 -//
Elongated rectangle of Iberian marble, with saffron-yellow veins. Broken in 1700.

305 Amianthus aliâs lapis asbestinus. P. Veneto Salamandra.
Earth-flax, otherwise known as asbestos; known to P. Veneto as Salamandra.

306 Pyrites aureus multiformis politus.
Irregular gold-coloured pyrites, polished.

307 Marmor Parium impolitum de Templo Apollinis in Civitate Delphi/orum\ juxta Pernassum.
Unpolished Parian marble from the Temple of Apollo in Delphi, near Mount Parnassus.

308 Marmor Parium impolitum de femore statuæ Apollinaris in eodem Templo.
Unpolished Parian marble taken from the thigh of the statue of Apollo in the same temple.

309 Robur Britannicum petrificatũ forma oblonga.
Elongated piece of petrified British oak.

310 Coagula Sulphurea Tiburensia, instar bellariorũ aridorũ saccharat. Italis, Confetti de Tivoli.*[53]
Conglomerate of sulphur from the River Tiber, looking like a lump

of dried sweetmeat. Called in Italian *Confetti di Tivoli*.

311 Lapides Bononienses tres \\[-desunt]//
Three Bolognese stones.

312 Lapis (ut videtur) scissilis oblongus, coloris subnigri, nominibus sacris Jesu, Mariæ, Josephi inscriptus, quod artificio (vereor) non naturaliter factũ: cujusmodi apud Germanos Gamahujæ dicuntur. \\de://
Elongated, darkish, laminar stone, inscribed with the names of Jesus, Mary and Joseph, which (I fear) was made artificially and not by nature. Stones of this kind are called gamahe among the Germans.
MacGregor 1983, no. 189.

313 Gamahuja alia, Lapis Crucis dictus, qui in corpore leucophæo crucem nigram ostentat.
Another gamahe, known as Stone of the Cross, showing a black cross on an ash-grey background.

314 Lapis crucis alius, forma quadrangulâ oblonga, qui in corpore robeo albescente, cruce etiã nigrã ostentat.
Another Stone of the Cross, rectangular and elongated, which also shows a black cross on a whitish-red ground.

315 Lapis Asteria dictus, lutei coloris.
Stone called asteria, saffron-yellow in colour.

316 Lapis Asteria dictus, coloris cinerei \\From Marston, NHshire.//[54]
Ash-coloured stone called asteria, from Marston in Northamptonshire.

317 Lapis Asteria dictus, coloris robei. \\From Humber Cliffs.//
Stone called asteria, red in colour. From Humber Cliffs.

318 Trochitæ et Entrochi e Comitatu Ordevicũ Flintensi.
Trochitæ and entrochi from Flintshire, the county of the Ordivices.

319 Lapis quodãmodo Bufonẽ referens. [-]
Stone, resembling some kind of toad stone.

320 Ætites, sive lapis Aquilinus coloris cinerei ad rotunditate accedens, alium lapidẽ vel argillã in se continens.
Ætites or eagle-stone, ash-grey in colour and roundish in shape, with another stone or a lump of clay inside it.
[20r]

321 Repræsentatio cretacea tum formâ tum magnitudine, Calculi e vesica urinariâ Hispanioli agrarij, excisi; in Com Icenorum Huntingdonensi. A.° 1654.[55]
Chalk facsimile, identical in shape and size, of a stone cut from the urinary tract of a Spanish peasant; in Huntingdonshire, 1654.

322 Lapis a Dnõ Goodale Navarcho Anglo excisus ex ventriculo Rhinocerotis a se confossi, in India orientali.
Stone cut by Mr Goodale, an English ship's master, from the belly of a rhinoceros which he had shot in the East Indies.

[49] **[f 17v]** Hæc omnia usque ad 326 [-] in infun[-\is] capsul[-\is] hujus scrin.
All of these up to 326 are kept in little boxes in the safe.
[50] 9
[51] **[f.17v]** Forte Ophites orientalis vid Philos. Transact. N. 185. p.223
Perhaps oriental ophites. *Philosophical Transactions of the Royal Society*, no. 185, p. 223.
[52] **[f.18v]** 302. Lapis é Latomijs ad pagum Rance [-effossus] in comitatu Northamptoniæ /effossus\ nobis videtur. E. Lh.
Stone which seems to us to have been excavated from quarries around Rance in the county of Northamptonshire. Edward Lhwyd.
[53] **[f.18.v]** *of these see Mr Ray's Observat. Topograph. p.376
Of these see Ray 1673, p.[367].

[54] **[f.18.v]**de:
[55] **[f.19v]** 321b Ingens Calculus [-]ex Vesica Canis, ab Edvardo Farbody, Northantoniæ desumptus.
Enormous stone removed from the bladder of a dog, by Edward Farbody of Northampton.

323 Calculus humanus e vesica urinaria Dñæ Cole de Bedhampton in Com Belgarum Hantoniensi, ab Obstetrice sine ulla sectione aut dilaceratione extract[g].

Stone from the urinary tract of Mrs Cole from Bedhampton in Hampshire, removed by the midwife without any incision or cutting.

324 Calculus humanus eximiæ magnitudinis e vesica urinaria puellæ octennis Cantuariensis a Johanne Eliot M.D. excisus.

Stone of exceptional size, cut from the urinary tract of an eight-year-old girl from Canterbury by John Eliot MD.

325 Calculus humanus tantæ magnitudinis e vesica cujusdã Be/a\tricis Shreve de Tunsted in Com Norwicensi sine ullâ aut sectione aut dilaseratione extractus, ut rei veritas, sub sigillo Coñuni Civitat. Norwic. posteris transmitti par esse videbatur. \\≱/[56]

Stone removed, without any incision or cutting, from the urinary tract of a certain Beatrice Shreve from Tunstead in Norfolk, of such a size that it seemed fitting to preserve the event for posterity, by recording it under the seal of the city of Norwich.

[-326 Globulus vitreus pomiformis opere Lucernali, multis tum figuris tum coloribus eleganter variegatus.

A small glass sphere, shaped like a fruit, made in Lucerne; it is elegantly decorated, with various figures and colours.

327 Vitrum aliud cuneoforme; similibus, opere, figuris, colorib[g].

Another, wedge-shaped glass, similar in workmanship, figures and colours.

328 Ampulla vitreo-Chrystallina eleganteâ ad stupore /usque\ cælata.

Bottle of crystalline glass, engraved with stunning elegance.

329 Fragmentũ Vasculi vitreo-chrystallini admirandâ itidem cælaturâ ornatum.

Fragment of a small crystalline glass vessel, as wonderfully engraved.

330 \\[-d]// Microscopium minimum ebore tornato munitum.

A very small microscope with a turned ivory support.

331 \\[-d]// Aleæ species ex ebore facta, inusitatæ formæ, maculis citrinis rubris, et virescentibus, insignita.

A type of die, made of ivory and of unusual form, marked with yellow, red and greenish spots.

332 Alearum alia species rarioris formæ.
Another type of die, of a rarer form.

333 Manipulus latrunculorũ lusoriorũ /semiuncialiũ\ cum globulo, ex Ebore tornati.

A set of playing men, turned in ivory and ½ in tall, together with a little sphere.

334 Pelvis et Aqualis item ex ebore tornati, plus minus unciales.

Basin and ewer, also turned in ivory, each about an inch high.

335 Plaustrum unciale item eburneum.
Wagon, also made of ivory, an inch high.

336 Dodecas cochleariũ argenteorũ in pyxide eburnea; magnitudine, nucẽ avellanâ sylvestrâ, non excedente.]

Twelve silver spoons in an ivory box, no larger in size than a hazel nut.

[21r]

[-337 /*\ Manipulus Latrunculorum ex ebore tornatorũ in unico piperis semine contentus.[57]

Set of playing men, of turned ivory, contained within a single peppercorn.

338 /*\ Tres globuli eburnei multifori, alius intra alium eximie tornati, cum alea versatili in ventro intimi.[58]

Three small ivory spheres, pierced with many holes, and all beautifully turned one inside the other, with a revolving die in the middle.

MacGregor 1983, no. 239.

339 Quinque Dodecædra quinquangula eburnea

[56][f.19v] **325a** ≱ Lapis vertebras nescio cujus animalis quodammodo referens, quem é medio saxo, in Lapicidina Marchamensi proprijs /manubus \ eruebam. A.° 1692.
A stone in some way representing the vertebræ of an unknown animal, which I excavated with my own hands in Marcham quarry in Middlesex, 1692.

325b Lapis cranij humani fragmentum /aliquatenus \ referens, suturis foliaceis, elegantissime exaratum. Eodem loco et tempore cum priore invenimus. E. Lh. \\intus exiguis Chrystallis nitidissime abundans./
A stone showing a small fragment of a human skull, elegantly formed, with leaf-like sutures. We found it at the same time and in the same place as the previous one. Edward Lhwyd. With many small glistening crystals inside.

325c Ostrea è colle Rungewell Hill in comitatu Surrey effossa. Hæc ead. sunt quorum meminit D. Joannes Raius in Tractatu Physico-Theologico pag...
Oysters dug up in Rungewell Hill in Surrey. These are of the kind mentioned by John Ray (1673, p. []).

325d Calculus repertus in uno de Renibus D.[ni] Thomæ Lyttelton de Frankley, Baronetti post ejus obitum, 23.[tio] Febr: 1649. Pondus 16[wt]. 18[gr] argenteâ lamellâ nitidissime munitus. Musæo D.D. Car: Lyttelton L.L.D. Coll. Univ: 1745
A stone, found in one of the kidneys of Thomas Lyttleton of Frankley, Bart., after his death on 23 February 1649, weighing 16 pennyweights 18 grains, mounted in polished silver. Given by the Museum by Charles Lyttleton, LL D, University College 1745.

* Monile ex globulis vitreo-Chrystallinis.
A necklace made of small spheres of crystalline glass.

⊕ Annulus ex vitro Chrystallino.
A ring of crystalline glass.

N.B. Pleraque. eorum quæ in hac capsula conservabantur /vel pessundantur vel\ alias transferuntur; quorum in locum Numismata argentea suffecta sunt.
Most of the objects kept in this case have either perished or been moved elsewhere; silver coins have been put in their place.

325e Fragmentum Tabulæ repræsentantis Caput S.[ti] Joh.[s] Baptistæ in Disco, duobus Angelis sustentato; infra habes Agnum flexis genibus & obverso capite. Rasuræ ejus [-ægris] oculis remedio a quibusdam habitæ sunt. D.D. G. Huddesford S. T.P Coll S.S. Individ. Trin. Præsidens hujusce musei cimeliarcha. Oct.11. 1740.
A fragment of a panel showing the head of St. John the Baptist on a dish held by two angels: below you have a lamb with its knees bent, and its head turned backwards. Scrapings from it were used by some as a remedy for eye-trouble. Given by Revd G. Huddesford, Professor of Theology, President of Trinity College and Keeper of this Museum, 11 October 1740.

325f Æneus ensis Tippsburiæ juxta Sarisburiam inventus 1704. Musæo D.D. Wyndham Knatchbull Baronettus. Vomere fractus. in manubrio novem sunt foramina.
Bronze sword found in Tippsbury near Salisbury in 1704. Given

to the Museum by Wyndham Knatchbull, Bart. Broken by the plough. There are nine holes in the handle.

[57][f.20v] d. latr. f

[58][f.20v] Alter ex intim: fract. Vide 480
One from the interior is broken. See 480**.

quaquaversum perforata, unum intra aliud, mirum in modum, torno elaborata.[59]
Five ivory dodecahedrons, with quinquangular faces, pierced on all sides; wonderfully turned on a lathe, one inside another. MacGregor 1983, nos. 244-8.

340 /⊕\ Tres globuli eburnei perforati; singuli in triginta, partim hexangula partim quinquangula alternatim posita, alius intra alium mirè detornati; in quorum Centro, globuľ solidus mobilis, aculeis hirsutus per foramina trajectis.
Three pierced ivory spheres, all marvellously turned, one inside the other; each of 30 pieces, some with hexangular, some with quinquanglular faces, arranged alternately. In the centre there is a solid moveable sphere with spikes which stick out through the holes. MacGregor 1983, no. 240.

341 Armilla seu monile ex 50 globulis e gagate, et quibusdã margaritis filo argenteo commixis, constans; in ossiculo Cerasi cordiformis comprehensa.[60]
Bracelet or necklace made of fifty small jet beads alternating with pearls on a silver thread, and kept in a heart-shaped cherry-stone.

342 Quatuor cultelli, cum bidente argentei; simili ossiculo inclusi.[61]
Four small silver knives, with two prongs, similarly contained in a cherry-stone.

343 Sex scutellæ argenteæ item in ossiculo contentæ.[62]
Six small silver saucers, also contained in a cherry-stone.

344 Cerasi /ossiculum\ in quo quondã dodecas Cochleariũ ligneorũ.[63]
Cherry-stone in which twelve wooden spoons were once kept.

345 Nucis avellanæ /sylvestris\ putamen /dimidium\ in quo quondã 70 utensilia.[64]
Half a hazel-nut shell, in which there once were seventy utensils.

346 Idem iterum.[65]
Another of the same.

347 Annulus e filis matallicis, pilisque multicoloribus artificiocissime textus, rubino insignitus.
Ring made of metal wires, skilfully intertwined with multicoloured balls, and set with a ruby.

348 [- Tres alij annuli] /[-annular]\ e pilis multicoloribus faberrimè plicatis.[66]
Three other rings, skilfully woven with multicoloured balls.

349 Crux aurea cavata, in qua (ut dicitur) segmentũ minimũ veræ crucis, in qua passus est Dñs.
Hollow gold cross, in which is found (so they say) a very small fragment of the True Cross, on which Our Lord suffered.

350 Catena pulicina aurea.
Gold flea-chain.

351 Catena pulicina aurea et argentea, commissuris

utrius alternatim positis.
Flea-chain of gold and silver, the links of each arranged alternately.

352 Quatuor aliæ, superiori similes, quibus sera pensilis annexa, e Margaritâ auro munita.
Four more chains, similar to the last, to each of which is attached a pendant bar and a pearl mounted in gold.

353 Digitale argenteum, in superiori limbo, auro et encausto interstinctum.]
Silver ring, with the upper part decorated with gold and enamel.
[22r]

354 Microscopium antiquum capsula argentea munitum.[67]
Ancient microscope in a silver case.

355 Fibula cuprea varijs coloribus encausto picta.
Copper brooch enamelled with various colours.

356 Cymbalum majus æneum.
Fairly large brass cymbal.

357 Cymbalum minus ejusdẽ metalli.
Smaller cymbal, of the same metal.

358 Quatuor catenæ pulicinæ ferreæ.
Four iron flea-chains.

359 Aliæ catenæ pulicinæ ferreæ, interruptæ et implicatæ.
Other iron flea-chains, broken and tangled.

360 Instrumenta Chirurgica in acuum cuspidibus fabrefacta
Surgical instruments formed on the points of needles.

361 Sclopus cum omni apparatu suo sesquiuncialis.
Scalpel, 1½ ins in length, with all other associated equipment.

362 Catena juncea, colorem cupreum tam polite referens, ut Judicem αὐτόπτην facile decipiat.[68]
Copper-coloured chain of rushes, so exquisitely made that it would deceive a judge looking at it with his own eyes.

363 Oratio Dominica intra ambitum Denarij Angl. conscripta cum benedictione Annæ Reginæ. per T. Baker.
The Lord's Prayer, written around the edge of an English penny, with a blessing on Queen Anne. Given by T. Baker.

364 Oratio Dominica; Symbolum Apostolorum; Præceptorum decalogi synopsis; Psal. 134; Psal. 147; Oratio pro Rege; Oratio pro bono statu Ecclesiæ; etc. intra ambitum Dioboli. by old Abraham ...
The Lord's Prayer; Apostles' Creed; list of the precepts from the Ten Commandments; Psalm 134; Psalm 147; Prayer for the King; Prayer for the well-being of the Church; all along the edge of a *diobolos*. By old Abraham [].

365 Chirotheca Scotica in globum complicata.[69]
(bracketed with 366)
Scottish glove folded into a ball.

366 Alia, explicata.
Another, not folded.

367 Tessella, pavimenti tessellati, deaurata, tria.
Three gilded cubes from a mosaic pavement.

368 Tessellũ coloris limonei.

[59] **[f.20v]** f:
[60] **[f.20v]** [-] d
[61] **[f.20v]** d ‡
[62] **[f.20v]** d ‡
[63] **[f.20v]** d. cochlear:
The spoons are missing.
[64] **[f.20v]** d W[-]
[65] **[f.20v]** d W[-]
[66] **[f.20v]** d ‡

[67] **[f.21v]** d Mic:
[68] **[f.21v]** D
[69] **[f.21v]** D:

Yellow cube from a mosaic.

369 Tessella cærulea duo, sive coloris cyanei.
Two blue, or rather blue-green, cubes from a mosaic.

370 Tessella lurida tria, seu potius cæsia.
Three yellowish, or rather blue-grey cubes from a mosaic.

371 Tessella duo smaragdina.
Two emerald-coloured cubes from a mosaic.

372 Tessellum unum subviride, sive coloris chrysolitholini. [70]
A greenish or topaz-coloured cube from a mosaic.

373 Tessellum coloris Persici.
Peach-coloured cube from a mosaic.

374 Tessella 32 coloris ferruginei. \\Horum figura naturalis est, et in lapide scissili per totam Wallium ferè occurrūt. Est Ludus Paracelsi ap.' Helmontii.
Thirty-two tesserae, of metallic colour. Their shape is natural and they are found in all the laminar stones of Wales. [Examples of] the Ludus Paracelsus and Ludus Helmontii.

375 Tessella 3 Anthracina.
Three deep black tesserae.

376 Idolum Isidis Ægyptiacum characteribus itidẽ. Ægyptijs insculptã, et incrustatione e cæruleo viridescente tectum.
Egyptian idol of Isis, incised with Egyptian characters, and covered with an incrustation of blue shading to green.

[23r]

377 Latrator Anubis simili incrustatione tectus. \\Idolum istud minùs cauté observavit [-] D. Plot: siquidem idem est omnino cum proximè [-ad] Sequenti.//
Anubis, the Dog, with a similar incrustation. Dr Plot paid less attention to this idol, since it is in all respects very close to the one below.

378 Idolum Ægyptium capite ovino, quod colebant in Sahid seu Ægypto superiori, incrustatione su/b\ viridi tectum.
Egyptian idol with a sheep's head, found in Sahid or Upper Egypt, and covered with a bluish incrustation.

379 Idolum Ægyptium sub forma Cati, quod Ægyptus tota adorabat, coloris ex viridi albescentis.
Egyptian idol in the form of a cat, which all the Egyptians worshipped, green in colour, shading to white.

380 Idolum Ægyptium sub forma Galli, incrustatione ex cæruleo viridiscente, tectum.
Egyptian idol in the form of a cock, with an incrustation of blue shading to green.

381 Idolum Ægyptium sub formæ Scarabæi, incrustatione simili tectum, de quo vid. Plutarchū in Iside et Osir.
Egyptian idol in the form of a scarab, with a similar incrustation. On this see Plutarch's *On Isis and Osiris*.

382 Osiris mitratus e lapide cineritio sculptus, forma fere quadrangulâ.
Mithraic Osiris, almost rectangular in form, carved from volcanic stone.

383 Lampas cuprea Romana, angulâ dotata, et foramine uno ampliore per quod oleũ infunditur, et duobus minoribus per quæ elychnia prominebant.
Roman lamp made of copper, with a little handle, and with a single large hole through which the oil is poured and two smaller ones through which the wicks protrude.

384 Atramentum Sinicum, formâ oblonga duarũ circiter unciarum, floribus utrinque ornatum.
Chinese inkwell, elongated and about 2 ins in length, decorated on both sides with flowers.

385 Ampulla in qua aliquantulum sanguinis qui per duas horas forma pluviæ decidebat in Insula Vecti, A° Dñi 1177°. et Reg. Regis Henr. 2. 23°. [71]
A bottle containing some of the blood which fell, like rain, for two hours on the Isle of Wight in 1177, the 23rd year of the reign of Henry II.

386 Aurantium, de malo aurantia, quæ Zabulonis sepulchro agnascitur.
Orange, from the orange-tree which grows on Zebulon's tomb.

387 Semina nonnulla, quæ (uti existimatur) per modũ pluviæ decidebant apud Paulers-perry in Com. Northampton.
Various seeds, which (it is thought) fell in the form of rain over Paulers Perry in Northamptonshire.

388 Tria Auditûs ossicula sc. malleus, incus, et stapes. \\Desunt.//[72]
Three small ear bones, that is a hammer, anvil and stirrup.

389 Ossiculum formâ pedis talpæ e carnosiori parte coxæ [-\suillæ].
Small bone shaped like a mole's foot, from the fleshier part of a swine's hip.

390 Crumenæ e serico nigro, Ebeno munito.[73]
Black silk purses, with ebony trimmings.

391 Annulus ex Ebeno sigillaris, imagine Christi in cruce pendentis insculpti, cum hac Inscriptione circum positâ: In hoc signo vinces.
An ebony seal-ring, engraved with the image of Christ hanging on the Cross, surrounded by the following inscription: In this sign shall ye conquer.
MacGregor 1983, no. 129.

392 Sex globuli electrini perforati majores, e quibus (ut opinor) quondam armilla electrina.
Six fairly large pierced amber spheres, which may once have formed part of an amber bracelet.
MacGregor 1983, no. 120.

[24r]

393 Sex globuli electrini perforati minores, e quibus forte olim etiam armilla electrina.[74]
Six smaller, pierced amber spheres, which perhaps also once formed part of an amber bracelet.
MacGregor 1983, no. 120.

394 Undecim globuli electrini forma quodãmodo depressiori, etiam perforati; e quib᷎ solis, aut cum

[70] **[f.21v]** 372. Lege argentatum.
Read 'silvered'

[71] **[f.22v]** [-]

[72] **[f.22v]** 388 Marmor ovi speciem petrifa/c\ti repræsentans.
Marble, in the form of a petrified egg.

[73] **[f.22v]** f

[74] **[f.23v]** [-d]

superioribus mixtis, forsan armilla electrina.[75]
Eleven amber beads, somewhat flatter, also pierced, which either alone, or with the beads mentioned above, perhaps formed part of an amber bracelet.
MacGregor 1983, no. 120.

395 Massa succini candidi vel potius mellei coloris non transparens, cæteris longè pretiosior.
Lump of opaque white or rather honey-coloured amber, much more valuable than the others.

396 Columellæ duæ e tali succino venulis albis distinctæ. \\Fract. 17a//[76]
Two little columns of amber of the same kind, marked with white veins.

397 Cranium humanum e tali succino sculptum.
Human skull carved from that same sort of amber.
MacGregor 1983, no. 177.

398 Succinum melleum transparens cordiforme, in quo B. Maria virgo filium in sinu gestans, forte ex ebore inclusa. \\Deest.// \\Imago Filii fract: 1700 [-]//
Transparent, honey-coloured, heart-shaped amber, in which is enclosed a figure, possibly in ivory, of the Blessed Virgin Mary holding her Son in her lap. The image of the Son is broken.

399 Massa ampla succini fulvi transparentis, instar auri rutilantis.
Large lump of transparent, deep yellow amber, like rose gold.

400 Massa alia ejusdẽ succini paulo minor, sed non minus rutilans.
Another somewhat smaller lump of the same amber, but no less red.

401 Succinum fulvum cordiforme in quo imago Herois cujusdam ex ebore inclusa.

Heart-shaped deep yellow amber, in which is enclosed an ivory figure of a hero.

402 Succinum fulvum ovale in quo [-19\9] orbes electrini splendide repræsentantur.
Ovoid, deep yellow amber, in which nine globes of amber are clearly visible.
MacGregor 1983, no. 180.

403 Succinum fulvum phryganio prægnans.
Yellow amber, with a creature embedded within it.

404 Quatuor musculæ succino flavo implicitæ.
Four small flies caught in yellow amber.

405 Aranea succino flavo cordiformi incarcerata.
Spider imprisoned in heart-shaped deep yellow amber.

406 Phryganeum aliud sepulchro suo succinato nobilitatum.
Another small creature notable for its amber tomb.

407 Idem iterum. [-Succini rudioris fragmentum, rubigine incrustatum; coloris intùs ocroleuci. D.vit D.na Madox]
Another of the same. Fragment of fairly coarse amber, encrusted with red, coloured whitish internally. Given by Mrs Madox.

408 Musca contempta funere item suo pretiosa.
Common fly rendered precious by its death.

409 Apis melleo suo carcere detenta.
A bee held in its honey-coloured prison.

410 Araneus binoculus longipes, Opilio quibusdã dictus, succino fulvo compeditus.
Spider with two eyes and long legs, called the Shepherd by some, trapped in yellow amber.

411 Idem iterum.
Another of the same.

412 [-Ranula formosissima succino hujusmodi congelata] /Succini flavi pellucidi lamella, in qua /Perla sivè\ Libella minima inclusa. Ex dono Dominæ... Madox.\
[A beautiful little frog frozen in amber of this type.] A flat piece of transparent yellow amber, in which a pearl or tiny silver coin is enclosed. Given by Mrs [] Madox.

[25r]

413 Ampulla nitidissima e succino fulvo elaborata.[77]
Polished flask made of yellow amber.

414 Succini fulvi frustulum tenne eleganter detornatum.
Little piece of yellow amber, elegantly turned.
MacGregor 1983, no. 179.

415 /[-Succini flavi sive mellei fragmentum, rubigine incrustatum. donavit Domina ... Madox.]\ [-Succinum fulvum cordiforme in quo Imago Christi in cruce pendentis, cum S.tis fæminis asseclis, insculpta.][78]
Fragment of yellow or honey-coloured fragment of amber, encrusted with red. Given by Mrs [] Madox. Heart-shaped yellow amber, with the carved image of Christ hanging on the Cross with the holy women around him.

416 Annulus e tali succino, in cujus parte sigillari eadem imago Christi; et sacra nomina S.ti Josephi et Mariæ, cum crucifixionis instrumentis, in circulo.

[75] [-d][**f.23v**] 394a Tres lapides ex Stomacho Troctæ piscis desumpti, Sarrat in agro Hertfordiensi captæ. An. 1748.
Three stones taken from the stomach of a trout, caught at Sarratt in Hertfordshire.

394b Quatuor digiti humani fulmine tacti.
Four human fingers struck by lightning.

394c Lacertæ duæ.
Two lizards.

394d Cauda Serpentis Americani caudisoni.
Tail of an American rattlesnake.

394e Concha marina, [-] Barnacle dicta.
Sea shell, known as a barnacle.

394f Panis e radice quadam Indica factus.
Bread, made from a certain Indian root.

394g Lapis e Porci pene desumptus Oxoniensi. D.D.D. Atwood.
Stone, taken from the penis of a pig in Oxford. Given by Mr Atwood.

394h Frustrum Sepulchri Edvardi Confessoris.
A fragment from the tomb of Edward the Confessor.

394i Ova Gallinæ minima deformata. D.D.D. Smith de civitate Oxon. Jul. 10.1747.
Tiny deformed hens' eggs. Given by Mr Smith of Oxford, 10 July 1747.

394j Lapis ex Bahama Insula delatus. D.D. Major Huntingdon.
Stone brought from the island of Bahama. Given by Major Huntingdon.

394l Crucifixum argenteum cum pyxide etiam argentea.
Silver crucifix, with a box, also of silver.

394m. Manus eburnea.
Ivory hand.

[76] [**23v**] [-]

[77] [**f.24v**] f

[78] [**f.24v**] d

frac.*[79]

Ring, made of this kind of amber; the seal shows the same image of Christ and the holy names of St. Joseph and the Blessed Virgin Mary, together with the instruments of the Passion arranged in a circle; broken.

417 /d\ [-Annulus alius e simili succino. frac.

Another ring, of similar amber; broken.

418 /d\ Item tertius ex eodẽ genere succini. fract.

A third ring, of the same kind of amber; broken.

419 /d\ Succini fulvi frustulum formâ stalactitis.[80]

Piece of yellow amber shaped like a stalactite.

420 /d\ Talcum argenteum.

Silver talc.

421 /d\ Talcum argenteum subrufescens.

Silver talc, reddish.

422 /d\ Talcum coloris limonei.

Lemon-coloured talc.

423 /d\ Talcum aureum.

Golden talc.

424 /d\ Talcum coloris chrysolitholini.

Topaz-coloured talc.

425 /d\ Talcum gramineum.

Green talc.

426 /d\ Talcum coloris robei.

Reddish talc.

427 /d\ Talcum nigrum

Black talc.

428 /d\ Torquis e succino fulvo, vel forte potius tesseræ precatoriæ, plerumque ovales, nonnullæ cruciformes, in quibus Crucifixonis instrumenta sparsim depicta.[81]

Necklace of deep yellow amber, or rather they may be prayer-beads; most of them are oval and several are cruciform, on which the instruments of the Passion are depicted here and there.
MacGregor 1983, no. 123.

429 Torquis é diversis particulis succini fulvi ac eboris varie formatis ac dispositis.

Necklace of various fragments of deep yellow amber and of ivory, variously shaped and arranged.

430 Torquis ex ovalibus vitreis, auro varijsque coloribus encausto pictis.

Necklace made of oval glass [beads], in gold and various colours of enamel.
MacGregor 1983, nos. 118-119.

431 Torquis e quadrangulis oblongis vitreis, colore lazurio, encausto pictis.

Necklace made of azure blue, elongated glass [beads], enamelled.
MacGregor 1983, no. 117.

432 Rosarium ligneum.

Wooden rosary.
MacGregor 1983, no. 122.

433 Rosarium ligneum cujus tesseræ cinnabrij coloris.

Wooden rosary with cinnabar-coloured beads.

434 Rosarium ligneum cujus tesseræ coloris æthiopici.[82]

Wooden rosary, the beads of which are black.
MacGregor 1983, no. 121.

435 Tres globuli eburnei perforati manubrio affixi, alius intra alium mire detornati, quorũ intimus aculeis hirsutus per foramina trajectis.

Three small pierced ivory spheres, attached to a handle, admirably turned one inside the other; the innermost has spikes which stick out through the holes.
[26r]

436 Decem tales globuli filo conserti.[83]

Ten similar spheres, joined with a cord.

437 Prisma æquilatero-triangulare vitreo-chrystallinum, pro repræsentandis coloribus Iridum emphaticis.

Prism of crystalline glass, in the form of an equilateral triangle, for producing the colours of the rainbow.

438 Prisma aliud, in omnibus simile, nisi colore citrino.

Another prism, similar in every way, except that it is yellow in colour.

439 Unum e Cornibus Mariæ Davies de Saughall in districtu Wyrehallensi in Com Cestriæ, quæ solet exuere, Cervorum instar quibusdam annis interpositis.[84]

One of the horns of Mary Davis of Saughall, in the district of Wirral in Cheshire, which she used to shed every few years, like a deer.

a. Catena gagatea Turcica, ex 12 lamellis quadratis [-constans] duobus globulis interpositis constans. Ex dono D.ni Buckridge. è Coll. divi Joan. Baptistæ Socio commensalis.

Chain of jet from Turkey, comprising twelve small square pieces each separated by a pair of spherical beads. Given by Mr. Buckridge, Fellow-commoner of St. John's College.

440 Manus e Gagate, cujusmodi solent Turci suis

[79] d [f.24v] * fr. lege fractus.
For fr. read 'broken'.

[80] [f.24v] 419a ✕ Succini pellucidi rutilantis, [-fragmentum\massa rudis] [-rude\[-massa]] sive impolita[-]
Lump of transparent red amber, natural or unpolished.

419b Succinum rude sive informe. Topazium referens.
Natural or unformed amber, resembling topaz.

419c Succini flavi semiopaci [-fragmentum\ frustulum]. Hæc tria donavit D.na Madox [-Londinensis.]
Fragment of translucent yellow amber. Mrs Madox of London gave these three.

419d Succini flavi, sive mellei, fragmentum rubigine incrustatum.
Fragment of deep yellow or honey-coloured amber, encrusted with red.

419e Succini rudioris fragmentum, rubigine incrustatum coloris intus ocroleuci hæc quinque donavit D.na Madox Londinensis.
Fragment of coarser amber, encrusted with red, internally whitish coloured. Mrs Madox of London gave these five.

[81] Ne nimis contrectaretur, in superiori Capsulâ inter reliqua...
Succina collocate.
Not much was stolen ... the amber is placed with the rest in the upper case.

[82] [f.24v] 434a Rosarium partim (ut opinor) ex ebore, partim ex ossibus Cum Cruce.
A rosary, made (I imagine) partly of ivory and partly of bone, with a cross.

434b Rosarium ex tesseris vitreis quarum sex Coloris cærulei, reliquo Chrystallini: quibᵉ annexæ duo parvæ Cruces hæc ex Ebore, Illa ex Matre Perlarũ. E Dono.
A rosary with glass beads, six of which are sky-blue, and the rest crystal to which are attached two small crosses, one of them ivory and one of them mother-of-pearl. A gift.

434c Rosarium vitreum.
Glass rosary.

[83] [f.25v] [-d 2]|d 4

[84] [f.25v] 14....

puerulis dono dare, utpote quorū virtute (uti stultè existimant) a fascinationibus tuentur.[85]
Hand of jet, of the kind that the Turks customarily made a gift of to their small boys, by the power of which (as they foolishly think) they are protected from the evil eye.
MacGregor 1983, no. 190.

b. Manus alia Turcica lunâ dimidiatâ insignita. Ex dono D[ni] ... Buckridge è Col. Divi Joannis Baptistæ Socio-commensalis.
Another Turkish hand inscribed with a half-moon. Given by Mr Buckridge, Fellow-commoner of St. John's College.

441 Ampulla argentea undique deaurata pro suffimentis conservandis.
Silver flask, gilt all over, in which to keep incense.

442 Alcoranum Turcicum in pyxide argentea rubino ornatâ varijsque coloribus encausto pictâ.
Turkish Koran in a silver box, adorned with a ruby and enamelled in various colours.
MacGregor 1983, no. 24.

443 Silex acuta qua utitur Sacerdos, cum exercet circumcisionis munus. \\Deest.//[86]
Sharp flint, used by a priest for the rite of circumcision.

444 Instrumentum argenteum quo perstringit præputium, characteribus Hebræis inscriptū, id innuentibus. David Aben Attar, his end be good. \\D.//
Silver instrument for performing the rite of circumcision, with an inscription in Hebrew letters meaning 'David Aben Attar, his end be good'.

445 Diversa specimina papyri Ægyptiacæ*, characteribus Arabicis inscripta. *Malabaricæ: in Ægypto enim hujusmodi chartâ (quæ aliud non est quam folium cujusdam palmæ) non utuntur, neque olim usi sunt.//
Various specimens of Egyptian papyrus, inscribed with Arabic characters.[Or] Malabarica, for this type of paper (being nothing other than a palm leaf) is not, and never was, used in Egypt.
cf. MacGregor 1983, nos. 80-82.

446 Inaurium par straminetum.
Pair of straw earrings.

447 Pegma ligneum pro glomerandâ bysso, intra phialam strictioris orificij exstractum. \\Deest//[87]
Wooden device in the form of a dish, for containing flax, with a narrow aperture through which it is drawn out.

448 Ventilabrū e ligno eleganter sculptū. \\Deest.//[88]
Fan, elegantly sculpted out of wood.

449 /*\Calamistrum, sive acus crinalis, item ligno cælata, cum simili ventilabro, /ac\ alijs ornamentis

fastigio appendentib[s].[89]
Curling-iron or hair-pin, again made of wood like the similar fan and with other decorations hanging from the top.

450 Larva lignea inusitati artificij. \\deest.//[90]
Wooden mask, of unusual workmanship.

451 [-Corpus solidum ligneum ea forma donatum; ut foramina, rotundū, ovale, quadrangulum, omnia ad unguem expleat.]
Solid wooden body of such a shape that it fits all holes perfectly, whether round, oval or square.

[27r]

452 Calendarium Suecicum ex asseribus oblongis fabricatū literis Runicis inscriptum, Suecis a Rimstock.
Swedish calendar made of oblong tablets, inscribed with runic letters, from Rimstock in Sweden.
MacGregor 1983, no. 194.

453 Abacus Japonicus, in quo rationes colliguntur per globulos stanneos perforatos filo ferreo consertos, stylo item ferreo huic inde mobiles.
Japanese abacus on which sums are calculated with perforated tin beads, strung on iron wire, and moveable from side to side on the said iron rod.
MacGregor 1983, no. 193.

454 Aliud genus Abaci ex quandrangulis eburneis encausto pictis, in quo rationes colliguntur per foramina immobilia variè disposita.[91]
Another kind of abacus with rectangular ivory beads, painted encaustically, on which sums are calculated by means of fixed holes, variously positioned.

455 Schema quasi topiarium in matre perlarum Chanquo dictâ, forma ovali.[92]
Mother-of-pearl (known as chanquo), oval in outline, looking almost like topiary work.

456 Schematis topiarij alia species, eisdē materiâ ac formâ.
Another piece resembling topiary, of the same form and substance as the former.

457 Vitrum Chrystallinū /rotundū\ flore, quasi in parmâ, erecte posito, insculptum.
Rounded crystalline glass intaglio, engraved with a flower placed upright as if on a shield.

458 Idem iterum. \\deest.//[93]
Another of the same.

459 Vitrum Chrystallinum /ovale\ Iride aureâ in solo cyaneo, encausto pictum. \\de://[94]
Ovoid crystalline glass intaglio, with a golden rainbow on a blue ground, painted in encaustically.

460 Vitrum Chrystallinum /octogonū\ flore coccinio in areâ deaurata encausto pictum.
Octagonal crystalline glass intaglio, with a scarlet flower on a

[85] **[f.25v]** f/

[86] **[f.25v]** 443 Pictura St Cuthberti jussu Ælfredi facta agro Somersetiensi apud vicum Athelney dictum inventa. D.D. Tho. Palmer Arm: de Fairfield Com. Som.
Picture of St. Cuthbert made by the order of Alfred, said to have been found in Somerset, near Athelney. Given by Thomas Palmer Esq., of Fairfield, Somerset.

[87] **[f.25v]** 447 Igniariume spurio auro fabrefactum eleganter cælatum inst/r\umentis suis innibus repletum.
Tinder-box made of false gold and elegantly carved, filled with all its appropriate implements.

[88] **[f.25v]** d
448 Catena e ligno solido exculpta.
Chain cut from solid wood.

[89] **[f.25v]** f |*d
449 Catena altera eburnea.
Another chain, of ivory.

[90] **[f.25v]** f.

[91] **[f.26v]** Frustrum ligni e medio saxi[-] desumptum.
A piece of wood found in Middlesex.

[92] **[f.26v]** [-fr.] 15 ...

[93] **[f.26v]** [-]

[94] [-d] d **[f.26v]** Opere posterganeo.
Worked from the back.

gilded backround, painted encaustically.

461 Carneolus /ovalis\ plantâ quadam insculptus. Italis, Intagli.[94]
Ovoid carnelian, engraved with a plant; an Italian intaglio
MacGregor 1983, no. 126.

462[-Vitrum Chrystallinum /rotundū\ pectine insculptum.][95]
Rounded, crystalline glass intaglio, engraved with a lyre.

463 Carneolus /ovalis\, animali nescio quo, cælatus.[96]
Ovoid carnelian, carved with an unknown animal.

464 Onyx /octogona,\ animali ignoto cælata, opere levato; Italis, in basso rilievo.[97]
Octagonal onyx, with an unknown animal carved in relief; the Italians call it bas-relief.

465 Vitrum Chrystallinum /ovale\ aquilâ Imperiali insculptum.[98]
Ovoid crystalline glass intaglio, engraved with an imperial eagle.

466 Vitrum item chrystallinum /ovale\ Gryphe erecto cælatum.
Another ovoid crystalline glass intaglio, carved with an upright griffin.
MacGregor 1983, no. 176.

467 -Aquila\Phoenix] coronata alis expansis e Corallio /rubro\ cælata opere elato, cum stalagmijs ex eadē materia appendentib'.[99]
Crowned phoenix with outstretched wings, carved in high relief in red coral, with pendants of the same material.
MacGregor 1983, no. 114.

468 Leo gradiens faberrimè sculptus in basso relievo [-ex onyche ovali] in obverso; et Leæna in reverso; uterque ex onyche ovali, auro munitâ.
Walking lion, skilfully carved in bas-relief on the obverse surface, with a lioness on the reverse; both on ovoid onyx and mounted in gold.

469 Stalagmiorum par elegantissimum e Corallio rubro affabrè cælatorum.
Very elegant pair of earrings, skilfully carved in red coral.

[28r]

470 Vitrum chrystallinum /ovale\ in quo Insignia gentilitia familiæ de ... in scuto bipartito insculpta.
Ovoid, crystalline glass intaglio, on which is carved on an impaled arms of the noble family of [].

471 Vitrum chrystallinum /octogonum\ in quo Insignia gentilitia familiæ de ... in scuto etiam bipartito cælata.
Octagonal, crystalline glass intaglio, on which is carved on an impaled shield the arms of the noble family of [].

472 Vitrum chrystallinim /rotundum \ in quo etiam Insignia gentilitia familiæ de ... simplici scuto incisa.[100]
Rounded, crystalline glass intaglio, on which is carved on a plain shield the arms of the noble family of [].

473 Vitrum chrystallinum /rotundum\ in quo Insignia familiæ de ... duobus distinctis clypeis opere posterganeo ostenduntur.
Rounded, crystalline glass intaglio, on which is displayed the arms of the family of [] on two separate shields. Worked from the back.

474 /d\ Vitrum chrystallinum octogonum, in quo Cor sanguineum in solo aureo, opere /item\ posterganeo exhibetur.
Octagonal, crystalline glass intaglio, on which a bleeding heart, on a gilt background, is displayed. Also worked from the back.

475 Vitrum chrystallinum rotundum, in quo Cor argenteum alis aureis, diademate ducali /aureo \ coronatum, /simili\ opere [-item] posterganeo adumbratur.
Rounded, crystalline glass intaglio, on which is shown a silver heart with golden wings, crowned with a golden ducal coronet. Worked from the back.

476 Vitrum chrystallinum ovale, duabus lævis junctis insculptum. \\[-deest]//[101]
Ovoid, crystalline glass intaglio, carved with two clasped left hands.

477 Vitrum chrystallinum ovale in quo Cranium humanum, inter clepsammidium, et duo ossa femoralia decussatim posita, cælatum.
Ovoid, crystalline glass intaglio, on which is carved a human skull between an hourglass and two crossed femoral bones.
MacGregor 1983, no. 175.

478 /[-d]\ Vitrum chrystallinum ovale, in quo Turci caput Tiarâ indutum in solo miniato, opere posterganeo exhibetur. \\[-de]//
Ovoid, crystalline glass intaglio, showing the head of a Turk wearing a turban on a red background; worked from the back.
MacGregor 1983, no. 172.

479 /d\Vitrum chrystalinum ovale, in quo item Turci caput Tiarâ indutū in solo cyaneo, opere posterganeo adumbratur. \\Deest.//
Ovoid, crystalline glass intaglio, also showing the head of a Turk wearing a turban, on a sea-blue background; worked from the back.

480 Vitrum chrystallinum ovale, in quo Herois caput galeatum in solo coccineo, simili opere posterganeo ostenditur.[102]
Ovoid, crystalline glass intaglio, showing the helmeted head of a hero on a scarlet background; similarly worked from the back.
MacGregor 1983, no. 173.

481 Vitrum chrystallinum ovale, in quo Æthiopis caput cælatum.[103]
Ovoid, crystalline glass intaglio, on which is carved the head of an Ethiopian.

482 Idem iterum. \\Deest.//[104]
Another of the same.

483 Cama, in qua Heroinæ caput Carneolo ovali incisum.
Cameo in which the head of a heroine is carved on an ovoid carnelian.
MacGregor 1983, no. 124.

[94] [f.26v] [-d]
[95] [f.26v] d
[96] [f.26v] d
[97] [f.26v] d
[98] [f.26v] frac: d
[99] [f.26v] [-deest]
[100] [f.27v] [-d]

[101] [f.27v] d [-]
[102] [f.27v] [-d]
[103] [f.27v] fractum
[104] [f.27v] d

484 Cama, in qua Herois caput galeatũ in onyche ovali cælatum.[105]
Cameo in which the helmeted head of a hero is carved on ovoid onyx.

485 Cama, in qua figura hominis integra in Lapide Lazuli insculpta est.
Cameo in which the complete figure of a man is carved on lapis lazuli.

486 Capita 12. Apostolorum in argento, toreumate /seu opere anaglyptico\ exhibita, contenta in pyxide item argenteâ, varijs coloribus encausto pictâ. \\de. unum.// \\ [-] deest 1700//[106]
Heads of the Twelve Apostles, in silver, in embossed or low-relief work, contained in a silver box enamelled in various colours. MacGregor 1983, no. 188.

[29r]

487 Apollo /Arion \ citharizans e Corallio cælatus, una cum multis stalagmijs circum circa pendentibus. \\Fract. 1700//
Apollo or Arion playing on the lyre, carved in coral, with many pendants hanging all around. Broken in 1700.

488 \\[-d]// /d\ Cama, in qua figura Achate /ovali\ insculpta super Columnam sedens, dextra tenet cassidem, sinistra columnæ innixa.\\d//
Cameo in which is carved, on an ovoid agate, a figure seated on a pillar holding a helmet with the right hand, and leaning on the column with the left.

489 Vitrum chrystallinum ovale, figurâ insculptum sagittâ jaculante.
Ovoid, crystalline glass intaglio, carved with a figure shooting an arrow. MacGregor 1983, no. 174.

490 Cama, in qua figura se inclinans carneolo ovali cælata.
Cameo in which a reclining figure is carved on an ovoid carnelian. MacGregor 1983, no. 125.

491 /[-d]\ Cama, in qua Angelus galeatus (S.[tus] Michæl) manibus tenens tubam; carneolo item ovali incisus. \\‡//[107]
Cameo in which a helmeted angel (St. Michael), holding a trumpet in his hands, is carved, also on an ovoid carnelian. MacGregor 1983, no. 127.

492 Cama, in qua homo vestitus dormiens, cum fæmina nuda astante, achate ovali insculptus.
Cameo in which is carved a clothed man sleeping and a naked woman standing by, on an ovoid agate. MacGregor 1983, no. 143.

493 /d\ Vitrum chrystallinum ovale, in quo, opere posterganeo, Salvator Mundi in Cruce pendens exhibetur, una cum S[tis] fæminis asseclis, et omnibus Crucifixionis instrumentis circum circa dispositis. \\fract.//[108]
Ovoid, crystalline glass intaglio, worked from the back, on which the Saviour of the world is seen hanging on the Cross, with the holy women followers, and all the instruments of the Passion lying around. Broken.

494 Christi nativitas, cum S.[to] Josepho, B. Mariâ, Angelo et Pastorib[s], in Pruni ossiculo faberrimè sculpta.
The Birth of Christ, with St. Joseph, the Blessed Virgin Mary, an Angel and shepherds, skilfully carved on a plum-stone.

495 Imago Dñi nr̃i Jesu Christi intra ovale incisa, in quo hæc Inscriptio Ecce Salvator mundi; supra, Spiritus sanctus descendens; infra Clepsammidium supra Calvariam:* in parte aversâ Christus in cruce pendens cum omnibus Crucefixionis instrumentis adjunctis: atque omnia hæc in Pruni ossiculo, opere multiforo, /mire\ cælata.[109]
Figure of Our Lord Jesus Christ carved within an oval, with the following inscription: Behold the Saviour of the World; above, the Holy Ghost descending; below, an hourglass over a skull. On the other side, Christ hanging on the Cross with all the instruments of the Passion around. All this marvellously carved on a plum-stone, in openwork.

496 Christi crucefixio, cum S.[tis] fæminis asseclis, Milite latus transfigente, totaque comitante caterva, in pruni item ossiculo graphice sculpta.
The Crucifixion of Christ, with his holy women followers and with a soldier piercing his side, accompanied by a crowd of people; finely carved on plum-stone. MacGregor 1983, no. 182.

497 [-Corbis ex ossiculo Cerasi, opere multiforo sculptus.] \\‡//[110]
Basket carved from a cherry-stone, in openwork.

498 /deest\ Imago Dñi nr̃i Jesu Christi intra ovale incisa, in quo hæc Inscriptio, Ecce Salvator mundi.[111]
Figure of Our Lord Jesus Christ, carved within an oval, bearing this inscription: Behold the Saviour of the world. MacGregor 1983, no. 185.

499 Imago B. Mariæ Virginis item itra ovale incisa, in quo hæc Inscriptio, Ecce mater Christi. utraque opere multiforo.
Figure of the Blessed Virgin Mary, also cut within an oval, bearing this inscription: Behold the Mother of Christ. Executed in openwork from both sides. MacGregor 1983, no. 186.

500 /[-d]\ Calceorum par nitidissimum e duobus Cerasorum ossiculis.[112]
Highly polished pair of shoes, made out of two cherry-stones.

501 [-Facies Heroinæ formosissimæ, ac Mortis, in eade Cerasi ossiculo.] \\‡//[113]
Face of a very beautiful lady, and of Death, carved on the same cherry-stone.

502 Orpheus citharizans in una facie ossiculi unius pruni sculptus, et omne genus bestiarum /comitatiũ\ in

[105] [f.27v] d
[106] [f.27v] [-d.1.]
[107] [f.28v] [-Lost 1697]
[108] [f.28v] d

[109] [f.28v] * fract. pars aversa.
The back is broken.
[110] [f.28v] frac. 1692 [-d]
[111] [f.28v] frac:
[112] [f.28v] d [-] d
[113] [f.28v] d‡

aliâ, opere multiforo.
Orpheus playing the lyre carved on one side of a single plum-stone, and on the other a following of all kinds of animals. Executed in openwork .
MacGregor 1983, no. 181.

[30r]

503 Sanctus Jacobus in Pruni ossiculo insculptus.
St. James carved on a plum-stone.
MacGregor 1983, no. 183.

504 Calceus nitidissimus e Cerasi ossiculo.
Highly polished boot, carved from a cherry-stone.

505 Cantharus e pruni ossiculo sculptus.
Tankard, carved from a plum-stone.

506 Item cymba e pruni ossiculo sculpta.
A boat also carved from a plum-stone.

507 Insignia sex familiarũ uno clypeo contenta, in unica facie ossiculi Pruni cælata \\d// \\fract//[114]
The arms of six families on one shield, carved on a single side of a plum-stone; broken.
MacGregor 1983, no.184.

508 Crux lignea in qua multa Christi gesta incisa.[115]
Wooden cross on which many of the deeds of Christ are carved.
MacGregor 1983, no. 228.

509 Cerasi ossiculum in cujus uno latere, S.tus Georgius cum Dracone in alio 88 Imperatorum facies, arte thaumaturgicâ, cælati.
Cherry-stone, with St. George and the dragon carved on one side, and the faces of eighty-eight emperors on the other, with wonderful skill.
MacGregor 1983, no. 439i.

510 Christi resurrectio e sepulchro, curn Angelis ipsi famulantibus, in miniatura eximie adumbrata.
The Resurrection of Christ from the Tomb, attended by angels, marvellously executed in miniature.
MacGregor 1983, no. 130.

511 Christi crucifixio intra latrones cum equitibus peditibusque astantibus omnes inclusi in theca vitro instructa. \\fract.//[116]
The Crucifixion of Christ between the thieves, with cavalry and foot-soldiers standing around, all enclosed in a glass case.

512 [-Facies Dñi nñi Jesu Christi et B. Mariæ Virginis miniaturâ exhibita. Chrystallo obductæ, et argento munitæ.][117]
Faces of Our Lord Jesus Christ and the Blessed Virgin Mary, shown in miniature; carved in crystal and mounted in silver.

512b Annulus argenteus antiquus sigillo [-ornatus] et quibusdam literis insculptus. Hunc annulũ in Collegio Ænei Nasi effossum; dedit Ds. B. Brown ejusd. Col. Soc. et. Acad. Proc/r\.

Ancient silver ring, carved with a seal and certain letters. This ring was dug up in Brasenose College. Given by Mr B. Brown, Fellow of that college and Proctor of the University.

513 Imago Dñi nñi Jesu Christi Crucem sua portantis, in ichthyocollâ.[118]
Figure of Our Lord Jesus Christ carrying his cross, in isinglass.

514 \\‡//[-Imago B. Mariæ Magdalenæ, selenite obducta, in theca auro et argento acupicta.]\\‡//[119]
Figure of the Blessed Mary Magdalene, covered in selenite and decorated with gold and silver.

515 Imago Jacobi primi Angl.etc Regis in Ichthyocollâ.
Figure of His Majesty King James I of England, in isinglass.

516 Ciphra ignota ex Ichthiocolla.
Unknown figure in isinglass.

517 Amator illecebris amasiam suã tentans, in Ichthyocolla.
A lover tempting his loved one, in isinglass.

518 \\‡//[-Facies humana encausto picta auro et Margaritarum circello munita.] Legatus Marocciensis. ex emplastro in circello vitri; accurante ... Simmonds. Donavit Guilielmus Charlton armiger, e medio Templo.
[-Human face enamelled in gold and mounted within a circle of pearls.] The Moroccan ambassador, in plaster, enclosed in glass ... by Simmonds. Given by William Charleton Esq., of Middle Temple.

519 [-Facies Senis duarumque fæminarum in testa cælatæ auroque Munitæ.] Quatuor figuræ in chalcedonio lapide insculptæ: quarum prima parvulum quendam exhibet, secunda fæminam cornu copiæ in dextra gestantem, tertia........et quarta martem vel Saltem militem quendam hastatum et galeatum. Don.vit Rev. V. Dom.[-] Carolus King Ædis Christi Alumnus.[120]
[-The faces of an old man and two women carved in shell and mounted in gold.] Four figures engraved in chalcedony, of which the first is a small person, the second a woman holding a horn of plenty in her right hand, the third ... and the fourth Mars or, in any event, a soldier with a spear and helmet. Given by the Revd Charles King, Student of Christ Church.

520 Caput humanum ignotũ in matre Perlam incisum.[121]
Head of an unknown person, engraved in mother-of-pearl.

521 Venus nuda navigans in dorso Delphini, in matre Perlarum cælata.
Venus, nude, riding on the back of a dolphin, carved in mother-of-pearl.
MacGregor 1983, no. 168.

522 Pictura Reverendissimi Patris ac Dñi D. Georgij Abbot Archiep. Cantuar. coloribus dilutis.
Portrait of the Very Revd Father and Lord Archbishop of Canterbury, George Abbot, in watercolours.
MacGregor 1983, no. 252.

523 Pictura Carmelitæ cujusdam, in sublitione lazuriâ.
Portrait of a certain Carmelite monk, on an azure background.
MacGregor 1983, no. 251.

[31r]

[114] [f.29v] [-d]
[115] [f.29r] 508b. Crux altera Lignea præcedante major, in qua etiam multa Christi gesta incisi- In caps: vitreâ parieti affixâ in fenestra.
Another wooden cross, larger than the previous one, on which are carved many of deeds of Christ. It is fixed on a glass panel in the window
MacGregor 1983, no. 229.

[116] [f.29v] f

[117] d [f.29r] 512.a Annulus argenteus in quo Corneolus Arabicè inscriptus. Donavit D. Georgius Walker. Arm.
Silver ring with a carnelian inscribed with Arabic characters. Given by George Walker, Esq.

[118] [f.29v] fract:
[119] [f.29v] d ‡
[120] [f.29v] des.
[121] [f.29v] d

524 Pictura Illustrissimi Ducis Chastillion Galliæ Thalassiarchæ, coloribus dilutis, item in sublitione lazuriâ.
Portrait of the most illustrious Duke of Châtillon, Admiral of France, executed in watercolours, also on an azure back-ground.
MacGregor 1983, no. 249.

525 Pictura cujusdam Herois ignoti formosissima, coloribus dilutis et simili sublitione.[122]
A most beautiful portrait of an unknown hero, in watercolours and on a similar background.
MacGregor 1983, no. 250.

526 Pictura [-B. Mariæ Virginis in miniaturâ chrystallo obducta, et Ebeno munita \ignoti cujusd. ex emplastro, [-] in circello vitri; auctore ... Symmonds Donavit Clariss. Vir. Guil. Charlton è medio Templo; armig.]
Picture [-of the Blessed Virgin Mary, in miniature, covered in crystal and mounted in ebony] of an unknown person, in plaster, enclosed in glass ... by Simmonds. Given by the celebrated William Charleton Esq., of Middle Temple.

527 Cama, seu Caput humanum Prasio cælatum, Italis Prasina di Smiraldo.[123]
Cameo, or human head carved in prase; called by the Italians, emerald prase.
MacGregor 1983, no. 133.

528 Cama, seu Caput humanum in /Leuc-\ Achate sculptum.
Cameo or human head, engraved in white agate.
MacGregor 1983, no. 134.

529 Cama, seu Caput humanum /item in Leuc-\Achate incisum.
Cameo, or human head, also incised in white agate.
MacGregor 1983, no. 135.

530 Cama, seu Caput humanum Turchesia insculptum.[124]
Cameo, or human head, incised in turquoise.

531 /Deest\ Cama, seu Caput Cherubini in /Leuc-\ Achate cælatum. \\d//[125]
Cameo, or Cherub's head, carved in white agate.

532 Cama, seu Caput humanum lapide quodam mortuo.
Cameo, or human head, carved as if on a funerary stone.
MacGregor 1983, no. 178.

533 Cama, seu Imago S.[ti] Michælis Archangeli lapide ite mortuo incisa. \\d//[126]
Cameo, or image of St. Michael the Archangel, also carved as if on a funerary stone.

534 [-Cama, ex Achate figurâ hominis humi procumbentis insculpta]\\d//[127]
Agate cameo, carved with the figure of a man lying on the ground.
MacGregor 1983, no. 145.

535 Cama, ex /Leuc-\ Achate figurâ Angeli cælata.

\\deest.//[128]
Cameo of white agate, carved with the figure of an angel.

536 Cama, ex Achate figurâ Angeli stantis incisa.[129]
Agate cameo, carved with the figure of a standing angel.

537 Cama ex Rubicello vel Amethysto albo, in quo Neptunus in concha navigans /& tridentem dextrâ gerens\. Cama auro munita.
Cameo of ruby or white amethyst, in which Neptune rides on a shell and holds a trident in his right hand; also mounted in gold.
MacGregor 1983, no. 152.

538 Cama ex Rubicello vel Amethysto albo, figurâ Herculis clavæ innixi sculpta, [-auro item munita.]
Cameo of ruby or white amethyst, engraved with the figure of Hercules leaning on his club; also mounted in gold.
MacGregor 1983, no. 151.

539 Cama, in qua figura Satyri vel forte Dei Panis tubas sonantis item ex Rubicello sculpta, [-auro inclusa.]
Cameo in which the figure of a satyr or possibly the god Pan blows his trumpets; engraved in ruby and framed in gold .
MacGregor 1983, no. 171.

540 Cama, in qua figura Mercurij dextra crumenam, sinistra Caduceum gestantis, Rubicello cælata, auro inclusa.
Cameo, in which the figure of Mercury, carrying a pouch in his right hand and a caduceus in his left, is carved in ruby and framed in gold.
MacGregor 1983, no. 150.

541 Cama, in qua figura hominis puerulū proijcientis /Saturni filium voraturi\, Rubicello insculpta, auro munita.
Cameo, in which the figure of a man throwing a young boy, or Saturn about to devour his son, is engraved in ruby and mounted in gold.

542 Cama, in qua figura Jovis vel forte Junonis læva fulmen gestantis, Rubicello incisa, auro item inclusa.
Cameo, with the figure of Jupiter (or perhaps Juno) brandishing a bolt of lightning with the left hand; carved in ruby and framed in gold.
MacGregor 1983, no. 149.

543 Cama ex Achate in quo figura Christi in cruce pendentis, una cum S.[tis] fæm[in]is asseclis, cælata.
Agate cameo, carved with a figure of Christ hanging on the Cross, with the holy women followers.
MacGregor 1983, no. 148.

[32r]

544 Cama ex /Leuc-\ Achate figurâ Equitis insculpta.
White agate cameo carved with the figure of a knight.
MacGregor 1983, no. 141.

545 Cama item ex Achate figura hominis procumbentis ac Cantauri ex arcu sagittam mittentis, incisa.
Another agate cameo, in which is incised the figure of a man lying down and a centaur shooting an arrow from a bow.
MacGregor 1983, no. 142.

546 Cama ex Achate in quo figuræ tres, duæ stantes, una procumbens cælatæ.
Agate cameo, in which are carved three figures, two standing and one lying down.

[122] **[f.30v]** fract.

[123] **[f.30v]** 16 ...

[124] **[f.30v]** De:

[125] **[f.30v]** d

[126] **[f.30v]** d

[127] **[f.30v]** d

[128] **[f.30v]** d

[129] **[f.30v]** d

547 Cama ex /Leuc-\ Achate, in quo figuræ duæ, una stans, alia sedens, sculptæ. \\[-d] deest.//[130]
White agate cameo, on which are carved two figures, one standing and the other sitting.

548 Cama ex Achate, in quo figura sedens cum puerulo astante insculpta.
Agate cameo, in which are carved a seated figure with a young boy standing by.
MacGregor 1983, no. 139.

549 Cama, seu Caput fæminæ illustris in /Leuc-\ Achate incisum.
Cameo or head of an illustrious woman, incised in white agate.
MacGregor 1983, no. 136.

550 Cama, seu Caput fæminæ illustris itẽ in Leucachate sculptum.
Cameo or head of an illustrious woman, also cut in white agate.
MacGregor 1983, no. 138.

551 Idem iterum.
Another of the same.
MacGregor 1983, no. 137.

552 Idem iterum.[131]
Another of the same.

553 /d\ Idem iterum. \\deest.//
Another of the same.

554 Idem iterum. \\[-deest]//
Another of the same.

555 Cama, seu Imago S.ᵗᵃᵉ Catharinæ lapide quodã mortuo cælata.
Cameo or the image of St. Catherine, carved as if on a funerary stone.
MacGregor 1983, no. 170.

556 Cama, seu Imago Veneris delphinŭ inequitantis in Leucachate sculpta.
Cameo or the image of Venus riding on a dolphin, engraved in white agate.
MacGregor 1983, no. 146.

557 Cama, ex Achate magno ovali, in quo figura Europæ in tergo Tauri æquora trajicientis, incisa.
Large ovoid agate cameo, in which is incised the figure of Europa crossing the seas on the back of the bull.
MacGregor 1983, no. 144.

558 Camæ duæ ex Leucachatibus, in quibus duæ dexteræ junctæ. \\De.//[132]
Two white agate cameos, on each a pair of clasped right hands.

559 Scarabæus in concha insculptus.
Figure of a scarab, carved in shell.
MacGregor 1983, no. 157.

560 Aquila volans item in concha cælata.
Flying eagle, also carved in shell.
MacGregor 1983, no. 164.

561 Gallus gallinaceus simili concha sculptus.
Domestic cock, engraved on a similar shell.
MacGregor 1983, no. 153.

562 Cama ex Achate insuasi coloris, in quo figura Basilisci /Camoli\ incisa.
Dark-coloured agate cameo carved with the figure of a basilisk or chameleon.

563 Basiliscus in testa cælatus. \\deest//
Basilisk carved in shell.

564 Cama ex achate persici coloris, in quo figura Gryphis sculpta.
Peach-coloured agate cameo, engraved with the figure of a griffin.
MacGregor 1983, no. 147.

565 Syren tubam sonans in testa cælata.
Siren blowing a trumpet, carved in shell.
MacGregor 1983, no. 156.

566 Crocodilus item testa insculptus. \\fract.//[133]
Crocodile, also engraved in shell. Broken.

567 Bufo in concha incisus.
Toad incised in shell.
MacGregor 1983, no. 162.

568 Serpens in Helicem contortus item in concha cælatus.
Serpent coiled in a spiral, also carved in shell.
MacGregor 1983, no. 163.

[33r]

569 Simia cum suo catulo in concha insculpta. \\deest.//[134]
Monkey with its young, again engraved in shell.

570 Sciurus item in concha incisus.
Squirrel, also incised in shell.

571 Elephantus in testa sculptus.
Elephant engraved in shell.
MacGregor 1983, no. 161.

572 Camælus item testa cælatus.
Camel, also carved in shell.
MacGregor 1983, no. 154.

573 Cama ex achate coloris persici, in quo figura Capri insculpta.
Peach-coloured agate cameo, engraved with the figure of a goat.

574 Capra in testa incisa.
Goat incised in shell.
MacGregor 1983, nos. 155,160.

575 Cama ex achate lurido, in quo figura ursi antrum intrantis sculpta.[135]
Pale-yellow agate cameo, engraved with the figure of a bear entering a cave.

576 Animal nescio quoddã monstrosum in concha cælatum. \\deest//
Figure of some unknown monstrous animal, carved in shell.
MacGregor 1983, no. 159.

577 Animal nescio quoddã item in concha insculptum.
Figure of some unknown animal, also engraved in shell.
MacGregor 1983, no. 158.

578 Simil[-e] animal ignotum in concha incisum. \\deest//[136]
Similar unknown animal, incised in shell.
MacGregor 1983, no. 165.

579 Salutatio B. M. Virginis arte cereoplasticâ. \\fract Anno 1694.//
Annunciation to the Blessed Virgin Mary, made in wax. Broken in 1694.
MacGregor 1983, no. 187.

[130] **[f.31v]** d
[131] **[f.31v]** d
[132] **[f.31v]** [-d |] d

[133] **[f.31v]** frac.
[134] **[f.31v]** fract d
[135] **[f.32v]** [-d]
[136] **[f.32v]** d [-d d]

580 /[-d]\ [-Salutatio/nes\ B. M. Virginis, et S.ᵗᵃᵉ Elizabethæ in Ebore cælata.]¹³⁷
The Annunciation to the Blessed Virgin Mary, and to St. Elizabeth, carved in ivory.
MacGregor 1983, no. 234.

581 Magi adorantes Christum, et ei offerentes, aurum, thus, et myrrham, ebore insculpti.
Adoration of Christ by the Magi, and their offerings to him of gold, frankincense and myrrh, carved in ivory.
MacGregor 1983, no. 233.

582 B. Maria Virgo filium in sinu gestans e Lapide deaurato.
The Blessed Virgin Mary holding her Son in her lap, in gilt stone.

583 B. Maria Virgo filiũ in sinu gestans in Ebore sculpta.
The Blessed Virgin Mary holding her Son in her lap, carved in ivory.
MacGregor 1983, no. 230.

584 Dñs noster Jesus Christus, quibusdã benedictionẽ impertiens, in Ebore incisus.
Our Lord Jesus Christ bestowing a blessing on some people, incised in ivory.
MacGregor 1983, no. 232.

585 Christi congressus cum Johanne in Eremo, item Ebore cælat⁹.
The meeting of Christ with St. John in the desert, also carved in ivory.

586 Christus in cruce pendens cũ Sanctis fæminis asseclis, multisq. alijs astantibus.¹³⁸
Christ on the Cross, with the holy women followers, and many other figures standing by.
MacGregor 1983, no. 235.

587 Duo pugiles equestres ex Ebore sculpti.
Two combatants on horseback, carved in ivory.
MacGregor 1983, no. 236.

588 Duo pugiles pedestres, cum Harpyijs comitantibus, itẽ ex Ebore cælati, in concavo rotundo.
Two combatants on foot, accompanied by Harpies, carved on a hollowed disc of ivory.
MacGregor 1983, no. 237.

589 Idem iterum (ut opinor) in simili concavo rotundo.
Another of the same, it seems, on a similar hollowed disc
MacGregor 1983, no. 238.

590 Duæ pugiles fæminiæ, in testæ convexo incisæ, quarum una clavam in sinistra gerens, aliã videtur prostrâsse.
Two female combatants, incised on a convex shell, one of whom, with a club in her left hand, can be seen to knock down the other.
MacGregor 1983, no. 167.

591 Tria navigia vento secundo vecta, Iride in cælis supereminente, simili testâ convexâ faberrime insculpta.
Three ships driven by a favourable wind, with a rainbow in the sky above; skilfully engraved on a similar convex shell.
MacGregor 1983, no. 166.

592 Caput Imperiale laureaturn Ebore cælatum, forte Antonini.¹³⁹

Imperial head crowned with laurel, carved in ivory; possibly of Antoninus.

593 Caput Imperiale fæmineum itẽ ebore incisũ, forte Cleopatræ.
Female imperial head, again carved in ivory, possibly of Cleopatra
MacGregor 1983, no. 169.

[34r]

594 Cultri manubrium forma balænæ ex Ebore sculptum, in cujus fastigio figura Jonæ, e faucibus ejus prodeuntis.
Knife-handle carved in ivory in the form of a whale, on the tip of which is the figure of Jonah emerging from its mouth.
MacGregor 1983, no. 207.

595 Cultri manubrium instar torquis ex ebore detornatum, in cujus fastigio Turci caput Tiara indutum.
Knife-handle turned in a spiral from ivory, on the tip of which is the head of a Turk wearing a turban
MacGregor 1983, no. 206.

596 Cultri manubrium forma puellæ ex Ebore cælatum.
Knife-handle in the form of a girl, carved in ivory.
MacGregor 1983, no. 204.

597 Idem iterum.
Another of the same
MacGregor 1983, no. 205.

598 Caput fæmineum item ebore incisum.
Head of a woman, also carved in ivory.

599 Cultri manubrium formâ humanâ ex Ebore imperfecte cælatũ.
Knife-handle in human form, incompletely carved in ivory
MacGregor 1983, no. 203.

600 Fastigium (ut dicitur) Pastoralis pedi S.ᵗⁱ Augustini Hipponensis Episcopi, ex Ebore cælatum.¹⁴⁰
The head of a bishop's crozier, said to be that of St. Augustine of Hippo, carved in ivory.

601 [-Pars Mitræ S.ᵗⁱ Polycarpi Archiep. Smyrnensis, præcisæ, et inde delatæ, a Tho. Shrine, Dec. 16 Anᵒ· Dñi 1640.¹⁴¹
A fragment from the mitre of St. Polycarpus, Archbishop of Smyrna, cut off and brought by Thomas Shrine, 16 December 1640.

602 Capita Caroli. I. et Henriettæ Mariæ Regis et Regin. Angl. gypso conflata.
The heads of Charles I and Henrietta Maria, King and Queen of England, in plaster.

603 Capita Henr. 4. et Mariæ Augustæ Regis et Regin Galliæ item gypso conflata.
The heads of Henry IV and Maria Augusta, King and Queen of France, also in plaster.

604 Caput (ut opinor) Honoratis. D. Gulielmi Comitis Pemb. etc. item gypso conflatum.
The head (I believe) of the most honourable William, Earl of Pembroke etc., also in plaster.

605 Caput Honoratis. Tho. Cary Regi Car. I. Cubicular. itẽ gypso conflatum.¹⁴²
The head of the most honourable Thomas Cary, chamberlain to King Charles I, also in plaster.

¹³⁷[f.32v] [-d f d]
¹³⁸[f.32v] [-d]
¹³⁹[f.32v] d|

¹⁴⁰[f.33v] 17...
¹⁴¹[f.33v] d
¹⁴²[f.33v] fract.

606 Caput Honoratis. D. Rich. Weston Com de Portland etc., Sum Angl. Thesaur. etiam gypso conflatum.

Head of the most honourable Richard Weston, Earl of Portland, Chancellor of the Exchequer of England, also in plaster.

607 Caput Johannis Tradescanti patris, Cimeliarchæ celebrati nominis, itẽ gypso conflatum.

The head of John Tradescant the father, collector of great renown, made in plaster.

608 Caput Bethlemi Gabor Transylvaniæ Principis, arte cereoplasticâ \\fract 1707//[143]

Head of Gabor Bethlen, prince of Transylvania, made in wax. Broken in 1707.

609 Caput B. M. Virginis in Selenite encausto pictũ. \\Fract. 170[]//[144]

Head of the Blessed Virgin Mary, painted encaustically on crystalline gypsum.

610 [-Caput Pelopidæ galeatum, in Vitro convexo, varijs coloribus encausto pictum.][145]

Helmeted head of Pelopidas, painted in various colours, on convex glass.

611 Sanctus Marcus in Selenite auro adumbratus, adorans Christum in cruce pendentem.]

St. Mark adoring Christ hanging on the cross, shown in gold on crystalline gypsum.

[35r]

612 [-Caput Dñi nr̃i Jesu Christi, in Selenite encausto pictum.

Head of Our Lord Jesus Christ, painted encaustically on crystalline gypsum.

613 Duo capita humana, in lapide coloris badij cælata, osculum charitatis invicem impertientia.

Two human heads, carved in chestnut-coloured stone, mutually bestowing a kiss of charity

614 Caput Antonij van Rosendael arte Thaumaturgica Buxo cælatum.[146]

Head of Antonius van Rosendæl, miraculously carved in boxwood.

615 Pictura Satyri, Nympham formosam perdite ardentis, coloribus dilutis. \\⊗//[147]

Picture in watercolours of a satyr desperately lusting after a beautiful nymph..

616 Prospectus amænus nigro delineatus, in sublitione aureâ, opere posterganeo.][148]

Beautiful landscape, drawn in black, on a golden background; worked from the back.

617 /*\ Pictura /*\ B. Mariæ Virginis filium in sinu gestantis, in cupro delineata.[149]

Picture, engraved in copper, of the Blessed Virgin Mary holding her son on her lap.

618 Magi Christũ adorantes, et Aurũ, Thus, /et\

myrrham, offerentes, Alabastro cælati, opere elato, margine deauratâ muniti. \\fract://[150]

Adoration of Christ by the Magi who offer him gold, frankincense and myrrh; carved in alabaster in high relief, in a gilt frame. Broken.

619 Angeli Christo ministrantes in præsepi, item Alabastro sculpti, et margine deaurata inclusi.[151]

Angels attending Christ in the stable; also carved in alabaster, in a gilt frame.
MacGregor 1983, no. 218.

620 Christi octavo die circumcisio; a Sacerdote, alabastro incisa; et simili margine munita. \\Frac: 1700-//[152]

The Circumcision of Christ on the eighth day by a priest, incised in alabaster, in a similar frame. Broken 1700.

621 Pictura Quercûs ingentis selenite obductæ.

Picture of a giant oak-tree covered in crystalline gypsum.

622 Pictura Capitis admodum deformis sine margine.

Picture of a head, much deformed, without a frame.

623 Pictura Sti Francisci arte cereoplastica in sublitione e Lapide scissili. \\fract. an.° 1706.//[153]

Picture of St. Francis, in wax, on a ground of laminar rock. Broken in 1706.

624 Pictura B. Mariæ Virginis precantis coram Imagine Christi in cruce pendentis.[154]

Picture of the Blessed Virgin Mary praying before an image of Christ hanging on the Cross.

625 Imago Christi in loco Gethsemane dicto precantis, discipulis /interim\ dormientibus, alabastro cælata, margine deauratâ munita.

Representation of Christ praying in the place known as Gethsemane, while his disciples sleep; carved in alabaster, in a gilt frame
MacGregor 1983, no. 219

626 Imago Christi ad Columnam virgis cæsi, alabastro sculpta, opere elato; margine deauratâ itẽ inclusa.

Representation of Christ bound to a column and scourged with rods; carved in alabaster in high-relief, also in a gilt frame.
MacGregor 1983, no. 220.

627 Imago Josephi Arimathæensis, et Nicodemi, Christum in sepulchro novo sepelientium, alabastro cælata opere levato, et simili margine munita. \\fract. 1700.//

Representation of Joseph of Arimathea and Nicodemus, burying Christ in a new tomb; carved in alabaster in high-relief, in a similar frame. Broken in 1700.
MacGregor 1983, no. 221.

[36r]

628 Pictura duorum Rusticorum et prospectûs amæni ruralis, Selenite obducta, et margine ex Ebeno inclusa.

Representation of two peasants and a pleasant rural landscape, carved in crystalline gypsum and kept in an ebony frame.

629 Pictura Principis Aransiensis quibusdam Psalmorum versiculis adumbrata, Selenite obducta, et margine ex Ebeno munita.

Picture of the Prince of Orange, with certain lines from the

[143][f.33v] fract
[144][f.33v] [-d]
[145][f.33v] ‡d
[146][f.34v] 614. in one of the windows.
[147]d/ ⊗ [f.34v] Satyrus opere figlino.
Satyr worked in clay.
[148][f.34v] f
[149][f.34v] *turn over 9 leaves 18 ...
*vel potius effigies, et sic de cæteris.
Or rather a representation, and so also with the others.

[150][f.34v] d
[151][f.34v] d
[152][f.34v] d
[153][f.34v] fundamento [-d]
[154][f.34v] [-d]

Psalms, covered in crystalline gypsum, in an ebony frame.

630 Pictura Caroli primi Mag. Brit. etc. Regis, margine ex Ebeno conservata.
Picture of Charles I, King of Britain etc., kept in an ebony frame.

631 /d\ Pictura Serenis. Henriettæ Mariæ Angl. Reginæ coloribus dilutis. \\[-‡] ‡//[155]
Picture of Henrietta Maria, Queen of England, in watercolours.

632 Figura Persei Pegasum inequitantis, Andromedam a Dracone liberantis, Ebore cælata.
Figure of Perseus, riding on Pegasus, and freeing Andromeda from the dragon, carved in ivory.

633 Imago Henrici magni Galliæ et Navar. Regis, opere in Cornu anaglyptico.
Figure of Henry the Great, King of France and Navarre, worked in low-relief in horn.

634 Pictura Johis Tradescanti senioris margine ex Ebeno ornata.
Picture of John Tradescant the Elder in an ebony frame.
MacGregor 1983, no. 253.

635 Pictura Prospectûs elegantissimi margine ex Ebeno insignita.
Picture of a most beautiful landscape, in an ebony frame.
MacGregor 1983, no. 254.

636 Pictura S[ti] Hieronymi coloribus dilutis.
Picture of St. Jerome in watercolours.

637 Pictura Desid. Erasmi Roter/o\dami.
Picture of Desiderius Erasmus of Rotterdam.
MacGregor 1983, no. 255.

638 Figura Navis, velis expansis, opere in Cornu anaglyptico.
Representation of a ship with its sails unfurled, worked in low-relief in horn.

639 /[-d] d\ Effigies S[ti] Francisci, Christum in cruce pendentem adorantis, opere cereoplastico.[156]
Representation of St. Francis worshipping Christ hanging on the Cross, in wax.

640 Effigies S[ti] Hieronymi serio meditantis, eodẽ opere.[157]
Similar figure of St. Jerome deep in thought, in wax.

641 /o\ Effigies dextræ ... Dñæ Claypoole Oliverij Angl. Protectoris filiæ dilectæ, item eodẽ opere. \\fract.//
Representation of the right ... Mrs Claypole, the beloved daughter of Oliver [Cromwell], Protector of England; also in wax. Broken.

642 Effigies Castri Windlesoriensis opere stramineo.

Model of Windsor Castle, in straw.

643 Tabula rerum Runicarum Sculpturâ exhibitarum.[158]
Panel carved with items in runes.

643.b Pictura Domini Hadriani Beverlandij, [-] quam ipse huic museo donavit A° 1692.
Picture of Hadrian Beverland, which he himself gave to the Museum in 1692.

644 Fons (ut puto) Jacobi ligno cælatus opere elato.[159]
Jacob's well (I believe), carved in wood in high-relief.
MacGregor 1983, no. 225.

645 Historia passionis Dñi nr̃i Jesu Christi tabulâ ligneâ insculpta. opere Italis Intagli.
The story of the Passion of Our Lord Jesus Christ, carved in a panel of wood; Italian intaglio work.

[-646 Pictura ... viri Johis...]
Picture of ... John [].

646 Pictura Breviarij vel Missalis Romani, in tabula querceâ.
Picture of a breviary or Roman missal, in a panel of oak.

[36v]

***646b** Icuncula marmorea Brachmanni Indici. Ex dono D. Rogeri Borrough civis Londinensis.
Small marble figure of an Indian Brahmin, given by Roger Burrough, citizen of London.

[37r]

647 Deformatio Henrici 4[ti]. Galliæ et Navar. Regis, speculo chalybeo cylindraceo in formam redigenda.
Anamorphic picture of Henry IV, King of France and Navarre, restored to its true form with the aid of a cylindrical steel mirror.

648 Deformatio Ludovisi 13[mi]. Galliæ et Navar. Regis speculo item chalybeo cylindraceo in formâ redigenda.
Anamorphic picture of Louis XIII., King of France and Navarre, again restored to its true form with a cylindrical steel mirror.

649 Deformatio Capitis (nescio cujus) humani, simili speculo in formam redigenda.
Anamorphic picture of a human head (I know not whose), corrected with a similar type of mirror.

650 Deformatio Calvariæ humanæ, eodem modo in formâ redigenda.
Anamorphic picture of a human skull, corrected in the same way.

651 Deformatio Bubonis, item eodem modo in formâ redigenda.
Anamorphic picture of an owl, also corrected in the same way.

652 Deformatio Asini ita etiam in formam redigenda.
Anamorphic picture of an ass, again corrected in the same way.

653 Deformatio Rustici Batavi, ad Amasiam suam citharizantis, simili speculo in formam redigenda.
Anamorphic picture of a Dutch peasant, playing on his lyre to his lover, corrected with a similar type of mirror.

654 Deformatio Angeli, Adamum et Evam gladio flammeo e Paradiso fugantis.
Anamorphic picture of an angel driving Adam and Eve from Paradise with a flaming sword.

[-655]Pictura doctissimi viri Johannis Seldeni, margine deauratâ munita. \\in Bibliotheca Ashm. sub. num.

[155] [f.35v] d
[156] [f.35v] d
[157] d f [f.35v] *Tabula plastica in qua exhibetur Jovis Historia in Creta Insula enutriti. Ex dono Cl Viri ... Harries Wigorn. arm. v. Montfaucon Antiquité expliquée Tom. 1. p: 33.
Moulded panel with the story of the early childhood of Jupiter on the Island of Crete. Given by the celebrated Harry Wighorn, Esq. See Montfaucon, *L'Antiquité expliquée*, vol. 1, p. 33.

æ Statua concata &c propè Iscam Legionis (Cær Lheion a Wysc) effossa. Hanc Statuam [-cujus si...] (de qua consule Camdeni Britanniam p. 607. & 697.) dedit D.[nus] Matthias Bird, navarchus Kærleionensis in agro monemuthensi.
Statue of an armed man excavated near Isca Legionis (Cærleon on Usk). This statue (for which see Camden's *Britannia* pp. 607 & 696) was given by Matthew Bird, a ship's captain of Cærleon in the county of Monmouthshire.

[158] [f.35v] Antiquitatum
[159] [f.35v] Jahakobi
644. Pictura Tigri discupro delineata.
Picture of a tiger, engraved on copper.

9.//[160]
Portrait of the most learned John Selden, in a gilt frame; in the Ashmolean Library, under the number 9.
MacGregor 1983, no. 256.

656 Pictura excellentissimæ Heroinæ Dñæ Molineaux, cathedrâ sedentis, sine margine.
Portrait of the most excellent lady, Mrs Molyneaux seated on a chair, unframed.
MacGregor 1983, no. 257.

657 Pictura M.[ri] le Neve, Pictoris celeberrimi.
Portrait of the famous painter, Master Le Neve.
MacGregor 1983, no. 258.

658 Pictura Dñi Oliverij de Cretz Pictoris item celeberrimi.
Portrait of Mr Oliver de Critz, also a renowned painter.
MacGregor 1983, no. 259.

659 Pictura Dñi Johis Tradescanti Senioris Cimeliarchæ egregij, in margine bullis aureis ornatâ.
Portrait of John Tradescant the Elder, the renowned collector, ornamented at the borders with golden bosses
MacGregor 1983, no. 260.

660 Pictura Cl. viri ...
Portrait of an illustrious man ...

661 Pictura Ornatissimi Viri ...
Picture of a most handsome man ...
MacGregor 1983, no. 284.

662 Pictura excellentissimæ Heroinæ ...
Portrait of a most estimable lady ...
MacGregor 1983, no. 261.

663 Picturæ Dñi Jōhis Tradescanti junioris et uxoris suæ, limbo aureo munitæ.
Picture of John Tradescant the Younger and his wife, in a gold frame.
MacGregor 1983, no. 262.

664 Le vray portrait du Siege de Pavie mist sur la fin d'Octobre en l'an 1524 par le Roy de Franse. Commen les Gens de L'Empereur deffirent les Francoys en pregnant le Roy le jour S. Matthias en l'an 1525.[161]
The true picture of the siege of Pavia, at the end of October 1524, under the King of France. And how the Emperor's people defeated the French by taking their King prisoner, on St. Matthew's Day, 1525
MacGregor 1983, no. 263.

[37v]

665b Pictura Bubali tum marij tum fæminæ ex dono Cl. Viri Wilhelmi Henrici Ludolphi.
Picture of oxen, male and female, given by the celebrated William Henry Ludolph.

[Nos. 665-712 are now missing from the catalogue, but see references to them in the Pars Secunda (pp. 59-65)].

[38r]

713 Pictura Classis navium velis expansis.
Picture of a fleet of ships with sails unfurled.

714 Pictura Excambij Londinensis ut floruit ante conflagrationem urbis, A°. 1666.
Picture of the Exchange in London in its prime, before the Great Fire of the city in 1666.

715 Pictura Mensæ dapibus stratæ.
Picture of a table laid for a banquet.

716 Pictura Vasculi floribus repleti.
Picture of a little vase full of flowers.

717 Idem, Iterum.
Another of the same.

718 Pictura fæminæ (ut opinor) in furorem adactæ.
Picture of a woman, so it seems, in a rage.

[-719 Insignia familiæ de ...]
Arms of the family of [].

720 Pictura Aleatoris, Limbo aureo munita.
Picture of a dice-player, in a gold frame.

721 Pictura ebrij cujusdam.
Picture of a drunk.

722 Pictura hominis Catum sinu gestantis.
Picture of a man, with a cat in his lap.

723 Insignia Johannis Tradescanti, cum margine bullis aureis insignitâ.
Arms of John Tradescant, decorated at the borders with golden bosses.
MacGregor 1983, no. 296.

724 Insignia illustrissimi Georgij Buckinghamiæ Ducis etc.
Arms of the most illustrious George, Duke of Buckingham.

725 Fastigium seu Crista ejusdem Ducis.
Device or crest of the same Duke.

726 Charta Chorographica antiqua Academiæ et Civitatis Oxoniensis.
Ancient map of the university and city of Oxford.

727 Charta Chorographica antiqua Academiæ et Oppidi Cantabrigiensis.
Ancient map of the university and town of Cambridge.

728 /d\ Africæ periplus, per Navigatores Portugallos.
Circumnavigation of Africa, by Portuguese navigators.

729 Pictura Papilionis elegantissimi, (Pavonis oculus) dicti, et Scarabæi elephantini sive Tauri volantis maximi anthrachini, aliorumque Insectorū.
Picture showing a most elegant butterfly, called *Peacock's Eye*, together with an elephant beetle or very large black flying beetle, and other insects.

730 Pictura venustissima Ornatissimi viri Dñi Eliæ Ashmole hujus Musæi instructoris munificentissimi, Limbo e Tiliâ arte prorsus Thaumaturgicâ cælato, adornata.[162]
A most beautiful picture of that great man, Elias Ashmole, munificent founder of this Museum; adorned with a frame of limewood, carved with consummate skill.
MacGregor 1983, no. 281.

731 Effigies Serenissimi Principis Caroli 2[di] Regis Angl. etc. Limbo e Tilia elegantissime cælato; ac deaurato, adornata.
Representation of Charles II, King of England etc., with a frame of limewood, most elegantly carved and gilded.
MacGregor 1983, no. 282.

732 Effigies Serenissimi Principis Jacobi 2.[di] Regis Ang. etc. simili Limbo adornata.

[160] **[f.36v]** 19......
[161] **[f.36v]** 664b Le Canal royal de Langudoc &c.
The royal canal of Languedoc.

[162] **[f.37v]** ^ Jahakobi

Representation of James II, King of England etc., decorated with a similar frame.
MacGregor 1983, no. 283.

[39r]

Ex dono Cl. Viri Johis Aubrey de Easton Piers in Com. Wilton Armigeri.
Given by the noble John Aubrey Esquire, of Easton Piercy in Wiltshire.

733 \\‡// [-Effigies Reverendissimi in Christo Patris Dñi Richi Bancroft Archi-Epi Cant. p Hilyardū coloribus dilutis depicta, pixide eburneâ inclusa, et selenite obducta.
Picture of the Very Revd Richard Bancroft, Archbishop of Canterbury, by Hilliard; painted in watercolours, enclosed in an ivory box and covered with crystalline gypsum.

734 \\‡// Effigies ipsius D. Johis Aubrey de Easton-Piers in Com Wilton Armigeri p Cowperū coloribus dilutis depicta, et margine ex Ebeno munita, Selenite item obducta.]
Picture of John Aubrey Esq. of Easton Piercy in Wiltshire, painted by Cowper in watercolours, with an ebony frame worked in crystalline gypsum.

[-735] \\[-d]// Effigies Olivarij (Angliæ etc. Protectoris nomine) Usurpatorum pessimi. \\num. 6.to in Bibliotheca Ashmoleanâ.//
Picture of Oliver, Protector of England etc., that worst of usurpers. No. 6 in the Ashmolean Library.

[-736] Effigies Judith, uxoris Guilielmi Dobson Pictoris regij scil. Car. 1. num 8.° in Bibl Ashm [-]
Picturet of Judith, wife of William Dobson, royal painter. No. 8 in the Ashmolean Library.

Picturæ á domino Ashmole huic museo legatæ quæ in Bibliotheca Ashm [-ashmoleanâ] asservantur.
Pictures bequeathed to this Museum by Mr Ashmole, which hang in the Ashmolean Library.

1 Erasmus Rot AV.)
Erasmus of Rotterdam, in gold.

2 Jacobus sextus Scotorum: ætate puerili.
James VI of Scotland as a boy.

3 Carolus I.
Charles I.
MacGregor 1983, no. 287.

4 Reverendus Vir. d ... SS. Th. D.
The Revd [], Doctor of Theology
MacGregor 1983, no. 288.

5 Joannes Lewen celebris comædus tempore Caroli I.mi.
John Lowin, the famous actor of the time of Charles I.
MacGregor 1983, no. 289.

6 Olivarius Cromewellus superiùs dictus. AV \\'Tis remov'd to ye stairs.//
Oliver Cromwell, referred to above, in gold. It is removed to the stairs.

7 Michæl Burck Eques Eleemosynarius Vindlesoriensis.
Michael Burck [Nicholas Burgh], pensioner of Windsor
MacGregor 1983, no. 290.

8 Uxor Guilielmi Dobson suprà memorata.
The wife of William Dobson, referred to above.

9 Clariss Seldenus jam anteà dicta.
The celebrated Selden, referred to earlier.

10 Joannes Dee SS. Th. P.
John Dee, Professor of Sacred Theology
MacGregor 1983, no. 291.

11 Richardus Napeyr Medicus et Astrologus percelebris.
Richard Napier, the most celebrated physician and astrologer.
MacGregor 1983, no. 292.

12 Gulielmus Lilly insignis astrologus.
William Lilly, the distinguished astrologer.
MacGregor 1983, no. 293.

[40r]

13 \\[-d]// Venus et Cupido.
Venus and Cupid.

14 Effigies Dñi Joannis Aubrey de Easton Pierce in agro Wiltoniensi, armigeri.
Picture of Mr John Aubrey Esq., of Easton Piercy in Wiltshire.

[41r blank]

[42r]

PARS SECUNDA

1 Pictura B. Mariæ Virginis filium in sinu gestantis, in Cupro delineata - 617.[163]
Image of the Blessed Virgin Mary holding her son in her lap, engraved in copper - 617.

2 Magi Christum adorantes, et Aurum, Thus et Myrrham offerentes, Alabastro cælati, opere elato, margine deauratâ muniti, fract: An: 1700 - 618.
Adoration of Christ by the Magi, who offer him gold, frankincense and myrrh; carved in alabaster in high-relief in alabaster, in a gilt frame. Broken in 1700 - 618.

3 Angeli Christo ministrantes in præsepi, item Alabastro sculpti, et Margine deauratâ inclusi. - 619.
Angels attending Christ in the stable; also engraved in alabaster, in a gilt frame. - 619.

4 Christi octavo die circumcisio a Sacerdote, Alabastro incisa, et Simili margine munita fract: An: 1700 - 620. \\hujus vicem jam supplet pictura M. Hier: Vide.//[164]
The Circumcision of Christ on the eighth day by a priest, incised in alabaster, with a similar frame; broken in 1700 - 620. There is now a picture of Marco Girolamo Vida in its place.

5 Pictura Quercûs ingentis Selenite obductæ - 621.
Picture of a giant oak-tree carved in crystalline gypsum - 621.

6a Pictura capitis admodum deformis sine margine - 622.[165]
Picture of a head, much deformed, without a frame - 622.

7 Pictura S:ti Francisci, Arte cereoplasticâ, in Sublitione è Lapide Scissili, fract. 1706 623.[166]
Picture of St. Francis, in wax, on a base of laminar stone. Broken in 1706 - 623.

[43r]

[163][f.41v] vel potius Effigies et sic de cæteris.
Or rather a representation, and so also with the others.
[164][f.41v] Fract. Marcus Hieronimus Vida Cremonen. Albæ Episcopus.
Marco Girolamo Vida of Cremona, Bishop of Alba.
[165][f.41v] 6b. Duo Scripta, nomen viri cujusdam John &c: præ se ferentia, quorum unum imitatio est, /usque\ ad amussim, alterius; & utrumque ebeno /et vitro\ munitum. \\per Thomam Gray.//
Two manuscripts, with the name of some man John etc at their heads, of which one is an exact copy of the other, and both framed in ebony and glass. By Thomas Gray.
[166][f.41v] fundamenti

8 Pictura B. Mariæ Virginis precantis coram imagine Christi in cruce pendentis - 624.

Picture of the Blessed Virgin Mary, praying before an image of Christ hanging on the Cross - 624.

9 Imago Christi in loco Gethsemane dicto precantis, Discipulis interim dormientibus, Alabastro cælata, margine deauratâ munita - 625.

Representation of Christ praying in the place called Gethsemane, while his disciples sleep; carved in alabaster, in a gilt frame - 625
MacGregor 1983, no. 219.

10 Imago Christi ad columnam virgis cæsi Alabastro Sculpta, opere elato, margine deauratâ item inclusa - 626.

Representation of Christ bound to a column and scourged with rods; carved in alabaster, in high-relief, also in a gilt frame - 626
MacGregor 1983, no. 220.

11 Imago Josephi Arimathæensis, et Nicodemi Christum in Sepulchro novo Sepelientium, alabastro cælata, opere levato, et Simili margine munita - 627.

Representation of Joseph of Arimathea and Nicodemus burying Christ in a new tomb; carved in alabaster in high-relief, in a similar frame - 627
MacGregor 1983, no. 221.

12 Pictura duorum Rusticorum, et prospectûs amæni ruralis, Selenite obducta, et margine ex Ebeno inclusa - 628.

Picture of two peasants and a pleasant rural landscape, carved in crystalline gypsum and kept in an ebony frame - 628.

13 Pictura principis Aransiensis quibusdam psalmorum Versiculis adumbrata, Selenite obducta, et margine ex Ebeno munita - 629.

Figure of the Prince of Orange, with certain lines from the Psalms, in crystalline gypsum with an ebony frame - 629.

14 Pictura Caroli primi Mag. Brit: &c: Regis margine ex Ebeno conservata. 630.[167]

Portrait of Charles I, King of Great Britain etc., kept in an ebony frame - 630.

15 Pictura Serenis: Henriettæ Mariæ Anglo: Reginæ, coloribus dilutis - 631[168]

Portrait of Henrietta Maria, Queen of England, in watercolours - 631.

[44r]

16 Figura Persei Pegasum inequitantis, Andromedam a Dracone liberantis, Ebore cælata - 632.[169]

Figure of Perseus riding on Pegasus, and freeing Andromeda from the dragon. Carved in ivory - 632.

17 Imago Henrici Magni Galliæ et Navar: Regis, opere in cornu Anaglyptico - 633.

Representation of Henry the Great, King of France and Navarre, engraved in low-relief in horn - 633

18 Pictura Johis Tredescanti Senioris, margine ex Ebeno [-munita\ornata] - 634.

Picture of John Tradescant the Elder, ornamented with an ebony frame - 634
MacGregor 1983, no. 253.

19 Pictura prospectûs elegantissimi margine ex Ebeno insignita - 635.

Picture of a most beautiful landscape, in an ebony frame - 635.

20 Pictura S.ti Hieronymi coloribus dilutis - 636.

Picture of St. Jerome in watercolours - 636.

21 Pictura Desid: Erasmi Roterodami - 637.

Portrait of Desiderius Erasmus of Rotterdam - 637
MacGregor 1983, no. 255.

22. Figura Navis velis expansis, opere in cornu Anaglyptico - 638.[170]

Picture of a ship with sails unfurled, engraved in horn in low-relief - 638.

23 Effigies S.ti Francisci Christum in cruce pendentem adorantis, opere cereoplastico - 639[171]

Effigy of St. Francis, in wax, worshipping Christ hanging on the Cross - 639.

24 Effigies Sti: Hieronymi seriò meditantis, eodem opere - 640. fract. 1700.[172]

Similar effigy of St. Jerome deep in thought, in wax. Broken in 1700 - 640.

25 Effigies dextræ ... Dnæ Claypoole Oliverij Angl: protectoris filiæ dilectæ, item eodem opere - 641.

[170][f.43v] **22a** Sententiæ ex Epicteto & Senecâ nitidissimé scriptæ manu I. Thomasen. Cestr: 1728. N.B. Eximius Artifex Artem Typographicam /in\ hoc M.S.S. imitatus est.

Thoughts from the work of Epictetus and Seneca, most elegantly copied by I. Thomasen of Chester, in 1728. NB. This master craftsman, in this manuscript, made his handwriting look like print.

22b Oratio Dominica /verbatim\ symbolum, & Decalog: abbreviat: &c, &c. Exiguo admodum spatio conscripta.

The Lord's Prayer, Sign and the Ten Commandments etc. etc., written in a very small space.

22c Insignia Regum Anglorum nitidissime e ligno ex sculpta. a tergo hæc habes: carved by Rich.d Chicheley at Chatham, where he is Master Carver and given to George Clarke Esq, and by Him to the University of Oxford, for the use of the Musæum. 1736.

Arms of the Kings of England very finely engraved in wood. On the back is the following. Carved by Richard Chicheley at Chatham, where he is Master Carver and given to George Clarke Esq., and by him to the University of Oxford for the use of the Museum. 1736.

22d Tres picturæ in eadem Margine contentæ; ita inter se involutæ, ut una vice unam tantum faciem adspicias: dum in fronte scil: geras, Carolas. 1. Rex sese exhibet, si paulum ad latus hoc inclines Archepiscop: Laud, si ad illud, Comes de Strafford.

Three pictures within the same frame, set up in such a way that you only see a single face at any one time. Charles I, as an old man, appears on the front, but if you turn it a little to one side, you see Archbishop Laud, while if you turn it to the other, you see the Earl of Strafford.

[-**22e** Icuncula ex variis feminibus &c confecta].
Small statue with various women etc., made of [].
[f.44v]
22e Pictura ex Numasmate in Scrinio D: Ashmole N°.7 Loc 1.
Picture from a coin in Mr Ashmole's cabinet no.7, drawer 1.
22f Rev:
The reverse of the same.
22g Pictura ex Lamina in Scrinio eodem Loc 2: No. 43.
Picture panel in the same cabinet, drawer 2, No. 43.
22h Rev:
The reverse of the same.

[167][f.42v] **14b**. Pictura Annæ DG ex Lamina Argentea in Scrinio Dni Ashmole no. 6 Loc: Imo

Picture of Queen Anne, engraved on a silver plate in Mr Ashmole's cabinet, no.6 in the first drawer.

14c. ex Eadem in Rev:
The reverse of the same.
[168]
[169][f.43v] fract:

[171]d
[172]f

fract.[173]

Figure of the right ... of Mrs Claypole, the beloved daughter of Oliver [Cromwell], Protector of England, also in wax - 641. Broken.

26 Effigies Castri Windlesoriensis opere Stramineo - 642.

Model of Windsor Castle, in straw - 642.

27 Tabula plastica, in quâ exhibetur Jovis Historia in Cretâ Insula enutriti. Ex dono Cl. Viri. . . .Harries Wigorn: Arm.[ri] * in fenestra Theatrum spectante.//[174]

Moulded panel showing the story of the early childhood of Jupiter on the island of Crete. Given by the celebrated Harry Wighorn, Esq. In the window facing the [Sheldonian] Theatre.,

[45r]

28 Statua loricata &c. prope Iscam Legionis (Cær Lheion an Wysc) effossa. Hanc Statuam (de quá consule Camdeni Britanniani p.607 & 697.) dedit D.[ns] Matthias Bird Navarchus Kaerleiunensis in Agro Monemuthensi- æ \\In eadem fenestrâ.//

Statue in chain mail, excavated near Isca Legionis (Cærleon on Usk). This statue, for which see Camden's *Britannia*, pp. 607 and 697, was given by Matthew Bird, ship's captain of Cærleon in the county of Monmouthshire. In the same window.

29 Tabula rerum vel Antiquitatum Runicarum Sculpturâ exhibitarum - 643. \\ibid. ut puto//

List of objects or antiquities, carved in runes - 643. In the same place, I believe.

30 Pictura D.[ni] Hadriani Beverlandij, quam ipse huic Museo donavit An. 1692. 643b.

Picture of Hadrian Beverland, which he himself gave to this Museum in 1692 - 643b.

31 Fons (ut puto) Jacobi ligno cælatus, opere elato, - 644.

Jacob's well, I believe, carved in wood in high-relief - 644. MacGregor 1983, no. 225.

32 Historia passionis Dñi nri Jesu Christi tabulâ ligneâ insculpta, opere Italis Intagli - 645.

The story of the Passion of our Lord, engraved on a wooden panel; in Italian intaglio work - 645.

33 Pictura Breviarij, vel Missalis Romani in tabulâ Querceâ - 646.

Picture of a breviary or Roman missal on an oak panel - 646.

34 Pictura Tigridis in Cupro delineata.[175]

Picture of a tiger engraved in copper.

35 Icuncula marmorea Brachmanni Indici ex dono Dñi Rogeri Burrough Civis Londinensis - 646.b. \\in fenestra Theatrum spectante.//

Small marble image of an Indian Brahmin, given by Mr Roger Burroughs, citizen of London - 646b. In the window facing the [Sheldonian] Theatre.

36 Deformatio Henrici 4.[ti] Galliæ et Navar. Regis Speculo chalybeo cylindraceo in formam redigenda - 647.

Anamorphic picture of Henry IV, King of France and Navarre, restored to its true form with the aid of a cylindrical steel mirror - 647.

[46r]

37 Deformatio Ludovici 13.[mi] Galliæ et Navar. Regis Speculo item chalybeo cylindraceo in formam redigenda - 648.

Anamorphic picture of Louis XIII, King of France and Navarre, again restored to its true form with a cylindrical steel mirror - 648.

38 Deformatio capitis (nescio cujus) humani, Simili Speculo in formam redigenda - 649.

Anamorphic picture of a human head (I know not whose), corrected with a similar mirror - 649.

39 Deformatio Calvariæ humanæ eodem modo in formam redigenda - 650.

Anamorphic picture of a human skull, corrected in the same way - 650.

40 Deformatio Bubonis, item eodem modo in formam redigenda - 651.

Anamorphic picture of an owl, also corrected in the same way - 651.

41 Deformatio Asini, ita etiam in formam redigenda. 652.

Anamorphic picture of an ass, again corrected in the same way - 652.

42 Deformatio Rustici Batavi ad Amasiam Suam citharizantis Simili Speculo in formam redigenda - 653.

Anamorphic picture of a Dutch peasant, playing on his lyre to his lover, corrected with a similar mirror - 653.

43 Deformatio Angeli Adamum et Evam gladio flãmeo è paradiso fugantis - 654.

Anamorphic picture of an angel, driving Adam and Eve from Paradise with a flaming sword - 654.

44 Effigies Serenissimi principis Caroli 2.[di] Regis Anglo: &c. Limbo è Tilia elegantissimè cælato, ac deaurato, adornata. 731.

Portrait of Charles II, King of England etc., adorned with a limewood frame, most elegantly carved and gilded - 731 MacGregor 1983, no. 282.

45 Effigies Serenissimi principis Jacabi [*sic*] 2.[di] Regis Angl. &c. Simili Limbo adornata - 732.

Picture of James II, King of England, adorned with a similar frame - 732 MacGregor 1983, no. 283.

46 Pictura venustissima Ornatissimi Viri D[ni] Eliæ Ashmole hujus Musei Instructoris munificentissimi, Limbo è Tiliâ arte prorsus Thaumaturgicâ cælato,

[173] f
[174] **[f.43v]** Vide Montfaucon: Antiquité Expliquée. Tom: 1 Lib: 2. Pag: 32.
See Montfaucon, *L'Antiquité expliquée*, vol. 1 book 2, page 32.
[175] **[f.44v]** 34c Lignum arte tinctum.&c. DD: Dn.[m] Seymour.
Artificially dyed wood etc., given by Mr Seymour.

34a Cadaver Balsamo conditum; simul cum loculo ferali ανθρωποειδη Pictura hieroglyphica pulcherrime insignito. ex vetustis Ægypti Sepulchretis sublatum Londinum attulit D. Guil. Lethieullier A.° D.[i] 1722. hæc pictura exhibet 1. Cadaver loculo inclusum. 2.Loculi conspectum anteriorem. 4. Conspectum lateralem 5. Conspectum posteriorem

A body preserved in balsam, together with a funerary casket in the form of a man; and marked with picture hieroglyphics. It was taken from an ancient Egyptian tomb, and brought to London in 1722 by William Lethieullier. The picture shows: 1, the body in the casket; 2, a frontal view of the coffin; 4, a side view; 5, a rear view.

34b Precatio ad Deum O.M. ex 26 carminibus /Acrostichiis\ Anglicanis /constans,\ magna pulchritudine & artificio, muliebri manu (ut opinor) scripta.

Prayer to God, Optimus Maximus, composed of acrostics of twenty-six English hymns, written with great skill and elegance in, I believe, a female hand.

adornata. 730.
A most beautiful picture of that great man, Elias Ashmole, munificent Founder of this Museum, adorned with a limewood frame carved with marvellous skill - 730
MacGregor 1983, no. 281.

[47r]

47 Rev:^{dus} Vir D....S.S. Th: D. 4.[176]
The Revd [], Doctor of Theology - 4.

48 Jacobus 6.^{tus} Scotorum R. ætate puerili - 2.
James VI, King of Scotland, as a boy - 2.

49 Pictura Veneris procumbentis cum filio Cupidine ad geniculante - 696.
Picture of the reclining Venus, with Cupid, her son, kneeling beside her - 696.

50 Pictura excellentissimæ Heroinæ Dñæ Molineaux cathedrâ sedentis - 656.
Portrait of the most excellent lady, Mrs Molyneaux, seated on a chair - 656
MacGregor 1983, no. 257.

51 /x\ Picturæ Dñi Johannis Tredescanti junioris, et Uxoris Suæ, limbo aureo munitæ - 663.
Picture of John Tradescant the Younger and his wife, in gold frame - 663
MacGregor 1983, no. 262.

52 Pictura excellentissimæ Heroinæ - 662.
Picture of a most excellent lady - 662
MacGregor 1983, no. 261.

53 Pictura Ornatissimi Viri - 661.
Picture of a very handsome man - 661
MacGregor 1983, no. 284.

54 Pictura clarissimi Viri - 660.
Picture of a distinguished man - 660.

55 Richardus Napeyr Medicus et Astrologus percelebris - 11.
Richard Napier, the renowned doctor and astrologer - 11
MacGregor 1983, no. 292.

56 Venus et Cupido - 13.
Venus and Cupid - 13.

57 Pictura Cranij humani in libro jacentis 697.
Picture of a human skull lying on a book - 697.

58 Pictura percelebris poetæ Ben: Johnson.
Picture of the most celebrated poet Ben Jonson.

59 Repræsentatio Mensæ dapibus Stratæ - 688.
Picture of a table laid for a banquet - 688.

60 Picturæ Herculis et Atlantis Orbem alternatim Sustentantium - 679.
Pictures of Hercules and Atlas holding up the world by turns - 679.

61 Le vray portrait du Siege de Pavie mist sur la fin D'Octobre en l'an 1524 par le Roy de France. Commen les Gens de L'Empereur deffirent les Francoys en pregnant le roy le jour S: Matthias en l'an 1525 664-a.
The true picture of the Siege of Pavia, the end of October, 1524, under the King of France, and how the Emperor's people defeated the French by taking their King prisoner on St. Matthew's Day 1525 - 664a.

MacGregor 1983, no. 263.

[48r]

62 Le Canal Royal de Languedoc &c. 664.b.
The royal canal of Languedoc etc. - 664b.

63 Pictura Bubali tum Maris tum fæminæ, ex dono cl: Viri Wilhelmi Henrici Ludolphi. 665.b.
Picture of oxen, male and female, given by the celebrated Henry Ludolph - 665b.

64 Picturæ duorum Pullorum Vituli marini. 710.[177]
Pictures of two young seals - 710.

65 Pictura papilionis Elegantissimi (pavonis Oculus) dicti, et Scarabæi Elephantini, sive Tauri volantis maximi Anthacini, aliorumque Insectorum - 729.
Picture of a most elegant butterfly called *Peacock's eye*, and an elephant beetle or very large black flying beetle, and other insects - 729.

66 Effigies Dñi Joh: Aubrey de Easton-Pierce in agro Wiltoniensi, Armigeri. 14.
Picture of John Aubrey, Esq., of Easton Piercy in Wiltshire - 14.

67 Johannes Dee Anglus Londinensis - 10.
John Dee, Englishman from London - 10
MacGregor 1983, no. 291.

68 Guilielmus Lilly insignis Astrologus - 12.
William Lilly, the distinguished astrologer - 12
MacGregor 1983, no. -293.

69 Pictura Honoratiss: Dñi Edwardi Baronis Wotton de Marley - 672.
Picture of the most honourable Edward, Baron Wotton of Marley - 672
MacGregor 1983, no. 270.

70 Pictura Dñæ Esthreæ Baronissæ Wotton uxoris suæ - 673.
Picture of his wife, Esther, Baroness Wotton - 673.

71 /x\ Pictura Joh: Tredescanti junioris Cimeliarchæ celeberrimi, Botanici habitu - 68[-5\4?].
Picture of John Tradescant the Younger, the great collector, dressed as a gardener - 685
MacGregor 1983, no. 274.

72 Pictura celeberrimi Senis Tho: Parr Salopiensis, qui annos centum quinquaginta unum complevit. 685.
Picture of the celebrated old man, Thomas Parr of Shropshire, who lived to be 151 years old - 685
MacGregor 1983, no. 275.

73 /x\ Pictura Mag.^{ri} Le Neve Pictoris celeberrimi - 657.
Picture of the famous painter, Master Le Neve - 657
MacGregor 1983, no. 258.

74 /x\ Pictura Dñi Joh: Tredescanti Senioris Cimiliarchæ egregij, in margine bullis aureis ornatâ. 659.
Picture of John Tradescant the Elder, the great collector, ornamented with golden bosses along the borders -659

[176][f.46v] 47.b Pictura cl: viri Roberti Plott. M:D. primi hujusce Musei Custodis.
Picture of the illustrious Robert Plot, Doctor of Medicine, the first keeper of this Museum.

[177][f.47v] 64b. Pictura Annæ Reginæ, Cui ad dextram Insignia Regis ad Sinistram excelsa Quercus cum hac inscriptione AGROS VBI NASCITVR ORNAT SERVATQVE.
Picture of Queen Anne, holding in right hand the insignia of state, and in her left a tall oak tree with the inscription `She serves and honours her birthplace'.

64c. Ecclesiæ S.^{ti} Patri & S.^{ti} Pauli in oppido Buckinghamiæ a parte Boreali Prospectus. \\- Vermiculis valde exesus. 1745//
The churches of St. Peter and St. Paul in the town of Buckingham, viewed from the north. 1745 - eaten by worms.

MacGregor 1983, no. 260.

[49r]

75 Pictura (ut dicitur) Inegonis Jones Architecti celeberrimi. 665.
Picture said to be of Inigo Jones, the most celebrated architect - 665
MacGregor 1983, no. 264.

76 Pictura eminentissimi Cardinalis Ricolocensis 705.
Picture of the most eminent, Cardinal Richelieu - 705.

77 Pictura Eversionis omne genus Artium - 678.
Picture of the overturning of all the arts - 678.

78 Pictura honoratissimi Dñi: Thomæ Comitis Essexiæ, Baronis Cromwell de Okeham, Vicarij generalis - 674.
Portrait of the most honourable Thomas, Earl of Essex, Baron Cromwell of Okeham and Vicar-General - 674.

79 Pictura B. Mariæ Magdalenæ Alabastrum nardi liquidæ manu tenentis. 687.
Picture of the Blessed Mary Magdalen, holding in her hand an alabaster vessel of liquid nard - 687.

80 Pictura Jacobi Somniantis cum Angelis Scalas cælestes ascendentibus, et descendentibus. 683.
Picture showing Jacob's Dream, with angels ascending and descending the heavenly stairs - 683.

81 Michæl Burck Eques Eleemosynarius Windlesoriensis - 7.
Michael Burck [Nicholas Burgh], knight, and pensioner of Windsor - 7
MacGregor 1983, no. 290.

82 Joh: Lewen celebris comædus tempore Car. I.^{mi} 5.
John Lowin, celebrated actor of the time of Charles I - 5
MacGregor 1983, no. 289.

83 Uxor Guilielmi Dobson pictoris celeberrimi - 8.
The wife of the famous painter William Dobson - 8.

84 Pictura mensæ varijs conchylijs stratæ.
Picture of a table laid with various shellfish.

85 /x\ Pictura Dñi Oliverij de Cretz pictoris celeberrimi - 658.
Portrait of the celebrated painter Oliver de Critz - 658
MacGregor 1983, no. 259.

86 /x\ Pictura Dñi Joh: Suckleing Militis 676.
Portrait of John Suckling, knight - 676
MacGregor 1983, no. 271.

87 Pict[ura] ut dicitur Edwardi 5.^{ti} Regis Angl &c.
Picture said to be of Edward V, King of England etc.

88 P... \\682.// Peregrini cujusdam Nobilis; ut opinor
A noble stranger, I think.

[50r]

89 Repræsentatio mensæ varijs fructuum speciebus stratæ. 700.
Representation of a table set with various kinds of fruit - 700.

90 Pictura Dñæ Elizabethæ Woodvile, Reginæ Angl. conjugis Edwardi 4.^{ti} Regis Angl. &c 680.
Picture of Elizabeth Woodville, Queen of England and consort of Edward IV, King of England - 680
MacGregor 1983, no. 273.

91 /x\ Pictura Joh: Tredescanti junioris cum amico Suo Friend Zythepsâ Lambethano. 667.
Picture of John Tradescant the Younger with his friend, the brewer of Lambeth - 667

MacGregor 1983, no. 265.

92 /x\ Pictura Uxoris Joh. Tredescanti cum filio filiaque astantibus - 671.
Picture of the wife of John Tradescant, with her son and daughter standing by - 671
MacGregor 1983, no. 269.

93 /x\ Pictura honoratissimi Dñi D. Thomæ Arundelliæ Comitis, Marmorum Arundellianorum procuratoris Solertissimi - 668.
Picture of the most noble Thomas, Earl of Arundel, most astute collector of the Arundel marbles - 688
MacGregor 1983, no. 266.

94 /x\ Pictura illustrissimi principis Thomæ Ducis Norfolciensis filij Sui natu Maximi. 669.
Picture of the illustrious Thomas, Duke of Norfolk, with his eldest son - 669
MacGregor 1983, no. 267.

95 Pictura Caroli primi Mag. Brit: Fran: et Hib: Regis. 670.
Picture of Charles I, King of Great Britain, France and Ireland - 670
MacGregor 1983, no. 268.

96 Pictura cl. Viri Mancunij Comitatis Cantab: Cancellarij - 677.
Picture of the celebrated Duke of Manchester, Chancellor of [the University of] Cambridge - 677
MacGregor 1983, no. 272.

97 Pictura (ut dicitur) Oliverij Cromwell Angl. protectoris - 675.
Picture said to be of Oliver Cromwell, Protector of England - 675.

98 Pictura cl: V. Joh: Seldeni. 9.
Picture of the celebrated John Selden - 9
MacGregor 1983, no. 256.

99 Pictura cl: v.....686.
Picture of a celebrated man 686.

100 Pictura mensæ dapibus stratæ. 615.
Picture of a table laid for a banquet - 615.

[51r]

101 Pictura Joh: Galliarum Regis in prælio pictavensi ab Anglis capti. * a.
Picture of John, King of France, captured by the English at the Battle of Poitou.

102 Pictura Ludovici Undecimi Galliæ item Regis. * b.
Portrait of Louis XI, King of France.

103 Pictura fæminæ /(ut opinor)\ in furorem [-] adactæ. 718.
Picture of a woman, so it seems, in a rage - 718.

104 Tabula Geographica Terrarum orbis per Joh: Senex
Map of the world by John Senex.

105 Pictura repræsentans Conventiculum Dæmonum, Veneficorum, Sagarumque, per Brugelium - 689.
Painting representing the assembly of demons, sorcerers and soothsayers, by Brueghel - 689.

106 Theatrum Historicum Imperij Romani.
Historical theatre of Imperial Rome.

107 Repræsentatio Descensûs Christi in Gehennam, per Brugle - 694.
Representation of the descent of Christ into Hell, by Brueghel - 694

108 Zodiacus Stellatus p. Joh: Senex.
Stars of the Zodiac by John Senex.

109 Pictura Persei Pegasum inequitantis, et Andromedam à Dracone liberantis - 693.
Picture of Perseus riding Pegasus, and freeing Andromeda from the dragon - 693.

110 Joh: Tradescanti Epitaphium, literis eleganter ligatis, lineisque undantibus, adornatum. - 695.
Epitaph of John Tradescant, adorned with elegantly joined letters and wavy lines - 695.

111 [-Joh] Pictura Joh: Tradescanti Senioris nuper admodum [-defuncti] mortui. 692.
Picture of John Tradescant the Elder, soon after his death - 692.
MacGregor 1983, no. 276.

112 Pictura S.ti Hieronymi meditantis. 711.
Picture of St. Jerome in meditation - 711.

113 Pictura Americani Boreazephyri in navigio istis partibus. 712.
Picture of an American from the North-West in a boat from those parts - 712.

114 Pictura Capitis ignoti - 701.
Picture of an unknown head - 701.

115 Pictura Vasculi floribus repleti. - 716.
Picture of a little vase full of flowers - 716.

116 Pictura Capitis Hispanioli Agrarij - 699.
Picture of the head of a Spanish peasant - 699.

[52r]

117 Pictura Diaboli miserè Verberibus accepti. 690
Picture of a devil miserably receiving lashes.

118 Pictura cl .V ... 691.b.
Picture of the celebrated []. - 691b.

119 Pictura cl. V ... 690.
Picture of the celebrated []. 690.

120 Pictura Ornatissimæ fæminæ.. 691.
Picture of a very beautiful woman - 691
MacGregor 1983, no. 285.

121 Pictura Vasculi floribus repleti. 717.
Picture of a little vase full of flowers - 717.

122 Musei Ashmoleani prospectus Orientalis. 701.b.
Ashmolean Museum viewed from the East - 701b.
MacGregor 1983, pl. clxxvii.

123 Pictura Excambij Londinensis, ut floruit ante conflagrationem Urbis An. 1666. 714.
Picture of the Exchange in London in its prime, before the Great Fire of the city in 1666 - 714.

124 Pictura Conjugis Joh: Tradescanti cum filiolo suo. 707.
Portrait of the wife of John Tradescant, with her little son - 707
MacGregor 1983, no. 280.

125 Pictura illustrissimi Henrici Ducis Glocestrensis Car. Imi filij natu m[-ax\in]imi. 706.
Portrait of the most illustrious Henry, Duke of Gloucester, the youngest son of Charles I - 706

126 Pictura Caroli I.mi Anglo: Regis &c. 3.
Portrait of Charles I, King of England - 3
MacGregor 1983, no. 287.

127 Pictura ornatissimi Juvenis. 703.
Picture of a very handsome youth - 703
MacGregor 1983, no. 277.

128 Pictura puellæ formosissimæ. 704.
Picture of a very beautiful girl - 704.
MacGregor 1983, no. 278.

129 Pictura Ebrij cujusdam. 721.
Picture of a drunk - 721.

130 Pictura Aleatoris, limbo aureo munita. 720.
Picture of a dice-player, in a gold frame - 720.

131 Pictura hominis catum in Sinu gestantis 722.
Picture of a man holding a cat on his lap - 722.

132 Castium Pontefracti in agro Eborac:
Pontefract Castle in Yorkshire.

133 Repræsentatio Volucrum peni, cum Cato unam è maximis occupante - 709
Picture of a collection of game birds with a cat taking one of the largest.

134 Pictura Classis navium velis expansis - 713.
Picture of a fleet of ships with their sails unfurled - 713.

[53r]

135 Pictura Hen. 4.ti Galliarum Regis. -
Picture of Henry IV, King of France.

136 Insignia Joh: Tradescanti, cum margine bullis aureis insignitâ - 723.
Arms of John Tradescant in a frame ornamented with golden bosses - 723
MacGregor 1983, no. 296.

137 Pictura Classis Hispanicæ Portum Cartagena appellentis. 708.
Picture of the Spanish fleet approaching the port of Carthage - 708.

138 Pictura Erasmi Roterod: - 1.
Picture of Erasmus of Rotterdam - 1.

139 Ectypum parmulæ Woodwardianæ.- [178]
Facsimile of the Woodward shield.

140 Pictura Joh: Radcliffe M.D.
Picture of John Radcliffe, Doctor of Medicine.

141 Elias Ashmole.
Elias Ashmole.

142 Tabula Geographica per Nic. Witsen
Map by Nicolæs Witsen.

143 Insignia illustrissimi Georgij Buckinghamiæ Ducis &c. 724. [179]
Arms of the most illustrious George, Duke of Buckingham - 724.

144 Fastigium, seu Crista ejusdem Ducis. 725. [180]
Device or crest of the same Duke - 725.

145 Africæ Periplus per navigatores Portugallos. 728.
Circumnavigation of Africa, by Portuguese navigators - 728.

146 Charta Chorographica antiqua Academiæ et Civitatis Oxoniensis. 726.
Ancient map of the university and city of Oxford - 726.

[178] [f.52v] 139 B. Id: in opere Plastico - forma rotunda - ebeno munitum in musæo. Ex dono ipsius Woodwardi, ut opinor ex lacerâ Epistolâ (in quam forte fortuna incidi) Woodwardi ad Joh: Whiteside Musei olim Cimeliarchæ; in quâ Votivi sui Clypei hujusmodi Ectypum se brevi huc missurum inquit.
Moulded, rounded in form and mounted in ebony in the Museum. Given by Woodward himself, as I understand from a torn letter (which I discovered by chance) from Woodward to John Whiteside, a former keeper of the Museum, in which he says that he is about to send him the promised cast of the shield.

[179] [f.52v] Lacera & seposita
Torn and removed elsewhere.

[180] [f.52v] Lacerum etiam & sepositum.
This is torn and has been removed elsewhere.

147 Charta Chorographica antiqua Academiæ et Oppidi Cantabrigiensis. 727.[181] *(bracketed with 148-9)*
Ancient map of the university and town of Cambridge - 727.

148 Plani sphærium Boreale Stellarium p Lamb.
Globe of the stars of the Northern sky, by Lamb.

149 Plani sphærium Australe Stellarium p Lamb.
Globe of the stars of the Southern sky, by Lamb.

150 Christophorus Wren Eques.
Sir Christopher Wren.

[54r]

151 Isaacus Newton Eq. aur.
Sir Isaac Newton.

152 Johannes Wallis. S.T.P. Geom. Prof. Savil. Oxonie &c.
John Wallis, Professor of Sacred Theology, Savillian Professor of Geometry at Oxford.

153 Edmundus Halleius. Astronomus Regius &c [-]
Edmund Halley, Astronomer Royal.

154 Johannes Flamsteedius Derbiensis Mathemat͠. Regius.
John Flamsteed of Derby, Mathematician Royal.

155 Galilæus Galilæi. Lynceus. Phil͠. & Mathem͠.
Galileo Gallilei, of the [Academy of the] Lynx, philosopher and mathematician.

156 La Scuola del Disegno dal Sig.ʳ Cavalier Carlo Maratti. &c
The Drawing School by the Cavaliere Carlo Maratti etc.

157 Cyclo-pædia. repræsentantio omnium artium & Scientiarum.
Encyclopædia, representing all the arts and sciences.

158 Expugnatio munimentorum. Archit. Mil.
Military Architecture, the besieging of fortifications.

159 Archit. Civ. scil. Quinque ordines Etrusc: Dor: Ion: Corinth: Compos:
Civil Architecture, namely the Five Orders - Etruscan, Doric, Ionic, Corinthian and Composite.

160 Nova Deceptio Visûstis. in medio Joh:ⁿᵉˢ Gay. Poeta lepidiss:
A new illusory picture, in the centre of which is John Gay, a most charming poet.

161 Homerus, De æro capite in Museo Rich.ᵈⁱ Mead M.D.
Homer, with a head of bronze, in the museum of Richard Mead, Doctor of Medicine.

162 Shakespearus.
Shakespeare.

163 Benjaminus Johnson.
Ben Jonson.

164 Galfredus Chaucer.
Geoffrey Chaucer.

[-**165** Johannes Radcliffe M.D.]
John Radcliffe, Doctor of Medicine

165 Matthæus Prior.
Matthew Prior.

166 Maria Davies.

Mary Davis.

167 Johan: Middleton.
John Middleton.

168 Ezechiel Spanhemius.
Ezechiel Spannheim.

169 Franciscus Junius.
Francis Junius.

170 Joh: Christophorus Pepusch. Mus. Doc: Ox.
John Christopher Pepusch, Doctor of Music in the University of Oxford.

171 Antonius a Wood.
Antony Wood.

[181] **[f.52v]** Seposita in[-] Bibliotheca Ashmoleana.
Held separately in the Ashmolean Library.

LIBER DOMINI VICE-CANCELLARII
The Book of the Vice-Chancellor

Transcribed by Julia White, translated and annotated by Arthur MacGregor

Ashmolean Museum, AMS 9, compiled 1685-6, with later additions. Leather-bound quarto volume with black leather labels on cover and spine, 'LIBER DÑI VICE-CANCELLARII', all within tooled borders. The first few pages are missing; 109 folios remain, 236 by 190 mm.

Apart from his library of books and manuscripts, Ashmole's collection of coins represented his principal personal contribution to the founding collection of the Ashmolean, the bulk of which was otherwise drawn from the Tradescants' cabinet of rarities. It is clear, however that not all of it came to Oxford: Ovenell (1986, p. 72) records that in 1683 Ashmole's collection contained more than 200 Greek, Roman and modern gold coins, but fewer than twenty of them found their way into the present catalogue.

Plot's work in cataloguing the initial collection had barely been completed in 1686 when Ashmole augmented his gift with a second collection of 560 silver coins, mostly Roman, English and Scottish, all of which were duly added to the Vice-Chancellor's catalogue. A third tranche arrived at the founder's death in 1692, comprising mostly medals and including those awarded to Ashmole himself by several Continental princes, following publication of his *History ... of the Order of the Garter* in 1672. It seems likely that Ashmole himself would have provided hand-lists enumerating and identifying these particular coins.

Several distinct collections from other donors are listed in the catalogue. Some forty-five Roman coins were given by Martin Lister in the founding year of the Museum (p. 78) and a smaller number followed in 1694 (p. 119). Thomas Braithwait of Ambleside in Westmorland bequeathed some 500 coins at his death in 1684 (pp. 81, 91, 94), a hundred of them quite rare and others too corroded to be identifiable. In the following year a small group of medals was given by Bishop John Fell, Dean of Christ Church (p. 78); Roman coins and some more recent medals came from John Aubrey in 1688 (p. 118); and thirty Roman coins were donated by James Ivie in 1694 (p. 120). Occasional mention is made of other donors of lesser importance.

A major influx of medals is recorded in the mid eighteenth century (pp. 116-18, 121-3), some entered on pages left blank by Plot and others on separate sheets pasted-in on guards. The writing is identified as that of 'Mr Parker', deputy and librarian to William Huddesford: given the enthusiasm of the latter for making good the shortcomings of his predecessors, it is possible that these items had entered the Museum some years before they were added to the inventory (see Ovenell 1986, pp. 134-7 for further discussion of this series).

Some difficulty of interpretation is presented by the various forms of nomenclature used in the catalogue − a problem that besets all numismatic literature of the period. The term *numisma* is used indiscriminately throughout the text to refer both to undoubted coins and to equally undoubted honours and portrait medals: in contemporary English the term 'medal' was applied with a corresponding looseness, but in the translations given here an attempt is made wherever possible to distinguish between coins and medals in the present-day sense. Use of the word *moneta* is perhaps a more certain indicator that a coin is involved, although when opposed to the term *lamina* (p. 77) it appears to carry the sense of 'medal'.

Roman coins predominate in the inventory, many evidently found in England − the presence of a number of moulds for the casting of (no doubt counterfeit) coins (p. 119) is noteworthy here − and others probably were imported through the numismatic trade. The few Greek coins listed no doubt arrived by the same mechanism. A handful of insular silver coins of Iron Age date (designated *numisma Britannicum*) can be recognized, accompanied by two 'runic' medals, perhaps early discoveries of bracteate pendants of Anglo-Saxon date. English, Scottish and Continental coins are all well represented, including some of early medieval origin, identified according to the moneyer and showing considerable astuteness on the part of the cataloguer. Others were of such recent date that some must still have been in circulation.

A few oriental coins make an appearance, notably a series of the Mogul emperor Jahangir (pp. 76-7, 116), perhaps all of them given by a Mr Eyres in 1749; a scatter of Indian, Persian, Turkish and Moroccan coins is to be found, together with representatives of more exotic forms of currency such as money woven from bark (from Angola) or made from shells in the form of wampum or roanoke from North America (p. 98).

Few works of reference are alluded to in the text: Hubert Goltz's *Sicilia et Magna Graecia* (1576) and Fulvio Orsini's *Familiæ Romanæ* (1577) are cited most frequently, with occasional reference being made to the Duc de Croy's *Numismata* (1654).

The coins, no doubt stored in cabinets with temptingly accessible trays, proved particularly vulnerable to theft: several annotations refer to coins lost in this way, while a note in Whiteside's hand (p. 116) refers to his discovery that 40 of the original 90 links in the gold chain given by the Elector of Brandenburg to Ashmole and bequeathed by him to the Museum in 1692 had gone missing.

In the interests of brevity the inscriptions (usually introduced by the words 'cum hac inscriptio' or 'cum iste') have not been translated in the following text; neither have the abbreviations Au (*aurum*, gold), Ag (*argentum*, silver), Ær (*aereus*, copper, or bronze), Pb or Plumb. (lead), and Stan. (tin). Weights quoted in the Latin texts (in pennyweights

and drams or grains) have not been repeated, and neither have the dates of coins. On the other hand, the translations include expanded or conventionalized forms of the rulers and subjects mentioned in abbreviated form in the original. The Latin and English texts are therefore intended to be used in a complementary manner.

[4r]
...l D.G.R. ... Siculon ...
[]

Carolus ix D.G. ...
Charles IX.

Matthias et M...
Matthias and Maximilian, Archdukes of Austria

Maximilianus mag ... diæ, et Mar ... oli filia ...
æres ... Brab. Conjuges ... tatis 20.1479
Maximilian I, Emperor, and Mary of Burgundy.

84 Mauritius Princeps Au...ae. Com Nasi. Cat.
Marc. Ver et vijs. Ær
Maurits, Prince of Nassau.

85 Ernestus Pr. et Com. Mans. Mur...Ne. P...B.
Held. Ar.
Ernst, Prince and Count of Mansfeld and Murbach.

86 Ferdinandus ... Mag. Dux Æetruria Ær.
Ferdinando, Grand Duke of Tuscany

87 Cos...s... Princ. Ætruriæ. Ær.
Cosimo, Prince of Tuscany.

[] ...ediricus Dux Saxoniæ ...us D.G. Dux
Saxoniæ. Sa. Roma. Imp. Archi. Ær.
Frederick the Great, Duke of Saxony.

88 ...us 5 D.G. Dani. N.V.G. Elec. Prin. Ær. fig.
ovali.
Christian V, King of Denmark; oval in outline.

89 ... Bona D. Desdigniensis, P. et Comis Tabilis.
Ær.
[]

9[0] ...onius Belliruræus. Æt. LXVIII. Ar.
[]

[91] ...Schifferus Arg. Prof. Upsal. 1679. Ar. *
Professor [] Schiffer of Uppsala.

94 Andreas Doria. P.P. Ær.
Andrea Doria.

95 Idem iterum. Ær.
Another of the same.

96 L.A. Lavaleta. D. Espern P. et Tot. Gal. pedit.
præf. Ær.
[]

97 Casimir March. Branden. æt. 46. et Susan
March. Branden. aet. 26. Ær.
Casimir, Marquis of Brandenburg and Susanna,
Marchioness of Brandenburg.

98 Stephanus de Witt Ultraject. Eq. Aur. ob
Patriam defensam. 6. Nov. Mai. 1567. Ær.
Stephan de Witt.

Albertus Dureres Noricus inter Pictores omnium
ætat... facile princeps. ætatis suæ 56. Ar. [-]
Albrecht Dürer.

Alberti Dureri aetatis suæ 56. 1527.
Albrecht Dürer.

[4v]
...Carolus Francorum Rex. Arg:
Charles, King of France.

[5r]
Ludovic. 13. D.G. Rex Chr. Gall. et Nav...
Louis XIII, King of France and Navarre.

... P.F. Ang. forma item ...Ær.
.... England ... of the same form ...

Gustavus Adolphus D.G. Suecorum Got. et Van.
Rex. Ar.
Gustavus Adolphus, King of Sweden.

Numisma in Honorem Fre... Hen. Princip. A...
cujus ...auspicijs Vesalia capta 19. Sext. 1629
pcussũ... Ær.
Frederick Henry, Prince of Orange; struck to commemorate
the capture of Wezel.

... in Honorem ejusdem Principis cusum ...jus au-
spicijs item Sil... Ducis capta. 17 Sept. 1629. Ær
Frederick Henry, Prince of Orange; also struck to
commemorate the capture of Bois-le-Duc.

Aliud in memoriã ... præclari facinoris. Ær.
Another coin, struck to commemorate [].

Numisma in Honorẽ Princip. Mauritij percussũ, jujus
auspiciijs Bergae ad Z...am receptæ Oct. 2 1622. Ær.
Maurits, Prince of Nassau.

Michael Angelus Bon. Arrotus. Flo. R.AES. Ann.
/88\ Ær.
Michelangelo Buonarotti of Florence.

Numisma in memoria Synodus Dodrectanæ. Ær
Medal to commemorate the Synod of Dordrecht.

... Geographica totius Mundi. Ar.
[Medal with a] map of the whole world.

JESUS Naz Salvator Mundi in obverse et.B.Maria
Virgo mater ejus in reverso. Ar.
obv: Jesus of Nazareth, Saviour of the World; rev: his
blessed Virgin Mother.

Numisma in memoriã Canonizationis Ignatij
Loyolæ Societatis Jesu Fundatoris. Ar.
Ignatius Loyola, in commemoration of the canonization of the
founder of the Society of Jesus.

...sedens ad dextram Patris. Ar.
[Jesus Christ] ...seated at the right hand of the Father.

...ESUS Christus Salvator Mundi. Ar...
Jesus Christ, Saviour of the World.

...iterum. Ar.
Another of the same.

...SUS Christus in gremio Matris. Ar.
...Jesus Christ, on his mother's lap.

...Cruce pendens. Ar.
[Jesus Christ] hanging on the Cross.

...Pontifex M... Ar.
... Pope ...

[5v]

...lus. Conjux in Reg. Rom. coronat 26. Jun...
Charles V, Emperor [?].

[6r]

...helmus Conquistor. Ar.
William the Conqueror.

102 Elizabeth D. G. Ang. Fra. et Hib. Regina cum insignijs regijs in obverso, et porta dimissoria in reverso. Ar.
Queen Elizabeth: *obv:* The Queen with the royal arms; *rev:* a portcullis.

103 Idem iterum. Ar.
Another of the same.

104 Maria Dei G. Sc...r. Regina. 1556. Ar
Mary, Queen of Scotland.

105 Jacobus 6. D.G. Rex Scotorum. 1593. Ar
King James VI of Scotland.

106 Carolus Imperator. 1552. Ar.
Charles V, Emperor.

107 Carolus 5 Imp. Ar.
Charles V, Emperor.

108 Matthias 2. D.G. H.B. Rex. Coron. in Reg. Roman...
Matthias II, as King of Rome.

109 Ferdinand 2. D. G. El. Ro. Imp. S.A. Cor. in Fran. f. Ar. forma Rhomboidali
Emperor Ferdinand II, rhomboid in outline.

110 F. II. Coronatus in Regem Romanorū 10 Sept. 1619. in eadem forma. Ar.
Emperor Ferdinand II, with the same outline.

111 Jo. Geo. Com. J. Zol. et S. R. Imp. Cam. Hær. Ær. formâ oval.
Emperor Johan Georg, oval in outline.

112 Johan. Vo. Leyden Coninck. z. Muns. Ar.
Johannes of Leyden, King of Münster.

113 Carolus 9. D. G. Franciæ Rex. Ar.
Charles IX, King of France.

114 Ludovicus Dei Gratia Francorū Rex Ar.
Louis, King of France.

115 Franciscus Dei Gra. Francor. Rex Ar.
François, King of France.

116 Fran. et Ma. D. G. R.R. Franco. Scotor. etc. Ar.
François II of France and Mary of Scotland.

117 Henricus 2. Dei G. Francor. Rex. Ar.
Henry II, King of France.

118 Henricus 3 D. G. Franc. et Pol. Rex. Ar.[1]
Henry III, King of France and Poland.

119 Henr. 4. Fr. et Nav. Rex. Ar
Henry IV, King of France and Navarre.

120 Ludovic. 13. D. G. Francorū et Navaræ Rex. Ar.
Louis XIII, King of France and Navarre.

121 Fran. D. Alen. Fi. Fr. R. 1573. Ar

François, King of France.

122 Fernandus D. G. Rex Nav. Ar.
Ferdinand, King of Navarre.

123 Philippus D. G. Hisp. Rex. Dñs. Traject. Ar.
Philip, King of Spain.

124 Numisma ejusdem /Princip.\ forma ovali cum hac Inscription... En tant (?) fideles an Poij. Ar. deaurat.
Medal of the same prince; ovoid.

[7r]

126 Gustavus Adolphus Suec. Goth. et Vand. Rex. Ar.
Gustavus Adolphus, King of Sweden.

127 Gust. Adolp. D. G. Suec. Got. Wand. Rex. M. P. F. D. E. et C. J. Do. Ar.
Gustavus Adolphus, King of Sweden.

128 Carolus 9. D. G. Suec. Got. Wand. etc. Rex. Ar.
Charles IX, King of Sweden.

129 Christianus 4. D.G. Dan. Norv. Vand. Gotoque Rex. Ar.[2]
Christian IV, King of Denmark.

130 /*\ Idem iterū. 1625. Ar.[3]
Another of the same.

131 Idem iterū. 1629. Ar.
Another of the same.

132 Sigismundus 3. D. G. Rex. Pol. M. D. Lith. Rus. Prus. M. Sam. Liv. nec n. Su. Got. Van. etc. Ar.
Sigismund III, King of Poland.

133 Idem iterum. Ar.
Another of the same.

134 Alphonso. D. G. Portugalliæ Rex Ar.[4]
Alfonso, King of Portugal.

135 Idem iterū. Ar.
Another of the same.

136 Idem iterum. Ar.
Another of the same.

137 Petrus D. G. Portugalliæ Rex. Ar.
Peter, King of Portugal.

138 Alphonsus D. G. Portugalliæ Rex. Ar.
Alfonso, King of Portugal.

139 Philippus Dei Garsia.
King Philip.

[1] **[f.5v]** ... Conjux in Reg... Rom. Coronat 26 Jun ...Capsula 4.ᵗᵃ
... crowned 26 June ... Fourth drawer.

[2] **[f.6v]** * Loco Numismatis amissi Substituitur Robertus Scotorum Rex ... \\fract//
The missing coin replaced by one of Robert, King of the Scots.
 Notand: quòd A.D.1746 inter alia quodam Musæo nostro restitutum fuerit numisma hujusce Regis A:ⁿᵒ 1608 cusum; quod huc retulimus & fractum hoc Scoticis aliis in Caps: g. adjunximus.
Note: the coin which, among others, was restored to this Museum in 1746, was one of this King, struck in 1608; we brought it here, broken, and added it to the other Scottish coins in drawer g.

[3] ...d

[4] **[f.6v]** Io III

140 Josias Rex Judæ in obverso et Herodes Ascalon. in reverso. Ar.
Obv: Josiah, King of the Jews: *rev:* Herod of Ascalon

141 Albertus et Elizabeth D. G. Arch-D. Austr. Duces Burg. et Braban. Ar.
Albrecht and Elizabeth, Archduke and Archduchess of Austria, and Duke and Duchess of Burgundy and Brabant.

142 Joaña et Karolus D. G. Castell. Leg. Re. Archid. Austr. Duces Burg. etc. Ar.
Karl and Joanna, Archduke and Archduchess of Austria, and Duke and Duchess of Burgundy.

143 Philippus Dei Gra. Archid. Aust. Duc. Burg. etc. Ar
Philip, Archduke of Austria and Duke of Burgundy and Brabant.

144 Idem iterū. Co. Fl. Ar.
Another of the same.

145 Albertus et Elizabeth. D. G. Archiduces Aust. Duces Burg. et Brab. Ar.
Albrecht and Elizabeth, Archduke and Archduchess of Austria, and Duke and Duchess of Burgundy and Brabant.

146 Joan. Guilhelm. Dux Saxonia. D. L. Lant. Thurin. et Mar. Misniæ. Ar.
Johan Wilhelm, Duke of Saxony.

[8r]

147 Sa. Augustus D. G. Dux Saxoniæ. Rom. Imp. Archmareseal et Elector. Ar. 1559.
Augustus, Duke of Saxony, Marshall and Elector of the Holy Roman Empire.

148 Henricus Julius D. G. /P.\Ep. Halb. D. Br. etc. D. M. Jus. Prin. Dn. Hed... March. Brand. D. Bruns. et Lun. Viduæ Matri dil. obijt XI Ca. Nov. An. 1602. etc. Ar.
Heinrich Julius, Prince-Bishop of Halberstadt, Duke of Brunswick and Lüneburg.

149 Fran. M. Magn. Dux Etruriæ. 1577. Ar.
Francesco de' Medici, Grand Duke of Tuscany.

150 F[-re\er]d. M. Car. Mag. Dux Etruriæ. 1588. Ar
Ferdinand de' Medici, Grand Duke of Tuscany.

151 Alexander Far. Dux 3 Plasentiæ et Parmæ etc. 1592. Ar.
Alessandro Farnese, Duke of Piacenza and Parma.

152 ... Comis Flandriæ. Ar.
... Count of Flanders.

153 Fed. Gon: Dux Man. et Mr. Mon. Fe. Ar.
Federico Gonzaga, Duke of Mantua.

154 Anton. Priol. Dux S. M. Venet: 1618. Ar.
Antonio Priuli, Doge of Venice.

155 Aloy. Moce. S. M. Venetus. Ar.
Alvise Mocenigo, Doge of Venice.

156 Carolus D. G. Cal. Loth. Bar. Gel. Dux. Ar.
Charles, Duke of Lorraine and Bavaria.

157 Ludovicus Dei. Gra. Comes & Dñs Flandriæ. Ar.
Louis, Count of Flanders.

158 Ject. de la Monn de Flnd etc. Ar.
Jetton of the mint of Flanders.

159 Henricus Julius P. Ep. Halb. D. Bru. et Lu. Ar
Heinrich Julius, Prince-Bishop of Halberstadt and Duke of Brunswick and Lüneburg.

160 Enno Comes et Dñs Phrigiæ orient. Ar.
Enno, Count of Phrygia.

161 Nic De Pont. S. M. Venet. Ar.
Niccolò da Ponte, Doge of Venice.

162 And. Griti S. M. Venet. Ar.
Andrea Gritti, Doge of Venice.

163 Petronius de Bononia. Ar.
Petronius da Bologna.

164 Moneta Arg. Civitatis Gandav. 1583. Ar.
Coin of the city of Ghent.

165 Moneta Nov. Civ. Hamburgensis. Ar.
Coin of the city of Hamburg.

166 Civitas Geneva. Ar.
[Coin of the] City of Geneva.

167 Numisma signatū, manu phialā porrigente, cū hâc Inscriptione, Francis data munera Cæli /1610\ in Reverso, Ludovic⁹ 13. etc. Ar.
Medal struck with a hand holding out a phiale; *rev:* Louis XIII.

168 Numisma signatū arcu & pharetrâ decussatim positis supra Lunam Crescentē, cum hâc Inscriptione, donec solū impleat Orbem. in Reverso, Insignia Gallica. 1552. Ar.
Medal struck with a bow and quiver forming quarterings, placed over a crescent moon; *rev:* arms of France.

169 Numisma signatū duobus Archistrategis manus super Arā;... cum hac Inscriptione. Securitas Galliæ... 16...⁵
Medal struck with two Generals, with their hand on an altar.

[9r]

170 Numisma signatū malo Punico dissecto, gloria desuper illustrato, cum hac Inscrip. tot Vota Meorū. 1604 in Reverso, Insignia Gallica. Ar.
Medal struck with a Punic apple halved [?], displayed from above in a gloria; *rev:* arms of France.

171 Numisma signatum Leone procumbente gladium strictū et Bilancem unguib⁹ tenente, cum hac Inscript. Suscitare quis audebit. 1619. in Reverso, Insignia Gall. Ar.
Medal struck with a recumbent lion holding a narrow sword and balance in its claws; *rev:* arms of France.

172 Numisma signat. guttis e nubibus decidentibus, cum hac Inscript. Ardorem extincta testantur vivere flamma. in Reverso. Catharina D. G. Francor. Regin. Ar.
Medal struck with raindrops falling from clouds; *rev:* Queen Catherine of France.

173 Numisma signat. Columna, ad Basin floribus, in medio Coronâ, infra Capitellū anguibus implicatis, ornatâ; cum hâc Inscript. Pax sospite Rege vigebit. in Reverso, Insignia Gallica. 1599. Ar.

⁵[f.7v] * Extraordinaire des guerres &c.

Medal struck with a column with flowers at the base and a crown in the centre; below the capital serpents entwined; *rev:* arms of France.

174 Numisma signat. Vulpecula gradiente inter maculas Muris Pontici circum circa respersas, cum hac Inscriptione. Non mihi sed cunctis. in Reverso, Insignia Thesaurarij Armoricæ. Ar.
Medal struck with a little Vixen walking within a circle of ermine scattered with spots; *rev:* arms of the Treasurer of Brittany.

175 Numisma signat. Manu de nubibus tres chordas implicatas tenente, cum hac Inscript. Rumpitur hand facile. in averso. Leo Belgicus. 1596. Ar.
Medal struck with a hand from the clouds holding three entwined cords. *rev:* the Belgian lion.

176 Numisma signat. in obverso, duobus Equitibus, totidemque peditibus, cõminus pugnantibus; in Reverso, duobus viris nudis captibus truncatis, et in hastas fixis, cum hac Inscript. Præstat pugnare pro Patria, quã simulatâ pace decipi. 1579. Ar.
Medal struck with: *obv:* two mounted knights and the same number of foot-soldiers, in close combat; *rev:* the severed heads of two male captives impaled on spears.

177 Numisma signat. Leone gradiente, cum hâc Inscript. Magnanimis ingenita pietas. In Reverso Insignia ...
Medal struck with a lion walking; *rev:* the arms of [].

178 Numisma signatũ in Obverso, Simiâ cum Catulis; in Reverso, Homine inter fumũ et Ignẽ; cum hac Inscriptione Libertas ne ita chara, ut Simiæ Catuli. Fugiens fumum incidit in ignẽ. Ar.
Medal struck with: *obv:* an ape with its young; *rev:* a man amongst fire and smoke.

[10r]

179 Numisma signatũ in obverso, Leone gradiente; in Reverso, Urso faucibus obfirmatis, et catenato, ad truncum arboris nodosum erecto, cum hac Inscriptione. Omnia tempus habent. Ar.
Medal struck with: *obv:* a lion walking; *rev:* a muzzled bear chained to the upright trunk of a knotty tree.

180 Numisma signat. Nave velis expansis, in quorũ maximo, nomen Jehovæ gloriâ circum circa illustratũ, cum hac Inscript. En altera quæ vehat Argo. in Reverso /signat\ Urbe, vallis, [-\et eodem] nomine glorioso, munitâ, cũ hac Inscript. Sic nescia cedere Fata. 1590. Ar.
Medal struck with: a ship in full sail with, on the main sail, the name of Jehova displayed within a gloria; *rev:* a walled city inscribed with the same exalted name.

181 Numisma in obverso signatũ figura Justitiæ, cum hâc Inscriptione. Justitia in sese virtutes continet omnes. in Reverso, figuris trium Dearũ, cũ hac Inscript. Nos Themis et Pax alma fovẽt, Bellona facessat. Ar.
Medal struck with: *obv:* the figure of Justice; *rev:* representations of three goddesses.

182 Numisma impressum figuris Davidis e Goliæ, cum hac Inscriptione. In solus Deus et magna facis. in Reverso, Leone et Apro pugnantibus, cum ista. Fide Dnõ, et ipse efficiet. Ar.
Medal impressed with the figures of David and Goliath; *rev:* a lion and a boar fighting.

183 I.H.S. gloria illustrat. cum ista Inscript. Spes mea unica in Reverso, Anchora, cũ ista. Fata viã invenient. Ar.
I.H.S. displayed within a gloria; *rev:* an anchor.

184 Numisma inscriptum sacro nomine Johavæ, cum isto symbolo, Justus judex. Ar.
Medal inscribed with the sacred name of Jehova with this symbol: the just judge.

185 Numisma in memoriam Civitatis liberatæ /cujũ\, cum hac Inscriptione, magna Dei misericordia sup. Nos. in Reverso, figura Ducis (puto Venetiarũ) in genua procumbentis coram S.ᵗᵒ Marco, cum ista; Seb. Venerio P. Munus. Ar.
Medal commemorating the liberation of a city; *rev:* the figure of a Duke (of Venice, I believe) kneeling in the presence of St. Mark.

186 Numisma in obsidione Newark cusum 1645 forma /Rhombo\idalis. Ar.
Siege-piece of the siege of Newark; rhomboid in outline.

187 Numisma insignitũ prospectu Civitatis Argentorati, supra quam, Angelus volans cum coronâ Civica. 1627. Ar.
Medal struck with a view of the City of Strasbourg, above which an angel flies with the civic crown.

[11r]

188 Numisma signat. duabus navibus; infra, Classis Hisp: cum hac Inscript. Venit. Ivit. Fuit. 1588. in Reverso; insignijs Zelandicis, cum ista, Soli Deo gloria. Ar.
Armada medal struck with: two ships with (below) the Spanish Fleet; *rev:* the arms of Zeeland.

189 Numisma inscriptum Ciphra Elizabethæ Regin. Angl. cum Inscriptione sequenti. Afflictorũ Conservatrix 1601. in Reverso, cum formã Elizabethæ; ac istâ Inscript. Unum a Deo duobus sustineo. Ar.
Medal inscribed with the cypher of Queen Elizabeth; *rev:* figure of Elizabeth.

190 Numisma cusum in Obsidione Bredæ forma Rhomboidali cum ista Inscript. Breda obses. 1625. Ar.
Siege-piece of the siege of Breda; rhomboid in outline.

191 Numisma (ut puto) amatorium his insignijs impressum, sc. decussi, sive cruce Sᵗⁱ Andreæ, inter 4 Cervos gradientes; cum hac inscript. Arthur shall be Henri and An. in Reverso signatũ Turture, cum istâ; being yours, I cease to be mine. 1564. Ar.
Medal or (I believe) a love token, struck with this device: quartered by a St. Andrew's cross, with four walking deer in the quadrants; *rev:* a turtle-dove.

192 Moneta (ut puto) Indica forma pentagona. 1621. Ar.
Coin, Indian I believe, pentagonal in outline.

193 Moneta ejusdem loci, forma rotundâ. 1621. Ar.
Coin from the same place, rounded in outline.

194 Numisma impressum hisce insignijs sc.
Vacerrâ tribus decussibus signata; super omnia,
Corona imperialis. 1578. Ar. Forma Rhõboidali.
Medal impressed with these arms: (perhaps) a post marked
with three crosses (XXX); over all, an imperial crown.
Rhomboid in outline.

195 Numisma signat. Tetraedro ordinato, cum ista
Inscrip. Gott ist unser eckstein. 1623. forma
Rhomboid.
Medal struck with a regular tetrahedron; rhomboid in outline.

196 Numisma impres. Herculeis Columnis cum
hac Inscript. pie plus ultra etc. Ar.
Medal struck with Hercules' Columns.

197 Numisma signat figuris (ut puto)
Hieroglyphicis forma ovali. Ar.
Medal struck with, I believe, hieroglyphic characters; ovoid in
outline.

198 Pallas armata forma ovali. Ar.
Pallas in armour; ovoid in outline.

199 Carolus I. Mag. Brit. etc. Rex et Henrieta
Regin (ut puto) Ar
King Charles I, of Great Britain and Queen Henrietta (I
believe).

200 Gustavus Adolphus (ut puto) cum sua Regina.
Gustavus Adolphus (I believe) with his Queen.

[12r]

201 Numisma inscriptum sacro nomine Jehovæ,
gloria circumcirca illustrato, forma Rhomboidali
1626. Aur.[6]
Medal inscribed with the sacred name of Jehova, displayed
within a gloria; rhomboid in outline.

202 Numisma Britannicum signatū Equo. Aur.
British coin struck with a horse.[7]

203 Aliud Britannicū signatū capite humano. Aur.
Another British [one] struck with a human head.

204 Aliud Britannicum minus, signatū (ut puto)
Cratere, et nonnulis lineis curvalis. Aur.[8]
Another small British [coin], struck with (I believe) a mixing-
bowl, and some curved lines.

205 Aliud Britannicū minus, signatū tantūmodo
lineis curvatis. Aur.
Another small British coin, struck only with curved lines.

206 Numisma antiqū signatū in obverso capite
humano, et in Reverso, homine equitante, gladio
suo stricto, cum Cruce ante fanem. Aur.
Antique coin struck with; obv: a human head; rev: a man on
horseback, with a drawn sword, with the Cross before the
temple.

207 Numisma antiqū (ut puto) Runicum. Aur.
Antique medal, runic (I believe).

208 Aliud (puto) Runicum signat figura humana.
Aur \\ deest//
Another medal, (I believe) runic, struck with a human figure.
Missing.

209 Bolus aureus, nulla impressione signat.
Gold bolus, not struck with any design.

210 Henric. vj Rex Anglorum. Aur[9]
King Henry VI of England.

211 Edwardus 3 Rex Angloru. Aur. \\+ -3-//
King Edward III of England.

212 /d\ Richardus 3 Rex Angloru Aur. (212-215
bracketed together) \\desunt.//[10]
King Richard III of England.

213 /d\ [-Henricus viij Dei G. Rex Angliæ et
Franciæ, Dñi Hiberniæ. Aur.][11]
King Henry VIII of England.

214 Elizabetha D. G. Angl. Fran. et Hib. Regin.
Aur[12]
Queen Elizabeth of England.

[-215] /d\ [-Philippus 3 (?)... D. G. Hispaniorū Rex
...][13]
Philip III (?), King of Spain.

216 Casimirus Rex. Polonie. Aur.
Casimir, King of Poland.

217 Lud. 13 D. G. Fran. et Navar. Rex. Ar.
deaurat.
Louis XIII, King of France.

218 Numisma signat. capite humano in obverso, et
Equo in Reverso. puto Britannicū esse. Ar.
Coin struck with: obv: a human head; rev: a horse. I believe
it to be British.

219 Numisma signat capite Regio, in obverso, et
(ut puto) Dracone, in reverso, forte Utheri
Pendragon. Ar. *[inserted from 11v]*
Coin struck with; obv: the head of a king; rev: a dragon;
perhaps Uther Pendragon.

220 Numisma signat. capite Regio, in obverso, et
Equo et (puto) Lepore, in Reverso. credo
Britannicū esse. Ar. \\[-] 6// *[inserted from 11v]*
Coin struck with: obv: the head of a king; rev: a horse and (I
believe) a hare. I believe it to be British.

221 Aliud Numisma Britannicū signat capite
humano in obverso, et equo in Reverso. Ar. \\Hoc
idem est planè cum priore sic not. *//
Another British coin struck with: obv: a human head; rev: a
horse. Note that this is distinct from the previous.

222 Numisma puto Runicū sive Gothicū signat
capite human. Ar.
Medal, I believe runic or gothic, struck with a human head.

223 Aliud Numisma Runicū signatū capite
humano. Ar.
Another runic medal struck with a human head.

[224] Aliud ...
Another [runic medal]...

[13r]

[6]Capsula 7.ma
Seventh drawer
[7][**f. 11v**] C.T. 2 N.B. 22
[8][**f.11v**] eadem plane Numismata *[bracketed with 205]*
These are clearly coins.

[9][**f.11v**] *10 Numisma signatū porta dimissoriâ. Aur.Coin struck
with a portcullis, 10.
[10][**f.11v**]d
[11][**f.11v**]d
[12][**f.11v**]d
[13][**f.11v**] C.T 2 N.B. 6 d

225 Quartum /et quintũ\ eodem modo signat. Arg. \\C. Tab.2.N.B.10.//
Fourth (and fifth) [runic medal] struck in the same manner.

226 Numisma signat. capite armato in Reverso. RR. Ar.
Medal struck with: *obv:* a helmeted head; *rev:* RR.

227 Numisma signat. capite equino. Ar[14]
Medal struck with a horse's head.

228 Numisma signat characterib⁷ quibusdã ignotis Ar.
Medal struck with some kind of unknown characters.

229 Numisma signat capite coronato in obverso, et Lilio, cum quibusdã characteribus ignotis in reverso. Ar.
Medal struck with: *obv:* a crowned head; *rev:* a fleur-de-lis, with some kind of unknown characters.

230 Massa argentea impressa[-] qibusdã figuris ignotis Ar.
A lump of silver, impressed with some unknown characters.

231 Massa argentea in se curvata et signat m.
A lump of silver, bent and struck with *m.*

232 Edwardus (senior) Rex. Ar.
King Edward (the Elder).

233 Eadweard (senior) Rex. Ar.
King Edward (the Elder).

234 ÆÐelstan Rex. Ar
King Athelstan.

235 ÆÐelstan Rex Brit. Ar.
King Athelstan, of Britain.

236 Edweard (Martyr) Rex. Ar.
King Edward (the Martyr).

237 Eadweard (Martyr) Rex. Ar.
King Edward (the Martyr).

238 Eadweard (item ut puto Martyr) Rex. Ar.
King Edward (again, I believe, the Martyr).

239 Eadward (Confessor) Rex Anglor. Ar.
King Edward (the Confessor), of England.

240 Eadward (Confessor) An. Rex. vid. Tab. 6. num. 17 in vita Ælfredi Regis. Ar
King Edward (the Confessor). See *Life of King Alfred*, tab. 6, no.17.

241 Harold Rex Ang. Ar
King Harold, of England.

242 Willemus (Conquestor) Rex. Ar.
King William (the Conqueror).

243 Willelmus (Conquestor) Rex. Ar.
King William (the Conqueror).

244 Numisma aliud ejusdem Regis Ar.
Another coin of the same king.

245 Willelmus (Rufus) Rex. Ar.
King William (Rufus).

246 Henricus (secundus) Rex Angl. Ar.
King Henry II, of England.

247 Henricus (quintus) Rex Angl. et Franc. Ar.
King Henry V, of England.

248 Elizabetha Angl. Fr. et Hi. Regina. Ar.
Queen Elizabeth, of England.

249 Numisma aquilâ signat. forte Imperiali. Ar.
Medal struck with an eagle, possibly imperial.

250 Numisma Venetũ. Ar.
Venetian medal.

251 Numisma quoddã concavũ impress Scuto Armorũ. Ar
Medal, somewhat concave, impressed with a shield of arms.

252 Numisma impressũ capite quodã Regio. Ar.
Medal impressed with the head of some king.

[13v]

252a [-]

252b LEOPOLDVS.D.G.R.I.S.A.G.H.E.B.REX P. Archidux Austr. &c. 1683. Aur.\\[-d]//
Leopold I, Holy Roman Emperor, Archduke of Austria.

252c MIC. APAFI. R. Par. Regni Hungariæ Dominus & Sicu. comes. 1688. Aur.\\d//
[], Lord of Hungary and Count of Sicily.

252d /MAX. GAND: D:G.AR:EP: SAL: SE: AP: L.\S:RVDBERTVS EPS. SALISBVRG: 1678. [-&\d] Aur.\\d//
Maximilian Gandolf, Archbishop of Salzburg. St. Rupert, patron saint of Salzburg.

252e MATTHIAS D.G. ROMANORVM Imperator &c. R. Hungariæ Patrona 1615. Ar.
Matthias, Holy Roman Emperor, Protector of Hungary.

252f LEOPOL. D.G. R. SAC. REX. R Patrona Hungariæ 1695. Arg. mixt.
Leopold, Holy Roman Emperor, Protector of Hungary.

252g LEOP. D.G.R.I.S.A.G.H.B.REX.R Patrona Hungariæ 1678. Virgo Deipara ut et in prioribus argenteis. Arg. mixt.
Leopold, King of Hungary. The Virgin Mary, as in the above silver coins.

[-252.h.] [-Eadred Rex Ær \\+//]
King Eadred

[14r]

ꝫ Ad.A.° 1701[15]

253 Moses Cornutus. in Reverso, Decalogi præcept. 1ᵐũ. Ar.
Moses with his horns: *rev:* the Ten Commandments.

254 Pallas armata, in Reverso Victoria, cũ hac Inscript. ΔΙΟΔ. Ar.
Pallas in armour; *rev:* Victory.

255 [-] ΠΡΙΑΜΟΣ ΒΑΣΙΛΕΥΣ\ in Reverso ΤΡΟΙΑ. Ar.
King Priam; *rev:* Troy.

[14] [f.12v] potius Gallo.
Or rather the head of a cock.

[15] [f.13v] ꝫ Qui sequuntur quatuor Aureos Nummos et tres Argenteos donavit Ricardus Dyer A.M. & Coll. Oriel Socius, 1.° Junij. A.°. 1701.
The following four gold and three silver coins were given by Richard Dyer, MA, Fellow of Oriel College, 1 June 1701.

256 ΔΙΔΩΝ ΒΑΣΙΛΙΣΣΑ. in Reverso
ΚΑΡΧΗΔΩΝ. Ar.
Queen Dido; *rev:* Carthage.

257 ΑΛΕΞΑΝΔΡΟΣ ΔΙΥΟΣ. in Reverso,
Alexander triumphans. /cum hac Inscrp: ΠΕΡΣΙΣ
ΑΛΩΘΕΙΣΑ\. Ar.
The Divine Alexander; *rev:* Alexander in triumph.

258 Stater Attic. Alexandri. 11. pw. 2 gr. Ar.
Attic stater; Alexander.

259 Stater Macedonum. 10 pw. - 5 gr. Ar.
Macedonian stater.

260 Stater Atheniensium. 11. pw. 3 gr. Ar.
Athenian stater.

261 Stater alius, sive Tetradrachmū Atheniense. II.
pw. - 4 gr. Ar
Another stater, or tetradrachm, of Athens.

262 Stater alius Atheniensis 9 p.w. 10 gr. Ar [16]
Another Athenian stater.

263 Stater. sive Tetradrachmum Ephesiorū. 10 pw.
- 11 gr. Ar.
Stater or Ephesian tetradrachm.

264 Tridrachmum ΜΗΝΑΝΙΝΩΝ cum hāc Inscrip
ΚΟΡΑΣ. 8 pw. - 2 gr. de quo vid. Goltzū inter
Numismata Syracusiorū Tab. 12. n. 7. Ar[17]
Tridrachm, Menaenum. See Goltz 1576, tab. 12 no. 7.

265 Didrachmum Syracusiorū. 5 pw. 9 gr. Ar.
Syracusan didrachm.

266 Numisma aliud ΣΥΡΑΚΟΣΙΩΝ. Ær.
Another coin, Syracuse.

267 Tridrachmum ΡΟΔΙΟΝ. 7 pw. 13 gr. Ar.
Tridrachm, Rhodes.

268 Drachma Rhodiorum. 2 pw. 18 gr. Ar.
Rhodian drachm.

269 Numisma aliud ΡΟΔΙΟΝ. Ær. [18]
Another coin, Rhodes.

270 Drachma Alexandri. 2 pw. 9 gr. Ar.
Alexander, drachm.

271 Idem iterū. 2 pw. 7 gr.
Another of the same.

272 Drachma ΧΑΜΙΩΝ 2 pw - 3 gr. Ar.
Drachma, Samos.

273 Drachma (ut puto) ΣΑΛΑΝΤΙΝΩΝ. vid
Goltziū inter Numismata Mag. Græc. Tab.
Drachma of, I believe, Selinus; see Goltz 1576, tab. [33].

274 Numisma (ut puto) ΕΠΙΡΩΤΩΝ. 6 pw. 1 gr.
Ar.
Coin of, I believe, Epirus.

275 Numisma signatū capite Jovis. Ar
Coin struck with the head of Jupiter.

276 Numisma impressū capite Mercurij. Ar

Coin impressed with the head of Mercury.

277 Aliud Numisma signatū literis græcis. Ar.
Another coin struck with Greek letters.

278 Drachma ΔΥΡΑΧΙΩΝ. 1. pw. 14 gr. vid
Goltz. Num Græc. Tab. 1. 8
Drachma, Dyrrhachium. Goltz 1576, tab. 1.

279 Didrachmum ΤΑΡΑΝΤΙΝΩΝ. 5 pw. Goltz.
Mag Græc Tab. 31.32.33
Didrachm, Tarentum. Goltz 1576, tab. 31-3.

280 Drachma ΜΑΣΣ...
Drachma, Massalia [Marseilles].

[13v]

281 Numisma signatū capite Equino forte
Romanorū Mag. Græc. de quibus vid. Goltz. Tab.
XVIII. Ær. vid. Parutā di Cortaginiesi
Medal struck with a horse's head, perhaps Roman, from
Magna Graecia. Goltz 1576, tab. 18.

282 Numisma aliud Græcū signatū Pegaso. de
quib' vide Etiā Goltz Ar
Another Greek coin struck with Pegasus. See Goltz 1576,
[tab. 4 or 12].
Numisma ignotum curvatum. Ær
Unknown coin, curved.

[14v]

Numismata Superaddita A.° 1700
Coins added in the year 1700

282b BRITANNIA svpplex 1696. 0 SERVES
ANIMÆ DIMIDIVM MEÆ. R. Insign Angliæ,
Scotiæ, Franciæ et Hiberniæ: PRÆLVCET
QVATVOR VNA. Ar.
[], struck with the arms of England, Scotland, France and
Ireland.

282c THE COMMONWEALTH OF ENGLAND.
R. GOD WITH VS 1653. AV..[19]

282d Nummus æreus serratus. Q.
Serrate bronze coin.

[15r]

283 M. Julius Camillus Dict. Ar.
Julius Camillus, Magistrate.

284 Cæsar Dict. perpetuus. Ar. deaurat.
Caesar, dictator perpetuus.

285 Divus Julius. Ar.
The deified Julius (Caesar).

286 Ti. Claudius Cæsar Aug. Ær.
S C. Minerva stans; dextra pilum, sinistra
scutum. Ær.
Claudius; Minerva standing, in her right hand a javelin, in her
left a shield.

287 Imp. Nerva Cæs. Trajan. Aug. Germ. P.M.
TR.P. 2.
COS. II. Templū cui insistit figura super basin, in
Coroninice DIANA PERG. Ar. Indescr.[20]

[16][f.13v] Ex dono Dñi. Jōhis Radcliff /M.D.\ e Coll. Lincoln.
Oxõn.
The gift of Mr John Radcliffe, MD, of Lincoln College,
Oxford.
[17][f.13v] 6 c d e Gold medals in ye Dean of xt church Cabin:
[18][f.13v] * Ex dono Dñi Gul. Charleton e med Temp. Lond.
The gift of Mr William Charleton of Middle Temple, London.

[19][f.14v] 282.c. probably has been transferred to yᵉ. best Cabinet,
the Drawer where the Gold Chains are N°. 353./ and 282.b. into ye
Drawer immediately under ye. other No. 329.
[20][-d]

Trajan; *rev.* temple in which stands a figure on a column.
Not previously described [in print].

288 AYTOK. KAI. M. AYPHΛ. ANTΩNEINOC.
ΛOY. CEΠTIMIOC ΓETAC. KAIC. Capita
Antonini & Getæ EΠICT. PATHΓOYIPPIOY.
EΛAITΩN. Figura Equestris juxta Trophæū Ær.
Caracalla and Geta; equestrian figure near a trophy.

289 Imp. Cæs. Domit. Aug. Ger. Cos. XII. Cons.
P.P.P.
Virtuti Augusti SC. Miles stans dextra hastam,
sinistra parazonium. Ær[21]
Domitian. Virtuti Augusti; a soldier standing, in his right hand
a spear, in his left a parazonium.

290 M. ÆMILLus Lepidus. Ar.
M. Aemilius Lepidus.

291 Ant. Aug. 3 VIR. R.P.C. Leg. XX. Ar.
Mark Antony.

292 Castor et Pollux Equitantes. Ar. \\Roma//
Castor and Pollux on horseback.

293 P. CLODius M.F. Ar.
P. Clodius, moneyer.

294 m. CORDIVS RVFVS III VIR. Ar.
Man. Cordius Rufus, moneyer.

295 CN. DOMitius Ahenobarbus. Ar. \\Roma+//
Cn. Domitius Ahenobarbus, moneyer.

296 C. FAbius C.F. Ex. A. PV. Ar.
C. Fabius, moneyer.

297 C. FABIus. C.F. Pictor.
EX. A. PV. Ar.
C. Fabius Pictor, moneyer.

298 C. FVNDANius Fundulus. Ar.
C. Fundanius Fundulus, moneyer.

299 L. FLAMINius Cilo Ar.
L. Flaminius Chilo, moneyer.

300 C. HOSIDIVs. CF GeTA III VIR. Ar.
C. Hosidius Geta, moneyer.

301 Julius CAESAR. Elephas.
Julius Caesar; an elephant.

302 Julius CAESAR. Æneas cum Anchise. Ar.
Julius Caesar; Æneas and Anchises.

303 L. Junius BRVtus. Ar[22]
L. Junius Brutus, moneyer.

304 L. MANLIVs PROQ L. Cornelius SVLLA. Ar
Q. Pompeius Rufus, moneyer; L. Cornelius Sulla.

305 L. MEMMius Gall Ar
L. Memmius Gallus (?), moneyer.

306 Q. Minutius THERMus. M.F. Ar.
Q. Minucius Thermus, moneyer.

[16r]

307 M. Papirius CARBonus. Ar.
M. Papirius Carbo, moneyer.

308 M PLAETORIus CESTIVS. C. Ar.
M. Plaetorius Cestius, moneyer.

309 L. PLAVTus PLANCus. Ar.

L. Plautus Plancus, moneyer.

310 Q. POMPEius. QF. RVFVS. COS. L
Cornelius SVLLA. CO. Ar.
Q. Pompeius Rufus, moneyer; L. Cornelius Sulla.

311 C. Portius CATO. Ar. \\Roma//
C. Porcius Cato, moneyer.

312 C. SERVILIVS. M. F. Ar.
C. Servilius, moneyer.

313 L. SCRIBONius. Libo.
BONEVENT. Ar.
L. Scribonius Libo, moneyer.

314 L. THORIVS BALBVS. Ar.
L. Thorius Balbus, moneyer.

315 L. TITVRius SABINus. Ar.
L. Titurius Sabinus, moneyer.

316 P. Titurius SABINus. Ar.
L. Titurius Sabinus, moneyer.

317 C. Valerius FLACcus. Ar.
C. Valerius Flaccus, moneyer.

318 L. VALERIus Flaccus. Ar.
L. Valerius Flaccus, moneyer.

319 C. VIBIVS. C. F. Ar. [23]
C. Vibius, moneyer.

320 C. VIBIVS. C. F.
PANSA. - Ar.
C. Vibius Pansa, moneyer.

321 Fabius MAXImus. Ar.
Q. Fabius Maximus, moneyed.

322 Ti SEMPRONius Graccus III VIR. Ar.
Ti. Sempronius Gracchus, moneyer.

323 SABINus
HISPAN. Ar.
M. Minatius Sabinus, moneyer.

324 Augustus CAESAR IMP. VII. Ar. \\R ASIA
RECEPTA//
Augustus; Asia Recepta [the East regained].

325 FLORA. PRIMVS. Ar.
C. Servilius, moneyer; *rev.* Floral Primus.

326 M. Æmilius Lepidus. Ar. vid. Fulv. Ursin.
fam. Rom. p. 7[24]
M. Aemilius Lepidus. Orsini 1577, p. 7.

327 L. Juli Bursio. Ar. vid ful. Urs. p. 122[25]
L. Julius Bursio, moneyer. Orsini 1577, p. 122.

328 C. NÆvius Balb. Ar. Ibid. p. 172. \\Numisma
serratū.//
C. Nævius Balbus, moneyer. Orsini 1577, p. 172. Serrate coin.

329 L. PISO L F. FRugi. Ar. Ibid. p. 44
L. Piso Frugi, moneyer. Orsini 1577, p. 44.

330 Q. Pompeius Rufus. Ar. Ibid. p. 208.
Q. Pompeius Rufus, moneyer. Orsini 1577, p. 208.

331 C. Servilius. Ar. Ibid. p. 240.
C. Servilius, moneyer. Orsini 1577, p. 240.

[21][-d]
[22]**[f.14v]** [-Hispania - Q]

[23]**[f.15v]** * Ex dono Dn Gul. Charleton. e med. Templo. Lond.
The gift of William Charleton of Middle Temple, London.
[24][-Q]
[25][-d\+]

332 C. Sulpicius. C. F. Ar. Ibid. 254.
C. Sulpicius, moneyer. Orsini 1577, p. 254.

333 Q. Titius. Ar. 261. Ac aliud Numisma familiæ insertæ Ar
Q. Titius, moneyer. Another coin issued by the family [].

334 Roma Urbs. Ær. \\x Britannicum esse nullus dubito.//
City of Rome; no doubt a British coin.

[17r]

335 Imp. Cæsar Vespasianus Aug. Caput laureatū. Pont max. TR.P. Cosi vj. figura sedens dextra ramum tenens, sinistra innixa sellæ. Ar.
Vespasian, his head wreathed in laurel; seated figure holding a branch in the right hand, leaning with the left on the stool.

336 Imp. Trajano Aug. Ger. Dac. P.M.TR.P
Cos. v. P.P. SPQR. Optimo Princ. figura stolata stans dextra ramum, sin. pilum, cum Struthione. Ar.
Trajan. Optimo princeps; a standing figure wearing a stola, a branch in her right hand and a javelin in her left, with an ostrich.

337 Hadrianus Augustus Cos. III. Luna Crescens in cujus medio stella. Ar. Indescr.
Hadrian. A crescent moon with a star in the centre; not previously described [in print].

338 Antoninus Aug. pius P.P. Cos. III.
Clementia Aug. Figura stans dextra pateram porrigens, sinistra Hastile. Ar.
Antoninus Pius. Clementia Augusti; figure standing with a dish held out in the right hand and a spear in the left.

339 Antoninus Aug. Pius P.P.
Cos. IIII. Dextræ junctæ cū duabᵉ Spicis, tenentes Caduseū. Ar. deaur
Antoninus Pius. Right hands clasped with two ears of corn, holding a caduceus.

340 Divus Antoninus. Ar.
The deified Antoninus.

341 Diva Aug. Faustina. - Mater.
Pietas Aug. Figura ad Arā sacrificans. Ar.
The divine Faustina. Pietas Augustae; figure sacrificing at an altar.

342 Julia Augusta - Septim. Severi.
Pudicitia. Pudicitiæ sedentis typus. Ar deaurat.
Julia Domna, wife of Septimius Severus. Pudicitia; Chastity seated.

343 Antoninus Augustus. - Caracalla.
Rector Orbis. Figura nuda stans dext. globū, sin. Pilū. Ar.
Caracalla. Rector Orbis; a standing naked figure, with a globe in the right hand and a spear in the left.

344 D.N. Mag. Maximus P.F. Aug.
Virtus Romanorū. Roma sedens cum Casside in capite et sphæra in dextra. Ar. deaurat. \\TRPS//
Magnus Maximus. Virtus Romanorum; Roma seated, with a helmet on her head and a globe in her right hand. Exergue: TRPS.

345 D.N. Arcadius. P.F. Aug.
Urbs Roma. figura galeata sedens, dextra Victoriolan, sinistra hastā tenens. Ar. [-] Indesc. \\TRPS//

Arcadius. Urbs Roma; city of Rome: a seated, helmeted figure with a Victory in her right hand and a spear in her left; not previously described [in print]. Exergue: TRPS.

346 D.N. Athalaricus Rex.
King Athalaric.

347 Numisma signat. Capite humano. in Reverso M.A. Ar.
Medal struck with: *obv:* a human head; *rev:* M.A.

348 Numisma ut puto signat, capite Caroli quinti Ar.
Medal struck with, I believe, the head of Charles V.

[349] Numisma aliud signat. capite Regio. Ar.
Another medal struck with the head of a king.

350? Duo alia Numismata signat.. Imperiali in Reverso... /1621 2\²⁶
Two other medals struck with; *rev:* Imperial [...].

[18r]

351 Rupia communis sive Tridrachmum argenteum Magni Mogoli. Giihân Ghîr a Trinûr (sive Tamberlano) noni, signat. Ahmed-abâdæ A.° Hegiræ 1027. Xᵗⁱ. 1617. Regni. 13. in Reverso, Sol, in Cancro. Ar. 7 pw. 8. gr.²⁷
Common rupee or three-drachma silver piece of the Great Mogul Jahangir, the ninth after Timur or Tamburlaine; struck in Ahmadabad, in AH 1027 (1617 in the Christian calendar), the 13th year of his reign; *rev:* the Sun, in Cancer.

352 Rupia alia ejusdem Imperatoris eodem Loco et Anno signat. in Reverso Sol in Tauro. Ar. ejusdem ponderis.²⁸
Rupee of the same Emperor, struck in the same place and year; *rev:* the Sun in Taurus. The same weight.

353 Rupia alia Com. ejusdem Imperatoris signat. Suratæ Anno Hegiræ 1034. Regni 19. Ar. 7 pw. 9 gr.²⁹
Another rupee of the same Emperor; struck in Surat in AH 1034, the nineteenth year of his reign.

356 Semi-Rupia, a half Rupih, ejusdem Imperatoris signat etiam Suratæ A°. Regni. 35. Ar. 3 pw. 16 gr. \\[-N...]//³⁰
Half-rupee of the same Emperor, also struck in Surat, in the thirty-fifth year of his reign

357 Mahmûdia forte Gjihân Ghîr, in qua inscript. Gjelâl Eddîn A° Hegiræ 1012. Ar. 3 pw. 15 gr.
A mahmudi, probably of Jahangir, with the inscription Jalal al-Din. AH 1012.

²⁶[f.16v] *Johans von Gott. Gna: Frwezu norwe Herzuo schl Hol:
²⁷[-d] [-d] [f.17v] 351. A Rupia alia. Ex Dono, D.ⁿⁱ Eyres. \\Best Cabinet.// An: D.ⁿⁱ 1749. Coins in the Cabinet at the lower End of the Musæum the first Drawer beginning at number (351) & ending at number (442). \\Ph//
²⁸| [f.17v] | Notandum nummos quibus hæc nota adjuncta est 21 Sept. Anno 1691. Sublatos fuisse.
Note that the coins to which this note has been added on 21 Sept 1691, were removed.
²⁹| *(see footnote to no. 252)* [-O]
³⁰[f.16v] 356.b. Semi-Rupia alia una cum Quadrante Rupia Dono dedit D.° Eyres, A. D. 1749.
Another half-rupee, with a quadrant rupee. Given by Mr. Eyres, 1749.

358 Mahmûdia Imperatoris Mogolorū Acber, a Timûr sive Tamerlano octavi, ejusdem ponderis. Ar.
A mahmudi of the Mogul Emperor Akbar, the eighth after Timur or Tamburlaine, of the same weight.

359 Mahmûdia alia ejusdē Imperatoris ac ponderis. Ar.
Another mahmudi of the same Emperor and of the same weight.

360 Mahmûdia alia ejusdē Imperat. ac pond. Ar.
Another mahmudi of the same Emperor and of the same weight.

361 Mahmûdia alia ejusdē Imperat. ac pond. Ar.
Another mahmudi of the same Emperor and of the same weight.

362 Semi-Mahmûdia sive drachma ejusdem Imperatoris a half Mahmûdi. Ar. 1. pw. 18 gr. \\[-]//
Half-mahmudi or drachma of the same Emperor.

363 Quadrans Mahmûdiæ Imperatoris Mogolorū Gjihân Ghîr signat. A°. Hegjræ 1014. Ar. 19. gr. \\[-]//
A quarter-mahmudi of the Mogul Emperor Jahangir, struck AH 1014.

364 Numisma aliud Mogolorū. Aur. 8 gr.
Another Mogul coin.

365 Aliud ejusdem ponderis. Aur.[31]
Another of the same weight.

366 Abbasia Persica, An Abbâsi. Ar. 4 pw. 18 gr. Didrachmum Persicum, Imperatoris Abbâtis.
A Persian abassi; a Persian two-drachma piece of the Emperor Abbas.

367 Semi-Abbasia sive drachma Persica, ejusdē Imperatoris 2. pw.1 gr. Ar.
Half-abbasi or Persian drachma of the same Emperor.

368 Semi-Abbasia alia. 2 pw. 9 gr. Ar.
Another half-abassi.

369 Semi-Abbasia alia. 2 pw. 12 gr. Ar \\x deest//
Another half-abassi.

[370] Laria, sive Moneta Civitatis Lar in Persia. Larî dic...
A larin, or coin of the city of Lar in Persia.

[371] ...lia Ar. Utraque.. 3 pwgr.

[19r]

372 Moneta Turcica Asper dicta. 2 gr. Ar.
Turkish coin known as an asper.

373 Asper duplex. 4 gr. Ar.
A double asper.

374 Asper quintuplex. Bejh-lik dict. 10. gr. Ar.
A five-asper piece known as a Beshlik.

375 Moneta Marocciensis gran. circiter. 16. vel. 18. Ar. n [-][32]
Moroccan coin.

376 Moneta Marocciensis gran. circiter 14. Ar. num. 2. \\x deest.//[33]
Moroccan coin.

377 Moneta Marocciensis gran. circiter. 2. vel. 3. Ar. n. [-\10]
Moroccan coin.

378 Moneta Moscovitica sive Russiensis. gr. circit. E 10. n. 5. Ar[34]
Muscovite or Russian coin.

379 Moneta Moscovitica gran. circit. E 8. num. 9. Ar[35]
Muscovite coin.

380 Moneta Moscovitica gr. circit. E 6. vel. 7. num 9./[-10]\Ar[36]
Muscovite coin.

381 Moneta seu potius lamina inscripta literis Sininsis, inusitatæ formæ \\[-N.2.] //Ar.\\ & Ær. [-]//.
Medal or perhaps a coin, inscribed with Chinese letters, of unusual form.

382 Lamina signata (ut puto) figuris Vulcani, Veneris, et Cupidinis. Ær. \\[-x deest.]//
Coin struck with, I believe, the figures of Vulcan, Venus and Cupid.

383 Lamina tessellata, figuris 20 Sāctorū impressa, in basso relievo. Ær.
Tesselated coin impressed with the figures of twenty saints in low relief.

384 Lamina tessellata, totidē Sanctorū figuris, eodem modo impressa. Ær.
Tesselated coin impressed in the same way with a similar number of saints.

385 Lamina Rhomboidalis insculpta transfiguratione Dñi nři JESU Christi in Monte. Ar. deaurat.
Rhomboid coin incised with the Transfiguration of Our Lord Jesus Christ on the Mount.

386 [-Numisma signatum figura Loti vinum bibentis cum filiabus suis, in obverso; et figura Davidis Bath Schibam se lavantem, de secto domus suæ conspicientis in Reverso. Ar. deaurat. \\+ Moneta Siamensis informis, Kopêk dicta n.2. Ar.// \\Numus Sinensis eodem ...//]
Coin struck with: obv: Lot drinking wine with his sons; rev: the figure of David watching Bathseba washing herself, from a part of his house.
An unshapely Siamese coin called a kopek. The same Chinese coin.

387 Numisma impressum figura Davidis cum Schaule disserentis de exitu suo in Goliatum Pelischthæum, in obverso; et figurâ Angeli

[31] d | [-I] **[f.17v]** In loc: amissi substituitur Numisma orientale. Ær: arabicis vel Persicis characteribus /ut puto\ signatum.
In the place of the one missing, an oriental coin, struck with (I think) Arabic or Persian characters.
[32] **[f.18v]** de: [-deest(?)\x]

[33] **[f.18v]** [-]
[34] **[f.18v]** Nowgrote[-] dicta. Hackluits voyages pag. [].
Said to be [?] of Novgorod. Hackluyt's *Voyages*, p. [].
[35] **[f.18v]** Denga dicta. Hackluits voyages pag. [].
Said to be a denga. Hackluyt's *Voyages*, p. [].
[36] **[f.18v]** Poledenga dicta (bracketed with footnotes for 378 & 379 vi[-de]. Hackluits voyages. pag. [].
Said to be a denga. See Hackluyt's *Voyages*, p. [].

Gabrielis B. Mariã Virginẽ salutantis, in Reverso.
Ar. deaurat. \\deest.//
Coin. *obv:* the figure of David with Saul; *rev:* the angel
Gabriel greeting the Blessed Virgin Mary.

388 Emblema Patientiæ opere anaglyptico. Ar.
deaurat.
The emblem of Patience, in low relief.

389 [-Emblema Mortalitatis forma ovali.] Ar.
\\Nummus cupreus suecic⁹ Signat 3.ᵇᵘˢ coronis &
Litteris C.R.S. .1. Carolus Rex Sveciæ. 1667.//³⁷
The emblem of Mortality, oval in outline. Swedish copper
coin struck with three crowns and the letters CRS: Charles,
King of Sweden.

390 Emblema 'Αντιπελαργιας, Puerperæ sc.
patrem familioru in Ca... cere lactantis. Ar. * [- ...
Hispanioru R 1642].³⁸
The emblem of 'cherishing': a woman with child suckling her
father in a prison-cell.

[20r]

391 Gott Durch Bergfall versuncken hat. Ar. ³⁹

392 Alles was war in Plure der Stat. Ar. ⁴⁰

[3]93 Numisma signatum capitibus. Rudolphi 1ᵐⁱ,
Alberti 1ᵐⁱ, Frederici 3ᵗⁱʲ, Alberti 2ᵈⁱ, Frederici 4ᵗⁱ,
Impp. Ar. [Inserted from f.19v]
Medal struck with the heads of Emperors Rudolf I, Albrecht
I, Frederick III, Albrecht II and Frederick IV.

39[4] Numisma signat. capitibus Maximiliani 1ᵐⁱ,
Caroli quinti, Ferdinand 1ᵐⁱ, Maximiliani 2ᵈⁱ et
Rudolphi 2ᵈⁱ. Ar.
Medal struck with the heads of Maximilian I, Charles V,
Ferdinand I, Maximilian II and Rudolf II;

39[5] Numisma signatum Insignijs Regum
Suesiae, cum Emblematibus adjunctis. Ar.
Coin struck with the arms of the King of Sweden, with
associated emblems.

**Numismata Musæo Ashmoleano donata, a
Reverendo admodũ in Christo Patre ac D. Dño
Johanne Episcopo Oxoniensi. A.° 1685**
Coins given to the Ashmolean Museum by the Revd
Father in Christ Master John [Fell], Bishop of Oxford, in
the year 1685

396 /Nummus Suecicus ôr dictus. [-Numisma ad
Inaugurationẽ Serenissimi Principis Jacobi 2.ᵈⁱ D.
G. Angl. Regis etc. percussũ. Aur.⁴¹
Swedish medal, said to be of gold. Medal struck for the
inauguration of the most serene prince James II, King of
England.

397 [-Numisma ad Inaugurationẽ Serenissimæ
Principissæ Mariæ Beatricis D. G. Angl. Regin
etc. p̱ Cussu. Ar.⁴²
Medal struck for the inauguration of the most serene
princess Mary Beatrice, Queen of England.

397a Numisma exequiale Sereniss.ᵃᵉ principis
MARIÆ magnæ Britanniæ &c. Reginæ. Ær. Ex
dono \\One Joannis// Ratcliffe M.D.
Medal struck for the funeral of the most serene princess
Mary, Queen of England. The gift of Dr John Radcliffe.

[-398] [-Numisma ex ... argento cusum ... Angli
navi Hispanorum (prope Jamaicam) ... fragâ ... Ex
dono Theoph. Leigh. Armig.]⁴³
Medal struck from the silver [found] by the English ... in the
wreck of a Spanish ship (near Jamaica) ... Given by
Theophilus Leigh, Esq.

**Catalogus Numismatũ quæ Ornatissimus Vir
Martinus Lister M.D. eidem Musæo contulit.
A.° 1683.**
Catalogue of the coins which that most distinguished
man Martin Lister, MD, gave to the same Museum in the
year 1683

[21r]

397b M. Agrippa L. F. Coss. III. Caput Agrippæ
cũ Corona rostratâ. S.C. Neptunus cum Delphino
dextra, Tridente sinistra. Ær.
Agrippa. The head of Agrippa in a radiate crown; Neptune
with a dolphin in his right hand and a trident in his left.

398 Divus Augustus. Caput Augusti
S.C. Imp. Nerva Cæsar Aug. REST. Ær.
The deified Augustus. Head of Augustus. Issued under
Nerva.

399 /3\ Claudius Caesar Aug. P. M. TR. P. IMP.
Caput Claudij. S.C. Libertas Augusta. Libertatis
typus cũ pileo. Ær.
Claudius. Head of Claudius. Libertas Augusta; Liberty with a
javelin.

400 /1\ Divus Augustus Pater. Caput Augusti.
SC. PROVIDENT. Templum Jani. Ær.
The deified Augustus. Head of Augustus. Providentia;
temple of Janus.

401 /2\ Cæsar Aug. Germanicus. Pon. M. TR. Pot.
S.C. Vesta. Vesta insidens. subsellio dextra
pateram, sinistra hastam tenens. Ær.
Germanicus [Caligula]. Vesta; Vesta seated on a bench,
holding a dish in her right hand and a spear in her left.

402 Nero Cæsar Aug. Germ. TR.P. Caput Neronis
laureatũ. S.C. Templũ Jani clusum. Pace P.R.
Ubique parta Janum clusit. Ær.
Nero. Head of Nero wreathed in laurel. Templum Jani
clausum; the Temple of Janus closed.

403 Imp. Vespasianus Aug. P.M. TR.P. Caput
Vespasiani. S.C. Aquila insistens globo. ælis
expansis. Ær.
Vespasian. Head of Vespasian. An eagle standing on a
globe, its wings extended.

³⁷|d
³⁸|d [**f.18v**] *The Storcks teach us how we must honour our
worthy Parents upon Earth. on the Obverse
 The Roman Woman loveth her Father and giveth him
norrishment at her breast. on the Reverse. These Medalls are
commonly given at Christenings ... in Germany. d.
³⁹fract: [**f.19v**] God thrô the fall of a Hill buryed
⁴⁰[**f.19v**] All there were in the Towne of Pleurs
⁴¹[-d]

⁴²[-d]
⁴³[-d]

404 Imp. Cæs. Vespasian. Aug. P.M. TR.P. Cos.
V. Caput Vesp. S.C. Roma. Figura militaris stans
dextra Victoriolã sinistra hastam. Ær.
Vespasian. Head of Vespasian. Roma; military figure
standing with a Victory in his right hand and a spear in his
left.

405 Imp. Cæs. Vespasian Aug. Cos. IIII. Caput
Vesp.
S.C. Pax Aug. Dea Pax dextra paterã super Ara,
sinistra Caduceũ et ramũ palmæ aut oleæ. Ær.
Vespasian. Head of Vespasian. Pax Augusti; Goddess Pax
with a dish in her right hand over an altar, and a caduceus
and a palm or olive branch in her left.

406 Imp. Cæs. Domit. Aug. Germ. Cos. XIIII.
Cens. perp. P.F. S.C. Fortunæ Augusti. Fortunæ
typus cũ temone et Cornucop.
Domitian. Fortunæ Augusti; Fortuna, with a rudder and
cornucopia.

407 Imp. Nerva Cæs. Aug. P.M. TR.P. Cos. III.
P.P.
S.C. Fisci Judaici Calumnia sublata Palma. Ær.
Nerva. Fisci Judaici Calumnia; raised palm.

[22r]

408 Imp. Cæs. Nerva Trajan. Aug. Germ.
P.M. TR.P. Cos. IIII. P. P. Victoria stans corã
Arâ accensa, dextra paterã, sinistra palmã. Ær.
Trajan. Victory standing before a lighted altar; a dish in her
right hand, a palm branch in her left.

409 Imp. Cæs. Nervæ Trajano Aug. Ger. Dac.
P.M. TR.P. Cos. vj. P.P.
*S.C. S.P.Q.R. Optimo Principi. Portus
Aõonilanus. Ær.[44]
Trajan. Optimo Principi; the Gate of Ancona.

410 Hadrianus Aug. Cos. III. P.P. Caput Hadriani
laureat.
S.C. Spes P.R. Spei typus dextra florẽ, sinistra
stolã sublevans. Ær.
Hadrian. Head of Hadrian wreathed in laurel. Spes; Spes
holding a flower in her right hand and raising her stola with
the left.

411 Antoninus Aug. Princ. P.P. TR.P. Cos. IIII.
Caput Ant. Laur.S.C. Felicitas Aug. Figura
stolata stans dextra Ibicem, sinistra Caduceũ. Ær.
Antoninus. Head of Antoninus wreathed in laurel. Felicitas
Augusti; standing figure in a stola, with an ibis in her right
hand and a caduceus in her left.

412 M. Antoninus Aug. Germ. TR.P. XXIX.
Caput Aurelij.
SC. Mars gradivus dextra Victoriolã, sin.
trophæu. Ær.
Aurelius. Head of Aurelius; Mars walking, a Victory in his
right hand and a trophy in his left.

413 Aurelius Cæs. Antoninus. Caput Aurelij.
S.C. /TR.POT.X.\ Figura lato velamine, dextra
stolã sublevans sinistra temonem. Ær.

Aurelius. Head of Aurelius; a veiled figure raising her stola
with her right hand and with a staff in her left.

414 M. Antoninus Aug.
Figura procumbens corã Imperatore. Ær.
Antoninus. A prostrated figure in the presence of the
Emperor.

415 Aurelius Cæsar Aug. Pij F.
S.C. TR. POT. XIIII. Cos. II. Mars gradiens cum
hasta et Trophæis.
Aurelius. Mars walking with a spear and with trophies.

416 Aurelius Cæs. Aug. Pij F. TR.P. Cos. II. Caput
Aurelij.
S.C. Pallas dextra hastã sinistra scutum. Ær.
Aurelius. Head of Aurelius. Pallas with a spear in her right
hand and in her left a shield.

417 Imp. Alexander pius Aug. Caput Alexandri
laureat.
Mars ultor Mars gradiens dextra hastã sinistra
scutum. Ar.[45]
Alexander Severus. Head of Alexander wreathed in laurel.
Mars Ultor; Mars walking, in his right hand a spear and in his
left a shield.

418 Imp. Gordianus pius fel. Aug. Caput Gordiani
S.C. Liberalitas Aug. III. Figura stans dextra
tenens tesseram frumentariã, sinistra duplicem
Cornucopiam.
Gordian. Head of Gordian. Liberalitas Augusti; standing
figure holding in the right hand a token for the distribution of
corn, in the left hand a double cornucopia.

[23r]

419 M. Jul. Philippus Cæs. Caput Philippi F.
S.C. Principi Juventutis. Figura militaris, dextrâ
gladium, sinistrâ hastã gestans. Ær.
Philip II. Head of Philip. Principi Juventutis; military figure
with a sword in his right hand and a spear in his left.

420 M. Jul. Philippus Cæs. Caput Philippi F. cũ
Coron. Radiatâ.
Principi Juvent. Figura militaris stans, dextra
globum, sinistra hastã. Ær.[46]
Philip II. Head of Philip with a radiate crown. Principi
Juventutis; standing military figure with a globe in his right
hand and a spear in his left.

421 Imp. C. Allectus P.F. Aug. Caput Alecti.
Lætitia Aug. Q. C. Navis.[47]
Allectus. Head of Allectus. Lætitia Augusti; a ship.

422 Imp. C. Postumus P.F. Aug. Caput Postumi
/Coronâ\ radiatâ.
Herc. Deus Oriens. Hercules dextra clavam,
sinistrâ pellem Leonis gestans. Ær.
Postumus. Head of Postumus with a radiate crown. Hercules
Deusoniensis, Hercules with a club in his right hand and the
skin of a lion in his left.

423 Imp. C.M. C. L. Tacitus Aug. Coronâ radiata.

[44][f.21v] vid Numismata Ducis Croyiaci Tab. 33.
See Croy 1654, tab. 33.

[45][-d]
[46]|
[47]|

Providentia Aug. Figura militaris stans ante globũ humi jacentem, sinistra Cornucop. Ær.[48]
Tacitus. Head of Tacitus with a radiate crown. Providentia Augusti; military figure standing before a globe lying on the ground, with a cornucopia in his left hand.

424 Imp. C.M. Aur. Probus Aug. Caput Probi Coron. Radiat.
Oriens Aug. Figura Solis capite radiato. Ær.[49]
Probus. Head of Probus with a radiate crown. Oriens Augustus; figure of Sol with a radiate crown.

425 Imp. C. Diocletianus P.F. Aug. Caput Diocl. Laureat.
Genio Populi Romani. Genius stans cũ paterâ et Cornucopia. Infra LON. Ær.
Diocletian. Head of Diocletian wreathed in laurel. Genio Populi Romani; a Genius standing with a dish and a cornucopia. Exergue: LON.

426 Imp. Maximianus P. Aug. Caput Maxim laureat.
S.F. Genio Populi Romani. Genius stans ut supra. Ær.
Maximian. Head of Maximian wreathed in laurel. Genio Populi Romani; Genius standing, as above.

427 Fl. Val. Constantius Nob. C. S.F. Genio Populi Romani, Genius nud⁹ stans etc. Ær.
Constantius I. Genio Populi Romani; nude Genius standing, etc.

428 Divo Constantio Pio. Caput Const. Laureatũ.
Memoria felix P. LN. Duæ Aquilæ juxta arã. Ær.
The deified Constantius. Head of Constantius wreathed in laurel. Memoria Felix; two eagles by an altar.

429 \\x// G. Val. Maximianus. Caput Maxim laureat.
Genio Populi Romani. Geni⁹ stans ut supra. Ær.[50]
Maximian. Head of Maximian wreathed in laurel. Genio Populi Romani; Genius standing, as above.

430 Constantinus Aug. Caput Constantini.
T.F. Soli invicto comiti. figura Solis ut supra. Ær.[51]
Constantius. Head of Constantius. Soli invicto comiti; figure of Sol as above.

431 Imp. Constantinus P.F. Aug. Caput Constant. Laureat.
T.F. Marti Patri Conservatori. Mars gradiens dextra hastã, sinistra clypeum. Ær[52]
Constantius. Head of Constantius wreathed in laurel. Marti Patri Conservatori; Mars walking with a spear in his left hand and a shield in his right.

[24r]

432 /4\ Crispus Nob. Cæs. Caput Crispi laureat.
Cæsarum nostrorum, intra coronam querceam. VOT.X. Ær.

Crispus. Head of Crispus wreathed in laurel. Cæsarum nostrorum; VOT.X. within a crown of oak [*coronica civica*].

433 /1\Imp. Constantinus P.F. Aug.
Principi Juventutis. Figura militaris utraque manu tenens signum militare. P.LN. Ær.
Constantine. Principi Juventatis; military figure holding in either hand a military standard. Exergue: P. LN.

434 /2\Constantinus PF Aug. Caput Const. laureat.
Marti Conservatori. Caput Martis galeat. Ær.
Constantine. Head of Constantine, wreathed in laurel. Marti Conservatori; helmeted head of Mars.

435 /3\Constanti[-]us Nob. C. Constanti[-]i Caput laureat.
S.N. Genio Populi Romani. Genius nudus stans ut supra. P.TR.
Constantine. Head of Constantine wreathed in laurel. Genio Populi Romani; standing nude Genius. Exergue: P. TR.

436 D. N. Magnentius P.F. Aug. Caput Magnentij.
A W Nota /2\ Christianismi ex duabus primis literis nominis Christi. Salus /1\ DD. NN. Aug. et Cæs. infra. AMB.
Magnentius. Head of Magnentius. Salus Augusti et Caesari; Christian symbol comprising the first two letters of the name of Christ. Exergue: AMB.

437 Constantinus Max. Aug. Constantini Caput
Gloria Exercitus. duo Milites galeati et hastati stantes, inter eos duo signa Militaria. Ær.
Constantine. Head of Constantine. Gloria Exercitus; two standing soldiers with helmets and spears, between them two military standards.

438 Imp. C. Tetricus PF. Aug. Caput Tetrici Patr. Corona radiat.
Pax Aug. Dea Pax stans sinistra hastam dextra ramum gestans. Ar[53]
Tetricus. Head of Tetricus with a radiate crown. Pax Augusti; the goddess Pax standing with a spear in her right hand, and a branch in her left.

439 C. Pivesu. Tetricus Cæs. Caput Tetr. filij Corana radiatâ.
Spes publica. Dea Spes dextra ram, sinistra... Ær.
Tetricus. Head of Tetricus in a radiate crown. Spes Augusti; the goddess Spes with a branch in her right hand and [] in her left.

440 Imp. C. Claudius Aug. Caput Claudij Coron. radiat.
Felicitas. figura stolata stans dextra Caduceum tenens. Ær.
Claudius. Head of Claudius with a radiate crown. Felicitas; standing figure in a stola holding a caduceus in her left hand.

441 Imp. C. Claudius Aug. Caput Claudij Corona radiat.
Victoria Aug. Victoria stans dextra [-palmam\ ramum] sinistra palmam gestans. Ær.
Claudius. Head of Claudius with a radiate crown. Victoria Augusti; standing figure of Victory with a branch in her right hand and a palm in her left.

442 Imp. C. Victorinus P.F. Aug. Caput Victorini Coron. [-laureat\radiat]...militi...stans dextra hastã sin.clypeũ.

[48]ll[-d]
[49][-l d l]
[50][f.22v] C
[51][-l]
[52][-l] 431 Duos invenimus
We have found two.

[53]l

80

Victorinus. Head of Victorinus with a radiate crown. ...
standing military figure with a spear in his right hand and a
shield in his left.

[25r]

Catalogus Numismatum Musæo Ashmoleano legatorũ per Cl. Virũ Thomam Brathwait de Ambleside in Comitatu Westmorlandiæ Armigerũ defunct. Aº Dn 1684

Catalogue of coins bequeathed to the Ashmolean Museum by that distinguished man Thomas Braithwait Esq., of Ambleside in Westmorland, who died AD 1684.

443 ΑΛΕΞΑΝΔΟΥ, in obverso Pallas cum Casside; in averso Victoria pennata cum Corona et Tridente, navalem aliquam Victoriam denotante. Aur[54]

Alexander. obv: Pallas with a helmet; *rev:* a winged Victory with a crown and trident denoting a naval victory.

444 Caput Romæ cum nota Denarij; in Reverso Castor et Pollux equitantes, infra ROMA. Ar.
Head of Roma with the mark of a denarius; *rev:* Castor and Pollux on horseback. Exergue: ROMA.

445 ANTonius AVGustus /*\, cum Navi Prætoriâ, in Obverso. LEG.III. Classica, cum signis Militarib° in Reverso, Ar. vid. Fulv. Ursini fam. Rom. p. 27[55]
Mark Antony. *obv:* the third legion, the Classica; *rev:* with military standards. See Orsini 1577, p. 27.

446 Julius CÆSAR cum Elephante, Cæsaris Victoriam in Jubam Mauritaniæ Regē significante, in Obverso. Signa Pontificialia, in Reverso. Ar. Ibid. p. 116.
Julius Caesar. *obv:* Julius Caesar with an elephant, signifying victory over Juba, King of Mauretania; *rev:* insignia of the Pontificate. Orsini 1577, p. 116.

447 ROMA. Caput Romæ, in Obverso.
C. SERVILIus M F. cum Sp. Melio et C. Servilio Ahala, Equestri ordinis, pugnantibus. Ib. p. 241. Ar.
Roma. *obv:* Head of Roma; *rev:* Sp. Melius and C. Servilius fighting on horseback. Orsini 1577, p. 241.

448 TI. Cæsar Divi Aug. F. Augustus. Caput Tiberij
Pontif. Maxim. Muliebris figura sedens cum hasta purâ et Lauri ramo. Ar.
Tiberius. The head of Tiberius; seated female figure with a spear without a head and with a laurel branch.

449 Imp. Nero Cæsar P.F. /*\ Neronis Caput laureat.
Jupiter Custos, Jupiter insideus subsellio, cum fulmine dextra, et hastâ in sinistra. Aur[56]
Nero. Head of Nero wreathed in laurel. Jupiter Custos; Jupiter sitting on a bench with a thunderbolt in his right hand and a spear in his left.

450 Imp. Otho. Cæsar Aug. TR.P. Caput Othonis.
Securitas P.R. figura stolata stans, dextra sertum, sinistra hastan gestans. Aur.

Otho. Head of Otho. Securitas Publicae Romanae; standing figure wearing a stola, holding a wreath in her right hand and a spear in her left.

451 Imp. Cæs. Vespasian. Aug. P.M. Cos. III. Caput Vesp. laureat.
Augur. TRI.POT. Quatuor signa Pontificialia, Capeduncula, Aspergill, guttus, Lituus. Ar.
Vespasian. Head of Vespasian wreathed in laurel; the four insignia of the Pontificate - a sacrificial bowl, a sprinkler, an oil lamp, an augural wand.

[26r]

452 Imp. Cæs. Vespasianus Aug. Caput Vespasiani laureat. Pon. Max. Figura sedens, sinistra sellæ incumbens, dextra ramum Lauri. Ar.
Vespasian. Head of Vespasian wreathed in laurel; seated figure leaning with his right hand on a bench and holding a laurel branch in his left.

453 Imp. Titus Cæs. Vespasian. Aug. P.M. Caput Titi laureat. TR.P.IX. IMP.XV. COS.VIII.PP. Sella Curulis Coronata. Ar.
Titus. Head of Titus wreathed in laurel; a crowned consular seat.

454 Imp. /2\Cæs. Domit. Aug. Germ. P.M. TR.P. VII. Caput Domit. laur. IMP. XIIII. COS. XIIII. CENS.P.P.P. Pallas armata stans, dextra pilum, sinistra clypeum. Ar.
Domitian. Head of Domitian wreathed in laurel; Pallas in armour standing, with a javelin in her right hand and a shield in her left.

455 VRBS ROMA: Caput Romæ in obverso. Lupa Romulũ & Remũ lactans, supra quã duæ stellæ. Quod Antiquarij potius pondusculũ, quam Numisma existimant, a Sex. Pomp. Faustulo cusũ, Imp. Titi Vespasiani jussu. vid. Hub. Goltz. in præfat. ad Lect. Ær.
City of Rome. *obv:* head of Roma; *rev:* the wolf suckling Romulus and Remus with two stars above. See Goltz 1576, preface.

456 Imp. Nerva Cæs. Aug. P.M. TR.P.II. COS.III. P.P. Æquitas August. Æquitas cum staterâ et Cornucop. Ar.
Nerva. Æquitas Augusti; Aequitas with scales and a cornucopia.

457 Imp. Cæs. Ner. Trajan. optim. Aug. Germ. Dac. Caput Traj. laureat. Parthico. P.M. TR.P. COS.VI. P.P. S.P.Q.R. Figura stolata stans; dextra ramum, sinistra Cornucopiâ. Ar.
Trajan. Head of Trajan wreathed in laurel; standing figure in a stola, with a branch in her right hand and a cornucopia in her left.

458 Imp. Trajano Aug. Ger. Dac. P.M. TR.P. COS VI.P.P. S.P.Q.R. Optimo Principi AET.AVG. figura stolata stans, singulis manibus caput gestans, forte Solis et Lunæ. Ar.
Trajan. Optimo Principi; standing figure in a stola, carrying in either hand a head, probably of Sol and Luna.

459 Imp. Cæs. Nerva Trajan. Aug. Germ. Caput Trajani laureat. PONT.MAX.TR.POT. COS.II. Figura sellæ insidens coram ara accensa, dextra paterã, sin. Cornucop. Ar.

[54][f.24v] Mr Ashmoles Cabinet. Capsula 2ᵈᵃ-
[55][f.24v] 45. * AVGur.
[56][f.24v] 49 * P.P.

Nerva. Head of Nerva wreathed in laurel. A figure seated on a chair before a lighted altar, holding a dish in the right hand and a cornucopia in the left.

460 Imp. Trajano Aug. Ger. Dac. P.M.TR.P. COS. III./VI\PP. Divus Pater Trajan. Figura sedens, dextra pateram sinistra hastile. Ar.

The deified Trajan. Divus Pater Trajan; the divine father Trajan; a seated figure, with a dish in the right hand and a spear in the left.

461 Imp. Cæs. Nervæ Trajano Aug. Ger. Dac. P.M.TR.P. COS.V.PP. S.P.Q.R. Optimo Principi S.C. Figura stans dextra Ramum Oleæ, sinist. Cornucop. Ær[57]

Trajan. Optimo Principi; standing figure holding an olive branch in the right hand and a cornucopia in the left.

463 [-]

[27r]

464 Imp. Cæsar Trajan. Hadrianus Aug. P.M.TR.P. COS.III. Figura muliebris stans dextra ramũ oleæ, sinistra hastam. Ar.

Hadrian. A standing female figure with an olive branch in her right hand and a spear in her left.

465 Imp. Cæsar Trajan. Hadrianus Aug. PM.TR.P.COS.II. VOT.PVB. Figura muliebris stans utramque manum quasi precando attollens. Ar.

Hadrian. Standing female figure with both hands raised as if in prayer.

466 Imp. Cæsar Trajan. Hadrianus Aug ...
S C. Libertas publica. Figura sedens dextra ramum sinistra hastia. Ær.

Hadrian. Libertas Publica; seated figure with a branch in the right hand and a spear in the left.

467 Antoninus Aug. Pius. P.P. Caput Anton. laureat. COS. IIII. Figura stolata stans dextra paterã sinistra hastã tenens Ar.

Antoninus Pius. Head of Antoninus wreathed in laurel. Figure wearing a stola holds a dish in her left hand and a spear in her left.

468 Antoninus Aug. Pius P.P.TR.P.XVI.
COS. IIII. Figura stans, dextra duas spicas, sinistrã imponens aræ. Ar.

Antoninus Pius. Standing figure with two ears of corn in the right hand and with the left hand on an altar.

469 Divus Antoninus
Consecratio Rogus extractus instar turris in summo Currus, in quo mortui Imperatoris Statua. Ar.

The deified Antoninus. Consecratio; a funeral pyre constructed like a tower, with a chariot at the top in which is placed a statue of the dead emperor.

470 Antoninus. Aug. Pius P.P.TR.P. Britannia Cos. IIII. S.C. Fig. mærens insidens spolijs dexterã capiti admovens. Ær.

Antoninus Pius. A mourning figure seated among the spoils of war, with the head resting on the right hand.

471 \Imp: Ca: Cl: Tacitus Aug./ Diva Faustina. Antonini pij Uxor. Æternitas. Figura muliebris sedens, Phœnisem Orbi in sistentem manu tenens. Ær. vid Numismat Ducis Croyiaci. Tab. 43. n. 19.

Tacitus. The divine Faustina, wife of Antoninus Pius. Aeternitas; seated female figure, holding a phoenix on a globe in her left hand. See Croy 1654, tab. 43 no. 19.

472 Antoninus Cæsar. Aug. Pius Cos...
Signa Pontificialia. Ar.

Antoninus. Pontifical insignia.

473 M. Antoni/n\us Aug. Armeniacus.
Profectio Aug. Aurelius Equo insidens cum hastæ, Imperatoris profectionẽ in Partiam denotans. Ar[58]

Aurelius. Profectio Augusti; Aurelius seated on a horse with a spear, denoting the departure of the Emperor into Parthia.

474 M. Antoninus Aug TR.P.XXIIII. Indescr.
COS. III. Fig. stans cum sagitta in dextra et arcu in sinist. Ar.

Aurelius. Standing figure with an arrow in the right hand and a bow in the left.

475 Divus. M. Antoninus Pius.
Consecratio. Aquila - insistens globo. Ar.

The deified Antoninus Pius. Consecratio; an eagle standing on a globe.

[28r]

476 /Severus\ M. Aurelius Aug. Imp. /VIII\ Pij F. Munificentia Aug. Elephas, in signũ Munificentiæ Antonini in spectaculis exhibendis. Ar. [59]

Caracalla. Munificientia Augusti; an elephant, signifying Antoninus's munificence in public displays.

477 M. Antoninus Aug. Arm. Parth. Max.
TR.P. XXIII. IMP.V. COS.III. Figura sedens, dextra bilancem, sinist. Cornucopiã. S.C. Ær.

Aurelius. A seated figure; in the right hand a balance, in the left a cornucopia.

478 M. Antoninus Augustus. Caput. Anton. Corona radiata. IMP. V. COS. III. S C. Figura galeata sedens dextera Victoriolam, sinistra hastam. Ær.

Aurelius. The head of Antoninus with a radiate crown. A seated helmeted figure with a Victory in the right hand and a spear in the left.

479 Faustinæ Aug. Pij Aug. Fil. - Aurelij Uxor.
VENVS. Venus stans dextra pomum aut globum, sinistra temonem. Ar.

Faustina II, wife of Aurelius. Venus; standing Venus with an apple or a globe in her right hand, in her left a rudder.

480 Imp. L. Aurel. Verus Aug.
Prov. Deor. TR.P. COS. II. Figura dextra globum sinistra Cornucopiã. Ar.

Lucius Verus. Figure with a globe in the right hand and a cornucopia in the left.

[57][-d] * [f.25v] * 462. Imp. Nerva Cæs. Aug. Germ. P.M. TR.P. II. Capt. Nervæ laureat. IMP. II. COS IIII. P.P. Duæ dextra junctæ. Ar.
Nerva. Head of Nerva wreathed in laurel; two clasped right hands.

[58][f.26v] 473 Ad Severum pertinet, Epigraphe omnino detrita: Relates to Severus. Inscription all worn away.
[59][f.27v] 476. Ad Severum * vid. Numismat. Ducis Croyiaci Tab. 42. n. 13.
Relates to Severus. See Croy 1654, tab. 42 no. 13.

481 L. Commodus Aug.

COS.P.P. Figura sedens dextra ramum tenens, sinistro cubito sellæ innixa, ante pedes serpens. Ar.

Commodus. Seated figure holding a branch in the right hand, the left elbow leaning on the chair, with a serpent at the feet.

482 Crispina Augusta - Commodi conjux.

Juno. Figura mulieb. dextra paterã, sinist hastã. Ar.

Crispina, wife of Commodus. Juno; a female figure with a dish in her right hand and a spear in her left.

483 Severus Aug. Part. Max.

Restitutori Urbis. Severus /dextrâ\ paterã in tripodem effundens, sinistra hastã tenens. Ar.

Severus. Restitutori Urbis; Severus pouring with his right hand into a dish on a tripod and with a spear in his left hand.

484 Severus pius Aug.

COS. II. Victoria dextra laureã, sinistra palmam. Ar.

Severus. Victory holding a laurel in the right hand and a palm leaf in the left.

485 Severus Aug. Part. Max.

P.M.TR.P.VIII. COS.II.P.P. victoria gradiens cum fune super scuto. Ar.

Severus. Walking Victory, with a rope over a shield.

486 Severus pius Aug.

Victoria Parth. Max. Victoria gradiens dextra lauream. Ar.

Severus. Victoria Parthicus Maximus; walking Victory, with a laurel in her right hand.

487 Julia Augusta - Severi uxor.

Pietas Aug. Sacrificans ad Arã. Ar.

Julia, wife of Severus. Pietas Augustae; sacrificing at an altar.

488 Clod. Sept. Albinus Cæs.

Munia /*\ Pacif. Cos. II. Figura galeata stans, dextra ramũ Oleæ sinist. hastã et clypeũ. Ar. *MINER//

Clodius Albinus. Minerva Pacifera; standing helmeted figure with an olive branch in the right hand, and a spear and shield in the left.

489 Antoninus (Caracalla) Augustus

Vict. Ætern. Victoria stans dextra scipionẽ, et ante pedes scutum. Ar.

Caracalla. Standing Victory, with a staff in her right hand and a shield before her feet.

490 Antoninus pius Aug. Brit.

P.M. TR.P.XVI. COS.IIII.P.P. Figura stolata stans, dextrã protendens, sin. hastã tenens. Ar.

Caracalla. A standing figure in a stola, her right hand extended, holding a spear in her left.

[29r]

491 Imp. Antoninus Aug. /Elagabalus.\ Fides Militum. Figura stolata stans dextra labarum sinistra signũ militare. Ar.

Elagabalus. Fides Militum; standing figure in a stola, in her right hand a basin and in her left a military standard.

492 Plautilla Augusta - Anton. Caracallæ Uxor.

Venus Victrix. Venus et Cupido uterque pomũ dextra, Ven[s] autẽ sinistra ramũ palmæ tenet, scuto innixa. Ar.

Plautilla, wife of Caracalla. Venus Victrix; Venus and Cupid each with an apple in the right hand, but Venus, leaning on a shield, holds a palm leaf in her left hand.

493 L. Septimius Geta Cæs.

Severi pij Aug. Fil. Vasa Pontificialia. viz.[t] Lituus, Secespita, Guttus, Capeduncula, et Aspergillũ. Ar.

Geta. The pontifical vessels, namely the augur's staff, the sacrificial knife, the cruse, the sacrificial bowl and the sprinkler.

494 Divus Antoninus Pontif. Caput. Getæ. D.N. Septimius ... Signa Pontificialia. Ar[60]

Geta. The pontifical insignia.

495 M. OPEL. Ant. Diadumenianus Cæs. \\deest.// Princ. Juventutis. Figura stans juxta tria signa Milit. Ar[61]

Diadumenianus. Principi Juventutis; standing figure beside three military standards.

496 Julia Paula Aug. - Elagabali uxor.

Concordia. Figura sedens dextra paterã cũ stella. Ar.

Julia Paula, wife of Elagabalus. Concordia; seated figure with a dish with a star in the right hand.

497 Julia Mæsa Aug. - Elagabali etiam uxor.

Pudicitia. Dea Pudicit. sedens sinistra hastã puram, \\q.// dextrã ori admovens. Ar.

Julia Maesa, also wife of Elagabalus. Pudicitia; the goddess Pudicitia seated, in her left hand a spear without a head, the right reaching up to her face.

498 Julia Mamæa Aug. - Elagabali etiã uxor.

Fecund. Augustæ. Fæmina sedens, cum puerulo astante, cui dextrã videtur porrigere. Ar.

Julia Mamaea, also wife of Elagabalus. Fecunditas Augustae; seated woman with a little boy standing by, to whom she seems to stretch out her right hand.

499 Imp. C. M. Aur. Sev. Alexand. Aug. Pax. Aug. Figura gradiens, dextra ramũ, sinistra bacillum. Ar.

Alexander Severus. Pax Augusti; walking figure, with a branch in the right hand and a wand in the left.

500 Imp. Alexander pius Aug.

Mars ultor. Mars gradivus, dextrã hastam, sinistrã scutum. Ar.

Alexander Severus. Mars Ultor; Mars the Marcher, with a spear in his right hand and a shield in his left.

501 Imp. C. M. Aur. Sev. Alexand. Aug.

Pietas Aug. Figura ad arã sacrificans. Ar.

Alexander Severus. Pietas Augusti; figure sacrificing at the altar.

502 Imp. Maximinus pius Aug.

Pax Augusti. Fæmina; dextrã ramũ, sin. bacillũ. Ar.

Maximinus. Pax Augusti; a woman with a branch in her right hand and in her left a wand.

[60][f.28v] Locum alio numismate inscriptione detersa, implevimus
We have replaced this with another coin, the inscription of which is all worn away.
[61]d [-l/d]

503 Imp. Gordianus pius fel. Aug. Caput Gord.
Corona radiat. Virtuti Augusti. [-Figura\Hercules]
nudus stans, [-pilo\clavo] innixus. Ar. [-]
Gordian. Head of Gordian with a radiate crown. Virtuti
Augusti; standing nude figure of Hercules, leaning on a club.

[30r]

504 Imp. Gordianus Pius fel. Aug. Caput Gord.
radiat. Sæculi fælicitas. Figura galeata stans,
dextra hastã sinistra globum. Ar.
Gordian. Head of Gordian with a radiate crown. Saeculi
Felicitas; a standing helmeted figure, with a spear in the right
hand and a globe in the left.

505 Imp. Philippus Aug. Caput Philippi. Coron.
radiat. Concordia Augg. Dea Concordia sedens in
subsellio dextra paterã, sinistra Cornucopiã. Ar.
Philip. Head of Philip with a radiate crown. Concordia
Augustorum; the goddess Concordia seated on a stool with a
dish in her right hand and a cornucopia in her left.

506 Imp. C.M. Jul. Philippus P.F. Aug. P.M.
Virtus Exercitus. Figura militaris stans dextra
pilum sinistra peltam. Ar.
Philip. Virtus Exercitus; standing military figure with a javelin
in his right hand and in his left a small shield.

507 Imp. Cæs. C. Vib. Treb. Gallus Aug.
Treboniani Caput Coron. radiat. Felicitas Publ.
Figura dextra Caduceũ, sinistra Cornucopiã. Ar.
\\x deest./[62]

Trebonianus Gallus. Head of Trebonianus Gallus with a
radiate crown. Felicitas Publica; figure with a caduceus in
the right hand and a cornucopia in the left.

508 Imp. Ca. P. Lic. Valerianus. P.F. Aug. Coron.
radiat Felicitas Augg. Figura stolata stans dextra
hastã, sinistra Cornucopiam. Ar.[63]

Valerian. A radiate crown. Felicitas Augustorum;standing
figure in a stola with a spear in her right hand and a
cornucopia in her left.

509 Imp. C.P. Lic. Gallienus P.F. Augg. Coron.
radiat. Virtus Augg. Figura militaris stans, dextra
hastam sinistra clypeum. Ar[64]
Gallienus. A radiate crown. Virtus Augustorum; standing
military figure, with a spear in the right hand and a shield in
the left.

510 Gallienus Aug. Securitas Aug. Fig. decussatis
crurib͛. columnæ innixa dextra hastã. Ær.[65]
Gallienus. Securitas Augusti; figure leaning on a column,
with legs crossed and a spear in the right hand.

511 Imp. C.P. Lic. Gallienus Aug.
Felicit. Temp. Figura stolata stans, dextra
Caduceum, sinist. Cornucopiã. Ær.
Gallienus. Felicitas Temporum; a standing figure in a stola,
with a caduceus in her right hand and a cornucopia in her
left.

512 Gallienus Aug.

Securitas Aug. Figura stolata cũ hasta in dextra.
Ær[66]
Gallienus. Securitas Augusti; standing figure in a stola with a
spear in her right hand.

513 Idem iterum. M.S.
Another of the same.

514 Gallienus Aug. Annona Aug. Figura sedens
dextra hastã sinistra paterã. Ær.
Gallienus. Annona Augusti; seated figure with a spear in the
right hand and a dish in the left.

515 Gallienus Aug.
Fides Militum. Figura militaris stans, dextra
signũ militare, sinistra hastã. Ær[67]
Gallienus. Fides Militum; standing military figure, with military
standard in the right hand and in the left a spear.

[] Idem Iter. Ær.
Another of the same.

[31r]

516 Gallienus Aug.
Virtus Aug. Fig. Milit. stans dextra clypeũ sin.
hastã Ær.
Gallienus. Virtus Augusti; standing military figure with a
shield in his right hand and in his left a spear.

517 Gallienus Aug.
Marti Pacifero. Fig. Milit. dextra ramũ Lauri
porrigens, sinistra clypeũ et hastã tenens. Ær[68]
Gallienus. Marti Pacifero; military figure extending a laurel
branch in his right hand and holding a spear and shield in his
left.

518 Idẽ iterũ Ær.

519 Idem iterum. Ær[69]

520 Idem iterum Ær.

521 Gallienus
Aug. Pax Aug. Figura stans dextra ramũ in altũ
attollens sinistra hastã per transversũ. Ær[70]
Gallienus. Pax Augusti; standing figure holding high a
branch with the right hand which forms a cross with a spear
held in the left.

522 Idem iterum. Ær.

523 Idem iterum. Ær.

524 Idem iterũ. Ær.

525 Idem iterum Ær.

526 Idem iterum. Ær[71]

527 Imp. Gallienus Aug.
Jovi ultori. Jupiter stans dextra fulmen tenens,
sinistra hastam. Ær.
Gallienus. Iovi Ultori; standing Jupiter holding a thunderbolt
in his right hand and a spear in his left.

528 Gallienus Aug.
Jovi Conservat. N. Jupiter stans dextra fulmen,
sinistra hastã. Ær[72]

[62][f.29v] 507 Gordianus.

[63][f.29v] 508 x An: Gallienus: 2 vid: 579:
Or Gallienus.See 579.
[64][f.29v] vid. N. 516.795.796.797.
[65][f.29v] vid N. 798.

[66][f.29v] vid. 800.801.802.
[67][f.29v] vid. N. 809
[68][f.30v] vid N. 780.781.782.
[69][f.30v] 519 [-Idem iterum]
[70][f.30v] [-Imp] vid. N. 799.
[71][f.30v] 526 [-Idem iterum.] Ær.
[72][f.30v] vid. N. 767.768.769.

Gallienus. Iovi Conservatori; standing Jupiter holding a thunderbolt in his right hand and a spear in his left.

529 Gallienus Aug.

Jovi Conservat. XI. Jupiter [-stans\gradiens] dextra fulmen Ær.

Gallienus. Iovi Conservatori; walking Jupiter holding a thunderbolt in his right hand.

530 Idem iterum. Ær.

531 Imp. Gallienus. Aug.

Æquitas Aug. Figura stans juxta stellã dextra bilancẽ. Ær. \\9//

Gallienus. Aequitas Augusti; standing figure beside a star, with scales in the right hand.

532 Gallienus Aug.

Victoria Aug. S. Fig. stans dextra sertũ sinist. palmã. Ær[73]

Gallienus. Victoria Augusti; standing figure with a wreath in the right hand and in the left a palm branch.

533 Gallienus Aug.

A[bun]dantia Aug. B. Fig. stans fundens e sinu pecunias. Ær.

Gallienus. Abundantia Augusti; standing figure, pouring money from her garment.

[32r]

534 Idem iterum. Ær.

535 Idem iterum. Ær.

536 Idem iterum. Ær.

537 Idem iterum. Ær.

538 Idem iterum. Ær.

539 Idem iterum. Ær.

540 Idem iterum. Ær.

541 Idem iterum. Ær.

542 Gallienus Aug.

Oriens Aug. Z. Figura nuda radiata [-stans\gradiens] dextram attollens, sinistra flagrũ. Ær[74]

Gallienus. Oriens Augusti; walking nude figure with radiate crown, with the right hand held high and a scourge in the left.

543 Idem iterum. Ær.

544 Idem iterum. Ær.

545 Idem iterum. Ær.

546 Gallienus Aug.

Uberitas Aug. Fæmina stans dextra crumenam, sinistrâ cornucopiam. Ær.

Gallienus. Uberitas Augusti; standing female figure with a pouch in her right hand and a cornucopia in her left.

547 Idem iterum. Ær.

548 Idem iterum. Ær.

549 Idem iterum. Ær.

550 Gallienus Aug.

Fortuna redux S. Fortuna stans cum timone et Cornucopia. Ær.

Gallienus. Fortuna Redux; standing Fortuna with a rudder and a cornucopia.

551 Idem iterum. Ær.

552 Idem iterum. Ær.

553 Idem iterum. Ær.

554 Idem iterum. Ær.

555 Gallienus Aug.

Provid. Aug. X. Figura calcans serpente, dextra rhabdum, sinistra Cornucop. Ær.

Gallienus. Providentia Augusti; figure with its heel on a serpent, with a rod in the right hand and a cornucopia in the left.

556 Idem iterum. Ær.[75]

[33r]

557 Gallienus Aug.

Liberal. Aug. S. Figura stans dextra tesseram frumentariam, sinistra Cornucopiã. Ær[76]

Gallienus. Liberalitas Augusti; standing figure with a token for the distribution of corn in the right hand and in the left a cornucopia.

558 Idem iterum. Ær.

559 Imp. Gallienus Aug.

Apollini Cons. Aug. z. Centaurus. Ær.

Gallienus. Apolloni Conservatori Augusti; centaur.

560 Gallienus Aug.

Apollini Cons Aug. z. Centaurus. Ær.

Gallienus. Apolloni Conservatori Augusti; centaur.

561 Idem iterum. H. Ær.

562 Idem iterum. Ær.

563 Idem iterum. Ær.

564 Idem iterum. Ær.

565 Idem iterum. Ær.

566 Gallienus Aug.

Soli Cons. Aug. B. Pegasus. Ær.

Gallienus. Soli Conservatori Augusti; Pegasus.

567 Idem iterum. H. Ær[77]

568 Idem iterum. Ær. *atque iterum. Ær[78]

570 Gallienus Aug.

Dianæ Cons. Aug.Γ. Animal cornutũ. Unicornu. Ær.

Gallienus. Dianæ Conservatrici Augusti; a horned animal, a unicorn.

571 Gallienus Aug.

Dianæ Cons. Aug. XI. Gazella stans Ær.

Gallienus. Dianæ Conservatrici Augusti; a standing gazelle.

572 Gallienus Aug.

Dianæ Cons. Aug. XII. Gazella stans. A.[79]

Gallienus. Dianæ Conservatrici Augusti; a standing gazelle.

573 Gallienus Aug.

Dianæ Cons. Aug. Gazella stans. Ær.

[73][f.30v] vid. N. 810. 811
[74][f.31v] vid. N. 793 .794.

[75][f.31v] vid. N. 805. 806. 807
[76][f.32v] vid. N. 803. 804
[77][f.32v] vid. N. 792
[78][f.32v] 569 Idem iterum. Ær.
[79][f.32v] vid N. 784. 785. 786. 787. 788.

Gallienus. Dianæ Conservatrici Augusti; a standing gazelle.

574 Idem iterum. Ær.

575 Idem iterum. Ær.

576 Idem iterum. Ær.

577 Idem iterum. Ær.

578 Gallienus Aug.
Dianæ Cons. Aug. Gazella currens.
Gallienus. Dianæ Conservatrici Augusti; a running gazelle.

[34r]

579 Gallienus Aug.
Iovi Cons. Aug. Gazella stans capite ad dextrã. Ær.
Gallienus. Iovi Conservatori Augusti; a standing gazelle with its head towards the right.

580 Idem iterum. Ær.

581 Idem iterum. Ær.

582 Gallienus Aug:
Dianæ Cons. Aug. Dama mas /stans\ capite ad lævam verso. Ær.
Gallienus. Dianæ Conservatrici Augusti; a standing hart, with its head towards the left.

583 Gallienus Aug.
Dianæ Cons. Aug. X. Dama mas etc. Ær.
Gallienus. Dianæ Conservatrici Augusti; hart, etc.

584 Idem iterum. Ær[80]

585 Gallienus Aug. Dianæ Cons. Aug.x. Dama mas stans capite ad dextram verso. Ær.
Gallienus. Dianæ Conservatrici Augusti; a standing hart, with its head towards the right.

586 Gallienus Aug.
Dianæ Cons. Aug. Dama mas. etc. Ær.
Gallienus. Dianæ Conservatrici Augusti; hart, etc.

587 Idem iterum. Ær.

588 Idem iterum. Ær.

589 Imp. Gallienus Aug.
Diana Cons. Aug. e Dama fæmina stans, capite ad Lævam reverso. Ær.
Gallienus. Dianæ Conservatrici Augusti; a standing hind, its head looking backwards towards the left.

590 Idem Iterum. Ær.

591 Idem iterum. Ær.

592 Idem iterum. Ær.

593 Idem iterum. Ær.

594 Idem iterum. Ær.

595 Idem iterum. Ær.

596 Idem iterum. Ær.

597 Salonina Aug. - Gallieni uxor.
Venus Felix. Venus sedens dextra pateram cum pavone, sinistra hastam puram. Ar.
Salonina, wife of Gallienus. Venus Felix; seated Venus, with a dish in her right hand with a peacock, and in her left a spear without an iron head.

[35r]

598 Salonina Aug.
Juno Regina. Figura stans, dextra paterã, sinistra hastam puram. Ar[81]
Salonina. Juno Regina; standing figure, with a dish in the right hand and in the left a spear without a head.

599 Cor. Salonina Aug. Junoni Cons. Aug /L\
Dama stans capite ad Lævam verso Ær[82]
Salonina. Junoni Conservatrici Augusti; standing hart with its head towards the left.

600 Idem iterum. Ær. \\9.//[83]

601 Salonina Aug.
Venus Victrix. dextra palmam sinistra hastã. Æ[84]
Salonina. Venus Victrix; Venus of Victory, with a palm leaf in her right hand and in her left a spear.

602 Idem iterum H. Ær.

603 Salonina Aug. \\q// ... Figura stolata stans[85]
Salonina. A standing figure in a stola.

604 Idem (ut puto) Iterum. Ær. \\[-d] q://

605 Imp. C. Posthumus P.F. Aug. Caput Postumi coronã radiat.
Victoria Aug. Victoria alata, dextra sertum sin. pilũ. Ær Argent.[86]
Postumus. Head of Postumus in a radiate crown. Victoria Augusti; winged Victory, with a wreath in her right hand and in her left a javelin.

606 Idem iterum Ær.

607 Imp. C. Postumus P. F. Aug.
Pax Aug. Figura stans; dextra ramũ, sin. hastã. Ær[87]
Postumus. Pax Augusti; standing figure, with a branch in the right hand and a spear in the left.

608 Imp. C. Postumus P. F. Aug.
Neptuno Reduci. Figura stans, dextra delphinum sinistra tridentem. Ær.
Postumus. Neptuno Reduci; standing figure with a dolphin in his right hand and a trident in his left.

609 Imp. Postumus Aug. \\x non de://
Provident. Aug. Fig. stans dextra rhabdũ, sin Cornucop. Ær[88]
Postumus. Providentia Augusti; standing figure with a rod in the right hand and in the left a cornucopia.

610 Imp. C. Victorinus P. F. Aug. Caput Victor. corona radiat Invictus. Solis vel Apollinis typus. Ær. \\9.//
Victorinus. Head of Victorinus with a radiate crown. Invictus; Sol or Apollo type.

611 Idem iterum. Ær.

612 Imp. C. Victorinus. P. F. Aug.
Providentia Aug. Fig. stans, dextra paterã, sin Cornucop. Ær.

[80][f.33v] vid. N. 789. 790. 791.

[81][-d]
[82][-d]
[83][-d]
[84][-d] [f.34v] vid. N. 813
[85][-d] [f.34v] Capsula 3ᵗⁱᵃ
[86][-d]
[87][f.34v] vid. N. 814.
[88][f.34v] [-]

Victorinus. Providentia Augusti; standing figure with a dish in the right hand and in the left a cornucopia.

613 Imp. C. Victorinus. P. F. Aug.

Pietas Aug. Fig. stans, dextra paterã super Aram, sinistra . . . Ær. \\d//[89]

Victorinus. Pietas Augusti; standing figure, holding in the right hand a dish over an altar and in the left [].

[36r]

614 Imp. C. Victorinus Aug.

Providentia Aug. Figura stolata stans, dextra rhabdum, sinistra Cornucopiã. Ær.

Victorinus. Providentia Augusti; standing figure in a stola, the right hand with a rod and the left with a cornucopia.

615 Imp. C. Pi. AV. Victorinus P F. Aug. - Filius Pax. Aug. V. Dea Pax ramum protendens, sinistra hastile per transversum. Ær.

Victorinus. Pax Augusti; the goddess Pax holding out a branch, crossed by a spear held in her left hand.

616 Idem iterum. Ær.

617 Idem iterum. Ær.

618 Idem iterum. Ær.

619 Idem iterum. Ær[90]

620 Imp. Tetricus. P.F. Aug. Tetr. Patris Caput corona radiata.

Hilaritas Augg. Dea stolata stans dextra palmam sinistra Cornucopiã gerens. Ær.

Tetricus. Head of Tetricus the father with a radiate crown. Hilaritas Augusti; standing goddess in a stola with a palm leaf in her right hand, and a cornucopia in her left.

621 Idem iterum. Ær.

622 Idem (ut puto) iterum Ær.

623 Imp. Tetricus P F. Aug.

Lætitia Aug. Figura stolata stans dextra corollam deorsũ tenens, sinistra Anchorã nudis brachijs. Ær[91]

Tetricus. Laetitia Augusti; standing figure in a stola with bare forearms, holding a garland downwards in her right hand and in her left an anchor.

624 Imp. Tetricus P.F. Aug

Spes publica. Spei typus. Ær.

Tetricus. Spes Publica; Spes type.

625 Imp. C. Pives. Tetricus. Cæs. Tetr. Filij Caput, corona radiat ...

Tetricus [Junior]. Head of Tetricus in a radiate crown.

626 Imp. C. Pives. Tetricus Aug.

Salus Aug. Salutis stantis typus, dextra paterã cum serpente, sinistra temonẽ. Ær.[92]

Tetricus. Salus Augusti; standing figure of Salus, in her right hand a dish with a serpent and in her left a staff.

627 Imp. Piv. Tetricus Cæs. \\[-deest\x]//

Hilaritas Aug. ut supra.

Tetricus [Junior]. Hilaritas Augusti; as the above.

628 Imp. Pivesu. Tetricus Cæs. \\d://

Comes Aug. Victoria stans dextra laureã, sin. palmã. Ær.

Tetricus [Junior]. Comes Augusti; standing Victory with laurel wreath in her right hand and a palm leaf in her left.

629 Imp. Claudius Aug. - Caput Claudij corona radiat. Jovi Custodi, Jupiter stans, dextra fulmen sinistra hastã p transversum. Ær.

Claudius. Head of Claudius in a radiate crown. Jovi Statori; standing Jupiter, with a thunderbolt in his right hand crossed by a spear held in his left.

[37r]

630 Imp. C. Claudius Aug.

Iovi Statori, Jupiter nudus stans, dextra hastã, sinistra fulmen. Ær.

Claudius Gothicus. Iovi Statori; standing nude Jupiter, with a spear in his right hand and a thunderbolt in his left.

631 Idem iterum. Ær.

632 Imp. C. Claudius. Aug.

Jovi Victori, Jupiter nudus stans dextra fulmen sinistra hastam. Ær.

Claudius. Iovi Victori; standing nude Jupiter, with a thunderbolt in his right hand and a spear in his left.

633 Idem iterum O. Ær.

634 Idem iterum. Æ[93]

635 Idem iterum. Ær. \\q.//[94]

636 Idem iterum. Ær.

637 Idem iterum. Ær.

638 Imp. C Claudius Aug.

Mart. Ultori - Mars gradiens dextra hastam sinistra spolia super humeros. Ær[95]

Claudius. Marti Ultori; walking Mars with a spear in his right hand and on the left the spoils of war on his shoulder.

639 Idem iterum. Ær. \\q//

640 Idem iterum. H. Ær. \\q//

641 Imp. Claudius P.F. Aug.

Virtus Aug. Mars gradiens dextra hastam, sinistra spolia ferens super humeros. Ær.

Claudius. Virtus Augusti; walking Mars with a spear in his right hand and the spoils of war on his left shoulder.

642 Idem iterum. Ær.

643 Imp. C. Claudius Aug. Virtus Aug. Figura militaris stans dextra ramũ sinistra hastam. Ær.

Claudius. Virtus Augusti; standing military figure with a branch in his right hand and a spear in his left.

644 Idem iterum. A. Ær.

645 Idem iterum. Ær.

646 Idem iterum. Ær.

647 Imp. C. Claudius Aug.

Spes publica. Spei typus. Ær.

Claudius. Spes Publica; Spes type.

[89][f.34v] vid. N. 814
[90][f.35v] [-\H]
[91][f.35v] vid. N. 816. 817. 818. 819. 820. 821.
[92][f.35v] vid. N. 822. 823.824.825.826.

[93][f.36v] [-d]
[94][f.36v] vid. N. 827.828.829.830.
[95][f.36v] vid. N. 831.832.833

[38r]

648 Imp. C. Claudius Aug. Provident. Aug. /XI\
Figura stans sinistra cornucopiam tenens
Columnæ innixa, dextra scipionẽ. Ær.
Claudius. Providentia Augusti; standing figure holding a
cornucopia in the left hand, leaning on a column, and with a
staff in the right hand.

649 Idem iterum. Ær[96]

650 Idem iterum XII. Ær.

651 Idem iterum XII. Ær.

652 Idem iterum. S. Ær.

653 Idem iterum Ær

654 Idem iterum Ær.

655 Idem iterum. Ær.

656 Idem iterum. Ær.

657 Imp. C. Claudius Aug.
Pietas Aug. Figura stans dextra ad Arã
sacrificans sinistra hastam. Ær[97]
Claudius. Pietas Augusti; standing figure sacrificing with the
right hand at an altar and with a spear in the left.

658 Idem iterum. Ær.

659 Divo Claudio.
Consecratio. cum Ara
Aurelian [?]. The divine Claudius. Consecratio; with an altar.

660 Idem iterum. Ær[98]

661 Imp. C. Claudius Aug.
Salus Aug. Dea Salus dextra paterã cũ serpente ut
videtur, sinistra hastam. Ær.
Claudius. Salus Augusti; the goddess Salus, in her right
hand a dish with what appears to be a serpent and in her
right a spear.

662 Imp. Claudius Aug.
Fortuna Redux. Fortuna temonẽ et Cornucop.
tenens. Ær.
Claudius. Fortuna Redux; Fortuna holding a staff and a
cornucopia.

663 Imp. Claudius. Aug
Fortuna Redux. S. eadem figura.
Claudius. Fortuna Redux; the same figure.

664 Idem iterum Ær. \\desunt. x// \\Claudius -
Mars Gradiens.//
Another of the same. Claudius - Mars walking.

665 Idem iterum E. Ær. \\desunt. x//

666 Imp. C. M. Claudius Aug.
Felicitas Aug. Figura stolata stans dextra
Caduceum, sinistra hastam tenens. Ær.
Claudius. Felicitas Augusti; standing figure in a stola, with a
caduceus in the right hand and holding a spear in the left.

667 Idem (ut puto) iterum. P. Ær.
Possibly another of the same.

[39r]

668 Imp. C. Claudius Aug.

Felicitas pub. S. C. Fig stans dextra ramũ sin.
Cornucop. Ær.
Claudius. Felicitas Publica; standing figure with a branch in
the right hand and a cornucopia in the left.

669 Imp. Claudius P. F. Aug.
Felicit. Publ. Fig. stans dextra ramũ sin. hastam.
Ær.
Claudius. Felicitas Publica; standing figure with a branch in
the right hand and a spear in the left.

670 Imp. C. Claudius Aug. Æquitas Aug. Figura
stolata stans, dextra bilancem, sinistra Cornucopiã.
Ær[99]
Claudius. Aequitas Augusti; standing figure in a stola, with a
balance in the right hand and a cornucopia in the left.

671 Idem iterum. Ær.

672 Idem iterum. Ær[100]

673 Imp. Claudius Aug.
Æquitas Aug. eâdem figura.
Claudius. Aequitas Augusti; with the same figure.

674 Idem iterum. Ær

675 Idem iterum. Ær.

676 Idem iterum. Ær.

677 Imp. Claudius Aug.
Æquitas Aug. eâdem figura.
Claudius. Aequitas Augusti; with the same figure.

678 Idem iterum. Ær.

679 Idem iterum. Ær.

680 Idem iterum. Ær.

681 Imp. C. Claudius Aug.
Libertas Aug. Figura galeata stans; dextra
ramum, sinistra hastam. Ær.
Claudius. Libertas Augusti; standing helmeted figure with a
branch in the right hand and a spear in the left.

682 Idem iterum. Ær.

683 Idem iterum. Ær.

684 Imp. Claudius Aug.
Libert. Aug. Figura stolata stans, dextra
marsupium, sinistra hastam. Ær.
Claudius. Libertas Augusti; standing figure in a stola, with a
pouch in the right hand and a spear in the left.

685 Idem iterum. Ær. *

686 Idem iterum. Ær.

687 Idem iterum. Ær.

688 Imp. Claudius Aug.
Libert. Aug. Figura stolata stans, dextra
marsupiũ, sinistra Cornucopiã. Ær[101]
Claudius. Libertas Augusti; standing figure in a stola, with a
pouch in the right hand and a cornucopia in the left.

689 Idem iterum. Ær.

[40r]

690 Imp. C. Claudius Aug.

[96] **[f.37v]** vid. N. 851
[97] **[f.37v]** vid. N. 856.
[98] **[f.37v]** vid. N. 834.835.836.837.838.

[99] **[f.38v]** vid. N. 853.854.855.
[100] **[f.38v]** 13.
[101] **[f.38v]** vid. N. 844. 845.

Liberalitas Aug. Figura stans, dextra tesserā frumentariam, sinistra Cornucopiā. Ær. \\q//
Claudius. Liberalitas Augusti; standing figure with a token for the distribution of corn in the right hand and a cornucopia in the left.

691 Imp. Claudius Aug.
Liberalitas Aug. Figura stolata stans, dextra marsupium sinistra Cornucopiā. Ær.
Claudius. Liberalitas Augusti; standing figure in a stola, with a pouch in her right hand and a cornucopia in her left.

692 Imp. C. Claudius Aug.
Annona Aug. Figura stolata stans, dextra spicas, sinistra Cornucop. Æ.
Claudius. Annona Augusti; standing figure in a stola, with ears of corn in her right hand and a cornucopia in her left.

693 Idem iterum. Ær[102]

694 Idem iterum. Ær.

695 Idem iterum L. Æ[103]

696 Idem iterum L Ær.

697 Idem iterum Ær.

698 Imp. Claudius P F. Aug.
Pax Aug. Figura gradiens dextra ramū protendens, sinistra hastā tenens p transversū Ær[104]
Claudius. Pax Augusti; walking figure holding out a branch with the right hand, crossed by a spear held in the left.

699 * Idem iterum. Ær[105]

700 Imp. Claudius Aug.
Genius Exerci. Deus Genius stans dextra paterā sinistra Cornucopiā. Ær.[106]
Claudius. Genius Exercitus; standing Genius with a dish in the right hand and a cornucopia in the left.

701 Idem iterum. Ær. \\q//

702 Idem iterum. Ær.

703 Idem iterum. Ær.

704 Imp. C. Claudius Aug.
Fides Exerci. Fig. stans inter duo signa militaria. Ær.
Claudius. Fides Exercitus; standing figure between two military standards.

705 Imp. C. Claudius Aug.
Fides Exerci /XI\ Fig. Militaris stans inter duo signa militaria, unū tenens p transversū.
Claudius. Standing military figure between two standards, one held across the other.

706 Idem iterum. XI. Ær

707 Idem iter. XI. Ær.

708. Idem iterum. XI. Ær.

[41r]

709 Imp. C. Claudius Aug.

Fides Exerci. Figura milit. stans inter duo signa militaria, unum tenens p transversū. Ær.
Claudius. Fides Exercitus; standing military figure between two standards, one held across the other.

710 Idem iterum. Ær.

711 Idem iterum. Ær. \\Id. cum 857.//

712 Idem iterum. Ær.

713 Idem iterum. Ær.

714 Imp. Claudius Aug.
Victoria Aug. Victoria gradiens dextra corollam, sinistra palmam. Ær[107]
Claudius. Victoria Augusti; walking Victory, with a garland in her right hand and a palm leaf in her left.

715 Idem iterum Ær[108]

718 Imp. C. Claudius Aug.
Victoria Aug. Victoria stans dextra sertum, sinistra palmam. Ær.
Claudius. Victoria Augusti; standing Victory with a wreath in her right hand and a palm leaf in her left.

719 Imp. C. Claudius Aug.
Victoria Aug. Victoria stans dextra sertum. Ær[109]
Claudius. Victoria Augusti; standing Victory with a wreath in her right hand.

720 Idem iterum. Ær.

721 Idem iterum. Ær.

722 Idem iterum. Ær[110]

723 Idem iterum. Ær.

724 Imp. C. M. Aur. Cl. Quintillus Aug.
Apollini Cons. Figura nuda, sinistra Columnæ innixa, dextra temonem. Ær.
Quintillus. Apolloni Conservatori; nude figure, leaning on a column with the left hand and with a staff in the right.

725 Imp. C.M. Aur. Cl. Quintillus Aug.
Æternit. Aug. /N\ Fig. nuda stans dextra ramum. Ær[111]
Quintillus. Aeternitas Augusti; nude standing figure with a branch in the right hand.

726 Imp. C. M. Aur Cl. Quintillus Aug.
Lætitia Aug. Figura stolata stans dextra spicas, sinistra (ut puto) temonẽ. Ær[112]
Quintillus. Laetitia Augusti; standing figure in a stola with ears of corn in her right hand and with, it seems, a staff in her left.

727 Imp. C. M. Aur. Cl. Quintillus Aug.
Virtus Aug. H. Figura stolata stans, dextra ramum, sinistra hastam, per transversum. Ær.
Quintillus. Virtus Augusti; standing figure in a stola with a branch in her right hand, crossed by a spear held in her left.
[42r]

728 Imp. Quintillus Aug ...
Fig. Milit. stans inter duo signa milit. Ær.
Quintillus. Standing military figure between two standards.

[102][f.39v] vid. N. 847.848.849.850.
[103][f.39v] [-d]
[104][f.39v] vid N. 842
[105][f.39v] de:
[106][f.39v] vid. N. 839. 840

[107][f.40v] vid. N. 859.
[108][f.40v] N.° 16.17. Rem?
[109][f.40v] vid. 858.
[110][f.40v] [-]
[111][f.40v] vid. N. 860
[112][f.40v] [-]

729 Imp. C. M. Cl. Tacitus Aug.

Æquitas Aug. Figura stans dextra bilancem sinistra Cornucopiam. Ær. *//[113]

Tacitus. Aequitas Augusti; standing figure with a balance in the right hand and a cornucopia in the left.

[41v]

730 Idem iterum Ær

[42r]

731 Imp. Cl. Tacitus Aug.

Mars Victor. Mars gradivus dextra hastā, sinistra spolia super humeros. Ær.

Tacitus. Mars Victor; Mars the Marcher, with a spear in his right hand and the spoils of war on his left upper arm.

732 Imp. C. M. Cl. Tacitus. Aug.

Temporum Felicitas. Figura stolata stans dextra Caduceum, sinistra Corucopiā. Ær.

Tacitus. Felicitas Temporum; standing figure in a stola with a caduceus in her right hand and a cornucopia in her left.

733 Imp. C. M. Aur. Probus Aug.

Providentia Aug. Mulier stans dextra globum sinistra Cornucopiā. Ær.

Probus. Providentia Augusti; standing woman with a globe in her right hand and in her left a cornucopia.

734 Imp. C. M. Aur. Probus Aug.

Salus Aug. Figura astans columnæ cui innititur sinistra, dextra ramum. Ær[114]

Probus. Salus Augusti; standing figure leaning on a column with the left hand, in the right a branch.

735 Imp. C. Probus P. F. Aug.

Abundantia Aug. Figura stolata stans sinistra (ut puto) marsupium. Ær.

Probus. Abundantia Augusti; standing figure in a stola with (it seems) a pouch in her left hand.

736 Imp. C. Probus. P.F. Aug.

Felicitas Aug. Figura stolata stans sinistra hastam tenens, sub dextra globus. Ær.

Probus. Felicitas Augusti; standing figure in a stola holding a spear in her left hand, and a globe below in her right.

737 Imp. Carus. P.F. Aug.

Dux Exercitus. /P.XXI\ Figura stans dextra sertū sin. hastam. Ær.

Carus. Dux Exercitus; standing figure with a wreath in the right hand and a spear in the left.

738 Imp. C. C. Val. Diocletianus. P.F. Aug.

Jovi Conser. Aug. Jupiter nudus stans, dextra fulmen trisulcū. sin hastā, ad pedes Icuncula (\\aquila f.//) cū serto. Ær.

Diocletian. Jovi Conservatori; standing nude Jupiter with a three-forked thunderbolt in his right hand and a spear in his left; at his feet a figure of an eagle with a wreath.

739 Imp. C. C. Val. Diocletianus Aug.

Jovi Conservat. Aug. Jupiter nudus stans, dextra fulmen trisulcū. sin. hastam. Ær.

Diocletian. Jovi Conservatori; standing nude Jupiter with a three-forked thunderbolt in his right hand and in his left a spear.

[43r]

740 Imp. Carausius P.F. Aug.

Pax. Aug. S.P. Figura stolata stans, dextra oleā, sinistra hastile. Ær.

Carausius. Pax Augusti; standing figure in a stola, with an olive branch in her right hand and a spear in her left.

741 Imp. Carausius Aug.

Moneta Aug. Figura cum bilance et Cornucop. Ær.

Carausius. Moneta Augusti; figure with a balance and a cornucopia.

742 C. Alectus Aug.

Pax. Aug. Figura stans, dextra ramum, sinist. hastā. Ær[115]

Allectus. Pax Augusti; standing figure with a branch in the her hand and a spear in her left.

743 C. Alectus Aug.

Æquitas Aug ... [116]

Allectus. Aequitas Augusti.

744 Fl. Val. Constantius Nob. C. - Cognomento Chlorus. Gloria Exercitus. Duæ figuræ militares /galeati & hastati\ stantes; inter eos, duo signa militaria. Ær. infra TRS.

Constantius Chlorus. Gloria Exercitus; two standing military figures, helmeted and carrying spears; between them two military standards. Exergue: TRS.

745 Constantinus Max. Aug.

Gloria Exercitus. Duo milites galeati et hastati stantes; inter eos, duo signa Milit. infra TRS. Ær.

Constantine. Gloria Exercitus; two standing soldiers, helmeted and carrying spears; between them, two military standards. Exergue:TRS.

[42v]

746 D. N. Crispus Nob. Cæs.

Beata Tranquilitas. Globus Aræ impositus, in qua votis XX. Ær.

Crispus. Beata Tranquilitas; a globe placed on an altar [cippus], on which VOTIS XX [votis vicennalibus].

747 Maxentius Aug.

Providen. Aug. Fig. stolat. stans dextra ...

Maxentius. Providentia Augusti; standing figure in a stola with [].

[43r]

748 Constantinus Jun. Nob. C.

Gloria Exercitus. Duo Milites etc. \\x deest//[117]

Constantine II. Gloria Exercitus; two walking soldiers.

749 ... Constantinus Nob. C.

Gloria Romanorū. Mars Gradivus dextra hastam, sinistra clypeum. Ær. \\x deest//[118]

Constantine II. Gloria Romanorum; walking Mars with a spear in his right hand and a shield in his left.

750 D.N. Constantius P.F. Aug.

Votis XXX Multis XXXX. in Corona. AR. infra S.CON.

[113][f.41v] [-d*]
[114][f.41v] Q [-d d]

[115][f.42v] d
[116][f.42v] [-d]
[117][f.42v] [-d\x]
[118][f.42v] De.

Constantius. VOTIS XXX MULTIS XXXX [*votis tricennalibus multis quadragennalibus*] in a wreath. Exergue: S.CON.

751 D.N Magenentius P.F. Aug.

Salus D.N. Aug et Cæs. AΩ nota Christianismi *[symbol-chi/rho]*. Ær

Magnentius. Salus Augusti; the symbol of Christianity.

752 D.N. Fl. Cl. Julianus P.F. Aug. \\deest//

Vot. X. Mult. XX. in Corona. S. Lug. AR. \\x//

Julian. VOTIS X MULTIS XX [*votis decennalibus multis vicennalibus*] in a wreath.

753 D.N Jovianus P.F. Aug.

Vot. v. Mult. X. in Corona S.CON. Ar.

Jovian. VOTIS V MULTIS X [*votis quinquennalibus multis decennalibus*] in a wreath.

754 D.N Valentinianus P.F. Aug.

Restitutor Reip. Imperat stans dextra Labarum, sinistra Victoriolam cum corollâ. Ar.

Valentinian. Restitutor Reipublicae; the Emperor standing with a labarum in his right hand and a Victory with a little wreath in his left.

[44r]

755 D.N Valentinianus P.F. Aug.

Restitutor Reipublicæ. /ANTE*\ Imp. stans dextra Labarum cum nota Christianismi, sinistra Victoriolã cum Corolla. Aur.

Valentinian. Restitutor Reipublicae; the Emperor stands with a labarum in his right hand with the symbol of the most Christian one and in his left a Victory with a little wreath.

756 D.N. Valens. P.F. Aug. Vot. V X Mult. XX. T*[symbol - chi/rho]* E. in Corona. Ar.

Valens. VOTIS VX MULTIS XX [*votis quindecennalibus multis vicennalibus*] and T [*chi-rho*] E in a wreath.

757 D.N Valens. P.F. Aug

Vot. V. Mult. X. RB. in Corona. Ar.

Valens. VOTIS V MULTIS X [*votis quinquennalibus multis decennalibus*] in a wreath.

758 D.N. Valens. P.F. Aug.

Securitas Reipublicæ. OF I. CONST. Victoria dextra Corollam Ær. \\sinist. palmam//

Valens. Securitas Republicae; Victory with a wreath in her right hand and a palm leaf in her left.

759 Idem (ut puto) iterum. Ær.

760 D.N. Gratianus Aug.

[-Vot. XV] Mult. XX. in Corona Ær.

Gratian. VOTIS XV MULTIS XX [*votis quindecennalibus multis vicennalibus*] in a wreath.

761 [-D.N Theodosius P.F. Aug.

Victoria Augg. N.D. CON. Duæ figuræ tenentes globum supra in medio Victoria. Ær.] \\x deest.//[119]

Theodosius. Victoria Augustorum; two figures holding a globe above a central Victory.

762 D.N. Arcadius P.F. Aug.

Virtus Romanorum MDPS Imperator sedens vestitu militari, dextra Victoriolã sinist. hastam. Ar.

Arcadius. Virtus Romanorum; the Emperor sitting in military dress, with a Victory in his right hand and a spear in his left.

Catalogus Numismatum obscuriorum ab eodē Cl. Viro Dño Thoma Brathwait legatorū, quæ tamen (ut opinor) sic interpretari possunt.
Catalogue of the rarer coins bequeathed by that same distinguished man, Thomas Braithwait, which may none the less (I believe) be identified.

[45r]

763 ΠΤΟΛΕΜΑΙΟΥ. Caput Ptolomæi galeat. In Reverso Aquila surgens alis expansis. Ær[120]

Ptolemy. Helmeted head of Ptolemy; *rev:* an eagle arising with its wings outspread.

764 Lucilla (ut puto) Aug. - L. Aurel. Veri, uxor. Ær

Lucilla, wife of Lucius Verus.

765 L. Septimius Severus (ut opinor) Aug. Ær.

Septimius Severus, I believe.

766 Imp. Valerianus P.F. Aug.

Victoria Aug. Dea Victoria, dextra sertū, sinist palmã Ær.

Valerian. Victoria Augusti; the Goddess Victory, with a wreath in her right hand and a palm leaf in her left.

767 Gallienus Aug.

Jovi Conserv. Aug. X. Jupiter gradiens, dextra fulmen sinistra hastã. Ær.

Gallienus. Jovi Conservatori Augusti; Jupiter walking, with a thunderbolt in his right hand and a spear in his left.

768 Gallienus Aug.

Jovi Cons. Aug. Jupiter gradiens, dextra fulmen. Ær.

Gallienus. Jovi Conservatori Augusti; Jupiter walking, with a thunderbolt in his right hand.

769 Gallienus Aug.

Jovi Conservat. Aug. XI. Imp. gradiens dext. fulmen. Ær. \\d//

Gallienus. Jovi Conservatori Augusti; the emperor walking with a thunderbolt in his right hand.

780 Gallienus Aug.

Marti pacifero N. Figura militaris /stans,\ dextra ramum Lauri porrigens, sinistra ... Ær.

Gallienus. Marti Pacifero; standing military figure, extending a laurel branch with the right hand and with the left [].

781 Idem iterum. Ær.

782 Gallienus Aug.

Marti Victori. Figura stans ... Ær.

Gallienus. Marti Victori; standing figure.

783 Gallienus Aug.

Neptuno Cons. Aug. Monstrum marinum, anteriore parte, Equus; posteriore, Cauda Serpentis. Ær.

Gallienus. Neptuno Conservatori Augusti; a sea-monster, the front part a horse and the rear the tail of a serpent.

784 Gallienus Aug.

Dianæ Cons. Aug. Gazella stans, capite ad sinistrã. Ær

Gallienus. Dianæ Conservatrici Augusti; standing gazelle, with its head towards the right.

[119][f.43v] l d

[120][f.44v] Capsula 4ta
Fourth drawer.

785 Gallienus

Aug. Dianæ Cons. Aug. Gazella stans, capite ad
dextr. verso. Ær.
Gallienus. Dianæ Conservatrici Augusti; standing gazelle,
with its head looking backwards to the right.

786 Gallienus Aug.

Dianæ Cons. Aug Gazella stans, capite sursū
protendente. Ær.
Gallienus. Dianæ Conservatrici Augusti; standing gazelle,
with its head stretched upwards.

[46r]

787 Idẽ iterum. Ær

788 Idem (ut opinor) iterum Ær.

789 Gallienus Aug.

Dianæ Cons. Aug. Dama mas stans, Ær. capite ad
dextram.
Gallienus. Dianæ Consevatrici Augusti; standing hart, its
head to the right.

790 Imp. Gallienus Aug.

Dianæ Cons. Aug. etc.
Gallienus. Dianæ Conservatrici Augusti etc.

791 Imp. Gallienus Aug.

Dianæ Cons. Aug. Dama fæmina stans, capite ad
Lævam reverso. Ær.[121]
Gallienus. Dianæ Conservatrici Augusti; standing hind, its
head to the rear and to the left.

792 Gallienus Aug.

Soli Cons. Aug. Pegasus. Ær
Gallienus. Soli Conservatori Augusti; Pegasus.

793 Gallienus Aug.

Oriens Aug. Z. Figura nuda radiata gradiens,
dextram attollens, sinistra flagrū. Ær.
Gallienus. Oriens Augusti; nude, walking radiate figure, the
right hand raised and in the left a scourge.

794 Idem iterum Ær.

795 Gallienus Aug.

Virtus Augusti. Miles dextro pede insistans
globo; dextra ramum, sinistra hastam. Ær
Gallienus. Virtus Augusti; soldier with his right foot placed on
a globe; in his right hand a branch, in his left a spear.

796 Idem iterum. Ær.

797 Idem iterum. Ær.

798 Gallienus Aug.

Securitas Aug. Figura decussatis cruribus,
columnæ innixa dextra ... Ær.
Gallienus. Securitas Augusti; figure with legs crossed,
leaning on a column with the right hand [].

799 Gallienus Aug.

Pax Aug. Figura stans dextra ramum in altū
tollens sinistra hastam per transversū. Ær.
Gallienus. Pax Augusti; standing figure with a branch held
high in the right hand, crossed by a spear held in the left.

800 Gallienus Aug.

Lætitia Aug. Dea stans stolata dextra sertū,
sinistra scipionẽ. Ær.

Gallienus. Laetitia Augusti; standing goddess in a stola with
a garland in her right hand and a staff in her left.

801 Idem iterum. Ær.

802 Idem iterum. Ær. atque iterum.

803 Gallienus Aug

Libert. Aug. Figura stolata stans, dextra hastam,
sinistra globum. Ær.
Gallienus. Libertas Augusti; standing figure in a stola with a
spear in her right hand and a globe in her left.

[47r]

804 Gallienus Aug.

Liberalit. Aug. E. Figura stans, dextra tesserā
frumentariam sinistra hastam. Ær.
Gallienus. Liberalitas Augusti; standing figure with a token
for the distribution of corn in the right hand and a spear in the
left.

805 Gallienus Aug.

[-Providentia\Abundantia] Aug. /B\ Figura stans,
fundens e gremio pecunias /spicas\. Ær.
Gallienus. Abundantia Augusti; standing figure, pouring
money or corn from her lap.

806 Idem iterum. Ær. [122]

808 Gallienus Aug.

Provid. Aug. X. Figura calcans serpentẽ, dex
rhabdum sinistra Cornucopiam. Ær.
Gallienus. Providentia Augusti; figure with its heel on a
serpent, with a rod in the right hand and a cornucopia in the
left.

809 Gallienus Aug.

Fides Militum. Figura militaris stans, dextra
signum militare, sinistra hastam. Ær.
Gallienus. Fides Militum; standing military figure with a
military standard in his right hand and a spear in his left.

810 Gallienus Aug.

Victoria Aug. Figura stans dextra sertū, sinistra
palmã. Ær.
Gallienus. Victoria Augusti; standing figure with a garland in
the left hand and a palm leaf in the right.

811 Gallienus Aug.

P.M. TR.P... COS ... P. ... Figura militaris stans,
dextra globum, sinistra hastam. Ær[123]
Gallienus. Standing military figure with a globe in his right
hand and a spear in his left.

813 Salonina Aug.

Pietas Augg. Figura sedens dextra ... sinist. hastã.
Ær.
Salonina. Pietas Augustorum; seated figure with a [] in the
right hand and a spear in the left.

814 Imp. C. Postumus P.F. Aug.

Virtus Aug. Figura galeata gradiens, dextra hastã
sinistra clypeum. Ær.
Postumus. Virtus Augusti; walking helmeted figure with a
spear in the right hand and a shield in the left.

[121][f.45v] d

[122][f.46v] 807 Idem iterum. Ær.
[123][f.46v] 812. Gallienus Aug.
Conservatori Perpetuo. Jupiter stans dextra protegens Icunculam,
sinistra hastã. Ær.
Gallienus. Conservatori Perpetuo; standing Jupiter, his right
hand protecting an idol, in his left a spear.

815 Imp. C. Victorinus

Pietas Aug. Figura stans dextra paterā supra Arā, sinistra ... Ær.

Victorinus. Pietas Augusti; standing figure, the right hand with a dish over an altar and the left [].

816 Imp. C. Tetricus. P.F. Aug.

Virtus Aug. Figura militaris galeata stans, dextra peltam sinistra hastam. Ær.

Tetricus. Virtus Augusti; standing, helmeted military figure, with a shield in his right hand and a spear in his left.

817 Imp. C. Tetricus P.F. Aug.

Victoria Aug. Victoria gradiens, dextra Lauream sinistra hastam. Ær.

Tetricus. Victoria Augusti; walking Victory, with a laurel in her right hand and a spear in her left.

818 Imp. C. Tetricus P.F. Aug.

Salus Aug. Dea Salus, dextra paterā, sinist. temonẽ. Ær.

Tetricus. Salus Augusti; the goddess Salus, with a dish in her right hand and staff in her left.

[48r]

819 Imp. Tetricus P.F. Aug.

Lætitia Aug. Figura stolata stans, dextra corollam deorsum tenens, sinistra anchoram. Ær.

Tetricus. Laetitia Augusti; standing figure in a stola, holding a little wreath downwards in her right hand and an anchor in her left.

820 Idem iterum. Ær.

821 Imp. Tetricus, P.F. Aug.

Lætitia Aug. Figura stolata stans, dextra corollam deorsum tenens, sinistra hastā , p transversū. Ær.

Tetricus. Laetitia Augusti; standing figure in a stola, holding a little wreath downwards in her right hand crossed by a spear held in her left.

822 C. Pivesu. Tetricus Cæs.

Pietas Augustor. Vasa Pontificialia. Ær.

Tetricus [Junior]. Pietas Augustorum; pontifical vessels.

823 Idem iterum. Ær.

824 Idem iterum. Ær

825 Idem iterum. Ær.

826 C. Pivesu. Tetricus Cæs.

Salus Aug. Salutis stantis typus, dextra pateram, sinistra temonem. Ær.[124]

Tetricus [Junior]. Salus Augusti; standing Salus type, with a dish in the right hand and a staff in the left.

827 Imp. C. Claudius Aug.

Jovi Victori, Jupiter /stans,\ dextra fulmen sinistr hastā. Ær.

Claudius. Jovi Victori; standing Jupiter with a thunderbolt in his right hand and a spear in his left

828 Idem iterum. Ær.

829 Idem iterum. Ær.

830 Imp. C. Claudius Aug.

Jovi Victori, Jupiter stans, dextra pil, sinistra hastam gestans, Ær.

Claudius. Jovi Victori; standing Jupiter, with a javelin in his right hand and a spear in his left.

831 Imp. C. Claudius Aug.

Marti Ultori, Mars gradiens, dextra hastā sinistra spolia super humeros. Ær.

Claudius. Marti Ultori; Mars walking, with a spear in his right hand and the spoils of war on his left shoulder.

832 Idem iterum. Ær.

833 Imp. C. Claudius Aug.

Apollini Cons. Apollo stans, dextra ramum, sinistra Citharam aut Lyram. Ær.

Claudius. Apolloni Conservatori; standing Apollo, with a branch in his right hand and a cithara or lyre in his left.

834 Divo Claudio. Consecratio cũ ... Ara. Ær.

The divine Claudius. Consecratio; with [] an altar.

835 Idem iterum. Ær

[49r]

836 Imp. C. Claudius Aug.

Fortunæ Aug. Fortuna temonem et Cornucop. tenens. Ær.

Claudius. Fortuna Augusti; Fortuna holding a staff and a cornucopia.

837 Idem iterum. Ær.

838 Imp. C. Claudius Aug

Sanitati Aug. Dea Salus dextra pateram cum Serpente. Ær.

Claudius. Sanitati Augusti; the goddess Salus, in her right hand a dish with a serpent.

839 Imp. Claudius Aug.

Genius Exerc. Deus Genius stans dextra paterā sinistra Cornucopiam. Ær.

Claudius. Genius Exercitus; standing Genius with a dish in his right hand and a cornucopia in his left.

840 Imp. C. Claudius Aug.

Advent. Aug. Imp. Claudius Equo succussanti insidens Ær.

Claudius. Adventus Augusti; Claudius seated on a jolting horse.

841 Imp. C. Claudius Aug

Virtus Aug. Figura militaris stans dextra ramum sinistra hastam. Ær.

Claudius. Virtus Augusti; standiing military figure with a branch in his right hand and a spear in his left.

842 Imp. C. Claudius Aug.

Pax Aug. Figura stans dextra ramum protendens sinistra hastam tenens p transversū. Ær.

Claudius. Pax Augusti; standing figure holding out a branch with his right hand, crossed by a spear held in his left.

843 Imp. C. Claudius Aug.

Beatitudo Aug ...

Claudius. Beatitudo Augusti.

844 Imp. C Claudius Aug.

Libertas Aug. Figura stolata stans dextra Marsupium, sinistra Cornucopiam. Ær.

Claudius. Libertas Augusti; standing figure in a stola holding a pouch in her right hand and a cornucopia in her left.

845 Imp. C. Claudius Aug.

Libertas. Aug. eadem figura. \\x d://

Claudius. Libertas Augusti; with the same figure.

[124][f.47v] d

846 Imp. C. Claudius Aug.

Liberal. Aug. Liberalitatis typus dextra Marsupiū sinistra Cornucopiam. Ær.
Claudius. Liberalitas Augusti; Liberalitas type, with a pouch in her right hand and a cornucopia in her left.

847 Imp. C. Claudius Aug.

Annona Aug. Figura stolata stans dextra spicas \\x// sinistra Cornucopiā. Ær
Claudius. Annona Augusti; standing figure in a stola with ears of corn in her right hand and a cornucopia in her left.

848 Idem iterum. Ær. \\x//

849 Idem iterum. Ær

850 Idem iterum. Ær.

[50r]

851 Imp. C. Claudius Aug.

Provident. Aug. XII. figura stans, sinistra Cornucopiam columnæ innixa, dextra scipionem. Ær.
Claudius. Providentia Augusti; standing figure leaning on a column with the left hand and with a staff in the right.

852 Imp. C. Claudius Aug.

Provid. Aug. Figura stans, dextra scipionẽ, sinistra hastam puram. Ær.
Claudius. Providentia Augusti; standing figure with a staff in the right hand and a spear without an iron head in the left.

853 Imp. C. Claudius Aug.

Æquitas Aug. figura stolata stans, dextra bilancem, sinistra Cornucopiā. Ær.
Claudius. Aequitas Augusti; standing figure in a stola with a balance in her right hand and a cornucopia in her left.

854 Idem iterum. Ær.

855 Idem iterum. Ær.

856 Imp. C. Claudius Aug.

Pietas Aug. Figura stans, dextra paterā sup Aram, sinistra Cornucopiā. Ær. \\9//
Claudius. Pietas Augusti; standing figure, a dish in her right hand on an altar, a cornucopia in her left.

857 Imp. C. M. Aur. Claudius P.F. Aug. etc.

Fides Militum E. Figura stolata stans, dextra signū militare, sinistra hastam. Ær.
Claudius. Fides Militum; standing figure in a stola, in her right hand a military standard and a spear in her left.

858 Imp. C. Claudius Aug.

Victoria Aug. Victoria, dextra ramū, sin. palmā. Ær.
Claudius. Victoria Augusti; Victory, with a branch in her right hand and a palm leaf in her left.

859 Imp. C. Claudius Aug

Victoria Aug. Victoria, dextra corollā, sin. palmā. Ær.[125]
Claudius. Victoria Augusti; Victory, with a wreath in her right hand and a palm leaf in her left.

860 Imp. C. M. Aur. Cl. Quintillus Aug.

Æternit. Aug. Figura nuda stans, dextra ramū. Ær

Quintillus. Aeternitas Augusti; standing nude figure, with a branch in the right hand.

861 Imp. C. Aurelianus Aug.

Conservat. Aug. Imp stans, dextra Captivum vel servum pileo donans, sinistra hastā tenens. Ær. \\[-q]//
Aurelian. Conservator Augusti; standing Emperor, giving a cap to a captive or slave with the right hand and holding a spear in the left.

862 Imp. C. Maximinus P.F. Aug.

Provide. Augg. et CÆSS.N.N.ST. Figura sedens, dextra ... sinistra Cornucop. Ær.
Maximinus. Providentia Augustorum; seated figure with a [] in the right hand and a cornucopia in the left.

863 Constantinus Aug. Beata Tranquilitas. Cippus in quo Vot. XX. Ær. \\0//
Constantine. Beata Tranquilitas; cippus inscribed with Vot. XX [*votis vicennalibus*].

[51r]

864 Constantinopolis - Caput Constantini M.

Victoria stans alis expansis dextra scipionem, sinistra clypeum. P.L.C. Ær.
Constantinopolis. Head of Constantine. Standing Victory with outstretched wings with a staff in her right hand and a shield in her left.

865 Constantinopolis - Caput Const. M.

Eadem figura. coram (ut puto) Aspergillū. TRP*. Ær. Hæc duo ultima, quidam potius ponduscula, quam nummos, existimant.
Constantinopolis. Head of Constantine. The same figure, before (so it seems) a sprinkler. Exergue: TRP. These last two are thought to be little weights rather than coins.

Praeter Numismata Rom superius explicata, Idem Thomas Brathwait de Ambleside Armig octoginta septem alia donavit, usque adeo exesa ac obliterata, ut de ijs vix aliqua probabilis aestimatio assignari possit. Idem Thomas Brathwait etiam sequentia contulit.
As well as the Roman coins listed above, the same Thomas Braithwait of Ambleside, Esq., gave eighty-seven others which are corroded or obliterated to the extent that they can scarcely be identified with any degree of probability. The same Thomas Braithewait also contributed the following sequence.

866 Moneta Moscovitica Denga dicta. Ar \\[-d]//
Muscovite coin called a denga.

867 Alexander Hengra /[Dei gra]\+ \\[-d]// Rex Scotorum +. Ar
Alexander, King of Scotland.

868 Edwar' (secundus) R' Angl. Dñs Hyb. \\[-d]// Civitas Cantor. Ar.
King Edward II (city of Canterbury).

869 [-Edwardus vj D. G. Ang. etc. Rex. Ær[126]
King Edward VI.

870 Carolus. I. D.G. Ang. Sco. Fr. et Hib. Rex. In utrumque poratus C.R. Gladius, et ramus Laureæ, decusscutim positi. Ær. \\deest.//

[125][**f.49v**] [-d]

[126][**f.50v**] 869 Alexander Rex Scotorum
King Alexander of Scotland.

King Charles I. Each side has C.R., quartered by a sword and a laurel branch.

[52r]

Catalogus Numismatum metallis plerumque mollioribus cusorum, quae insuper clarissimus Vir Dñs Elias Ashmole suo Musæo adjecit.
Catalogue of coins and medals struck from softer metals, which that distinguished man Mr Elias Ashmole gave additionally to his Museum.

871 Caput Salvatoris nostri Dñi Jesu Christi diademate e Spinis contexto coronatus, cum, hac Inscriptione: Ego sum Via, Veritas et Vita, in Obverso. Et Idē Jesus Christ*ᵉ* portans Crucem suam cum hac Inscript. Et Livore ejus sanati sumus. Esa. 53. in Reverso. Plumb[127]
The head of Our Saviour Jesus Christ crowned with a diadem of woven thorns; *rev:* Christ carrying the cross.

872 Imago B. Mariæ Virginis, matris Dei, velatæ, opere anaglyptico, forma ovali. Pl.
Picture of the Blessed Virgin Mary, Mother of God, cloaked, in low-relief; oval in outline.

873 Eadem B. Maria Filium gestans in sinu suo. Pl.
Blessed Mary carrying her Son at her breast.

874 Eadem B. Maria /velata\ Filium mortuum gestans sinu suo, opere anaglyptico, forma ovali. Pl.
Blessed Mary carrying her dead son at her breast, in low-relief; oval in outline.

875 ΑΡΤΕΜΙΑΣ ΒΑΣΙΛΙΣΣΑ. Caput muliebre velatum in Reverso ΜΑΥΣΩΛΕΙΟΝ. Pl.
Queen Artemisia; head of a cloaked woman; *rev:* Mausoleion.

876 Effigies Karoli Quinti. 1521. Ær.
Likeness of Charles V.

877 Mar. Magdalena Arch. Austr. Mag. D. et R. opere anaglyptico. Pl.
Maria Magdalena, Archduchess of Austria, in low-relief.

878 Elizabetha D. G. Angl. Fr. et Hib. Regin. Plumb. deaurat.[128]
Queen Elizabeth.

879 Jacobus.I. D.G. Mag. Brita. Fr. et Hi. Rex +. Fidei Defensor. forma ovali. \\x//
King James I; oval in outline.

880 Carolus I. D. G. Magn. Brit. Franc. et Hib. Rex. Ætatis suæ ...opere anaglyptico. Pl.
King Charles I, at age []; in low-relief.

881 Carolus 2. D. G. Magnæ Brit. Fra. et Hib. Rex. in Reverso Classis Britannica, supra quam Angelus volans, tubam sonans, et schedulam gestans cum hac inscriptione: Soli Deo gloria. In margine: In nomine meo exaltabitur Cornu ejus. Psal. 89. Stanno. [129]

King Charles II. *rev:* the British fleet with an angel flying overhead, sounding a trumpet and carrying a small leaf of paper.

[53r]

882 Henricus 4 Franc. et Navar. Rex Christianiss. In reverso Mars prosternens Centaurum dextra Coronam radiatam porrigentem, cum hac Inscript. Martis cedunt hæc Signa Planetæ. Ær. deplumbat.
Henry IV, King of France and Navarre. *rev:* Mars throwing a centaur to the ground and holding out a radiate crown in his right hand.

883 Henr. 4. R. Christ. Maria Augusta. In Reverso Rex et Regina dextras jungentes, inter eos puer Cassidē ferens; supra, Aquila Coronam radiatan porrigens. Ær. \\cum hac Inscript:ᵉ PROPAGO IMPERI 1603//[130]
King Henry IV with Maria Augusta. *rev:* the King and Queen with right hands clasped; between them a boy carrying a helmet, and above, a crowned eagle holding out a radiate crown.

884 Idem iterum. Pl.

885 Maria Augusta Galliæ et Navarræ Regina, opere anaglypcio. Pl.
Maria Augusta, Queen of France and Navarre, in low-relief.

886 Philippus Rex. Princ. Hisp. Æt. S. An. 28. Opere item anaglyptico. Pl.
Philip, King of Spain at age 28; also in low-relief.

887 Marcus Antonius Memmo Dux Venetiarū, Opere item anaglyptico. Pl.
Mark Anthony Memmius, Duke of Venice; also in low relief.

888 Pri. Feder. Gonz. Dux Mantuæ. Eodē opere. Pl. deaurat[131]
Federico Gonzaga, Duke of Mantua; in the same technique.

889 Guilhel. 3. D. G. Princ. Aur. Holl. et Westf. Gub. in Reverso. Insignia Duc. Periscelide inclusa. Stan.
William III. *rev:* the ducal insignia, including the Garter.

890 D. Prinseps Franciscus Medices. Pl.
Francesco de' Medici.

891 Cosmus II.(?) Magn. Dux Etruriæ. Opere Anaglypt. Pl.
Cosimo II, Grand Duke of Tuscany; in low-relief.

892 Ant. Perrenot S.R.E. P ... Card. Archiepi. Mechl. opere anaglypt. Pl. deaurat.
Anthony Perrenot, Cardinal-Archbishop of []; in low-relief.

893 Imago (ut opinor) Alberti Dureri. 1514. Plumb. \\AD.//
Picture, it seems, of Albrecht Dürer.

894 Jacobus Dux Ormoniæ. In Reverso, Gladius et ramus Laureæ, intra Coronā Ducalem decussatim

[127] **[f.51v]** In Scrin. D. P. 14.
[128] **[f.51v]** In loco sequentis -
In place of the following [coin] -
[129] **[f.51v]** * Numisma cusum /in\ Hollandia, cum Idem Carolus ad Regna sua restitutus est. An. 1660. Jun. 2.
Coin, minted in Holland when the same Charles was

restored to his kingdom, 2 June 1660.
[130] **[f.52v]** Capsula 5ta Potius Dea Pallas
Fifth drawer. Probably the goddess Pallas.
[131] **[f.52v]** d * 888.b. Sigillum societatis a /cruce\Ros/e\a dictæ. Ex dono D. Joannis Edgebury. L.D. \\Lign://
Seal, said to be that of the Fellowship of the Rose Cross. Given by John Edgebury. Of wood.

positi, cum hâc Inscript. Præsidium et dulce decus.
1682. Stan.[132]

James, Duke of Ormonde. *rev:* a sword and a laurel branch placed crosswise within a ducal coronet.

895 Cæsar Duc. de Vandosme. D. Mercoeur. D.
Pentheure. D. Beaufort des Tampes. Prin. Dannet.
Marti P. D. Franc. Opere anaglypt. Ær.

[], Duke of Vendôme, etc.; in low-relief.

[54r]

896 Ni. Brulartus a Sillery Franc. et Navar.
Cancel. In Reverso, Phæbus in Eclyptica cum hac
Inscript. Labor actus in Orbem. Ær.

Nicolas Brulart, chancellor of France and Navarre. *rev:* the Sun in eclipse.

897 Antonius Van Roesendael. XXXI. 1532. Pl.

Antonie Van Roesendael.

898 Effigies primi Militis creati a Rege Angloru̅ ex
Venlo. Pl.

Picture of the first regiment created by the King of England at Venlo.

899 Martinus Bucerus Minister Evangelij D.N.J.
Christi Ætat. suæ 53. Opere anaglypt. Pl. deaurat.

Martin Bucer, aged 53; in low-relief.

900 Martinus Luther Anno Æt. suæ. 63. in
Reverso, in Silentio et Spe erit fortitudo vestra.
Esaiæ. 30. Pl. deaur.

Martin Luther, aged 63.

901 Olivar D.G. RP. Ang. Sco. Hiberniæ
Protector. In Reverso, Olea, cum hac Inscriptione.
Non deficiet Oliva. Sept. 3. 1658. Stan.

Oliver Cromwell. *rev:* an olive branch.

902 Cleopatra (ut opinor) opere anaglyptico. Pl.
forma ovali

Cleopatra (or so it seems), in low-relief; oval in outline.

903 Caput (ut puto) C. Caligulæ. Opere eodem. Pl.
form. oval.

Head of (it seems) Caligula, in the same technique; oval in outline.

904 Fæmina illustris, Opere anaglypt. forma ovali.
Pl. \\orbiculari//

An illustrious lady, in low-relief; oval (rounded) in outline.

905 Alia fæmina illustris, eisdẽ Opere et forma. Pl.

Another illustrious lady, in the same technique and form.

906 Item alia similis fæmina. Pl.

Again, another similar lady

907 Item quarta, eisdem opere et formâ /x\. Pl. \\x
orbiculari//

A fourth one, in the same technique and (rounded) form.

908 Georgio Duce Buc. Sum. Angl. Ammirallio.
in Revers. Hemispherium Globi terrestris. Ær.

George, Duke of Buckingham, Admiral of England. *rev:* a hemispherical terrestrial globe.

909 \\x// Repræsentatio eruptionis militã ex Arte
obsissa inferentium signa recidentibus. Opere
anaglypt. Pl.[133]

Representation of a military sally being launched against a party in retreat, from the Art of Seigiecraft; in low-relief.

910 Repræsantatio (ut opinor) Armilustrij, præ
foribus Arcis munitissimæ, eodem opere. Supra
Angelus volans dextra corollã, sinistra palmã
gerens. Pl.

Representation of (I would suggest) the Armilustrum, in front of the gates of a heavily fortified castle; overhead flies an angel with a wreath in the right hand, holding out a palm leaf in the left. In low-relief.

911 Repræsentatio (ut conjicio) proditionis
Munimenti; supra Angelus volans dextra flagrum,
sinistr. Marsupium, eodẽ opere. Pl.

Representation of (I would conjecture) the betrayal of a defence; overhead an angel flies, with a scourge in its right hand and a pouch in its left; in the same technique.

912 Alia Repræsntatio Armilustrij, præ forib⁵
Arcis, eodẽ Opere. Pl.

Another representation of the Armilustrum, before the gates of a fortress; in the same technique.

[55r]

913 Emblema Concordiæ; supra, Dea concordia
curriculo insidens a Leonibus tracto, super dextrã
duo Turtures, sinistrâ palmam gestans in eodem
Opere. Pl.

Emblem of Harmony. Above, the goddess Concordia in a chariot drawn by lions; holding high two turtle doves in the right hand and a palm in the left; in the same technique.

914 Emblema Pacis dextra palmam gestans, supra
Angelus volans dextra corollam etc, eodem opere.
Pl.

Emblem of Peace, with a palm in her right hand; an angel flies above, with a wreath in its right hand, etc; in the same technique.

915 Numisma a Batavis cusum in memoriam pacis
Bello partæ ab Anglis et Hispanis, et Commercij
reducti, A.° 1667. in Reverso, Classis Navium, et
Leo Belgicus insistens tormentis bellicis etc cum
hac Inscriptione. sIC FInes nostros Leges tVtaMVr
et VnDas. Stan.

Dutch medal struck in commemoration of the conclusion of a peace in the Anglo-Spanish war, and the resumption of trade in 1667; *rev:* a fleet of ships, with the lion of the Belgian lion standing on the engines of war.

916 Judicium (ut puto) Paridis, pomum aureum
Veneri tradentis, forma /2\ octogona. Opere /1\
anaglypt. Pl.

The Judgment of Paris (it seems), handing the golden apple to Venus; in low-relief, octagonal in outline.

917 Bacchus, dextra cyathum sursum tollens,
sinistra Cornucopiam eodem opere, forma ovali.
Pl. deaurat.

Bacchus holding high a ladle in his right hand and with a cornucopia in his left; in the same technique, oval in outline.

918 Prospectus ruralis, eisdem opere et formâ. Pl.

[132][f.52v] * 894.b. Sigillum Æneum Macarij Patriarchæ
Antiocheni. Ex dono D. Johannis Gosche &c.
Bronze seal of Makarios, Patriarch of Antioch. The gift of John Gosch, etc.

[133][f.53v] In Scrin. opt. 15. Capsula 6ᵃ -
In the best cabinet; 6th drawer.

A view of a landscape, in the same technique and of the same form.

919 Neptunus et Tethys, Delphinis insidentis. opere anaglypt. Pl.

Neptune and Tethys, riding on a dolphin; in low-relief.

920 Pastores invenientes Dñi nostrū Jesū Christū in præsepi, et gloria Dñi circumfulgens eos. Opere anaglypt. Ær.

The shepherds discovering Our Lord Jesus Christ in the stable, and the glory of the Lord shining all around; in relief.[134]

921 Cacus Boves in Speluncam suā retrocedentes trahens, Hercule interim juxta dormiente. Ær. \\O MODERNI. Inser./

Cacus dragging back into his cave the oxen which were being returned, with Hercules sleeping nearby.

922 Christus inter duos Latrones crucifixus, cum tota turba quæ simul ad hoc spectaculū accesserat. fig. quadrata. Pl.

Christ crucified between the two thieves, with all the crowd gathered to witness this event; rectangular in outline.

923 Hercules Centaurum occidens, fig. quadratâ. Ær.[135]

Hercules killing the centaur; rectangular in outline.

924 Magi Christū adorantes, et offrentes ei Munera. Opere anaglyptico. Pl./2\ deaurat. figura quadrat /1\.

Adoration of Christ by the Magi, and their offering of gifts to him; rectangular in outline; executed in low-relief.

925 Duo Cupidines sibimet invicem inversi, et per Lumbos colligati. Pl. opere anaglyptico[136]

Two Cupids, arranged alternately upright and upside down, and joined at the hip; in low-relief.

926 Emblema (uti auguror) Industriæ, aut Agriculturæ. Pl. eodem opere.

Emblem of (it may be conjectured) Industry or Agriculture; in the same technique.

[56r]

927 Emblema quoddam Justitiæ. Pl. deaurat. opere anaglypt.

An emblem of Justice; in low-relief.

928 Vasculum floribus plenum. Pl deaurat. eodē opere

A little vase full of flowers; in the same technique.

929 Emblema Fortitudinis Morti obviam euntis. Pl.

Emblem of Fortitude confronting Death.

930 Emblema aliud Fortitudinis aut Constantiæ, dextra palmam attollens licet ponderibus degravata, cū hac Inscriptione; Superanda omnis fortuna. Pl.

Another emblem of Fortitude or Constancy, holding up a palm leaf in her right hand, which is burdened with weights.

931 Emblema Grammaticæ, forma ovali. Pl.

Emblem of Grammar; ovoid in outline.

932 S.ᵗⁱ Johannis Baptistæ decollatio in Castere[?], forma quadratâ. Pl. opere anaglypt

The severed head of St. John the Baptist, on a shield [?]; rectangular in outline, executed in low-relief.

933 Christus lavans pedes Discipulorū, eisdē forma et opere. Pl.

Christ washing the feet of the disciples; the same form and technique.

934 Christus ductus ad Caipham Pontificē maximū, opere item anaglyptico, et forma quadrata. Pl[137]

Christ led before Caiaphas, Pontifex Maximus; also in low-relief and rectangular in outline.

[55v]

935 * Idem iterū. Pl.

[56r]

936 Christus stans vinctus coram Pontio Pilato, eisdem opere ac forma. Pl.

Christ standing, bound, in the presence of Pontius Pilate; the same technique and form.

937 Pilatus abluens manus suas dimittit Jesum. eisdē opere ac formâ. Pl.

Pilate washing his hands off Jesus; the same technique and form.

938 Christus Lazarum evocans e Sepulchro, eisdem opere, ac forma, et sic omnia sequentia. Pl.

Christ raising Lazarus from the tomb; the same technique and form, as are all the following.

939 Christus ad Columnam virgis cæsus. Pl.

Christ scourged at the column with rods.

940 Christus precans in loco qui dicitur Gethsemane, discipulis interim dormientibus. Pl.

Christ praying in the place called Gethsemane, while the disciples sleep.

941 Christus ultimam cænam celebrans. Pl.

Christ celebrating the last supper.

942 Petrus servum Pontificis maximi, gladio percutiens. Pl.

Peter striking the servant of Pontifex Maximus with his sword.

943 Milites Coronam spineâ circa caput Christi plicantes, arundine in dextrâ ejus imponentes, ac illudentes ei. Pl.

Soldiers winding the crown of thorns about the head of Jesus, placing a reed in his right hand, and mocking him.

944 Simon Cyrenæus portans Crucem Dñi. Pl.

Simon of Cyrene carrying Our Lord's Cross.

[57r]

945 Christi fixatio Cruci. Pl.

Christ nailed on the Cross.

946 Christus in cruce pendens. Pl.

Christ hanging on the Cross.

947 Josephus Arimathæusis tollens de Cruce Corpus Dñi. Pl.

Joseph of Arimathaea lifting the body of Our Lord from the Cross.

[134][f.54v] deest figura ipsius Christi
The figure of Christ himself is missing
[135][f.54v] Inser: O MODERNI.
[136]d [f.54v] d|:

[137][-d] *

97

948 Idem Josephus et Nicodemus involventes Corpus Dñi sindone purâ, cum Aromatibus. Pl.
The same Joseph and Nicodemus wrapping the body of Our Lord in clean linen, with aromatic herbs.

949 Milites vigilantes coram Sepulchro Dñi. Pl.
Soldiers guarding the tomb of Our Lord.

950 Christi resurrectio, et Custodes /Sepulchri\ perculsi timore, et facti sicut mortui. Pl.
The Resurrection of Christ, with the guardians of the tomb overcome with fear, and looking as if struck dead.

951 Sigillum antiquum in quo Imago B.M. Virginis filium in sinu suo gestantis, cum hac inscriptione in Limbo, seu margine. Virgo flos florum, pia tutrix sis miserorum.
Ancient seal on which is an image of the Blessed Virgin Mary holding her son at her breast.

952 Moneta ferrea cruciformis in castello Pontis fracti in Comitat. Ebor. ab antiquis temporibus conservata. \\6//
Cross-shaped iron money, preserved since ancient times in Pontefract Castle, Yorkshire.

953 Moneta /textilis\ Angolæ in Africa, ex Arborū corticib' contexta, valoris 2. solidorum[138]
Woven currency of Angola in Africa, woven from the bark of a tree, worth 2s.

954 Lamina aurea prope Bali-shani apud Hibernos effossa &c narrationem vide apud Camdonum edit. Gibs. p. 1022. Ex dono D. Caroli Hopkins.
Gold sheet dug up near Ballyshannon in Ireland, for an account of which see Camden, ed. Gibson, 1695, p. 1022. Given by Charles Hopkins.

955 Cingulum quoddam Americanum ex moneta testaceâ apud Novæ Angliæ Indigenas receptâ tubulorum nicotianæ framina referente confectum. Donavit D. Justinian Shepherd.[139]
An American belt made from shell-money used by the natives of New England and resembling fragments of tobacco pipes. Given by Justinian Shepherd.

956 Numisma Hispanicum Argenteum, Pseudocorallio quodam adnato coopertum; ex thesauro isto quem e navi Hispanicâ, regnante Elizabethâ alto ocano submersâ, expiscati sunt Angli. A.° 1687. Ex dono D. Th. Creech.
Spanish silver coin encrusted with pseudo-coral; found in the treasure of a Spanish ship sunk on the high seas during the reign of Elizabeth, fished up from it by the English in 1687. The gift of Thomas Creech.

[58r]

Catalogus Numismatum tum Romanorum tum Anglicorum, Scoticorū, etc: quae Cl. Vir D. Elias Ashmole Musæo suo Oxonij Secundâ vice donavit A.° Dñi. 1687.
Catalogue of Coins, of the Romans as well as the English, Scots, etc., which that distinguished man Elias Ashmole gave to his Museum in Oxford in his second series of gifts, in 1687.

1 A. PLAVTIVS ÆD.CVRS.C. BACCHIVS IVDAEVS. Ur. fam. Rom. p.200. Ar.[140]
A. Plautius, moneyer. Orsini 1577, p. 200.

2 Jul CAESAR. Elephas. Ib. p. 116. Ar.
Julius Caesar; an elephant. Orsini 1577, p. 116.

3 Jul. CÆSAR. Captivi duo, cum trophæis. Vr. fam. p. 116. Ar.
Julius Caesar. Two captives, with trophies. Orsini 1577, p. 116.

4 RVFVS III VIR. MV. CORDIVS. Ur. p. 70. Ar.
Man. Cordius Rufus, moneyer. Orsini 1577, p. 70.

5 P. NERVA ROMA. Ur. p. 134. Ar.
P. Licinius Nerva, moneyer. Orsini 1577, p. 134.

6 L. IVLI. L.F. CAESAR. Ur. p. 13. Ar.
L. Julius [Bursio]; Caesar. Orsini 1577, p. 13.

7 ROMA SEX. Pom. Fostulus. Ur. p. 280. Ar.
S. Pompeius Faustulus, moneyer. Orsini 1577, p.280.

8 M. ANTON. C. CAESAR. R.P.C. III VIR. Ur. p. 24. Ar.
Mark Antony. Orsini 1577, p. 24.

9 CAR.O. p. 49. Ar.
T. Carisius [?], moneyer. Orsini 1577, p. 49.

10 L. CASSI. Q.F. p. 56. Ar.
L. Cassius, moneyer. Orsini 1577, p. 56.

11 L. CÆSI. p. 42. Ar.
L. Caesius, moneyer. Orsini 1577, p. 42.

12 CAESAR III VIR. R.P.C. CAES.DIC PER..Ur. p. 114. Ar.
Julius Caesar, Dictator Perpetuus. Orsini 1577, p. 114.

13 L. PLAETOR. L.F.Q. S.C. MONETA. S.C. p. 198. Ar.
L. Plaetorius, moneyer; *obv.* Head of Moneta. Orsini 1577, p. 198.

14 LONGIN. III VIR. p. 53. Ar
Cassius Longinus, moneyer. Orsini 1577, p. 53.

15 C. IVNI. C.F. ROMA. Ur. p. 125. Ar.
C. Iunius, moneyer. Orsini 1577, p. 125.

16 C. MAMIL. LIMEĀN. Ur. p. 150. Ar.
C. Mamilius Limetanus. Orsini 1577, p. 150.

17 M. ANTON. IMP. CAESAR DIC. Ur. p. 21. Ar.
Mark Antony. Orsini 1577, p. 21.

18 L. FVRI. CN. F. III VIR. BROCCHI. Ur. Rom. fam. p. 104. Ar.
L. Furius Brocchus. Orsini 1577, p. 104.

[59r]

19 Q. MINV. ROMA RVF. Ur. p. 164. Ar.
Q. Minucius Rufus, moneyer. Orsini 1577, p. 164.

20 CN. GEL. ROMA. p. 106. Ar.
Cn. Gellius, moneyer. Orsini 1577, p. 106.

21 MA. CAO.

[138][f.56v] d.
[139][f.56v] d.

[140][f.57v] Capsula -7ᵐᵃ Mʳ Ashmoles Cabinet. [-3ᵈ drawer.]

S.T. VICTRIX. Ur. fam. Rom. p. 215. Ar.
M. Porcius Cato, moneyer. Orsini 1577, p. 215.

22 IMP. M. ANTON. R.P.C.
III VIR. p. 19. Ar.
Mark Antony. Orsini 1577, p. 19.

23 M. LVCILI. RVF.
PV. p. 144. Ar
M. Lucilius Rufus. Orsini 1577, p. 144.

24 C. LICINIVS. I.F. MACER. p. 137. Ar.
L. Licinius Macer, moneyer. Orsini 1577, p. 137.

25 CLODIVS M.F. p. 61. Ar.
Claudius, moneyer. Orsini 1577, p. 61.

26 L. M. F. FOVRI
ROMA. p. 104. Ar.
M. Furius Philus, moneyer. Orsini 1577, p. 104.

27 RVBRI.
DOS. p. 225. Ar
Rubrius Dossenus, moneyer. Orsini 1577, p. 225.

28 L. PROCIL. I.F.
S. C. p. 221. Ar
L. Procilius [Filius?], moneyer. Orsini 1577, p. 221.

29 C. VIBIVS. C.F.C. Jovis Axur
PANSA. p. 215. Ar.
C. Vibius Pansa, moneyer. Orsini 1577, p. 215.

30 Q. FABI
ROMA. LABEO. p. 93. Ar.
Q. Fabius Labeo, moneyer. Orsini 1577, p. 93.

31 C. PLAVTIVS.
PLANCVS. p. 200 Ar.
C. Plautius Planca. Orsini 1577, p. 200.

32 Idem iterum. Ar

33 P. CREPVSI. Ur. p. 81. Ar
P. Crepusius, moneyer. Orsini 1577, p. 81.

34 A. LICIN.
NERVA FIDES. p. 134. Ar
A. Licinius Nerva, moneyer. Orsini 1577, p. 134.

35 Q.m. SERGI.
ROMA. p. 239. Ar.
M. Sergius Silus [?], moneyer. Orsini 1577, p. 239.

36 Q. CASSIVS. p. 56. Ar.
Q. Cassius, moneyer. Orsini 1577, p. 56.

[60r]

37 SCRIBON. Puteal.
LIBO. BON.EVENT. Ur. fam. Rom. p. 233. Ar.
Scribonius Libo, moneyer. Orsini 1577, p. 233.

38 Q. NASIDIVS NEPTVNI. p. 173. A/u\r, \\vel
saltem deaurat.//
Q. Nasidius, moneyer; gold, or at least gilded. Orsini 1577, p. 173.

39 L. POST. A.F. ROMA. p. 219. Ar.
Postumius Albinus, moneyer. Orsini 1577, p. 219.

40 ANT. AVG. III VIR R.P.C.
LEG. XII. p. 26. [-A/u\r, \\vel saltem deaurat.//]
Mark Antony [?], gold or at least gilded. Orsini 1577, p. 26.

41 C. POBLICI. Q.F. p. 202. Ar.
Poblicius [Malleolus?], moneyer. Orsini 1577, p. 202.

42 Q. LVTATI. Q.
ROMA. Cerco. p. 147. Ar.

Q. Lutatius Cerco, moneyer. Orsini 1577, p. 147.

43 CAESAR. IMP. VII.
VISV /ASIA\RECEP[-\TA]. Ar.
Caesar Octavian; *rev.* Asia received.

44 Idem iterum. Ar.

45 M. FONTEI. C.F. p. 100. Ar
Manius Fonteius, moneyer. Orsini 1577, p. 100.

46 CAESAR. p. 116. Ar.
Caesar. Orsini 1577, p. 116.

47 Q Met EL. PIVS
SCIPIO IMP. Ur fam Rom. p. 38. Ar.
Q. [Caecilius] Metellus, moneyer. Orsini 1577, p. 38.

48 P CRASSVS M.F.
S. C. p. 134. Ar.
P. Licinius Crassus, moneyer. Orsini 1577, p. 134.

49 C CENSO. p. 154. Ar.
Caicus Censorinus, moneyer. Orsini 1577, p. 154.

50 LENT. MR. COS. p. 75. Ar.
Cossus Cornelius Lentulus, moneyer. Orsini 1577, p. 75.

51 CN. LEN. Q. \\S.C.//
C. P. R. p. 71. Ar.
Cneius Lentulus, moneyer. Orsini 1577, p. 71.

52 LEPIDVS PONT. MAX. III VIR R.P.C.
CAESAR IMP. III VIR R.P.C. p. 10. Ar.
Marcus Lepidus. Orsini 1577, p. 10.

53 MAG. PIVS Imp. iter.
Præf. Claseor. Æ. MR. it. ex SC. p. 206. Ar.
[]. Orsini 1577, p. 206.

54 ALBINVS BRVTI.F.
Pietas. p. 131. Ar.
Postumus Albinus Brutus, filius, moneyer. Orsini 1577, p. 131.

[61r]

55 C. COEL. CALDVS.
CALDVS III VIR. p. 66. Ar.
Coilius Caldus. Orsini 1577, p. 66.

56 ANCVS.
Philippus. p. 152. Ar.
Ancus. Marcius Philippus, moneyer. Orsini 1577, p. 152.

57 BRVTVS
LIBERTAS. p. 152. Ar.
Junius Brutus, moneyer. Orsini 1577, p. 152.

58 ROMA M. BÆBI. Q. F.
TAMPIL. p. 36. Ar.
M. Baebius Tampilus, moneyer. Orsini 1577, p. 36.

59 NVMA POMPIL.
L. Pompon. MOLO. p. 210. Ar
L. Pomponius Molo, moneyer. Orsini 1577, p. 210.

60 C.M. FLac. IMPERAT. EX SC. p. 266. Ar
[]. Orsini 1577, p. 266.

61 L. Memmi. p. 158. A[141]
Memmius, moneyer. Orsini 1577, p. 158.

62 Philippus. p. 152. Ar[142]
Q. Marcius Philippus [?], moneyer. Orsini 1577, p. 152.

[141][-d] [**f.60v**] [-d]
[142][-d] [**f.60v**] [-d]

99

63 ...

64 ...

65 ...

66 ...

67 ...

68 ...

69 ...

70 ...

[62r]

71 Cæsar Augustus Divi F. Pater Patr.

Pontif. Maxim. Dea Clementia sedens, dextra ramum Lauri, sinistra hastam tenens. Ar.
Augustus. The goddess Clementia seated, with a laurel branch in her right hand and a spear in her left.

[insert on 61v]

72 Cæsar Augustus Divi F. Pater Patriæ.

C. L. Cæsares Augusti F. Cos. Desig. Princ. Juvent. Caius et Lucius Agrippæ filij (ab Augusto adoptari) cum Clypeis hastis, sympulo et lituo. Ar.
Augustus. C. L. Caesares Augusti Filii; Caius and Lucius, sons of Agrippa (adopted by Augustus) with shields, spears, ladle and staff.

73 Idem iterum. Ar.

74 Ti. Cæsar Div. Aug. F. Augustus.

Pontif. Maxim. Figura sedens dextra hastam. Ar.
Tiberius. Seated figure with a spear in the right hand.

[62r]

75 C. Cæsar Aug. Germ. P. M. TR Pot.

Cos. Ar.
Caligula.

76 C. Cæsar Aug. Germ. P. M. TR. Pot.

Agrippina Mat. C. Cæs. Aug. Germ. Ar.
Caligula; rev: Agrippina, his mother.

77 Ti. Claud. Cæsar Aug. P. M. TR. P. x P. P. Imp. XVIII.

Paci Augustæ. Dea Pax alata, sinistra Caduceum (cum serpente) gestans, dextra colo admovens bullã. Ar.
Claudius. Paci Augustae; winged goddess Pax, holding a caduceus (with serpent) with her left hand and with her right placing a bulla on her neck.

78 Nero Cæsar Augustus.

Vesta. Templum Vestæ. Ar
Nero. Vesta; temple of Vesta.

79 Imp. Ser. Galba Cæsar Aug.

Victoria. Victoria stans, dextra sertum, sinistra palmam gerens. Ar.
Galba. Victoria; standing Victory with a wreath in her right hand, and a palm leaf in her left.

80 Imp. Ser. Galba Cæsar Aug.

Salus Generis humani. Figura stolata stans coram Ara accensa, dextra pateram, sinistra veluti facem. Ar.
Galba. Salus Generi Humani; figure in a stola standing Before a lighted altar, with a dish in the right hand and what looks like a torch in the left.

81 Imp. Ser. Galba Cæsar Aug.

Diva Augusta. Figura stolata stans, dextra pateram, sinistra hastam. Ar.
Galba. Diva Augusta; standing figure in a stola, with a dish in her right hand and a spear in her left.

82 Imp. M. Otho Cæsar Aug. TR. P.

Securitas. P. R. Figura stans dextra ramum, sinistra hastam. AR. \\q ://[143]
Otho. Securitas; standing figure with a branch in the right hand and a spear in the left.

83 Cæsar Vespasianus Aug.

Imp. XIX. Canistrum cum spicis. Ar.
Vespasian. A basket with ears of corn.

[63r]

84 Imp. Cæsar Vespasianus Aug.

Judæa. Judææ captivæ typus humi desidentis ad trophæum. Ar.
Vespasian. Judaea; captive Judaea type, sitting on the ground by a trophy.

85 Imp. Cæs. Vespasianus

Pontif. Maxim. Figura sedens, dextram attollens sinistra lauream. Indescr. ut opinor. Ar.
Vespasian. Seated figure, holding up the right hand and with a laurel in the left. Not described [in print], or so it seems.

86 Imp. Cæsar Vespasianus

Cos. VII. Aquila insistens cippo alis expansis. Ar.
Vespasian. Eagle standing on a cippus with wings outstretched.

87 Imp. Cæsar Vespasianus Aug.

Cos. iter TR. Pot. Figura stolata stans. Ar. forte Ind.
Vespasian. Standing figure in a stola. Perhaps not described [in print].

88 Imp. Cæsar Vespasianus P. M.

Pon. Max. TR. P.Cos. VII. P. P. Figura nuda Columnæ innixa dextra hasta per transversum, sinsitra globus Ar. Q. an descript.[144]
Vespasian. Nude figure leaning on a column with a spear held in the right hand crossing a globe in the left. Has it been described [in print]?

89 Imp. Cæsar Vespasianus Aug.

Cos. VIII. Mars stans, dextra hastam, sinistra spolia gestans. Ar.
Vespasian. Standing Mars with a spear in his right hand, and the spoils of war in his left.

90 Imp. Cæsar Vespasianus Aug.

Cos. iter. TR.P /OT\Figura sedens dextra ramum, sinistra Caduceum. Ar.
Vespasian. Seated figure with a branch in the right hand and a caduceus in the left.

91 Idem iterum. Ar.

92 Imp. Cæsar Vespasianus Aug.

Pon. Max. TR. P. Cos. II. Figura sedens dextra spicas Ar.
Vespasian. Seated figure with ears of corn in the right hand.

93 Imp. Cæsar Vespasianus Aug.

[143][f.61v] Concordia
[144][f.62v] d

Pon. Max. TR. P Cos. VI. Figura sedens dextra ramū sinistra innixa sellæ. Ar[145]
Vespasian. Seated figure with a branch in the right hand, the left leaning on a chair.

94 Imp. Cæsar Vespasianus Aug. Pon./tif\MAx/im\TR. P. Cos. V. Caduceus alatus. Ar.
Vespasian. Winged caduceus.

95 Imp. Cæsar Vesp. Aug. Pon. Max. T. R. P. Cos. V Caduceus item alatus. Ar.
Vespasian. Also a winged caduceus.

[64r]

96 Imp. Cæs. Domitianus Aug. P. M. Juppiter Conservator. Aquila insistens fulmini Ar.
Domitian. Jupiter Conservator; eagle standing on a thunderbolt.

97 Cæsar Divi F. Domitianus Cos. VII Princeps Juventutis. Sella cum galea superimposita. Ar.
Domitian. Princeps Juventutis; a chair with a helmet on it.

98 Idem iterum.

99 Imp. Cæs. Domitianus Aug. P. M. TR. P. Cos. VII. Design. VIII. P. P. Ara cum fulmine. Ar.
Domitian. An altar with a thunderbolt.

100 Imp. Cæs. Domit. Aug. Germ. P. M. TR. P. VI.
Imp. XIIII. Cos XIII Cens. P.P.P. Pallas armata dextra fulmen, sinistra hastam cum clypeo seu pelta ad pedes. Ar.
Domitian. Pallas in armour with a thunderbolt in her right hand, a spear in her left and a small shield or pelta at her feet.

101 Imp. Nerva Cæs. Aug. P. M. TR. P. Cos. III. P. P.
Æquitas Augusti. Æquitas cum statera et Cornucopia Ar.
Nerva. Aequitas Augusti; Aequitas, with scales and cornucopia.

102 Imp. Nerva Cæs. Aug. P. M. TR. P. Cos. III. P. P.
Libertas publica. Libertatis typus, dextra pileum sinistra hastam puram. Ar.
Nerva. Libertas Publica; Liberty type, with a javelin in her right hand and a spear without an iron head in her left.

103 Imp. Cæs. Nerva Trajan. Aug. Germ. Pont. max. TR. Pot. Cos. II. Figura sedens, dextra ramū; sin. cubito sellæ incumbens. Ar.
Trajan. Seated figure with a branch in the right hand, and the left elbow leaning on a chair.

104 Imp. Cæs. Nerva Trajan. Aug. Germ. P. M. TR. P. Cos. III. Victoria sedens dextra pateram, sinistr ... Ar.
Trajan. Seated Victory, with a dish in her right hand and [] in her left.

105 Imp. Cæs. Nerva Trajan. Aug. Germ. P. M. TR. P. Cos. IIII. P. P Victoria stans dextra corollam, sinistra palmam. Ar
Trajan. Standing Victory, with a wreath in her right hand and a palm leaf in her left.

106 Idem iterum. Ar.

107 Imp. Trajano Aug. Germ. Dac. P. M. P.P. Cos. V. P. P. S.P.Q.R. Optimo Princ. Figura, dextra staterā, sinistra Cornucop. Ar.
Trajan. Optimo Principi; figure with scales in the right hand and a cornucopia in the left.

[65r]

108 Imp. Trajano Aug. Ger. Dac. P.M. TR.P. Cos. V. PP. S.P.Q.R. Optimo Princ. Figura sedens, dextra victoriolam, sinistra hastam.
Trajan. Optimo Principi; seated figure with a Victory in the right hand and a spear in the left.

109 [-110] Idem iterum. /10\ [-Idem iterum.]

111 Imp. Trajano Aug. Germ. Dac. P. M. TR. P. Cos. V. PP.S.P.Q.R. Optimo Princ. Dac. Cap. Dacia capta, insidens spolijs lugubri habitu, sinistra manu caput sustinens.
Trajan. Optimo Principi; Dacia captured, sitting among the spoils in mourning dress, supporting her head on her left hand.

112 Imp. Trajano Aug. Ger. Dac. P. M. Tr. P. Cos. V. PP.
S.P.Q.R Optimo Principi. Figuræ duæ, alia Trajani, hastam dextra tenentis; alia Victoriæ, corollam Capiti ejus imponentis. Ar. forte Indescr.
Trajan. Optimo Principi; two figures, one of them Trajan, holding a spear in his right hand, the other is of Victory, placing a wreath on his head; probably not described [in print].

113 Imp. Trajano Aug. Ger. Dac. P. M. TR. P. Cos. V. P.P. S.P.Q.R Optimo Princ. Spolia Dacica. Ar. Indesc.
Trajan. Optimo Principi; the spoils of Dacia; not described [in print].

114 Imp. Trajan[-\us] Aug. Ger. Dac. P. M. TR. P. Cos. VI. PP.
Divus Pater Trajanus. Figura sedens, dextra paterā sinistra hastile. Ar.
Trajan. Divus Pater Trajanus; seated figure, with a dish in the right hand and a spear in the left.

115 Imp. Trajano Aug. Ger. Dac. P. M. TR.P. Cos. VI. PP.
S.P.Q.R. Optimo Principi. Tria signa militaria Ar.
Trajan. Optimo Principi; three military standards.

116 Imp. Cæs. Ner. Trajano optimo Aug. Germ. P.M. TR.P. Cos. VI. P.P. S.P.Q.R. Columna Trajani Cochlidis forma. Ar[146]
Trajan. Trajan's column, in the form of a spiral.

117 Imp. Trajano Aug. Ger. Dac. P. M. TR.P Cos. VI. PP. S.P.Q.R. Optimo Principi. Columna Trajani Cochlidis forma. Ar. forte Indescr. Indesc.

[145][**f.62v**] [-d]

[146][**f.64v**] Ger. Dac.

Trajan. Optimo Principi; Trajan's column, in the form of a spiral; probably not described [in print].

118 Imp. Trajano Aug. Ger. Dac. P.M. TR.P. Cos. VI. P.P. S.P.Q.R. Optimo Princ. Victoria globo insistens, dextra corolam, sinistra palmam. Ar Indesc[147]

Trajan. Optimo Principi; Victory standing on a globe, with a wreath in her right hand and a palm leaf in her left; not described [in print].

119 Imp. Cæs. Ner. Trajano optimo Aug. Ger. Dac. P.M. TR.P. Cos. VI. PP. S.P.Q.R. Deus Genius stans, dextra pateram, sinistra spicas. Ar.

Trajan. Standing Genius, with a dish in the right hand and ears of corn in the left.

[66r]

120 Imp. Cæs. Nervæ Trajano Aug. Ger. Dac. P.M. TR.P. ... S.P.Q.R Optimo Princ. Figura stolata stans dextra tenens ramum, sinistra hastã purã et ante pedes Struthionem habens, Arabiæ typum. Ar

Trajan. Optimo Principi; standing figure wearing a stola, with a branch in the right hand, a spear without an iron head in the left, and with an ostrich before her feet; Arabia type.

121 Imp. Cæs. Trajan. Hadriano Aug. Divi Tra. Parth. F. Divi Ner. Nep. P.M. TR. P. Cos. Figura sedens dextra pateram porrigens, sinistra sellæ innixa; sub qua, Concordia. Ar.

Hadrian. Seated figure holding out a dish in the right hand, and leaning on a chair with the left; below which, Concordia.

122 Idem iterum. Ar.

123 Imp. Cæsar Trajan Hadrianus Aug. P.M. TR.P. Cos. II. Figura sedens, dextra pateram sinistra hastam tenens, sub qua, Justitia. Ar Indesc

Hadrian. Seated figure, with a dish in the right hand and a spear in the left; below which, Justitia. Not described [in print].

124 Hadrianus Augustus. Cos. III. Figura stans, dextra pateram super Aram porrigens, sinistra Corncopiam. Ar.

Hadrian. Standing figure, with a dish held over an altar with the right hand and a cornucopia in the left.

125 Hadrianus Augustus. \\P.P.// Cos. III. Pallas, dextra hastam, sinistrã imponens scuto. Ar.

Hadrian. Pallas, with a spear in her right hand and a shield in her left.

126 Hadrianus Augustus Cos. III. Figura stans, dextra ramũ, sinistra stolã sublevans. Ar. Ind...

Hadrian. Standing figure with a branch in her right hand, holding up her stola with the left; not described [in print].

127 Hadrianus Augustus. Cos. III. Figura sedens, dextra paterã tollens, sinistra Cornucopiam. Ar. Indesc[148]

Hadrian. Seated figure, holding up a dish in the right hand and a cornucopia in the left.

128 Hadrianus Augustus.

Cos. III. Figura sedens, dextra pateram tollens supra Aram, sinistra Cornucopiam. Ar. Indesc.

Hadrian. Seated figure, holding a dish over an altar with the right hand, and in the left a cornucopia. Not described [in print].

129 Hadrianus Augustus. Indulgentia Aug. PP. figura sedens, dextram porrigens, sinistra bacillum tenens. sub Sella. Cos. III. Ar.

Hadrian. Indulgentia Augusti; seated figure with a dish in the right hand and a wand in the left. Exergue: Cos III.

[67r]

130 Hadrianus Aug. Cos. III. P.P. Romulo Conditori. Romulus opima spolia referens, occiso Achrone Ceninensium duce. Ar.

Hadrian. Romulo Conditori; Romulus bringing back rich spoils after killing Acron, King of the Caeninenses.

131 Hadrianus Aug. Cos. III. PP. Annona Aug. Panarium, cum spicis propendentibus. Ar. [-Indes.]

Hadrian. Annona Augusti; Bread-basket, with ears of corn hanging down.

132 Hadrianus Aug. Cos. III. P.P. Salus Aug. Figura stans coram Ara accensa. Ar.

Hadrian. Salus Augusti; standing figure before a lighted altar.

133 Hadrianus Aug. Cos. III. P.P. Tellus Stabij. Figura stans cum aratro et Spicis. Ar.

Hadrian. Tellus Stabilitae; standing figure with a plough and ears of corn.

134 Hadrianus Aug. Cos. III. P.P. Africa. Figura humi dessidens, dextra Scorpione. Ar.

Hadrian. Africa; figure sitting on the ground, with a scorpion in the right hand.

135 Hadrianus Aug. Cos. III. PP. Germania. Figura tunicata(?) cum hastili, et Scuto. Ar.

Hadrian. Germania; figure in a tunic, with a spear and shield.

136 Imp. Cæsar Trajan [-Ha\A]drianus Aug. P.M. TR.P. Cos. III. Victoria cum trophæo. Ar.

Hadrian. Victory with a trophy.

137 Imp. Cæsar Trajan Hadrianus Aug. P.M. Tr.P. Cos. III. Sal. Aug. Imperator distribuens Congiarium. Ar.

Hadrian. Salus Augusti; the Emperor distributing gifts [congarium].

138 Imp. Cæsar Trajan [-Ha\A]drianus Aug. P.M. TR.P. Cos. III. Figura sedens dextra ... sinistra hastam, sub sella Lib Aug. Ar.

Hadrian. Seated figure with a [] in the right hand and a spear in the left. Beneath the stool: Libertas Augusti.

139 Imp. Cæsar Trajan Hadrianus Aug P.M. TR. P. Cos. III. Figura sedens dextra ... sinistra Cornucopiam, sub Sella. Fel. P.R. Ar.

Hadrian. Seated figure, with a ... in the right hand and a cornucopia in the left. Beneath the stool: Felicitas Populi Romani.

140 Imp. Cæsar Trajan Hadrianus Aug.

[147][f.64v] annon V?
[148][f.65v] [-d]

P.M. TR.P. Cos. III. Figura stans dextra paterã super Aram accensam, sinistra spicas. Ar.

Hadrian. Standing figure holding a dish over a lighted altar with the right hand, and ears of corn in the left.

[68r]

141 Sabina Augusta

Junoni Reginæ. Figura stans dextra pateram, sinistra hastam. Ar.

Sabina. Junoni Reginae; standing figure with a dish in the right hand and a spear in the left.

142 Sabina Augusta Hadriani Aug. P.P.

Concordia Aug. Concordia sedens, dextra pateram, sinistra Cornucopiam. Ar. \\9//[149]

Sabina. Concordia Augustae; seated Concordia, with a dish in her right hand and a cornucopia in her left.

143 L. Ælius Cæsar.

TR.P. Cos. II. Pietas. Pietatis typus dextram elevantis super Aram. Ar.

Lucius Aelius. Pietas; Pietas type, raising her right hand over an altar.

144 L. Ælius Cæsar

TR.P. Cos. II. Dea Concordia sedens dextra paterã tenens, ad sinistram Cornucopia, sub Sellâ Concord. Ar.

Lucius Aelius. The goddess Concordia seated, holding a dish in her right hand and a cornucopia in her left. Exergue: Concordia.

145 Antoninus pius Aug.

Indulgentia Aug\\g//. /Cybela\ Imperator Leonem equitans, sub pedibus Leonis. Incarum. /x\. Ar. Indesc[150]

Antoninus Pius. Indulgentia Augustorum; the Emperor (or Cybele) riding a lion, with 'Incarum' below the lion's feet. Not described [in print].

146 Imp. Antoninus pius Aug.

Invictus Sacerdos Aug. Imperator sacrificans, dextra pateram super Aram tenens, sinistra rhabdum, coram facie Stella. Ar Indesc.

Antoninus Pius. Invictus Sacerdos Augusti; the Emperor sacrificing, with a dish held over an altar in his right hand and rod in his right. Not described [in print].

147 Antoninus Aug. Pius. PP.

Aed. Divi Augusti. /REST. COS.IIII.\Templum octo columni, suffultum. Ar.[151]

Antoninus Pius. Aedes Divi Augusti Restitutae; a temple with eight columns.

148 Antoninus pius Aug. Brit

P.M. TR.P. XI. Cos. III. PP. Figura stolata dextram sursum tollens, sinistra hastam puram per transversum. Ar.

Antoninus Pius. Figure in a stola, holding high her right hand crossed by a spear, without an iron head, held in her left.

149 Antoninus Aug. Pius PP. TR.P. Cos. III.

Clementia Aug. Figura stolata stans, dextra pateram, sinistra hastam. Ar.

Antoninus Pius. Clementia Augusti; standing figure in a stola with a dish in her right hand and a spear in her left.

[69r]

150 Antoninus Aug. Pius P.P. TR.P. Cos. III.

Aurelius Cæsar Aug. Pij F. /COS\Caput M. Aurelij. Ar.

Antoninus Pius. Head of Marcus Aurelius.

151 Antoninus Aug. Pius PP. TR.P. Cos. III.

Apollini Augusto. Apollo dextra pateram, sinistra Lyram gerens. Ar.

Antoninus Pius. Apollini Augusto; Apollo with a dish in his right hand, and a lyre in his left.

152 Antoninus Aug. Pius P.P. TR.P. XVI.

Cos. IIII. Figura stans dextra duas spicas, sinistram imponens Aræ. Ar.

Antoninus Pius. Standing figure with two ears of corn in the right hand, the left hand placed on an altar.

153 Antoninus Aug. Pius P.P. TR.P. XXII.

Vota sucepta Dec. III. Cos. IIII. Figura sacrificans. Ar.

Antoninus Pius. Vota Suscepta decannalibus III; sacrificing figure.

154 Antoninus Aug. Pius. P.P. TR.P. XXIII.

Saluti Aug. Cos. IIII. Salutis stantis Typus, ad Aram sacrificantis, dextra pateram, sinistra hastam. Ar.

Antoninus Pius. Saluti Augusti; standing Salus type, sacrificing at an altar, with a dish in her right hand and a spear in her left.

155 Antoninus Aug. Pius P.P.

TR. Pot. Cos. II. Imperator ... dextra tenens, sinistra Cornucopiam. Ar.

Antoninus Pius. The Emperor holding a [] in his right hand and a cornucopia in his left.

156 Divus Antoninus

Consecratio; Rogus, qualis Herod. describit in Severo. Ar.

The Divine Antoninus. Consecratio; funeral pile such as Herodian describes in Severus.

157 Diva Faustina

Augusta. Figura stans dextra hastam, sinistra stolam attollens. Ar.

The Divine Faustina. Augusta; standing figure with a spear in her right hand, raising her stola with her left.

158 Idem iterum.

159 Diva Aug. Faustina.

Æternitas. Figura stolata stans dextra . . . sinistra hastam. Ar.

The Divine Faustina. Aeternitas; standing figure in a stola with a [] in her right hand and a spear in her left.

160 Diva Faustina.

Æd. Div. Faustinæ. Templum. Ar. \\d//[152]

The Divine Faustina. Aedes Divi Faustinae; a temple.

161 M. Aur. Antoninus. P.P. TR. P

[149][f.67v] 142. L. Aelius Cæsar Cos. II. Dea stans dextra spicas sinistra Cornucopiam tenens.
Lucius Aelius. Standing goddess with ears of corn in her right hand and a cornucopia in her left.
[150][f.67v] 45. [-Ad Caracallam Spectat.] (Incarth)
46. [-Ad Elagabalum.]
[151][f.67v] 48. [-Ad Caracallam]

[152]d [f.68v] d

103

... Felicitas. Figura stans dextra ... \\9// ... Ar.[153]
Aurelius. Felicitas; seated figure with [] in the right hand.

[70r]

162 Aurelius Cæsar Aug. Pij F.

Cos. II. figura stans dextra ramum lauri, sinistra
Cornucopiam. Ar. \\9//
Aurelius. Standing figure with a laurel branch in the right
hand and a cornucopia in the left.

163 Imp. Aurel. CÆs. Antonini F.

TR. Pot. Cos. Figura stolata stans dextra
sagittam, sinistra Arcum /Serpentem\ ferens. Ar.
\\An potius Ælius?/[154]
Aurelius. Standing figure in a stola, with an arrow in her right
hand, and a bow or a serpent in the left. Or could it be
Aelius?

164 Aurelius Cæsar Aug. Pij Fil.

TR.P. IIII. Cos. II. Figura sedens dextra ramum
sinistra hastam. Ar.
Aurelius. Seated figure with a branch in the right hand and a
spear in the left.

165 Aurelius Cæsar Aug. Pij F.

TR.P. VIII. Cos. II. Pallas stans dextra noctuam
sinistra hastam. Ar.
Aurelius. Standing Pallas with an owl in her right hand and a
spear in her left.

166 M. Aurelius Aug. Part. Max.

P.M. TR.P. VIII Cos. II. P.P. Victoria dextrâ
porrigens supra globum. Ar.
Aurelius. Victory stretching out her right hand over a globe.

167 Aurelius Cæsar Aug. Pij F.

TR.P. XI. Cos. II. Figura militaris sinistra
hastam, dextra ignotum quiddam. Ar.
Aurelius. Military figure with a spear in his left hand and in
his right I know not what.

168 Idem iterum.

169 M. Antoninus Aug. Armeniacus.

P.M. TR.P. XIX Imp. III. Cos. III.
Aurelius.

170 M. Antoninus Aug. Germ. Sarm.

TR.P. XXXI. Imp. VIII Cos. III. PP. Figura
stolata stans, dextra lauream, sin. Cornucop. Ar.
Aurelius. Standing figure in a stola, with a laurel in her right
hand and a cornucopia in her left.

171 Imp. Aurelius Aug ... Ar.
Aurelius.

172 Faustina Aug. Pij aug. Fil.

Concordia. Figura sedens dextra spicas, sinistra
Cornucopiam. Ar.
Faustina. Concordia; seated figure with ears of corn in the
right hand and a cornucopia in the left.

[71r]

173 Faustina Augusta

Fecunditas. Figura stans dextra hastam, sinistra
puerulum. Ar.
Faustina. Fecunditas; standing figure with a spear in the
right hand and a little boy in the left.

174 Imp. L. Aurel. Verus Aug.

Prov. Deor. TR.P. Cos. II.
Lucius Verus. Providentia Deorum.

175 M. Antoninus Commodus. Aug.

TR.P. VI. Imp. IIII. Cos. III. P.P. Figura militaris
stans dextra Victoriolam, sinsitra hastam. Ar.
Commodus. Standing military figure with a Victory in his right
hand and a spear in his left.

176 Imp. Cæs. P. Helv. Pertin. Aug.

Vot. Decenn. TR.P. Cos. II. Figura sacrificans.
Ar.
Pertinax. Votis Decennalibus; sacrificing figure.

177 L. Sep\\t//. Sev. Pert. Aug. Imp. VIIII.

Herculi Defens. Hercules dextrâ Clavam, sinistrâ
Arcum. Arg.
Septimius Severus. [Hercules Defensor]; Hercules with a
club in his right hand and a bow in his left.

178 Imp. Cae. L. Sep. Sev. Pert. Aug. Cos. II.

Bona Spes. Spei Typus. Ar.
Septimius Severus. Bona Spes; Spes type.

179 L. Sept. Severus . . . III.

Securit ... Figura sedens dextrâ pateram. Ar[155]
Septimius Severus. Securitas. Seated figure with a dish in
the right hand.

180 Severus Pius Aug.

Vota suscepta. /XX\ Figura stolata dextra tenens
pateram coram tripode. Ar.
Septimius Severus. Vota Suscepta Vicennalibus; figure in a
stola, holding a dish in her right hand, before a tripod.

181 Severus Pius Aug.

P.M. TR.P. XIIII. Cos.III. PP. Figura sacrificans
Ar.
Severus. Figure sacrificing.

182 Severus Pius Aug.

P.M. TR.P. XVII. Cos. III. P.P. Figura sedens
dextra serpentem, sinistra Cornucopiam. Ar.
Septimius Severus. Seated figure with a serpent in the right
hand and a cornucopia in the left.

183 Julia Augusta.

Pietas Augg. Figura stans, sacrificans ad Aram.
Ar.
Julia Domna. Pietas Augustorum; standing figure, sacrificing
at an altar.

[72r]

184 Julia Augusta

Diva Lucifera. Figura stolata tedam ferens. Ar[156]
Julia Domna. Diva Lucifera; figure in a stola, with a torch.

185 Julia Augusta

Juno Lucina. Juno dextra pateram, sinistra
hastam. ad pedes Pavo. Ar
Julia Domna. Juno Lucina; Juno with a dish in her right hand
and a spear in her left, at her feet a peacock.

[153][f.68v] 161. [-Ad Caracallam referendus, sicque inscribitur.
M. AVR. ANTON. CÆS. PONTIF.] Cap. nud. juven.
TEMPORVM FELICITAS.
Caracalla? Bare youthful head. Felicitas Temporum.
[154][f.69v] 163 [-Ad Tit. Antoninum: IMP. T.AEL. CAES.
ANTONINVS.
[Lucius] Aelius Caesar.

[155][f.70v] [-d]
[156][f.71v] Diana

186 Plautilla Augusta (Anton. Caracalla uxor)

Venus Victrix. Venus et Cupido, uterque pomum dextra ferens. Venus sinistra palmam. Ar.

Plautilla, wife of Caracalla. Venus and Cupid, each holding an apple in the right hand; Venus has a palm leaf in her left.

187 P. Sept. Geta Cæs. Pont.

Nobilitas. Nobilitatis typus figura stolata, dextra hastam, sinistra Victoriolam. Ar.

Geta. Nobilitas; Nobilitas type, with a figure in a stola, a spear in the right hand and a Victory in the left.

188 P. Sept. Geta Cas. Pont. I F.

Princ. Juvent. Figura dextra ramum, sinistra hastam, cum trophæo a tergo. Ar[157]

Geta. Princeps Juventutis; figure with a branch in the right hand and a spear in the left, with a trophy behind.

189 P. Septimius Geta Cæs.

Spei perpetuæ. Securitatis /Spei\ typus, dextra ramum /florem.\. Ar.

Geta. Spei Perpetuae; Securitas or Spes type, with a branch or flower in the right hand.

190 Idem cum num. 187.

191 P. Sept. Geta Cæs. Pont.

Securit. Imperij. Figura sedens, sinistra sellæ innixa, dextra globum tenens. Ar.

Geta. Securitas Inperii; seated figure, leaning on a stool with the left hand and holding a globe in the right.

192 Julia Mæsa Augusta (Elagabali uxor)

Pudicitia. Dea Pudicitia sedens, sinistra hastâ puram, dextram ori admovens. Ar.

Julia Maesa, wife of Elagabalus. Pudicitia; seated goddess Pudicitia, with a spear, without a head, in her left hand, and holding her right hand to her face.

193 Imp. C. M. Aur. Sev. Alexand. Aug.

P. M.TR. P. VI. Cos. II. PP. Figura militaris gradiens dextra pilum, sinistra spolia sup humerū ferens. Ar.

Alexander Severus. Walking military figure with a javelin in his right hand and with the spoils of war on his left shoulder.

194 Imp. C.M. Aur. Sev. Alexand. Aug.

Pax Aeterna Aug. Figura stans dextra ramū, sinist. hastam. Ar.

Alexander Severus. Pax Aeterna Augusti; standing figure with a branch in the right hand and with a spear in the left.

[73r]

195 Imp. Cæs. M. Ant. Gordianus Aug.

Pax Augusti. Figura Pacis dextra ramum, sinistra hastam puram. Ar

Gordian. Pax Augusti; figure of Peace with a branch in her right hand and a spear without a head in her left.

196 Imp. Gordianus Pius Fel. Aug.

Diana Lucifera. Figura stolata stans, utraque manu facem tenens. Ar.

Gordian. Diana Lucifera; standing figure in a stola, holding a torch in each hand.

197 Imp. Cæs. M Ant. Gordianus Aug.

Providentia Aug. Figura, dextra globum, sinistra bacillum; Providentiæ typus. Ar

Gordian. Providentia Augusti; figure with a globe in the right hand and a staff in the left; Providentia type.

198 Imp. Cæs. Gordianus Pius Aug.

Aequitas Aug. Figura dextra bilancẽ, sin. Cornucop. Ar.

Gordian. Aequitas Augusti; figure with a balance in the right hand and a cornucopia in the left.

199 Imp. Cæs. M. Ant. Gordianus Aug.

Virtus Aug. Figura galeata dextra clypeum, sinistra hastam. Ar.

Gordian. Virtus Augusti; helmeted figure with a shield in the right hand and a spear in the left.

200 Imp. Cæs. M Ant. Gordianus Aug.

P. M. TR. P. II. Cos. P.P. Figura stolata, et tutulata sacrificantis ritu, dextra pateram, sinistra scipionem tenens. Ar.

Gordian. Figure in a stola, wearing the tutulus for the ritual of sacrifice, with a dish in her right hand and in her left a staff.

201 Imp. Gordianus Pius Fel. Aug.

Securit. Perp. Dea securitas columnæ innixa, bacillum tenens dextra. Ar.

Gordian. Securitas Perpetua; the goddess Securitas leaning on a column, holding a staff in her right hand.

202 Imp. M. Jul. Philippus Aug.

Felicitas Temp. Fig. stans dextra caduceum sinistra cornucopiam. Ar. \\d.//

Philip I. Felicitas Temporum; standing figure with a caduceus in the right hand and a cornucopia in the left.

203 Imp. M. Jul. Philippus Aug. \\d://

Romæ æternæ. Roma insidens scuto, dextra tenens victoriolam, sinistra scipionem. Ar.

Philip I. Roma sitting on a shield, holding a Victory in her right hand and a staff in her left.

204 M. Jul. Philippus Cæs.

Principi Juvent. Figura militaris dextra globum, sinistra pilum. Ar.

Philip II. Principi Juventuti; military figure with a globe in his right hand and a javelin in his left.

[74r]

205 Dioclesianus Aug.

Virtus Militum. Castra Prætoria.

Diocletian. Virtus Militum; Praetorian camp.

206 D N Constantius P. F. Aug.

Votis XXX multis XXXX in Corona quercea. Ar.

Constantius. Votis Tricennalibus Multis Quadragennalibus, in a wreath of oak leaves.

207 Fl. Cl. Julianus P.P. Aug.

Victoria DD. NN. Aug. Victoria stans, dextra corollam, sinistra palmam. Ar.\\ L. FL.//

Julian. Victoria dominorum Nostrorum Augustorum; standing Victory, with a wreath in her right hand and a palm leaf in her left.

208 D N Cl. Julianus Aug.

Votis V. Multis X. in Corona quercea. TR. Ar.

Julian. Votis quinquennalibus Multis Decenalibus, in a wreath of oak leaves.

209 DN. Fl. Cl. Julianus P.F. Aug.

Vot. X. Mult. XX. in Corona quercea. Ar.

Julian. Votis Decannalibus Multis Vicennalibus, in a wreath of oak leaves.

210 DN Valentinianus P.F. Aug.

[157] [-d] [f.71v] [-]

Restitutor. REIP. Imperator stans, dextra
Labarum cum (symbol) Christianismi nota
/sinistra victoriolam\

Valentinian. Restitutor Reipublicae; standing Emperor, in his
right hand a labarum marked with the symbol of Christ, and
in his left a Victory.

211 D.N. Valens P. F. Aug.

Virtus Exercitus T.R.P.S. Imperator stans dextra
Labarum, sinistra Scutum. Ar.

Valens. Virtus Exercitus; standing Emperor, with a labarum
in his right hand and a shield in his left.

212 D.N. Valens. P. F. Aug.

Vot. V. Mu.lt. X. in Corona quercea. Ar.

Valens. Votis Quinquennalibus Multis Decennalibus, in a
wreath of oak leaves.

213 D.N. Valentinianus jun. P.F. Aug.

Victoria Augg. TRPS Victoria [-stans\gradiens]
dextra corollam. /sin. palmam.\Ar.

Valentinian II. Victoria Augustorum; walking Victory with a
wreath in her right hand and a palm leaf in her left.

214 D.N. Theodosius P.F. Aug.

Concordia Auggg. Imperator inthronizatus dextra
. . . . sinistra Cornucopiam, sub Cathedra TRPS[158]

Theodosius. Concordia Augustorum; the Emperor enthroned
with a . . . in his right hand and a cornucopia in his left.
Exergue: TPRS.

215 ... \\[-m. Aurelius Antoninus.]// ar.

Aurelius

[75r]

216 ... ar.

217 ... ar.

218 ... ar.

219 ... ar[159]

220 ...[160]

[76r]

Numismata Anglica
English coins

1 Henricus Rex III. cum Corona et Sceptro. \\-//
Davi on Lundei. Ar[161]

King Henry III, with crown and sceptre; moneyer Davi of
London.

2 Henricus Rex III. item cum Corona et Sceptro.
\\-// Henri on Lunde. Ar.

King Henry III, also with crown and sceptre; moneyer Henri
of London.

3 Henricus Rex III. cum Corona et Sceptro. \\-//
Water on Lun. Ar.

King Henry III, with crown and sceptre; moneyer Water of
London.

4 Henricus Rex III. cum Corona et Sceptro. \\-//
Ricard on Lund. Ar.

King Henry III, with crown and sceptre; moneyer Ricard of
London.

5 Henricus Rex III. cum Corona et Sceptro. \\-//

Johs. on Lunden. Ar.

King Henry III, with crown and sceptre; moneyer Johs of
London.

6 Henricus Rex III. cum Corona et Sceptro. \\-//
Nicole on Lun. Ar.

King Henry III, with crown and sceptre; moneyer Nicole of
London.

7 Henricus Rex III. cum Corona et Sceptro. \\-//
Robert on Cant. Ar.

King Henry III, with crown and sceptre; moneyer Robert of
Canterbury.

8 Henricus Rex III. cum Corona et Sceptro. \\-//
Willem on Cant. Ar.

King Henry III, with crown and sceptre; moneyer Willem of
Canterbury.

9 Henricus Rex III. cum Corona et Sceptro. \\-//
Jon on Canter. Ar.

King Henry III, with crown and sceptre; moneyer Jon of
Canterbury.

10 Henricus Rex III. cum Corona et Sceptro. \\-//
Renaud on Lund. Ar.

King Henry III, with crown and sceptre; moneyer Renaud of
London.

11 Henricus Rex III. cum Corona et Sceptro. \\-//
Gilbert on Can. Ar.

King Henry III, with crown and sceptre; moneyer Gilbert of
Canterbury.

12 Henricus Rex III. cum Corona et Sceptro
Willem on Lund. Ar.

King Henry III, with crown and sceptre; moneyer Willem of
London.

[77r]

13 Henricus Rex III. cum Corona et Sceptro.
Nicole on Cant. Ar. \\- 2 *//[162]

King Henry III, with crown and sceptre; moneyer Nicole of
Canterbury.

14 Henricus Rex III. cum Corona et Sceptro. \\-//
Rond. on Beri. Ar.

King Henry III, with crown and sceptre; moneyer Rond of
Bury St. Edmunds.

15 Henricus Rex III. cum Corona et Sceptro. \\-//
Ed...in on Cant. Ar.

King Henry III, with crown and sceptre; moneyer Ed[]in of
Canterbury.

16 Henricus Rex III. cum Corona et Sceptro. \\-//
Rob... on Lund. Ar.

King Henry III, with crown and sceptre; moneyer Rob[] of
London.

17 Henricus Rex 3 sine Sceptro. \\-//
Henri on Lunde Ar.

King Henry III without the sceptre; moneyer Henri of London.

18 Henricus Rex III. sine Sceptro. \\-//
Philip on Nor. Ar.

King Henry III without the sceptre; moneyer Philip of
Northampton.

19 Henricus Rex III. sine Sceptro. \\-//

158[-d] **[f.73v]** [-]
159**[f.74v]** d
160**[f.74v]** [-d] [-]
161**[f.75v]** 3rd ...? of Numbers begin here Capsula 8.ᵛᵃ -

162**[f.76v]** * 13.a. alter:-Id. cum /13./, nisi q.ᵈ desit sceptrum. - huc
allat: Jun. 18. 1747
Another, the same as No.13, without the sceptre. Brought
here on 18 June 1747.

Henri on Oxon. Ar.
King Henry III without the sceptre; moneyer Henri of Oxford.

20 Henricus Rex III. sine Sceptro. \\-//
Nicole on Cant. Ar.
King Henry III without the sceptre; moneyer Nicole of
Canterbury.

21 Henricus Rex III. sine Sceptro. \\-//
Nicole on Lund . Ar.
King Henry III without the sceptre; moneyer Nicole of
London.

22 Henricus Rex III. sine Sceptro. \\-//
Tomas on ... Ar
King Henry III without the sceptre; moneyer Tomas of [].

23 Henricus Rex III. sine Sceptro.
Edmund on ...ond. Ar
King Henry III without the sceptre; moneyer Edmund of
London.

24 Henricus Rex III. sine Sceptro. \\-//
Willem on Cant. Ar.
King Henry III without the sceptre; moneyer Willem of
Canterbury.

25 Henricus Rex III sine Sceptro.
Ricard on Linc. Ar. \\-//
King Henry III without the sceptre; moneyer Ricard of
Lincoln.

[78r]

26 Henricus Rex III. sine Sceptro. \\-//
... Rug. Exonie. Ar.
King Henry III without the sceptre; moneyer [] of Exeter.

27 Henricus Rex III. sine Sceptro. \\-//
Jacob on Norwi. Ar
King Henry III without the sceptre; moneyer Jacob of
Norwich.

28 Henricus Rex III. sine Sceptro. \\-//
Ranulf on Ber. Ar
King Henry III without the sceptre; moneyer Randulf of Bury
St. Edmunds.

29 Henricus Rex III. sine Sceptro. \\-//
... on Oxon. Ar
King Henry III without the sceptre; moneyer [] of Oxford.

30 Henricus Rex III. sine Sceptro. \\-//
Lor... on Sros. Ar
King Henry III without the sceptre; moneyer Lorenz of
Shrewsbury.

31 Henricus Rex III. sine Sceptro. \\-//
Jacob on Norwi. Ar
King Henry III without the sceptre; moneyer Jacob of
Norwich.

32 Henricus Rex III. sine Sceptro. \\-//
Will... on Wilt. Ar
King Henry III without the sceptre; moneyer Willem of
Wilton.

33 Henricus Rex III. sine Sceptro. \\-//
Ricard on Sro... Ar
King Henry III without the sceptre; moneyer Ricard of
Shrewsbury.

34 Henricus Rex III. sine Sceptro. \\-// \\d://
Robert on Lun. Ar
King Henry III without the sceptre; moneyer Robert of
London.

35 Henricus Rex III. sine Sceptro. \\-//
Jacob on ... vit. Ar
King Henry III without the sceptre; moneyer Jacob of [].

36 Henricus Rex III. sine Sceptro. \\-//
Rener on Everw. Ar
King Henry III without the sceptre; moneyer Rener of York.

37 Henricus Rex III. sine Sceptro. \\-//
Ricard on Lon. Ar
King Henry III without the sceptre; moneyer Ricard of
London.

38 Henricus Rex III. sine Sceptro. \\-//
Walter on Linc. Ar
King Henry III without the sceptre; moneyer Walter of
Lincoln.

39 Henricus Rex III. sine Sceptro. \\-//
Gilbert on Can. Ar.
King Henry III without the sceptre; moneyer Gilbert of
Canterbury.

[79r]

40 Henricus Rex III. sine Sceptro. \\-//
Jon on ... Ar.
King Henry III without the sceptre; moneyer Jon of [].

41 Henricus Rex III. sine Sceptro. \\-//
Willelm on Linc. Ar.
King Henry III without the sceptre; moneyer Willelm of
Lincoln.

42 Henricus Rex terci. sine Sceptro \\-// ... Ar.
King Henry III without the sceptre.

43 Henricus Rex III. cum Sceptro et Corona.
\\-// Davi on Divali. Ar
King Henry III with sceptre and crown; moneyer Davi of
Dublin.

44 Henricus Rex III. cum Sceptro et Corona. \\-//
Ricard on Dive. Ar.
King Henry III with sceptre and crown; moneyer Ricard of
Dublin.

45 Henricus Rex, cum Corona et Sceptro \\-//
Gelaimer on Lun. Ar
King Henry with crown and sceptre; moneyer Fil Aimer of
London.

46 Henricus Rex, cum Corona et Sceptro \\-//
Henric on Cant. Ar
King Henry with crown and sceptre; moneyer Henric of
Canterbury.

47 Henricus Rex, cum Corona ... \\-//
Osber. on Lund. Ar
King Henry with crown ... moneyer Osbert of London.

48 Henricus Rex cum Corona et Sceptro. \\-//
Rener on Lund.
King Henry with crown and sceptre; moneyer Rener of
London.

49 Henricus Rex, cum Corona ... \\-//
... berd on L ... Ar
King Henry with crown; moneyer [] of [].

50 Henricus Rex cum Corona et Sceptro \\-//
Walter on Lu. Ar
King Henry with crown and sceptre; moneyer Walter of
London.

51 Henricus Rex ... \\-//
Heneric on Lu. Ar

King Henry []; moneyer Heneric of London.

52 Henricus Rex cum Corona et Sceptro \\-//
 Walter on Lun. Ar.
King Henry with crown and sceptre; moneyer Walter of London.

53 Henricus Rex cum Corona et Sceptro \\-//
 Cierei on Lun. Ar.
King Henry with crown and sceptre; moneyer Gifrei of London.

[80r]

54 Henricus Rex. Coronatus
 Henri on Cant. Ar.
King Henry, crowned; moneyer Henri of Canterbury.

55 Henricus Rex. cum Corona et Sceptro \\-//
 Ranul. on Lund. Ar.
King Henry, with crown and sceptre; moneyer Ranul of London.

56 Henricus Rex cum Corona et Sceptro \\-//
 \\H//Entelis on Lund. Ar.
King Henry, with crown and sceptre; moneyer Elis of London.

57 Henricus Rex cum Corona et Sceptro \\-//
 Ilce ... Lund. Ar
King Henry, with crown and sceptre; moneyer Ilger of London.

58 Henricus Rex, cum Corona et Sceptro \\-//
 Willelm on Lu. Ar.
King Henry, with crown and sceptre; moneyer Willelm of London.

59 Henricus Rex, cum Corona et Sceptro \\-//
 Ali ... he on Ci . Ar
King Henry, with crown and sceptre; moneyer Alisandre of Ipswich.

60 Edward. D.G.R. Angl. \\-//
 Civitas Cantor Ar
King Edward; city of Canterbury.

61 Henric. D.G.R. Angl. \\-//
 Civitas Norwi. Ar.
King Henry; city of Newcastle.

62 Edwa. R'. Anglo. D. Hyb. \\-//
 Civitas Dureme. Ar.
King Edward; city of Durham.

63 Henric Rex Anglie. \\-//
 Civitas London. Ar.
King Henry; city of London.

64 Edwa. R.' Angl. \\-//
 Civitas Derham Ar.
King Edward; city of Durham.

65 Edw. R.' Anglorum. \\-//
 Civitas London. Ar.
King Edward; city of London.

66 Henr. R'. Angl. \\-//
 Civitas Lond. Ar.
King Henry; city of London.

67 Edw. R' Ang. y Dns. Hyb. \\-//
 Civitas Cantor. Ar.
King Edward; city of Canterbury.

[81r]

68 Edw. R' Ang. Y Dns Hyb. \\-//

Civitas London. Ar.
King Edward; city of London.

69 Henric'. R. Ang y Dns Hyb. \\-//
 Posui Deum Adjure' meum
 Villa Callis. Ar.
King Henry; Calais.

70 Edward. D... \\-//
 Posui Deum Adjutore' meum
 Civitas Cantor. Ar.
King Edward; city of Canterbury.

71 Edward R Aug ... \\- 2.//
 Posui Deum Adjurtore' meum
 Civitas London. Ar
King Edward; city of London.

72 Henric' Di Gra. Rex Anglor. \\-//
 Posui Deum Adjutore' meum
 Civitas Cantor. Ar.
King Edward; city of Canterbury.

73 Henric D. G. Rex An. Dux Nor s H.R. \\-//
 Posui Deum Adjutore' meum
 Villa Bristow. Ar.
King Henry VI; Bristol.

74 Edward ... \\-//
 Posui Deum Adjutore' meum.
 Civitas Eborum. Ar.
King Edward; city of York.

75 Edward ... n s Franc. \\-//
 Posui Deum Adjutorem meum.
 Civitas London. Ar.
King Edward; city of London.

76 Henric' Dj' Gra Rex Angl' s H'. \\-//
 Posui Deum Adjutore' meum.
 Villa Calis
King Henry; Calais.

77 Henric' D. Gra. Angl. . . . \\-//
 Posui Deum Adjutore' meum
 Civitas Cantor.
King Henry; city of Canterbury.

[82r]

78 Henric D.G. ... \\-//
 Posui Deum Adjutore' meum.
 Civitas London. Ar.
King Henry; city of London.

79 Henricus Di. Gra. Rex Agl ...
 Civitas Eborum. Ar[163]
King Henry; city of York.

80 Edwardus ...
 ... Ar.
King Edward.

81 Edward Angl. Rex . . .
 Civitas Eborum. Ar[164]
King Edward; city of York.

82 ... Dns Hyb.
 Vill. St. Edmundi. Ar[165]

[163] ...
[164] [-d]
[165] [-d]

[]; Bury St. Edmunds.

83 ...
 Posui Deum Adjutore' meum
 Villa Calis. Ar.
[]; Calais.

84 Henric' Di' Gra Rex Anglor s Franc.
 Posui Deum Adjutore' meum.
 Civitas London. Ar.
King Henry; city of London.

85 Edward' Di' Gra. Rex Angl. s Franc.
 Posui Deum Adjutore' meum.
 Civitas London. Ar.
King Edward; city of London.

86 Henric' Di' Gra. Rex. Angli. s. Fr.
 Posui Deum Adjutore' meum.
 Civitas London. Ar.
King Henry; city of London.

87 Edward' Di' Gra. Rex Angl s Franc.
 Posui Deum Adjutore' meum
 Villa Bristow. Ar.
King Edward; Bristol.

88 Edward' Di' Gra. Rex Angl. s Franc.
 Posui Deum Adjutore' meum
 Civitas London. Ar.
King Edward; city of London.

[83r]

89 Edwrd Di' Gra. Rex Angl s Franc.
 Posui Deum Adjutore' meum.
 Civitas London. Ar.
King Edward; city of London.

90 Henric' Di' Gra. Rex Angl. s Franc.
 Posui Deum Adjutore' meum.
 Civitas London. Ar.
King Henry; city of London.

91 Henric' Di' Gra Rex Agl s H.
 Posui Deum Adjutore' meu.
 Civitas London. Ar.
King Henry; city of London.

92 Edward Di' Gra. Rex Angl. s Franc. D. Hyb.
 Posui Deum Adjutorem meum.
 Civitas London. Ar[166]
King Edward; city of London.

93 Ricard. Di' Gra. Rex Angl. et Franc.
 [-B ...\Posui Deum Adjutorem meum.
 Civitas London.] Ar.
King Richard; city of London.

94 Henric' VII. Di' Gra. Rex Agl. etc. Posui Deu'
Adjutore' meu'. Ar.
King Henry VII.

95 Henric' VII Di' Gra. Rex Angl. etc.
 Posui Deu' Adjutore' meu'. Ar.
King Henry VII.

96 Idem iterum. X.B. Ar.

97 Idem iterum. [-duce Claves]. Ar.

98 Henric' VIII'. D' GR' Rex Agl. z Fra.

 Civitas [-Eboraci] [-/London\] T.W. Ar.
King Henry VIII.

[insert on 82v]

99 [-Idem iterum.] \\99. Deest.//[167]

[83r]

100 Henric' 8. D' G' Agl. Fra z Hib. Rex.
 Posui Deu' Adjutore' meu'. Ar[168]
King Henry VIII.

101 Henric' VIII D. G. R. Agl. z Franc'
 Posui Deu' Adjutore' meu'. Ar[169]
King Henry VIII.

102 Henric' VIII' Di' Gra' Rex Agl. z Fr. cum
porta dimissoria.
 Posui Deu' Adjutore' meu'. Ar[170]
King Henry VIII; with portcullis.

103 Henric' VIII' D. G' R. Agl. z. Fra' cum radijs
solarib' e rubib'.
 Posui Deu' Adjutore' meu'. Ar[171]
King Henry VIII; with rays of the sun and rose.

[84r]

104 Henric' VIII' D.G.R Angliæ. Insignia Regia.
 France, Dominus Hibernie. Lyra Hibernica. R.A.
King Henry VIII; with the insignia of the crown and the harp
of Ireland.

105 Henric' VIII'. D.G.R. Agl. z. Fr'
 Posui Deu' Adjutore' meu'. Ar.
King Henry VIII.

106 Henric'. 8. D.G.Rex Agl. z. Fr'.
 Civitas London. Ar.King
Henry VIII; city of London.

107 Henric' VIII' D.G.R. Agl. z F.
 Civitas Cantor. Ar.
King Henry VIII; city of Canterbury.

108 Henric' VIII' Di' Gra' Agl ...
 Civitas Cantor W.A. Arg.^L
King Henry VIII; city of Canterbury.

109 Henric' VIII' D.G.R. Agl' z.F.
 Civitas Cantor W.A. Arg^L
King Henry VIII; city of Canterbury.

110 Henric' VIII' D.G.R. Agl' z Fr.
 Civitas Cantor T.C. Ar.
King Henry VIII; city of Canterbury.

111 Henric' VIII' D.G.R. Agl. z Fr'.
 Civitas Eboraci. Ar.
King Henry VIII; city of York.

112 Henric' VIII' D.G.R. Agl. z Fr'.
 Civitas Eboraci T.W. Ar.
King Henry VIII; city of York.

113 Henric' VIII. Di' Gra. Rex Agl.
 Civitas Eboraci; cum Clavib', et Galero
Cardinalitio. Ar[172]

[166][-d]

[167]D1
[168][**f.82v**] [-d] - [-d\+]
[169][**f.82v**] [-] - [-d]
[170][-d]
[171][-d]
[172][-d] [**f.83v**] [-]

King Henry VIII; city of York, with keys and cardinal's hat.

114 Idem iterum. Ar[173]

115 Henric' VIII' D. G. Agl. z. Fr. Rex.
Civitas Eboraci. Ar.
King Henry VIII; city of York.

116 Henric'. VIII'. D.G.R. Agl. z. F. R.
Civitas Eboraci E.L. Ar.
King Henry VIII; city of York.

117 Henric' VIII' D.G.R. Agl. z. Fr'.
Civitas Eboraci LE. Ar.
King Henry VIII; city of York.

118 Henric' 8 D.G. Agl. z. Hib. Re
Civitas Bristolie. Ar.
King Henry VIII; city of Bristol.

119 H.D.G. Rosa sine Spina.
Civitas London. Ar.
King H[enry VIII]. Rose without thorns; city of London.

[85r]

120 Henric'. D...
Civitas Eboraci. Ar
King Henry [VIII]; city of York.

121 H. D.G. ...
Civitas Eboraci. Ar.
King Henry [VIII]; city of York.

122 H. D. G. Rosa sine spini.
Civitas Durram. Ar.
King Henry [VIII]. Rose without thorns; city of Durham.

123 Henric' Di' Gra. Agl. Rex.
Civitas Durram. T. D. Ar.
King Henry [VIII]; city of Durham.

124 H. D. G. Rosa sine spina.
Civitas Durram. T.W. Ar.
King Henry [VIII]. Rose without thorns; city of Durham.

125 H. D. G. Rosa sin. spina.
Civitas Durram. I. D. Ar.
King Henry [VIII]. Rose without thorns; city of Durham.

126 Henric' Di' Gra ...
Civitas Durram. R.D. Ar.
King Henry [VIII]; city of Durham.

127 Idem iterum. Ar.

128 Henric'. Di' Gra. Re. An.
Civitas Durram. D. S. Ar.
King Henry [VIII]; city of Durham.

129 Henric' ... Ang Civitas Durram.B. Ar[174]
King Henry [VIII]; city of Durham.

130 Edward' VI. D. G. Agl'. Franci' z Hib. Rex. 1551.
Posui Deum Adjutore' meu'. Ar[175]
King Edward VI.

131 Edward' VI. D. G. Agl. Fra. z Hiber' Rex. 1551.
y. Posui Deum Adjutore' meum. Ar[176]

King Edward VI.

132 Edward' VI. D. G. Agl. Fra' z Hib. Rex. 1551.
Posui Deu' Adjutore' meu'. Ar[177]
King Edward VI.

133 Edward' VI. D. G. ... ra. z Hib. R. ...
Inimicos ejus nid ... Confusio ... ER. Ar.
King Edward VI.

[86r]

134 Edwardus VI. Rex Angli. Franc. Hiberni.
Timor Domini Fons vitæ. MDXLVIII. ER. Ar.[178]
King Edward VI.

135 Edward' VI. D.G. Agl. Fra. z. Hib. Rex.
Civitas Eboraci. Ar[179]
King Edward VI; city of York.

136 Edward' VI. D.G. Agl. Fra' z. Hib. Rex y.
Posui Deu' Adjutore' meu'. /y\Ar.
King Edward VI.

137 Edward' VI D.G. Agl. Fra' z. Hib. Rex.
Posui Deu' Adjutore' meu'. Ar.
King Edward VI.

138 Philip et Maria D.G.R. Ang. Fr. Neap. Pr. Hisp.
Posuimus Deum Adjutorem nostrum. Ar[180]
Philip [of Spain] and Queen Mary.

139 Philip et Maria D.G.R. Ang. Fr. Neap. Pr. Hisp. 1554.
Posuimus Deum Adjutorem nostrum. XII. Ar.[181]
Philip [of Spain] and Queen Mary.

140 Philip et Maria D.G. Rex et Regina Angl.1555.
Posuimus Deum Adjutorem nostrum. /XII\Ar[182]
Philip [of Spain] and Queen Mary.

141 Philip et Maria D.G. R. Aug. Fr. Neap. Pr. Hisp.1554
Posuimus Deum Adjutorem nostrum. VI. Ar.
Philip [of Spain] and Queen Mary.

142 Philip et Maria D.G. Rex z Regina Angl. 1557.
Posuimus Deum Adjutorem nostrum.
Philip [of Spain] and Queen Mary.

143 Maria D.G. Ang. Fra' z Hib. Regi.
Veritas temporis filia. Ar.
Queen Mary.

144 Philip et Maria D.G. Rex et Regina.
Posuimus Deum Adjutorem nostrum. Ar.

[173][-d] [f.83v] [-]
[174][-d] [f.84v] [-]
[175][f.84v] d
[176][f.84v] deest

[177][-d] [f.84v] [-d]
[178][-d] [f.85v] [-d]
[179]* [-]/d d [f.85v] *n.b. Amissi locum jam supplet alterum Numisma ejusdem Regis. Edward' VI. D.'G.' Angl: Fran.' z: Hib. Rex. x intra Orbitam XII. Rev: Posui Deum Adjutorem meum. D.D. Georg: Huddesford S.T.P. Coll. S.S. & Individ. Trinit:' Præsidens x hujusce muse`i Cimeliarcha. A.D. 1746 .
Replacing the lost coin is another of the same King Edward VI. Given by George Huddesford, Professor of Theology, Fellow and President of Trinity College and keeper of this Museum; 1746.
[180][f.85v] [-d]
[181][f.85v] [-d]
[182][f.85v] deest

Philip [of Spain] and Queen Mary.

145 Idem iterum. Ar.

146 Philip et Maria D.G. Rex et Regina.
Posuim. Deum Adjuto. nos. Ar.
Philip [of Spain] and Queen Mary.

147 Elizabeth. D.G. Ang. Fra. et Hiber. Regina :i.
:i: Posui Deum Adjutorem mum. Ar. }Coronat.[183]
Queen Elizabeth; crowned.

[87r]

148 Elizabeth. D.G. Ang. Fra. et Hiber. Regina. :i:
i. Posui Deum Adjutorem meum. Ar. }Semi-
Coronat[184]
Queen Elizabeth.

149 Elizabeth. D.G. Ang. Fr. et Hib. regina
Posui Deu' Adjutorem meu'. Ar. }cum Cruce
cruciata.
Queen Elizabeth; with cross crosslet.

150 Elizabeth. D.G. An. Fr. et Hi. Regina
Posui Deu' Adjutorem meu'. Ar }cum hirundine
apode.
Queen Elizabeth; with a martlet.

151 Elizabeth. D.G. Ang. Fra. z Hib. Regi.
Posui Deu' Adjutorem meum }Ar. cum Lilio.
Queen Elizabeth; with fleur-d-lis.

152 Elizab. D.G. Ang. Fr. et Hib. Regi.
Posui Deu' Adjutorem meu' Ar }cum Litera .
Queen Elizabeth; with the letter Â.

153 Idem iterum. cum Dolio.
Another of the same; with a wide jar.

154 Elizab. D.G. Ang. Fr. et Hib. Regi. i. cum
Rosa.
Posui Deu' Adjutorem meu'. 1601. Ar.
Queen Elizabeth; with a rose.

155 Elizabeth D.G. Ang. Fr. et Hi. Regina.
Posui Deu' Adjutorem meu' Ar }cum Rosa et
Cuspide Sagittæ. 1561.
Queen Elizabeth; with a rose and arrowhead.

156 Elizabeth. D.G. Ang. Fr. et Hi. Regina
Posui Deu' Adjutorem meu' Ar }Cum Castello.
1570.
Queen Elizabeth; with a castle.

157 Idem iterum, cum Lilio[185]
Another of the same; with a fleur-de-lis.

158 Elizabeth. D.G. Ang. Fr. et Hi. Regina.
Posui Deu Adjutorem meu'. Ar }cum Insignijs
Zelandicis et Cuspide Sagittæ. 1601[186]
Queen Elizabeth; with the arms of Zeeland and an
arrowhead.

159 Elizabeth. D.G. Ang. Fr et Hi. Regina
Posui Deu' Adjutore' meu'. Ar }cum Cruce.
Queen Elizabeth; with a cross.

160 Idem iterum. Ar. 1582.

161 Idem iterum. Ar. 1565.

162 E.D.G. Rosa sine Spina.
Civitas London. Ar.
Queen Elizabeth. With a rose without thorns; city of London.

163 Idem iterum. Ar. \\1572//

164 Idem iterum. Ar.

165 Idem iterum. Ar.

166 Idem iterum. Ar.

[88r]

Numismata Elizabethæ, molâ trusatili cusa.
Coins of Elizabeth, minted with a mill

167 Elizabeth. D.G. Ang. Fra. et Hib. Regina
Posui Deum Adjutorem meum. Ar. \\}cum
Stella.//[187]
Queen Elizabeth; with a star.

168 Idem iterum. Ar.

169 Idem iterum. cum Lilio.
Another of the same, with a fleur-de-lis.

170 Elizabeth. D.G. Ang. Fra. et Hib. Regina
Posui Deum Adjutorem meum Ar }cum Rosa et
stella. 1562.
Queen Elizabeth; with a rose and star.

171 Idem iterum. Ar. 1561.

172 Idem iterum. Ar. 1562.

173 Idem iterum. Ar. 1564.

174 Idem iterum. Ar. 1566

175 Idem iterum. Ar. 1567. cum Lilio

176 Idem iterum. Ar. 1568.

177 Idem iterum. Ar. 15. . . cum Rosa et stella.[188]
Another of the same; with rose and star.

178 Jacobus D.G. Mag. Brit. Fran. & Hib. Rex
Quæ Deus conjunxit nemo separet. Ar }cum
Carduo. /Lilio\
King James [I]; with a thistle or fleur-de-lis.

179 Jacobus D.G. Mag. Bri. Fran. et Hib. Rex.
Quæ Deus conjunxit nemo separet. Ar }cum
trifolio et Rosa coronata, /et\ Plumis
Struthiocameli; Principis Walliæ Emblemate.
\\deest//[189]
King James [I]; with clover-leaf and crowned rose, and with
ostrich feathers - emblem of the Prince of Wales.

180 Jacobus D.G. Ang. Sco. Fran. et Hib. Rex
Exurgat Deus dissipentur inimiti. Ar. \\cum
Carduo//[190]
King James [I]; with a thistle.

181 Jacobus D.G. Mag. Brit. Fran. & Hib. Rex.
Quæ Deus conjunxit nemo separet Ar }cum
Insignijs Scoticis; primo loco[191]
King James [I]; with the arms of Scotland in the first quarter.

[183] d [f.85v] [-]
[184] d [f.85v] d [-d]
[185] [-d] [f.86v] [-d] d-
[186] d [f.86v] d-

[187] [f.87v] Capsula 9.ᵃᵃ -
[188] [-d]
[189] [-] [f.87v] d [-d d]
[190] [-]
[191] d [-] [f.87v] d [-]

182 Jacobus D.G. Mag. Bri. Fra. et Hi. Rex.
Quæ Deus conjunxit nemo separet. Ar. cum Lilio.
\\[-deest]//[192]
King James [I]; with a fleur-de-lis.

[89r]

183 Jacobus D.G. Mag. Brit. Fra. et Hi.Rex.
Henricus Rosas, Regna Jacobus. Ar. Cum Lyra
Hibernica.
King James [I]; with the harp of Ireland.

184 J.D.G. Rosa sine Spina. - Rosa coronata
Tueatur unita Deus. Ar. - Carduus coronatus.
King James [I]; with crowned rose and thistle.

185 Idem iterum. Ar \\cum Lilio//
Another of the same; with a fleur-de-lis.

186 J.D.G. Rosa sine spina. - Rosa Tueatur unita
Deus Ar - Carduus. \\}Cum Lil://
King James [I]; with a fleur-de-lis.

187 Idem iterum. Ar.

188 J.D.G. Rosa sine Spina. Ar.
King James [I]; rose without thorns.

189 Idem iterum. Ar.

190 Carolus D.G. Mag. Bri. Fra. et Hib. Rex.
Christo Auspice Regno. Ar. -}(P) \\deest//[193]
King Charles [I].

191 Idem iterum. Ar. cum Sole. \\non D://[194]
Another of the same; with the sun.

192 Idem iterum. Ar. cum Lilio. \\[-deest] non
D//[195]
Another of the same; with a fleur-de-lis.

193 Idem iterum. Ar. cum Corolla. \\[-deest]
deest//[196]
Another of the same; with a wreath.

194 Idem iterum. Ar. cum Anchora. \\non D.//[197]
Another of the same; with a anchor.

195 Idem iterum. Ar. cum Castello. (*bracketed with
196*) \\Desunt//[198]
Another of the same; with a castle.

196 Idem iterum. Ar. cum Lyra et C.R[199]
Another of the same; with a harp.

197 Carolus D.G. Mag. Brit. Fran. et Hiber. Rex.
Exurgat Deus dissipentur inimiti.
Relig. Prot. Leg. Ang. Liber. Par. V. 1642 }cum
Lilijs[200]
King Charles [I]; with fleurs-de-lis.

198 Carolus D.G. Magn. Britann. Franc. et
Hibern.
Rex. Quæ Deus conjunxit nemo separet. Ar \\[-d]
d//

cum Insignijs Scoticis in primo loco.[201]
King Charles [I]; with the arms of Scotland in the first
quarter.

199 Carolus D.G. Mag. Bri. Fr. et Hi. Rex.
Christo Auspice Regno. Ar. -}cum Lilio. \\d//[202]
King Charles [I]; with a fleur-de-lis.

200 Carolus D.G. Mag. Br. Fr. et Hi. Rex. B.
Exurgat Deus dissipentur inimiti.
Relig. Pro. Le. An. Li. Par. B. 1644. }cum Lilijs.
King Charles [I]; with fleurs-de-lis.

[90r]

201 Carolus D.G. Mag. Brit. Fran. & Hib. Rex. -
Quæ Deus conjunxit nemo separet. Ar \\[-+]//
}cum Carduo, et cum Insignijs Scoticis in primo
loco. \\[-d]//[203]
King Charles [I]; with a thistle and with the arms of Scotland
in the first quarter.

202 Carolus D.G. Mag. Bri. Fra. et Hib. Rex.
Christo Auspice Regno. Ar - }\\a// cum Litera T.
\\deest//[204]
King Charles [I]; with the letter T.

203 Idem iterum, cum Anchora. Ar. \\deest://[205]
Another of the same; with an anchor.

204 Idem iterum, cum Porta demissoria. Ar
Another of the same; with a portcullis.

205 Idem iterum, cum Lilio. \\deest//[206]
Another of the same; with a fleur-de-lis.

206 Carolus D.G. Ma. Br. Fr. et Hi. Rex
Christo Auspice Regno. C.R. Ar }cum
Emblemate Princ. Wall. \\deest//[207]
King Charles [I]; with the emblem of the Prince of Wales.
Missing.

207 Idem iterum cum Libello, et Emblematib'
Principis Walliæ. Ar
Another of the same; with a little book [mint-mark] and with
the emblem of the Prince of Wales.

208 Idem iterum. Ar[208]

209 Idem iterum. Ar. \\2.//[209]

210 Carolus. D.G. Mag. Br. Fr. et Hib. Rex.
Exurgat Deus dissipentur inimiti.
Relig. Prot. Leg. Ang. Liber. Par. Ar 1642 }cum
Lilijs. \\deest//[210]
King Charles [I]; with lilies.

211 Idem iterum, Ar. 1643. \\d//

212 Idem iterum, Ar. 1644. \\d: [-d]//[211]

213 Idem iterum, Ar. 1644. Ox.

214 Idem iterum. Ar. 1645. A.

[192][**f.87v**] d [-d]
[193][**f.88v**] [-d] -
[194][-] [**f.88v**] [-d]
[195][**f.88v**] [-d] -
[196][**f.88v**] d
[197]d [**f.88v**] [-d] -
[198]d [**f.88v**] d -
[199]d [**f.88v**] d -
[200][-d] [**f.88v**] [-d] -

[201]d [**f.88v**] deest [-d] -
[202]d [**f.88v**] deest
[203][**f.89v**] [-d]
[204][-d] [**f.89v**] [-d]
[205][-d] [**f.89v**] [-d]
[206][-d]
[207][-d] [**f.89v**] [-d] d
[208][**f.89v**] [-d]
[209]d [**f.89v**] [-d d]
[210][**f.89v**] [-d d]
[211][**f.89v**] [-d]

215 Idem iterum, A. 1646.

216 Carolus D.G. Mag. Brit. Fran. et Hib. Rex

Christo Auspice Regno. Ebor. Ar - }cum Leone.

\\d//[212]

King Charles [I]; city of York, with a lion.

217 Carolus D.G. Magn. Britan. Franc. et Hib. Rex.

Quæ Deus conjunxit nemo separet. Ar - }cum Carduo et Insignijs Scoticis in primo loco. C.R. \\d/[213]

King Charles [I]; with a thistle, and with the arms of Scotland in the first quarter.

218 Carolus D.G. Mag. Brit. Fran. et Hib. Rex.

Quæ Deus conjunxit nemo separet. Ar }cum Carduo et Insignijs Scoticis in primo loco[214]

King Charles [I]; with a thistle, and with the arms of Scotland in the first quarter.

[91r]

219 Carolus D.G. Mag. Bri. Fra' et Hib. Rex.

Christo Auspice Regno. Ar \\deest// }cum Sole[215]

King Charles [I]; with the sun.

220 Carolus D.G. Mag. Br. Fr. & Hi. Rex

Christo Auspice Regno. Ar ... cum Libello et Emblemate Princ. Walliæ. \\deest//[216]

King Charles [I]; with a little book [mint-mark], and with the emblem of the Prince of Wales.

221 Carolus. D. G. Mag. Br. Fr. et Hi. Rex.

Exurgat Deus dissipentur inimici.

Relig. Prot. Leg. Ang. Liber. Par. }Ar. 1643. cum Emblematib' Principis Walliæ etc.

King Charles [I]; with the emblem of the Prince of Wales.

222 Carolus D.G. Mag. B.F. et H. Rex. B. -

Exurgat Deus dissipientur inimici.

Rel. Prot. Leg. Ang. Lib. Par. 1646. Ar }cum Emblematibus Principis Walliæ. \\[-deest]//[217]

King Charles [I]; with the emblem of the Prince of Wales.

223 Idem iterum. Ar. 1644.

224 Idem iterum. Ar.

225 Car. D. G. Mag. Brit. Fran. et Hi. R.

Fidei Defensor. *[symbol]* coronat. Ar.

King Charles [I]; with crowned interlinked Cs.

226 Carolus. D.G.M.B.F. et H. Rex.

Firmat Justitia thronum. Ar.

King Charles [I].

227 Idem iterum. Ar.

228 Idem iterum. Ar.

229 Idem iterum. Ar.

230 Idem iterum. Ar.

231 Idem iterum. Ar.

232 C.D.G. Rosa sine spina. \\Rosa coronata.//

Jus thronum firmat Ar. \\Rosa coronata.//

King Charles [I]; with a crowned rose without thorns.

233 Idem iterum. Ar.

234 Lamina Argentea forma Rhomboidali. C.R.XII.

Obs. Newarke. 1645.

Silver sheet, rhomboid in outline; from the siege of Newark.

235 The Commonwealth of England.

God with us. V. 1653[218]

236 Idem iterum. II VI. 1652.

[92r]

237 Idem iterum. XII. 1649. Ar.

238 Idem iterum. XII. 1652. Ar.

239 Idem iterum. XII. 1653. Ar. \\deest//

240 Idem iterum. XII. 1656. Ar.

241 Idem iterum. VI. 1654. Ar. [-][219]

242 Idem iterum. II. Ar.[220]

243 Idem iterum. I. Ar.

244 Idem iterum. Ar.[221]

245 Olivar D.G. RP. Ang. Sco. Hib. &c. Pro.

Pax quæritur bello. 1658. Ar.

Has nisi periturus, mihi adimat nemo[222]

Oliver Cromwell, Protector of England.

246 Idem iterum. Ar. \\desunt// *(bracketed with 247)*[223]

247 Idem iterum. Ar[224]

248 Carolus II. D.G. Mag. Brit. Fran. et Hib. Rex.

Christo Auspice Regno. Ar.[225]

King Charles II.

249 Carolus II. Dei Gra.

Mag. Bri. Fra. et Hib. Rex. 1678. \\d//[226]

King Charles II.

250 Carolus II. D.G. Mag. B.F. et H. Rex.

/sub\Corona,

Hanc Deus dedit. 1648.

Post mortem Patris, pro Filio. P.C. Obs. Ar. }forma octogonâ.

King Charles II; octagonal in outline.

251 Carolus Secundus. 1648. P.C. obs.

Dum spiro spero. C.R sub Coronâ. }eadem forma. Ar.

King Charles II; of the same form.

252 Carolus II. D.G. Mag. Brit. Fr. et Hib. Rex.

Christo Auspice Regno. Ar.

King Charles II.

[212][f.89v] d
[213][f.89v] d
[214][-d] [f.89v] [-d]
[215][f.90v] d
[216][-d] d
[217][-deest]

[218]d [f.90v] [-d d]
[219][f.91v] [-d]
[220]d
[221][-d]
[222][f.91v] [-d]
[223][f.91v] d
[224]d [f.91v] d d d
[225][f.91v] vid. Numis. 274.
[226]d [f.91v] d d

253 Carolus. II. D.G. Mag. Br. Fr. et Hib. Rex.
Christo Auspice Regno. Ar.[227]
King Charles II.

254 Carolus II. Dei Gra. \\deest//
 Mag. Bri. Fra. et Hib. Rex. \\1673//
King Charles II.

[93r]

255 Idem iterum. Ar. \\deest//[228]

256 Idem cum Numismate 253. Ar. \\d deest//

257 Carolus II. D.G. M. Br. Fr. et Hi. Rex.
 Christo Auspice Regno. Ar
King Charles II.

258 Idem iterum. Ar. \\[-d]//

259 Idem iterum. Ar.

260 Carolus II. D G. M.B.F & H. Rex.
 Christo Auspice Regno. Ar.
King Charles II.

261 Idem iterum. Ar.

262 Carolus II. Dei Gra
 Mag. Br. Fra. et Hib. Rex 1679. Ar.
King Charles II.

263 Idem iterum Ar. \\d//

264 Idem iterum. Ar. 1680.

265 Idem iterum. Ar.

266 Idem iterum. Ar.

267 Carolus II. D.G. Mag. Bri. Fra. et Hib. Rex.
 Christo Auspice Regno. Ar.
King Charles II.

268 Idem iterum. Ar.

269 Carolus II. D.G. M.B.F. et Hib. Rex
 Christo Auspice Regno. Ar.
King Charles II.

270 Idem cum Numismate. 260. Ar.

271 Idem iterum. Ar.

272 Carolus a Carolo.
 Britannia Ær.
King Charles II; rev. Britannia.

273 Idem iterum. Ær. \\d//[229]

274 Honori Princ. mag. *Brit*. Fra. et Hib. Nat. 29.
Mai. Ann. 1630.
 Hactenus Anglorum nulli. Ar.
King James II.

275 Jacobus Dux Ebor. Nat. 15 Oct. Baptiz' 24
Nove. 1633.
 * Non sic mille Cohortes. Ar.[230]
James, Duke of York.

[94r]

276 Jacobus II. D.G. Ang. Sco. Fr. et Hi. Rex. \\d//

A militari ad Regiam. Inaugurat 23. Ap. 1685.
Ar.
King James II.

277 Maria D.G. Ang. Sco. Fr. et Hi. Regina
 O Dea certe. Ar[231]
Queen Mary.

278 Jacobus II. Dei Gratia. \\d//
 Mag. Br. Fra. et Hib. Rex. 1685. Ar.
\\GVLIELMVS.III. DEI. GRA. MAG. BR. FRA.
ET. HIB. REX. 1695. n.2.//[232]
King James II.

279 [-Idem iterum. Ar. 1686.] \\d//[233]

280 Ch. Mag. et Hen. Ma. Brit. Rex. et Reg.
 Fundit Amor Lilia mixta Rosis. Ar. \\1625//
King Charles I and Queen Henrietta Maria.

Numismata Scotica
Scottish Coins

281 Alexander Rex.
 Alex. on Eden. Ar
King Alexander; moneyer Alex. of Edinburgh.

282 Alexander Rex
 Adam on Re... Ar
King Alexander; moneyer Adam of [].

283 Alexander Rex. \\d//
 Will. on Ber. Ar
King Alexander; moneyer Will. of Berwick.

284 Alexander Rex.
 Walter on ... Ar
King Alexander; moneyer Walter of [].

285 Alexander Rex.
 Walter on PRES. Ar.
King Alexander; moneyer Walter of [].

286 Alexander Rex \\d//
 Robert on Be. Ar
King Alexander; moneyer Robert of Berwick.

287 [-Maria et Henricus Dei Gra R & R Scotoru'.
\\d//
 Exurgat Deus et dissipentur inimici ejus. Ar
Dat Gloria vires. 1565[234]
Queen Mary and King Henry [Darnley] of Scotland.

[95r]

288 Carolus II. Dei Gra.
 Sco. Ang. Fr. et Hib. Rex. 1676. cum Carduis.
Ar[235]
King Charles II; with a thistle.

289 Idem iterum. Ar. 1675[236]

290 Idem iterum Ar. 167[237]

291 Carolus D.G. Scot. Ang. Fr. et Hib. Rex.
VI.\\8//

[227] [-]
[228] [f.91v] d d
[229] [f.92v] d
[230] [f.92v] vid. Numb. 294. ubi Idem iterum.

[231] [f.93v] [-]
[232] d [f.93v] [-]
[233] d [f.93v] 279. C.R. sub Corona imperiali. d d
[234] d [f.93v] 287. Alexander Rex. &c.ᶜ-- [-]
[235] d [f.94v] [-d]
[236] d [f.94v] d [-d]
[237] d [f.94v] d [-d]

Christo Auspice Regno. Ar[238]
King Charles.

292 C R. sub Corona Imperiali.
/S D\ II VI. Ar.
CR beneath an Imperial crown.

293 Idem iterum. XII /D\. Ar.

294 Idem cum Numismate. 275.

295 Richardus. z. R. obijt 20. Sept. 1399.
Rained 22. years, buryed at Westminster. Ar.
King Richard II.

296 Robert ...
Rex. ... Ar.
King Robert.

297 Masathusets in New England
An. Dom. 1652. XII. Ar. [-]
Massachusetts.

298 Cæcilius Dns Terræ Mariæ &CT.
Crescite et Multiplicamini XII. Ar.
[]

299 Idem iterum. VI. Ar.

300 Idem iterum. IV. Ar.

Numismata Principū Exterorum. etc.
Coins of the Princes of other lands.

301 Alexan. VII. Pont. Max. An. XI.
Beato Francesco Episcopo inter san/c\tos relato.
Ar.[239]
Pope Alexander VII.

302 Lud. XIIII D.G. Fr. et Nav. Rex.
Sit nomen Domini benedictum. 1648.[240]
Louis XIV, King of France and Navarre.

303 Ferdinan. 2. D.G. Ro. I. S.A.X. 1623.
Mo. Nov. Civi. Magdeburgensis. Ar.
Ferdinand II, Emperor

[96r]

304 Fridericus III. D.G. Dannorum
Vandalorum Gothorumque Rex.
Dominus providebit. Ar.
Frederick III, King of Denmark.

305 Christina Regina
M.M. Ar.
Queen Christina.

306 [-] Junctisque feruntur Frontibus.
Nunc una ambæ. De la P. de M.R. Myron. 1616.
Ar.
[]

307 Carolus Dei Gra Dux Burgundiæ .
Sit nomen Domini benedictum. Ar.[241]
Charles, Duke of Burgundy.

308 An. D.G. Rex Po. Mag. Dux Li ...
Moneta magni Ducis Litua. 1568. Ar
[], King of Poland and Duke of Lithuania.

309 S.M. Venetus. Aloy. Moce.
Memor ero tui Justina virgo. Ar 40.
Alvise Mocenigo, Doge of Venice.

310 Fr. Gon. Dux Man. E Mar. Mont. Fe. Recepto
nichil isto. TRIST. Ar.
Federigo Gonzaga, Duke of Mantua.

311 Carolus IX. D.G. Suec. Got. Van & G. Rex
Mark ... Enska. Ar.
Charles IX, King of Sweden.

312 Christianus IIII. D.G.
Mon. nov. Gluckstad 1643. Ar.
Christian IV, King of Denmark.

313 Alfonsus Qu ...
... otium nostrum. Ar. \\[-d]//[242]
Alfonso

314 ...
Et Legionis et Castell. Rex. Ar [-d][243]
[]

315 Ferdinandus et . . . D. G.
Rex ... Cast. Ligio. Arago. Sic. ... Ar.[244]
Ferdinand, King of ... Castile, Leon, Aragon, Sicily...

316 Martinus Buserus Minister Evangelij. D.N.I.
Christi Ætatis suæ. LVI
1. Cor. 2. Nihil judico me scire quam Jesum
Christum, et hunc crucifixum. Ar. M.D.XXXXVI
Martin Bucer, at the age of 56.

[97r]

317 Die ¹⁴/₄ Jul. Vrbs Vienna obs I Det Vr. T Vr
CIa fLens reMoVerVr ¹²/₂ Sept. Urbs Vienna. Ar.
City of Vienna.

318 Idem iterum. Ar.

319 Siclus Sanctuarij. Ar.
Sanctuary shekel.

320 Siclus communis. Ar.
Common shekel.

321 Numisma (ut puto Græc) signat in obverso,
capite humano in Reverso, Equite. Ar
Coin (it may be Greek), marked with a human head on the
obverse and a knight on the reverse.

322 Aliud, in obverso signatum capite humano, in
reverso, Characteribus nescio quibus. Ar.[245]
Another, marked with a human head on the obverse and with
unknown characters on the reverse.

323 Aliud, in obverso signatum item capite
humano, in reverso charecterib M A . Ar.
Another, also marked on the obverse with a human head and
on the reverse with the letters MA.

324 Numisma nescio quoddam Gallicum. Ar. \\[-
an potius Danicum?]//[246]
Gallic coinage of I know not what sort. Could it be Danish?

325 ... Hispaniarum

[238][-] **[f.94v]** d [-d]
[239]**[f.94v]** Capsula 10ma
[240][-d] **[f.94v]** [-]
[241][-d]

[242][-d]
[243][-d]
[244][-d]
[245]**[f.96v]** d
[246][-d] **[f.96v]** -

D ... Ar[247]

[]

326 Ph. II ... Insignia Portugalliæ.

F. XX ... Ar[248]

Philip II ... with the arms of Portugal.

327 Moneta Moscovitica Denga dicta. Ar. [-\An potius Danica?][249]

Russian coin known as a denga; or could it be Danish?

328 Numisma signatum characteribus nescio quibus. Ar.[250]

Coin struck with characters of I know not what sort.

329 Wilhelm Tell von urz Stonsfacher Schwitz Erni vo Underwald; Anfang dess Tuntz. Im. Jar. Christi. 1206.[251]

William Tell

330 Rupia communis, sive Tridrachmum Argenteum magni Mogul. Gjihân Ghîr, a Timûr (sive Tamberlano) noni, A° Hegjræ 1027. Christi 1617. Regni 13. in Reverso; Sol in Leone. Ar. 7 pw. 8 gr.

Common rupee, or three-drachma silver piece of the Great Mogul, Jahangir, the ninth after Timur or Tamburlaine, AH 1027 (1617 in the Christian calendar); *rev:* the Sun in Leo.

[98r]

331 Aliud Numisma ejusdem Gentis, senentijs quibusdam Judicis signatum. Ar.

Another coin of the same people, inscribed with the thoughts of a judge.

332 Aliud Numisma ejusem generis. Ar.[252]

333 Aliud ejusdem Gentis, forma Rhomboidali. Ar.

Another of the same people; rhomboid in outline.

334 Aliud ejusdem generis. Ar.

335 Aliud ejusdem generis. Ar.

336 Aliud ejusdem generis, forma quadrangulâ oblonga. Ar. \\d//[253]

Another coin of the same people, elongated and rectangular in outline.

Honoraria quædam numismata et Catenæ, quæ à Principibus Viris accepit Clariss. Ashmolus, atque huic museo anno 1692. moriens legavit. [254]

Honours in the form of various medals and chains which the distinguished Ashmole received from various princes and which he bequeathed to this Museum on his death in 1692.

337 Catena aurea cum adjuncto numismate Regis Danorum Christiani quinti. \\p: 14. Un: 18. den: 4 gr//.

Gold chain to which is attached a medal of Christian V, King of Denmark

338/a Catena aurea cum numismate Friderici Wilhelmi, D.G. Electoris Pomeraniæ, Ducis Brand. R. Stralesundiâ favente numine, ductu sereniss. [-] Elect. Brandenb. deditione captâ. A°S. MDCLXXVIII. [xv]/[xxv] octob. \\Ann: 50 p: 12 ½ Un: 5. den: 12. gr.[255]

Gold chain with a medal of Fredrick Wilhelm, Elector of Pomerania, Duke of Brandenburg.

339 Carolus Ludovicus comes Palatinus Rheni, sacri Romani Imperij Archit. et E.B.D.

D. non me quæ cætera, 1671[256]

Karl Ludwig, Count of the Rhineland Palatinate, [Prince] of the Holy Roman Empire.

340 Numisma Georgianum, ab Illustrissimo Duce Norfolciensi accep/tum.\

Medal of the Order of St George, which he was given by the most illustrious Duke of Norfolk.

341 ANNA D.G. MAG. BR. FR. ET HIB. REGINA.

Vicem gerit illa tonantis. Inaugurat. XXIII. Ap. MDCCII. Ex dono D. Gul. Bromley Arm. pro Academiâ Oxõn. sen. in Parl. Ang[257]

Queen Anne; given by William Bromley Esq., Member of Parliament for the University of Oxford.

342 GEORGIVS D.G. MAG. BR. FR. ET HIB. REX. F.D. R. SPES ALTERA. nec non ORD. EQVIT. DE. BALN. REST. ET INSIG. AVCT. MDCCXXV. ær

King George I.

[3]43 LIPSIA. &c. 1631. R. Alcidi puero Virtus en monstrat atque Qui placet, huic dicas, Tu mihi care places. aur:

Leipzig.

[98v]

344 I. W. C. P.R.S.R.I. ARCHIT ET EL.B.I.C. ET M.D.C.V.S. M.R. ET M.D.I.R. in Rev. Navis fluctus tranans. superscrip: DOMINVS VIRTVTVM NOBISCVM. aur:

[]; *rev:* a ship on the waves.

345 ERN. AVGVSTVS. D.G. EP. OS. DVX. BR. ET. LVN. [-] R Bellicum Trophæum, cui superinscrip. EN. LABOR. EN. PRÆMIVM. infra 1691. aur.

Ernst August, Bishop and Duke of Brunswick and Luneburg; *rev:* the spoils of war.

346 IOAN. PHIL. CARD. DE LAMBERG. D.G. EP. PASAV. S. R. I. PRINC. R. Puerulus tenui filo Leonem, qui ferreas jam fregerit catenas, ducens.

[247] [-d] **[f.96v]** -
[248] [-d] **[f.96v]** -
[249] [-d] **[f.96v]** -
[250] [-d] **[f.96v]** -
[251] **[f.96v]** *William Tellvonure Stonsfacher(?), free Lord of Underwald, and Fangford upon (the River) Tuntz. in the year of Christ. 1206.
[252] **[f.97v]** [-d]
[253] **[f.97v]** d
[254] **[f.97v]** *N.B. Hæc cum cæteris hâc serie sequentibus in pretiosissimo Scrinio conservantur. in Caps: cui superinscibitur aureis characteribus BEN. SWETE. ARM. D.D.
These, together with the others which follow in this sequence, are kept in the most precious cabinet, in a drawer inscribed 'Ben[jamin] Swete Esq., Doctor of Divinity.'

[255] **[f.97v]** 338.b. Catena aurea cum Numism:ᵉ Scil: IOSEPHI IMPERATORIS. R. AMORE ET TIMORE.
Gold chain with medal.
[256] **[f.97v]** a
[257] **[f.97v]** [-d]

PERAGIT. TRANQVILLA POTESTAS. QVOD. VIOLENTA. NEQVIT. aur. \\1705//
Johann Philip, Cardinal of Lamberg, Bishop of Passau and Prince of the Holy Roman Empire; *rev:* a small boy leading by a slender cord, a lion that had already broken its iron chains.

347.b. GVL: ET MARIA D.G.M.B.F. ET H REX ET REGINA. R. PVGN. NAV. INT. ANG. ET FR. 21 MAII. 1692. Superinscrip. NOX. NVLLA. SECVTA. EST. Arg.
King William and Queen Mary.

348 Carolus D.G. Francorum Rex R. XRS. Vincit. XRS. Regno XRS. imperat. aur.
Charles, King of France.

349 STABIT QVOCVNQVE GESSERIS. R. SANS CHANGER. ær.
[]

350 GEORGIVS. DEI. GRATIA. REX. R. ROSA. AMERICANA. nec non VTILE. DVLCI. 1722. ær: deaurat:
King George I.

351 LVODVICVS. D.G. FRANCORVM. REX. R. id. ac 348. aur:
Louis, King of France.

352 Id. ac 349. arg:
The same as 349.

353 THE. COMMONWEALTH. OF. ENGLAND. R. GOD. WITH. VS 1653. aur.

354 PRO. REGE. ET PATRIA &c. Numisma octogonale. arg.
An octagonal coin.

355 Id ac 350.
The same as 350.

356 MONETA. NOVA. ORDIN. TRAIECTEN. R. CONCORDIA. RES. PARVÆ. CRESCVNT. Aur. \\d-1754. GH Anna, Comp: &c//
[]

357 FERNANDVS. ET. ELISABET. D.G. REX ET REGINA. Aur.
Ferdinand and Elizabeth, King and Queen of Bohemia.

358 HENRICVS D.G. FRANCORVM. REX. &c. Aur.
Henry, King of France.

359 MAXIMIL. COM. PAL. RH. VT. BA. DVX. S. R. I. ARCHIDAP. ET ELECT. R. NISI. DOM. CVSTODIERIT. CIVIT. FRVSTRA VIGIL. QUI. CVSTODIT. 1640. Aur.
Maximilian, Count of the Rhineland Palatinate and Duke of Bavaria.

[99v]

360 Id. ac 349. ær.
The same as 349.

361 CAROLVS. D.G. FRANCORVM. REX. aur. [-d/e:] Numismata argentea conservata in altera capsula cui aureis characteribus inscribitur. D.D. BEN. SWETE. ARM.
Charles, King of France. Silver medal enclosed in a separate drawer inscribed in gold letters `The gift of Benjamin Swete, Esq'.

362 MENNO. BARO. DE. COEHOORN. SVMMVS. APV/D.\ BATAVOS. AR. MORVM. PRÆFECTVS. &c. R. Eversio BONNQ. arg.
[]

363 BRITANNIA SVPPLEX. 1695. R. PRÆLVCET QVATVOR VNA. arg.
Death of Queen Mary. Britannia suppliant. One outshines four.

364 A.D. VIGOS PORT. GALLICIÆ. &c. 1702. R. SPES. ET. VIRES HOSTIVM. FRACTÆ. &c. arg.
Expedition to Vigo Bay, 1702.

365 Numisma forma quadrangulari. BARCELONA. LIBERATA. &c. arg:
Medal, rectangular in outline; liberation of Barcelona.

366 IOH. D.G. S.R.I. PR. D. MARL. EXERC. ANGL. C.G. R. GALLIS. ACIE DEVICTIS. &c. &c. 1706. arg:
John, Duke of Marlborough.

367 SVB. DVCE. MARLEBVRG. VICTORE PERPETVO. GALL. PROFLIGATIS. &c.&c. MDCCVI. R. SOLIS. ECLIPSIS. D.12. Maii.
John, Duke of Marlborough; *rev:* Eclipse of the sun.

368 Eugenius Princeps & Dux Marlburg: flexo genu concorditer fundentes preces. suprascript: VT. SESE. TERTIVS. ADDAT. DVX. DEVS. Legend: EVGENII VIRTVS COELO MISSIQVE IOHANNIS. R. Pugna ad Hochstet. arg:
Prince Eugene and the Duke of Marlborough kneeling in prayer; *rev:* the Battle of Hochstet.

369 IOHANNES D. MARLEBVRG. ANG. EXER. CAPIT. GENER. R. OB GALLOS ET BAVAROS DEVICTOS. TALLARDO DVC. AD. HOCHSTAD CAPTO. 1704. &c. arg.
John, Duke of Marlborough.

370 Bellicum trophæum. supra quod ANNVS FELICITER CLAVSVS infra DEVICTIS GALLIS ET BOIIS. R. TRANSEVNTIS EXERCITVS VICTORIÆ. &c. arg:
A trophy of arms.

371 LVDOVICVS MAGNVS. ANNA MAIOR. R.Mors Abimelechi. Judic. c.g. arg:
Queen Anne overthrows Louis XIV. *rev:* the death of Abimelech.

372 EVGENIVS SAB. PRINC. &c R IMPETVS GALLORVM FRACTVS AD ATHESIN. D.9. IVL. MDCCI. &c. arg.
Prince Eugene.

373 HANS CARL. L.B. DETHVNGEN. S.C. M. GEN. CAMP. MARESCH. R. VLMA GALL. EREPT. D. 13. Sept. 1704. arg:
Hans Carl [].

374 VICTOR. AMADEVS. II. D.G. DVX SABAVD. &c. R. AVGVSTA TAVRINORVM TRIMESTRI OBSIDIONE LIBERATA.1706. &c. arg.
Victor Amadeo, Duke of Savoy.

[100v]

375 LVD. WILH. M. BADEN. EX. CÆS. GEN.
LOC. R. HOSTE CÆSO FVGATO CASTRIS
DIREPTIS AD SCHEL LENBERGAM
DON/AW\ERDÆ. 1704. arg.
Ludwig Wilhelm, Margrave of Baden.

376 IOSEPHVS D.G. ROM. ET. HVNG. REX. R.
ARMORVM PRIMITIÆ. LANDAVIA RECEPTA
D.10. SEP. 1702. arg.
Joseph, King of Hungary.

377 IOSEPHO R.ET H. REGI. PRIMA AD
RHENVM EXPEDITIONE CONFECTA. R.
CESSIT LEOPOLDO MAGNO ET IOSEPHO teil:
LANDAVIA. POSTHC CEDET NEMINI. Arg.
Joseph, King of Hungary.

378 LEOPOLDVS MAGNVS ROM. IMP. S.A. R.
SVEVIA RESTITVTA HOSTES IMPER. CÆSI
FVGATI. 1704. Arg.
Leopold, Emperor.

379 IOSEPHVS. D.G. ROM. IMPERATOR S.A.
R. Hercules dextra sustinens Clavum, sinistrâ
Globum. MDCCV. arg.
Joseph, Emperor: *rev*: Hercules holding his club with his
right hand and a globe with his left.

380 \\D)// STABIT QVOCVNQVE GESSERIS. R.
SANS CHANGER. arg.
[]

381 CAROLVS. III. D.G. REX HISPAN. ARCH.
AVST. R. A PATR. ET FRAT. A A. CESSION.
FACTA. XII. SEPT. HISP. PETIT. 1703. &c. arg.
Charles III, King of Spain, Archduke of Austria.

382 CAROLVS. III. &c R. EXPECTATO
VINDICI LÆTA SE SVBIICIT BARCELONA
D.14. OCT. 1705. arg.
Charles III, King of Spain.

383 CAROLVS. III. HISPANIAR. ET INDIAR.
REX. CATHOL R. BARCELONA AB OBSID.
IRRIT LIBERATA. 12 MAII. 1706. &c. arg.
Charles III, King of Spain.

384 CAROLVS. III. &c. R. Alveare, apibus inter
se pugnantibus (ut videtur) de principatu, vacuum.
VACVA MELIOR NVNC REGNET IN AVLA.
MADRITO IN FIDEM RECEPTO. MDCCVI
\\mur.//
Charles III, King of Spain; *rev*: an empty beehive, with bees
fighting for the leadership.

385 Numisma per-elegans, argento affabre
elaborato circumcinctum, hinc præ se ferens CVM
ME LAVDARENT SIMVL ASTRA MATVTINA.
inde DECOR EIVS GLORIA SANCTORVM
A most beautiful medal, enclosed in skilfully worked silver.

386 STANISLAUS Aug. D.G. Poloniæ Rex &c.
Rev. Coron. Imp. Hanc jussit Fortuna mereri Elect:
un. voce VIII Sept. Coron. XXV. Nov. 1764. æs.
Stanislas, King of Poland; *rev*: an imperial crown.

[Insert 1r]

347.a. Anna D.G. in R. Mag. Br: Fr: & Hib: Reg:
1713. Aur. Given to the University to be kept in
the Museum by the Rev^nd M^r Nelson Fellow of
University College May. y^e 7^th 1745
Queen Anne.

[insert on 99r]

**Catalogus Numismatū quibus Cl. Vir Johannes
Aubrey /Armig^r\ Musæum Asmoleanum lubens
auxit. A°. 1688.**
Catalogue of the coins which that distinguished man
John Aubrey Esq, willing added to the Ashmolean
Museum, 1688

1 Imp. Cæs Nervæ Trajano Aug. Ger. Dac. P. M.
TR.P. Cos. V. PP. S.P.Q.R. Optimo Principi.
Figura stans dextra tenens ramum Oleæ, sinistra
Cornucopiam; ante cujus pedes Icuncula, in cujus
humeros prior imponit podem dextrū, quasi eam
supplantans. Ær.
Trajan. Optimo Principi; standing figure holding an olive
branch in the right hand and a cornucopia in the left; with his
right foot on the shoulder of an idol in front of him, as if about
to throw it over.

2 Imp. Cæs. M. Ant. Gordianus Aug.
Liberalitas Aug. II. Figura stans dextra tenens
tesseram frumentariam, sinistra duplicem
Cornucopiam. Ar.
Gordian. Liberalitas Augusti; standing figure holding a
tessera for corn in the right hand, with a double cornucopia
in the left.

3 Imp. Pivesu Tetricus Cæs.
... Ær.
Tetricus.

4 Constantinus Max. Aug.
Gloria Exercitus. TR.S. Duo milites galeati et
hastati stantes, cum signis militaribus. Ær.
Constantine. Gloria Exercitus; two standing soldiers with
helmets and spears, with military standards.

5 Constantinus Max. Aug.
Gloria Exercitus S.L.C. Duo milites galeati et
hastati stantes, inter eos signum militare. Ær.
Constantine. Gloria Exercitus; two standing soldiers with
helmets and spears, with a military standard between them.

6 Jul. Crispus NOb. C.
Cæsarum nostrorum ... Vot. X. intra Lauream.
Ær
Crispus. Votis Decennalibus Caesarum Nostrorum, inside a
laurel wreath.

7 Imp. Constantinus Nob. C.
Victoria alata stans, dextra hastam tenens,
sinistra clypeum. Ær.
Constantine. Standing winged Victory holding a spear in her
right hand and a shield in her left.

[100r]

8 Constans P.F. Aug.
Gloria Exercitus P.L.C. Duo milites galeati et
hastati tenentes Labarum. Ær.
Constans. Gloria Exercitus; two soldiers with helmets and
shields, holding a labarum.

9 Edwardus ... Arg.^t
Edward . . .

10 ...

11 ...

12 ...

13 ...

14 ...

15 ...

16 ...

17 ...

Ista Numismata reperta fuere in arvis juxta Kensestriam in Com ...
These coins were discovered in fields near Kenchester in the county of [Hereford]

18 Imp. Cæsar Trajan Hadrian Aug.

... Figura stolata stans dextra temonem, sinistra hastam tenens. Ær.

Hadrian. Standing figure in a stola holding a staff in her right hand and a spear in her left.

19 Hadrianus Augustus.

Justitia Aug. P.P. Figura subsellio insidens dextra pateram, sinistra hastam. infra Cos. III. Ær.

Hadrian. Justitia Augusti; figure seated on a stool with a dish in the right hand and a spear in the left. Exergue: Cos III

[101r]

20 Gallienus Aug.

Providentia Aug. Figura stolata stans, dextra . . . tenens, sinistra hastam puram per transversū. Ær.

Gallienus. Providentia Augusti; standing figure in a stola, holding a ... in her right hand, crossed by a spear, without a head, in her left.

21 Imp. Diocletianus P.F. Aug.

Salvis Augg. et Cess. Fel. Kapt. figura stolata stans dextra ... Ær.

Diocletian. Salvis Augustorum et Caesarum Felix Carthago; standing figure in a stola with a ... in her right hand.

22 Imp. Carausius P. Aug.

Pax Aug. Figura stolata stans dextra oleam, sinistra hastile per transversū. Ær.

Carausius. Pax Augusti; standing figure in a stola, with an olive branch in her right hand crossed by a spear held in her left.

23 Crispus Nob. Cæs.

Soli invicto Comiti. Figura Solis capite radiato S.C. Ær.

Crispus. Soli Invicti Comiti; figure of Sol with a radiant head.

24 D.N. Magnentius Aug.

... Reparatio. Figura militis Navi insistentis, Labarum sinistra, dextra Victoriolam tenentis, inter duos captivos. Ær.

Magnentius. Reparatio ... ; military figure standing in a ship holding a labarum in his left hand and a Victory in his right, between two prisoners.

25 D.N. Valens P.F. Aug.

Urbs Roma. TR.P.S. Urbs Roma galeata insidens subsellio, dextra victoriolā, sinistra hastā tenens. Ar.

Valens. Urbs Roma; personification of the city of Rome, helmeted and sitting on a stool, holding a Victory in her right hand and a spear in her left.

26 ...

27 ...

28 ...

29 ...

30 ...

[102r]

31 ...

32 ...

33 ...

Ista numismata reperta fuere apud Hedington in Com ... \\q. an Wiltonensi?//
These coins were discovered in Headington in the county of ... [could it be Wiltshire?]

34 Divus Antoninus.

Divo Pio. Antoninus, subsellio insidens, dextra aspergillum, sinistra hastam. Ar.

Antoninus Pius. The divine Antoninus, seated on a stool, with a sprinkler in his right hand and a spear in his left.

35 Diva Faustina.

Augusta. Faustina, dextra bacillum, sinistra facem. Ar.

Faustina. Augusta; the divine Faustina, with a staff in her right hand and a torch in her left.

36 Imp. Gordianus, pius fel. Aug.

Liberalitas Aug. III. Figura stolata stans dextra tesseram frumentariam, sinsitra Cornucopiam. Ar.

Gordian. Liberalitas Augusti; standing figure in a stola with a tessera for corn in her right hand and a cornucopia in her left.

37 D.N. Fl. Cl. Julianus P.F. Au.

Vot X. Multis XX. in Corona. infra Const. repert. in Sharston-field in Com Wilts. Ar.

Julian. Votis Decennalibus Multis Vicennalibus in a wreath; below: CONST. Found at Sharstonfield in the county of Wiltshire.

38 Matrises Numismatum Romanorum lateritiæ, numero 12. apud /Edinton in parochiâ de Murlinch\[-Chedsey] in Comitat Somersetensi repertæ A.° 167.

Twelve clay moulds for casting Roman coins, found near Murlinch in the county of Somerset.

39 Operis tessellati sive Musivi fragmentum prope Castrum de Farleigh repertum, in Agro Somerset. A.° 1683.

Fragment of mosaic or tessellated pavement, found near the fort at Farleigh in the county of Somerset.

[102v]

϶ϵ Imp. C. Aurelianus Aug. R Vabalthus ucrimor. M. Ashm. dedit D. Martinus Lister M.D. A.° 1699

Aurelianus; rev. Vabalthus. Given to the Ashmolean Museum by Martin Lister, MD., in 1699.

[103r]

A Martino Lister M.D. donati A°. 1694.
Given by Martin Lister, MD, 1694

40 - AVGVSTVS DIVI F.PATER PATRIAE. Caput Augusti laureatum. R. [-] ROM. ET AVG. Templum cum duabus Victorijs alatis, dextris sertā tenentibus. Æ. II.

Augustus. Head of Augustus wreathed in laurel; *rev:* Romae et Augusto; a temple with two winged Victories holding a wreath in their right hands.

41 IMP. CAESAR NERVAE TRAIANO AVG.GER.DAC.P.M.TR.P.COS V.PP. Caput Trajano laureatum. R. SPQR OPTIMO PRINCIPI SC. Figura equestris captivum prosternens. Æ.I.
Trajan. Head of Trajan wreathed in laurel; *rev:* Optimi Principi, equestrian figure trampling a captive.

42 M. COMMODVS ANT. P. FELIX AVG. BRIT. Cap. Commodi laureatu. R PVBLICA FEL PM.TR. P. XIIIMPVIII COS VI... Figura stolat, stans, dextrâ pateram, sinistrâ hastam. /S.C.\Æ. I.
Commodus. Head of Commodus wreathed in laurel; *rev:* Felicitas Publica, standing figure in a stola, with a dish in her right hand and a spear in her left.

43 FAVSTINA AVGVSTA. Caput [-\Faustinæ] Ant. Pij uxoris. R Figura stans dextra hastam sinistra ... SC. Æ. I.
Faustina. Head of Faustina, wife of Antoninus Pius; *rev:* standing figure with a spear in the right hand, and in the left ...

44 IVLIA MAMAEA AVGVSTA Cap. I. Mamæa matris Alex. Severi. R. FELICITAS PVBLICA SC. Figura sedens dextrâ caduceum, sinistrâ cornu copiæ. Æ. I.
Julia Mamaea. Head of Julia Mamaea, mother of Alexander Severus; *rev:* Felicitas Publica, seated figure with a caduceus in the right hand and a cornucopia in the left.

45 IVLIA MAMÆA AVGVSTA. R V E S T A SC. Figura stolata stans /Æ I. [-]\&c.
Julia Mamaea. *rev:* Vesta, standing figure in a stola.

46 IMP MAXIMI[-]NVS PIVS AVG. Cap maximini laureatum. R VICTORIA AVG. Victoria gradiens dextra sertum, sinistra palmam. Æ. I.
Maximinus. Head of Maximininus wreathed in laurel; *rev:* Victoria Augusti, walking Victory with a wreath in her right hand and a palm leaf in her left.

47 ... Æ. II.

48 ... Æ. III.

A D.ⁿᵒ Iacobo Ivie[-,] accepti /,\ Anno 1694
Given by Mr James Ivie, 1694

49 IVL. CRISPVS NOB. CÆ.. R VIRTVS EXERCIT[-] Duo captivi labaro assidentes, in quo VOT XX T.F. Æ. III.
Crispus. *rev:* Virtus Exercitus, two captives seated by a labarum, with Votis Vicennalibus.

50 D.N. CONSTANS P.F. AVG. R ... REPARATIO P.L.C. Figura militaris in Navi, dextrâ victoriolam, sinistrâ Labarum; /christianum;\ et victoria navim gubernans. Æ. 3.
Constans. *rev:* [Felicium Temporum] Reparatio; military figure in a boat, holding a Victory in his right hand and in his left a labarum with a Christian symbol; and with Victory steering the boat.

51 D.N. CONSTANS P.F. AVG. R. FEL. TEMP. REPARATIO. R.B. Figura militaris in navi dextra victoriolam, sinistra labarum cruce signatum: et victoria navim gubernans. Æ. 3.
Constans. *rev:* Felicium Temporum Reparatium, military figure in a boat with a Victory in his right hand and in his left

a labarum with a sign of the Cross; and with Victory steering the boat.

52 D.N. CONSTANS P.F. AVG. R FEL. TEMP. REPARATIO. R*P. Miles gradiens, dextra captivum trahens, à tergo arbor. Æ.3.
Constans. *rev:* Felicium Temporum Reparatio; walking soldier dragging a captive, and a tree behind.

53 Id.ᵐ nummus cum priore. R. TR. S. Æ. 3.
Same coin as the last.

54 Id.ᵐ - - - R. R.*S. Æ.3.

55 Id.ᵐ - - - R. R.Q.S. Æ.3.

56 Id.ᵐ - - - R. R.*T. Æ.3.

57 DN. CONSTANTIVS P.F. AVG. /A\ R FEL. TEMP. REPARATIO /A\. PARL. A Captivus ab Equo prolapsus, a figurâ militari propugnatur. Æ. 3.
Constantius II. *rev:* Felicium Temporum Reperatium, a captive fallen from a horse, and attacked by a military figure.

58 Id.ᵐ ... R. A M B. Æ. 3.

[103v]

59 D.N. CONSTANTIVS P.F. AVG. R. FEL. TEMP. REPARATIO. T.R.P. Imperator /in Navi\ stans dextra [-Labarum\phenicem] [-in qua christi monogramma], sinistra S[-cutum] /p[-henicem]\. [-Ad] Labarum [-captivas. Æ. 3] \\victoria navim gubernante.//
Constantius II. *rev:* Felicium Temporum Reperatium, the emperor standing in a boat with a phoenix in his right hand and in his left a labarum with a Christian monogram; Victory steering the boat.

60 Id.ᵐ ... R TR.S. Imperator in navi, dextra phænicem, sinistra labarum, in quo christi monogramma: ad pedes Victoria navim gubernans. Æ. 3.
[Constantius II]. *rev:* the emperor in a boat, holding a phoenix in the right hand and a labarum (with a Christian monogram) in the left; at his feet, Victory steering the boat.

61 Id.ᵐ ... R Figura militaris puerum ex antro educens; juxta antrum arbor. Æ. 3.
[Constantius]. *rev:* military figure leading a little boy out of a cave; a tree near the cave.

62 Id.ᵐ ... R. P. ARL. Æ. 3.

63 Id.ᵐ ... R. TR.P. Æ.3.

64 Id.ᵐ cum 57. ᵐᵒ

65 D.N. MAGN/EN\TIVS PF AVG. R. SALVS DDNN AVG ET CÆS A*(symbol)*Ω AMB. Æ.2.
Magnentius. *rev:* Salus Dominorum Nostrorum Augusti et Caesaris, A *(symbol chi/rho)* Ω.

66 Id.ᵐ ... R. P.P. L.C. Æ. 3.

67 Id.ᵐ ... R * AMPQ. Æ 3.

68 Id.ᵐ A. ... R GLORIA ROMANORVM PPLC. Imperator eques captivum supplantans. Æ.3.
Magnentius. *rev:* Gloria Romanorum, the Emperor on a horse throwing a captive to the ground.

69 Id.ᵐ A. ... R RSLC. Æ.3.

70 Id.ᵐ A ... R RPLC. Æ.3.

71 IM.CÆ.MAGNENTIVS AVG. R FELICITAS REI PVBLICE A.TR.P. Figura militaris stans, dextra victoriolam, sinistrâ Labarum, in quo christi mongramma. Æ.3.

Magnentius. *rev:* Felicitas Reipublicae, standing military figure with a Victory in his right hand and in his left a labarum, with a Christian monogram.

72 Id. Æ. 3

73 Id.^m ... R PPLC. Æ.3.

74 Id.^m ... R TR.S. Æ.3.

75 Id.^m ... R RPLC. Æ.3.

76 Id.^m ... R T.A. Æ.3.

77 D.N. MAGNENTIVS.P.F.AVG. A. VICTORIAE DD NN AVG ET CAE AMB. Duæ Victoriæ /clypeum tenentes in quo\ VOT.V.MVLT.X. Æ.3.

Magnentius. *rev:* Victoriae Dominorum Nostrorum Augusti et Caesari, two Victories holding a shield, with Votis quinquennalibus Multis Decannalibus.

78 Id.^m et in summo clypeo christi monogramma [-] Æ.3.

The same, with a Christian monogram on the top of the shield.

79 Id.^m absque monogrammate TRS. Æ.3.

The same, without the monogram.

80 Nummus cupreus Swecicus valoris 2/s\-5/d\. monetæ Anglicanæ. * ¹/₂* DALER SÖLff: MŸT Donavit D.ˢ Joannes souter Mercator Londinensis.

Swedish copper coin of the value of 2s. 5d. in English money. Given by John Sowter, merchant of London.

[104r]

Numismata ex dono Johis Newman Gen.
Coins given by John Newman, gentleman

1 Carolus II. Dei G. Mag. Bri. Fran. et Hib. Rex. in obverso Catharina D. G. Mag. Bri. Fran. et Hiber. Regina. in reverso. Stan.

King Charles II; *rev:* the Queen.

2 Ludovic. XIII D. G. Francor. et Navaræ Rex. in obverso. Ut Gentes tollatque primatque. Iustitia insidens subsellio, dextra gladium tenens, sinistra bilancem in reverso. Plumb.

Louis XIII, King of France and Navarre. *rev:* Justice sitting on a throne, holding a sword in her right hand and a balance in her left.

3 Joannes Dominicus Comes Montezegius etc. Belgij et Burgundiæ Gubernator. 1675. in obverso. Cede mari Neptune vagis mons regnis undis Imperat, et domitas Flandria læta stupet. Flandria sedens ad urbem munitam, Mercurio opus cum Caduceo dirigente, et Victoriâ (super omnia) rem tubis proclamante. Stan.

[] Governor of Belgium and Burgundy; *rev:* Flanders seated in a defended city, Mercury directing things with his caduceus and Victory, above, proclaiming the event with trumpets.

4 Constantinus

Constantine.

5 Moneta recepta Anno hoc currente 1695. viz. Semicorona ærea argento obducta; semicorona,

solidus et semisolidus accisa. Donavit D.ˢ Richardus Dyer A.M. et Collegij Oriel Socius. - Hi nummi tanquam legalis Angliæ moneta habiti erant, 1695.²⁵⁸

Coins received in this current year of 1695, namely a copper half-crown silvered; half-crown, shilling and sixpence. Given by Mr Richard Dyer, MA, Fellow of Oriel College. These coins were used just as if there were legal English money.

[-5\6] Part of Prince Ruperts Colours divided amongst yᵉ Soldiers when He left Oxford. \\d//

7 Gulielmus & Maria: R. Brittannia. Nummorum famulus. 1690. \\d//

William and Mary; *rev:* Britannia.

[Insert: 1r]

1 Anna D.G. Mag. Br. Fr. et. Hib. Regina. in Revers: Cor quaquaversum emittens radios subter Diadema. QVIS SEPARABIT intus Corollam confectam e cordibus Rosis insertis: extra quam VNITED BY GOD IN LOVE AND INTEREST. ær.

Queen Anne. *rev:* a radiant heart below a diadem; 'Quis separabat' within a crown of cords mingled with roses.

2 Anna &c in Rev: Pallas armata tenens dextrâ hastam, sinistrâ clypeum Gorgone insignitum. [-] NOVÆ PALLADIVM TROIÆ. Ær.

Queen Anne. *rev:* Pallas in armour, holding a spear in her right hand and a shield in her left marked with a Gorgon.

3(?) Anna &c. in Rev: ab unâ parte Britannia sedens super Orbem (ut videtur) tenens dextrâ hastam sinistrâ Victoriolam: Quam e regione intuetur Captivus, manibus post tergum revinctis, sedens supra capta spolia. in vertice Numismatis [-] DE.GALL.ET.BAV: AD.BLENHEIM. ad infra CAPT: ET. CÆS. XXX M. SIGN. RELAT. CLXIII. MDCCIV. ær.

Queen Anne. *rev:* in one part Britannia sits on a globe (or so it appears), holding a spear in her right hand and in her left a Victory , at whom, from the other side, a prisoner looks, seated upon the spoils, his hands tied behind his back.

4(?) Anna &c. in Rev. Neptunus in curru stans, tenens dextrâ Tridentem ornatam Coronâ Regum Gallorum (ut videtur) sinistrâ coronam muralem e Regione Britannia tenens dextrâ hastam, sinistrâ imposita supra clypeum Regum Anglorum insignibus ornatum. in vertice VICTORIÆ NAVALES ad infra CALPE. EXPVG. ET GALL. VICT. MDCCIV. ær.

Queen Anne. *rev:* Neptune, standing in a chariot, holding a trident in his right hand ornamented with the crown of the Kings of France (or so it appears); and opposite, Britannia holds a spear in her right hand and a mural crown in her left which rests upon a shield ornamented with the arms of the Kings of England.

²⁵⁸D

[Insert: 1v]

5 Anna &c. in Rev: [-] Pallas sedens dextrâ inclinata super Clypeum Gorgone terrificium, Lævâ tenens hastam Corona murali ornatum. TORNACO EXPVGNATO. MDCCIX. ær.

Queen Anne. Pallas seated, her right hand leaning on a shield with a fierce Gorgon, her left holding a spear ornamented with a mural crown.

6 ANNA AVGVSTA corona triumphali redimita ad infra I.C. in Rev. PVGNA EQVESTRIS. HISPANIS. AD. ALMENARAM VICT. IVLII. XVI. MDCCX. ær.

Queen Anne, with a wreathed crown of Victory.

7 Anna &c. in Rev: Regale Diadema suspensam supra Cor cinctum ramis Quercinis &c. ENTIRELY ENGLISH. ad imum /in Basi columnæ\ATAVIS. REGIBVS. ær.

Queen Anne. *rev:* the royal diadem suspended over a heart wound around with oak branches, etc.

8 ANNA DEI GRATIA in Rev. Id. Ær:

Queen Anne; *rev:* the same as above.

9 Anna &c. corona triumphali redimita. in Rev: Britannia /nudo capite\ stans tenens dextra ramum olivæ, sinistra hastam, supra brachium Clypeum. Prospectus amænus hinc maris, inde arvorum &c. COMPOSITIS.VENERANTVR. ARMIS. MDCCXIII. ær.

Queen Anne, with a wreathed triumphal crown. *rev:* Britannia standing, bare headed, holding an olive branch in her right hand and a spear over her arm; a pleasant view of the sea from one side, and of fields from the other.

10 Anna &c. in Rev. Britannia /armata\ citato curta minitabunda per littus in Classem Gallic: fertur Scotia interea amplexâ genua ejus x veluti tutelam exorante. in vertice CLASSE.GALL.FVG. ad infra AD FRETVM EDENBVRG XIV. MARTII. MDCCVIII[259]

Queen Anne. *rev:* Britannia in arms, hastening threateningly over the shore after the French fleet; while Scotland, as if seeking safety, is borne in her embrace.

11 Anna &c. in Rev. FAma duplex, utraque tenens hâc. manu Tubam, illâ sustinens Chartum Geographicam GALLIS. AD. RAMELLIES. VICTIS. XII. MAII. MDCCVI. ad infra FLANDR. ET. BRABANT. RECEPT. ær

Queen Anne. *rev:* double Fame holding a trumpet in one hand and a map in the other.

[Insert: 2r]

12 ANNA AVGVSTA corona triumphali redimita. in Rev. [-\hâc parte Victoria] stans inter spolia Gall: appendens columnæ Clypeum, in quo SALUS PROVIN corona murali ornatum. alterâ parte Britannia /per Vallum dirutum\persequens Gallum fugientem. Superscript: VALLO. GALLORVM. DIRVTO. infra ET. DVACO. CAPTO. MDCCX. ær.

Queen Anne, with a wreathed triumphal crown. *rev:* in one part Victory stands among the spoils of France, her shield hanging from a column, ornamented with a mural crown; in the other part Britannia, through demolished ramparts, pursues the fleeing French.

13 Anna &c. in Rev. [-\Victoria] stans in Concha marina fluitante per undas tenens dextrâ Vescillum sinistrâ ramum palmæ. Superscript. SARDINIA. ET. BALEARIS. MINOR. CAPTÆ infra MDCCVIII

Queen Anne. *rev:* standing Victory in a sea-shell, floating on the waves, with a standard in her right hand and a palm branch in her left.

14 Anna &c. in Rev. Duo Captivi, manibus post tergum revinctis, alligati Columnæ Gallicis vescillis &c. ornatæ, in vertice cujus stat [-exigua alata figura\Victoriola] tenens dextrâ coronam triumphalem, sinistra ramum palmæ. Superscript. GALLIS.AD.ALDENARD. VICTIS infra XXX.IVNII.MDCCVIII. ær.

Queen Anne. *rev:* two captives, their hands bound behind their backs and tied to a column ornamented with the French standard, at the top of which, Victory, holding a triumphal crown in her right hand and in her left a palm branch.

15 [-] Id: ac 12. in Rev: Trophæum bellicum basi columnæ sustentum. superscript. BETHVNIA. FANO. S.ᵀᴵ VENANTII. ET. ARIA. CAPTIS. infra INSPECTANT. GALL. CENT. MILL. MDCCX. ær.

The same as 12. *rev:* trophy of war on the base of a column.

16 Anna &c. in Rev. Pallas vibrans fulmen in Rebellem quendam Terrigenam. superscript. VICEM. GERIT. ILLA. TONANTIS. infra INAVGVRAT. XXIII. AP. MDCCII. ær.

Queen Anne. *rev:* Pallas brandishing a thunderbolt.

17 Anna &c. in Rev. Regina sedens in solio tenens sinistrâ Sceptum, porrigens dextra diploma, ([*Insert:* 2v]) quod episcopi, flexo genu, accipiunt. Superscript. PIETAS. AVGVSTÆ infra PRIMITIIS. ET. DECIMIS. ECCLESIÆ. CONCESSIS. MDCCIV. ær.

Queen Anne. *rev:* the Queen sits on a throne with the sceptre in her left hand, holding out with her right a document which the bishops accept on bended knee.

18 Anna &c. in Rev. Insignia Regum Anglor: &c. superscript. MAII.I. MDCCVII. Ær.

Queen Anne. *rev:* arms of the kingdom of England.

19 Anna &c. in Rev. Victoria [-] utrâq. manu tenens coronam triumphalem, x supervolans /super\ Exercitum fugientem hostem insequenten Superscript: CONCORDIA.ET.VIRTVTE. infra GALLIS.AD.TAISNIERE.DEVICTIS. AVG: XXXI. MDCCIX. ær.

Queen Anne. *rev:* Victory holding in each hand a triumphal crown, and flying above, pursuing the fleeing enemy army.

20 vid. 15. in Rev. Regina in solio sedens juxta quam stat Britannia, dum ante Reginæ pedes Victoria vexilla capta projicit. superscr: HISPANIS.PROFLIGATIS. infra AD.CÆSARIAM.AVGVSTAM.AVG.IX. MDCCX. ær.

[259] ær:

See 15; *rev:* the Queen seated on a throne beside which stands Britannia, while Victory throws captured standards at the Queen's feet.

21 Anna &c. in Rev. Expugnatio Urbis. Superscript. VIRES. ANIMVMQVE. MINISTRAT infra CAPTIS. COLONIA. TRAJANA. VENLOA. RVREMVNDA. STEPHANOVERDA. LEODIO. MDCCII. ær:
Queen Anne. *rev:* storming of a city.

22 Anna &c. in Rev. Sol emergens ex Eclipsi, Naves ad urbem tranantes. Superscr: BARCELONA. LIB GALLIS. FVG. infra I.MAII.MDCCVI. ær.
Queen Anne. *rev:* the sun emerging from an eclipse, with ships sailing to a city.

23 Anna &c. in Rev. Classes incensæ. Superscr: CAPTA. ET. INCENSA. GAL. ET. HISP. CLASSE. infra AD. VIGVM. XII. OCT. MDCCII. ær.
Queen Anne. *rev:* Fleets on fire.

[Insert: 3r]

24 Anna &c. in Rev. Victoria corona murali redimita tenens dextra ramum palmæ, sinistra sustinens clypeum Insigni Gallorum ornatum. &c. superscr: INSVLÆ.CAPTÆ.MDCCVIII. ær.
Queen Anne. *rev:* Victory with a wreathed mural crown holding in her right hand a palm branch, her left supporting a shield ornamented with the arms of France.

25 vid. 12. in Rev. Miles flexo genu tradens Ensem &c Britanniæ sedenti super orbem inter spolia capta, tenenti dextra hastam, sinistra Clypeum in quo FORTVNA MANENS Superscr: HOSTES AD DEDITIONEM.COACTI. infra VALLO.GALLORVM.SVPERATO.ET.BVCHEM IO.CAPTO.MDCCXI. ær.
See 12. *rev:* a soldier, bent at the knee, handing a sword over to Britannia seated on a globe amongst the spoils of war, holding a spear in her right hand and a shield in her left.

26 Anna &c. in Rev: Insignia Reginæ. &c. ær
Queen Anne. *rev:* the Queen's arms, etc.

27 Annæ Reginæ Quadrans. 1714. ær
Queen Anne farthing.

28 Anna &c. in Rev: Mulier corona murali edimita, flexo genu, offert dextrâ tres claves Duci malburiensi, u fallor, Equo insidenti. Superscrip: SINE.CLADE. VICTOR. infra [-] CAPTIS.BONNA.HVO.LIMBVRGO. 1703. Ær[252]
Queen Anne. *rev:* woman in a mural crown, on bended knee, offers with her right hand three keys to the Duke of Marlborough (unless I am mistaken), seated on a horse.

[Insert: 4v]

***29** Id: ac N: 9. excepto q.[d] ibi Britannia stet, hic sedeat.
The same as no. 9, except that there Britannia is standing while here she is seated.

30 Carol: D.G. M.B.F. et H. Rex & Glor: Mem: in Rev: Manus e nubibus exporrecta sustinens coronam martyrii. Superscrip: VIRTVT EX.ME FORTVNAM.EX.ALIIS.

King Charles I. *rev:* a hand emerging from the clouds holds a martyr's crown.

31 Maria. II. D.G. &c. in Rev. Luna inter stellas. Superscrip. VELVT. INTER. IGNES. LVNA. MINORES. ær.
Queen Mary. *rev:* the moon amongst stars.

[Insert: 3v]

32 Anna &c in Rev: Geor: Dan. P[-]: M. Adm. et Dux sup: Angliæ. ær.
Queen Anne.

33 Anna &c. in Rev: Victoria super urbem volans, superscript. MONTIBVS.IN.HANNONIA. CAPTIS. infra MDCCIX. ær.
Queen Anne. *rev:* Victory flying over a city.

34 Anna &c. in Rev. Regale Diadema suspensum supra caput Britanniæ sedentis. ær
Queen Anne. *rev:* the regal diadem suspended over the head of the seated Britannia.

35 Id: ac N.° 23. arg:
The same as no. 23.

36 Georgius. D.G. Mag. Brit: &c. in Rev. Rosa. superscrip: ROSA.AMERICANA. infra UTILE.DVLCI. deaurat:
King George. *rev:* a rose.

[105v]

Numismata.		1638.
		732.
953.		488.
87.	oblit.	433.
220.		627.
336.		810.
1596.	Total.	4728.
42.		
1638.		

29 Anna Dei Gratia &c.[a] in Revers: Britannia sedens, in dextra palmam, sinistra hastam tenens. Compositis venerantur armis MDCCXIII
Queen Anne. *rev:* Britannia seated, holding a palm leaf in her right hand and a spear in her left; with a guard of honour.

[106v]

George
George The only way.

LIBER PROCURATORIS SENIORIS
The Book of the Senior Proctor
Transcribed and translated by Philippa Walton, annotated by Arthur MacGregor

Ashmolean Museum AMS 7, compiled 1684. Leather-bound quarto volume with black leather labels on cover and spine, 'LIBER PROCURATIS SENIORIS 1684', all within tooled borders. 90 folios, many of them blank, 235 by 19 mm.

Edward Lhwyd undertook the compiling of this catalogue of shells as an early priority following his appointment as Plot's assistant: by 1684 it was complete. On the evidence of the comparanda cited, Lhwyd relied for comparisons partly on the specimens in Martin Lister's collection, presented to the Museum in 1683 along with a catalogue prepared by the donor and referenced to his *Historiæ Animalium Angliæ* of 1678 (see pp. 153-8, below), and partly on what must have been a very fresh copy of Filippo Buonanni's *Recreatio mentis et oculi in observatione animalium testaceorum*, published in Rome in 1684.

Cochlearum qotqot in Museo Ashmoleano conservantur, Distributio Classica. Accurante Ed. Lh. è C. Jesu ejusd. Musei Procustode A. 1684
Shells preserved in the Ashmolean Museum, arranged by class. Undertaken by Edward Lhwyd of Jesus College, under-keeper of the same Museum, in 1684.

[7r]

De Cochleis tam Terrest. et Fluviat. qàm Marinis
Shells, both terrestial and riverine, as well as marine

Pars Prima. De Anfractuosis s. intortis
First part: Spiral or twisted shells

Sectio Prima
First section

De Muricatis
Pointed shells

Membrum I.ᵘᵐ Buccinum, Buccinocochlea, Echino-purpura buccinites, Purpura rostrata, Aporrhais [1]
Class 1. Buccinum, Buccino-cochlea, Echino-purpura buccinites, beaked Purpura, Aporrhais

Capsula 1ᵘᵐ de Buccino
First drawer: Buccini

1 Buccinum alatum Sesquipedale tenuius fascijs ex albo et atrorubenti variegatis cinctum, intùs ruberrimū. [2]
Buccinum, winged and rather thin-walled, 1½ feet long, encircled by bands of white and dark red; the interior is deep red.

2 Buccinum ex atrorubenti et subalbido versicolor non alatum.
Buccinum, not winged, coloured dark red and off-white.

3 Buccinum ex albo et atrorubenti versicolor, crassum.
Buccinum, thick-walled, coloured white and dark red.

4 Buccinum [-crassum] ex albido atrorubens mucrone rubro-purpureo aperturâ hinc rugosâ, inde crenatâ.
Buccinum, white shading to dark red, the point reddish purple, and the aperture wrinkled on one side and crenulate on the other.

5 Buccinū ex albo et atrorubenti versicolor tuberosum.
Buccinum, coloured white and dark red, covered in tubercles.

Buccinum 1.ᵘᵐ Rond. ([-2\1]) 2
First Buccinum of Rondelet

6 Buccinum clavellatum ex albo et atrorubenti versicolor mucrone rubro-purpureo, apertura crenata et striata. Idem forte cum 3.ⁱᵒ.
Buccinum, with little knobs, coloured white and dark red with a reddish purple point, the aperture ridged and crenulate. Perhaps the same as no. 3.

7 Buccinū albidum crassiusculum læve. Buon. Clas.3.n. 190 [-(2)].
White Buccinum, smooth and rather thick-walled. Buonanni 1684, class 3 no. 190.

8 Buccinum albidum, majusculū, confragosum.
White Buccinum, quite large, and rough.

[8r]

9 Buccinum cinereum minus, mucrone creberrimè fasciato, purpuram fundens Anglicanum.
Smaller, ash-grey Buccinum, the point repeatedy banded; it produces the English Purpura.

10 Buccinum minus crassum, albidum asperum, intra 5ᵗᵃᵐ spiram finitum, littorale. Listeri p.158. Id.ᵐ cum priore.
Smaller, thick-walled Buccinum, spattered with white, and with five coils; from the sea-shore. Lister 1678, p.158. The same as the last.

11 Buccinum breviusculum albicans, mucrone cinereo, fasciis rubris bullatis præditum.
Whitish Buccinum, somewhat short, with an ash-grey point, and with studded red bands.

12 Buccinum minus albidum lævissimum.
Smaller, white Buccinum, very smooth.

13 Buccinum crassum rufescens striatum et undatum. List. p.159. Buon. Cl. Cl.3.n.78. [-(2)] (2)
Thick-walled, reddish Buccinum, striated and undulated. Lister 1678, p. 159; Buonannani 1684, class 3 no. 178.

[1] [f.6v] Capsula I.ᵐᵃ
The first drawer.

[2] [f.6v] deest.
N.° 1 / Supra scrinium inter alias / ut opinor /
No. 1, I think, is in the case above, among the others.

14 Buccinum turbinatum, fasciatum et sulcatum albidum.
White, conical Buccinum, banded and furrowed.

15 Buccinum turbinatum ex albido rufescens, maximè clavatū. \\[-deest]//
Conical Buccinum, white shading to red, covered extensively with knobs.

16 Buccinum turbinatum ex pallido rufescens mucrone leviter et creberrimè striato.
Conical Buccinum, pale-coloured shading to red, with a point repeatedly but lightly grooved.

17 Buccinum turbinatum cinereum, valde clavatum et utrinque fimbriatum.
Conical, ash-grey Buccinum, very knobbly and fringed on both sides.

18 Buccinum ex albido rufescens tuberosum.\\(2)//
Buccinum, white shading to red, covered with tubercles.

19 Buccinum crassum læve ex fusco et cinereo versicolor.
Thick-walled Buccinum, smooth, coloured dark grey and ash-grey.

20 Buccinum luteum exiguum, sulcis crenatis profundioribus ex aratum. \\(2)//
Small, yellow Buccinum with deep furrows.

21 Buccinum [-album lævissimum\eburneum] bivalve. \\T.//
Buccinum, ivory-coloured.

22 Buccinum ex albido rufescens, breviusculum crebrò striatum et fasciatum.
Buccinum, white shading to red, somewhat short, extensively striated and banded.

23 Buccinum exiguum clavatum nigrocæruleum. \\(1) [-2]// \\deest//
Small, knobbly Buccinum, blue-black in colour.

24 Buccinum ex luteo rufescens valdè striatum et fasciatum. \\[-(2)]//
Buccinum, yellow shading to red, heavily striated and banded.

25 Buccinum fuscium, bullatis fasciis cinctus.
Buccinum, quite dark and encircled with studded bands.

26 Buccinum cinereum bullatis fasciis.
Ash-grey Buccinum with studded bands.

27 Buccinum ex fusco lutescans bullatum.
Buccinum, dark-coloured shading to yellow, and studded.

28 Buccinum ex albo & rubro versicolor, creberrimè fasciatum, minùs tuberosum. \\(2)//
Buccinum, coloured white and red, heavily banded, with fewer tubercles.

[9r]

29 Buccinum ex albidum clav/ell\atum. \\[-(3)]5//
Whitish Buccinum, with little knobs.

30 Buccinum ex albo et fusco versicolor crebrò fasciatū tuberosum.
Buccinum, coloured white and dark grey, repeatedly banded and covered with tubercles.

31 Buccinum ex albo et atrorubenti versicolor [-crebrò fasciatum] profundius striatum, et crebro fasciatum. \\[-]//

Buccinum, coloured white and dark red, quite deeply striated, and repeatedly banded.

32 Buccinum ex albido rufescens fasciatum, [-et] striatum, et valdè gibbosum. \\(2)//
Buccinum, white shading to red, banded, striated and very humped.

33 Buccinum versicolor confragosum minus.
Buccinum of various colours, less rough.

34 Buccinum albidum confragosum apertura ferè rotundâ.
White Buccinum, rough, with an almost circular aperture.

35 Buccinum albidum profundiùs sulcatum; aperturâ ovali \\[-]//
White Buccinum, quite deeply grooved; with an ovoid aperture.

36 Buccinum albidum fasciis rubris clav/ell\atis.
White Buccinum, with red knobbly bands.

37 Buccinum rufescens fasciis profundiorib. bullatis cinctum.
Reddish Buccinum, encircled with fairly deep studded bands.

38 Buccinum rubrum lævius, fasciâ unica vel alterâ albâ. \\D//
Red Buccinum, quite smooth, with one or two white bands.

39 Buccinum rubrum tuberosum.
Red Buccinum, covered with tubercles.

40 Buccinum exiguum cinereum, striatum et fasciatum \\[-5\4]/\\D//
Small Buccinum, ash-grey, striated and banded.

41 Buccinum ex albido rufescens, profundius, striatum et creberrimè fasciatum. \\[-\5]//
Buccinum, white shading to red, quite deep, striated and repeatedly banded.

42 Buccinum subluteum tuberosum.
Yellowish Buccinum, covered with tubercles.

43 Buccinum majus ex albido rufescens, tuberculis majoribus. \\D//
Large Buccinum, white shading to red, with somewhat large tubercles.

44 Buccinum fuscum creberrimè fasciatum, productius. \\Buō Cl.3 n./46V//
Dark Buccinum, heavily banded, quite long. Buonanni 1684, class 3 no. 46.

45 Buccinum nigrum confragosum.
Black Buccinum, rough.

46 Buccinum album fragosum /bivalve\ apertu[-l\r]â tribus fasciolis insignitâ. \\[-(2)]//
Buccinum, white and fragile, with an aperture marked by three little bands.

47 Buccinū fragosum ex albo rufescens, valdè labrosum.
Fragile Buccinum, white shading to red, with a very large lip.

48 Buccinum ex albo rufescens labro tenui. \\(2)//
Buccinum, white shading to red, with a delicate lip.

49 Buccinum fuscum creberrimè fasciatum, aculeatis fimbrijs. \\D [-D]//
Dark Buccinum, heavily banded, with prickly ends.

50 Buccinum fimbriatum vel labrosum creberrimè fasciatum rufescens.
Reddish Buccinum, fringed or rather lipped, heavily banded.

51 Buccinum subluteum crebrò fasciatum, labro crasso dentato rufescenti. \\()//
Yellowish Buccinum, repeatedly banded, with a thick, toothed lip shading to red.

52 Buccinum ex albido lutescens crebrò fasciatū et striatum. \\()//
Buccinum, white shading to yellow, repeated banded and striated.

[10r]
Buccinū rost/r\atū
Beaked Buccinum

53 Buccinum rostratum tuberosum nigrum, ventricosum.
Beaked Buccinum, black, covered with tubercles, and swollen.

54 Buccinum rostratum tuberosum nigrū, fasciâ luteâ productius.
Beaked Buccinum, black and covered with tubercles, and with a yellow band; quite long.

55 Buccinum rostratum nigrū fasciis albis, oblongum.
Beaked Buccinum, black with white bands; elongated.

56 Buccinum rostratum nigrū tuberosum, fasciis albis; breviusculum.
Beaked Buccinum, covered with tubercles, black with white bands; quite short.

57 Buccinum rostratum tuberosum ex albo et russo versicolor.
Beaked Buccinum, with tubercles, varying in colour from white to red.

58 Buccinum rostratum tenue crebro fasciatum et striatum, colore fusco, [-fasciâ albâ] \\[2]//
Beaked, delicate Buccinum, repeatedly banded and striated, dark in colour.

59 Buccinum rostratum exiguum tuberosū col. aurantiaco. \\D//
Beaked Buccinum, small and covered with tubercles, golden in colour.

60 Buccinum longirostrū, creberrimè fasciatum, tuberosū ex albido rufescens.
Buccinum with a long beak, heavily banded and covered with tubercles, white shading to red.

61 Buccinum rostratum turbinatum, colore ex albido.
Beaked, conical Buccinum, whitish in colour.

62 Buccinum rostratum tuberosum albidum du[-abus\plici] fasci[-js\a] ruberrim[-â] insignitum. Buon. Cl. 3. n.47
White, beaked Buccinum, covered with tubercles, marked with two deep red bands. Buonanni 1684, class 3 no. 47.

63 Buccinum rostratum læve /ventricosius\: colore ex albido rufescenti
Beaked Buccinum, smooth and swollen, white shading to red.

Buccinum fluviatile Anglicanū
English riverine Buccinum

64 Buccinum fluviatile longū 6 spirarū omnium et max. et productius, subflavum, pellucidum in tenue acumen ex amplissimâ basi mucronatum List. p. 137. ([-3]) \\D//
Riverine Buccinum, quite elongated with no more than six coils, golden yellow in colour, translucent and tapering to a fine point from a broad base. Lister 1678, p. 137.

65 Buccinum pellucidum subflavum 4 spirarum, mucrone acutissimo apertura omnium maximâ \\List. (2)//[3]
Translucent Buccinum, golden-yellow, with four coils, a very sharp point and a very large aperture. Lister 1678, p. [139]

66 Buccinum fluviatile subflavū pellucidum trium Spirarū. ejusd. p.140 ([-5]) \\fract.//[4]
Translucent, golden-yellow, riverine Buccinum, with three coils. Lister 1678, p. 140. Broken.

67 Buccinum minus fuscum 6 spirarum; ore angustiore. ejusd. p.139 ([-4]). \\[-D\Fr.]//
Smaller Buccinum, dark, with six spirals and a somewhat narrow mouth. Lister 1678, p. 139. Broken.

Buccinum Veneris
Venus Buccinum

68 Buccinum Veneris fasciatū ex albo et atrorubenti versicolor /[-1]\
Venus Buccinum, banded and coloured white and dark red.

69 Buccinū Veneris leviter fasciatū ex rubro et albo versicolor /3\ \\D//
Venus Buccinum, lightly banded, and coloured red and white.

70 Buccinum Veneris ex albo et rubro versicolor læve. \\(2)//
Venus Buccinum, smooth and coloured white and red.

71 Buccinū Veneris fascijs crebris minutissimis cinctum ex albo et [-fusco\livido aut atrorubenti] versicolor.
Venus Buccinum, coloured white and blue-black or deep red, repeatedly encircled with tiny bands.

[11r]

72 Buccinum Veneris læve ex fusco et cinereo varieg. \\D//
Venus Buccinum, smooth, striped in dark and ash-grey.

73 Buccinum Veneris dorsum nigricans, latera rufescens, albis maculis punctatum. \\D//
Venus Buccinum, shading to black at the back and to red at the sides, and marked with white dots.

74 Buccinum Veneris ex ilius ex albo et russo versicolor. \\D//
Venus Buccinum, of poor quality, coloured white and red.

75 Buccinum degener, S. pinnatum tenue rufescens. \\deest//[5]

[3] [f.9v] 64 65 66: desunt.
Nos. 64-66 missing.

[4] [f.9v] Plurimas fractas ... suspicamur: et de Veneris Buccinis dubitamus.
We suspect that most are broken ... and we have doubts about the Venus Buccini.
[5] Buccinum degener deest.
Poor quality Buccinum.

Poor quality Buccinum, or feathered Buccinum, delicate and shading to red.

Additamentum
An addition.

[11rA,12r blank;13r]

C: 2.um De Buccinocochlea6
Second drawer: Buccino-cochlea

Buccinococh. ventricosa
Buccino-cochlea, swollen

1 Buccinocochlea è maximis, colore ex albo et atrorubenti elegantissimo. Buon. Cl. 3. n.40 Inverted Wilk snayl M.R.S. T.10^7
Buccino-cochlea (snail shell), among the largest, most beautifully coloured in white and dark red. Buonanni 1684, class 3 no. 40. Inverted Wilk snail: Grew 1681, pl. 10.

2 Buccinocochlea ex albo, atrorubenti et subviridi variegata.8
Buccino-cochlea (snail shell), striped in white, dark red and greenish.

3 Buccinocochlea è max. ex luteo et nigro versicolor.9
Buccino-cochlea (snail shell), among the largest, coloured yellow and black.

4 Buccino-cochlea atrorubens, /a sinistrā in dextrā obvoluta\ mucrone lutescenti obtuso.10
Dark red Buccino-cochlea (snail shell), spiralling from left to right, with a blunt point shading to yellow.

5 Buccino-cochlea obscurè alba, ex luteo maculata.11
Buccino-cochlea (snail shell), dull white with yellow spots.

6 Buccino-Cochlea albida leviter striata, ora rufescent. \\deest//
White Buccino-cochlea (snail shell), lightly striated, its aperture shading to red.

7 Buccino-Cochlea russa, profundius striata. \\deest//
Red Buccino-cochlea (snail shell), quite deeply striated.

8 Buccino-cochlea ex fusco albida, sulcis profundioribus exarata. Buon. Cl.3.n.147.12
Buccino-cochlea (snail shell), dark grey and white, with deep grooves. Buonanni 1684, class 3 no. 147.

9 Buccino-cochlea exigua, crassiuscula, col. subalbido.
Small Bucchino-cochlea (snail shell), fairly thick-walled and whitish in colour.

6[f.12v] Capsula 2da
7[f.12v] [-Nos. 1, 3 & 4 remov'd to the capsule] Nos. 1, 3 & 4 removed to the cabinets above stairs.
8[f.12v] [-1, 2, 3, 4 desunt 7-10 deest -]
Nos.1 - 4, and 7-10 missing.
^9Nos. 1, 3 & 4 found in other capsulae.
10[f.12v] Buccino-cochlea majuscula heterostropha, colore subrubenti. intus q.d script hoc ... Rara avis in terris nigroque simillima cygno.
Buccino-cochlea, largish and coiled contrariwise, reddish in colour, within which is inscribed... A rare bird in these lands, very like a black swan.
11[f.12v] [-deest]
12[f.12v] 8 idem ac:11
No. 8 is the same as no.11.

[-10 Buccino-cochlea exigua rufescens.]13
Small Buccino-cochlea (snail shell), shading to red.

Bucchinococh. Compressa
Compressed Bucchino-cochlea

11 Buccino-cochlea ex albido rufescens compressa, spiris crenatis parū eminentibus, apertu[-l\r]â dentatâ.
Compressed Buccino-cochlea (snail shell), white shading to red, with crenulate coils which are a little prominent, and a toothed aperture.

12 Buccino-cochlea compressa, ex albo et russo versi/color\ fasciis parùm eminentibus apertu[-l\r]â dentatâ.
Compressed Buccino-cochlea (snail shell), coloured white and red, with bands which are a little prominent, and a toothed aperture.

[14r]
C.3.um De Echino-purpurâ bucchiniti
Third drawer: Echino-purpura buccinites

1 Echino-purpura buccinites maxima, valdè fragosa ex albido rufescens. Buon. Cl.3. N.285.
Very large Echino-purpura buccinites, white shading to red and extremely fragile. Buonanni 1684, class 3 no. 285.

2 Echino-purpura buccinites fragosa cinerea. \\D//
Ash-grey Echino-purpura buccinites, fragile.

3 Echino-purpura buccinites fragosa, ex cinereo rufescens.
Echino-purpura buccinites, ash-grey shading to red, fragile.

[-B3\4] Echino-purpura buccinites minùs fragosa, /rubro-\cinerea. \\2//
Greyish red Echino-purpura buccinites, less fragile.

[-4\5] Echino-purpura buccinites minùs fragosa rufescens.
Echino-purpura buccinites, less fragile and shading to red.

[-5\6] Echino-purpura buccinites minus fragosa albida.14
White Echino-purpura buccinites, less fragile.

[-6\7] Echino-purpura buccinites cinerea, crebris striis, brevioribus aculeis consitis insignita.
Ash-grey Echino-purpura buccinites, with repeated grooves marked by dense, shortish spines.

[-7\8] Echino-purpura buccinites tuberosa obonga, crassa, colore albo.
Echino-purpura buccinites, covered with tubercles, elongated, thick-walled and white in colour.

[-8\9] Echino-purpura buccinites tuberosa, crassa, colore subalbido, brevier. \\D// \\[-#]//
Echino-purpura buccinites, covered with tubercles, thick-walled and white in colour; shorter.

[14Ar]

C. 4.um De Purpurâ [-] rostratâ
Fourth drawer: Purpura rostrata

Purpura rostrata fasciata
Banded Purpura rostrata

13[f.12v] deest 10.
No.10 missing.
14[f.13v] [-deest]

1 [-] Purpura rostrata fasciata lutescens maj. S. operculo alato Porpora echinata clavata &c. Buon. Jonst. prior T.20. Purpura Rond. p. 64. Pelagiū Plinio; concha operculea Politano.[1]

Larger, banded beaked Purpura, shading to yellow, or Purpura echinata with a winged operculum and knobbles; see Bounanni [1684, class 3 nos. 282-3] and Jonston 1650a, pl. 10; the Purpura of Rondelet 1554, p. 74. The Pelagium of Pliny and the Concha operculea of Politanus.

2 Purpura rostrata fasciata lutescens minor, S.operculo non alato.

Banded, beaked Purpura, smaller and shading to yellow, or beaked Purpura with an operculum which is not winged.

3 Purpura rostrata fasciata lutescens major, spirarum vinculis minoribus.

Banded, beaked Purpura, rather large and shading to yellow, with small chains of spirals.

4 Purpura rostrata fasciata, cinerea aut subalbida \\(2)//

Banded, beaked Purpura, ash-grey or off-white in colour.

Purp. rostr. striata [-sive Echinopurp. rostrata]
Striated Purpura rostrata

5 Echinopurpura rostrata striata albicans. \\(2)//

Striated, beaked Echino-purpura, shading to white.

[-5\6] Echino-purpura rostrata striata [-striata] rufescens.

Striated, beaked Echino-purpura, shading to red .

[-6\7] [-Echino-purpura exigua, rostrata striata fusca.] \\deest//[2]

Small Echino-purpura, beaked, striated and dark in colour.

8 Purpura rostrata striata tuberosa, s. minus aculeata, colore ferrugineo alata. \\deest//

Striated, beaked Purpura with tubercles, with fewer barbs, winged and rust coloured.

9 Purpura rostrata striata tuberosa, col. cinereo.

Striated, beaked Purpura, covered with tubercles, ash-grey in colour.

10 Purpura rostrata striata minùs tuberosa ex albido rufescens.

Striated, beaked Purpura, with fewer tubercles, white shading to red.

[15r]

11 Purpura rostrata striata, tuberosa, alba.

A white, grooved, beaked Purpura with protuberances.

12 Purpura rostrata striata alba valdè rugosa, [-valdè rugosa], operculo dentato.

White, striated, beaked Purpura, very rough, with a toothed lid.

[16r]

C. 5.ᵘᵐ De Aporrhaide
Fifth drawer: Aporrhais

Aporrhais maj. s. digitata
Larger or fingered Aporrhais (Pelican's foot)

1 Aporrhais maxima utrinque digitata. Vide Buon. Cl.3. n.312 & 313

Very large Aporrhais (Pelican's foot), fingered on both sides. See Buonanni 1684, class 3 nos. 312-13.

2 Aporrhais heptadactyla sublutea, valdè gibbosa. Aporrhais Rond. 79.

Seven-fingered Aporrhais (Pelican's foot), yellowish-gold and very humped. Rondelet 1554, p. 79.

3 Aporrhais crassior ex albo & atrorubenti versicolor sex chelis brevioribus et magis obtusis, armata. \\An. Rond? p.79// \\[-deest]//

Thicker-walled Aporrhais (Pelican's foot), coloured white and dark red, with six claws which are rather short and very blunt. Could it be Rondelet 1554, p. 79.

4 Aporrhais ex albo et atrorubenti versicolor, pentadactylites. Murice Pentidattilo &c. Buon. Cl. 3.n 3ij.

Aporrhais, coloured white and dark red, with five fingers. The Murex Pentadattilo etc. of Buonanni 1684, class 3 no. 311.

Aporrh. Min. s. alata
Smaller (or winged) Aporrhais

5 Aporrhais alata ex cinereo albicans et rufescens. \\(2)//[3]

Winged Aporrhais (Pelican's foot), ash-grey shading to white and red.

6 Aporrhais alata albida, valdè crenata.[4]

White, winged Aporrhais (Pelican's foot), heavily crenulate.

7 Aporrhais minus alata ex albo aut cinereo rufescens[5]

Smaller, winged Aporrhais (Pelican's foot), white or ash-grey shading to red.

[17r]

Membrum 2ᵘᵐ. Murex tuberosus /fimbriatus\ Murex lævis, Murex cochleatus et Murex rhomboides[6]
Second Part. Murex tuberosus and fimbriatus, smooth Murex, Murex cochleatus and Murex rhomboides

C. 1ᵘᵐ De Murice tuberoso
First Drawer: Murex tuberosus

Murex Tuberos. patulus major s. alatus
Large (or winged) wide-mouthed Murex tuberosus

1 Murex tuberosus patulus maximus tuberibus minoribus obtusis. Murex marmoreus. Rond. p. 76 \\deest//[7]

Very large, wide-mouthed Murex tuberosus, with smallish, blunt tubercles. The Murex marmoreus of Rondelet (1554, p. 76).

2 Murex tuberosus patulus digitatus intùs valdè purpurascens.

Fingered, wide-mouthed Murex tuberosus, shading to deep purple inside.

[1] [f.14v] [-deest 1] Purpurā rostratā cū animali et operculo, transmittere promisit Gallia Josephus Tournefort A°. 1686 at nomen nondum liberavit A°. 1700.
Beaked Purpura with animal and operculum, which Joseph Tournefort promised to send in 1686, but had still not done so in 1700.

[2] [f.14v] 7 deest.
No. 7 missing.

[3] [f.15v] [-unus deest]

[4] [f.15v] deest

[5] [f.15v] deest

[6] [f.16v] Capsula 3.ᵗⁱᵃ
The third drawer.

[7] [f.16v] [-] On yᵉ top of yᵉ Cabinet 1 Deest.

3 Murex tuberosus minùs patulus, tuberculis minoribus.
Smaller, wide-mouthed Murex tuberosus, with smallish tubercles.

4 Murex tuberosus subluteus compactilior, pentadactylites.
Five-fingered Murex tuberosus, yellowish and quite compact.

5 Murex tuberosus rufescens compactilior.
Murex tuberosus, shading to red and quite compact.

6 Murex tuberosus [-fere turbinatus\Trochoides s. Coniformis], cū spiculis acutioribus [-du\com]plicatis.
Murex tuberosus, trochoides or coniformis, with rather sharp, folded spines.

Murex tub. Patulus, min.
Smaller, wide-mouthed Murex tuberosus

7 Murex tuberosus patulus minor ex albo et luteo versicolor. \\(2)//
Smaller, wide-mouthed Murex tuberosus, coloured white and yellow.

8 Murex tuberosus patulus minor luteus.
Small, wide-mouthed, yellow Murex tuberosus.

9 Murex tuberosus patulus minor, ex albo et russo versicolor valdè /rugosus\.[1]
Smaller, wide-mouthed Murex tuberosus, coloured white and red, very rough.

10 Murex tuberosus patulus, minor albus, tuberculis crebris obtusis præditus. \\(2)//
Smaller, wide-mouthed Murex tuberosus, with numerous blunt tubercles.

11 Murex tuberosus patulus minor ex pallido lutescens, fasciâ unicâ albâ insignitus. \\(2)//
Smaller, wide-mouthed Murex tuberosus, pale-coloured shading to yellow, marked with a single white band.

12 Murex patulus minor omninò tuberosus, ex atrorubenti et albido versicolor. \\(2)// [2]
Smaller, wide-mouthed Murex, covered all over with tubercles, coloured dark red and white.

13 Murex patulus minor tuberosus, corniculatus. \\(2)//
Smaller, wide-mouthed Murex tuberosus, horn-shaped.

14 Murex patulus tuberosus min. dorso lævi, ad extremum fasciatus colore pallido. \\(2)//
Smaller, wide-mouthed Murex tuberosus with a smooth back, pale in colour and banded at the tip.

15 Id^m lutei coloris. \\(2)//
The same, yellow in colour.

16 Id^m ex luteo rufescens. \\(2)//
The same, yellow shading to red.

Murex tuber. Angustior
Narrower Murex tuberosus

17 Murex tuberosus angustior maximus, colore albo.
Narrower Murex tuberosus, very large and white in colour.

18 Murex tuberosus angustior, lateritus, longus.

Narrower Murex tuberosus, long and brick-red.

19 Murex tuberosus angustior, macrodactylus, rugosus, luteus. \\d//
Narrower Murex tuberosus, long-fingered, rough, and yellow in colour.

20 Murex tuberosus angustior, ex albo et atrorubenti versicolor spiculis crebris acutioribus.
Narrower Murex tuberosus, coloured white and dark red, with numerous sharp spines.

21 Murex tuberosus angustior ex albido subluteus tuberculis...
Narrower Murex tuberosus, white and yellowish in colour, with tubercles.

[18r]

22 Murex tuberosus angustior, ad extremū incurvus, tuberculus majoribus.
Narrower Murex tuberosus, curved at the end, with quite large tubercles.

23 Murex tuberosus angustior, ad extremū [-ad extremū] incurvus, tuberculis minimis.
Narrower Murex tuberosus, curved at the tip and with tiny tubercles.

24 Murex tuberosus angustior lucidus, spirarū ultimâ rubrâ; cæterùm coloris ex albo et luteo elegantiss... tuberculis minimis. Buon. Cl. 3 n. 291, quod figuram.
Narrower, translucent Murex tuberosus; the last coil coloured red and the others an elegant white and yellow [] with tiny tubercles. Buonanni 1684, class 3 no. 291.

25 Murex tuberosus angustior nitidus, ex albo et luteo variegatus.
Polished, narrower Murex tuberosus, striped in white and yellow.

26 Murex tuberosus angustior albus fusiformis duabus fasciis russis insignitus.
Narrower, white Murex tuberosus, shaped like a spindle, marked with two red bands.

Murex tuberos. Sulcatus[3]
Murex tuberosus, grooved

27 Murex tuberosus sulcatus maximus ex albo et atrorubenti eleganter variegatus.
Very large, grooved Murex tuberosus, elegantly striped in white and dark red.

28 Murex tuberosus sulcatus variis coloribus perelegans. Buon. Cl. 3 n. 296.
Grooved Murex tuberosus, very fine and variously coloured. Buonanni 1684, class 3 no. 296.

29 Murex tuberosus \sulcatus/ ex albo russo et cinerea versicolor.
Grooved Murex tuberosus, coloured white, red and ash-grey.

30 Murex tuberosus sulcatus ex albo et subbuteo variegatus.[4]
A grooved Murex tuberosus, striped in white and a yellowish colour.

31 Murex tuberosus sulcatus versicolor, per longitudinē canaliculatus, [-tuberculis] maculis nigris

[1] [f.16v] [-unus deest]

[2] [f.16v] [-unus deest]

[3] [f.17v] Musick Shells

[4] [f.17v] [-30 deest]

interstinctus.
Grooved Murex tuberosus of various colours, with little channels along the length, and marked with black spots.

32 Murex tuberosus sulcatus cinereus ex russo fasciatus et maculatus; tuberculis minimis.
Grooved Murex tuberosus, ash-grey banded and marked in red; with a few tubercles.

33 Murex tuberosus sulcatus ex fusco et cinerea variegatus. \(-)/
Grooved Murex tuberosus, striped in a dark grey and ash-grey.

34 Murex sulcatus lævis s. non tuberosus ex albo, fusco, cinereo, &c variegatus. Buon. Cl. 3 n. 298.
Grooved Murex, smooth or rather without tubercles, striped in white, dark grey, ash-grey etc. Buonanni 1684, class 3 no. 298.

Murex fimbriatus
Murex fimbriatus

N.B. go to page ye 37th

[-35 Murex fimbriatus pallidus fascia unica crenata.][5]
Pale-coloured Murex fimbriatus, with a single crenulate band.

[-36 Murex fimbriatus cinereus spiris crenatis.]
Ash-grey Murex fimbriatus, with crenulate coils.

[-37 Murex fimbriatus crassiusculus eburneus, maculis russis nota fasciâ tuberosâ.]
Ivory-coloured Murex fimbriatus, fairly thick-walled, marked with red spots and a band of tubercles.

[-38 Murex utrinque fimbriatus candidus 2[abus] fasciis tuberosis.]
Bright white Murex fimbriatus, fringed on both sides, with two bands covered with tubercles.

[-39 Murex fimbriatus nitidus, ex pallide rufescens lævis.]
Polished Murex fimbriatus, smooth and pale-coloured shading to red.

[19r]

C. 2.[um] [-] De Murice fimbriato[6]
Second drawer: Murex fimbriatus

Murex fimbriatus tuberos. S. fimbr. major
Fringed Murex tuberosus or larger Murex fimbriatus

1 Murex fimbriatus omnium maximus pentadactylites, valvulâ adinstar tegulæ planâ et latissimâ.[7]
Murex fimbriatus, one of the largest, five-fingered, and broad and smooth like a roof-tile.

2 Murex fimbriatus tuberosus, admodum crassus colore rubro purpureo, adinstar conchæ Veneris rim...us \\[-deest]//
Fringed Murex tuberosus, very thick-walled, coloured reddish-purple, and grooved like a Venus Conch.

3 Murex fimbriatus tuberosus superficies reticulatâ.[8]
Fringed Murex tuberosus, the surface reticulated.

4 Mur. fimbr. tuberosus ferè triangularis.
Fringed Murex tuberosus, almost triangular in shape.

5 Murex fimbriatus tuberculis minorib. præditus, laminatus ad oras maximè rugosus.
Murex fimbriatus, with quite small tubercles, laminated and very rough at the edges.

6 Mur. fimb. cinereus tuberculis minimis at creberrimis albis et russis cinctus. \\[-2] (2)//**
Ash-grey Murex fimbriatus, covered with tiny tubercles and banded repeatedly in white and red.

Murex fimbriatus lævis s. fimbr. Minor
Smooth Murex fimbriatus or smaller fringed Murex

7 Mur. utrinque fimbriatus lævis valvulis angustis. \\[-]// \\deest//
Smooth Murex fimbriatus, fringed on both sides, with narrow little folds.

8 Murex ex alterâ parte solummodo fimbriatus lævi valvulis angustis. Buon. Cl. 3 R 162. \\[-2] [-2]//[9]**
Murex, fringed on only one side which is smooth, with narrow folds. Buonanni 1684, class 3 no. 162.

8B Murex ex alterâ parte fimbriatus minus speciosus. \\(2)// \\8.B.2//
Murex, fringed on one side, less fine.

9 Murex fimbriatus lævis auriculatus; minus fasciatus colo. subcin. [-] \\[-cl] D// \\[-]//
Smooth, fringed Murex, ear-shaped, greyish in colour and with fewer bands.

10 Mur. fimbr. lævis auriculatus, coloris subalbidi, fasciis luteis maculatis cinctus.
Smooth Murex fimbriatus, ear-shaped, off-white in colour, encircled with bands of yellow marks.

11 Mur. fimbriatus lævis auriculatus transversè sulcatus, subalbidus. Buon. Cl. 3 N. 160
Smooth Murex fimbriatus, ear-shaped, grooved cross-wise and off-white in colour.

12 Murex ex albo et russo varius [-\muricis] fimbriati mucron... cæterum cochleam turbinatam referens. Ad cochleam turbinatam transferri potest.
Murex, striped in white and red, with a fringed spire; the remainder resembles a Cochlea turbinata It could be transferred to the Cochlea turbinate.

Mur. fimbriatus minor lucidus
Smaller, shiny Murex fimbriatus

13 Mur. fimbriat. pallidus spirarū ultimâ crenatâ.[10]
Murex fimbriatus, pale in colour, the last coil crenulate.

14 Mur. fimbr. cinereus spira ultima crenatâ.
Ash-grey Murex fimbriatus, the last coil crenulate.

15 Mur. fimbriatus crassiusculis eburneus, maculis russis notatum, spirâ ultimâ crenatâ.
Murex fimbriatus, quite thick-walled and ivory-coloured, marked with red spots, the last coil crenulate.

[5] [f.17v] [-Ad trochos-fimbriatos...] \\[-]//
[Transferred] to the Trochi fimbriati.
[6] [f.18v] Capsula 4ta
[7] [f.18v] On y[e] top of y[e] Cabinet.
[8] [f.18v] 3 D

[9] [f.18v] d [-unus deest]
[10] [f.19v] 13. Murex Cylindroides alatus albidus [-deest] 1754
Cylindrical Murex, winged and white. Missing, 1754,

16 Mur. utrinque fimbriatus candidus duab. spiris tuberosis.
Bright white Murex, fringed on both sides, with two coils covered in tubercles.

17 Murex fimbr. longiusculus tenuis, ex pallido rufescens. \\d//
Murex fimbriatus, delicate and quite long, pale-coloured shading to red.

18 Murex fimbriatus pyramidalis lævis, e minoribus. \\(2)//[1]
Murex fimbriatus, cone-shaped and smooth, one of the smaller specimens.

Turn to p. 35

[20r]

Cap. 3.um De Murice lævi s. nō tuberoso
Third drawer: smooth Murex or Murex without tubercles

Murex lævis ventricosus
Smooth Murex ventricosus

1 Murex lævis ventricosus è maximus ex albo lutescens. Buon. Cl. 3. N. 147. [-(5)] [-(5)] [-]²
Smooth Murex ventricosus, one of the largest specimens, white shading to yellow; Buonanni 1684, class 3 no. 147.

2 Murex lævis ventricosus ex albo et russo elegantissimè striatus. \\(2)//
Smooth Murex ventricosus, most elegantly grooved in white and red.

3 Murex lævis ventricosus ex pallido lutescens, [-strijs/fascijs] minimis creberrimis cinctus. \\deest//
Smooth Murex ventricosus, pale-coloured shading to yellow, repeatedly bound with tiny bands.

4 Murex lævis ventricosus tenuis albidus, maculis russis notatus, mucrone [-quadrangulo\triqetro].
Smooth Murex ventricosus, white and delicate, marked with red spots, and with a triangular point.

5 Murex lævis ventricosus, tenuis, exiguus, albidus. \\[-]//
Smooth Murex ventricosus, delicate, small and white.

6 Murex lævis ventricosus, tenuis, exiguus, colore albo, fasciis atrorubentibus. \\(2)//
Smooth Murex ventricosus, small, delicate and white in colour, with dark red bands.

Murex lævis angustior
Smooth Murex, narrower

7 Murex lævis angustior albidus vel ex albo rufescens, spirâ ultimâ latissimâ. Buon. Cl. 3. N. 150 [-6]
Smooth, narrower Murex, white or white shading to red, the last coil very wide. Buonanni 1684, class 3 no. 150.

8 Murex lævis angustior ex albido rufescens involucris crenatis S. aliquantenùs tuberosis. \\[-2] (2)//
Smooth, narrower Murex, white shading to red; the outer covering crenulate, or covered with a few tubercles.

9 Murex lævis angustior, pallidus, spiris rubris. \\[-D]//
Smooth, narrower Murex, pale in colour with red coils.

10 Murex buccinites, nonnihil tuberosus, [-colore cinereo] fimbriatus ferè, colore pallido rubris maculis interstincto.
Murex buccinites, with some tubercles, almost fringed, pale-coloured and marked with red spots.

11 Murex buccinites nonnihil tuberosus colore cinereo, ad ora... et extremum nigricanti. \\[-][-4][-]//
Murex buccinites, with some tubercles, ash-grey in colour, shading to black at the edge and the tip.

12 Murex lævis angustior eburneus quibusd. maculis rubris insignitus mucrone obtuso \\[-deest]//
Smooth, narrower Murex, ivory-coloured, marked with red spots and with a blunt point.

13 Murex cylindraceus ferè involucris crenatis \\[-deest]//
Murex, almost cylindrical in shape, the outer covering crenulate.

14 Murex cylindraceus involucris crenatis. \\[-(3)](4)//
Cylindrical Murex, the outer covering crenulate.

N.B. Turn to page the 73d.

[21r blank; 22r]

Cap. 4um De Murice rhomboide[1]
Fourth drawer: Murex rhomboides

Murex Rhomb. fasciatus
Banded Murex rhomboides

1 Murex rhomboides admodum crassus, fasciis albis angustioribus cinctus.
Murex rhomboides, very thick-walled, bound with quite narrow white bands.

Murex rhomb. sulcatus
Grooved Murex rhomboides

2 Murex rhomboides latè sulcatus, versus mucronem aculeatus, colore ex albo et atrorubenti pulcherrimo.
Murex rhomboides, with wide grooves, sharpening towards the point, beautifully coloured in white and dark red.

3 Murex rhomboides sulcatus versus mucronem aculeatus, ex albo, fusco, &c. versicolor.
Grooved Murex rhomboides, sharpening towards the point, coloured white, dark grey, etc.

4 Murex rhomboides sulcatus, versus mucronem aculeatus [-color.. Nigro, fusco, et cinereo variegatus] ex nigro, rubro, albido &c. elegantissimus. \\[-deest]//
Grooved Murex rhomboides, sharpening towards the point, most elegantly coloured in black, red, white etc.

5 Murex rhomboides sulcatus, versus mucronem aculeatus, ex nigro, fusco, et cinereo versicolor.
Grooved Murex rhomboides, sharpening towards the point, coloured black, dark grey and ash-grey.

[1][f.18v] [-18 deest.]
[2][f.19v] [-duo desunt et unus deest.]

[1][f.21v] This drawer does not ans[wer]. to the cat[alogue]

6 Murex rhomboides, fimbrijs angustioribus præditus, ex albo et fusco varius. \\[-(...)]//
Murex rhomboides, with quite narrow fringes, coloured white and dark grey.

7 Murex rhomboides fimbriis angustioribus, versicolor, ad mucronem lævis. \\2//
Murex rhomboides, with quite narrow fringes, of various colours, smooth at the point.

8 Murex rhomboid. sulcatus minor, ex russo, cinereo, &c. versicolor. \\[-]//
Smaller, grooved Murex rhomboides, coloured red, ash-grey, etc.

9 Murex rhomboides sulcatus minor colore fusco. Turbine Indiano &c. Buon. Cl. 3. N. 65. \\14//[1]
Smaller, grooved Murex rhomboides, dark grey in colour. The Turbo Indianus etc. of Buonanni 1684, class 3 no. 65.

[23r]

Cap. 5.ᵘᵐ De Murice cochleato
Fifth cabinet: Murex cochleatus

1 Murex cochleatus tuberosus fuscus. \\(3)//
Murex cochleatus, dark grey and covered with tubercles.

2 Murex cochleatus tuberosus subcinereus, fasciâ unicâ vel alterâ albâ.
Greyish Murex cochleatus, covered with tubercles, with one or two white bands.

3 Murex cochleatus tuberosus subalbidus, mucrone rufescenti.[2]
Off-white Murex cochleatus, covered with tubercles, the point shading to red.

4 Murex cochleatus tuberculis lævibus, rufescens.
Murex cochleatus, covered with smooth tubercles, shading to red.

5 Murex cochleatus tuberculis lævibus, rufescens.
Murex cochleatus, covered with smooth tubercles, shading to red.

6 Concha umbricata ex insula Lomboc. d.d. dom. Rawes e Chedworth [-] in comitatu Gloces.
Concha imbricata from the island of Lombok, given by Mr Rawes of Chedworth.

[24r]

Membrum 3.ᵘᵐ Turbo, Strombus, Trochus
Third Part: Turbo, Strombus, Trochus

Cap. 2.ᵘᵐDe Turbine
Second drawer: Turbo

Turbo lævis
Smooth Turbo

1 Strombus p. 47. No.1.2.

[-2] [3]

3 Turbo niger è maximis creberrime fasciatus.
Black turbo, one of the largest examples, heavily banded.

4 Turbo profundè Trochleatus, fasciatis involucris ex albo et fusco versicolor. Buon. Cl.3.n.34. \\[-deest]//
Turbo, with deep flutings, and a banded periostracum; coloured white and dark grey. Buonanni 1684, class 3 no. 34.

5 Turbo trochleis profundioribus fasciatis albus maj. Buon. Cl. 3. n.[-34\23].

Larger, white Turbo, with rather deeply banded flutings. Buonanni 1684, class 3 no. 23.

6 Turbo trochleis profundioribus fasciatis, albus minor.
Smaller, white Turbo, with rather deeply banded flutings.

7 Buccinum tenue densè striatum 12 minimum spiris donatum. Listeri 161.
Delicate Buccinum, thickly covered with striations, and with at least twelve coils. Lister 1678, p. 161.

8 Turbo eburneus trochleis profundioribus lævis.
Smooth, ivory-coloured Turbo, with fairly deep flutings.

9 Turbo ex albo lutescens, trochleis profund. lævis \\([-])//
Smooth Turbo, white shading to yellow, with fairly deep flutings.

10 Turbo cinereus trochleis parum eminentibus. \\([-])//
Ash-grey Turbo, with slightly prominent flutings.

11 Turbo ex albo et russo varius trochleis parū eminentibus.
Turbo, striped white and red, with slightly prominent flutings.

12 Turbo ex albo et atrorubenti varius, trochleis fasciatis parum eminentibus.
Turbo, striped white and dark red, with slightly prominent banded flutings.

13 Turbo ex albo et atrorubenti variegatis involucris /lævibus\.
Turbo, with a smooth periostracum striped white and dark red.

14 Turbo albidus exiguus involucris russis leviter crenatis. \\[-D] d//
Small, white turbo ,with a red periostracum, slightly crenulate.

15 Turbo exiguus atrorubens.\\[-D] d//
Small Turbo, shading to dark red.

16 Turbo albus involucris vix conspicuis atrorubentibus. \\[-d]//
White Turbo with a dark red periostracum, which is scarcely visible.

17 Turbo albus involucris crenatis, parum eminentibus.
White Turbo, with a slightly prominent, crenulate periostracum.

18 Turbo pallidus ventricosior involucris crenatis. Buon. Cl.3.n.84. \\[-2]//
Pale-coloured Turbo, quite swollen, with a crenulate periostracum. Buonanni 1684, class 3 no. 84.

19 Turbo albus densè trochleatus maculis crebris atrorubentibus stipatus. Buon. Cl.3 n.107. \\[-deest]//
White turbo, densely marked by flutings, with numerous dark red spots. Buonanni 1684, class 3 no. 107.

[1] [f.21v] Turn to page 31
[2] [f.23v] Quere de 3°
[3] [f.23v] deest 2

20 Turbo luteus è maximus utrinque macronatus, [-operculo\aperturâ] dentatâ. Buon. Cl. N.121.[1]
Yellow Turbo, one of the largest examples, pointed at both ends, with a toothed aperture. Buonanni 1684, class 3 no. 121.

[25r]

A [-è D. D. Cl. Plot][2]
21 [-] Turbo è maximis, ex albo et atrorubenti versicolor involucris parûm eminentibus. Buon. Cl.3.n.317. \\2//
Turbo, one of the largest examples, coloured white and dark red, with a slightly prominent periostracum. Buonanni 1684, class 3 no. 317.

22 [-][3]

Turbo asper
Rough Turbo

23 Turbo fuscus crassiusculus, clavis nigerrimis fasciatim dispositis insignitus. \\D//
Dark Turbo, quite thick-walled, marked with very black knobs, arranged in bands.

24 Turbo albidus ex russo maculatus, fasciis bullatis /creberrimus donatus\. \\[-d]//
White turbo, with red marks, and with numerous studded bands.

25 Turbo ex cinereo rufescens, fasciis crebris bullatis. \\[-2]//
Turbo, ash-grey shading to red, with numerous studded bands.

26 Turbo albidus clav/ell\atus et canaliculatus. Buon. Cl.3.n.108. \\[-d]//
White turbo, covered with little knobs and channels. Buonanni 1684, class 3 no. 108.

27 Turbo albus exiguus involucris profundioribus, per longitudinem alatus.
Small, white Turbo, with a rather deep periostracum, winged along its length.

28 Turbo albus cylindraceus striatus, operculo ferè lunato Buon.Cl.3 n.140.
White, cylindrical, striated Turbo, with an almost moon-shaped operculum. Buonanni 1684, class 3 no. 140.

29 Turbo subalbidus, in volucris echinatis. \\[-2]//
Off-white Turbo with a spiny periostracum.

30 Turbo cinereus tuberosus. \\D deest.//
Ash-grey Turbo with tubercles.

31 Turbo ex fusco albicans involucris bullatis rufescentib. \\deest//
Turbo, dark-coloured shading to white, with a reddish studded periostracum.

32 Turbo clav/ell\atus, ex albo nigro et atrorubenti versicolor.
Turbo covered with little knobs, coloured white, black and dark red.

33 Turbo cinereus tuberculis majoribus insignitus. \\2//
Ash-grey Turbo, marked with largish tubercles.

34 Turbo ex fusco nigricans, crebris striis et fasciis. Crenatis insignitus. Buon. Cl.3 n.68
Turbo, dark shading to black, with numerous striations and crenulate bands. Buonanni 1684, class 3 no. 68.

35 Turbo buccinites, ex pallido rufescens, elegantissime /striatus\ \\D deest//
Turbo buccinites, pale-coloured shading to red, very elegantly striated.

Turbo ventricosius longus
Long, swollen Turbo

36 Turbo ventricosus longus subtenuis, lævis, colore albo. Buon. Cl. 3 n. ii6. \\[-deest]//
Long Turbo, swollen and quite delicate, white in colour. Buonanni 1684, class 3 no. 116.

37 Turbo ventricosus longus involucris echinatis niger. \\[-deest]//
Long, swollen, black Turbo, with a spiny periostracum.

Brevis
Short Turbo

38 Turbo ventricosus brevis, fasciis rubris, nigris et aliorum colorū perelegans. Buon. Cl.3. N.66
Short, swollen Turbo, most elegantly marked with bands in red, black and other colours. Buonanni 1684, class 3 no. 66.

39 Turbo ventricosus brevis, eburneus, cum fasciis luteis et viridibus.
Short, swollen Turbo, ivory-coloured with yellow and green bands.

40 Turbo ventricosus brevis [-] albus ex russo fasciatus.
Short, swollen Turbo, white with red bands.

[26r, 27r blank; 28r]

Cap. 2ᵘᵐ. De Strombo
Second drawer: Strombus

1 Strombus atrorubens creberrimè fasciatus lævis. Strombo lungo &c. Buon. Cl.3. n.52
Smooth, dark red Strombus, repeatedly banded. The Strombo lungo etc. of Buonanni 1684, class 3 no. 52.

2 Strombus niger echinophorus. \\deest//
Black Strombus, covered with spines.

[-numerus] primus deest. secund.adest.
The first is missing, the second in place.

C. 3ᵘᵐ. De Trocho & verticello
Third drawer: Trochus and Verticillus

Trochus mucronatus
Pointed Trochus

1 Trochus maximus argenteus lævis. \\{ [-In scrinio primo, Nautilorū capsulâ//][4]
Very large Trochus, silver and crenulate.

[1][f.24v] [-19] 20 deest. \\[-deest]//
[2] A. Corona Papale /da\ Francesci e Olandesi. Buon. Class 3a. n. 119 [-donavit]
The 'Papal crown' of the French and Dutch. Buonanni 1684, class 3 no.119.
[3][f.24v] [-D. D. ...] A° 86. Turbo apertura sulcata et canaliculata crenatis spiris, coloris ex albo et rubro eleganter variegati. [-d] D. Ex dono Dñi. Guilielmi Charleton e Med. Temp. Lond. 1686. Turbo with grooved and channelled aperture and crenulate coils, elegantly striped white and red. Given by William Charleton of Middle Temple, London.
[4][f.27v] On the top of the cabinet.

2 Trochus argenteus minor crenatus. \\(2)//
Smaller Trochus, silver and crenulate.

3 Trochus ex albo et atrorubenti versicolor, scaber, mucronatus. Buon. Cl. 3. n.102. \\itẽ in scrinio primo.//
Scabrous, pointed Trochus, coloured white and dark red. Buonanni 1684, class 3 no.102. Also in the first cabinet.

4 Trochus ex albo et rubro versicolor fasciis crebris asperis.
Trochus coloured white and red, with numerous rough bands.

5 Trochus subalbidus valdè tuberosus, subtus asper. Strombo tuberoso. Buon. Cl.3 n.90.
Off-white Trochus with numerous tubercles, the underside rough. Strombus tuberosus of Buonanni 1684, class 3 no. 90.

6 Trochus argenteus valdè tuberosus, subtus lævis et circularis.
Silver Trochus with numerous tubercles, the underside smooth and circular.

7 Trochus tuberosus ex albo et rubro versicolor, mucrone /argenteo\.
Trochus with tubercles, coloured white and red, with a silver spire.

8 Trochus tuberosus subalbidus, luteis [-] maculis conspersus.
Off-white Trochus with tubercles, spattered with yellow spots.

[-9 Trochus tuberosus ex albo et viridi versicolor.] \\[-deest]//
Trochus with tubercles, coloured white and green.

10 Trochus exiguus tuberosus albidus involucris viridibus.
Small, white Trochus with tubercles, with green periostracum.

11 [-Trochus fuscus mucrone alba, ad marginem dentatus.] \\[-deest]//
Dark-coloured Trochus, with white spire, toothed at the edge.

12 Trochus albidus maculis rubentibus distinctus, 6 minimum /spirarum\ ...ist n.166 [page trimmed]
White Trochus, marked with reddish spots, with at least six coils. Lister 1678, p. 166.

13 ...itarium vergente.[5]

[29r]

Trochus compressus s. verticillus
Compressed or whorled Trochus

14 Verticillus asper margine dentato. Strombo umbilicato Buon. Cl.3. n.69.
Rough Verticillus with a toothed edge. The Strombus umbilicatus of Buonanni 1684, class 3 no. 69.

15 Verticillus exiguus tuberosus.
Small Verticillus, covered with tubercles.

16 Verticillus albus concavus, ex rubro elegantissimè fasciatus. Buon. Cl.3. N. 27.
Concave, white Verticillus, elegantly banded in red. Buonanni 1684, class 3 no. 27.

17 Verticillus albus utrinque tumidus, terebratus.

White Verticillus, swollen at each end, and perforated.

18 Verticillus exiguus crebrò fasciatus, involucris crenatis.
Small Verticillus, repeatedly banded, with a crenulate periostracum.

19 Verticillus exiguus pellucidus, coloris fusci, striis albis minimis at creberrimis insignitus.
Small, transparent Verticillus, dark in colour, marked repeatedly with tiny white striations.

[30r]
Sectio II
Second section

De Cochleatis
Cochlea

Membrum 2^um. Cochlea rugosa, Ostracopoterion, Cochlea simpliciter dicta, Cochlea umblicata, et Nerita
Second part: wrinkled Cochlea; Ostracopoterion, commonly called Cochlea; Cochlea umbilicata, and Nerita

C. 2^um. De Cochlea rugosâ
Second drawer: wrinkled Cochlea

1 Cochlea rugosa maxima, subtenuis, cinerea. Cochlea rugosa Jonst. T.10. fig. 9. An Cochlea rugosa et umbilicata Rond. p. 206? Cochlea rugosa et Umblicata Mosch. p. 216 Buõ. Cl. 3. /n. 26\
Wrinkled Cochlea, very large and quite delicate, ash-grey in colour. The Cochlea rugosa of Jonston 1650a, tab. 10 fig. 9; Could it be the Cochlea rugosa et umbilicata of Rondelet 1555, p. 106? The Cochlea rugosa et umbilicata of Moscardo 1672, p. 216; Buonanni 1684, class 3 no. 26.

[-\2] Cochlea rugosa maxima rugis [-] ex luteo et russo versicoloribus. \\[-deest]// \\Fr.//
Very large, wrinkled Cochlea, striped yellow and red. Broken.

[-2\3] Cochlea rugosa maxima, crassior, colore fusco. \\Fr.//
Very large, wrinkled Cochlea, thick-walled and dark-coloured. Broken.

4 Cochlea rugosa è minoribus [-] rugis versicoloribus et simplicibus alternè positis. Buon. Cl.3. n.17. \\D//[6]
Wrinkled Cochlea, one of the smaller examples, with plain and multicoloured wrinkles arranged alternately. Buonanni 1684, class 3 no.17.

5 Cochlea rugosa ex albo et fusco varia, rugis latioribus minùsque eminentibus.
Wrinkled Cochlea, striped white and dark, with broad and less prominent wrinkles.

6 Cochlea rugosa ex albo et fusco varia, rugis crebris angustioribus prædita, figurâ productiori.[7]
Wrinkled Cochlea, striped white and dark, marked with numerous rather narrow wrinkles, with quite an elongated form.

7 Cochlea rugosa minima crebrò admodũ fasciata ex albo et fusco varia. \\D//[8]
Tiny, wrinkled Cochlea, with numerous bands in white and dark.

[5][**f.27v**] 13. Trochus exiguus colore ad margaritarium vergente.
 13 Small Trochus, green shading to a pearly colour.

[6][f.29v] 4 deest.
[7][**f.29v**][-desunt] (bracketed with 7, 8, 9)
[8][f.29v] [-deest] 1751

8 Cochlea rugosa, crassissima, buccinites, colore obsoleto.
Wrinkled Cochlea buccinites, very thick-walled, the colour pale.

9 Cochlea rugosa buccinites e viridi, nigro, albidóque versicolor.[9]
Wrinkled Cochlea buccinites, striped green, black and white.

Turn to p. 55

[31r blank; 32r]

C. 2^um. De ostracopoterio et cochleâ simpliciter dictâ
Second cabinet: Ostracopoterion and common Cochlea

1 Ostracopoterion maximum viride cum striis tuberosis.[10]
Very large, green Ostracopoterion, with striations which are covered with tubercles.

2 Ostracopoterion maximum argenteum, involucris viridibus \\-deest]//
Very large, silver Ostracopoterion, with a green periostracum.

3 Ostracopoterion minus argenteum involucris viridibus.
Smaller, silver Ostracopoterion, with a green periostracum.

4 Id.^m Ostrac. argenteum varii generis picturis /deauratis\ apud Indos delineatum. \\fract:1764//
Similar silver Ostracopoterion, decorated by the Indians with gilded pictures of a various kinds. Broken in 1764.

5 Ostrac. arg. minus involucris rufescentibus. \\deest.//
Smaller, silver Ostracopoterion, with a periostracum shading to red.

6 Ostracopot. atrorubens tuberosum. \\deest.//
Dark red Ostracopoterion, with tubercles.

7 Ostracopoterion viride fasciis ex albo et fusco /versicoloribus\.
Green Ostracopoterion, with alternate bands of white and dark.

8 Ostracopoterion ex albo viridi et atro[-rubenti] versicolor tuberosum. \\D [-d 2]//[11]
Ostracopoterion, with tubercles, coloured white, green and black.

Cochlea
Cochlea

9 Cochlea exigua ex nigro et [-viridi] maculata mucrone arg/enteo\.
Small Cochlea, with black and green marks, and a silver spire.

10 Cochlea exigua ex albo et nigro versicolor, mucrone argenteo.
Small Cochlea, coloured white and black, with a silver spire.

11 [-Cochlea ex viridi, alba, et nigra versicolor valde rugosa][12]
Cochlea, very wrinkled, and striped in green, white and black.

12 Cochlea viridis rugosa, involucris ex albo nigróque variis, neritæ operculo lunato.
Green, wrinkled Cochlea, with a white and black periostracum, and with the moon-shaped operculum of a Nerita.

13 Cochlea crenata argentea. \\4//
Silver, crenulate Cochlea.

14 Cochlea crenata viridis mucrone argenteo.
Green, crenulate Cochlea, with a silver spire.

15 Cochlea fusca tuberosa et aspera.
Dark-coloured Cochlea, rough and covered with tubercles.

16 Cochlea rufescens tuberosa, umbilico compresso.[13]
Reddish Cochlea with tubercles, and a compressed umbilicus.

17 Cochlea aspera mucrone productiori.[14]
Wrinkled Cochlea, with an elongated spire.

18 Cochlea lævis, involucris minùs eminentibus, ex albo nigróque varia[15]
Smooth Cochlea, with a less prominent periostracum, striped in white and black.

19 Cochlea fusca fasciis crebris angustisque prædita List.
Dark Cochlea, with numerous narrow bands. See Lister.

20 Cochlea cinerea operculo lunato oblongo. An Nerites Bellon?
Ash-grey Cochlea with an elongated, moon-shaped operculum. Could it be the Nerites of Bellon?

[33r]

[-21 Cochlea rubescens, striis] fuscis prædita, ad umbilicum argentea. \\deest//
Reddish Cochlea with dark striations, silver at the umbilicus.

22 Cochlea lutea ex nigro striata.
Yellow Cochlea, with black striations.

23 Cochlea alba ex nigro striata.
White Cochlea, with black striations.

24 Cochlea coloris subluteis unicâ striâ albâ et fasciâ nigrâ insignis. \\[-d] D//
Cochlea, yellowish in colour, distinguished by a single white striation and a black band.

[9][f.29v] [-deest]
[10][f.31v] Removed the glass case [-opposite\ upstairs]. (1,2,3 bracketed)
[11][f.31v] Most of these wanting (nos. 1-8)

[12][f.31v] Ad Cochleâ rugosam transtulimus, numb. 9.
We have transferred this to the wrinkled Cochlea, no. 9.
[13][f.31v] 16 Cochlea minima subalbidens trium spirarum.
Tiny, off-white Cochlea, with three coils.
[14][f.31v] 17 Cochlea subfusca creberrime striata 4^or spirarum.
Dark Cochlea, repeatedly striated, with four coils.
[15][f.31v] 18 Cochlea albida sex spir: ad mucronem Rufescens.
18. White Cochlea, with six coils, shading red towards the spire.

25 Cochlea russa unicâ striâ albâ et fasciâ nigrâ insignis.
Red Cochlea, distinguished by a single white striation and a black band.

26 Cochlea pallida rotundiuscula, ex pullo striata.
Pale-coloured Cochlea, slightly rounded, with dark grey striations.

Turn to p. 59

[34r]

Cap. 3.ᵘᵐ De cochleâ umbilicatâ, s. auriculata
Third drawer: Cochlea umbilicata or Cochlea auriculata

1 Cochlea umbilicata è maximis aspera, foraminosa.
Rough Cochlea umbilicata, one of the largest examples, and perforated.

2 Cochlea umbilicata ex albo et atrorubenti versicolor.
Cochlea umbilicata, coloured white and dark red.

3 Cochlea umbilicata scabra ex nigro et margaritario versicolor. \\[-2]//
Scabrous Cochlea umbilicata, black and pearl-coloured.

4 Cochlea umbilicata lævis ex nigro et argenteo versicolor. Cochlea umbilicata Buon. Cl.3.n.29 et 30. \\D 1766//
Smooth Cochlea umbilicata, coloured black and silver; the Cochlea umbilicata of Buonanni 1684, class 3 nos. 29-30. Missing 1766.

5 Cochlea umbilicata versicolor ex nigro, cinereo et subviridi superficie inæquali. \\2//
Cochlea umbilicata, coloured black, ash-grey and greenish, with an uneven surface.

6 Cochlea umbilicata ex toto ferè argentea s. margaritaria cum fasciis ex nigro aut viridi versicoloribus. \\[-] 2//
Cochlea umbilicata, a silver or rather pearl-colour all over, with bands in black or green.

7 Cochlea umbilicata ex albo et russo varia, fasciis crenatis. \\([-])//
Cochlea umbilicata, striped in white and red, with crenulate bands.

8 Cochlea umbilicata ex nigro et subviridi varia, mucrone argenteo. \\[-D] deest//
Cochlea umbilicata, with black and greenish stripes, and a silver point.

9 Cochlea umbilicata [-herbacea\colore herbido], valdè rugosa.
Cochlea umbilicata, the colour of grass, and very wrinkled.

10 Cochlea umbilicata ex rubro, fusco et subluteo varia, fasciis crenatis. \\2//
Cochlea umbilicata, with red, dark grey and yellowish stripes, and crenulate bands.

11 Cochlea umbilicata ex russo et subluteo insigniter fasciata. \\[-deest\deest]//
Cochlea umbilicata, strongly banded in red and a yellowish colour.

[-11\12] Cochlea umbilicata sublutea fasciis crenatis.
Yellowish Cochlea umbilicata, with crenulate bands.

[-12\13] Cochlea umbil. è minimis fusca, valdè [-compressa\rugosa] umbilico compresso. \\deest//
Dark Cochlea umbilicata, one of the smalles examplest, very wrinkled, with a compressed umbilicus.

[-13\14] Cochlea umbil. ex albo et coccineo varia, mucrone argenteo, fasciis crenatis. \\deest//
Cochlea umbilicata, striped in white and scarlet, with a silver spiret and crenulate bands.

[35r]

[-15\14] Cochlea umbilicata ex albo et russo striata mucrone argenteo compresso.
Cochlea umbilicata, with white and red striations and a compressed silver spire.

[-16\15] Cochlea umbilicata fusca /aut rufescens\ ex luteo fasciata, involucris profundioribus.
Dark-coloured or reddish Cochlea umbilicata, with yellow bands, and a rather deep periostracum.

Cochlea umbil. turbinata
Top-shaped Cochlea umbilicata

[-17\16] [-Cochlea umbilicata /et\ turbinata, cinerea, involucris alatis.]¹
Ash-grey, conical Cochlea umbilicata, with a winged periostracum.

[-18\17] Cochlea umbil. et turbinata rufescens. Buon. Cl. 3.n.43
Conical Cochlea umbilicata, shading to red. Buonanni 1684, class 3 no. 43.

[-19\18] Cochlea umbilicata et turbinata albida.
White, conical Cochlea umbilicata.

19 Cochlea terrestris mediá, tæniolâ albâ duas nigras trajiciente, insignis.\\deest//
Terrestrial Cochlea of medium size, with a little white band crossing over two black bands.

De Septem ultimis prorsus dubitamus.
We are utterly uncertain about the last seven.

[36r blank; 37r]

Cap. 4.ᵘᵐ De Neritâ
Fourth drawer: Nerita

Nerita umbilicat
Nerita umbilicatus

1 Nerita umbilicatus tuberosus argenteus. Chiocciola del mare Mediterraneo del... da Rond. Echinophora. Buon. Cl. 3.n. 18 Finger'd snayl M.R.S.T. ij.
Silver Nerita umbilicatus, with tubercles. The Mediterranean Chiocciola of Rondelet; the Echinophora of Buonanni 1684, class 3 no. 18; Grew 1681, [p.134].

2 Nerita umbilicatus tuberosus ruber. \\4//
Red Nerita umbilicatus, with tubercles.

3 Nerita umbilicatus ex albo et russo variegatus. \\(2)//
Nerita umbilicatus, striped in white and red.

4 Nerita /umbilicatus\ ex albo et fusco varius involucris cinereis. Cochlea rufescens, fasciis maculatis, maximè ad imos orbes distincta. List. p.163, Buon. Cl.3.n.225. Hujus iconem exhibuit Jonst. T.12. Sub titulo cochleæ operculi. \\(3)//
Nerita umbilicatus striped in white and a dusky colour, with an ash-grey covering. Cochlea shading to red, marked with

¹[f.34v] [-deest]

spotted bands especially at the lower whorls. Lister 1678, p. 163; Buonanni 1684, class 3 no. 225; an illustration of this is given in Jonston 1650a, tab. 12, under Cochleae operculi.

5 Nerita umbilicatus ex albo et luteo insigniter variegatus. \\(3)//
Nerita umbilicatus, with distinctive stripes in white and yellow.

6 Nerita umbilicatus albidus ex luteo maculatus, fasciis crenatis.
White Nerita umbilicatus, with yellow spots and crenulate bands.

7 Nerita umbilicatus albus fasciis crenatis.
White Nerita umbilicatus with crenulate bands.

8 Nerita umbilicatus compactilior, ex albo subcæru/leus\ maculis russis guttatus.
Nerita umbilicatus, more compact, white shading to a bluish colour, spattered with red spots.

9 Nerita umbilicatus cinereus maculis cæruleis fasciatus.
Ash-grey Nerita umbilicatus, with bands of blue spots.

10 Nerita umbilicatus ex fusco rufescens.
Nerita umbilicatus, dark-coloured shading to red.

11 Nerita umbilicatus compactilior, albidus, fuscis maculis interstinctus
White Nerita umbilicatus, more compact, with dark-coloured spots.

12 Nerita umbilicatus albidus ex fusco maculatus, superficie reticulatâ.
White Nerita umbilicatus, with dark-coloured spots, and a reticulated surface.

Nerita Vulg. Nerita maj. fasc.
Common Nerita. Larger, banded Nerita

13 Nerita major fasciatus ex albo et viridi versicolor. \\(4)/
Larger, banded Nerita, coloured white and green.

14 Nerita major fasciatus ex albo et nigro versicolor. \\(5)//
Larger banded Nerita, coloured white and black.

15 [-Nerita maj. fasc. dorso candido, cætera nigerrimus] \\deest//
Larger, banded Nerita, with a white dorsum, the rest very black.

16 Nerita maj. fasc. ex albo viridescens cum strijs rubris.
Large, banded Nerita, white shading to green, with red striations.

[38r]

17 Nerita maj. fasc. ex albo, viridi [-et subflavo\variegatus] striis luteis. \\(4)//
Larger, banded Nerita, striped white and green, with yellow striations.

Nerita major striatus s. rugosus
Larger Nerita, striated or wrinkled

18 Nerita maj. Striatus ex nigro lutescens.
Larger, striated Nerita, black shading to yellow.

19 Nerita maj. striatus ex albo, nigro et rubro versicolor. \\(2)//
Larger, striated Nerita, coloured white, black and red.

20 Nerita ex albo et cæruleo aut nigro, speciosè admodum striatus. Cochlea labrosa or yᵉ blobber lip. M.R.S.T. ij. Buon. Cl. 3 n. 220 \\(3)//
Nerita, heavily and quite beautifully striated, coloured white and blue or black. Grew 1681, [p.134]; Buonanni 1684, class 3 no. 220.

21 Nerita striatus albus lævis.
Striated Nerita, white and smooth.

22 Nerita Striatus albus, asper et crassiusculus.
White, striated Nerita, rough and quite thick-walled.

23 Nerita Striata albidus, valde crassus, mucrone prominenti.
White grooved Nerita, very thick-walled, with a prominent spire.

24 Nerita maximus undatus, creberrimè striatus, fusci coloris aperturâ cochleæ terrestris. \\[-d]//
Very large, undulated Nerita, heavily striated, with the dark-coloured aperture of a terrestrial Cochlea.

Nerita longus
Long Nerita

25 Nerita longus eburneus.
Ivory-coloured, long Nerita.

26 Nerita longus tenuissimus, ex albo et fusco varius.
Very delicate, long Nerita, striped in white and a dusky colour.

[-27A\27] Nerita longus purpureus denticulatus fasciis albis punctatis. \\(4)//
Purple, toothed, long Nerita, with bands of white spots.

Nerita min.
Smaller Nerita

28 Nerita minor ex fusco nigrans. \\[-\2]//
Smaller Nerita, dark-coloured shading to black.

29 Nerita minor ex fusco rufescens. \\[-\2]//
Smaller Nerita, dark-coloured shading to red.

30 Nerita minor rubicundus. \\([-22\17])//
Smaller, red Nerita.

31 Nerita ex toto flavescens modò pallidè modò intensè ad colorem mali aurantii maturi. List. p. 164. \\(12)//
Nerita, golden yellow all over but pale in some parts and intense in others, rather like a ripe golden apple in colour; Lister 1678, p. 164.

32 Nerita minor ocroleucus. \\([-25\19])//
Smaller Nerita, pale-coloured.

33 Nerita minor albus. \\(4)//
Smaller, white Nerita

34 Nerita minor versicolor. \\(2)//
Smaller, multi-coloured Nerita.

Ner. minimus
Very small Nerita

35 Nerita minimus ex albo et russo variegatus. \\10//
Very small Nerita, striped white and red.

36 Nerita minimus versicolor fasciis albis insignitus. \\8//
Very small, multicoloured Nerita, marked with white bands.

37 Nerita minimus ex nigro purpurascens, albis maculis exiguis et creberrimis conspersus. \\4//
Very small Nerita, black shading to purple, thickly speckled with small, white spots.

38 Nerita minimus ex fusco et cinereo varius. \\(2)//
Very small Nerita, striped in a dusky and ash-grey colour.

[39r]

39 Nerita fluviatilis è cæruleo viridescens, maculatus, operculo subrusso, lunato et aculeato donatus \\List. P. 136. [-fract] Deest.//
Riverine Nerita, blue shading to green, spotted and with a reddish operculum which is moon shaped and spiny; Lister 1678, p. 136.

Finis.[2]

[40r blank; 41r]

Membrum 2.ᵘᵐ S.2. Nautilus, Cochlea /compressa\
2ⁿᵈ Part. Second section: Nautilus, compressed Cochlea

Cap. 1 de Nautilio
First drawer: Nautilus

1 Nautilus ex albo et castaneo versicolor, intus argenteus. Nautilio Buon. Cl.2. n.2. Nautilus Jonst. T.10
Nautilus, striped in white and a chestnut colour, and silver inside. Buonanni 1684, class 2 no. 2; Jonston 1650a, tab. 10.

2 Nautilus argenteus varii generis picturis ab Indis confusè ad modum delineatus \\fract.//[3]
Silver Nautilus, decorated by the Indians with drawings of a different kinds, and in no order at all. Broken.

3 Nautilus albus è maximus. \\fract//
White Nautilus, one of the largest examples. Broken.

4 Nautilus argenteus [-cælatus] major.\\[-deest]//
Larger, silver Nautilus.

5 Nautilus idem variis iconobus apud Indos affabrè cælatus.[4]
Nautilus of the same kind, skillfully carved with various images by the Indians.

6 Nautilus argenteus minor sed fortassis ejusd. Speciei. An Cochlea margaretifera vulgo dicta Rond. p.97? Nautilus alter, cochlea margaritifera Bellonii Jonst.
Smaller, silver Nautilus, but perhaps of the same species. Could it be the Cochlea margaritifera, as it is commonly called, of Rondelet 1554, p. 97. The other Nautilus, the *Cochlea margaritifera* of Bellon; see Jonston [1650a, p. 41].

7 Nautilus tenuis echinatus et auriculatus ramosus, colore pallido. Nautilio dell' altra Specie &c. Buon. Cl.1.n.13. Testa nautili Jonst. T. 10. n.7. Nautilio Opolijpo Mosk. Spiked Sayler M.R.S. \\D//[5]
Delicate, spiny, ear-shaped and branching Nautilus, pale-coloured. Nautilus of different species etc., see Buonanni 1684, class 1 no. 13; the Nautilus shell of Jonston 1650a, tab.10 , no. 7; the Opolypo of Moscardo [1672, p. 198]; the Spiked Sayler of Grew 1681, p. 137.

N.B. turn to p.77

[42r]

C. 2.ᵘᵐ De cochlea compressâ
Second drawer: compressed Cochlea

1 Cochlea fusca, alterâ parte planior, et limbo insignita 4 spirarum. List. p.145
Dark Cochlea with one part flatter; marked with a border, and with four coils; Lister 1678, p. 145.

2 Cochlea pulla ex utraque circa umbilicum cava ejusd. p.143.
Dark grey Cochlea, hollow\concave at each end around the umbilicus; Lister 1678, p.143.

3 Cochlea exigua subfusca alterâ parte planior, fine limbo, 5 spirarum \\ejusd. P145//
Small Cochlea, darkish in colour, one part flatter, with a border at the edge and five coils ; Lister 1678, p. 145.

[43r]

Membr. 3. Auris marina
Third part: Sea-ears

1 Auris marina maxima margine æquali, sextarij capax.
Very large, Auris marina, with an uneven border, and capacious enough to hold a pint.

2 Auris marina media. \\(3)//
Auris marina of medium size.

3 Auris mar. eadem cum balanis gigantis Jonst. adnatis
Auris marina of the same kind as the huge native Balanus of Jonston [1650a, p. 49].

4 Auris marina minor s. Anglicana. Auris marina quibusd. λεπὰς αγεὶα Arist. Listeri. Auris marina Rond. Jonst. Aura marina Mosch. p.205. Orecchia marina Buon. Cl.1a. n.10 & 11.
Smaller Auris marina or English Sea-ear; to some, the lepas ageia and Auris marina of Aristotle and Lister [1678, pp. 167-8]; the Auris marina of Rondelet and Jonston; the Aura marina of Moscardo [1672, p. 205]; the Orecchia marina of Buonanni 1684, class 1, nos. 10-11.

5 Auris marina minima colore utrinque argenteo. \\[-deest]//
Very small Auris marina, coloured silver on both sides.

[44r]

Partis 1.ᵒʳⁱˢ Sect. III
First part, third section

De Anfractuosisi Obvolutis.
Spirally-twisted shells

Membrum 1.ᵘᵐ Concha Persica maj. Concha Persica terebrata
First class: larger Persian Concha , pierced Persian Concha

C.1.ᵘᵐ De Concha Pers. majori
First drawer: larger Persian Concha

1 Concha Persica alba omnium maxima et capacissima, umbilico introrsum propendenti, ad oras valdè rugoso.[6]

[2][**f.38v**] Turn to page 39.
[3][f.40v] [-deest]
[4][f.40v] 5 fract.
[5][f.40v] 7 fract.

[6][f.43v] On yᵉ top of yᵉ cabinet. Cap 6

White Persian Concha, the largest and most capacious of all, with an inverted umbilicus, very wrinkled at the mouth edges.

2A Concha Persica è minoribus alba, ad umbilicum tuberosa.
White Persian Concha, one of the smaller examples, with tubercles at the umbilicus.

2B Concha Persica /fusca\ umbilico aperto tenuior.
Dark Persian Concha, rather delicate, with an open umbilicus.

3 Concha Persica lutea umbilico aperto, crassior.
Yellow Persian Concha, with an open umbilicus, thicker-walled.

4 Concha Persica alba ad umbilicum magìs convoluta.
White Persian Concha, twisting more at the umbilicus.

5 Concha Pers. minor. Jonst. T.17. Buon. Cl.3 n.6.
Smaller Persian Concha; see Jonston 1650a, tab. 17; Buonanni 1684, class 3 no. 6.

6 Concha Persica minor valdè tenuis colore castaneo.
Smaller Persian Concha, very delicate and chestnut-coloured.

7 Concha Persica minor ex albo et castaneo versicolor, mucrone bifido.
Smaller Persian Concha, striped in white and a chestnut colour, with a cleft spire.

8 Concha Persica minim[-â\a] ex albo et castaneo varia, mucrone /integro\.
Very small Persian Concha, striped in white and a chestnut colour, with an intact spire.

9 Concha Persica longiuscula cymbam referens membranul[-am\â] fictili subluteâ obducta. Buon. Cl.3 n.2.
Persian Concha, quite long, rather like a cymba, and covered with a yellowish, clay-like membrane. Buonanni 1684, class 3 no. 2.

[-N.B. Turn to page yᵉ 95ᵗʰ\Turn to p.81].

[45r]

Cap. 2.ᵘᵐ De Concha Pers. terebratâ
Second drawer: perforated Persian Concha

10 Concha Pers terebrata maj. ferruginea. Buon. Cl.3, n.3. Dipping Snayl M.R.S. T.g.
Rust-coloured, perforated Persian Concha; see Buonanni 1684, class 3 no.3; the Dipping snail of Grew 1681, [p. 128].

11 Concha Persica terebrata ex albo et fusco varia.
Perforated Persian Concha, striped in white and a dusky colour.

12 Concha Pers. terebrata fusca
Dark-coloured, perforated Persian Concha.

13 Concha Pers. terebrata cinerea.
Ash-grey, perforated Persian Concha.

14 Concha Pers. terebr. albida. \\(8)//
White, perforated Persian Concha.

15 Concha Pers. terebrata ex albo [-cinerea\et russo variegata]. \\(4) [-15]//
Perforated Persian Concha, striped in white and red.

16 Concha Pers terebr. alba ad utranque extremitatem creberrimè fasciata.
White perforated Persian Concha, repeatedly banded at either end.

Turn to p.95ᵗʰ

[46r]

Membrum Secundum
[-2ⁿᵈᵃ] De Conchâ Veneris et Venereæ affini
Second class: Venus Conch and related Venus shells

N.B. Conchã Ven. post Cochleā Turbinatā collocari volumus.
N.B. We wish to place the Venus Conch after the conical Cochleae.

Concha Veneris
Venus Conch

1 Concha Veneris è maximis oblonga ex fusco rufescens, albis maculis guttata.
Elongated Venus Conch, one of the largest examples, dark-coloured shading to red, spattered with white spots.

2 Concha Venerea atrorubens, in dorso tribus 4vè fasciis candicantibus, et ad latera ejusd. coloris maculis insignita.
Dark red Venus Conch, marked on the dorsum with three or four white bands, and at the side with spots of the same colour.

3 Concha Veneris flavescens ex albo guttata, et fasciata ex fusco. Buon. Cl. 3. n. 263.
Venus Conch, shading to yellow and spattered with white, and with dark bands; Buonanni 1684, class 3 no. 263.

4 Concha Veneris oblonga atrorubens guttata.[7]
Elongated Venus Conch, spattered and shading to dark red.

5 Concha Veneris oblonga tota albicans.
Elongated Venus Conch, shading to white all over.

6 Concha Veneris oblonga candicans, dorso ex luteo striato, et duabus fascis albis notato.
Elongated, white Venus Conch, the dorsum marked with yellow striations and two white bands.

7 Concha Veneris é maximis rotundiuscula S. compactitior colore admodum vario. Concha Venerea Jonst. T.17. Concha Veneris S. Murex Mutiani Rond. p. 101. B. Cl. 3. n.232. \\[-2\1]//[8]
Venus Conch, one of the largest examples, quite rounded or compact, and very varied in colour. The Concha Venerea of Jonston 1650a, tab. 17; the Concha Veneris or Murex Mutiani of Rondelet 1554, p. 101; Buonanni 1684, class 3 no. 232.

8 Concha Veneris gibbosa, coloris in dorso varii; sed ad latera, anthracini. Buon. Cl.3 n.261. \\2//
Humped Venus Conch, with coloured stripes on the dorsum, but black striped at the side. Buonanni 1684, class 3 no. 232.

9 Concha Veneris gibbosa; coloris ad latera pulli, dorso ex albo et russo eleganter variegato; ad utramque etiam extremitatem albâ maculâ insignita. Buon. Cl. 3. N.258
Humped Venus Conch, striped beautifully in dark grey at the sides, and in white and red on the dorsum; also marked with

[7][f.45v] 4B Concha Veneris [-str] atrorubentibus in dorso strijs et ad latera maculis, [-insignita] eleganter variegata.
Venus Conch, elegantly marked with dark red striations on the dorsum and spots at the sides.
[8][f.45v] [-7B]

a white spot on both sides, at the very edge. Buonanni 1684, class 3 no. 258.

10 Concha Veneris minùs speciosa albicans.
Venus Conch, less beautiful, shading to white.

11 Concha Veneris minùs speciosa, sublutea.
Yellowish Venus Conch, less beautiful.

12 Concha Veneris è minoribus gibbosa, colore castaneo. \\(3)//
Humped Venus Conch, one of the smallest examples, chestnut in colour.

13 Concha Ven. è minorib. cinerea, fasciâ unicâ in medio dorso /coloris\ castanei.
Ash-grey Venus Conch, one of the smallest examples, with a single band at the centre of the dorsum, and chestnut in colour.

14 Conchâ Veneris adinstra ovi gallopavonis variegata. \\(2)//
Venus Conch, striped like the egg of a peacock.

15 Concha Ven. è minus speciosis dorso luteo, cæterū albicans. \\[-(4)]//
Venus Conch, one of the less beautiful examples, the dorsum yellow in colour, the rest shading to white.

16 Concha Veneris albicans, rubrâ maculâ ad utramque extremitatem venustâ. \\(2)//
Venus Conch shading to white, with a red spot at either end.

17 Concha Veneris sublutea fasciis in dorso albidis. \\(2)//
Yellowish Venus Conch, with white bands on the dorsum.

18 Concha Veneris [-] albo et russo, eleganter variegata, subtùs cand..a. \\deest//[9]
Venus Conch, elegantly striped in white and red, and white underneath.

[47r]

19 Concha Veneris ex albo et russo eleganter, variegata, subtùs rubra. \\(4)//
Venus Conch, beautifully striped in white and red, the underneath red.

20 Concha Veneris Subcinerea, [-fasciis] fuscis undatim striatis prædita. \\3//
Greyish Venus Conch, with dark undulating striations.

21/A Concha Veneris tenuissima sublutea, duabus in dorso fasciis subalbidis.
Very delicate, yellowish Venus Conch, with two whitish bands on the dorsum.

21/B Concha Veneris exigua alba, fasciis pullis admodum speciosa. \\(2)//
Small, white Venus Conch, very beautiful with dark grey bands.

22 Concha Veneris purpurea. \\4//
Purple Venus Conch.

23 Concha Veneris dorso cinereo septo luteo incluso, cæterùm /candicans\ 4ª Spec. Conchæ Veneris Rond. p.103. Buon, Cl.3 n.241. 4ª Specie Con. Ven. Mosch. P.209. \\12//
Venus Conch with an ash-grey dorsum, the seventh coil yellow, the rest shading to white; the fourth type of Venus Conch of Rondelet 1554, p. 103; Buonanni 1684, class 3 no.

241; the fourth type of Venus Conch of Moscardo 1672, p. 209.

24 Concha Veneris dorso cinereo inæquali subtùs candida. \\(10)//
Venus Conch with an uneven ash-grey dorsum, the underneath bright white.

25 Concha Veneris dorso luteo tuberoso, subtùs candida. Concha Venerea Jonst. T. 17. Buon, Class. 3. n.233. \\[-25\22]//
Venus Conch, the dorsum yellow and covered in tubercles, the underneath white. The Concha Venerea of Jonston 1650a, tab. 17; Buonanni 1684, class 3 no. 233.

26 Concha Veneris exigua, admodum ventricosa, ex albo et luteo versicolor, aperturâ ferè clusili.
Small Venus Conch, very swollen, coloured white and yellow, with an aperture which closes readily.

27 Concha Veneris exigua ventricosa alba et quasi arenulis conspersa.
Small, white, swollen Venus Conch, and as though scattered with sand.

28 Concha Veneris ex toto albicans, fascia in dorso eminenti, labro unico duntaxat ferrato. \\(3)//[10]
Venus Conch shading to white all over, with a projecting band on the dorsum, and a single iron-coloured lip.

29 Concha Veneris exigua alba striata. Listeri p.168 \\[-deest]//
Small, white, striated Venus Conch. Lister 1678 p. 168.

30 Concha Veneris turbinata cinerea admodum tenuis ventricosa fasciis fuscis intermissis prædita; aperturâ ad bas... hianti.
Ash-grey, conical Venus Conch, very delicate and swollen, with intermittent dark bands, and a gaping aperture at the base [?].

31 Concha Veneris turbinata ex fusco et cinereo versicolor, [-limbo prominanti]
Conical Venus Conch, coloured dark and ash-grey.

Conchæ Veneræ aff.
Shells related to the Venus Conch

32 Concha Veneris cylindroides (quod inter veneream et cylindraceam ambigat) alba, strijs sanguineis crebris ornata. Buon. Cl. 3. N. 138 \\[-(2)] (1)//
White, cylindrical Venus Conch (because it is doubtful whether it is a Concha venerea or cylindracea), decorated with numerous blood-red striations. Buonanni 1684, class 3 no. 138.

33 Concha Veneris cylindroides [-alba] eburnea. \\T//
Ivory-coloured, cylindrical Venus Conch.

34 Concha Veneris Cylindroid. ex albo et purp. varia. \\[-deest]//
Cylindrical Venus Conch, coloured white and purple.

[48r]

[9][f.45v] 18 D

[10][f.46v] [-deest]

35 Concha Veneris cylindroides ex albo et rubro versicolor. \\[-2]//
Cylindrical Venus Conch, coloured white and red.

36 Concha Veneris cylindroides admodum exigua subalbida. \\[-2]// \\[-3]//
Very small, whitish, cylindrical Venus Conch.

37 Conchæ Venereæ affine Leucostracum grandisculū ventre ab infirmâ parte prominenti, arcuatis valvalis minùs ferratis.
Quite large Leucostracum, related to the Venus Conch, with a swelling from the lower part, and little curving folds which are less pointed.

38 Conchæ Venereæ similis, alba, longiuscula, superficie inæquali, fasciâ in dorso multum prominenti, valvalis non ferratis Buon. Cl.3. N.249.
Shell similar to the Venus Conch, white and quite long, with an uneven surface, a distinct projecting band on the dorsum, and with little folds which are not pointed; Buonanni 1684, class 3 no. 249.

39 Concha Veneris ex albo et punctis atro-rubentibus versicolor.
Venus Conch, coloured white, speckled with dark red.

[49r]

40 Concha ejusdem coloris sed unica in dorso Lineâ Insignita. \\D [-deest]//
Conch of the same colour, but marked with a single line on the dorsum.

41 Concha Veneris viridis albis punctis insignita. DD. SL. \\[deest]//[1]
Green Venus Conch marked with white spots.

[50r]

Membr. 3.^{um} Cochlea Pyramidalis, cochlea cylindroides, cochlea turbinata
Third class: Cochlea pyramidalis, Cochlea cylindroides, Cochlea turbinata

C.2^{um} De cochlea pyramidali
Second drawer: pyramidal Cochlea

Cochlea pyramidalis ad extremum integra
Pryamidal Cochlea, with the protoconch intact

1 Cochlea pyramidalis integra, colore ex albo, castaneo et suaverubenti, vario; fuscis punctis creberrimis fasciata.
Intact pyramidal Cochlea, striped in white, chestnut and a pleasant shade of red, with bands of numerous dark spots.

2 Cochlea pyramidalis integra, suaverubens.
Intact pyramidal Cochlea, a pleasant red in colour.

3 Cochlea pyramidalis integra, gracilior alba, creberrimè striata.
Intact pyramidal Cochlea, an elegant white in colour, heavily straited.

4 Cochlea pyramidalis integra, [-crassior\minor] colore pallido, superficie lævi.
Smaller, intact pyramidal Cochlea, pale-coloured with a smooth surface.

5 Cochlea pyramid. integra ex albo et castaneo versicolor. \\5//
Intact pyramidal Cochlea, coloured white and chestnut.

6 Cochlea pyramid. integra admodum crassa, nigris maculis fasciatim positis [-insignita\elegantissima] Buon. Cl. 3. n.122. \\2//
Intact pyramidal Cochlea, very thick-walled, with black marks elegantly arranged in bands; Buonanni 1684, class 3 no. 122.

7 Cochlea pyramid. integra crassa, ex albo et atrorubenti versicolor.[2]
Intact pyramidal Cochlea, thick-walled, and striped in white and dark red.

8 Cochlea pyramid. integra rubescens, fasciis ex maculis atrorubentibus majoribus et minoribus alternatim positis, ornata. \\(3) una deest//
Intact pyramidal Cochlea, shading to red, decorated with alternate bands of large and small spots.

9 Cochlea pyramid. integra alba, lineolis atrorubentibus indiquaque ductis, speciosa. \\(3) una deest// \\unus d//
Beautiful, intact pyramidal Cochlea, white with little dark red lines running in all directions.

10 Cochlea pyramid. integra, subrubra, fasciâ albâ unicâ intûs [-ferrugineâ\purpurea].
Intact pyramidal Cochlea, reddish with a single white band, purple inside.

11 Cochlea pyramid. integra, colore ...atico Cum duabus fasciis albis.
Intact pyramidal Cochlea, with two white bands.

12 Cochlea pyramidalis integra alba, cum 2^{ab}: fasciis luteis punctatis.
White, intact pyramidal Cochlea, with two bands of yellow spots.

13 Cochlea pyramid. integra, coloris castanei cum 2.^{abr} fasciis albis.
Intact pyramidal Cochlea, chestnut in colour, with two white bands.

14 Cochlea pyramid. integra, ex albo sublutea fasciolis crebris arenariis prædita, mucrone purpureo.
Intact pyramidal Cochlea, white shading to yellow, marked with numerous little, sandy bands, and with a purple spire.

15 Cochlea pyramid. integra, alba, fasciolis punctatis russis conferta. \\2// \\[-deest]//
White, intact pyramidal Cochlea, packed with little bands of red spots.

[51r]

16 Cochlea pyramidalis integra, exigua fasciis atrorubentibus deductis et intermissis striata.
Small, intact pyramidal Cochlea, striated and with irregular dark red bands.

17 Cochlea pyramid. integra alba creberrimè fasciata.
White, intact pyramidal Cochlea, with numerous bands.

[17]A [-Cochlea pyramid integra alba, labro reverso.][3]
White, intact pyramidal Cochlea, with an inverted lip.

Cochlea pyr. bisulca s. ad extremū bifida

[1][f47v] quare

[2][f.49v] 7 Cochlea pyram: fasciata ex albo et Russo versicolor.
Banded Cochlea pyramidalis, coloured white and red.
[3][f.50v] Ad murices fimbriatos transtulimus.
Removed to the fringed Murexes.

Pyramidal Cochlea, grooved or cleft to the end

18 Cochlea pyramidalis bisulca et mucronata maxima, ex albo et fusco varia. Cochlea ultima Buon. cujus etiam iconem dedit n.133 ejusd. Class. Cochlea cylindroid. altera Jonst. T.12.
Very large, pyramidal Cochlea, cleft by a groove and pointed, striped in white and dark grey. The last Cochlea of Buonanni 1684, class 3 no. 133, with an illustration; the second Cochlea cylindroides of Jonston 1650a, tab. 12.

19 Cochlea pyramidalis bisulca et mucronata media, ex albo et russo varia. Buon. Cl.3. n.126. \\[-5\3]//
Pyramidal Cochlea, cleft by a groove, of medium size and pointed; striped in white and red. Buonanni 1684, class 3 no. 126.

20 Cochlea pyramidalis bisulca et mucronata, longiuscula, coloris cinerei.
Pointed, quite long pyramidal Cochlea, cleft by a groove, ash-grey in colour.

21 Cochlea pyramid. bisulca et mucronata crassior, col. castaneo.
Pyramidal Cochlea, cleft by a groove, pointed and quite thick-walled; chestnut-coloured.

22 Cochlea pyramid. bisulca et mucronata subrubens. \\(3)// \\un. d//
Reddish pyramidal Cochlea, cleft by a groove and pointed.

23 Cochlea pyramid. bisulca et mucronata lucida ex fusco \\([-15])//
Pyramidal Cochlea, cleft by a groove and pointed; shading from dark to light.

24 Cochlea pyramidalis bisulca et mucronata lucida, ex viridi cinerea. Buon. Cl.3.n.142. \\[-d]//
Pyramidal Cochlea, cleft by a groove, pointed and transparent; green shading to ash-grey. Buonanni 1684, class 3 no. 142.

25 Cochlea pyramid. bisulca et mucronata lucida ex albo et luteo varia, cum tribus fasciis viridibus. \\[-d]//
Pyramidal Cochlea, cleft by a groove, pointed and light-coloured, striped white and yellow-brown with three green bands.

26 Cochlea pyramidalis bisulca et mucronata versus mucronem exilis coloris cinerei.
Pyramidal Cochlea, cleft by a grooved and pointed, projecting at the spire; ash-grey in colour.

P. 101.

[52r blank; 53r]

C. 2ᵘᵐ. De Cochlea cylindroide; s. pyram. bisulca non mucronata
Second drawer: cylindrical Cochlea, or pyramidal Cochlea, cleft by a groove but without a point

27 Cochlea cylindracea ex albo et russo varia, cum fasciâ unicâ aut alterâ castaneâ.
Cylindrical Cochlea, striped white and red, with one or two chestnut-coloured bands.

28 Cochlea cylindr. lucida speciosè admodum variegata incerto colore. \\[-deest] deest//
Translucent cylindrical Cochlea, very beautiful, striped in indeterminate colours.

29 Cochlea cylindracea minùs lucens, ex albo, fusco, et russo speciosa.
Cylindrical Cochlea, less translucent, beautifully coloured in white, dark grey and red.

30 Cochlea cylinder. cinerea ex fusco striata.
Ash-grey cylindrical Cochlea, with dark striations.

31 Cochlea cylindr. minor ex fusco et cinereo punctata. \\D//
Smaller cylindrical Cochlea, with spots in a dusky and ash-grey colour.

32 Cochlea cylindr. exigua lucida, sublutea.
Small, translucent cylindrical Cochlea, yellowish in colour.

To page 103.

[54r]

C.3ᵘᵐ. De Cochlea turbinata
Third drawer: Top-shaped Cochlea

Cochlea turbinata involucris in basi lævibus
Top-shaped Cochlea with a smooth periostracum at the base

1 Cochlea turbinata longissima, coloris ex luteo et subalbido mixti.
Very long, top-shaped Cochlea, a mixture of yellow and off-white in colour.

2 Cochlea turbinata ex albo et luteo variegata et ex utroque fasciata.
Top-shaped Cochlea, striped white and yellow, and banded at either end.

3 Cochlea turbinata subalbida maculis luteis striatim conspersa.
Top-shaped Cochlea, off-white in colour, scattered with yellow marks like striations.

4 Cochlea turbinata crassissima, coloris lutei, maculis nigris interstincti.
Very thick-walled top-shaped Cochlea, yellow in colour with black marks.

5 Cochlea turbinata a basi in mucronem sulcis profundioribus exarata, umbilico plano et quasi lævigato, coloris ex albo rufescentis
Top-shaped Cochlea, with quite deep furrows from the base to the spire, with a flat umbilicus as if smoothed; white shading to red.

6 Cochlea turbinata alba aut sublutea maculis atrorubentibus elegantissimè depicta.
White or yellowish top-shaped Cochlea, very elegantly decorated with dark red spots.

7 Cochlea turbinata alba, fasciis luteis, maculísque atrorubentibus, ex ordine positis perelegans, unmbilico ferè plano.
White, top-shaped Cochlea, with yellow bands and dark red spots beautifully and regularly arranged, and with an almost flat umbilicus.

8 Cochlea turbinata candida, umbilico planiori maculis atrorubentibus fasciatim positis speciosa. Coch. cylindr. Rond. p.99.
Bright white top-shaped Cochlea, with a flattish umbilicus, and dark red spots beautifully arranged in bands; the Cochlea cylindroides of Rondelet 1555, p. 99.

9 Cochlea turbinata cinerea, aut albicans, rubris maculis crebris ex ordine insignita. \\[-deest]//⁴

⁴[f53v] 9 deest

143

Top-shaped Cochlea, ash-grey or shading to white, marked with numerous red spots arranged regularly.

10 Cochlea turbinata albida, cum fasciâ et mucrone atrorubenti. \\deest//[5]
White, top-shaped Cochlea, with a dark red band and spire.

11 Cochlea turbinata ex albo et castaneo varia. Cochlea cylindroide Mosch. p. 214. \\(2)//
Top-shaped Cochlea, striped in white and chestnut; the Cochlea cylindroide of Moscardo 1672, p. 214.

12 Cochlea turbinata castanei coloris fasciâ unica albicanti. p.214. \\()//
Top-shaped Cochlea, chestnut in colour, with a single band shading to white.

13 Cochlea turbinata è minoribus sublutea. \\[-4\3]// \\D//
Yellowish, top-shaped Cochlea, one of the smallest examples.

14 Cochlea turbinata obscurè alba mucrone purpureo.
Dull white, top-shaped Cochlea with a purple spire.

15 Cochlea turbinata minùs speciosa, albida, fragosa.
White and fragile, top-shaped Cochlea, less beautiful.

16 Cochlea turbinata alba umbilico maculis russis punctato. \\ 2 [-fract]//
White, top-shaped Cochlea, the umbilicus marked with red spots.

17 Cochlea turbinata omnin̄ [-tenuissima, colore albi, maculata ex russo maculâti\ alba, ex rubro guttata]. \\deest//
Top-shaped Cochlea, white all over, and spattered in red.

[55r]

Cochlea turbinata eriocephala, s. involucris in basi [-tuberosis\tuberculosis]
Top-shaped Cochlea eriocephala, or with a tubercle-covered periostracum at the base

18 Cochlea turbinata eriocephala ex fusco et albo versicolor.
Top-shaped Cochlea eriocephala, coloured dark grey and white.

19 Cochlea turbinata eriocephala [-] colore subcinereo, minùs speciosa.
Top-shaped Cochlea eriocephala, greyish and less beautiful.

20 Cochlea turbinata eriocephala, fasciolis bullatis crebris, insignita.
Top-shaped Cochlea eriocephala, marked with numerous little studded bands.

21 Cochlea turbinata eriocephala, bullatis s. arenosis fasciolis cincta, suaverubens. \\2//
Top-shaped Cochlea eriocephala, shading to a pleasant reddush-brown, bound with little studded or sandy bands.

22 Cochlea turbinata eriocephala, incerti coloris, fasciâ albâ unicâ [-insignita\aut alterâ] cincta; fasciolis arenarijs ut cæteræ insignita. \\2//

Top-shaped Cochlea eriocephala, of indeterminate colour, encircled with one or two white bands; marked like the rest with little sandy bands.

23 [- Cochlea turbinata eriocephala, hepatici[?] coloris. \\deest//] Cochlea turbinata eriocephala cinerea, ex fusco maculata. \\deest//
Ash-grey, top-shaped Cochlea eriocephala, with dark marks.

24 Cochlea turbinata eriocephala subcinerea.
Ash-grey, top-shaped Cochlea eriocephala.

[-25 Cochlea turbinata eriocephala, subrubra, striata ex fusco ...]
Top-shaped Cochlea eriocephala, reddish in colour with dark striations.

N.B. Turn to page ye 87th.

[56r, 57r blank; 58r]

Pars Altera Seu De Cochleis Minime Anfractuosis
Second part: slightly spiral-twisted Cochlea

Sect. I. de bivalvibus asperis et striatis
First section: bivalves, rough and striated

Membrum i.[um] Concha imbricata, Ostrea foraminosa, Ostreæ congener, Gaideropoda, Echinostracum
First class: Concha imbricata, perforated Oyster shells, Ostrea congener, Gaideropoda and Echinostracum

Cap. 1[um] De Concha imbricata
First drawer: Concha imbricata

1 Concha imbrica/ta\ è majoribus albida, creberrimè fasciata, margine rostri adinstar dentatâ. Conchiglia imbricata &c. Buon. Cl.2. n.83. An concha tridachnes Jonst. T.13? Conch imbricata Mos. p.205[6]
White Concha imbricata, one of the larger examples, heavily banded, with a toothed edge like a beak. The Conchiglia imbricata, etc of Buonanni 1684, class 2 no. 83; perhaps the Concha tridachnes of Jonston 1650a, tab.13; the Concha imbricata of Moscardo 1672, p. 205.

2 Concha imbricata alba è minoribus, creberrimè fasciata.
White Concha imbricata, one of the smaller examples, heavily banded.

3 Concha Striata. Mosch. P.205.[7]
Striated Concha; see Moscardo 1672, p. 205.

[59r]

C. 2[um] De Ostreâ foraminosâ
Second drawer: perforated Oyster shells

1 Ostreū foraminosū admodum crassū marginis colore ad gridem accidente [-major]. \\Maj. estquam ut scrinijs locari possit//.[8]
Oyster covered in perforations, very thick-walled, the colour at the edge approaching []. It is large enough to be placed in the cabinets.

[5][f.53v] 10. Hujus locum tenet Cochlea Turbinata albo et Cinereo variegata.
Here instead is a top-shaped Cochlea, striped white and ash-grey.

[6][f.57v] The great Shell on ye window.
[7][f.57v] Pectunculis annumeri debent.
These ought to be counted among the Pectunculi.
[8][f.58r] Sup Scriniū primum
Above the first cabinet.

2 Ostrea foraminosa admodum crassa, margine incolori, minor.
Oyster covered in perforations, very thick-walled, the edge of indeterminate colour; smaller.

C.3.^{um}. De [-Ostrea] Pectunculo affini
Third drawer: shells related to the Pectunculus

1 [-Ostrea\Pectunculo] affinis, striata rubra.
Red, striated shell related to the Pectunculus.

C. 4.^{um}. De Gaideropoda
Fourth drawer: Gaideropoda

1 Gaideropoda ex albo subrubra. Buon. Cl. 2.n.21. \\(2)//
Gaideropoda, white shading to a reddish colour. Buonanni 1684, class 2 no. 21.

C. 5^{um}. De echinostraco
Fifth drawer: Echinostracum

1 Echinostracum rubrum. \\(fract)//
Red Echinostracum. Broken.

[60r]

Membrum 2^{um}. Chama Glycymerides magna Rond. Concha dondroides s. aborigena
Second part: the large Chama glycymerides of Rondelet; Concha dendroides or Concha aborigena

C. 1^{um} De Chamâ Glycymeride magnâ Rond.
First drawer: the large Chama glycymeris of Rondelet

1 Chama della Glycymerid. Magna. Buon. Cl. 3. N.59.
The great Chama glycymeris. Buonanni 1684, class 3 no. 59.

C. 2^{um}. De Conchâ arborigenâ quod ramis arborū adnascatur, sic dicta
Second drawer: Concha arborigena, which grow on the branches of trees, so it is said

1 Concha arborigena maj. alba, intùs purpurascens. \\(2)//
Larger, white Concha arborigena, shading to purple on the inside.

2 Concha arborigena minor subcæruluea \\fract.//
Smaller Concha arborigena, bluish in colour. Broken.

[61r]

Membrum 3^{um}. Pecten Pectunculus
Third part: Pecten pectunculus

C. 1^{um}. De Pectine
First drawer: Pectens

Pecten /amphiotis, seu\ utrinque auriculatus
Pecten amphiotis, or eared on both sides

1 Pecten utrinque auriculatus maximus 12 circiter radiis, colore cinereo.
Very large Pecten, eared on both sides, with about twelve ridges, ash-grey in colour.

2 Pecten utrinque auriculatus è maximis, 16 circiter radijs striatis, colore luteo.
Pecten, eared on both sides, one of the largest examples, with about sixteen striated ridges, yellow in colour.

3 Pecten utrinque auriculatus tenuis, creberrimè striatus, colore versus mucronem rubro, cæterùm candicans.
Delicate Pecten, eared on both sides, and heavily striated; red towards the point, the rest bright white.

4 Pecten utrinque auriculatus è minoribus magis excavatus suaverubens.
Pecten, eared on both sides, one of the smaller examples, quite deeply hollowed, shading to a pleasant reddish-brown.

5 Pecten utrinque auriculatus, crebrô et profundè striatus.
Pecten, eared on both sides, deeply and repeatedly striated.

6 Pecten utrinque auriculatus, [-planus], ex subluteo rubens, strijs depressis.
Pecten, eared on both sides, yellowish shading to red, with deep straitions.

7 Pecten utrinque auriculatus, planus coloris rubri, strijs depressis. \\[-deest]//
Pecten, eared on both sides, flat, red in colour, with deep striations.

8 Pecten utrinque auriculatus planus, depressis strijs, atrorubens. \\deest//
Flat Pecten, eared on both sides, with deep striations, shading to dark red.

Pecten monotis seu ex unâ parte duntaxat auriculatus
Pecten monotis or with an ear on one side only

9 Pecten monotis colore rubro-purpureo.
Pecten monotis, reddish-purple in colour.

10 Pecten monotis colore aurantiaco ferè.
Pecten monotis, almost golden in colour.

11 Pecten monotis ex fusco rufescens. Pectunculus Rond.
Pecten monotis, dark-coloured shading to red. The Pectunculus of Rondelet.

12 Pecten monotis fuscus, maculis albis interstinctus.
Dark-coloured Pecten monotis, with white spots.

13 Pecten monotis exiguus atrorubens, creberrimè striatus.
Small, dark red Pecten monotis, heavily striated.

14 Pecten monotis exiguus albus.
Small, white Pecten monotis.

15 Pecten monotis asper colore albo, cum tuberculis rubris corallinis adnatis. Pecten asper Jonst.
Rough Pecten monotis, white in colour, with red tubercles like coralline; the Pecten asper of Jonston.

16 Pecten asper degener, colore aurantiaco, striis ægrè [-conspicuis]
Rough Pecten, a poor specimen, with a golden colour and scarcely any striations.

vid. P.121
See p.121

[62r blank; 63r]

C. 2^{um}. De Pectunculo
Second drawer: Pectunculi

Pectunculus profundiùs striatus
Deeply striated Pectunculi

[18\17] Pectunculus albus polyleptogynglimos Columnæ, crassissimus, latis strijs; profundè in ambitu crenatus.

White Pectunculus polyleptogynglimos of Colonna [1616, pp. 20-1], very thick-walled, with wide striations; deeply crenulated at the edge.

[-19\18] Pectunculus albus maximus dentatis radijs. Buon. Cl. Cl.2.n.96.
Very large, white Pectunculus with toothed ridges. Buonanni 1684, class 2 no.96.

[-20\19] Pectunculus dentatus minor subalbidus.
Smaller, off-white, toothed Pectunculus.

[-21\20] Pectunculus tenuis albus, alatis strijs. Concha exotica margine in mucronem emissâ. Columnæ de Purp. p.26. \\fract//[9]
Delicate, white, winged Petunculus, with striations. Rare Concha with a border right up to the point. See Colonna (1616, p. 26).

[-22\21] Pectunculus tenuis albus, alatis strijs fasciatus.
Delicate, white Petunculus, banded and with winged striations.

[-23\22] Pectunculus echinatus. List. p.188. Concha echinata Rond. Gesn. Aldr. \\[-deest]//
Pectunculus with spines. Lister 1678, p. 188; the Concha echinata of Rondelet, Gessner and Aldrovandi.

[-24\23] Pectunculus echinatus minor, colore aurantiaco. Buon. Cl. 2.n.89.
Smaller Pectunculus echinatus, golden in colour. Buonanni 1684, class 2 no. 89.

[-25\24] Pectunculus echinatus minor albidus. Buon. Cl. 2.n.72.
Smaller, white Pectunculus echinatus. Buonanni 1684, class 2 no. 72.

[-26\25] Pectunculus vulg. albidus, rotundus, circiter 26 strijs majusculis et planioribus donatus. List. P.189. Buon. Cl. 2.n.63.
Common Pectunculus, white, rounded and with about twenty-six rather large, flat striations. Lister 1678, p. 189; Buonanni 1684, class 2 no. 63.

[-27\26] Pectunculus ex albido rufescens rotundus non fasciatus.
Rounded Pectunculus, white shading to red, not banded.

[-28\27] Pectunculus exiguus ex albido lutescens, semicircularis.
Small Pectunculus, white shading to yellow, shaped like a half circle.

Pectunculus inæqualis /ungularis
Asymmetrical or clawed Pectunculus

[-29\28] Pectunculus inæqualis albidus valdè crassus. Buon. Cl.2.n.74. \\cho...ha rhomboides Rond. forsan pag. 27.
White, asymmetrical Pectunculus, very thick-walled. Buonanni 1684 class 2 no. 74; the Concha rhomboides of Rondelet 1554, perhaps p. 27.

[-30\29] Pectunculus inæqualis longissimus, crebrò striatus, ex albido lutescens. \\Arca Noae.//
Asymmetrical Pectunculus, very long and heavily striated, white shading to yellow. Noah's Ark.

[-A\30] Pectunculus longissimus ex albo et atrorubenti versicolor.

[9][f.62v] fract

Very long Pectunculus, coloured white and dark red.

31 Pectunculus triangularis ex albo et russo versicolor, nō. fasciatus.
Triangular Pectunculus, coloured white and red, not banded.

32 Pectunculus albus triangularis.
White, triangular Pectunculus.

Pectunculus leviter stratus
Pectunculus, lightly striated

33 Pectunculus leviter striatus, Anglicanus, multum fasciatus colore castaneo. Buon. Cl.2.n.92.
Lighted striated, English Pectunculus, repeatedly banded, chestnut in colour. Buonanni 1684, class 2 no.92.

34 Pectunculus maximus, at minùs concavus; plurimis minutioribus et parū eminentibus strijs donatus, rostro acuto, minusque incurvato. List. p. 187. Ejusd. spec. videtur cū priore.
Very large Pectunculus, but less hollowed, with numerous, tiny, slightly projecting striations; and a sharp beak; less curved. Lister 1678, p. 187. Apparently the same species as the last.

[64r]

35 Pectunculus prorsus lævis, fasciatus, colore versus mucronem ex albo rubescenti; cæterum virescens.
Very smooth, banded Pectunculus, white shading to red towards the spire, the rest shading to green.

36 Pectunculus prorsus lævis, colore cinereo, creberrimè striatus et fasciatus ex fusco; margine ferrugineo, intùs serrato.
Very smooth, ash-grey Pectunculus, heavily striated, and with dark-coloured bands; a rust-coloured border, with the inside serrated.

[65r]

Sect. II
Section II

De Bivalvibus Fasciatis Lævibus.
Bivalves, smooth and banded

Membrū 2[um]. Musculus, concha margaritifera
Second part: Mussels, pearl-bearing shells

Cap. 1[um] De Musculo
First drawer: Mussels

Musculus mucronatus s. mytilus
Pointed Mussel or Mytilus

1 Musculus Aldr. Jonst. Buon. Cl.2.n.30. \\(2)//
Mussel. The Musculus of Aldrovandi and Jonston; Buonanni 1684, class 2 no. 30.

2 Musculus mucronatus rubro-purpurens.
Reddish purple, pointed Mussel.

3 Musculus mucronatus parvus, undatus et minutissimè striatus, colore incarnato. Mitylo Mosch. 209
Small, pointed Mussel, undulated and with tiny striations; flesh-coloured. The Mytilus of Moscardo 1672, p. 209.

4 Musculus mucronatus parvus, minutissimè striatus, colore subcær. fasciis fuscis [-cincto\ cinctus].
Small, pointed Mussel, with tiny striations, bluish in colour, encircled with dark-coloured bands.

Musculus latus s. fluviatilis
Broad or riverine Mussels

5 Musculus latus maximus testâ admodum tenui ex fusco virides... pal. List. append. p. 8ª. Chamæ Glycimeridi similis sed majoris mytili. Species Aldr.

Very large, broad Mussel, with a very delicate shell, dark-coloured shading to green ...; Lister 1681, p. 8; a species of the Mytilus of Aldrovandi, similar to the Chama glycimeris but larger.

6 Musculus niger omnium crassissimâ et ponderossimâ testâ List. Append. p.ij. Conchæ longæ Spec. Gesn. Aldr. \\ (2)//[10]

Black mussel, with the thickest and heaviest shell of all. Lister 1681, p. 11; a species of the Concha longa of Gessner and Aldrovandi.

7 Musculus latus flammeus. \\[-]//

Flame-coloured, broad Mussel.

8 Musculus triquetrus subviridis.

Greenish, triangular Mussel.

9 Musculus exiguus pisi magnitudine, rotundus, subflavus, ipsis valvarum oris albidis. List. p.150. \\D// \\(2)//

Small, rounded Mussel, the size of a pea; yellowish in colour, and white at the edges of the valves. Lister 1678, p. 150.

10 Margaritæ cujusdam musculi fluviatilis. Vid. List. 149. \\d//

Pearls from a river Mussel; see Lister 1678, p. 149.

[66r blank; 67r]

C.2ᵘᵐ De Conchâ margaritiferâ
Second drawer: Pearl shells

1 Concha mater unionum Rond. Conchiglia della Madreperla Buon. Cl.2. n.1. Madreperla Mosch. P.198.

The Concha mater unionum of Rondelet; the Conchiglia della madreperla of Buonanni 1684, class 2 no. 1; the Madreperla of Moscardo 1672, p. 198.

2 Concha margaritifera minor, pectinis figurâ. [-ferè][11]

Smaller, pearl-bearing Concha, with the form of a Pecten.

Membr. 2ᵘᵐ Chama, Tellina
Second class: Chama and Tellina

Cap. 2ᵘᵐ. De Chamâ
Second drawer: Chama

1 Chama aspera alba figurâ ferè cylindroidi. Concha altera longa Rond. \\An Peloridis Antigorū Spec? Meirionydh shire.//

Rough, white Chama, almost cylindrical in shape. The second Concha longa of Rondelet [1555, p. 23]; could it be a species of Peloris Antigorum? From Merioneth.

2 Chama Glycemeris Rond. An concha longa latáque in medijs cardinibus cavitate quadam pyriformi insignita List.? Ibid. inve/nitū\

The Chama glycimeris of Rondelet [1554, p. 13]. Perhaps a long, broad Concha with a cone-shaped hollow in the middle of the hinge? See Lister 1681, p. 146.

3 Chama foris pallida, intùs lutescens s. ocroleuca, cardine rubro Tellina lunga &c. Buon. Cl.2. n.41. \\2//

Chama, pale-coloured on the outside, yellowish or whitish on the inside, with a red hinge. The Tellina lunga of Buonanni 1684, class 2 no. 41.

4 Chama pallida minor fasciis crebris minutissimis omnino cincta. \\2//

Smaller, pale-coloured Chama, encircled all over with numerous tiny bands.

5 Chama Ocroleuca, fasciis creberrimis minutissimis cincta. \\d//

Pale-coloured Chama, encircled with numerous tiny bands.

6 Chama /recurvirostra\ crassiuscula admodum lævigata, [-figura quasi rhomboide], ex albo et hepatico versicolor.

Chama with a curved beak, smooth and very thick-walled; striped in white and liver-colour.

[68r]

C. 2ᵘᵐ. De Tellinâ s. chamâ minori serratâ
Second drawer: Tellina or smaller, serrated Chama

Tellina lata
Broad Tellina

7 Tellina ex albo lutescens.

Tellina, white shading to yellow.

8 Tellina intùs ex viola purpurascens, in ambitu serrata \\List. p.190//.

Tellina, the inside violet shading to purple, serrated around the border. Lister 1678, p. 190.

9 Tellina parva albida, fasciis ex luteo virescentibus. \\(5)//[12]

Small, white Tellina, with yellow bands shading to green.

Tellina cuneiformis
Wedge-shaped Tellina

10 Tellina cuneiformis ex albido purpurascens, elegantissima. Tellina della Spiaggia di Nettino Buon. Cl. 2. n.47.

Wedge-shaped Tellina, white shading to purple, and very beautiful. The Tellina Spiaggia di Nettuno of Buonanni 1684, class 2 no. 47.

[10][f.64v] 6B. Musculus medicæ Magnihidinis cui Vermium Exuviæ adhærent dense admodum congregate.
Musculus medicae of great size, to which the casts of worms adhere in great quantity

[11][f.66v] [-2 deest]

[12][f.67v] [-deest]

11 Tellina cuneiformis ex albido subviridis, intùs purpurea.\\[-d]//
Wedge-shaped Tellina, white shading to a greenish colour, and purple on the inside.

12 Tellina cuneiformis ex albido subrubra; profundius striata.
Wedge-shaped Tellina, white shading to a reddish colour, and deeply striated.

13 Tellina cuneiformis ex albido [-subrub] purpurascens, minutissimè striata. \\(5)//
Wedge-shaped Tellina, white shading to purple, with tiny striations.

[69r]

Membr. 3um Concha triquatra, Concha tenuis, Concha rugosa
Third class: three cornered Concha, delicate Concha, and wrinkled Concha

Cap. 1um. De Conchâ triquetrâ[1]
First drawer: three-cornered Concha

1 Concha triquetra alba; fasciâ luteâ obducta. \\(5)//
White three-cornered Concha, with a yellow band.

2 Concha triquetra rostrata ex albido lutescens. \\(levissime fasciata)//
Three-cornered, beaked Concha, white shading to yellow; very lightly banded.

3 Concha triquetra ex albido lutescens rostrata minor.[2]
Smaller, three-cornered, beaked Concha, white shading to yellow.

4 Concha triquetra sublutea lævis.[3]
Three-cornered Concha, yellowish and smooth.

5 Concha triquetra lævis subalbida. \\forte Concha Galeas Rond.//
Three-cornered Concha, off-white and smooth. Perhaps the Concha galeas of Rondelet.

6 Concha triquetra crassiuscula, subrussa. An concha crassa ex alterâ parte compressa, ex altera subrotunda. List. p. 174?
Three-cornered Concha, quite thick-walled and reddish in colour. Could it be the thick-walled Concha,compressed on one side and roundish on the other, described in Lister 1678, p. 174?

7 Concha triquetra ex albo et rubro versicolor. Tellina di color roseo, listata di candido Buon. Cl. 2. n.44. Tellina Jonst. T. 15. n.8 Tellina Mosch. P.202.
Three-cornered Concha, coloured white and red. The pink Tellina, listed under the white specimens, of Buonanni 1684, class 2 no. 44; the Tellina of Jonston 1650a, tab. 15 no. 8; the Tellina of Moscardo 1672, p. 202.

8 Concha triquetra ex russo et cinereo versicolor.
Three-cornered Concha, striped in red and ash-grey.

9 Concha triquetra albida, rostro et fascijs rubentibus. \\Fract.//
White, three-cornered Concha, with a beak and red bands.

10 Concha triquetra alba, rostro et fascijs pallidis.
White three-cornered Concha, with a beak and pale-coloured bands.

11 Concha triquetra crassa, è minoribus, alba.
Thick-walled, three-cornered Concha, one of the smaller examples, and white in colour.

12 Concha triquetra albida, fasciis et mucrone cæruleo. \\deest//[4]
White, three-cornered Concha, with bands and a blue point.

[70r]

Cap. 2um. De Concha tenui
Second drawer: delicate Conchae

13 Concha tenuis minutissimè fasciata, ex pallido et subluteo versicolor.
Delicate Concha, with tiny bands, of a pale and yellowish colour.

14 Concha tenuis ex albido et subluteo, aut russo versicolor.
Delicate Concha, striped in white and a yellowish or red colour.

15 Concha tenuis alba.
Delicate, white Concha.

16 Concha parva subrotunda, ex parte internâ rubens. List. 175.
Small, roundish Concha, reddening on the inside; Lister 1678, p. 175.

17 Concha tenuis subalbida, rostro et fasciis colore ocroleuco.
Off-white, delicate Concha, the beak and bands in a whitish colour.

18 Concha admodum tenuis compressior, longiuscula, colore albo, vel ex albo rubenti.
Very delicate Concha, quite compressed and long; white in colour or rather white shading to red.

Cap. 3ium. De conchâ rugosâ recurvirostrâ
Third drawer: wrinkled Concha with a curved beak

1 Concha è maximus rotundiuscula, admodum crassa, ex nigro rufescens. List.173.[5]
Concha, quite rounded and one of the largest examples, with very thick walls; black shading to red. Lister 1678, p. 173.

2 Concha valdè rugosa, crassa et rotunda, colore albo, vel ex albo subluteo. Concha della rugata dal Rond. &c. Buon.
Very wrinkled Concha, thick-walled and round, white in colour, or rather white shading to yellowish. The Concha della rugata of Rondelet [1555, p. 25] and Buonanni [1684, class 2 no. 75].

3 Concha rugosa purpurascens.
Wrinkled Concha, shading to purple.

4 Concha rugosa et striata fusca, aliquantulum rufescens.

[1][f.68v] Cum hujus Capsulæ Conchas nequaquam catalogo convenrire deprehendimus alio more describere fas ... existimavimus - 1756
When we discovered that the Conchae in this drawer had never been catalogued, we decided they should be described elsewhere.
[2][f.68v] Rugosa cinerea ad latus declive tuberculis notata.
Ash-grey, wrinkled, marked with tubercles and sloping at the side.
[3][f.68r] 4and 5. rugosa 5 cancellata.
4. and 5. Wrinkled 5. Latticed

[4][f.68v] 12 cinerea eleganter cancellata
12. Ash-grey, and elegantly latticed.
[5][f.69v] Curvirostra &c.
Beaked Concha, etc
1. Concha rotund: Lævis ex albo et Russo Notat:
Rounded Concha, smooth, white in colour with red markings.

Wrinkled Concha, dark-coloured and striated, reddening just a little.

5 Concha rugosa ex albo et russo versicolor.
Wrinkled Concha, coloured white and red.

6 Concha fascijs minutioribus rugosa, alba, ferè orbicularis.
Wrinkled Concha, with very tiny bands, white in colour and almost spherical.

7 Concha rugosa minor, colore subluteo aut cinereo.
Smaller, wrinkled Concha, colored yellowish or ash-grey.

8 Concha rugosa et leviter striata ex albido lutescens.
Wrinkled, lightly striated Concha, white shading to yellow.

9 Concha quasi rhomboides, in medio cardine utrinque circiter tribus exiguis denticulis donata. List. p. 171.
Concha, like a rhomboid Concha, with about three small teeth on either side of the middle of the hinge. Lister 1678, pp. [170-1]

10 Concha tenuissimis fascijs rugosa, rotunda, admodū crassa, alba.
Wrinkled Concha with very thin bands, round and very thick-walled; white in colour.

11 Concha alba reticulata.
White, reticulated Concha.

[71r]

12 Concha profundiùs reticulata, alba, maculis russis ... striata.
Concha, deeply reticulated, white and striated with red marks.

13 Concha rotunda minutissimè fasciata, triangularis cruentatis insignita. Buon. Cl.2 n.43[6]
Round Concha, finely banded, marked with blood-red triangular marks. Buonanni 1684, class 2 no. 43.

14 Concha fasciata orbicularis ex albo et russo versicolor, [-margine striatâ]
Banded, spherical Concha, coloured white and red.

15 [-Concha rotundiuscula admodum crassa squamosa? An ostrei spec?]
Concha, quite rounded, very thick-walled and scaly? Could it be a species of oyster?.

[72r]

Sect. III. De Bivalvibus Longissimis
Third section: very long Bivalves

Membr. 2[um]. Pinna
Second class: Pinna

1 Pinna magna Jonst. T.13 La [-] Conchiglia della Pinna i Latini Buon. \\fract://
The Pinna magna of Jonston 1650a, tab. 13; the Italian Conchiglia della Pinna of Buonanni; broken.

2 Pinna Perna Rond. Jonst.
The Pinna perna of Rondelet [1554, p. 52] and Jonston [1650a, p. 51].

3 Sericum e Pinna marina ex dono Dñi Gul. Charleton e medio Temp. Lond. \\Byssup marina//
Silk from a Pinna marina, given by William Charleton of Middle Temple, London. Marine Byssus.

4 Ostreum Virginianum.
Virginian oyster.

Membrum 2[um]. Solen
Second class: Solen

1 Solen Græcorum, Unguis Latinorum Buon. Cl.2.n.57. Solen maj. Rond. Jonst. \\2 minor fract.//
The Greek Solen and the Latin Unguis: see Buonanni 1684, class 2 no. 57. The Solen major of Rondelet [1554, pp. 42-4] and Jonston [1650a, p. 50]. Two small breaks.

[73r blank; 74r]

Sect IV. De Cochleis Univalvibus
Fourth section: univalve Conches

Membr. 1[um]. De patella et Balano
First class: Patella and Balanus

Cap. I.[um]. De Patellâ
First drawer: Patella

Patella lævis, s. non striata
Smooth Patella, or Patella without striations

1 Patella Indica omnium maxima, margine atrorubenti. Patella grande del' India Buon.
Patella Indica, the largest of all, with a dark red border. The Patella grande of India; see Buonanni.

2 Patella lævis ex luteo argentea, margine ex albo et atrorubenti striatâ.[7]
Smooth Patella, yellow shading to silver; with a straited border, coloured white and dark red.

3 Patella lævis compressior subalbida, margine ex albo et atrorub. striatâ. \\[-D]//
Smooth, off-white Patella, quite compressed; with a striated border, white shading to dark red.

4 Patella lævis vertice candido, margine fuscâ leviter striatâ.
Smooth, bright white Patella, with a lightly striated, dark-coloured border.

5 Patella lævis sublutea, vertice productu.
Smooth, yellowish Patella, with an elongated spire.

6 Patella lævis vertice argenteo, cæterum subfusca. \\([-2\1])//[8]
Smooth Patella with a silver spire, the rest a dusky colour.

7 Patella lævis vertico cæruleo nonnihil producto, cæterum sublutea \\(2)//
Smooth Patella with a somewhat elongated blue spire, the rest a yellowish colour.

8 Patella lævis sublutea vertice albo.
Smooth, yellowish Patella, with a white spire.

Patella Striata
Striated Patella

9 Patella profundius striata, subalbida, pyramidata.[9]
Patella with deep striations, off-white in colour, and conical in shape.

[6][f.70v] [-deest]

[7][f.73v] [2 d]
[8][f.73v] [-una deest]
[9][f.73v] [-deest]

10 Patella leviter striata, vertice albo, cæterum ex albo et atrorubenti variegata.
Lightly striated Patella, with a white spire, the rest striped in white and dark red.

11 Patella striis majoribus et minoribus insignita ex albido rufescens.
Patella marked with both small and large striations, white shading to red.

12 Patella striis majoribus et minoribus, ex albido nigricans, intùs subviridis. \\(2)//
Patella with both small and large striations, white shading to black, the inside a greenish colour.

13 Patella profundiusculè striata, albida, vertice subcæruleo. Patella Aldr. Jonst. Buon. Cl. 1. n. 3.
Patella with quite deep striations, white in colour with a bluish spire. The Patella of Aldrovandi and Jonston; Buonanni, 1684 class 1 no. 3.

14 Patella alba reticulata. Buon. Cl. 2ª n. 6.
White, reticulated Patella. Buonanni 1684, class 2*, no. 6.

[-15 Patella ex albo nigricans stellata; S. 7 radijs majusculis notata.] \\deest//.
Patella, white shading to black; or a Patella distinguished by seven sizeable ribs.

16 Patella radijs majusculis alba.
White patella with quite large ribs.

17 Patella exigua atrorubens, crebrò striata.
Small Patella, shading to dark red, with numerous striations.

18 Patella striata compressa, in ambitu serrata, colore albo.
Striated, compressed Patella, serrated at the edge, and white in colour.

[75r]

Patella rostrata
Beaked Patella

19 Patella [-stria] rostrata, alba tenuis, minutissimè striata. Tellina Jonst. T.15.n.7
Beaked Patella, white and delicate, with tiny striations; the Tellina of Jonston 1650a, tab. 15 no. 7.

20 Patella fluviatilis fusca, vertice mucronato, inflexóque. List. p.151.
Riverine, dark-coloured Patella, with a pointed, bent spire. Lister 1678, p.151.

21 Patella rostrata compressa, ex albido rufescens. \\2//
Compressed, beaked Patella, white shading to red.

22 Patella rostrata compressa, ex albido et atrorubenti variegata.
Compressed, beaked Patella, striped in white and dark red.

23 Patella rostrata compressa purpurea ex albo punctata; minutissimè fasciata. \\[-d] D//
Compressed, beaked Patella, purple in colour with white spots; and with tiny bands.

24 Patella rostrata compressa admodum crassa, colore et superficie fagum referens. \\(2)//
Compressed, beaked Patella, very thick-walled, its colour and surface like that of a beech tree.

C. 2 de Balano
Second drawer: Balanus

25 Balani 2ªSpecies Rond. p.30. Balanus Gigantes Jonst. Buon. Cl.1. n.15. v. p.149.
Second species of Balanos, see Rondelet 1554, p. 30; the Balanus gigantis of Jonston [1650a, p. 49], Buonanni 1684, class 1, no.15.

[76r blank; 77r]

C. 2.ᵘᵐ De Balano
Second drawer: Balanus

25 Balani 2ª Species Rond. p.30. Balanus Gigantis Jonst. Buon. Cl. 1.n.15. \\vid. p. 145//
Second species of Balanus, see Rondelet 1554, p. 30; the Balanus gigantis of Jonston, Buonanni 1684, class 2 no. 15.

Membrum 2ᵘᵐ Echinus
Second part: Echinus

[-\1] Echinus magnus foraminosus, pentaphylloides. Riccio marino Buon. Cl.1.n.16. Jonst.T.12. \\[-deest]//
Large, perforated Echinus pentaphylloides. The Riccio marino of Buonanni 1684, class 1 no. 16; Jonston 1650a, tab. 12.

[-\2] Echinus clavatus, clavis majoribus insignitus.
Echinus clavatus, with rather large knobs.

[-\3] Echinus clavatus, clavis minoribus. \\D//
Echinus clavatus, with smaller knobs.

4 Echinus laticlavius maj. /Buon.\ Cl.1ª p.18 \\(fract)//
Echinus with broad knobs. Buonanni 1684, class 1 no. 18; broken.

[78r, 79r; 80r, 81r, 82r, 83r][10]

Aporrhais	p23	Cochlea compressa	75
Auris marina	77	Cochlea Cylindroides	101
Balanus	149	Cochlea Pyramidalis	95
Buccino-cochlea	15	Cochlea rugosa	51
Buccinum	1	Cochlea simpliciter dicta	63
Chama	129	Cochlea turbinata	[-8] 103
Chama Glycymerides magna Rond.	115	Cochlea umbilicata	59

[f.84][11]

[10][f.81v] Cochlea auriculata, eadem qæ umbilicata. 59
Ear-shaped Cochlea, the same as Cochlea umbilicata, no.59.
[11][f.83v] Concha Arborigena. p.115
Concha aborigena.

Concha imbricata	111	Concha Veneris cylindroides	89
Concha margarit-ifera	129		
Concha Persica major	79	Echino-purpura buccinites	17
Concha Persica terebrata	81	Echino-purpura rostrata	19
Concha rugosa recurvi-rostra	135	Echinostracum	113
Concha tenuis	135	Echinus	149
Concha triquetra	133	Gaideropoda	113
Concha Veneris	87		

Mytilus	125	Trochus compressus [-Trochus Fimbriatus] [-]	49
Nautilus	73	Trochus vulg. S. mucronatus	47
		Turbo	39
Nerita	65	Verticillus	49

[85r, 86r, 87r, 88r, 89r, 90r blank]

[f.84r]

		Ostrea foraminosa	113
		Ostreo congener striata rubra	Ibid.
Margaritæ	125	Ostraco-poterion	55
		Patella	143
Murex cochleatus	37	Pecten	117
Murex fimbriatus	29	Pectunculus	121
Murex lævis	31	Pectunculus affinis	113
		Pinna	139
Murex rhomboides	35	Purpura rostrata	19
Murex tuberosus	25	Solen	139
Musculus	125	Strombus	47

151

VIRI CLARISSIMI MARTINUS LISTER M.D. CONCHÆ ET FOSSILLIA QUÆ IN HISTORIA ANIMALIUM ANGLICARUM DESCRIBUNTUR

Shells and fossils which are described in the *Historiæ Animalium Angliæ* of that distinguished man, Martin Lister, MD

Transcribed by Julia White, translated and annotated by Arthur MacGregor

Ashmolean Museum, AMS 19, compiled 1683. Vellum-bound octavo notebook, inscribed on the cover 'Viri Cl: M. LISTER M.D. Conchæ & Fossilia quæ in Historia Animalium Anglicarum Describuntur. Sen^ris Proc^ris Pars altera'. 28 folios, 200 by 158 mm, 19 of them blank.

By its sub-title, 'Sen^ris Proc^ris Pars altera', the text in this volume is identified as forming an annexe to the Book of the Senior Proctor (AMS 7: see pp. 125-51); it records in detail the gift made by Martin Lister (*c*.1638-1712) in the Museum's founding year of 1683.

From this very earliest phase of the Ashmolean's establishment, Lister was a frequent and generous benefactor to the new institution, second in importance only to Ashmole himself (see, for example, p. 5). Arthur Charlett was later to recall that Lister had been at that time 'very familiarly intimate' with Robert Plot, the Museum's first keeper, and indeed Charlett went so far as to suggest to Lister that 'it was your Letters, Gifts and offers that encouraged the then V[ice] C[hancello]r and B[isho]p Fell [then Dean of Christ Church] to undertake the erecting that Noble Building, so that to you is due our Thanks for every thing belonging both to the Fabric, Contentes and Uses thereof' (MacGregor and Turner 1986, p. 640). Within a year of its opening, Edward Chamberlayne confirmed that among the 'several worthy persons' who had enriched Ashmole's foundation was 'the learned Martin Lister, Dr. of Phys., who has presented the University with a larg cabinet of natural rarities of his owne collection and of several Romane antiquities, as altars, medalls, lamps, etc. found here in England', and when the Museum was visited by Ralph Thoresby in 1684 he was shown there a special cabinet, the 'Scrinium Listerianum', in which some part of this collection was exhibited (M. Welch, in MacGregor 1983, p. 60). Doubtless the display would have included at least some of the material listed here, comprising the very specimens that Lister had described in his *Historiæ Animalium Angliæ* of 1678; the gift included also Lister's notes, the present manuscript catalogue and a copy of the printed volume itself to which reference is made by the page numbers recorded in the following text.

In time the friendly terms that Plot had enjoyed with this important benefactor were to be perpetuated in the mutual respect and admiration that developed between the august Lister and the young assistant who eventually succeeded Plot in the keepership, Edward Lhwyd. At his death in 1712, Lister made a final gift to the Museum in the form of the bequest of his library and of the copper plates from which the illustrations in his *Historiæ* had been printed.

The catalogue is prefaced by the transcript of a letter from Lister to Plot, announcing the dispatch of the cabinet full of specimens to Oxford, and by a much later insertion of 1796 to the effect that the specimens had been removed from display by the late keeper (i.e., William Sheffield, keeper 1772-95). These two records effectively mark the beginning and the end of the institutional history of this exceptionally important element of the Ashmolean's historical collections. It is noteworthy that Lister readily acknowledges in his letter the unremarkable nature of some of the specimens (many of which were gathered locally in Yorkshire or in the Oxford region), maintaining that 'even those common Things are not known till they are well distinguisht' - a precept that sets the scholarly tone of the new institution that had been founded on the basis of the Tradescant collection in which, by contrast, singularity had been estimated above every other consideration. The role of the Ashmolean as an active research laboratory is also alluded to in the analytical experiments that Lister anticipates will be carried out by Plot on certain of the specimens, in order to establish their true nature.

[2r]
Copy of D^r. Listers Letter to D^r. Plot with his Cabinet of Shells described in Hist: Animal: Angliæ; his Ores &c.

S:^r

I have Sent you a Small present to make in my name, and after your obliging manner to the most Illustrious Universitie of Oxford. It is a Collection of Certain English Things belonging to the Histories of Nature. I am not a little proud, If it is in my Power to Contribute to the musæum; w^ch I doubt not, but will in a Short time exceed even the most renown'd ones of Italy or Europe.
[2v]

There are many Things indeed in my Present which seem common; but yet those would take up much Time to collect; and even those common Things are not known till they are well distinguisht; & how difficult that is to do, those that Exercise themselves in these matters well understand. But yet I think I may affirm, that there are some things of value, because not to be Sampled for any price; I will not say, there is but one of the Kind, but I cannot tell, when any one shall be so happie as to light upon them again.

Together with the Cabinet I have Sent a Catalogue, in which are some notions about them. & I had willinglie furnish'd it out, but that I

cannot well part with some things under present Consideration, they are so necessary to my notes: but if I understand this to be welcome, I shall not onlie adde the remainder of my Stores, but, if the Emptie Cabinet be returned me doe hope to fill it with new ones, youle find the Catalogue in the first drawer, the Key with it & two Books are [-\put] w^th the rest. I am very well pleas'd, you are examining (as you told me) the Figures of the Crystalls of Salts, that I may, in [? if] what I have done in the Kind be found true, or corrected by [-\so] good /a\ Hand where I have err'd.

[3r]

I pray add this to the rest of yo[ur] Obligations, if you will get the Iron ores, (w^ch I have sent) or any w^ch you have (w^ch may be done in a little quantity in Small covered Crucibles) w^ch are not in my Collection Carefullie calcined or Nealed, and the time noted, when they first begin to own y^e Loadstone. It will be for my Credit & our Country Man Gilberts, for on this, his Account of the Loadstone very much depends, and therefore he is very Cautious & particular in the manner of Calcination, he requires 12 Hours in the Calcination, but I have known some take 24 Hours, before they would acknowledge the Loadstone. Our Curator now is so very idle & conceited, y^t, altho' I sent up 17 ores ready prepared, yet I find they are yet prejudiced & believe I Imposed upon them, & those y do not, begin generally to think that all mineral Bodies whatsoever will yeild to [any] Loadstone after calcination. but I doubt not if the Experiment be Carefully tryed, they will find neither true, for I have purposely had some stones 5 days & as many Nights in the fire, without gaining any thing upon them, because not Iron.

As for the Experiment - stones participating of Iron I doe not think it will ever fail, for I tryed it twice in Yorkshire, besides the Superficial tryal I made of a half calcined terra dat - before the Society, and at our

[3v]

trial, from a Noe great stone I had above 30 graines of Iron, Tho' I say I think we never will fail yet the brownest or most Ocre like are to be made Choice of for this Experiment where they are to be had.

[4r]

Rerum Naturalium, Maxime Anglicanarum, Catalogus
Catalogue of natural specimens, mostly English

Quibus autem Scrinijs sive loculis quæque res dispositæ sunt, ex Numerorum Indice intelliges.
Which of the cabinets or drawers these items are distributed in can be identified from the numerical index.

Cat: Procuratoris [-junioris\Senioris] Pars altera.
Catalogue of the Senior Proctor: the other part

[4v]

Most of /the\ Articles mentiond in this Catalogue removed by the late Keeper
sig.^d 1796 -

[5r]

Cochlearum Marinarum in Orâ aliquâ Angliæ Maritimâ, Collectarum, Testæ
Sea-shells collected on some [unidentified] shores of England

Buccina Rostrata
Beaked Buccina

1 Buccinum rostratum læve, maximum, 7 minimum spirarum Historiâ An: Angl. p. 155. [-Q]
Very large, smooth, beaked Buccinum, the spire with at least seven coils. Lister 1678, p. 155.

2 Buccinum crassum rufescens, striatum et undatum. 156.
Thick, reddish Buccinum, striated and undulated. Lister 1678, p. 156.

3 Buccinum tenue et minùs ponderosum, Striatum et undatum
Delicate and light Buccinum, striated and undulated.

4 Buccinum angustius, tenuitèr admodum striatum, octo 157 minimùm Spi[-t\r]um ibidem.
Narrow Buccinum, very delicately striated, the spire with at least eight coils. Lister 1678, p. 157.

5 Buccinum minus crassum, albidum, asperum, intra quintam spiram finitum, litorale. 158
Small, thick Buccinum, white and rough, the spire ending at the fifth coil; from the sea-shore. Lister 1678, p. 158.

6 Buccinum alterum litorale, ex albido subviride, ore dentato eoque ex flavo levitèr rufescente. 159.
Another Buccinum from the sea-shore, white shading to greenish, the margin denticulated and yellow lightly shading to red. Lister 1678, p. 159.

Buccina productiora aperturâ planâ
Elongated Buccina with flat aperture

7 Buccinum Crassum duabus aut pluribus acutis, et inæqualitèr altis strijs in si[-..ic\ng]ulis spiris quæ Duodec[-e\i]m minimùm sunt, donatum, 160.[1]
Thick Buccinum with two or more points and with furrows of unequal height on the individual coils; at least twelve coils. Lister 1678, p. 160.

Buccina Compactilia, Sive Coch/le\æformia
Compressed or spiral Buccina

[5v]

9 Coch[-e\le]a fusca, fascijs creb/r\is a[-u\n]gustisque prædita. 162.
Dark-coloured shell, with groups of narrow bands. Lister 1678, p. 162.

10 Cochlea rufescens, fascijs maculatis, maximè ad [-\im]os orbes distincta.
Reddish shell with spotted bands, most clearly seen at the lowest rounded ends. [Lister 1678, p. 163].

Neritae
Sea-snails

[1][f.4v] 8 Buccinum 9 spirarum fasciatum funo-rufescens
Buccinum, dark red and banded, with nine coils.

11 Nerita ex fusco viridescens, aut ex toto flavescens.

Nerita (Sea-snail), dark-coloured shading to greenish; or at any rate, with an all-over yellowish tinge. *[Probably Littorina littoralis L.].*

12 Nerita fasciatus, [-\unic]â latâ fasciâ insignitus, cæt[-\e]rùm subfuscus ex viridi. 165

Banded Nerita (Sea-snail), distinguished by a single broad band, green shading to dark. Lister 1678, p. 165.*[Probably Littorina littoralis L.]*

13 Nerita reticulatus ibidem.

Reticulated Nerita (Sea-snail). Lister 1678, p. 165.

14 Trochus albidus major, maculis rubentibus distinctus 6. minimùm Spirarum. 166.

Large, white Trochus (Sea-snail), marked with reddish spots; the spire with at least six coils. Lister 1678, p. 166. *[Probably Gibbula magus L.].*

15 Trochus minor/,\ crebris strijs fuscis, et transverse et undat[-\i]m dispositis, donatus ibidem.

Small Trochus (Sea-snail) with repeated striations, undulating and arranged transversely. Lister 1678, p. 166.

16 Auris Marina quibusdam &c.167

Sea-ear. Lister 1678, p. 167. *[Haliotis tuberculata L.].*

17 Concha Ven[-o\e]ris exigua alba striat[-æ\a]. 168.- d. \\No. 17. supplied.-//

Venus shell, delicate, white and striated. Lister 1678, p. 168.

18 ... [-\E]chinus ...²

Echinus (Sea-urchin).

[6r]
Loculus 2.ᵈᵘˢ
Second drawer

19 Concha longa &c. (2) 170

A long Concha. Lister 1678, p. 170.

20 Concha quasi rhomboides &c. 171

Concha, almost rhomboid in outline. Lister 1678, p. 171. *[? Arca tetragona Poli].*

21 Pholas ... Deest. 171

Pholas (bivalve); missing. Lister 1678, p. 171. *[? Pholas dactylus].*

[-**22** Concha tenuis 174]

Delicate Concha. Lister 1678, p. 174.

22 Concha è maximis rotundiuscula, admodū crassa

Concha of the most rounded kind, very thick. [Lister 1678, p. 173].

23 Concha tenuis &c. 174.

Delicate Concha. Lister 1678, p. 174.

24 Concha crassa &c 174.

Thick Concha. Lister 1678, p. 174.

25 Concha parva levitèr rubens 175.

Small Concha, pale red. Lister 1678, p. 175.

26 Ostreum Vulgare Majus. 176.

Large common Oyster. Lister 1678, p. 176.

27 \\э∈// Ostreum parvum v[-\e]lu[-\t]j striatum rufescens. 181. \\d//.

Small Oyster, reddish and looking as though striated. Lister 1678, p. 181. *[? Chlamys sp.].*

28 Musculus ex cæru[-\l]eo niger. 182.

Mussel, blue shading to black. Lister 1678, p. 182. *[? Mytilus edulis L.].*

[6v]
Loculus tertius
Third drawer

29 Pecten Maximus. 184.

Pecten (Oyster) of the largest kind. Lister 1678, p. 184. *[Pecten maximus L.].*

30 Pecten tenuis, maculosus 185.

Delicate Pecten (Oyster), covered with spots. Lister 1678, p. 185.

31 Pecten in-equalis &c 186.

Pecten (Oyster), the valves of unequal size. Lister 1678, p. 186.

32 Pectunculus maximus [-\ro]stro acuto. 187.

Pectunculus (Ark-shell) of the largest kind, with a pointed beak. Lister 1678, p. 187.

33 Pectunculus echinatus. 188.

Spiny Pectunculus (Ark-shell). Lister 1678, p. 188.

34 Pectunculus Vulgaris. 189.

Common Pectunculus (Ark-shell). Lister 1678, p. 189.

35 Tellina in Ambitu [-\ser]rata &c. 190.

Tellina (bivalve), serrated around the margin. Lister 1678, p. 190.

36 Concha lævis &c. 191.atque hæc quoque Pholas est.

Smooth Concha (bivalve); this too is a kind of Pholas. Lister 1678, p. 191.

37 Concha longissima, sole[-\a] dict. 192. [-1 Deest]

Very long Concha (bivalve), called 'solea'. Lister 1678, p. 192.

38 Concha, aspera ex parte dimidiâ, ex altera lævis &c. ibid. atque hæc Pholas est, ut in appendice ostendam.

Concha (bivalve), one half of which is rough and the other smooth; this too is a Pholas, as set out in Lister 1685 [p. 44].

39 Concha candida &c atque hæc quoque Pholas est. 193. \\Deest.//³

White Concha (bivalve); this too is a Pholas. Lister 1678, p. 193.

40 Patella maxima Striata.

Large striated Patella (Limpet). [Lister 1678, p. 195].

40 Patella minima &c. vide Appendicem.

Small Patella (Limpet). See Lister 1685 [p. 38].

41 Balanus ... [-deest.]⁴

Balanus (Barnacle).

41b Muricis Marmorei fragmentum.

Fragment of Murex marmorea (snail).

[7r]
Loculus 4ᵗᵘˢ
Fourth drawer

²d

³fract:
⁴[-D]

Cochlearum Terrestrium, Anglicanarum Testæ &c.
Shells of English terrestial snails, etc.

42 Cochlea cinerea, Maxima Historiæ Animal. Ang. p. 111.[5]
Large, ash-grey Snail. Lister 1678, p. 111.

43 Cochlea vulgaris hortensis Major. 113.[6]
Large, common or garden Snail. Lister 1678, p. 113. [Helix aspersa Müll.].

44 Cochlea colore admodum varia 116.
Snail, very varied in colour. Lister 1678, p. 116.

45 Cochlea maculata, &c. 119.
Spotted Snail. Lister 1678, p. 119.

46 Cochlea elegantèr striat[-\a] cum Bellicul[-\i]s. ibid.
Snail, elegantly striped, with []. Lister 1678, p. 119.

47 Buccinum exiguum, mucrone obtuso &c. 121.
Little Buccinum, with a blunt point. Lister 1678, p. 121.

48 Buccinum exiguum, mucrone acuto &c. 122.
Little Buccinum, with a sharp point. Lister 1678, p. 122.

49 Buccinum rupium &c. ibidem.
Buccinum from the cliffs. Lister 1678, p. 122.

50 Trochilus Sylvati[-\cus] ... deest.
Forest Trochilus (Ear-shell).

51 Buccinum pullum &c - 123. Vide Figuram in Appendicem.
Dark-coloured Buccinum. Lister 1678, p. 123; see illustration in idem, 1685.

52 Buccinum pellucidum &c. 124.
Translucent Buccinum.

53 Cochlea sinu ad umbilicum exiguo [-\circin]at[-\o], &c 125.[7]
Small shell with an encircling fold at the umblicus. Lister 1678, p. 125.

54 Cochlea fasciata Ericetorum. 126.
Banded Field-snail. Lister 1678, p. 126. [? Helicella itala L.].

55 Cochlea Sylvatica &c. ibidem
Forest-snail. Lister 1678, p. 126.

56 Limax ater.
Black Limax (Slug).

57 Lapides execti è Limace Cinereo Maximo.
Stones cut out from a very large ash-grey Limax (Slug).

[7v]
Loculus 5tus

Cochlearum Fluviatilium Anglica/na\rum Testæ
Fifth drawer: shells of English river snails

58 Cochlea Maxima Nigricans &c. Hist. An. Angl. pag. 133
Very large, black Snail. Lister 1678, p. 133.

59 Cochlea parva subflava, intra 5 spiras finita. 135.
Small yellowish Snail, with five coils. Lister 1678, p. 135.

60 Nerita fluviatilis &c. 136

River Nerita (Snail). Lister 1678, p. 136. [Theodoxus fluviatilis L.].

61 Buccinum maximum &c. 137.
Very large Buccinum. Lister 1678, p. 137.

62 Buccinum Minus, fuscum &c. 139.
Small, dark-coloured Buccinum. Lister 1678, p. 139.

63 Buccinum, testæ aperturâ omnium maximâ[-] 139.
Buccinum, the aperture of the shell the biggest of all. Lister 1678, p. 139.

64 Buccinum minùs pellucidum trium spirarum. 140.
Buccinum, less translucent, with three coils. Lister 1678, p. 140.

65 Buccinum pellucidum trium Spirarum, a Sinistrâ[-] in dextram convolutarum. 142.
Translucent Buccinum (bivalve), with a spiral of three dextral coils. Lister 1678, p. 142.

66 Cochlea pulla, ex utraque parte circa Umbilicum Cava. 143
Dark-coloured snail, the area around the umbilicus hollowed-out. Lister 1678, p. 143.

67 Cochlea 4 spirarum, limbo insignita. 145
Snail with four coils, with a marked keel. Lister 1678, p. 145.

68 Cochlea exigua, Sine limbo, 5 spirarum, Ibidem.
Little Snail, without a keel, with five coils. Lister 1678, p. 145.

[8r]
Loculus 6tus.

Musculorum Fluviatilium Anglicanorum Testæ
Sixth drawer: shells of English river mussels

69 Musculus ingèns, niger, vide Appen. fract. 146
Prodigious black Mussel; broken. See Lister 1678, p. 146; idem 1685, [p. 15].[Margaritifera margaritifera L.].

70 Musculus [-angustior, validus &c. 149.\major, testâ ad modum tenui.] \\Fract.//
Large Mussel with a very delicate shell; broken. Lister 1678, p. 149. [? Unio sp.].

71 Musculus a[-u\n]gustior, Validus &c. 149.
Narrow, robust Mussel. Lister 1678, p. 149. [? Unio sp.]

72 Musculus a[-u\n]gustior, Minor &c, Vide Appen.
Small, narrow Mussel. Lister 1685, [p. 17]. [? Unio sp.]

73 Musculus minùs tenuis, minor, latiusculus v. App. pag. 10
Smaller Mussel, less delicate and a little wider. Lister 1685, p. 10.

74 Musculus Exiguus, pisi magnitudine &c 150
Little Mussel, the size of a pea. Lister 1678, p. 150.

75 Patella Fluviatilis. 151.
River-limpet. Lister 1678, p. 151. [Ancylus sp.].

76 Margaritæ, Cujusdam Musculi Fluviatilis. Vide quæ posui de his p. 149.
Pearls from some sort of River-mussel. See what I said on them: Lister 1678, p. 149. [Probably from M. margaritifera].

[8v]
Loculus 7mus Cochlitae[-] Angliae.

Cornua Ammonis, quibusdam di[-\ct]a

[5]D
[6]D
[7]D

Seventh drawer: English snails, and so-called ammonites

77 Ammonis Cornu Maximum; olim à me Missum, et jam in Musæo Oxoniensi Servatum H.A.A. p. 205
Very large Ammonite; once sent by me and now lodged in the Ashmolean. Lister 1678, p. 205.

//x\\ Ejusdem Cor[-um\nu] Ammonis Minimus Lapis. 205.
A tiny Ammonite, of the same kind, of stone. Lister 1678, p. 205.

78 Ammonis Cornu, spinâ in ambitu emin[-\ent]e strijs lateralibus dimidiatis &c. ibidem.
Ammonite, with a prominent spine around the edge and with lateral striations over one half. Lister 1678, p. 205.

79 Am: Cor: alterum, spinâ in amb. Eminente, strijs ex toto &c. 207.
Another Ammonite, with a prominent spine running around the edge, striated all over. Lister 1678, p. 207.

80 Am: Cor: Strijs lateralibus in medio ambitu, sive dorso ad acutos angulos concurrentibus.
Ammonite, with lateral striations around the edge, running together to form acute angles along what could be the back. [Lister 1678, p. 208].

81 Am: Cornu, 5. a[-\n]fractuum, strijs dorsum traijcientibus et ad latus mutuò ad plicitis &c. 209. Hujus tres varietates mitto; aliasque plurimas vidi, N.B. Hujus generis lapides prægrandes in Mu[-\sæo] S.R. Servantur.
Fifth Ammonite (broken ?), with striations across the back and joining up at the sides. I sent three varieties of this type of ammonite, and I have seen many more. Very large examples are kept in the Museum. Lister 1678, p. 209.

82 Am̃onis cornu reticulatum &c 213. [-\d]
Reticulated Ammonite. Lister 1678. p. 213.

83 Suturæ conspicuæ et Diversæ; quarum mentionem feci in App.
Ammonite, with the sutures conspicuous and varied, of which mention is made in Lister 1685, [p. 43].

[9r]
Loculus. 8.vus
Lapides Turbinati
Eighth drawer: turbinated stones

84 Buccinites Magnus Ventricosus, et strijs, et rugis quibusdam inordinatis donatus. p. 214.
Large swelling Buccinites, with striations and some irregular furrows. Lister 1678, p. 214.

85 Buccinites exiguus, striatus &c. p. 215
Little Buccinites, striated. Lister 1678, p. 215.

86 Buccinites lævis, Sublividus, spiris octonis ar[-\ct]e inter se conjunctis. 217.
Smooth Buccinites, bluish, with a spiral of eight closely interlocking coils. Lister 1678, p. 217.

87 Buccinites Majusculus, lævis, alvidus, spiris numerosis, inter se haud contiguis. 216.
Large, smooth Buccinites, white [], with numerous coils not touching each other. Lister 1678, p. 216.

88 Cochlites lævis, ore exiguo ad [-\a]mu[-\ssim] rotundo. 218
Smooth Cochlites, with a small, perfectly round aperture. Lister 1678, p 218.

89 \\x// Echinites orbiculatus, depressus, silice[-\u]s, quibusdam ombria. /dictus.\220.
Rounded Echinites (Sea-urchin), flattened and silicious, called ombria by some. Lister 1678, p. 220.

//x\\ **89a** Echinites Pileatus - siliceus. depressus.
Echinites Pileatus (Sea-urchin), somewhat flattened, and silicious.

90 Echinites vertice planiore, strijs è Tuberibus quibusdã, grandioribus conflatis donatus. 221.[8]
Echinites (Sea-urchin), flattish at the top, with stripes radiating from a large swelling. Lister 1678, p. 221.

100 Echinites è lapide selenite &c 223.[9]
Echinites (Sea-urchin), from selenite. Lister 1678, p. 223.

101 Belemnites niger, maximus &c 226.
Very large, black Belemnite. Lister 1678, p. 226.

102 Belemnites minimus, instar succini pellucidus, Quibusdam Lapis Lyncurius dictus. 227.
Tiny Belemnite, resembling translucent amber; called by some tourmaline stone. Lister 1678, p. 227.

[9v]
Loculus 9nus
Ninth drawer
Lapides Bivalves, læves
Fossil bivalves, smooth

103 Conchites Major, rugosus &c 229.
Large, rough Conchites. Lister 1678, p. 229.

104 Ejusdem Lapidis interna Facies.
The same, the interior mineralized.

105 Conchites lividus, è rupibus aluminosis. 230.
Bluish Conchites, from aluminous rocks. Lister 1678, p. 230.

106 Conchites levitèr rugosus, depressior &c. è F[-\erri]-fodinis. 231.
Slightly rough Conchites, and flattened, dug up from an iron mine. Lister 1678, p. 231.

107 Conchites albidus, oblongus et a[-u\n]gustus. 232.
White Conchites, narrow and elongated in outline. Lister 1678, p. 232.

108 Conchites, margine lato &c 233.
Conchites with a broad ledge. Lister 1678, p. 233.

109 Conchites rugosus &c. [-\è] Silice propriè sic dicto 234.
Rough Conchites, from flint to be precise. Lister 1678, p. 234.

110 Ostracites Magnus, niger admodum concavus, ex agro Hunt[-\i]ntoniensi. 236.
Large Ostracites, black and very concave, from Huntingdonshire. Lister 1678, p. 236.

111 Ostracites Maximus cinereus, minùs concavus r[-\u]pium - ad Philo.[10]
Very large, ash-grey Ostracites, less concave in form, from the cliffs at Philo.

112 Ostracites minimus, cardine augustiore &c 238.
Tiny Ostracites, with a narrow hinge. Lister 1678, p. 238.

[8] D
[9] d
[10] d

113 Conchites anomius, rostro adunco &c. 238. [-\inte]ger sive biforis: quod admodu rarò occurrit. ejus alt[-\era] tantum pars concav[-\a]. opercul[-e\u]m

Conchites (of a different kind), with a hooked beak; intact, with both valves - a rare occurrence. Only one part - the lid - is concave. Lister 1678, p. 238.

114 Conchites anomius, rostro pertuso &c 240.

Conchites (of a different kind), with a perforated beak. Lister 1678, p. 240.

115 Conchites anomius, Compressior. 241.

Conchites (of a different kind); locked together. Lister 1678, p. 241.

[10r]

Loculus. 10.^{mus}

Lapides bival[-\v]es, læves
Tenth drawer: Smooth fossil bivalves

116 Solenites, Vide Append. p. 22. [-deest]

Solen. See Lister 1685, p. 22.

117 Conchites quidam non descriptus Ejusdem Conditor Matrix.

Conchites of some type not yet described [in print], set in a matrix of the same.

[10v]

Loculus. 11^{mus}

Lapides bivalves, Striati.
Eleventh drawer: striated fossil bivalves

118 Pectinites rarioribus strijs. 242.

Pecten (Oyster), with very few striations. Lister 1678, p. 242.

119 Pectinites Membranaceus &c 243.

Membranous Pecten (Oyster). Lister 1678, p. 243.

120 Pectinites Minor Strijs capillaribus &c 243.

Small Pecten (Oyster), with hairy striations.

121 Pectunculites den[-\s]issimè striatus. 245.

Pectunculus (Ark-shell), very dense and striated. Lister 1678, p. 245.

122 Pectunculites cinereus &c ibidem.

Ash-grey Pectunculus (Ark-shell). Lister 1678, p. 245.

123 Pectunculites albidus &c. è Cra[-\t]ace[-\is] montibus 246.

White Pectunculus (Ark-shell), from the chalk hills. Lister 1678, p. 246.

124 Pectunculites subsphæricus &c 247. N.B. id genus ingent[-ium\em] lapidem olim Oxoniam Misi.

Sub-spherical Pectunculus (Ark-shell). n.b.: I have already sent a large specimen of this type to Oxford. Lister 1678, p. 247.

Oxoniam misc.
Oxford miscellanea

125A Pectines from Stock. Cra[]

Pecten (oyster) from Stock.

125 Pectunculites anomius, cuj insignis qua[e]dam Lacunca[-m] per Medi[-\u]m dorsum rectè procedit. 247.

Pectunculus (Ark-shell), of a different kind, which has a distinctive hole straight through the middle of the back. Lister 1678, p. 247.

126 Pectunculites Anomius, Trilobæ/u\s. 249.

Pectunculus (Ark-shell), different kind, with three lobes. Lister 1678, p. 249.

127, 128 Two Copper Plates, of the Entrochi and the Asteriæ described in *Phil.Trans.* N° 100. & N° 112.

LIBER DOMINI PROFESSORIS REGII MEDICINÆ
The Book of the Regius Professor of Medicine
Transcribed by Julia White, translated and annotated by Arthur MacGregor

Ashmolean Museum, AMS 10, compiled c.1755. Leather-bound quarto volume; leather label on cover reading (erroneously) 'LIBER DÑI PRINCIPALIS COLL ÆNEI NASI', all within tooled borders; identified correctly in manuscript on the flyleaf, 'Liber Prof. Reg. Medicæ'. 124 folios, 235 x 175mm, many of them blank.

The original Book of the Regius Professor of Medicine, compiled by Edward Lhwyd c.1685, had concerned itself largely with specimens of materia medica appropriate to the Professor's interests, including a number of items whose origins could be traced back to the Tradescant catalogue of 1656. Almost a century after its arrival in Oxford, much of this material evidently was in a state of decay or had already perished. The present text, however, contains verbatim accounts of several fragments of earlier records, amongst which at least one (p. 161, no. 105), with its mention of a specimen of wood given in 1615 to Sir Thomas Roe by an apothecary at the court of the Great Moghul and then given to 'me', was certainly written by John Tradescant the Elder; others may originate from the same source.

Ovenell (1986, p. 170) suggests that it was in 1775, or perhaps in 1772 when Dr William Vivian succeeded to the chair, that this recension was compiled. The new volume brought together disparate groups of objects previously found in the books allocated respectively to the Dean of Christ Church and to the Junior Proctor. Ovenell judges it 'a slender and arbitrary selection the purpose of which is not now clear unless it represented an attempt to bring into juxtaposition and exhibit some scattered parts of the collection which might be considered to give a chronological conspectus, however incomplete, of human development.' The same author (p. 121) attributes the addition of the popular names to Lhwyd's Latin original to John Whiteside. As to the remaining materia medica, by the time a further eighty years had passed and J.S. Duncan had succeeded to the keepership, he had to report to the Visitors that what remained of the materia medica in the Catalogue of the Regius Professor of Medicine was so fragmentary as no longer to merit notice.

The items recorded here begin with specimens from the animal kingdom illustrative of a range of beliefs that have failed the test of time, before progressing to plant varieties whose curative powers in many cases continue to be recognized. Even the human skull with which the sequence opens may be counted here, for the *Pharmacopœia* of Nicholas Culpepper (1702, p. 69) recommends as a cure for palsies and falling-sickness the powdered skull of a man mixed with 'betony water', and, in keeping with the Ashmolean specimen, he specifies that it should never have been buried. Explanations for several other animal-derived specimens are also to be found in the *Pharmacopœia*: dried foxes' lungs (*pulmones vulpis*), for example, are deemed (p. 68) 'an admirable strengthener to the lungs', while beaver oil (*castoreum*) is recommended as an antidote to poisonous bites and as an aid to childbirth, besides which 'it expels Wind, easeth Pains and Aches, Convulsion, Sighings, Lethargies', etc. The presence here of an elk's hoof is explained by its efficacy in curing cramp (although Culpepper (p. 69) quotes authority that 'it must be the Hoof of the Right Foot behind'). Among the more surprising inclusions is an entry for moss from 'the Stones at Stonehinge in Wiltshire' – hitherto unrecorded amongst the materia medica. The enigmatic 'Virgin's wax' (p. 164) is more properly virgin wax, traditionally the purest form of beeswax, produced by bees in their first season.

The level of recording is very varied, from simple Latin names, to entries for plants in particular to which English translations have been added, to the corals for which extended accounts have been compiled including references to published sources. While most (if not all) of these may have entered the collection in the guise of materia medica, their taxonomic features evidently attracted early curatorial attention. A consistent deviation in spelling in these passages, in which u is frequently omitted following q, suggests that Lhwyd's original texts were faithfully transcribed in the eighteenth century, for his addiction to this practice had been a source of irritation to his keeper, Dr Plot (Ovenell 1986, p. 42). Occasionally (e.g. pp. 165, no. 3; 169, no. 108) we find Lhwyd's personal observations interpolated in the text.

[1r]
Liber Prof. Reg. Medicæ

[2r-5r blank; 6r]

Materia Medica Officinarii
Medicinal materials of the Dispensary

De Partibus Animalium &c
Parts of animals, etc

1 Cranium humanum inhumatum.
Human skull which has never been buried.

2 Mumia.
[Powdered] mummy.

3 Ungula Alcis. \\[-deest]//
Elks hoof.

4 Rasura Ebonis.
Shaving of Ebony.

5 Rasura Cornu Cervi.
Shaving of a Stag's antler.

6 Bezoarticum Orientale.
Oriental mineral bezoar.

7 Bezoarticum Occidentale.
Western mineral bezoar.

[-8 Moschus]
Musk

9 Cornu cujusd. animalis exotici frustulū. Johanni Tradescantio donabat qidam D.ʳ Borle.[-]

A small portion of the horn of some exotic animal. A certain Dr Borle gave it to John Tradescant.

10 Hepar Lupi.
Wolf's liver.

11 Pulmones Vulpis.
Fox's lungs.

12 Castoreum.
Beaver oil.

13 Lapis animalis. \\forte Apri.//
Stone from an animal (perhaps from a wild boar).

14 Lapis mana[-\t]i, est forte lapis Manati, qui est os capite exemplu
'Manali' stone, perhaps the Manatee stone, a type of bone found in the head [of the Manatee].

15 Id^m. prorsùs.
Another stone, exactly the same.

16 Id^m. coloris rufescentis.
Another of the same, reddish in colour.

17 Glans Penis Crocodili.
Crocodile penis.

[7r blank; 8r]

18 Sperma Ceti.
Spermaceti.

19 Ichthyocolla.
Isinglass.

20 Dentes Canis Charchariæ. \\(Shark)//
Teeth from a White Shark.

21 Lapis Canis carchariæ. qd?
Stone from a White Shark; which?

22 Blattae [-]. Bizaciæ.
Cockroach wings.

23 Aliæ angustiores longiusculæ. \\[-]//
Other [wings], narrower and a little longer.

24 Cantharides. \\x dest.//
Beetles ['Spanish flies'].

[9r-12r blank; 13r]

De Vegetabilibus
Vegetable substances

Radices
Roots

25 Acorus verus. \\(Sweet-Cane).//¹

26 Althæa. \\(Marshmallows.)//

27 Aristolochia longa. \\(Long Birthwort)//

28 Aristolochia rotunda. \\(Round Birthwort)//

29 Asarum. \\(Asarabacka)//

30 Ben album. \\(White Ben, al: Spatling Poppy)//

31 Ben[-] rubrum. \\(Red Ben, al: Sea Lavender)//

32 Radix Bistortæ [-radix B...] \\(Snake weed)//

33 Radix Brusci. \\(Butchers Broom)//

34 Calamus Aromaticus. \\(Sweet-Cane)//

35 Radix Chinæ. \\(China-Root)//

36 Eadem.

37 Curcuma. \\(Turmerick)//

38 Cyclamen. \\(Snow-bread)//

39 Cyperus longa. \\(Cyprus)//
Long cypress

40 Cyperus rotunda.
Rounded cypress.

41 Cyperus pulverizata.
Powdered cypress.

42 Doronicū Romanū. \\(Leopards Bane-)//

42A. Radix Dictamni \\(Dittany)//

[14r blank; 15r]

43 Doronicum Romanū. \\(Leopard's-Bane)//

44 Eryngium. \\(Erȳgo, or Sea Holly) (2)//

45 [-Galanga\Gentiana]. \\(Gentian Root.)//

46 [-Gentiana\Galanga] \\(Galangal)//

47 Heliotropium. \\(Turnsole, or Waterwort.//

48 Helleborus albus. \\(White Hellebore)//

49 Helleborus niger. \\(Black Hellebore)//

50 Hermodactylus. \\(Hermodactylus)//

51 Lanquash /major\. qd.? Spica Nardi \\([-\Spikenard.])//

52 Nardus.
Spikenard

53 [-\Iris] \\(Orrice) 53 Iris floren://

54 Pœanæ \\(Piony)//

55 Ph[-y\u] maj. \\(Valerian)// *[bracketed with 56]*

56 Ph[-y\u] minor.

57 Polypodium yercinum. \\(Polypody)//

58 Pyrethru majus. \\(Pellitory)// *[bracketed with 59]*

59 P[-h]yrethrum minus.²
Pellitory

60 Rhabarbarum. \\(Rhubarb)//

61 Rubia Tinctorū. \\(Madder)//

62 Serpentaria. \\(Snake-Weed//

63 Tormentilla. \\(Tormentil)//

64 Turpethum: Turbith.
Turpentine [?].

[16r]

65 Radix Chinæ. (Gingsang dict) DD: Cooper M.D. Oxon 1757:

¹A

²D

Chinese root known as ginseng. Given by Dr Cooper of Oxford, 1757.

[16v]

Caps: 3
Third drawer

[17r]

Folia, caules et Flosculi
Leaves, stems and florets

65 Of these we found this account, in yᵉ Paper w.ᶜʰ contain'd them. The tree that bears these is tall and streight Like a mast hath noe limbs only a plume of long leaves at the top. These tooth picks grow naturally just as you see and as thick as they can stand just as as [*sic*] the bristles of a hedghog.

66 Of these the paper gives this account. The Leaf of a tree that had life.

67 Tea.

68 Balaustia \\(Balaustines)//

69 Chamepithos. \\(Ground pine)//

70 Cetterack. \\Ceterack Spleenwort//

71 Cuscuta. \\(Dodder, or Devils Gutts)//

72 Capillus veneris. \\(Maiden Hair)//

73 Dictamnus Cretica. \\(Dittany)//

74 Epithymum. \\(Dodder of Thyme).//

75 Mala Batrum. \\(Indian Leaf)//

76 Polium montanū. \\(Poly-Mountain)//

77 Nardus Celtica \\(Spike nard)//

78 Sena Alexandrina \\(Sena)//

79 Scordium Cretense. \\(Water Germander)//

80 Schœnantum \\(Squinanck)//

81 Juncus indicus orientalis. Of a great Vallue. \\(Sweet Rush)//

81a Xylum se: Leuconium \\(Cotton)//

[18r blank; 19r]

Cortices
Barks

82 Costus amarus \\(Costmary)//

83 Cinamonium album. \\(Cinnamon)//

84 Cassia lignea. \\(Cassia.)//

85 Cinamonium of S.ᵗ Christophors.
Cinnamon of St. Kitts

86 Cort: Guiaci \\(pock-wood.)//

87 Cort: Mandragoræ. \\(Mandrake)//

88 Cort: Tammarissee. \\(Tamarisk)//

89 Cort: Winteranus verus.
True Winter's bark.

89a Cort: Peruvianus \\(Jesuit's Bark.)//

Ligna
Woods

90 Lignum Aloes. \\(Aloes Wood)//

91 Idem.
The same.

92 Idem.
The same.

93 Lignum Asphaltum \\(Rosewood)//

94 Santalum Citrinum. \\(Citrin-Saunders)//

95 Santalum rubrum. \\(red.Saund[ers].ˢ)//[

96 Santalum album \\(White Saund[ers].ˀ)//

97 Lignum Persicum. \\(persic W[ood]:)//

98 Lignum Neph[-\ret]icum \\(Nephritic-Wood//

99 Lignum Rhodium. \\(Rosewood)//

100 Lignum Vitæ.

101 Snake wood.

102 Radix Sassaphrase. \\Sassafras//

103 Xylo balsamum.
Balsam wood.

104 Costus amarus. \\(Costmary)//

105 Of this we found this account, in the paper which contained it. In the years 1615 this wood was given to S.ʳ Thomas Row by on Apothicary in the great Maguls Court for a rare thing and unknown who hath given it to me.

[20r blank; 20v]

Caps: 4
Fourth drawer

[21r]

Gummata &c.
Gums, etc

106 Assa fœtida
Asa foetida (Devil's dung)

107 Burg... pitch
Burgundy [?] pitch

108 Benzoinum
Gum benzoin (Styrax benzoin)

109 Car[-r]abe \\[-]. (Amber)//

110 Cambogia
Gamboge

111 Chambogia
Gamboge

112 Catto. \\(Catechu)//

113 [-\Sarcocolla.] [-Quid?]
Penaea sarcocolla

114 Gū. [-Ænomi.] \\Anima.// \\[-]//

115 Gū. Arabbach.
Gum arabic.

116 Gũ. Lack. the good-sort.
Lacca.

117 Gũ. Hedderæ.
Ivy gum.

118 Gũ. Amoniæum.
Gum ammoniac

119 Gum̃ Lack the [-Shell][-Sheere][-\good] sort.
Lacca

120 Gum̃. Sandrach.
Gum sanderac

121 Gũ. Galbanum
Gulbaniflua gum (Ferula gummosa)

122 Gũ. Lack.
Lacca

123 Gũ. Guajacium.
Lignum vitae gum

124 Gũ. indigerum. Quid? \\Juniperi.//

125 Gu Tragga [-g\C]anthum.
Gum tragacanth

126 Gum [-Se....\Cerasi]
Cherry gum

127 [-Hiposistis.\Hypocistis.]
Hypocistis

128 Manna such as Israel had from heaven.

129 Manna Calabriæ

130 Manna

131 Mastick
Herb mastic

132 Minha

133 Mumia
[Powdered] mummy

134 Nardus Celtica
Celtic Spikenard

135 Olibbanum
Frankincense

136 Opium Thobaicum
Opium

137 Labdanum
Laudanum

138 Sanguis Draconis
Dragon's blood (Calamus draco)

[22r blank; 23r]

139 Sanguis Draconis
Dragon's blood (Calamus draco)

140 Sanguis Draconis the Lump sort.
Dragon's blood (Calamus draco)

141 Sanguis Draconis
Dragon's blood (Calamus draco)

142 Scamonia
Scammony

143 Scamony fine

144 Styrax Calamita
Storax

145 Storax calamita
Storax

146 Thus. frankincense
Frankincense

147 Turks Balsum

148 [-Terra Sigilatum. Quid.? \G... ignotũ.]
Terra sigillata ... from whence?

[24r blank; 24v]

Caps 5
Fifth drawer

[25r]

Fructus & semina
Fruits and seeds

149 Agnus Castus
Chaste tree

150 Sem: Am̄[-i\e]es veræ
Seeds of true Ammi

151 Cassia ffistula
Cassia (or Senna) pod

152 Cardamomum minus
Lesser cardamom

153 Cardamomum
Cardamom

154 Cardamomum majus
Greater cardamom

155 Sem: Carthami
Seeds of Safflower (or Bastard saffron)

156 Sem: Citrulli
Seeds of Colocynthis

157 [-Cocomoat\Cacaonut] of Maldivia
Coconut from the Maldives

158 Cocculus indicus
Berries of *Anamirta*

159 Coloquintida \\al Colocynthis)//

160 Co[-p\s]tus dulcis
Sweet costus

161 Cubebes
Fruit of cubebe vine

162 Sem. Cucurbitæ
Seeds of gourds

163 Sem: fæniculi dulcis
Sweet fennel

164 Grana paradi[-ce\si]
Grains of Paradise (or Guinea-grains)

165 G[-inny\uinea] Pepper. Cap[-acum\sicum]
Capsicum

166 Lari[-]x.
Larch

167 Myrabolanus indic[-us\a]
Indian balsam

168 Myrabolanus Beller[-ex\ica]

Belleric (or Bastard) balsam

169 Myrabolanus [-Rebbilus\Chebula]
Chebula balsam (Terminalia chebula)

170 Myrabolanus Citri[-\na]
Yellow balsam

171 Myrabolanus Embli[-c]a
Emblic balsam (Phyllanthus emblica ?)

172 Mecheac[-\a]n/a\ \\d//
Ipomea

173 M[-a\i]nneken nutmegs
Dwarf Nutmegs

174 M[-i\y]rt[-\l]le Berryes.

175 Nutmegg.

176 Nux vomica

177 Nux Cupressi
Cypress nut

178 Orig[-g]anum
Marjoram

179 Long pepper

[26, 27r blank; 28r]

180 St. Christophors pepper
St. Kitt's pepper

181 Sem: Petro Sel[-e\i]n[-æ\i] ma[-ss\c]edonic[-æ\i]
Seeds of Stone-parsley

182 Sem: P S[i\y]lly
Seeds of Fleawort [?]

183 Sem: Sesel[-i\e?]os
Seeds of Saxifrage

184 [-S\C]isers Red. \\(Cicer) Chiches//
Chick pea

185 [-S\C]isers white
White chick-pea

186 Sirie
Mogwort

187 Staph[-esa\is][-he.\agria] \\agria.//
Wild Stavesacre

188 Steckades. \\stæchai//
French Lavender

189 Sem: Thlasp[-e\i]os
Seeds of Cress

190 The fruit of the Pinan tree

191 Sem. ignota
Unidentified seeds

192 Sem: eadem.
Seeds of the same kind

193 [-Ignota] \\Bacc. Cheem ...//
Unidentified (dwarf Elder?)

194 /Siliquæ\ [-Cris]tæ Pavonis Breynij
Pods of Breyn's peacock

[29r blank; 29v]

Caps:6

Sixth drawer

[30r]

Plantae imperfectae
Plants without flowers or seeds

195 Agaricus
Larch fungus

196 [-\Jewes] Eares. \\Fungus Sambuci.//
Jew's ear fungus (Auricularia auricula-judae or Hyphodontia sambuci)

197 Corallina[-m]
Coralline

198 Mose from Ston-henge

199 The mose of the Stones at Stonehinge in Wiltshire

200 Muscus humanus
Human [skull] moss

201 Spunk

Metalla; metallica &c
Metals, minerals, etc

202 Folia alba \\Trim-foyle.//

203 Antimonium crudum.
Antimony

204 A/n\timonium præparatum. \\Vite. ⊙.ʲ//
Prepared antimony

205 Lead Red

206 Cerussa veneta
Venetian white lead

207 Cinnab[-\ar]is mineralis
Mercuric sulphide

208 Talcum aureum
Magnesium silicate

209 Vermillion. \\2//
Mercuric sulphide

209.[-A] [-Cerussa.]
\\209 b. Ceruss.//
White lead

Salia
Salts

210a Asbestos

210b Borax

211 Fflos æris.
Flowers of copper

212 [-An] Tartarum?
Tartaric acid

213 Cr[-\e]mor of Tartar
Cream of Tartar

214 Vitrolum Romanum
Copper sulphate

215 [-Idem forsan\Chrysocolla.]
Borax

[31r blank; 32r]

Bitumina &c.

Bitumens, etc.

216 Asphaltum
Asphalt

217 Gagates anglicanus
English jet

218 Ambarum
Amber

219 Stone pich

220 Flos Sulphuris
Flowers of sulphur

221 Rust of iron

222 Auripigmentum
Orpiment (yellow sulphide of arsenic)

223 Lead black

224 Virgins wax [-]

224b Sulphure Vive Italorum (Sulphur Earth-native) DD: Cooper M.D. Oxon: 1757.
Given by Dr Cooper, MD, of Oxford, 1757.

Lapides
Stones

225 Alumen plumosum. \\Asbestus.//

226 Asbestus

227 Lapis asbestus Amianthus Cyprianus. \\x Remov'd to the new Cabinets//
Asbestos stone, from Cyprus

228 Lapis Calaminaris
Mineral calamine

229 Christalli
Rock crystal

230 Corallium album
White coral

231 Corallium rubrum
Red coral

232 Lap. Smaragdus
Emerald

233 Gypsum

234 Granatus
Garnet

235 Lap. Hæmatites
Haematite

236 Lap. Hyacinthus. \\Amethystus Remov'd x//
Blue sapphire

237 Lap. Judaicus
Jew's stone

238 Lap. Lineis
'Linen stone' (asbestos)

239 Margos
Pearls [?]

240 Marmur album
White marble

241 Marcha sila aurea. \\x Remov'd to the new Cabinets//
Yellow ochre?

242 Talcum venetum
Venetian talc

243 Lapis [-\Rubri.] Granati
Garnet

[33r blank; 34r]

244 Petiola

245 Gypsum.

246 Lapis Saphiris
Sapphire

Boli; Terrae &c.
Clays, earths, etc

247 Lap. Tutia
Tuttia [Zinc oxide]

248 Bolus Armenius
Armenian clay

249 Terra Sigillata alba
White terra sigillata

250 Eadem terra alba[-]
More white terra sigillata

251 Terra Sigillata alba
White terra sigillata.

252 Terra Sigillata ru[b]ra
Red terra sigillata

253 Eadem.
The same

254 Eadem.
The same

255 Terra Sigilata rubra
Red terra sigillata

256 Eadem.
The same

257 Eadem.
The same

258 Eadem.
The same

259 Terra Sigillata.

260 Terra Sigillata.

261 Spodium.
Ashes.

[35r blank; 36r]

Frutices marini corallia, corallinæ, pori, alcyonia, &c
Plants of the sea, corals, corallines, madrepores, sponges, etc

1 Corallina cortice reticulato, maculoso, pupurascente C.B. Corallina reticulata plana purpurascens Park. p. 1298. Frutex marinus elegantiss. albus Corallium Nautis J.B. Rai. Hist. Plantarū pag. 67. Tom.1. Harum pleræque tunicæ tartareæ qæ corticis munere funguntur

purpurascunt, qædam albicant. Nonnullæ plant in varias lacinias divaricantur, C.h.e. flabella è crassiorib. ramulis flabellula alia utrinq̃ emittunt at pleræque Planæ Sunt. Frutex marinus elegantissimus Clusii in Exot.[3]

Coralline of Caspar Bauhin, the surface of which is reticulated, spotted and purplish in colour. The purplish flat reticulated coralline of Park. [?], p.1298. The very elegant *Frutex marinus*, or white sailor's coral of Ray (1686, p. 67). The darkish membrane, which serves as an outer covering, on most of these shades to purple, but on some it shades to white. Several 'twigs' branch out into smaller parts; [c.h.e.] fans from the thicker branches form other smaller fans on either side; most of the 'twigs' are flat. The elegant *Frutex marinus* of Clusius [1605, pp.120-1].

2 Corallina marina, corallinæ montanæ nostrati æmula An Kali Spec.

Marine coralline, imitating the corallines of our native mountains. Perhaps a kind of Kali.

3 Muscus marinus maj. argutē denticulatus Raij Hist Plant. Tom 1. pag. 78. Unde allatus sit, non constat; in Insula autem monensi copiosè nasci observavimus. Edw. Lh.

Greater marine moss, sharply toothed; see Ray 1686, vol. I, p. 78. From where it comes is unknown; however, we recall that we have seen great quantities of it growing on the island. Edward Lhwyd.

4 Fruticulus marinus compressus (Seu flabelliformis) densè ramulosus, tuberculosa crusta candicanti. Altitudo ejus dodrantalis plus minùs: nullâ nititur radice sed lapis adhæret lata basi Suffultus, ut marini [-] fere omnes. Truncus qà rupibus alligatur, pennæ anserinæ crassitiem vix attingit: et truncus et ramuli potiùs lati dicantur aut compressi, qàm rotundi vel teretes. Nulli ramuli [-pe] in caudice per duas a radice uncias; tum verò dextrorsū et sinistrorsū in ramos dispertitur. ramelli versus ramoru extrema prodeuntes, tenuissimi sunt et fibras qodammodo referentes. Candicantis corticis tubercula foraminibus

[37r blank; 38r]

pertusa sunt. Tota planta crustâ hac denudata, coloris anthracini est, Substantiæ corneæ.

Flattened (or fan-shaped) marine plant, with densely-packed branches and with a whitish knobbly surface. More or less 9 in tall; it has no root but a stone, supported on a wide base, is attached to it, as is the case with almost all marine plants. The part of the stem which is fastened to the rocks, is hardly as thick as a goose-quill; both the stem and the branches are described as broad and flattened rather than rounded or smoothed. No branches on the stem grow within 2 in of the root; then the stem divides into branches growing to the left and right. The little branches springing from the ends of the stems are very delicate and look a little like filaments. The little knobs on the whitish outer covering are perforated with holes. The whole plant, stripped off its outer coat, is coal-black in colour and like horn in texture.

5 v.ᵉ 2.

See no. 2.

[3][f.35v] Desunt usque ad Num. 51-1[-\0]9 ∝. nisi 25. -
Missing nos. 51-109, with the exception of no. 25.

6 Tamarisco nonnihil similis duobus ex adverso ordinibus ramulorū, Chordas musicas referentium. In rupibus substantia qædam fungosa, Striata, ligneæ proxima partem ferè dimidam nucis Cocao per latitudinem sectæ referens, adnascitur. Exindè caules, qatuor [-] (in alijs forsan plures aut pauciores) assurgunt, tripedales, nonnihil compressi, per longitudinem striati, colore castaneo. Ex hisce qà latiores prodeunt binæ ramulorū series ex adverso positæ, a radice usque ad Summitates porrectæ: hi ramuli chordulas musicules qàm proximè referentes, coloris punicei, æqali ferè distantiâ a se invicem collocantur. Undè delata est non constat; at submarinâ esse patet ex radice fungosâ et viminibus setaceis mox descriptis.

A plant not unlike a tamarisc, with regular rows of branches arranged in pairs opposite each other, like the strings of a musical instrument. On the rocks grows a substance, somewhat spongy, striated and similar to wood, resembling a halved coconut cut lengthwise. From it emerge four (in some cases, possibly more or fewer) stems, 3 ft tall, somewhat flattened, striated longitudinally and chestnut-coloured. From these stems, which are wider, grow two rows of branches arranged opposite each other, and extending from the root to the very top. These branches, which closely resemble musical strings and are reddish in colour, are attached at almost equal intervals. Its place of origin is not known, but, from the spongy root and hairy stems just described, it is clearly marine.

7 Idem frut. cum priore.

The same plant as the preceding.

8 Fruticulus marinus flabelliformis longis capillis ad radicem insignis. 4.ᵗᵒ loco descripto similis est sed crebriùs ramosus consimili etiam crustâ tegitur qo ille; qemadmodū et plerèque. omnes hujus [-] [-\generis] plantæ submarinæ.[4] *[bracketed with 9 & 9b]*
Little, fan-shaped marine plant, remarkable for the long hairs growing at the root. Similar to no. 4, but with many more branches; it also has a similar outer coat. In this and many other ways, all marine plants are of this type.

9 Fruticulus marinus asperulus flabelliformis, ferulaceu/s\ Donavit D.ˢ D.ʳ Pl.
Small marine plant, a little rough in texture and fan-shaped; like the giant fennel. Given by Dr Plot.

9b [-Conc] Corallina /Africana\ lonchitidis asperæ adinstar pinnata; cereo cortice obducta. donavit D. Rob. Clavering A.M. & Collegij. Univ. S.
African coralline, feathered like the prickly satyrion (stander grass); the surface is covered with wax. Given by Robert Clavering, MA and Fellow of University College.

[38v]

undiqaque + latus] i.e. ramis solummodō dextrorsū et Sinistrorsum Spectantib. [-Haud fructic...]
... all over ... wide i.e. with branches which face left and right.

[39r blank; 40r]

10 Frutex marinus /flabelliformis vesicarius\[-latus, capsulis aut vesiculis qibusd. in ramis

[4][f.37v] 8 9 9b In the Window.

insignitus.] Altitudinem sesqipedalem attingit. Ramos ad dextram et sinistram incerto ordine protrudit. Crustâ tegitur porosâ colore ex ocroleuco pupurascenti: ramuli ad extrema tralucentes sunt, instar succini; et ejusdem cum succino coloris: gluten qoddã referre non absurdè dixeris.

Marine plant, fan-shaped, with little blisters. It reaches a height of 7 ft The branches are produced irregularly to the left and right. It has an outer coat which is porous and pale yellow shading to purple; the little branches at the ends are translucent, like amber, and they are also amber-coloured; it would not be foolish to say that it resembles a resinous gum.

11(ij.) Poro grande Imperati. Corallio affinis Porus magnus [-] C.B. J.B.

The Great Porus of Ferrante Imperato [1672, p. 624]. The coral-related porus of Caspar Bauhin and Johannes Bauhin [1651, vol. 3, p. 803].

12 v.^e 42.

See no. 42.

13 Corallium rubrũ Joh. Bauh. Ger. rubrũ maj. P. Corallu rubrũ C.B. \\x//

Red coral of Johannes Bauhin [1651, vol. 3, p. 791].

14 Corallium albidum digitatum, ramis hinc inde contiguis ad latitudinem dispositis.

White finger coral, its branches arranged here and there along the width, and close to each other.

15 /Porus ?\ Corallium astroites albũ complurimis ramis incerto ordine dispositis; et sibi invicem hinc inde coalitis. \\Corallium stellatũ minus albũ J.B. Tom. 3. pag. 794.//

White star coral, its several branches arranged at irregular intervals, and joined together here and there; the lesser white star coral of Johannes Bauhin (1651, vol. 3, p. 794).

16\\x// Spezie di Corallo Stellato, portata a [-noi\noi] da mari di Spagna; Imper. p. 627. Q.[-\an] a priore differat Specie.

'A kind of star coral, brought to us from the Spanish sea' (Imperato 1672, p. 627). This specimen is different from the previous one.

17\\x// Porus albus [-omnino] majusculus, omninò terebratus, ramis incerto ordine sibi invicem coalitis.

Larger white coral, perforated all over, its branches growing together at irregular intervals.

18 v.^e 46.

See no. 46.

19-20 Corallo bianco fistuloso, Spezie di Corallo di rami frequenti, bucati nella superficie portata a noi da Sicilia, Imperati p. 627.

'White, porous coral; a species of coral with abundant branches, perforated on the surface; brought to us from Sicily' (Imperato 1672, p. 627).

21-22 Aliud minùs speciosum, sed fortè ejusd. speciei.

Another coral, less beautiful, but perhaps of the same species.

[41r blank; 42r]

23-24 Porus albus ramosior, pumilus, creberrimè stellatus.

A dwarf variety of white, many-branched star coral, densely packed with 'stars'.

25 v.^e 16.

See no. 16.

26 An Coralli[-js\o] affinis Porus ramosus C.B? \\An potius id^m. q^d. 11^us//

Could it be the coral-related branched porus of Caspar Bauhin. Possibly the same sort as no. 11?

27 v.^e ij.

See no.11.

28 v.^e 26.

See no. 26.

29 Madrepora ramosa con le Stremita terminate in piano &c. Imperati pag. 629. \\Corallijs affinis madrepora ramosa J. Bauh. Tom. 3. pag. 795.// \\Deest.//

'Branching madrepore with the extremities flattened' (Imperato 1672, p. 629). A coral similar to the branching madrepore of Johannes Bauhin (1651, vol. 3, p. 795).

30 Id^m Porus cum 26 & 28.

The same coral as nos. 26 and 28.

31 v.^e 47.

See no. 47.

32 v.^e 42.

See no. 42.

33 Tubularia purpurea Alcyonio milesio secondo Alcuni Imperati pag. 631. Corallijs affine alcyonium rubrum C.B. Corallijs affine alcyonium fistulosum rubrum J.B.

'Purple tubularia, or Milesian alcyonium according to some' (Imperato 1672, p. 631). The coral-related red alcyonium of Caspar Bauhin. The coral-related red porous alcyonium of Johannes Bauhin.

34-35 Porus albus erectior [-superficie omninò \omininò] fistulos[-a\us] apicibus dextrorsùm et sinistrorsùm ramosis. Plantâ [illeg.] abrotanoides Clusij in Exotic.

White upright coral, porous all over, and branching to left and right at the tips. The [] abrotanoides of Clusius (1605, p.123). (Artemisia abrotanum, Southern wood).

36 Porus albus cupressiformis; S. Porus albus /ramulis\ capreoli cornua qodammodò referen[-s\tib], t[-\u]berculis fistulosis dẽsè admodũ refertus.^5

White cypress-coral, or white coral with branches a little like goats' horns, completely covered with lumps full of holes.

37 Porus albidus planus frondiporæ adinstar cribri[-\formis]

White flat coral, like leaf-coral, and shaped like a sieve.

[42v]

* Fungus Saxeus minor Clusij in Exot. /qoad figurã\ huic ad amussim respondet.

Lesser *Fungus saxeus*: see Clusius (1605, p.125), corresponding exactly to this specimen in form.

[43, 44r blank; 45r]

^5**[f.41v]** In y^e Window

38 Porus s. corallium astroites humilis, verrucosum, ramis aliàs latis et compressis, aliàs incertæ figuræ.[6]
Porus or common star coral, covered with warts, with some branches broad and flattened, and others of indeterminate shape.

39 Id.[m] cum priore.[7]
The same as the last.

40 An fungus lapideus major in Nilo natus C.B.? Saxeus nili major Clusij? Non esse fung/ū\ Lap. [-&c] \\in nilo natu; nos [-] monuit Ds. Dr. Tournfort. Botanicus Regius Paris// *
Larger *Fungus lapideus*, formed in the Nile: see Caspar Bauhin. The greater *Saxeus nili* of Clusius? We are advised by Dr Tournefort, Royal Botanist in Paris, that this is not a *Fungus lapideus* from the Nile.

41 Hornie Sea Shrub incrustated M.R.S.T. 18.
Grew 1681, p. 18.

42 Corallium albidum latum et compressum ad extrema tantū ramosum : S. Corallium spurium ex varijs qasi tegulis sibi invicem incumbentibus conflatum. Corallium foliatum. D.[ris] Tournefort.
White coral, broad and flat, densely packed with branches at the tips; or false coral composed of branches lying one on top of the other like roof-tiles. The *Corallium foliatum* of Dr Tournefort.

43 v.[e] 41.
See no. 41.

44 v.[e] 26.
See no. 26.

45 I.[dm] cum 33 vel ei congener.[8] *[bracketed with 46].*
The same as no. 33, or related to it.

46 Corallium /Spurium\ albidum, polyschides, dumosum.
False white coral, with many twigs and thorns.

47 An id[m]. q.[d] 42.
This the same as no. 42.

48 Pseudocorallium album digitatū, tegulæ ferè adinst: compressum.
White, false coral, fingered and flattened almost like roof-tiles.

49 v.[e] 42 et 47.
See nos. 42 and 47.

50 Astroites marinus elegantior, lamellatis stellulis eminentibus.[9]
Elegant marine star coral, covered with a layer of prominent little stars.

51 Corallo bianco Fistuloso Imperati, idē. cum. 20°. ex dono Dñi Gul. Charlton.[10]
'White porous coral' (Imperato 1672, p. 627); the same as no. 20. Given by William Charleton.

[46r - 50r blank; 51r]

Ligna, folia, fructus, &c. exotica
Wood, leaves, fruits, and other exotica

51 [*sic*] Arundo Indica arborea cortice Spinoso Hermanni. [-De] Transact. Philos. Vol. 13. p. 120/102\. n. 145. Ily Hort. Malab. ex Sententiâ D.[n] Bobertij. \\deest//[11]
Cane from an Indian tree, with a thorny bark, of Hermann; see *Philosophical Trans*actions 13 no. 145 (1683), p. 102. The garden malobathron (*Hortensis malobathron*) of Bobart, see *Sententia*.

109-110 Arboris exoticæ truncus, femur humanum crassus, Arundinis adinstar cavus et geniculatus. Id[m]. forsan cum priore.[12]
Trunk of an exotic tree, as thick as a human femur; hollow and jointed like a cane. Probably the same as the last.

iii [-110] An ramulus palmulæ cujusd. Indicæ ? Qâ trunco adhæret latus est et compressus, texturâ filamentosâ. Qoad magnitudinem, colorem et figurâ, rostrū vel gladiū. Xiphiæ Piscis referens. Qia amputa[-]tur longitudinem ejus prætereo. Ubi incipit gracilescere et ramificare, Sulcis per longitudinem exaratur. Ramuli ejus pennas olorinas crassi Sunt, longitudine 3.[ium] circiter pedum, figuræ insigniter angulosæ, scil nunc qodrangularis nunc etiâ hexagonæ, &c. densè admodū congesti; crebris tuberculis (qæ fortassis gemmæ sunt) nodosi, adeo ut minus curiosè intuenti radices qædam videantur.
Could this be a branch of some sort of Indian palm? Where it joins the trunk it is flattened and broad, with a fibrous structure. Of the same size, colour and form as the bill of a bird or a sword; rather like a sword-fish. I do not mention its length because it has been cut off. Where it begins to taper and to form branches, it has longitudinal furrows. The twigs are the thickness of swans' quills, about a third of a foot long, and remarkably angular in form, rectangular and even hexagonal in section etc., and they are quite densely packed together. It has numerous nodular tubercles (which are perhaps buds), so that, to a careless observer, they appear to be roots.

52 Cucurbita è maximis, longitudine ferê 4 pedum; cujus partem crassissimâ filum 15 unciarū vix circumambit. Ad radicem angustior est et capitata.
Gourd of the largest sort, about 4 ft long, the thickest part of which is barely encircled by a cord 15 in long. It is narrower at the base and has a cap.

[52r blank; 53r]

53 Tuba marina. Longitudo ejus 6 pedum. Radix ejus (modo radix sit) algas vel qercus marinas plurimas æmulatur. Teres est; filum autem 5 unciarū ubi crassissimum vix circumambit. Capitulum habet glandē p. hū. referens. Cortex ejus niger, Scaber, Solidi /(nummi)\ crassitie; nec plantæ qicqid superest crassius est.
Sea trumpet. It is 6 ft long; its root (or what serves as a root) looks like seaweed or sea oak. It is smooth; on the other hand, a filament 5 in long barely encircles the thickest part. It has a small head and looks like a human glans penis. Its

[6][f.44v] Wind -
[7][f.44v] in y.[e] Window
[8][f.44v] Win. -
[9][f.44v] W -
[10][f.44v] W -

[11][f.50v] d
[12][f.50v] Adf.

outer coat is black and scabby, and is as thick as a shilling. No other part of the plant is thicker.

54 Ead. Tuba marina.
Sea trumpet, of the same type.

55 Cucurbita ejusd. [-cum] figuræ cum Cucurbitâ nū. [-2\52]. mox dictâ: minor tamen. An fortè ead. spec. \\[-d]//
Gourd of the same shape as no.52, just described, but smaller. It is perhaps of the same species.

56 Fungus arborigena admodū crassus, margine sinuato, supernè admodū rugosus, infernè planus. \\d//[13]
Tree fungus, very thick, with a wavy edge, rather wrinkled above and smooth below.

57-59 Calibash an Cucurbita Caseiformis, aut pulvinaris. Ambitus ejus ferè [-\...] pedalis, latitudo 14 unciarum. [-lutei coloris] \\[-58.d 57 deest]//[14]
Calabash or gourd in the form of a cheese or a pillow; in circumference it measures about a 1 ft 14 in across. (Yellow in colour).

62 Id[m]. fructus cum prioribus nisi qod minor sit. \\d.//[15]
The same kind of fruit as the last, but smaller.

63-64 Fructus Calibash figurâ ovali. magnitudo ejus et figura vesicæ bubulæ inflatæ. \\Hill(?) 68//
Calabash fruit, ovoid in shape; its size and shape are like the inflated bladder of an ox.

68 Calibash Sphæricus, magnitudine pitæ pedalis.
Spherical calabash, 1 ft in diameter.

65 Calibash, an potiùs [-c\C]ucurbita fig. et mole vesicæ Suillæ &c. altera extremitate strictior est et angustior.
Calabash, or perhaps a gourd, in shape and size like the bladder of a pig; one of the ends is thinner and narrower.

67 Q. inter artificialia.
Query: among the artificialia?

[54r blank; 55r]

69-74 Nuces Coco.
Coconuts.

75-76 [-] Eæd. Nuces Coco cortice denudatæ.
Similar coconuts stripped off their husk.

[-] **77** Cucurbita ampulliformis.
Flask-shaped gourd.

[-68, 69\78, 79] **80, 81** Eæd. prorsus Cucurbitæ at longè minores. \\80: fract//[16]
Exactly the same gourds, but much smaller; no. 80 broken.

82 Calibash sphæricus; idē forsan cum 68.
Spherical calabash; perhaps the same as no. 68.

83 [-84] Idem Calibash ad huc minor.
The same sort of calabash, but smaller.

84 Calibash alter [-priori\superiori] qā simillimus fig. è Sphærica ad ovalem aliqantulum accedenti.
Another calabash very like the above in shape, which is spherical though approaching an oval.

85 Calibash pulvinaris è minoribus.
Cushion-shaped gourd, smaller in size.

86 Calibash Sphæricus putamine nitido duriori, &c.
Spherical calabash, the husk hard and polished, etc.

87 Calibash alter Sphæricus superficiè minùs Speciosâ &c.
Another spherical calabash, with a less attractive surface, etc.

88 Calibash ovalis, id[m]. prorsus si figurā excipias, cum 86. Color utriusque atrorubens lituris albi... undique conspersus[-;\:] texturæ est secundā ambitum striatæ.
Ovoid calabash, very like no. 86 in the same shape. The colour of both is darkish red, smeared with white all over, and striated around the circumference.

89 Cucurbita cylindrovalis lutea.
Gourd, ovoid-cylindrical in shape, yellow in colour.

[56r blank; 57r]

90 Cucurbita lutea pyramidalis, collo angustiori longissimo.
Yellow, pyramidal gourd with a very long, narrow neck.

91-92 Eæd. Cucurbitæ.
Similar gourds.

93 Ead. Cucurbita eujus tamen media pars colli aliqantul ventricosior. \\fract.//[17]
Similar gourd, but the middle of its neck swells a little more.

94-97 Q. inter Artficialia.
Query, among the artificialia?

98 Cucurbita [-] pyriformis.
Pear-shaped gourd.

99 Nux qid. an Cucurbita; testem Taurinū figura et mole referens?
Gourd or even a nut, resembling the head of a bull in shape and size.

100 Cortex arboris Coker S. Cocao forsan.
Bark of a tree, perhaps of a Coker or Cocoa tree.

101 Q. inter artificialia.
Query: among the artificialia?

102 Melocardui species qam nondū descriptā existimo. Radix ejus Betulæ vetustæ ramulum qam proxime simulat, cortice suo tenuissimo, &c. [-] Fructus ejus (mod... fructus sit de hoc enim aliqantulu dubitamus) dodrāta ferè longitudinis est, teres, 4 vel 5 unciarū in ambit pediculis creberrimis uncia longis undique stipatur qi ad Summitates Suas in spinas setaceas rigidas tamen et acutissimas, ut plurimū 12, stellatim qodammodò dispositas, divaricantur. Harum 2 priores ex adverso ortæ, cæteris longiores,

[13][**f.52v**] [-d]
[14][**f.52v**] [-d 57]
[15][**f.52v**] d
[16][**f.54v**] 78, Decayed 80 fract -

[17][**f.56v**] 93 fract

sescunciales sunt, et Geranij rossell[-\a] prorsus æmulantur. deindè binæ ex adverso positæ, priorū respectu cruciatæ, paulo breviores; [-] Reliqæ semunciam longæ sunt, et intra hos emergun...
A kind of thistle-melon, of which I do not think there is any published description yet. Its root is closest in appearance to a small branch of an ancient birch tree. Its fruit (although whether it is truly a fruit we are a little uncertain) is smooth, almost 9 in. in length, and 4-5 in. in circumference, thick with pedicles 1 in long on all sides, crowding together, which at the top bristle with stiff and very sharp spines, as many as twelve, arranged radially like a star; of these, two rise above the rest opposite each other and are longer, about 6 in tall, and they closely resemble the [] of Gerard. Thereafter they are arranged in pairs, in crosses, and are a little shorter. The rest are ½ in tall and grow in between them.

[58r blank; 59r]

103 Cortex qidam cinereus vetustus in tùs fora minulosus, ext... rugosus aut vermiculatus &c. \\fract//[18]
Bark, ash-grey and old, full of little holes on the inside and wrinkled and worm-eaten on the outside, etc. broken.

104 Id.[em] Cortex[19]
Similar bark.

10[-\5][-7\5] Caudex malvæ Indicæ arboreæ, /Fract\\\An potius Ricinus. /Palmæ Christ\//
Stem of Indian Tree-mallow; broken. Or it may be Castor-oil plant (Palm of Christ).

106 Ilicis glandifere ramus.[20]
Acorn-bearing branch of Ilex.

108 Ramus Fraxini monstrosè compressus et contortus. Salicem observavimus in agro montis Gomerici 20 plus minùs hujus modi ramulis onustam. \\[Edw. Lhw.]//
Branch from a deformed Ash tree, flattened and contorted. We have seen a Willow in Montgomeryshire laden with about twenty branches of this sort. Edward Lhwyd.

105 V.[e] \\Artific.//
See under the artificialia.

114 Folium alicujus palmæ longitudine circiter 4 pedu &c.[21]
Leaf of some kind of Palm, about 4 ft long, etc.

115 Folium cujusd. palmæ cærinætū.[22]
Leaf of some kind of angular Palm.

116 Lignū monstrosū tuberosū &c.[23]
Deformed and lumpy piece of timber.

117 V.[e] 114. \\deest//[24]
See no. 114.

118 Phaseolus Americanus /arboreus\ maximus, lobo post 2 qæ[-]libet interssifi[-\a] angustâto.
Very large American tree-bean, with a very narrow node at every second joint.

119-120 Duo alii iidem phaseoli intertitiis n[-\u]llis insigniti.
Two more of the same sort of Tree-bean, not distinguished by any joints.

[60r, 61r blank; 62r]

121-122 Cassia fistula phaseoliformis. Semina ejus rubra sunt, et qoad figuram semina melonū referunt, sed triplo aut 4.[plo] ma[-\j]ora sunt. Siliqæ longitudo bipedalis est. [-et] [-\...plet], latitudo 2.[arū] unciarum: ab utroque laterè fimbriatur, hinc unicâ, indè 2.[bus] fimbrijs, sulco medio disterminatis. Siliqa crassa, durissima nigra, scubra.[25]
Bean-shaped Cassia (or Senna-pod). Its seeds are red and resemble those of a melon in shape, but are three or four times bigger. The pod is 2 ft long and 2 in thick, and fringed on both sides, with a single fringe on one side and two on the other, divided in the middle by a furrow. The pod is thick, very hard, black and scabby.

12[-3\4], [-122] Cassia fistula priori congener, crassior tamen, brevior, et ad latera magis rugosa.
Bean-shaped tubular Cassia (or Senna-pod) similar to the last, but thicker and shorter, and rather more wrinkled at the sides.

[-124 d] 123 Cassia fistula nigra, teres, digiti humani crassitiem exuperans, nullis fimbrijs insignita, per Semuncias leviter fasciata, longit.[e] 15 aut 16. unciarū[26]
Black Cassia (or Senna-pod), smooth, thicker than a human finger, not distinguished by any fringes; it is lightly banded every ½ in, and is 15 or 16 in long.

125 Cucurbita buccinalis [The Trumpet Gourd] Tripedalis est et longior.[27]
Trumpet gourd, 3 ft or more in length.

126-130 /Q\/deest.130\Q. inter artificialia. \\130 deest//
Query: among artificialia?

131 Cucurbita fusiformis.
Spindle-shaped gourd.

132 Phaseolus qidam arboreus fructu phalloide. Nulla huic rima in lobo qâ aperiatur. \\dd//[28]
Bean from some kind of tree with a phalloid-like fruit. There is no crack on the pod by which it may be opened.

133 Melo arte confectus.
Artificially made melon.

[63r blank; 64r]

134-135 Melo verrucosus. \\de 134 d. 134//[29]
Melon covered with warts No. 134 missing.

136 Nux qæd. exotica, an Calibash marmore[-\j].[30]
Some kind of exotic nut, perhaps a marbled calabash.

137-138 Nuces qæd exot. prorsus Sphæricæ, superficie qasi marmoreâ, sordidè lutescenti.[31]

[18][**f.58v**] fract -
[19][**f.58v**] D
[20][**f.58v**] [-] *(deest?)*
[21][**f.58v**] deest [-d]
[22][**f.58v**] [-d]
[23][**f.58v**] D
[24][**f.58v**] d

[25][-72]
[26][-D] [**f.61v**] [-D]
[27][**f.61v**] d
[28][**f.61v**] deest
[29][**f.63v**] 134 deest
[30][**f.63v**] [-deest]
[31][**f.63v**] [-deest] d

Some kind of exotic nuts, completely spherical, the outside seemingly marbled, of a dirty yellow colour.

139-140 Melo qidam Mali aurantii maximi mol[-\e] et figurâ. An Anguriæ Species.?
Melon in size and shape like a very large golden apple. Perhaps a type of *Anguria*?

141-144 Artific. (*141* /dx\; *142* /d x\; *144* /d x\³²
Among the artificialia. Nos. 141, 142 and 144 missing.

145 Frustulū ligni coniforme ferè, admodum sulcatū et confragosū. \\deest//
An almost conical piece of wood, heavily ridged and rough.

146 Lobus siliqâ admodū crassa, an Locustæ spec? Consule J. Bauhinum. Longitudo ejus 4 vel etiam 5 circiter unciarū, color rufus, superficies qodammodo lucida et arenaria, omnino qalis vasculis figulinis vulgatioribus. Siliqæ latitudo 3 ferè unciarū. Semen omnino nigrū, fabā referens, extremitate altera tenuiori, in cujus apice punctuli qoddam aciculæ capitelli adinstar; cui Seminis petiolum affixum esse arbitramur. Qoad magnitudinē inter fabā eqinā et Hortensem ambigit.
Bean-pod, very thick; perhaps a kind of Locust bean, according to Johannes Bauhin. It is about 4 or 5 in. in length, reddish in colour, the surface somewhat shiny and sandy, very like the more common little earthenware pots. The pod is about 3 in thick; and the seed is black all over, similar to a horse-bean, and thinner at one end, at the top of which are small points, like the heads of little pins; we think that the stalk was attached to this part of the seed. In size it is roughly between that of a horse bean and a garden bean.

147 Phaseolus arboreus siliqâ alata, Semine caseolū ex primente, nigro; vel qod ex nigro subrufescat. \\deest//³³
Tree-bean with a winged pod; the seed looks like a little cheese and is black; or even black shading to reddish.

148 V.ᵉ 146.
See no. 146.

[65r blank; 66r]

[-149] /deest\ Melo echinatus vel Senticosus, an Melocardui /spec?\ Hujus, aculei nullis pediculis (qemadmodū melocarduus sub numero 102) niluntur; sed ex ipsius fructus cortice prorumpunt, 8 ut plurimum, aliqando [-\decem] aculei nigri, rigidi, acutissimi, teretes, qi a primo exortu ad mucronem usque gracileseunt, spinulas oxyocanthinas crassi, unciali circiter longitudine, ordine Stellato dipositi, [-qorū centro] extrorsum: nonnihil arcuati; e qorū centro alius nascitur erectus, &c.
Prickly or thorny Melon, or perhaps a kind of Thistle-melon. The thorns do not rest on any feet (just like the thistle-melon in no. 102), but break through the skin of the fruit itself; they are black, stiff, very sharp and smooth, usually eight but sometimes ten; they taper gradually to a point, and are thick with sharp little prickles. They are about 1 in long, arranged radially like a star and slightly curved; from their midst grows another straight spine.

150 Lobus siliqâ venosâ, semine fere qadrato, compresso, rugoso.
Veined bean pod, the seeds almost square, flattened and wrinkled.

151-153 Eæd. Siliqæ. (*152* /x\)
Pods of the same kind. No. 152 missing.

154 Phaseolus arboreus strepsilobos, semine cylindroval magnitudine fere nucis avellanæ.
Tree-bean with a twisted pod; the seed is ovoid cylindrical, about the size of a hazel-nut.

155 Daburi Clusij. \\d fract//³⁴
Daburus of Clusius; broken.

[-166] [-Fructus Ricini cujusd. Avellanæ mole]
Fruit of the Castor-oil plant, the size of a hazel-nut.

156 /deest\ Fructus s. Pe[-]ricarpium alicujus Apocini Gossipini Id.ᵐ fructus \\d fract//³⁵
Fruit or pericarpium of the Cotton plant (Gossypium apocini). Broken.

157 Conus an Cedri Lybani. Non adeo concius est ac reliqi, [-&c] apice adeo obtuso ut mucronatus non dici possit.³⁶
Cone from the Cedar of Lebanon. Nothing is yet known of the rest; the top is broken and it is not possible to say whether it had a point.

[67r blank; 68r]

158 Nucidactylus Mus. R.S. p. 204. Tab.16. \\d fract://³⁷
Fingered nut: see Grew 1681, p. 204, tab. 16. Broken.

159 Spongia chirothecā referens.
Sponge resembling a glove *[Isodictya palmata]*.

160 Siliqæ cujusd. arboris exoticæ, breviusculæ, nigræ, rugosæ, rostro adunco &c. Harū 5 simul prodeunt ex apicib. ramulorum. \\deest//³⁸
Pods from some kind of exotic tree, quite short, black, wrinkled, with a hooked beak, etc. Of these five grow together from the tips of the stalks.

161 Thlaspi qoddam Scopiarium; an rosa Hieræcuntina? \\.deest://³⁹
Cress, somewhat like a broom [?]. Could it be a rose of Hieraecuntina [?].

162 Gingidij S. Visnagæ umbella. \\deest://⁴⁰
Gingidii, or Ammi visnaga.

163 Lobi membranacei tenuissimi &c. Qd?
Pods, membraneous and very delicate, etc. What are they?

[-164] Spica sorghi fortassis aut Milij Turcici. \\d//⁴¹
An ear of Sorghum perhaps, or Turkish millet.

³⁴deest **[f.65v]** deest

³⁵**[f.65v]** d

³⁶D

³⁷**[f.67v]** D. 1764 Desunt sequentia. 158-160-161-162-164-166. 171-172-173.
The following are missing.

³⁸**[f.67v]** d

³⁹**[f.67v]** d

⁴⁰**[f.67v]** d

⁴¹**[f.67v]** d

³²**[f.63v]** [-deest d]

³³**[f.63v]** 1&

165 Ve. 134 et 135.42
See nos. 134 and 135.

[-166] Fructus [-r\R]icini cujusd. avellanæ mol[-\e]. /deest\ \\deest//43
Fruit of the Castor-oil plant, the size of a hazel-nut.

167-169 Graminis Species ([-]) [-\ignota] exotica
Unknown exotic species of grass.

170 Ventilabū Indicum è folio palmæ.
Indian fan made from a palm leaf.

171 Ahoaî guaçù pisonis44 *[bracketed with 172 & 173]*
Ahoay guacu of Piso [1648, p. 49].

172 Gramen qoddam arenaceum [-et] [-videt Dn.° Bob...]
Some kind of dry/sandy grass; see Mr Bobart [?].

173 Malum aurantium maximum ex Insula Bermudo. \\fractū.// \\desunt 71-2-3. 1755//
Very large golden fruit from the island of Bermuda; broken. Nos. 71-73 missing in 1755.

42**[f.67v]** d
43 **[f.67v]** d
44**[f.67v]** 171:172 desunt

LIBER DOMINI ÆDIS CHRISTI DECANI
The Book of the Dean of Christ Church
Transcribed by Julia White, translated and annotated by Arthur MacGregor

Ashmolean Museum, AMS 12, compiled 1756. Leather-bound, large quarto volume; leather label on cover, 'LIBER DNI AEDIS CHRISTI DECANI', all within tooled borders; 90 folios, 290 x 230mm, many of them blank.

This revised version of the earlier Book of the Dean of Christ Church (AMS 8: see pp. 33-65) was compiled by William Huddesford in 1756. Huddesford discovered that many items listed in the earlier catalogue were missing at this time, as indicated by his emendations. New material had also arrived: some items which had appeared as inserts in the seventeenth-century catalogue are here brought into the main sequence of numbers (see, for example, the entries for the Alfred Jewel on pp. 49 and 188, and the descriptions of Dr Woodward's notorious shield (discussed at length in Levine 1977), which was represented in the Ashmolean by a plaster-cast (pp. 64, 197). Only occasionally were entries expanded in the process of copying, as with no. 175 on p. 179 which acquired a new interpretation and a reference to the *Musæum Wormianum* in the mid-eighteenth century. It may be noted that a surviving amulet in the form of a hand of jet, hitherto equated with an example in the Tradescant collection (MacGregor 1983, no. 190), can now be seen to correspond more closely with the description of another such amulet, recorded here as the gift of a Mr Buckridge of St. John's College.

Later annotations to the catalogue record the removal of some items to the 'Great Room' (sometimes abbreviated to 'GR') or the 'Lower Room' ('LR'), while many of the mineral specimens are taken 'to the new cabinets' or 'to the Mineral cabinets' ('m.c.'), the latter sometimes identified by letter codes. These moves marked not a revision of the exhibits but rather the beginning of the end of mineralogy as a component of the Ashmolean displays. The notes date from the era following the election of William Buckland as the University's first Professor in Mineralogy, in 1813. On his appointment Buckland was provided with accommodation in the Museum's basement, furnished with new cabinets in which to store his teaching collections. All the mineralogical holdings seem to have been transferred into his care at this time and his priorities clearly lay in completing the mineralogical series for demonstration purposes rather than enhancing the displays. Buckland and his collections were later moved to the adjacent Clarendon Building and thence to the University's new Natural Science Museum in 1858, marking the final severance of these materials from the Ashmolean (see Ovenell 1986, pp. 211-23; MacGregor and Headon 2000).

[1r-5v blank]
[6r]
Liber Dñi Ædis Christi Decani
The Book of the Dean of Christ Church

1 Sapphirus una naturalis impolita.[1]
A natural, unpolished sapphire.

2 Sapphiri duæ politæ. Plinio Cyani.[2]
Two polished sapphires, known to Pliny as bluestones.

3 Smaragdi, seu Prasini duo naturales impoliti.[3]
Two natural, unpolished emeralds, or prase.

4 Cyathus è Smaragdo opaciori.
Ladle in cloudy emerald.

5 Prasinus unus naturalis, lineis rubris insignitus.
A natural prase, marked with red lines.

6 Smaragdus magnus politus.
Large, polished emerald.

7 Duo Smaragdi minores, politi.
Two smaller, polished emeralds.

8 Smaragdi quinque minimi, politi.
Five very small polished emeralds.

9 Topasius vel Topasium Orientale, politum.[4]
Topaz or oriental topaz, polished.

[7r]

10 Chrysolithi, Chrysopatii duo politi, Plinio Chrysolampides.[5]
Two polished chrysolites or chrysopatii, known to Pliny as chrysolampis.

11 Hyacinthus magnus, /(\spurius [-]/)\\[6]
A large jacinth; fake.

12 Hyacinthi duo minores, ejusdem generis.
Two smaller jacinths of the same kind.

13 Berillus, seu Beryllus major, politus.[7]
Berillus or large beryl, polished.

14 Berillus minor item politus.
Smaller beryl, likewise polished.

15 Opalus seu Opalis, olim Pæderos, Italis Girasole, verus politus.[8]
Highly polished opal, known to others as opalis pæderos and to the Italians as girasole.

16a Opalus alius (ut opinor) spurius.

[1] a
[2] m.c [f.5v] one removed to the new Cabinets
[3] m.c. [f.5v] removed to the Minerals
[4] m c. [f.5v] in the new Cabinets
[5] m.c
[6] L.R. [f.6v] one removed
[7] m.c [f.6v] Removed
[8] m c [f.6v] Do

Another opal (or in my opinion) a fake.

16b Calcedonii, alias Carchedonii 3 pellucidi majores.[9]
Three large, transparent chalcedonies, otherwise known as carbuncles.

17 Calcedonii quinque /tres\ opaciores minores. \\-3//
Five [three] smaller, opaque chalcedonies.

18 Amathystus naturalis, impolitus.
A natural, unpolished amethyst.

19 Amathystus magnus naturalis, impolitus.
A large, unpolished amethyst.

20 Idem iterum.
Another of the same.

21 Amethysti duo minores naturales, impoliti.
Two smaller, unpolished, natural amethysts.

22 Amethystus magnus quadratus politus.[10]
A large, square, polished amethyst.

23 Amethystus item magnus figuræ mixtæ, politus.
A similarly large, polished amethyst of irregular form.

24 Amethysti tres item politi.
Three amethysts, similarly polished.

25 Amethysti quatuor minores, item politi.[11]
Four smaller amethysts, similarly polished.

26 Amethysti quatuor minimi, item politi.
Four very small amethysts, similarly polished.

27 Granati duo Bohemici maxime, politi.[12]
Two very large, polished, Bohemian garnets.

[8r]

28 Granati item duo Bohemici magni, politi.[13]
Another two large, polished, Bohemian garnets.

29 Granatus Bohemicus minor, politus.[14]
Smaller, polished, Bohemian garnet.

30 Granati 4 Bohemici superioribus paulo minores.[15]
Four Bohemian garnets, a little smaller than the above.

31 Granati 4 Bohemici adhuc minores politi.
Four polished, Bohemian garnets, still smaller in size.

32 Granati 4 Bohemici minimi politi.
Four very small, polished, Bohemian garnets.

33 Granatus politus palâ impositus, formâ rosaceâ.
Polished, rose-shaped garnet, set in a ring bezel.

34 Granati communes majores, numero [-22\6]
Twenty-two [six] larger common garnets.

35 Granati communes paulo minores, numero [-22\21].

Twenty-two [twenty-one] common garnets, a little smaller in size.

36 Granati communes adhuc minores, numero 17.
Seventeen still smaller common garnets.

37 Granati communes paulo dilutiores, numero 10. /8\
Ten [eight] somewhat less impressive common garnets.

38 Leucachates formâ rotundâ.[16]
A rounded white agate.

39 Annulus ex Leucachate quo utuntur Turci in sagittando.
White agate ring, used by the Turks in archery.
MacGregor 1983, no. 60.

40 Idem iterum.[17]
Another of the same.
MacGregor 1983, no. 61.

41 Mucro Sagittæ ex Leucachate.[18]
Arrow-head, of white agate.

42 Cyathus ex Leucachate.[19]
Ladle, of white agate.

43 Globus ex Leucachate paucis intercurrentibus venulis tum citrinis sive ravis tum molochinis.[20]
Sphere of white agate with a few intermingled veins, both yellow and mallow-coloured.

44 Globus ex Leucachate quodammodo flavescente.
Sphere of white agate, with a hint of yellow.

45 Idem iterum.
Another of the same.

46 Achates oblongus ex alterâ Parte luridi Coloris ex alterâ albis lineis et cæruleis et rufescentibus distinctus.
Elongated agate pale yellow in one part and in the other marked with white, blue and reddish lines.

[9r]

47 Mucro Sagittæ ex Leucachate paululum rufescente.[21]
Arrow-head of white agate, slightly reddish.

48 Mucro Sagittæ ex Achate coloris insuasi.
(bracketed with 47)
Arrow-head of dark, orange-coloured agate.

49 Cyathus ovalis ex Achate magno ejusdem coloris paucis venulis subcæruleis distincto.
An oval ladle made from a large agate of the same colour marked with a few small bluish veins.

50 Achates longus utroque fine mucronatus, subcæruleus et paululum flavescens.
Elongated bluish and slightly yellowish agate, pointed at both ends.

[9] **[f.6v]** Do.
[10] L.R
[11] L.R
[12] m.c **[f.6v]** Do 2 removed
[13] mc **[f.7v]** removed to the Minerals *(bracketed with 29)*
[14] m.c *(bracketed with 28)*
[15] Duodesunt

[16] L. -
[17] L.R.
[18] D
[19] L.R
[20] [-B]
[21] removed m. c. *(bracketed with 48)*

51 Globus ex Achate maximâ in parte subcæruleo, aliquantulum cæsio, nonnullis lineis albis insignito.
Sphere of agate, for the most part bluish in colour, also somewhat bluish grey, and marked with some white lines.

52 Achates oblongus sulcatus ex subcæruleo rufescens.
Elongated agate, grooved and bluish in colour shading to red.

53 Globus ex Achate livido subrubente quibusdam lineis ex cæruleo albescentibus et miniatis notato.[22]
Sphere of agate, blue-black in colour with a reddish tinge and with some whitish blue and red lines.

54 Annulus ex Achate è cæruleo rufescente, quo utuntur Turci in sagittis emittendis. \\[-fract]//[23]
Agate ring, blue shading to red, used by the Turks in archery; broken.

55 Annulus ex Achate, coloris luridi, venis albis distincto.
Agate ring, pale yellow in colour, marked with white veins.

56 Achates ovalis, coloris Bætici seu subnigri, duobus notis ex albo flavescentibus ex adverso signatus.
Ovoid agate, Bætic or blackish in colour, with two markings of white shading to yellow on the back.

57 Achates lividus flavescens penè cordiformis.
Blue-black, almost heart-shaped agate, yellowish within.

58 Achates chrystallinus octogonus, lineis tum albis tum rubris notatus.
Octagonal crystalline agate, marked with variegated red and white lines.

59 Achates chrystallinus quadratus colore insuaso tinctus.
Square, crystalline agate, dark orange in colour.

60 Achates chrystallinus ovalis lineis citrinis insignitus.[24]
Ovoid, crystalline agate, marked with yellow lines.

[10r]
61 Achates chrystallinus item ovalis lineis albis et citrinis discriminatus.[25]
Similarly ovoid, crystalline agate, with white and yellow lines.

62 Achates subcæruleus maculâ flavescente signitus.[26]
Bluish agate, marked with yellowish spots.

63 Achates chrystalinus rufescens.[27]
Reddish, crystalline agate.

64 Achates chrystallinus in pila Annuli argentei maculis nigris fœdatus.[28]
Crystalline agate mounted on a silver ring, stained with black spots.

65 Achates chrystallinus ovalis maculis nigerrimis inquinatus.[29]
Ovoid, crystalline agate, stained with deep black spots.

66 Achates chrystallinus cylindraceus tertiâ parte Leucachate, et prasi/n\o compositus.
Cylindrical, crystalline agate, combined in a two-to-one ratio with white agate and prase.

67 Achates ovalis subcæruleus lineis flavescentibus insignitus.
Ovoid, bluish agate, marked with yellowish lines.

68 Achates ovalis maculo rubro, et flavescente circumvoluto insignitus.
Ovoid agate stained red and marked around its circumference with yellow.

69 Achates cæsius cordiformis, quibusdam maculis insuasi coloris fœdatus. \\[-qre?]//
Bluish-grey, heart-shaped agate, stained with spots of a dark orange colour.

70 Achates luteus sive insuasus cordifomis lineis albis ornatus.[30]
Heart-shaped, golden-yellow or orange agate, embellished with white lines.

71 Achates luteus cylindraceus lineis albis signatus.[31]
Cylindrical, golden-yellow agate, marked with white lines.

72 Achates decem ovales, eisdem colore et lineis tincti.[32]
Ten ovoid agates of the same colour and marked with similar lines.

73 Achates duo quadrati, eisdem colore et lineis distincti.[33]
Two square agates of the same colour and marked with similar lines.

74 Achates rotundus maculâ molochinâ insignitus.
Rounded agate stained with a mallow-coloured spot.

75 Achates rotundus lineis albis ornatus.[34]
Rounded agate embellished with white lines.

[11r]
76 Achates ovalis coloris flavescentis maculis albis ornatus.
Ovoid yellowish agate embellished with white spots.

77 Achates figurâ conicâ ejusdem coloris, lineis tum albis tum subcæruleis ornatus.[35]
Conical agate of the same colour, embellished with both white and bluish lines.

78 Achates 3 quadrati coloris luridi lineis albis distincti.[36]

[22] min. C. removed
[23] L.R.
[24] min c [f.8v] removed to the Minerals
[25] min c. [f.9v] removed to the Minerals
[26] min c.
[27] min c.
[28] d.

[29] min cab. [f.9v] removed
[30] min. cab.
[31] min. cab. [f.9v] removed to the minerals
[32] [-] [f.9v] 6 removed
[33] [f.9v] one removed
[34] [-] [f.9v] removed to the new cabinets.
[35] min. Cabt. removd.
[36] duo desunt [-]

Three square agates, pale yellow in colour, marked with white lines.

79 Achates duo rotundi eisdem colore et lineis insigniti.[37]
Two rounded agates of the same colour and marked with similar lines.

80 Achates octogonus eisdem colore, et lineis notatus.
Octagonal agate of the same colour and marked with similar lines.

81 Achates cordiformis eisdem etiam colore & lineis ornatus.
Heart-shaped agate of the same colour and embellished with similar lines.

82 Achates ovalis, duabus maculis albis signatus.
Ovoid agate, marked with two white spots.

83 Achates duo ejusdem coloris maculis albescentibus tincti.[38]
Two agates of the same colour marked with whitish spots.

84 Achates tres cylindracei ejusdem coloris, lineis albis notati.[39]
Three cylindrical agates of the same colour, marked with white lines.

85a Achates ovalis subcæruleus lineis albis ornatus.
Ovoid agate, bluish in colour, embellished with white lines.

85b Achates ovalis, lineis tum albis tum rubris tum flavesentibus ornatus.
Ovoid agate, embellished with both white and red as well as yellowish lines.

86 Achates tres ovales cærulei, lineis albis ornati.
Three ovoid agates, embellished with white lines.

86b Oculus Cati.
Cat's eye agate.

86c Oculus Beli.
Cat's eye agate.

87 Hæmachates ovalis punctis sanguineis passim conspersus.[40]
Ovoid, blood-coloured agate, spattered with blood-coloured spots.

88 Hæmachates ovalis venis sanguineis quasi tabo fœdatus.[41]
Ovoid, blood-coloured agate, with blood-coloured veins and discoloured as if by the plague.

89 Hæmachates rotundus, lineis albis insignitus.
Rounded, blood-coloured agate, marked with white lines.

90 Hæmachates rotundus lineis tum albis tum nigris notatus.

Rounded, blood-coloured agate, marked with both white and black lines.

91 Hæmachates duo ovales, venis albis distincti.
Two ovoid, blood-coloured agates, marked with white veins.

92 Hæmachates ovalis maculis albis ad marginem ornatus.
Ovoid, blood-coloured agate embellished with a white spot towards the edge.

93 Hæmachates quadratus, parte minori albescens.
Square, blood-coloured agate, with a small, whitish area.

94 Hæmachates conicus lineis albis signatus.
Conical, blood-coloured agate marked with white lines.

[12r]

95 Hæmachates ovalis nubeculâ infectus.
Ovoid, blood-coloured agate, somewhat clouded.

96 Hæmachates lividus, pene cordiformis.[42]
Bluish, blood-coloured agate, almost heart-shaped.

97 Hæmachates ovalis maculo albo ornatus.[43]
Ovoid, blood-coloured agate, embellished with a white spot.

98 Hæmachates ovalis maculis rubris insignitus.[44]
Ovoid, blood-coloured agate, marked with reddish spots.

99 Hæmachates venis quibusdam nigris notatus.[45]
Blood-coloured agate, marked with black veins.

100 Hæmachates duo ovales quasi tabo conspurcati.
Two ovoid, blood-coloured agates, defaced as if by the plague.

101 Oculus Beli. \\d.//
Cat's eye agate.

102a Oculus Beli minor, formâ depressiori.[46]
Smaller cat's eye, more flattened in form.

102b Hæmachates rotundus, lineis cæruleis ornatus. \\[-d.]//
Rounded blood-coloured agate, embellished with blue veins.

103 Lycophthalmi quatuor Gesneri.
Four wolfs' eyes of Gessner.

104 Argus Lapis, multis quasi oculis conspersus, formâ ovali.[47]
Ovoid Argus stone, looking as though sprinkled with many eyes.

105 Argus Lapis minor, rotundus.\\d//
Rounded, smaller Argus stone.

106 Gladii manubrium ex Achate subcæruleo paululum flavescente.[48]
Sword-handle of bluish agate, with a little yellow.

[37]tres [-]
[38][U:d:]
[39]U:d:
[40]min.C.
[41]min C. **[f.10v]** removed

[42]min. C.
[43][m c\x]
[44][m c\x] **[f.11v]** removed
[45][m c\x]
[46]**[f.11v]** removed -
[47]**[f.11v]** removed -
[48]C. min Cabt.

107 Gladii manubrium ex Achate subcæruleo venis quibusdam ex albo flavescentibus distinctum.[49]
Sword-handle of bluish agate, marked with yellowish-white veins.

108 Cultri manubrium ex Achate subcæruleo, venis quibusdam albis ac rufescentibus ornatum.[50]
Knife-handle of bluish agate, embellished with white and reddish veins.

109 Gladii manubrium ex Hæmachate, lineis ac venis albescentibus insignitum.
Sword-handle of blood-coloured agate, marked with whitish lines and veins.
MacGregor 1983, no. 200.

110a Cultri manubrium dimidiatum &c. Ex dono J. Aubrey Armig: R.S.S.
Half a knife-handle, etc. Given by John Aubrey, Esq., FRS.

110b Cultri manubrium ex Hæmachate venis cæruleis ac albis notatum.
Knife-handle of blood-coloured agate, marked by blue and white veins.
a, b, c, d, e Quinque Achates nitidissimi, formâ ovali, vel prope ad eam accedente.
Five very shiny agates, ovoid or approaching an ovoid in shape.

[13r]

f Cyathus amplus ovalis ex Achate magno.
Large, oval ladle, made from a large agate.
g Pars Armillæ ex quinque Achatibus rotundis, fulvi metalli palis infixis, et concatenatis.
Part of a bracelet made of five rounded agates, fastened onto bars of yellow metal and linked together.

111 Torquis ex Achatibus Jaspidibusque variorum generum numero 12.
Necklace of agate and jasper of various kinds, twelve in number.
MacGregor 1983, no. 65-6.

112 Armilla plerumque ex Leucachatibus ac Sardachatibus, numero 18.[51]
Bracelet mainly of white and carnelian agates, eighteen in number.

113 Monilia tria ex Leucachatibus. numero 129.[52]
Three necklaces made from white agates,129 in number.
MacGregor 1983, no. 67.

114 Torquis ex Leucachatibus aliquantulum rufescentibus.81.
Necklace of reddish-white agates, eighty-one in number.
MacGregor 1983, no. 65.

115 Torques duo ex Achatibus coloris Leucophæi. numero 128.
Two necklaces of ash-coloured agates,128 in number.

116 Torquis ex Leucachatibus, et Achatibus citrinis, alternatim positis. numero 172.
Necklace of alternating white agates and yellow agates,172 in number.

117 Torquis ex Leucachatibus colore citrino tinctis, cum Globulis floribusque deauratis, alternatim positis. num: [-73/71]
Necklace of white agate tinged with yellow, arranged alternately with gilded spheres and flowers, seventy-three [seventy-one] in number.

118 Cultri manubrium ex Sardachate.[53]
Knife-handle of carnelian agate.
MacGregor 1983, no. 202.

119 Sardachates formâ quadrangulâ oblongâ.[54]
Rectangular carnelian agate.

120 Sardachates cordiformis.
Heart-shaped carnelian agate.
MacGregor 1983, no. 191.

121 Sardachates cordiformis minor.
Smaller heart-shaped carnelian agate.

122 Sardachates octogonus.
Octagonal carnelian agate.

123 Sardachates formâ triquetrâ.
Triangular carnelian agate.

124 Sardachates minor formâ triquetrâ.
Smaller triangular carnelian agate.

125 Sardachates multiformis.
Irregular carnelian agate.

126 Corallachates formâ octogonâ.
Octagonal coral-agate.

127 Corallachates cuspidem sagittæ referens.[55]
Coral-agate shaped like the tip of an arrow.

128 Cultri manubrium ex Corallachate.
Knife-handle of coral-agate.

129 Corallachates formâ ovali.
Ovoid coral-agate.

[14r]

130 Corneolus vel Carneolus potius, formâ ovali.[56]
Ovoid cornelian, or rather carnelian.

131 Corneolus ovalis convexior.[57]
Ovoid carnelian, more convex in outline.

132 Corneolus formâ ovali adhuc convexiori.[58]
Ovoid carnelian, still more convex in outline.

133 Corneolus cylindraceus.[59]
Cylindrical carnelian.

[49] min. Cabt. removed
[50] min. cabt.
[51] **[f.12v]** 3 removed
[52] min. c. removed I|

[53] D
[54] **[f.12v]** removed to the new Cabts.
[55] min. C. removed
[56] min C. **[f.13v]** removed to the new Cabts.
[57] min c *(bracketed with 132 and 133)*
[58] min c
[59] min c

134 Corneolus hemisphericus. \\fract//[60]
Hemispherical carnelian; broken

135 Annulus e Corneolo, quo utuntur Turci in sagittando.[61]
Carnelian ring, used by the Turks in archery.
MacGregor 1983, no. 62.

136 Corneolus cruciformis.
Cruciform carnelian.

137 Annulus è Corneolo.
Carnelian ring.

138 Annulus è Corneolo minor.
Smaller carnelian ring.

139 Annulus è Corneolo minimus.
Very small carnelian ring.

140 Leucachates rotundus maculâ nigrâ insignitus.
Rounded white agate, marked with a black spot.

141 Jaspis orientalis puntis sanguineis conspersa, formâ Rhomboidali.[62]
Rhomboid oriental jasper, spattered with blood-coloured spots.

142 Jaspis orientalis formâ ovali.
Ovoid oriental jasper.

143 Jaspis orientalis formâ item ovali.
Another ovoid oriental jasper.

144 Jaspis orientalis cylindracea.
Cylindrical oriental jasper.

145 Terebinthizusa Dioscoridis paululum rufescens.
Turpentine stone [?] of Dioscorides, a little reddish.

146 Jaspis viridis paucis venulis sanguineis intercurrentibus distincta, forma ovali.[63]
Ovoid green jasper, with a few blood-coloured veins running through.

147 Jaspis item viridis formâ quadratâ angulis perforata.[64]
Another green jasper, rectangular in shape and perforated.

148 Cultri manubrium è Jaspide viridi.
Knife-handle of green jasper.
MacGregor 1983, no. 201.

149 Cultelli manubrium item è Jaspide viridi.
Handle from a small knife, also of green jasper.

150 Jaspis viridis formâ ovali.
Ovoid green jasper.

151 Jaspis viridis ovalis, paululum flavescens.
Ovoid green jasper, slightly yellowing.

152 Jaspis item viridis formâ ovali, magis flavescens.
Another ovoid green jasper, but with more yellow.

153, 154 Jaspides orientales duæ formâ octogonâ, in quibus Imago cujusdam aquam haurientis &c:[a] Ex donis Rever: Viri D. Caroli King Æd: Christi Alumni[-].
Two octagonal oriental jaspers, with the image of a water carrier etc. Given by Revd Charles King, Student of Christ Church.
MacGregor 1983, no. 131.

[15r]

155 Globus e Jaspide purpureâ.[65]
Sphere of deep red jasper.
MacGregor 1983, no. 115.

156 Achates cordiformis lineis cæruleis et purpureis ornatus.
Heart-shaped agate, embellished with blue and purple lines.

157 Idem [-cum 145,] sed multo minus.[66]
The same (as 145) but much smaller.

158a Achates ovalis fusci coloris maculis nigris insignitus.[67]
Ovoid agate of dark colour marked with black spots.

158b Achates rotundus priori similis.
Rounded agate similar to the last.

159 Prasius formâ ovali.
Ovoid prase.

160 Prasius cordiformis. \\deest//[68]
Heart-shaped prase.

161 Prasius octogonus.
Octagonal prase

162 Onyx niger. seu Onyx proprie sic dictus; formâ ovali.[69]
Ovoid, black onyx, i.e. onyx in the strict sense.

163 Onyx cornea formâ ovali.[70]
Hard, ovoid onyx.

164 Onyx luteus eâdem formâ.[71]
Golden-yellow onyx of the same shape.

165 Onyx aureus eâdem formâ.[72]
Golden onyx of the same shape.

166 Onyx viridescens.
Greenish onyx.

167 Sardonyx ovalis. \\2m.//
Ovoid sardonyx.

168 Sardonyx cordformis.
Heart-shaped sardonyx.

169 Turcois, turcosa, sive Turchesia magna formâ conicâ.

[60] fract
[61] L. R.
[62] [-min. Cabt.\x] [f.13v] Removed to the new Cabinets
[63] min. Cabt. [f.13v] removed
[64] fract: min Cabt.

[65] d
[66] d
[67] [-min. Cab\x] [f.14v] Removed
[68] [f.14v] 160 removed to the new Cabts.
[69] [-min. Cabt\x] [f.14v] 162 163 164 165 removed to the Minerals
[70] [-min. Cabt\x]
[71] [-min. Cabt\x]
[72] [-min. Cabt\x]

Large, conical turquoise.

170 Turcosa magna formâ conicâ depressiori.
Large, conical turquoise, flatter in form.

171 Turchesia sive Turchina cuneoformis.
Wedge-shaped turquoise.

172 Turchosæ tres depressiores formâ ovali.
Three ovoid turquoises, flatter in form.

173 Turchesiæ tres minores.
Three smaller turquoises.

174 Turchosæ duæ mimimæ.[73]
Two tiny turquoises.

175 Turchosæ tres viridescentes atque hoc pacto viliores, forte Malachites 4ᵗⁱ generis Wormii, vid. Mus. p. 95.
Three greenish turquoises, less valuable for this reason; probably the fourth kind of malachite described by Worm 1655, p. 95.

176 Corallii rubri specimina quatuor.
Four specimens of red coral.

177 Corallii rubri fragmenta duo.
Two fragments of red coral.

178 Corallii rubri fragmenta decem perforata.
Ten perforated fragments of red coral.

[16r]

179 Corallii albi specimen.
A specimen of white coral.

180 Idem.
The same.

181 Corallii rubri fragmentum.
Fragment of red coral.

182 [-Specimen Corallii albi et rubri unitorum.][74]
Specimen of combined red and white coral.

183 Chrystallus oblonga hexagona, formâ suâ naturali.
Oblong, six-sided crystal in its natural state.

184 Chrystallus hexagona ut è matrice suâ crescit.
Six-sided crystal in the form in which it grew from its matrix.

185 Chrystallus hexagona obtusa.
Blunt, six-sided crystal.

186 Chrystalli hexagonæ quatuor oblongæ ïmpolitæ.
Four elongated, six-sided crystals, unpolished.

187 Chrystalli tres multiformes politæ.[75]
Three irregular crystals, polished.

188 Chrystallus pyriformis polita.
Conical crystal, polished.

189 Chrystalli duæ pyriformes politæ.[76]

Two conical crystals, polished.

190 Chrystallus multiformis subfusci coloris.[77]
Irregular crystal, dark in colour.

191 Chrystallus pyriformis multifariam polita, ejusdem coloris.
Conical crystal of the same colour, polished at various points.

192 Chrystalli quadrangulæ decaëdræ 14 et majores & elatiores.
Fourteen large and impressive ten-sided crystals, with quadrangular faces.

193 Chrystalli quadrangulæ decaëdræ 14 paulo minores.
Fourteen rather smaller ten-sided crystals with quadrangular faces.

194a Chrystalli quadrangulæ decaëdræ /6\1[-] ejusdem magnitudinis.[78]
Six [one] ten-sided crystals of the same size, with quadrangular faces.

194b Chrystallus oblonga hexagona, formâ suâ naturali.
Oblong, six-sided crystal in its natural state.

195 Chrystalli quadrangulæ decaëdræ 14 ejusdem fere magnitudinis cum 194a.
Fourteen ten-sided crystals with quadrangular faces, almost the same size as 194a.

196 Chrystalli quadrangulæ decaëdræ 15 paulo minores.
Fifteen rather smaller ten-sided crystals with quadrangular faces.

197 Chrystalli quadrangulæ decaëdræ 15 multo minores.[79]
Fifteen much smaller, ten-sided crystals with quadrangular faces.

198 Chrystalli quadrangule decaëdræ 7 minimæ.
Seven tiny, ten-sided crystals with quadrangular faces.

199 Chrystallus figurâ conicâ multifariam polita.
Conical crystal, extensively polished.

200 Chrystalli 3 multifariam politæ, formâ triquetrâ.
Three extensively polished, triangular crystals.

201 Chrystallus magna oblonga multifariam polita.
Large, elongated crystal, extensively polished.

202 Annulus è Chrystallo politâ.
Ring of polished crystal.
MacGregor 1983, no. 128.

203 Annulus è Chrystallo polita.
Ring of polished crystal.

[17r]

204 Chrystallus multiformis polita, ære infixa.
Irregular, polished crystal, mounted in bronze.

[73]Unus deest
[74][**f.15v**] 182 Ebur seu Dens, ruberrimo Colore Tinctus.
Ivory or tooth, tinged with deep red.
[75][-2 Desunt\Min. Cabt]
[76][-]

[77][-min. cabt.\x] [**f.15v**] 190 removed to the new Cabinets
[78]E un.d.
[79]desunt 3

205 Chrystallus polita musco prægnans.[80]
Polished crystal, full of moss.

206 Calculus globosus transparens naturaliter sic formatus.
Transparent, spherical pebble, naturally formed.
MacGregor 1983, no. 192.

207 Ombria triangularis palâ argenteâ munita, è calculo transparenti naturaliter formata.
Triangular ombria mounted in a silver bezel, naturally formed from a transparent pebble.

208 Ombria triangularis superiori multo minor, palâ non munita, e Calculo item transparenti naturaliter formata.
Triangular ombria much smaller than the above, not mounted in a bezel, again naturally formed from a transparent pebble.

209 Ombria similis, superiori paulo minor.[81]
A similar ombria, a little smaller than the above.

210 Ombria similis, superiori paulo depressior.[82]
A similar gem, a little flatter than the above.

211 Ombria similis, superioribus omnibus multo minor et rotundior, a triangulo propemodum recedens.[83]
A similar ombria, much smaller than all the above and more rounded, less markedly triangular.

212 Ombria triangularis oblonga, superioribus figurâ similis.[84]
Elongated triangular ombria, similar in shape to the above.

212b Ombria Elliptica. Ex dono Johannis Wills. S. The. Prof: de Bishop's Ithington Com: Warw:[85]
Elliptical ombria. Given by John Wills, Professor of Sacred Theology, of Bishop's Itchington, Warwickshire.

212c Alia ejusdem figuræ et magnitudinis ex dono Johannis Aubrey Armigeri. R.S.S.[86]
Another of the same shape and size, given by John Aubrey Esq., FRS.

212d Calculus flavescens multiformis. Achates potius.
Irregular, yellowish pebble. Perhaps an agate.

[80][f.16v] removed to the new Cabts.
[81]☞ [f.16v] ☞ 209. Achates rotundus ex parte albus, ex parte rufescens - perforatus. \\removed//
Rounded agate, partly white, partly reddish, and perforated.
[82] [f.16v] 210. Achates rotundus luridus perforatus cirulis albis distinctus. *(bracketed with note to 209)*
Rounded agate, pale yellow and perforated, marked with white circles.
[83] [f.16v] 211. [-Achates rotundus luridus lirculis albidis notatus] \\deest.//
Rounded agate, pale yellow, marked with white circles.
[84][f.16v] 212 [-b] Globulus crystallinus albidus multifariam politus, perforatus.
A small white crystalline sphere, polished at various points, and perforated.
[85][f.16v] 212. [-c\b] Globulus achatis luridus perforatus Major.
Small pale yellow sphere of agate, perforated and larger than the last.
[86][f.16v] 212 [-d\c] Idem minor.
The same, but smaller.

213 Ostreæ margaritiferæ frustulum nitidissimum.
A small shining piece of pearl-bearing oyster.

214 Margaritæ tres vel forte quatuor naturaliter unitæ, et Leucachati appensæ, intecedente ornamento quodam ovali ex auro fabrifacto.
Three, or rather four naturally joined pearls, and hanging white agates, mounted on an oval ornament worked in gold.

215 Margaritæ sive Perlæ 3 nobiliores sive orientales.
Three splendid pearls, perhaps oriental.

216 Margaritæ 3 minores orientales.
Three smaller oriental pearls.

217 Margaritæ 6 nobiliores, superiori paulo minores.
Six splendid pearls, a little smaller than the above.

218 Margarita oblonga conica, sive Belemnitis forma.
Elongated, conical pearl, shaped like a belemnite.

219 Margaritæ [-9\5] minimæ.
Nine [five] tiny pearls.

[18r]

220 Margaritæ [10-\9] sordidiores.
Ten [nine] spoilt pearls.

221 Margaritæ 6 fœdissimæ perforatæ, forsan igne deformata.
Six pearls, perforated and badly damaged, probably by fire.

222 Margaritæ 3 fœdissimæ.
Three badly damaged pearls.

223 Eadem.
The same.

224 Eadem.
The same.

225 Lapis Lazuli magnus oblongus octogonus.[87]
Large, elongated lapis lazuli, octagonal in outline.

226 Armilla ex Lapidibus Lazuli oblongis spuriis, et baccis Indicis rubris quodammodo depressis alternatim positis.
Bracelet made from [beads of] false, elongated lapis lazuli, arranged alternately with slightly flattened Indian pearls, red in colour.

227 Lapis Nephriticus longus et rotundus.
Nephrite, long and rounded.

228 Lapis Nephriticus planus crenatus ejusdē coloris.
Nephrite, flat, of the same colour.

229 Lapis Lazuli formâ quadrangulâ oblongâ.
Lapis lazuli, forming an elongated rectangle.

230 Achates rotundus rufescens.
Reddish, rounded agate.

[87][min. Cabt.\x] [f.17v] removed to the new cabinets -

231 Lapis Nephriticus cylindraceus viridis
pediculo transverso.
Cylindrical, green nephrite on a little transverse base.

232 Idem iterum, sed minus.
Another of the same, but smaller.

233 Lapis Lazuli ovalis, ex uno Latere tribus
figuris insculptus; ex alio, 14 foraminibus aliquo
usque terebratus.
Ovoid lapis lazuli, incised with three figures on one face; on
the other, fourteen small, scattered holes have been drilled
through.
MacGregor 1983, no. 132.

234 Lapis Lazuli hexagonus spurius.
False, six-sided lapis lazuli.

235 Lapis Lazuli formâ quadratâ.
Square lapis lazuli.

236 Lapis Lazuli cylindraceus.
Cylindrical lapis lazuli.

237 []

238 []

239 Leucachates rotundus maculis nigris fœdatus.
Rounded, white agate, stained with black spots.
a Leucachates ovalis maculis flavescentibus
notatus.[88]
Ovoid, white agate, marked with yellowish spots.
b Leucachates rotundus luridus.[88]
Rounded, yellowish, white agate.
[19r]
c Achates rotundus flavescens maculâ nigrâ
notatus.
Rounded, golden-yellow, white agate, marked with a black
spot.
d Leucachates lineâ albescente insignitus.
White agate distinguished by whitish lines.
e Achates rotundus flavescens maculis fuscis
notatus. \\perf.//
Rounded, yellowish-white agate, marked by dark spots;
perforated.
f Marmor Chrystallinum ovale, flavis venis
distinctum. politum.
Ovoid, crystalline marble, distinguished by yellow veins;
polished.
g Marmor politum quadratum Rufescens.
Square, reddish marble.

240 Torquis è Gagatibus magnis oblongis, vereor
adulterinis. \\numero 24//[89]
Necklace made of large, elongated (and, I fear, false) jet
[beads]; twenty-four in number.

241 Armilla e Gagatibus genuinis oblongis &
rotundis.
Bracelet of genuine jet [beads], elongated and rounded.

242 Armilla è Gagatibus cylindraceis veris.
Bracelet of true jet cylindrical [beads].

243 Armilla è Gagatibus Deaedris forte spuriis filis
Aurichalicis invicem connexis cum cruce S:ᵗⁱ Johĩs
Hierosolymitani è matrice Perlarum appendente.
Bracelet of ten-sided jet [beads], probably false, alternately
linked with golden brass wires, with a pendant cross of St.
John of Jerusalem in mother-of-pearl.

244 Astroites formosissimus formâ ovali.
Ovoid astroites, most beautifully formed.

245 Lapis serpentinus spissius virens formâ
quadratâ. Ophites etiam dictus.
Square, dull green serpentine; also known as ophites.

246 Silex formosissimus coloris sanguinei
quodammodo transparens.[90]
Very beautiful, blood-coloured flint, almost transparent.

247 Marmor rubrum punctis albis interstinctum,
forte Porphyrites, formâ rotundâ.
Rounded, red marble spattered with white spots, possibly
porphyry.

248 Porphyrites alius formâ quadrangulâ oblongâ.
Another porphyry in the form of an elongated rectangle.

249 Marmor rubrum venis flavis intermixtum,
formâ ovali.
Ovoid, red marble threaded with yellow veins.

250 Marmor rubrum formosissimum, venis
flavescentibus et glastinis conspersum.
Very beautiful red marble, with scattered, yellowish and blue
veins.

[20r]

251 Marmor rubrum et album æquis partibus
commixtum, formâ quadrangulâ oblongâ.
Elongated rectangle of marble, with red and white intermixed
in equal parts.

252 Marmor rubrum (ut opinor) factitium venis
albis et viridescentibus conspersum; formâ
Quadratâ.
Square of red marble, false (I suspect), with scattered white
and greenish veins.

253 Marmor griseum (ut opinor) item factitium
venulis albis, rubris et nigris interstinctum, eâdem
formâ.
Grey marble of the same shape and also (I suspect) false,
with scattered little veins of white, red and black.

254 Marmor album paulo flavescens. \\Isabella.//
White marble, a little yellowish. Isabella.

255 Marmor flavescens venis albis notatum.
Yellowish marble marked with white veins.

256 Idem iterum.
Another of the same.

257 Marmor flavescens notis citrinis conspersum.
Yellowish marble spattered with yellow spots.

258 Marmor flavescens venulis albis et fuscis.

[88] *[bracketed with b] removed*
[89] F -

[90] min. C. [**f.18v**] removed to the new Cabinets.

Yellowish marble with little white and dark veins.

259 Marmor flavescens venis subnigris maculatum.
Yellowish marble, marked with dark-coloured veins.

260 Marmor citrinum venis rufescentibus.
Yellow marble with reddish veins.

261 Marmor citrinum venis sanguineis.
Yellow marble with blood-coloured veins.

262 Marmor citrinum venis albis et rubentibus.
Yellow marble with white and reddish veins.

263 Marmor venis citrinis albis et rubris æqualiter conspersū.
Marble veined equally with yellow, white and red.

264 Marmor ex citrino purpurascens.
Yellow marble shading to purple.

265 Marmor ex fusco viridescens.
Dark-coloured marble shading to green.

266 Marmor ex albo viridescens.
White marble shading to green.

267 Marmor rufescens lineis albis distinctum.
Reddish marble distinguished with white lines.

268 Marmor flavescens lineis albis et viridis notatum.
Yellowish marble marked with white and green lines.

269 Marmor coloris ravi vel Xerampelini, venulis albis.
Greyish or dark red marble, with small white veins.

270 Marmor coloris robei venis albis.
Red marble with white veins.

271 Idem iterum.
Another of the same.

272 Idem iterum.
Another of the same.

273 Idem iterum.
Another of the same.

274 Marmor coloris hiberi venis albis ornati.
Iberian coloured marble embellished with white veins.

275 Idem iterum atque hæc omnia formâ quadrangulâ oblongâ.
Another of the same; all of these are elongated rectangles.
a Achates subrufescens venis albis distincta.
Reddish agate, marked by white veins.
b Achates valde obfusca. Anglice 2 Gun flints.
Two deeply opaque agates; in English gun-flints.

[21r]

275c Marmor calcarium Melanoleucon ex Agro Pembrochiano.
Black-and-white limestone marble from Pembrokeshire.

276 Marmor obsidianum sive Numidianum, venis albis.[91]

Obsidian or Numidian marble, with white veins.

277 Marmor ex fusco viridescens. formâ quadrangulâ oblongâ.
Elongated rectangle of dark-coloured marble shading to green.

278 Globulus è marmore Gruino.
Small sphere of speckled marble.
MacGregor 1983, no. 64.
a Marmor albescens subfusco ad marginem ornatum. formâ quadrangulâ oblonga.
Elongated rectangle of whitish marble darkened at the edge.

279 Globulus è marmore ferreo.
Small sphere of ferrous marble.

280 Marmor citrinum lineis rufescentibus ornatum. formâ ovali.
Ovoid yellow marble embellished with reddish lines.
a Granatus ex Malverni montibus, Vigorniensi.[92]
Garnet from the Malvern Hills in Worcestershire.

281 Marmor subfuscum lineis albis et flavescentibus.
Dark-coloured marble with white and yellowish lines.

282 Marmor florentinum Civitatis prospectum quodammodo referens. formâ quadrangulâ oblongâ.
Elongated rectangle of Florentine marble, in some way representing a view of a city.

283 Idem iterum.
Another of the same.
c Globulus è marmore Gruino.
Small sphere of speckled marble.
d Lapillus ovalis coloris insuasi, macula albescente signatus.[93]
Small ovoid gem, dark orange in colour, marked with a whitish spot.

284 Marmor Florentinum montium precipitia exhibens, formâ quadrangulâ oblongâ.[94]
Elongated rectangle of Florentine marble, showing mountain crags.

285 Marmor Florentinum pedale, magnæ Civitatis ruinas referens, formâ ovali.
Florentine marble, a foot long and ovoid, depicting the ruins of a great city.

286 Embuscatum formâ quadrangulâ oblongâ, Ebeno munitum. Ex dono M:rs Whiting E. Coll: Wadh:
Elongated rectangular embuscatum [?], framed in ebony. Given by Mrs Whiting of Wadham College.

287 Embuscatum formâ ovali.
Ovoid embuscatum [?].

288 Embuscatum formâ quadrangulâ oblongâ.
Elongated rectangular embuscatum [?].

[91] Remov'd

[92] D
[93] Vide Lit. I Page 20 G [f.20v] [-in Let: Z.*]
[94] G

289 Embuscatum formâ octogonâ.[95]
Eight-sided embuscatum [?].

[22r]

290 Marmor Florentinum ædium /edium\ et Ecclesiarum ruinas ruinas referens, formâ quadrangulâ oblongâ.[96]
Elongated rectangle of Florentine marble, depicting the ruins of churches and buildings.

291 Duo alia minora ejusdem formæ, eadem exhibentia.[97]
Two others of the same form, showing the same scene.

292 Marmor Florentinum Civitatem referens quasi sub monte Teneriffâ, basano munitum.[98]
Florentine marble depicting a city below what looks like the mountain of Tenerife, framed in basanite.

293 Marmor Florentinum ædificiorum ruinas referens, et Ecclesiæ pyramidem altissimam.[99]
Florentine marble depicting the ruins of buildings and the very tall spire of a church.

294 Ophites, seu Marmor serpentinum Zeibicium. formâ quadrangulâ.[100]
Square ophite or serpentine marble of Zeiblicium.

295 Marmor hiberum venis luteis interstinctum, formâ quadrangula oblongâ.
Elongated rectangle of Iberian marble with scattered saffron-yellow veins.

296 Lapis impolitum arbores referens.
Unpolished stone with a representation of trees.

297 Lapis magnus cuneoformi coloris thalasini, rupe solidâ repertus, in fodinâ Virginiæ 40 Orgyias altâ.[101]
Large, wedge-shaped stone, sea-blue in colour, found in solid rock in Virginia, in a pit cut 40 fathoms deep.

298 Phengites sive Marmor Parium translucens formâ quadrangulâ oblongâ.
Elongated rectangle of crystallized gypsum or translucent Parian marble.

299 Basaltes formâ globosâ.[102]
Sphere of basalt.

300 Thyites Italis Verdello, lapis viridis cuneoformis. forte Ophites Orientalis. vid. Philos. Trans. N.185. p.223.
Thyites, called *verdello* in Italian; a green wedge-shaped stone, perhaps oriental serpentine. See *Philosophical Transactions* no. 185, p. 223.

301 Marmor Leucophæum formâ ovali.[103]
Ovoid, ash-coloured marble.

302 Marmor cinereum Seravitanum maculis cinereis insigne. formâ quadrangulâ oblongâ.[104]
Elongated rectangle of ash-grey marble with grey markings.

303 Pyrites aureus multiformis politus.[105]
Irregular, gold-coloured pyrites, polished.

304 Amianthus alias Lapis asbestinus P. Veneto Salamandra.[106]
Earth-flax, otherwise known as asbestos stone (Pliny). Known in Venice as Salamandra.

[23r]

305 Marmor Parium impolitum de Templo Apollinis in Civitate Delphi juxta Parnassum.[107]
Unpolished Parian marble from the Temple of Apollo in Delphi, near Mount Parnassus.

306 Marmor Parium impolitum de femore statuæ Apollinaris in eôdem Templo.[108]
Parian marble from the thigh of the statue of Apollo in the same temple, unpolished.

307 Robur Brittanicum petrificatum, formâ oblongâ.[109]
Elongated piece of petrified British oak.

308 Coagula Sulphurea Tiburensia, instar bellariorum aridorum saccharat Italis, Confetti de Tivoli, vide Raii Observat: Topograph. p. 376.
Conglomerate of sulphur from the River Tiber, looking like a lump of dried sweetmeat. Called in Italian *confetti di Tivoli*. See Ray 1673, p. [367].

309 Lapis (ut videtur) Scissilis oblongus coloris subnigri, nominibus sacris Jesu, Mariæ, Josephi inscriptus quod artificio (vereor) non naturaliter factum: cujusmodi apud Germanos Gamahujæ dicuntur.[110]
Elongated, darkish, laminar stone, inscribed with the names of Jesus, Mary and Joseph, which (I fear) was made artificially and not by Nature. Stones of this kind are called gamahe among the Germans.
MacGregor 1983, no. 189.

310 Gamahuja alia, Lapis Crucis dictus, qui in corpore Leucophæo crucem nigram ostentat.
Another gamahe called the Stone of the Cross, exhibiting a black cross on an ash-grey background.

311 Lapis Crucis alius, formâ quadrangulâ oblongâ, qui in corpore robeo albescente, crucem etiam nigram ostentat.

[95] **[f.20v]** [-Do]
[96] **[f.21v]** removed
[97] un fract.
[98] H. **[f.21v]** [-in Letter Z -]
[99] **[f.21v]** [-Do. -]
[100] **[f.21v]** [-in Letter Z -]
[101] H 2 [!]
[102] [-H 2.] **[f.21v]** * H 2
[103] **[f.21v]** H 2

[104] d-
[105] d
[106] Removed **[f.21v]** str. Gypsum
[107] H 2
[108] ☞ **[f.22v]** 306 Ad novum Scrinium translatum /est\ inter Fossilia polita.
Removed to the new cabinet; it is amongst the polished fossils.
[109] ☞ **[f.22v]** 307 Ad novum Scrinium translatum est inter Fossilia polita.
Removed to the new cabinet. It is amongst the polished fossils.
[110] Gt. Room

Another Stone of The Cross, rectangular and elongated, exhibiting a red body shading to white, also showing a black cross.

312 Lapis quodammodo Bufonem referens.
Stone resembling a kind of toad-stone.

313 Ætites, sive Lapis Aquilinus coloris cinerei ad rotunditatem accedens, alium Lapidem vel Argillam in se continens.
Aetites or eagle-stone, ash-grey in colour and rounded in shape, with another stone or a lump of clay inside it.

314 Representatio cretacea tum forma tum magnitudine, Calculi è vesica urinaria Hispanioli agrarii, excisi: in Com: Icenorum Huntingdonensi Anno. 1654.
Chalk facsimile, identical in shape and size, of a stone cut from the urinary tract of of a Spanish peasant, in the county of Huntingdon, 1654.

315 Lapis à Dño: Goodale Navarcho Anglo excisus ex ventriculo Rhinocerotis à se confossi in Indiâ Orientali.[111]
Stone cut by Mr Goodale, English ship's captain, from the belly of a rhinoceros, which he had shot in the East Indies.

[24r]

316 Calculus humanus è vesicâ urinariâ Dñæ Cole de Bedhampton in Com: Belgarum Hantoniensi, ab obstetrice, sine ullâ sectione, aut dilaceratione extractus.
A stone from the urinary tract of Mrs Cole of Bedhampton in Hampshire, removed by the midwife without any incision or cutting.

317 Calculus humanus eximiæ magnitudinis è vesicâ urinariâ puellæ octennis Cantuariensis à Johanne Eliot M.D. excisus.
Human kidney stone of exceptional size, removed from the urinary tract of an eight-year-old girl from Canterbury, by John Elliot, MD.

318 Lignum petrefactum.[112]
Petrified wood.

319 Lapis Fungi caput referens.[113]
Stone shaped like the cap of a mushroom.

320 Ostreum petrefactum.[114]
Petrified oyster.

321 Fragmentum Lapidis in quo est Representatio S:ᵗⁱ Johannis Baptistæ Capitis &c:ᵃ de quô fertur quod in Pulverem redactus Oculis lippis et male se habentibus plurimum inservit.[115]
Piece of stone in which is exhibited the head of St. John the Baptist etc. from which scrapings reduced to powder were commonly used to cure inflamed and watery eyes.

322 Calculus humanus tantæ magnitudinis è vesicâ cujusdam Betricis Shreve de Tunsted in Com: Norwicensi sine ullâ aut sectione aut dilaceratione extractus, ut rei veritas sub Sigillo Communi Civitat. Norwic; posteris transmitti par esse videbatur.
Stone removed, without any incision or cutting, from the urinary tract of a certain Beatrice Shreve of Tunstead in Norfolk, of such a size that it seemed fitting to preserve the event for posterity by recording it under the seal of the city of Norwich.

323 Globulus vitreus pomiformis opere lucerniali, multis tum figuris tum coloribus eleganter variegatus.[116]
A small glass sphere, shaped like a fruit, made in Lucerne; it is elegantly decorated with various figures and colours.

324 Cymbalum minus æneum queis utuntur Judæi. \\vid. Caps. a Swete donat.//[117] [bracketed with 325]
Small bronze cymbal, used by the Jews; see Drawer a. Given by [Benjamin] Swete.

325 Cymbalum majus æneum. [bracketed with 324] [118]
Large brass cymbal.

326 Exemplar istius percelebris Adamantis à Dño Pitt Regi Franciæ Venditi ex Adamante Bristoliensi seu Chrystallo confictum.[119]
An example of the kind of renowned diamond sold by Mr Pitt to the King of France, made from Bristol diamond or rock-crystal.

[25r]

327 Tessellæ pavimenti tessellati deauratæ tres.[120]
Three gilded cubes from a mosaic pavement.

328 Tessella coloris limonei.
Yellow-coloured cubes from a mosaic.

329 Tessellæ cæruleæ duæ, sive coloris cyanei.
Two blue or blue-green cubes from a mosaic.

330 Tessellæ luridæ tres, seu potius cæsiæ.
Three yellowish, or rather blue-grey cubes from a mosaic.

331 Tessellæ duæ Smaragdinæ.
Two emerald-coloured cubes from a mosaic.

332 Tessella una subviridis, seu coloris chrysolitholini.
One greenish or topaz-coloured cube from a mosaic.

333 Tessella coloris Persici.
Peach-coloured cube from a mosaic.

334 Tessellæ 32 coloris ferruginei. Harum figura est naturalis, et in lapide Scissili per totam

[111][-Gt. Room]
[112]Drawer above
[113]Do.
[114]**[f.23v]** 320 Inter Fossilia
Amongst the fossils.
[115]Gt. Room

[116]Fract. 1762 deest.
[117][-I]
[118][-]
[119]Dr. opposite x Gt. Room **[f.23v]** [-\P] 422
[120]g *[f.24v] * Omnia ex Numero 327 - usq; ad numerum 354. ad novum translata sunt Scrinium.
Everything from number 327 up to number 354. They are removed to the new cabinet.

Walliam fere occurrunt. Est ludus Paracelsi apud Helmont.

Thirty-two mosaic cubes of a metallic colour. Their shape is natural and they are found in all the laminar stones of Wales. [Examples of] the Ludus Paracelsus or Ludus Helmontii.

335 Tessellæ tres Anthracinæ.
Three black cubes from a mosaic.

336; 337 Idola Ægyptiaca characteribus itidem Ægyptiis insculpta, et incrustatione è cæruleo viridescente tecta.[121]
Egyptian idols incised with Egyptian characters and with an incrustation of blue shading to green.

338 Idola Ægyptiaca capitibus ovinis, quæ colebant in Sahid, seu Ægypto superiori, incrustatione subviridi tecta.
Egyptian idols with sheeps' heads, which were found in Sahid or Upper Egypt, with a greenish incrustation.

339 Idolum Ægyptium sub formâ Cati, quod Ægyptus tota adorabat, coloris ex viridi albescentis.
Egyptian idol in the form of a cat, which all the Egyptians worshipped; green in colour shading to white.

340 Idolum Ægyptium sub forma Galli, incrustatione ex cæruleo viridescente tectum.
Egyptian idol in the form of a cock, with an incrustation of blue shading to green.

341 Idolum Ægyptium sub forma Scarabæi, incrustatione simili tectum. de quô vide Plutarchum in Iside & Osir.
Egyptian idol in the form of a scarab, with a similar incrustation; on this, see Plutarch's *On Isis and Osiris*.

342 Osiris mitratus è Lapide cineritio sculptus, formâ ferè quadrangulâ.
An almost square Mithraic Osiris, carved from volcanic stone.

343 Lampas cuprea Romana ansula dotata, & foramine uno ampliore per quod oleum infunditur, et duobus minoribus per quæ Elychnia prominebant.
Roman copper lamp with a little handle and with a single large hole through which the oil is poured and two smaller holes through for the wicks.

[26r]

344 Icuncula (ut opinor) Martis ænea, Regulbii reperta.
Small brass figure of Mars (I believe), found in Reculver.

345 Sigillum antiquum æneum, cum hâc inscriptione in Limbo. S. Potis. M̅r̅i Ebie oratis beate Marie de Carmel.
Ancient bronze seal, with this inscription around the edge: `The Seal of the most powerful [?], pray for us blessed Mary of Carmel'.

346 Annulus Romanus æneus, gemmâ è loculo excussâ.
Roman brass ring, the gem knocked out of its setting.

347 Idem iterum, vel forte fibula gymnastica.
Another of the same, or perhaps a fibula used in exercise.

348 Cinguli forte Romani ansula ænea.
Girdles with a brass buckle, perhaps Roman.

349 Cinguli Romani, bulla ænea, effigie militis impressa, labarum dextra tenentis.
Roman girdles, with a brass stud impressed with the image of a soldier holding a standard in the right hand.

350 Fibulæ Romanæ æneæ. Johis Rhodii, in præfat:
Roman brass fibulae. See Rhode (1728), preface.

351 Idem iterum. N. Joh̅i̅s Smetii commissura. p. 86.
Another of the same. Deposited by John Smith.

352 Fibula Romana quadrata oblonga.
Elongated rectangular Roman fibula.

353 Fibulæ Romanæ æneæ, canaliculâ effigiatâ.
Roman brass fibulae, with a little moulded groove.

354 Fibula vestiaria adunca ænea, sine acu. Joh. Rhodii, p. 54.[122]
Fibula or dress-pin of brass, bent inwards, lacking a pin. Rhode (1728), p. 54.

355 Lapis ex Porci Pene desumptus.[123]
Stone taken from a pig's penis.

356 Lapis ex Bahamiâ Insulâ allatus.
Stone brought from the Island of Bahama.

357 Lapis ex Reni Tho: Lyttleton de Franckly Bart: post mortem ejus, argento munitus.
Stone taken from the kidneys of Thomas Lyttleton of Franckley, Bart., after his death; mounted in silver.

358 Tres Lapides ex Stomacho Troctæ piscis desumpti, Sarrat in agro Hertfordiensi captæ. Anno 1748.
Three stones taken from a trout's stomach, caught at Sarratt in Hertfordshire, 1748.

359 Cauda Serpentis Americani caudisoni.
Tail of an American Rattle-snake.

360 Quatuor digiti humani fulmine tacti.
Four human fingers struck by lightning.

361 Lapis ex Stomacho - Gore Primarii Civis Londinensis. \\fract.//
Stone from the stomach of Mr Gore, Mayor of London; broken.

362 Marmor ovi speciem petrifacti representans.
Marble in the form of a petrified egg.

[121]L.R.

[122][f.25v] Omnia ex numero 327 - usq. ad numerum 354 ad novum translata sunt scrinium.
Everything from no. 327 to no. 354 removed to the new cabinet.
[123]#

363 Scloppus cum omni apparatu suo sesqui-
uncialis.[124]
Musket with all its apparatus, measuring 1½ in.

364 Æneus Ensis Tippsburiæ juxta Sarum
inventus. D.D. Wyndham Knatchbull Baronett:
\\transfer'd.//
Bronze sword found at Tippsbury near Old Sarum. Given by
Sir Wyndham Knatchbull; transferred.

[27r]

365 Massa succini candidi vel potius mellei coloris
non transparens, cæteris longe pretiosior.[125]
Mass of opaque white or rather honey-coloured amber, much
more valuable than the others.

366 Columellæ duæ è tali succino venulis albis
distinctæ.
Two little columns of amber of that same kind, marked with
small, white veins.

367 Cranium humanum e tali succino sculptum.[126]
Human skull carved from that same sort of amber.

368 Duo Globuli electrini perforati majores e
quibus (ut opinor) quondam armilla electrina.
Two little spheres of amber, mostly perforated, once (so it
seems) from an amber bracelet.

369 Massa ampla succini fulvi transparentis, instar
auri rutilantis.[127]
Large mass of transparent, yellow-brown amber, like reddish
gold.

k. Massa alia ejusdem succini paulo minor, sed
non minus rutilans.[128]
Somewhat smaller lump of the same sort of amber, but no
less red.

370 Succinum fulvum cordiforme, in quô Imago
Herois cujusdam ex Ebore inclusa. \\fract://
\\Imp://[129]
Heart-shaped, deep yellow amber, enclosing an ivory figure
of a hero; broken. A general.

371 Succinum fulvum ovale in quo 9 orbes
electrini splendide repræsentantur. \\fract//
Ovoid, deep yellow amber, in which nine shining spheres are
formed.
MacGregor 1983, no. 180.

372 Succinum fulvum phryganio prægnans.[130]
Deep yellow amber with a creature embedded within it.

373 Quatuor musculæ succino flavo implicitæ.
\\fract://[131]
Four flies caught in yellow amber; broken.

374 Aranea succino flavo cordiformi incarcerata.
Spider imprisoned in heart-shaped amber.

375 Tres Gemmæ auriculares succini flavi, in
quibus Animalia continentur.[132]
Three ear-rings of yellow amber, in which small creatures are
enclosed.

376 Succinum oblongum animalia inclusa[-m]
\\&c//[133]
Elongated amber in which small creatures etc. are enclosed.

377 Succinum flavum Araneam inclusam. &c.
Yellow amber enclosing a spider etc.

378 Idem iterum. \\[-]//[134]
Another of the same.

379 Araneus binoculus longipes, Opilio quibusdam
dictus, succino fulvo compeditus.
Spider with two eyes and long legs, called the Shepherd by
some, trapped in amber.

380-383 Quatuor Globuli electrini perforati
majores e quibus (ut opinor) quo/n\dam armilla
electrina.
Four small amber spheres, mostly perforated, probably once
from an amber bracelet.

[28r]

384-385 Idem iterum, sed superioribus minora.
Another of the same, but smaller than the above.

386 Globulus Succini fulvi transparentis.
Small sphere of transparent, yellow amber.

387 Succini pelucidi rutilantis, massa rudis sive
impolita.
A lump of transparent blood-red amber, in its natural or
unpolished state.

388 Succinum formâ cylindraceâ. \\fract://
Amber; cylindrical in form, broken.

389 Succinum rude sive informe.
Natural or unformed amber.

390 Succini flavi sive mellei fragmentum rubigine
incrustatum.[135]
Fragment of yellow or honey-coloured amber, encrusted with
red.

391 Succini rudioris fragmentum, rubigine
incrustatum, flavi coloris intus.[136]
A fragment of coarser amber, encrusted with red; yellow on
the inside.

392 Tres Globuli perforati succini flavi.
Three small perforated spheres of yellow amber.

393 Duo globuli depressi perforati, succini flavi.
Two small flattened spheres of yellow amber.

[124] D
[125] K
[126] [-K]
[127] L.R. **[f.26v]** 369 373 & 379 removed to the Minerals
[128] L.R.
[129] d.
[130] D
[131] [-L.R.\x]

[132] [-un.d.] **[f.26v]** Removed to the new Cabinets .
[133] L.R. **[f.26v]** 376.b. Idem iterum. D.D. J:Chamberlayne A.M. [-]
Coll: Trin: Oxon: Soc. 1757
Another of the same given by J. Chamberlayne, MA, Fellow
of Trinity College, 1757.
[134] [-D\x]
[135] removed *(bracketed with 391)* L.R.
[136] **[f.27v]** 391. b. Fragmentum pellucidius, sed etiam Rude.
A transparent fragment, but still in its raw state.
(See also footnote to 390)

394 Idem iterum.
Another of the same.

395 Idem iterum.
Another of the same.

396 Idem iterum.
Another of the same.

397 Tres Globuli depressi ejusdem succini.[137]
Three small flattened spheres of the same amber.

398 Fragmenta tria succini flavi.[138]
Three fragments of yellow amber.

399 Fragmenta tria Succini flavi, elaborata.
Three worked fragments of yellow amber.

400 Fragmenta 11 succini flavi.[139]
Eleven fragments of yellow amber.

401 Torquis è succino fulvo, vel forte potius tesseræ precatoriæ, plerumque ovales, nonnullæ cruciformes, in quibus Curcifixionis instrumenta sparsim depicta.[140]
Necklace of yellowish-brown amber, or rather they may be prayer-beads, most of them oval, several of them cruciform, in which the instruments of the Passion are depicted here and there.
MacGregor 1983, no. 123.

402 Torquis è diversis particulis succini fulvi, ac eboris varie formatis, ac dispositis.
Necklace made of various fragments of yellowish-brown amber and of ivory, variously shaped and arranged.

403 Torquis ex ovalibus vitreis, auro variisque coloribus encausto pictis.
Necklace made of oval glass beads, painted encaustically in gold and various colours.
MacGregor 1983, nos. 118-19.

[29r]

404 Torques 6 è quadrangulis oblongis vitreis, colore Lazurio, encausto pictis.
Six necklaces made of azure blue, elongated rectangular glass beads, encaustically painted.
MacGregor 1983, no. 117.

405 Rosarium ligneum.
Wooden rosary.
MacGregor 1983, no. 122..

406 Rosarum ligneum cujus tesseræ cinnabarii coloris.[141]
Wooden rosary with beads the colour of cinnabar.

407 Rosarium ligneum cujus tesseræ coloris Æthiopici.
Wooden rosary of which the beads are black in colour.

408 Rosarium partim (ut opinor) ex ebore, partim ex ossibus cum Cruce.
A rosary, partly made (so it seems) of ivory, partly of bone, together with a cross.

409 Rosarium ex tesseris vitreis, quarum sex /quatuor\ Coloris cærulei, reliquæ Chrystallini: quibus annexæ duæ parvæ cruces, Hæc ex Ebore, Illa ex Matre Perlarum.
Rosary with glass beads, of which six [four] are sky-blue, the rest crystalline, to which are attached two crosses, one of ivory, the other of mother-of-pearl.

410 Rosarium vitreum.
Glass rosary.

411 Tres Globuli eburnei perforati manubrio affixi alius intra alium mire detornati, quorū intimus aculeis hirsutus per foramina trajectis.[142]
Three small, admirably turned, pierced ivory spheres, attached to a handle, one inside the other; the innermost has spikes which stick out through the holes.

412 Decem tales Globuli filo conserti.
Ten similar spheres, joined with a cord.

413 Prisma æquilatero-triangulare vitreo-chrystallinū pro repræsentandis coloribus Iridum emphaticis.
Prism in the form of an equilateral triangle of crystalline glass, for producing the colours of the spectrum.

414 Prisma aliud in omnibus simile, nisi colore citrino.
Another prism similar in every way, except that it is yellow in colour.

415 Unum è cornibus Mariæ Davies de Saughall in districtu Wyrehallensi in com: Cestriæ, quæ solet exuere cervorum instar quibusdam Annis interpositis.[143]
One of the horns of Mary Davis of Saughall in the district of Wirral in Cheshire, which she used to shed every few years in the manner of deer.
MacGregor 1983a.

416 Catena gagatea Turcica ex undecim lamellis quadratis duobus globulis interpositis constans. Ex Dono Dñi Buckridge è Coll Divi. Johan: Bapt. Socio. Com:
Chain of jet from Turkey, comprising eleven small square pieces each separated by a pair of spherical beads. Given by Mr Buckridge, Fellow-commoner of St. John's College.

[30r]

417 Manus è Gagate cujusmodi solent Turci suis puerulis dono dare, utpote quorum virtute (uti stultè existimant) à fascinationibus tuentur.
\\fract.//

[137]2 desunt
Two are missing
(bracketed with 398, 399 and 400:) [-desunt]
[138][-un d.]
[139]D
[140]L. L.R.
[141]**[f.28v]** 406 B. Catena ex ossiculis mali Armeniæi conficta D.D. Davies A.M.
Chain made from the small bones of an Armenian criminal. Given by [] Davies, MA.

[142]Stair Case
[143]M. L.R

Hand of jet of the kind that the Turks customarily give as a gift of to their small boys, by the power of which (as they foolishly think) they are protected from the evil eye; broken. MacGregor 1983, no. 190.

418 Manus alia Turcica lunâ dimidiatâ insignita. Ex Dono Dñi Buckridge e Coll: Divi: Joan: Bapt: Socio-Com: \\fract.//

Another Turkish hand inscribed with a half-moon. Given by Mr Buckridge, Fellow-commoner of St. John's College. Broken.

419 Ampulla argentea undique deaurata pro suffimentis conservandis.

Silver ampulla, gilt overall, in which to keep incense.

420 Alcoranum Turcicum in pyxide argenteâ rubino ornatâ, variisque coloribus encausto pictâ.

Turkish Koran in a silver box adorned with a ruby and enamelled in various colours. MacGregor 1983, no. 24.

421 Pictura S:ᵗⁱ Cuthberti jussu Alfredi facta. agro Somersetensi apud Vicum Athelney dictu inventa. D.D. Tho:ˢ Palmer Armig: de Fairfield. in Comit: Somerset:[144]

Picture of St. Cuthbert, made by the order of Alfred, said to have been found in Somerset near Athelney. Given by Mr Thomas Palmer Esq., of Fairfield in Somerset.

422 Diversa specimina papyri Ægyptiacæ Malabaricæ, characteribus Arabicis inscripta: in Ægypto enim hujusmodi chartâ (quæ aliud non est quam folium cujusdam palmæ) non utuntur.

Various specimens of Egyptian papyri or [Indian] Malabarica, inscribed with Arabic characters; in Egypt, indeed, documents of this type (being nothing more than a leaf from some sort of palm) are not used. MacGregor 1983, nos. 80-3.

423 Manuscriptum Caroli Primi. Angl: Regis in vitreū.[145]

Handwriting of Charles I, King of England, under glass.

424 Igniarium è spurio Auro fabrefactum eleganter cælatum instrumentis suis omnibus repletum.[146]

Tinder-box, made of false gold and elegantly engraved, filled with its appropriate instruments.

425 Catena è Ligno solido exsculpta.[147]

Wooden chain, carved from a single piece of wood.

426 Catena ex Ebore solido exsculpta.

Chain carved from solid ivory.

427 Corpus solidum ligneum eâ formâ donatum, ut foramina rotundum, ovale, quadrangulum, omnia ad unguem expleat.

Solid wooden body, of such a shape that it fills all holes perfectly, whether round, ovoid or square.

428 Calendarium Suecicum ex asseribus oblongis fabricatum, literis Runicis inscriptum, Suecis a Rimstock[148]

Swedish calendar, made of oblong tablets, inscribed with runic characters, from Rimstock in Sweden. MacGregor 1983, no. 194.

[31r]

429 Abacus Japonicus, in quo rationes colliguntur per globulos stanneos perforatos filo ferreo consertos, Stylo item ferreo hinc inde mobiles.[149]

Japanese abacus, in which sums are calculated with perforated tin beads strung on iron wire, and movable from side to side on the said iron rod. MacGregor 1983, no. 193.

430 Frustrum ligni è medio Saxi desumptum: Oxõn. 1742.

Piece of wood found in Middlesex; [brought to] Oxford 1742.

431 Schema quasi topiarium in matre Perlarum Chanquo dicta; formâ ovali.[150]

Mother-of-pearl, known [in Portuguese] as *chanquo*, oval in outline, looking almost like topiary work.

432 Schematis topiarii alia species, eisdem materiâ ac formâ.

Another piece resembling topiary, of the same form and substance as the former.

433 Vitrum chrystallinum ovale, Aquilâ Imperiali sculptum. fract.[151]

Ovoid crystalline glass intaglio, engraved with an imperial eagle; broken.

434 Vitrum chrystallinum octogonum flore coccinio in area deaurata encausto pictum opere posterganeo.

Octagonal crystalline glass intaglio, worked from the back, and encaustically painted with a scarlet flower on a gilded background.

435 Vitrum chrystallinum ovale, Gryphe erecto cælatum.

Ovoid crystalline glass intaglio, carved with an upright griffin. MacGregor 1983, no. 176.

436 Vitrum chrystallinum ovale, in quo Cranium humanum, inter clepsammidium et duo ossa femoralia decussatim posita, cælatum.

Ovoid crystalline glass intaglio, on which is carved a human skull between an hourglass and two crossed femoral bones. MacGregor 1983, no. 175.

437 Vitrum chrystallinum, in quo Turci caput Tiarâ indutum in solo miniato, opere posterganeo exhibetur.

Crystalline glass intaglio, worked from the back, on which is shown the head of a Turk wearing a turban, on a red background. MacGregor 1983, no. 172.

[144]Lit P L.R.
[145]D
[146]L.R.
[147]Fract.

[148]removed L.R. **[f.29v]** in Letter F
[149]Stair Case
[150]N **[f.30v]** deest
[151]Fract

438 Vitrum chrystallinum ovale, in quo herois caput galeatum in solo coccineo, simili opere posterganeo ostenditur.
Ovoid crystalline glass intaglio, showing the helmeted head of a hero, on a scarlet background, similarly worked from the back.
MacGregor 1983, no. 173.

439 Vitrum chrystallinum ovale, in quo Æthiopis caput cælatum. \\fract://
Ovoid crystalline glass intaglio, on which is carved the head of an Ethiopian; broken.

440 Cama, in quâ figura hominis integra in Lapide Lazuli insculpta est.
Cameo, on which is carved the complete figure of a man in lapis lazuli.

441 Vitrum chrystallinum ovale, figurâ insculptum sagittam jaculante.
Ovoid crystalline glass intaglio, carved with a figure shooting an arrow.
MacGregor 1983, no. 174.

[32r]

442 Vitreum chrystallinum rotundum in quô Cor argenteum alis aureis, diademate ducali aureo coronatum opere posterganeo adumbratur.[152]
Rounded crystalline glass intaglio, worked from the back, on which is shown a silver heart with golden wings, crowned with a gold ducal coronet.

443 Vitrum chrystallinum ovale in quo Insignia Gentilia familiæ de ... in scuto bipartito cælata.
Ovoid crystalline glass intaglio, on which is carved, on an impaled shield, the arms of the noble family of [].

444 Leo gradiens faberrimè sculptus in basso relievo in obverso, et Leæna in reverso; uterque ex Onyche ovali auro munita.[153]
Lion rampant skilfully carved in bas-relief on the obverse surface, with a lioness on the reverse; both made from ovoid onyx mounted in gold.

445 Aquila coronata alis expansis è Corallio rubro cælata opere elato, cum stalagmiis ex eâdem materiâ appendentibus.
Crowned eagle with its wings outstretched, carved in high-relief from red coral with pendants of the same material.
MacGregor 1983, no. 114.

446 Stalagmiorum par elegantissimum, e Corallio rubro affabrè cælatorum.[154]
A most elegant pair of earrings, skilfully carved from red coral.

447 Apollo citharizans è Corallio cælatus, unâ cum multis stalagmiis circum circa pendentibus.[155]
Apollo playing his lyre, carved from coral with many pendants hanging all around.

448 Vitrum chrystallinum octogonum in quô Insignia gentilia familiæ de ... in scuto bipartito cælata.[156]
Octagonal crystalline glass intaglio, on which is carved, on an impaled shield, the arms of the noble family of [].

449 Vitrum chrystallinum rotundum, in quô etiam Insignia gentilia Familiæ, de ... simplici scuto incisa.[157]
Rounded crystalline glass intaglio, on which is carved, on a shield, the arms of the noble family of [].

450 Idem iterum.[158]
Another of the same.

451 Idem iterum. \\fract.//[159]
Another of the same; broken.

452 Cama, in quâ figura se inclinans carneolo ovali cælata.
Cameo, in which a reclining figure is carved on an ovoid carnelian.
MacGregor 1983, no. 125.

453 Cama, in quâ Angelus galeatus (S:tus Michæl) manibus tenens tubam, carneolo item ovali incisus.
Cameo in which a helmeted angel (St. Michael), holding a trumpet in his hand, is carved on an oval carnelian.
MacGregor 1983, no. 127.

454 Cama, in quâ Heroinæ caput Carneolo ovali incisum.[160]
Cameo, in which the head of a heroine is carved on an oval carnelian.
MacGregor 1983, no. 124.

455 Cama, in quâ Plantæ figura Carneolo ovali incisa.
Cameo, in which a picture of a plant is carved on an oval carnelian.
MacGregor 1983, no. 126.

[33r]

456 Sanctus Jacobus in Pruni ossiculo insculptus.
St. James carved on a plum-stone.
MacGregor 1983, no. 183.

457 Sportula è Cerasi ossiculo sculpta.[161]
A little basket carved from a cherry-stone.

458 Calceus nitidissimus è Cerasi ossiculo.
Highly polished boot, carved from a cherry-stone.

459 Insignia sex familiarum uno clypeo contenta in unicâ facie ossicula pruni cælata.
The arms of six families on one shield, carved on a single side of a plum-stone.
MacGregor 1983, no. 184.

[152]D
[153]L.R
[154]Fract(?)
[155]Do

[156]D
[157]D
[158]D
[159]D
[160][-D]
[161][f.23v] 457. Eadem 3tis Die Augusti huic Museo data 1759.
This item given to this Musuem on 3 August 1759.

460 Cerasi ossiculum in cujus uno latere, S.:tus Georgus cum Dracone in alio 88 Imperatorum facies, arte thaumaturgicâ cælati.
Cherry-stone on which is carved, on one side, St. George and the Dragon and on the other eighty-eight emperors' faces, carved in a miraculous manner.
MacGregor 1983, no 439i.

461 Christi crucfixio, cum S.:tis Fæminis assecIis, Milite latus transfigente, totaque comitante catervâ, in pruni ossiculo item graphicè sculpta. \\fract.//[162]
The Crucifixion of Christ, with the Holy Family, with the soldier piercing his side, accompanied by a crowd of people, all finely carved in a plum-stone; broken.
MacGregor 1983, no. 182.

462 Imago Dñi ñri Jesu Christi intra ovale incisa, in quô hæc inscriptio Ecce Salvator mundi. \\fract://[163]
Image of Our Lord Jesus Christ carved within an oval bearing this inscription: 'Behold the Saviour of the World'; broken.
MacGregor 1983, no. 185.

463 Imago B. Mariæ Virginis item intra ovale incisa, in quo hæc inscriptio. Ecce Mater Christi. utraque opere multiforo. \\fract://[164]
Image of the Blessed Virgin Mary, also cut within an oval bearing this inscription: 'Behold the Mother of Christ'; each side executed in openwork; broken.
MacGregor 1983, no. 186.

464 Orpheus citharizans in unâ facie ossiculi unius pruni sculptus, et omne genus bestiarum comitantium in aliâ, opere multiforo.[165]
Orpheus playing the lyre carved on one side of a plum-stone, and on the other, a following of all kinds of animals; carved in openwork.
MacGregor 1983, no. 181.

465 Christi nativitas, cum S.:to Josepho, B. Maria, Angelo et pastoribus in pruni ossiculo faberrimē sculpta.
The Birth of Christ, with St. Joseph, the Blessed Mary, an angel and shepherds; skilfully carved on a plum-stone.

466 Cantharus è pruni ossiculo sculptus.
Tankard, carved from a plum-stone.

467 Cymba è pruni ossiculo sculpta.
Boat carved from a plum stone.

468 Capita XII Apostolorum in argento, toreumate seu opere anaglyptico exhibita, contenta item in pyxide argenteâ, variis coloribus encausto picta.
Heads of the twelve Apostles in silver, in embossed or low-relief work, contained in a silver box, enamelled in various colours.
MacGregor 1983, no. 188.

[34r]

469 Christi resurrectio è Sepulchro, cum Angelis ipsi famulantibus in miniatura eximiè adumbrata.
The Resurrection of Christ from the Tomb, attended by angels, marvellously executed in miniature.
MacGregor 1983, no. 130.

470 Achatis fragmentum varis coloribus eleganter signatum.
Fragment of agate beautifully marked in various colours.

471 Annulus ex Ebeno sigillaris, imagine Christi in Cruce pendentis insculpti, cum hac inscriptione circum posita: In hoc signo vinces.
Signet ring of ebony, carved with an image of Christ on the Cross, surrounded by this inscription: 'In this sign you will conquer'.
MacGregor 1983, no. 129.

472 Annulus argenteus in quô Corneolus Arabicè inscriptus. Donavit D. Georgius Walker Armig:
Silver ring with a carnelian inscribed with Arabic characters. Given by George Walker, Esq.

473 Annulus argenteus antiquus sigillo et quibusdam literis insculptus. Hunc Annulum in Coll: Ænei Nasi effossum, dedit D.s Brown ejusdem Coll:Soc. & Acad: procurat:
Ancient silver signet ring inscribed with lettering. This ring was dug up in Brasenose College, given by Mr Brown, Fellow of the same College and University Proctor.

474 Crux lignea, in quâ multa Christi gesta incisa.[166]
Wooden cross on which are carved many of Christ's deeds.
MacGregor 1983, no. 228.

475 Crux altera lignea præcedente major, in quâ etiam multa Christi gesta incisa.[167]
A second wooden cross, larger than the previous one, on which many of Christ's deeds are also carved.
MacGregor 1983, no. 229.

476 Achates duo transparentes. Anglice 2 Gun Flints.
Two transparent agates, called in English gun-flints.

477 Ciphra ignota ex ichthyocollâ.
Unknown figure in isinglass.

478 Imago Jacobi primi Angl: &c:a Regis in Ichthyocollâ.
Figure of James I, King of England etc., in isinglass.

479 Amator illecebris Amasiam suam tentans in Ichthyocollâ.
A lover tempting his loved one, in isinglass.

480 Legatus Marocciensis ex emplastro in circello vitri; accurante ... Simmonds. Donavit Gulielmus Charlton e medio Templo.
The Moroccan Ambassador in plaster, enclosed in glass; executed by [? Abraham Simons]. Given by William Charleton of Middle Temple.

[162]M
[163]Gt R
[164]Gt. R.
[165]L.R

[166]L.R.
[167]L.R.

481 Pictura Reverendissimi Patris ac Dñi D. Georgii Abbot. Archiep. Cantuar. coloribus dilutis.
Portrait of the Most Reverend Father and Lord, George Abbot, Archbishop of Canterbury, in water-colours.
MacGregor 1983, no. 252.

482 Pictura Carmelitæ cujusdam, in sublitione Lazuriâ.
Portrait of a certain Carmelite monk, on an azure background.
MacGregor 1983, no. 251.

483 Pictura cujusdam Herois ignoti formosissima, coloribus dilutis, et simili sublitione.
A most beautiful picture of an unknown hero, executed in water-colour on a similar background.
MacGregor 1983, no. 250.

[35r]

484 Pictura illustrissimi Ducis Chastillion Galliæ Thalassiarchæ, coloribus dilutis, item in sublitione Lazuriâ.
Portrait of the most illustrious Duke of Châtillon, Admiral of France, executed in water-colours, also on an azure background.
MacGregor 1983, no. 249.

485 Pictura cujusdam ignoti ex emplastro, in circello vitri; auctore ... Simmonds. Donavit Clar: Vir. Guil: Charlton e medio templo Armig:
Portrait in plaster of an unknown person, enclosed in glass, by [? Abraham Simons]. Given by that splendid man William Charleton Esq., of Middle Temple.

486 Venus nuda navigans in dorso Delphini, in matre Perlarum cælata. \\fract.//
Naked Venus on the back of a dolphin, carved in mother-of-pearl; broken.
MacGregor 1983, no. 168.

487 Tria naviga vento secundo vecta, Iride in cælis supereminente testâ convexâ faberrimè insculpta.
Three ships driven by a favourable wind, with a rainbow in the sky above; skilfully carved on a convex shell.
MacGregor 1983, no. 166.

488 Duæ Pugiles fæminiæ, in testæ convexo incisæ, quarū una clavam in sinistrâ gerens aliam videtur prostrâsse.
Two female combatants carved on a convex shell, one of whom, with a club in her left hand, can be seen to knock down the other.
MacGregor 1983, no. 167.

489 Caput Imperiale fæmineum Ebore incisum; forte Cleopatræ.
Female imperial head, carved in ivory; possibly of Cleopatra.
MacGregor 1983, no. 169.

490 Cama, seu Caput humanum in Leucachate incisum.[168]
Cameo, or human head carved in white agate.
MacGregor 1983, no. 135.

491 Cama, seu Caput humanum in Leucachate sculptum.
Cameo, or human head carved in white agate.
MacGregor 1983, no. 134.

492 Cama, seu Caput fæminæ illustris in Leucachate insculptum.
Cameo, or head of an illustrious woman, carved in white agate.
MacGregor 1983, no. 136.

493 Idem iterum.
Another of the same
MacGregor 1983, no. 137.

494 Idem iterum
Another of the same.
MacGregor 1983, no. 138.

495 Idem iterum. \\[-d]//
Another of the same; missing.

496 Cama ex Rubicello vel Amethysto albo, figurâ Herculis clavæ innixi sculpta, auro munita.
Cameo of ruby and white amethyst, carved with the figure of Hercules leaning on his club, mounted in gold.
MacGregor 1983, no. 151.

497 Cama ex Rubicello vel Amethysto albo, in quo Neptunus Conchâ navigans, et tridentem dextra gerens, auro item munita.
Cameo of ruby and white amethyst, in which Neptune sails in a shell, carrying a trident in his right hand; also mounted in gold.
MacGregor 1983, no. 152.

[36r]

498 Cama, in quâ figura Mercurii dextrâ crumenam, sinistrâ caduceum gestantis, Rubicello cælata, auro inclusa.
Cameo, in which the figure of Mercury, carrying a pouch in his right hand and brandishing the caduceus in his left; is carved in ruby and mounted in gold.
MacGregor 1983, no. 150.

499 Cama, in quâ figura Jovis vel forte Junonis Cæva fulmen gestantis, Rubicello incisa, auro item inclusa.
Cameo, in which the figure of Jupiter, or perhaps Juno, brandishes a thunderbolt; incised in a ruby, also mounted in gold.
MacGregor 1983, no. 149.

500 Cama, seu caput humanum Prasio cælatum, Italis Prasina di Smiraldo.
Cameo, or human head carved in prase, called in Italian *prasina di smiraldo*.
MacGregor 1983, no. 133.

501 Cama ex Achate in quâ figura Christi in cruce pendentis, una cum S:tis fæminis asseclis, cælata.
Agate cameo carved with the figure of Christ on the Cross, together with the holy women followers.
MacGregor 1983, no. 148.

502 Cama ex Leucachate figurâ Equitis insculptâ.
Cameo of white agate incised with the figure of a knight.
MacGregor 1983, no. 141.

[168] O L.R. to No 509 & to 530 [f.34v] removed *[bracketed with nos 491 & 492]*

503 Cama ex Achate in quô figuræ tres, duæ stantes una procumbens cælatæ.
Agate cameo on which are carved three figures, two standing and one lying down.
MacGregor 1983, no. 140.

504 Cama, in quâ figura Saturni filium voraturi.[169]
Cameo on which the figure of Saturn is about to devour his son.

505 Cama, in quâ homo vestitus dormiens, cum fæminâ nudâ astante, achate ovali insculptus.
Ovoid cameo on which is carved a clothed, sleeping man and a standing, naked woman.
MacGregor 1983, no. 143.

506 Cama ex Achate in quô figura sedens cum puerulo astante insculpta.
Agate cameo on which is incised a seated figure with a small boy standing by.
MacGregor 1983, 139.

507 Cama, in quâ figura Satyri, vel forte Dei Panis tubas sonantis ex Rubicello sculpta.
Ruby cameo on which is incised the figure of a Satyr, or perhaps the god Pan, playing on the pipes.
MacGregor 1983, no. 171.

508 Cama seu Caput humanum lapide quodam mortuo.[170]
Cameo or human head, carved as if on a funerary stone.
MacGregor 1983, no. 178.

509 Cama ex Achate figura hominis procumbentis, ac Centauri ex arcu sagittam mittentis incisa.
Agate cameo in which is incised the figure of a recumbant man, and a centaur firing an arrow from a bow.
MacGregor 1983, no. 142.

510 Cama, seu Imago S:tae Catharinæ lapide quodā mortuo cælata.[171]
Cameo or image of St. Catherine, carved as if on a funerary stone.
MacGregor 1983, no. 170.

511 Cama ex Achate magno ovali, in quo figura Europæ in Tergo Tauri æquora trajicientis, incisa.
Large, ovoid agate cameo, in which is incised the figure of Europa crossing the seas on the back of the bull.
MacGregor 1983, no. 144.

[37r]

512 Cama, seu Imago Veneris Delphinum inequitantis in Leucachate sculpta.
Cameo, or image of Venus on a dolphin, carved in white agate.
MacGregor 1983, no. 146.

513 Cama ex Achate Persici coloris, in quo figura Gryphis sculpta.
Cameo of peach-coloured agate, on which is carved the figure of a griffin.
MacGregor 1983, no. 147.

514 Cama, seu Caput fæminæ illustris, in vitro viridi incisum.[172]
Cameo, or head of an illustrious woman, incised in green glass.

515 Cama ex Leucachate, in quo duæ dexteræ junctæ.
Cameo of white agate, on which two right hands are clasped.

516 Cama ex Achate insuasi coloris, in quo figura Cameli incisa.
Cameo of agate, of a dark orange colour, carved with the figure of a camel.
cf. MacGregor 1983, no. 154.

517 Cama ex Achate Coloris persici, in quô figura Capri insculpta.
Cameo of peach-coloured agate, carved with the figure of a goat.
cf. MacGregor 1983, no. 155.

518 Cama ex Achate eisdem coloris, in quô figura Galli gallinacei insculpta.
Agate cameo of the same colour, on which is incised the figure of a domestic cockerel.
cf. MacGregor 1983, no. 153.

519 Syren tubam sonans in testâ cælatâ.
Siren blowing a trumpet, carved in shell.
MacGregor 1983, no. 156.

520 Bufo in Conchâ incisus.
Toad incised in shell.
MacGregor 1983, no. 162.

521 Serpens in Helicem contortus, in Conchâ cælatus.
Serpent coiled into a spiral, carved in shell.
MacGregor 1983, no. 163.

522 Sciurus in Conchâ incisus.[173]
Squirrel engraved in shell.

523 Simia in Conchâ incisus.
Monkey engraved in shell.

524 Animal nescio quoddam in Conchâ item insculptū.
Some sort of unknown animal, again incised in shell.
MacGregor 1983, no. 158.

525 Simile animal ignotum in Conchâ incisum.
A similar unknown animal, incised in shell.
MacGregor 1983, no. 165.

526 Aquila volans in Conchâ cælatâ.
Flying eagle, carved in shell.
MacGregor 1983, no. 164.

527 Scarabæus in Conchâ insculptus.
Beetle incised in shell.
MacGregor 1983, no. 157.

528 Capra in testâ incisa.
Goat incised in shell.
MacGregor 1983, nos. 155, 160.

[169]Deest
[170][-D]
[171][-n]

[172][-Superest D]
Surviving / missing *(bracketed with 515)*
[173]d d.

529 Ursus Antram intrans, in concha incisus.[174]
A bear entering a cave, incised in shell.
MacGregor 1983, no. 161.

530 Gryphis in Conchâ incisus.[175]
Griffin incised in shell.

[38r]

531 Salutatio B.M. Virginis arte cereoplastica, fr: Anno. 1694.[176]
Annunciation to the Blessed Virgin Mary, made in wax; broken in 1694.
MacGregor 1983, no. 187.

532 Salutationes B.M. Virginis, & S:[tae] Elizabethæ in Ebore cælatæ.
Annunciation to the Blessed Virgin Mary and St. Elizabeth, carved in ivory.
MacGregor 1983, no. 234.

533 Magi adorantes Christum, et ei offerentes, aurum, Thus, et myrrham, ebore insculpti.
Adoration of Christ by the Magi, and their offerings to him of gold, frankincense and myrrh; carved in ivory.
MacGregor 1983, no. 233.

534 Caput fæmineum Ebore incisum.[177]
Female head carved in ivory.

535 B. Maria Virgo filium in sinu gestans e Lapide deaurato.
The Blessed Virgin Mary with her son in her lap, in gilded stone.

536 B. Maria Virgo filium in sinu gestans in Ebore sculpta.
The Blessed Virgin Mary with her son in her lap, carved in ivory.
MacGregor 1983, no. 230.

537 Dñs noster Jesus Christus, quibusdam benedictionē dans, in Ebore incisus.
Our Lord Jesus Christ, bestowing a blessing on some people, incised in ivory.
MacGregor 1983, no. 232.

538 Christi congressus cum Johanne in Eremo, item Ebore cælatus.
The meeting of Christ with St. John in the desert, also carved in ivory.
MacGregor 1983, no. 231.

539 Christus in cruce pendens cum S:[tia] fæminis asseclis multisque aliis astantibus.
Christ on the Cross with the holy women followers and many other standing figures.
MacGregor 1983, no. 235.

540 Duo pugiles equestres ex Ebore sculpti.
Two combatants on horseback, carved in ivory.
MacGregor 1983, no. 236.

541 Duo pugiles pedestres, cum Harpyiis comitantibus, item ex Ebore cælati, in concavo rotundo.
Two combatants on foot, accompanied by Harpies, also carved on a hollowed disc of ivory.
MacGregor 1983, no. 237.

542 Idem iterum (ut opinor) in simili concavo rotundo.
Another of the same, it seems, on a similar hollowed disc.
MacGregor 1983, no. 238.

543 Diana ex Ebore cælatus.
Diana, carved in ivory.

544 Cultri manubrium formâ Balenæ ex Ebore sculptum, in cujus fastigio figura Jonæ, e faucibus ejus prodeuntis.
Knife-handle carved in ivory in the form of a whale, on the tip of which is the figure of Jonah emerging from its mouth.
MacGregor 1983, no. 207.

545 Cultri manubrium instar torquis ex Ebore detornatum, in cujus fastigio Turci caput Tiarâ indutum.
Knife-handle turned in a spiral from ivory, on the tip of which is the head of a Turk wearing a turban.
MacGregor 1983, no. 206.

[39r]

546 Cultri manubrium forma puellæ ex Ebore cælatum.
Knife-handle carved in ivory in the form of a girl.
MacGregor 1983, no. 204.

547 Idem iterum.
Another of the same.

548 Cultri manubrium formâ humanâ ex Ebore imperfectè cælatum.
Knife-handle in human form, incompletely carved in ivory.
MacGregor 1983, no. 203.

549 Fastigium (ut dicitur) Pastoralis pedi Sancti Augustini Hipponensis Episcopi, ex Ebore cælatum.[178]
Head of a bishop's crozier, said to be that of St. Augustine of Hippo, carved in ivory.

550 Pictura ex Avium Plumis conficta &c:[a179]
Picture made from birds' feathers, etc.

551 Collare miro artificio ex Chartâ acus puncturis confict: opera A.M. Woodford.[180]
Paper collar, intricately made by piercing with a needle; the work of A.M. Woodford.

552 Equi Imago forficibus Scissoribus confict: \\deest//[181]
Figure of a horseman, made with a scissors; missing.

553 Folii sceleton \\[-\F]ract// *(bracketed with 554)* \\ambo desunt//

[174] D
[175] [-D]
[176] L.R. to No 551
[177] d

[178] P [f.38v] Letter H
[179] [f.38v] Do.
[180] Removed
[181] D

Skeletons of leaves; broken; both missing.

554 Idem iterum. \\deest// *(bracketed with 553)*
Another of the same; missing.

555 Quatuor Seræ pensiles, /quæ\in loculo Argenteo continentur. \\un. deest//
Four silk hangings; enclosed in a little silver box; one missing.

556 Cultri duo queis utuntur Chinenses.
Two knives used by the Chinese.

557 Chinese pocket Sundial.[182]

558 Chinese Swam pan.[183]

559 Do.[184]

560 Yellow Saunders Wood & piece of Cinnamon Tree.

561 Picture of St. Cuthbert worn by K. Alfred [the Alfred Jewel].

562 Model of Pitts Diamond.[185]

563 Sanscrit MS.[186]

564 Old Watch.[187]

565 Do., date 1613.[188]

[40r]

Lecticae gestatoriae Indicae Palanquin dict: Exemplar. Naviculae vectoriae quâ utuntur Veneti Gondola dict: Exemplar.
Naviculae item Venetorum Pæota dictæ: Exemplar. \\e cortice confictum.//
Haec tria Ric:[dus] Rawlinson L.L.D. et Soci: Antiq: soc: Museo Ashmoleano moriens legavit. Anno 1755.
Model of an Indian travelling litter, called a palanquin. Model of a little passenger boat, used in Venice, called a gondola. Model of another little Venetian boat called a paota (made of cork). These three were left to the Ashmolean Museum by Richard Rawlinson, LL D and FSA, on his death in 1755.

\\Persian Slipper//

\\Tartarian Slipper//

\\Chinese Slipper//

[41r]

The Things in the Windows & on the Stair case removed by desire of the Dean of Ch[rist].Ch[urch]. - 1799

[42r]

1 Marmor Florentinum magnæ Civitatis ruinas referens, marmoribus quadrangulis variegatis circumseptum.[189]
Florentine marble representing the ruins of a great city, enclosed in variegated marble frames.

2 Pictura Mariæ Davies \\[-on the stair-case\in the ? Room]//[190]
Picture of Mary Davis.

3 Embuscatum formâ ovali.
Oval embuscatum.

4 Marmor Florentinum magnæ Civitatis ruinas referens. formâ ovali.[191]
Florentine marble representing the ruins of a great city; oval in outline.

5 Marmor [-Florentinum] [-idem\Arbusta] referens, formâ quadratâ. \\e Cothami Fodinis Juxta Bristoliam.//
Florentine marble representing a tree, quadrangular in outline; from a mine at Cotham, near Bristol.

6 Flores ex Charta scalpello confict:
Flowers cut from paper with a scalpel.

7 Pictura B.M. Virginis filium in sinu gestantis, in Cupro delineata.
Picture of the Blessed Virgin Mary with her son in her lap, engraved in copper.

8 Magi Christum adorantes, et Aurum, thus et myrrham offerentes, Alabastro cælati, opere elato, ma/r\gine deauratâ muniti.
The Adoration of Christ by the Magi, with offerings of gold, frankinsense and myhrr; carved in alabaster in high relief, with a gilt frame.

9 Angeli Christo ministrantes in præsepi, item Alabastro sculpti et margine deaurata inclusi[192]
Angels attending Christ in the stable, also carved in alabaster and enclosed by a gilt frame.
MacGregor 1983, no. 218.

10 Marcus Hieronymus Vida Cremonen albæ Episcopus.
Marco Girolamo Vida, Bishop of Cremona and Alba.

[43r]

11 Pictura Quercûs ingentis Selenite obductæ.
Picture of a giant oak tree covered in crystalline gypsum.

12 Pictura Capitis admodum deformis.
Picture of a much misshapen head.

13, 14 Duo scripta, nomen Viri cujusdam John &c.ª præ se ferentia, quorum unum imitatio est[193]
Two texts, with the name of some man named John, one of which is a copy of the other.

15 Pictura B.M. Virginis precantis coram Imagine Christi in cruce pendentis.

[182][**f.38v**] Lett. 2 Stair Case
[183]Do-
[184]Removed to Letter H
[185][-Gt. R\Letter H]
[186]Stair Case
[187]Gt R-
[188]Gt. R

[189]in the Window
[190][**f.41v**] on the Stair Case
[191][**f.41v**] The greatest Part of these removed or decayed.
[192]Lower Study
[193]leading to the [illeg.]

Picture of the Blessed Virgin Mary, praying before an image of Christ on the Cross.

16 Imago Christi in loco Gethsemane dicto precantis, discipulis interim dormientibus, Alabastro cælata, margine deauratâ munita.
Representation of Christ praying in the place known as Gethsemane, with his Disciples sleeping; carved in alabaster with a gilt frame.
MacGregor 1983, no. 219.

17 Imago Christi ad columnam virgis cæsi, Alabastro sculpta, opere elato, margine deauratâ item inclusa. \lower study/
Representation of Christ bound to a pillar and scourged with rods; carved in alabaster in high-relief, enclosed in a gilt frame.
MacGregor 1983, no. 220.

18 Imago Josephi Arimathæensis et Nicodemi, Christum in sepulchro novo sepelentium, alabastro cælata opere levato, et simili margine munita.[194]
Representation of Joseph of Arimathea and Nicodemus, burying Christ in a new tomb; carved in alabaster in relief, and with a similar gilded frame.
MacGregor 1983, no. 221.

19 Pictura duorum Rusticorum et prospectus amæni ruralis, Selenite obducta, et margine ex Ebeno conservata.
Picture of two peasants and a pleasant rural landscape; covered in crystalline gypsum and kept in an ebony frame.

20 Pictura Principis arausiensis quibusdam Psalmorum versiculis adumbrata, Selenite obducta & margine ex Ebeno munita. \\Fract 1758//[195]
Picture of the Prince of Orange, with certain lines from the Psalms; carved in gypsum with an ebony frame. Broken 1758.

[44r]

21 Pictura Caroli primi Mag: Brit. &c.ª Regis margine ex Ebeno conservata.
Picture of Charles I, King of Great Britain etc., kept in an ebony frame.

22 Pictura Annæ Dei Gratiæ &c.ª Jacobi primi Uxoris. \\ex Lamina Argentea in Scrinio D:ⁿⁱ Ashmole. No. 6 Loculo 1.ᵐᵒ//
Picture of Anne, by the Grace of God etc. wife of James I. From a silver plate in Mr Ashmole's cabinet; no. 6 in the first drawer.

23 Ex eadem in Rev:
The same in reverse.

24 Exemplar ex Ligno Ægyptiacis Hieroglyphicis insculpto.
A specimen of Egyptian hieroglyphics carved in wood.

25 Figura Persei Pegasum inequitantis, Andromedam a Dracone liberantis, Ebore cælata. \\fract.//
The figure of Perseus riding Pegasus, freeing Andromeda from the dragon; carved in ivory; broken.

26 Imago Henrici magni Galliæ et Navar: Regis, opere in Cornu Anaglyptico.
Representation of Henry the Great of France and Navarre, worked in low-relief in horn.

27 Pictura Johannis Tradescanti senioris, margine ex Ebeno ornata.[196]
Picture of John Tradescant the Elder, in an ebony frame.
MacGregor 1983, no. 253.

28 Pictura prospectus elegantissimi margine ex Ebeno insignita.[197]
Picture of a most beautiful landscape in an ebony frame.
MacGregor 1983, no. 254.

29 Pictura Erasmi Desid: Roterodami.[198]
Picture of Desiderius Erasmus of Rotterdam.
MacGregor 1983, no. 255.

30 Insignia Regum Anglorum nitidissime è ligno exsculpta, à tergo hæc habentia: Carved by Richard Chicheley at Chatham, where he is Master Carver and given to George Clarke Esq:ʳ and by him to the University of Oxford for the use of ye Museum. 1736.[199]
Arms of the King of England carved in polished wood with this on the back: 'Carved by Richard Chicheley, etc...'

[45r]

31 Oratio Dominica verbatim, Symbolum, et Decalog: abbrevat:&c.ª &c.ª exiguo admodum spatio conscripta.
The Lord's Prayer, His Sign, and The Ten Commandments: Abbreviated etc., written out completely in a very small space.

32 Sententiæ ex Epicteto & Seneca nitidissime scriptæ manu, I. Thomasen, Cestr: 1728.[200]
The opinions of Epictetus and Seneca written most elegantly by hand by J. Thomasen, 1728.

33 Lignum Ægyptacis Hieroglyphicis insculptum.[201]
Egyptian hieroglyphics carved in wood.

34 Effigies Castri Windlesoriensis opere stramineo.[202]
Model of Windsor Castle made in straw.

35 Pictura S:ᵗⁱ Hieronymi coloribus dilutis.
Picture of St. Jerome in water-colours.

36 Figura navis velis expansis, opere in cornu Anaglyptico.
Representation of a ship with its sails unfurled, worked in low-relief in horn.

37 Pictura ex lamina in scrinio D. Ashmole loc. Z. No. 43.

[194] Lower Study
[195] Fract * [f.42v] 20: Lithophyta varia

[196] [f.43v] Stair Case - o
[197] o
[198] lower Study o [f.43v] Stair Case -
[199] In the window Lower Study
[200] [f.44v] In yᵉ 3rd Window
[201] [f.44v] removed to the Sarcophagus
[202] large room

Panel picture in Mr Ashmole's cabinet, drawer Z no. 43.

38 Ex eadem in Revers:
The reverse of the same.

39 Pictura ex Numismate in Scrinio D. Ashmole
No. 7 Loc. S.
Picture of coins in Mr Ashmole's cabinet, drawer S no. 7.

40 Ex eadem in Revers:
The reverse of the same.

41 Tres picturæ in eadem Margine contentæ; ita
inter se involutæ, ut una vice unam tantum faciem
adspicias, dum in fronte scil: geras, Carolus. 1.ˢ
Rex, sese exhibet, si paulum ad latus hoc inclines
Archiepiscop: Laud, si ad illud, Comes de
Strafford.
Three pictures within the same frame; set up in such an
intricate way that you can see only one side at any one time;
King Charles I, as an old man, appears on the front, but by
turning it a little to one side, you see Archbishop Laud, and
by turning it to the other, you see the Earl of Strafford.

42 Precatio ad Deum O.M. ex 26 Carminibus
Anglicanis Acrosticis constans.
Prayer to God, Optimus Maximus, composed of acrostics of
twenty-six English hymns.

[46r]

43 Pictura D:ⁿⁱ Hadriani Beverlandii, quam ipse
huic Museo donavit. Anno. 1692.²⁰³
Picture of Mr Hadrian Beverland, which he gave himself to
this Museum in 1692.

44 Fons (ut puto) Jacobi ligno cælatus, opere elato.
Jacob's well (I believe), carved in wood in high relief.

45 Il vero ritratto del sanctissimo sudario &c.ᵃ
The true likeness of the Holy Shroud.

46 []

47 Historia Passionis D.ⁿⁱ ñri Jesu Christi tabulâ
ligneâ insculpta, opere Italis Intagli.
The story of the Passion of Our Saviour Jesus Christ carved
in a panel of wood; Italian intaglio work.

48 Pictura Brevarii, vel Missalis Romani in tabulâ
Querceâ.
Picture of a Roman breviary or missal in a panel of oak.

49 Pictura Tigridis in Cupro delineata.²⁰⁴
Picture of a tiger engraved in copper.

50 Cadaver balsamo conditum, simul cum loculo
ferali Ανθρωποειδη &c.ᵃ D.D.Guil: Lethieullier.
An: 1722.
A body preserved in balsam, together with a funerary casket
in the shape of a man. Given by William Lethiullier, 1722.

51 Lignum arte tinctum &c.ᵃ D.D.D:ⁿᵘˢ Seymour.
Wood coloured by chemical dye, etc., given by Mr Seymour.

52 Pictura Uxoris Joh: Tradescanti cum filio filiâq.
astantibus. \\Stair Case.//²⁰⁵
Picture of the wife of John Tradescant with her son [John]
and daughter [Frances] standing by.
MacGregor 1983, no. 269.

53 Pictura Joh: Tradescanti junioris cum Amico
suo Zythepsâ Lambethano. \\Stair Case//²⁰⁶
Picture of John Tradescant the Younger with his friend
[Roger Friend] the brewer of Lambeth.
MacGregor 1983, no. 265.

54 Effigies serenissimi Principis Caroli 2:ᵈⁱ Regis
Angl: &c.ᵃ Limbo è tiliâ elegantissime cælato, ac
deaurato, adornata.
Likeness of the Most Serene Prince Charles II, King of
England etc., adorned with a frame of most elegantly carved
and gilded limewood.
MacGregor 1983, no. 282.

[46v]

1 Deformatio Henrici 4:ᵗⁱ Galliæ et Navar: Regis.
speculo chalybeo cylindraceo in formā redigendâ.
Anamorphic picture of Henry IV, King of France and Navarre,
restored to its true form with the aid of a cylindrical steel
mirror.

2 Deformatio Ludovici 13.ᵐⁱ Galliæ et Navar:
Regis. speculo item chalybeo cylindraceo in
formam redigenda.
Anamorphic picture of Louis XIII, King of France and
Navarre, again restored to its true form with a cylindrical steel
mirror.

3 Deformatio Capitis (nescio cujus) humani, simili
speculo in formam redigenda.
Anamorphic picture of a human head (I know not whose),
corrected with a similar type of mirror.

4 Deformatio Calvariæ humanæ eodem modo in
formam redigenda.
Anamorphic picture of a human skull, corrected in the same
way.

5 Deformatio Bubonis, item eodem modo in
formam redigenda.
Anamorphic picture of an owl, also corrected in the same
way.

6 Deformatio Asini, ita etiam in formā redigenda.
Anamorphic picture of an ass, again corrected in the same
way.

7 Deformatio Rustici Batavi ad Amasiam suam
citharizantis, simili speculo in formam redigenda.
Anamorphic picture of a Dutch peasant playing on his lyre to
his lover, corrected with a similar type of mirror.

8 Deformatio Angeli Adamum et Evam gladio
fla\m\meo e Paradiso fugantis. ita etiam in formam
redigenda.
Anamorphic picture of an angel driving out Adam and Eve
from Paradise with a flaming sword, corrected in the same
way.

²⁰³in a bad state... [illeg.]
²⁰⁴[f.45v] Stair Case - bottom of the

²⁰⁵[f.45v] Stair Case -
²⁰⁶[f.45v] Stair Case -

[47r]

55 Effigies Serenissimi Principis Jacobi 2.ndi Regis Angl: &c:a simili limbo adornata.
Anamorphic picture of the serene ruler James II, King of England etc, adorned with a similar type of frame.
MacGregor 1983, no. 283.

56 Ectypum parmulæ Woodwardianæ in opere Plastico, formâ rotundâ, Ebeno munitum.207
Facsimile of the Woodward shield, cast in plaster; circular in form, framed in ebony.

57 Pictura venustissima Ornatissimi viri Dñi Eliæ Ashmole hujus Muse Instructoris munisscentissimi, Limbo e Tiliâ arte prorsus Thaumaturgicâ cælato, adornata.
A most beautiful picture of that great man Elias Ashmole, the munificent founder of this Museum, adorned with an openwork frame of limewood, carved with consummate skill.
MacGregor 1983, no. 281.

58 Pictura clar: Viri Roberti Plot. M.D. primi hujusce Musei Custodis.
Picture of the famous Robert Plot, Doctor of Medicine, first keeper of this museum.

59 Reverendus Vir D. Nichs Fyske S. S. Th: D. /1633 Prof. Ph.\ \\Stair Case//208
The Reverend Nicholas Fiske, Doctor of Theology (in 1633 made Professor of Philosophy).
MacGregor 1983, no. 288.

60 Jacobus 6:tus Scotorum R: ætate puerili. \\Stair Case//
James VI, King of Scotland, in his youth.

61 Pictura Veneris procumbentis cum filio Cupidine adgeniculante. \\in Wood's Study.//
Picture of the reclining Venus with her son, Cupid, kneeling beside her.

62 Pictura excellentissimæ Heroinæ Dñæ Molineaux Cathedra sedentis. \\Stair Case//
Picture of the most excellent of ladies, Mrs Molineaux, seated on a chair.
MacGregor 1983, no. 257.

63 Charta chorographica antiqua Academiæ et Civitatis Oxõn:. \\worn out.//
Ancient map of the University and City of Oxford.

64 Tabula Geographica Terrarum orbis per Joh: Senex. \\Ami f-//
Map of the countries of the globe by John Senex.

65 Pictura Excellentissimæ Heroinæ.
Picture of a most estimable lady.

66 Venus et Cupido. \\in Woods Study.//
Venus and Cupid.

67 Picturæ duorum pullorum Vituli marini. \\Stair Case//
Picture of two young seals.

[48r]

68 Pictura Bubali tum Maris tum Fæminæ, ex dono d: Viri. Wilhelmi Henrici Ludolphi.
Picture of oxen, male and female, given by William Henry Ludolph.

69 Pictura Annæ Reginæ, Cui ad dextram Insignia Regia, ad sinistram excelsa Quercus cum hac inscriptione, agros ubi nascitur ornat servatque.209
Picture of Queen Anne, holding in her right hand the insignia of state and in her left hand a tall oak tree, with this inscription: `She serves and honours her birthplace'.

70 Ecclesiæ S:ti Petri & S:ti Pauli in oppido Bucking: a parte Boreali Prospectus.
The church of Saints Peter and Paul in the town of Buckingham, viewed from the north.

71 Pictura Papilionis elegantissimi (Pavonis oculus) dicti, et Scarabæi elephantini, sive Tauri volantis maximi Anth/r\acini, aliorumque insectorū.
Most beautiful picture of a butterfly called Peacock's Eye, and of an elephant beetle or very large black flying beetle, and other insects.

72 Effigies Dñi Joh: Aubrey de Easton Perce in Agro Wiltoniensi, Armigeri.
Picture of John Aubrey Esq., of Easton Piercy in the county of Wiltshire.

73 Pictura ornatissimi Viri.
Picture of a most distinguished man.

74 Pictura clarissimi Viri.
Picture of a most illustrious man.

75 Richardus Napeyr Medicus et Astrologus percelebris.
Richard Napier, the most celebrated physician and astrologer.
MacGregor 1983, no. 292.

76 Pictura Cranii humani in Libro jacentis.
Picture of a human skull lying on a book.

77 Pictura percelebris Poetæ. Ben: Johnson.
Picture of the most celebrated poet Ben Jonson.

78 Representatio Mensæ dapibus stratæ. \\Wood's Study//
Picture of a table laid for a banquet. [Hanging in] Wood's Study.

79 Picturæ Herculis et Atlantis Orbem alternatim sustentantium. \\Wood's Study.//
Picture of Hercules and Atlas, supporting the globe by turns. [Hanging in] Wood's Study.

[49r]

80 Johannes Dee Anglus Londinensis.
John Dee, Englishman, of London.

81 Gulielmus Lilly insignis Astrologus.
William Lilly, the distinguished astrologer.
MacGregor 1983, no. 293.

^{207}Stair Case
^{208}Stair Case

209[f.47v] Stair Case-

82 Pictura Honoratiss: D.ni Edwardi Baronis Wotton de Marley.
Picture of the most honoured Edward, Baron Wotton de Marley.

83 Pictura clarissimi Viri.
Picture of a most illustrious man.

84 Pictura Dñæ Esthreæ Baronissæ Wotton, Uxoris D.ni Edwardi Baronis Wotton.
Picture of Esther, Baroness Wotton, wife of Master Edward, Barron Wotton.

85 Pictura.
Picture.

86 Pictura celeberrmi Senis Tho: Parr Salopiensis, qui Annos centum quinquaginta unum complevit.
Picture of the most celebrated old man Thomas Parr of Shropshire, who lived for one hundred and fifty one years.
MacGregor 1983, no. 275.

87 Pictura (ut dicitur) Oliverii Cromwell Angl: protectoris.
Picture said to be of Oliver Cromwell, Protector of England.

88 Pictura Caroli 1.mi mag: Brit: Fran: et Hib: Regis.
Picture of Charles I, King of Great Britain, France and Ireland.
MacGregor 1983, no. 268.

89 Pictura (ut dicitur) Ignatii Jones Architecti celeberrimi.
Picture said to be of Inigo Jones, the most celebrated architect.

90 Pictura eminentissimi Cardinalis Ricolosensis.
Picture of the most eminent Cardinal Richelieu.

91 Pictura B. Mariæ Magdalenæ Alabastrum nardi liquidæ manu tenentis. \\Wood's Study//
Picture of the Blessed Mary Magdalene, holding in her hand an alabastrum of liquid nard.

92 Pictura Eversionis omne genus Artium. \\Do.//
Picture of the destruction of all the arts.

93 Pictura honoratissimi Dñi: Thomæ Comitis Essexiæ, Baronis Cromwell de Okeham, Vicarii generalis.
Picture of that most honourable Thomas, Earl of Essex, Baron Cromwell of Okeham, Vicar-General.

94 Pictura Dñæ Elizabethæ Woodvile, Reginæ Angl: Conjugis Edvardi 4:ti regis Angl: &c.a
Picture of the lady Elizabeth Woodville, Queen of England, wife of Edward IV, King of England, etc.
MacGregor 1983, no. 273.

[50r]

95 Pictura (ut opinor) Peregrini cujusdam nobilis.
Picture of (I believe) some noble pilgrim.

96 Le vray portrait du Siege de Pavie &c.a
The true picture of the Siege of Pavia etc.
MacGregor 1983, no.26.

97 Le Canal Royal de Languedoc &c.a
The royal canal in Languedoc.

98 Pictura Johannis Middleton de Hale &c.a
Picture of John Middleton of Hale, etc.

99 Pictura Conjugis Joh: Tradescanti cum filiolo suo.
Picture of the wife of John Tradescant, with her little son.
MacGregor 1983, no. 280.

100 Pictura illustrissimi Principis Thomæ Ducis Norfolciensis filii sui natu maximi.
Picture of the most illustrious Lord Thomas, Duke of Norfolk with his eldest son.
MacGregor, 1983, no.267.

101 Pictura honoratissimi Dñi: D. Thomæ Arundelliæ Comitis, Marmorum Arundellianorum procuratoris solertissimi.
Picture of the noble Thomas, Earl of Arundel, the astute collector of the Arundel Marbles.
MacGregor, 1983, no.266.

102 Picturæ Dñi Joh: Tradescanti junioris et Uxoris suæ, limbo aureo munitæ.[210]
Picture of Mr John Tradescant the Younger and his wife, in a gilded frame.
MacGregor, 1983, no. 262

103 Pictura Dñi Joh: Suckling Militis.[211]
Picture of Sir John Suckling, Knight.
MacGregor 1983, no. 271.

104 Pictura Dñi Le Neve Pictoris celeberrimi.
Picture of Mr Le Neve, the most celebrated painter.
MacGregor 1983, no. 258.

105 Pictura Joh: Tradescanti Junioris Cimeliarchæ celeberrimi, Botanici habitu.
Picture of John Tradescant the Younger, the celebrated collector, dressed as a gardener.
MacGregor 1983, no. 273.

106 Pictura Dñi Joh: Tradescant Senioris Cimeliarchæ egregii, in margine bullis aureis ornatâ.
Picture of Mr John Tradescant the elder, the famous collector, ornamented at the edges with gold bosses.
MacGregor 1983, no. 260.

107 Pictura D.ni Oliverii de Crat's Pictoris celeberrimi.
Picture of Mr Oliver de Critz, the celebrated painter.
MacGregor, 1983 no. 259.

108 Pictura cl: Viri Mancunii Comitis Cantab: Cancellarii.
Picture of the celebrated Earl of Manchester, Chancellor of the University of Cambridge.
MacGregor,1983 no. 272.

[210]**[f.49v]** 102.a. Pictura diversorum animalium &.c Ex Dono Geo: Scott. L.L.D. F.R.S. \\pinxit Sartorius//
Picture of various animals. Given by George Scott, LLD and FRS. Painted by Sartorius
[211]**[f.49v]** 103 a. Imago G. Fairfax Hortulani, Angli. Ex Dono Caroli Moore Arm: LL.D. \\+ ? if not Fairchild. v. no. 182.//
Image of G. Fairfax, English gardener. Given by Charles Moore, Esq. LLD. (Query if not Fairchild: see no. 182).

109 Michæl Burck Eques Eleemosynarius
Windesor:
[Nicholas Burgh] pensioner of Windsor.
MacGregor 1983, no. 290.

[51r]

110 Pictura representans conventiculum
Dæmonum Veneficorum, sagarumque, per
Brugelium.
Picture representing the assembly of devils, sorcerers and
soothsayers by Brueghel.

111 Theatrum Historicum Imperii Romani.
The Historical Theatre of the Roman Empire [?].

112 Pictura Ludovici 11:mi Galliæ Regis.
Picture of Louis XI, King of France.

113 Pictura Persei Pegasum inequitantis, et
Andromedam à Dracone liberantis. \\Wood's
Study.//
Picture of Perseus riding Pegasus and freeing Andromeda
from the dragon.

114 Zodiacus Stellatus per Joh: Senex.[212]
The stars of the Zodiac, by John Senex.

115 Representatio Descensus Christi in
Gehennam. per Brugle.
Representation of the Descent of Christ into Hell, by
Brueghel.

116 Pictura Mensæ dapibus stratæ.
Picture of a table laid for a banquet.

117 Pictura Joh: Tradescanti senioris nuper
admodum mortui.
Picture of John Tradescant the Elder soon after his death.
MacGregor 1983, no. 276.

118 Pictura Diaboli miserè Verberibus accepti.
Picture of a devil miserably receiving lashes.

119 Pictura Capitis Hispanioli agrarii.
Picture of the head of a Spanish peasant.

120 Pictura Vasculi floribus repleti.
Picture of a little vase full of flowers.

121 Pictura Capitis ignoti.
Picture of an unknown head.

122 Pictura Americani Boreazephyri in navigio
istis partibus.
Picture of an American from the North-West in a boat from
those parts.

123 Pictura S:ti Hieronymi meditantis.
Picture of St. Jerome in meditation.

124 Pictura fæminæ (ut opinor) in furorem adactæ.
Picture of a woman, (so it seems) in a rage.

[52r]

125 Pictura clarissimi Viri.
Picture of celebrated men.

126 Pictura ornatissimæ fæminæ.

Picture of a most beautiful woman.
MacGregor 1983, no. 285.

127 Pictura Vasculi floribus repleti.
Picture of a little vase full of flowers.

128 Pictura clarissimi Viri.
Picture of a celebrated man.

129 Fulleri Pictura ad Altare Coll: Magd: Oxon.
Picture by Fuller for the altar of Magdalen College, Oxford.

130 Figura Halcyonis colorata.
Coloured representation of a Kingfisher.

131 Papiliones duæ.
Two butterflies.

132 Musei Ashmoleani prospectus Orientalis.[213]
Eastern prospect of the Ashmolean Museum.
MacGregor 1983, pl. clxxvi.

133 Pictura Excambii Londinensis, ut floruit ante
conflagrationem Urbis An: 1666.
Picture of the Exchange at London in its prime, before the
Great Fire in the city in 1666.

134 Ectypum parmulæ Woodwardianæ.
Facsimile of the Woodward shield.

135 Pictura Erasmi Roterod:
Picture of Erasmus of Rotterdam.

136 Pictura Joh: Galliarū Regis in prælio
Pictavensi ab Anglis /(capti).\
Portrait of King John of France, captured by the English at
the Battle of Poitou.

137 Uxor Gulielmi Dobson pictoris celeberrimi.
\\[Wood's Study]//
The wife of William Dobson, the celebrated painter.

138 Pictura (ut dicitur) Edwardi 5:ti Regis Angl:
&c:a
Picture said to be of Edward V, King of England etc.

139 Pictura illustrissimi Henrici Ducis
Glocestrensis Caroli 1:mi filii natu minimi.
Picture of the most illustrious Henry, Duke of Gloucester,
youngest child of Charles I.

140 Pictura cl: Viri Joh: Seldeni.
Picture of the celebrated John Selden.
MacGregor 1983, no. 256.

141 Representatio Volucrum peni, cum Cato unum
è maximis occupante.
Representation of a collection of game birds, with a cat
taking one of the largest.

142 Joh: Lewen celebris comædus tempore Caroli
1:mi.
John Lowin, the celebrated actor of the time of Charles I.
MacGregor 1983, no. 289.

[53r]

143 Pictura Caroli primi Anglo: Regis.
Picture of Charles I, King of England.

[212][f.50v] 114.B. Pavimentum, Stunsfeldicè effossum.
Pavement [mosaic], dug up at Stonesfield.

[213]missing

144 Pictura ornatissimi Juvenis.
Picture of a handsome youth.

145 Pictura Puellæ formosissimæ.
Picture of a very beautiful girl.

146 Pictura Aleatoris, limbo aureo munita.
\\[Wood's Study]//[214]
Picture of dice-players, in a gilt frame.

147 Pictura Ebrii cujusdam.[215]
Picture of a drunkard.

148 Pictura hominis catum in sinu gestantis.
\\[Wood's Study]//[216]
Picture of a man holding a cat in his lap. [Hanging in]
Wood's study.

149 Castrum Pontefracti in Agro Eborac: \\[in
Do.]//
Pontefract Castle in Yorkshire.

150 Pictura Mensæ variis Conchyliis stratæ. \\[in
Do.]//
Picture of a table laid with various shellfish.

151 Pictura Classis navium velis expansis.
Picture of a fleet of ships with their sails unfurled.

152 Pictura Hen: 4.[ti] Galliarum Regis. \\[in Do.]//
Picture of Henry IV, King of France.

153 Insignia Joh: Tradescanti, cum margine bullis
aureis insignita.
The arms of John Tradescant, with a frame ornamented with
golden bosses.
MacGregor 1983, no. 296.

154 Pictura classis Hispanicæ portum Cartagenæ
appelle/a\ntis.
Picture of the Spanish fleet approaching the port of
Cartagena.

155 Pictura Mensæ dapibus stratæ. \\[in Wood's
Study]//
Picture of a table laid for a banquet.

156 Nova deceptio visûs, in medio Joh: Gay. Poeta
Lepidiss:
A new illusory picture, in the centre of which is John Gay, a
most charming poet.

157 Archit: civ: scil: Quinque ordines, Etrus: Dor.
Jon: Corinth: Compos.
Civil architecture, namely the Five Orders - Etruscan, Doric,
Ionic, Corinthian, Composite.

158 Expugnatio munimentorum. Archit: Mil:
Military architecture, the attack of fortifications

159 Cyclo-pædia. representatio omnium Artium [-
]Scientiarū
Encyclopaedia, representing all the arts and sciences.

160 Homerus, de æreo Capite in Museo Rich.[di]
Mead. M.D.

Homer, with a head of bronze, in the museum of Richard
Mead, Doctor of Medicine.

161 Guil: Shakespearus.
William Shakespeare.

[54r]

162 Benj:[s] Johnson.
Ben Jonson.

163 Galfredus Chaucer.
Geoffrey Chaucer.

164 Matthæus Prior.
Matthew Prior.

165 Johannes Radcliffe M.D.
John Radcliffe, Doctor of Medicine.

166 Joh: Christophorus Pepusch. Mus: Doct:
Oxōn.
John Christopher Pepusch, Doctor of Music, of Oxford.

167 Franciscus Junius.
Francis Junius.

168 Ezechiel Spanhemius.
Ezekiel Spannheim.

169 A Giovani studiosi del Disegno.
Youths at their drawing lessons.

170 Johannes Flamsteedius Derbiensis Mathem:[s]
Regius.[217]
John Flamsteed of Derby, Mathematician Royal.

171 Edmundus Halleius Astronomus Regius &c.[a]
Edmund Halley, Astronomer Royal etc.

172 Joh: Wallis. S.T.P. Geom: Prof: Savil: Oxōn.
John Wallis, Professor of Sacred Theology, Savillian
Professor of Geometry at Oxford.

173 Isaacus Newton Eq: Aur:
Sir Isaac Newton.

174 Christophorus Wren Eques &c.[a218]
Sir Christopher Wren, Knight etc.

175 Elias Ashmole.

176 Antonius a Wood.
Anthony Wood.

177 Galilæus Galilæi Lynceus. Phil:[s] et Mathem:[s].
Galileo Galilei of the [Academy of the] Lynx, philosopher and
mathematician.

178 Joh. Tradescantus Pater &c.[a]
John Tradescant the father, etc.

179 Joh: Tradescantus Filius &c.[a]
John Tradescant the son, etc.

[214][f.52v] Stair Case
[215][f.52v] Do
[216][f.52v] Do

[217][f.53v] 170. B. Jacobus Bradley. D.D. &c.
James Bradley, DD.
[218][f.53v] 174.b. Gulielmus Derham Canonicus Windesor: D.D.
Gul: Derham Coll: Divi: Joh: Bapt: Oxōn Præs:
174 C. Johannes Rajus. F.R.S. D.D. Geo Scott. A.M. F.R.S.
William Derham, DD, Canon of Windsor, President of St.
John's College, Oxford.
174C. John Ray, DD, FRS; George Scott, MA, FRS.

180 Thomas Hearne. A M.
Thomas Hearne, Master of Arts.

181 Radulphus Bathurst M.D. (Ex Dono Tho.
Warton A M. P. P.
Ralph Bathurst, Doctor of Medicine. Given by Thomas
Wharton, Master of Arts, Professor of Philosophy.

182 Fairchild de Hoxton Hortulanus a Van: Black.
Ex Dono Caroli Moore Arm: olim e Coll. Div:
Joh: Bapt: Oxon.
Fairchild the gardener, of Hoxton, by van Bleeck. Given by
Charles Moore Esq., formerly of St. John's College, Oxford.

⊕ Pictura Wolseij Cardinalis. d. d P. Bliss LLB a
coll. D. Jo. Bapt. Ox. soc Oct. 1817[219]
Picture of Cardinal Wolsey. Given in October 1817 by P.
Bliss, Bachelor of Laws, Fellow of St. John's College.

+ Effigies Jul. Dugdale. Ex dono Custodis
Ashmoleani. Sept. 1817[220]
Portrait of [Sir] William Dugdale. Given by the Keeper of the
Ashmolean [Thomas Dunbar], September 1817.

[55r]
Mus. Ashmoleani ectypeum ab cereâ tabulâ do.T
Dunbar M.A. Marmora Ashmoleana - d.d. T
Dunbar MA
Model of the Ashmolean Museum, made in relief on a wax
panel; given by Thomas Dunbar MA. *Marmora Ashmoleana,*
given by T. Dunbar.

[Final page]

Musæum Ashmoleanum. D: A:C: Liber.

[Inside back cover]

E. Thos omn: anim: Coll: 1792.
E. Thomas, All Souls College, 1792.

[219][f.53v] ⊕ In Ashmole's study
[220][f.53v] + do

LIBER DOMINI PRINCIPALIS COLEGII ÆNEI NASI
The Book of the Principal of Brasenose

Transcribed by Julia White, translated and annotated by Arthur MacGregor

Ashmolean Museum, AMS 13, compiled *c.*1756. Leather-bound, large quarto volume; leather label on cover, 'LIBER D.NI PRINCIPALIS COLL. ÆNEI NASI'; all within tooled borders. 76 folios, 290 x 230 mm, many of them blank.

The earliest version of this catalogue, *c.*1685, no longer exists, and a degree of uncertainty surrounds its content (see Ovenell 1986, pp. 39, 42-3). One version is said to have been compiled by Plot: an excerpt copied about 1840 by W.H. Black is entitled 'Catalogus Librorum, Diplomatorum Regiorum, Literarum Credentialium aliarumque Chartarum, quae cl. vir Elias Ashmole Musaeo suo Oxonij primâ vice donavit A.° sc. Domini 1683'.[1] Alternative evidence for the contents of this earliest catalogue is provided by the Vice-Chancellor's comprehensive catalogue of 1695 (see p. i, note 5) which suggests that the Principal of Brasenose's responsibility was for the zoological specimens and that his inventory, compiled by Edward Lhwyd, was in fact titled 'Liber Dñi Principalis Coll. Aenei Nasi Catalogus Animalium quae in Museo Ashmoleano conservantur'. Ovenell suggests that these two lists were separately compiled but were united for administrative convenience.

The text reproduced here is from the revised catalogue compiled by Willliam Huddesford *c.*1756. At their meeting on 8 January of the previous year the Visitors had found a considerable number of the zoological specimens to be in such an advanced state of decay that they had to be withdrawn from display. Ovenell (1986, pp. 142-3) observes that the numbers assigned to items in the present catalogue were entered first in the Vice-Chancellor's comprehensive catalogue of 1695, where a marginal note explains that specimens listed there to which no number was assigned in 1756 were withdrawn. The decayed material included the majority of the birds (most famously the dodo, for which see Ovenell 1992), the eggs and the insects other than those preserved in jars. The quadrupeds fared rather better, while the fish (whether in spirits or, more likely, having been selected in the first instance for the toughness of their dried cases) survived largely intact.

In the decades that followed, the processes of decay continued inexorably, fuelled by a degree of curatorial neglect: as a result, when J.S. Duncan was appointed to the keepership in 1823, he found that 'the skins of animals collected by the Tradescants had fallen into total decay' (Ashmolean 1836, p. vi). Duncan set about re-founding the zoological collections in a comprehensive manner, a process continued under the regime of his brother, P.B. Duncan, who succeeded to the keepership in 1829. So successful were they in their joint mission that by 1836, from a total of over 2,600 zoological specimens then existing, fewer than 120 could be traced to the original collections (see MacGregor and Headon 2000).

A different fate befell one item – the 'Giant's leg-bone' referred to on p. 210. This survived in the collection up until the 1820s, when the keeper, disapproving of its continuing public appeal and identifying it as an elephant bone, had it re-labelled as such, after which time it ceased to be an object of interest and vanished from the records. Given that the burghers of Baldock would have had little opportunity of acquiring modern elephant remains at such an early date, it seems reasonable to suggest that it might in fact have derived from a mammoth or from some other fossil elephant species, recovered from local Pleistocene levels.

Avium exoticarum rostra
Beaks of exotic birds

[3r]

1 Corvi Indici cornuti rostrum, s. Rhinocerotis Avis Bontii in Hist: Nat: et Med: Ind. Orientalis Pag. 63. Aldrovandi Topau. Willugbeii. p. 127. Rhinocerotis Aldrov: Caput Willugbeii Tab. 17 Edit: Ang:
Beak of a horned Indian Raven or Rhinoceros hornbill, Bont (1658, p. 63); the Topau or Rhinoceros bird of Aldrovandi [1599]; Willughby (1678, p. 127); head in Willughby (1678, tab. 17), English edition.

2 Ejusdem.
Another of the same.

3 Ejusdem generis rostrum aliud sed brevius; An forsan minoris cujusdam Rhinocerotis Avis speciei?
Beak of another type, but shorter; perhaps a smaller variety of this species of Rhinoceros hornbill.

4 Avis Topau, s, Rhinocerotis varietas prima. Will: Tab. XVII.
Topau, or first (recorded) variety of the Rhinoceros hornbill. Willughby (1678, tab. 17).

[4r]

5 Corvi Indici Bontii. p. 62 Will: Tab: ult:
Rhinoceros hornbills of Bont (1658, p. 62); Willughby (1678, tab. 17).

6 Rostrum Corvi Indici. Will: Tab: ult:
Beak of a Rhinoceros hornbill. Willughby (1678, tab. 17).

7 Idem.

8 Idem

[1]Bodleian Library, MS Ashmole 1834, fols. 16-19.

9 Ligneum an veri alicujus Rostri simulachrum, an pro libitu confictum, non constat.

It is not agreed whether this is the wooden model of some actual beak or whether it was fashioned at a whim.

10 Rostrum Onocrotali, s, Pelicani Aldrov: Will: p. 327. T. 63

Beak of an Ονοκροταλος, or Pelican. Aldrovandi [1559]; Willughby (1678, p. 327, tab. 63).

11 Idem.

12 Idem.

13 Idem.

14 Primæ varietatis Rhinocerotis avis Will: Tab. XVII. Mandibula inferior.

Lower beak of the first variety of Rhinoceros hornbill. (Willughby 1678, tab. 17).

15 Rhinocerotis avis superioris mandibulæ pars anterior.

Front part of the upper beak of a Rhinoceros hornbill.

16 Mandibula superior Corvi forsan Indici. N. D. Per Longitudinem Sulcata.

Upper beak, perhaps from a Rhinoceros hornbill; with a longitudinal groove.

17 Head of an Indian Stork. M.S.R. p. 64. Tab: V.

Grew (1681, p. 64, tab. 5).

18 Head of an Indian Heron. M.S.R. P.63. Tab: V.

Grew (1681, pp. 63–4, tab. 5).

19 An Rostrum Maguari Bras: Marggr. Will.p. 287? Ciconiæ Spec.

I am inclined to think the beak of a Brazilian Maguari; a type of Stork. [Piso and] Markgraf [1648, p. 204]; Willughby (1678, p. 287).

20 Rostrum Guaraunæ Pisonis Will: p.[-91\292].Tab. LIII

Beak of Piso's Guarauna. Willughby (1678, pp. 291-2, tab. 53).

[5r]

21, 22 Guaraunæ itidem Rostra, at forte non ejusdem speciei.

Beaks of the same Guaraunae, though perhaps not from the same species.

23 Guaraunæ Avis mandibulæ inferioris.

Lower beaks of Guarauna.

24 Idem.

The same.

25 Rostra Tlauquechul Mexiocanorum Franc. Hernandez, Aiaiæ, Bras. Margr. Will: p. 289. Lusitanis Brasiliæ incolis Colherado Plateæ, s, Pelicani Gesn: spec.

Beaks of Tlauhquechul or Aiaia. Found in Mexico, Hernandez [1651]; Brazil, [Piso and] Markgraf [1648, p. 204], and Willughby (1678, p. 289); The Portuguese inhabitants of Brazil call them *Colherado plateæ*; a species of the Spoonbill or Pelican of Gessner.

26 Idem.

27 Plateæ, s, Pelicani Gesn: Leucorodiis, Albardeolæ, Aldrov: Lepelær, Belgarum. Will: p. 288. Tab. LII.

Rose-pink [Λευκοροςιος] Spoonbill or Pelican of Gessner. Aldrovandi [1599]; Willughby (1678, p. 288, tab. 52).

28 Rostrum cujusdam Avis exoticæ, quam nondum descriptam suspicamur, figuræ est admodum obsoletæ, nempe ad latera compressum, adeo ut gladioli mucronem omnino referat 3 Dig: longum, coloris ad basin un[-i]c/i\æ dimidiæ Spatio, \\albidi, deinde alrorubentis//.

Beak of some exotic bird which, we suspect, has not yet been described; it appears quite worn, and is narrowed laterally to the degree that it recalls the blade of a little sword; it is 3 inches long, white in colour at its base and for half its length, then reddish-white.

29 Caput et rostrum avis Emeu vulgo Casoaris. Bontii. p: 71. Will: p. 151. Tab: XXV.

Head and beak of the Emu, commonly called Cassowary. Bont (1658, p. 71); Willughby (1678, p. 151, tab. 25).

30 Rostrum Avis Americanæ Albitros dictæ. M.S.R. Tab: VI. p. 73. See Ligons Hist: of Barbados p. 61. An Cygno cucullato Nierembergii congener? rostrum enim utriusq consimile.

Beak of a bird from the Americas called Albatross. Grew (1681, p. 73, tab. 6); see also Ligon (1657, p. 61)..Perhaps related to the Hooded swan of Nieremberg [1635, p. 232], for the beak of each is similar.

[6r]

31 Idem.[2]

32 Ignotum.

Unknown.

33 Alkæ cujusdam N.D. Rostrumve. Will: p. 323.[3]

Rostrum or beak of some kind of Razorbill. Willughby (1678, p. 323).

34 Monocerotis avis alicujus caput cornutum. num e genere Gallinaceo.[4]

Head of some kind of Rhinoceros hornbill, if not some sort of Dodo.

35 Rostrum Toucan Marggr. et aliorum quorundam Xochitenacatl Mexiocanis Nieremb. Pica Brasilica Aldr:L.12.C.19. Will: p. 128. Tab.20. Picis Martiis anumerat D.s Ray.

Beak of the Toucan of Markgraf, called by others the Mexican Xochitenacatl of Nieremberg [1635, pp. 208-9]. Pica Brasilica; Aldrovandi (1599, pp. 801-3); Willughby (1678, p. 128, tab. 20); Mr Ray assigns it to the 'warlike [mag]pies'.

36 Idem.

37 Idem.

38 Idem ad margines minimè serratum, colore superius ocroleuco, cæterum e castaneo fusco. An diversæ a priore Speciei rostrum, an potius sexu, vel ætate discrepantis.

The same, serrated at the edges, partly white above, otherwise dark chestnut-coloured. Either a beak of a different species from that above or different from it because of sex or age.

[2] **[f.5v]** penit
[3] **[f.5v]** Decayed
[4] **[f.5v]** Dr Kidd

39 Rostrum avis toucan anthracinum, brevius ad verticem nonnihil compressum. Nullus dubito quin rostrum sit avis a prioribus distinctæ.
Beak of a Black Toucan, shorter and somewhat narrower at the tip. Doubtless it is the beak of a different bird from those described earlier.

40 Picæ Bras: Aldrov. Mandibula inferior.
Lower beak of the Brazilian Toucan of Aldrovandi.

[6v]

46B Cornua Condomæ Buffonii XII. 301. Tab. XXXIX. cf Vol. XV. 142. Pennant Synopsis Quadrup. No 24. p.31. The Striped Antelope. Ex Dono Viri Ornat: Th: Pennant. Arm: vide inter Cornua.
Horn of the Condoma (Striped Antelope). Buffon (1764, vol. 12, p. 301, tab. 39; see also vol. 15, p. [192]); Pennant (1771, p. 31, no. 24). The gift of that distinguished man Thomas Pennant Esq. See amongst the horns.

[7r blank; 8r]

41 Mandibula superior Aracari Brasil Pisonis. p. 92 Aracari Marggraviii. Xochitenacatl altera Nieremb: Will: p. 140. Tab: XXII. Fleming of Surinam. M.S.R. p. 60.
Upper beak of a Brazilian toucan, the Aracari of Piso (1658, bk. 3, p. 92) and [Piso and] Markgraf [1648, p. 217]; the Xochitenacatl of Nieremberg [1635, pp. 208-9]; Willughby (1678, p. 140, tab. 22); Grew (1681, p. 60).

42 Eadem.

43 Eadem.

44 Columbi maximi caudati Rostrum. Will: p. 341. Tab: LXI. maximus stellatus ejusdem. Tab: LXII. Mergus maximus Farrensis S. Arcticus Clusii.
Beak of a Greater Speckled Diver. Willughby (1678, p. 341, tab. 61), the most heavily speckled of them (tab. 62); the Great Merganser of Clusius from the sub-arctic Faroes.

45 Rostrum Ara[-c\r]acangæ. Jons: Tab: LIX.
Beak of an Aracanga. Jonston (1657b, tab. 59).

46 Penguini, s. Anseris Magellanici Clusii Spec, (ut nobis videtur) N.D. videtis Penguini descriptionem apud Will: p. 322. Tab: LXV. An columbi spec?⁵
Penguin, or a species of the Magellanic Goose of Clusius (or so it seems to me). See the description of the Penguin in Willughby (1678, p. 322, tab. 65). Perhaps a type of Diver?

47 Otis sive tarda Avis. Will. Tab XXXII.
Bustard, or Great Bustard. Willughby (1678, tab. 32).

48 Idem quod 13.
The same as no. 13.

49 Gallus gallinaceus peregrinus Clusii, Jonstoni .p. 122 Tab. LVI. Cygnus cucullatus Nieremb:; Avis Dronte Bontio. Dodo Will: p. 153. Tab. XXVII.
Dodo. The Gallus gallinaceus peregrinus (wandering cock) of Clusius, Jonston (1657b, p. 122, tab. 56); Cygnus

cucullatus of Nieremberg [1635, p. 232]; the Dronte of Bont; Dodo of Willughby (1678, p. 153, tab. 27).

50 Caput & Rostrum Anseris Bassani. Will: p. 342. T. LXIII
Head and beak of a Soland Goose [Gannet]. Willughby (1678, [pp. 328-9], tab. 63).

[9r]

51 Idem quod 44.
The same as no. 44.

52 Anas Arctica Clusii Will: p. 325. Tab: LXV.⁶
Arctic Duck [Puffin] of Clusius [1605, pp. 104-5]. Willughby (1678, p. 325, tab. 65).

53 Vespertilio Americana magnitudine fere anatis. Andira Guagu forte Brasil: Pisonis p. 290. Hoc Animal quamvis minùs congruè avibus annumeretur, inpresentiarum tamen loco amovere non tanti duximus.
American bat, almost the size of a duck. The Andira Guacu, probably of Brazil, Piso (1658, bk. 5, p. 290). This animal, although not so suitable, is included with 'Birds'. However, for the present, we have thought it not worthwhile to remove it from its place.

54 Alka Hoieri in Epist: ad Clusium. Anglis septentrionalibus. an Auk, Cornubiensibus a Murre; alicubi a Razor Bill. Will: p. 323. Tab. LXIIIII/V]⁷
The Alka hoieri, described in the letters of Hoier to Clusius. In northern England termed an Auk, in Cornwall a Murre, and elsewhere a Razorbill. Willughby (1678, p. 323, tab. 64-5).

55 Anseris Bassani rostrum. Will: p. 342. Tab: LXIII.
Beak of a Soland Goose [Gannet]. Willughby (1678, pp. [328-9], tab. 63).

Avium exotic: cruza cum unguibus
Legs of exotic birds, with claws

56 Crus cum unguibus Pygargi, Albicallæ, s, Hinnularii Will: p. 61. An Crysaitos Gesn: Will: Tab.1: ᵐᵃ
Leg of the White-headed Eagle, with claws. Willughby (1678, p. [58-9]); perhaps the Crysaitos of Gessner: Willughby (1678, tab. 1).

57 Ungues 5: varii rapacium Avium majorum, sed quarum nobis non constat.
Five different claws of large raptors, but of which we do not know.

58 Ungues Avis exoticæ è genere galinaceo.
Claws of an exotic bird of gallinaceous type.

[10r]

59 Os cruris cum unguibus Avis emeu, vulgo Cassoaris Bontii p. 71. Will: p. 151. Tab: 25. An forsan Nhanduguacu Bras: Marg: Will: p. 150.
Leg bone of the Emu, with claws; commonly called the Cassowary. Bont (1658, p. 71); Willughby (1678, p. 151, tab.

⁵[-penit]

⁶52. decayed
⁷[f.8v] decayed

25); or perhaps the Brazilian Nhanduguacu of [Piso and] Markgraf [1648, p. 190]: see Willughby (1678, p. 150).

60 Ignotum.
Unknown.

61 Ignotum.
Unknown

62 Os Cruris Struthio Cameli Will. p. 149. Tab. XXV.
Leg bone of the Ostrich, with claws. Willughby (1678, p. 149, tab. 25).

63 Galli gallinacei crura calcaribus triplicibus permagnis munita.
Legs of a domestic cock armed with huge triple spurs.

64 Crura Columbi maximi caudati Will: p. 341
Legs of the Greater Speckled Diver. Willughby (1678, p. 341).

65 Crura Araracangæ. Jons: Tab: LIX.
Legs of the Araracanga. Jonston (1657b, tab. 59).

66 Crura dodonis. Will: p. 153. Tab. XXVII
Legs of the Dodo. Willughby (1678, p. 153, tab. 27).

67 An Caput Mergi Longirostri Jons. Tab. XLVII.
Perhaps the head of a Long-billed Merganser. Jonston (1657b, tab. 47).

68 2rc.

69 Avis mellivora curvirostris Edvardi Tab. 226.[8]
Curved-billed Honey-thief [Humming bird]. Edwards (1743-51, pt. I, vol. II, tab. 226).

70 Vespertilio ecaudatus naso simplici - Canis volans Dictus, Linnæi Vampyrus. Edvardi. Tab. 180.[9]
Tail-less plain-nosed Bat, called Flying Dog; the Vampire of Linnaeus. Edwards (1743-51, pt. III, tab. 180).

71 Aluco minor Aldrov. WILL. P. 104 Tab XI.[10]
Common Barn Owl of Aldrovandi [1599]. Willughby (1678, p. 104, tab. [13]).

72 Pica Glandaria WILL. pag. 130. Tab XIX.[11]
The Jay. Willughby (1678, p. 130, tab. 19).

73 Rallus Aquaticus WILL. pag. 314 Tab. LVIII.[12]
Water-rail. Willughby (1678, p. 314, tab. 58).

74 Pica varia Caudata. WILL. pag. 127. Tab. XIX.[13]
The Magpie. Willughby (1678, p. 127, tab. 19).

75 Merula Vulgaris. Will. pag. 190.
The Blackbird. Willughby (1678, p. 190).

[8]Decayed. **[f.9v]** 69: Avis item altera mellivora, e Philadelphia. D.D. Nat: Bliss A.M. Astronomus Regius; ett apud Oxonienses. Geometrice Professor Savilianus. D.
Another Honey-thief [Humming bird], from Philadelphia. The gift of Nathaniel Bliss MA, Astronomer Royal and Savilian Professor of Geometry at Oxford.
[9]Decayed
[10]Decayed
[11]Decayed
[12]Decayed
[13]Decayed

[11r]

Ova
Eggs

1, 2, 3 Ova Struthio Cameli. Will: p. 149. Tab XXV
Ostrich eggs. Willughby (1678, p. 149, tab. 25).
4 *(as 1-3)* broken.

Nidi
Nests

1, 2, 3 Aviculæ cujusdam Indicæ Nidi è ramulis suspensi; cujus meminit Will: Tab. LXXVII. consule etiam M.S.R. Tab. 6
Nests of some sort of small Indian birds, suspended from branches. Mentioned by Willughby (1678, tab. 77) and considered also by Grew (1681, tab. 6).

4 An Vespetum quoddam ex Indiâ Occidentali?
Probably some sort of Bat from the West Indies.

5 Ignotum.

6 Crab/r\onum Nidus, miri Artificii, e Villa Brightwell in Com Oxon allatus. DD. Phil: Hayes. M.B. Oxon.
Hornet's nest, a wonderful construction, brought from a house at Brightwell in Oxfordshire. The gift of Philip Hayes, MB Oxon.

7 Avis. vulgò dict. oriolus, Nidus e ramalis suspensus. NB. Avis prædict: est Picus-Oriolus Clariss: Linn:
Nest of a bird commonly called the Oriole, suspended from a twig. Note: the aforementioned bird is the *Picus oriolus* of the learned Linnaeus.

[12, 13r blank; 14r]

Quadrupeda cum Vivipara, tum Ovipara. Terrestria, Aquatica, Amphibia; eorumq. partes.
Quadrupeds, both viviparous and oviparous; terrestrial, aquatic and amphibious; and parts of them

Hæc quemadmodum et Aves, et Insecta, quia admodum pauca sunt, in methodum revocare, minus necessarium duximus; quare eo ordine quo jam collocantur, impræsentiarum recensebimus.
These also, as well as the birds and insects, because they are few in number, we thought less necessary to put back in their proper order; for this reason we shall review them for the time being in the order in which they are now placed.

1 Lutra: Jonstoni. p. 104. Tab. LXVIII.
Otter. Johnston (1657a, p. 104, tab. 68).

2 A Devil Shock from New England.

3 Ai erecti cauda, Pisonis Ignavi Jonst: p. 101. Tab. LXII[14]
Erect tail of an Ai or Sloth of Piso [1658, bk. 5, pp. 321-2]; Jonston (1657a, p. 101, tab. 62).

4 Cauda Elephantini Jons. p. 17. Tab. VII. VIII. IX.

[14]**[f.13v]** 3B. Vu.

Elephant's tail. Jonston (1657a, tabs. 7, 8, 9).

5 Cows Tails from Arabia.

6 Idem.

7 Vitulis marinus Rondoletii. p. 458.[15]
Sea-calf. Rondelet (1554, p. 458).

8 Idem.

9 Wild Cat from Virginia. Mus: Tradesc: p. 5[16]
Tradescant (1656, p. 5).

[15r]

10 Virginia Fox. ibid

11 An Carigueija ?Bras: Jonst: Tab. LXIII.
Perhaps a Brazilian Carigueija. Jonston (1657a, tab. 63).

12 Lacertus Indicus è majoribus quatuor in dorso fasciis, ex albis maculis majusculis insignitus.
Indian Lizard, distinguishable by the four bands on its back and by fairly large white spots.

13 Idem.

14 Idem.

15 Idem.

16 Idem.

17 Lacertus squamosus capite Testudinis.
Scaly Lizard with the head of a tortoise.

18 Lacertus virid[-]is, Liguro Bononiensibus. Jonst. Tab. LXXVI.
Green Lizard, from Bologna in Liguria. Jonston (1657a, tab. 76).

19 Senembi Brasiliensibus. Jonst: p. 135. Tab. LXXVII.[17]
Brazilian Senembi. Jonston (1657a, p. 135, tab. 77).

20 Idem.

21 Idem.\\decayed.//

22 Idem.

23 Idem.

24 Idem.

25 Lacertus Indicus sqamosus Bontii. p. 60. in Sylvis Javanensibus.
Indian Scaly Lizard. See Bont (1658, p. 60); [found] in the forests of Java.

26 Ejusdem Lacerti Indici exuvium.[18]

[15][f.13v] No. 7. Loco Vituli peruentis substituitur Lutra Linnaei olim.
At some time or other, a Linnaean Otter is being substituted for a decaying Seal.
[16]Decay'd
[17][f.14v] 19B; Idem iterum.
The same again.
[18][f. 14v] 26. B. Chamaelion cinereus verus Johnstoni. Tab. LXXIX.
Genuine Ash-coloured Chameleon of Jonston 1657a, tab. 79.

Shed skin (slough) of the same lizard.

27 Cauda Castorea Rond: de Amphibiis. p. 236. Jonst. T. 68. p. 102
Beaver's tail. Rondelet (1555, p. 236); Jonston (1657a, p. 102, tab. 68).

[16r]

28 Lacertus cæruleus e minoribus.[19]
Blue Lizard of the smallest type.

29 Chamæleon cinereus verus. Jonst: p. 140. Tab. LXXIX.
A genuine ash-coloured Chameleon. Jonston (1657a, p. 140, tab. 79).

30 Crocodilus. Jonst: p. 141. Tab. LXXIX.
Crocodile. Jonston (1657a, p. 141, tab. 79).

31 Idem.

32 Idem.

33 Tatu seu Armadillo. Jonst: p. 120. Tab. LXII. Tatu porcinus M.S.R. p. 18.
Tatu or Armadillo. Jonston (1657a, p. 120, tab. 62); the Hog-tatu of Grew (1682, p. 18).

34 Ejusdem exuvium.
Shed skin of the same.

35 Tatu /seu Armadillo\ Mustelinus. Apara. M.S.R. p. 19. Tab. 1: [ma].
Tatu or Weasle-headed Armadillo, or Apara. Grew (1682, p. 19, tab. 1).

36 Tatu Apara Bras: Jonst: Tab: LXIII. Tatu, s, Armadillo Pisonis. P. 100.[20]
Brazilian Tatu Apara: Jonston (1657a, tab. 63). Tatu or Armadillo of Piso (1658, bk. 3, p. 100).

37 Ejusdem exuvium.
Shed skin of the same.

38 Mandibula superior Baby-roussæ Pisonis, apud Bontium; p. 61. Skull of y:ᵉ Horned Hog. M.S.R. p. 27.[21]
Upper jaw of the Babyroussa of Piso, after Bont (1658, p. 61). Skull of the Horned Hog, Grew (1682, p. 27).

39 Cranium ejusdem Animalis. M.S.R Tab. 1.ᵐᵃ p. 27.
Skull of the same animal. Grew (1682, p. 27, tab. 1).

40 Ejusdem mandibula inferior.[22]
Lower jaw of the same.

41 Pars ejusdem mandibulæ.
Part of the same mandible.

42 An piscium quorundam cetaceorum mandibula?
Perhaps the jawbone of a fish or of some cetacean?

42b Idem.

[19][f.15v] 28. Decayed.
[20]36. Decay'd
[21][f.15v] Apri Ethiopici, vide Pallas Miscell.
Ethiopian Boar; see Pallas Miscellany.
[22][f.15v] [-decayed]

43 Mandibula Acus Indicæ, Will: Tab. P.8. pag: 4.
Jawbone of an Indian Needle-fish or Gar-pike. Willughby (1686, Appendix p. 4, tab. P8).

[17r]

44 Den[-\s] Hippopotami. Jonst: p. 76. Tab. XLIX. M.S.R. T.[-2\1].
Hippopotamus tooth. Jonston (1657a, p. 76, tab. 49); Grew (1682, tab. 1).

45 Dens Quadrupedis marini è genere Phocarum Anglis et Russis Wallrus aliis Morse, Danis et Islandis Rosmarus dict. Wormius p. 289. Jonst. p. 159. T. 44
Tooth of a marine quadruped of the seal type called a Walrus by the English and Russians, a Morse by some others, and a Rosmarus by the Danes and Icelanders. Worm (1655, p. 289); Jonston (1650b, p. 159, tab. 44).

46 Ignotum. \\of Antelope//[23]
Unknown.

47a, b Dentes Quadrupedis marini. Vide 45.
Teeth of a marine quadruped. See no. 45.

48 Dentes Hippopotami interiores.
Cheek-teeth of Hippopotamus.

49 Maxillæ ovinæ
Sheeps' jaw-bones.

50 Maxilla Tigridis superior. Bontius. p. 52. 53.
Upper jaw of a Tiger. Bont (1658, pp. 52, 53).

51 Ignotum.

52 Ignotum.

53 An Dentes Rhinocerotis?
Perhaps Rhinoceros teeth?

54 Ignotum.

55 Part of y:ᵉ Ear-bone of a Whale. M.R.S. p. 82.
Grew (1681, p. 82).

56 Idem.

57 Ignotum.

58 Priapus //Penis\\ Hippopotami. Jonst: p. 76. Tab. XLIX.
Hippopotamus penis. Jonston (1657a, p. 76, tab. 49).

59 Idem.

60 An Cornu alicujus Piscis Exotici Pira Aca/?\ Bras.

[18r]

congeneris? de Pira Aca Bras: s, Monocerote pisculo Clusii in Exoticis Lib.6.C.28. Consule Will; Tab. I. IV. p. 150.

Perhaps the horn of some exotic fish, related to the Brazilian Pira or Aca; or the little Marine unicorn of Clusius (1605, bk 6, ch 28); considered by Willughby (1686, p. 150, tab. 4).

61 An Mandibula alicujus Acûs aut forsan Sphyrænæ Exoticæ. Will. Tab. R.2.
Perhaps the jaw of some kind of Gar pike or perhaps of some exotic sea fish. Willughby (1686, tab. R2).

62 Idem.

A Crocodilus. Jons: p. 141. Tab. LXXIX.
Crocodile. Jonston (1657a, p. 141, tab. 79).
B Idem.
C Scutum e Tergore Crocodili.[24]
Scale from the skin of a Crocodile.

63 Ignotum.
Unknown.

64 Costæ cujusdam Animalis.
Ribs of some animal.

65 Idem.

66 Rostrum serræ Piscis. Jonst: Tab. IIII. Lat. Edi:
Snout of a Saw-fish. Jonston (1650b [Latin edition], tab. 4).

67 Idem.

68 Idem.

69 Idem.

70 Idem.

71 Idem.

72 Cornua Ibicis fæminæ Bellonio.
Horns of a female Ibex of Bellon.

[19r]

73 Cornua Capræ sylvestris. Jonst: Tab. XII. An fortasse potius arte elaborata, quam genuina cujusvis animalis cornua?
Horns of a wild goat. Jonston (1657a, tab. 12). Or perhaps they may have been artificially fashioned rather than being the genuine horns pf some real animal?

74 Idem.\\Gazella Linnæi 7.//
The same.

75 Cornua Hirci Hispanici. \\Algazel.//
Horns of a Spanish goat. Gazelle.

76 Cornua Capræ Lybicæ Jonst: Tab: XXV. Eadem fortè quæ Dama Veterum. Jonst. Tab. XXVII. \\Coba vid Buffon.//
Horns of a Scimitar Oryx. Jonston (1657a, tab. 25). The same, perhaps, which the antelope of our ancestors had. Jonston (1657a, tab. 27). Coba: see Buffon [1767, vol. 12, p. 267].

77 Cornua Ibicis. Jonst: Tab. XXV.
Ibex horns. Jonston (1657a, tab. 25).

78 Cornua cervina at cujus Speciei non constat.
Antlers of a Stag, though of which species is uncertain.

79 Cornua Arietis quatuor.

[23][f.16v] 46.B. Cornua condomae Buffonii XII.301. Tab. XXXIX, cf Vol. XV.142. Pennant Synopsis Quadrup. No 24.p.31. The Striped Antelope. Ex Dono Viri Ornat. Th: Pennant. Arm.
Horn of the Condoma of Buffon 1764, vol. 12, p. 301, tab. 39 (cf. vol. 15, p. [192]; Pennant 1771, p. 31 no. 24. The Striped Antelope; the gift of that distinguished man Thomas Pennant.

[24][f.17v] D. Caput Crocodili.
Head of a Crocodile.

Four Rams' horns.

80 An Cornua Cervi palmati? Jonst: Tab. XXXVII. p. 63.
Antlers of, perhaps, Fallow Deer. Jonston (1657a, p. 63, tab 37).

81 Indian Goats Horns.

82 Cornua Cervi Greenlandici. Mus: Trad. p. 7.
Antlers of Greenland Deer. Tradescant (1656, p. 7).

83 Dens, s, potius Cornu Babyroussæ Pisonis apud Bontium p. 61. Horned Hog M.R.S. p. 27. Tab. I.
Tooth, or moore likely the horn of the Babyroussa of Piso, after Bont (1658, bk. 5, p. 61). Horned hog, Grew (1681, p. 27, tab. 1).

84 Idem.

85 Ignotum.

86 Cornu Rupicapræ Jonst: Tab. XXX/[-V]\II. p. 52.
Horn of the Chamois. Jonston (1657a, p. 52, tab. 27).

[20r]

87 Cornua
Horns.

88 Cornu Cervi palmati Jonst: Tab. XXXVII.
Antler of Fallow Deer. Jonston (1657a, tab. 37).

89 Ignotum. \\Roe-Buck; a Variety//

90 Cornua Capreoli marini Jonst: Tab. XXXIII. sed quare marinum vocat?
Antlers of a Water Deer. Jonston (1657, tab. 33), but why does he call it marine?

91 Idem.

92 Tria cornua naturalia Leporis.
Three natural Hares' horns.

93 Horns of a Roe Buck from Cape de Verde. Mus: Tradesc: p. 7.
Tradescant (1656, p. 7).

94 Cornua Cervina cujus speciei non constat.
Antlers of Deer whose species is unknown.

96 An Cornu Tragelaphi? Jonst. Tab. XXXIV.
Horn of a Tragelaphus [deer]. Jonston (1657a, tab. 34).

97 Ignotum.

98 Cornu bisontis. Jonst. Tab. XVI. Nū. 1. p. 36.
Horn of the Bison. Jonston (1657a, p. 36, tab. 16).

99 Idem.

100 Idem

101 Idem

102 Cornu Bubali Africani Jonst: Tab. XVIII.
Horn of an African ox. Jonston (1657a, p. 37, tab. 18).

[21r]

103 Cornua Gazellæ. Jonst. Tab. XXIX.
Horns of the Gazelle. Jonston (1657a, tab. 29).

104 Cornu Capræ Strephicerotis. Jonst: Tab: XXIV. p: 38. sub titulo Bovis strepsicerotis.
Horn of a Goat (with twisted horns). See Jonston (1657a, p. 38, tab. 24), under the title Bovis strephicerotis.

105a Cornu Alcis. Jonst: Tab. XXXI.
Elk antler. Jonston (1657a, tab. 31).

105b Cornu Rhinocerotis Jonst. Tab. XXXVIII.
Horn of the Rhinoceros. Jonston (1657a, tab. 38).

106 Cornua Alcis.
Elk antlers.

106b Cornu Rhinocerotis.
Rhinoceros horn.

107 Cornu Cervi mirabilis. Jonst. Tab. XXXVI.
Curious antler of a Deer. Jonston (1657a, tab. 36).

108 Cornu Alcis varietas altera.
Antler of another sort of Elk.

109 Cornu Cervi monstrosum.
Deformed antler.

110 Cornua Arietis monstrosa.
Deformed Ram's horn.

111 Cornua an Hirci Cotilardici? Jonst. Tab: XXVII. The same perhaps with those call'd Muscovy Rams Horns. M.R.S. Tab. 2.[25]
Perhaps the horn of the *Hircus cotilardicus* of Jonston (1657a, tab. 27). Grew (1681, tab. 2).

112 Horn of the Tuck Fish M.R.S. p. 86.
Grew 1681, p. 86.

113 Cornu Monocerotis. Jonst: Tab. X1.
Horn of the Unicorn. Jonston (1657a, tab. 11).

113b Cornu Rhinocerotis.
Rhinoceros horn.

114 A Sow's Head from Surat. Mus: Tradesc: p. 7. an Tajagu? Pisonis. p. 98.
Tradescant (1656, p. 7); perhaps the Taiaçu of Piso (1658, bk. 3, p. 98).

[22r]

115 Porcus Monstrosus. \\decayed//
Deformed pig.

116 Crus cum Ungulis Alcis: Jonst: Tab. XXXI
Leg of the Elk, with hooves. Jonston (1657a, tab. 31).

117 Idem perforatum.
The same, perforated.

118 Idem.

119 Ungula Alcis trisulca.
Hoof of the Elk, thrice grooved.

120 Cranium Elephantini. Jonst: p. 17. Tab. VII. VIII. IX.
Skull of an Elephant. Jonston (1657a, p. 17, tab. 7, 8, 9).

121 Idem.

[25][f.20v] Decayed.

122 Cranium Hippopotami. Jonst: Tab: XLIX. p. 76.
Skull of a Hippopotamus. Jonston (1657a, p. 76, tab. 49).

123 Idem.

124 Mandibula Hippopotami inferior. \\I//[26]
Lower jaw of a Hippopotamus.

125 Ejusdem Mandibulæ [-superior].
Upper jaws of the same.

126 Mandibula superior rhinocerotis. Bont: p.50. Iavanensibus Abadæ. Jonst. Tab: XXXVIII. p. 66.[27]
Upper jaw of a Rhinoceros. Bont 1658, p. 50. The Abada of Java. Jonston (1657a, p. 66, tab. 38).

127 An Pars vertebræ Elephantini? \\an Rhinocerotis?//
Perhaps part of the vertebrae of an Elephant (or a Rhinoceros?).

128 Una è vertebris Balenæ.
One of the vertebrae of a Whale.

129 Os rotundum Balenæ.
Round bone of a Whale.

130 Scapula ejusdem dicta.
Said to be the shoulder-blade of the same.

131 Ejusdem costa.
Rib of the same.

132 Os femoris Elephantini.
Elephant's femur.

[23r]

133 Os Humani femoris montrosum. \\ see over leaf//[28]
Deformed human femur.

134 Priapus /Penis\Balenæ.
Whale's penis.

135 Idem.

136 Pellis Zebræ Indicæ. Jonst: p. 15. Tab. V. \\Stair Case//
Skin of the Indian Zebra. Jonston (1657a, p. 15, tab. 5).

137 Capræ Africanæ Pellis. viz. Mohair Goat.
Skin of an African Goat, namely Mohair Goat.

[26][f.21 v] 124. Sent by Order of the visitors to Mr. Lever [later Sir Ashton Lever] of Manchester. 1769.

[27][f.21v] ☞ in Mr Buckland's Collection ☞

[28][f.23v] A giant said to be buried, (in Weston Church, near Baldock in Hertfordshire) where there are /two\ stones fourteen feet distance, said to be the head and feet stones of his grave. This Giant, says Salmon, as fame goes Lived in a Wood here, and was a great robber, but a generous one, for he plundered the rich to give to the poor. He frequently took Bread for this purpose from the Baldock Bakers, who catching at an advantage, put out his eyes, hanged him in Baldock field, at his Death, he requested to be buried in Weston Church yard,. About seventy years ago a large thigh-Bone was taken out of the church Chest, where it had lain many years for a shew, and sold by the Clerck to Sir John Tradescant, who gave it to the Museum at Oxford.

138 Leonis Africani Pellis. Jonst: p. 77. Tab. L. LI.
Skin of an African Lion. Jonston (1657a, p. [78], tab. 50, 51).

139 Phocæ sive Vituli marini Pellis. Jonst: Tab. XLIV.[29]
Skin of a Seal or Sea-calf. Jonston (1650b, tab. 44).

140 Zebra Indica. Jonst: p. 15. Tab. V.[30]
Indian Zebra. Jonston (1657a, p. 15, tab. 5).

141 Cervus Laplandicus.
Lapland Deer.

142 A Muscovite Fox. E, legatis Ric: Rawlinson L.L.D.
A Muscovy Fox, bequeathed by Richard Rawlinson, LL D.

143 Pellis Croc/o\dili. Ex Dono G.L. Scott Arm. R.S.S.[31]
Skin of a Crocodile. The gift of G.L. Scott Esq., FRS.

144 Felis Indiæ Orientalis sc. de Cap: Bonæ Spei.[32]
Cat from the East Indies, namely Cape of Good Hope.

145 Viverra Indis dicta Mungutia e Cap: bonæ Spei ex Dono Edvardi Dampier.
Ferret, called Mongoose by the Indians; from the Cape of Good Hope. The gift of Edward Dampier.

146 Penes Hippopotami. Ex Don. Geo. Scott. A.M. R.S.S. (1762).
Hippopotamus penis. The gift of George Scott MA, FRS (1762).

[24r]

Testudines
Tortoises

1 Testudo è maximis marinæ, Indica.
The Indian Turtle, from the largest of that marine species.

2 Testudo corticata Rond: p. 445. Testudo aquatica Jonst: de Quadrupedibus. Tab: ult:
The barked Turtle of Rondelet (1554, p. 445). Marine Turtle of Jonston (1657a, tab. 80).

3 Testudo e majoribus dorso præter cæteras depresso et lævi. &c:
Tortoise of the largest kind, with the shell flattened more than the others and smooth.

4 Testudo corticata. Rond.
Barked turtle of Rondelet.

5 Caput Testudinis marinæ. Jonst. Tab: ult.
Head of a marine Turtle. Jonston (1657a, tab. 80).

6 Testudo dorso aculeato.
Tortoise, the back of which is covered with prickles.

7 Idem.

[29][f. 22v] decayed.

[30][f.22v] skin decayed.

[31] [f.22v] 143B. Vulpes aureus. s. Lupus Aureus Linnaei. Aug. Jackall. }\\Decay'd 1764.// Golden Fox, or Golden Wolf. Called in Linnaeus's enlarged edition (1788, vol. 1, p. 72 no. 7) Jackall. 143C. Lutra Linnaei Aug: Otter, Vide no. 7. Otter: see Linnaeus's enlarged edition (1788, vol. 1, p. 93).

[32][f.22v] Decayed 1764.

8 Idem.

9 Idem. [-numeramus 2]
The same (we find two of them).

10 An Testudo squamosa (Scaley Tortoise Shell)
M.R.S. Tab. 3.
Probably a Scaley Tortoise. Grew (1681, tab. 3).

11 Testudo minor versicolor tessellata, valde
rugosa. Iaboti Pisonis. p. 105.
Smaller, tesselated, vari-coloured Tortoise, heavily ridged.
The Iaboti of Piso (1658, bk. 3, p. 105).

12 Idem.

13 Idem.[33]

14 Testudo terrestris minor, versicolor, tessulis
majusculis prominentibus, triplici ordine
dispositis. M Mosc. p. 118. Num 2.
Lesser terrestrial Tortoise, vari-coloured, with somewhat
larger, overhanging plates arranged in threes. Moscardo
(1672, p. [218], no. 2).

15 Testudo terrestris e minoribus, dorso depresso,
exluteo, et atrorubenti versicolor.
Terrestrial Tortoise of the lesser sort, with a flattened back,
in many shades of red and yellow.

16 Idem.

[26, 27r blank; 27v]

A Caput Canis Carchariæ. Species altera Johns.
Tab: VI
Head of another species of Dogfish. Jonston (1650b, tab. 6).

[28r]

Piscis eorumque partes
Fishes and their parts

Pisces Vivipari
Viviparous fishes

1 Corneæ laminæ quæ in Balænis dentium munere
funguntur, quarum meminit Faber Lyncæus &c.
Consule will: p. 36. 37.
Horny plates [baleen] which serve as teeth in whales, as
mentioned by Faber. Considered in Willughby (1686, pp. 36,
37).

2 Delphinus Will: p. 28. Tab. A.s. Cartilaginei
longi
Dolphin. Willughby (1686, p. 28, tab. A1: 1).

3 Mandibulæ Catuli majoris Salviani, Caniculæ
Aristotelis. Rond, Aldrov: Lib: 3. C. 34. Pese
Gatto Venetorum, Cornubiensibus a Bounce. Will.
p. 62. \\Squabus Caniculæ L.//
Jawbones of the greater Catulus of Salviano [1554, p. 138];
the Canicula of Aristotle: see Rondelet [1554, pp. 380-3];
Aldrovandi (1613, bk. 3, ch. 34). Called by the Cornish a
Bounce. *Squabus caniculae* Linnaeus.

[28v]

May 27 /1817\ Head, shoulder, and vertebra of a
Grampus. Vid. Linn. Cete. Delphin. orca.
Grampus. *Delphinus orca* Linnaeus.

4 Mandibula canis Carchariæ, s, Lamiæ Rond: et
aliorum Gesn. de Aquatilibus. p. 204. Aldrov: de
piscibus. p. 379 The white Shark Will: p. 47.
Jawbone of the White Shark, the Lamia of Rondelet [1554,
pp. 390-3] and others; Gessner [1620, pp. 173-8];
Aldrovandi (1613, p. 379); the White Shark of Willughby
(1686, p. 47).

4b Ejusdem Pinnæ.
Fin of the same.

5 Zygæna integra ex dono Dñi Gul: Charleton. \\e//
Rond. Bellonii, Salviani, Gesn. 1255. Aldrov: de
Pisc: Lib: 3. Cap. 43. The Ballance Fish. Will: p.
5. Tab. B.1[34]
A complete Hammer-headed Shark given by Mr William
Charleton. Rondelet [1554, pp. 389-90], Belon, Salviano
[1554, pp. 129-30], Gessner [1620, pp. 1050-51]; Aldrovandi
(1613, bk. 3 ch. 43); the Balance Fish of Willughby (1686, p.
[55], tab. B1).

6 Ejusdem maxilla[35]
Jawbone of the same.

7 Pristis, s, serræ Piscis Clusii in Exot: Lib: 6.
Cap. 9 Rond, et aliorum. The Saw Fish. Will: p.
61. Tab. B.9.
The Pristis or Saw-fish of Clusius (1605, bk. 6 ch. [19]),
Rondelet [1554, pp. 487-8] and others; the Saw-fish of
Willughby (1686, p. 61, tab. B9: 5).

8 Raiarum Testæ Ovariæ Will: p. 76. Rond. p.
386. Jonst: p. 16. Tab. XII.[36]
Egg-cases of the Ray. Willughby (1686, p. 76); Rondelet
(1554, pp. [342-4]); Jonston (1650b, p. 16, tab. 12).

9 Guacucuia Bras: Marggr. Monoceros piscis qui
Vespertilio aquatica dici possit. Will: p. 9. Tab.
E.2.
Brazilian Guacucuia: the Sea-unicorn of Markgraf, which
may be the so-called Sea-bat. Willughby (1686, p. [89], tab.
E2: 3).

10 Guaperva Bras: Marcgr. The American Toad
fish. Will: p. 90. Tab. E.2. An Spec: N.D.?
The Brazilian Guaperva of [Piso and] Markgraf [1648, pp.
145, 150, 163]. The American Toad-fish. Willughby (1686, p.
90, tab. E2: 1).

[30r]

Anguilli-formes
Eel-like types

11 An Lupus marinus Schonfeldii. Will: p. 130.
Tab. H.3 an potius Lupo congener, piscis nondum
descriptus.

[33]Dec- (illegible)

[34]**[f.28v]** [-decayed]
[35]Decayed.
[36]Decayed.

The Sea-wolf of Schonfeld. Willughby (1686, p. 130, tab. H3: 1). Or it could be a fish similar to the Sea-wolf but not yet described.

12 Iperuquiba et Piraquiba Bras. Marggr. Lusitanis Peixe, Pogador et Peixe, Pioltho; Begis Suyger. Remora Imperati Aldrov: Sucking Fish. Will: p. 119. Tab: G.VIII. et App: Tab: 9.[37]
Brazilian Iperuquiba and Piraquiba of [Piso and] Markgraf [1648, p. 180]. In Portuguese *Peixe pogador* and *Peixe piolho*. The Remora of Imperati and Aldrovandi. The Sucking Fish of Willughby (1686, p. 119, tab. G,8: 2 and Appendix tab. 9: 2).

Corpora contractiora. qui pinnis ventralibus carent
Narrow-bodied fish, without ventral fins

13 Piscis triangularis ex toto cornibus carens Listeri apud Will: App: p. 20. Tab. I. XVIII.
Triangular fish [Trunk Fish ?] without any horns. Lister, quoted in Willughby (1686, Appendix p. 20, tab. I, 18).

14 Pisces triang: minores duo ad imum ventrem prope caudam tantum cornuti ex toto maculis subrufis insigniti Lister, apud Will: App. p. 20.
Two Triangular fish [Trunk Fish ?] of the lesser sort, with spines only on the ventral surface near the tail, marked all over with reddish spots. Lister, cited in Willughby (1686, Appendix p. 20).

15 Piscis tres triangulares Cornuti Clus: Will: Tab. I. XIV. His corniculi supra caudam et ex opposito in ventre mucronata prominentia. H.2.qui a se invicem nonnihil variant.
Three-horned Triangular fish [Trunk fish ?] of Clusius. Willughby (1686, tab. I, 14). On these fishes are small spines above the tail and on the opposite side a pointed projection on the belly, which spikes are sometimes different from one another.

[31r]

16 Pisces duo Qu[a]drangulares, an Rostratus Listeri apud Will: App: Tab. I.X. p. 20. in App.?
Two Quadrangular fish [Trunk fish ?], seemingly beaked. Lister, cited in Willughby (1686, Appendix p. 20, tab. I, 10).

17 Orbis caudâ productiore, dorso lævi, ventre spinoso Will: p. 144. Tab. I.II. Orbis Lagocephalus (Hare globe fish) M.R.S. Tab. VII.
Globe fish with elongated tail, with a smooth back and a spiny belly. Willughby (1686, p. 144, tab. I, 2). Hare-headed Globe Fish. Grew (1681, tab. 7).

17b Idem. \\decayed.//

18 Guaperva longa caudâ fere quadratâ, et minime forcipata, capitis vertice latiusculo List: ap~d. Will: App: pag: 21. Tab. I.XX.
Guaperva, with a long, almost square tail, slightly forked, the head slightly swelling at the top. Lister, cited in Willughby (1686, Appendix p. 21, tab. I, 20).

19 Guaperva maxima caudata. List. apud Will: App: 21. Tab.I.XXIII.

The greater-tailed Guaperva. Lister, cited in Willughby (1686, Appendix p. 21, tab. I, 23).

20 Idem.

21 Acarauna major pinnis cornutis. List. apud Will: App: p. 23. Tab. O.III. An Paru Brasil: Marggravii?
Greater Acarauna with horned fins. Lister, cited in Willughby (1686, Appendix p. 23, tab. O, 3). Perhaps the Brazilian Paru of [Piso and] Markgraf [1648, p. 144]?

22 Monoceros piscis e M.R.S. Willoughb. O. IV. Descriptio nulla, Q, An hujus loci sit? Monoceros minor Grevii M.R.S. p. 104. Tab: VII.
Little Sea-unicorn of the Royal Society museum. Willughby (1686, tab. O, 4), without description. Query: does it belong here? Little Sea-unicorn of Grew (1681, p. 104, tab. 7).

[32r]

23 Acarauna minor pinnis cornutis Listeri ap~d Will: App: p. 23. T. O.III. An. Paru Brasil Marggr? an Jonst: Tab. XXXII.
Lesser Acarauna with horned fins. Lister, quoted in Willughby (1686, Appendix p. 23, tab. O, 3: 2). Perhaps the Brazilian Paru of [Piso and] Markgraf [1648, p. 144]. Jonston (1650b, tab. 32).

24 Guamaiacu Guara Brasil Peixe Porco et Diabe Lusit: Macgr. Will: p. 147. Tab. I.V. maculis atrorubentibus undiq. conspersus est. Numeramus VI.
Brazilian Guamaiacu Guara; in Portuguese the *Peixe porco* and *Diabe*. [Piso and] Markgraf [1648, pp. 142-3]. Willughby (1686, p. 147, tab. I, 5). Covered with reddish spots from every viewpoint. We count six of them.

25 Orbis muricatus et reticulatus List. apud Will: p. 155. Tab: I.VII.
Globe fish, and with square scales. Lister, cited in Willughby (1686, p. 155, tab. I7).

Aculleati duabus in Dorso Pinnis anteriore autem spinis rachata.
Spiny fish with two dorsal fins but with spines projecting forwards.

26 Cuculi species. Mutilatus est piscis. proinde quænam sit cuculi Spec: non constat. An fortè Cuculus Salv: i.e The Red Gurnard? Will: p. 281. Tab. S.II.
A species of Gurnard. The fish is damaged; hence what species of Gurnard it belongs to cannot be established. Perhaps the Cuculus of Salviano [1554, p. 191], i.e. the Red Gurnard. Willughby (1686, p. 281, tab. S, 2).

27 Milvus alius Jonst. Tab. XXII. p. 66. Milvus Salv: Bellonii et Aldrov: Lib: 2. C. 5. Hirundo Rond: Gesn. p. 514. Rondine Romæ, in Sicilia & Melita Falcone, the flying Fish. Will. p. 283. Tab. S.VI.
Another Flying Fish of Jonston (1650b, p. 66, tab. 22); the Milvus of Salviano [1554, p. 187]; Belon [1553, pp. 195-6] and Aldrovandi (1613, bk. 2, ch. 5); the Hirundo of Rondelet [1554, pp. 284-6]; Gessner [1620, pp. 434-7]. Called the Rondine in Rome and the Falcone in Sicily and Malta. The Flying fish of Willughby (1686, p. 283, tab. S, 6).

[37][f.29v] decayed.

[33r]

28 Buphthalmus argyrocephalus. Piscem quem nondū descriptum suspicamur, impræsentiarum sic placuit nominare.
Silver-headed Buphthalmus. A fish which we suspect has not yet been described, so for the present we are content to name it thus.

Aculeati unicâ in dorso pinnâ, radiis anterioribus spinosis, posterioribus mollibus.
Spiny fishes with a single dorsal fin, with spines projecting to the front, but smooth at the back.

29 Luciopercæ piscis nonnihil similis, pinna in dorso unicâ, inferiori mandibulâ prominente. An descriptus sit necne nobis non constat.
A fish not unlike a Perch, with a single fin on the back and with a prominent lower jaw. No description of it is known to us.

30 Hiadula Indica Cyprini formis. Hunc etiam nondum descriptum suspicor. 2.
Indian Hiadula with the outline of a Carp. This also, I believe, has not yet been described.

31 An Rostri Phocænæ pars anterior? Will: Tab. A.1.
Perhaps the front part of the beak of a Porpoise. Willughby (1686, tab. A,1).

32 Cancer Mollucensis. Jonst.Tab. VII. numera: 3
Moluccan crab. Jonston (1650a, tab. 7). We count 3 of them.

33 Cauda Cancri Mollucani.
Tail of a Moluccan crab.

34 An Pagurius? Jonst. tab. V. vel. VI.
Perhaps a Pagurus [Crab]. Jonston (1650a, tab. 5 and probably 6).

35 Chelæ Cancrorum 7. Ind: admodum magnæ.
Seven Indian Crabs' claws, quite large.

[34r]

36 Os quoddam compressum orbiculatum. An ex ossibus Balenæ?
Some kind of bone, narrow and rounded. Perhaps from the skeleton of a Whale?

37 Stellæ marinæ duæ. \\one decayed//
Two Star-fish.

38 Mola Salviani Will: Tab: I. XXVI.
The Sun-fish of Salviano [1554, p. 154]. Willughby (1686, tab. I, 26).

39 An Delphinus Will. Tab. J.
Perhaps a Dolphin. Willughby (1686, tab. [A,1]).

40 Accipenser Rond Silurus Salviano, Sturio Will: p. 239. Tab. P.VII.
Sturgeon of Rondelet [1554, pp. 410-17]; the Silurus of Salviano [1554, pp. 113-15], the Sturio of Willughby (1686, p. 239, tab. P7: 3).

41 Idem minor.
A smaller version of the same.

42 Phocæna. Will. Tab. J.
Porpoise. Willughby (1686, tab. [A,1]).

43 Salmon Bone.

44 Guaracapema Bras: Marcgr. Dorado i.e. Auratus Piscis Nierembergii. Delphinus Belgis. Will: Tab: O.II. p. 214.
Brazilian Guaracapema of [Piso and] Markgraf [1648, p. 160]; the Gilded-fish of Nieremberg [1635, pp. 255-6]; the Belgian Dolphin of Willughby (1686, p. 214, tab. O,2).

45 Idem.

46 Acus maxima squamosa. List: apud Will: App: p. 22. Descriptio huic nostræ per omnia convenit, at figura ejus P.8. ob dorsum arcuatum, pinnaque singulari in medio insigitum neq. huic pisci,

[35r]

neq. Descriptioni Listerianæ respondet.
The greater scaley Pipe Fish. Lister, cited in Willughby (1686, Appendix p. 22). This description appears to correspond in most respects, but his drawing on p. 8, because of its arched back distinguished by a single dorsal fin in the centre, neither corresponds with this fish nor with Lister's description.

47 Naeld visch, i.e. Acus piscis Jonst. Nieuhofs, cited in Will: App: p. 2. Tab. III.
Needle-fish of Jonston [1650b, p. 56]; [] cited in Willughby (1686, Appendix p. 2, tab. 3: 2).

48 Nautis Anglicis.
The Sea-tench.

49 Caput Umblæ é Lacu Lemani. Aldrov: de Pisci: Lib: 5. Pag: 650. Will: Tab: N:i: Fig: 1-2. D. Cooper MD
Head of a Charre from Lake Geneva. Aldrovandi (1613, bk. 5, p. 650); Willughby (1686, tab. N,1). The gift of Dr Cooper, MD.

[36, 37r blank; 38r]

Serpentes
Snakes

1 An Boicininga: Jonst: Tab. VI. p. 23.
Perhaps a rattlesnake. Jonston (1665, p. 23, tab. 6).

2 Anquis Æsculapii. Jonst: Tab. V.
Snake or eel of Aesculapius. Jonston (1665, tab. 5).

3 Boiguacu. Jonst: Tab. VI.
Boa constrictor. Jonston (1665, tab. 6).

4 Ignotus. \\fract.//
Unknown (damaged).

5 Boicininga
Rattlesnake.

6 Idem. \\decayed.//

[39r blank; 40r]

Animalia in spiritu vini inclusa[38]
Animals preserved in spirits of wine

1 Anguis Æsculapii vulgaris. Jonst. Tab: V.
Common Eel or Snake of Aesculapius. Jonston (1665, tab. 5).

[38] Third window.

2 Mater formicarum Clusii.
The mother of Ants of Clusius.

3 Serpens Indicus.
Indian Snake.

4 Idem, sed diversi coloris.
The same, but of a different colour.

5 Idem.

6 Lacertus, \\volans//.
Flying Lizard.

7 Lacertus Indicus volans. Bontii.
Indian Flying Lizard of Bont.

8 An African Toad.

9 Serpens Indicus.
Indian Snake.

10 Aranea Surinamensis. an Tarantulæ species?
A Spider from Surinam, perhaps of the Tarantula type.

11 An Guaperva? Will: Tab. E.II.
Perhaps a Guaperva. Willughby (1686, tab. E, 2).

12 Limax, (ut opinor) vide Jonst. Tab. XXIV.
Slug, or so it seems. See Jonston (1653, tab. 24).

[41r]

13 An Stellio ex Matthiolo? Jonst: Tab: LXXVIII.
Perhaps the Gecko of Matthiolus? Jonston (1657a, tab. 78).

14 Scolopendra marina. Aldrov: Jonst: Tab. XXVII.[39]
The Sea-fish (or multipede) of Aldrovandi. Jonston (1650b, [p. 155, tab. 44]).

15 Centipedæ vel Hippocampi. Jonst. Tab. XXVIII.
A Centipede or Sea-horse. Jonston (1653, tab. [26]).

16 Eædem.

[42r]

2[40]

1 Partus monstrosus, duo scilicet Porcellorum corpora, quibus unum tantum est caput. e vico Eifley dicto huc allat:
Monstrous birth, evidently two piglets' bodies with but a single head. Brought from the village of Iffley.

2 Lacerti. *[bracketed with 3]*
Lizards.

3 Idem. \\in unum congest cum numero priori.// [41] *[bracketed with 2]*
The same. Combined with the previous number.

4 Crocodili duo.
Two Crocodiles.

5 Piscis volans et forsan Draco marinus Will: Tab. S. X.

Flying fish, perhaps a Sea-dragon. Willughby (1686, tab. S,10).

6 Lacerti, Tarantula et Scolopendra.
Lizards, tarantula and multipede (or sea fish)

7 Lacerti tres.
Three Lizards.

8 Insectæ.
Insects.

9 Foetus humanus.
Human foetus.

10 Salamandra India Gecko Bontii.
Indian Salamander, the Gecko of Bont.

11 Idem. \\No. 11 et 9 in unum congest.//
The same. Nos. 11 and 9 together.

12 Canis Piscis et Grillo Talpa.
Dog-fish and Mole-cricket.

13 Animalia partim piscium partim ranarum corpora habentia.
Animal with a body which is part fish and part frog.

[43r]

14 Scorpius Indicus major Zeylanensibus Ghonissa dictus Hermanni.
Greater Indian Scorpion said by Hermann [1711, p. 1] to have come from Ghonissa in Ceylon.

15 Lacerti volantes Indici Bontii.
Indian flying lizards of Bont.

16 Stellæ marinæ. Jonst: Tab. XXVII.[42]
Star-fish. Jonston (1653, tab. [26]).

17 Nidus Avis susurrantis duas continens aviculas.
Nest of a Humming-bird containing two little birds.

18 Aranea magna ex Jamaicâ quæ Avium susurrantium occisor audit.
Large Spider from Jamaica with the reputation of living on Humming-birds.

19 Pullus monstrosus \\decay'd//
Deformed chicken.

20 Scorpio parvus Indicus
Small Indian Scorpion.

21 Cantharides. \\decayed.//
Beetles.

[44r]

3[43]

1 Serpens Caudisonus.
Rattle-snake.

2 Tarantulæ, Serpentes, et Lacerti.
Tarantulas, Snakes and Lizards

3 Crocodilus parvus
A small Crocodile.

4 Serpentes et Lacertus volans.
Snakes and Flying Lizard.

[39]**[f.40v]** 14 - & 9 In unum congest.
Nos. 14 and 9 together.
[40]1 window [displayed in the first window].
[41]

[42]
[43]2nd win. [displayed in the second window]

5 Papilio magna.
A large Butterfly.

6 Tarantulæ duæ.
Two Tarantulas.

7 Scorpio et Locustæ.
Scorpion and Locusts.

8 Lacertus viridis et magni Scarabæi
Green Lizard and large Beetles.

9 Talpa, Ferrantis Imperati, Aldrov: de Insectis Lib.
5 /s\ Pag= 571. - *[bracketed with 10]*
The Mole-cricket of Ferrante Imperato: see Aldrovandi (1602, p. 571).

10 Cancer minutissimus ex Stomacho Musculi Fluviatilis excerptus. D.D. Cooper M.D. Oxon 1758 \\fract.//
Tiny Crab, retrieved from the stomach of a river mussel. Given by Dr Cooper, MD, of Oxford, 1758. Broken.

11 Corpora Avis gallinaceiæ Juncta, monstrosa.
Deformed (joined) bodies of Chickens.

[45r]

4[44]

1 Serpentes, Lacerti et tarantulæ.
Snakes, Lizards and Tarantulas.

2 Eorundem varia specimina.
Various specimens of these.

3 Eorundem.
More of the same.

4 Serpens Caudisonus Americanus.
American Rattle-snake.

5 \\☞//Lacerti Bufones an Africani?
Buffon's Lizards, perhaps African.

6 Salamandra et Hippocampi.
Salamanders and Sea-horses.

7 \\☞//Insectæ.[45]
Insects.

8 Vermiculi vulgo dict: obcæcati ex uno nido excerpti.
Small Worms, commonly called sightless, taken from a nest.

9 Pomum seu fructus \\Cashew.//
Apple or fruit. Cashew.

10 Lacerti.
Lizards.

11 Idem.

12 Felis monstrosa habens corpora dua, unum caput &c:[a]
Deformed Cat, having two bodies, one head, etc.

13 Pyri Sceleton.
Skeleton of a fish.

14 Porci pedes monstrosi.
Deformed pigs' feet.

15 Vermiculus, vulgo dict: Joint Worm ex Infantis visceribus excerptus.
Small Worm, commonly called a Joint-worm, taken from the guts of a child.

[46r]

16 Amygdalæ faucium.[46]
[] of an Almond tree

17 Hippocampi.
Sea-horses.

18a-18b Ova duo Testudini marinæ, ex Visceribus ejus extracta.[47]
Two Turtles' eggs, taken from its viscera.

19 Acus Aristotelis. Aldrov: de Pis: pag: 103. Jonst: Tab: XV. Fig: 14. et de Insectis marin: Tab: XXVII. Will: I. 25. fig: 1.
The Sea-pike of Aristotle; Aldrovandi (1613, p. 103); Jonston (1650b, tab. 15, fig. 14; and 1653, tab. 27); Willughby (1686, p. [158], fig. [I,25]).

20 Grillot Talpae-. \\Grillo-Talpha given by a Lady//
Mole-cricket.

[44] 4th window. [displayed in the fourth window].
[45] In unum congest. 5.7.
In one mass.

[46] Quare. 16.
Is this the same as 16?
[47] 18 decay'd.

CATALOGUE BORLASE

Transcribed by Julia White, annotated by Arthur MacGregor

Ashmolean Museum, AMS 20, compiled 1758. Paper-covered exercise book with a paper label on the cover, 'Catalogue Borlase'. 13 folios (some incomplete), 200 by 160 mm.

William Borlase (1695-1772), rector of Ludgvan in Cornwall, was a key figure in the revitalization of the Ashmolean that took place under the keepership of William Huddesford (see p. iii). As well as providing sage advice for the young Huddesford (who described him as 'my First and greatest Patron'), Borlase was to send to the Museum a collection of mineral specimens accompanied by the present list of contents, compiled by himself.[1] The University had a cabinet made specially to hold them, with the painted legend 'GUL.s. BORLASE A.M. F.R.S. D.D.'; it survives today in the University Museum of Natural History. The specimens concerned had formed the basis of Borlase's own *Natural History of Cornwall*, which was published in that same year and to which the page- and plate-numbers quoted in the following text refer.[2] None of the specimens can be identified today and indeed there is evidence that some of them were early casualties of the Ashmolean's unwholesome atmosphere: in a letter to Borlase, Huddesford had to declare himself 'sorry to find the Mundics so perishable a treasure - some of the best specimens being crumbled to peices' and later he had to report that the same specimens were now 'gone to decay in spite of varnish and every other care' (see MacGregor and Turner 1986, p. 655). So complete was the extinction of the collection that Gunther (1925, p. 223) was to comment that 'Borlase might as well have sent his treasures to Twickenham to add to the decorations of his friend Pope's grotto.'

[inside front cover]
Those marked + are the Clays &c found near Kynans cove near the Lizherd [Lizard]. Nat: History page 67. 68-69:

[1r]
Steatites, Clays

1 Pure white clay. Nat: Hist. pag: 67. Chap 6: p: 15 \\+// Do. Dissolved.

2 White chalky Earth: 16 pag 67: ib \\+// Do. Dissolved

3 The same chalky earth mixed with Red ib: \\+// [-Steatites (Lizerd) bruised.]

4 The same clouded with Purple. ib: \\+//

5 Glossy pearl-coloured hard clay. with its Incrustation of Green amianthus pag: 67 68 \\+//

6 A Fat mass of steatites: Brown and Purple. p: 68

7 Green gritty chalk. ib: \\+//

8 A deeper Purple and more stony steatites. ib: \\+//

9 A Blackish steatites. ib. \\+//

10 The Tesselated Spar, found with ye soapy Rock. 69

11 Lisherd Steatites describd, page 65 /66\Do. Bruised

12 Chocolate Earth (Illogan) pag 62. 63.

13 Amabree Clay Depurated: pag 63 64

14 Trewren clay. Depurated and baked in my study. pag 64

15 Ochre from Gwynar Downs. pag 62. vid...

16 [-The Ta] Marga Micacea. pag 86

[2r]
Stony Substances, Talks &c

1 Foliaceous Talks [-\f]rom Bell Chapell in Gwenap: pag 112 /No. 3\

2 Radiated Stiated Talk from ib: Ib: No. 4.

3 St. Clare Asbestos on a gritty green kilas pag 1[-3\1]3 No. 1

4 Asbestos from the P[ar]ish of St Clare in a Tender Killas pag 254. 113. Plate: XXV. fig XXX

5 Asbestos with the Longest Filaments. from Do. pag 113-No. 3

6 Alabastrine Incrustation from Holywell in [St.] Cuthbert Parish pag 111.

7 The Swimming Stone ib:

8 Free Stone from Caranctoc P[ar]ich sparry base: pa: 95.

9 White Free Stone near St. Teath of a Christal Base page 97. Note 1.

10 Spar intermixed with Shells from Falmouth Harbour page 282.

11 White Granite from Tregonin

12 Porphyrite No. 1 pag 109

13 Porphyrite No. 111. pag 110.

14 Bismuth vulgo Tin Glass pag 129

15 Zink - pag 129.

[3r]
Chrystals

1 Mislayd: WB.

2 Mamillary Cristal. pla: XIII fig 2: pag 119.

3 Crystalline Stalactites. Plate XIII fig. 3. pag 119

4 Do. ib: 120.

[1] An extensive correspondence between Borlase and Huddesford still survives: see MacGregor and Turner 1986, p. 654). On Borlase see Poole 1986.

[2] Borlase also deposited in the Museum his draft manuscript for the *Natural History*, on being rediscovered in 1883 this was transferred to the Bodleian Library. He also contributed a number of antiquities that had featured in his *Antiquities of Cornwall* (1758).

5 Mislayd: WB.

6 A supplemental One of Less distinct shoots but of Like Process. Plate 13. No. 6

7 Mislayd? WB. a Supplemental One its Criterions not so distinct, a more entire and Perfect Specimen: pag 122.

8 Crystal describ'd pag 120 Plate XIII fig 8.

9 Pyramidal Chrystal: 4 Specim: 2 brown, two white. describd. pag 120. Plate XIII fig 9.[3]

10 Columnar Chrystal. capped with a Pyramid: pag 120. Plate 13: No. X.

11 Columnar Chrystal: Pyramidical at Each End: ib: Pl.ib: No 11.

12 Chrystals sharp[-ed] Edged at the /tetragonal\Point: pag 120 Pl: 13 No. 12

13 Notched Point pag 120 \\(upside down) Walter//

14 Pyramidal. Forming another cuspis. pag 121 fig: 14

15 Unequal sided Chrystal: pag 120: fig. 15

16 Triangu[-\l]a[-\r]. pag 121 Plate XIII fig. 16

17 Tabular Pentagonal planes quadrangular sides pag 12[-]. Fig 16.

[3v]
Christals without No.

A Lump of Pyramidal white Do

B Larger Do. Bluish Colour

C Pyramidal Pentago[-\n]al Christal semi opace

D Clump of Pyramidal yellowish

E Of White Do.

F Small ones arisen from ore -

G Cluster of Pentagonal Columns elegant

[4r]
18 A Shaft on a Rhomboid Base. pag 121 Fig 28

19 Pentagonal shafts with obtuse Points. pag ib: Fig 19.

20-21 Hexagonal flattish Peice. pag ib: fig 20 21.

22 A Poly hedron of Chrystal. pag ib:. 22.

23-24 Two cylindrical Columns. of shotten Xstal: ib: fig 23 ?

25-26 Frustrum of a Cone pag 121: fig 25 26.

27 Hexagonal Xstal of the finest Water including Green sprigs ib.

28 A Cluster of semipellucid Xstals. Shot into reclind Cones. ib: fig 28

29 Borrowd of Mrs. Percival & returnd WB:

30 Mislay'd WB.

31 A Group of Hexagonal Xstals pag 125. Plate 13: fig 31

32 From Mr. Allens Works near Bath: not sent WH.

33 2re.

34 A Triangular Pyramid. 122 fig 34

35 A Triangular cunoeid Chrystal pag 122: fig 35

36 The Crystal mixed with Mundic describd pag 136.
[4v]
Circular Protuberant Mund.

[5r]
Mundics engraved in Plates XV & XVI

1 Blisterd mundic. described: pag 137. WB three Supplemental /specimens\

2 Blister'd high Releivo: [-ib]: Do. ib.

3 Squamose Do. ib:

4 Part of an Oval Incrustation. Do. 16.

5 Three Lumps of Hexagonal Mundic capping a Peice of Xtal. ib

6 A Ball of Brass colourd Do. ib.

7 A nodule of Pyrites. ib.

8 The same fallen into Pegs. ib.

9 Botrueid [-Do.\Mundic] Incrustation [-into] over Clear Christal. 138 pag

10 Stillatitious Do. (Illogan). ib.

11 Do. with Oval Blisters. ib.

12 Do. Brown oval Blisters on a bed of Copper. ib.

13 Do. Bras colour'd wreathd in the shape of a turben. ib.

14 Do. with Blisters like parrallell Rings. ib.

15 Buttony mundic five Protuberances ib.

Concave circular Mundics

16 A wavy Bo/r\dure of Brass colourd Mundic. ib.

17 Several segment[-\s] of Circles Do. ib

18 A Peice of Brass colourd Do. with a fringed edging. ib.

19 A Peice of Lace Work of Do. (Ludgvan). ib.

20 A molding fringed an Tufted Brass colourd Do. ib.

21 Do. the Colour of Polis[he]d Silver. [-ib.] 139 pag

22 A list of small Beads on a greenish sparkling mundic Plate XVI.ib.

[6r]
Mundics

23 Broke to Peices by Accident WB. ib.

24 Do. In form of an Harp on a yellow Spangled. ib.

25 An Embossed Fower like a Gooses Head. on a Gold Colourd m. ib

[3] [f.2v] Hexagonal

26 A Birds Head on a thin Plate of Purple Spangled Mundic powder'd with Gold Dust. ib.

27 A Triangle of spangled yellow Do. ib.

28 Granules of Brass colourd do. in a Rhomboid on a white opace Quartz.

29 A Cluster of spangled Do. with stems. ib.

30 Fungoeid, Dental Do. ib. Rectangular Grains /2\crested /1\with

31 Fungoeid Tufted Crest Do. ib

32 The same as 30 but not indented ib

33 Fungoeid Do. with wavy Grits &c ib.

34 Stillatitious Mundic in Capillary Tubes. Lead colour. 140

35 Cinereous stillatitious Do. ib.

36 Thin acuminated wedges of Ditto. ib.[4]

37 A shoot of columnar [-Do.] Plate mundic. ib.

38 A Rhombo Columnar clump of Plate Mundic. ib

39 A Rhomboidal Die of Mundic. ib.

40 A Clump of Cubical Do. ib.

41 Two Cubes of Do. joined ib.

42 A Perfect Cubes of brass colourd Do. ib.

43 A Polyhedron. Do ib.

44 Do. Brass colourd. ib.

45; 46 A Bunch of Mundic Rhombus's. ib.

[7r]

47 A Triangular Pyramid Do. ib

48 One Grain do. convex in Front &c ib.

49 A cubical Die of Mundic &c pag: 141.

50 A Rhombus between four slopes. ib. *(bracketed with 51)*

51 from Huel Cock in St. Just: P[a]rish. ib

52 An exact Parallelopipied. Gold Colourd Do. ib.

53 A cube Do. &c : ib.

54 A Peice of Tubulary. brass colourd do. ib.

55 Do. ib.

56 []

57 An Heptahedral Cuspis of yellow Do. ib

58 A Tetrahedral Cuspis of Brass Colourd Do. ec ib

59 Tetrahedral cuspides of Mundic &c. ib.

60 2 Pyramids /Do.\ joind Base to Base. ib.

61 Buttony Do. (Pool.). ib

62 A variety of Do. ib

63 Do.

64 Three Balls Connected Do. .ib.

[65] Mundics of Modern concretion Nat: Hist pag 136

[8r]

66 Samples of Plate Mundic:

67 of Brass Co[-u]lourd M:

68 of Brown Do

69, 70, 71 Arsenical Efflorescences of Do. from the Burning House pag 134

70 Do. Incrustation formd into Circular Hollows.

[9r]

1 Compress'd oblate Pyramidal Tin Grain. pag 186.

2; 3 Borrow'd and returnd By WB.

4 Ten inclined Planes &c. ib.

5 Irregularly quadrangular Planes. &c. ib.

6 Misplaced WB.

7 A Grain divided into light \triangle planes. 187

8 A Columnar grain on a Rhomboidal Base. ib.

9 Do. the Apex a Quad: Pyramid Mislayd WB

10 Bunch of Tin grains &c ib.

11 An Equilateral Triangular Plane projecting from a Parallell Ground. ib.

12, 13 Pyramidal Pentahedral Grain ib

14 Quadrilateral irregularly Pyramidal Grain. ib

15 Do. more perfect Figure and higher Polish ib.

16; 17 [-Plan an] Quad. Pyramid on a Column with nearly a Sqr. Base in

18 Grain Tin Melted &c. ib

19 The Property of Mr. Crab of St. Austel. ib. WB.

20 A Curious grain of Tin &c ib.

[10r]

21 A Pentahedral Pyramid of Crystalline Tin. pag 188.

22 Quadrilateral Pyramid of Tin &c ib.

23 A Tin Grain extended like a Book unfolding - &c ib. These four last from Huel fortune in Breag.

24 Two Quad Pyramid on a Rhomboidal Base

25 Two Pentahedral Pyramids Base to Base. *(bracketed with 24)* }from St. Mewan Glebe

26, 27 }Two Hexagonal Pyramids joind base to Base. ib.

28 The original is now the Property of Mr. Soper &c WB

29 Not Sent WH

30 A Red tetrahedral Pyramid explaining the Zony texture of 29.

31A Tin grains &c

31B, 32 Buttony from Ore Nat Hist pag 196

33, 34 Tessellated Lead Ore. \\212//

32 to 38 Six Samples of prepared Tin.

[4] [f.5v] Geometrical Angular M:

37 one Grain of Lead

39 Tin grains of various Colours St. Austel Moor.

40 []St Aust: Moor

41 Tin ore from [...] Bosehan. St. Just 185

42 [] from [] Polberou St. Agnes. 188

[11r]

43 Gwenap Grain Tin shot into Christals.

44 Godolphin Work

45 Largest Tin Crystals with Flammulae of Gold: pag 215

46 Cockle a Mock Tin

[12r]

1 Virgin Ore somewhat Blisterd &c pag 199.

2 Brass Colourd specimen: with circular Laminae &c. 200.

3 Flake Ore blisterd &c ib.

4 Brass coloured flake Do.with concave cells. ib.

5 Brass colour'd formd in filaments more fungitarū. ib

6 Do. filaments at right Angles. ib

7 Conic Cluster of wreathed Threds [...] ib

8 Hexagonal [-Column\Tubes] of Flake Copper with a Bandage of Blisterd Ore. ib.

9 Brush Copper Ore in parallell Tubes [...] ib.

10 A solid Peice of finest Gren. ib

11 Less solid Green of a Glossy Coat [...]. ib.

12 Solid Branchy Green [...]. ib.

13 Green with fine Glossy filaments with a Coat of Blisterd flake Ore ib

14 Smooth Solid high blisterd Copper (from Huel fortune in Ludgvan. 201

15 The Same Sort mamillary with a drop at ye Bottom ib.

16 Virgin Leaf Copper Branchy ib

17, 18 Do.

19 Virgin Ore Branched and fibrous. ib

20 Virgin Ore fringed at ye Edges ib

21 Elegant Specimen of Virgin Ore in Filagre ib not sent WB

22 a b c d Brightest Virgin Ore Shott into Daggers &c

23 Purest Ore from Mullion in Drops

24 Spread into Leaves and Bunchy

[12v (upside down)]

Groop of hexaedral Amethiestine

[-] A Large Specimen of No. 9.

M One of No 33.

K Groop of Hexaedral Amethestine cuspide

[M\L] Of Green Do.

[-\M] Groop of Hexaedral Cuspides of a Brown Colour [-not tran] space

[-\N] The same [-of\as] no. 33. of a yellow colour ?efer Crystalls shooting from the sides of the columns

O Groops of small Cuspides rising [-fro] in Globular forms of a Brownish Colour

P [C]luster of Transparent Crystall from a Brown stone

Q A specimen of No. 7.

R of No. 9.

S of 33

T Largest Crystalls.

U Groop of Pentahedral Cupides opate shooting from each side a Partition

W Large Hexaedral Do. semiopate.

X Groop of small Brown Crystalls.

[13r]

Supplemental Coppers

1 Green Copper Ore referrd to pag: 198

2 Blue do. ib.

3 Grey Ore ib.

4 Black Ore ib

5 Red of Fire Ore [-ib] 199

6 Red fire Ore in a green Crust ib.

7 Red Ore and Argentum Rubrum of Germany Compared ib

8 Fire Ore supposed to be Zink ib.

9 Richest fire Ore Filamentary ib.

[]

11 Praecipitated Copper in the Rust of Iron pag 207.

12 Purest granulated ore from Binner Downs.

13 in Powder Do. resembling Gold Dust.

Melted Copper and Natural Compared in four Degrees

14 First degree of Purity from the furnace *(bracketed with 15)*

15 Its resemblance from the Mine. [-ib.]

16 Second degree of Purity *(bracketed with 17)*

17 Its resemblance

18 Third degree *(bracketed with 19)*

19 its Resemblance

20 Purest from the furnace refined for manufacture

21 from the Mine in Mullion described. pag 199-201

22 Large Specimen of Blisterd flake Ore. pag 197

[13v (upside down)]

Class 3

181 Supplyd from [-Lower\mid] Study -

182 from the Cabinets below

183 Do

186 2.re

192 Not: quite: right.

To Compare [-\225] with the Waxen Vein in Dr. Hill
or &c.

2re. What Stuposus?

[Inside back cover]

Quod scriptores, observatum fuissit, non species haud
facile irata, nec non Iram saepe demonstrant, quum
[]otae homo naris in suae opera criticum agunt.

Scriptores hand vulgariter eruditi argumentam
hoc in Literarum Republicâ probaverunt *(over pencil
sketch of the cabinet mentioned on p.217)*

Writers learned above the common level have approved this
argument in the Republic of Letters.

CATALOGUES RELATING TO THE LETHIEULLIER, PENNANT AND ANGERSTEIN COLLECTIONS

Transcribed by Julia White, annotated by [1-2] Arthur MacGregor and [3] Justin Brooke

Ashmolean Museum, AMS 4, compiled 1759. Loose leaves pasted into a modern folio volume. (1) fols. 5-6: two leaves (folded), 245 x 187 mm; (2) fols. 7-8: two leaves (folded), 325 x 205 mm; (3) fols. 9-10: two leaves (folded), 300 x 178 mm.

Although all three documents listed here bear the date 1759, they relate to quite disparate collections and may be taken to owe their preservation (though not their authorship) to the industry of William Huddesford, following his appointment to the keepership of the Ashmolean in 1755 at the age of twenty-three.

1

The items included in the first of these catalogues, of 'natural bodies' belonging to 'Mr Lethieullier', probably never reached the Ashmolean, although the possibility that such a fate was contemplated for them is at least implied by its inclusion in the archives. The element of indecision enshrined in the incomplete heading seems ultimately to have been resolved in favour of another recipient.

The highly succesful dynasty established by the Lethieulliers, Huguenot immigrants to England in the seventeenth century, included at least two members with noteworthy museum connections. Lieutenant Colonel William Lethieullier (1701-56), who had visited Egypt as a young man of twenty, bequeathed to the British Museum its earliest Egyptological acquisitions in the form of a fine mummy and other antiquities; he was also associated with at least one mummy in a painted coffin that came to the Ashmolean (p. 61), although not, it seems, as the donor. On the other hand, William's cousin, Smart Lethieullier (1701-60) is recorded in the Book of Benefactors as the donor of a number of preserved animal specimens (p. 11) and he was also one of the more experienced mentors to whom the youthful Huddesford turned for curatorial advice (see MacGregor and Turner 1986, p. 653). Smart too possessed a small collection of Egyptian antiquities, some of which, at least, had been given to him by his uncle. He likewise drew up a bequest in favour of the British Museum which, however, was never executed; the items concerned, together with others in his collection, remained at his house for some years following his death before being dispersed (Bierbrier 1988, p. 222). Which Lethieullier was the owner of the specimens listed here is hard to say: William was certainly dead by the date with which the list is headed. Amongst the items bequeathed to the British Museum by William in 1755 were 'The Skull of a mummy' and 'Two feet and a Hand, seemingly of a mummy' (ibid., p. 225), possibly relating to items included in the list. More likely, though, is a correspondence between the two skulls here numbered 1 and 2 and two entries in a manuscript 'Catalogue of ye Agyptian Antiqus' belonging to Smart: 'A:16 The Skull of an Agyptian Mummy Entire & presev'd wth Gums & Spices', and 'A:17 Another where ye Cranium is broke & the Brain and Inside of ye head Visible all filled with ye Gums &c' (ibid., p. 228). Since this list was annotated in 1774 with the locations of various items within Smart's house, it seems clear that the skulls, at least, were never donated to the Ashmolean.

Mʳ. Lethiulliers Catalogue ⁻ 1759
A List of natural Bodies which I would send either to [...]

[5r]
1 The entire Skul of an Egyptian Mummy; filled with gums, which after so many ages still preserved their Scent &. fluid property as is evident from a quantity having run out at the Sockets of the Eyes, by its' having stood where the Sun shone full upon it since it was in my possession.

2 another human Skul. [-the] muck broke the Brain & inside of the head visible. all saturated with gums; a quantity of w.ᶜʰ is melted by the same Accident. These were in Dʳ. Woodwards Collection

3 the right hand *[bracketed with 4]*

4 & left Foot of an Egyptian Mummy. The Flesh still preserved & dry'd upon the Bones with gums. These must have belong'd to a Child or some very small person ⁻ The Foot being only 6 Inches long

& the hand 7. brought from Egypt by Pitt Lethieullier Esqʳ.

[5v]
5 three large Stones of a whitish color & of the Bezoar kind, these with eleven more of the same nature were taken out of the great gut of a horse who died naturally at Barking in Essex Annᵒ: 1753 the largest of these weighs 2 p.ᵈ 2 Ounces the remainder were less, but of different Sizes.

6 a very large & rugged Stone taken out of the kidney of a horse at Stephen Skinner's Esqʳ. at Walthamstow in Essex, the Creature was in a miserable condition & being killed for the Dogs this Stone was found in him.

7 a small Stone taken out of the Bladder of a horse at Stratford in Essex, the Creature lived & did very well after the operation. 27

8 4 of those hair Balls frequently found in Cows Stomachs & commonly called Cow Besoars

9 a peice of the upper Cranium of a Cow taken off in order to come at a Bag of small Worms which lies betwen the Skul & the dura mater & by pressing of it causes a humor in the eyes & a dissines in the head, upon removing of which the Creature recovers, the Gentleman who gave me this peice saw the operation performed & afterward saw the same Cow with calf in Aug.st 1724 this is a common practise in Norfolk & performed by ordinary country fellows.

[6r]

10 some small Stones found in the late Earl of Bradfords lungs after his Decease Jan.y 1734

11 a Calculus humanus very rough the size of a Walnut taken out of the bladder of Mr. Taylor Journeyman to Mr. Chase His Majesty's Apothecary æt. 34

12 2 more of the same nature, the one very rugged the other smoother ... \\29 30//

2

'Mr Pennant's catalogue' may be taken more confidently to be the enumeration of the gift of 'various specimens natural, metallic, mineral and crystalline' recorded from Thomas Pennant (1726-98) in the Book of Benefactors in the year 1758 (see pp. 12-13). Pennant and Huddesford enjoyed a warm friendship over many years (Ovenell 1986, p. 151), of which the small collection listed here formed a tangible expression. Many of the entries relate to specimens which Pennant, himself a native of Flintshire, is likely to have collected by his own hand. The final endorsement, addressing the list to Huddesford at his Oxford lodgings, implies that the catalogue is Pennant's own work and that it may have followed separately from the cabinet of fossils presented in the previous year, to which it relates. None of the specimens listed can be recognized today in the collections of the University Museum of Natural History. A more significant collection of some 800 specimens collected by Thomas Pennant, and by his son David, was presented to the British Museum (Natural History) in the early years of the twentieth century (Campbell Smith 1913).

Mr Pennants Catalogue
1759

[7r]

1 The various sorts of Lapis Calaminaris found in Flintshire. \\x//[1]

2 a mass of Cubic Lead ore. Derbyshire.

3 Steel grained Lead ore. Flintshire.

4 Pebble Lead ore ... Ibid.

5 Lead ore with a smooth black surface. Ibid.

6 White flaky Lead ore, very scarce.

7 Green Lead ore. Flintshire

8 Green & white Lead ore. Ibid

9 Lead ore mixed with other matter. Ibid.

10 Stoney Lead ore. Ibid

11 Gritty black lead ore. Ibid

12 Another sort of Lead ore. Ibid.

13 Coarse Haematites ... Ibid

14 Columnar Iron ore ... Ibid.

15 Fine Hæmatites ... Cumberland.

16 Copper ore ... Caernarvonshire.

17 Copper united with Lead ore ... Ibid

18 Red copper ore ... Ibid.

19 /an odd marcasite\ [-Pellucid rhombic spar]... Ibid.

20 Pellucid rhombic spar ... Ibid

21 Ditto veined with green sulphur. Ibid

22 Red opake spar ... Ibid.

[7v]
23 Columnar Red spar. Ibid.

24 Crystallized white spar. Ibid

25 Very curious Ditto on marcasite. Derbyshire.

27 Mica aurea. Flintshire

28 Fine white clay. Holyhead.

Foreign Fossils

29 Osteocolla. Sicily.

30 a sulphur from M. Ætna.

31 A very corrosive saline Earth. Sicily.

32 Black sand vomited out of Ætna, & carried as far as Catania by the force of the great Eruption that happened a few years ago.

33 A sulphur from [] in Italy.

34 A soapy Earth with which the Sicilian Peasants wash their Cloths.

35 A Pot of Bitumen from Sicily.

36 Corallina aretosa Anglica. from some Rocks in Anglesea.

37 Fossil wood. Ireland.

[8r]
38 A mass of vegetable matter compressed together Ibid.

39 Liver-colered Copper ore. [-\Flintshire.]

To The Revd Mr Huddesford \\at M.rs Stean's in Little Park-Street// [-at Trinity College] [-Oxford] Coventry [illeg].

[1]+ some of these are crystallised or very curious.

3

The significance of the third list is explained by an endorsement added by Huddesford to the end of the catalogue and reproduced here as its heading. The detailed content and the deviant spelling leave no doubt that the list is the work of the 'Mr Angerstein' referred to by Huddesford, although he is mistaken in identifying the author as Swiss. Johan Angerstein (1672-1720), son of an eminent mineralogist of the same name (1646-1716), was in fact Swedish by nationality, as might be expected from the annotations in Swedish (as well as German) which he helpfully added to his English text.

The English and Welsh provenances for these specimens is explained by the fact that in 1702-3 Angerstein undertook a tour of those parts, evidently seeking out some of the most significant sources for the ores and other minerals which were of special interest to him. (Between 1698 and 1705 Angerstein travelled widely in Norway, Germany and Austria for the same purpose: Christer Nordlund, personal communication). Edward Lhwyd provided Angerstein (in addition, no doubt, to much practical advice) with letters of introduction to those with local expertise. One of these letters, addressed to Thomas Tonkin at St. Piran in the Sands, Cornwall (1 October 1702) is published by Gunther (1945, pp. 470-1); it describes Angerstein (and his father) as occupying 'some considerable places in the King of Sweden's copper works'. Having already toured 'some of the most celebrated mines in Europe' (see above) and, more recently, 'the (reputed) silver mines of Cardiganshire', the Swede has come now to Tonkin, Lhwyd tells him, 'to see your tin works of Cornwall'. The small but interesting collection of specimens detailed here doubtless was presented to the Ashmolean in gratitude.

Helpful as it is, Angerstein's list is so wayward in its spelling – particularly of place-names – that a formalized version of each entry is included here, prepared by Justin Brooke. So reduced is the Cornish mining industry that even the location of some of the sources quoted by Angerstein is no longer clear. Mr Brooke reports that 'Heligan' is most probably to be equated with Illogan, an extensive parish between Redruth and the north coast, which, from the second half of the sixteenth century, after a period as a tin-producing area, became important in the production of copper; cobalt has been found in several of the mines there, although not in commercial quantities. 'Alicon by Asbarn' may refer to Ausewell, near Ashburton: a mine there called Ausewell Wood in 1791 became known as Hazel in the nineteenth century after numerous intermediate spelling changes; there was an iron smelter on the site, while a nearby mine named Wheal Widdon (openwork, in Cornish) produced both copper and tin.

Other sites are better-known: Trewellard lay in the valley below Geevor mine and took its name from a nearby hamlet; Chacewater (then spelt Chasewater) later became part of Wheal Busy; Poldice mine is at Gwennap; Carnkie is in Illogan parish; Polgooth mine lay at St. Mewan; and Guarnek (St. Allen) is in the vicinity of Truro.

Some of the names applied to ores have proved equally difficult to interpret. 'Avownow' is quite unknown. 'Cachill' is also unrecorded, but may equate with 'cockle', a Cornish dialect word for tourmaline school (see also p. 220).

Catalogue of Mineral Bodies found in M^r. Lhwyd's Cabinet below stairs & now placed under Ashmoles Picture in drawers. mineralia 1-2.

[9r]

1 Fine Copper oare from Tra[-\v]ullard and St Joust. germanice Kupfer glass.
Fine copper ore from Trewellard and St. Just. In German *Kupferglass*.

2 Gray Coppar oare from nord moulten.
Grey copper ore [chalcocite] from North Molton.

3 Gray [-Copp oare] and bleu Coppar oare. N. moulten germanice Kupfer Lazur. Suetici Koppar Lazur.
Grey copper ore and blue copper ore, North Molton. In German *Kupferlazur*, in Swedish *Koppar lazur* [azurite].

4 the same sort[-e].
The same sort.

5 green Coppar oare. mixt [-med] with gray N. moulten. germanice Kupfergrün [-] Suetice Koppar gröna.
Green copper ore mixed with grey, North Molton. In German *Kupfergrün*; in Swedish *Koppar gröna* [malachite].

6 Jallow Koppar oare with Sparr. Suetice hård malm med miäl Spaat. 2:p: from Kaswat[-h]er.
Yellow copper ore with spar. In Swedish *hård malm med miöl* [hard ore with sugary spar].Two pieces from Chacewater mine.

7 most the same with [-vi] purper Reed.
Almost the same, with purple ore [erubescite or bornite].

8 the same in [-y] spar. suetice et germanice [illeg.] spar. quartz. 2: p.
The same in spar. In Swedish and German [illeg.]. Spar quartz. Two pieces.

9 Jallow oare, Suetice blät malm from Kaswater 2. pieces.
Yellow [copper] ore. In Swedish *blät malm*. From Chacewater. Two pieces.

10 Copper and ten oare with mundick, from the same Suetice. [-me] Koppar [-] och ten malm, med [-wall] wattn Kies [-] och mispickel.
Copper and tin ore with mundic [arsenopyrite] from the same. In Swedish *koppar och ten malm med watten kies och mispickel* [copper and tin ore with shale and mispickel].

11 Mundick from Heligen – Suetice Koppar marcasit fron Heligen.
Mundic from Illogan. In Swedish *Koppar markasit från Heligen* [copper marcasite].

12 Avownov from Heligen. germanice federerz.
Avownow [?] from Illogan. In German *Federertz* [? native copper or a variety of mispickel].

13 Blend with Sparr and Copp oare, suetice blende med quarts och Koppar malm.
Blende with spar and copper ore. In Swedish *blende med quarts och koppar malm* [blende with quartz and copper ore].

14 the same Blew by the sun beams
The same [which reflects] blue in sunshine.

15 [-mis] white mundick from Heligen Suetice [-and] et germ. mispickel.
White mundic from Illogan. In Swedish and German *Mispickel*.

16 Co[b]alt from Heligen. germanice ausgevittert [-oare erts Ertz] *[symbol]* over *[symbol]* erts. Suetice the same.
Cobalt from Illogan. In German *ausgewittert Ertz [oder] Kupfer*, in Swedish the same.
[9v]

17 fine Graine tin oare from St Joust and Traveillard. germanice fein Zwitter.
Fine-grain tin ore from St. Just and Trewellard. In German *fein Zwitter*.

18 Ten ston from the same. germ: zin stein.
Tin stone from the same. In German *Zinnstein*.

19 a sort blend. anglice Cachill.
A sort of blende, known in English as cockle.

20 Grain oare from Germou, germ: zwitter. 2 p.
Grain [tin] ore from Germoe [parish]. In German *Zwitter*. Two pieces.

21 Grain oare from Heligen. germanice propter magnitudinem. Zingraupen.
Grain [tin] ore from Illogan. In German *propter magnitudinem Zinngraupen*.

22 Zinder [-graupen from] of ten. germ: Zin schlagk.
Tin slag. In German *Zinnschlag*.

23 Tin ston from Carencei. germ: ten [-stone] stein.
Tin stone from Carnkie, in German *Zinnstein*.

24 the same from Poulzeist 2 p.
The same from Poldice. Two pieces.

25 grain oare from fetterwarck.or St Calomb 2: p: germ. Zwitter.
Grain ore from the Fat Work, St. Columb; two pieces. In German *Zwitter*.

26 Common ten stone from the same germ: gemein Zin stein.
Common tin stone from the same. In German *gemein Zinnstein*.

27 Fine grain oare from Poul goust germanice fein. Zwitter.
Fine-grain [tin] ore from Polgooth. In German *fein Zwitter*.

28 ten ston from the same.
Tin stone from the same.

29 *[symbol]* and *[symbol]*. Brimstone and victriol oare fom Poul goust.
[?] Brimstone and vitriol ore [probably sulphur mundic and arsenical mundic] from Polgooth.

30 Lead oare from warneck by Truro germ: bley glants.
[Blue] lead ore from Guarnek, near Truro. In German *Bleiglanz*.

31 galmy from mendip in Somersethshir
Calamine from the Mendips in Somerset.

32 Jallow and Purpel blew Copper oare m Sparr from alicon by Asbarn in Devenshir
Yellow and purple-blue copper ore with spar from Ausewell near Ashburton in Devonshire.

33 Jallow *[symbol]* oare from the same. \\d.//
Yellow copper ore from the same.

34 Jallow mundick. from the same. \\d// suetice marcasit
Yellow mundic from the same. In Swedish *marcasit* [marcasite].

35 Lead oare white galmey from \\d// mendips hul in Sommersetshir
Lead ore and white calamine from the Mendip Hills in Somerset.

[10r]

36 the same. 2 pieces
The same. Two pieces.

37 white Lead oare from mendip. [-w]
White lead ore from the Mendips.

38 galmey from ditto. \\d//
Calamine from the same.

39 Iron pin oare from Lhanell in Moanmouth shir and wels. suetice järn fin malm.
Iron ore from Llanellen in Monmouthshire and from Wales. In Swedish *järn fin malm* [lit. Iron fine ore].

40 the same fein 2 p:
The same, fine; two pieces.

41 Red iron oare from tinten in moanmouth shir. Suetice Röd järn malm.
Red iron ore from Tintern [Parva] in Monmouthshire. In Swedish *röd järn malm*.

42 iron oare from the forest in glouster shir.
Iron ore from the Forest [of Dean] in Gloucestershire.

43 poar iron oare with sparr from the same [-place]
Poor iron ore with spar from the same place.

44 Iron zinder from the old Blum warks of the Danes in glouster shir 2 p.
Iron slag from the old bloomworks of the Danes in Gloucestershire. Two pieces.

45 Brown marbel from Bristol
Brown marble from Bristol.

46 black marbel.
Black marble.

47 tin oare from alicon /in Devenshir\ with white mundick. germanice Zin stein. mitt mispickel.
Tin ore from Ausewell in Devonshire, with white mundic. In German *Zinnstein mit Mispickel*.

48 From St Vincents Rock near Bristol
From St. Vincent's Rock, near Bristol.

49 Quere
Query [location and substance]
\\removd to the Windows 1760 They were sent I
think to M͏ʳ. Lhwyd by M͏ʳ. Angerstein. a Swiss.
who travelld over England & Wales -//

CATALOGUE OF FOSSILS PRESENTED TO THE ASHMOLEAN BY JOSHUA PLATT

Transcribed by Julia White, annotated by Arthur MacGregor

Ashmolean Museum, AMS 1, compiled 1765. Two gatherings of unbound quarto pages, inscribed on the front page: '1765 November the 22d. I presented the following Collection of Fossils to the Ashmolean Museum Oxon. Joshua Platt Aged 67'; 21 folios extensively stained, damaged and repaired, 240 x 190 mm.

Joshua Platt (1698->1765), described in the list of donors (p. 239) as 'Tributorum Exactor Oxon.' ‑ in effect the Collector of Taxes for Oxford ‑ is described by Ovenell (1986, p. 157) as the sole naturalist in the Oxford area that William Huddesford (keeper 1755-72) could find to share his interest in fossils.[1] Platt's collections first enriched the Ashmolean when a large quantity of specimens was bought from him for 10 guineas (ibid. p. 152). In time his friendship with the keeper resulted in the larger donation recorded here when, on 22 November 1765, the sixty-seven-year-old Platt presented what was perhaps the major surviving part of his collection to the Museum.

The majority of the 563 specimens listed are from the environs of Oxford and doubtless represent the fruits of Platt's own enterprise. He may well have collected personally those from other well-known fossiliferous centres in central and southern England, while the smaller number of foreign specimens are perhaps more likely to have been acquired through purchase or exchange.

An insert on fol. 6v (p. 231), referring to John Woodward's attempts to explain the formation of fossils in terms of the Deluge, serves as a reminder that it was with specimens such as those listed here that the precepts of modern palaeontology, whose foundations had been laid in Britain by Lister and Lhwyd, were gradually evolved.

[2r]

Conchylia Univalvia tubulosa

1 A plain Curved Tubulus, from Garsington Rubble.

2 Two Cylindrical Tubuli, plain and smooth. Ibid

3 Do. Ribbed and Striated. Ibid

4 Do. cover'd with smaller twisted Tubuli. Ibid

5 Two Tubuli with the smaller end Coiled. Ibid

6 D.° with the impress of a Turbinated Shell. Ibid

7 D.° adhering to an Auriculated Oyster - Ibid

8 Two Coiled Tubuli; from Sheppy Island[2]

9 One D°. from Garsington Rubble

10 A Group or Cluster of round Tubuli Ibid.

11 A Cluster of small Ribbed Tubuli.Ibid

12 D°. - Ibid.

13 D°. of small round coiled Tubuli Ibid

14 Four Dentalia, from Hordel-Cliff. Hampshire

15 D°. from Sheppy Island

16 D°. Fluted, from Verona

17 A Patella or Limpin, from Hordel. Cliff

18 A group of fluted Tubuli, [-adhering to...] [-\from] Garsingt[on].

19 D°. Ribbed, adhering to a small Oyster. Ibid

20 Several curv'd small Tubuli, adhering to a fungites. Ibid

21 Tubuli Ridged upon the Back, adhering to an Oyster Shoto[ver].

22 ...Tubulus and a small Auricular Oyster adhering

23 D°. adhering to the Tree Oyster. Ibid

24 D°. Very small, adhering to Plotts Auriculares. Ibid

25 Tubuli adhering to a Smooth-back Pebble. Garsington... This is another argument which refutes Woodwards ... of a dissolution of of all Minerals...

[3r]

26 A large knot of Tubuli adhering to the lower value of an auricular Oyster. Garsington

27 Tubuli adhering to Anomiae planae. Campsfield near Woodstock

28 D°. with small Oysters adhering to Anomiae Striatae. Shotover

30 D°. Adhering to a broken Belemnites. Ibid

Turbinated Shells

31 A large Muricated Trochus, of a compressd formed Clavickle from near Coalbrook Dale in Shropshire

32 Trochites, or an impress formd in the Shell of a Trochus. Ibid

33 Two D°. from Bullington Green near Oxon

34 Trocus with longitudinal Striae Coalbrook Dale

35 A Trochite/s\ or impresses, with /a\ round blunt point of Flint, from Beckfords Quarry. Wiltshire

36 A Trochus with the Clavicle more elate. Sheppy Island

[1] In 1760 Huddesford published at his own expense a new edition of Lhwyd's *Lithophylacii* and did much to honour his admired predecessor.

[2] [f.1v] No 8, has so great an affinity to the Trocus, that I esteem it the Link of the Chain which connects them.

37 D°. filled with Pyrites. Ibid

38 Trochites, of a Shining Metallick colour, formd of Pyrites...

39 Two D°. the Cavickles more exerted. Garsington field

40 Two Trochi Saturated with Spar. Ibid

41 Three curious Muricated Buccina from Hordel Cliff, Han[ts.].

42 One larger D° Ibid

43 Two smooth D°. Ibid

44 Buccinum Heterostropha. Clavickle turnd from the right ha[n]d to the left. Harwich Cliff, and Woodbridge

45 Two Small Buccina; from Woodbridge in Suffolk.

46 Two Buccinitae, or impresses. Garsington field. Oxon.

[4r]

47 Two Cochleae, from [-Bas...\Bassilsly] Berkshire

48 Two D°. Umbilicated. Hordel Cliff Hampshire

49 A nerite. Bassilsly, Berks

50 Three Strombi or Spires. Hordel Cliff

51 Three D° - Ibid

52 A Muricated Spire, from Woolwich Sand-Bed

53 Three long Clavicled Buccina. Hordel Cliff

54 Buccinites: all Spar. Warwickshire

55 D°. of Pyrites. Sheppy Island

56 Three Strombitae - Ibid

57 Three Strombi, fild with Pyriters. Ibid \\two decayed//

58 Two Strombitae, form'd of lapidescent Matter. Oxon

59 Leptopolyginglymus. from Verona. and a recent one

60 Two valves of the Ribbed-Cuneus. Hordel

61 Single Valve of a Pecten with Tubuli adhering. Bullington Green

62 Both Valves of the Same from Hedington Heath.

63 Three single Valves of different Pectins. Bullington Green

64 Two single Valves of the Tree Oyster. Hordel

65 Two deep furrowed Cockles. Ibid

66 Two smaller Striae. Ibid

67 [-One\Two] D°. larger Size Ibid

68 Chama; from Essex

69 Cuneus, or Wedged Cockle. Kent[3]

70 Four Anomiae Planae, et terebratulae. Chatham Chalk Pits

71 Two curious D°. with Indented verges. Campsfield, Oxon.

72 Two Gibbous Sacculi. sharp in the Verge. Blackthorn

73 Two D°. flat and peaked in the Verge Ibid

74 Three D°. with Round Verges. Ibid

[5r]

75 Two small round and flatt Anomiae. Campsfield

76 A Concave Anomia. Moorlands of Staffordshire

77 Anomia Striata, with an Auricularis adhering. Shotover

78 D°. Washed with Spirits of Salt. Ibid

79 Two D°. from Banbury, one of them compressed

80 Concha Trilobos. Four Striated, and two plain More tonsa. 213

81 Gryphites. the lower valve only, from Wiltshire

82 D°. from Leicestershire. Made Smooth by rolling in the water

83 Upper /&\Lowere Valves of the Auriculated Oyster. Hordel Cliff

84 An Oyster which adherd to some other body. near Woodstock

85 An Oyster from Stonsfield, Called the Sickle Oyster[4]

86 The deep furrowd Tree Oyster. Shotover Clay

87 The lower Valve of the largest sort. Ibid

88 Pholades. Out of the Coralloide Bodies. Heading[ton ?] Heath

89 The largest Auricularis found at Shotover, both Valves.

90 D°. the Valves Open. Ibid

91 Two lower Valves, out of a White Rubble, Bullington Green

92 Two young Flat Oysters. Shotover Clay. See No. 214.

93 The Laminated Tellina, or River Muscle. [-Red hill, Leicester/Drayton Salop] [-]

94 D°. smaller, [-with one of the deeper Shells adhering. Ibid\and more compressed - from Red hill near Leicester.]

[3][f.3v] No 69. Doctor Plott could not find both valves in one Specimen; which rather strengthened his erronious opinion of their being Lusus Naturae. Nat. Hist. Oxon pa. 103.

[4][f.1v] This proves Woodward to be mistaken, when he tells us, that all Corals were dissolv'd at the Delu[ge in] his Nat. Hist of the Earth pa. 89

95 The Smerna muscle. Stonsfield.

96 Musculites. from Bladen near Woodstock

97 An uncommon thin Shelld Muscle. Thame

98 An Impress of the same. Ibid

99 The Long Narrow Muscle or Solen. Bladen

100 Two long Musculitae. Bicister - Oxon

[6r]

In the 2.ᵈ Drawer

101 Echinus Cordatus, from the Chalk-pitts at Chatham

102 Echinus Spatagus, cordiformes. Shotover Stonepitt.

103 Echinus Galeatus, from Chatham

104 Echinus Piliatus - Ibid

105 Echinus Clypeatus, seu Discoides. Stonsfield

107 Echinus Ovarius, large Mamille. Bladen near Woodstock

108 Echinus Rotundus, Seu Clypeatus. Ibid

109 Echinus Ovalis. Dorsetshire

110 Echinus Ovarius. chalk-pitts in Kent and Surry

111 A Plate of the large Mamillated Echinus. Chatham

112 Acculii Echinorum. Chatham, & Wooton Basset, Wilts

113 Entrochi et Trochitae. Staffordshire Moorlands

114 Appendicula, or Appendages to the same. Ibid

115 Asteriae. Oxfordshire &c &c

116 Pediculus Marinus. Dudley in [-Shropshire\Worcestershire]

117 Crabs and Lobsters, or Squillae. Sheppy Island in Kent

118 Part of a fish - Ibid

119 Vertebrae of Fishes - Ibid

120 Teeth of Fishes - Ibid

121 Teeth of fishes imbeded in Stone. Stonsfield

122 Tusks of fishes. Ibid

123 Palates of Fishes, and Bufonites. Ibid, & Sheppy Isle.

124 Jaw Bone of a Fish in Stone. Ibid[5]

125 The Tibea of a Crane, or some other water fowle Ibi...

126 The Bone of a Quadrupede from Shotover

127 A Vertebra from Bladen.

[7r]

128 Belemnites from Shotover Clay

129 D°. from Stonsfield Slate-Pitt. Fusiformis

130 D°. from Thame, of a small kind, as all are found there

131 Nautilites from Sheppy Island, having the Pearly shell remaining

132 Four vertebrae of the same. Ibid

133 Nautilus Compressed. - Ibid

134 Ammonitae of various kinds, from different parts of England[6]

135 Ammonitae of a Smaller kind - Ibid

136 Fossil Wood from Shotover Stone Quarry

137 Wood perforated by worms from Sheppy Island[7]

138 American Seeds, Saturated with Pyrites. Sheppy. \\deest//

In the 3.ᵈ Drawer

139 The Stem and leaves of Fern, in a Grey Stone which lyes above the Coal at Scot-Hey, near Newcastle Staffordshire

140 The /single leaf of the\ Polypode in a Nodule of Iron Stone. Coalbrook Dale.

141 A [-kind of Bamboo\Curious Fern]. Lancashire near Wigan. Haigh

142 American Fern in Iron Stone Calbrook Dale Shropshi[re]. \\[-A Plant from ... Coalbrook Mass of Fern leaves.]

143 [-The Head of an American Grass. Ibid from Haigh, Wigan\A Plant with the impress - Coalbrook Dale]

144 The Twig or Bud of a Fir-Tree. Ibid

145 Equisetum: from Swansey in Wales. above the Coal

146 Impress of a Quincunx plant in Coal. Staffordshire

147 D° - from Scot-Hey. See No. 139. \\This lay above the Coal from Stonsfield//

[5][f.5v] 124. The small Serrated Teeth are very curious.

[6][f.6v] 134 and 135. These take their names from their Forms and different Striae

[7][f.6v] 137. Lapis Scringoides; or the piped waxen vein of Doctr Grew. Museum Reg. Soci. Woodwards Cat. pa. 98. Doctr. Woodwards dissolution of Matter at the Deluge, run him [a]ground very much, and led him into many palpable Errors; particularly in this very Article where, in his Cat. pa. 98. he tells us, "that the Tubules were ... taken into the stone [-] at the Deluge (which Stone was[..]ken only Sand) with Sea Shells; had this been the Case, the tubules - would have been fild with Sand, as well as the Shells, and they would have been in Groups or Clusters - but we see them lye parallel to each other, which are never seen in the Recent State, being curved in some part, [w]hen found Single. These are incontestably perforated in Wood, pe[tr]ified by the Spar, which lined the Tubes; in the manner that Potters Moulds are lined with Slip, that forms their carved Potts. J Platt

148 The leaf of a Reed, or the Yoko Plant, in the Physick Garden

149 An Impress of a curious Quincunx. Scot Hey. See No. ...

150 A Single leafed Plant, in Iron Stone. Coalbrook Dale

151 The Blossom of the Maiden Pink. Scot-Hey. \\Staffords[hire]. Newcastle und[er Lyme].//

[8r]

152 [- A very curious Fern leaf, with the Impress. Stonsfield Slate] [/-An American Seed, or Nut - Coalbrook Dale Shropshire\][8]

[8r]

153 Stem of a Plant that was Hollow like the Ilex.

154 Bud of a Pine Tree. Coalbrook Dale Iron Stone

155 [-An American Seed, or Nut. Ibid] [-/ A Jointed Plant, compressd from Stonsfield Slate][9]

156 The small sharp pointed le/a\fed, Fern. Ibid[10]

157 [-The Bud and leaves of a Fir-Tree. Ibid\A Jointed Plant or Bamboo, from Stonsfield Slate]

158 [-A jointed Plant (I think) compressed. Stonsfield][11]

159 Leaf of a Plant with Seed vessels. Coal

160 Sprig of a Fern which appears to be decayed. Stonsfield

In the 4.th** Drawer**

161 A Pectunculus. Bullington Green near Oxford.

162 The Cast or Impress of an Anomia Plana. Staffordshire

163 D°. of a Concave-Convex Striated Anomia. Ibid

164 The Cast of the double Wedged Chama Wiltshire

165 Cast of a Plano-Convex Anomia, reticulated Striae. Staffordshire

166 Cure - Rostrum Chamites - from Sheppy Island

167 Bucardites, from Thame field

168 The Impress of a Scallop from Wiltshire

169 A Curious Pectunculus from Bath

170 Telenites, or Impress of the Telina

171 A Cockle with Tubercled Striae the Valves expanded Garsington

172 Cuneites from Chearsley. Bucks

173 D°. from Shotover

174 Archa Noe or the Cast of the Polyginglymus Garsington

175 Hippocephaloides in Flint from Beckfords Quarry Wiltshire

176 Tubercled Cuneus from Roddepole. this Shell forms the Hippocephaloids

177 Single Valve of a chame, from Balderton Stone Pitt, near Newark upon Trent

[9r]

178 Pectunculus from Green Hythe in Kent

179 An Eared Oister from Thame

180 An uncommon Cuneites from Piddington

181 D°. from Drayton Shropshire

182 Chamites, Single Valve with Tubercled Striae, Chearsley in Bucks

183 Cuneites Single Valve with high tubercled Striae & wide Furrows, Marsham

184 D°. with smooth ridges and deep Furrows, transversely placed. Ibid.

185 Two of Plotts Hippocephaloides, being the impresses or Casts of the same kind of shells as the two last - The Valves were spread open Ibid

186 A Pectunculus from Thame - Oxon

187 Single Valve of a Chama - from Garsington

188 The broad Skerted Gryphites, or Hooded-bill Oister Piddington Oxon

189 The lower Valve of an Oister, with the Chalky matter preserved. Thame

190 A very Curious Oister both Valves from Catsgrove near Reading Berks

191 A fine Specimen of the true Gryphite Oister, Pyrton-Passage Glocester

192 The deep furrowed Tree-Oister - Wiltshire

193 An uncommon Pectunculus, from Balderton near Newark on Trent

194 A single Valve of Archa Noah, or Leptopolyginglymus. Garsington

195 A Pectunculus with the Cardo or joint Sliped or displaced - Thame

196 A curious Concave-Convex [-upper Valve of an] Anomia Striata Moorland Satt.

197 Single Valve of an [-An] anomia Striata - Ibid.

198 D°. Ibid. Mutilated

199 The upper Valve of an Oister, reduced by Worms. Catsgrove Read.[in]g

[8][f.7v] 152. [-Pulvus] Fungus Pulverulentus - Coalbrook Dale
[9][f.7v] (15?)5 [-A very curious Fern leaf with the impress, in Stonsfield Slate]
[10][f.7v] ...A Furrowed Plant, with seed Vessels on the Ridges Newcastle under Lyme - Staffordshire
[11][f.7v] 158 A very curious Fern leaf with the impress, in Stonsfield Slate

200 A Concave Oister (adherence) St. Clements Gravel

201 Hooked bill Oister from Piddington, Oxon

202 D°. narrow Skirted - Lurgershall

203 D° with the upper valve crushed into the lower, St. Clements

204 The lower valve of an Oister, exhibiting the Stages of its growth or increment, from the Siz of a Vetch. from Hoston, Oxon

205 D°. out of the Limestone pits in Thame field

206 D°. With a large Worm Tube adhering - Shotover

[10r]
207 An Oister Stained with Ferrugineous Steams where Selenites are formed, some of which adhere to it. Shotover Clay[12]

208 The Single Valve of an oister, coverd with Selenites Ibid

209 The thin flat Oister - Ibid

210 A large Eared Oister from a Stratum of green Rubble - Thame

211 Lower Valve of an Oister with a Scallop adhering. Bullington green

212 The lower Valve of an Oister odly formed by adhering to some other Subject - Shotover Clay

213 An Oister which adhered to Wood - Ibid

214 A curious large thin flat Oister - Ibid

215 Three of the Same shells adhering, very curious Ibid

216 Pectunculus from Thame, the joint displaced by the incumbent load of matter - Small Pholades are seen upon part of an Oister adhering

217 The narrow Pinna or Solen - Bullington green

218 A fine Mass of Anomiae & Coral from Dudley, Staffordshire

219 A Mass of small Bivalves from Sheppy Island

220 D°. of Auricular Oisters - Bullington green

221 A mutilated Ammonite - from Garsington

222 D° Ibid

223 The Center of D° exhibits the Chambers and Diaphragms Marsham Berks

224 Tortoise Shell, from Sheppy Island

225 A Lobster - Ibid

226 A Crab - Ibid

227 A Fish's head Ibid

228 A curious Hart cockle from Berkshire Marsham

229 The Winged Buccinum from Hordel-Cliff, Hampshire[13]

230 Long Clavicled Buccinum - Ibid

231 Pinna Marina from Thame

232 Buccinites, or Strombites, from Newnam, Oxon

[11r]
233 Echinus Galeatus, from Green Hithe in Kent - Chalk pit

234 D°. filled with Flint Ibid

235 Echinites Galeatus, or a Cast of the same. High Wycomb

236 Echinus Piliatus, (Spatagus) - Green Hyth

237 Echinites Piliatus, or a Cast of D° - Wycomb

238 Echinus Cordatus - Chatham Chalk Pits

239 Echinites Cordatus - Wycomb

240 Echinus spatagus, Seu Discoides - Stonsfield

241 Echinites Clypiatus, or a Cast of the Discoides - Iffley

242 Large Trochites - Garsington

243 Impress or Cast of a Single valve of the Cuneites, or Plotts Hippocephaloides. Ibid[14]

244 [-The Marks of the] Groupe of Plotts Auriculares Bullington Green

245 Nautilites Modiolares Luidii - Wiltshire

246 An Ammonites, in Pipe Clay - Leicestershire

247 Two D° from Marsham, Berks

248 Impress of D° Horsley, Yorkshire

249 Two Vertebrae of the Ammonites Marsham

250 Sections of Entrochi - near Castleton, Derbyshire[15]

251 Single Valve of a Pectunculus - Thame

252 Bucardites - Ibid

253 A mass of Anomiae Striatae near Dedington, Oxon

254 A mass of Asteriae - Glocestershire

255 Fossil wood - Shropshire near Drayton

256 D° from Shotover Clay, near Oxford

257 D° with Selenitae Shooting & forming, where the wood parts Ibid

258 Pholades in a Mutulated Virginia Oyster. Thame

[12][f.9v] 207. The Vitriolick Acid takes up Copper and Iron, til it meets with Animal juices, of which it forms Selenites.

[13][f.9v] 229 The Wing when perfect is more than two inches broad
[14][f.10v] 243. The marks of the Cardo or Hinge are curious
[15][f.10v] These Sections exhibit the interior part of the entrocus where the joints Seperate into Trochites

field

259 Clay Perforated by Worms, and the Cell of a large Pholas or Dactyle rubbed smooth by rolling in Water - Sheppy Island

260 Chamites - Ibid

[12r]

261 An uncommon Mutilated Trochus - from Sheppy Island

262 Tail of a Lobster - Ibid

263 A mutilated Spire or Strombus - Marsham Berks

264 Alveolus of a Belemnites - Banbury

265 A curious Mass of the small Tree Oisters or Coxcombs. Marsham

266 The round Sulcated gibbous Pectin, both Valves; Sherborne Dorcet

267 Very large Anomia from Moorlands Staffordshire

268 Broad Skirted Gryphite Oister - flat Oisters adhering. St. Clements

269 Fossil Wood in Iron Stone Shropshire

270 An Oister single Valve, from Bath

271 Large Gryphite Oister from Weymouth

272 Impress of a Cornu-Ammonis - Garsington

273 Large Gryphite Oister lower Valve adhering to a Smaller - Cowley Field

274 Pectunculus with fine Striae - Bullington Green

275 D°. with larger Striae - Thame

276 Bucardites, the commissure or joint distorted - Thame

277 A small Oister adhering to a Gryphites - Perton Passage Gloster

278 A large Mutilated Ear Oister, [illeg.] of the Nodule Shotover hill

279 Buccinites - Garsington

280 Vertebra of a Fish - Thame

281 D°. from Shotover

282 D° out of Balderton Stonepit; near Newark upon Trent

283 Three Vertebrae Attatched, of a rounder sort with Processes Ibid

284 A vertebra different to the rest, with worm tubes adhering. Shotover

285 The Rib of a Seacalf or Walrus. Nat. Hist. Norway. Stonsfield

286 Mutilated Rib, out of Stonsfield Slate

287 A Vertebra from Shotover

288 Part of the Thighbone of an Elephant found at

Culham near Abingdon the bone measured round the Trochanter 56 inches. I sold it to Charles ... Forster Esq.r It is with him at Alnwick - Northumberland J Platt

[13r]

289 The bone of a Quadrupede from [].

290 A Vertebra from Shotover Clay above the Stone[16]

291 An Eared Oister attatched to a Madrapore Coralloides Thame

292 Part of a Trichite Oister from Whitam hill

293 Impress of a Muscle with Transverse Striae in Flint. High Wiccomb.

294 The long-narrow ...ick Oister from Lisbon[17]

295 Tibia or Shinbone of the Hippopotamus - Shotover Clay

296 Sing[le] Valve of a large Scallop, from Kew, Oxon

297 Three Vertebrae or Diaphragms of an Ammonite. Marsham in Berks

298 A mass of large Vertebrae of a Fish. Shotover Clay

299 Ammonites with the impress - Stonsfield

300 Four vertebrae or Diaphragms of a Nautilus from Sheppy Island Kent

301 Fragment of D° - Ibid

302 Nautilites from Garsington, near Oxon

303 Ammonites from Scarbro'

304 D° from Wiltshire

305 The Rib of a Quadrupede from Stonsfield

306 Two Anomiae Planae Kidlington

307 Single Valve of D° with indented Verge

308 An uncommon Anomia from Bath

309 Single Valve of a Pectunculus Ibid

310 The Cast of two valves of a Cuneus extended Stonsfield

312 A Bucardites from Garsington

313 Ichthyomorphites from Wales

314 Lobster from Sheppy Island in Kent

315 A Fossil Fish mutilated Ibid

316 The Head of a Fish Ibid

317 Tusk of a Fish, or Plectronites Luidii Stonsfield Slate ston...

[16] [f.12v] 290. The Cancreae must be reduced & destroyed by the Vitriolick Acid or some other Menstruum: which has crushed in the sides so close together by the incumbent load of matter in the Stratum where it lay.

[17] [f.12v] 294. The City of Lisbon is Sittuated upon a Stratum of these Shells and other Marine productions.

318 D° Ibid

319 Lamiodontes, with the Epiphyses Ibid

320 D° Ibid

[14r]
321 D° Mutilated

322 A mass of Chamae from Kent

323 Fragment of a Nautilus Shell Sheppy

324 Pectinites from Bath

325 Pectunculus Ibid

326 D° out of Chalk, from Chatham Kent

327 Anomiae Planae Staffordshire

328 D° Striatae - Ibid

329 Cuneites from Garsington

330 Part of the Tibea of a Bird Stonsfield

331 Scallop from Garsington

332 Groupe of Auricular Oisters, Bullington Green

333 Bucardites - Garsington

334 Pectunculus - Ibid

335 Anomia Striata et Sulcata Staffordshire

336 Pectin with a Trochites - Bath

337 Two Pectunculi - Ibid

338 Pinna marina Garsington

339 Musculites - Thame

340 Strombites Garsington

341 Broad skirted Gryphite Oister Piddington Oxon

342 Single Valve of a Pectin - Stonsfield Slate

343 D° of a Pectunculus from Thame

344 Mass of Bivalves - Sheppy Island

345 Echinus Clypiatus - Headington

346 Impress of the Cardo of the indented Oister Thame

347 Belemnites with Worm Tubes from Garsington

348 D° P...ai... Ibid

349 D° With a Coiled Worm Tube attached Ibid

350 D° with a mutilated Alveolus Ibid

[15r]
351 D° Calcined by the ...ague Acid, which exhibits the Lamine. Ibid

352 D° from Shotover clay, with a Small Selenites attatched

353 D° with small flat Oisters adhering - Ibid

354 D° broken and cemented by Spar, the Alveolus gone Ibid

355 D° Perforated with Pholades, & filld with Mud & Sand Garsing[ton].

356 Ammonites exhibiting the Sutures, with a Crenated Dorsus Wiltsh...

357 D° with bandages crossing the back - Ibid

358 D° with a smooth Dorsus, and ribbed Striae Ibid

359 D° with small undulated Striae meeting on the back Ibid

360 D° with a Seam on the back, bifurcated Striae, interrupted by tubercles Ibid

361 Echinus Clipeatus - Stonsfield

362 Echinites Clipeatus or a Cast of the Same Ibid

363 Volute of a Trochus. Newcastle Staffordshire

364 Lower valve of a broad skirted Gryphite - Piddington

365 D° from Cotsgrove - Reading Berks

366 Upper valve of an Oister - Stonsfield

367 Impress of a deep furrowed Oister in Flint Wycomb

368 Chama Bullington Green

369 An uncommon Oister from

[370] Bucardites - Thame

[37]1 D° from Crendon - Bucks

372 Pecton from Bullington Green

373 Eared Oister Thame

374 Bones of a Fish-Head Sheppy

[375] Bone in Pyritical Clay Ibid

[376] Three Vertebrae - Ibid

[377] Ammonites in Allom Stone - Scarborough

[378] Mass of shells Hordel - Hampshire

[379] A mass of curious Spires, in Portland Sto[ne].

[380] D° of Entrochi Moorlands Staffordshire

[381] [D]° of Small Shells - Hordel

[382] ...of Auricular Oisters attatched to ...Oister. Th...

[16r]
383 Groupe of Auricular Oisters - Bulington Green

384 Single Valve of the tubercled Cuneites - Chearsley in Bucks

385 Pectunculus Bullington Green Oxon

386 Cast of the Cuneites - Ashingdon Bucks

387 Cruched Nautilus - Sheppy

388 Sutures of a Mutilated Ammonite - Garsington

389 Pholades upon an Eared Oister - Thame

390 Upper & lower Valves of two different Oisters H

391 D° with worm Tubes attatched - Iffley

392 Oister both Valves perfect - St Clements Oxon

393 Piece of an uncommon Oister - Coalbrook Dale Salop

394 Long Muscle - Garsington

395 Bone with Worm-tubes attatched Shotover

396 An uncommon Palate of a Fish Stonsfield Slate

397 Echinus Mamillares - Wooton Basset - Wilts

398 Echinites Mamilaris - Headington

399 Anomia Striata in Flint - Kent

400 Coralloides - Dudley Staffordshire

401 Pectunculus with Spines - Green Hith Kent

402 D° Plain & smooth Ibid

403 D° from Bath

404 Anomia Plana Chatham

405 Single Valve - D°

[406] ...tes Crust...d - Lincoln Heath

407 ... from Stonsfield

408 Oister - Piddington

409 Upper Valve of an Oister with Tubules Garsington

410 Lower D° from Woodbridge - Suffolk

411 ...ar Oister out of a Gree.. Stratum of Earth Thame

412 Tooth of the Canis Carcarius, or large Shark from Malta

[17r]

413 A curious Pecten from Virginia

414 D° from Sicily

415 D° from Maryland

416 An Oister from Sicily

417 Two Echini Cordatus Switzerland

418 Ammonites from Anconia

419 A Fish from Verona

420 Corallia Fistulosa et ramosa, from Messina

421 D° Articulata. Ibid

422 Lapides Nummularii, Verona

423 Various teeth of Fishes, from Malta

424 Sand from a hill near Paris

425 Fungites from Messina

426 Trochites Ibid

427 Vermiculus - from Malta

428 Buccinum, near Paris

429 D° from Asti

430 Asteriae from Malta

431 Occhii di Serpe, or Bufonitae - Ibid

432 Anomiae Planae, Switzerland

433 Cochliae from Asti

434 A Rhombus - near Paris

435 Strombi, from Piedmont

436 Fluted Dentalia, from Verona

437 Pecten near Paris

438 Auricular Oister - Ibid

439 Ammonites from Nurenburg

440 Anomia Plana, from Gottengen

441 Anomia Striata from Norway

442 D° from Sweden

443 Various small Articles from West India

[18r]

444 Tubercled Cockle from near Paris

445 Ammonites from Norway

446 Operculi from Verona

447 Trochi from Verona

448 Small shells from Sicily

449 Mutilated Scallop - near Paris.

450 Vermiculus, Cochliaformis - Ibid

451 Single Valve of a Chama from Chaumont

452 Cockles from Verona

453 Mutilated Volute from Turin

454 Single valve of a Chama Ibid

455 Single valve of an Oister Ibid

456 Mutilated Oister Ibid

457 Sand from Asti

458 Fossil Wood from Turin

459 Ammonites from Joux du Plane, Switzerland

460 Corallium rubrum Fossile - Verona

461 Echinites Cordatus in flint - Wycomb

462 D° Ovarius, with a Fungites inclosed - Headington-heath

463 Mass of Anomiae Planae - Saculus - Wilts

464 D° With indented Verge - from Banbury

465 D° of Buccinitae, in Iron stone

466 D° of Coral and Entrochi - from Dudley Staffordshire

467 D° of Anomiae Striatae - Ibid

468 D° with a Limpet, Ibid

469 Scallop from Bullington-green

470 Pectunculus, with Tubuli Ibid

471 D° both Valves, from Headington-heath

472 D° Single Valve from Thame

473 Oister with the impress of the interior sh...

474 Buccin from Hordel Cliff

[19r]

475 D° with longer Clavicle Ibid

476 Buccinites from Garsington

477 D° from Bullington green

478 Trochites from Garsington

479 D° from Bullington gren

480 Strombus, Ibid

481 D° Ibid

482 Strombites from Shotover

483 D° Bullington green

484 D° from Garsington

485 Chama from Chalk-pit at Greenhith in Kent

486 D° from Bullington green

487 Mutilated Nautilus Split - from Sheppy Island

488 A Fish-head, Ibid

489 The bones of a Fish head Ibid

490 D° with part of the body

491 Horse-tooth - Ibid

492 Jaw bone of a Fish - Ibid

493 A Crab - Ibid

494 The Claw of a Crab - Ibid

495 Coral invelloped in a Flinty nodul - Bucks

496 Rush-Coral from Middleton Stoney Derbyshire

497 Astroites from Headington heath

498 Stalagmites, Ibid

499 Punctured Coral, from Coalbrooke Dale

500 D° in Chalk from Chatham

501 Juncus Corallium, Coalbrook Dale

502 D° from Newport Astbury Cheshire

503 Coral: Ramosum Coalbrooke Dale

[20r]

504 Lithostrotion from Coalbrook dale

505 A digression from the latter to the Astroites Ibid

506 Fibrous Coral Ibid

507 Digression from the Astroite to the Fungites Ibid

508 Groupe of Fungitae Ibid

509 Fungites detatched - Ibid

510 A larger D° - Ibid

511 D° branched, with Tubules & a Pholas attatched Garsington

512 Astroites - Wiltshire

513 D° with large Asterisms, Coalbrook-Dale

514 Brassica Florida Corallia, Stoney Middleton, Derbyshire

515 Corallia Radula - Ibid

516 Five small Masses of Coral, from Coalbrook-Dale

517 Coral: Ramosum - Shotover Clay

518 Mass of Juncated Coral, from Coalbrook-Dale

519 Coral with Collumnar Asterisms, from Bath

520 Chain Coral - Shropshire

521 Tubulitae et Pholades, from Bullington-Green

522 Mass of Auricular Oisters

523 Impress of a large Hart-Cockle, from Campsfield

524 A muscle imbedded in Stone; Thame

525 Two vertebrae from Sheppy

526 Mutilated Tooth, from Cullam Berkshire

527 Nondescript - from Sheppy

528 Ammonites - from Garsington

529 Impress of D° - Ibid

530 Compressed Ammonites - Ibid

531 Ammonites with more swelled Dorsus - Ibid

532 Ammonites, from Newark upon Trent

533 D° from Scarborough

534 Impress of an Ammonites, Ibid

[21r]

535 Ammonites bedded in Allom-stone & Impress - Scarbrough

536 D° out of the Rubble at Boarstall - Bucks

537 Lignum Fossile - Drayton, Salop

538 D° in Stone - Shotover

539 D° with Spar - Ibid

540 D° with Pholades - Ibid

541 D° from Bladen

542 Large Trochites from Garsington

543 Lignum Fossile - Shotover Clay

544 Lower Valve of an Oister perforated by Pholades

545 Flat Coral - Fungites

546 Ramous Coral upon a mutilated Oister

547 Mass of Coral from Dudley, Shropshire

548 D° of Entrochi - Moorlands of Staffordshire

549 D° of Smaller Entrochi Ibid

550 D° of Fungitae Ibid

551 Musculites from Thame

552 Pholades in a Bivalve, [-Oister] (Chama) Marsham

553 Belemnites, exhibits the Caminae Ibid

554 D° exhibits the Siphunculus Ibid

555 An uncommon Mass of Pyritical Sticks in Clay; Sheppy

556 Small Oisters from Barrow Slate Pit, Leicestershire

557 Part of a Rib from Thame

558 Nautilus from Garsington

559 D° from Sheppy Island in Kent - Split & Polished

560 D° invelloped in the Ludus Helmontii - Ibid

561 D° detatched from the Ludus Ibid

562 Diaphragms of a Nautilus from Marsham

563 Part of a Nautilus from Sheppy

DONATIONS FROM 1757 TO 1769, 1824 TO 1829

Transcribed by Abigail Headon, translated and annotated by Arthur MacGregor

Ashmolean Museum, AMS 3, compiled 1757-1829. Leather-bound quarto volume, inscribed in ink on the cover 'Benefactions... Donations from 1757 to 1769. 1824 to 1829'. 90 folios, 245 by 185 mm, many of them blank.

Amongst the reforms instituted during the keepership of William Huddesford may be counted the re-establishment of a record of benefactions to the Museum, the original Book of Benefactors (pp. 1-13) having earlier fallen into abeyance. No more than a handful of donations is recorded for most years of Huddesford's tenure, with some (including the final three years of his keepership) being blank. Thereafter the record of donations evidently fell out of use again until the arrival in 1823 of John Duncan. By the time it was definitively abandoned in the year of his retirement, preparations were well advanced for publication of a printed catalogue (Ashmolean 1836), a factor which may have been decisive in the decision to let the present record lapse.

The new donors' register was a much more prosaic document than its prestigious predecessor. With paper leaves in quarto format, it formed a working record for the benefit of the curators rather than a roll of honour for the gratification of the benefactors. It provides little in the way of biographical detail for the latter, beyond either their origins and profession or their collegiate affiliation. In the earlier section there is an even sprinkling of private citizens and University men. A notable number of donors from Bath in the second section may be attributed to family connections on the part of the Duncan brothers. An increasing number of women can also be counted among the donors at this time.

Under John Duncan, more detailed scientific nomenclature is used to record individual specimens, reflecting the change in emphasis which he imposed on the Ashmolean at this time (p. iv). Changing tastes among the wider public can also be detected in the donation by the Revd John Risley in 1824 of three cases in which zoological specimens had been mounted in dramatic tableaux – the first evidence for a departure from the no-doubt rather staid and academic presentations that would have been typical of the earlier collections.

It may be noted that the donation in 1828 by Sir Richard Colt Hoare of the Anglo-Saxon collections excavated in Kent by the Revd James Douglas during the final decades of the eighteenth century (see Ashmolean 1836, pp. 128-31) formed a foundation on which the Museum's increasingly important archaeological collections were to be built up in the years that followed. This was the first time that specifically British antiquity had been incorporated into a systematic museum display, either in Oxford or indeed anywhere else.

Growing numbers of ethnographic specimens also reached the Ashmolean at this time from members of the colonial service, the clergy and others. It may be noted that these entries were heavily annotated in the later nineteenth century, mostly with details relating to the transfer of this material to the Pitt Rivers Museum: in the interests of clarity, these later interpolations have been omitted from the present text.

[1r]
Benefactores
Benefactors

D.D.
The gift of:

Joshua Platt Tributorum Exactor Oxon: Rerum naturalium Vir peritissimus, Massam concharum lapideam à Pago Brill allatam.
 Idem Vir Tubum nicotianum Hollandicū.
Joshua Platt, tax-collector of Oxford, a man most expert in natural history: a mass of petrified shells brought from the neighbourhood of Brill.
 From the same man, a Dutch tobacco-pipe.

Gulielmus Corne A.B. Coll: Trin: Oxon: Porci Pedes monstrosos.
William Corne, BA, of Trinity College, Oxford: monstrously deformed pigs' feet.
[2r]
Anna Creswell de Bibury in Comitatu Gloces: Pugionem Turcicam Veneno accerrimo tinctam. 1757
Anne Creswell of Bibury in Gloucestershire: a Turkish dagger dipped in the most deadly poison. 1757.

Laurentius Horner de Oxon Os monstrosum (forsan) humani Capitis. 1757
Laurence Horner of Oxford: a monstrous bone, (perhaps) from a human skull. 1757.

[] Cooper M.D. Oxon. Talpam Ferrantis Imperati, Aldrov: de Insectis. Lib: 5. pag 571.
 Cancrum minutissimum ex Stomacho Musculi fluviatilis excerptum. 1758
 Idem Vir. Caput Umblæ e Lacu Lemani, Aldrov: de Pisc: Lib^m. v. pag. 650. Will. tab: N:1.1-2. 1758.
Dr Cooper, MD, of Oxford: A Mole-cricket of Ferrante Imperato: see Aldrovandi 1602, bk. 5, p. 571.
 A tiny Crab extracted from the stomach of a river Mussel. 1758.
 From the same man: the head of a Charre from the Lake of Geneva. See Aldrovandi 1613, bk. 5, p. 650; Willughby 1686, pl. 1.25j. 1758.

Isaacus Parsons, de Oxon. Acum Aristotelis Ald: de Pis: pag: 103. Jonson. Tab: xv. fig: 14. et de Insectis marin: Tab: XXVII Will: 1.25.j. 1758.
Isaac Parsons of Oxford. A Pipe fish of Aristotle: Aldrovandi 1613, p. 103; Jonston 1650b, tab. 15, fig. 14 ; idem, 1653, tab. 27; Willughby 1686, [p. 158, fig. l, 25]. 1750.

[3r]

/Carolus\ Daniel Melsom, Bathonensis, eximium Ligni Petrefacti specimen. D.D. 1758.
Charles Daniel Melsom of Bath: a choice specimen of petrified wood. Given 1758.

Gul^s. Huddesford, Massam Conchitarum petrefact. a Pago Garsington in Com. Oxon. allatam. D.D. 1758.

William Huddesford: a mass of petrified shells brought from the village of Garsington, Oxfordshire. Given 1758.

D. Dumaresque Coll. Exon. soc. Securim Borussicam. D.D. 1758.
D. Dumaresque, Fellow of Exeter College: a Prussian axe. Given 1758.

Tho⁵. Williams. A.M. Coll. Jesu Soc: Arcum una cum sagittis queïs utuntur, Indi Sinûs (Hudsons Bay dict.) Incolæ. Aliud Item, Saculum forsan vil Hastam, quo in avibus captandis utuntur. 1759. D.D.
Thomas Williams, MA, Fellow of Jesus College: a bow with arrows, used by the inhabitants of the Indian bay (known as Hudson Bay). Also another object – a javelin, perhaps, or a spear used to capture birds. Given 1759.

Bridgeman Aldersey Pharmacopola de Liverpool in Com: Lanc: Avem mellivoram curvirostrem Edvardi. Tab. 226. Nat. Hist. D.D. 1762.
Bridgeman Aldersey, pharmacist of Liverpool in Lancashire: a curved-beaked Humming bird. See Edwards 1743-51, pl. 226. Given 1762.

Philippus Hayes Mus: B. Crabonum Nidum miro artificiis elaboratum procuravit, e Pago Brightwell Com: Oxon et Museo contulit 1762.
Philip Hayes, B.Mus: a wasps' nest of extraordinarily complex construction, acquired from the village of Brightwell in Oxfordshire and presented to the Museum, 1762.

Gul⁵. Huddesford. Vulpem Aureum Linnæi ang: Jackall D. 1762.
William Huddesford: the *Vulpes aureus* of Linnaeus, known in English as the Jackal. Given 1762.

[3v]

Georgius Scott. LL.D. Picturam varia animalium Genera exhibentem, præcipue Reptilia, DD. 1769 et alteram microcosmum exhibentem: 1780.
George Scott LL.D: a picture showing various kinds of animals, chiefly reptiles, given 1769; and another one representing a microcosm, 1780.

[4r]

[] Phelps Gen: Illustrissimo Comiti de Macclesfield apud Shirburn in Com. Oxon ad Res Astronomicas inserviens Lutram Linnæi. Ang: Otter D.D. 1763.
Mr Phelps, gentleman, astronomer in the service of the illustrious Earl of Macclesfield, from Shirburn in Oxfordshire: a *Lutra* of Linnaeus, known in English as an Otter. Given 1763.

Rev [] Lovelace A. B. olim e Coll. Exon Magnetem Artificialem D.D. 1764.
Revd Lovelace, BA, some time of Exeter College: an artificial magnet. Given 1764.

Joshua Platt Ludum Helmontii ex Insula Sheepy. 1765
Joshua Platt: Ludus Helmontii from the Isle of Sheppey. 1765.

Isaacus Hughes Mercator Londinensis, de Crutched Fryars, Cadaver Infantis Balsamo conditum. DD. 1766.
Isaac Hughes, merchant of Crutched Friars in London: the body of a child preserved in balsam. Given 1766

Harriet Masters de Springfeild. Com. Essex Chartam, floribus forsicum Usu delineatis, repertam et ornatam. DD. 1766.
Harriet Masters of Springfield in Essex: a piece of paper, embellished and filled with flowers, worked with scissors. Given 1766.

Jacobus Gilpin Arm: Civ: Oxon. Recordator exemplar Naviculæ Americanæ una cum Regnis alioque apparatu DD 1767
James Gilpin Esq., citizen and Recorder of Oxford: an example of a little American boat [?canoe], together with its paddles and other equipment. Given 1767.

Johannes Bell, Londinensis, Ludi Helmontii Specimen insignem, 1769
John Bell of London: an outstanding specimen of Ludus Helmontii. 1769.

[5r]

Carolus Moore Arm, Effigiem Viri eximii. Fairchild, de Hortulani a Van Black depictam DD. 1769
Charles Moore, Esq.: portrait of that exceptional man Thomas Fairchild, the gardener, painted by Van Black [?Van Bleeck]. Given 1769.

Thomas Galden e Coll Pemb: Lampada Romano Jam Argillosam DD. 1769.
Thomas Galden of Pembroke College: a Roman lamp of clay. Given 1769.

[6r – displaced]

An Indian Fan; brought from the East Indies in the Prince William commanded by Captain Webber A.D. 1750 and given to the Museum by Mʳ. Drought of Sᵗ. Clement's Parish Oxford Purser to the aforenamed ship.

These stones or rather Incrustations were found in the stomach of a[-n] Horse belonging to [] Dudley the Southampton Carrier and given by him to the Museum 1748.

An Account of the Great Shoe made of small Pieces of Leather
This Shoe belonged to John Bigg Clerk to Simon Mayne one of King Charles the 1ˢᵗ's Judges after Mayne's Attainder A.D. 1660 he grew melancholy and lived in a Cave /at Dynton, Bucks\ between 30 and 40 years, his Cloathes were of the same manner as his Shoes, /made with\ a 1000 Patches, which he threw off his Back all at once, and laid at Nights in Straw; In the Day he went about the Country with three Bottles and a Pouch girded about him, never begged but made Signs, and they filled his Bottles and Pouch; When that was gone he went about and got more, he was buried at Dynton Aprill the 4ᵗʰ 1696 bein very old.
/the other shoe now (1885) is in the possession of the Revᵈ. W. Goodhall of Dynton.\

Two unfledged Humming Birds in their Proper Nest.
Given by Captⁿ. Wᵐ. Burnaby of Broughton Poggs in Oxfordshire.

[6v – displaced]

A Copy of the Paper about the Ancient Picture given to the University by Tho⁵. Palmer Esqʳ.
/Alfred Jewel\

Mem[oran]dum. Novʳ. 16 1718
Thomas Palmer Esqʳ of Fairfield in Somersetshire put this ancient Picture of Sᵗ. Cuthbert, into my Hands,

made by the order of King Alfred, to be conveyed to the Bodleian Library in Oxford, where his father Nat. Palmer Esqr. lately dead desired it might be placed and preserved.
George Carle
Vide Philosophical Trans: and Dr. Hicks's Thesaurus, where an Account is given of this Picture & ye finding of it, found at Athelney in Somersetshire.
441 Lowthorpe's Abridgement.

The Salmon's Head and Backbone sent by Mr. Philip Griffin to Mr. Dawkins for the Museum taken at Colchester, 300 wt. – Tail 18 Inches. \This is not a salmon but an Albacore/

A Copy of Mr. Hodges's Account of the great Stone taken out of a Dog's Bladder
This Stone was taken out of the Bladder of a Cur-Dog that was fed to be killed for fferrits to feed upon by one Edward Farbody that kept a Company of Fferrits at Northampton.

[7r]

This he offered to take oath of before 4 or 5 Gentlemen at his House; I affirm and Believe the Truth of this witness my Hand.
Wm. Hodges Apothecary in Towcester in Northamptonshire

A Paper concerning Oliver Cromwell's Scull
In the Year 1672 Oliver Scull was blown off the North End of Westminster Hall down into the Leads of the Same, and taken from thence by Mr. John Moore a Clerk then in the old Petts; and sometime after this he gave it to Mr. Warner Apothecary living in King Street Westm:; and them Mr Warner sold it for 20 Broad Pieces of Gold to Humphrey Dove Esqr then Deputy Pay Master to the Treasurer of the Chamber; But had been Secretary to Fines when Keeper of the Seals to Oliver this scull was taken out of Mr. Dove's Iron Chest att his Death in Decemr. 1687 by his Daughter Mrs. Mary Fisher of Westminster. With whom /which family\ it hath remained 'till given to Mr. Edw. Smattrel.
Westm: Octr. ye. 10th., 1720
/See Vice-Chancellor's Catalogue\

[8]

Donations 1824
Misses Nowell Ifley Oxon Ornithoryncus New. Holland 2 Terebratula rare shells from D^0.

Revd. L. Lee New: Coll[ege]. Buffon 127 Vols. 8vo.
Medals. Viz:
Bonaparte. Reip: Ital: Praeses. anno III.
Napoleo. I. Gall. Imp: Ital. Rex. Germanicus Ruthenicus.
Napoleone Imperatore Rex 1814. Silver.
Felice Elisa P.P. Di Lucca & Piombino 1808. Silver.
Gioachino Napol. Re Delle Due Sicil. 1810. Silver.
Gaule Subalpine 5 Francs silver.
Louis 18. Roi De France 5. Fr. silver. 1817.

J. Parkinson Esqr. 3 Brazilian Birds.

W. Burchell Esqr. African Leopard. Ichneumon. Wind Pipe of an Ostrich. Small Knife, Earrings & Bracelet from Southern Africa.

Revd. Mr Buckland Prof: of Geology. A large Roman Amphora.

S.P. Stacy Esqr. /of Calcutta\ Curious Mss. Outline of an Hindoo Temple.

Mrs. Maria Graham. A Gold Ring taken after death from the finger of Cardl. York. containing port[rait] of the 1st Pretender & his wife.

[9]

Dr. Kidd Ch[rist]. Ch[urch College]. Reg: Prof: of Medicine. Birds. Viz. Buzzard. Jay. Emberiza Finches &c. Golden Pheasant. Crowned Pigeon. Young Emeu. Ruffs. 3 Cases contg. Ducks &c.

Dr. Ogle Trin[ity]: Coll[ege]. M.D. A Collection of English Moths & Butterflies. a pair of Wrynecks.

Mrs. Hornby Several Indian Coins, and Indian Almanack.

Col: T. Shaw Bath. Hindoo Copy of an undecyphered Inscripn. in Benares also very ancient Coins found buried in the interior of India thought to be of Thibet.

Revd. Mr Nixon London. Models of the Dresses & Canoe of the Esquimaux Also specimens of their Flax and Cloth make of the same

A. Bloxam Esqr. Worc[ester]: Coll[ege]: Wilkes on English Moths & Butterflies. Shells &c.

James Paxton Esqr. Surgeon Oxford. A Model made by himself, representing the distribution of the Nerves of the Face &c.

[10]

The Ld. Bishop of Durham. A large Lump of Native Gold found in the County of Wicklow Ireland Wt. 2oz:

Revd. Mr. Ellison Ball[iol]: Coll[ege]: A Babylonish Brick

W. Bragge Esqr. New: Coll[ege]. A Silver watch with a gold Dial wch. belonged to Oliver Cromwell.

W. Bullock Esqr. London. Horns of ye. Wapeti. 2 Specimens of ye. Mexican Humming Birds.

Miss Sibylla Bullock. A Model in Wax of the great Mexican Kalendar Stone.

[] Blandy Esqr. St Johns Coll[ege]. Horns of the Chamois. Shells.

W.C. Trevelyan Esqr. Univ[ersity]: Coll[ege]: Spongia pateria Sincapori East Indies. Also Memoirs of Llwyd.

W. Tuckwell Esqr. Oxford. *Histoire Naturelle des Tangaras* &c.

G. Smith Esqr. St Johns Coll[ege]. 7 Bottles containing Scorpions, Serpents & Lizards from the Interior of India. Several Silver Coins. Head of a Tiger.

[11]

Chs. Annesley Esqr. All Souls Coll[ege]. Saxon Lances discovered June 1824 on Mœan Hill in the County of Gloucester. Roman Coins found at Silchester.

Edwd Winterbottom St. Johns Coll[ege]. Skin of a Rattle Snake also Quills of ye. Histrix prehensilis.

Mr. Sherrard Camberwell. The Lasso & riding apparatus of the South American Indians.

Sir J.T. Stanley Bart. Views of the Hot Springs in Iceland. with an Account of Do.

Dr. Daubeny Mag[dalen]: Coll[ege]. Rostrum of the Sword Fish. A Piece of Roman pavement from Pompeii.

Revd. Dr. Ellerton Mag[dalen]: Coll[ege] The Half Crown of Chs. 1st. Ano 1642. found at Islip Oxon.

J. Ireland Esqr. Oxford A Chinese Pillow.

Revd. Dr. Bridges president of Corpus [Christi] Coll[ege]. A Medallion of Ric: Fox Bp. of Winchester.1

[12]

Chas. Courtenay Esqr. Buckland House Berks. Black Game M. & F. White Owl.

Revd. Mr. Risley New: Coll[ege]. Handsome Oak Inkstand. Pintail Duck & Swallow. Woodpecker.

Revr. Dr. Ingram Trinity Coll[ege]. A Gold Coin of the Empr. Mauritius found at Dorchester Oxon.

Revd. Mr. L. Lee New. Coll[ege]. English Partridges

1825

J. Mellersh Esqr. Midhurst Sussex. A British Spear-head found in digging a Chalk Pit at Heyshot Sussex. 1824

Revd. Mr. Chs Clerke Ch[rist]: Ch[urch College]: a Pied Pheasant.

Revd. Mr. Geo: Booth Ma[gdalen]: Coll[ege]. 6 Gold Coins. Viz. Guinea of Wm. & Mary. Do. of Anne. ½ Guinea of Do. Guinea of George 1st. A Double Johannes. of Portugal. a Moidore of Do.

1[pasted-in sheet]: Richard Fox, an English prelate, the son of poor parents, and educated first at Boston School, and afterwards at Magdelan College Oxford, whence, on account of the plague, he removed to Pembroke Hall, Cambridge. He next went to Paris, whence he gained the friendship of Dr Morton, Bishop of Ely, who recommended him to the earl of Richmond, afterwards Henry VII. On the accession of the monarch, Dr Fox was made privy councillor, and preferred /to\ the see of Exeter. He was also sent on several embassies, and, after obtaining different church preferment, was advanced to the see of Durham, whence he was removed to Winchester. He founded Corpus Christi College in Oxford, and the free schools of Grantham and Taunton in Somersetshire. Born near Grantham; died at Winchester, 1528.

Revd. Mr. /G.M\. Nelson Mag[dalen]: Coll[ege]. A Stone Celt found in ploughing at Peasemore near Newbury Berks. Tusk of the Narwall Indian Bow & Arrows.

[13]

W. Nelson Clarke Esqr. Ardington Berks. Parochial Topography of the Hundred of Wanting.

Miss Morland Abingdon Berks A Collection of Fresh Water Shells.

Mrs Hare. Shrivenham Berks 2 Skins of Monkeys from the Interior of Africa.

T. Gayfere Esqr. Merton Coll[ege]. Coronation Medal of George IId & his Queen. Do. of George IIId. Spanish Dollar & half Dollar. Medalion of Pope Innocent XII. Small Silver Coin of Pius ye. 6th. Several Roman Coins.

Revd. Mr. Wilkinson Ch[rist]: Ch[urch College]: 2 Bottles containing the Eggs of the Common Snake and of Do. just hatched. 17 Roman coins. 6 English Coins.

W.C. Trevelyan Esqr. A Slab containing 40 polished Specimens of Devonshire Marbles.

Revd. Mr. Walker Mag[dalen]: Coll[ege]. A Collection of dried English Plants.

[14]

Revd. Mr. Bissland Ball[iol]: Coll[ege]: Tetras lagopus Ptarmigan. Male & Female.

R.A. Cox Esqr. Merton. Coll[ege]. Corvus Corax. Raven.

The Lord Bishop of Durham. Head of the Ceylon Elephant.

Robt. Stephen Hawker Esqr. Magdalen Hall. A Skin of a Fox from Prince Edwards Island.

Revd. Mr. Risley New: Coll[ege]. 3 Cases containing 1st. The Buzzard with Woodpigeon as Prey. 2nd. Do. with a Snake as Prey. 3rd. Do. with Rabbit as Prey.

Captn. Lyon. N.R. 1. A Bag made of ye. hinder foot or flapper of a Seal. 2. Cuticle of the Black Whale. 3. Ornamental Fringe of Foxes Bones. 4. Deers sinews from the Spine used as thread. 5. Head of the Phoca Vitellina or smaller seal. 6. Head of the White Fox. 7. Skin of ye. Walrus. 8. & 9. Pair of Shoes made of Seal Skin. 10. Jacket of the Intestines of the Walrus, used outside the fur dress to keep it dry. 11. Cap of a little boy named Kā-pōo-yoo. 12. Jacket of a little girl. 13. Cup & Ball.

[15]

14. Seals Skin bladder and is used as a float in killing Walrus's or Whales. 15. Sandals from Sudan (Africa). 16. prepared seals leather Esquimaux 17. a very valuable & efficacious charm for the headache prepared by a wise man & worn by me on my left arm. Invaluable of course (African). 18. Kolla Gorroo mat of

Park (Africa.) 19. Esquimaux Arrow. 20. Esquimaux Bird Spear & casting board. 21. line of the skin of the larger Seal with the moveable spear head. 22. Bow String. Whales Gum, shewing the arrangement of the blades of Bone in the mouth. Beard of the Walrus. Knife used by the Esquimaux. Dried plants from the shores of Southampton Island.

Mrs Schutz Shotover Oxon. A Seal.

J. Thornhill Esq[r]. Woodleys near Woodstock Oxon. A Match Lock-Gun made at Delhi.

Rev[d]. D[r]. Payne S[t]. Johns Coll[ege]. A Pied Pheasant.

A. Rowlandson Esq[r]. Brazen Nose Coll[ege]. A Bronze Medal of Bonaparte. Viz. Bataille De Montenotte 1796.

[16]

The Honb[le] & Rev[d]. C. Perceval Rector of Calverton Bucks. A Collection of British. Birds viz –
Falco Apivorus. Honey Buzzard. –
Falco Aruginosus. Moor Buzzard 2. Varieties
Falco Milvus. Kite.
Falco Nisus Sparrow Hawks 3 Specimens.
Falco Gyrfalco. Jer. Falcon.
Falco Peregrinus. Peregrine Falcon.
Falco Lagopus. Rough Legged Falcon.
Falco Lanarius. The Lanner.
Falco Cyaneus. Dove coloured Falcon.
Falco Pygargus Ringtail.
Falco Tinnunculus. The Kestrel.
Strix Otus. Long eared Owl.
Strix Brachyotos Short eared Owl.
Strix Flammea. White Owl.
Strix Stridula. Tawny Owl.
Strix Passerina. Little Owl.
Lanius Excubitor. Shrike.
Lanius Collurio. The Redbacked Shrike. 2 Specimens.
Corvus Frugilegus. The Rook.
Corvus Monedula. Jackdaw.
Corvus Pica. Magpie M. & F.
Corvus Coryocatactes. Nutcracker.
Corvus Glandarius. Jay.
Ampelis Garrulus. Chatterer.
Sturinus vulgaris. Starling.
Turdus Torquatus. Ring Ouzel.
Turdus Merula. F.
Turdus Pilaris M & F.

[17]

Turdus Iliacus. Redwing. M.& F.
Turdus Musicus. Throstle.
Cuculus Canorus. Cuckoo. 2 specimens.
Jynx Torquilla. Wryneck.
Picus Viridis. Green Woodpecker M. & F.
Picus Major the Greater Woodpecker
Picus Minor the lesser spotted Woodpecker.
Loxia Chloris. Green Finch.
Certhia Familiaris. Creeper.

Citta Europæa Nuthatch.
Emberiza miliaria. Bunting.
Emberiza citrinella. Yellow Bunting.
Fringilla domestica. House Sparrow.
Fringilla montana. Mountain Sparrow.
Fringilla montifringilla. Mountain Finch.
Fringilla Linaria. Linnet.
Motacilla Alba. Pied Wagtail.
Motacilla Salicaria. Sedge Bird.
Motacilla Sylvia. White Throat.
Motacilla trochilus. Willow Wren.
Motacilla troglodytes. Wren. D[o]. White.
Motacilla rubetra. Whinchat.
Motacilla rubicota. Stonechat.
Motacilla.
Parus biarmicus. Bearded Titmouse.
Hirundo apus. Swift.
Caprimulgus Europeus. Night Jar.
Columba ænas. Wild Pigeon.

[18]

Columba palumbus. Ring dove.
Columba turtur. Turtledove.
Phasianus Colchicus. female in male plumage
Tetrao Tetrix. Black Game M. & F.
Tetrao Scoticus. Red Grouse M. & F.
Tetrao Coturnix. Quails M. & F.
Rallus Crex. Land Rail.
Charadrius Oedicnemus. Norfolk Plover.
Tringa vanellus. Pee-wit.
Charadrius Pluvialis. Golden Plover
Charadrius Morinellus. Dotterel.
Charadrius Hiaticula. Ring Dotterel.
Rallus Porzana. Spotted Rail M. & F.
Rallus Aquaticus. Water Rail.
Alcedo ispida. Kingfisher.
Ardea Major. Heron.
Ardea nycoratica. Night Heron.
Ardea stettaris. Bittern.
Ardea minuta. Little Bittern.
Scolopax arquata. Curlew.
Scolopax Rusticola. Woodcock.
Scolopax Gallinago. Snipe.
Scolopax Lapponica. Red Godwit.
Scolopax Glottis. Greenshank.
Scolopax Calidris. Redshank.
Tringa Pugnax M. & F.
Tringa Alpina. the Dunlin.
Fulica Atra. Coot.
Tringa Cobata. Grey Phalarope.

[19]

Recurvirostra Avosetta. Avoset.
Larus nævius. Grey Gull.
Larus ridibundus. Black-headed Gull.
Anas Boschas. Mallard.
Anas Fuligula. Tufted Duck.
Mergus Albellus. The Smew.
Several skins of birds from the Cape of Good Hope.

Mustela Erminea. Ermine.

Miss Morland Abingdon Berks Falco subbuteo Hobbys M. & F.

Rev[d]. M[r] Wilson Queens Coll[ege]. Tetras Canadensis. Canada Goose.

Cha[s]. Webb Esq[r]. Surgeon Oxford. A male specimen of the Sphinx atropos. A Waterloo Medal. A Proof farthing of a coinage of Geo. III[d] too large for circulation.

M[rs]. Wall S[t]. Giles's Oxford. A Pewter plate on which King Cha[s]. II[d]. dined the day preceeding the Battle of Worcester, with this inscription round the figure of the King /Chas. 1st.\ on horseback. Viz - "Where grace and virtue lies true love never dies."

[20]

D[r] Such. 4 Skins of Brazilian Toucans. Viz -
The Yellow Breasted Toucan
Red-breasted D°.
Aracari D°.
Piperine D°.

[] Tawney Esq[r]. Ifley Oxon. a 5 franc piece of Bonaparte of the Coinage of 1811.

M. Metirier Triest Esq[r]. Bath. Proteus Anguineus, Eel shaped Proteus from the Lakes in Carniolea.

Rev[d]. M[r]. Wilson Trinity Coll[ege]. A British Urn found in a Barrow on Wroxall Down in the Parish of Newchurch in the Isle of Wight May 1825. It was rather to the North of the center of the Barrow & about four feet from the surface. It was found with the mouth downwards. There were two other deposits in the same Barrow, both near the surface; on the S.E. Side, the other on the N.W. but no bones in either but many ashes apparently of wood. This Urn when opened by D[r]. Kidd was discovered to be full of human bones burnt by a very strong fire. Amongst them are some which appear to have been those of a Child, the remainder those of an adult. No Beads or trinkets of any kind, or weapon was discovered either in the Urn or Barrow. The fire in which the Body was burnt, had been made in the N.E. corner of the Barrow, which was of the Bell shape. It was situated on the N.W. brow of the hill, looking towards Appuldurcombe.

[21]

Rev[d]. M[r]. Ranken Ch[rist]. Ch[urch]. Coll[ege]. A Collection of Humming Birds from the East Indies.

Miss Annesley. A Small brass medal found 1820 in digging a drain at Bletchingdon Park, the seat of Arthur Annesley Esq[r]., with this inscription
A Pransua a Dafin a Navara 1604 - Henric IIII la Roi ce Fran. H.K.

[-]

Henry Wise Esq[r]. 3rd Officer of the Honb[le] East India Company's Ship Castle Huntly. A Model of a Chinese Junk.

[] Upcott Esq[r]. London Institution Moor Fields. Specimens of the Silver Coinage of George III[d] & 4th. viz - 5/ of the Coinage of 1818, 1819, 1820. half Crowns of 1818, 1819. Shillings of 1816, 1817, 1818, 1819, 1820. Sixpence of 1818, 1820. Half Crown of 1820. 5/ of 1821. 1/ of 1821. 6[d]. of 1821. Copper 1[d]., 1/2 & 1/4 of 1806. Medal of the Edystone Lighthouse.

[22]

Rev[d]. Mr. Stacy New Coll[ege]. []

Rev[d]. Mr. Spring. S[t]. Edmunds Hall. A Weapon of War used by the Natives of the Coory country & hence denominated a Coory knife. It is It is carried at the back the Blade being uppermost as high as the top of the shoulder. It is a weapon of so formidable a nature, that a Buffalo has been decapitated by it at one blow. Coory is a small country situated in the mountains about 30 miles inland on the Malabar Coast and governed by an independent and despotic rajah. Also a Nair knife, used along the same Coast. An Airootanie or Style and Knife in a silver case the apparatus used for writing. A small white Cap curiously wrought worn by the natives in the interior of the Malabar Country.

W. Meterier Trieste Esq[r]. Bath. Proteus Anguineus. Eel shaped Proteus from the lakes in Carniolea.

Miss Pugh. A Large Collection of Shells.

[23]

1826

[- H. Wise Esq[r]. of the Hon: E. India Service. Model of a Chinese Junk.]

D[r]. Sims. Wimpole Street. London. African bow with a Quiver of poisoned Arrows and Leathern Pouch from Sierra Leone.

F. Drake Esq[r]. Worcester Coll[ege]. A Roman pillar from the Peristyle of the Roman Villa near Stonesfield Oxon.

M[r]. H. Howell. Wooden Beads worn by the Bramins & Seapoys of H[le]. Service.

M[r]. R. Sharman Windsor Berks. Scolopax ruber. Red Curlew.

G. Smith Esq[r]. S[t] Johns Coll[ege]. An English Fox.

[24]

Rev[d]. D[r]. Knatchbull. All Souls. A Collection of English Butterflies &c.

A. Bloxam Esq[r]. Worcester Coll[ege]. A Collection of Articles from the Sandwich Islands. Vizt. - 14 Specimens of Talpa or Native Cloth Patterns used for dyeing the same 1 D°. from the Island of Mauti. Small Pillow used by the Natives. Bracelets made of Hogs tusks, 3 Specimens. A Stone used in playing at a peculiar game called Maita Uru. A Stone Hatchet of Black Basalt. Hook used for catching of Sharks. Ornamented Calebash for holding water. An Akua or

Idol of wood with an Helmet shaped Head piece. Rana Cornuta or Horned Frog – S. America.

W. Hamper Esqʳ. Birmingham.
An Ancient Iron Padlock, found at Freeford near Lichfield.

[25]

Mʳ R. Surtees A.M. Ch[rist]. Ch[urch College]. Mainsforth Co. Durham. Roman Coins. Vizt. – 6. Silver. Macrinus. Treb. Gallus. Volusianus. Numerianus. Magnentius. 9. Brass & Copper. Mes. Decius. Gallienus. Quintillus. Aurelianus. Florianus. Carinus. Leo. Anastastius. Justinianus.

Wᵐ. Cotton Esqʳ. Letherhead. A Rare Shell Mytilus fluviatilis. Mulette.

Revᵈ. Mr Hall. Chaplain to the British Forces in India. 2 Sheets of Burmese Dispatches picked up at Rangoon.

Revᵈ. R. Walker. Magdalen Coll[ege]. A Collection of English Butterflies.

George Hitchings Esqʳ. Surgeon. Oxford. Scull of a Bear.

[26]

Revᵈ. R.M. White. Fellow of Mag[dalen]: Coll[ege]. Model of a Farm House in the Canton of Berne Switzerland.

Captⁿ. Lyon R.N. Fragment of a Female Idol found whilst making a Survey of the River Panuco on the Mexican Coast at a Town or Village of the same name.

R.G. Lewis Esqʳ. Wadham Coll[ege]. A Stuffed Specimen of the Manis Pentadactyla. Five-toed Manis or Pangolin.

Sir Thoˢ. Phillipps Middle Hill Worcestershire 2 Seal Skin Dresses of the Esquimaux Indians

Mʳˢ. Schutz. Shotover House Oxon. An English Peacock.

Revᵈ. Mʳ. Jenkins Mag[dalen]: Coll[ege] A Collection of Marine Plants

Robᵗ. J. Wilberforce Esqr. Oriel Coll A preserved specimen of the Hoopoe.

[27]

Revᵈ. Dʳ. Rowley. Master of University Coll[ege] 2 Fine Specimens of the Hercules & Acteon beetles.

[] Justice Esqʳ. Abbey House nʳ. Abingdon 2 Specimens of Sea Rods from the Islands of Bermuda

Miss Bishop Holywell Oxford a Collection of Bird Skins from the Cape of Good Hope.

J. Parkinson Esqʳ. British Consul at Pernambuctou. A Collection of Skins of Brazilian Birds.

Revᵈ. Mʳ. White Mag[dalen]: Coll[ege]. Model of a farmhouse in the Canton of Berne Switzerland.

Sir Henʸ. Torrens Bᵗ. A Large Burmese Idol /of wood gilt\.

Mʳˢ. Jones Exeter Coll[ege] Skin [of] of large Snake preserved specⁿ. of the Jᵏ. Snipe. 2 African Birds.

Revᵈ. W.C. Risley New. Coll[ege] preserved specimen of the Polecat.

[28]

1827

Lieuᵗ. Francis Harding Esqʳ. R.N. A Collection of the Instruments used by the Eskimaux Indians. Vizᵗ.
A Boat Sail made from the Intestines of the Walrus.
3 Large Spears wᵗʰ. they attack the Polar Bear.
Bird Spear pointed with Ivory.
Several harpooning Instruments wᵗʰ. lines &c. compleat.
Esquimaux knife. Mittens &c.
Skull of a Esquimaux Dog. Upper Jaw of a Walrus. A Pair of Canadian Snow Shoes.

Revᵈ. Dʳ. Cotton Ch[rist]. Ch[urch College]. A Collection of Copper Tokens circulated by Trading Companies Bankers &c.

Lord Byron a feather Idol (or War God) Sandwich Islands

Mrs Landon Worcester Coll 5 Bottles containᵍ. Snakes Centipedes &c. from the West Indies. Also a curious Wasp Nest resembling in its shape a Bell attached to the Branch of a tree. [*drawing*]

Revᵈ. Mʳ. Jenkins Mag[dalen]. Coll[ege] 2 Silver Coins viz. Trajan – found at Chichester Philip – ploughed up at Earndley 8 miles from Chichester

Mʳˢ. Hornby [-Bath] 4 /Small\ Burmese Idols of Wood /Cement\ covered with thin laminæ of Silver. A chain of [illeg.] work.

[29]

Revᵈ. Dʳ. Buckland Ch[rist]. Ch[urch College]. Head of an Elephant Asiatic Species. Preserved specimen of the Marmot. Wax Models of Fungi &c.

Revᵈ. J. Bishop. Gloucʳ. Casts in Plaster of a Coronation Medal of Edw:VI and of Buonapartes Vaccine Medal.

Revᵈ. C. Trelawney Collins Baliol Coll[ege]. Emberiza Cirlus Lin. Cirl Bunting Shot near Plymouth 1827.

J. Robinson Esqʳ. Banker Oxford. A Crown piece of Charles 1ˢᵗ Mint mark an Eye 1645.
4 Catholic Medals of Brass. Inscribed S. Antonio de Pad. – S. Augustine O.P.N. – Refugium Peccatorum ora P.N. – S. Fran. Dasisi.

Revᵈ. J. Gould Mag[dalen]: Coll[ege]. Under Jaw Bone of an Elephant (Asiatic Species) 2 young teeth of Dᵒ.

Viscountess Sidmouth. Egg of a Chamelion laid in the Tower of London 1826.

[30]

1827

Masters Chas. & Edwd. Thornhill Woodleys Oxon.
Indian Dagger with handle of greenish Agate.

J.W. Chambers Esqr. St. Johns Coll[ege]. Snakes
Insects &c. collected in Columbia by James
Williamson Esqr. Vizt. 2 dried Skins of Serpents. 5
Specs. of Snakes in Spirits. Large Locusts. Do.
Cerambyx. Centipedes &c.

Revd. Dr. Hall: Pembroke Coll[ege]. An Indian Basket
curiously ornamented with Shells.

Edwd Winterbottom Esqr. St. Johns Coll[ege]. Ursus
Lotor. Lin: The Racoon.

Lady Frances Trail Bath. Humming Bird in its Nest.
Several Indian Beetles. A Jug 3 Cups & Saucers made
of Lava.

Col: Shaw Bath. 5 Packetts of Asamese Mss picked up,
during the Burmese War, in the Temples which the
Burmese had destroyed.

Robt. Barclay Esqr. Bury Hill Dorking Surr[e]y. Head
and fore Arms of the Meremaid. Various skins of rare
Birds from the East Indies. 2 Snakes from Do.

[31]

Revd. W.D. Thring Model of the Pigot Diamond.

Revd Augustus Short Ch[rist].Ch[urch College]:
Various Specimens of Sponge from New South Wales.

Saml. Smith Esqr. B.A. Ch[rist].Ch[urch College].
Preserved Specimen of an English Pied Pheasant Shot
at Glimpton Oxon.

Captn. H.F. De Lisle /Guernsey\. Various Articles from
the Cape of Good Hope Vizt.
Head of a South African Buffalo
A Portion of the Proboscis of an Elephant
Tail and Ear of an Hippopotamus
Models of the native costume vizt.
A Caffre Chief in his War Costume
A Caffre Woman in her winter dress
A Booshman in his war dress
A Booshwoman in her winter dress
A Booshman Bow Quiver & Poisoned Arrows
Caffre War Feathers Calabash Snuff Box Necklaces
Ivory, brass & bone ornaments Tobacco Pipe
Caffre Musical String Instrument called a Goura.
Caffre & Tamboocki Assagais
 Do. Basket & Knob. Karie Malay Hat
Caffre Woman's Petticoat

[32]

Miss Louisa de Lisle. Head Dress worn by the Caffre
Women of the Cape of Good Hope.

Miss Harriet de Lisle. A Woman's Caross of a South
African Nation situated beyond Latakoo.

Revd. M.S. Wall Ch[rist]. Ch[urch College]. an ancient
brass Seal found at Islip Oxon. Inscribed S. FELIPI
FIE hAMVND DE ESON. +.

Revd. Wm. Morice BD. FAS Tackley Oxon. a perfect
specimen of the Paper Wasp's nest as found attached to
the eaves of an outhouse belonging to the Rectory

Wm. Barley Esqr. New Coll[ege]. Fragment of the
Roman Pavement at Northleigh Oxon.

Mrs Wall St. Giles's. A Finely preserved specimen of
the Crested Curassow.

Revd. Wm. Lee M.A. New Coll[ege]. Preserved specn. of
the Moschus Javanicus or Java Musk.

[33]

Mathew Boulton Esqr. Soho Staffordshire. A Set of the
Medals & Coins struck at the Mint at Soho. in number
18 of Medals Coins of the British Govermt 13. Do. of
the French Govermt. 3. Colonial 23. Also. a Roman
Flue, Fragment of a tessellated pavement, and of
earthen vessels found in the excavations at Great Tew
Oxon.

[]Staniforth Esqr. Ch[rist]. Ch[urch College]. A
Preserved Specn. of the English Swan.

J. Huyshe Esqr. M.A. Braz:N[ose].Coll[ege]. Case of
Birds vizt. Kite & Sparrow Hawk with Woodpigeon as
Prey.

W. Bennett Esqr. Farringdon House Berks.
Model of a New Zealand Canoe & of the Canoe used by
the Natives of the Melucca Islands also a large specn. of
the Saw Fish.

J. Murray Esqr. Albermarle St. London. A Collection of
Skins of African Birds.

Revd. D.G. Stacy New Coll[ege]. Head of a Leopard.

[34]

Revd. Andrew Irvine Charter House Square London
Scalp of the double-horned Rhinoceros, also 5 pair of
Antelope's Horns from the Cape of Good Hope.

Mrs. Clarke of Swakeley near Uxbridge Middlesex. 2
Silver Pennys of Edward ye Confessor.

Dr. Macbride President of Magd[alen]: Hall Small Gold
Coin (British) as described by Camden. Tab II. No 9.
Brass Coin of Augustus & Agrippa found at Nismes.

Revd. R. Greswell Wor[cester]. Coll[ege].
Penna[n]t's British Zoology. 4 Vol: 8vo.

Revd. R. Walker. Magd[alen]: Coll[ege]. 5 Cases of
English Moths & Butterflies.

Revd. Mr. /J\ Spring St Edm[und]. Hall Ivory Ball
containing 10 /11\ Smaller ones cut from a solid piece
of Ivory.

[35]

Revd. Mr. Spring /St.\ Edm[und]: Hall. Indian Coins,
various Vizt. 8 Gold. 8 Silver.

[36]

1828

Revd. Wm. Lee New Coll[ege]. Gold Coins Vizt.
Napoleone Imperatore. 20 Lire 1809.
Napoleon Empereur. 20 Francs 1815.
Napoleon Empereur. The Head is stamped on each side.
Maria Luigia. 40. Lire 1815
Maria Luigia. 20 Lire 1815.
Joseph. Nap: Hisp & Ind: R. 1809
Hieronymus Napoleon 5 Thaler 1812.
Gioachino Napoleone 1813 20 Lire
Lodew Nap. Kon. von Holl. 1808

Revd J. Lamb D.D. Chipping Warden Northamptonshire Roman Antiquities found under the walls of Brough Castle Westmorland. Vizt. 4 Roman Styles. 4 Pins. 7 Fibulæ. 2 Fragments of Do. Phallus. Small fragments of spear & Arrow Heads. Also Roman Coins: 1 Trajan Gold. 2 Do. Brass. 1 Hadrian 1st. Brass. 1 Gallienus. 1 Tacitus. 1 Theodosius. 1 Silver penny Hen:3d. 1 Nerva.

Revd. Dr. Buckland Ch[rist]: Ch[urch College]: Specimen of Roman Pipes found in London Roman Tile with Inscription.

[37]

The Ld. Bishop of Jamaica. Hammocks made by Red Indians. Mosquito Shore. Honduras 1826. Small hand fan. Pearls from the Conch Shell Nassau new Providence.

P.J. Selby Esqr. Twizell House Belford Northumberland. 36 Skins of British Birds.

R. Barclay Esqr. Bury Hill Dorking Surrey Band Fish. File Fish. Legs of the Cassowary.

Dr. Prattinton Bewdley Worcestershire A Collection of Bird Skins from the East Indies in number 39.

R.W. Mackay Esqr. Braz:Nose Coll[ege]. A finely preserved specimen of a Chamois Goat.

Mr. Delf. Mercer Oxford. Preserved Specimen of the Tarrock Gull.

[38]
Revd. R. Walker Magd[alen]. Coll[ege]. 5 Cases of British Lepidoptera

N.C. Strickland Esqr. Linc[oln]. Coll[ege]. Long-tailed Duck. Red breasted Merganser. Spotted Fly-catcher.

Dr. Latham Winchester. his General History of Birds. 10 vol: 4to. coloured plates.

L.W. Dillwyn Esqr. A Descriptive Catalogue of Recent Shells. 2 vol. 8vo. Lond: 1817.

[39]

1829

Revd. J.W. Mackie Ch[rist]. Ch[urch College]. 5 Roman Coins. Vizt. Pescennius Niger. Balbinus. Hostilianus. Mes. Decius.

Edwrd Astley Esqr. St. Mary Hall. Japanese Organ Case of Knots in Summer & Winter plumage.

Mrs. R. Calvert Bath. The original privy seal of O. Cromwell with the following attestation ‒ "The original privy seal of Oliver Cromwell came into the possession of the Fremans from Ann Webb one of the daughters of John Webb of Broomfield Essex Esqre who married into the Fiennes family. Teste. Richd Freman Grandson.

This Seal was cut by Jo. Simons an Engraver in the Usurpers time & one of the most eminent in Europe."

Wm. Calverly Trevellyan Esqr. Univ[ersity]. Coll[ege]. A small Urn and Patera found at Paestum.

Revd. Joseph Carter St. John's Coll[ege]. a fine specimen of the Barnacle Goose

[40]

Captn. Parry R.N. ...

'CURIOSITIES SENT TO OXFORD': THE FORSTER COLLECTION OF ETHNOGRAPHIC MATERIAL FROM CAPTAIN COOK'S SECOND PACIFIC VOYAGE

Transcribed and annotated by Jeremy Coote, Peter Gathercole and Nicolette Meister

Pitt Rivers Museum, MS Cook 1, compiled 1776. Inscribed on the front page in an ornate hand, 'Catalogue of Curiosities sent to Oxford'. Sixteen unnumbered pages, four of which are blank, formed from four sheets of folded, double-foolscap paper. 335 by 215 mm.

The 'Catalogue of Curiosities sent to Oxford' lists the artefacts given to the University in 1776 by Johann Reinhold Forster (1729-1798) and his son Johann George Adam Forster (1754-1794), commonly known as Reinhold and George respectively. The items listed constitute part of a larger collection of material culture acquired by the Forsters while serving as naturalists on Captain Cook's second famous voyage of discovery from 1772 to 1775.[1] Another large part of their collection is in the Institut für Ethnologie der Universität Göttingen (Hauser-Schäublin and Krüger 1998), while further material collected by them is dispersed amongst other European collections. The material at Oxford is regarded as the most important collection of Forster material and as one of the most significant of the collections made in the course of Cook's three voyages.[2]

The 'Catalogue' contains 179 entries (1 to 177 plus 55a and 101a) divided geographically – 'Otaheitee [Tahiti] and the Society Islands', 'The Friendly Isles [Tonga]', 'New Zeeland', 'Easter Island [Rapa Nui]', 'Marquesas', 'Mallicollo [Malakula, Vanuatu]', 'Tanna [in Vanuatu]', 'New Caledonia', 'Terra del Fuego'. The text is unsigned, but the hand is identified as that of George Forster. It is also undated, although we know that the collection itself – or at least the bulk of it – was sent to Oxford in late January 1776, for on 1 February the Forsters wrote from London to the Vice-Chancellor of the University:

Some days ago we sent to Oxford certain small volumes published by us, and also some clothing, arms and domestic goods of the races inhabiting the islands of the Pacific Ocean brought back by us from a distant voyage; the books to the Reverend John Price, most worthy custodian of the Bodleian Library; the remaining items to the Reverend William Sheffield, most deserved custodian of the Ashmolean Museum.[3]

Reinhold Forster had met and corresponded with Oxford scholars since at least the summer of 1767 when he visited the Botanic Garden and the Ashmolean (Hoare 1982, p. 29). He counted both William Huddesford and his successor William Sheffield (keeper 1772-95) among his friends (ibid., p. 41, note 7; Hoare 1976, pp. 51-2). These close relations with Oxford scholars led to his being awarded the degree of DCL on 22 November 1775. Evidently he commanded admiration and respect at Oxford, for among some eighty-five subscribers to his *Observations made during a Voyage round the World* (1778) more than a third were Oxford academics.

Inclusion of the word 'sent' in the title of the manuscript suggests that it was forwarded to Sheffield some time after the collection itself had reached Oxford. This suggestion is supported by the fact that the last section of the catalogue is of items which 'were omitted before'.

Whatever the early history of the manuscript, its later history is itself curious, for no reference to it can be found prior to its 'rediscovery' by Adrienne Kaeppler in 1969, in a pocket at the back of the Pitt Rivers Museum's accession book for material transferred from the Ashmolean.[4] Its whereabouts between 1776 and 1969 remain a mystery.

A catalogue of the Forster collection, giving detailed provenances as well as publication and exhibition histories, is now available on-line: for details see the Pitt Rivers Museum's Website at: www.prm.ox.ac.uk.

[1]
Catalogue of Curiosities

Otaheitee and the Society Isles

The Mourning Dress

1 The principal part or Mask, by the natives called Paraï Hèva; the upper parts Mother-of-pearl shells, with an edging of feathers from the tails of Tropick-birds. The apron, of small bits of Mother of pearl curiously put together, & ornamented with European beads, and opercula of shells; the Tassels of pigeons feathers.

[1]For the Forsters' own published accounts of the voyage, see G. Forster 1777 and 2000 and J.R. Forster 1778, 1982, and 1996. See also Hoare 1976. George went on to greater fame, especially in Germany where the publication of an 18-volume critical edition of his *Werke* (1958-85) is testament to his importance to German intellectual history.

[2]For the dispersed Cook-voyage collections, see Kaeppler 1978a; 1978b; 1998.

[3]Oxford University Archives: NEP/Subtus/Reg Bi 36, Register of Convocation 1766-76. Translation from the Latin of the opening paragraph of the Forsters' letter, the text of which is entered in the register. The full text of this letter is reproduced (with English translation) in Coote *et al.* 2000, where a more extended account of the Forster catalogue is given.

[4]See Kaeppler 1972, p. 195, where it is argued that the manuscript establishes the collection as 'the best documented second-voyage collection, and as the only ethnographic collection made on Cook's voyages with undisputed original documentation of provenance and use'.

2 The Turband called Ta-oopo consisted of many sorts of their cloth pasted together, and ornamented with cords of the same.

3 The Cloth with Buttons of Coco-nut shells, named the Ahow-Iboo, worn before the knees together with the belt.

4 The feathered Coat, or Ahow-roopè, consisting of strings in form of a Net, covered with bunches of feathers, and worn on the back.

The Warriors Dress
5 The Helmet, (Whow) of Wickerwork four feet and a half high, covered with pigeons feathers in front, and ornamented with tropic birds feathers on the edges.

6 The Breastplate or Ta-ōomee, likewise Wickerwork covered with pigeon's feathers, ornamented with triple rows of Shark's teeth and edged with Dog's hairs.

7 The Warriors Battle ax.

8 The Turband; being nothing more than a piece of their cloth, in order to fix the helmet upon.

Cloth
9 Brown. 10 Red. 11 White. *[bracketed]* belonging to the Mourning dress, & put on one over the other, beginning with the white, the red next & the brown over all.

[2]

12 a piece of brown cloth, made of the Fig-tree-bark.

13 a piece of fine white cloth of the Mulberry bark.

14 a piece of thick d°.

15 a yellow piece with red spots.

16 a red piece.

17 a rose-colored piece.

18 a black piece.

19 a cinnamon colored piece.

20 an exceeding soft yellow piece.

21 22 *[bracketed]* Two Otaheitee Matts.

/Utensils
23 a large stone hatchet.

24 a large Clothbeater.

25 a drum covered with Shark's skin.

26 a flute, of Bamboo.

27 funeral Clappers, of mother of pearl Shell.

28 the paste-beater, of Lava.

29 an Otaheitee wooden platter.

30 an Otaheitee stool.

31 an Otaheitee Basket of [-platted] matted work.

32 another, of Canes.

33 a Travelling Trunk, consisting of /part of\ a hollow tree.

34 Fishhooks of Mother of pearl.

35 /a\ [-little] /large\ gourd[-s] /for\ containing the oil of coconuts, with which they anoint their hair.

[3]

37 Tattowing or puncturing Instruments.

38 39 *[bracketed]* Wooden representations of human figures.

40 The Tamow, or Headdress of platted hair.

41 42 *[bracketed]* an Otaheitee Bow and arrows, used onely for amusement.

43 a piece of the perfume-wood.

44 a string of oily-nuts, used as candles.

/appendix
45 another Breastplate, the same as No. 6.

46 a tail of particolored feathers, being a Warrior's ornament.

47 a parcel of [-ropes] strings.

48 another parcel of Otaheitee cloth.

The Friendly Isles
49 a piece of their brown cloth.

50 another, striped with blackish lines.

51 another, of a pale brown.

52 another, with white checquered lines.

53 a Strong matt, with a black pattern.

54 a Small Smooth matt. 55 another of the same Sort. *[bracketed]*

/[-56a\55a] a matt with red stripes.\

56 another pierced with holes.

57 a Strong matt.

58 a very smooth matt, with a border of leaves.

59 a belt made of Coconut Core.

60 a fishing Net.

61 an apron made of fibres of coconut; beset with feathers & bits of shells.

[4]

62 a shield made of Bone, probably of a cetaceous animal.

63 a weight made of shells & Stone, to sink their fishing lines.

64 a parcel of Fishhooks of various Sizes.

65 a wooden dish or platter from which they eat.

66 a roll of rope, of the coconut's core.

67 a bow and arrow.

68 a spear with a jagged point.

69 a paddle.

70 71 72 73 74 75 76 77 78 79 *[bracketed]* Ten clubs of different shapes, some curiously carved.

80 a pestle or paste beater of wood; being an instrument with which they macerate their breadfruit.

81 a spatula of wood to mix up their paste of breadfruit with.

82 83 *[bracketed]* Two flutes, for the nose.

[5]

84 85 *[bracketed]* Two of Pan's pipes or syringae.

86 a strong wicker-basket.

87 a round wooden box covered with basket work of shells & Coconut fibres.

88 89 90 *[bracketed]* Three baskets of Coconut core with shellwork.

91 a strong basket of Coconut Core.

92 a Square matted basket, of palm-leaves.

93 a wooden hook to be fixed to the top of the house, to which they hang baskets with [-] provision, so that the board prevents the rats from coming at the meat.

94 95 *[bracketed]* Two stools or pillows to rest the head upon.

96 a rasp made of a ray's skin.

97 a parcel of combs.

98 Nine different kinds of necklaces; together with three mother of pearl shells which hang on the breast.

99 Three Earsticks, one of wood covered with coconut core, & two of bone.

100 a bracelet of a piece of shell, and some [-] Dentals.

101 a fly flap of the fibres of coconut.

/(101a) an old nail brought to the friendly Isles by Tasman in 1642 and preserved by the Natives, & used as a googe or borer.\

[6]

New Zeeland

102 a feathered Coat, made of the N.Z. flax, & /inter\ woven with parrots & ducks feathers: this from Dusky Bay.

103 a Dogskin coat.

104 105 106 *[bracketed]* Three plain coats of the flax plant, two with dogskin at the corners.

107 a Shaggy great Coat.

108 a matted belt.

109 a hatchet of green stone, the handle curiously carved.

110 a carving knife, carved & painted, [-] with an edge of jagged teeth.

111 a battle-ax or halberd.

112 a pattou-pattou, or short club of Lava.

113 a ditto of wood.

114 a ditto of bone.

115 a ditto of green nephritick stone.

116 a flute.

117 a Scoop, with which they bale the water out of their canoes.

118 a bundle of their flax.

119 a piece of the green nephritick stone, shaped for a hatchet.

120 another piece, being an amulet [-] with a rude carving of a human figure.

[7]

121 a chissel of green stone.

122 an ear-stone of the same.

123 124 125 *[bracketed]* bodkins with which they fasten their [-cloth?] coats, one of greenstone, & two of bone.

126 a bundle of teeth, worn on the breast.

127 a headdress of feathers.

Easter Island

128 a piece of their cloth.

129 a headdress of small ropes.

130 D°. of feathers.

131 132 *[bracketed]* Two bones worn on the breast.

Marquesas

133 a gorget of light wood, set with red beans, (of the abrus precatorius Linn.).

134 a headdress of mother of pearl & tortoise shell, with cock's feathers.

135 a small headdress of feathers.

136 a bonnet of coconut core, broken.

137 a bunch of hair, tied on the arms, knees or ancles.

[8]

138 an ornament for the ear.

139 140 *[bracketed]* Two bones /or teeth of porpesses?\ hung before the neck.

141 Two pieces of wood, to scratch the head with.

Mallicollo

142 a club.

143 a bow.

144 a bundle of arrows, some of them poisoned.

Tanna

145 a jagged spear.

146 another plain.

147 a becket or piece of rope with an eye at one end & a knot at the other; used to give velocity to the Spear.

148 a bracelet of Coconut shell.

149 a Nose-stone, passing through the septum narium.

150 Two combs, one black & one white.

151 a bow.

152 a bundle of arrows.

153 an ornament of green stone hung round the neck.

[9]

154 a syringa.

New Caledonia

155 A Cap, with feathers & ferns.

156 157 158 159 *[bracketed]* four clubs, variously shaped.

160 a becket to give velocity to the spear.

161 a carved spear.

162 a plain black spear.

163 A sling.

164 a bag filled with stones for slinging.

Terra del Fuego

165 a Sealskin Coat.

166 a spear pointed with a *[elided with 167]*

167 [-] piece of jagged bone.

168 A necklace of shells.

[10]

Appendix; were omitted before

169 170 *[bracketed]* Two fanns from the Marquesas.

171 New Zeeland Comb.

172 bunch of leaves, which the New Zeelanders use to stick in their ears.

173 piece of wood with which the New Zeelanders bruise their fern-roots.

174 Shark's tooth set in wood, from the Friendly Isles.

175 a little matted pouch from the Friendly Isles.

176 an Otaheitee sling.

177 A bundle of ropes from the friendly Is.

[]

For Mr Sheffield
Musæum

CATALOGUE OF CURIOSITIES FROM THE FIGI OR CANNIBAL ISLANDS

Transcribed and annotated by Arthur MacGregor

Ashmolean Museum, AMS 16 (1), compiled 1867. Three loose sheets, 225 by 185 mm, pasted into Museum, letter-book.

The items included in this list, purchased in 1867 from 'an old Resident among the Savages', represent one of the last extensive acquisitions of ethnographic specimens by the Ashmolean prior to the transfer of all such material to the Pitt Rivers Museum in 1886. Many of the specimens are described in greater detail in the catalogue drawn up on that occasion (see pp. 255-413, *passim*). The present list represents the primary record of these items within the Ashmolean's collection. The annotations reproduced here as footnotes are by Edward Evans, *c*.1884-6.

Catalogue of Curiosities and Very Old Carved War Clubs &c &c Col[l]ected at the Figi or Cannibal Islands by an old Resident among the Savages

Purchased in 1867

1-3 Fine Old Carved War Clubs formerly belonging to Bakthorn Bau the principal Chief or King of the Figi Islands.

4-5 Dancing Clubs used by the Savages in the War Dance before engaging their Enemies.

6-8 The Boomerang Clubs of the Figians.

9-10 Short Clubs taken from an Idol Temple after hanging there some time, as an offering to their Gods.

11 Native War-Drum or Tongituri.

12-15 Four Hunting Spears thrown by the Savages with great dexterity and marvellous precision.[1]

16 Shield used by the Natives to protect their Bodies from the Spears of their Enemies.

17-18 Shields used in War as a defence against the Arrows.[2]

19 Native Hunting Club.

20-25 Six Figian Bows & Bundle of Arrows.

26 A Small instrument used by the Savages in Tattooing their Faces & other parts of their Bodies.

27 Native Flute.

28 A Dish used to offer Human Sacrifices to their Idols.

29 Large Tray used on the occasion of a Fish offering to their Gods.

30 A Wig made by the Savages of Hair Taken from the Scalps of Captives Taken in Battle.

31 A Chiefs Cap made of Feathers from Figian Birds and worn by them at their great Cannibal Feasts after a Victory over their Enemies.

32-35 Sun Shades worn on the Heads & Native Womens Head dresses.

36 Apron belonging to a Chiefs Daughter and worn at their Feasts.

37 Piece of Cloth made by the Natives from the Bark of the White Mulbery Tree.

38 Wedding dress made from the Bark of a Tree, and Dyed with Sandal Wood and dried in the Sun.

39 A Small Collection of Native Shells.[3]

40 Fine piece of Native Cloth made from the Bark of a Tree and used to bind round their Heads to protect them from the Heat of the Sun.[4]

[1] One of these spears was given to the Trustees of the Christy Collection in 1869 in exchange.
[2] One of the shields was given to the Christy Collection in 1869, in exchange.

[3] If purchased, gone to the Nat: Hist: Museum.
[4] Not yet identified among the many pieces we have.

LIST OF ANTHROPOLOGICAL OBJECTS TRANSFERRED FROM THE ASHMOLEAN TO THE PITT RIVERS MUSEUM

Transcribed by Alison Petch, annotated by Arthur MacGregor

Pitt Rivers Museum, AMS 25, compiled 1884-6. Two vellum-bound volumes, inscribed in ink on the cover 'List of Anthropological objects Transferred from the Ashmolean to the Pitt Rivers museum, 1886. [vol. I] Asiatic, African, Esquimaux, and American [vol. II] New-Zealand, Australian, S. Pacific Islands, etc'. Either vol. *c.*370 folios, 320 by 200 mm, some of them blank.

From the earliest days of the Tradescants' museum a significant component of their collection was formed by the 'artificial rarities' – man-made objects from around the world. To some degree this element was eclipsed following Ashmole's donation of the collection to Oxford, where (at least amongst the academic community) it was the more 'scientific' dimensions of the collection that were valued most highly. The donation in 1776 by Reinhold and George Forster of material from Captain Cook's second voyage to the South Seas (see pp. 249-52) should have added significantly to the Ashmolean's prestige in this field, although contemporary records of public expressions of interest are hard to find (see Coote *et al.* 2000). Under the successive keeperships of the Duncan brothers (1823-29 and 1829-54) the artificial rarities took a further step backwards as the Duncans rearranged the collections with a primary emphasis on the natural history specimens while relegating the works of man to a secondary position; under the arrangement which they devised, it was anticipated that the visitor 'w[oul]d be able to give his undivided attention to ... the Animal Kingdom, and then omitting the works of art or reserving them to the last, would proceed to the great room up stairs, where the ... birds would attract his notice' (MacGregor and Headon 2000, p. 405).

To judge from entries in the Duncans' own catalogue (Ashmolean 1836) and the subsequent printed list of additions (Ashmolean 1836-68), the tide of public interest was already running contrary to the view that the works of man had little place in the Museum, for a steady (if modest) flow of donations can be detected, doubtless fostered by Britain's colonial adventures during this period. Of special note are important collections acquired from a number of sea-captains, including W.E. (later Sir William) Parry (1790-1855), who led successive expeditions in search of the North-West Passage. One of these took place in 1819 in the *Hecla* with the *Griper* in company, and another in 1821-3 in the *Fury*, accompanied by the *Hecla* then under the command of another donor, Commander G.F. Lyon (1795-1832). Lyon returned to the Arctic in 1824 with the rank of Captain on the *Griper*; Francis Harding, a lieutenant on the *Griper* under Lyon, also gave material to the Ashmolean. A number of other items of significant importance came from the explorer Captain (later Sir Frederick) Beechey (1796-1856), who voyaged in the *Blossom* to the Bering Strait in 1825-8.

Some small but interesting collections of African material are associated with William Burchell (1782-1863), the explorer and naturalist who spent the years 1810 to 1812 penetrating deeply into the South African interior. The collections he amassed on that occasion, mostly donated to the Ashmolean by Burchell's sister, are referred to in his own account of these *Travels*, published in 1822-4. (A number of natural history specimens donated by Burchell in 1824 are referred to on p. 241, above).

After the departure of the entire natural history collection for the new Natural Science Museum, completed in 1860, and the purchase in 1867 of a small but significant collection of Pacific material (p. 253), almost twenty years were to pass before signs of active curatorial interest in this material can be detected, although the attentions of the newly appointed Arthur Evans (elected 1884) seem to have been focused particularly on items from the founding collection, prized for their significance in terms of the Museum's institutional history rather than for their independent interest. Although Evans took pains in this context to correlate the surviving specimens with the early catalogues (using particularly AMS 8 and 18) and to redisplay them in an integrated manner, the fate of the other ethnological material had already been sealed by a decision of the University that as part of a process of rationalization, all such specimens should pass to the Pitt Rivers Museum, whose establishment had been agreed in the year of Evans's appointment (see most recently Petch 1998). It was in this context that the catalogue reproduced here was compiled, although it may be noted that (no doubt due to Arthur Evans's intervention) the Ashmolean ultimately withheld from transfer those items which could be associated with its own founding collection.[1] The complementary nature of the two institutions is further indicated by the retention (as recorded in the following texts) of a few specimens from modern, stone-using cultures in order to illustrate the significance of prehistoric stone tools in the Ashmolean's collections. Very few items were alienated from the collections at this time, although occasional references appear to specimens sent in exchange for material from the Christy collection, which had passed by bequest in 1865 from its founder, Henry Christy, to the British Museum, but which (due to lack of space at Bloomsbury) remained at that time in its original premises at 103 Victoria Street in Westminster, in the charge of the British Museum's Keeper of British and Mediæval Antiquities, Augustus Wollaston Franks (see Cherry and Caygill 1997, *passim*).

[1] A number of items now recognized as coming from the Tradescant collection escaped notice at that time and accompanied the other material to the Pitt Rivers Museum, where they remain. A list of those items, prepared by Lynne Williamson, is given in MacGregor 1983, pp. 338-45.

By 1884, when the under-keeper Edward Evans drew up this remarkably astute 'List of Anthropological Objects', the discipline of anthropology had only just begun to make an impact on the academic curriculum at Oxford. Evans surely went as far as could reasonably have been expected in ensuring that the collections which reached the Pitt Rivers Museum from the Ashmolean arrived with proper documentation. The impressively full descriptions we may take to be his own work,[2] while information on the origins and collection history of the objects, together with details of their donors, was drawn from the various printed and manuscript catalogues produced by his predecessors in the post. For the most recent acquisitions, including the Ramsden collection purchased by the University in 1878, these inventories were largely the work of George Rowell, who had acted as handyman and general assistant at the Museum since the 1820s and who succeeded to the under-keepership in the 1850s; Edward Evans worked under Rowell from the time of his appointment in 1869 and was to succeed him in 1879; the relationship seems not to have been entirely amicable.

Rowell's final years at the Ashmolean were clouded by disputes concerning the printing of catalogues he had prepared for some parts of the archaeological collections, and following his resignation an incident was to erupt involving elements of the anthropological material listed below. After Rowell's departure from office, Edward Evans had begun to explore the contents of an 'outhouse' within the Museum's perimeter, where he discovered numbers of items identifiable as belonging to the Tradescant collection as well as more recently acquired ethnological objects. In the ensuing spate of accusation and counter-accusation concerning the apparent lack of exercise of proper care over this material, the Museum and its servants attracted the severest criticism (see Ovenell 1986, pp. 237-40; MacGregor 1997, pp. 604-5). Several of the entries in the following list are annotated in the original catalogues as having been 'rediscovered' in this way, but due to the repetitive nature of the information it has been omitted here.

Also omitted from the transcript are all the administrative details relating to the transfer of the collection to the Pitt Rivers Museum and later annotations which may be regarded as secondary in nature. Inserts made in the text itself are, however, included here and are designated thus: \Fiji/. Again in the interests of brevity, details of dimensions which are written out *in extenso* in the original are abbreviated here as follows: Length, L; Height, H; Thickness, Th; Diameter, D; feet, ft.; inches, in.; page-numbers within the catalogue volumes are omitted. References in the original text (however speculative) to the printed catalogues of the Ashmolean Museum are cited at the end of the relevant entry so as to conform with conventions adopted elsewhere in the present publication, while other references within the text are reproduced as given and are identified in the bibliography (see pp. 417-19). Evans makes particular use of Samuel Rush Meyrick's *Ancient Arms and Armour* (1854) and John George Wood's *Natural History of Man* (1874). Surviving items from the founding collection are also referred to the Ashmolean's tercentenary publication, *Tradescant's Rarities* (MacGregor 1983); a number of more speculative references to the original catalogue of that collection (Tradescant 1656) have not stood the test of time and have been omitted so as to avoid confusion.

Edward Evans's original text is peppered with amendments inserted at various dates and by various hands, amounting at times to a commentary on the primary records and enlarging, amending and sometimes contradicting the information given there (and deriving mostly from Rowell's notes) concerning the collection, provenance, donor, and history within the Museum of the various specimens. At times these amendments themselves contain statements which are demonstrably wrong and in order to give some coherence to what follows they have largely been excluded from the transcript. In our attempt to provide a clear *ur*-text we have been forced at times to take editorial decisions that can only be described as arbitrary: this is especially true in relation to the extensive amendments by Evans himself, but our difficulties extended too to remarks appended by later specialists which re-provenance or re-identify some of the material. For all details of these, readers are referred to the full text which is recorded in the form of a database at the Pitt Rivers Museum. This valuable resource was compiled in 1998-9 by Alison Petch and it is from this that our own text has been abstracted. Any shortcomings arising from the editing that has taken place for the present publication must be attributed to us rather than to her.

Volume I: Asiatic, African, Esquimaux, and American

[Asiatic]

1 Burmese Manuscripts, in the sacred Pali characters, (in which only the sacred books of the Budhists may be written). Written with black \slightly/ raised letters on seven thin sheets of ivory, each sheet being L 22 in. and W 3 3/4 in., the two ends \and the whole of the backs of two of them on each side of each leaf/ being ornamented \with diaper/ in red and gold. [-The two outside covers \thicker, apparently wooden/ being richly painted in like manner \in brown and gold/ on the outer side and plain [-red\brown] on the inside.] Size L 22 by W 4.
Ashmolean 1836, p. 180 no. 57; MacGregor 1983, no. 80.

2 Ditto, ditto, on twenty-four lacquered sheets made out of leaves of the Talipot Palm, richly illuminated in red and gold, with \five rows of slightly/ raised black letters. The wooden covers being also [-red\richly

[2]Evans's notes on items associated with Cook's voyages are particularly detailed. His notes on the published accounts of the voyages, in which he attempts to list every item that might have been collected and which survive in the archives of the Pitt Rivers Museum, provide eloquent proof of his scholarship.

256

painted in brown] and gold on the \outside and plain brown on the inside./ Size of each sheet L 21 ½ in. and W 3 3/4 in. Size of the covers L 22 in. W 4 in.
Ashmolean 1836, p. 180 no. 58; MacGregor 1983, nos. 81, 83.

3 Burmese book, in smaller, and the ordinary Pali characters; written or engraved on one hundred and sixty-four plain sheets made of Talipot leaves, with an Airootanie or style, (see No. 50), in a similar manner to the writing of the Ancients on wax. These are the characters used by the Burmese for ordinary business and other matters. Each leaf L 20 in. and W 2 1/4 in. \the edges being ornamented in red and gold/. The covers are of wood painted of a plain shiny red. Given by the Rev John Watts. Univ[ersity]: Coll[ege]: 1827.
Ashmolean 1836, p. 180 no. 59.

3a Two leaves similar to the preceding No. 3 but rather larger, and the characters not blackened after being scratched in. They probably do not belong to the same book. L 21 6/10 in. W 2 1/4 in. The edges gilt only.
MacGregor 1983, no. 82.

4 Malabar Manuscript written or engraven on one hundred and seventy-four plain sheets of Talipot leaves in a similar \manner/ to No. 3, except that the characters are Tamil, a language used in the South of India. With carved wooden covers. L 14 1/10 in. W 1 7/10 in. Given by the Rev: Innes Warwick, 1796.
Ashmolean 1836, p. 180 no. 61.

5 A letter written in like manner, on a narrow strip of Talipot leaf, in Telegu characters, a language also used in the south of India. L about 18 in. W 7/10 in. Given by Lady F. Trail, Bath. 1831.
Ashmolean 1836, p.180 no. 74.

6 Burmese dispatches, picked up on the field of battle at Rangoon 1824. They are written in the ordinary Pali characters, with white on two pieces of coarse black coloured paper, \in size 16 3/10 by 12 4/10 in.: and 15 by 11 6/10 in./ each piece being [-L 16 in. and W 12 1/2 in]. Given by Rev: Mr. Hall, Chaplain to the British Forces in India 1826. Ashmolean 1836, p. 180 no. 60.

7 Thirty-one unburnt clay models of Chatyas or Dahgopes a form sacred amongst the holders of the Bud\d/hist faith, consisting of a dome surmounted by a spire, and used for covering sacred relics; erections of solid masonry for that purpose being known of more than 500 ft. in height. These models, with many others, were discovered in a cave on the side of a hill called Moneragalle, or the Peacock Rock, situate[d] in the south-east coast of Ceylon, and not far from the famous Temple "Kattregam". The models admit of a portion being easily detached, and within them are found seals (of like material) impressed with Sanscrit characters, in relief, which, from their having been inclosed when the outer part at least was in a plastic condition, are much defaced and obliterated. The seals were submitted for examination by the late Professor H.H. Wilson, who stated that the characters are Sanscrit of an early date, probably the 13th century, and the

sentances, as far as they could be made out, relative to the Budhist faith. It is stated that no such objects are known to have been found in any other place. In general they were of about D 1 3/4 in., only a very few of the larger size, D 3 in. being found. Given by Lieut. Colonel Sim, R.E. Surveyor General of Ceylon, 1854 [? 1857].
Ashmolean 1836-68, p. 15.

8 A Hindoo, oblong-shaped wooden box, with sliding lid. Richly and elaborately painted in gold and colours with figures of various deities, \seated/; and containing one hundred and twenty, circular-shaped, highly painted playing cards of various patterns. They are in eleven suits, ten of the suits being marked as in the ordinary playing cards, from one up to ten, but with figures of human heads, Lions, Horses, Pigs, Tortoises, Battleaxes, Bows, Standards and Umbrellas etc. The eleventh set of twenty cards, (and which perhaps is not complete), are all elaborately painted picture cards, with figures similar to those on the box. \Some of which are represented on horseback/. Size of box L 7 3/4 in, by 2 5/8 in. square. Size of cards D 2 in. (There are four odd cards wrapped in paper). Given by the Rev. George Barnes, D.D. sometime Fellow of Exeter College, and late Archdeacon of Bombay, 1845.
Ashmolean 1836-68, p. 4.

9 A Ceylonese Comb of ivory, on which is carved on each side, in the oblong space between the two rows of teeth, the Indian deity Buddha, with elephants performing his sprinkling, or inauguration, by emptying vessels of water over his head. The carving is cut completely through and ornamented with red lines and gilding, the oblong frame surrounding being ornamented in like manner. L 4 1/2 in. W 6 in. Given by Lady F\rancis/ Trail, Bath, 1831.
Ashmolean 1836, p. 180 no. 72.

10 A Burmese comb, of hard black wood, with very \fine/ teeth of \hard/ light brown wood along each side, the four corners being \also/ of the black wood and rounded off. It is ornamented along the middle, (which is elevated considerably above the teeth), with \two rows of/ oriental characters incised and silvered. L 5 1/10 in. W at ends 2 3/10 in., in the middle 2 in. Th 1/2 in. Given by Mrs F. Spring \Lady of the Rev: F. Spring A.M. Presidency Chaplain of/ Madras. 1836. \(See no. 110)/. [Letter pasted in catalogue] '2nd June 1836. Sir, I have just received from India the accompanying curiosities, which I am directed to \forward to/ the Ashmolean Museum. They consist of a Ceylon basket [1.110], a Burmese comb [10] and a piece of Marble from the Coorg Rajah's Palace [254], and are presented by Mrs. Spring, lady of the Revd. F. Spring, AM, Presidency Chaplain of Madras in the Hon'ble E.I. Company's Service. I understand that the Ceylon Basket is made of the leaf of the Date tree and that similar baskets are generally used by the natives for the purposes of keeping betel in - i.e. areca nuts, black pepper, vine leaves and chunam [?], which they

are accustomed to masticate. I am, Sir, Your humble serv't, T.J. Spring 100 Grove St. Camden Town, W. London. To The Keeper of the Ashmolean Museum.'
Ashmolean 1836, p. 181 no. 85b.

11 Batta \manuscript/ inscribed on a piece of bamboo, obtained from the interior of Sumatra. L 9 in. D 1 1/4 in. The characters are incised. Given by J. Park Harrison, Esq M.A.1880.

12-15 Four miscellaneous bundles \or packets/ of manuscripts, written on one hundred and ninety-six sheets of Cajan or Palm leaves (Bark \and paper/), "Supposed to contain the sacred writings of the Assamese, as they were mostly picked up in the Temples of that nation, which had been defiled and partly destroyed by the Burmese, who with ruthless hands destroyed and laid waste all that was held sacred in every country in which they obtained a footing". Sizes from 10 1/4 by 3 in. to 7 by 2 in. Found during the Burmese War. Given by Colonel \T./ Shaw. Bath. 1827. [Letter pasted in catalogue]: Bath 25th Jany 1829: Dear Duncan, My young Friend Edwin Hotham w[illeg.] and this with a bundle of Cajan or Palm leaves, supposed to contain the Sacred Writings of the Assamese, as they were mostly picked up in the Temples of that nation, which had been defiled, and partly destroyed by the Burmese who with ruthless hands despoiled and laid waste, all that was held sacred in every country in which they obtained a footing. The [illeg.] such Barbarians was [illeg.] the Curse of Humanity and in that respect Lord Amhurst has done good. With every good wish for you in which my Wife joins believe me Thos. Shaw.

16 An Indian scratchback of ivory, elaborately carved, having on each side [of] the handle a winged figure, sitting in Oriental fashion \with a man and woman on one side above, and a flower on the other,/ and ending in [-the head of] what looks like the head of a boar or wolf. It has unfortunately been broken. L 5 6/10 in. Width of scratching end 1 7/10 in. Given by W. Lloyd. B.C.L. Wadham College. Keeper of the Ashmolean 1796-1815.
Ashmolean 1836, p. 180 no. 69.

16a 'A Mother of pearl saucer, and implement used by the Indian Ladies to remove the irratation occasioned by Musquitoe, which w[h]en in use has a long handle attached to it.' (Both neatly carved. Diameter of shallow oval saucer with scalloped edges 4 3/10 by 3 5/10 in., and size of the other object which has a copper cylindrical socket at the smaller end for insertion of the handle, L 3 1/10 in.: D 1 7/10 in.) Found by Lieut. Augustus Abbott in the Fort, after the Seige of Bhuetpore Jan'y 18th 1826. Presented by him to the Rev'd Alexander R.C. Dallas, \Yardly vicarage, Buntingford, Herts/ July 4 1828.

17 A [-Japanese\Persian] Spoon of carved \pale brown (box?)/ wood, used for drinking Sherbert. The boat-shaped bowl is extremely thin, and together with

the fine openwork of the \upper part of the/ handle is a good deal broken. Present L 12 1/2 in.
Ashmolean 1836, p. 181 no. 81; MacGregor 1983, no. 69.

18 A circular, flat, box of ivory, with rounded edge: ornamented \with/ various circles enamelled in black, and with wrought silver mountings at the hinge and clasp. Used in India for carrying leaves of the Betel tree. W 2 5/10 in. and Th 7/10 in. It has a small chain of white metal \not silver/ [-attached\connected] by one end to the clasp, to the other end of which is attached a little paddle-shaped cutting implement, the whole measuring 7 1/2 in. in length. Given by Lady Francis Trail in 1831. Bath.
Ashmolean 1836, p.180 no.73.

19 A circular wooden box, [-flat] with flat bottom and lid; coloured an uniform green on the inside, and mottled red and yellow outside. Used by the natives of Hindustan as a snuff-box, the cover has been broken. D 2 4/10. H 9/10 in. Given by Master Robert Tudman Oxford, 1882.

20 A Matchlock gun [-from\made at] Delhi. The stock (which reaches nearly to the muzzle) is richly painted with flowers and birds, in gold, blue, \green,/ and red, on [-and] a white ground. The barrel L 3 ft. 9 in. in length, is made of mixed metal, and beautifully inlaid at both ends with a diaper pattern in gold, together with the metal mountings and end of ramrod. It has a long fuse, \or slow match made/ of green blue and white \coloured/ cotton, attached, \and/ wound around the stock. Whole L 5 ft. 4 5/10 in. A similar Gun is figured in Meyrick's "Ancient Armour" vol. 2. Plate CXXXVIII fig 11. Given by T. Thornhill, Esq., Woodleys, near Woodstock, Oxon. 1825.
Ashmolean 1836, p. 179 no. 28.

21 A two edged, double-grooved Dagger, with curved blade, and handle of pale green jade and curved also. From Delhi. The sheath of green velvet is elaborately and beautifully ornamented with silver mountings, enamelled with blue and green in patterns and which has been a good [-del\deal] damaged. L of dagger 15 1/10 in., or in the sheath 17 in. Given by Masters Ed. and Chs. Thornhill, Woodleys [-1825\Near Woodstock, Oxon. 1827]
Ashmolean 1836, p. 179 no. 29.

22 A two-edged Coorg knife, or \East Indian/ dagger; the haft, and the upper portion of the wooden sheath being of highly wrought silver work. The blade 7 1/2 in. in length, and greatest width 2 in., diminishing and curving to the point, with a strong ridge down the middle. Whole L 12 1/2 in.: L of sheath 8 1/4 in. D 2 2/10 in. It appears to have been covered with thin brown leather, at least on one side, which remains, the other side shewing the bare wood. (A similar weapon is figured in Wood's "Nat: Hist. of Man" vol: 2. p. 770 fig. 5) Given by A.E. Knox, Esq. Brasenose College. 18[].
Ashmolean 1836, p. 179 no. 30).

23 A small three-edged Indian ? dagger, the blade being of steel, L 4 1/2 in., the hilt portion \of which is/ ornamented and coraseley [*sic*] engraved. The haft of ivory L 3 3/8 in., fluted lengthways each \of the eight flutes or/ hollows being set with a row of \small/ white metal studs. \It/ appears to be intended to represent a man's foot and trowsers, the \lower/ end being capped with lead, which appears to have held a large stud, or jewel. Point of blade lost. Present L 8 9/10 in.
Ashmolean 1836, p. 179 no. 38 [?].

24 A Malay Kris; the blade waved, L 13 5/10 in. Handle of wood, curiously carved to represent a grotesque human and animals' \(probably a cat's or tiger's)/ face on one side and at the back the head of some monster, which has been partly broken off. Whole L 19 in. For a weapon of this sort see Wood's "Nat: Hist: of Man" vol: 2. p. 472. Also Meyrick's "Ancient Armour" vol: 2 Plate CXLVII fig 12, 13.
Ashmolean 1836 p. 179 no. 32; MacGregor 1983, no. 29.

25 A Malay Kris; the blade waved and of mixed metal, L 13 7/10 in. Haft of brown [-coloured] wood, elaborately carved in a grotesque representation of some animal with a Parrot-like beak. Whole L 17 8/10 in.
Ashmolean 1836, p. 179 no. 32; MacGregor 1983, no. 30 [?].

26 Malay Kris; the blade of mixed metal, straight, L 11 1/10 in. Haft of brown wood, and delicately carved into the form of a grotes[q]ue human figure, probably that of a woman as it has long hair, \down the back/. It appears to have lost four square-shaped stones or jewels from the ferrule of the handle. Whole L 15 in.
Ashmolean 1836, p. 179 no. 33; MacGregor 1983, no. 28.

27 Malay Kris; the blade waved, of two metals blended together, (steel and silver?) which gives the metal a singular wavy appearance; L 14 5/10 in. Handle of wood slightly curved and 4 in. long. Sheath of light brown wood, quite plain. L 16 3/4 in. Given by the Rev: H.O. Coxe, M.A., C.C.C., Bodley's Librarian. 1865. This is very like the one figured in Meyrick's "Ancient Armour" vol 2. plate CXLVII, Fig 12, 13.
Ashmolean 1836-68, p. 6.

28 Malay Kris; the blade of \two/ metals curiously blended; similar to no. 27. L 12 8/10 in. Handle elaborately carved in somewhat similar manner to that of No. 25 above, L 3 8/10 in. Sheath of light brown wood, quite plain, and bound round \the lower half/ with a narrow strip of cane, with a bit of black wood \projecting/ at the end. Given by the Rev. H.O. Coxe. M.A.\1865/
Ashmolean 1836-68, p. 6.

29 Malay Kris, with slightly waved blade made of one kind of metal, L 15 6/10 in. Handle of brown wood, carved with a grotesque figure similar to the preceding but not so elaborately \executed/. L 4 in. Sheath of dark brown wood quite \plain/ with the top \and bottom/ wanting L 15 5/10 in. (Ramsden collection No. (?)1). Purchased by the University in 1878.

30 Malay Kris with straight blade of mixed metal L 11 1/10 in. Handle of dark brown [-wood\horn], turned at a sharp angle with the blade and not carved. L 4 5/10 in. Sheath of light brown wood, and bound round the lower part \for the distance of 3 6/10 in./ with thin cane, with a \lozenge shaped/ piece of wood \projecting/ at the end, \and a ferrule of horn at the top/ (Ramsden collection no (?)\76/). Purchased by the University in 1878, etc, as above.

31 A Coorey (Kookery?) knife, used as a weapon of war, and for other purposes, by natives of the Malabar coast, (also by the Polygars of South India). The blade is W 4 in. near the upper end and abruptly curved to a point, ([-very\somewhat] similar to a woodman's ducket); nearer to the handle it is contracted to W 1 3/10 in. The handle is L 6 in. and cased in moulded brass and steel. Given by the Rev. F. Spring, \St./ Edm[und]: Hall. 1825. A similar weapon is figured in Meyrick's "Ancient Armour" vol. 2 pl CXXXVII fig 13, and called "a Polygar knife".[3]
Ashmolean 1836, p. 179 no. 25.

32 A Nair knife, from \and used along/ the same coast as the preceding, to which it is somewhat similar in form, but still more resembling a woodman's ducket. Blade L 15 in., 3 3/10 in. in greatest width, and 2 2/10 in narrowest part. Handle of wood and steel L 4 5/10 in. Given by the Rev. F. Spring \St Edm[und]. Hall/ 1825. A similar weapon is figured in Wood's "Nat: Hist: of Man", vol. 2 p. 760, also Meyrick's "Ancient Armour", vol.2 pl. CXXXVII fig 13.
Ashmolean 1836, p. 179 no. 24.

33 A sheath, worn by the Marhattas; of black leather, ornamented or embroidered with fine \split/ quill work, and tipped at the end with engraved silver. Containing a Goorka Cookree knife, (a weapon of war), two small knifes, \(kurds)/, of the same form, [-and] a \large/ pair of steel tweezers with moveable brass head, and a little pouch for holding a portion of the Koran, written out as a charm. (Which is wanting). The cookree is L 20 2/10 in. from tip to tip, the back of the blade and the handle together forming a convex section of a circle of about D 2 ft.; blade L 14 in. measuring along the back, greatest W 1 8/10 in. diminishing near the handle to 1 in. The two knives are L 8 in. and 7 2/10 in. respectively measuring along the back, from tip to tip. Tweezers L 4 5/10 in. Given by the Hon. F.J. Shore, 1830 (?). See Meyrick's "Ancient Armour" vol. 2 pl. CXXXVIII figs

[3] 'A weapon of war used by the natives of the Coory country and hence denominated a Coory knife. It is carried at the back, the blade being uppermost as high as the top of the shoulder. It is a weapon of so formidable a nature that a Buffalo has been decapitated by it at one blow. Coory is a small country situated in the mountains about 30 miles inland, on the Malabar coast, and governed by an independent and despotic rajah. Also a Nair knife used along the same coast. An Airootanie or style and knife in a silver case, the apparatus used for writing. A small white cap curiously wrought, worn by the natives in the interior of the Malabar Country.'

14 to 16. Also Wood's "Nat. Hist. of Man", vol. 2. p. 760.
Ashmolean 1836, p. 181 no. 77.

34 A larger Kookree knife than the preceding, from India. The [-blade] \whole L/ is 21 in. measuring down the back, and \the blade/ 2 in. in greatest W. The sheath is of black leather, sewn together down one side, L 16 1/2 in. measuring the outside curve. Given by E.R. Owen Esq, Beaumont Street, Oxford 1874. For figure of similar object see Wood's Nat: Hist: of Man, vol. 2 p. 760.

35 A Kookree knife, in black leathern sheath, the wooden handle having a border of quatrefoils carved round it. Whole L on outside curve 18 5/10 in. Greatest W of blade 1 8/10 in. The small sheaths at the side of the larger one were empty when it was acquired by the Museum. \Length of case 14 in. on greatest curve/. From India. Given by Dr Jarbo, H.M. Bengal Ecclesiastical Establishment, 1878.

36 A sword-belt of Deerskin, dyed black, \stamped with Diagonal lines/ and elaborately embroidered with fine quills from peacocks' feathers \on the outside/. From Belaspore, an ancient Hindoo city in the lower Himalaya range of the Sutteje. Whole L 6 ft. 8 in. Greatest W 6 1/4 in. Given by C. Raikes, Esq. Bengal Civil Service, 1838.
Ashmolean 1836-68, p. 13.

37 A chukee, or War Quoit, used by the Sikhs \or Singhs in the Punjab/. They are of different sizes and are carried \one above another/ fitting over the crown of a conical-shaped hat, and are thrown from on horseback, being whirled round the fore-finger, and discharged with sufficient force to strike off a limb (?). It is a flat ring of steel, W 9/10 in., with the outer [-edge\circumference] brought to a thin edge; thickened and rounded on the inner [-edge\circumference], which is about Th 1/20 in. D 6 5/10 in. For a similar article and the way they were carried, see Wood's "Nat. Hist of Man" vol 2. p. 771. Given by the Hon. F.J. Shore. 1830.
Ashmolean 1836, p. 181 no. 78.

38 A small purse, or bag, of blue and white cotton; containing twenty-five small copper coins, used amongst the Hill Tribes of India. About 800 of these coins go to the Rupee (value about two shillings), that is about 33 to one penny. Each coin is about D 4/10 in., and stamped on one side only with an oriental character, but these differ considerably. Given by Mr. G.A. Rowell. Oxford. 1865.

39 A small purse, of knitted cotton cords, coloured in red, blue, yellow and white stripes, with long strings at top which act as reeving strings for closing the mouth, [-of the bag], and probably for carrying it also. Used by the natives of Hindustan. Size about 3 in. square. Given by Mr Robert Tudman, Oxford. 1882.

39a A bag made of closely knitted brown cotton, attached by two loops at the sides, to a stout brass ring, the ends of which overlap and are rudely ornamented with incised lines, D 2 5/10 by 2 3/10, and Th 3/20, L of bag 7 in.: W at top 6 1/2 in. Probably belonging to the Chuckmuk, No. 40, or No. 41.

40 A chuckmuck or Tinder-box, formed of a piece of flat steel L 4 3/10 in. and W 1 in., fastened at the back into a pouch of \thick/ leather which is bound and ornamented with embossed brass-work, and containing a kind of tinder. They are carried by the men of Kanowr (a mountainous district 32° N. Lat. 78° E. Long. between the Himalayas and Chinese Tartary); attached to a double [-line\cord] which encircles the waist, the [-line\cord] being made of [-some fab[illeg.]] brown coloured cotton interlaced with fine brass wire. The steel is not with it. Whole L 23 1/2 in. Given by C. Raikes, Esq. Bengal Civil Service. 1838.
Ashmolean 1836-68, p. 13.

41 A strong narrow leathern strap, ornamented with a double row of Cowry shells, each shell being [-partly\slightly] ground down; to which is attached by a \short/ cotton line encircled by brass wire, a brass box, having \something of a pincushion shape with/ four long projecting corners \and/ holding a small steel, flint, and tinder. The cotton line passes round both top and bottom of the box, through a loop attached to each, and the wire above being moveable is drawn \up or/ down [-to keep] as the box is open or shut. Usually worn among the Hill Tribes of the N. East of India. L of strap 3 ft. 10 5/10 in. W 7/10 in. Size of box from corner to corner 2 8/10 by 3 in.; L of cotton line 4 2/10 in. Given by Mr G.A. Rowell, Oxford, 1865.
Ashmolean 1836-68, p. 14.

42 A trefoil-shaped brass ornament, the upper foil forming \almost/ a \complete/ ring of \Th./ 7/10 in. and D \4 2/10/, to which is loosely attached a strong iron pin for fastening it to the dress. The two lower foils are \spiral/ disks D 3 2/10 in., each [-having\with] a button-like projection in the centre. The whole ornament is elaborately but somewhat coarsely engraved. Used as a brooch for fastening the blanket worn by females of Kanowr, between the Himalayas and Chinese Tartary. Whole size 6 9/10 by 6 5/10 in. Given by C. Raikes. Esq. Bengal Civil Service, 1838.
Ashmolean 1836-68, p. 13.

43 An ornament made of a piece of brass rudely engraved, D 4/10 in. in the middle, which is perforated and attached to a copper ring; and diminishing to a point, and curved to form a hook at each end. Used for a like purpose as No. 42 preceding by the males of Kanowr. L 4 in. Given by C. Raikes, Esq. Bengal Civil Service, 1838.
Ashmolean 1836-68, p. 13.

44 A pipe with two tubes, on the principle of the double flag\e/olet, used by the peasants of Kanowr, who procure them from the Lamas or Priests of Thibet. The

tubes are of Bamboo, D 6/10 in. and L 15 in., and bound together side by side by eleven, separated, embossed brass bands of different \widths/, the two at the ends being much \the/ widest [-than the others]. The \two/ narrow \and moveable nearest/ bands [-next] the mouth piece, appear to have been put on by way of ornament only, the uppermost having been set with three turquoises \arranged triangular form,/ one of which has been lost. Each tube has six holes for the fingers, and is tuned for the two octaves. Given by C.Raikes, Esq. Bengal Civil Service, 1838.[4]
Ashmolean 1836-68, p. 13.

45 A pair of rudely made leaden ear-rings, used by the natives of Hindustan. They are dome-shaped, having a large ring fastened with hook and eye, for the ear, [-passing\and which passes] through a projecting piece on the top of the dome, and having sixteen globular shaped pendants suspended round the lower edge of the dome by little pieces of twisted flat wire. The whole work appears to have been cast. L 2 7/10 in. D 9/10 in. Given by Master Robert Tudman, Oxford, 1882.

46 [-Six\ Five] bone or ivory beads, [-] circular with one end concave and the other convex, and orna[mented] round the sides with lines of black and blue. D 9/20 in. and 7/20 in. Indian ? (or Arabic? from Cairo?) Given by Greville J. Chester Esq. B.A. 1872.

47 A pair of Turkish slippers \with pointed turned up toes: they are/ of dark blue cloth, highly decorated with gold and silver embroidery work, edged with red ribbon and gold lace, and ornamented at the toe and heel with tassels of fine pink silk threads, the soles being of bright coloured leather. L 9 5/10 in.: W 3 5/10 in. Given by Mrs Birkbeck, widow of Dr. Birkbeck, originator of the Mechanics' Institutions. 1873.

48 A Turkish tobacco-pipe bowl, of fine brown coloured clay, ornamented with borders of embossed fleur-de-Lys pattern, etc., which [-have been gilded \are enriched with gilding]. H 2 in. L 4 in. D 1 19/20 in of projecting flat circular-shaped bottom 2 3/10 in. Given by Mrs Birkbeck 1873.

49 Ditto of a similar shape, but smaller, and darker in colour, and without any gilt. Ornamented round the place for the insertion of the tube with a moulded pattern. It has been used for smoking. H 1 5/10 in. L 3 1/10 in. D of top 1 7/10 in., of bottom 1 9/10 in. Given by Mrs Birkbeck, 1873.

50 A silver sheath or case holding a Malabar Airootanie or style, [-are\a pointed] instrumented [*sic*] used for writing with (see No. 3). It is \octagonal except the point part which is rounded,/ made of steel richly and minutely ornamented with inlaid silver, with a projecting boss D 8/10, at about 1/4 from the top. L

11 in., D near the boss 9/20 in. Also a steel knife in a richly embossed silver handle; L 8 19/20, D blade 8/10 in., (which has been much injured by rust), L 5 4/10 in. and is rather thin and sharp pointed. [-Usually] L of case 7 1/10 in.; greatest D which is the top 1 1/10 by 19/20 in. Given by the Rev. F. Spring St. Edmund's Hall. 1825.
Ashmolean 1836, p. 179 no. 48.

51 A small cap, worn by natives (Mahomedans) of the interior of Malabar. It is of white cotton curiously wrought on a grey underground in a kind of quilted pattern. D 6; H 4 in. Given by the Rev: F. Spring. 1825.
Ashmolean 1836, p. 179 no. 46.

52 A Tartar skull cap, in silk embroidered work in patterns of a great variety of colours. In shape it is about half globular, and made in six separate pieces and then sewn together, the seams being visible on the inside. H 5; D 6 ½ in. Given by J.J. Knowles [T.J. Knowlys?] Trinity College, Oxford. 1834.
Ashmolean 1836, p. 179 no. 47.

53 A spoon of hammered copper, symbolic of []. Used by the Hindoos for drinking water from the river Ganges. L 3 2/10, D 1 2/10 in. Given by Miss Wright, Park Crescent, Oxford, 1875.

54-56 Three Persian thumb-rings, used with the bow; Of Cornelian or Agate. One of bright red with darker clouds and streaks, \1 8/10 by 1 7/20in./. One of white streaked with brown, size 1 11/20 by 1 3/10 in. and the third of nearly transparent white clouded with more opaque white, \size/ 1 13/20 by 1 5/20 in. One [-side\half] of each ring is like an ordinary ring flat on the inside and rounded on the outside, the other half being prolonged [-into\to] a heart-shaped point thus [*drawing*]. (For figure of a similar object see Meyrick's "Ancient Armour" vol. 2, pl. CXXXV fig. 10).
Ashmolean 1836, p. 141 no. 398; MacGregor 1983, nos. 60-62.

57-58 A pair of Oriental, probably Indian bracelets, each formed of nine circular studs of red, white, and green enamel (cloisonné?) in gold, and each stud being semi-globular at the back, and flatly co[n]vex on the face and set with either a gem or a pearl, the gems in each bracelet following in the same order, as followers [*sic*] 1st reddish-brown (Turquoise?) 2nd Pearl. 3rd bright yellow () 4th blue (Amethyst?) 5th transparent white (crystal or diamond?) 6th red (ruby or carbuncle?) 7th bright-yellow same as No. 3; 8th green (Emerald?), and 9th bright yellow, same as Nos. 3 and 7. The studs are fastened to a double parallel line which appears to pass through the centre of the back of the studs [*drawing*]. The \ends of the/ cords \which are about L 4 in./ are partly bound [-together\round] with gold thread, the extremities being platted into four, thus [*drawing*] and ending in two little knobs at one end, the other end being without them and forming a double loop, which appears to be the means of fastening. L 11 8/10; D of studs which are not truly circular 5/10 by 9/20 in. [*drawings*].

[4]Kanowr is said to be a Mountainous District 32° N. Lat . and 78° E. Long. between the Himalayas and Chinese Tartary.

59 Turkish pens, knife, [-and] scissors, \and brush;/ in a case of crimson velvet embroidered with gold and silver thread. They belonged to the Ambassador Ibrahim Sarem Effendi. The three pens are merely pieces of hollow \brown/ reed, L between 8 and 9 in., \two of which have been pointed/ The scissors are [-\of steel/] L 9in., beautifully [-made\finished] having the inside of the \steel/ blades [-hollow\concave], and the outer side convex and longitudinally fluted, and the ornamented handle \[-apparently] brazed mixed metal/ of [-], W 1 5/10; of blades 5/10 in. The knife has a blade L 2 7/10 and barely W 5/10 in., the edge being [-rounded\curved] off to the back at the end, the other end being inserted into \a round/ handle of some mottled whitish substance, which looks like bone, or ivory, L 4 1/20, D 7/20 in.; to the end of which is fixed a \nearly round, but/ crooked piece of red coral L 1 3/10 in. Whole L 8 1/20 in. Brush inserted into a piece of [-reed\bamboo] for handle, L 6 15/20 in., with another piece of the same material L 3 1/10 to protect the [-brush\hairs]. A small specimen of the Ambassadors handwriting \on paper/ is with them. Given by Mrs Birkbeck, widdow of Dr. Birkbeck, 1865.
Ashmolean 1836-68, p. 4.

59a A double bag, or pouch, of dark brown leather; the mouth of one being just above that of the \other,/ and both covered with an overlapping flap or lid, and each having three rows of white stitches all round the lower part. The edges of the lids are scalloped and stitched with circles along a straight line. Depth 11 5/10, W 11 in. The bottom has a pendant cord of dark green silk with a tassel on the lower end, L 7 in. Perhaps Turkish.
MacGregor 1983, no. 370 [?].

60 A Chinese \(or Japanese?)/ mouth Organ, made of seventeen small bamboo pipes of different lengths, from 5 to 14 in., arranged in pairs as to length, which \are/ inserted by the lower ends into a circular teacup shaped hollow base H 2 5/10, W 2 8/10 in. and Japanned black, with a projecting [-] shaped piece L 1 5/10 on one side plated at the end with a flat egg-shaped piece of ivory D 2 7/10 by 19/20 in., having a square-shaped aperture down it \in connection with the face/ for the insertion of a mouthpiece.[5] H 16 5/10 in. Given by Edward Astley, Esq. St: Mary Hall. 1829. (For figure and description of these instruments see Wood's "Nat: Hist: of Man", vol. 2, p. 827).
Ashmolean 1836, p. 181, no 79.

61 A necklace of \52/ hollow beads, made of some kind of nut, or perhaps of some hard brown wood; each bead being D 5/10 in., and carved into a variety of \draped/ human figures \in different postures and holding fruits,

leaves, and other objects,/ except one of the beads which is rather larger than the rest, and carved with foliage only.\The whole of the figures are carved right through/ Said to be worn by the Brahmins of India \(are they Chinese?)/. L 2 ft. Given by W. Lloyd, B.C.L. Wadham College Keeper of the Ashmolean Museum 1796-1815.
Ashmolean 1836, p. 180 no. 68.

62 A necklace or Rosary, of 66 seeds (). Used by the Burmese. They are of a circular shape but excedingly rough as if the surface [-] had been deeply and irregularly carved all over, and each is divided lengthways into sections by five deep natural gro[o]ves or cracks from end to end. Whole L 3 ft. 8 in. D of seeds 8/10 in.
Ashmolean 1836 p. 181 no. 84 [?].

63 A string of seventy-seven somewhat similar but much smaller beads, not so rough, and without the division down the sides. Probably Indian. L 1 ft. 8 in.: D of seeds 3/10 in.
Ashmolean 1836, p. 181 no. 84[?].

64 A string of fifty-four rough and gilt, and plain \and smooth/ black beads, threaded alternately on a string of \white/ cotton threads having dark brown ends. The beads appear to be made of some waxy substance. \The rough ones being marked by deep diagonal grooves [*drawing*]/. Probably Indian. L 10 in. D of beads 4/10 and 3/10 in.
Ashmolean 1836, p. 181 no. 84 [?].

65 Ditto, of 32 beads, of the same pattern, but all gilt, and threaded on a like string. Probably Indian. L 9 in. D of beads 4/10 and 7/20 in. \Probably Indian/.
Ashmolean 1836, p. 181 no. 84 [?].

66 An ornamented gilt bracelet \Probably Indian/ made of sixteen separate pieces, of similar \material/ to the two preceding sewn on reddish-brown [-linen] cotton cloth the strings at the ends being dark brown. Each piece except the two end pieces being nearly like this [*drawing*]. L 6 2/10 in., or with strings 15 in. W 1 in.
Ashmolean 1836. p. 181 no. 84 [?].

67 A string, probably a bracelet, of twelve nearly oval-shaped beads, made of some golden grass-like substance, or fibre, strung on a cord of white cotton threads twisted. Each bead seems to \have/ been made by twisting the material round and round, [-] the middle portion being crimped up the opposite direction [-] to the winding which is from end to end. L 5 2/10 in. D of beads 4/10 in.
Ashmolean 1836, p. 181 no. 84 [?].

68 A string of numerous minute beads of light brown wood, each apparently turned with a lathe. Whole L 2 ft. 10 2/10 in. D of the beads 1/12 in., and threaded on a yellow string. Indian (?). [*drawing*] thus.
Ashmolean 1836, p. 181 no. 84 [?].

69 Two strings of \one of 28, and the other of 26/ wooden beads of similar shape to the preeceding, but large, and coloured brown. L 17 1/2 in. D of beads 4/10

[5]"Some of the pipes are dummies, and are only inserted to give the instrument an appearance of regularity. The length of the pipes have nothing to do with the pitch of the note as they speak by means of brass vibrations inserted into the lower end, like those of harmoniums".

to 8/10 in., chiefly like No. 1 [*drawing*] but some few like No. 2 [*drawing*]. There is nothing to show that these are Indian.
Ashmolean 1836, p. 181 no. 84 [?].

70 [-Fragment of a chain, composed of fifteen links of two sizes. Of a shining gold coloured \round/ grass (?) very similar to No. 67 above, but brighter and thicker, said to be from Abyssinia, but (?). L 3 in. D of links 4/10 and 5/20 in. Given by Master Robert Tudman, Oxford, 1882.]

71 A string of \seventeen/ oval-shaped beads. Locality uncertain. They are apparently made of coarse porcelain, or terra-cotta, and coated with glass, or some other viterous [*sic*] substance, in horizontal stripes, in blue, red, \and/ black [-and\with] gold \scroll ornament/; and here and there white dots \on each stripe/. L 14 8/10 in. Size of beads L 1 in. by D 8/10 in. The red and blue bands give the beads a ridgy appearance.
Ashmolean 1836, p. 181 no. 84 [?].

72 A swampan or Chinese numerical table, described in the catalogue of "Musaeum Tradescantianum", 1656, as "Beads strung upon stiffe wyers, and set in four-square frames wherewith the Indians cast account". It is formed of two shallow-wooden trays hinged together behind so as to shut together like a book the inside of each tray being crossed by six stiff wires on each of which are strung a number of small moveable metal beads. The hinges have been broken \and consequently the thing is in two halves/. Size 3 8/10 by 2 6/10 in., and 1 in.deep.
Ashmolean 1836, p. 180 no. 63; MacGregor 1983, no. 193.

73 A Swampan, or Chinese numerical table, consisting of a shallow \oblong/ wooden tray of Mahogany wood, containing 19 rows of \moveable light brown wooden/ beads, each row consisting of seven beads strung upon wood, [-and] the rows being divided lengthways of the tray by a partition, into two, and five beads each. The two \upper/ beads stand for five each, and the five \lower ones for/ as units. Size of case 12 8/10 by 4 8/10 in., and 7/10 deep. Given by W. Lloyd, [-Esq.] \B.C.L. Wadham College/ [-late] Keeper of the Ashmolean 1796-1815.
Ashmolean 1836, p. 180 no. 64.

74 Chinese ballance, called Dotchias, which are used in the manner of European steelyards. The case is of \dark brown/ wood, somewhat battledoor-shaped, and apparently intended for carrying in the pocket, the one half sliding over the other, the two [-halves] being attached together by a rivet through the smaller end. The lower [-part\half] is hollowed out so as to hold a shallow brass scale dish D 2 13/20 in.; a slender, round bone, or ivory rod, L 8 13/20 in. and [-and] D 2/10 in. near one end which is tipped with copper, diminishing in size to the other end. It has various scales marked out along it by numerous \small/ black dots. [-And\also] a curious shaped brass weight, D 1 3/10 in. and Th 3/20 in. [*drawing*] this shape. Whole L \of case/

11 8/10 in. W of widest end 3 in., of the other end 2 2/10. For a figure and description of a similar article see Wood's "Nat: Hist: of Man" vol: 2 p. 823. Given by W. Lloyd. B.C.L. \Wadham College/ Keeper of the Ashmolean 1796-1815.
Ashmolean 1836, p. 180 no. 65.

75-76 A pair of Chinese boxes, made to open like dyptichs, or books. \They are/ of wood covered with silk coloured red, blue, yellow, and white in horizontal stripes, each stripe having a green red or white flower pattern, the inside edge being of another [-design] \of the same colour but of another pattern/. The inside of each box or book, has two moveable slides, one in each half, which together with \the/ bottoms are ornamented with figures, [-and] birds, \trees, homes/ and other objects beautifully [-worked\carved] in white steatite [-ornamented with \picked out in] various colours and gold, and stuck on the painted backgrounds so as to form bas-reliefs. The subjects are not known, and unfortunately many of the carved objects have been [-lost\removed]. They are said to be at the least one hundred years old. Size when unfolded 15 8/10 in. by 10 1/10 in. and 1 5/10 in. deep when closed. Given by Greville J. Chester B.A. \Bloomsbury Court/ London \W.C./ 1882.

77 Chinese sundial and compass. It is an oblong-shaped flat piece of yellow coloured \wood/. The compass being at one end [-and the dial at the other]. The needle being still magnetic. The [-dial is] months are marked at the other end, with a moveable slide below \on which is painted the dial/. The characters are painted in black and red and the whole board varnished \or lacquered/ over. The small objects [-(probably a pin)] \(a small wooden peg, and a fine needle for the dial)/ from the under side are wanting. \The makers name is written on the back/. Size 3 8/10 by 1 19/20 and 5/10 in. thick. Given by W. Lloyd \B.C.L. Wadham College/ Keeper of the Museum. 1796-1815.
Ashmolean 1836, p. 180 no. 66.

78 A pair of Chinese Chopsticks of ivory, L 12 2/10 in., the upper parts being square \or quadrangular/ for the distance of 5 in., and the rest rounded. D 5/20 in. The upper parts are finely engraved \or etched/ with Chinese figures and characters, the lines being afterwards blackened. Used for eating rice. Given by W. Lloyd, B.C.L., Keeper of the Ashmolean. 1796-1815. For figure and description of similar article, see Wood's "Nat: Hist: of Man". vol: 2. p. 809. fig. 1.
Ashmolean 1836, p. 180 no. 68a.

79 A Chinese case of [-ebony\wood encrusted with some black composition] neatly inlaid designs in mother of pearl and ivory, \with brass mountings/; and containing an \ivory or bone/ chopstick L 7 11/20 in. and D 2/10 at one end tapering to 1/10 at the other; an ivory handled knife, the end of which [-has] formed a receplate [*sic*] of two other objects, which together with

the lid are wanting. L 8 1/10 in., D of handle 7/10 in., the blade being a good deal worn. There are also compartments in the case for other objects, which are lost. At the bottom of the case there is a box with sliding lid for holding small dice, one of which remains, D 5/20 in. \L of case 8 in. greatest D 8/10 in/. Given by W. Lloyd B.C.L. \Wadham Coll[ege]:/ Keeper of the Ashmolean, 1796-1815.
Ashmolean 1836, p. 180 no. 67.

80 Chinese case of dark brown wood, having \bright/ iron [-bright] mountings, ornamented with lacquered pattern in brass between engraved lines, Containing a steel knife with each side of the \straight/ blade hollow, and slightly engraved near the handle, which is of horn of nea[r]ly a black colour, the end being mounted as in the case. L 11 8/10 in., of blade only, 7 5/10; D 6/10 in.; A pair of white bone Chopsticks. L 11 6/10 in.; D 3/10 in. at the larger ends, \which are capped with brass/ decreasing to 3/20 in. at the other. An \iron/ earpick and a toothpick, L 3 8/10, and 3 7/10 in., of rather coarse make, and which fit into holes in the side of the wooden case. L of case 9 1/10 in., D 1 in. Given by Lieut. Colonel [-Riguad\Rigaud] Mag[dalen]: Coll[ege]: 1865.
Ashmolean 1836-68, p. 13.

81 A chinese cap worn by the Nobility. It is half globular shape. the upper part made of six pieces, \[of black satin]/ a separated piece forming a band round the rim: of black satin ornamented with figures of butterflies \above/ and some other figures below \all/ [-embroidered\worked] in gold thread and sewn on; with a large round button [-at\on] top from which hangs a long tassel, both of \reddish/ brown silk. H 4 in. D 7 in. lined with dark blue cotton. Given by the Rev: F. Spring, St. Edmund Hall, 1827.
Ashmolean 1836, p. 179 no. 45.

82-83 A piece of the pith of the Sola () from which, when, cut into sheets, a kind of rice paper is made by the Chinese. L 8 5.10 in.: D 1 5/10 in. Also three specimens of sheets so cut, previous to being pressed. Size 2 ft. 10 in. by 6 1/2 in.; 1 ft. 10 in. by 6 1/2; and 9 by 5 in. Given by Sir David Brewster, 1832.

84 A Chinese razor, with thick somewhat triangular-shaped blade, and rather \small/ rough [-round\cylindrical] wooden handle with a brass ferrule. [-Size\Length] when opened 5 6/10 in., when shut 3 2/10 in. Greatest W of blade, which is at the end, 1 2/10 in. Given by Professor Prestwich, 1882.

85 Ditto, larger, and the blade being wider and the edge and back nearly parallel, and the ferrule being of iron. L when opened 6 4/10 in.; when shut 3 15/20 in. Greatest W of blade 1 4/10 in. Given by Mr Edward Evans. Oxford. 1883.

86-89 [-Three\Four] specimens of extremely thin felted cloth, \or paper,/ made by the Chinese, and printed with white, blue and drab patterns. Size 15 by 11 ins, and one little piece plain white, several small

fireworks, and toys made of pith, used for amusement amongst the Chinese. A Chinese flint in \bright/ metal [-case\mounting], D 1 1/10 by 19/20 in.; and four common Chinese brass coins or money [*drawings*]. Given by Mrs Lightfoot, Exeter Coll[ege]: 1866.
Ashmolean 1836-68, p. 10.

90 A Turkish gun flint set in an \ornamentally/ perforated, pewter (?) casing. Size 1 3/10 by 1 1/10 in. Given by Greville J. Chester. B.A. 1872.

91 A Chinese Lady's shoe of pink satin, neatly ornamented with [-with] flowers in fine blue, white, [-] and green silk embroidery, with gold spangles, inclosed \or surrounded/ with black and white narrow lace and a do\u/ble gold thread; and bound round the top with [-brown\red] silk thread. L 5 1/10 in., Greatest D 1 5/10 in. which is at the heel, \H 2 2/10 in./ decreasing to a point and turned up at the toe. Outside of sole which does not reach the end of the \toe of the/ shoe bound with white cotton or linen. Given by Mrs J. Penson, Charlbury (Date? \previous to 1836/).
Ashmolean 1836, p. 179 no. 41.

92 A Chinese Lady's pocket \with folding flap/ of fine red flannel, ornamented with flowers in fine blue white, and green silk embroidery, [-and] gold spangles, and narrow green braid, and edged all round with an inter[-laced\woven] binding of red silk \thread/, which has very much faded. The inside and back are lined with unbleached calico, and the fastening is simply a metal button and a loop. Size 5 5/10 by 4 3/10. Given by Mrs J. Penson, Charlbury (Date? \previous to 1836/).
Ashmolean 1836, p. 179 no. 41.

93 A Chinese ball, containing eleven other balls, all detached and cut concentrically from a solid piece of ivory. The inner balls are pie\r/ced in various small and beautiful geometrical patterns; the outermost being also pierced through, and elaborately carved with representations of hunting scenes. The innermost ball of all is solid. On one side is attached a long tassel of red silk threads, \ L 8 in./; something having been broken off the opposite side and lost, \perhaps another tassel/. The outermost ball but one has also been somewhat broken. D 3 5/10 in. Given by the Rev: F Spring. St Edmund Hall, 1827.
Ashmolean 1836, p. 179 no. 43.

94-104 Eleven balls of ivory, or portions of balls, of similar make to the preceding, but of much inferior workmanship, all more or less imperfect. D 1 6/10 to 5/10 in.
Ashmolean 1836, p. 179 no. 44; MacGregor 1983, nos. 239-48.

105 An impression in gutta-percha, (painted \red/ to resemble wax,) of the Imperial seal of the Emperor of China; which seal was brought as the spoils of war from the Imperial palace of "Yuen Ming Yuen", near Pekin, by Lieut: Col: Allgood in 1860. The original seal is made of the precious Jade stone, and weighs 6 1/2 lbs, which sells in China for four times its weight

in gold. Size 5 1/10 in. square. Given by W. D\ean/ Fairless. D.M. Park Crescent. Oxford, 1879. The translation of the Characters is said to be "The Imperial Seal of the receiver (from Heaven) of the three impartials", i.e. the Emperor.[6]

106 An impression in red wax, from a seal given by the Imaum of Muscat, 1820, to Sir \Charles/ Colville, Commander in Chief at Bombay. Size 1 19/20 by 1 7/10 in.; or of the seal only 1 1/0 by 9/10 in. Given by F.E. Viret, Esq. 1843. Translation written in this way, but only about half the length in co[m]parison to the width shown here [*drawing annotated round four sides of central message* 'Charles Colville', 'In the day of Battle may the God of the world be thy protection', 'There is no victory but with God', 'In the day of Glory may the heads of thy enemies be as dust in thy path', 'Suc[c]ess is with God and victory is near'.]

107 A basket made of narrow plaited strips of [-the] palm leaf \ornamented/ in patterns in black, pink, green and the natural straw colour. It is somewhat globular in shape, but seven-sided, each side having been made separately and then sewn together at the edges, with circular bottom and top, the lid also being round, and hinged, and having a \green/ tassel on the top. A double cord is attached to the middle of each side of the basket, which are tied together at the top, \forming a sling/ for suspending or carrying it. Probably from Ceylon. H 5 in.: D 5 5/10 in. In exchange from the Trustees of the Christy Collection, 1869.

108 A small oblong-shaped basket of narrow, plaited, strips of palm-leaf; with \deep/ overlapping lid. Coloured in patterns in red, black, and straw colour. The bottom, and the edges of the lid and lower part, being much coarser work than the rest of the basket. From Ceylon. Given by G.W. Cripps. Esq. L 5 5/10 in. W 4 in. H 2 8/10. In exchange from the Trustees of the Christy Collection 1869.

109 A very small cylindrical case or basket, and \deep overlapping/ cover, made of finely plaited strips of palm leaf coloured in a pattern in black, pink, and the natural [-white\straw] colour. Probably from Ceylon. L

2 in. D 1 4/10 in. In exchange from the Trustees of the Christy Collection 1869.[7]

110 An oblong-shaped, flat-sided, small \Ceylonese/ basket, of curiously plaited strips of \date/ palm leaf, with deep overlapping cover; and coloured red, yellow, and white, the bottom part having a \re/moveable \inner/ lining of a simpler pattern, and uncoloured, together with the whole of the inside of the basket. The colouring has very much faded. Used for holding betel, that is arica nuts, black pepper vine leaves, and Chunan, which they are accustomed to masticate. Size 6 5/10 by 4 1/10 in. and Th 1 6/10 in. In shape it much resembles a pincushion. Given by Mrs Spring, Lady of the Rev: F. Spring, A.M. Presidency, Chaplain of Madras, in the Hon'ble E.I. Company's service \June/ 1836.
Ashmolean 1836, p. 181 no. 85a.

111 A Bow from northern China; principally made of whale bone, \with a piece of cork in the centre for the hand/ and highly ornamented on the front with flowers and other devices, in various colours, in relief, the background \for which/ being chiefly of light and dark brown, the flowers being on the lighter of the two, in red, black, white, and green. The back of the bow is not painted, being of the plain black whale bone, with the two ends painted all round in green, [-with\and having] black \horn or whalebone/ tips. With this bow the concave side is the front which becomes convex when strung for use. L \measuring along the curve/ 5 ft. 8 in. \or as bent measuring from tip to tip 3 ft. 9 5/10 in./ Greatest D 1 5/10 in. which is the centre, being much less to about 9 in. from the ends. The line [is] 5 ft. 1 in. L [-\or as bent measuring from tip to tip 3 ft. 9 1/2,/] and D 2/10 in., [-and\is] made of \one strip of/ raw hide neatly twisted. From where the ends begin to taper, on the inside of the bow, are fixed two projecting pieces of bone or ivory. Given by Lieut Colonel Riguad \Rigaud/. 1865.
Ashmolean 1836-68, p. 13.

112 An \ordinary/ wooden arrow, from Northern China, with triangular shaped flat \iron/ head, having a round long neck. Painted red green, \and black/ at the other end, which has three feathers L 7 1/2 in., stuck on round it, each feather being in \nearly/ a straight line. L of iron head 3 9/10 in., D 8/10 in. Whole L 35 5/10 in. D of shaft 7/20 in. [*drawing*]. Given by Lieut. Colonel [-Riguad\Rigaud] 1865.
Ashmolean 1836-68, p. 13.

113 Ditto, ditto, with iron head of a different shape to the preceding, fixed by a shank and the upper end neatly bound with a strip of smooth, polished black bark. It has had three feathers round the other end, stuck on in a curved line. L of head 2 9/10 in.; D 1

[6]Note. The three impartials are the Equal actions of Heaven, the Earth, and the Sun and Moon, and allude to the happy administration of the Empire. 1st Heaven impartially diffusing all good, the defender of the righteous, and the punisher of the evil doer. 2nd The Earth, also impartial, sustaining and subservient to the wants of man in every clime, supporting him in life, and when life is over, like an affectionate mother piously wrapping him in her bosom, ie. the grave. 3rd The Sun and Moon, alike impartial, giving life and light and heat to all the world, bringing forth food and special wants for every creation that moveth, thus unitedly fulfilling equal and perpetual actions, for the good of all. What the t[h]ree Impartials are to the world at large, the Emperor assumes and adopts the same attributes for the happy administration of the Empire and people.

[7]Very small cylindrical case and cover of similar make [*Drawing annotated '2 in'*].

3/10 in., Whole L 38 2/10 in. D of shaft 9/20. Given by Lieut Col: [-Riguad\Rigaud] 1865. [*drawing*].
Ashmolean 1836-68, p. 13.

114 A wooden arrow, from ditto, with hollow detachable wooden head, perforated in front with five holes. Used for amusement from the whistling it produces when shot through the air. L of head 1 8/10, D 1 in. L of shaft 36 8/10 in. It is painted red green and black round the other end, which has three feathers \about 9 in. long/ stuck round it, in nearly straight lines. Given by Lieut Col: Riguad \Rigaud/, 1865. [*drawing*].
Ashmolean 1836-68, p. 13.

115 A Bow from Japan, nearly [-square \quadrangular in shape], black Japaned and neatly bound with very fine slit cane, so as to form alternate bands of black and cane from one end of the bow to the other, those of the cane being the widest. L 7 ft. 3 in. D 1 2/10 by 8/10 in. Taken at Simono-Seki. 1864. Given by R. Williams, Paymaster, R.N. 1868.
Ashmolean 1836-68, p. 17.

116-19 Four Japanese arrows, each having a different pattern, quadrangular head of iron. The shafts are of stout reed, or cane, [-three\two] of which have been stained \dark brown/ and polished \another polished without staining/ and \the dark brown ones/ gilt at the [-other\lower] ends. They each have three \three of them with white, and one with brown and black/ feathers, L about 6 in. stuck on, each in a straight line \the binding at the ends being blackened/ and have deep notches [-at the ends] for the bow-string. The heads are inserted by long shanks into the [-reed] shafts, which are bound with thread, [-and] coloured yellow and black. L of heads 1 5/10 to 1 in. Whole L 35 1/10; 34 9/10; 34 8/10; and 34 7/10 in. Taken at Simono-Seki, 1864. Given by R. Williams, Paymaster, R.N. 1868.
Ashmolean 1836-68, p. 17.

120 A Japanese sword \or sabre called siobookatana/. The sheath is of wood \oval-shaped in section/, Japaned black, to which is attached a cord of plaited blue and yellow silk W 4/10 in. The blade is but slightly recurved, L 2 ft. 4 1/10 in., W 1 3/20 at the handle, decreasing to 7/10 in. at the point, and is as sharp as a razor from the point to the hilt. The handle \which is oval in section/, is on the same curve with the blade, L 9 5/10 in., has a circular and slightly perforated, [-thick] iron guard, D 2 8/10 in. and Th. 3/20, and appears to have been intended to be [-used\held] with both hands. It is covered with sharks' skin over which [-is\are] bound bands of plaited white silk, which cross one another down the sides for firmness of grip. The end of the handle is capped with iron. Whole L 3 ft. 2 in., of case 2 ft. 7 in., D 1 6/10 by 19/20 in. Taken at Kagosima, 1863. Given by R. Williams \Paymaster/ R.N. 1868 (For figure and description of a similar article see Wood's "Nat: Hist: of Man" vol: 2 p 843).

Also Meyrick's "Ancient Armour" Pl. CXLVI, fig. 4, vol. 2.
Ashmolean 1836-68, p. 17.

121 Indian Bow, made of two pieces of Buffalo horn, the centre and the tips being of hard wood, the whole thickly encased with animal sinews, and richly painted on both sides in patterns in red, gold, green, and black. It is flatly convex on each side, diminishing in width but thickened at the ends, and also in the middle, which is nicely shaped to fit the hand. L from [-curve] point to point, across the curve, 35 in., \greatest D 1 9/10 in./ In this bow as in the Chinese specimen, No. 111, the curved side is the front, which is reversed when strung. For figure and description of a similar bow see Wood's "Nat: Hist: of Man" vol: 2 p. 766. No. 2.
MacGregor 1983, no. 33.

122 Indian [-Qiver\Quiver] made of brown leather, covered on the inner side, which is worn next the body, with crimson velvet; the outer side being entirely covered with embroidery in gold thread and spangles, with one very long (6 ft. 5 in.) and one short (10 1/2 in.) strap for [-fixing\carrying] it, ornamented in a like manner. At the side, near the top are attached two sets of pendants, five in each set, the upper 24 1/2, and the lower 21 1/2 in. in L. Each pendant is closely bound round with gold and silver thread and ends in a kind of long knob with a loop at the end, thus [*drawing*]. Width of two straps 1 in., and one short connecting strap not quite so wide and less ornamented. L 26 in. W at top 4 in., decreasing to 3 5/10 at the bottom. For a similar article see Wood's "Nat: Hist: of Man" vol: 2. p. 766. No. 3. Given by the Hon. F.J. Shore. 1830. [-Also Meyrick's "Ancient Armour" vol: 2 Pl. CXXXXI fig 4.] Exhibited at the Art Treasures Exhibition, 1857. Museum of Art.
Ashmolean 1836, p. 180 no. 75.

123 Indian Arm-guard, (Bow-case?), fellow to the quiver preceding, of the same material and ornamentation. L 1 ft.; W of top, 8 in., of bottom 5 1/2 in. See Wood's "Nat: Hist: of Man" vol: 2 p. 766. No. 3 Given by the Hon. F.J. Shore. 1830. [*drawing*].
Ashmolean 1836, p. 180 no. 75.

124 Indian Bow, of similar shape and [-make \material] to No. 121 preceding, painted with a (now almost obliterated) diaper pattern in gold. It has afterwards been strengthened by four bands of raw sinews, each band being about L 4 in., two of them being immediately on each side [of] the centre or handle, and one at each curve nearer the ends. L from point to point across the curve 27 in., or along the outside of curve 49 in. \greatest W 1 6/10 in/. The line is made of green and red silk, with loops at the ends of raw hide, L 37 5/10 in. It appears to have been a good deal injured. Given by the Hon. F.J. Shore, 1830.
Ashmolean 1836 p. 180 no. 75.

125 Twenty-four Bheel arrows, from A\h/madabad, Province of Gujarat, East India, highly ornamented at

the two ends and in the middle, with patterns painted in red, green, and gold. The shafts appear to be of reed which have been dyed of a light brown \color/, the heads being of steel, \about 1 3/10 in. in length/ and of six separate patterns; fourteen have quadrangular sharply pointed heads, [*drawing*] thus; two are cylindrical and obtusely pointed [*drawing*] thus; three are leaf shaped or nearly so, (as one of them is more like half a leaf) thus [*drawings*] two are flat with drill-shaped point, [-and] two are flat chisel shaped [*drawing*] and the last is an ordinary round spike thus [*drawing*]. The ends are of wood, with large notch for the [-arrow] bow-string, and have three small feathers each, not stuck on the curve to make the arrow revolve in its flight. Full L 2 ft. 5 6/10 to 2 ft. 5 3/10 in. For description of similar arrows see Wood's "Nat: Hist: of man", vol: 2. p. 767, and figures see Meyrick's Ancient Armour, vol: 2 plate CXLI fig 7. Given by the Rev. J.H. Hug\h/es, Magd[alen]: Coll[ege]: Date? \previous to 1836/.
Ashmolean 1836, p. 181 no. 76.

126 Fifteen arrows, probably from Eastern India; of stout reed with leaf-shaped iron heads, each with a prominent ridge along the middle on each side. The upper portion of the arrows appear to have been smeared with some substance, perhaps poison. All the feathers if indeed they ever had any have been lost. Locality unknown. Whole L 31 1/10 to 25 8/10 in. The shorter ones appear to have been broken [*drawing*].
MacGregor 1983, no. 371.

127 Four arrows, the shafts being of smaller size than the preceding and the \iron/ heads though somewhat leaf-shaped, of a different pattern, and the tops of the shafts strengthened by two white metal bands. The bottoms have been painted and apparently feathered. Probably Indian. L 29: 28 9/10 and 24 in. [*drawing*].
MacGregor 1983, no. 372.

128 One ditto, with head rather different in shape, and top and bottom of the arrow \shaft/ painted. The feathers have been lost. L 28 3/10 in. [*drawing*]. Probably Indian. [-Feathers gone]
MacGregor 1983, no. 373.

129 One ditto, with quadrangular pointed head, the shaft painted at top and bottom. Feathers gone. Probably Indian. L 28 2/10 in. [*drawing*].
MacGregor 1983, no. 374.

130 Two ditto, with short round points the shaft painted at top and bottom, and feathers lost. Probably Indian. L [-23\28] 2/10 and 28 1/10 in. [*drawing*].
MacGregor 1983, no. 375.

131 One ditto, of light coloured wood with round obtuse iron head, the top of the shaft bound round spirally with a piece of bark. It has had three feathers. Perhaps Japanese. L 24 4/10 in. [*drawing*].
MacGregor 1983, no. 376.

132 A coat of crimson velvet lined with ornamental blue silk, and trimmed on the outside with gold braid

and spangles. Found in the King of Ava's tent after the battle of Rangoon, 1824. L 4 ft. 2 in. Given by the Rev. W. Dallas. Date (?) \July 4th 1828/.[8]
Ashmolean 1836, p. 180 no. 56.

132a Eight pieces of Indian? quilted work, each piece composed of [-of] two or three overlapping pieces covered on the face with crimson velvet, the edges being scalloped and bound with pale green ribbon, and above that with gold lace. The backs are lined with [-green\plain brown] silk. I think the four larger pieces, (three of which are stitched together), may have been used on the shoulders as a kind of collar \perhaps of this dress 132/. The other four appear to have been part of the same thing, but are different in shape. Size of the four larger pieces about 16 by 8 in. History [-unknown] uncertain.

132b Three large pieces of Horse covering, of quilted work. The outside covered with dark blue velvet, embroidered all over with patterns in white silk, (but which appears to have been formerly some other colour but has faded), the pattern consisting of stars and crescents, the crescent being in twos and threes inclosed within somewhat shield shaped ornaments of two different shapes, the twos being in one and the threes in the other, and the star-shaped ornaments scattered between them. Round the bottom edges runs a deep fringe of faded silk, ([-perhaps\apparently] formerly pink), and gold threads. This is backed by yellow silk doubled. The inner side is lined with plain red cotton cloth. Many of the straps and buckles remain. The two larger pieces appear to be for the sides of the horse, and the other for the breast. L of the two larger pieces 56 & 57 in., Depth 29 in. Size of the small piece 24 by 24 in. Perhaps Turkish.

132c Portion of a Horses? Head gear, of thick narrow brown leathern straps, with small square-shaped eye-shades of leather covered on the outside with crimson velvet surrounded with a silk crimson fringe. L of one strap 24 5/10 in: W 9/10 in. L of each strap to which the shade is attached 6 5/10 in.

133 A small bag of red gauze, ornamented with gold lace. It contained an intercepted letter of Tippo Saibs \Sultan of Mysore/ and has the seal of his father \Hyder Ali/ attached. L 8 in.; W at bottom 5 in. Size of seal, which is oval with Arabic? inscription 2 by 1 6/10 in.
Ashmolean 1836, p. 181 no. 82.

134 A board on which are stuck three small \poisoned/ arrows, and one ditto in its case. Used with the

[8] From Mr Philip Bury Duncan's original correspondence in the Ashmolean M.S. book 1820-1840 -'A dress belonging to the Burmese Chief Bundoola, and some books in the native language taken at the capture of one [of] the stockades, in or near Rangoon, by Lieut Frederick Abbott (Bengal Engineers) in the Burmese war 1824'. 'The oddly indented appendage to the dress is worn over the shoulders after the fashion of capes behind and before.' Presented by Lieut F. Abbott to the Rev'd Alexander R.C. Dallas. Yardly Vicarage Buntingford, Herts, who gave it to the Ashmolean Museum July 4th 1828.

Sumpitan, or blow gun by the Dyaks in Borneo and the Eastern Archipelago; [-and] when used one end of the arrow is inserted into a small cylinder of pith to fit the bore of the tube (see No. 135) L 7 9/10 to 6 8/10 in. Given by the Hon: Capt: John Spencer. R.N. 1857. (For figure of such an arrow see Wood's "Nat: Hist: of Man"; vol: 2, p. 467, and description of their use p. 465.)
Ashmolean 1836–68, p. 15.

135 A Dyak quiver containing thirty-four arrows \(many of which have been lost their points and some the [pith?] for use with the Sumpitan or blow gun. The quiver is made of a piece of bamboo \L 9 in. and D 3 5/10 with cover of the same material, and is furnished with an appendage by which it can be stuck into the belt and carried at the side. The appendage is made of [-the] hard black wood, and is lashed to the quiver by a broad belt of ratten neatly plaited \another belt surrounding the lid/. The arrows are made of the thorn of the Sago-palm, and are about L 7 or 8 in., [-and] Th 1/8 in.; tapering gradually to a sharp point, which is cut round \partly through/ so as to easily break off in the flesh, and poisoned: the butts being inserted into conical pieces of white pith, [-or softer wood] so as to exactly fit the bore of the tube to be propelled by the breath. The poison, (which is made of the juice of the Upas tree (Autiaris toxicaria), and which belongs to the natural order Astocarpeae, the best known species of which order is the well known bread-fruit tree), although deadly to any creature into which it is struck, does not render the animal unfit for food, as it \the flesh/ may be swallowed with impunity. See also No. 134. For a similar article and description See Wood's "Nat: Hist: of Man" vol: 2. p. 467. L with lid on 13 in. Given by the Hon: Capt: John Spencer R.N. 1857.
Ashmolean 1836–68, p. 15.

136 A Sumpitan or blow-tube; used by the Dyaks of Borneo, for shooting small poisoned arrows, as those described in the two preceding numbers. This implement is L 6 ft. 11 in., D 1 3/10 in. at the mouth decreasing to 8/10 in. at the other end: of hard compact reddish-brown wood like Mahogany, highly polished, and having a remarkable straight and smooth bore from end to end down the centre, D about 3/10 in. It is difficult to conceive by what means it has been so regularly and wonderfully bored. Given by the Hon: Capt: John Spencer. R.N. 1857 (For figure and description of similar article see Wood's "Nat: Hist: of Man" vol: 2 p. 465.
Ashmolean 1836–68, p. 15.

137 A Hindoo God of War called Kartikeya, riding on a Peacock, elaborately carved in ebony. The figure is represented with six heads and twelve arms, the hands of eight \of/ which hold different weapons or symbols. The peacock is supported under the breast by a three headed Cobra snake. It is mounted on an oblong stand of the same kind of wood, which has four little feet at the corners. H 1 ft. 2 in.; L 9 1/2 in. Size of stand 11

2/10 by 6 in. Given by Captain Masters, Bath, Date (?) \previous to 1836/. (The Idol itself can be detached from the Peacock into the back of which it is fixed by a mortice and tenon.)
Ashmolean 1836, p. 180 no. 52.

138 A pair of [-Chinese] Man's slippers of crimson velvet, with square toes and open, \or the upper part cut away/ at the heel; soles of thin leather, and heels of wood encased with leather. (It presents a strong contrast in point of size to the Chinese ladies shoe No. 91). L 9 9/10 in.: W 3 5/10 in.
Ashmolean 1836, p. 181 no. 80 [?]; MacGregor 1983, no. 57.

139 A Persian shoe with pointed and turned up toe; covered with red cloth embroidered with coloured silk, silver thread and green and white small glass beads in a flower pattern in the centre, on the top. Inside of shoe and sole of brown leather. L from tip to tip 13 in. W 3 5/10 in. Given by \Sir Christopher/ Pegge, D.D. Ch[hrist]: Ch[urch College]: 1796.
Ashmolean 1836, p. 181 no. 80 [?].

140 A pair of Persian shoes, similar in form to the preceding ornamented with gold thread and rosettes of [-crimson\red] cloth \or flannel/. Insides lined with red cloth; soles of brown leather. L from tip to tip 13 in. W 3 4/10 in.
Ashmolean 1836, p 181 no. 80 [?]; MacGregor 1983, no. 52.

140a A single shoe of similar form to the preceding the red flannel of which has been destroyed by moth. Ornamented all over thickly with spangles and embroidery in gold or silver thread. but this has very much faded the spangles being all turned black. Inside brown leather. On the under side there is a pattern cut out of white leather and stuck on. L 12 in.: W 3 5/10 in.
Ashmolean 1836, p. 181 no. 80 [?]; MacGregor 1983, no. 51.

141 Eastern slipper \cut away at the back/, perhaps Turkish; of brown velvet ornamented with [-silver] \fine curled/ wire, and [-gold] \small/ spangles, \and flat copper thread, all of which may originally have been gilt but/ which have \now/ turned black; and in the centre on the toe a ring of pale green beads with a red one in the centre. The sole is brown leather lined inside with green cloth or flannel. L 10 6/10 ins; W 3 in.
Ashmolean 1836, p. 181. no. 80 [?]; MacGregor 1983, no. 55.

141a A slipper, of nearly similar form to the preceding, but not [-quite] so much cut away-like at the back part, and having a shorter and squarer shaped toe. Of black velvet very much worn, ornamented with embroidery in gold thread. Sole of thick rawhide? \or felt? having thin/ [-with] brown leather sewn on the bottom with coarse white stitches. In this and the previous one, the upper edge is bound with white cotton cloth, and there is a thickness of the same \which forms a whelt/ between the soles and the uppers. L of sole 8 6/10 in. W 2 6/10 in. I think this shoe is from the same locality as No. \425/.
Ashmolean 1836, p. 181 no. 80 [?]; MacGregor 1983, no. 56.

142 A pair of Chinese? sandals, the upper portion made of fine wicker or basket work; the soles being apparently of raw hide, with twisted cords above for attachment, but these have been much injured. L 8 5/10 in., W 2 5/10 in.
Ashmolean 1836, p. 181 no. 80 [?].

143 A pair of Chinese Mans' boots, with thick soles covered with white cotton, and a thin piece of leather sewn on the bottom; the high tops being made of black satin lined \inside/ with white linen. H 17 in., L of sole 12 in. W 3 8/10 in.; Th 1 in. (They have been much injured).
Ashmolean 1836, p. 181 no. 80; MacGregor 1983, no. 47.

144 A pair of Chinese man's stockings of quilted work. The outsides are of brown and white silk, the lower [-parts\half] being of the white and the upper half of the brown, the soles being of white linen. The padding is made of tow and samaiima silk, the inside lining being of very coarse linen. The tops are bound with black satin. L 21 in. W at top 7 in. (They have been much injured).
Ashmolean 1836, p. 181 no. 80; MacGregor 1983, no. 47.

145 A pair of Eastern, probably Indian \(Borneian?)/ slippers, of shiny, thin, green coloured leather, with sharp pointed toes, and a silken tassel of a brighter green stiched above near the toe. L 10 4/10 in. W of sole 2 6/10 in. Soles of thin brown leather. Given by the Executors, of Captain C.C. Bristow, Bodicote, Oxon, 1875.

146 Ditto of similar kind of leather of a violet colour with black silk rosettes [-of black silk] on the forepart: lined with white linen. L 10 7/10 in. W 2 9/10 in. Given by the Executors of Captain C.C. Bristow, Bodicote, Oxon, 1875.

147-148 Two pairs, of the same shape and leather; one entirely of white leather except for the soles; the other being like it, but [-brown\bound] with brown where the former is bound with white. L 10 5/10, W 2 7/10 ins; and L 10 6/10; W 2 6/10 in. Ditto, as above.

149 A pair of Japanese? clogs, of reddish-brown wood, from the "Island of Joanna". The peg has been broken from the top of one of them. H 2 2/10 in. L 9 7/10 ins: Greatest W 3 9/10 in.
Ashmolean 1836, p. 181 no. 80 [?]; MacGregor 1983, no. 20.

150 A single Japanese? clog, for the left foot, of light-coloured softish wood carved on the top into a kind of pattern. Locality unknown. L 7 in. H 1 2/10; Greatest D 2 5/10 in. (See Wood's "Nat Hist of Man" vol: 2. p. 849, w[h]ere women are figured wearing similar clogs.)
Ashmolean 1836, p. 181 no. 80 [?]; MacGregor 1983, no. 59.

151 A Tartarian slipper most beautifully and neatly made of twisted \yellow/ grass \woven/ in a kind of \fine/ network pattern. Lined with white linen; sole of brown leather. The pattern is remarkably fine above the toes. L 11 in. D 3 2/10 in. H 2 4/10 in.

Ashmolean 1836, p. 181 no. 80 [?]; MacGregor 1983, no. 49.

152 A cylindrical-shaped Indian \or Chinese?/ basket \on stand/; of split cane, in an interlacing openwork pattern, strengthened \externally with prominent/ [-by] longitudinal and transverse bands. It has a lid of the same pattern. H 14 5/10 in.: W 7 5/10 in. of stand 5 in.
MacGregor 1983, no. 377.

153 A Chinese, nearly cylindrical shaped pillow, being smaller in the middle than at the two ends. It is made of ornamental basket work of split cane, having a lid or cap at each end of the same material with a wooden rim; the [-] whole then varnished or Japanned of a glossy reddish-brown colour, the pattern of the cane-work shewing through the japan, and which appears to form the foundation for it. L 16 5/10 in.; D of ends 6 3/10 in., in the centre 5 in. Given by I. Ireland, Esq, Oxford, 1824.
Ashmolean 1836, p. 180 no. 70.

154 A squat, and obese Chinese figure, or Idol, carved in white steatite, or marble, and mounted on an oblong-shaped throne, or stand, of somewhat a sofa or couch shape, and made of a framework of dark wood mitred together. With pannels of black and white \coloured marble/ (with the exception of the left hand end one which is yellow); [-coloured marble], the back and ends being detachable from the bottom part, which is supported on four legs, and stands 2 in. in height. The figure is detachable from the stand. H of figure 4 5/10 in. D 4 2/10 by 2 6/10 in. L of stand 7 4/10 ins: W 4 in. H to top of back 5 1/20 in. Given by Miss Hind(s?) Mill End, Henley, Oxon, 1848.
Ashmolean 1836-68, p. 8.

155 A Chinese [-Joss] \Doll of the Ming Dynasty, and of the date about 1500/, of white biscuit-like china, except the belly part which is covered by an oval shape[d] patch of dark [-bluish]-green enamel, which \joins to and/ extends round the back in a wide band. Otherwise it is represented as a naked male child seated, laughing, with both arms somewhat raised, and holding in the right hand a Cowry shell (?), his head being bare except two knobs one on each side of the head. Left foot and fragment of right thigh lost. H 4 5/10 in.
Ashmolean 1836, p. 179 no. 51.

156 A \dome-shaped/ Chinese basket and cover, called a Joss house; in which the Chinese carry their Idols. It is made of basket-work of split cane, covered on the outside with thin, coarse brown linen, or canvas, and thickly ornamented \all over/ with \white/ Cowry shells (Cyp[r]aea), each shell having \or having had/ a bit of red \green/ or blue flannel tied in the mouth. The \centre of the/ lid has an upright high projection made of four lean to sticks, from the top of which hang 4 pendants made of bunches of Cowry shells. The bottom part being ornamented [-in a\with four] simmilar [-manner] bunches. Around the sides are four little ornaments made of single disks of mica, to [-with\each] of which [-are\is] suspended a single \Cowrie/ shell. H

1 ft. D 7 5/10 in. Given by Rev: Dr. Hall, Pembroke Coll. [-1839\1827]
Ashmolean 1836, p. 180 no. 74a.

157-160 Four small Burmese figures of the idol [-Gotama\Gautama] or Buddha; Of thin silver, the insides being filled up with some kind of cement. One of them has an inscription etched on \the front of the pedestal/. One has lost its right ear and the top of the headdress, another has lost the top of the headdress only, and two are perfect. The two broken ones have the pedestals of the same \pattern, those of/ the other two being different from each other, and from the other two. The figures are all in the same attitude, sitting crossleg[g]ed, the right hand hanging down over the knee, the left hand resting in the lap. H 5 8/10 in. D of base 3 1/10 by 1 5/10 in.; H 5 2/10, D of base 2 7/10 by 1 7/10 in. Present H 4 9/10 in.; D of base 2 5/10 by 1 5/10 in. and present H 4 7/10 in.; D of base 2 6/10 by 1 5/10 in. Given by Mrs Hornby, 1827.
Ashmolean 1836, p. 180 no. 54.

161-162 Two small Hindoo idols, of bronze or copper, Buddha?; sitting cross-leg[g]ed, with right hand resting on the left, and \both/ in the lap. Headdress rather different to the preceding. H 3 2/10 and 3 3/10 in.
Ashmolean 1836, p. 180 no. 55.

163 A small slab of [-light] brown stone, with figure of the Hindoo Idol Ganesa, the god of wisdom, represented Elephant headed, carved in relief. At the back is an indentation carved out. H 2 in.: W 1 6/10 in.
Ashmolean 1836, p. 180 no. 53.

164 A slab of hard dark brown wood, having \on the front/ a rudely carved \figure/ in relief of the Hindoo Idol Ganesa, the god of wisdom. The back is also partly carved out. [-Given] H 6 3/10 in.: W 3 5/10 in. Given by Dr. Jarbo of H.M. Bengal Ecclestiastical Establishment \1878/.

165 Figure of the [H]Indoo deity [], cast in brass, or bronze. It is represented as a female with four lower arms, one of which on the left supports a child or small figure holding some object in the right hand, on the knee; the other three hands holding some \objects perhaps/ emblems, At the back, or rather springing from the head, is another small figure. It has a detachable pedestal and back plate, the latter being ornamented with a Cobra and some devices: the pedestal being ornamentally moulded. It appears to have lost some other object or objects from the \square/ holes in front. H of figure 3 5/10 in.; H of the whole 6 9/10 in. Given by Greville J. Chester, B.A. \1 Bloomsbury Court London W.C./ 1872.

[-166 Indian Hookah, or tobacco-pipe with long tube, ornamented with black crape, beetles \golden green/ wing]

166 Indian Hookah, or Tobacco-pipe wanting only the bowl. Entirely covered with black crape, which is highly ornamented with beetles shards or wing covers, of a species of Buprestis, of a golden green metalic lustre surrounded by rich gold lace. L of tube 11 ft. 10 in. D of foot 7 5/10 in. D of circular mat below 22 5/10 in. Given by the Rev: Dr. Collinson. Queen's College, 1810. The bowl with perforated dome shaped lid, (which has unfortunately been broken and mended again); \of drab unglazed ware/ the lower half being neatly enriched with leaves etc, in relief in darkish brown, appears to belong to the next article No. 167 rather than \to/ this.
Ashmolean 1836 p. 180 no. 62.

[-167 Tube of an Indian Hookah, and an upright stem of bamboo. The tube is covered with black \crape/ and partly ornamented \with beetles/ green wing-cases, and gold lace. Perhaps belonging to the above pipe, or maybe to the next article. L 11 ft. 10 in.]

[167] Long tube of an Indian Hookah, and upright double stem of bamboo, for insertion into stand by the lower end the two upper [-tubes] \ends/ being used one for fixing on the clay bowl, and the other for the insertion of the long tube. The whole richly ornamented with beetles' wing cases of a golden green colour, thickly bound in a diagonal pattern with gold thread, and thickly studded all over with little rings of opaque white \glass/ beads, each ring inclosing two transparent green ones of the same size. The upright stem is more sparingly ornamented with the beadwork than the tube. Stand, etc, wanting. L of tube 13 ft. 10 in.; L of double stem 14 5/10 in.
MacGregor 1983, no. 378.

168 An \old/ Persian Hookah, of ornamented silver work, richly inlaid in patterns with flat pieces of green and blue turquoises, which have been cut to shape and put in. The greater number of these however have dropped \out/ or been purposely extracted. This metal portion of the pipe appears to be complete, and takes into several different parts. (The lid and the curved [-piece\tube] which were \formerly/ detached \from the other portion/ I have had mended). The bowl is of \thick brown shiny/ clay with indented ornament round the upper edge, and has been broken \and mended again a fragment being wanted/. There is no certainty of its belonging to this pipe, though it was in the drawer stowed away with it, together with the hookah tube \of No. 166 [-and] mentioned under the foregoing number. H 1 ft. 2/10 in. \Greatest D 3 in./
MacGregor 1983, no. 379.

169 Indian god, Vishnu, finely cut in relief on a slab of dark slate stone. He is represented with four arms and holding in the upper right hand his mace, the lower hand having the lotus impressed on the open palm: in the upper left arm he holds a fabulous gem, and in the lower a conch shell. He is attended by two Gopis or Nymphs, one of whom is playing on a kind of lute. Whole H 3 ft. 1 in. W 1 ft. 6 in.: and Th 5 in.
Ashmolean 1836, p. 146 no. 499.

170 A \nearly/ similar \carved/ figure to the above, and of like stone, but of smaller size, and more elaborately

ornamented. Much broken, \and/ having lost all the upper limbs except the upper portion of one of the right arms. Whole H 2 ft. 10 in.: W 1 ft. 3 in.; and Th 5 in.

171 A Turkish Bow-case of black leather, ornamented on the outside with flowers, etc, embroidered in very fine silver wire, \and/ over the whole surface. This decoration has \now/ turned nearly black. The back side is quite plain. L 2 ft. 1 8/10 in. W of top 12 5/10 ins; of bottom 6 in.

171a A Bow case of the same shape as No. 171 but the outside being of an ornamental diaper pattern in green plush: the other side being of plain brown velvet. Bound all round the edges with a braid of a mixed red and green colour. Perhaps Turkish. L 27 5/10 in. W 13 3/10 in.

172 A conical-shaped, Malay hat; made of long narrow \longitudinal/ layers of some plant (probably the palm), sewn together with cotton thread \in twelve horizontal seams/, and bound round the edge with split cane \having a curiously looped external binding; and a kind of [illeg.] to the top/. H 11 5/10 in. D 17 in. (For \figure/ of a similar hat see Wood's "Nat: Hist: of Man", vol: 2 p. 474, fig. 2.) \There is a separate band fixed inside to fit the head and covered with white cotton. W across 7 5/10 in. depth about 2 in./ Given by Captain H.F. de Lisle, Guernsey, 1827.
Ashmolean 1836, p. 179 no. 42 [?].

173 A conical-shaped Hat, \from Corea/ [-perhaps \Malay or/ Indian]; made of layers of leaves, enclosed on the outside and the inside with interlaced open-work of split cane, \or some such material/ something after the [-manner\pattern] of \the common/ cane bottom of a chair, that on the outside being much finer than the inside; and about 3 in. wide round the rim \the material is/ of a closer pattern, like basket-work, the edge being strengthened by a thicker piece of cane curiously looped up \something but not exactly after the manner of No. 173. [*sic*]/ The apex \of the hat/ has a loop probably for suspension. H 8 in.: D 14 1/2 in. Given by Dr. Jarbo of H.M. Bengal Ecclesiastical Establishment \1878/.

174 A three pointed dagger, [-\or shield ?/] two points of which are made of the horns of the common Indian Antelope (A Cervicapra), the larger ends or butts of which overlap in a straight line about 5 in., are capped with iron and strongly fastened in position with two iron pins, so that the curves of the horns being opposite allow room for the forepart of the hand to pass through, the hinder horn forming the handle. The third point is a projecting two-edged leaf-shaped spike L 3 5/10 by 1 5/10 in. broad, fastened in the centre of the front, at right angles with the other two. The tips of the horns appear to have had ferruled iron spikes, L about 2 in., which have been lost, and the end of one of the horns has been broken off. "The two horns are arranged with their bases crossing each other about six inches. The curvature of the bases thus furnishes a kind

of handle which can be grasped in such a way that the holder of the weapon can strike right and left with it, and also forward with the iron spike in front, and among a lot of people, could do a vast amount of damage in a very short time." Wood's "Nat: Hist: of Man" vol: 2 p. 770 No. 9. Present L from tip to tip 24 5/10 in. L of perfect horn 16 in.
Ashmolean 1836, p. 181 no. 87.

175 Indian dagger made entirely of steel: and one which is in great favour especially amongst the rich. The handle which has been gilt being made of two straight parallel bars L 9 in., Th 5/10 by 3/10 in., and 3 in. apart, with two plain transverse many-sided bars close together at 7 in. from the extremities. The blade which tapers to a point is in a line with the handle, \and/ is L 10 in., W 2 3/10 and Th 4/10 where it joins the handle, and ornamentally ridged for the distance of 6 4/10 in. whence to the point it is four-sided or lozenge shaped in section, When used the hand grasped the two cross bars which form the handle, having the blade projecting in front, the back long parallel bars protecting the lower part of the arm. Whole L 19 in. "When this dagger is grasped, the steel continuations of the handle project on either side of the wrist, and effectually guard it and the lower part of the arm from a sword-blade. The weight of this instrument, as well as the force with which a thrust can be delivered by a straight blow as in boxing, render the weapon well calculated to drive its way through the folds of dress, or even between the joints of armour". (See Wood's "Nat: Hist: of Man" vol: 2. p. 770. figs 7.8).
Ashmolean 1836, p. 179 no. 38.

176 Indian Dagger of the same kind as the preceding, but the blade much wider, shorter, and thinner, and with only a faint ridge running along the middle of each side, the point being somewhat thickenned. The two transverse bars are octagonal, much thickened in the middle where they are connected. The whole dagger appears to have been ornamented with gilt scroll work \painted on/ some of which remain. L of parallel bars of the handle 7 inches. W apart \which is also the width of the blade/ 3 1/10 in. L of blade 7 7/10 in. Whole L 14 2/10 in.
Ashmolean 1836, p. 179 no. 38.

177 Ditto, with wide handle, and wide and short blade, the grasp for the hand being formed of two small plain round bars 1 1/10 in. apart. L of [-of] parallel bars for the protection of the hand 5 5/10 in., distance apart 4 3/10 in., L of blade 6 6/10 in. Whole L 12 4/10 in.
Ashmolean 1836, p. 179 no. 38.

178 Indian dagger of the same kind as the preceding but in shape more like No. 176, but smaller, and the two cross bars of the handle four sided, or lozenge-shaped in section and not quite toughing [touching] each other. L of parallel bars 6 in., W apart 3 in., L of blade 8 in. Whole L 12 8/10 in.
Ashmolean 1836, p. 179 no. 38.

179 Ditto, with the blade much narrower than \in/ the preceding four numbers, and of the handle part, the parallel bars 6 8/10 in. long ornamented \with a/ perforated pattern. The cross bar for this grip and the lower portion of the blade is or[na]mentally moulded. This specimen is quite distinct from the preceding four. W of handle part 3 1/10 in.; L of blade 10 2/10 in., W 1 5/10 in.

180 Ditto, in embossed black leathern sheath, with wider blade, which is ornamented with four longitudinal grooves, which are finished off by scallops at the back, the handle being made of a pair of moulded bars which are larger and [-tough] touch each other in the middle. The \side/ parallel bars are 6 1/10 in. long, and 3 2/10 apart, and are perforated with numerous small holes but not in such a neat way as the preceding specimen. L of blade 6 8/10 in.; W 2 6/10 in., Whole L 12 in., L of [-] sheath 7 7/10 in. (Ramsden collection No. ?) Purchased by the University in 1878.

181 Battle axe, used either by the Sowrahs or Khonds, Hill tribes of India. It has a socketted steel head with flat sides, and sharp cutting edge hollowed out in the middle and the points reflected backwards; the handle being round and of hard black wood; The blade is ornamented at the junction with the socket with a few incised lines. Depth of blade 7 in. W of cutting edge, 10 2/10 in. L of handle 31 in. D 1 2/10 in. [*drawing*] Dr Jarbo, H.M. Bengal Ecclesiastical Establishment, 1878.

182 Ditto, ditto, smaller but of same shape[.] Depth of blade 5 8/10 in. W of cutting edge 8 5/10 in. L of handle 29 5/10 in. D 1 in. Ditto same as above.

183 Ditto, ditto, ditto. Depth of blade 5 6/10 in. W of cutting edge 8 6/10 in. L of handle 27 in., the top having an ornamental ferrule under the head. Ditto ditto.

184 Ditto, ditto. W of cutting edge 8 4/10 in. L of handle 24 8/10 in. Depth of blade 6 in. Given by Dr Jarbo, H.M. Bengal Ecclesiastical Establishment \1878/.

185 Indian battle axe (?), having a somewhat \butcher's/ chopper-shaped blade, L 9 7/10 in.; 3 4/10 broad at the top, which is straight as well as the back; the cutting edge being sharpened from one side only, \and/ sloping inward \from the top/ towards the handle, where it is reduced to 1 in. \in width/. Handle L 23 5/10 in., oval-shaped in section, D 1 5/10 by 1 in., with iron ferrule 1 in. wide, below which is a band \5 in. long/ of fine [-interlaced\plaited split] cane \or wicker/ work. One of the sides at the bottom of the handle, for the distance of 5 in., is ornamented with tufts of reddish-brown hair, five or six inches in length, each tuft being fastened into a hole made in the wood. End of the handle rounded. The handle has \been painted black/. Given as in the above.

186 A large Indian \(Naga)/ spear-head of iron: the upper part being flag-leaf shape, L 16 in. and W 1 7/10 in., below which for the distance of 9 in. are five long barbes on each side, curved outward and upward, L from 2 5/10 to 3 5/10 in., the two lowermost of which on one side have been broken off. Below these barbes is the socket, L 6 in. and D 8/10 in., this has a slit down the side. Whole L 2 ft. 5 5/10 in. Given as in the above. [*drawing*]

187 Indian shield, made of an oblong-shaped piece of \Buffalo/ hide, pressed \out/ in the middle of the back side to allow room for the hand. It is painted black, one end on the outside being ornamented with two \conical shaped circular/ bosses of thin brass, D 2 5/10 in., fixed at 5 5/10 in. from each other. The handle appears to have been made of a double loop of wicker-work. L 2 ft. 2 in.; W at one end 20 8/10 in.; at the other end 17 5/10 in. Given by Dr Jarbo, H.M. Bengal Ecclesiastical Establishment, 1878.

188 Indian \(Polygar?)/ circular convex shield, made of hide \probably of the Buffalo/ painted black, and ornamented on the outside with four iron studs, three of which remain, arranged in a square about 5 5/10 in. apart, the shanks of which pass through the shield and form loops at the back for the attachment of the handle, which is made of two loops of wicker-work, \or split cane/, bound round with coarse \brown/ cotton \cloth/ and fastened together in the middle. D 2 ft. 5 in. For a similar shield see Meyrick's "Ancient Armour", vol: 2 plate CXXXVII, figs 10 and 11. Given as in the above.

189 Seventeen arrows, used by the Hill Tribes of India. They are of stout reed with large iron heads, each of which is barbed \at the back/ in the ordinary fashion \or else square/, and fixed by a long tang into the end of the reed [*drawings*]. The feathers which are four or five in number, are rather clumsily bound on and chiefly on the twist. L 25 to 30 in. Size of the heads L 5 5/10 by W 1 4/10 to L 3 3/10 by W 8/10. Given by Dr Jarbo, H.M. Bengal Ecclesiastical Establishment, 1878. Arrows of this kind are mentioned in Woods' "Nat: Hist: of Man", vol. 2 p. 767.

190-191 Two Tulwar Sabres, with leathern scabbards, from Bengal. They have sharply curved and pointed blades, the handles being of moulded cast iron and comparatively small. Blades 27 5/10 and 30 in. long respectively, and about 1 5/10 in. wide. Whole L 2 ft. 7 5/10 in., and 2 ft. 11 in. For similar weapons, see Meyrick's "Ancient Armour" vol: 2. pl. CXXXVIII, fig. 17 and [-pl. CXLI fig 9]. Given by the preceding.

192 A sabre in \plain/ steel sheath, probably of English manufacture, with \horizontally/ grooved wooden handle mounted with brass. It is very like those used by the English Horse Artillery. Length 2 ft. 11 in. W of blade 1 3/10 in. L of scabbard 34 5/10 in. \diam 2 1/10 in.;/ with two metal rings for the strap, and [-marked\stamped] at the top "Johnson" with some other

letters not discernable. The scabbard looks too large for the sword. Given as in the above.

193 Indian spear-head of iron, with large socket for the handle. L 8 8/10 in., W 2 7/10 in. L of socket 6 3/10 in. D of bottom 1 4/10 in., tapering upwards to 5/10 in. Given by Dr Jarbo, H.M. Bengal Ecclesiastical Establishment, 1878. [*drawing*]

194 A very large Indian spear-head of wrought iron, or steel, with flat, broad, long, leaf-shaped blade with two prominences opposite to each other on the edges at the lower end, near the socket, [-which] which is small compared with the blade. Whole L 24 7/10 in.: Greatest W which is across the projections mentioned, above 3 in. Given as in the above. [*drawing*]

195 Spear-head of the same pattern as the preceding, but smaller, and much narrower; Length 18 3/10 in.; greatest W 1 5/ 10 in. Given as in the above.

196 An Indian wooden article, labelled "Naga Chief's drinking vessel". It is somewhat in the form of a Buffalo's horn, \painted black/ and hollowed out at the large end to the depth of 9 in., and perforated at the small end, through which is suspended a loop made of numerous \brown/ cotton threads, with bits of yellow grass tied on the ends; possibly for carrying or suspending it by. Small end broken off. L on the outside curve 2 ft. 6 5/10 in.: D of mouth 7 2/10 by 4 1/10 in., and 3/10 thick. Given as in the above. [*drawing*].

197 An Indian \(Naga)/ spear shaft?, [-Processional staff? or standard] ? of hard light brown wood, the two ends being roughly pointed. The upper portion for the length of 45 in. is ornamented with [-short] crimson hair, apparently human, with two pairs of rings in black bound horizontally, or brush like, round the wood and cut short so as to have much of the appearance of a gigantic bullrush, with a gap or bare space in the middle apparently for the hand, and the lower part ornamented with a fringe of reddish brown hair 5 in. in length. L of stick 6 ft. 9 in.; D 1 in.: D of hair 3 to 1 8/10 in. Given by Dr Jarbo H.M. Bengal Ecclesiastical Establishment, 1878.

198 Ditto, similar to the preceding, but having a socketed square shaped spike at one end, 9 5/10 in. long. L 7 ft. Given as in the above.

199 Two large Cocoa-nut shells coloured black on the outsides with circular \hole/ in [-] top of each. D 1 in.; and attached together by \a/ loop[-s] \or handle/ of split cane. D 5 5/10 in. Used for carrying the sacred water of the Ganges. Given as in the above.

200 Indian spear-shaft?, [-Standard? or Processional staff?] of hard dark wood, pointed at the top, and with a [-square\quadrangular] shaped iron spike, 11 3/10 in. long on the lower end. The middle portion of the staff for the length of 2 ft. is bound \thickly/ with long black hair, seemingly human. L 5 ft. 8 in. D 8/10 in. Given

by Dr Jarbo H.M. Bengal Ecclesiastical Establishment, 1878.

201 Indian spear, commonly called a Pig-sticker. The shaft is of bamboo, with a leaf-shaped socketed \and/ apparently cast-iron head, the socket being large in comparison with the [-head\blade]. The other end of the shaft is inclosed in a heavy cylindrical shaped lump of lead L 3 4/10 ins, and D 1 1/10 \diminishing upwards to 1 5/10 at the bottom/. Whole L 6 ft. 7 5/10 in.: L of head 9 1/10 in., the tip being broken off; D of shaft 1 in. Given as in the above. [*drawing*]

202 Two long Indian (?) arrows of bamboo, headed with very long, round, and pointed pieces of hard brown wood, the junction of the heads with the shafts [-are bound\being] bound round with string. The tops of both shafts have been split apparently \accidentally/ by the further penetration of the heads, Whole L 53 3/10 in., and 51 5/10 in.; of the heads only 27 3/10, and 18 3/10 in. Given as in the above.

203 A bamboo stick having the stumps of the side shoots left on. The smaller end appears to have been formerly capped with a socketed spike, and the other end has been \worn/ much, as if it had been used for walking with. It may have been used for a spear-shaft, or as a walking, or climbing stick. L 4 ft. 11 in.: D 1 3/10 in., tapering to 8/10 at the top, which is pointed. Given by Dr Jarbo H.M. Bengal Ecclesiastical Establishment, 1878.

204 Indian article perhaps a sheath or quiver; made of woven basket-work, coloured black, the outside being extremely fine and close, so as to somewhat resemble coarse canvas. The top is open and resembles a fishes mouth open, that is with two projecting round lips, size 4 by 2 3/10 in. from whence it de[c]reases to 1 in. at the bottom \or small end/ which is stopped by a \removable/ perforated wooden peg. There are two small [-side] loops near the mouth at the sides. L 1 ft. 5 5/10 in. Given as in the above. [*drawing*]

205 Indian wedge-shaped celt of chipped, hard, black stone, with curved ground cutting edge, [-the] L 5 in.: W of cutting edge 3 2/10 in. It is partly incrusted with a thin light sediment, and the edge is somewhat broken. Given as in the above.

206 Ditto, of coarse brown stone, of similar shape to the above, but the whole surface rounded, and the cutting edge slightly curved. L 5 1/10; W of cutting edge 3 in. Given as in the above.

207 Indian celt of nearly the same form as the preceding, of rather finer brown stone, the sides being rather flatter and the angles of the cutting edge more rounded off. L 4 6/10; W of cutting \edge/ 2 3/10 in. Given by Dr Jarbo, H.M. Bengal Ecclesiastical Establishment, 1878.

208 A Malay? dagger with thin two-edged blade, on each side of which are three faint ridges, two of them at

4/10 in. from the edges and parallel with them, and the other down the middle. The handle is small, made of light coloured wood: and the sheath is rudely made of two flat pieces of soft light wood, L of blade 5 9/10 in.; W 2 1/10 in. Whole L 9 2/10 in. L of sheath 6 7/10; W 2 8/10 in. For figure of a somewhat similar weapon see Meyrick's "Ancient Armour", vol: 2 Pl: CXLVII fig: 11. Ramsden collection, No. 77? Purchased by the University 1878.

209 A small Japanese clock with brass works, inclosed in square upright case of dark wood, something after the shape of the old English upright clockcases. The drawer at the bottom is for the key. The glass door at the top slides up for the purposes of winding, The thirteen metal numbers down the wooden plate in front (and which is detached by the brass screw at top to get at the weight), are moveable and are arranged according to the sun's declinations. The Japanese divide their days into six portions and the nights the same, the[re]fore in summer the six upper numbers should be far apart, and the six at the bottom close together. The clock is supposed to be wound up at sunrise. The mechanism is very simple. Whole H 8 9/10 in. H of glass framework surrounding the works 2 6/10 in.; D of ditto 1 7/10 by 1 5/10 in. L of bottom part of the weight \only/ 5 7/10 in.; D 1 5/10 by 8/10 in. Not of recent manufacture. Given by the Rev: Wm. Warner Parry M.A. Worcester College. Chaplain of H.M. Ship Excellent 1878.

209a Also the box of \pale/ wood with lid, on which are painted Japanese characters. L 9 3/4 in. W. 2 3/10 in. D 2 2/10 in

210 Indian ? tool? or weapon? with dark brown wooden handle, horizontally grooved round its whole length. The blade is double and fixed at right angles with the handle, one side being hatchet shaped, the other like the top portion of the blade of a bill-hook or ducket, and cuts by drawing forward towards the person. L of blade 8 8/10 in.; greatest W of the hatchet side 2 3/ 20; of the other side 2 4/10 in. L of handle 7 6/10 in. [drawing]
MacGregor 1983, no. 102.

211 Carved figure of a Chinese Philosopher, of white red and yellow veined or stained steatite stone, standing \on/ but detachable from a pedestal of carved open rock-work of the same material, holding some object in his left hand and resting on his arm, with the figure of a fawn reclining on the pedestal on his right. The drapery is ornamented with numerous faintly etched lines in patterns, and some few characters, the whole of which have been gilt. The right foot of the figure, as well as the head of the fawn, and some other smaller portions, have been broken off and lost. H off stand 8 8/10; or on stand 12 2/10 in. Given by Dr. Rawlinson, St. John's College, 1719.
Ashmolean 1836, p.179 no. 50.

212 A wooden figure of an Indian idol or devil, on a stand having a hollow dome-shaped back. A very correct representation of this figure appears in page 37 of the "Travels of Sir Thomas Herbert", London, 1634. It is at the head of "a description of the Bannyans of Indya". The plate exhibits "An Indyan Merchant or Bannyan". who is pointing to the figure, before which is a dish of fruit, and above it, on the framework, is a small vessel containing fire. No direct allusion is made to the figure, or the merchant, but in reference to the inhabitants it is stated, that "they worship the Devill in sundry shapes and representations." The figure has a conical shaped hat, from which, and [at] the back of the head there have been sixteen spikes \inclined/ outwards and more or less upwards, about half of them are left, and some of those in a broken condition. In the plate the figure is represented with four horns, which spring from beneath the cap, two on each side [of] the front of the head; these are large and twisted like ropes, the two lower ones incline downward and outward, the two upper turn upward and outward: the figure has but one of these horns remaining and that imperfect. The face is \very/ ugly but still human, except that the beard forms seven distinct rays. The arms and body are those of a woman, with large pendant breasts; the thighs, legs and feet appear to be intended to represent those of an Eagle. Over the region of the pelvis the figure holds the head of an animal, having two large ox-like horns, and large open mouth. One of the horns and the tip of the other have been lost. The whole is coloured black, except the eyes lips and beard of the figure, the eyes and mouth of the head below, and the hollow back of the stand, all of which are red. It appears to have had a tail which is also gone. H of figure 15 8/10 in.; on stand 20 in. Given by Dr Rawlinson, St: John's College, 1719.
Ashmolean 1836, p. 147 no. 502.

213 The emblem of the god Siva carved in white marble; reduced size of Somerath. H 9 3/10 in. D of circular base \which is detachable from the other portion/ 5 7/10 in. Given by H.H. Wilson, M.A. Exeter College, Professor of Sanscrit 1841.

214 Representation of an Hindoo Temple, enshrining the emblem of the god Siva; the lines \of the whole/ formed by the words [drawing] Sree Doorga. God. Inclosed in a black frame ornamented with five parallel longitudinal beads, with plain \flat/ gilt fillet \W 7/10 in./ within, on which is painted the description and Donor's name. Given by Sam'l Prattinton Stacy Esqr of Calcutta 1824. Size as framed 17 8/10 by 14 in. Whole W of frame 2 4/10 in., and Th 9/10 in.
Ashmolean 1836, p. 177 no. 76.

215-22 Two Indian sepulchral Urns or Chatties with covers, fragments of another very large one and cover, three others without covers, and more or less broken, and one lid or cover \only/, the lower part \of the chatty/ being wanting; and some other odd fragments of urns; \all of brown pottery/ together with \a few/

remains of calcined human bones, and metal objects found in them. From a Cairn on the Neilgherry Hills, near the coast of Malabar. Presented by the Rev J. Griffiths, \of Madras/ M.A. Ch[rist]: Ch[urch]: Coll[ege]: \June/ 1844.

Ashmolean 1836-68, p. 7.

They are as follows:

215 (1) Chatty containing \a few/ calcined bones of an adult, one arrow-head, one razor shaped instrument, one hand sickle, [-and] a broken article, and one thin ring of white metal \(silver)/. D of chattee 8 5/10 in.: H 6 3/10 in., the lower part being globular in form with six concentric ridges round the shoulder; greater portion of rim broken away, brown clay. The arrow head appears to be wanting. L of \iron/ razor shaped instrument 4 4/10 in.: W 1 9/ 20 in.; it appears to be imperfect. L of iron hand sickle 6 7/10 in.: D 7/10 in. L of broken iron article, which is \cylindrical and/ club-shaped at either end \(and appears to be of the same shape as the bronze article found with No. 218 Chatty No. 4)/ from 4 to 5 in.; their is another half of a similar object with it. (It appears rather uncertain which are the cor[r]esponding halves of these three). A finger ring ? of round silver wire, rather larger in the middle then at the ends, which are not joined together, and are rather pointed. D 8/10 in. Cover wanting.

216 (2) Chatty with cover, both perfect. It contained bones of an adult with one arrow-head, and a knife. In shape it is similar to the preceding the upper portion near the neck being ornamented with three concentric hollows, the upper of which has an incised chevron border [*drawing*] thus. It has a \flat/ projecting lip \or rim/, and the cover is \plain/ about half globular or dome shaped \with a projecting rim round it 1 in. from the bottom and a little hole through the top/. The arrow-head is wanting. A double edged iron knife with long \round/ tang for insertion into the handle, which has perished. L 6 6/10 in.: Greatest W which \is/ at the lower part near \where/ the handle \should be/, 1 in. tapering to 9/ 20 at the point which is very obtuse. D \of chattie/ 7 2/10 in.: H 4 8/10 in., \or/ with lid 7 in. W of lid 6 8/10 in.

217 (3) Chatt[-ie]y with cover, of nearly the same form as the preceding, but the upper half ornamented with eight concentric ridges, and \with/ a border of close set indentations near the top. The cover being plain but much more depressed. Both portions have been slightly broken. It contains a few calcined human bones. H 5 3/10 in.; D 6 8/10 in., H with lid 6 5/10 in.; D of lid 6 4/10 in.

218 (4) Four fragments of a Chatt[-ie]y \(two of the rim and two of the cover)/ which was the largest found in any cairn hitherto, being 3 ft. in circumf[e]rance at the bulge. Containing one bill hook, one grass cutter's knife or sickle; two arrow-heads, one brass article; one piece of pumice stone. The upper portion of the urn has been highly ornamented with crossed and diagonal

indentations [*drawings*] thus. The cover was dome shaped as in the other specimens, a good deal ornamented, and had a kind of incised star ornament on the top. L of iron billhook 7 3/10 in.; D 1 5/10 in.; L of sickle 8 8/10 in.; D 9/10 in.; L of arrow-heads 2 1/10 and 2 3/10 in., only one of them appears to be perfect, [-and that] is quadrangular, and has a socket to fit onto the shaft; the other appears to have been barbed on one side. The article of brass is cylindrical-shaped and rather enlarged or club-shaped at each end \and in shape resembles some objects of iron found in Chatty No. 1/; L 4 in. D 2/10 in. Size of pumice stone 4 2/10 by 3 3/10 in. and Th 1 2/10. (The fragments of this vessel have since been joined).

219 (5) A very small C\h/atty which contained bones of a child and mould. This was inclosed in a larger chatty which was broken by the pressure of the grave stones. It is imperfect and there are no bones in it. D 3 5/10 in., present H 2 4/10 in.

220 (6) Cover, of a large Chatty similar in shape to a bucket, ornamented with concentric ridges and a double border of indented vandyke lines, thus [*drawing*]. It is of quite a different shape to the covers of the other chatties, being more like a teapot lid. D 4 9/10 in. H 2 7/10 in. [*drawing*].

\(7) "Fragment of an Earring in the same Chatty with which was a gold link (since lost) of a triangular shape."/ (Neither of these three are in the collection).

221 (8) Lower half of \a/ Chatty, ornamented round the middle \with/ incised Vandyke lines [*drawing*] \and an indented ridge below it; and on the shoulder above, with prominent ridges and two sets of incised Vandyke lines or rather cross lines, the rim flat./ It contained calcined human bones (two or three small fragments of which remain). D 7 3/10 in.; present H 3 1/4 in. The bronze bowl, No. 222 (9) was found in this Chatty, also on the rim of the bowl three arrow-heads like those found in Chatty 218 (4).

222 (9) Bronze bowl, on the brim of which rested edgeways three arrow-heads, like those in No. 4, which was inclosed in the Chatty No. 8. The arrow-heads were not brought to England. The bowl is semi-globular in form, of very thin metal and ornamented with several faintly incised concentric circles on the inside \at the bottom/ [-having] \surrounding/ a slight projection in the centre pressed up from below. D 4 9/20 in.; H 1 8/10 in. It is well made the edge being a perfect circle [*drawing*]. An account of a discovery of this kind is given in the "Proceedings of the Society of Antiquaries of London", vol: 4 p. 169, in which it is stated that "the tombs are situated at a short distance from the banks of the river Noyel, in the district of Coimbatore \Coimbatoor (Koimbatur) 10.58 N 76.57 E/. Upwards of a hundred may be counted at one place, forming an extensive burying-ground; their position is easily recognized above the surface of the ground, by a heap of stones

lying over each. On removing the stones, a granite slab, which seems to have formed a cover to the chamber, is first exposed about a foot below the surface, the slab is generally very much decayed. \The chambers below this are always found filled with earth and stones but w[h]ether originally so I am unable to determine./ It is \not until digging down [-at\to]/ the bottom of the large chambers of this kind that human bones earthenware \vessels, or/ "chatties", [-etc] \and pieces of iron very much corroded/ are discovered. The bones, chatties, and iron, are always found at the corners of the large chambers. The walls and partitions are formed of large slabs, some of them measuring 8 ft. square, and from 6 in. to 9 in. thick. The general plan or design of the tombs is invariably the same; some little variation is, however, observable in the mode of supporting the granite slabs. The natives with whom I have conversed cannot give any trustworthy information regarding the date or origin of these curious stones chambers. On being questioned they have always given some vague and improbably story or tradition, that a race of pigmies built and dwelt in them. I have \[not]/ seen any inscriptions, or figures of any kind, on the stones. Many of the finer slabs are removed from time to time from the burying-place by the stone "Wudders", or masons, for building purposes. The "wudders" state that when excavating they find chatties, bones, and pieces of iron, but never coins; and I believe that, had coins been found, the tombs would have been rifled long ago. An earthenware urn (a drawing of which is exhibited) was found in the same neighbourhood, buried about 2 ft. below the surface, and in excellent preservation. A large slab which crumbled to pieces on being removed, rested on the top. Several small chatties, filled with red earth, were found placed around the urn on a level with its mouth, and were also covered by the superincumbent slab. The interior was filled at the top with earth and stones; at the bottom were human bones, a copper ring, and pieces of corroded iron. Some of the chatties which I have dug up are very elegantly shaped, and are generaly glazed, black or red, the red ones being sometimes striped with a dark and lighter shade. Among the pieces of iron I recognized a spearhead and a sort of spade."

223 Coat of [-male\mail] \from Delhi/ of [-steel] chain armour, made of small steel rings each of which is separately rivetted together; with padded leathern collar ornamented with numerous small brass studs. Used by the Polygars of Southern India, and also with little deviation by other Mahomedan peoples. Length about 3 ft. A similar coat is figured in Meyrick's "Ancient Armour" vol: 2 Plate CXXXVII fig. 1 See also Wood's "Nat. Hist: of Man", vol: 2 p. 770 fig 3. Given by Major Stacy (Samuel P[r]attinton Stacy of Calcutta).
Ashmolean 1836, p. 179 no. 26.

223a-b Two thick, heavy bre[ast]plates, of quilted work, of coarse cotton cloth stitched through and through with string. The fronts lined with thin faded silk which at one time [-may have been \was] pink, and the backs with coarse brown cotton cloth. L 21 in.; W 20 in. No. 223a has the two ornamental \white/ metal buckles for fastening it attached to bits of leather at the top.

223c A back plate fellow to one of the preceding breast plates, of the same make but rather different in shape \being much flatter/. The four straps of softish leather covered with silk remain \perfect/ on the lower part, two of which have the buckles attached to them but of a different shape to those on No 233a. Size 20 5/10 by 20/ 5/10 in.

223d A smaller piece of the same kind of work somewhat of a long crescent shape with strings of plaited pink silk attached by which it appears to have been tied on to the lower part of the breast \covering/ No 223a to protect the thighs. W 19 in. Depth 6 3/10 in.

224 A circular-shaped, convex, Target or Shield, from Chinese Tartary?; made of thin wood covered with hide, and painted plain red on the outside; and red with a design in black, yellow, and what appears to have been originally silver, [-with \and] figures of parrots \in black/, on the inside. It has an oblong pad behind for the hand, [-with \which had] originally a loop at each end, one of which has been lost. D 24 5/10 in.
MacGregor 1983, no. 381.

225 Ditto ditto, with the pattern at the back almost obliterated. Handle gone. Size 23 7/10 by 22 1/10 in. Plain red on the outside.
Ashmolean 1836, p. 184 no. 164; MacGregor 1983, no. 43.

226 Ditto ditto, approaching a flattened cone shape, and painted on both sides with a similar design, consisting of star-shaped ornaments in yellow black and silver, the latter being much faded. The handle behind is perfect, and the shield incloses shot or some such article which rattles when the shield is shaken. D 22 in.
Ashmolean 1836 p. 184 no. 162; MacGregor 1983, no. 382.

227 Ditto ditto, with a different pattern in yellow black and silver on a red ground, the silver as usual having very much faded, the same design being on both sides. The shield is [a] flattened cone shape with the sides somewhat pinched in like. D 21 4/10 by 20 in.
Ashmolean 1836, p. 184 no. 161.

228 A circular convex shield of wood covered on both sides with hide which also extends over the rounded edge. The ground painted black, ornamented on the inner side with well painted figures of birds animals flowers, etc. with an ornamental border round the edge, all in gold. The outside which has been much damaged apparently by arrow and sword cuts has a coat of arms \in colours/ in the centre, surrounded by a border of

stars, outside which has been birds flowers etc all in gold. Perhaps Indian. D 21 4/10 in. and about 5/10 in. thick. Handle gone. Coat of Arms like this [*drawing*] surrounded by foliage in gilt.
MacGregor 1983, no. 42.

229 East Indian \([-Japanese \Ceylonese])/ Spear with large iron head, the blade of which is L 14 5/10 in., and W 1 5/10 tapering to the point, with a very prominent ridge running along the middle of each side; the socket being 7 5/10 in. long, and ornamented with concentric [-and\circles with] cross lines between them, \all rather faintly/ incised. The blade has a deep notch cut in each edge near to the socket, something after the manner of the Kookree knives. The shaft which is L 4 ft. 7 in. and D 8/10 is round and made of four pieces of cane joined together longitudinally, and painted or japanned with patterns in red black and yellow. It has been very much injured.
Ashmolean 1836, p. 179 no. 27; MacGregor 1983, no. 383.

230 East Indian (?[-Japanese \Ceylonese]) lance with moulded, round and socketted spike on one end L 5 4/10 in. and D 8/10 in. Shaft of wood L 5 ft. 4 4/10 in. and D 8/10 in. at the spiked \end/, decreasing in D to 5/10 in. at the other end, which appears to have lost six long feathers, which were bound on as in an arrow. The shaft has been painted red, with circles, spirals, and other ornaments in black and yellow, in \nearly/ the same style as the shaft of the preceding object. Whole L 5 ft. 9 8/10 in.
Ashmolean 1836 p. 179 no. 27; MacGregor 1983, no. 384.

231 East Indian (?[-Japanese \Ceylonese]) bow, of wood painted or japanned \of a bright shining/ red, and ornamented in the middle \for the L of 18 5/10 in./ and at the ends \for 10 in./ with designs in black green and yellow; much after the style [-as\of] the two preceding objects \229 & 230/. It is cylindrical in shape. L 6 ft. 7 in.; D in the middle 1 1/10 in., gradually decreasing in size \but keeping the same form/ to the ends, to 4/10 in. There is no line attached.
Ashmolean 1836, p. 179 no. 27; MacGregor 1983, no. 33.

232 Indian ? \or Ceylonese ?/ bow of cane bound throughout its whole length with what looks like thin bark, and painted plain \dull/ red. The bow is cylindrical, and largest in the middle decreasing and flattened at the ends which have projections for the string to slip over. L 7 ft. 6 in.; D in the middle 1 3/10 in., decreasing to 8/10 in. at the ends.
MacGregor 1983, no. 34

233 A Glaive from Chinese Tartary? Shaft \straight/ of \brown/ wood oval-shaped in section, D 1 3/10 by 1 in., [-japaned \coloured] black and towards the top bound round with three [-from\brass or bronze] bands, at intervals. \The upper one with the guard at the top being [-] engraved and apparently inlaid/. The blade is L 1 ft. 9 in., [-and] somewhat sabre-shaped and D 1 5/10 in. Whole L 6 ft. 4 in. For figure of a similar weapon see Meyrick's "Ancient Armour" vol: 2 plate CXLIV: fig: 13.

Ashmolean 1836, p. 179 no. 37.

234 A Malay? Javelin [-with\a well made but] unequally barbed \and socketted/ iron head, and nicely \and smoothly/ rounded shaft of hard dark, \almost black/ wood. L of head 7 6/10 in.; present L of shaft 41 in.; D \near the head/ 5/10, gradually tapering to the end, about 5 or 6 in. of which has been broken off. There is slight traces of the joint down \the socket/. [*drawing*] Head of No. 234.
MacGregor 1983, no. 385.

235 Ditto, ditto, with similar but rather smaller head, \L 7 in./; the shaft being complete. Whole L 53 8/10 in. For a weapon with this kind of head see Meyrick's "Ancient Armour" vol: 2 Plate CXLVII: fig 4 but not the shaft
MacGregor 1983, no. 386

236 Javelin, probably from the same locality as the two preceding, as the shaft appears to be of the same kind of wood. It has a well made and nearly leaf-shaped iron head L 11 8/10 in., \(the socket of which is 5 3/10 in. of it)/ and D 1 5/10 in. The shaft is nicely rounded the end being apparently broken off. Whole L 54 6/10 in. There is no traces of the joining down the socket.
MacGregor 1983, no. 387.

237 Indian (?) Javelin, with an exceedingly well formed, \nearly flat/ thin, steel head, of the long leaf-shaped pattern, the edges being very sharp; the socket small as compared with the blade, and open down the side; L 13 in., D 1 8/10 in. L of shaft 33 in.; D 7/10 in., decreasing gradually to the end to 5/10, from which a considerable length may have been cut off; it is nicely rounded and polished \and made of a wood resembling mahoghany/. Whole L 3 ft. 10 in. Locality unknown. Ramsden Collection No. ? Purchased by the University 1878.

238 Eastern spear, [-perhaps from the Eastern Archipelago], with nearly leaf-shaped iron head [-with\having] two small projections on the edges; and rather rudely made, by closing the two lower edges to form the socket, as in an ordinary woodman's ducket \this lower part being covered with hammer marks/. L 11 7/10 in., W 1 4/10 in. The shaft is of hard black wood, rather roughly rounded, L 53 5/10 in. and D 9/10 in.; ornamentally \closely and neatly/ bound round for the length of 40 5/10 in. of its middle portion with \interwoven/ rattan, (a kind of wickerwork), coloured red and yellow \in a kind of pattern/ and bound round with two tufts of human hair dyed of a reddish brown, L 6 in., at about 26 in. from each other, bound in with the ratten on the middle portion of the shaft. The bottom of the shaft has a pointed spike L 5 in., the ferrule of which is made in the same manner as that of the head. Whole L \of Spear/ 5 ft. 10 in. Purchased. (Probably a comparatively recent addition to the collection, the history having been lost. It was added previous to 1869, when first I had to do with the museum) Ed. Evans Assist Keeper 1884.

239 Spear with thin, long, and rather wide leaf-shaped blade, [-with\having a] faint central ridge down each side, and a short octagonal shaped socket, [-the] the ends of the rivet of which used for fastening it on to the shaft, project, forming square studs at the sides; L 15 5/10 in., W 2 1/10 in. Shaft of hard, dark brown wood, rather roughly rounded, and somewhat warp[-h]ed, L 6 ft. 10 in. and D 9/10, the bottom being capped with a screw shaped piece of iron L 1 3/10 in. Whole L 8 ft. 2 in. (This spear may be African). Capt[n]. H.F. de Lisle. 1827 (?).[9]
Ashmolean 1836, p. 181 no. 88.

240 Spear, probably Malay \or Indian/ with long narrow well formed head, made of two [-two] metals blended \together/ in a kind of wavy pattern as in the Malay Kris \(see No. 27)/. L 16 8/10 in. W near the socket 1 4/10 in. \with edges straight/ gradually diminishing to 5/10 at the point, which is rounded, with a strong central ridge along each side of the blade, from which the sides slope off to very sharp edges. It appears to have been fixed in the end of the shaft by a tang, and has a somewhat ornamented shoulder, \and is altogether well and neatly made/. Shaft nicely rounded and of polished \or varnished/ mahogany, or some similar \reddish brown/ wood. L 5 ft. 10 5/10 in. and D 1 in., the sides being parallel and the end squared off. Whole L 7 ft. 3 5/10 in. [*drawing*] Ramsden Collection No. ?. Purchased by the University 1878. (The top of the shaft for the distance of 7 4/10 in. seems to have lost a ferrule, or else it has been purposely scraped).

241 Spear \(from Borneo?) or India?/ with head apparently of blended metals, and [-and] rather rudely made, L 11 7/10 and 1 1/10 in greatest W, diminishing to the point but not regularly, the edges being nearly parallel for some distance. Ferrule of ornamented silverwork L 5 5/10 in. Shaft of hard black wood as in No. 238, L 6 ft. and D 8/10 in. and enclosed throughout its whole length except the bottom 3 8/10 in. (which is octagonal and somewhat tapering to the end), in a close network of catgut \or string/ plaited round the shaft and apparently without any join \and then [-apparently] coated with some varnish/. Whole L 7 ft. 6 4/10 in. Is it Indian? Given by the Executors of [-the] Captain C.C. Bristow, Bodicote, Oxon, 1875. I should say that all Captain Bristows things are from the same place. See 145.146.147. 148 & 257. 258 [*drawing*].

242 A shield from Nias Island (Pulo Nias), on the east coast of Sumatra: of very light, reddish-brown wood, cut into somewhat the shape of the keel of a boat, with [-rounded \cylindrical] projections at each end, that at the bottom being much the longest. The front is convex with a prominent ridge down the middle, which in the

centre of the shield swells into a rounded boss \which is/ hollowed out at the back to allow room for the hand, the bar of the handle being cut from the back of the shield, w\h/ich is concave. An ornamental ridge runs round the back and the front about 1 5/10 in. from the margin closely following the outline, and within these there are a number (22) horizontal bands of split cane or rattan bound opposite on both [-sides\back and front] each band being about 1 in. apart. L 3 ft. 11 5/10 in. Greatest D, which is across the middle 9 8/10 in. Ramsden Collection. No. ? Purchased by the University, 1878 [*drawing*].

242a Two oblong shaped pieces of Armour from Java, said to be a back plate and breast plate, each is made of sixteen horizontal rows of pieces of horn cut into shape to represent scales of the Scaly Manis, and arranged overlapping each other like fish scales, there being eleven such pieces of horn in each row [-on] which compose one piece of the armour, and 10 pieces in each row in the other. Each piece of horn is about L 4 1/4 by W 1 1/2 in., flat on the underside, slightly rounded above and peaked at the lower end except the bottom row which are square. Size as fastened on two thin boards 2 1/2 by 15 in. (Ramsden Collection No. ?) Purchased by the University in 1878 [*drawing*].

243 A C\h/inese, somewhat heart-\shaped/ fan, made of pleated [-bambo\palm] leaf, bound round the edge with thin pieces of split cane tied together \so as to form a stiff rim/; with a turned handle of wood coloured dark brown. L 16 3/10 in., W 12 4/10 in.[10]
Ashmolean 1836, p. 181 no. 83 [?]; MacGregor 1983, no. 388.

243a A \cylindrical/ stringed musical instrument made of a piece of Bamboo L 14 7/10 in. and D 2; the strings being merely narrow strips detached from the surface except at the two ends, where they are each propped up with a little block or bridge of wood, and the ends strengthened with a plaited binding of rattan. Through the hole down the centre of the bamboo is strung a large pleated piece of palm leaf. The strings were formerly nine in number only 3 of which are perfect. [-Locality unknown\Madagascar] Ramsden collection, No. ?. Purchased by the University in 1878.

244 Ditto, [referring to 243] much broken and the rim of split cane gone. L 16 5/10 in. Ramsden collection No. 657. Purchased by the University, 1878.

245-246 Two Eastern fans, \Indian [-Borneo]/ each made of a piece of pleated Palm leaf, the leaf forming the \circular/ top \or fan/ and portion of the split stem the handle. The upper part or fan, being painted in a rude manner with green, blue, and red, and bound round the edge with a double fringe of

[9](This may be from the Cape of Good Hope, and if so, may belong to De Lisle's donation; but it cannot be called an Assagai. It is probably a mistake in the catalogue of 1836.) It may be Soudenese, as Capt. De Lisle was Governor of the Soudan at one time.

[10]Possibly this is the \Chinese/ fan given by Mrs Birkbeck along with a Chinese figure carved in ivory. Which is not now in this Collection without it be the ivory carving of a French woman with two shoes by her sides under a small glass globe see Ashmolean 1836-68, p. 4.

[-pink muslin\violet gauze] ornamented on the edge with silver paper, which has much faded. \L 21 5/10 in. W 9 5/10 in./ Given by Joseph Hugh Chambers, Esq. Mag[dalen]: Coll[ege]: 1875.

247-248 Two Chinese? fans[11] of nearly circular shape, made of small, interwoven roots, which are left \unwoven/ as a wide fringe round the edge, except in one place, where a large semicircular wooden handle \is fixed/, which is covered with very thin paper daubed with patches of red green and black paint \probably in imitation of flowers/. The fans are strengthened here and there and round the edge with [-pieces\narrow strips] of split cane \bent into shape/. D to outside of fringe about 2 ft. D to outer circle of cane 17 5/10 and 15 8/10 in.
Ashmolean 1836, p. 181 no. 83 [?]; MacGregor 1983, no. 389.

249 Indian ? \North American/ fan[12] \made/of numerous \(67)/ small lengths of Palm-leaf, cut to one pattern, and arranged so as to spread out in a circle, the pieces overlapping each other, and connected together at the \outer/ edge by a single \strong/ cotton thread. They all fold up by overlapping, and lie between two flat sticks \cut to shape and/ which form the handles. L when open 14 5/10 in. D 10 5/10 in.
Ashmolean 1836, p. 181 no. 83 [?].

250 Eight cores of brown flint from which flakes have been struck perhaps to use as Knives. From the Rohri Hills, India. L 4 5/10 to 2 8/10 in. \Compare these with the flint cores from Pressigny-le-Grand Poitou./ Given by Sir John Lubbock, Bart. \April/ 1878.

251 A Ceylonese \walking/ stick painted red, and decorated round the top and \near the/ lower end with a pattern in yellow and black [-\the lower end being entirely black and pointed]. Slightly hollowed out round \near/ the top \which is/ rounded; and slightly tapering to the bottom which is pointed \and coloured black/ L 40 5/10 in. D at top 7/10 in. at bottom above point 4/10 in. Given by the Trustees of the Christy Collection \in exchange in/ 1869.

252 A Persian Battle-axe. Handle of wood, rounded, [-and coloured\painted] black, and slightly bent outward \or backward/ from the head, which is of \black/ steel, heavy, and very Tomahawk in form, [-and] having a square hammer like back, the sides having formerly been ornamented with a pattern in gilt \traces of which remain/. L of handle 24 3/10 in., D 1 in. L of head 5

1/10 in. W of cutting edge 3 5/10 in. Whole L 24 5/10 in. A similar weapon is figured in Meyrick's "Ancient Armour", vol: 2. Plate CXXXV, fig. 12.
Ashmolean 1836, p. 179, no. 23.

253 Indian? \or Persian?/ Battle-axe, with \bright/ steel head, [-the top of] the blade being curved downwards and the cutting edge sloping inwards towards the handle, and the back part of the head produced into a square shaped hammer. All the sides except underneath being ornamentally engraved \with figures of leaves or flowers/. The handle which is \straight/ thick, and \nearly/ oval-shaped in section, appears to be of oak, [-and] is somewhat polished, and is [-somewhat] larger at the head than at the other end. L of head 7 in. W of cutting edge 2 5/10 in. D of handle at top 1 6/10 by 1 3/10; at bottom 1 3/10 by 1 in. Whole L 22 3/10 in. Ramsden Collection, No.? \87/. Purchased by the University 1878.

254 A \small/ thin, oblong-shaped slab of black marble, with the figure of a crouching Lion carved in low relief in the middle, the margin having an ornamented border. From the Coorg Rajah's palace. L 2 9/10 in. W 2 2/10 in. and Th 5/20 in. Given by Mrs F. Spring \Lady of the Rev: F. Spring, A.M. Presidency Chaplain of/ Madras, 1836 \(see No. 110) /.
Ashmolean 1836, p. 181 no. 85c.

254a A bag, or cushion cover? of exceedingly fine woven grass in a kind of raised pattern much resembling plush, the colours being different shades of brown, the pattern being in lozenges and formed by the ends of the material projecting \upright/ and cut very close. There is a border of little knobs all round the edge and four larger ones at the corners made in the same manner. Both the outer sides have the same pattern, but the inside is plain light brown. Locality uncertain but probably Eastern. L 18 5/10 in. W 9 5/10 in.
MacGregor 1983, no. 359.

255 A sash, or belt, perhaps from India; made of exceedingly fine woven grass, in various patterns, in reddish-brown, yellow, and white, and fringed at the ends by being left unwoven. L 6 ft. 2 5/10 in. W 5 in. Ramsden Collection No. ? Purchased by the University 1878.

256 Ditto ditto, of [-double the\three times the] width, but coarser and rather different make; with coloured patterns in brown, black, and white, with long fringe at the ends. L 5 ft.; W 15 in. Ramsden Collection No. ? Purchased by the University 1878.

257 A sash, or belt, perhaps Indian, \(Borneo?)/ made of various sized threads, \some/ of cotton, and others of silk; of a variety of colours, closely woven, with the threads \of the ends/ or warps, plaited to form a \kind of open/ border 1 in. in width, outside which they are left single to form a fringe. The colours \being/ blue, red white yellow, green, the centre being a kind \of indistinct/ lozenge pattern in white on a blue ground, [-

[11]247 & 248 Old Chinese from the Northern Provinces bordering on Tartary. They are getting rare, [- now], and are said to be not now in use.
[12]Is Chippewa Indian and should go in the N. American case. They are difficult to obtain now. Possibly this may be the Chinese fan given together with Chinese figure carved in ivory which is not now in the collection unles it should happen to [be] the small ivory carving of a French woman with two shoes at her sides given by Mrs Birkbeck; see Ashmolean 1836-68, p. 4. Mrs Birkbeck gave several North American Indian things.

the\and the] sides [-being] filled up with narrow stripes of different colours. L 8 ft. 5 in. W 8 in. Given by the Executors of Captain C.C. Bristow. Bodicote Oxon: 1875.

258 Ditto, very similar to the preceding, but made entirely of cotton threads, the colours being the same but a little different in their arrangement, and the ends left in long fringes. L 10 ft. 2 in. W 6 3/4 in. Given as in the above.

259 A piece of \woven/ cloth \from the Dyaks Borneo/ made in a width, in a pattern something after the style of the two preceding articles \No. 257 & 258/ entirely of cotton threads, coloured brown black and white, edged on the sides with stripes of the same colour. [-From Borneo] L 45 in. W 19 in. [-Apparently given by the Trustees of the Christy Collection [-1878] 1868 As] There is an original parchment label tied to it "Borneo. Sir J. Brooke 24/6/54 dup. from Kew". From the Trustees of the Christy Collection in exchange 1869.

260 Japanese Mosquito network, made of green coloured cotton, with messhes D about 5/10 in. L 8 ft. 3 in. W 2 ft. 8 in. Brought from Japan about 1825. Given by \W / J. Bernard Smith, Esq. London. [-1878\1875].

261 Japanese Cloak of fine grass, the innerside being a fine [-but] network, the ends \of the grass/ left long so as to fall over each other on the outside. Brought from Japan about [-1878\1825]. L 5 ft. W 32 in. Given \by W./ J. Bernard Smith. Esq. London. 1875.

262 Japanese hat, or headdress, of various grasses \etc, dyed/ [-coloured] yellow and black, thickly overlapping one another, and bound on the outside in an ornamental pattern with alternating borders of blue, \black/ and green cotton threads. It has a long and very thick fringe to cover the neck, the outside layer of which is made of one kind of grass \only/ dyed black, and crimped, so that it looks like a \kind of/ seaweed. W 29 in. Depth 22 in. See Wood's "Nat: Hist: of Man" vol: 2 p. 852. Given by W. J. Bernard Smith Esq London. 1875.[13]

263 A Chinese Rain coat, made of the fibre of the Coirs Palm, which grows in abundance in the province of Chelsiang. Coats of this description are commonly worn by the poor of that province, they are very durable and cheap, costing from six to sixteen shillings each. L 42 in. W at shoulders 46 in., at bottom 30 in. Given by Charles W. Everard, Esq 1882 \Through Greville J. Chester. B.A./.

264 Circular-shaped, bronze, Japanese mirror, flat and polished on one side, the other side having a deep hollow, and having feather-like ornaments, etc, \to within 1/8 in. of the edge which forms a projecting

rim, perhaps intended for trees/ cast in relief at the bottom with what looks like the figure of a turtle in the centre \which is perforated sideways through the back/ D 4 1/10 in. [-W \Depth] of rim 4/10 in. Given by Greville J. Chester, B.A. 1881.

265 Small oblong-shaped \Japanese/ bronze mirror polished on one side \and silvered;/ with picture in relief on back \and two little perforated projections 1 7/10 in. apart/. Size 2 6/10 by 1 8/10 in. Given by Greville J. Chester B.A. 1878.

266 A Hindoo painting on glass, of a female figure, probably of a deity, which is wearing Crown, necklace, bracelets etc: In gold and colours. It has had four \arms/, but has been much injured \by rubbing/ and the glass broken. In an \almost black/ frame [-with\having] four longitudinal beads \on the front/; Size 7 1/10 by 5 2/10 in., as framed; Ramsden Collection No. ?. Purchased by the University 1878.

267 Photograph of "a group in Chinese ware. The extremities of the figure are much broken off. The original stands 15 in. high". Size as mounted on cardboard 7 by 5 in., of photograph only, 3 9/10 by 2 7/10 in. Given by J. Pilbrow Esq 1875 Through J.H. Parker, Esq. C.B. the Keeper of the Ashmolean.

268 Fragment of polished \coloured/ marble. Brought home from the Mount of Olives, 1834 Size 2 6/10 by 2 4/10 in., and Th 1 3/10. Given by R.H. Inglis. Date?

269 Irregular shaped fragment of pale opaque green glass, from the Kings palace at Agra. Size 3 4/10 by 2 7/10 in. Given by Master Robert Tudman, Oxford 1882.

270 Triangular shaped fragment of white marble \flat on the sides/. From the King's bath at Delhi. Size 4 2/10 by 2 5/10 in., and Th 1 in.

271 Portion of a flat oval shaped stone of many colours; polished and \the/ edge bevelled. Perhaps for inlaying. Found in the ground at Muret, about 40 miles from Delhi. Size 1 5/10 by 1 2/10 in. a[nd] Th 2/10. Given by Master Robert Tudman. Oxford. 1882.

272 Semi-globular stone of an [-cream\opaque yellowish] colour \with white zone round the edge;/ perhaps the stud of a ring, or of some other article. Found at the same place as the preceding. D 7/10 in. Given by the same as above.

273 Small fragment of \semitransparent/ red stone, Cornelian, from the King's palace at Delhi, L 9/20. Given by the same.

274 Figure of a Chinese Philosopher, [-carved \made] out of a singularly knotted piece of wood; the head and the hands being the only portions carved, the remainder left in the natural growth of the wood; together with the curious openwork kind of stand to which it is fixed by a pin. H including the stand 33 in.; \or/ off the stand 20 5/10 in. The right hand holds some cocoa-nut shaped object; the object from the left hand

[13]No. 260-262 were given through Prof: J.O. Westwood M.A. Hopeian Prof: of Zoology.

having been lost. Given by H.N. Moseley, Esq. M.A. Exeter College 1876.

275 A Chinese cross-bow, \of \brown/ wood, something like Oak, the bow itself probably being made of a piece of female bamboo/ for shooting two arrows at one time, and several in succession. The box above is meant to hold the arrows, and when they are discharged others drop down from the box each time the bow is bent by the lever. See Wood's Nat: Hist: of Man. Vol: 2 p. ? \where they are described/ L 27 4/10 in. L of bow 32 4/10 in., the line has been lost. H 6 3/10 in. Ramsden Collection No. ? Purchased by the University, 1878.

276 Four Chinese bronze weights. They are square-shaped and hollow, fitting one inside the other like a nest of boxes. Three of them are inscribed on their five faces, the [-letters \characters] being either in relief or incised \on the respective faces/. They appear to belong to a set, and that originally there were at least five of them, the one next to the innnermost (which is solid and inscribed \in relief/ on the six sides), is wanting. D 1 7/20 in.; 1 1/10; 9/10; and 11/20 in. Given by Greville J. Chester, B.A. 1882.

277 Five modern Afghanistan coins of copper, no two of which appear to be \of/ the same kind, as the characters and symbols on each are different. Procured during the Afghanistan war, 1878. Given by Master R. Tudman, Oxford, 1882. [5 outline drawings, below each of which is an impression in sealing-wax of the relevant coin].

278 Two modern Eastern Egg cups \or said by Mr Evans the keeper to be coffee cups/ (probably Turkish); of \bright/ white metal, apparently stamped out; one is plain except a notched edge at top [drawing] thus; the other has figures \(Trophies)/ near the top in relief with a scalloped edge \thus/ [drawing] \above/. H 2 in. D 2 in. Given by Greville J. Chester, B.A. 1872.

279 [-Turkish gun flint, with openwork leaden mounting] Two oval-shaped pieces of Japanese, or Chinese money, having square holes through the middle as in their common round money. Size 1 9/10 by 1 3/10 in. Given by Dr. W. Dean Fairless, Park Town Crescent, Oxford 1880.

280-285 [-Two\Twelve Chinese] round coins with \square/ holes through them for stringing, [-Chinese] \of the Emperors of the present (or the Ja Tsing) Dynasty. They are as follows:

280 Two of the Emperor Shun Che \ascended the throne 1643-4. Reign closed/ 1661 reigned 18 years).

281 Ditto of the Emperor Kang He, reign closed 1722, reigned 61 years.

282 Ditto of the Emperor Yung Ching, reign closed 1735, reigned 13 years.

283 Ditto of the Emperor Keen Hung, resigned 1795, reigned 60 years.

284 Ditto of Kea Kung, died 1820 reigned 25 years.

285 Ditto of the Emperor Taou Kwang 1836, in the 16th year of his reign.

286-353 Sixty-seven Chinese brass coins, one Japanese, and one Cochin-Chinese; all of the ordinary circular shape, and each having a square hole through the middle for stringing them. Given by Professor Legge, Professor of Chinese in the University of Oxford. 1880. The numbers in parenthesis are those of the Professors MS list, had with the coins, and from which the following is copied.

Of the Han dynasty, B.C. 206-220 A.D.

286 (1) The Wû Chû. May have been made in B.C. 118, But Wû Chû cash were cast occasionally on into our sixth century.

287 (2) The Fo Ch'wän, made by the usurper Wang Mang AD 9-23. Of the northern Chân Dynasty AD 557-581

288 (3) The Jâ-ting. A.D. 581. But there was also a Ja-ting period under the Kiu dynasty, the year 1161

Of the Thang Dynasty. A.D. 618-906

289 (4) The Khâi-yüan. A.D. 713-741

290 (5) The Ch'ien Yüan A.D. 758-759

291 (6) The Thai-ho A.D. 827-835. Of the Later Chân Dynasty

292 (7) Of the later Han dynasty. The Han-Yüan A.D. 936-948

293 (8) The Chân-Yüan. A.D. 951-960. Of the Sung Dynasty. A.D. 960-1126

294 (9) The Sung-yüan A.D. 976-997 [-]

295 (10) The Thai-p'ing A.D. 976-983

296 (11) The Shun-hwa. A.D. 990-994

297 (12) The Chih-tâo A.D. 995-997. Of the Sung Dynasty

298 (13) The Hsien -pi'ing A.D. 998-1003

299 (14) The King-teh A.D. 1004 -1007.

300 (15) The Hsiang-fu. A.D. 1008-1016

301 (16) The Thien-hsi A.D. 1017-1021

302 (17) The Thien-shäng A.D. 1023-1031

303 (18) The Hwang-sung A.D. 1023-1063

304 (19) The Ming-tâo A.D. 1032-1033

305 (20) The King-yû A.D. 1034-1037

306 (21) The Chih-ho A.D. 1054-1055

307 (22) The Kiâ-yû A.D.1056-1063

308 (23) The Chih-pi'ing A.D. 1064-1067

309 (24) The Hsi-ning A.D. 1068-1077

310 (25) The Yüan-fâng A.D. 1078-1085

311 (26) The Yüan-yû A.D. 1086-1093

312 (27) The Shâu-shǎng A.D. 1094-1097

313 (28) The Yüan-fû A.D. 1098-1100

314 (29) The Ch'ung-ning A.D. 1102-1106

315 (30) The Jâ-Kwan A.D. 1107-1110

316 (31) The Chǎng-ho A.D. 1111-1117

317 (32) The Hsüan-ho A.D. 1119-1125

Of the southern Sung Dynasty

318 (33) The Kien-yen A.D. 1127-1130

319 (34) The Shâo-hsing A.D. 1131-1162

320 (35) The Khien-tâo A.D. 1165-1173

321 (36) The Shun-hsî A.D. 1174-1199

322 (37) The Shâo-hsî A.D. 1190-1194

323 (38) The Khing-yüan A.D. 1195-1200

323a (39) The Kiâ-thâi A.D. 1201-1204

324 (40) The Kiâ-hsî A.D. 1205-1207

325 (41) The Kiâ-ting A.D. 1208-1224

326 (42) The Shâo-ting A.D. 1228-1233

327 (43) The Kiâ-hsî A.D. 1237-1240

328 (44) The Shûn-yû A.D. 1241-1252

329 (45) The King-ting A.D. 1260-1264

Of the Kin dynasty, a Tartar rival of the two Sungs A.D. 1115-1234

330 (46) The Chang-lung A.D. 1156-1160

Of the Ming dynasty A.D. 1368-1643

331 (47) The Hung-wû A.D. 1368-1398

332 (48) The Yung-lo A.D. 1403-1424

333 (49) The Hung-chih A.D. 1488-1505

334 (50) The Chǎng-teh A.D. 1506-1521

335 (51) The Kiâ-tsing A.D. 1522-1566

336 (52) The Wan-lî A.D. 1573-1619

337 (53) The Thâi-ch'ang A.D. 1620

338 (54) The Thien-khî A.D. 1621-1627

339 (55) The Ch'ung chǎng A.D. 1628

340 (56) The Hung-kwang

341 (57) The Lung-wû

342 (58) The Shâo-wû

343 (59) The Yung-lî

344 (60) The Tâ-shun.

These five [55-60] and many more coins were made during the concluding struggles of the Empire with the conquering Manchus. They were cast by one "king"

and another who maintained the standard of patriotism in different parts against the Tartars.

Of the present-Manchû Tartar dynasty

345 (61) The Shuu-chih A.D. 1644-1661

346 (62) The Khang-hsî A.D. 1662-1722

347 (63) The Yung-chǎng A.D. 1723-1735

348 (64) The Khien-lung A.D. 1736-1795

349 (65) The Kiâ-khing A.D. 1796-1820

350 (66) The Tâo-kwang A.D. 1821-1850

351 (67) The Hsien-fǎng A.D. 1851-1867

352 (68) A Japanese coin. The Khwan-yung (?) A.D. 1794

353 (69) A Cochin-Chinese coin. The Shâo-p'ing, about A.D. 1349

354 A carved cup of Rhinoceros horn, Chinese?, or Indian?; of a light brown colour, and carved both inside and outside as if formed to represent the flower and [-petals\and other parts] of some plant, the \5/ petals being lapped one over the other \at the edges/. Around the outside are carved the buds, leaves, and twisted stems, the foot-stalk of the flower forming one of them. Most of the stalks and tendrils are detached from the cup itself. H 3 in. \Greatest/ D 5 by 3 3/20 in.
MacGregor 1983, no. 74.

355 Portion of the shell of Nautilus pompilius, carved in relief with Chinese figures. Size 4 3/10 by 3 8/10 in.
MacGregor 1983, no. 78.

356 Terracotta vase, with shining dark red glaze; body globular-shaped, with narrow, nearly straight [-narrow] neck, scalloped round the top. Locality uncertain, but perhaps modern oriental. H 2 8/10 in. D 2 3/10 in. \diameter/ of neck 1 in. Given by John Henderson, Esq. M.A. Ball[iol]: Coll[ege]: 1879. (This came along with the collection of the Ancient Greek & Etruscan vases; it may be modern Egyptian).[14]

357 Small irregular shaped, fragment of white porcelain; broken from the porcelain tower of Nankin, China. Size 4 by 1 4/10 in. (No other history known)

358 A small Hindoo amulet of silk, red on one side and blue stripes on a white ground on the other; ornamented round the edge with small opaque white glass beads sewn on, with a plaited loop of fine yellow hair at top for suspension. It is supposed to contain some relic of a relation or friend. Worn suspended round the neck, under the dress. L 1 7/10 in. W 1 1/10 in. [*drawing*]. Given by Master Robert Tudman, Oxford 1882.

359 Burmese image of Gotama or Buddah of carved and gilt wood, sitting crossed leg[g]ed \with the right foot resting on the left knee and the left foot on the

[14]The Keeper A.J. Evans Esq thinks this is from S. America.

right - the soles being upwards,/ on a plinth or base. Ears and arms touched with red. The spike on the top of headdress has been broken, and there is a hole in the right breast. The whole has been carved from a solid block. H 3 ft. 5 in.; D of bottom of stand 1 ft. 7 8/10 by 1 ft. Given by Sir Henry Torrens, Bart. 1826.
Ashmolean 1836, p. 146 no. 500.

360 Ditto, ditto, of smaller size and better finish, and with rather different details, but in the same attitude. Quite perfect except portion of the gilt. It has a square hole cut in the back apparently for fixing it. H 2 ft. D of bottom of stand 10 3/10 by 6 in. Given by C. Porcher, Esq. Oriel College. 1829.
Ashmolean 1836, p. 146 no. 501.

361 Ditto, ditto, of white alabaster, or marble, partly gilt, more like 359 than 360. The thumb of the left hand, and the spike on top of the head have been broken off. H 2 ft. 7 in. D of bottom of base 19 5/10 by 9 in.
MacGregor 1983, no. 79.

362 A Chinese vessel of white porcelain, glazed of a shiny green ground colour on the outside, with moulded leaves and flowers in low relief in yellow and brown. It is similar in shape to a Roman cinerary urn of the ordinary common form, with five loops placed at equal distances from one another on the shoulders close to the neck, one of which has been broken off, each loop being ornamented with two deep grooves longitudinally. H 1 ft.; Greatest D 10 8/10 in.; D of bottom 7 in.; of top 5 5/10 in.
MacGregor 1983, no. 76.

363 Chinese Vessel of somewhat the same form as the preceding, but not so contracted towards the bottom, of white, glazed porcelain, with patterns of foliage, monsters or dragons, etc, in dark blue burnt in: the whole of the bottom and a piece of the top has been lost. It has four perpendicular bands of split and plaited cane round the sides, which are attached to two others each of which are made of three whole canes twisted and which pass around the top and bottom of the vessel. Joined to the upper one of these are two loop handles, one on each side of plaited split cane like the \4/ upright bands, which are held together by way of [a] handle above the top, like a basket, and to these handles are loosely tied a strong loop of hide or leather, possibly for hanging the vessel up, or for carrying it on a stick \or pole/. H 13 5/10 in. Greatest D 13 3/10 in.; D of bottom 9 in.; of top 7 5/10 in.
MacGregor 1983, no. 77.

364 A Japanese [-or Chinese] globular shaped box with cover. The middle portion or sides being of interwoven split cane, or basket work, and the cover and bottom of wood. The whole has been Japanned black inside and out, the interwoven work being visible only on the inside \all the outside being plain black/. H 12 6/10 in. Greatest D 16 4/10 in. D of top 8 9/10 in.: of bottom 12 3/10 in.
MacGregor 1983, no. 75.

365 A Chinese paper note with signature of the present Emperor of China. Size 10 by 3 5/10 in. Given by Master E.V. Richards, Oxford, 1877.

366 An oblong shaped pi[e]ce of thin yellow paper, stamped with Chinese characters \and border/ in black, with four stamps in red, three of them at one corner and one at another. Perhaps a note. Size 8 5/10 by 6 5/10 in.

367 A wooden spoon, probably Eastern, with narrow long handle, and bowl egg-shaped in outline, [-with\having] a small peak \or projection/ in front, and painted brown, green, violet, and black in bands and dashes, chiefly in a diagonal manner across the bowl. Size of bowl 4 2/10 by 2 4/10; W of handle 4/10 which is not flat but ridged. Whole L 11 6/10 in.
Ashmolean 1836, p. 180 no. 71.

367a A spoon with similar shaped bowl to the preceding, except that it is more curved forward in front, is without the peak on the bowl, and has a very short cylindrical handle. Painted plain dark brown. Whole L 5 5/10 in.
Ashmolean 1836, p. 180 no. 71.

368 A spoon? or pipe?, probably Eastern, cut out of one piece of [-light\pale] brown wood, with boat shaped bowl rounded at the two ends, and a cylindrical-shaped hollow stem or handle connected with the bowl as in a tobacco-pipe. Perhaps intended for smoking opium. Size of bowl 2 3/10 by 1 5/20 in.; L of stem 6 3/10 in.; D at the bowl 5/10 in. decreasing to 7/20 at the end. Whole L 8 11/20 in.
Ashmolean 1836, p. 180 no. 71; MacGregor 1983, no. 70.

369 A spoon of light brown wood, with somewhat heart-shaped bowl having a small projection or beak in front. The handle is cylindrical \becoming larger/ and ornamentally turned at the top. Size of bowl 3 by 1 19/20 in.; Whole L 8 7/20 in. Greatest D of handle 7/20 in. Locality uncertain.
Ashmolean 1836, p. 180 no. 71.

370 Wooden spoon of singular shape, the bowl part being nearly like half an egg supposing it separated lengthways, the larger end \being/ in connection with the handle, which is the same [-with\width] with it at the junction, flat, tapering to the end, [-and] serrated along the two edges, and has a triangular perforation in the middle. Locality uncertain. Whole L 7 9/20 in. W of bowl 2 3/10 in. [drawing].
Ashmolean 1836, p. 180 no. 71.

371 The Imperial flag of China, taken from the summit of the Porcelain Tower [-of] at Canton, 1840. It is triangular in shape, the centre being a fine drab material \(silk)/ with figure of a dragon painted on, in what was perhaps silver, (but which has faded? to a green colour); with black outlines. The bottom, and the upper, or sloping [-end\side], are edged with scalloped borders of red, of like material, W 15 in. The side for the pole \has a border/ of greenish cotton with tapes of

the same colour for tying it. L of the back and bottom \which are straight/ 8 ft. each; of the upper \or sloping/ side about 11 ft. Given by the Rev: William Langley Pope, D.D. Pembroke College, [-1863?; or] 1865 [-?]. (This flag has been injured \of late years/ by fixing against a damp wall at the bottom of the staircase in the basement).

372 A pair of shoes of raw hide, \(Goat's?)/ with the white hair preserved on the \outside of the/ soles only. They have long thongs of the same material, which are laced all round the top, through holes cut in the material, the ends \of the laces/ being left long at the back, so as to act as reeving strings, and for tying also. The toes are pointed and \smartly/ turned up at the tips, which are ornamented with little upright tassels of red wool, behind which \at the distance of 1 1/2 in./ is fastened a single black button on each. The turned up toes resemble those represented on the Hittite monuments in Asia Minor. Usually worn by the peasantry in Anatolia, in Asia Minor, and called by the donor "sandals or moccassins". L 11 in.; D about 3 5/10 in. Given by C.W. Wilson Esq. Oriel College 1883.

373 A curious vessel of black, rather shining ware, with two spouts on opposite sides, and two horizontal loop handles between them, one of which has been broken. It may have had a lid which is lost. The ware is a good deal like the early Etruscan black ware. H 5 7/10 in.; D across the spouts 8 6/10 in., D of top 4 4/10 in.; of bottom 3 4/10 in. (It may not be oriental). (Found knocking about in the Museum without any history.) [*drawing*]

374 [-A weapon called a Parang-Ihlang, and carved wooden sheath strengthened with cane, and ornamented at the bottom with one white feather, and portion of another spotted one from the wing of the Argus Pheasant, and at the top with a disk of wood and a tassel. The hilt of the weapon is made of \carved/ stag's horn, ornamentally mounted with brass, and fringed with tufts of human hair dyed red. Used by the Dyaks of Borneo. The real inventors and principal makers of it are the Kayans, who belong to the Malayan division of the Land Dyaks. See Wood's "Nat: Hist: of Man", vol: 2, p. 469. L 2 ft. 5 8/10 in.; Greatest W of blade 1 1/2 in. L of scabbard 2 ft. 1 1/2 in.; W 2 3/10 in. (On loan from Mr Craddock, Old Clarendon Building Broad Street, Oxford).[15]]

375 A large model of a Chinese Junk, with masts, sails of matting-work, cords etc. The model is of wood painted black on the outside, and covered along the top with 13 separate cross boards which are removeable at pleasure, and form the deck. L of boat 10 ft. W in the middle 2 ft. 8 in. L of the three masts, which are also painted black, 7 ft. 9 1/2; 6 ft. 6 in.; and 4 ft. 3 in. H of

rudder 2 ft. 9 in.; W 1 ft. 4 in. Size of the two \brown/ matting sails, which are \bound round the edges with strong cotton cloth, and/ strengthened by cross bars of bamboo tied to the sail with split cane. L 6 ft. 3 by 4 ft. 2 in.; and \L/ 4 ft. 3 1/2 by 2 ft. 11 in. Brought to Europe in the Hon[orab]le East India Company's ship "Castle Huntley". Captain Henry Andrews Drummond. Given by Henry Wise, Esq. 3rd Officer of the above ship, 1825.
Ashmolean 1836, p. 174 no. 11.

376 \Small/ Tom-tom, or drum, \or model of ditto?/ of hard wood cut into a bowl or basin shape which is painted \dark/ red and covered at the top with white skin[-g], [-apparently\perhaps] human \and fastened down/ by numerous flattish \headed/ iron [-headed] nails round the edge of \the/ skin. At the sides are two moveable iron rings attached by staples to the drum, apparently for its suspension. H 4 8/10 in.; D 5 in. Found in the hold of the moddle [*sic*] \No. 375/ without any history, and may belong to it, and if so was probably used for striking the hour.

377 A small gong \or model of ditto,/ of \thin/ mixed metals, (yellow, with black streaks), with a string for suspension. D 6 1/10 in.; Depth 1 in. Found in the hold of the model, \No. 375 without any history/ and like the above article \No. 376/ probably belonging to it, as it has the same kind of cord attached as that on the sails of the Junk.

378 A couple of Chinese cylindrical shaped [-latter] lanterns of very fine lattice work of split cane, and what looks like a very fine network of silk, covered or coated with a thin dried starchy substance, and painted with designs in colours. The bottoms have been coarsely turned out of wood and coloured black, attached to which is a double wire, which projects in the form of a loop at \the/ top to hang it by. The wire has been lost from one of them. H 9 8/10, D 4 3/10 in.; Found in the hold of the model of the Chinese Junk \?/ No. 275 \3[75]/ but probably has nothing to do with it. No history known. \Described by Conrad v. Uffenbach. Merkwürdige Reisen; who visited Oxford 1710./

379-83 Five Chinese pennants, or small flags \used by the soldiers \as colours of the regiment/ and comparatively scarce in collections;/ four of yellow and one of green coloured silk, with figure of dragon on each, painted in black, which may have been originally silver but faded, as have also the flags. They are each attached to an ordinary pi[e]ce of cane, and ornamented \at the top/ with tufts of human hair dyed red with a flat duck's-bill-shaped end which has been gilt. Down the side next the stick in four out of the five, is an inscription in \either/ green or red letters, the same inscription being on each of the four [-flags]. The flags are attached to the sticks by strips of strong cotton \cloth/. L \or H/ from 28 1/2 to 29 1/4 in. the end of each piece of cane has been \roughly/ pointed for insertion into something. Found in the hold of the

[15]This was restored to the owner in 1884 by request.

model of the Chinese Junk No. 375, without any history, and has probably nothing to do with it.

384-5 Two circular shields, probably Japanese, Chinese or Tartarian: made of ordinary cane, twisted concentrically close together from the centre to the edge, and bound together by narrow, split, interwoven pieces of the same material; and each has a loop for the lower arm and a hand grasp made in like manner \at the back, the fronts being slightly convex/. One is entirely plain, the other being ornamented on both sides with concentric patches, with a star of 11 rays in the centre, all in black. D 24, and 22 in.
Ashmolean 1836, p. 184 nos. 165-6; MacGregor 1983, no. 45.

386 A model of a Chinese or Japanese Boat, with rudder \and oar, and cover of split cane/ attached. It is very broad in co\m/parison with its length, and painted brown, white, green, and red on the outside, and an inscription on the inside in yellow on a red ground. It appears to be incomplete. L 2 ft. 2 in. W 8 8/10 in. (Ramsden collection No. ? \101/). Purchased by the University \1878/

387 A Japanese or Chinese long Canoe-shaped article, with flat bottom, and flat sloping sides, japanned black on the outside, with figures of trees, houses, and boat on each side, the same design being repeated Inside with a leaden lining which now is detachable \from the wood/ L 19 3/10 in.: Greatest D, which is in the middle, 2 8/10 in., sloping to 1 8/10 at the bottom, Depth 1 6/10 in. (Ramsden collection No. ?\102/ Purchased by the University 1878).

388 An object [-use unknown] \apparently a \stringed/ Musical Instrument \on the principle of the Fiddle/ made of a piece of bamboo \L 18 5/10 in. and D 7/10/ coloured brown \pierced with two holes/ and stopped at one end with an ivory disk, the other end being inserted at right angles through a wooden cylinder L 4 2/10 in. by D 1 8/10, which is covered at on[e] end with snakes skin. [-It may be some musical \instrument/ and probably is imperfect. Locality unknown.] Chinese [-?]. Ramsden collection No. ? Purchased [-for\by] the University 1878 See Wood's Nat: Hist: of Man, vol: 2 p. [].

388a [- The top of a similar object, also covered with snakes' skin. \Broken./ L 4 4/10 in; D 1 9/10. Ramsden Collection No ? Purchased by the University 1878. These are Chinese Guitars.]

389 A small hand shield very neatly made of \brown/ grass, wound round concentrically from the centre to the margin, and stained in the middle and round the edge with black patches. It somewhat resembles the cane shields No. 384 385 in the manner of construction. At the back is a strong leathern loop. It looks imperfect, and may be the centre only of a much larger shield. D 1 ft. Locality unknown. Ramsden collection No. ?. Purchased by the University 1878.

390 An Indian guitar of carved wood which [-have \has] been afterwards blackened over. On the front is \the upper part of/ a winged human figure, and on each side a cobra or snake, with flowers leaves, etc. The lower part is hollow open \in front/ and somewhat fiddle shaped, with a carved bridge across the contracted part. Only one screw and catgut string remain of the [-four\two]. L 41 5/10 in. Greatest W 5 in. Ramsden collection No. ? Purchased by the University 1878.

391 Indian \?/ \large/ sunshade, or umbrella; of stiffened cotton, painted plain green on the outside, the inside being the same \ground colour/ with coarse pattern painted in yellow, white, brown \and/ black. With very long but light stick, the lower portion of which is painted brown, with lattice pattern in black and yellow \on it/, with a white star in each space; the pattern being divided into three lengths by horizontal bands of black and white, with a leaf like ornament as a finish above. H of top closed, 2 ft. 5 in. L of stick which is detached from the other part, 7 ft. 3 in.; D at bottom 2 in., diminishing to the top to 1 3/10. Ramsden collection, No. ? \140/. Purchased by the University, 1878.

392 Ditto, ditto, the upper side being gilded paper coloured black underneath \except the edge which is gilt/, and ornamented with numerous red green and yellow crossed silk threads. The stick is long and solid and has apparently been cut to resemble bamboo and coloured brown, with a great long knob on the top which has been gilt. L of stick 8 ft.; D 1 3/10 in. W of top when open 4ft. 2 in.; the \latter/ has been very much injured. Ramsden collection, No. ? Purchased by the University 1878.

393 Ditto ditto, the cover scarcely any of which remains \perfect/ being of green silk and painted in various bright colours \with figures of birds, flowers etc/ on the outside, being edged with black underneath; the middle portion of which is ornamented with numerous, red, white, blue, green, yellow and brown crossed cotton threads in a kind of pattern. Handle of dark brown wood turned at the end. L of stick 27 5/10 in.; W across top \when open/, about 4 in. \!! ft.?/ Probably Chinese. Ramsden collection No. 227. Purchased by the University, 1878.

394 A set of [-seven out of what was perhaps originally] eight copper gongs or bells, all of the same shape, having a deep hollow in the centre which projects on the other side. They appear to have been suspended on strings \from having/ [-the] four holes through the edge of each, in which portions of the strings remain. D 6 8/10; 6 3/10; 6; 5 5/10; 5 5/10; 5 2/10; 5; and 4 2/10 in. Locality uncertain but perhaps

Chinese or Burmese.[16] Ramsden collection No. ?
Purchased by the University 1878.

395-6 Two fly-flaps or [-whisks] whisks, made of
grass, with taper[ing] wooden handles coloured red
yellow and green, and the grass bound at the top with
coloured cotton. End of one of the handles broken off.
L 24 and 22 in. Probably Indian. Ramsden collection
No. 159? Presented \?Purchased/ by the University
1878.[17]

397 A flatly conical shaped hat made of rushes, [-a]
strengthened round the edge with a piece of split cane,
and covered on the outside with \what/ looks like fishes
scales, \sewn on/, overlapping each other, and
decreasing in size from the rim to the apex, which is
finished with a circular piece. These scales have been
coloured in a star-like pattern in green and black, the
latter reaching to the edge, the remainder are white.
Possibly the scales may be those of the Manis, and
some of them at least appear to have been trimmed to
shape \round the edges/. Probably from China or
somewhere that way. D 10 in. Ramsden collection No.
? Purchased by the University 1878.

398 A circular flat gong, or cymbal; of thick metal,
having a deep hollow in the centre on one side with a
corresponding prominence on the other. It has a loop
of cord through the hole in the centre. Locality
unknown [-by] but probably Eastern. D 8 4/10 in.; Th
of metal 2/10 in. Ramsden collection, No. ? \99/
Purchased by the University 1878.

399 Model of an Indian palanquin made of black and
brown woods, inlaid round the sides and ends in
panels, with bottom in open canework \like a cane
bottom chair/. Bed, cushion, pole, and cover attached.
L 12 6/10; W 7 in.; Whole H 10 5/10 in., L of pole 33
3/10 in. Given by the will of Richard Rawlinson,
L.L.D. St: John's College, Oxford. 1755.

400 A piece of very closely woven, and strong cotton
material, of a light brown colour with a border 7 in.
deep along the bottom, and 1 1/4 up the sides, in a kind
of lozenge pattern and chevrons, in black red and
brown. It seems to have been a cloak, and would very
well serve the purpose of a water proof. It appears to
have been made in five \horizontal/ widths independent
of the coloured border, and very neatly joined. W 53
in.; L 39 5/10 in. Perhaps from [-] India. Ramsden
collection No. ? Purchased by the University 1878.

401 Eastern horse harness, perhaps Turkish, consisting
of the tail piece, and head gear. Of leathern straps,
ornamented on the upper sides with numerous
\moveable/ embossed and gilt metal plates, and five
bosses. The head piece having two large tassels of
various coloured silk. The straps have been
ornamentally stitched with silver thread, but this has

turned black. L of tail piece 40 in. L of the head piece
about 37 in., with portion of a crescent-shaped pendant,
engraved on each side and gilt, to hang on the horses
breast. A few of the plates on the head portion [-are
gone\are wanting] (Ramsden collection No 413, 414.
Purchased by the University 1878).

402 A flatly conical shaped hat of fine ornamental
basket-work material, portion of which has been
underlined with red silk, and green cotton. It has been
very much injured. Perhaps from China or somewhere
that way. W 14 in. Ramsden collection, No. ?,
Purchased by the University 1878.

403 A hat or helmet?, somewhat conical shaped above
with a broad projecting rim \slanting downwards/.
Apparently pressed out of raw hide, [-and] painted
black all over and \on the outside/ ornamented with two
rows of gilt objects, perhaps intended for \the
representation of/ some fruit, one row being round the
upper part and [-one\the other] round the rim, eight [-
ornaments\such objects] being in each row. At the
junction of the upper part with the brim is an angular
fillet stuck [-on\round], and immediately above it are
two holes on each side of the hat, [-the holes\each pair
of holes] being about 4 in. apart, perhaps for strings?,
and a large hole in the top for ventilation?. Locality not
known but possibly Eastern \Burmese?/. H 8 5/10 in. W
13 4/10 in. Ramsden collection No. ? Purchased by the
University, 1878.

404 An implement, or weapon, with heavy iron head
which is worked into a semicircular hatchet like cutting
edge \on one side/, and a long somewhat curved,
\quadrangular pointed/ pick at the other. It has a long
\and stout/ handle of brown wood, which is somewhat
rounded in the middle portion, the ends being left
nearly [-square \quadrangular]. Locality uncertain, but
perhaps Eastern. L of head 13 6/10 in.: W of cutting
edge 6 4/10 in. Whole L 2 ft. 11 in. Ramsden collection
No. ? \86/. Purchased by the University 1878.

405 Drum or tom-tom, of a barrel shape; turned with
concentric incised lines in the middle and at each end
e[x]teriorly, and hollowed out by \the/ gouge on the
inside. The ends being covered with white skin \or
parchment/ and the bracing lines of well made cord,
with little brass rings for tightening them. One end of
the parchment has been smashed. Locality unknown
but may be eastern \(Indian?)/. L 15 5/10 in.; W across
the ends 10 2/10 in. Ramsden collection, No. 230.
Purchased [-from\by] the University 1878.

406 \Cylindrical/ Ornament made of a piece of bamboo,
perhaps an armlet; delicately engraved on the outside
with \4/ figures of Lizards? \arranged following each
other/ [-in a] in a zig-zag pattern with eight rayed stars
between. At the ends are ornamental borders from 6/10
to 7/10 in. wide. The design is made but [by] cutting
away portion of the surface and filling in with black, a
kind of Niello?, and has a very good effect. Locality
uncertain, but perhaps Eastern \Timor ? or somewhere

[16]"I think these are Burmese".
[17]396 is 141 of Ramsden collection.

that way/. L 4 15/20 in.; It has split down one side. W when squeezed together 3 1/10 in. Ramsden collection, No. 106. Purchased by the University 1878.

407 A shield from the Eastern Archipelago. It is made of light, brown wood, and apparently cast out of a solid piece, but looks like as if made of two long flat pieces W 6 5/10 in. in the middle and \decreasing to/ about 5 at the ends, joined together at their \long/ edges at right angles, the angle bein[g] outermost and forming the centre of the shield. The two ends have been strengthened by horizontal binding of split cane \or ratten/ on the front and back, and other pieces, peg[g]ed on surround [-the sides and ends\all the edges]. The front has been coloured black, and ornamented at intervals from bottom to top with \triangular shaped/ \double horizontal/ rows of small white shells \which have been/ rubbed down and stuck on; pieces of [-inlaid] inlaid mother of pearl shell; and \rows of [-small]/ small tufts of black human hair, very neatly arranged by \each tuft/ being fixed in little holes in the wood itself. The mother of pearl is inlaid in a kind of pattern in three rows having double rows of shells at each side. The shells are let in \square/ grooves so as not to project beyond the surface \of the shield/. It has a long handle at the back cut from the wood itself. L 43 in.; W in the middle across the back 9 3/10 in.; at the ends 7 in. It is a very neatly made object, and perfect excepting a few of the shells, and of the \pieces/ of pearl shell. Ramsden collection No. 383. Purchased by the University 1878.

408 A shield of brown [-and] light wood, very similar \to/ if not the same \kind/ as \that of/ the preceding, \No. 407,/ painted black \and brown/ on the outside, and ornamentally inlaid with various sized pieces of Ovulum ovum and other white shells. The front is convex both length and width ways, and the ends are square. It is ornamented at each end with three \horizontal separate/ bands of split cane \[-or rattan]/ (rattan), bound through \3 5/10 in. apart, and has had pieces of cane round the edges and down the centre peg[g]ed on those from the ends being missing/. A similar shield is figured in Meyrick's "Ancient Armour" Vol: 2 Plate CL, figs 10, 11 and is said to be from the New Hebrides. L 4 ft.; W at the ends 12 5/10 in.; in the middle 10 8/10 in. From the Molucca Islands.

409 Model, of an Outrigger Canoe, of light brown wood; used by the natives of the Mollucca Islands. The outrigger is wanting, and one side has been smashed in. L 6 ft. 7 in. Greatest W 4 in.; W across top 2 7/10 in. The straight sides have been lashed on to the rounded and much wider bottom part, and the ends slope sharply upwards from below. Given by W. Bennett, Esq. Farringdon House. Berks 1827.
Ashmolean 1836, p. 174 no 13.

410-412 Two large fans? or sunshades? \Perhaps Indian, or C[e]ylonese/ made of pleated lengths of

palm leaves stitched together, the two outer sides \or rather edges/ being ornamented with narrow strips \of the same material/ dyed brown and woven in an ornamental pattern through slits cut in the lighter material. L 5 ft. 6 in. and 4 ft. 7 in. And another of the same kind but better preserved and more ornamented, [-with\having] a cut-out pattern in yellow and dark brown on a lighter brown ground, covered with sheets of mica, at the \edges or/ sides. L 5 ft. 2 in. Only one end \of each fan/ spreads out, the outher being bound together with string. Ramsden collection No. 403 on [-the last\one of them]. Purchased by the University, 1878.

413-414 Coat of Mail, or breast plate and back plate, each made of numerous overlapping plates of horn, and each plate being cut to shape [*drawing*] thus; and the whole perhaps being intended to represent the scales of the Scaly Manis. From Java. L 21 and 22 in. W 16 and 15 in. Ramsden collection No. (?). Purchased by the University \1878/.

415 Headdress? \locality unknown;/ in shape something like the women's bonnets were some 50 years back; made of very finely twisted yellow grass, and fine white catgut resembling horse hair, woven \or knitted/ together in a very ornamental openwork pattern. L from front to back 11 in. W from bottom to top 15 in. [-locality lost] Given by Greville J. Chester \B.A./ about 1875.

416-417 Two bags, or pockets, \perhaps Eastern:/ of extremely fine woven \or knitted/ grass, in an ornamental open work pattern like lace, and ornamented with rosettes of the same material. The bottoms are like ornamental open wire work, and perhaps of thin cane, but closely bound round with grass. At the top is a double reeving string with tassel attached, to close the mouth. L 19 in. W at bottom 10 in. Ramsden collection No. ?. Purchased by the University, 1878.

418-419 Two large \Indian?/ fans or sunshades, of like make to 410-412, the sides \or rather edges/ being ornamented with a border of oval \shaped/ pieces of Mica having a raised edging of plaited palm-leaf of light and dark brown, with small \cross/ pieces of black \and brown/ woven in at intervals. L 5 ft. 9 in. and 5 ft. 6 1/2 in.
Ashmolean 1836, p. 181 no. 83 [?]; MacGregor 1983, no. 390.

420 Indian? fan made like No. 245, 246, of a round piece of palm leaf, the leaf forming the pleated top, and portion of the split stem the handle. The whole of the upper part has been painted in patterns in red, yellow, green, black, and brown, the edge being encircled by an openwork border of split cane. L 5 ft.; W 2 ft. 3 in. It is a good deal broken.
Ashmolean 1836, p. 181 no. 83.

421 Eastern shoe \perhaps Persian/ with very thick sole of brown leather \somewhat shiny, and ornamented with incised lines/ the front part of which turns up.

Embroidered on the outside with green, yellow, and black silk, and silver thread \in a kind of rosette pattern on cotton cloth/. Tassel on the toe of green and yellow silk, \of different size threads, and rather large,/ but this as well as the rest \of the ornamentation/ has much faded and the left side, \of the embroidery/ has been much torn \away exposing the rough brown leather underneath./ [-Apparently Eastern] L 10 3/10 in.; W 3 in.
Ashmolean 1836, p. 181 no. 80 [?]; MacGregor 1983, no. 53.

422 A pair of \Eastern/ shoes of dull brown and rather soft leather, with thin \flat/ soles \very/ much contracted between [-that\the sole] and the heel, and slightly turned up at the toe, the upper part of which is ornamented \with a perforated piece finely/ stitched round red cloth for the distance of 4 in. from the point in a kind of leaf-like pattern. They have high points or straps at the [-heel\back] and have had straps on the sides sewn on, which are wanting, others behind them remain \which are of a different kind of leather to the boot/. \The sole is ornamented with indented lines and the sole and side straps have been sewn on with narrow thongs of leather./ Locality unknown, [-perhaps not oriental]. L 11 3/10 in.; W of sole 3 2/10 in.
Ashmolean 1836, p. 181 no. 80 [?]; MacGregor 1983, no. 54.

423 A top boot to reach to the knee of dark brown, crinkley \and shiny/ leather, lined with light [-blue? \green] coarse cotton cloth \which has faded a good deal/. It has been made of three pieces of leather, the seams being up the two sides and across the instep. Sole thin and rather bent up at the sides and toe apparently from use \and toe pointed/ [-]. The heel has been strengthened with a stitching of thick white thread and has a thin \semicircular/ tip of iron 5/10 in. deep. The front of the top portion \of the leg/ projects considerably above the back. Probably Eastern \Perhaps Persian/ H 22 in. L \of sole/ 10 8/10 in. W of sole 4 2/10 in.
Ashmolean 1836, p. 181 no. 80 [?].

424 A shoe of rather soft brown leather, covered on the outside with coarse yellow \plush or/ velvet, ornamented round the back part with various [-with] widths of a material made of numerous small [-flat] copper rings \flat on the front but round on the back and each ring split, and/ joined \or linked/ together, like fine coat of mail, \and/ sewn on with yellow silk [-round the edges only]. The shoe has been fastened at the back and the front by [-a] laceing. Sole of thin leather covered on the underside with black felt. The velvet has been a good deal worn at the toe and sides of the fore part of foot \as if used in a stirrup in riding/. The rings appear to have been cast separately. Probably Eastern. L of sole 10 3/10 in.; W 3 2/10.
Ashmolean 1836, p. 181 No. 80 [?]; MacGregor 1983, no. 48.

425 A small slipper, \probably of a Female,/ with sole of brown leather sewn on through the sides, and gradually narrowing from the middle and turning upwards \very much/ to the toe which is square and

consequently very much raised \(over 3 in.)/. The heel has been rudely fastened on with seven large iron nails. Upper part covered with red satin, which has faded to almost a yellow, embroidered with gold thread. Inside of sole ornamentally stamped \with star like ornaments/. L of Sole 8 9/10 in. W 2 4/10 in. \It has been damaged on the upper part./ Perhaps from Albania, or \somewhere/ that way.
Ashmolean 1836, p. 181 no. 80 [?].

425a Arabic Charm \against the Evil Eye/ made of the foot of a Porcupine fixed with the claws projecting downwards into a hollow casing of thin brass of an oval shape round the sides, the top being flat, with a small ring attached for suspension. The sides of the brass mounting are \rudely/ ornamented with a diamond pattern in raised lines in the centre of each lozenge being a raised knob or pellet. L 3 2/10 in. Greatest W 1 4/10 in. Algeria. Given by Greville J Chester. 1872.

[African]

426 A native-made, \dark brown/ leathern figure of a Caffre Chief, in his war costume; with five iron-pointed assagais for throwing by hand; oval-shaped shield of \raw/ cow-hide, behind which they are carried, knob-kerrie or club, also used as a missile \in the hand of the figure/, war feathers \on head/, etc. H 15 in., mounted on a [-circular ivory\flat oval wooden] stand. L of shield 14 in.; of assegais 13 5/10, 13, 12 9/10, 12 4/10, and 12 2/10 in. Given by Captain H. F. De Lisle, \Guernsey/, 1827. From the Cape of Good Hope.
Ashmolean 1836, p. 181 no. 95.

427 Ditto, ditto, of a Caffre woman in her winter dress, with ivory, and copper armlets, [-and] headdress, necklace, earrings, and anklets of coloured beadwork. From the Cape of Good Hope. H 15 in. Given by the above.
Ashmolean 1836, p. 181 no. 96.

428 Ditto, ditto, of a Caffre man in rather different dress to No 426, and without the war feathers and the knob-kerrie; but with shield and three assagais, one of which has lost the iron head. His ears, neck, and waist are ornamented with coloured glass beads. H 14 5/10 in. L of shield 10 5/10 in., of assagais 14 6/10, 14 5/10 and 12 3/10 in. (Burchell Collection.) Given by Miss Burchell, his sister, 1865.
Ashmolean 1836-68, p. 5.

429 Ditto, ditto, of a Caffre woman, the dress being very different to that of No. 427, with earrings, necklace, bracelets, and anklets of \glass/ beads, all except the earrings being of a transparent white colour. H 14 8/10 in. (Burchell Collection.) Given by Miss Burchell his sister, 1865.
Ashmolean 1836-68, p. 5.

430 A Caffir Chief's headdress, or war feathers. It is a band of brown leather, \2 in. wide/ to pass round the forehead and tie behind the back of the head, with a

bunch of tall [-brown] brown feathers with black tips, arranged so as to stand upright on each side. L of band 3 ft. 2 5/10 in. H of feathers about 2 ft. From the Cape of Good Hope. Given by Captain H.F. de Lisle \Guernsey/ 1827.

Ashmolean 1836, p. 182 no. 101.

431-437 Seven Tambooki assagais. Such weapons as a rule are about 5 ft. 6 in. The heads being of wrought iron and very various in size and shape. The shafts are of tough pale brown wood, D about 6/10 in. \at the head/ tapering almost to a point at the other end. They are thrown with great dexterity and precision, and were used by the Caffirs as their principal weapon [-until] until firearms were introduced amongst them. L of three 5 ft. 7 in., and L \of the others/ 5 ft. 6 3/10; 5 ft. 4 in.; 5 ft. 2 3/10; and 5 ft. 2 in. From the Cape of Good Hope. Given by the same as the above.

Ashmolean 1836, p. 182 no. 88.

438-446 Nine Assagais \with different shaped heads,/ perhaps belonging to Captain De Lisles collection, but put aside before the 1836 catalogue was compiled, and consequently the history of them got lost. L 6 ft. 2 5/10; 6 ft. 1 8/10; 6 ft. 5/10; 5 ft. 7 8/10; 5 ft. 7 8/10; 5 ft. 8; 5 ft. 6 8/10; 5 ft. 6 3/10; 5 ft. 6 1/10 in.

447 One ditto, with very long, nearly flat, double-edged blade, stamped along each side 1 7 3 8 [*drawings*] L of blade 13 8/10 in. Whole L 5 ft. 5 5/10 in.

448-450 Three ditto, one with a broken shaft, one with a broken point; and the third with a long cylindrical head, decreasing in size to the point which is quadrangular. L as entered here 5 ft. 3 2/10; 5 ft. 5 8/10 and 5 ft. 4 3/10 in.

451-452 Two Assagais with long cylindrical-shaped \iron/ heads ending in sharp two-edged leaf-shaped blades, L 15 8/10 and 16 3/10 in. The shafts which are of deal smu[d]ged with black, and bound round the top with what looks like waxed thread, are probably not the originals, but were said \by Mr Chandler/ to have been made by the natives, and are of the same size the whole L \through/. Whole L 5 ft. 3 6/10; and 5 ft. 3 3/10 in. Brought from the Zulu war \of/ 1880 \by / Mr Chandler \Oxford,/ of the Royal Engineers, of whom they were purchased. Given by J.H. Parker Esq C.B. 1881.

453 One of the Caffir's short or stabbing Assagais, with broad leaf-shaped blade; chiefly used in close quarters with the enemy for stabbing. Round the top by way of [a] ferrule is a piece of leather which has the appearance of \having/ been a good deal bitten \perhaps/ to make it fit tighter, below which is another wider piece \of leather/ for the hand to grasp. Whole L 31 8/10 in.; L of blade 7 1/10 in.; W 1 15/20 in. Procured in the late Zulu war, \on the Umfolizi river,/ by Mr Mark Elsie, \Oxford/ Private in the Royal Engineers, of whom it was bought. Given by J.H. Parker, Esq. C.B. 1882.

454 A Caffir's knob-kerrie, or club, \of brown wood and apparently of the same kind as that of the shafts of the Assagais:/ also used as a missile weapon. It is a stick of about D 8/10 in. at the upper end which has a \round/ knob, D 1 7/10 in. \and/ slightly tapering to the other end, which is scored with close set diagonal incised lines for firmness of grasp. L 40 5/10 in. These weapons differ considerably in size, and shape, and are sometimes club-like, being thicker, and not more than L 20 in. The natives are very expert in throwing them. Given by Captain H.F. De Lisle, Guernsey. 1827.

455 A Zulu knob-kerrie of pale brown wood, \similar to 454; but/ with shorter handle and larger knob [-than the preceding]. Procured during the late Zulu war \on the Umfolozi River/, by Mr Mark Elsie, private in the Royal Engineers, of whom it was purchased. L 2 ft. 4 in.; D of knob 2 7/10 in. Given by J.H. Parker Esq C.B. 1882.

456 Model of a Caffir shield, made of cow hide \which is/ covered on the outside with black and white hair. Brought from the Zulu war of 1880 [-\on the Umfolozi river/] by Mr Chandler, of Oxford, of the Royal Engineers, of whom it was purchased. L 1 ft. 11 in.; W 1 ft. 2 in. Given by J.H. Parker Esq C.B. 1881.

457 A Caffir's tobacco-pipe, with two bowls, one being behind the other on the same \round/ stem, cut out of hard pale brown wood, with cylindrical shaped mouth-piece, also of wood, inserted in the end, with ferrule of horn; L 7 in.; H 2 2/10 in. From the \Cape of Good Hope./ Given by Captain H.F. De Lisle, Guernsey, 1827.

Ashmolean 1836, p. 182 no 104.

458 Ditto, of a different kind. The bowl which is in a line with the stem is of brown \stone/ slightly \and somewhat diagonally/ grooved round \the fore part/ for ornament, and \deeply/ contracted round the middle. The stem is made of a \long yellow natural/ stick, with the pith extracted \and stripped of the bark/. L 22 6/10 in., D 7/20 in. L of bowl 2 3/10 in. D in front 1 5/10 in. at the back 1 1/10 in. From the Cape of Good Hope. Given by Captain H.F. De Lisle. Guernsey. 1827.

Ashmolean 1836, p. 182 no 104.

459 A Caffir's snuff-box, or bottle, and spoon. The box is pear-shaped, L 3 4/10 in. and D 2 4/10, and made of a substance closely resembling pale coloured gutta-percha, the surface roughened up into a pattern. In Wood's "Nat: Hist: of Man" vol:1, p. 171, "Africa", it is stated that such articles are made of a paste composed of Cow's blood and fine earth, spread coat after coat, upon a clay model till of about 1/12 in. thick, and then, just before it becomes quite hard, the surface is raised by some pointed instrument according to the desired pattern; the model is afterwards [-crushed] crushed up and extracted. The spoon, carved out of bone, is L 4 17/20 in. and greatest W 5/10 in. and attached, together with the stopper, by a string, to a loop of leather round the neck of the bottle. From the

Cape of Good Hope. Given by Captain H.F. De Lisle, Guernsey, 1827.
Ashmolean 1836, p. 182 no 104.

460 A Caffir's bracelet, neatly made of Rhinoceros horn \of a brown colour/ with two plain oval-shaped projections carved at the sides, \on the outside opposite to each other./ Size 2 8/10 by 2 5/10 in.; greatest Th of material 7/20 in. From the Cape of Good Hope. \It is now cracked through, perhaps originally done intentionally./ Given by Captain H.F. De Lisle, Guernsey, 1827.
Ashmolean 1836, p. 182 no 104.

461 A Caffir's bracelet of copper. It is in one piece L 8 in. W 4/10 and Th 3/10 in the middle decreasing in size to the ends, which are bent round so as to almost meet, and form an oval 2 8/10 by 2 6/10 in. \D/ From the Cape of Good Hope. Given by Captain H.F. De Lisle, Guernsey, 1827.
Ashmolean 1836, p. 182 no 104.

462-463 Two Caffir armlets, made of sections of Elephants' tusks, one a good deal thicker than the other, and both nicely rounded off on the outsides, the edges being left square. Size 3 8/10 by 3 6/10; and 3 8/10 by 3 7/10 in. W \of material/ 6/10 and 5/10 in. From the Cape of Good Hope. Given by Captain H.F. De Lisle, Guernsey, 1827.
Ashmolean 1836, p. 182 no 104.

464 A Caffir woman's covering for the breast, apparently made of cow's paunch dyed brown. It is fringed along the upper edge, with 49 pendant strings of green, and dark blue, rather small, opaque glass beads; the strings varying in length from 2 5/10 to about 4 in., the \blue/ beads being the largest; and a single \horizontal/ row of opaque red ones along the bottom, and \[-half a row of]/ red, green, and black along the right side, and black entirely on the left; the two last are short rows, not reaching much more than half way along the upper part of the edges, \neither does the bottom row reach quite to the ends/. It has a long narrow strap of leather attached to the right corner of the top, and a loop on the left-[-on the left]hand corner, of the same material, for fastening it. It is W 22 in. at the top; 16 5/10 at the bottom; and 17 5/10 deep. From the Cape of Good Hope. Given by Captain H.F. De Lisle, Guernsey, 1827.
Ashmolean 1836, p. 182 no 103.

465 A Caffir woman's Apron or "Petticoat" made of softish brown leather, \having the outer skin removed from both sides,/ ornamented on the outside with 13 perpendicular rows of opaque blue, and white, small glass beads, \sewn on/ in the following order, rec[k]oning [-from\in] the way it \was/ worn, from right to left, two rows of blue, two of white, one of blue, three of white, two of blue, two of white, and the last of white with a few blue at the bottom, each of the rows, as a rule, \are/ 4 or 5 beads in width; a row of single white \beads/ entirely surrounding the margin. W at the top 6 3/10 in. L 9 8/10 in.; W at bottom

scarcely 4 in.; \which/ is divided into two tongue shaped pieces, by having a wedge shaped piece L 4 in. cut from the middle. A similar article is figured in Wood's "Nat: Hist: of Man", vol: 1 p. 25 fig: 2. From the Cape of Good Hope. Given by Captain H.F. De Lisle, Guernsey, 1827.
Ashmolean 1836, p. 182 no 103.

466 A Bag used by Wives of Caffir Chiefs as a cradle or knapsack, in which, strapped upon the shoulders the child is carried. It is made of soft prepared antelope's skin, having the hair on the inner side to keep the child warm \(the greater portion of this is now worn off)/. One of the outersides is covered with longitudinal [-] rows of dark blue, light blue, and white, opaque glass beads; the rows being 29 in number and each row four or five beads in width, and arranged in the following order, \looking at it/ as the thing is worn on the back, from right \side/ to left. 1st six white; \then/ one dark blue; three light blue; one dark blue; two light blue; four white; one dark blue; three light blue; two dark blue; two light blue; and lastly four white. The other side is the bare leather excepting at \the/ side edges from the top to about half way down, each of which has six perpendicular rows \of beads/ arranged two of dark blue with two of dark red each side of them, and a few white at the bottom of the blue to make up the length. It is also sometimes used as a headdress, and the manner of wearing it is shown on the native made model of a Caffir woman No. 427. L 19 3/10 in.; extreme W of top 13 8/10 in.; W of bottom 8 8/10 in. \From the Cape of Good Hope/. A similar article is figured in Wood's "Nat: Hist: of Man" vol: 1, p. 9. Given by Miss Louisa De Lisle, 1827.

467 A pear-shaped calabash made of a brown \Gourd/ the small or stalk end forming the spout, which is curved \to one side/. It is surrounded by eighteen sets of fine strings, three to six in each set, [-and\which are] attached to a cord at the shoulder, to which \also/ is fastened a narrow band of thin hide for suspension. The mouth has a \long/ stopper \(5 5/10 in.)/ ingeniously made of split rush plaited \together/ at the top. Used by the Caffirs as a bottle for holding liquids. H 9 5/10 in.; D 8 in. From the Cape of Good Hope. Given by Captain H.F. De Lisle, Guernsey, 1827.
Ashmolean 1836, p. 182, no 102.

468 A Caffir's bowl-shaped basket made of very tightly woven \straw-coloured/ grass: used for holding liquids. H 5 8/10 in. W across the top 9 in. "Bought from a Caffir at Kanna Kraal", by Mr Burchell. See Burchell's "Travels in Africa", vol:[] p. []. (Baskets for a like purpose are made by the Indians of California, see the N. American Collection, No. 823 824). (Burchell Collection "16. 8. 11." Given by Miss Burchell \his sister/. 1865.
Ashmolean 1836-68, p. 5.

469 A Caffir basket of straw-coloured grass, made in the same manner as the preceding. Form circular, the lower part rounded, with flat bottom. The top is flat

\also/ with a small \[-circular]/ lid 3 in. wide, neatly made to fit in a circular hole in the middle. There are two small loop handles at the sides of the top, as if intended for a strap to pass through for suspension or for carrying. H 5 5/10 in.; D 7 8/10 in. From the Cape of Good Hope. Given by Captain H.F. De Lisle, Guernsey, 1827.
Ashmolean 1836, p. 182 no 106.

470-471 Two Caffir made spoons of pale brown wood, with very long handles carved into distorted figures of the Giraffe. Bowl L about 3 in. W 2 in., plain part of handle L about 3 in. and rounded, and the figure above H 14 5/10 and 15 5/10 in. the four legs being brought close together at the feet so as to continue on with the plain part of the handle. The bowls are cut at an angle with the handles, and the \numerous black/ spots on the figures [-are scorched\have been burnt] in. Whole L 21 and 9 3/10 in. Given by the Rev W.C. Salter, Principal of St. Alban's Hall, 1868.

472-473 Two large \wide/ Amphora shaped vessels, one of which has kept its shape better than the other, and has a globular shaped body somewhat compressed at the sides, and covered from the neck downwards with 37 longitudinal raised ridges, as if it had been made on a wicker framework. The neck is short with narrow mouth having a recurved lip which is stuffed inside with clay. H 2 ft. 3 in.; D 22 by 16 in., circumf[e]rence 5 ft. The other is \of similar make/ more globular in shape, and smaller but a good deal altered in shape by being battered in on one side. H 23 in.; circumference 4 ft. 8 in. They are thought to be Caffir milk bottles, and are said by some persons to be made of Cow's blood \and fine earth/ after the manner of the snuff box No. 459, but they look like raw hide. They are marked with large Nos. 453 and 454 but these appear to agree with no catalogue. I should think that they belonged to the Tradescant collection. They are considered to be valuable specimens.
MacGregor 1983, nos. 72-73.

474 A spoon of brown wood, given as of Caffir make, but it is identical in shape, and style of ornament, with spoons figured in Burchell's "Travels in Africa", vol: 2 p. 795, who states that spoons of their fashion had not been received from the colony, and that probably they were entirely of Bachapin, or Bichuana invention. Handle L 10 5/10 in. \cylindrical and much curved backward/; bowl rather shallow L 3 3/10 and W 2 5/10, \and/ the underside carved with six spiral ornaments of many coils, the intervening spaces being coloured black, leaving the pattern in the colour of the wood. Whole L 13 4/10 in. From the Cape of Good Hope. Given by Captain H.F. De Lisle Guernsey 1827.
Ashmolean 1836, p. 182 no. 104.

475 A somewhat similar spoon to the preceding, with oval-shaped handle L 9 3/10 in. and bowl wider in comparison to its length \L/ 3 in.; W 2 5/10. The carving being \of the same style but/ quite different \in pattern/ [*drawing*] thus. Whole L 11 5/10 in. Called

Lūshua and used by the Bachapīns. See "Burchell's Travels" as above referred to \in No 474/ (Burchell's Collection) \Given by W. Burchell/ 1824. [-Given by Miss Burchell his sister 1865.]
Ashmolean 1836, p. 182 no. 111.

476 African? spoon of light coloured wood stained red and black; with long \somewhat/ boat-shaped bowl, much wider in front than at the back which appears as if stuck on above the handle, which is moulded. L of bowl 3 7/10 in.; W 1 13/20 in. Whole L 6 8/10 in. [*drawing*]. (Locality and history unknown)

477-479 Three Bachapin armlets, made of sections of Elephant's tusks; one of them \(No. [-479\477])/ of very superior make and finish is represented in Burchell's "Travels \in Africa"/ vol: 2 p. 571. It is greatest D 3 8/10 in.; W 1 1/10 in., and Th 1/3 in.; flatly convex both outside and inside, with a finish which could hardly be surpassed by lathe-work. Another is greatest D [-3\4] in.; Th 5/10 in.; and W 6/10 in.; flatly rounded on the outside, and flat on the inside. It is figured together with the preceding, and in reference to it Burchell says - "it was presented to me by Mollemmi (a chief), the last time I saw him, and two months after I finally left Litākün. He took it off his arm at the moment of parting, and delivered it to me as a proof of his friendship. It is the only thing of [-its] the kind which, during my travels among the Bichuanas I ever received gratuitously." \The third is much more massive, of ruder make, and a remarkable contrast to the first. Greatest D 4 7/10 in., W 9/10 in.; greatest Th 8/10 in./ (Burchell collection). Given by Miss Burchell his sister in 1865.
Ashmolean 1836-68, p. 5.

480 [-A\The] Liséeka or Bracelet, worn by Bachapīns and other Bichhuána nations; made of small copper rings, strung upon hair, and having, except in its flexibility, much the appearance of a solid circle of beaded metal. See Burchell's "Travels in Africa", vol: 2 p. 567. D 2 6/10 in.; Th of metal 3/20 in. Brought from Litākun. Given by W. Burchell Esq 1824.
Ashmolean 1836, p. 182, no 110.

481 A [-bracelet] necklace, used by the Bachapins: It is made of numerous little copper rings, \each/ D 2/10 in. and Th 1/10, \or about 18 or 19 to the inch/ strung on a leathern thong, so as to appear as a solid but flexible metal cord; a hemispherical shaped button \D 5/10 in./ of copper forming a fastening at the ends. L 2 ft. 6 in. It appears to have originally had a double row of beads, but is now \in 1884/ incomplete. (Burchell collection) Given by Miss Burchell his sister, 1865.
Ashmolean 1836-68, p. 5.

482 The Manjéna (or Manyána) or ear-ornament, worn by the Bachapins. Not now in the collection, without it may be one of the white stone ornaments mentioned next as No. 483, 484, in this list.
Ashmolean 1836, p. 182 no. 109.

483 A cylindrical shaped article of semi-transparent white stone, having a vein of more opaque white in it. Ends square. Probably an Ear or lip ornament. History and locality unknown. L 1 8/10 in.; D 5/10 in. (Compare this with No. 519).

484 A cylindrical shaped object of white shell, being rather smaller at the ends than in the middle. L 3 in., D in the middle 3/10 in. Apparently not entered in the catalogue of 1836 unless it should chance to be No. 109 \p. 182. See/ No 482 preceding.

485 A knife, or \rather a/ chisel, used by the Bachapins in carving their spoons. The blade is a thin piece of iron L 1 7/10 in., and breadth 1 1/20, with nearly a semicircular cutting edge. The handle is of black horn, L 3 8/10 in. and W 1 1/10 \at the bottom/ where the blade is inserted, gradually tapering to 4/10 at the other end, flattish, rounded off on all sides, and somewhat curved. Whole L 5 5/10 in. Figured in Burchell's "Travels in Africa" vol: 2 p. 595, and Woods "Nat: Hist: of Man" vol: 1 p. 314. (Burchell collection) Given by Miss Burchell [h]is sister 1865.
Ashmolean 1836-68, p. 5.

486 [-A\The] Tipa, or knife, used by the Bachapins \and Bichūana nations. / The iron or steel blade is L 4 3/10 in. W 8/10 in. near the handle, and gradually tapers to a point, double edged and thin. The handle is of black horn, L 3 1/10 in., and W 19/20 at the insertion of the blade, but much narrower to the end where it widens again to 6/10 in.; it is very neatly made. The sheath of two flat pieces of \brown/ wood covered round the two ends with leather, is also neatly made, and ornamented [-down one side] with a currugated or snake-like line \like those on the spoon, No. 475/ carved on the front, and has a narrow leathern thong L \8 8/10 in./ at the top for attachment, probably to the belt. L 6 in. This implement is represented in Burchell's Travels, by the upper figure Vol: 2 p. 575. Brought from Litākun \(Lataku?/ \in S. Africa/ (Burchell's collection) [-1824] Given by W. Burchell, 1824.
Ashmolean 1836, p. 182 no. 108.

487 A Bachapin milk-bag or bottle; made of a piece of raw oxhide, cleared of the hair, folded together, the inner part of the skin being outside, and cut into somewhat of a semicircular shape; size 18 5/10 in. along the straight folded edge; and 38 in. along the \sewn or/ circular edge, leaving a sort of bottle neck at one corner of the folded edge for a \pointed/ wooden plug or stopper L 10 3/10 in. and D 2 2/10, and close to it a suspending loop. At the opposite corner an aperture is left for a plug of only D 3/10 in., by which the whey or thin part of the milk is drawn off, as the milk is generally used in a coagulated condition, "in which state it is found to be more refreshing and agreeable in hot weather, than when fresh and sweet." This article is figured in Burchell's "Travels in Africa" vol: 2 p. 593 and also in Wood's "Nat: Hist: of Man",

vol: 1 p. 327 (Burchell's collection) Given by Miss Burchell [h]is sister, 1865.
Ashmolean 1836-68, p. 5.

488 A Bachapin's Blacksmiths bellows, of Cow skin? the brown hairy side [-of] out, with a piece of cow's horn tied in for a spout. It is made in the same manner as the previous object, that is the skin is folded together and sewn up on the rounded side. L 30 in.; greatest W 17 in. A great deal of the hair has been destroyed, and it has been very much patched up, but this appears to have been done by the natives. For the way in which these articles are used, see Burchell's "Travels in Africa" vol: 2 p. 483. "The most ingenious contrivance was his Muubo or bellows: this was formed of two leathern bags made from goat-skins taken off entire or without being cut open lengthways. The neck was tightly bound to a straight piece of the horn of an antelope, which formed the nozzles of the bellows. These two nozzles lay flat upon the ground, and were held in their place [-by] firmly by a large stone laid upon them; they conveyed the wind to a short earthen tube, the end of which was placed immediately to the fire. The hinder part of the bag was left open, as a mouth to receive the air, and was kept distended by two straight sticks sewed along the lip on opposite edges, in a manner which admitted of opening the mouth to the W of three in. These sticks were so held in the hand that they may be opened by raising the mouth and closed on depressing it; by which means the wind is collected and forced through the tube. By taking a bag in each hand, and continuing the action of raising and depressing them alternately, a strong and constant stream of wind was produced, which presently raised a very small fire to a degree of heat equal to rendering a hatchet red hot in two minutes". (Burchell collection). Given by Miss Burchell his sister, 1865.
Ashmolean 1836-68, p. 5.

489 A Bachapin \globular shaped/ vessel or pot of red earthenware, with a thong of hide encircling the top, to which is attached another thong across the top by way of handle, or for suspending by. It is hand made and well formed, but without the least attempt at ornament. H 5 in.; D 6 5/10 in.; D of mouth 4 8/10 in. Brought from Litakun (Lataku?) South Africa. Burchell collection. Given by his sister Miss Burchell, 1865.
Ashmolean 1836-68, p. 5.

490 A pair of rudely made African sandals. The soles are single pieces of raw [-ox\cow] hide L 11 in. and greatest W 5 5/10 in. \bent up at the sides and somewhat rounded at the ends,/ with straps of similar but rather softer material, \and ingeniously contrived./ Such sandals are figured in Burchell's "Travels in Africa", vol 2: p. 380, where they are called "Bachapin's sandals" and in in p 459 of [-the same volume\vol 1] a Bushman is represented wearing a pair. (Burchell collection) Given by Miss Burchell his sister, 1865.
Ashmolean 1836-68, p. 5.

490a A pair [-pair] of shoes made of \brown/ untanned hide, probably of the cow, with single soles made of similar but thicker material neatly sewn on, the stitches not being visible from the outside. They appear to have been worn as the sole is \have being pressed into/ somewhat in shape of that of the foot. They were fastened together over the instep with \a/ leathern thong[-s], which remain. The outside or smoother part of the skin is turned inside. Probably from S. Africa. (Burchell collection) L 9 5/10 and 9 1/10 in. W of sole 3 3/10 in. Probably Bushman, as compare with No. 508. Given by Miss Burchell his sister in 1865.
Ashmolean 1836-68, p. 5.

490b A somewhat similar shoe but made of thinner and whiter hide the outer side of which is turned outermost, and the upper made of one piece the seam being at the back. This too has been worn and is made for the right foot. L 10 2/10 in., W of sole 3 4/10 in. (Burchell collection no. ?) Given by Miss Burchell his sister in 1865.
Ashmolean 1836-68, p. 5.

490c African shoe made of one piece of skin or hide, probably of the Zebra, (as compare with the basket, No 510) pulled into the size of the ankle by a reeving string round the top also as in No 510. The shoe is made for the left foot and has been a good deal worn, but most of the hair remains on the upper part. L 8 2/10 in. W 4 in. (Burchell collection) Given by Miss Burchell, 1865.
Ashmolean 1836-68, p. 5.

491 A chain, or necklace, used by Bachapin women. It is made of \numerous/ rings, each D 3/10 in., very neatly made of fine plaited \brown/ grass, \and/ arranged in contrary directions. Whole L 4 ft. 10 in. (Burchell collection) Given by Miss Burchell his sister, 1865.
Ashmolean 1836-68, p. 5.

492 A girdle or rope made of the shell of the Ostrich? It is L 17 ft. and made of disks of shell D 3/10 in., with discs of the same size of [-some\a] material which looks like millboard or some such stuff between, threaded on an \ordinary/ piece of string, and worn several times round the body by Bachapin and Hottentot women. "This girdle has the appearance of a cord of ivory, and very correct idea may be given, by a string of small bone button-moulds, such as are sold in the shops." (Burchell collection). Given by Miss Burchell his sister, 1865.
Ashmolean 1836-68, p. 5.

492a Ditto, of disks of white shell only. Each disk being D 5/20 in. Whole L 10 ft. 2 in. Very skilfully made. (Ramsden Collection No ? \162/) Purchased by the University 1878.

492b Ditto, the disks being of the same diameter and thickness \as the preceding,/ but their edges much rougher, and the whole string being very dirty. L 32 in.

(Ramsden Collection No ?). Purchased by the University 1878.

492c Ditto, ditto. L [-5 ft. 1\59] in. (Ramsden Collection No ?). Purchased by the University, 1878.

492d Ditto of disks of white shell D 3/20 in. and Th 1/16, with black disks of the same diameter, but very thin [-between disks] between them; the whole being very uniform, and beautifully made, the thread on which they are strung being of twisted fibres. L 25 3/10 in. (Ramsden Collection No ?\165/). Purchased by the University 1878.

493 A Nuakketu hat, made of woven grass, in in a \flatly/ conical shape, without the slightest attempt at ornamentation. With side strings made of strips of hide. Worn by the Bachapin women as a stylish and expensive article of dress. It is figured in Burchell's "Travels in Africa", vol: 2, p. 510. In make it resembles the Caffir-made baskets. No. 468, 469. D 13 in. H 5 in. (Burchell collection) Given by Miss Burchell, his sister, 1865.
Ashmolean 1836-68, p. 5.

494 A Bambus, or wooden jar, of common use amongst the Hottentots, and made by them out of a solid piece of soft but tough kind of willow wood, in a low cylindrical form, contracted at the neck which is straight, with a perforated square shaped projection on the shoulder. H 7 5/10 in.; D of the bottom 7 5/10 in., of the mouth 4 8/10 in. H of neck 1 8/10 in. Figured in Burchell's "Travels in Africa". vol: 1 p. 406. It is now very full of worm holes. (Burchell collection) Given by Miss Burchell, his sister 1865.
Ashmolean 1836-68, p. 5.

495 A native made model in [-reddish] brown leather of a Bushman or Bosjesman, \in his war dress, with/ [-in] his cap and cloak of \rather rough/ reddish brown leather, [-with\and] earrings, necklace, and waist-belt of coloured glass beads, \one of the strings round the neck, and the double string round the waist being composed entirely of opaque black and opaque white; and the other necklace of transparent green and yellow/; together with models of bow, and leathern quiver [-with] containing three arrows slung at his back, and wearing a \nearly/ triangular shaped apron of leather \of similar kind to that of the cloak/. H 12 in., mounted on a nearly circular-shaped stand of elephant ivory \which is/ surrounded on the upper side near the edge with numerous close-set little pegs of black horn by way of ornament, eight of which are wanting. \This stand appears to be made of an outer ring which may at one time have very well [served] the purpose of an armlet, having a thin circular piece now to fill up the centre, and the little pegs may have been intended to serve the purpose of wedges to keep it in its place/. D 5 by 4 4/10 in.: depth \of [-outer] edge/ 8/10 in. From the Cape of Good Hope. Given by Captain H. F. De Lisle, Guernsey, 1827.
Ashmolean 1836, p. 182 no. 97.

496 Ditto of a Booshwoman, in her winter dress [-with\consisting of a] cap \(rather unlike that of the man in that it is peaked and folded down over the back of the head, with a tassel at the end)/, cloak, and fringed pet[t]icoat, of reddish-brown leather, \and/ with pendants on forehead, earrings, necklace, and belt above hips, all of coloured glass beads, \the two latter being entirely of opaque black and white/; together with armlets, wristlets, \bands just below the knees/, and anklets apparently in imitation of coiled copper wire \but of what appears to be some kind of thread probably made of twisted animal sinews/. Slung at her back [-are\is] the bag, and the pointed stick with which they dig for roots. From the Cape of Good Hope. H 11 in., on a similar stand to the preceding, but most of the pegs lost. Given as in the preceding.
Ashmolean 1836, p. 182 no. 98.

497 A Bushman's quiver [-with\containing] three poisoned arrows: from the Cape of Good Hope. It is cylindrical in shape, of coarse hide, \sewn together up the back, covered with a glutinous substance, and/, bound round the top and the bottom with [-snake's or lizards\serpent's] skin. L 1 ft. 9 1/2 in.; and 4 in \greatest/ D \which is at the top/[.] The \cap for the/ bottom and lid for the top are [-made, are also] made of \separate pieces of/ hide pressed into shape. L of arrows 18 3/10; 17 5/10 and 17 5/10 in. A similar quiver is figured in Meyrick's "Ancient Armour" vol: 2: Pl: CXLVIII, fig 4. Given by Captain H.F. De Lisle. Guernsey. 1827.
Ashmolean 1836, p. 182 no. 99.

498 A Bushman's bow; and three poisoned arrows which belong to the previous quiver \No 497./ The bow is [-small] of pale brown wood, L 33 8/10 in. and D 7/10 in. in the middle, tapering to almost a point at the ends. The line is made of twisted sinews. The arrows are made of thin reed, with long poisoned [-points\bone heads], two of which are detachable \at the point/, to come off in the wound. [-and\They] are either simply pointed or tipped with iron. L 18 3/10; 16 5/10; and 14 8/10 in. From the Cape of Good Hope. Given by Captain H.F. De Lisle, Guernsey 1827.
Ashmolean 1836, p. 182. nos. 99-100.

499-500 Ditto, perfect and bound round \near/ the ends with sinews. L 45 1/10 in.; D in the middle 8/10 in. And another, \(500)/, which has lost the line; L 36 in.; D in the middle 7/10 in.

501 A quiver of arrows used by the Bushmen of southern Africa. It is made of a piece of [-hide curved and stretched together\bark apparently got of[f] the wood in one piece], a bit of [-the same\hide] by having been wetted and pressed into shape is so contrived as to serve as a moveable cover for the top. It is thickly encrusted all over, excepting the cover, with a \black/ glutinous substance, and wrapped round near the top with three pieces of sinew \and round the rim with a piece of snake's skin, perhaps as charms/. L 21 5/10 in.

D 2 5/10 in. The present number of arrows amounts to sixteen, \varying/ from L 16 8/10 to 19 4/10 in. and are made of thin reed, into \the ends [of]/ which are inserted long cylindrical heads of bone. Upon the ends of these are placed \easily/ detachable points, each covered with a quantity of \thick/ glutinous poison of a vegetable and animal nature combined, which [-seems\helps] to hold the small flat barbes of iron at the end. Any attempt to withdraw an arrow of this kind after it has struck an object only draws away the reed and bone head, leaving the poisonous part within the wound. The reeds \or shafts/ are strengthened at both ends with a binding of sinews. The sockets at the ends of the bone heads, \and used for fixing the detachable points,/ are made of bits of reed L 3/10 to 4/10 in. strengthened on the outside with sinews, and resemble the small caps \of quill/ used on fishing floats. The poisoned points vary from about L 1 5/10 to near 3 in., and are made of bone having a slit in the end for the \insertion of the/ flat triangular iron points or barbs [-and these \which] are kept pretty tightly in their place by a binding of sinews \immediately below,/ which also tends to hold on the incrusted poison. Fifteen of these arrows in the quiver are made in this way, the other has simply a detachable poisoned bone spike L 2 in. See Meyrick's "Ancient Armour", vol: 2. Pl: CXLVIII figs \4 &/ 5.

501a A quiver made of one piece of, apparently, untanned hide, formerly of a lightish colour, but now dark brown with dirt; made of one piece bent round and rudely stitched up the side; the bottom being stopped by an overlapping cap, also formed of one piece of thinner hide. The tie for the top if it possessed one, is lost. A few very rude straps made of narrow thongs suspend it through two small holes cut through the sewn edges. L 27 8/10 in. D of top 2 8/10 in. of bottom 2 2/10 in. It is entirely without ornament. Probably from S. Africa, but locality uncertain. It reminds me of the Booshman's quiver, but probably it is too large for that. (Burchell collection) Given by his sister Miss Burchell in 1865.
Ashmolean 1836-68, p. 5.

501b A whip, or stick of a cylindrical form tapering gradually from the lower end to the upper which appears to have been broken off. It appears to be made of thick hide, perhaps of the Hippopotamus. or perhaps Rhinoceros. Present L 3 ft. Greatest Th 1/2 in. (Burchell collection). Given by his sister Miss Burchell in 1865.[18]
Ashmolean 1836-68, p. 5.

502-505 Ten [-Arrows] Bushmen Arrows, much longer than any of the preceding, but of similar reed all of which \are of one type/ having long [-pointed] bone spikes pointed at each end, one end being much thinner, finely pointed, and encrusted with poison.

[18]Probably African.

294

They appear as if intended to be used poisoned or not poisoned by reversing the [-heads \spikes] each point of which will fit into the top of the hollow reed, [-and] which is prevented from splitting by a binding of sinews. The unpoisoned ends are much thicker \and more obtuse/ than the others, and in shape their bone heads \or spikes/ are something like porcupine quills. L of reed shafts \varying from/ 22 8/10 to 18 4/10 in.; L of bone \spike/ heads 7 5/10 to 3 6/10 in. Also one \(503)/ arrow \23 4/10 whole L/ and head of another \504 L 4 2/10 in./, both made on the same principal \as the other ten except in having/ [-but with] barbed flat triangular iron points 13/20 in. wide and a barb made of quill bound \on/ at the side \of the bone below; Also/ one \arrow/ with triangular \iron/ point 5/10 in. wide, and made [-after\of the same manner as] those of the preceding number \(501). Whole/ L 23 4/10: 4 2/10: [-and] 23 in., all thickly encrusted with black poison.

The shaft of 503 is 19 3/10, and the detachable head L 4 9/10 in. The head 504 is L 4 2/10 in. and possibly may belong to 503 instead of the longer and similar head \which is now/ fixed in it. The shaft of 505 is L 18 in., and the head (the lower end of which is broken off) is L 5 3/10 in.

(Burchell collection). Given by Miss Burchell his sister, 1865.[19]
Ashmolean 1836-68, p. 5.

506 A musical \string/ instrument of the Bushmen, called a Gorāh, or Goura. This article is simply a slender, pale brown stick, of L 3 ft. 10 5/10 in. and D 5/10 in. at one end, tapering to nearly a point at the other, and bent into a bow by a thin string of twisted sinews strained from the two ends; but to the lower end of the string \or near the large end of the stick,/a flat piece, of about L 1 5/10 in. of the quill of an ostrich \feather/is attached, so as to constitute part of the length of the string; and the sound is produced by this quill being applied to the lips, and made to vibrate by strong inspirations and expirations of the breath. See Burchell's "Travels in Africa", vol: 1. p. 458, where a man is represented playing the instrument, his music described, and a scale of the notes produced by him is given. This kind of instrument is generally from L 2 ft. 9 to 3 ft. 6 in. From the Cape of Good Hope. Given by Captain H F de Lisle. Guernsey. 1827.
Ashmolean 1836, p. 102 no 105.

507 A stone called a Grafstock, used by the Bushmen, and other \South/ African tribes, to give weight to the stick with which they dig for roots. It is a coarse, red, circular stone, \(conglomerate?)/ not \quite/ globular, being depressed above and below, with a hole W 1 in. \perpendicularly/ through the centre. The stick \which is wanting/ is hard, pointed, and L about 3 ft., and when used is fastened in the hole of the stone by a

wedge on one side. Size \of stone/ D 5 in. and Th 3 in. An implement of this kind is figured in Burchell's "Travels in Africa", vol: 2 p. 45 \see also p. 29/ and in Wood's "Nat: Hist:of Man", vol: 1, p. 254. (Burchell's collection), Given by Miss Burchell his sister 1865.
Ashmolean 1836-68, p. 5.

508 A Bushwoman's cap: It is made of \four pieces of/ thin skin \(Ostrich?)/ \sewn together lengthways with threads made of sinews/ and intended to fit close to the head; the \feathers or/ hair \of the skin/ is removed and the inside is worn outwards \and the top has a bit sewn on by way of crest or tassel/. It is hardly possible to imagine a more miserable article of dress. H 8 5/10 in. (Is it made of cow's paunch? like No.464) (Burchell collection) Given by Miss Burchell his sister, 1865.
Ashmolean 1836-68 p. 5.

509 A rudely shaped \African/ article [-probably] a club \(or more likely a beater for using flat ways)/ made of raw hide of the giraffe \with the hair preserved on/. L 2 ft. 1 5/10 in. Greatest W 6 6/10 in., \which is about the middle narrowing to 2 5/10 in. at the handle portion/. Locality unknown. (Burchell's collection) Given by Miss Burchell his sister, 1865.
Ashmolean 1836-68, p. 5.

510 An African bag or basket, roughly made of pieces of zebra skin sewn together, the sides and bottom being of one piece bent round, the ends being separate pieces coarsely sewn in and leaving the tops projecting \considerably/ above \the sides/. The hairy side of the skin is outside. Two of the thongs (of the same material) by which one of the ends is bound in project at [the] top as if for the purpose of a handle \probably there was also a double thong at the other end to match/ L 11 in.; depth at the sides 5 in.; at the ends 7 5/10 in.; and W 4 in. There are close set slits cut through all round the top, \similar to but closer together than those down the ends/ Locality unknown (Burchell collection) Given by Miss Burchell his sister, 1865.
Ashmolean 1836-68, p. 5.

511 Iron head of an implement, use unknown but perhaps used for digging. W 2 9/10 in.; flat, sides straight and parallel for the distance of 2 2/10 in., from which point it decreases sharply to an obtuse point, L 3 5/10 in. It has been fastened to its wooden handle by a thick ferrule of lead L 2 1/10 in. and D 1 4/10, whole L 5 6/10 [*drawing*] (Burchell collection) Given by Miss Burchell his sister, 1865.
Ashmolean, 1836-68, p. 5.

512 An \African/ implement, with a long, wide, \and flat/ chisel-shaped iron or steel blade, and rather short cylindrical handle of hard pale brown wood, rounded off [-on\at] the top \and/ with a copper ferrule flush with \the wood at the lower end/. L of blade 8 4/10 in.; W of cutting edge 2 5/20 in., \sides straight / decreasing \gradually in width/ to 1 in. at the handle, which is L 4 5/10 in. \and 1 1/10 greatest D./ Use and locality unknown. Probably not of native workmanship.

[19]It is quite possible that the bow No. 499 belongs to these arrows, and the bow No. 500 may belong to the quiver of arrows No. 501 or vice versa.

It has a rough sheath made of raw hide \(goat's ?)/ with \some of/ the hair on, \made of one piece/ bent over at the bottom, and sewn together [-at\up] the sides with a thong of like material. \Whole/ L 8 8/10 (Burchell collection). Given by Miss Burchell his sister, 1865. Ashmolean 1836-68, p. 5.

513 A necklace of globular-shaped iron beads of native South African (said to be Caffir) manufacture. Each bead D about 3/10 in. and threaded on a narrow thong of leather. From the Cape of Good Hope. L 2 ft. 6 6/10 in. Given by Captain H.F. de Lisle, Guernsey, 1827. Ashmolean 1836, p. 182 no. 104.

514 A circular \native-made/ basket from the Zambezi river, S.E. Africa, of neatly plaited thin and flat wickerwork closely and evenly worked, the top and bottom rounded, the edges or rather the sides being of flat hoops of split wood, \to which the other parts are lashed/. the lid sh[u]tting on \or rather over/ after the manner of an ordinary pillbox, Colour \dark/ brown \with hoops lighter./ D \of lid/ 6 in. of lower part 5 6/10 in. H with lid on 4 in. Sent home by Dr. H. Waghorn, 1864. Given by Professor J.O. Westwood \Hon. M.A. Mag[dalen]: Coll[ege]: Hope Professor of Zoology/ [-same year] 1865.[20] Ashmolean 1836-68, p. 17.

515 Ditto, of quite a different construction and shape, with nearly flat lid. It is of rather coarse make, and much resembles a minature straw beehive, if [-you] turned [-it] upside down, and the manner of construction \somewhat/ resembles it too. Straw colour. H with lid 4 in.; greatest D which is across the lid 6 in. Sent home by Dr. H. Waghorn, 1864. Given by Professor J.O. Westwood \Hon. M.A. Mag[dalen]: Coll[ege]: Hope Professor of Zoology/ same year 1865.[21] Ashmolean 1836-68, p. 17.

516 A bow and [-four\five] arrows, of superior make, from Quiloa, or Kiloa, \or Kilwai/ on the east coast of Africa, 9° 0', south 39° 29' east; a settlement belonging to Arabs. The bow which is of hard, dark \reddish/ brown polished wood, is perfectly round, L 4 ft. 5 8/10 in. and D 9/10 in. in the middle, gradually tapering to 3/10 in. at the ends, which are ornamentally bound \round/ at intervals \for the L of 12 in./ with several plaited bands of what looks like \fine/ wickerwork or grass, each band having 2, 3, 4 or more distinct plaits, fourteen such bands being at one end \of the bow/ and eleven at the other. The line is very neatly made of a twisted thong of raw hide W 3/10 in., (\somewhat/ as in the Chinese bow No. 111) this, as well as the plaited bands \round the ends of the bow/ are turned black \and shiny/ apparently from use. The line is in one length and is twice as long as the bow, the spare portion being bound round one end of the bow apparently as

provision in case of breakage. Altogether it is very neatly made. Two of the arrows appear to be made of \brown reed,/ cane, or \else/ round pieces of stick, (one of which has lost its feathered end) ornamented with black patches, apparently burnt, lattice or lozenge pattern, the iron heads being large \but thin,/ and of the narrow \pointed/ leaf-shaped pattern. L 3 2/10 \and 3 7/10 in./ W 6/10 in. Whole L 33 8/10; and the broken one 24 4/10 in. \The bindings of these two are made of the same material as that round the ends of the bow but not plaited, probably grass./ The other [-two \three arrows] are of unornamented knotted brown reed, with large, flat, ordinary-shaped barbed iron heads the narrow necks of two \of them/ being jagged; the other ends having three feathers each, of a black and brown colour bound on \the threads being smeared with some black substance,/ and [-with \having] wide notches for the bow string. [-\Perhaps poisoned/.] L 33 3/10; 32 8/10; and 32 3/10 in. They appear to have been poisoned. Given by the Rev: G.M. Nelson, Mag[dalen]: Coll[ege]: 1825. Ashmolean 1836, p. 181 no. 91.

517 A spear from Quiloa or Kiola, shaft of [-\polished/] reddish-brown polished wood \something like the bow 516/ D 9/10 in. at the upper part, and 1 5/10 at the lower [-end]; just above which it is ornamentally carved in mouldings for the distance of 12 in., almost resembling lathe-work, and \where it is/ bound with three ornamental bands of lead, \at certain distances from each other,/ at 15 in. from the lower end, which is capped with a black horn ferrule L 1 4/10 in. and D 17/20 at the end. The head is of iron of the long pointed leaf-shaped pattern \of the same shape as that of two of the arrow-heads No. 516/ L 11 7/10 in. and greatest D 1 5/10, inserted into the top of the shaft by a round tang or stem D 5/10 in., the blade being slightly ribbed along the middle, with hammer marks very distinct. Whole L 5 ft. 7 5/10 in. Given by the Rev: John Nelson. Queens Coll[ege]. 1833. Ashmolean 1836, p. 181 no. 90.

518 A small hand shield from [-Coast of [-]] (Quiloa), Eastern coast of \S. / Africa; of Rhinoceros or Hippopotamus hide, which by great pressure, and perhaps heat, has been brought into shape to form the umbo. It appears \then/ to have been worked in a lathe, the front being \cut into/ a series of \fine/ concentric circular ridges, separated at intervals by larger ones, from the edge to the centre. A thick piece of the same material \roughly cut to shape,/ is [-rivetted\put] across the hollow at the back to form a handle, \and/ which has been fastened at each end to the shield by \an/ iron rivet which passes through it and [-has\is] [-] to an/ ornamental brass \star-like/ stud or head: on the face. These rivets are bent up or looped at the back of the shield, through one of which is suspended a brass \or copper/ ring D 1 1/10, perhaps intended for a strap for carrying it. A similar object is figured in Meyrick's "Ancient Armour" vol: 2 pl: CXLVIII fig 7. D of our

[20] The Professor's writing on article when given 'Zambesi 1864. H. Waghorn'.
[21] 'Zambesi Dr Waghorn'.

specimen 10 5/10 in. H in the middle 4 5/10 and Th of the material 5/10 in. Given by Rev. J. Nelson, Queen's College, 1833.

Ashmolean 1836, p. 181 no. 89.

519 An ornament of semi-transparent whitish stone [-[-]\(stalactite)] worn by women of the Neam Nam tribe of East central Africa, It is a well formed cone of H or L 2 1/0 in. and D 9/20 in. at the large end, \which is flat, decreasing to a point at the other end,/ and in shape much resembling the pointed \end/ of a Belleminite. Worn with the pointed end projecting through a hole in the lower lip. See "Petherick's Travels". vol: 1. P. 291. Given in exchange, by the Trustees of the Christy Collection. 1969. (From Mr Petherick's collection) H. M. Consul for the Soudan. (He has written a book on "Egypt, the Soudan and Central Africa". London 1860.)

520 Three iron loops of a singular shape, use unknown, suspended to two small \rudely shaped/ rings of the same metal; made either by the Mundo or Dôr [-Negroes\ tribes] of E. Central Africa, on the Upper Nile, near the Equator. L 1 8/10; 1 6/10 and 1 5/10 in.; Greatest D of rings 7/10 and 6/10, these are made out of [-square\quadrangular] shaped lengths \of metal/ [-rudely] bent [-together] round, the ends not being joined. (From Petherick's collection). Given in exchange by the Trustees of the Christy Coll[ectio]n 1869.

521 An instrument used as a Call by the Mundo Negroes, on the Upper Nile, near the Equator. It is made of very dark brown wood, cylindrical, and hollow except a tail-like projection L 4 in. at the \smaller/ end, which is left solid, and which together with the larger part is spirally bound with thin bands of iron W hardly 2/10 in. \The sound is easily produced by blowing in the larger end after the manner of blowing in the neck of a bottle, the note being varied by closing the small hole with the thumb below./ L 10 6/10 in., D 1 in. at the mouth, decreasing gradually to 3/10 in. at the other end. (Petherick's collection) Given in exchange by the Trustees of the Christy Coll[ectio]n, 1869.

522 A small hunting horn, or call,[22] made from the pointed end of an Elephant's tusk; used by the Dôr Negroes of E. Central Africa. L on the longest curve 10 6/10 in. the mouth being oval in shape, D 1 8/10 by 1 5/10; the point at the other end has been cut off leaving a hole D 5/10 \in./ near which on the \in/side \curve/ a hole for the mouthpiece has been bored. The whole thing has been scraped down to a certain thickness, as is shewn by the considerable projection of the mouthpiece \above the rest of the horn/. (A horn on this principle figured in Meyrick's "Ancient Armour" vol: 2 PL: CXLVIII, fig. \18/ used by the Mandingoes, is said to resemble the ancient Irish specimens of

bronze, one of which is figured in Vol: 1 Pl: XLVII fig: 13 of the same work) also Kembles "Horae Ferales" Pl XIII [*drawing*] (From Petherick's collection) (\(Lot 89)/ Given in exchange, by the Trustees of the Christy collection, 1869.

523 Three long ivory hairpins, used by the Negroes of the Neam Nam tribe, on the Upper Nile E. Central Africa. They are simply like \long/ skewers, cylindrical, and somewhat bent; \one of them/ D 3/10 \in./ and \the other two/ somewhat less at the top in D and gradually decreasing in size to the other \end/ which is pointed. "When the hair is combed out and arranged, two of the largest pins are stuck through it horizontally, and a number of shorter pins are arranged in a radiating form so as to make a semicircle". See Wood's "Nat: Hist: of Man" Vol: 1 p. 489, L 1 ft. 3 5/10, 1 ft. 1 3/10, and 11 3/10 in. (Petherick's collection). Given in exchange by the Trustees of the Christy collection, 1869.

524 A \small/ female deity from the interior of Southern Africa: It is carved out of a solid piece of pale brown wood, entirely uncoloured except the top of the head, on which is a kind of loop handle, both of which are painted dark blue, and perhaps intended to represent the hair, or \possibly/ the handle may have been used for carrying it. The face is tolerably well carved and very ugly \with prominent eyes, \ears/, lips, and broad nose/ \and incised marks on the cheeks, perhaps intended for paint, or tattoo;/ but the body and limbs are curious, as the feet are longer than the legs \the heels extending farther back,/ and the upper arms, that is from shoulder to elbow, longer than either of them. Considerable pains have been taken in carving the apron \the middle portion of which is ornamented with diagonal incised lines with perhaps what is intended to represent a fringe around the outer edge/ excepting which the figure is nude, and ornamented round the neck with a small doubled copper chain, and four separate necklaces of small, variously coloured \opaque & transparent/ glass \and red coral/ beads \strung on cotton threads/ and the hands \the fingers of which are not represented/, with eight and eleven strung \white/ cowry shells respectively, each shell being \broken or/ ground off at the top. The pupils of the eyes have been inlaid with bits of lead, the right of which is gone. H with circular pedestal, \which is in one piece with the figure/ 15 in. D of pedestal 4 2/10 in., Th 1 1/10 inch. Given by the R[evd]. J.W. Weeks. \Missionary from Sierra Leone/ 1836.

Ashmolean 1836, p. 182. no.114e.

525 A large circular carved fan of light coloured wood, in appearance much like pine, \but/ stained brown. It is a flat disk D 11 in. and Th 4/10 in., with a straight, quadrangular handle L 7 in. and D 1/13 by 1 in. at the \lower/ end, the four sides of which \for the distance of 8/10 in./ are bevelled \or chamfered/ off to almost a point \immediately above which it is perforated/ and gradually decreasing in size to the other end which overlaps \like, or is raised above/ the disk \for the L of/

[22]This article smells very strangely of Tobacco, and possibly may have been and also used for smoking purposes.

4 in.; the whole of the object being cut from one piece of wood. The carving consists of various circles or semicircles edged with serrated or toothed borders \all cut in/ Whole L 17 6/10 in. Probably African. Given in exchange by the Trustees of the Christy Coll[ectio]n. \1869/.

526 A cylindrical shaped box with cover, \perhaps also used as a seat;/ each cut out of a solid piece of rather soft brown wood, the foot \of the lower part,/ and the top of the lid projecting \considerably/ beyond the body of the box; and each \part/ having \square/ projecting perforated ears which overlap \each other/ apparently for a pin \or cord to pass through/ to fasten the lid and the lower part together. The sides are thickly \but rudely/ ornamented with numerous perpendicular and diagonal, coarsely incised lines, the top of the lid being left plain. Probably from \the central part of/ S. Africa, but locality and history unknown. H \with lid on/ 11 in. D of sides 7 8/10; and of top 10 5/10 in.; and of bottom 9 8/10 in.
MacGregor 1983, no. 360.

527 Ten of the fangs or long teeth of the Lion, somewhat ground wedge shape and drilled through sideways at the upper ends, and strung \together side by side/ upon a thong of thin leather, Worn as trophies, or ornaments, (perhaps anklets \or armlets?)/ by natives of central Africa. L 2 7/10 to 2 in. Given by Mrs Birkbeck (Widow of Dr Birkbeck, originator of Mechanics Institutes). 1865.
Ashmolean 1836-68, p. 4.

528 Ditto. ditto, of a darker colour, ten in number, but the perforation of one of them is broken out \so that it is not strung with the rest, and another with double perforation./ They have been restrung on a piece of copper wire, except the broken one, \which is with the rest/. Apparently fellow to the preceding. L from 3 1/10 to 2 in. Given by Mrs Birkbeck, 1865.
Ashmolean 1836-68, p. 4.

528a A single large tooth of some carnivora, probably of the Lion. Ground off at each end, and bound round with (not drilled to receive) shreds of animal sinews. Probably \African/ and possibly worn as a bracelet or pendant trophy. Present L 3 1/10 in.: D 1 in. A very old and dirty specimen, and probably of the Tradescant collection. But no history known.

529 Any \Eastern/ African? lance or javelin: The socketted iron head L 7 1/10 in. \ and 8/10 greatest D/ having two deeply cut \narrow/ barbs and \on the stem/ immediately below \them / four rows of \close set/ smaller barbes, three in each row \and all directed backwards./ Dark brown wooden shaft D 5/10 in. and not very smoothly rounded, and rather crooked, terminating in a \very/ long, slender, quadrangular, socketted iron spike L 14 in. Whole L 5 ft. 3 3/10 in.
MacGregor 1983, no. 361.

530 An Eastern African ? spear or lance, with \a rather/ well wrought pointed leaf-shaped iron head,

having a small rim or shoulder round the lower edge of socket [-and a split down outside] and a slit up the side. Whole L 11 5/10 in., Greatest D 1 13/ 20 in. Shaft of dark brown wood rather roughly rounded, 9/10 in. greatest D, and ornamented just below the socket of the head, and at about 20 in. from the other end with a little carved work, which looks almost as if it had been turned in a lathe. On the bottom a socketted spike L 12 4/10 in., the portion below the socket being quadrangular, then twisted, below which it is round and diminishing to a point. Whole L of spear 5 ft. 6 3/10 in.
MacGregor 1983, no. 362.

531 A javelin, or lance, probably East African, with [-[-]\unequally] barbed, and socketted iron head L 7 6/10 in. and W 1 6/10 in. Shaft of dark brown wood D 7/20 in. gradually increasing in size to the other end which is D 6/10 in. and not pointed. The shaft is better rounded than in the two preceding Whole L 5 ft. 2 8/10 in.
MacGregor 1983, no. 363.[23]

532 A very long iron head of an African Javelin?, or perhaps harpoon. The blade barbed 3 8/10 \long/ by 1 7/10 in. broad; the neck below being jagged. L 2 2/10 and W 5/10, below which, on one side, is a larger pointed hook, turned downwards, from which to the end it is quadrangular, with the angles slightly flattened down \the fore somewhat approaching octagonal/ L 16 5/10 in., D 4/16 in., the end being pointed apparently for driving into a shaft. \Whole L 22 in./ It may have been the head of an Assagai. [drawing] Locality uncertain.
MacGregor 1983, no. 364.

533 A finger-ring of North African gold and workmanship. It is a flat band of W 5/20 in. worked into four small \parallel/ rope-like lines, having three pl[a]in lines between them, with the same pattern inside \the ring,/ but less distinct; and a small, plain, oval-shaped piece \L 7/20 in. and / the same W as the ring covering the joining, on the outside. D 17/20 in.; weight 2 dwts 9 grain. Locality uncertain. Given by the Rev: E. Ashton, B.D. Brasenose College, Huyton Vicarage, Prescot, Lancashire. 1857. [drawing].
Ashmolean 1836-68, p. 1.

534 A \small/ pear-shaped basket from Nubia; the lid which forms the small end is ingeniously made to fasten stopper-like into the lower part. It is made of a kind of grass or rush of a straw colour, portion of which is coloured pink and brown; and has a loop on the top of the lid. H 7 in. D 5 in. Given by Greville J. Chester B.A. 1872.[24]

[23]Probably Gaboon, W. Africa. There is I think scarcely any doubt that the preceding three articles, 529, 530 & 531, are from the same place, the wood seems to be the same.
[24]There is a smaller basket of the same make but of an oval shape, put to compare with No 116 in Ancient Egyptian Colection.

535 An Eastern African dagger, or short sword, having a straight two edged, [-long] leaf-shaped blade, L 13 3/10 in. and 1 6/10 greatest D, with \with a faint central ridge down the centre/ very sharp edges and point; the haft for L 4 9/10 in. \and 1 8/10 D/ being of greenish-brown horn, nearly long oval shaped in section, [-and\but] deeply hollowed out on opposite sides for firmness of grip, and mounted at each end and in the middle with some white metal \like lead, but harder,/ the mount at the end, \or pommel/ having an eight sided spike L 1 5/20 in. \projecting in a line with the blade/ Whole L 19 9/10 in. A similar weapon is figured in Wood's "Nat: Hist: of Man" Vol: 1 p. 658 Given by W. Weston Esq. Oxford 1874.[25]

536 A bow made of bamboo, \of a dark brown colour,/ strung with a narrow [-piece\strip] of the same material. From the River Gambia? The string is made of two pieces, securely lashed together in the centre and the ends being fastened to the bow by a strong binding of hide, or leather \thongs/ the ends of the bow itself \for the distance of 5 in./ being also strengthened by a binding of like material. L 5 ft. 8 3/10 in. D about 1 in. \W of strip by which it is strung 3/10 in./. A similar bow is figured in Meyrick's "Ancient Armour" Vol: 2. Pl CXLVIII. fig: 11. (Very similar bows are used by the natives of Torres Straits. N. Australia. see Polynesian Collection) Given by Mr W. Sibley. London. 1864.

537 A cylindrical shaped drum, made out one piece of pale brown, rather soft wood. It is hollowed out to Th 1 in., and \has/ a piece of sharks skin? strained over each end, by lacings of narrow strips of hide \(some of which have the hair on)/ from one to the other, so arranged that the strips lie in pairs lengthways. Locality uncertain, but most likely African, L 23 5/10 in. D of one end 8 3/10 in., gradually [-sloping \diminishing] to 3 8/10 in. at the other.
Ashmolean 1836, p. 184 no. 160; MacGregor 1983, no. 25.

538-541 Four tom-toms, or drums, of diff[e]rent sizes, but all of the same make, cylindrical in shape and each cut from a solid piece of \dark brown/ wood, but being much shorter than the preceding \No. 537/ each of the ends covered with whitish hide or skin \perhaps human/ the numerous braces down the sides being of thicker material, apparently raw hide, and the straining being arranged in a different manner, the thongs not going through slits cut in the edge of the skin \covering,/ but over \two rings or/ hoops [-like \made] of twisted thongs, the \bracers or/ straining lines appears to be in one length but doubled backwards and forwards. 1st H 16 5/10 in., D at the ends 11 8/10 and 7 8/10 in.; 2nd H 12 3/10, D of ends 7 and 5 8/10 in., 3rd H 12 5/10 in., D of ends 6 and 5 in., 4th H 12 in., D of ends 5 3/10 and 4 in. Locality unknown \but

probably African/. (Ramsden collection No. ?) Purchased by the University, 1878.

542-546 Five \hollow/ cylinders of wood, of similar form to \those of / the preceding and probably belonging to the same, or \to/ a similar set of drums. But not a trace of the skin covering or of the straining strings remain. Nothing but the bare cylinders, each cut out of a solid piece of wood. \1st/ H 13 3/10; D of ends 6 8/10, and 5 in.; 2nd H 11 6/10, D of ends 4 and 3 in., 3rd H 10 8/10 in., D of ends 3 6/10 and 2 8/10 in.; 4th H 10 4/10, D of ends 3 and 2 4/10 in.; 5th H 9 6/10, D of ends 3 and 2 2/10 in. (Ramsden collection No. ?) Purchased by the University 1878.

547 A cylindrical drum cut out of a solid piece of dark brown wood; of the same form as 538-541 \and 542-546 and/ covered with [-white\stet./] [-parchment or] skin, the bracing string being also similar but lacing through holes cut in the edge of the skin itself, not over hoops \at the ends/ made of twisted thongs, [-in this way \stet./] it therefore more resembles 437. H 15 in.; D of ends 8 in. and 7 1/10 in. (Ramsden collection No ?) Purchased by the University 1878.

548 A cylindrical shaped drum cut from a solid piece of brown wood, left open at the small end which projects considerably \at the sides/, is ornamentally [-carved\scalloped out,] and painted black; the large end being covered with \parchment or/ skin by a binding of what appears to be \the outer shiny surface of/ split cane \which is/ tightened by \four/ little flat [-wooden\wedges or] pegs \of light wood/. It has a little loop, apparently for suspension, worked in the cane. H 13 1/10 in.; D of top 4 6/10 in.; of bottom 4 in. Locality not known, doubtful if African. (Ramsden collection No?) (Purchased by the University 1878).

549 Small model of a canoe, used on rivers of Angolia, etc, Western Africa. They are narrow, long, and being cut from the trunk of a tree of light wood, it is hardly possible for them to sink. The natives use them with great dexterity, as being pointed alike and somewhat curved upward at both ends, they may be propelled in either direction. In the model the outsides are coloured black, and ornamental patterns are cut through it to show the lighter brown wood. L 25 in.; greatest W 2 in. Depth 1 3/10 in. Given in exchange by the Trustees of the Christy collection, 1869.[26]

550 A west African spoon of ivory, the handle being in one piece with the bowl and carved to represent the nude \and grotesque/ figure of a man standing, having a large and very ugly face, with eyes very oblique or [-] \sloping/ towards a very flat and broad nose, and pointed chin or beard and wearing a conical shaped hat. His legs are very short as compared with the body, the arms being very long, and folded \one over the other/ in front over the belly. The bowl is in shape

[25]?Somali.

[26]This model has Haslar or some similar \word/ written \on it/ in pencil.

much like No. 476. Whole L 6 in. L of bowl 3 1/20 in. Greatest D 1 11/20 in. H of figure only 3 5/20 in.
MacGregor 1983, no. 22.

551 Ditto. the bowl being just the same shape, but the handle carved to represent two interlaced rods. Whole L 6 7/20 in., L of bowl 3 in.; W 1 5/10 in. [*drawing*] thus.
MacGregor 1983, no. 23.

552 A quiver and [-nine\ten] poisoned arrows, and the \iron/ head of another; from the coast of Guinea. The quiver which is L 25 in. and D 2 3/10, except at the bottom which has a flat disk W 3 4/10 in., is made interiorly of wood covered with raw hide sewn up the side and covered [-with] except in the middle portion for the distance of 8 in., with thin, shiny, dark brown leather, that on the lower part being [-ornamentally] perforated in an ornamental pattern showing the lighter coloured hide beneath, and to which is attached, one below the other, two tufts of narrow strips of dull reddish brown leather which are attached to various sized buttons made of plaited narrow strips of the shining dark brown leather of which also two loops are made at the side \of the quiver/ for [-suspending\carrying] it. The arrows are of pale brown \knotted/ reed with very sharp [-and] barbed heads of iron having long thin \either/ quadrangular, or roughly rounded stems [-of] which [-are\were] encrusted with poison but most of this has fallen off. L of the arrows 27 4/10 to 25 1/10 in. and one \the shaft of/ which has been broken, 20 in., and \L/ of the detached iron head 6 8/10 in. The blades of the heads are recurved opposite ways so as to make the arrows revolve in their flight. (A similar quiver is figured in Meyrick's "Ancient Armour", Vol: 2. Pl: CXLVIII. fig. 9, said to have come from the River Gambia.) \There is no cover or lid with this specimen/.
Ashmolean 1836, p. 181 no. 92; MacGregor 1983, no. 365.

553 A quiver and two iron heads of arrows; of nearly the same pattern as the preceding, except that there is not so much of the goat's hide seen below the \[-perforated]/ brown leather and the openwork pattern being different on the lower portion, Round the middle portion of the quiver are three thick projecting [-disks\rings] the edge of each being divided into three by indented concentric lines. It is also distinguished from the previous specimen by having three tufts, or tassels, of long narrow strips of leather dyed black, arranged one below the other and attached as arranged \either/ to four, three [-and\or] five buttons of plaited leather, all the buttons being of one size, the bottom also has a wider \projecting/ disk. L 22 3/10 in., D 2 in. or of the three discs a little over 3 \in./ and of the bottom 4 in. It has a strap at the side apparently for slinging over the shoulder. L of iron heads 6 3/10 and 5 8/10 in. The covers of both these quivers are wanting.
MacGregor 1983, no. 366.

553a A quiver of brown leather different to any other now in the collection, by gradually increasing in diameter from the top to the bottom, which is rounded. The hole is at the side at the top, and it is ornamented with two wide bands of thin green leather, each perforated or cut out in the same pattern and very neatly sewn on; one near the bottom, and one near the middle; besides which are two sets of pendants or tassels \of twisted narrow thongs,/ in straight rows cros[s]ways, one just below the mouth and the other near the middle and just below the ornamental band of thin leather; but many of these are broken off. The leathern strap W 8/10 in., is passed through \the plain and the/ plaited upper portion of the thongs which form the tassels. A piece of thin brown leather having scalloped edges, and neatly stitched on covers and joining along the back. L 26 5/10 in. D at top 2 in., gradually increasing to 4 in. at the bottom. It contains one barbed iron headed arrow having a shaft of thin reed, L 24 in., the head being bent and the very point broken off. Locality not known but no doubt Western African.
MacGregor 1983, no. 367.

554 A quiver of somewhat similar make, and probably from about the same locality, but being much wider; the white hide or goat skin being replaced by coarse white cotton cloth, and the upper dark thin brown leather not perforated but only indented in an ornamental way. The prominent \circular/ ridges or disks also are not nearly so large. All the long [-[-]\narrow] pendants and the cover are wanting. L 23 in. D 3 in.; of the bottom 3 2/10 in., of the top 2 2/10 in. (Ramsden collection No ?). Purchased by the University, 1878.

555 African girdle, or waist-belt, probably from Fernando Po, W. Africa. It is formed of nine strings of black and white disks \alternately,/ each string 25 5/10 ins long. The white disks are of \cross sections of/ shell, [-probably of the Ostrich shell egg of the Ostrich]. D 5 /20 in., and Th 1/14 in., perforated in the centre; the black ones being rather smaller, and apparently made of cross sections of the stem of a Gorgonia. The strings are kept apart by seven small stretchers of \hard brown/ wood perforated through sideways \for/ them to pass through, the nine strings being plaited together at the ends to form bands for tying it. The strings are made of some twisted fibre or grass. The whole forms a belt L 26 5/10 by 3 in. wide. Extreme L 4 ft. 2 in. Given by Mr G. Dorrell, Oxford, 1874.

556 A small pouch made of narrow strips of plaited palm-leaf. Used by the natives of the river Niger, \West Africa,/ to carry. Brought home by Dr. Baikie. L about 10 in., W 2 in. The strips of leaf are left [-strag[g]ling\unplaited] and tied together at the top. Given in exchange by the Trustees of the Christy collection, 1869.

557-559 Three poisoned ? arrows from the mouth of the river Niger, West Africa. Shafts of yellowish \grass stem,/ reed, or something of the sort, without any knots, and not perfectly round; the \[-lower]/ ends \and the joinings of the wooden heads with the shafts/ being bound with some kind of grass, the binding ex[t]ending all round the bow string notch. The heads \[-to which the iron points are affixed]/are of cylindrical pieces of hard brown wood, considerably less in diameter than the shafts, [-to\in] which are [-fixed\inserted] the iron points, one of which \No. 557,/ is a thin quadrangular spike L 3 7/10 in.; another \No. 558 something of a long & narrow triangular shape/ [-a leaf-shaped] sharply barbed and \the [-blades] sides of the blade,/ slightly recurved [-blade] on a narrow round shank. L 3 4/10 in.; the third \No. 559/ having ten small barbes \or jags/ down each side [-and\which are] recurved in opposite directions. L 3 2/10 in. Whole L 28 1/10; 27 6/10; and 27 in. "Procured in 1841".

560 A bag made of woven palm fibre (grass ?), square checked red and yellow pattern, the unwoven material at the top forming a loop handle \of [-four\six] strings tied at the top,/ for its suspension[.] From Liberia. West Africa. L 18 in. or to top of strings about 27 in. Given by the Trustees of the Christy Collection in exchange 1869.

561 A somewhat similar bag \but/ of coarser make, and although it may have formerly been woven with a kind of pattern it is now of nearly an uniform dirty yellow colour, the unwoven material at the top being twisted into numerous \(33)/ cords, and left \unwoven/ at the bottom \and tied/ in a kind of \rude/ tassel. L 20 in., or to top of strings, about 37 in. Locality unknown, but probably African.
MacGregor 1983, no. 368.

561a A similar made bag, of woven grass, dyed yellow and black, but very narrow as if it had \been/ purposely shrunk. Whole L 28 in. W 2 in.

562 A Mandingo dagger, \from Sierra Leone,/ W. coast of Africa. Blade of good workmanship ornamented alike on both sides with three long grooves \one in front of the other two, and each/ surrounded by \faintly/ indented zig-zag lines, with a straight line indented parallel to and all round \close to/ the [-eg] edges, about 1/10 in. in: \the cutting edge of [-the]/ the blade being sharply curved backwards [-con] towards the end and coming to a sharp point: L 11 8/10 in., W 1 3/10 in. Handle short, of carved dark brown wood \somewhat like turned work/ bound \at the top/ with an engraved brass ferrule, and inlaid [-on the outside\below it] with numerous small brass rings, \some of which are arranged in triangles/. L 4 5/10 in. The sheath which is of dark brown and rather shiny leather is well made, and ornamented with numerous faintly impressed parallel lines arranged in different directions, and terminates in a button like projection of D 1 5/10 in. \at the lower end/. L 12 1/10 in. A weapon

of this kind is figured in Meyrick's "Ancient Armour", vol: 2. Pl: CXLVIII. fig. 16, of which it is state[d] that the end of the sheath was made to contain poison. From Sierra Leone. Whole L \when/ in sheath, 16 5/10 in. Given by Dr Simms, Wimpole Street, London, 1826. Or Sims?
Ashmolean 1836, p. 181 no. 86.

563 A Mandingo ? horn or trumpet, carved out of the smaller end of Elephant's tusk. It is ornamented along the sides with nine well worked longitudinal flutings, which follow the curve of the tusk, from the small end to within 2 3/10 in. of the mouth, \which is plain/, where each [-are\flute is] rounded off \forming together/ a raised scalloped edge above the plain part. A considerable portion of the small end has been broken off, but it is probable that the mouth\piece/ was at the side as in No. 522. \present L 15 in.; D of mouth 3 8/10 by 3 2/10 in./ An instrument of the kind is figured in Meyrick's "Ancient Armour" Vol: 2. Pl: CXLVIII fig: 18, where it is called "a speaking [-trumpet\horn] used by the Mandingoes".
MacGregor 1983, no. 26.

564 A pair of Mandingo sandals, [-from West Africa\from Mandingo W. Africa]. The soles are made of several layers of raw hide sewn together with a narrow leathern thong, and the two outside layers, at least, dyed brown. The straps are made of thin leather shiny on the outside, [-and] coloured brown, pale brown, and black, and ornamented with numerous diagonal lines of indented dots, forming a kind of chevron pattern down the middle, and that part which would come over the instep ornamented with a \circular flatly/ conical shaped button D 1 6/10 in., covered with narrow interwoven \or interlaced/ strips of shiny brown leather having a double diagonal line in black. L 9 7/10 in.; greatest W 3 6/10 in. Given by the Rev: Mr \J.W./ Weeks, Missionary from Sierra Leone, 1836.
Ashmolean 1836, p. 182 no, 114b.

565 A very similar pair of Sandals to the preceding, from Sierra Leone. The soles are made of one piece of raw hide having a fillet of \shiny/ brown leather stitched on the upper side round the edge, with a narrow thong of leather dyed black, which on the under side of the sole [-are\is] left of the natural brown colour and projects considerably like a series of little loops all round the edge [-of the sole]. The straps are ornamented by having narrow \and rather irregular/ longitudinal strips [-taken\cut] from the dark surface of the leather [-leaving\shewing the] lighter colour beneath; the buttons are conical, D 1 8/10, covered with one piece of dark shiny leather stitched round the edge with a flat thong of lighter colour. L 9 9/10 in.; W 3 6/10 in. Given by Dr Sims, Wimpole Street, London, 1826.
Ashmolean 1836, p. 182 no. 113.

566 One of a pair of sandals in make more like 564 than 565, the upper side of [the] sole being ornamentally stamped. The straps and conical button much broken. L 10 6/10 in. W 3 8/10 in.
MacGregor 1983, no. 21.

567 A piece of extremely coarse [-cotton] cloth \made of grass/ woven in plaid stripes in red, yellow, green and brown. In a square piece L 36 in. by W 21 8/10. Manufactured at Sierra Leone. Given by the Rev. Mr. \J.W./Weeks, Missionary from Sierra Leone, 1836.
Ashmolean 1836, p. 182 no. 114c.

568 Ditto, of white cotton, of still coarser make, \and very rough,/ being part of the first piece of cloth made by liberated Africans in Sierra Leone, 1834. In an oblong piece, L 23 1/2 \ins/ by W 15. Given by the Rev. Mr. J.W. Weeks, Missionary from Sierra Leone, 1836.
Ashmolean 1836, p. 182 no. 114d.

569 A quiver and poisoned arrows from Sierra Leone. The quiver is cylindrical in form, the inside made of wood probably bamboo, covered \on the outside/ with coarse cotton, and then with thin shiny brown leather, ornamented with numerous faintly indented \longitudinal & horizontal parallel/ lines, and \surrounded/ with three raised ridges \at certain distances apart,/ the two side ones of which are double and the middle one [-single\tripple]; it is also stained round with bands of black, and has the strap for carrying it, and the cover attached. L 20 in.; and of cover 7 in. Greatest D 3 4/10 in. The arrows forty in number are between 25 and 26 in. long, the shafts being of \yellow/ reed, with sharp and well formed iron heads which \are/ all of the same pattern, the blades being much recurved in opposite [-ways\directions], sharply barbed, and having long, thin, cylindrical stems, to fit into the ends of the shafts, but most of these are hidden [-by\with] a thick coat or incrustation of poison, which also extends some distance down the shafts, about [-6\7] or 8 in. downwards from the point. They are not feathered and have no nick for the bow string. It is worthy of notice that the heads are formed so as to cause the arrows to revolve in their [-progress\flight], \by/ the blades being curved in opposite directions \(as before stated)./ This form \more or less/ very generally prevails in African missile weapons. An arrow of this kind is figured in Wood's "Natural History of Man" vol: 1 p. 679 fig 1. Given by Dr Sims \or Simms?/ Wimpole Street, London, 1826.
Ashmoean 1836, p. 181 no. 93.

570-571 Two \globular-shaped/ gourds from Sierra Leone, elaborately but rudely carved by the natives; one with [-which\what] appears to have been intended for two Turtles on the sides of the cover the [-details] deta[i]ls consisting of numerous close set parallel grooves. Both the upper and lower part of the other having at intervals square-shaped spaces in which are very grotesque figures of birds, some of which are possibly intended to represent the Ostrich; and four

legged animals. In some of these squares there is what appears to be the head of some barbed weapon descending onto the animal. D 11 and 10 7/10 in. Given by \Mr/ G.A Rowell, \Oxford/, [-date (?)] 1865.

572 A large Sun-hat from Sierra Leone; made of two kinds of plaited rush, one much coarser than the other, a circle on the outside round the crown, W 3 in., and a broader band round the edge of the rim being of the finer material; the under side \of the hat/ shewing only the coarser rush, except at the margin of the rim which is overlapped by the band above being turned over the edge. The crown is rounded so as to fit close to the head. Whole W 3 ft; W of brim only 14 in. The whole is very thick. Given by Mr G.A. Rowell, Oxford [-date (?) \1865 ?]

573 A hat, worn by natives of Timmance, Africa. Made of tough twisted grass-like material, woven in ornamental concentric bands of black, red, and the natural straw colour, from the peak of the crown to the edge of the brim. Shape of crown conicial, H 7 in., with a flat and somewhat turned up brim between 4 and 5 in. in width. It is b\o/und with four equidistant perpendicular strips of brown leather W 5/10 in. \extending/ from the top to the \edge of the/ brim, \these being/ crossed by an horizontal band \of the same width/ at the bottom of the crown. It is made in one piece, \flexible,/ and has a narrow leathern loop, apparently for suspension, \fastened/ on top. Whole W 17 in. Given by the Rev: J.W. Weeks, Missionary from Sierra Leone \1836/.
Ashmolean 1836, p. 182 no. 114a.

574 A hat of somewhat similar shape but of rather different material, and quite different construction; the brim being flat, and the whole [-thing\article] altogether of a stiffer make. Ornamented with \seven/ narrow \horizontal/ bands of black, at intervals, from the top to the rim, with four perpendicular, equidistant, lines of lozenge-shaped ornaments, of two different patterns, in the \broad and/ lighter spaces, between. The leathern strips are narrower than in the preceding and have been broken. H 7 in.; whole W 15 3/4 in. (Ramsden collection No ?) Purchased by the University \1878/.

575 A small conicial shaped hat of woven grass, in yellow black, and brown bands, with ornamental border round the rim in black and yellow. From Africa. H 6 in. W 1 ft. Given in exchange by the Trustees of the Christy collection 1869.

576 A native-made umbrella, \(Chinese make?)/ which belonged to the King of Ashantee, Western Africa, and was given to a Missionary of the Wesleyan Society. It is constructed on the same principle as the common umbrella; the handle of dark brown bamboo, terminating at the top in a piece of wood in which the ribs work; these are of split cane, forty eight in number. The covering is of coarse paper lacquered brown on the

inside, and green on the outside. The inner supporting rods are ingeniously made to work in an ascending and descending block. H 4 ft.; W when open about 3 ft. Given by J.T. Smith, Esq. St Mary Hall, 1847.
Ashmolean 1836-68, p. 15.

576a An ornamental throne, or seat, probably from Ashantee? or some other adjacent country of Western Africa. Cut out of one piece of pale brown wood. The top which is flat widthways, is very deeply concave or hollowed out from end to end and measures 1 ft. 8 in. in L by 1 ft. in W at the ends, and 10 in. in the middle. It stands on four somewhat square shaped pillars or legs, each D 2 8/10 by 1 6/10 in. [-which] \and which/ have a kind of notched ornament \or border/ projecting on the [-sides\outside]. In the middle between the four corner posts, is a hollow cylinder as it were, D 4 5/10 in., perforated with numerous square shaped holes in regular order; this has been hollowed out from underneath the bottom or stand, which is flat below, and nearly so above, and is about the same size as the top. The middle of the top is ornamented with a band W 6 5/10 in. of faintly indented lines in a kind of pattern, with a few perforations through on each side. H at the ends 14 in., H in the middle 10 3/10 in. (Ramsden collection No ?). Purchased by the University in 1878. It is marked [*drawing*] which perhaps means Guinea.

577 A Nubian woman's apron or petticoat, made of very narrow thongs of leather, the top being plaited into a kind of narrow belt, from which hang a fringe 7 in. in [-L\Depth]. It is ornamented along the top with eighteen white cowry shells ([]) of different sizes. W 16 in.

578 A somewhat similar Apron of \softer/ brown leather, but having the thongs much longer and wider, and the top edge ornamented with twelve white cowry shells of different sizes, five \opaque/ blue glass beads cut into facets, and three little button-shaped bells; W 1 ft. 8 8/10 in.; Depth varying from 8 to 12 in. Otherwise made in \much/ the same manner as the preceding. (Burchell collection). Given by his sister Miss Burchell 1865.
Ashmolean 1836-68, p. 5.

579 The one half of a \yellow/ globular-shaped gourd, from Maharraka, \(on the Nile 25° N 32° 30' E)/ Nubia, rudely carved all over the outer surface with triangular ornament, of crossed incised lines, with plain triangles between them, the bottom forming a plain star-like ornament, with a rude figure of a crocodile \also/ in crossed \incised/ lines in the centre. D 3 8/10 by 3 3/10 in. \H 2 in./ Probably a drinking cup. Given by Greville J. Chester B.A. 1872.

580 An \Eastern/ African shield: (probably used by the Arabs of the Soudan). Made of hide, of an oval shape, and flat, \except/ having a well formed umbo in the middle \D 9 by 7 5/10 in. and H 3 in./ pressed up from the body of the shield; across the back of which and

forming the handle, is a piece of thick hide, fastened through from the front with iron staples. The front of the shield appears to have been dressed and coloured black, but the edges are left roughish \with marks apparently [-of] of the nails used in stretching and drying it round the edge/. A similar shield is figured in Wood's "Nat: Hist of Man" Vol: 1. p. 479. Given by Alderman J.R. Carr, Oxford. 1866.
Ashmolean 1836-68, p. 5.

581 A Mahomedan Negro's shirt \made/ of very coarse white cotton cloth covered all over with sentences from the Koran painted or written on in black and brown. It is W 21 in. and L 54 in., having a slit, L 14 in., cut lengthways in the middle for the head to go through. The inscription is in \horizontal/ lines across the article. Given by Mrs Hare, Shrivenham, Berks, 1834.
Ashmolean 1836, p. 181 no. 94.

582 A circular flat tray, or basket \with sloping sides; entirely/ of woven yellow grass, with patterns in brown; made after the manner of making a beehive. From N. Africa. D 1 ft.; depth 2 in. (In make similar to the Caffir basket No. 469.) Given in exchange by the Trustees of the Christy collection, 1869.

583 A pair of massive iron spurs shallowly inlaid with an ornamental pattern in silver. I[n]stead of rowells they have pointed \cylindrical[-octagonal]/ spikes \of the same thickness throughout/ L 4 8/10 in. and D 5/10. Used by the Moors of N. Africa? L 11 5/10 in. \Greatest W of the perfect one 4 4/10 in. but it appears to be out of the original shape/. One of them has lost a shank, and has \also/ been injured by rust.
Ashmolean 1836, p. 179 no. 39; MacGregor 1983, no. 19.

584 Ditto, but with different shaped spikes \being round, but swelling out very much in the middle/ and quite unornamented. Spikes L 3 4/10 in. Whole L 11 3/10 in. \Greatest W 3 6/10 in./ A spur of this shape is figured in Meyrick's "Ancient Armour" Vol: 2. Pl: CXLVIII, fig: 20, and is said to be used by the Moors of N. Africa.
MacGregor 1983, no. 17.

585 Ditto of smaller size than 583 and 584, but very similar to 584, except that the spikes \as well as the shanks/ are octagonal \instead of round./ L 10 in. Greatest W 3 in.
Ashmolean 1836, p. 179 no. 39; MacGregor 1983, no. 18.

586 Iron horse-bit; used by the Moors of N. Africa. It much resembles the Spanish snaffle bit in common use with the South American Indians. L, not [-rec[k]oning\including] the \two/ rings at [-one\each] end and the chain at the other, 9 6/10 in.; \Greatest/ W 5 2/10 in.
Ashmolean 1836 p. 179 no. 39.

587-591 Five Moorish copper coins, each having a double triangle with dot in the centre on one side, and various numerals on the other; all in relief. The double triangle is called Solomon's seal: and the numerals have to do with the year in which the coins were made.

D 1 1/10; 1; 17/20; 15/20; and 13/20 in. Given by Greville J. Chester B.A. 1867.

592 An African? \or Polynesian?/ Club, of heavy black wood. Handle straight L 1 ft. 6 in., cylindrical, and D 1 1/10. Head long pointed oval shaped, L 8 in. and greatest D 2 4/10. Locality uncertain. Whole L 27 5/10 in.

593 A pair of \large/ sandals from Soudan, [-West] Africa. The sole is made of four thicknesses of hide or leather, and kept on the foot by \four over lying/ straps which pass from the sides of the heel and unite on the instep in a round [-cord\strap] fastened near the front of the sole. When worn the [-cord\round strap] passes between the great and the next toe. The straps are of pliable, [-and] well finished, and rather shiny brown leather, ornamented with cross bands and dots in black. L 11 5/10 in. Greatest W of sole 4 5/10 in. (They appear never to have been worn.) Given by Captain Lyon R.N. 1825.
Ashmolean 1836, p. 182 no. 112.

594 A wooden spoon from Biscara, Algiers: Bowl nearly circular and rather shallow. D 2 7/20 by 2 3/20 in.: W of handle 7/10 in. decreasing to 4/10 at the end. It is of rather rude make and having a few diagonal notches on the front of the \lower part of the the/ handle, near the bowl, for ornament. Whole L 8 5/10 in. It is made of a wood resembling pine. Given in exchange by the Trustees of the Christy collection, 1869.

595 An ancient silver brooch: used amongst the Kabyles, a tribe in north Africa. In shape the upper part is triangular, the apex being prolonged into a square-shaped projection W 5/10 in. having a hole through it. The lower part is a pin L 2 in., through a side perforation in the upper part of which, a copper ring having recurved ends, and D 1 2/10 in. is suspended. Whole L 3 7/10 in.; Greatest W 1 6/10 in. The face of the triangular portion is ornamented \with/ three raised bosses, incised lines parallel with the edges, and numerous irregular indented crescent-shaped dots. Given by Greville J. Chester, B.A. 1867.
Ashmolean 1836-68, p. 5.

596 A modern, silver plated copper Kayble ornament, of a similar kind, and of somewhat similar shape to the preceding; but the upper part instead of being triangular, is of perforated scroll pattern, ornamented with numerous close-set incised cross lines, and having a projecting boss in the centre set with a red opaque glass? stud. The lower part is prolonged into a pin [-with\and having] a suspended ring, but the ends of the ring are flattened out, not recurved \as in the preceding article./ L 3 3/20 in.; Greatest W 1 15/20 in. Given by Greville J. Chester B.A. 1867.
Ashmolean 1836-68, p. 5.

597 A pair of modern silver Armlets, used by the Kaybles. They are made of a thick cylindrical wire, bent round into a semi-circular shape, one end of which is flattened and perforated, the other end being soldered on to a dome-shaped ornament which is divided into partitions by twisted or plaited wire \(probably a righ[t] and a left-hand twist put together to resemble a plait)/ the partitions or cells being filled with blue and yellow enamel, the centre being set with a bit of red coral, and perforated along the square outer edge with four small \circular/ holes. D 2 4/10 by 1 8/10 in. Th of the wire 1/10 in. Given by Greville J. Chester B.A. 1867. (A similar article \with objects appended/ is figured in Wood's "Nat: Hist of Man". Vol: 1. p. 502).
Ashmolean 1836-68, p. 5.

598 A modern silver finger-ring, of rather coarse workmanship, used by the Kaybles. It is a hoop W 3/20 in. and D 17/20, plain inside, but ou[t]side \composed/ of four twisted wire cords joined together side by side, to which at the junction of the ends, is soldered a \semi circular/ hollow boss D 7/10 in. and H 4/10 in., perforated round about with six holes, each of which is surrounded with a single row of cord pattern wire: the centre \or apex/ being set with a red stone \or coral,/ and also surrounded with cord pattern. D to top of stud 1 2/10 in. Given by Greville J. Chester. B.A. 1867.
Ashmolean 1836-68, p. 5.

599 A pair of bracelets from Tripoli, N. Africa; \each/ roughly made of \one quadrangular piece of/ Rhinoceros? horn, bent round so as to form the \circular/ ring; the joining being made by a tongue at one end which fits into a slit [-into] in the other end. They are inlaid on one side and the outer edge, with small leaden rings and \minute/ points. Greatest D 1 5/20 in.; Greatest W of material, which is nearly square, 7/10 in. Given by Greville J. Chester, B.A. 1867.
Ashmolean 1836-68, p. 5.

600 A Mammeluke's horse-bit: This implement is very massive; weight 3 [lbs] 5 oz and from the length of leverage in the cheek arms which are 15 in., must be enormously powerful.

601 A one-handled vessel of terra-cotta, called a Gullah, brought from Egypt by Captain Hon[ora]ble Courtney Boyle R.N. about 1802. It is modern work, of a greenish drab colour, unglazed, and quite plain. Whole H 6 in.: Greatest D 4 1/10 in. The [-rim\neck] is straight but devulging towards the top H 2 in. and W 3 2/10, and separated internally from the lower part of the vessel by a transverse perforated partition or strainer. Given by the Rev: Dr J. Wilson, F.S.A. President of Trinity College, 1866.

602 A two-handled, somewhat similar shaped vessel to the preceding, of a \pale/ yellowish brown coloured unglazed clay, ornamented in a rude manner with a few cross lines of darker brown paint. The stoppage in the neck is perforated simply with round holes. Probably Arabic, or modern Egyptian? H 7 in.:

Greatest D 5 in.: D of mouth 2 7/10 in. Purchased in 1876.

603 A semi-circular shaped bowl of a rich shining red coloured clay: modern work from Egypt. It appears to have been made by hand, that is either partly shaped when in a plastic state, or else cut out of a solid piece, but probably the latter. The inside is quite plain. The central portion of the outside is carved by portion of the surface being cut away, leaving a [-rather\very] elegant and classical \leaf-shaped cross/ pattern in the red, the cut away portion \round it/ being coloured of rich cobalt blue. H 2 1/10 in. D 5 5/10 in. Given by Greville J. Chester B.A. 1872.

604-607 Four lances or javelins from Fernando Po, West coast of Africa. These are mere sticks of the natural growth, none of which are anything like straight from end to end, and having the bark and side shoots cut off. They are about L 8 ft. and D 8/10 in. towards the head, tapering gradually to the other end to D about 3/10 in., the head of each being pointed with three angles, each angle having five barbes. L 8 ft. 2 in.; 8 ft. 1 5/10; 7 ft. 11 8/10; and 7 ft. 6 1/10 in. They much resemble the rude spears or lances used by the savages of Australia, except in the barbes. Given by Lieut. Cole, R.N. 1828.
Ashmolean 1836, p. 182 no. 114.

608 A paddle, or broad-bladed spear, from Fernando Po. It is of brown wood, the blade sharp pointed leaf-shape, L 29 in. and greatest W 4 4/10; the handle round, D 1 3/10 at the junction with the blade, tapering gradually to 6/10 in. \D/ at the end. Whole L 5 ft. 5 5/10 in. A faint central ridge extends from the \bottom of the/ handle half way down the centre of each blade. It equals many of the Polynesian weapons, in general form, but is inferior in finish. Given by Lieut. Cole R.N. 1828.
Ashmolean 1836, p. 182, no. 114.

609 A paddle from Fernando Po? West coast of Africa, of the same kind of wood as the preceding specimen. Blade thin and of a peculiar form, L 20 in. and from 6 3/10 to 3 4/10 in. broad, and extended into a kind of beak at the end, and has a \wide but/ shallow central gro[o]ve down each side. Handle roughly rounded D 1 1/10 in., and obtusely pointed at the end. Whole L 3 ft. 11 in. (On the original label it is stated to be from Sierra Leone). Given by Lieut Cole R.N. 1828.
Ashmolean 1836, p. 182 no. 114.

610 "An ornament worn just above the Hips by the Natives of the Island of Fernando Po, in Africa". It is a double twisted string, L 9 feet 4 in. of black beads \each bead/ D about 5/20 in., made apparently of cross sections of the black stems of a Gorgonia. Given by Lieut. Cole R.N. 1828.

611 "An Armlet worn by the natives of the Island of Fernando Po in Africa", made of six strings of similar but \somewhat/ smaller beads to the preceding article plaited into a circular band W 8/10 in. D as worn 4

5/10 in.; or as fol[d]ed [-up \together] flat, about 6 5/10 in. Given by Lieut: Cole R.N. 1828.

612 An ivory carving on the point portion of a young Elephant's tusk. Round the lower part three figures in bas-relief, each standing and holding cups in their hands; one of them which has the cup \in the right hand and holding it/ to his lips appears from his hair to be intended for a Negro, \and/ has a kind of petticoat round the legs the upper portion of the body being naked. The middle figure which stands facing the last \described/ has a kind of close fitting cap \having a fold round the bottom and a button on top,/ a petticoat, and a short jacket above, and holds the cup in the left hand in front of the body. The third stands behind him having on a low flat cap, the upper portion of the body being naked, with a petticoat below, the top of which is turned down at the hips, and holding the cup in front with left hand the right being elevated \level with the head./ On the top is a seated figure, nude except a cloth round the loins, wearing a small conical cap or else perhaps the hair done up in that way, and holding some object which looks like a box or basket with a lid, between his feet and hands. Below this figure and between \it/ and the heads of the three standing figures is a \carved/ border of some objects perhaps meant for cowry shells. From the Congo river, West Africa. Extreme L 4 5/20 in. Greatest D 1 1/10 in. Given by Greville J. Chester B.A. 1878.

613 A Water bottle made of a double shaped gourd, the upper portion answering to the neck being somewhat oval in shape, L 6 in. and D 3 in. in the middle, but decreasing rapidly to 1 2/10 at the top and 1 8/10 at the lower part where the gourd swells out into a globular shape D 5 5/10 in. Whole H 10 6/10 in. It has a rough thong of hide fastened round the contracted middle, to the other end of which a small stopper \made of a bit of thick leather,/ for the mouth is attached. Locality not stated, but perhaps from Africa. \Probably \from/ Abyssinia or thereabouts/. Given by the Rev: T. Daubeny. 1878.

614 Headrest or pillow, cut out of a solid piece of pale brown wood: flat and hollowed out lengthways at the top, L 9 5/10 in., and W 3 5/10 in., the ends being recurved, below which it is Th 8/10 in. with upright or straight sides, but sloping downwards at the ends to a circular foot or stand D 5 2/10 in. The whole of the surface [-expet] except the middle portion of the top is ornamented with thickly set incised cross lines which have been coloured black. Greatest H 7 in. From the neighbourhood of the Red Sea. Given by the Rev: T. Daubeny 1878 [*drawing*].

615 Ditto, of pale brown wood entirely unornamented. Top L 5 3/10 in. W 2 2/10, the ends being straight, supported below by a double plain \upright/ column, which springs from a circular \flatly/ conical base as in the preceding. It has a small strip of leather attached

through a hole in the upper part. From Abysinnia H 5 6/10 in. Given by the Rev: T. Daubeny 1878.

616-617 Two Agra beads, from the coast of Africa, D 6/10, greatest Th 7/20 in.; and D 5/10, greatest Th 3/10 in. The largest is opaque brown with concentric rings in red white and yellow inclosing a blue centre all opaque except the blue which is semitransparent. The smaller one is bright yellow ornamented round the sides with five rings, each in red black and white, and all opaque. They are round with flat ends but thinner on one side than the other, as if many had been intended to have been threaded [-in] \together to form/ a ring, as in a bracelet, or armlet for instance, so that they would fit close to each other (Burchell Collection) ("Capt^n Fisher J 17.8.18"). Given by his sister Miss Burchell, 1865.
Ashmolean 1836-68, p. 5.

618 Cushion or bag of white leather sewn up on three sides with string, and stuffed with a brown scented powder. [-Mand] It has "Henna" written on it. Size 4 8/10 by 3 7/10 in.; and Th 2 in. Locality not stated \(Probably from Abyssinia or near as see No. 613. 614 and 615)/ Given by Rev: T. Daubeny, 1878.

619 A Cutlass, in a highly ornamented leathern sheath. Used by the Mandingo Mahomedans in Sierra Leone. The weapon has a curved blade, L 2 ft. 4/10 in., and W 1 6/10, inserted into an embossed or rather moulded handle of shiny black leather, which has a globular shaped pommel of turned brass [-it\but] has no guard. L 7 3/10 ins. The sheath which is of a singular shape, being very much wider towards the point than it is above, is made \of/ fine shiny yellow leather, ornamented on the upper half, at intervals with five prominent ridges, or rather embossed mouldings, \which are/ coloured \or stained/ black on central or highest part, and vandyke of red and yellow on each side. The other portion of the sheath [-being\is] of the plain yellow colour and having various geometrical and other designs, chiefly coloured brown, some of which have evidently been struck with a compass. It is L 28 2/10 ins. and follows the curve of the blade to within 13 ins. of the end, from which point it gradually increases in width to 3 5/10 ins. and then rounding off to a point. It is worn slung under the left arm, and the double rope for carrying it is made of scarlet wool, [-having \with] two tassels of the same colour, the knobs of which have cross threads of yellow and blue, in a kind of woven pattern, to wear on the right shoulder. This cord is attached \at each end/ by neatly plaited \rounded/ loops of brown leather to two [-double\pairs of] circular convex buttons D 2 7/10 ins. fixed to the top edge of the sheath at about 6 ins. apart, those on the inner side being plain black leather like that of the handle, etc. with edging of brown, and those on the front yellow, with geometrical designs in brown to match the lower portion of sheath. Underneath these buttons, and attached to the lower edge of the sheath hang two \sets of / streamers 14 in. long, each

composed of numerous narrow strips of whitish leather, having [-on\at] each side \of them/ two pieces of brown-faced leather, \which are/ narrow where they are attached, but gradually increas[e] to over 2 in. \in width/ at the ends; these are very neatly ornamented in a kind of lattice and chequered pattern on the four [-outsides\faces] by the surface being cut away, the pattern shewing in the white colour beneath. [-and] the[-pattern\design] on each [-side\face] being different. Whole L when in scabbard 2 ft. 7 5/10 in. Given by J.R. Maxwell. Merton College 1879.

620 Iron dagger in an ornamented leathern sheath; used by the Mandingoe Mahomedans in Sierra Leone. The blade is L 9 7/10 in. W 1 1/10, acutely and sharply pointed, and stamped along each side near the [-the] edge with a border of serrated crescent-shaped indentations. The handle is of brown wood rudely turned or carved \into a roundish pommel/ and thickly ornamented with brass \and iron/ work L 5 in. The sheath is of embossed \shining/ leather, coloured red and black \to match that of the sword 620/ and ornamented on the face with numerous close-set parallel grooves, \arranged in various directions/ and has a large tassel made of numerous narrow strips of leather, L 5 5/10 in., of like colour at the end, and a plaited loop and button of ditto at the top for carrying it. Whole L when in sheath \measuring to bottom of tassel/ 19 5/10 in. Given by J.R. Maxwell. Esq. Merton College. 1879.

621 A cap \used by the Mandingoe Mahomedans in Sierra Leone;/ made of neatly woven grass [-coloured\stained] yellow, red, brown, green \black,/ and the natural straw colour, in horizontal stripes and in chequers. It is made of one piece of material, sewn up the sides and bent over and pleated in at the centre of the top to form the crown the joining of the pleats being covered by a circular piece or button from which hangs a small tassel, both of the same material as the cap. H 4 in. D 6 5/10 in. Given by J.R. Maxwell. Esq. Merton College. 1879. (Mr Maxwell was a native, and he formerly wore these things).

622 African iron battle-axe, with handle of dark brown wood. The blade is somewhat angular crescent shaped, the angle being outwards, L 10 4/10 in., and W 2 in. in the middle, decreasing to 7/10 in. at the ends. From the middle of the back of the blade, and at right angles with it a cylindrical shank L 4 5/10 in. and Th about 5/10 projects, the end [-being\of which] is driven through a club-shaped handle L 23 2/10 in., at 1 7/10 in. from the top. The handle is of hard wood D 8/10 in. at the bottom rather less for some distance above, and at the top thickening to D 1 5/10 in. Locality not known (Ramsden collection No. ? Purchased by the University, 1878).

623 A double pouch, or knapsack; of shining dark brown leather, ornamented on the lid with various \parallel/ impressed lines and \[-different shaped]/ dots;

and with \two/ tassels made of narrow strips of the same material at the angles of the top, and [-and\with] one attached to a button on the bottom of the lid \the button being used for fastening the pouch/. In shape it is straight at [the] top and partly down the sides but \rounding off to/ semi-circular at the bottom. It has long round cords of plaited leather \attached to the top/ for carrying it, probably slung across the shoulders. \The back is plain except a loop of leather used for fastening to the button./ Size 7 5/10 in. deep by W 7 in. That is the body of the purse only, not rec[k]oning the appendages. Probably from West \Central/ Africa. (Burchell Collection) given by his sister Miss Burchell 1865.
Ashmolean 1836-68, p. 5.

624 An oblong shaped pouch of similar leather and ornamented in a similar manner, but with a different pattern, the stamping being on both sides, \but/ the design not being the same on [-both\each] side. The lid which only reaches half way down the side is rounded; and it has been lined throughout with coarse white cotton. It has five buttons attached, the two larger ones \being/ made of [-of] or \covered with/ interwoven narrow strips of \thin/ leather, and the other three of leather and yellow grass, and has long \cords or/ strings of twisted leather for carrying it.[-L\Depth] 7 in. W 4 8/10 in.
MacGregor 1983, no. 369.

624a Horses bridle made of dark brown leather in numerous narrow plaited thongs, with \iron/ snaffle bit attached. The reins are made of eight round cords of the same plaited leather, four in each rein. At the end nearest the rider these come together and appear to pass through two oval shaped knobs L 4 in. D 1 7/10 made of finer plaited thongs of black and brown leather, and which are separated from each other by a space of 3 5/10 in., the last one of the two forming the handle of a whip, the lash of which is of twisted raw hide over which are thongs of plaited leather. Thus the bridle reins and the whip being in one length, and perhaps intended to be used with one hand. The leather work of the bridle cords is done over string. The leather has been a good deal broken. L of bit 8 in.: W of cheek bars 3 1/2 in. Compare this with the S. American bridle etc No. 883 & 884 (Ramsden Collection No. 340). Purchased by the University in 1878.

625 Ditto, of a different shape, being wider than it is deep and stamped on both sides with a different pattern \consisting chiefly of indented parallel crossed lines like lattice pattern except on the lid which are chiefly idols/. The lid being semicircular with a large button attached [-made of\covered with] narrow interwoven strips of thin leather and yellow grass, the other four buttons, as well as the round, \plaited/, whip-lash like cord attached \to the sides,/ being entirely of leather. It is lined with coarse white cotton and has apparently been used for bullets, four of which of different sizes

remain. D 5 in. W 6 5/10 in. Probably for the same locality as the preceding two. \The fastening of these last two pouches is on the same principle as 623./ (Ramsden collection) \No.?/ Purchased by the University. 1878.

626 A bag of softish \and rather thin/ brown leather, made out of the skin of some small \female/ animal, the head part forming the bottom of the bag, \ornamented/ with \four sets of four/ pendants L 9 in., made of small knotted thongs of leather, and leaden beads, \which have been moulded,/ tied to the places where the legs would be. The top \edge/ is ornamented \all round/ with a border of variously coloured glass beads, \red yellow green and black/. L 17 5/10 in. D of top about 9 in. Locality uncertain Possibly it may be N. American. (Ramsden collection No ?). Purchased by the University. \1878/.

627 A bag or pouch of hard whitish skin \something like parchment,/ coloured black round the edges, [-and\which is then] rudely ornamented by scratches through the black to the [-white skin\lighter colour] beneath. The \four/ angles of the sides are edged with blue cotton cloth with white flowers \[-covering a piece of thin rope,]/ and outside \this/ a round cording covered with red cotton cloth, to which is attached a line of the same size, for carrying it, [-and] bound round with blue cotton cloth. It has been much injured, and contains four \large/ bullets and a small piece of black flint. \Depth 8 in. W 7 4/10 in./ Locality uncertain. Ramsden Collection No ?. Purchased by the University. 1878, perhaps this is Indian.

628 A Gaboon fiddle, from Gaboon river West Africa, near the Bight of Benin. This is simply a squat coffin-shaped box cut out of a solid piece of rather soft wood, having a very thin lid [-nailed\pegged] on the top, and rudely carved with three ornamented circles on each side, and coloured black. The five strings which were probably of copper wire have been lost. L of one side 9 3/10 in.; of the opposite, (which appears to be the top), 8 in. Greatest W \(which is at about 1/3 of the widest end)/ 4 8/10 in. W at one end 4 1/10 in.: Depth 4: W at the other end 3 3/10, depth 3 in. (Ramsden Collection No ?). Purchased by the University, 1878.

629 The end of an Elephant's tusk having a large slanting hole pierced through it on one side, at about the middle; the point having apparently been [-subjected\exposed] to the action of fire.[-Ramsden Collection]. L on the greatest curve 14 4/10 in. D of large end 2 3/10 by 1 8/10 in. (Ramsden Collection No ?. Purchased by the University. 1878).

630 A circular shaped Arabic vessel of red earthenware, imperfect. Probably a \double wick/ lamp. Ornamented with incised scroll pattern which has \formerly/ been painted white \traces of which

remains/. D 6 in. H 3 5/10 in. Locality and history unknown.
Ashmolean 1836, p. 126 no 144.

631 \An Abyssinian/ Iron [-spoon\implement], with nearly circular-shaped shallow bowl, the handle being straight and narrow, and forming a short fork at the other end. \Whole/ L 7 4/10 in.; D of bowl, 1 13/20 in.; D of fork end 19/20 in. [-Probably African, but locality and history unknown.] Given by F.H. Field. Esq. Oxford. 1868.
Ashmolean 1836-68, p. 7.

632 African? spear, with large iron head. Probably from the upper Zambesi. The shaft is made of a straight stick, with the side shoots cut off, and rather roughly rounded, D 6/10 in. where it enters the socket of the head, but widening to 8/10 in. at the other end. The head is L 21 8/10 in., (including the socket which is 6 5/10;), and W 4 4/10 next the handle, [-and\graduall[y]] tapering to a point, thin, and having a square central ridge down each side. The socket has a wide slit down the side. Whole L 7 ft. 1 5/10 in. (Ramsden collection No ?) Purchased by the University, 1878.

633 African? spear, locality uncertain. The head is of iron, L 10 1/10 in., the upper part being long leaf-shape 6 3/10 by 1 3/10 in., [-with\having] a cylindrical neck D 9/20 in. where it enters the shaft, but rather less above. The shaft appears to be of bamboo having the knots neatly trimmed off, D 8/10 in. at the top which is bound with a ferrule of twisted iron, tapering to 5/10 at the bottom, which is shod with an iron spike about L 4 in. The whole of the shaft appears to have been formerly roughly bound with thin hide, perhaps goat skin having the hair on it, some of which remains, and with three rings \each/ made of little tufts of hair, [-probably \perhaps] of the Monkey. Whole L 6 ft 10 5/10 in. (Ramsden Collection No. 988) Purchased by the University, 1878.

634 A globular-shaped vessel cut out of a solid piece of wood carved with numerous \parallel/ diagonal grooves arranged in opposite directions. At the sides [-to] \are/ t[w]o projecting perforated ears [-p] also carved and having a cord through them for suspending the vessel. H 9 5/10 in.; D 9 3/10 in. The whole exterior coloured black[.] Ramsden Collection No. 193. Purchased by the University 1878.

635 Ditto, smaller, with similar ornamentation, the grooves being more curved, not so evenly arranged, and and separated in irregular widths by perpendicular grooves running from top to bottom. The two ears placed nearer the mouth, plain and with cord for suspension. H 8 3/10 in.; D 7 6/10 in. (Ramsden Collection No ? Purchased by the University, 1878).

636 Ditto, of rather narrower form, and carved from top to bottom with parallel horizontal grooves, divide[d] or crossed by four \sets of/ equidistant, perpendicular grooves, three in three of the sets, and

four in the other. Two projecting ears near the mouth, perforated and two below near the bottom \placed/ in opposite direction \to those above/ and not perforated. \One side of the top broken./ H 9 6/10 in., W 7 8/10 (Ramsden collection No. 194. Purchased by the University 1878).

637 Ditto, more globular in shape than the last, with the gro[o]ves in various directions divided by four equidistant sets of upright grooves. It has eight projecting ears three only of which are perforated. One of them has a loop of cord suspended in it. Cracked on one side. H 8 in. D 8 3/10 in. Ramsden Collection No 92? Purchased by the University 1878.

638 Apron, made on the same principle as No 577. 578, but \composed/ of numerous closely knotted threads, and then coated with some brown dirty looking substance, and attached at top to a narrow strip of leather. W about 6 1/2 in. depth 5. It appears to be only about the one half of the object. Probably African. (Ramsden collection No ?. Purchased by the University 1878.)

638a Another apron exactly like No. 638. but much more worn away. The leathern thongs remain at the ends for tying it. May be both these are leg or arm ornaments instead of Aprons. (Ramsden Collection. No. ?) Purchased by the University in 1878.

639 A pear shaped flask or bottle with short narrow neck. Apparently made of wood covered all over with a network of string which has then been dipped in some \black/ solution, like gutta-percha. Locality unknown. H 4 8/10 in. D 2 7/10 in. [-Indian?] Ramsden Collection No ?. Purchased by the University. 1878.

640 A Nubian nose-ring of soft white metal, circular in shape, the metal being [-round \cylindrical] except at the ends, which have been flattened out and stamped with numerous small indentations separated into groups by faintly incised cross lines. D 1 2/10 by 1 3/20 in.; Th of metal 3/20 in. From Shelal First cataract of Nile. Given by Greville J. Chester, B.A. London. 1882.

641 Ditto, ditto, similar in shape but larger, the flattened ends being ornamented by numerous minute indented circles having double incised lines at the sides. D 1 4/10 by 1 3/10 in.; Th of metal 3/20 in. Given by Greville J. Chester, B.A. London. 1883.

642 A small Thermometer with double scale on narrow strip of ivory. Fah.t. and Cen.e. Maker J. Tagliabue, London. Embedded in a groove cut in a piece of pith, \and/ tied round the bottom with a bit of thin yellow silk. The glass has unfortunately been broken in the middle. L of ivory 7 3/10 in.: W 7\2[0] in. L of pith 10 1/10 in.; W 1 3/10. Used by Dr Burchell during his African travels. Given by his sister Miss Burchell 1865.
Ashmolean 1836-68, p. 5.

643 A weapon of the tomahawk type: \Locality unknown;/ the head being of iron, the end of which has a serrated cutting edge, the other being quadrangular

and obtusely pointed. The handle is simply a piece of crooked and knotted stick \D about 7/10 in./ mottled brown and black, with an iron ferrule at the other end and a projecting spike which appears to have been broken. L of head 4 5/10 in.; W of cutting end 1 5/10 in. of the other end 9/20. Whole L 29 3/10 in. (Ramsden collection No.\88/ ?) Purchased by the University 1878.

644 A Camel's head gear ?, locality unknown; made of raw hide, (which formerly may have had the hair on), covered on the outside with various rude ornaments of stamped-up, and perforated, thin plates of white metal, like tin; to which are attached by little round staples or rings of flat metal, but moveable, a number of small lozenge-shaped pendants of stamped [-thin] white metal, and numerous small globular bells of thin brass each with a cross slit below, all of thin metal, \and/ which rattle very much when shaken. It is lined with coarse white cotton or canvas, and [-it] has a kind of bit of \made of/ flat iron links, \and/ attached at the sides to two quoit-shaped rings. L 20 in. (Ramsden collection No ?). Purchased by the University 1878.

645 A piece of South African matting work, made of a round tough rush \resembling wicker rods/ laid close together crossways, being kept in their position by seventeen cords running lengthways at about three inches apart, each rush being split for the cords to pass through, the cords not being visible but at the two ends of the matting. The ends of the rushes are bound in pairs by a separate double twisted cord. All the cords are made of twisted grass. L 11 ft. 5 in.; W 3 ft. (Burchell coll[ectio]n) Given by his sister Miss Burchell. 1865.
Ashmolean 1836-68, p. 5.

646 Ditto, ditto. L 7 ft. 9 in.; W 2 ft. 6 in. Given by ditto.
Ashmolean 1836-68, p. 5.

647 Ditto, ditto. L 9 ft. 7 in.; W 2 ft. 8 in. Given by ditto.
Ashmolean 1836-68, p. 5.

648 Ditto, ditto. L 7 ft. 10 in.; W 2 ft. 4 in. Given by ditto.
Ashmolean 1836-68, p. 5.

649 Ditto, ditto. L 9 ft. 6 in.; W 2 ft. 10. Marked B.C. 33. Given by ditto.
Ashmolean 1836-68, p. 5.

650 Ditto, ditto. L 7 ft. 3 in.; W 4 ft. 10 in. Given by ditto.
Ashmolean 1836-68, p. 5.

651 Ditto, ditto. L 4 ft. 11 in.; W 5 ft. 8 in. Marked B.C. 23. Given by ditto.
Ashmolean 1836-68, p. 5.

652-653 Two pieces of matting, made of plaited rushes or a coarse kind of grass ornamentally worked in a kind of pattern in stripes lengthways by the plait being either lengthways or widthways, the rushes being left as a deep fringe at the bottom. [-It\Each] has a plaited

loop tied to the middle of the top, apparently for suspension. L 4 ft. 3 in. W 2 ft. 9; and L 4 ft., W 2 ft. 3 in. (Burchell collection.) Given by his sister Miss Burchell. 1865.
Ashmolean 1836-68, p. 5.

653a Bronze object of an oval \somewhat/ crown shape with shots inclosed in it on the inside which are loose and rattle when shaken. Possibly an Anklet or Armlet. Ornamented on the outer side with a raised pattern [.] Where from uncertain. Ramsden collection No ? Purchased by the University 1878.

653b An old cloak or mat of goat's hide neatly sewn together of pieces, but the greater part of the hair worn off or eaten off by insects. Possibly African. L 5 ft. 3 in.; W 5 ft. 7 in. Can this be the Tartar Lamb cloak given to the Bodleian by Sir Rich: Lee in 1609, and is supposed to have got transferred to the Ashmolean or lost afterwards. It was inquired for in 1885 for by the Rev: Lee Warner, St John's Coll[ege] Cambridge through one of the Assistants at the Bodleian who brought me paper on opposite side of book \Tartary lamb cloak given \(to the Bodl[eian]) by Sir Rich. Lee in 1609/. \Probably this is a Woman's Caross of a South African nation, situated beyond Latakoo and presented by Miss Harriet de Lisle in 1827./

653c Broad & thin iron spear or javelin head perhaps of an Assagai with small socket in which a fragment of the wood shaft remains, and curious indented ornament on the lower part of blade resembling a smaller \& leaf-shaped/ spear blade. Probably from some part of Africa. Present L 11 1/4 in. just the point being broken off: greatest W of blade 2 1/2 in. and of socket rather less than 1/2 in. [*drawing*]

653d String of small beads, probably African; made it appears of cross-sections of a gorgonia and disks cut from the shell of the Ostrich. L 19 in., the beads being about D 1/8 in. Ramsden coll[ectio]n 166. Purchased by the University in 1878.

653e Necklace made of the [-vertebrae\vertebrae] of a small snake. Locality and history lost. L 10 1/2 in.

Catalogue of the Esquimaux collection in Ashmolean Museum in 1884. Copied from Mr G. Rowell's M.S. with additions, etc.

654 A shirt, or outer Jacket; made of the intestines of the Walrus, sewn together with thread made of shreds of sinews of the Reindeer, and probably a fine fish bone for a needle. Worn by the Esquimaux in Kotzebue Sound, Behring's Strait (66° 30' N, 163° west), over their fur dress in wet weather. Captain Beechey describes them as soft, pliable, thoroughly water-proof, and "on the whole as good as the best oilskins in England", when kept well oiled as by the natives, but, if neglected on that point, they readily crack and become useless. L 3 ft. 8 in. W of bottom 3 ft. Captain Beechey's collection. Probably given in 18[].

Ashmolean 1836, p. 186 no. 331.

655 Ditto, ditto, of about the same size as the preceding and from the same locality, but the seams being sewn in quite a different manner. L 3 ft. 8 in.; W at bottom 2 ft. 8 in. Ditto, ditto.
Ashmolean 1836, p. 186 no. 331.

656 A similar but smaller shirt, and sewn together in a different manner to either of the preceding. Worn by the Eastern Esquimaux of Hudson's Strait (61° 30' N 69° W.) Copy of original writing on breast of the article "Jacket of the intestines of the Walrus, used outside the Fur dress to keep it dry, Captain G.F. Lyon \R.N./1825" L 2 ft. 10 in. W at bottom 2 ft. 6.
Ashmolean 1836, p. 186 nos. 329-30.

657 A similar, but [-better\not quite so well] preserved Esquimaux outer Jacket, and from \about/ the same locality as the preceding. Copy of original label attached "The outer Jacket of an Esquimaux, made from the intestines of [-the] seals. Griper, 1824. Presented by Lieut. Harding, 1827". L 2 ft. 10 in.; W at bottom 2 ft. 1 in. Given by Lieut. Francis Harding, Esq. R.N. 1827.
Ashmolean 1836, p. 186 nos. 329-30.

658 Reindeer sinews from the spine, used as thread, by the Esquimaux of Hudson's strait. L 2 ft. Given by Captain Lyon, 1825.
Ashmolean 1836, p. 187 no. 398.

659 A [-landing] net (?Ice net, for clearing away the fragments of ice after having broken through a hole in the ice for fishing with the spear). From Cape Thompson, North-West Esquimaux. It is a kind of sieve, formed of a circular rim of bone D 7 3/10 in., and about 1 3/10 deep, having a kind of projecting beak in front, with a netting of thin strips of whalebone across the bottom, in pattern much like the ordinary seat of a cane-bottomed chair, and attached to a rounded wooden handle L 3 ft. 8 in., and D about 1 1/10. Whole L 4 ft. 11. It does not appear that such an implement is in use amongst the Eastern Esquimaux. (Beechey coll[ectio]n) Given by Captain F.W. Beechey R.N. in 18[].
Ashmolean 1836, p. 186 no. 344.

660 A pickaxe, obtained from the Esquimaux at the N.W. extremity of America. Made of a pointed and curved piece of Walrus tusk L 14 in. measured on the outer curve, and greatest D about 1 5/10 in., securely lashed on with strips of Walrus hide to the hollowed out end of a flat wooden handle, 2 ft. 1 in. long \and/ varying in W from 3 1/10 to 1 4/10 in.; and 9/10 in. greatest thickness; the under edge being cut as a stay for each hand. All the edges somewhat rounded. Captain F.W. Beechey R.N. [], given by him in [].
Ashmolean 1836, p. 186 no. 342.

661 An Esquimaux landing hook used by the natives of Kotzebue Sound, Behring Strait. Made of a pointed piece of Walrus tusk L 7 5/10 in., and greatest D 1 3/10, strongly lashed on with narrow strips of whalebone to the side of the end of a somewhat rounded wooden handle the other end of which is bent down at right angles L about 6 in., as a hand grip. Whole L 27 in. Captain F.W. Beechey, R.N. [], given by him in [].
Ashmolean 1836, p. 186 no. 343.

662 An Esquimaux \Adze/ from Point Franklin, N.W. America. Made of a flat celt-like piece of iron with slightly rounded cutting edge W 2 6/10 in. the angles of which are a little recurved, firmly set in a solid lump of bone L 4 in. by W 2 4/10, and Th 1 1/10 in., which is lashed on to the end of another curved piece of bone, L 1 ft. 4/10 in., which forms the handle, with narrow thongs of hide, which are also extended to the end of the handle to close a long saw cut, it evidently having been used \or intended to have been used/ previously for the handle of a knife, saw, or some such implement by the plugged up rivet holes. (Compare blade with the flat celts of the Early bronze period). Captain F.W. Beechey, R.N.[] given by him in 18[].
Ashmolean 1836, p. 187 no. 380.

663-664 Two knives with blades made from the tusks of the Walrus[27] lashed on to handles of bone. One of them with bindings of narrow strips of whalebone, the \other/ with bindings of sinews, the blade of this is made of two pieces lashed together in the middle with a double binding of plaited sinews. L 16 8/10 in. Greatest W 2 in. L of the first 15 1/10 in. greatest W 2 3/10 in. These appear to be chiefly used amongt the Eastern Esquimaux, and especially in the district about Winter Island; the Western Esquimaux having iron knives (See Nos 765. 766). Given by Captain G.F. Lyon R.N., 1825.
Ashmolean 1836, p. 187 nos. 392-3.

665 A band L 2 ft. 4 in. and W 1 1/10 in., formed of the semicircles of teeth from the front of the lower jaw of seventy-three Arctic foxes, of various sizes, sew[-e]n on to a strip of seal skin, and arranged in opposite directions from the middle, [-and] the jaws decreasing in size to the ends. Worn round the head, [-and procured from\"of the Esquimaux] \to the/ N.E. of Icy Cape". (Similar ornaments of Monkey's teeth are used in Central Africa). Captain F.W. Beechey, R.N. []. given by him in 18[].
Ashmolean 1836, p. 187 no. 367.

666-667 Two sets of instruments ("Bird slings") used by Esquimaux for catching birds by entangling their wings. Each set consists of five [-oval, or egg-shaped, [-and\or] long oval-shaped pieces of bone, each of which are alike in form and size, of about three quarters of an ounce in weight, \and / attached to fine lines of plaited sinews, L about 1 ft. 11 in., tied together at end to a bunch of quills of small feathers, which forms a handle. "When used the balls are

[27]Snow knives used in cutting or shaping the blocks of snow wherewith they build their Houses.

dexterously made to whirl round with great velocity in one plain but separate from each other, and then while still influenced by that motion, the whole is cast over the object aimed at. Very young boys become expert in this mode of catching birds, which they do for amusement."L 2 ft. 3 5/10; and 2 ft. 3 in. Captain F.W. Beechey, R.N. []. given by him in 18[].N. West Esquimaux. A similar instrument is figured and described in Wood's "Nat: Hist: of Man", Vol: 2, p. 711.
Ashmolean 1836, p. 186 no. 357.

668 One set of five similar \bone/ balls of a rounder form than either of the preceding. The feathers which formed the handle \are/gone. N. West Esquimaux. L 1 ft. 10 in. Captain F.W. Beechey, R.N. []. given by him in 18[].
Ashmolean 1836, p. 186 no. 357.

669 A set of long cylindrical balls, with rounded ends, seven in number five of them being of walrus ivory, and two of bone, one of the latter being imperfect. L 2 ft. 5 8/10 in. N. West Esquimaux. Captain F.W. Beechey R.N. [] given \by him/ in 18[].
Ashmolean 1836, p. 186 no. 357.

670 Ditto, of six nearly oblong shaped balls, that is with the sides and ends squarer than in the preceding: four of bone and two of ivory. N.West Esquimaux. L 2 ft. 1 in. Captain F.W. Beechey, R.N. []. given by him in 18[].
Ashmolean 1836, p. 186 no. 357.

671 A narrow band apparently of skin 5/10 in. wide, to which are suspended from the one end by short twisted threads \of sinews,/ forty-nine perforated bones of some small animal, which vary from L 1 3/10 to 2 3/10 in. Whole L \of band/ 14 5/10 in. Locality and history uncertain, but perhaps "Ornamental fringe of Foxes Bones". Given by Captain G.F. Lyon, R.N. 1825 (?).

672 Portion of an ornament of a similar character to the preceding, but to which instead of bones, [is\are] attached seven neatly formed perforated pendants of ivory, which vary from L 1 8/10 to 1 4/10 in. L 5 5/10 in. Locality and history not known.

673 A bag made of the skin of the hinder foot or flapper of [-the] \a/ Seal. Size of bottom which is oval shaped and flattish 7 2/10 by 4 5/10 in.; H 6 3/10 in. D of mouth which is circular about 2 in. \D/ The whole is stiffened out and resembles a bottle. Given by Captain G.F. Lyon, R.N. 1825.
Ashmolean 1836, p. 187 no. 396.

674-675 Eastern Esquimaux bird or fish spear (the Nŭgŭee), and casting board (Noke-shak). The shaft of the spear is of wood, L 3 ft. 7 in., and D about 1 in. capped, at one end with a small piece of bone to prevent its splitting, which is indented to receive the point on the throwing board. To the head of the shaft is lashed a nearly quadrangular piece of bone, L 14 in., and D 6/10 where it joins the shaft, but decreasing to 4/10 at the point, which is slit to receive a nearly

triangular shaped flat iron blade, L 1 3/10 by W 8/10 in. Midway on the wooden shaft three curved pieces of bone \or prongs/ \L 6 5/10 in./ are securely bound on, which are pointed and project forward at 1 5/10 in. from it, on each of the three sides, each of which is furnished with two barbes on the inner side: these are intended to strike the object aimed at if not struck with the point. The bindings are of thin strips of whalebone, and twisted sinews. Whole L 4 ft. 8 in. A weapon of this kind together with the t[h]rowing board are figured in Wood's "Nat: Hist: of Man", vol: 2, p. 706, by the \two/ right-hand figures. The casting board is L 16 1/10 in.; W 3 7/10 in. at the grasping end, and 1 5/10 at the other, with a shallow groove or channel along the middle having a point of bone at the narrow extremity to receive \the indentation in/ the end of the shaft. This instrument is rather roughly made, but with strict attention to affording good grasping hold for the hand, the thumb and each of the fingers having a place cut [-for] \to/ receive it (For other specimens with prongs on the shaft, see No 681. 725) Given by Captain G.F. Lyon. R.N. 1825.
Ashmolean 1836, p. 187 no. 389.

676 A large "spear, used by the W. Esquimaux of Kotzebue Sound, Behring Straits for killing the Whale or Walrus after sucking". It is L 7 ft. 11 in. and D nearly 2 in. at the head \but/ decreasing to 1 in. at the other end; \and is/ of wood, headed with a slightly curved and pointed walrus tusk, L 1 ft. 10 3/10 in., and greatest D 2 in. fastened into shaft \and strengthened/ with a binding of thongs of [-walrus] hide. Captain F.W. Beechey R.N.[] given by him 18[].
Ashmolean 1836, p. 186 no. 333.

677 A large spear used by the Eastern Esquimaux in attacking the Polar Bear, (\also the/ Whale, and Walrus?). The staff is of wood L 3 ft. 7 in. and D 2 5/10 by 2 in. in the middle part, decreasing in size to 1 5/10 in. at each end. On the head a lump of Walrus-tusk is (or rather was as it is now worked loose) firmly fixed, this is hollowed out to form a socket, which receives the one end of another piece of Walrus tusk L 16 in., really made of two pieces tra[n]sversely and neatly joined, and greatest D 1 2/10 in., slit at the point into which is inserted and rivetted a flat iron [-head\blade] L 3 in., and W 1 13/20. The long ivory head is fastened to the shaft by two strong thongs of walrus hide, which keep it in place but will admit of considerable motion in the socket, so as to prevent the weapon being forced out of the hands by the immense power of the animals attacked with it. About the middle of the shaft a lump of bone lashed on with strips of whalebone to prevent the slipping of the hand either in striking or withdrawing the spear. Towards the lower end of the shaft is a narrow strip of whalebone coiled round apparently to strengthen a split in the wood. Whole L 5 ft. 2 5/10 in. Given by Lieut. Francis Harding, R.N. H.M.S. Griper, 1827.
Ashmolean 1836, p. 185 no. 317.

678 A harpoon used by the Eastern Esquimaux with the casting or throwing board (such as No 675), for taking seals. The shaft is made of two pieces of wood spliced and firmly tied together with three bindings of narrow strips of whalebone; it is L 3 ft. 5 in., and D 1 2/10, the two ends being strengthened with bindings of whale bone like that used in splicing the shaft, probably to prevent them from splitting, and the upper end formed into a socket to receive the end of the head spike which is fashioned of a piece of walrus tusk L 15 in., and greatest D 1 in. at the end which enters the socket in the top of the shaft, [-and] decreasing to a point at the other end so as to receive the Siatko, or harpoon head: this consists of a piece of ivory L 3 3/10 in. and D 1 in., having a leaf-shaped flat iron blade fastened in a slit cut in [-one end\the top], and at the [-other\lower] end, (which has two side barbes), a hole or socket to receive the point of the ivory head spike. A strong line of walrus hide, three or four yards long is fastened [-to\through] the lower or thick end of the ivory head[s]pike, and passing through the middle of the harpoon head is coiled round the shaft, and attached at that end to a large bladder. When used the bladder is inf[l]ated, and the line keeping the \harpoon/ head in its place \on the spike/ is brought tightly down and fastened with the bladder round the middle of the shaft by what seamen call a "slippery hitch", which becomes instantly disengaged by a pull at the other end of the line.[28] As soon as the spear has been thrown and the animal struck, the harpoon-head, [-bone\ivory head] spike, line and bladder, all become detached from the wooden shaft, the bladder acting as \a drag, and also as/ a buoy to indicate the whereabouts of the animal beneath the water, and the harpoon head, being slung by the middle, effectually performs the office of a barb by turning at right angles to the direction in which it entered the body. This device is in principle superior to that of the barb, as on a slight pull it opposes its length to a wound only as wide as its own breadth. An instrument of this kind is represented by fig: 18 in the plate of Esquimaux implements in the "Journal of Parry's Second Voyage", and also in Wood's "Nat: Hist: of Man", Vol: 2. p. 706. Whole L with harpoon head in position, 4 ft. 9 5/10 in. Given by Captain G.F. Lyon R.N. 1825.
Ashmolean 1836, p. 187 no. 390.

678a Ditto of the same kind with the wooden shaft broken and piece of it lost, but the long ivory spike harpoon head with fixed iron blade, line of walrus hide, and bladder all attached, though the latter has been [-much] damaged a good deal. L of harpoon head

4 3/10 in. of blade only 1 9/10 in., W 1 4/10. L of ivory spike on which harpoon head fixes 14 8/10 in. Present L of shaft 34 5/10 in. It has been made of two pieces of wood spliced, the upper piece being that wanted. Central Esquimaux Given by Lieut: Francis Harding R.N. 1827.
Ashmolean 1836, p. 185 no. 321.

679 The \ivory/ top \or head/ of a similar spear to No. 677; [-and] the ivory socket from the top of the wooden shaft, in which [-it\the head] worked, and the small ivory hand grip from the side of the \middle of the/ shaft. L \of head/ including the metal blade 20 in. L of socket 1 6/10 in.; W 2 2/10 in.; Size of hand grip, 7/20 by 1 3/20 in. The hide thongs are attached to the head by which it was fastened to the [-wooden] shaft. There is no doubt I think but that these are portions of the of the fellow spear to that described under No. 677. and of which the shaft has perished, being worm eaten. The next to be described makes up the three \large spears/. Given by Lieut: Francis Harding R.N. 1827.
Ashmolean 1836, p. 185 no. 318 or 319.

680 Another large Eastern Esquimaux bear spear, of similar make to No 677, and the preceding; except that it never had an iron blade fastened into the [-end] point of the ivory head, which is L 17 in. and [-which] has been broken, and mended again with three iron rivets by the natives. Whole L 5 ft. 6 in. Given by Lieut: Francis Harding. R.N. 1827. (This spear may have been used with a moveable harpoon head, similar to No. 684)
Ashmolean 1836, p. 185 no. 318 or 319.

681 An Eastern Esquimaux bird or fish spear, for use with the throwing board. This implement is like No. 674, except that the head is \different, being/ formed of two slightly diverging, slender strips \of walrus tusk,/ L 11 in., \and D 5/10/ outside measure, which act on the same principle as an eel spear being slightly elastic, and barbed, the barbes being three in number on the inner side of each strip [-and set\and directed] backwards, and thus firmly holding [-any\an] object clasped between them. Whole L 4 ft. 9 5/10 in. L of three \barbed/ prongs on middle of shaft \two of them/ 9 in. each, and one 8 in., \measured on the outside curve./ D of shaft 1 2/10 in. \The shaft has been spliced near the middle and bound with narrow strips of whalebone, all the other bindings being of finely plaited sinews. (For another \very/similar spear see 725)./ See fig 19 in plate of instruments "Parry's Second Voyage". And for spears having [-heads\barbed wooden points] on the same principle, see Polynesian collection No. [] (Given by Lieut: Francis Harding R.N. 1827). A similar spear is figured in the hand of an Esquimaux man in plate facing p. 17 of Lyon's Private Journal.
Ashmolean 1836, p. 185 no. 322.

682 An Esquimaux instrument forming both whale spear, and harpo[o]n. Of superior workmanship. From Kotzebue Sound, Behring Strait. The wooden shaft is L

[28]This is not quite correct as the end of the lines is tied firmly to the middle of the shaft, which probably acts as a hand-grip when recovering the wounded animal. The bladder is only slung on the line through a hole in the ivory mouth piece used for inflating it, and which is stopped by a small ivory peg.

4 ft. 4 5/10 in. and D 1 5/10 in. at one end decreasing to 1 2/10 in. at the other, and the whole nicely rounded. This end is armed with a formidable well worked, curved lance or spear-head of walrus tusk L 13 5/10 in., [-of walrus tusk, L 13 5/10 in.] and greatest D 1 1/10. The other end is capped with a \heavy [-lump]/ piece of Walrus tusk, L 6 in., and D 1 7/10 in., having a \small/ socket bored at the end for the reception of a straight, rounded and pointed piece of the same material L 10 3/10 in. and greatest D 6/10 in. The shaft is in part ornamentally bound with narrow strips of whalebone of a black and brown colour alternately, and partly [-bound] with thongs of Walrus hide; and the small block of ivory fixed about the middle of the shaft to prevent the hands from slipping, is carved to represent a seal's head, the eyes, ears, and nostrils being [-represented \marked] with inlaid bits of whalebone. The harpoon head used with this implement, but detachable from it, is similar \in principle/ to No 678, 684 \and/ 685, but much smaller, and handsomely worked, L 3 5/10 in.; the slate blade (of which [-of which] there are five others \of the same pattern/ in the collection \see No 730)/, is not certain to belong to it, but it appears to have been used with some such detachable blade, or [-else \otherwise] it must [-be] be \in an/ unfinished [-as\state because] wanting the rivet hole through the ivory by which the blade was fixed, \(see Nos above referred to)/. There is no certainty of these blades being Esquimaux, but \it is probable as/ there [are] other implements in this collection which are furnished with slate blades \and/ which are undoubtedly of Esquimaux make \see 709 729/. [-It\The head] is attached to an evenly cut and rounded line of walrus hide, L about 120 ft., without join, having at the other end a handgrip of ivory L 4 3/10 in., the two ends of which are also carved in imitation of seals heads, the eyes being inlaid with green glass beads. Whole L 7 ft. Captain F.W. Beechey R.N. [] given by him in 18[].
Ashmolean 1836, p. 186 no. 332.

683 A smaller but similar implement to the preceding but of rather ruder make: the ivory spike, harpoon head, and line wanting, and the bindings being \all/ of thongs of walrus hide, instead of whalebone. Whole L 5 ft. 6 in. L of ivory spear-head 12 8/10 in. L of socketed piece of tusk at the [-head\other] end 3 8/10 in., D 2 in. From Kotzebue Sound, Behring Strait. Captain F.W. Beechey, R.N. [] given by him 18[].
Ashmolean 1836, p. 186 no. 332.

684 A spear or "katteelik", used by the Eastern Esquimaux in attacking the whale or walrus \(also the Bear?)/. This implement is like No. 680; [-it is also similar to 677 and 679, except that the ivory head runs quite to a point, and has not a fixed iron blade.] It can therefore be used either as a spear, or with a \detachable/ harpoon head and line as No. 685 \and 706/. Whole L 5 ft. L of ivory head 18 3/10 in.;

greatest D 1 4/10 in. L of wooden shaft only 3 ft. 4 in., greatest D 2 1/10 in. Captain G.F. Lyon R.N. 1825.

684a The ivory spike-head of a somewhat similar spear having holes bored through diagonally by which the thongs of hide held it in an upright position in the socket on the top of the wooden shaft. It has been made of two pieces neatly joined end to end and strongly kept in that position by a building of sinews. The upper piece is much more curved than in 684. L 16 8/10 in.; greatest D 1 1/10 in. From Point Franklin, W. Georgia? Captain F.W. Beechey R.N. [-1825-1828]? Given by him 1829?
Ashmolean 1836, p. 187 nos. 371-8 [?].

684b Ditto, made in the same manner as the preceding, but straight: the point which appears to have been spliced on has been lost. L 13 5/10 in. greatest D 1 3/10 by 1 in. Ditto ditto[.] From ditto[.]
Ashmolean 1836, p. 187 nos. 371-8 [?].

684c The spike head of a Kattelik ? but made of bone instead of ivory and having only one hole through it, in that way more resembling No. 678 or 682, but a good deal curved. L 12 5/10 in. D 1 2/10 by 7/10 Ditto, ditto[.] From ditto[.]
Ashmolean 1836, p. 187 nos. 371-8.

684d The point of what appears to be a young walrus tusk. L 5 17/20 in.: greatest D 9/10 in. Ditto, ditto.
Ashmolean 1836, p. 187 nos. 371-8.

685 Harpoon head of walrus ivory, with flat, triangular-shaped, fixed iron blade: whole L 4 5/10 in.: and thick line of walrus hide. L 37 ft. attached \by one end/ by being slung [-by\through] the middle of the \side of the/ head. Used \(together with a seal skin drag or buoy,)/ by the Eastern Esquimaux with the "Kattelik" \(see No 684 680)/ in catching whales, walruses or the larger kind of seals. (See also No 706. 794. 793) Captain G.F. Lyon, R.N. 1825. Similar articles to Nos 684 and 685, are figured in the plate \of instruments/ in "Parry's Second Voyage" fig. 20 and 21. Also in Wood's "Nat: Hist: of Man" Vol: 2 p. 708, an Esquimaux is represented using such implements. (This harpoon-head and line \probably/ may have belonged to the preceding article No 684, [-but it is hardly probable from the looseness of the ivory \spike/ head of the latter. But] I think it should be kept with it).
Ashmolean 1836, p. 187 no. 391.

686 A shallow circular tray, the rim made of birch wood, 2 in. in depth, the bottom being of pine wood, in three pieces, the middle piece being W 4 5/10 in. and projecting about 7 in. beyond the rim, probably for fixing it to the Canoe. D 13 in. Used by the Eastern Esquimaux to coil the harpoon line in to avoid danger from its becoming entangled. Given by Lieut: Francis Harding R.N. 1827.
Ashmolean 1836, p. 186 no. 325.

687 A large net "used by the natives of Port Jackson": made of lines of walrus hide, with meshes about 6 in. square. Used for catching porpoises, small whales, seals, etc. L about 150 ft.: depth about 9 ft. See Beechey's Narrative p. 254. Captain F.W. Beechey R.N.[] Given by him in 18[].
Ashmolean 1836, p. 187 no. 385.

688 Fishing net with small meshes; \(1 1/10 in. square)/, made of finely twisted sinews, which with the weights, made of round flattish \grey coloured/ pebbles, \D 2 to 2 1/2 in./, are attached to a [-cord\line] of \seal or/ walrus hide by [-a] bindings of \thin strips of/ whalebone; the floats being of pieces of fir wood cut to somewhat of a long kidney shape, size 7 in. by 2, and fastened to the line at each of their ends also with bindings of whalebone. Used by the natives of Port Clarence \Behring Strait/, N. W. Coast of America. L 21 ft.: depth about 2 ft. Captain F. W. Beechey R.N. [] Given by him in 18[].

689 Two plain round pieces of fir wood somewhat pointed at one end, L 19 5/10 in., and D 5/10 in.; with portion of a net of fine plaited sinews attached. Probably from the same locality as the preceding No 688. Apparently the netting needles by which the article was \in making/. Captain F.W. Beechey R.N. [] given by him in 18[].

690 A fine line of \seal or/ walrus hide, tied together in two places, \in size etc/ exactly like the two lines in the net No. 688, and [-possibly \probably] may belong to it; anyhow it is probably from the same locality. L 73 ft.: Th 1/8 in. (Possibly a fine harpoon line). Captain F.W. Beechey R.N. [] Given by him [].

691 Four sewing [-implements\instruments], Esquimaux? "2000 miles inland from Port Jackson" (see original writing on one of the articles). Made of small bones, apparently two ribs, and portions of two leg bones, of some bird. The two ribs have been pointed at one end to use as [-[-]\piercers]. L 4 6/10, and 4 1/20 in.: the other two are simply hollow cylindrical pieces, L 2 3/10, D 2/10 in.; and L 2 1/10, D 3/10 in.
Ashmolean 1836, p. 185 nos. 312-13.

692-694 Three Esqu[i]maux Drill-bows from Kotzebue Sound, Behring Strait; made of long quadrangular pieces of walrus tusk; each side of each bow being etched or engraved with representations of their various occup[ent]ations and pursuits. L 15 9/10 in., D 4/10 by 7/20 in.: L 13 9/10, D 5/10 by 4/10: and L 12 6/10, D 4/10 by 3/10 in. exact measure the diameters being taken about the middle, but they decrease somewhat towards the ends which are somewhat rounded off and perforated through for the string. The subjects though many of them can be made out are too numerous to mention, each of the four sides of each bow being different. Captain F.W. Beechey R.N. [] given by him in 18[].

Ashmolean 1836, p. 186 nos. 346-50.

695 One ditto, of darker coloured ivory, much wider one way than the other, the figures being on the \two/ flat \wide/ sides, the two edges which are somewhat rounded having borders only, that on each being distinct, but a \repeated/ representation of the same animal. One end has been broken out and re-pierced, and the line of hide is attached. L 14 7/20 in. D 7/10 by 3/10 at one end, decreasing to 6/10 by 5/20 at the other end, exact dimensions. From Kotzebue Sound Behring Strait. Captain F.W. Beechey, R.N.[] given by him 18[].
Ashmolean 1836, p. 186 nos. 346-50.

696 One ditto, nearly cylindrical, with very little carving, probably unfinished. Both ends perforated twice. From Kotzebue Sound Behring Strait. L 15 7/10, D 9/20 by 4/10 in., exact measure. From Kotzebue Sound, Behring Strait. Captain F.W. Beechey, R.N.[] given by him 18[].
Ashmolean 1836, p. 186 nos. 346-50.

697 One ditto, hollow along the middle of one side, and half round on the other which is engraved with a row of 34 different sized figures of fishes, \all of about the same form,/ arranged crossways the bow from end to end, and divided into three groups of 11, 13 and ten, by two incised cross lines. Each end is pierced by two holes. L 16 2/10 in., D 1 by 4/10 in. From Kotzebue Sound, Behring Strait. Captain F.W. Beechey, R.N.[], given by him in 18[]. One side of [-three\four (stet.)]/ of the preceding drill bows is figured in Sir John Lubbock's "Prehistoric Times" p. 498. The dexterity of the Esquimaux in drilling into walrus ivory or bone is obvious, as there are very few of their instruments in which this art is not exhibited. This they effected with rounded strips of bone, one end of which being formed to revolve freely in a stone socket (see No. 698. 699) held between the teeth, the other end being of the necessary size, and either tipped with a cutting stone, or used with fine gritty sand; the revolving motion being given to the drill by means of a string passing round it and attached to each end of the so-called drill-bow. The engravings on these drill-bows although rudely done, show in a remarkable degree the ability in the natives for the delineation of forms and comparative sizes; and in reference to their skill and the truth of their representations, also see Beechey's Narrative, p. 251.
Ashmolean 1836, p. 186 nos. 346-50.

698 A drill, used by Esquimaux of Kotzebue Sound, Behring Strait. It is a piece of birch wood, cut to somewhat a crescent shape, having a projection left in the middle of the inner or concave side, which is held [-by\firmly between] the front teeth when used, the hollow side fitting against the mouth and the back of the square projecting piece being also hollowed to receive the end of the tongue. On the other or convex side, a square-shaped piece of hard fine-grained brownish-grey stone or slate 1 3/10 by 1 2/10 in. D \is/

let in, but projecting 1/10 in. above the wood and rounded off to the same curve both L and W ways. A[t] the ends are two large square holes [-no doubt\perhaps] for a strap of some kind apparently to tie at the back of the neck to hold the thing in position or more likely for breathing. L \across the back/ 4 3/10 in.; W 1 6/10 in.; thickness from face of stone to back of projecting piece, 1 7/10 in. Size of holes through woodwork D 6/10 or 7/10 in. Captain F.W. Beechey, []given by him 18[].
Ashmolean 1836, p. 186 no. 351.

699 Ditto, of quite another shape, being curved so as to fit against the mouth, but nearly cylindrical \in form instead of flat,/ and decreasing in D \from the middle/ to the ends; projecting piece worn off by use, and stone socket in front not so prominent above the wood, and the hole [-vey] very deep from wear. No holes in the ends of wood. L across back 5 1/10 in. W in middle 1 3/10 in., decreasing to 5/10 in. at the ends, which are bevelled off from the front. Size of stone socket which is the same sort and colour as that in the previous object D 1 in. Captain F.W. Beechey, R.N. given by him 18[]. Though these two drill sockets are of quite a different shape they probably both belong to Beechey's collection, as there are no such objects entered as given by Captn Lyon, or Lieut Harding in M.S. list of Benefactors 1757 to 1829 pp. 14 28. The Eastern Esquimaux use drill sockets but I believe [-not] not of this kind of make. See Lyon's Private Journal These have both the same kind of stone centres.
Ashmolean 1836, p. 186 no. 351.

700 A pair of wooden eye-[-screens\shades], or spectacles (from Cape Thompson (?)) N.W. America, used by the Esquimaux to protect the eyes from the bright glare of reflected light from the \ice and/ snow (and \probably/ also to protect the eyes from sleet \[-drifting]/ snow etc when falling or drifting). The narrow slits afford a very free lateral scope for vision, and a slight elevation of the head would extend the view: they are therefore not [-not] inconvenient to those accustomed to the use of them. But Captain Parry supplied his men with black crape for the protection of their eyes, as Ophthalmia and Snow blindness prevailed amongst them to a serious degree during bright spring and early summer weather. "Three who were on a short excursion on land, from sudden attack, could only find one useful eye amongst them, and that in a very indifferent condition." In a plate representing the natives of Cape Thompson, in Beechey's Narrative, an Esquimaux is shown wearing eye-screens of this kind. L across the back 5 1/10 in.: W 1 3/10 in. The insides of the slits are chamferred off and coloured black Captain F.W. Beechey, R.N.[] given by him 18[]. (For European goggles or glasses worn for the same purpose see No 797.)
Ashmolean 1836, p. 187 no. 382.

701 A piece of wood carved into a kind of boat shape; in preparation for a pair of eye-[-screens \shades]. From the Esquimaux of West Georgia. (See No. 700) L

5 6/10 in.; W 2 in.: Th 1 2/10 in. Captain F.W. Beechey R.N.[] given by him 18[].
Ashmolean 1836, p. 187 no. 383.

702 A pair of Esquimaux wooden spectacles, or eye [-screens\shades], differing in shape from No. 700, particularly in having a projecting rim along the top, which gives an extra shade to the eyes. The Esquimaux [-from\of] the Savage Islands, Hudson's Strait, represented in Plate p. 14 in Parry's Second Voyage, seems to be wearing spectacles of this kind. From the collection of Lancelot Chambers Esq. L 5 in.; W 1 3/10 in. Given by George Rolleston, Esq. M.D., Linacre Professor of Physiology. 1866.
Ashmolean 1836-68, p. 14.

703 A model of a similar eye-[-screen\shade] to the preceding, [-from\in] [-the same collection \gutta percha]. L 5 5/10 in. W 1 3/10 in. From the same collection as No. 702. Given by ditto. ditto.
Ashmolean 1836-68, p. 14.

704 An Eastern Esquimaux toy, from Hudson's Strait, used after the manner of the cup and ball. It is an irregular shaped \long/ lump of walrus ivory, drilled with \a number of/ holes in [-various \different] directions, and of \about one size but/ various depths: the game consisting of throwing it up and catching it by one of the holes on a small peg of bone, which is attached to it by a short string of plaited sinews. Captain Lyon states in his "Brief Narrative" p. 38, that this toy is of a description he had not before seen. L 5 9/10 in.: greatest D about the middle 1 8/10 in.: D of small end 8/10 in.: of large end about that of the middle. L of peg 4 in.: D 3/10 in. L of string 7 in. Given by Captain G.F. Lyon R.N. 1825.
Ashmolean 1836, p. 187 no. 394.

705 The sail of an Eastern Esquimaux's Oŭomīak; woman's or family boat. (Umiak, Greenland). From Hudson's Strait. Made of the intestines of the Walrus, sewn together lengthways in strips about W 4 5/10 in. W at the head 5 ft. 6 in.: W at the foot 7 ft. 4 in.: H 9 ft. 8 in.: Wt. 2 lbs. 1 oz. The [-gut\material] of which it is composed, \is/ of breadths [-of \running] the whole length, neatly sewn together with thread made of shreds of Reindeer sinews, (for which see No 658). It is edged all round with narrow strips, \of seal skin,/ and has several loops of the same material along the top for the yard arm and two lines of walrus hide at the corners, and also one at each corner at the bottom. Given by Lieut: \Francis/ Harding, R.N. 1827. See note \b/ to No. 768.
Ashmolean 1836, p. 186 no. 328.

706 Hudson Strait Esquimaux Siatko and Allek, (or harpoon head and line), with a seal skin attached, which when inflated acts as a buoy, or drag. These articles are used with the spear or katteelik, (see No. 680, 684) for attacking the walrus and whale. The method with which the attack on the whale is conducted by the Esquimaux is described in "Parry's Second Voyage", p. 500. The western Esquimaux

appear to kill the whale by similar means to those described \at the/ above \reference,/ as stated in "Beecheys Voyage" p. 270. L of harpoon head (Siatko), including metal blade 4 9/10 in., W 1 4/10 in. L of line, 34 ft., L of buoy 33 5/10 in.: W across [-ft. 19 in.] from point of one foot to that of \the/other 19 in. Given by Lieut Francis Harding R.N. 1827.[29]
Ashmolean 1836, p. 186 no. 324.

707 A peg? or stopper? of deal wood, with large flat \round/ top which has been let into a white shell the latter being neatly ground down on all sides to the shape of the head. Whole L 2 9/10 in., of the peg part only 2 1/10, D 3/10, which is cut to a point from one side, and has a small perforation about half way from the point. D of head 1 3/10 in., Th 8/10 in., just below which is tied a piece of string made [-apparently] of bark? Found amongst some odd articles of [-ivory\bone] and ivory said to be from Point Franklin, West Georgia, in the storeroom in the old Clarendon, 1880.[30]
Ashmolean 1836, p. 187 nos. 371-8.

[-708 (A cylindrical shaped object, rather smaller at the ends than in the middle portion. L 3 in.: D in the middle 3/10 in. Made of [-exactly\what appears to be] the same kind of shell as the top of the preceding article \No 707/ is cased with. Probably a nose, ear or lip ornament.) See African [-collection\catalogue] in this book No. 484 where it is described[.] Captain F.W. Beechey R.N.

709 Eastern Esquimaux harpoon-head of bone, [-or ivory], with leaf-shaped blade of greenish slate, tied in with a string made of plaited animals sinews; and protected by a bag of skin. It is of a different construction to any other in the collection. L 4 6/10 in. L of blade 2 4/10, W 1 5/10 in. "Used for killing seals etc." Captain G.F. Lyon, R.N. 1825 ? or Lieut Francis Harding R.N. 1827?, but I should [-say\think] the former from the resemblance of the writing on the blade to that on other articles which he gave; and also because \in make/ it more resembles the arrow \[-belonging to the collection]/ No 729 which Lyon gave in having a slate blade, and \also/ in the way in which the blade is attached to the bone, and again by the blade having a cover of skin. [-By the date written on it, it could not possibly belong to Beechey's collection.] (Captain G.F. Lyon (?), R.N. 1824. Given in 1825, or Lieut. Francis Harding? R.N. given 1827 (?).
Ashmolean 1836, p. 187 nos. 371-8.

710 Ivory \or bone/ stud with double overlapping shoulder, and perforated through the middle. \Probably/ Used for insertion into the hole made in the sealskin buoy as a mouthpiece for inflating it, the hole

being then plugged with an ivory peg, see No. 706 D 1 3/10 by 1 3/20 in., and Th 8/10 in. D of the hole 5/10 in. From Point Franklin, West Georgia (?) Captain F.W. Beechey ? R.N. [] given by him 18[].
Ashmolean 1836, p. 187 nos. 371-8.

711 Esquimaux bone stud with flattish overhanging head, from which it decreases a little in size to the end, near which it is perforated diagonally with two holes, one hole crossing through the other. L 1 in. D of head 1 by 8/10 in.; of the other end 6/10 by 5/10 in. Use uncertain, but could have \been/ used for plugging a hole in sealskin buoy From Point Franklin. West Georgia (?) Captain F.W. Beechey R.N. ?[] given by him in 18[].
Ashmolean 1836, p. 187 nos. 371-8.

712 A small hand grip of ivory, with hole bored through \on inside/ as if for attaching a line. Probably from the end of a sealing harpoon line. L 2 2/10 in.: W 13/20 in. \and Th 4/10/. From Point Franklin West Georgia ? Captain F.W. Beechey R.N.? Given by him 18[].
Ashmolean 1836, p. 187 nos. 371-8.

713 Small Esquimaux article of bone, rather rudely shaped, and having a large hole drilled through each end. Perhaps a hand grip for a line. L 1 4/10 in.: greatest W 8/10 and Th 5/10. From Point Franklin, West Georgia ? Captain F.W Beechey R.N. [] given by him 18[].
Ashmolean 1836, p. 187 nos. 371-8.

714-715 Two small articles of ivory, of an oval shape, and flattish. The largest of the two \(No 714)/ is L 2 5/10 in.[-and] W 1 7/10, and Th 3/10 in the middle, from which it has been cut to a blunt edge all round: it is flat on one side and flatly convex on the other. The [-] use is uncertain, but it could very well have served the purpose of a scraper in preparing skins, or perhaps \as a plug/ for stopping a hole in the sealskin buoy, as \that/ in No 706. The other \(No 715)/ is L 1 4/10 in. and W 19/20 in. Very little convex on one side, and flat on the other with a rabbit [-running\cut] round the edge, and perforated in the middle (as in No 712), to which is attached a bit of line of plaited sinews. From Point Franklin: West Georgia ? Captain F.W. Beechey R.N.? given by him 18[].
Ashmolean 1836, p. 187 nos. 371-8.

716 Esquimaux (?) article, made of a hollow tooth apparently of the whale. It has been ground \[-]/ square\[-ish inside] and perforated at \the sides of/ the large end \with small holes,/ as if intended to fix as a cusp on the end of a spear or harpoon shaft; though of course the \two/ little holes at the sides may have been used for a string to suspend it as an ornament on the person. L 3 6/10 in. D 1 5/10 by 9/10 in. From Point Franklin, West Georgia ? Captain F.W. Beechey R.N.? given by him 18[]. Possibly it is Polynesian and may have been a pendant.
Ashmolean 1836, p. 187 nos. 371-8.

[29]There is no spear or Katteelik of Hardings collected which this headline and buoy appears to belong to, the point of No. 680 being too large to fit the head.
[30]It is doubtful if this and the next article can be Esquimaux at all. Perhaps they are Polynesian or African. Captain F.W. Beechey R.N.?

717 An Esquimaux harpoon from Cape Thompson, N.W. coast of America; used for throwing with the hand only, and used in taking reindeer, foxes, birds, etc. on land \(and of course also on the ice)/. The shaft is of wood, L 5 ft. 3 5/10 in. and D 1 3/10 in., at the bottom. It is headed with a piece of walrus tusk L 6 5/10 in. and of the same thickness as the shaft, so that this end is very weighty as compared with the other. A stout line of walrus hide, about three yards long, is fastened by the one end to the wooden shaft at two ft. from the top and coiled round it upwards, the other end being attached to a sharp pointed and barbed harpoon head of bone 3 in. long and 5/10 in. wide, which fits into a hole 3/10 in. wide and 5/10 deep in the end of the ivory head of the shaft. When the implement is thrown and the animal struck, this article becomes detached from the socket, [-of the head], and the shaft falls to the ground, and, as the line becomes uncoiled, acts as a drag, cheques the animal in its flight and prevents escape. Whole L with harpoon-head fixed in its place 6 ft. 3 5/10 in. Captain F.W. Beechey R.N.[] given by him in 18[].
Ashmolean 1836, p. 186 no. 335.

718 Ditto. From Kotzebue Sound, Behring Strait. Similar in every respect to the preceding No 717, except that it is altogether smaller, and the large ivory head neatly rounded. L of wooden shaft 4 ft. 3/10 in., the end being broken off. L of ivory head 7 8/10 in., D 1 in. L of harpoon head 3 9/10 in. D 13/20 in. The bindings on the shaft are of plaited sinews. Whole L 5 ft. Captain W.F. Beechey R.N. given by him 18[].
Ashmolean 1836, p. 186 no. 336.

719 Ditto, similar to the preceding No 718, but much smaller, and has been made to use with the throwing board, having a hole in the end of the shaft for that purpose. From Kotzebue Sound, Behring Strait. L of wooden shaft 3 ft. 9 5/10 in. Greatest D 7/10 in., decreasing to 5/10 at the end. L of ivory head piece 4 6/10 in. Whole L 4 ft. 4 5/10 in. From Kotzebue Sound Behring Strait. Captain F.W. Beechey, R.N.[] given by him 18[].
Ashmolean 1836, p. 186 no. 337.

720 Ditto. ditto. Longer, but not so thick as the preceding, and with three feathers tied at the end, and having the quills directed outward, the bindings being of finely plaited sinews. The line [-is] made of hide is fine, and single to near the shaft where \it is double/ one part is then made of plaited sinew and attached just above the feathers to the shaft, the other being a continuation of the line of hide and fastened below the head. L of wooden shaft 3 ft. 11 in. L of ivory head 4 6/10 in., D 7/10 in. L of harpoon head 2 in., D 4/10. This also has a hole in the end for the throwing board. Whole L with harpoon head fixed as in the three preceding, 4 ft. 5 5/10 in. It is hardly necessary to state that the lines \in No 717 - 720/ de[c]rease in size in correspondence with that in the size of the harpoon.

From Kotzibue Sound, Behring Strait. Captain W.F. Beechey R.N. given by him 18[].
Ashmolean 1836, p. 186 no. 335-7.

721-722 Two Esquimaux rests, or throwing boards, from Kotzebue Sound, Behring Strait: used with the bird harpoon \or spear/ (No 719, 720). These articles show the attentive care with which firm grasping hold is provided for the hand, a hole being cut for the end of the fore finger, and also places to fit each of the other fingers and the thumb. They are much alike, but one is a little longer than the other. L 16 6/10, D 2 1/10 in., in this the sides are grooved on the underside; and L 16 in., D 2 1/10 in.; in this the underside is rounded. Captain F.W. Beechey R.N.[] given by him 18[].
Ashmolean 1836, p. 186 nos. 352-3.

722a Esquimaux throwing stick or board, of superior and somewhat different make to either 721 or 722, of deal wood stained brown, the groove for the end of the spear to lie in being semicircular, a hole being cut on the underside of the other end to receive the end of the \fore/ finger, and a bone peg driven into the side \and/ which comes between the second and third finger. The bone projection at the end of the groove to receive the end of the spear has been broken off. The general form is diminishing in width from the handle \end/ which is D 2 5/10 in. to almost a point at the other end; the upper side rounded, the underside keeled. L 18 5/10 in. Ramsden collection. [-Ramsden] (Purchased by the University 1878).

723 A bird or fish spear of the Esquimaux of Point Franklin, West Georgia; used with the throwing board, (see No 721. 722). The shaft is of wood L 4 ft. 10 2/10 in., D 6/10 in. at the head, tapering to 4/10 in. at the other end, and rounded. It is headed with three slender strips of bone \about/ L15 5/10 in., arranged triangular ways by being let in round the top, and diverging from each other an inch or two at the point, and [-being] notched backwards into \eight or nine/ barbes along the inner sharply keeled edges, act on the principle of eel-spear with a kind of grasping power. Whole L 5 ft. 11 1/10 in. (Compare this spear with No. [] in the Polynesian Collections). Captain W. F. Beechey R.N. given by him in 18[]. It has a fine line of plaited sinews tied round the shaft. The Eastern Esquimaux use a similar spear see Lyon's Private Journal, p. [].
Ashmolean 1836, p. 186 no. 338.

724 The head of a spear of the same character as the preceding, the three prongs being much shorter, [-and] made of ivory, only keeled and notched towards the points \for the distance 3 8/10 in. and less/ and the notches turned outwards instead of inwards,\and smaller, and much closer together./ Only a bit of the \wooden/ shaft L 2 5/10 in. remain. L of prongs two of them 10 in., and one 8 5/10 in. The bindings in this and No 723 are of finely plaited sinews. From Point Franklin, West Georgia. Captain W. F. Beechey, R.N.[] given by him in 18[]. I think this must be remains of the fellow spear to the preceding.

Ashmolean 1836, p. 186 no. 339.

725 An Eastern Esquimaux bird or fish spear, very similar to No 681, but having a longer shaft, the two ivory prongs \forming the point/ being not so long, and armed near the point on the inner edges \with/ four closer set barbes. The shaft has been spliced towards the head, but the binding which has been of whalebone is wanting. The binding of the head spikes is of plaited sinews, and that of the three prongs on the middle of [the] shaft is of narrow strips of whalebone. L of wooden shaft 5 ft. 4 in. L of head spikes 8 5/10 and 7 5/10 in. L of \the/ three ivory prongs on middle of shaft, two 7 5/10 and one 7 in., measured on outward curve. Whole L \of spear/ 6 ft. 5/10 in. Lieut Francis Harding R.N. 1824? Given by him 1827?

725a A set of three ivory prongs from the shaft of an Esquimaux spear of the same character as No 674 or 681, 725, but not exactly like either, the sides being flat with the inner edge keeled and each having three barbes and a hole through sideways below them. The outer edge or back is rounded[.] They are very neatly made. Full size as shown here [drawing]. Ramsden Collection No ? Purchased by the University, 1878.

726-727 Two Esquimaux spears or lances, with small heads of dark grey chipped flint, or stone, bound in, one with plaited sinews, and the other with narrow strips of whalebone. Shafts round, and of deal wood much worm eaten. From Kotzebue Sound, Behring Strait. \No 726/ Whole L 6 ft. 5 8/10 in.: D of shaft 1 in. in the middle part but decreasing in size towards each end. L of blade 2 3/10 in., W 1 7/10. And \No 727,/ Whole L 5 ft. 10 in. the shaft being rather smaller but of the same shape as the previous. L of blade 2 3/10 in., W 1 1/10. Captain W.F. Beechey. R.N.[] given by him 18[].
Ashmolean 1836, p. 186 no. 334.

728 An \Eastern/ Esquimaux bow made of a piece of pine wood. L 4 ft. 4 in.; W 2 in., and Th 1 in. in the middle, and slightly tapered off at the ends to W 1 8/10 in. and Th 8/10 in., but this is merely the fulcrum for the strain, as the elasticity of the bow is produced by a number of strings (about 40 \at the ends but increasing to about 70 in the middle/) of fine plaited sinews, which are secured along the front or outer face of the bow by cross lines. From the contraction of the sinews the form of the bow is reverted, and the front is become the concave side of it. Two bits of thin metal (copper and iron?) one on each side are tacked on, probably as a curiosity. Captain G.F. Lyon R.N.[] given by him 1825.

729 An Eastern Esquimaux arrow, the shaft being formed of L 18 in. of bone, and \the hinderpart / 10 in. of wood \which seems to be of two lengths spliced together/ about 3/8 in. thick; with a leaf-shaped head of slate 1 7/10 in. long and 9/10 wide, tied in with sinews, into a slit in the end of the bone; this head has apparently been made out of some larger object as there

are two holes on one side \of it/, which [-are apparently\appear to be] of no use now, but rather a source of weakness. It \(the head)/ has a case of skin, with which the natives guard the heads of their arrows, etc, when not in use, (for which see also No 709.) \It has two feathers clumsily tied on at the bottom and all the bindings are of animal sinews/ Whole L 2 ft. 6 3/10 in. Captain G.F. Lyon R.N.[] given by him 1825.
Ashmolean 1836, p. 187 no. 395.

730 [-Six\Five] leaf-shaped arrow-heads of \dark grey/ slate, slightly hollowed out in the middle [-of \on] both sides, apparently for \the purposes of/ fixing in the end of the shaft, and ground to a sharp point and edges. L \of two of them/ 8/10 in.; one 7/10 in.; of two \others/ 6/10 in.; and one with point broken off, 1 4/10 in. One of them \is/ in the head of the harpoon No 682, to which perhaps they all may belong. History unknown. Possibly not Esquimaux. (For other slate heads see No 709 and 729).

731-732 Two Esquimaux arrows of somewhat similar make to No 729. One \(No 731)/ has a shaft made of L 7 in. of wood, and 20 in. of bone, the latter being formed of two pieces of about equal lengths, lashed together with a binding of plaited sinews; the head being made of a small piece of chipped light grey flint L 1 1/10 in., and W 5/10 in., the stem of which is secured to a square notch cut from one side of the end of the bone, by a binding \of shreds/ of sinews. Whole L 27 7/10 in., D about 4/10 in. The other arrow \(No 732)/ is of similar make, but formed of 11 2/10 in. of wood, and 13 4/10 of bone, the latter \being/ in one length; the head being of chipped dark brown flint, L 1 in., and W 5/10 in., of the same shape [drawing] thus and fixed in the same manner as No 731. Whole L 27 5/10 in. In each arrow the pieces of wood are somewhat larger than the bone, are lowermost, \and/ have three feathers clumsily bound on [-as in the heads.] with fine shreds of sinews, \as with the flint points;/ the binding of the splicings of the \bone and/ wood being all of plaited \shreds of/ sinews, the [-lot] wood seeming to be made of two pieces in each arrow, flattened at the ends and notches for the \bow string/. These arrows, although no immediate locality is given with them, seems [sic] to be examples of a scarceness of wood approaching that amongst the Esquimaux alluded to in the "Introduction", who were met with by Captain Lyon about 62° 30' N Lat: 83° W. Long: (Southampton Island). See Captain Lyon's "Narrative" p. 60. Lieut. Francis Harding R.N. 1824. Given by him 1827.

732a The shaft of a similar arrow to the preceding and probably belonging to the same set; made of a piece of bone L 13 in. spliced to a piece of wood L 7 8/10 in. It appears to have also had a similar head by the way the bone is broken at the [-end\top]. History unknown.

733 A bow obtained from the Esquimaux to the N. East of Icy Cape \(see original label on object)/. This

although made on the same principle, is far superior in make to the \Eastern Esquimaux/ bow No 728, and differs from it in many respects. It is of pine wood, L 4 ft. 5/10 in. (measured straight from end to end [-with\along] the bow line), W 1 5/10 in. and \Th/ 9/10 in. in the middle, slightly tapered off towards the ends; but instead of forming a regular curve when strung, the bow is straight for about 1 ft. of its length at each end, and of a bow shape in the middle, at [the] ends \or rather terminations/ of which being the parts most sharply curved it is strengthened \on the front/ with plates of bone, (and at one end \a plate/ at the back \also/, as if the wood had been broken there), and very securely bound with numerous lines of plaited sinews, not only to keep the bone plates in place but also to bring the band, or cord \which is/ made of numerous \plaited/ lines of the same material, \and/ on which the elasticity depends, into contact with the middle of the front of the bow throughout its whole length. The bow string is made of a number of small plaited lines of sinews \similar to those on the front/ twisted together. Captain F.W. Beechey R.N. (See Wood's Nat: Hist: of Man, Vol: 2. p. 709). Captain Beechey remarks that "these bows are superior to any on the Eastern coast of America, as on the western coast the drift wood is so abundant that the inhabitants have their choice of several trees and are never obliged to piece their implements. It requires some care to bring a bow to the form which they consider best: and for this purpose they wrap it in shavings soaked in water, and hold it over the fire: it is then pegged down upon the earth to the form required."
Ashmolean 1836, p. 186 no. 340.

734 A bow of similar make to the preceding one No 733, but misformed from the line having slipt out of its place, so \that/ that which should be the inner or concave is now the outer and convex side. It has in addition to the numerous strings of plaited sinews a piece of skin, about 1 in. wide, extending along the whole length of the middle or curved portion of the bow \on the front/. The bow line is made like \that of/ the preceding. Length from end to end across the hollow 4 ft. 1 in. The middle of this \bow/ is more formed into a handle than \that in/ the last. Captain F.W. Beechey R.N. "If not attended to when used, the bows are apt to get out of order, and the string to get out of its place, by which the bow bends the wrong way" Beechey's "Narrative", p. 575.
Ashmolean 1836, p. 186 no. 341.

735 An arrow obtained from the Esquimaux to the N. East of Icy Cape. The shaft is of pine wood \L 22 8/10 in. and D 7/20 rounded, [-and] flattened at the feathered ends: and headed with a piece of bone L 6 7/10 in. \which/ somewhat rounded on all sides except one, which is increased in width by 1/4 in., worked to a sharp keeled edge and notched to form two barbes. The blade or point is of chipped jasper or flint, of a \mixed/ brown and blue \colour/ L 1 8/10 and W 7/10 in.,

serrated along the edges, and bound by a narrow stem into a slit or groove cut in the end of the bone, the binding \of twisted sinews/ resembling catgut. The feathers are three, which, with the notched end for the bow string, are also bound with sinews twisted into thread. Whole L 31 2/10 in. Captain F.W. Beechey R.N. For a similar arrow see Wood's "Nat: Hist: of Man", Vol: 2. p. 709. With respect to the skill of the Western Esquimaux in the use of the bow and arrow, Captain Beechey gives some curious illustrations in his Narrative, p. 559. With regard to skill in archery shown by the Winter Island Esquimaux, see Parry's Second Voyage, p. 511.
Ashmolean 1836, p. 186 nos. 340-41.

736 An Esquimaux arrow from the same locality as the preceding, and of similar make except that the shaft is dyed \dark/ brown, L 26 5/10 in., D 4/10 in.: the bone head being only L 3 8/10 in. greatest D 13/20, and has one barb. It has a blade of chipped black flint L 1 9/10 in. and W 6/10, serrated along the sides, and pointed. Whole L 32 1/10 in. Captain F.W. Beechey R.N.
Ashmolean 1836, p. 186 nos. 340-41.

737-738 Two Esquimaux arrows somewhat similar to the preceding, the shafts being of pine wood coloured dark brown, but without flint [-heads \tips] the bone \heads/ being sharply pointed, keeled along the side, one of which is notched with five notches, and the other arrow with only one notch. Whole L \of 737/ 31 1/10 in.; \L/ of bone head 6 7/10 in., D 11/20; and whole L \of 738/ 31 2/10; L of bone head 6 3/10 in., D 6/10 in. The ends are flattened and feathered, as in the two preceding. Captain F.W. Beechey R.N.
Ashmolean 1836, p. 186 nos. 340-41.

739-741 Three arrows, of similar make and probably from about the same locality as the four preceding. One [-of which\of them is similar to 736 but] has lost the flint tip; present L 30 7/10 in., and the other two \have lost/ both bone and flint \only the wooden shaft remaining/. \L 28 7/10 and 24 5/10 in./ All the shafts stained brown. Captain F.W. Beechey R.N.
Ashmolean 1836, p. 186 nos. 340-41.

742 Esquimaux Man's outer boot made of seal skin \(seals hide or leather?)/ to reach up the greater part of the thigh, and having a reeving string all round the upper part of foot, and which projects in two loops at the sides to tie in at the instep. The hair on the outside, if it possessed any has been destroyed. H 2 ft. 4 in. Colour dark brown except the sole which is of a lighter colour. Locality not stated[.] Given by Archibald Wicks. Esq. Wad[ham]: Coll[ege]: 1835.
Ashmolean 1836, p. 187 no. 400.

743 Another high boot, no doubt fellow to the above No 742, but not pressed out. Given by ditto.
Ashmolean 1836, p. 187 no. 400.

744 Esquimaux Man's boot of similar make to the preceding, of sealskin denuded of hair, and now of a dark brown colour; with reeving strings at the instep and at the back of the leg below the knee, the former

being of thongs of hide, and the latter of plaited sinews. H 1 ft. 5 5/10 in.; L of sole 9 5/10 in. Given by Archibald Wicks, Esq. Wad[ham]: Coll[ege]: 1835.
Ashmolean 1836, p. 187 no. 400.

745 A similar boot no doubt the fellow one, but not pressed out; with reeving strings intact as in No 744. Given by ditto. No locality was given it appears with these articles, \No. 742-745/ but both Eastern and Western Esquimaux wear boots of moderate size; whereas the women of Winter Island, and thence to Labrador, wear boots of normal dimensions, which are made the receptacles for anything that will go into them. Captain Beechey says that the women of West Georgia wear boots fitting closely, instead of being adapted for the reception of oil or infants.
Ashmolean 1836, p. 187 no. 400.

746 An Eastern Esquimaux man's inner shoe, made of prepared seal skin, \(leather?)/ of a pale brown colour almost yellow, and ornamentally and finely pleated round the forepart and at the heel, the toe being \obtusely/ pointed. L 10 4/10 in. \H 3 7/10 in./. It has a string of twisted sinews at the back of the top. Captain G.F. Lyon R.N. 1825.

747 An Eastern Esquimaux man's inner shoe, of prepared seal's skin \(leather?)/ of a brown, and pale brown colour; of similar make to the preceding, the string behind being of plaited sinews, and it has four narrow transverse pieces of thicker leather sewn across the sole \part/ two being near the toe and two [-at\under] the heel, apparently to keep it out straighter. L 9 9/10 in. H 3 5/10 in. Captain G.F. Lyon R.N. 1825.

748 A pair of Eastern Esquimaux \summer, or fishing/ seal skin \gloves or/ \"mittens"/ [-or gloves] \denuded of the hair and looking now like stiff black or dark brown parchment./ In these there is only one receptacle for the fingers, but the thumb being separate. \They appear to have lost some edging from round the top, which may have been of fur or hair; and each is made of several pieces of skin sewn together with sinews./ L of the Right-hand glove 12 5/10 in. W across the top 7 5/10, L of the left-hand, 11 5/10 in. W across top 7 in. (The[re]fore that for the right hand is a good deal the largest, which is the case with savage people in general.) Lieut Francis Harding. 1824. Given in 1827.

749 A chain composed of 18 links of [-walrus \fossil Elephant] ivory, each link being between L 2 4/10 and 2 3/10 in., and near about W 6/10, with parallel rounded sides 1/10 in. D, \but/ the ends being semicircular \much wider,/ and flat. Cut by Esquimaux of Escholtz Bay, from a solid piece of tusk, and forming one length. It is exceedingly well made, and this article and the spoon No 750 appear to be the only objects in the collection which have been made \out/ of the \fossil/ elephant ivory. L 2 ft. 11 8/10 in. See Captain Beechey's "Narrative" p. []. Captain F.W. Beechey, R.N.
Ashmolean 1836, p. 179 no. 491.

750 A spoon made by the Esquimaux of Cape Thompson, from fossil ivory [-from\of] the tusk of an extinct species of Elephant, found in mud cliffs on the south side of Escholtz Bay. The bowl is large and somewhat oval-shaped. L 3 1/10 by W 2 3/10 in. and has about two thirds of a ring cut on the top to form a \handle or/ hold for the thumb and finger, D 1 3/20 in. and Th 5/20. Whole L of spoon exactly 4 in. It appears to be as strong and solid as recent ivory though somewhat darker in colour. One of the tusks found in the bank by Captain Beechey, and now in the British Museum, "measured ten feet in the curve, and six inches in diameter at the largest part." See Beechey's Narrative where this or a similar spoon is figured. Captain F.W. Beechey. R.N.[31]
Ashmolean 1836, p. 187 no. 381.

751 An Esquimaux \snow/ knife from Point Hope N.W. Coast of America: \used for scratching off the snow adhering to the dress, etc./ made on the curve, from the tusk of a walrus. It is somewhat scymitar shaped with parallel edges, L 17 3/10 in. from point to point across the hollow, or 18 3/10 along the outside curve, and greatest W 1 5/20; two edged, fluted down the centre on both sides throughout its whole length; and ornamented on the round side with eighteen, and on the hollow side with sixteen \separate incised/ circles each [-having\surrounding] an indentation, [-in the centre], and the whole afterwards blackened. The handle portion which is L 6 5/10 in. is scalloped out with six scallops on each edge, the scallops being uniform in size; and also perforated through the middle with an oblong shaped hole, through which a loop of hide L 8 in., apparently for the wrist, is fastened. Top end semicircular and edged, the other end also somewhat round and edged. Captain F.W. Beechey R.N.
Ashmolean 1836, p. 187 no. 379.

752 An Esquimaux [-unfinished ?knife, or scraper\measure used as a measure for the mesh when manufacturing their \fishing/ nets, the thick portion held against the stomach, the mesh being made on the flat blade portion]: from Point Franklin, West Georgia; made on the curve out of a walrus tusk. One side of the back, which is broader and therefore projects beyond the sides of the blade portion is ornamented with seventeen deeply cut notches, and \which/ decreasing in size to the point resembles the vertebra of some [-animal \quadruped] or fish; the other side of the back being fluted lengthways, the plain part or blade below being about W 1 in. [-and] Th 3/20, [-and] square edged, and L 6 4/10 in. The handle portion which is L 4 8/10 in. and greatest D 1 3/10 by 8/10, is left \in/ rather a rough state but is hollowed out from [-the\immediately] behind the blade, on the underside to

[31]These spoons are not used for feeding themselves, but for supplying their lamps with oil.

nicely fit the fore fingers, with two long notches. The end of the back projects \in front/ 5/10 in. beyond the blade. It is very possible that it [-is\may be] in an unfinished state. Whole L measured on the hollow side 11 5/10 in.; on the round side 11 8/10. Greatest W 1 7/20 in. Captain F.W. Beechey, R.N. (?).

753 An Esquimaux mask, made of a flattish oval-shaped, or nearly so, piece of light brown wood, [-apparently] (deal?) apparently stained \[-brown]/; and \on one side/ rudely carved to represent the human face, with nose and forehead only a little projecting, and having two light blue glass beads, resembling turquoise, D 7/20 in. inserted for eyes, the mouth being a transverse curved slit, the nose broad and flat and nostrils punctured. It is rather deeply grooved all round \on/ the edge, in which is some thread made of twisted sinews, and it is perforated near the edge, with four holes one on the top, and thre[e] at equal distances \from each other/ round the lower part of [the] face, in which are fastened small thongs of hide, strips, of whalebone and in the lowermost or that at the bottom of the chin some object which looks like small \dried/ intestines. L 5 3/10 in., W 4 6/10; and greatest Th 8/10 which is at the point of the nose. Thickness round the edge about 4/10 in. \The back is quite plain and slightly concave./ "Obtained from the Natives of Port Clarence supposed to be used by them in their Religious ceremonies". Captain F.W. Beechey, R.N.
Ashmolean 1836, p. 187 no. 369.

754 An Esquimaux netting needle of pine wood [-dyed\stained] brown: used by the natives of [-Behring] Kotzebue Sound, Behring Strait, in making there nets, (see No. 687.) The resemblance to the European instrument for the same purpose is very remarkable. L 18 in. W 1 8/10 in., and Th 8/10 in. Captain F.W. Beechey, R.N.
Ashmolean 1836, p. 187 no. 384.

755 An Esquimaux netting needle made of pine wood, and [-dyed\stained] brown?, and of quite a different shape to the preceding No 754. \(Probably)/ Used by the Esquimaux on the N. East of Icy Cape \(as see whalebone net 756)/ in making there whalebone nets, porti[o]n of one of which is attached. L 16 9/10 in.; D 8/10 by 11/20 in. Captain F.W. Beechey, R.N.
Ashmolean 1836, p.186 no. 354.

756 A fishing net made of whalebone split into very thin and narrow strips: the floats being [-pieces\made] \some/ of oblong and \others of/ oval shaped \pieces of/ wood, flat on one side, and more or less convex on the other, 3 to 3 5/10 in. long. "Made use of by the Esquimaux to the N. East of Icy Cape". Length as now rolled up in a kind of hourglass-shape, or \being/ much less in the middle than at the ends, about 2 ft.; and \greatest/ W about 5 in. Captain F.W. Beechey, R.N.
Ashmolean 1836, p. 187 no. 368.

757 A plaited rope made of the inner bark of some tree, perhaps \the/ willow. Used in the boats (Baidares) by the Esquimaux of Kotzebue Sound, Behring Strait. It is made of a plait of three strands, and \is/ about 8/10 in. wide. L 44 ft. Captain F.W. Beechey. R.N.
Ashmolean 1836, p. 186 no. 356.

758 An Esquimaux labret or cheek stud of white stone, resembling marble. This is an ornament worn by the men only of Behring Strait, West Georgia, and the N. West Esquimaux generally. It is \formed/ something after the manner of a shirt stud; and they are worn in pairs through two small holes \made/ in the cheek in the lower jaw, just below the corners of the mouth, the round part projecting outwards. Such ornaments are made of stone, ivory or jade; and Captain Beechey says that he met with some of ivory with a blue bead in the middle, the ivory showing as a white projecting ring around it. See Beechey's "Narrative" p. []. Diameter of the back, or that portion which goes back into the mouth, 1 1/20 by 13/20 in., \and/ which is nearly oval in outline, and slightly concave the longest way; Th or depth 7/10 in. D of the front projecting part, 7/10 by 13/20 in. being nearly globular, but a little flattened on the top. [*drawing*] Given in exchange by the Trustees of the Christy Collection, 1869.

759 An Esquimaux implement, formed of a somewhat roughly rounded handle made of a piece of walrus tusk, L 3 1/10 ins, D 7/10 by 6/10 at the top, which is [-nearly] flat \except being rounded off on the edge,/ and decreasing to 5/10 in. at the other end, into which is inserted a small piece of iron, \probably meteoric or/ perhaps a portion of a nail; which has been ground with four angles to a point. Its [-probable\possible] use was in making the first indentation for the operation of drilling. Whole L 3 3/10 in. It may be a worn out drill itself, as the cutting blade is so short.

760 A North-western Esquimaux implement of walrus ivory, L 3 5/10 in. and D 6/10 by 4/10 in. in the middle portion which is slightly curved, and apparently made to grasp with the fingers; the two ends curving over [-both] on the same side and one of them being much worn as if by handling, the other having a tapering perforation. It is ornamented on three of its sides with a row of small incised circles surrounding a central indentation, as in No. 751, but on a much smaller scale, the circles being W 1/8 in. All the angles are rounded off. With it are ten peg shaped ivory articles varying from L 1 \in./ to 7/10 in., each having one end large and flat, resembling the head of a nail, the stems \or shanks/ being much less in diameter one [-way\side] than the other, and the ends perforated through the narrowest way. Most of these pegs fit into the tapering perforation in one end of the larger object, but will not pass through being prevented by the projecting heads. They are described as "Toggles used by the Esquimaux for securing articles round their bodies". With them is another small perforated ivory object of quite another shape, and probably is not part of the set. There is no certainty that the pegs \or studs/ belong to the larger handle-like object. [*drawings*]. Captain F.W. Beechey. R.N.

Ashmolean 1836 p. 186 No. 360.

761 An article of bone probably Esquimaux, use uncertain. It is cylindrical in shape, L 11 9/10 in. and D 9/10 in., cut to somewhat a wedge shape at one end, the other being squared off, with a hole drilled through near it which is grooved out to the end on each side forming like an eye as if for carrying a line. At one third the length from the chamfered end are two holes in a line with the length of the article, and near together, which are connected inside, the hole \being/ only partly through the bone [*drawings*]. In these holes a bit of thong of [-walrus] hide remain. Captain F.W. Beechey R.N. (?)

Ashmolean 1836, p. 187 no. 371-8.

762 A grey stone lamp "used by the Esquimaux of Kotzebue Sound, Behring Strait, for burning a wick in their winter habitations". Form the \lesser/ segment of a circle. L 6 5/10 in.; W in the middle 3 in.; and Th 1 in. [*drawing*] Captain F.W. Beechey R.N. As Captain Beechey was only a summer visitor to the Western Esquimaux, he could learn but little of their winter habits and pursuits, and, as their huts were partly built of wood, which was plentiful as drift, it is probable that they only used the lamp for lighting purposes, whereas amongst the Esquimaux of Winter Island, (East), it was the only source for light and fire. Except in its diminutive size, and its having a dividing ridge along the middle, this lamp is like the one figured and described in Parry's Second Voyage, p. 501.

Ashmolean 1836, p. 186 no 359.

763 An Eastern Esquimaux knife. The handle is of wood L 4 4/10 in. W 1 3/10 and Th 7/10; on the end of which is fastened a piece of bone L 2 3/10 in. W 1 1/10 and Th 4/10; in a groove cut in the end of which is fastened by a binding of sinews, a small triangular shaped flat \double-edged/ blade of meteoric ? iron, L 1 3/10 in. and W 1 in. \The end of the handle is perforated./ Whole L 8 5/10 in. Lieut. Francis Harding. R.N. 1824. Given by him 1827. The Esquimaux met with by Captain Lyon in 60° 30' N. Lat. and 83° W Long: seems to have hardly known the use of iron, as he says "Observing a dirty looking bone in each man's hand, I asked what they were 'Pannas or knives': which on examination I found to be formed of a rough piece of chipped flint, somewhat like a poplar leaf in form, and clumsily lashed to small bone handles of about six in. in length. Such were the only cutting instruments of these wretched people". Lyon's Narrative. p. 56.

Ashmolean 1836, p. 186 no 326.

764 An Eastern Esquimaux knife; Handle of bone, round on one side and flat on the other, and in the middle of w\h/ich is a large [-round hole\circular indentation apparently] made [-apparently] to receive the end of the thumb [-apparently] and at the end is portions of another such hole./ L 6 8/10 in.; W 1 1/10; and Th 7/20; in the \other/ end of [-which] which is inserted and rivetted, a blade made of meteoric ? iron L

3 3/10 in. and W 1 in. rounded at the point, and edged all round on all sides. Whole L 9 2/10 in. The end of the handle is perforated. Given by J.P. Pratt. Esq. Bath. 1824.

Ashmolean 1836, p. 187 no. 399.

765-766 Two iron knives used by the Esquimaux of Kotzebue Sound, Behring Strait, which they obtain from [-Behring Strait\Tschutchi] (Tchukchees?) on the opposite Asiatic [-shore \coast.] The largest of these knives \(No 765)/ is entirely of iron, L 11 9/20 in. the narrow and thicker part forming the handle \being/ L 3 5/10 in., 1 in. broad, and Th 4/10, and bound round with a narrow thong of [-walrus] hide. The blade is long pointed leaf shape, greatest W 2 3/20 and double edged. The other knife No 766 is also of iron, L 12 7/20 in., the shank part 3 8/10 being inserted into a \small/ wooden handle, one side of which is wanting. The blade is 1 in. broad at the base, straight and square on the back, and slightly curved and tapering to a point on the edge, which [-appears to have\has] been sharpened from one side only, and near the handle marked with a double set of parallel in[-cised\dented] cross lines. Captain F.W. Beechey. R.N.

Ashmolean 1836, p. 187 no. 387-8.

767 A native-made model of an Eastern Esquimaux man's canoe; called a Kayak, Kajak or Kia; from Winter Island. Probably a child's toy, as see Lyon's Private Journal p. []. L 19 5/10 in.; D 2 3/10 in. It is made of a framework of thin wood covered with [-covered with] a transparent oilskin like substance, probably the intestines or bladder of the seal, with a triangular \shaped/ hoop \or frame/ of whalebone round the hole at the top. The back and the front are \about/ equally pointed. Captain G.F. Lyon. R.N. 1825.

Ashmolean 1836, p. 187 no. 397.

768 Ditto, ditto. On a larger scale than the preceding and rather different in shape, being much narrower and more pointed in front than behind, and covered with prepared skin, \or leather,/ probably of the Seal, the hole above having had a wooden hoop round it which has been destroyed by worms, the thong of sinews by which it was fastened alone remaining. It has a model of the double bladed paddle along with it. From the Savage Islands, Hudson Strait. L of boat 30 5/10 in.; D 3 8/10 in. L of paddle 13 in., D 6/10 Lieut. Francis Harding R.N. 1824, given by him 1827. (Probably a Child's toy, as see Lyon's Private Journal p. [-].

Note (a) The former, No. 767, is a model of the boats used by the men of Melville Island and the neighbouring parts, the other \(No. 768)/ those used by the natives of the Savage Islands, Hudson's Strait; and Captain Beechey found similar canoes in use, but not so common, amongst the Western Esquimaux. They are propelled at times, with great rapidity with a double paddle (see No. 790) which also serves the purpose of a balance pole, the boat being very light and lying as it were upon the water, the rower being seated in the hole, and upon the bottom. See Captain Parry's

description of these boats, Second Voyage, p. 506. See also Wo[o]d's "Nat: Hist: of Man", Vol: 2. p. 704, and pp. 712 & 713.

(b) Another kind of boat called the Oōmīak is used by the Esquimaux on the more open seas in both Davis and Hudson Straits. It is generally called the womens or family boat, from being chiefly used by the Women and children, is described \and figured / in Captain Lyon's Private Journal pp. 39 and 41. \A sail is occasionally used with these boats, No. 705 being described as one of the kind/

(c) Amongst the Esquimaux of Kotzebue Sound and West Georgia, in addition to the Kaiak (No 767. 768), or single man's boat, boats called "Baidars" are used which are described by Captain Beechey in his Narrative p. 254.

The Esquimaux of Southampton Island do not appear to have boats, see Lyon's "Narrative" p. 60, and those of the Winter Island district none but small kayaks.
Ashmolean 1836, p. 186 no. 327.

769 A superiorly made model of an [-Eastern \Greenland] Esquimaux's Kajak or Kia or man's canoe, complete; covered with one piece of transparent thin skin or the entrails of some animal; of a pale brown colour, the seam being along the centre of the top, to which is attached various small fittings of ivory \and bone/ to narrow straps, and round the hole a reeving bag of black skin or leather with fastenings connected: L 31 3/10 in.; greatest W 2 7/10 in.; Depth 1 5/10 in. H of reeving bag 2 in. Together with model of [-double paddle of] two bladed paddle tipped and bound along the edges of the blade with bone, L 9 6/10 in. and D 9/10. A harpoon with wooden shaft and detachable \and/ barbed ivory head with iron blade, harpoon line, skin drag or buoy, and throwing board attached; L with head in position 10 6/10 in.; L of head, line and buoy detached 47 in. of the buoy only 5 in. of throwing board 3 in. A circular framework of \composed of/ bone and wood for winding the harpoon line [-on\within] to prevent its getting entangled (?) size 3 2/10 by 2 3/10 in. A whale spear, with moveable but not detachable ivory head tipped with a metal blade, and ivory head stay on the middle of shaft; L 9 2/10 in. A bird spear with pointed bone head and three \barbed/ prongs \of ditto/ tied on the middle of the wooden shaft, and a rest or throwing board: L of spear 8 6/10 in., of rest 2 3/20 in. And a bone knife L 2 8/10 in. and W 3/10. Esquimaux make. Presented in 1877 by Mr Ruben Francombe \seaman/ of H.M.S. Alert in the English Arctic expedition of 1876. One of the men who went with the sledging [-expedition] parties, and experiencing great difficulties reached the high lattitude of 83° 20' 30", the highest point hitherto reached by any human beings. The model was [-procured\purchased] at Disco on the Greenland coast by Mr Francombe on his outward journey to the Pole.

770 A small native made model of an Esquimaux sledge, [-probably] a toy of the Esquimaux children. From Kotzebue Sound Behring Strait: \made of fir wood./ L 8 8/10 in.: W 4 5/10 in.; H 1 3/10 in. This model not only shows the skill of the Western Esquimaux, as it is mortised and tenonted together on carpentering principles, but also affords another illustration of the plentiful supply of wood amongst them. Descriptions of sledges and of the mode of travelling with them are given in the works of Capt[ain]s Beechey Parry and Lyon. Also in Wood's "Nat: Hist of Man", Vol: 2, p. 713 - 716.
Ashmolean 1836, p. 186 no. 355.

770a An Esquimaux whip lash (?), made of one length of hide. L 11 ft. 5 in.: greatest width at the end which joins the handle 8/10 in., which has a loop, and diminishing to almost a point at the other end. The edges appear to have been somewhat rounded by scraping, or may be only the result of ordinary wear. Locality and history unknown. It probably belongs to either Lyon's Harding's or Beechey Coll[ectio]n.

771 An ivory skewer or "Toopoota". This is simply a rounded [-piece\pin] of ivory, with the head portion a little larger than the rest, triangular \shaped,/ and deeply notched on each angle; the point being chisel shaped. L 5 7/20 in. D of the head 3/10 in., of the stem 2/10 in. Captain F.W. Beechey. R.N. (?) For the way such articles are used see Parry's Second Voyage, p. 510 \ "As the blood of animals which they kill is used as food of the most luxurious kind, they are careful to avoid loosing any portion of it, for which purpose they carry with them on their excursions a little instrument of ivory called "toopoota", in form and size exactly resembling a twenty penny nail, with which they stop up the orifice made by the spear, by thrusting it through the skin by the sides of the wound and securing it with a twist."/ Also Wood's "Nat: Hist: of Man", Vol: 2; p. 708.

772-773 Two long and narrow strips of walrus ivory, each having an incised line down the centre on each side, and a small hole drilled through the middle. Used by the Esquimaux, \by/ several of them \being/ strung side by side, to prevent the wrist from being injured by the recoil of the bow-string, when used, as for that purpose "they had a guard made of several pieces of ivory or wood fastened together as an iron holder". L 4 5/20 in.; and D 5/10 by 3/10 in the middle, but decreasing a little in size towards the ends [-the ends having\which have] small cross ridges on \the/ opposite sides. Captain F.W. Beechey. R.N. (?). See Wood's "Nat: Hist of Man". Vol: 2. p. 710, upper figure.[32]

774-775 Two Esquimaux implements of walrus ivory, somewhat like the preceding; probably used for smoothing down the edges of their skin work when

[32]These are said to be two of the kind used in a game like quoits to pitch to the pegs Nos. 774-777.

sewn together. The sides are flat, decreasing in width towards the bottom and obtusely pointed, the angles being rounded off. The upper part which seems to have been intended for a handle is rather smaller, with an incised line down the centre on each side and each object is perforated near the middle, [-besides\in addition to] which, one of them has an incised circle surrounding an indentation. L 6 9/10, greatest D 9/20 by 7/20 in.; and L 6 5/10, greatest D 9/20 by 3/10 in. They may originally have been like No. 772 and 773, and afterwards converted into smoothers. Captain F.W. Beechey. R.N.[33]

776-777 Two ditto, very similar but much smaller, and having the top part more decidedly handle formed, nearly resembling cricket bats \in shape,/ except that they are more pointed; perforated through the middle. L 4 in., greatest D 7/20 and L 3 8/10 in. D 7/20. Captain F.W. Beechey R.N.

778 A fish-hook from Icy Cape; made of a strip of whalebone about L 16 in. and D 2/10; bound on at the lower end to a piece of pithy wood L 5 5/10 in. and D 3/10 at top, but increasing to 4/10 at the bottom; near which [-at\on] the side [-but\and] forming an acute angle \with stem,/ is bound on a sharply pointed strip of bone L 4 8/10 in. and greatest D 5/20 in. The binding being a narrow strip of [-hide\bark] W 5/20 in. and apparently the whole of one length. The top of the whalebone is turned over to form a loop. Whole L 16 5/10 in. W at point of barbe outside measure 1 11/20 in. inside 1 3/10 in. Captain F.W. Beechey. R.N. (?). Ashmolean 1836, p. 187 no. 366.

779 Twenty whalebone snares, used by the Western Esquimaux for catching birds and small animals. They are all alike in pattern, and each made of a thin strip of whalebone L about 22 in. or somewhat less, one end of which is tied [-round \in] a groove cut round the end of a small tube or cylinder of fir-wood L 2 3/10 in. and D 7/20; the other [end] of the whalebone sliding very freely through the hole in the tube, but the noose being prevented from opening beyond a certain extent, being stopped from opening further back by a small round piece of wood of the same diameter but about half the length of the sliding pieces, but solid; and tied firmly crossways the whalebone allowing the noose to open [to] [-D\W] about 3 in. Captain F.W. Beechey, R.N. (One or more of this set of snares was given in exchange to the Christy Collection). Ashmolean 1836, p. 186 no. 358.

780 A hand grip? of ivory for use with a sealing harpoon line of hide, a loop 11 in. long of which is attached. Carved by Esquimaux to represent the head of some animal, perhaps a fox, wolf or dog? with eyes and nostrils represented by inlaid bits of whalebone. The left ear is broken. The thong is attached through a large perforation through sideways \in/the lower part of head. L 2 19/20 in., D 9/10 by 15/20 in. Captain F.W. Beechey R.N. (?).[34]

781 An Esquimaux fish hook, from Behring Strait, made of a piece of [-bone\ivory] 6 5/20 in., nearly triangular shape in section greatest D 6/10 in., somewhat of a fish form, the belly part being rounded, the back keeled and the greater portion of the sides stained brown \to increase the deception/ the head being flattish with bits of whalebone inlaid in rings of white metal (iron pyrites?) to represent eyes, the mouth and the gills being marked by incised lines. A [-bent] sharply pointed and headless nail is fixed at right angles through the head, and having the point [-directed] bent upwards towards the tail on the belly part, forming the hook. [-To] The tail part is fastened to one end of a narrow strip of whalebone L 14 in., by two holes drilled through sideways, one much larger than the other and 6/10 in. apart, the whalebone passing through the largest and forming a secure loop, a similar one being at the other end for attaching to the line. Whole L 19 5/10 in., projection of iron hook from ivory 15/20 in. Captain F.W. Beechey R.N. (?).

782-786 Five artificial fish of ivory somewhat similar to the preceding but without hooks, and their eyes made of whalebone inlaid in ivory, the backs of four of them being stained brown. Underneath, each of them has a hole through near the head, and \another/ through the tail part, for fixing the line. They are used by the Esquimaux as decoys, by being dangled in a hole made through the ice, to attract the fish, which are then struck by the fish spear, (see No. 674, 725). For the manner of using them see Wood's "Nat: Hist: of Man". Vol: 2, pp. 710-711. Captain F.W. Beechey R.N. (?). L 5 6/10; greatest D 17/20 in.; L 5 5/20, greatest D 7/10 in. (back unstained); L 5 5/20, greatest D 15/20 in.; L 4 8/10, D 13/20 in., 1 with the back slightly ornamented \on the snout, and near the tail with incised lines/; and L 2 7/10, greatest D 11/20 in.

787 An artificial fish of ivory, somewhat fish shaped, and set about the middle with four sharp, pointed spikes of ivory, L about 3 4/10 in. one of which is lost, and another broken off; each a little curved, diverging, and the points direct[ed] backwards. About 1 in. in front of which, and in a line with them are \also/ inserted, four slender and very pliable strips of whalebone 3 or 4 in. long and knotted at the top, securely fixed in holes drilled to receive them with pegs of the same material, and spreading out further but in the same direction as the ivory barbes [-behind] behind

[33]These and the following two articles, all of which may be called pegs, are said to be used to stick in the ground for to pitch other pieces of ivory of a different shape at them, in a game somewhat resembling the English Quoits.

[34]Used for dragging home a dead seal, by the line being hitched through a slit cut in the nose, the seal then being drag[g]ed along the ice or snow; but this appears to be used instead of sledges when not a great distance from the huts.

them. Both ends are perforated. L 7 7/10 in. Greatest D 1 5/10 by 1 in. A similar article to this is figured in Wood's Nat: Hist of Man, Vol: 2, p. 710, fig 1 where it states that "no bait is required with them, they are simply moved up and down in the water so as to attract the attention of the fish, and then are jerked sharply upwards, so as to catch the fish on one of the projecting points." Captain F.W. Beechey R.N. ? Western Esquimaux?
Ashmolean 1836, p. 187 nos. 371-8 [?].

788 A rudely made fish-shaped article of ivory, of somewhat similar form to the preceding No. 787, but very much smaller, and without any projections at the sides; the two ends being perforated. Probably a sinker for fish-hooks. L 3 4/10 in.; greatest D 1 1/10 in. Western Esquimaux? Captain F.W. Beechey R.N. (?)
Ashmolean 1836, p. 187 nos. 371-8 [?].

789 A sinker for small fish-hooks. Probably western Esquimaux. It is [a] large lump of walrus tusk roughly rounded at the bottom, and more smoothly on all the sides, and decreasing almost to a point a[t] the top which is perforated for the line which was of whalebone. There is a strong loop on each side near the bottom, cut out of the ivory itself, to which remains of two thin looped strips of whalebone are attached which may have been fastened to hooks, but are now incomplete. It is oval shaped in section, L 7 1/10 in. and greatest D 2 4/10 by 1 4/10, which is at the side loops. It must have been made out of a very large tusk, and the surface has many little cracks. F.W. Beechey. R.N. (?).
Ashmolean 1836, p. 187 nos. 371-8 [?].

790 A double, or two-bladed paddle, of a kayak \or men's canoe,/ from the Esquimaux of North Bluff, Hudson Strait. It is made of two pieces of drift wood [-and] (apparently two sorts of fir), which are well joined and lashed together in the middle of the handle with a thong of hide, the joining being strengthened by an iron pin passing through, and also with a thick plate of walrus tusk L 11 in. pegged on lengthwa[y]s on one side and covering the joint. Each blade is edged with narrow rounded strips of bone, \(of the walrus?)/ securely fastened on with small bone and whalebone pegs for the distance of 25 5/10 to 30 in. along each of the four edges, and the ends are tipped with flat pieces of the same material 5 5/10 and 8 5/10 in. long, to prevent splitting and probably as a guard against injury by ice. The wood at one end of the paddle is made up in length with a bit of oak L 6 5/10 in. which is ingeniously and remarkably well fitted on, with a curved joint, and securely fastened with \four cross/bindings of plaited sinews. In one blade several good sized round holes have been stopped up with plugs of wood; and one of the rings [-which\to prevent the dripping of the water down the arms, and] made of coiled, narrow strips of whalebone, with edging of hide, has been lost. Whole L 9 ft. 2 5/10 in.; W of

blades 2 8/10 in. Lieut Francis Harding, R.N. 1824 Given in 1827.
Ashmolean 1836, p. 185 no. 320.

791 Esquimaux (?) two bladed paddle, made of one piece of pine wood, much shorter and the blades much wider than in the preceding No 790. The middle or handle portion is oval-shaped in section, L 30 in. and D 1 6/10 by 1 in., swelling out into long leaf-shaped blades, L 27 in. and W 4 8/10 in. Whole L 6 ft. 10 5/10 in. It has had a strip of some material, perhaps ivory, bone or whalebone, fastened by pegs along one side of the \middle of the/ handle part, apparently to strengthen it, but this has been lost. Locality uncertain.

792 A double bladed paddle, of brown uncoloured wood, something like the appearance of Oak but not so heavy. It is round in the middle or handle portion for the length of about 30 in., and D 1 7/10, the ends widening out into straight oar-shaped blades slightly and gradually widening to the ends which are [-straight\squared] and W 5 4/10 in., the blades not being quite flat, but the sides slightly sloping off from a faint central ridge to the \side/ edges, the ridge \being more prominent near the handle and/ dying out into a flat round gradually to the ends, and side edges nearly sharp. Whole L 7 ft. 9 5/10 in. If this is Esquimaux it does not appear to be of native workmanship. History and locality unknown.

793 A harpoon line from the Esquimaux of Port Clarence, West Georgia; cut out of a piece of walrus \hide/ without a join. L 50 yards; D 3/10 to 4/10 in. For the manner in which such lines are cut, see Wood's "Nat: Hist: of Man", Vol: 2, p. 708, Captain F.W. Beechey. R.N.
Ashmolean 1836, p. 187 no. 370.

794 A large seal-skin buoy or drag, denuded of the hair \which/ with the line of hide, and the harpoon, is used by the \Eastern/ Esquimaux in attacking and killing the Whale, Walrus, various kinds of seals, and other large marine animals; when being inflated or distended with air by the mouth, it serves the purpose of a drag through the water when the animal has been struck, and dives, or as a buoy or float to indicate its whereabouts when it comes near the surface (see also No. 706). L 2 ft. 11 in.; greatest W 17 in. Lieut. Francis Harding. R.N. 1824. Given by him 1827.

795 A piece of prepared seals leather. Eastern Esquimaux L 24 5/10 in.: W 3 8/10 in.; of a pale brown almost white colour. Captain G.F. Lyon. R.N. 1825.

796 A rudely made, small model of an Esquimaux harpoon, with line and buoy attached. [-Probably a] Childs toy. In bad condition, the ivory spike being broken, and the buoy injured by moth. L 8 in.; D 5/10 in. From Kotzebue Sound (?) Captain F.W. Beechey R.N. (?).
Ashmolean 1836, p. 187 no. 386.

[-797] The following articles were presented in 1877, by Mr Ruben Francombe of Oxford, and seaman of H.M.S. "Alert" in the late expedition to the Arctic regions. The sledging suit, \etc,/ worn by him on the 3rd of April 1875, temp 70° below freezing, when the sledging parties started on their ever memorable journey, and experiencing great difficulties reached the high latitude of 83° 20' 30" the highest point ever attained by human beings. Finding the way to the pole impracticable they returned greatly exhausted to the Alert.

797 Goggles, or glasses, worn to protect the eyes from snow blindness, caused by the glare of the reflected light from the snow and ice, and also from snow storms, etc. They are made of dark transparent glass set or inclosed in a framework of fine, \black/steel gauze, bound round the edges with black velvet, and having a piece of narrow black elastic to keep them on the face. Whole W not reckoning the elastic 6 in.; size of each shade 2 5/10 by 1 8/10 in. (The Esquimaux use wooden eye-shades \for the same purpose,/see No 700 - 703).

798 Oval-shaped tin box, with upright sides and convex lid, lacquered or japanned of a brown colour on the whole of the outside. Used \by Francombe/ as a case for the goggles, No 797. D 2 9/10 by 2 in., and H 1 3/10 in.

799 A spoon made of [-black and white horn\horn of a black and white colour,] and perforated at the end of the handle. Specimen used on the expedition. The bowl is \now/partly split through. L 8 2/10 in.; D of bowl 2 3/10 in. W of handle at junction with bowl 1 1/10 in., tapering to 4/10 at the end which is roughly rounded.

800 Hose or short breeches; of very thick flannel, with flap in front, and eleven large black wooden buttons D about 1 3/10 in. firmly sewn on. The legs would reach a little below the knee \and in that particular resembling those of the Esquimaux./ L 2 ft. 10 in. W at top 19 in.; W of bottom of \each/ leg 10 1/2 in.

801 Conical shaped cap of seal skin, with the hair on; \made/ with lappet to protect the ears and neck, the upper part \being/ lined with dark grey flannel, and strings to tie under the chin. Size 12 by 12 in.

802 A pair of outer boots having soles of leather with broad squarish toes, and flat heels, with a good thickness of cork introduced between them and the feet; the upper portion to protect the legs being of thick brown flannel as in the trowsers No 800. Two leathern straps are sewn to the sides and fastened together by a strong brass buckle over the instep. L of sole 1 ft. 1 in.; W of [-sole\ditto] 4 3/10 in.; Th of [-sole\ditto] 1 5/10 in. and of heel 1 5/10 in. Whole H 29 in. Worn round about the ship not when sledging on the ice.

803 A pair of [-inner] boots? or stockings? of softish brown leather, perhaps deer skin, with upper portion \made/ of \dirty/ blue and white striped cotton \cloth/

with a reeving string round the top to tie above the knee; and another of leather on the leathern portion \or foot/ to tie round the ankle. Whole H 23 in.; of leather portion only 12 in., W at top of ditto 9 in. Worn outermost when sledging, the feet being wrapped in flannel etc. previously.

804 Outer smock, or overall; made of coarse white \linen,/ or canvas, having a hood to cover all but the face, two large pockets on the sides of the front fastened by two large black wooden buttons like those on the trowsers No 800, and two others to fasten the front \on the breast/. It is now very dirty from use. L 4 ft.: W from extremity of one arm to that of the other 5 ft. 7 in.

805 A strong belt; made of compactly woven, fine wool[l]en webbing, originally white but now discoloured with dirt, L 4 ft. 9 in., and W 3 in. connected \at each end/ by eyelet holes worked with string to a cord \L/ 18 in. to which \again/ is connected by a mettle ring a shorter piece of cord \L/ 8 in. at the end of which is fastened crossways a broad flat ring of the same metal, (apparently copper). Said to have been used for drawing the sledge. (These things are not of Esquimaux manufacture but were supplied by the Government for the purpose of the expedition).

805a-805f Six models found by the workmen in the Cellar of Mr Golightly's house, Holywell Street, Oxford, and purchased of them for two shillings and sixpence, the day that they brought in the model of the Frigate. Many of the little figures were in a bad state through the moth, and it was said by the men that the models had evidently been put aside as of no consequence.

805a Model of a Boat, shape something like a washing tray, made of a framework of wood of a white colour, probably pine, covered with prepared seal skin or leather. Two figures in it, dressed, but the clothes somwhat injured by moth. L 10 4/10 in. W in the middle 5 in.

805b Model of a Man's Canoe, or kayak, covered with some material resembling intestines, with man sitting in it, together with paddle, harpoon, and buoy. Figure slightly injured by the moth. L 14 in. Greatest W 1 91/0 in.

805c Model of a sledge in deal wood, with man on it, dressed, and drawn by five dogs also of white wood. At the sides of the sledge are fastened two oar-shaped wooden objects. L 7 in. W 2 in. L of oars 10 in.; of the dogs 2 in.

805d Model in white wood, probably pine, of the semi-globular or beehive-shaped houses or huts of snow, made of two huts joined together by a kind of triangular wall or screen so as to protect the do[o]rways of each which are nearly opposite each other. The models are made of sundry pieces fastened together with little pegs, except one piece at the top of each

which is made to take out to show the interior. The double hut is fixed onto a flat piece of similar wood 10 in. wide. D of each hut 4 1/2 height 3 1/2 in.

805e Model of a hut, or rather tent, of wooden poles of an oblong shape at bottom, but the poles converging together and projecting at the top at one end above the covering which is of seal-skin. The front of the tent being kept open by two cross poles. Inside is the model of a man dressed, a wooden box, and the figure of a seal in wood. The bottom is a flat board with a raised notched border of the same material, perhaps intended for to represent Stones or blocks of ice all round the lower edge of the skin. Size 10 by 6 3/4 in.

805f Model, probably of a Greenlanders Log house; all the parts of the roof which are gabeled being made of long round logs arranged parrallel and sloping downwards; the upright walls being boards. It is made in two separate compartments both on the ground floor, but one being much larger than the other but connected with it by a door. One side of the roof of the larger compartment is made to take out to show the models within; which are those of two men, (their flannel jackets having been destroyed by moth, also various other small models namely a tin stove, and guns, Harpoons, vessels, etc of wood. It is mounted on a square flat board. Size 14 by 8 1/2 in.

805g 805h Two fragments of some Esquimaux articles. The first a piece of walrus tusk cut to turn at right angles with four holes bored through it, with a narrow strip of whalebone through two of them[.] Possibly a hand-grip from a spear-shaft. D 2 by 1 4/10 in. Greatest W 8/10. The other is L 2 6/10 in. with a hole through the small end & two deep grooves cut in the larger lumpy end and a shred of animal sinews round it. Possibly a fragment from a model of Canoe or something. No history known.

Catalogue of the American collection in the Ashmolean Museum in 1884[.] Copied from by [*sic*] G. Rowell's M.S. with additions

806 A piece of brown leather, worn in Mexico around the bottom of the trowsers as a boot or gaiter. It is thick, soft, well dressed, and stamped or embossed with several very elaborate and beautiful patterns in relief, apparently by the other portion of the surface \being/ cut away. It is a very elegant piece of work. Whole L or rather depth 3 ft. but only the lower 15 in. being ornamented. W at bottom 2 ft. 11 in. Given by Captain King, R.N. 1831. (Exhibited at the Art Treasures Exhibition 1857).
Ashmolean 1836, p. 183 no. 115.

807 A Mexican whip, made of thin and well plaited thongs of white leather, inclosing shot or something of the kind in the lash, which is heavy and flexible; L 19 5/10 in., exclusive of a loop at one end for the wrist, and a single thong lash at the other end. Whole L 40

5/10 in., Greatest Th 5/10 in. Given by Captain King. R.N. 1831.
Ashmolean 1836, p.183 no. 116.

808 A pair of Canadian ? or Mexican ? Moccasins or slippers of soft brown and white leathers, neatly ornamented on the front of the upper part with opaque white black blue yellow, and transparent green, and amber, very small glass beads, on a ground of red flannel. The white leather being unornamented and forming lappets like round the top. L 10 in. W of bottom 4 8/10 in.; H at heel with lappets turned up, 6 in. Given by Mrs Birkbeck, widdow of Dr Birkbeck, originator of [the] Mechanics' Institutes in 1865. [-Inverness Road. Bayswater. London. [-W.] 1878.

809 A pair of Mexican slippers of soft light brown leather, ornamented on the side lappets or flaps and on the front with rows of pleated porcupine quills stained red yellow and black, and double rows of opaque white glass beads, and a single row of quillwork along the back of the heel, the edges of the flaps being bound with green ribbon. L of sole 10 in.: W 5 in.: whole H at heel with lappets turned up 6 3/4 in. Given by Captain King. R. N. 1831. (For the way of using these porcupine quills see Wood's Nat: Hist of Man Vol. 2. p. 693.)
Ashmolean 1836. p. 183 no. 120.

810 Ditto, ditto, of soft brown leather, the front ornamented with a row of pleated porcupine quills stained red and blue and edged with very small opaque white glass beads. The side lappets being lined on the face with pink silk and edged with green ribbon, the silk having a kind of design worked in the same size beads beads as those on the front, the ribbon edging being bordered with opaque white glass beads of a much larger size than the rest. L of sole 10 in., H at back of heel with lappets turned up 5 5/10 in. Given by Captain King R. N. 1831.
Ashmolean 1836 p.183 no 120.

811 A pair of Canadian Indian Moccassins of soft leather like wash leather, dyed brown, and ornamented on the front, and side lappets with flower patterns worked in transparent and opaque white, opaque light and dark blue, two kinds of opaque yellow, transparent green, and opaque pale green, transparent crimson, and opaque pale brown small glass beads on a black velvet ground, the beads being sewn on over a paper pattern. They are lined inside with common glazed cotton. L of sole 9 9/10 in. H at back of heel 3 in. Given by the Rev. R.S. Hawker, M.A. Magd[dalen]: Hall 1828?, or given 1865.
Ashmolean 1836-68, p. 7.

812 A Red Indians wooden war club: the handle flat and curved to one side at the top, terminating in an oval ball which is 4 5/10 by 3 7/10 in. diameter. Each side of the lower part of handle, for the distance of 9 in. is ornamented with a zig-zag row of small square shaped pieces of copper irregular in size stuck in, and the knob has also a few larger pieces of a similar

character fastened in here and there, apparently to add to its weight as well as ornament[.] On the back of the upper portion of handle are twelve wedge-shaped holes, each measuring about an inch in length, which appear to have been formerly inlaid with copper or some other material, as well as two plain strips along the sides of these; the resin or some such material remaining in the grooves and which seems to have at least helped to keep the material in its place. L 21 5/10 in. It is evidently very old, and probably was part of the Tradescant collection. For a club of this kind see Wood's Nat: Hist: of Man, Vol: 2, p. 650, right hand figure.
MacGregor 1983, no.2.

813 A similar shaped club to the preceding 812, but the head being more globular shaped, and the whole entirely without copper inlayings. It is now full of worm holes, and is certainly very old. L 19 5/10 in.
MacGregor 1983, no. 3.

814 Ditto of the same shape but the top not so much curved over, and the head being globular shaped, and studded with a few small pieces of copper. L 23 in., D of head 4 3/10 in.
MacGregor 1983, no. 4.

815 Ditto of somewhat similar shape to the preceding, but having a flat iron blade inserted and projecting 1 in. in front of the head which is quite globular. The decoration consists of a vandyke border in red and blue painted along one side of the flat handle \portion/ the end being cut to nicely fit the hand and decorated with a bunch of small Eagle's feathers tied on with a bit of yellow satin ribbon. From Indian tribes in the Rocky Mountain. L 28 3/10 in.; greatest W of handle, which at the top, 3 in., decreasing to 1 5/10 at bottom w\h/ich is sloped off at an acute angle and the edges scalloped: \Th 6/10 in./ D of head 3 5/10 in. Given by C.A. Pope, Esq. D.M. St: Louis, Missouri, United States of America, Received from Dr Acland 1866. A similar club is figured in Wood's "Nat: Hist: of Man" vol: 2 p. 650 right hand figure.
Ashmolean 1836-68, p. 12.

816 Ditto, with the sides of the head flat and not \so/ much thicker than the handle, and having a pointed spike of bone, or perhaps the tooth of some large animal, 2 in. long, projecting from it in front. The sides of the club are coloured except the handle part with ornamental vandyke pattern round the edges of the upper portion which extend 9 5/10 in. downwards, and which are made by cutting through the black \colour/ to the lighter wood beneath. Within this vandyke border are plates of tin nailed on with little brass or copper nails, and which follow the curvature of the head, probably for ornament, but which serve the purpose of strength as well. The end of the handle is flat, projects considerably, so as to prevent [-its] \the weapon from/ being snatched out of the hand, and is perforated \(as are also the three preceding clubs)/, apparently for the insertion of a loop for twis[t]ing

round the wrist. L 22 7/10 in. D of head, 3 by 2 in., decreasing to 1 4/10 by 8/10 in. immediately above the handle \From Indian tribes in the Rocky Mountains/ Given by C.A. Pope, Esq D.M. St: Louis Missouri United States of America. Received from Dr Acland 1866.
Ashmolean 1836-68, p. 12.

817 Ditto, the [handle] being a straight round stick L 17 in. and Th 7/10, headed with a well shaped round heavy ball D 2 4/10 in. inclosed in raw hide or skin, which also forms a flexible neck, covers the handle, and forms \a loop/ at the end of it through which is fastened a loop of soft \brown/ leather something like wash leather for the wrist. All the stitching of the covering is done with animal sinews, and there is a bit of skin tied to the loop in the end of the handle covering, which is perhaps intended for a charm. Whole L 24 3/10 in. From Indians of the Rocky mountains. A similar weapon is figured in Catlin's "North American Indians", Pl: 65. Given by C.A. Pope Esq. D.M. St: Louis, Missouri, United States of America. Received from Dr Acland. 1866.
Ashmolean 1836-68, p. 12.

818 An Osage Indians' war club, of a class which is manufactured for the Indians, but seems to be much used amongst them, (see Catlin's North American Indians, Pl: 254, 255, 257, etc). It is quite flat, Th 7/10 in., the upper end somewhat resembling the outline of a gun stock; on the front edge of which is \fixed/ a projecting pointed iron blade L 4 7/10 in. and W 4 in. It is bordered and edged with double rows of thick-set brass furniture nails, and it is [-coloured\painted] red on one side and green on the other, on which ground colours are painted in gold and black, the bow and arrows, the Tomahawk, the Eagle, and the sun. The widest part or the head has a heart-shaped hole surrounded with a single row of furniture nails on each side. L 34 in.: greatest W 9 3/10 in. From the Indians of the Rocky mountains. Given by C.A. Pope. Esq. D.M. St: Louis, Missouri United States of America. Received from Dr Acland. 1866. For a club of similar form see Wood's Nat: Hist: of Man vol: 2. P 650. left hand of figure.
Ashmolean 1836-68, p. 12.

819 North American Indians tomahawk with hollow handle of dark brown wood, and ornamented head of copper, one side of which forms a tobacco pipe the other side probably having had a cutting blade which has been broken off and lost. The handle also forms the tube of the pipe. Locality unknown. L 17 3/10 in. D of top of handle 1 1/10 by 8/10 in., gradually tapering to 8/10 by 5/10 at the other end and very slightly curved from end to end, being oval shaped in section. It was formerly in the collection of P.B. Duncan Esq. M.A. New Coll[ege]; Keeper of the Ashmolean Museum, 1826-54. Given by Mr T.A. Prestor [Preston?] \Bed Maker, New College/ Oxford. 1880.

819a A North American Indian's Tomahawk, with handle of brown wood, flattish, but much wider at the top than at the bottom. It has been set edgeways with a dark stone cutting blade into a mortice made in the wood, portion of which remain. L of handle 24 9/10 in., W at top 2 4/10 in., decreasing but irregularly to almost a point at the handle end, which is perforated for a string for the wrist. Greatest Th 1 1/10 in. (Ramsden collection No \22/.) Purchased by the University 1878.

820 A bow and six arrows, used by Osage Indians, United States of America. The bow is made of two pieces of Buffalo horn strongly lashed together about the middle with strips of canvas, and faced along the whole of the front with a broad flat piece of Buffalo sinews, the line being made of shreds of the same material twisted together. This bow is exceedingly elastic. L measured alon[g] the line 38 6/10 in. W in the middle 1 4/10 in., gradually diminishing to the ends to 6/10 in.; greatest Th which is about the middle 8/10 in. The arrows are straight round shafts of pale brown hard, and rather heavy wood, from L 22 8/10 to 22 3/10 in. and D about 3/10; three of which are smooth, the others having each three longitudinal grooves or scratches. Each is feathered with three long dark coloured feathers, and headed with flat iron blades from L 3 1/10 to 2 2/10 in. and W 8/10 in. at the bottom, tapering to a point both edges being ground sharp, but without barbes: these heads are \cut out/ of sheet iron, which is not of Indian manufacture. All the bindings are of fine shreds of animal sinews, L 25 6/10; 25 5/10; 25 4/10; 25 2/10; 24 4/10; 24 3/10 in. The feathering is well done in the ordinary way, and are stuck on straight, and each arrow has a large [-[-]\notch] for the bow string. Given by C.A. Pope, D.M. St: Louis, Missouri, United States of America. Received from Dr Acland 1866. See Wood's Nat: Hist: of Man: vol: 2. p.p. 661 & 662. (One of these arrows was given away in exchange to the Trustees of the Christy Coll[ectio]n. in 1869).
Ashmolean 1836-68, p. 12.

821 A Comenshes' (Comanche or Camanchee) Indian's shield taken from them by the Osage Indians, in a battle on the [-bend\head] of the Arkansas, in November 1854. It is a flat slightly concave disk, D 19 5/10 in. of Buffalo hide, the inside to the front. Around the edge is a narrow border of pleated coarse scarlet flannel, from which are suspended by little threads, a number of Eagles, and what appears to be Guinea Fowls wing feathers, the threads passing through the quills so that all the feathers hang downwards. In the centre is fastened a disk of \red/ flannel D 4 5/10 in. ornamented round with a row of opaque white glass beads, and around this are suspended as trophies or charms, portion of a human \scalp,/ part of the rattle of the rattle snake, and three small bunches of Bears hair. At the back is hung a small globular brass bell, of the same pattern as ancient horse bells and a fringed

leather bag containing red colour. The cover of thick soft leather resembling Chamois, is coloured red on the outside and when worn is fastened over the shield by a strong reeving string of leather which passes through thickly set holes round the edge. There is also a loop apparently for suspending it when not in use, at the ends of which are tied what may be little charms, one of which appears to be a small piece of bone. Given by C.A. Pope, Esq. D.M. St: Louis, Missouri, United States of America. Received from Dr. Acland, 1866. (For figure and description of these shields, see Wood's "Nat: Hist: of Man", vol: 2. p. 650.)
Ashmolean 1836-68, p. 12.

822 An Indian's scalp, with long black hair, the inside of the skin painted red. History and locality unknown, perhaps Old Ashmolean collection. L about 13 in.; W 7 in. (For the mode of scalping employed by the North American Indians, see Wood's Nat: Hist: of Man, Vol: 2 p. 653).

823 A bowl or basin of basketwork, made and used by Indians of California for holding water, etc. Such baskets are watertight simply from the compact way in which they are woven, as they are in no way varnished, and require no soaking before being used. It is worked in ornamental patterns of black and light brown colour, and originally ornamented with scarlet and yellow feathers woven in, traces of which remain. These may have been intended to make the work closer, and not only for ornament. D 9 in.; depth 4 5/10 in. Baskets for a similar purpose, but differently and less ornamentally worked are made by the Caffirs. See African collection No. 468. Given by F.W. Beechey. R.N. probably about 1832.
Ashmolean 1836, p. 183 no. 139.

824 Ditto. ditto. ornamented with a kind of lozenge pattern in black and light brown on a light brown ground. H 5 in. D 6 3/10 in. Given by F.W. Beechey R.N. about 1832.
Ashmolean 1836, p. 183 no. 139.

825 A Birch bark bowl, made by North American Indians, of one piece of bark, the sides being split down in eight places, to bring into a circular shape and the joints firmly and ornamentally stitched with some vegetable substance, the joinings overlapping. The rim being bound alternately with with the same material as the seams are sewn with and coloured porcupine quills. D 9 2/10 by 8 6/10 in.: H 3 in. From the Trustees of the Christy Collection, in 1869. Given in exchange. (Christy Number 3591).

826 A carved wood (Birch wood?) spoon, made by North American Indians; the bowl being a good deal wider than it is long 3 4/10 by 2 in., with a keel or ridge along the middle of the under side and which projects in front in a faint beak. The handle is a spiral curve in form \backwards the end forming a complete ring/, with three short equal distant projections on top.

L 4 6/10 in., From the Trustees of the Christy Collection, 1869?, and probably in exchange.

827 A Birch-bark box, richly ornamented or embroidered with fruit (wild strawberrys?) and flowers worked with variously coloured small quills, or Moose deer's hair, by Indians of Upper Canada. Shape oval, with flat top and bottom. H 3 8/10 in. D 2 2/10 by 1 1/10 in. Given by Greville J. Chester B.A. 1872.

828 A pair of North American Indian's garters, \of leather/ covered \on the front/ in various chequer patterns with dyed quills of the porcupine, or Moose deer hair, each end of the leather being cut into shreds and threaded with variously coloured glass beads, some of the shreds being short and only ornamental, and others being longer, plaited together except just at the ends which which are also threaded with beads; these [-latter] \longer shreds/ were used for tying. The ends of the quill work are bound with thin plates of white metal. L of this part only 11 3/10 in: W 17/20 in. Whole L 33 in.

829-830 Two odd North American Indian garters of leather ornamented in the front only with coloured quill work; one in (No 829) stripes in red white and black, with bows of pink ribbon at each end. L 13 5/10 in.; W 1 in. The other is ornamented with stripes and small chequers, in the same colours, and in the same manner, the quills being worked over thin strips of bark, so as to give them a raised appearance. The ends of this one No 830 have three little conical shaped copper pendants each of which has apparently held little tufts of hair. L 14 in. not including the pendants 14 in.; W 1 in.

831-832 Two odd N. American Indian garters, probably part of the set of the preceding numbers 829 830 but all the quill work destroyed from the face. L 14, and 12 5/10 in.

833 A band of blue and white Wampum beads, woven closely together in five rows, the white forming three lozenge-shaped ornaments along the centre, and a square patch at each end, the strings there forming a rude fringe. The beads are cylindrical \in shape/, L from 2/10 to 3/10 in.; and D about 3/20 in. The strings on which they are worked are made of hemp. L of beadwork only 12 in. Extreme L of band 17 in.: W 1 5/10 in. History unknown.
MacGregor 1983, no. 354.

834 A wider band of the same kind of beads, the beads being near about the same size and threaded on thin strings [of] leather or skin. The band is very incomplete, only about one-half the beads remaining. L uncertain: W 2 2/10 in. History unknown.
MacGregor 1983, no. 10.

835 A Chippewa Indians arrow-head, of chipped brown flint?, or chert?. L 2 5/10 in.; W 9/10 in., and 3/10 in. thick. Given by F.H. Field Esq Oxford 1868. [*drawing*].

836 A Javelin head, or large arrow head of grey chert or slate?; leaf-shaped and rudely chipped into form, the lower part perhaps somewhat broken away. L 3 9/20 in. W 2 in. Form[er]ly used by N. American Indians. Dug up on a Farm at Oxford, Connecticut, United States of America. Given by Jerome Candee Smith Esq. M.D. of the above town 1881.

837 Ditto, arrow head of brown flint or chert, of a long pointed form, the point being broken of[f]; the lower end being nicked on each side for fastening in the shaft. Present L 1 4/10 in.; W 7/10 in. Dug up on a Farm at Oxford, Connecticut, United States of America. Given by Jerome Candee Smith Esq. M.D. of the above town 1881.

838-839 Two ditto, of semitransparent white stone; one of them triangular, L 9/10 W 17/20. The other apparently having been also triangular, but having a projecting stem for insertion into the shaft. Point broken off. Present L 1 3/20 in.: W 19/20. Dug up on a Farm at Oxford, Connecticut, United States of America. Given by Jerome Candee Smith Esq. M.D. of the above town 1881.

840 A Chippewa Indian's arrow-head of chipped brown flint, or chert. Ploughed up at Galt, Ontario Canada. It is somewhat leaf-shaped in front with two deep side nicks on the sides the back being straight. L 1 7/10 in. W 17/20 in. Given by Edward Alfred Taunt, of the above place. [*drawing*].

841 A mask of wood representing a Wolf's head, worn by the Priests or Conjurors, of the Indian Tribes of the coast north of the Oregon Territory. It is made of one thin flat piece of deal Th 3/10 in., which \is/ so arranged that it forms the nose and the two flat sides of the head, and is cut and painted \in brown and dark green/ to resemble a \head with/ large mouth, the teeth being represented by little strips of wood tied across it on the inside, and the eyes inlaid with bits of white window glass cut or ground to a pointed oval shape, one of which \(the right hand)/ is wanting. L of the sides 14 9/10 in.; greatest W of ditto 6 6/10 in.; W of nose part 2 in.; depth from top to bottom 5 9/10 in. The back has crescent shaped pieces cut away as if to fit over the ears. Given by Captain Hen: Kellatt \not a?/ R.N. C.B. 1850.
Ashmolean 1836-68, p. 10.

842 A North American Indian woman's apron made of a piece of hide (deer's?) coloured red and cut into sixty narrow strips leaving a band about W 4 in. along the top \uncut/, each strip being ornamented with two, three, or four bands of a bright yellow substance, resembling rush or straw bound round it at intervals, and having a deer's hoof, or a copper pendant suspended at the bottom, there being only three of the latter. From North-west Oregon, Depth 20 in. W at top 18 8/10 in. The hoofs, etc, are suspended to the ends of the strips either with twisted sinews or with little

thongs of hide, and some apparently of vegetable fibre twisted. Seven of the hoofs, etc are wanting. Given by Captain Henry Kellatt R.N. C.B. 1850.
Ashmolean 1836-68, p. 10.

843 An oblong shaped article: Probably a N. American Indian woman's Apron. It is 17 in. wide, and 8 5/10 in. deep, of parchment like hide or skin, covered on both sides with dark brown flannel, strengthened at the sides with round sticks sewn in which are covered with blue silk, with a vandyke border of the same material, 1 3/10 in. wide down by the sides sewn on to the flannel. The middle portion of the article for the width of 9 6/10 in., and the whole of its depth is covered with four bands, each W 2 1/10 in., of \an/ elaborately wrought pattern in very fine pleated quill work, done in lengths upon strings, so that each of the four bands appears as if formed of fifteen or seventeen rows of sections of small quills of feathers, about L 1/10 in. and Th 1/20. This quill work has been dyed red, yellow, green, and black, the colours being arranged in regular but singular patterns, chiefly giving one the idea of flights of steps in different positions, and others resembling \low/ doorways or chimney-pieces of a square shape, each of the two side bands and the two centre ones being the same in pattern. Each end of the four bands is edged with a tripple row of dark crimson glass beads. From the lower edge of this article [-are suspended numerous \is sewn] a piece of leather of nearly the same W, and cut into numerous narrow thongs and six side straps, each of which is ornamentally bound with the same material that the [-the] pattern is stained on; and the end of each of which supports an extinguisher shaped pendant of [-[-]\thin sheet iron] 2 in. or less in length, having the larger ends downwards, and each inclosing a little tuft or brush of black hair, probably human which projects downwards beyond the tin. There are now 57 of these pendants, six of which have lost the tin ornaments. The leathern straps or tongues are arranged three on each side, only one of which now retains the tin pendant. Whole depth 2 in. Ramsden Collection No ? Purchased by the University 1878.

844 A Knick Kneck. A pouch or bag used by North American Indians for holding their tobacco, (or substitute for it) with flint, steel, and material for lighting the pipe. It is made of an Otter's skin taken off the body entire, dressed with the fur on and retaining the skull; the underside of tail, and each of the four feet being fancifully ornamented with fine porcupine quills dyed of various colours worked in stripes on pieces of softish leather and the leather sewn to the skin; these are ornamented round the edges with fringes of small cone-shaped or extinguisher-shaped copper pendants, those on the feet being much the smallest, and only about half the size as those on the tail, and of four pairs down the middle of the back. The narrow thongs of leather by which the pendants are hung are also bound round with coloured quills. L of skin 47 in.; greatest W

11 in.; the pendants project 4 5/10 in. beyond the tail. Articles of this kind are figured in Catlin's "North American Indians" Pl. 68. p. 242. History unknown.

845 North American Indians' legging of light coloured soft leather, cut to form a fringe along the seam at the back, and also along the top. L in front 29 5/10 in.; W at top 10 in. at bottom 6 5/10 in. History unknown.

846 North American Indians dress, probably of a woman; of the same kind of leather as the preceding No 845, and long sleeves. The whole ornamented with various bands of coloured porcupine quill work, with fringes made of the same material to which are suspended pendants of claws of the porcupine, or perhaps Eagles talons. On the left shoulder is a kind of epaulet ornament, the fellow one on the left shoulder being wanting, and on each wrist are stripes also done in coloured quill work. It is made to put on over the head, and a piece has been cut out of the bottom of the front to allow for the motion of the legs. L 4 ft. 3 in.; W at bottom 2 feet 8 in. History unknown.
MacGregor 1983, no. 11.

847 A bow and six arrows, used by the Clapet Indians, Straits of Juan de Fuca, W. Coast of N. America. The bow is well shaped, L 36 8/10 in., rather broad and thin, and entirely of fir \wood/ strengthened in the middle with a binding of narrow strip of whalebone, and was probably used chiefly for shooting fish, or the smaller mammalia, as it is not by any means a powerful weapon. W 1 6/10 in., rather less in the middle, and pointed towards each end, and a groove down the middle of the back. The line is a piece of string. The arrows are 33 4/10; 32 3/10; 29 5/10; 29 3/10; 28 8/10 and 27 6/10 in. long respectively, made of rather roughly rounded strips of pine wood of different lengths, about 2 ft. to 1 ft. 8 in. long, headed with pieces of bone, L 10 7/10 to 7 5/10; of which one is simply rounded and pointed; four are pointed, and have several small barb-like notches cut along one side which is worked to more or less of a keeled edge for the purpose, and the other is rounded, with the ordinary triangular shaped double-barbed head worked at the point. They are simply feathered, each having two feathers which are tied on on the twist, to make the arrow revolve. All the bindings are of strips of bark. Given by Lieut. J. Wood R.N. Commander of H.M.S. Pandora 1850.
Ashmolean 1836-68, p. 18.

848 Harpoon head and line, used by the Clapet Indians, Straits of Juan de Fuca, West Coast of N. America for harpooning the whale, etc. It is made of a mussel, strengthened with a mass of yellowish gum-like cement on both sides, and inclosing the end of the line to which the shell is attached. The shell is ground into a pointed oval shape L 4 5/10 in., and W 2 5/10, the edges being very sharp. Two pointed pieces of bone are bound in behind with the shell and rope forming barbes projecting [-beyond] across the plane of the cutting edges. The line attached which is about L 23 ft., and

Th 6/10 in., is made of two ropes of twisted deers' sinews formed into one, and closely bound round throughout the whole length with thin string, and having at the other end, when in use, an inflated sealskin as a buoy. How a staff is used with the head to strike with does not appear. A piece of tough bark doubled, L 8 in.; W 4 in. forms a kind of case for the head. This article is an illustration of the abilities of men in a rude state, making a powerful instrument from simple and fragile materials. Given by Lieut: J. Wood, R.N. Commander of H.M.S. Pandora, 1850.
Ashmolean 1836-68, p. 18.

849 A Decoy Duck, made out of a block of fir wood; used by the Clapet Indians of the Straits of Juan de Fuca, W. coast of N. America. This when floating on the water, at a distance, might easily pass for a swimming duck, except that the head is small; but this probably was corrected by feathers stuck in the holes along the back of the head and neck, and as there are cuts across the back and other parts of the body it is probable that the whole of the figure may have been roughly covered with feathers formerly. There is a double hole cut on the underside in front, \forming a kind of loop/, so that it could be drawn about on the water by an unseen line, and probably it was thus used to decoy \the/ birds within range of their arrows. L 19 in. D 8 9/10 in. H to top of head 8 2/10 in. Given by Lieut. J. Wood R.N. Commander of H.M.S. Pandora 1850.
Ashmolean 1836-68, p. 18.

850 A "Chisel" made of Deer's (Elk's ?) horn. Used by Indians of the Clapet Tribe, Straits of Juan de Fuca, W. coast of N. America. It is L 16 2/10 in. and D 2 7/10 in. at the top, which is roughly rounded off for \convenience in/ handling; from whence it has \been/ gradually ground off on one side to a rounded flat cutting point or edge at the other end, but it appears hardly sharp enough for anything but digging purposes The other side, which is somewhat concave lengthways has been left rough in its natural state except at the top and the cutting edge. Given by Lieut: J. Wood R.N. Commander of H.M.S. Pandora 1850.
Ashmolean 1836-68, p. 18.

851 Nine disks of wood, each about D 2 in. and Th 3/10 in. They are slightly concave on the two sides, with the edges nicely rounded, and are so truly made that they might almost pass for lathe work, although on examination it is evident that they have been scraped into form. Each is perforated near to the middle, and has the pith mark in it. They are labelled "Gambling Rollers Used by the Clapet Tribe, Juan de Fuca. They stake all they possess, and even their own liberty on the game. Lieut. Wood." Given by Lieut: J. Wood R.N. Commander of H.M.S. Pandora 1850. If one or more of the set are wanting, they appear to have been given to the Trustees of the Christy Collection in 1869, in exchange.
Ashmolean 1836-68, p. 18.

852 A Cape, or Poncho; worn by Clapet Indian women in their Canoes, Straits of Juan de Fuca, W. Coast of N. America. It is made of Cedar-bark string or fibre, a coarse hemp like material, and is woven in [-nearly\exactly] the same manner as the mat or Cloak of the New Zealanders. \as seen Cook's 3rd voyage vol: 2 p. 280/ Size 1 ft. 6 in. deep; 3 ft. 2 in. across the bottom from point to point, when double, or 7 ft. 7 in. measure all round the bottom edge; and at the upper edge for the neck, to an apperture (which is edged with marten fur) of W 11 in. for the passage of the head, the cape or cloak being of one piece and without seam. It is woven in a peculiar manner, and somewhat similar (except that it is coarser) to a specimen from Robenhausen, in the Swiss Lake (Pfahlbauten) collection, namely by stretching the warp threads parallel to each other on a frame, and tying them together at intervals of about 1/2 in. with cross threads which represents the woof. The enlargement from the neck downwards being effected by the frequent introductions of fresh strands. Given by Lieut J. Wood R.N. Commander of H.M.S. Pandora 1850. A cloak of this kind is described in Woods Nat: Hist: of Man vol: 2 p.p. 724 and 725.
Ashmolean 1836-68, p. 18.

853 A piece of matting, made apparently of the tough inner bark of some tree, (Cedar?), but looking uncommonly like rushes, by Clapet Indians on the Straits of Juan de Fuca. It is very closely and well made, and plain except a narrow border in dark green and dark brown interwoven around the edges and across the middle. Size 7 ft. by 3 ft. 10 ins. Given by Lieut: J. Wood, R.N. Commander of H.M.S. Pandora \1850/.
Ashmolean 1836-68, p. 18.

854 A wooden Needle; used by the Clapet Indians, on the Straits of Juan de Fuca in making their matting. L 3 ft. 5/10 in. D 4/10 in. at the eye, slightly and gradually widening to near the other end to 15/20 in., and pointed. It is curved from end to end, and somewhat triangular shaped in section, or the back flatly convex and the front keeled [*drawing*] thus, the broad end or point being [-a\ somewhat] flattened [-above\or less keeled] above. It is a well made instrument much resembling a three edged and curved surgical [-instrument \needle in shape, but co[m]paratively more slender and less curved. Given by Lieut: J. Wood R.N. Commander of H.M.S. Pandora 1850.
Ashmolean 1836-68, p. 18.

855 A bone club or sword, from an inland tribe of Nasqually, at the head of Paget Inlet \(Washington State)/ It is apparently made of \the/ jaw-bone, or blade-bone of the whale, and is L 21 6/10 in. Th 8/10 to 3/10 in.; and W 2 5/20 in. at the widest part of the blade, which is near the point; decreasing gradually to 1 3/20 in. at the handle part, (which is also the

thickest), this end being much wider (about 2 5/10 in.) for the length of 4 in., and carved into what looks like a grotesque parrot's head form, the eyes of which may possibly have been formerly inlaid. The point which is very obtuse is ornamented on one side with a rudely incised figure of a face; and on the opposite side with a double transverse parallel row of indentations, some of which are now larger and deeper than others. The sword has also three deepish parallel grooves along the centre of the blade, which extend from near the point for the distance of 13 in. on one side, and 15 on the other. The edges are very obtuse even near the point, increasing in width to half round at the handle. There are also several incised crescent-shaped lines, as well as a ring of round indentations round the right eye, on the carved head, which seems to have served the purpose of a pommel, being perforated near the upper part of the back edge probably for a string for the wrist after the manner of the New Zealander's Patoo-patoo, to which it bears some resemblance except being longer and much narrower. See No. [] in South Pacific collection. A similar shaped weapon though differing in details is figured in Meyrick's "Ancient Armour" vol: 2 Pl: CL Fig: 7 where the locality is not given. Given by Lieut: J. Wood R.N. Commander of H.M.S. Pandora. 1850.
Ashmolean 1836-68, p. 18.

856 A wooden cup, (birch wood?) \probably made after the pattern of birch bark cups/ used by an Inland Tribe of Indians, at a place called Nasqually \(Nisqually?)/, at the head of Paget's Inlet, W. coast of N. America, (near the Straits of Juan de Fuca). It is neatly cut from a solid piece of Maple wood and varnished of a bright-colour both outside and inside \(with Caoutchouc?)/ and is somewhat of a flat bottomed boat shape with keeled ends, but extended out on the sides till it is a trifle wider than it is long, and the two ends projecting above the rim. L 4 in.; W 4 1/10 in. H 3 1/10 in.; the sides sloping to the bottom, which is L 2 8/10 in. by W 1 8/10. The cup is not very uniformly cut, as one end is higher than the other, and one of the sides a little higher than the other side. Given by Lieut: J. Wood, R.N. Commander of H.M.S. Pandora. 1850.
Ashmolean 1836-68, p. 18.

857 A small basket, probably intended for use as a drinking cup; Used by an Inland Tribe of Indians at a place called Nasqually, Paget Inlet: It is worked in patterns \in squares/ of black and straw colour, but of rather coarse make; the material apparently being \bark covered exteriorly with/ grass, \the black being some colour put on, and/ being ornamented round the rim with a double cord of worsted dyed black. Greatest D 3 7/10 in. H 2 9/10 in. Th 5/20 in. It appears to be of different make to the Mexican baskets No 823 824 Given by Lieut: J. Wood, R.N. Commander of H.M.S. Pandora. 1850.
Ashmolean 1836-68, p. 18.

858 A Bowl of dark brown wood: taken from the Canoe of an Indian Chief, on the Coast of Vancouver's Island: West coast of N. America. It is carved in imitation of a Turtle, having the back removed, the body part forming the vessel; with the head at one end, and the tail and feet at the other, forming ornamental handles. The [] is large and not very turtle like, but the whole is freely designed and skilfully executed. The plates are boldly defined, and the bottom is flat. D to outer edge of the bowl portion 6 6/10 by 5 8/10 in. Whole L 11 in.; Greatest H 3 8/10 in. Given by Lieut: E. Bouverie Pusey, R.N. 1864.
Ashmolean 1836-68, p. 12.

858a The lid of a box or bowl of dark brown wood, of a pointed oval shape, perhaps intended for the rude representation of a turtle. The rounded upper side is carved with various curved and straight rather deeply incised lines perhaps intended for scales or plates, with a projecting piece at one end. The underside is deeply hollowed out, plain, and has a prominent rim all round. Locality uncertain. L 13 3/10 in. Greatest W 7 3/10 in. H 2 7/10 in.

859 An Indian's spoon, from the West coast of N. America. Made from a horn of the mountain Goat. Bowl L 3 9/10 in. and greatest W 2 4/10, long oval shape, and much curved forwards lengthways. Handle L 4 5/20 in. and D 7/10 in., round, slightly curved backwards, [-and] diminishing to a point at the end, and carved much in the same style as the bowl No 858 above. Colour entirely black. Exact whole L 7 9/10 in. Given by Lieut: E. Bouverie Pusey, R.N. 1864.[35]
Ashmolean 1836-68, p. 12.

860 A bow thought to have been used by Indians of the neighbourhood of Vancouver's Island, W. coast of N. America. This article is ingeniously made and rather ornamental. L 4 ft. 3 in., straightish to the extent of 12 in. from each end, the middle part only being curved. In the centre it is nearly square except at the back, and D 1 2/10 in., thence becoming thinner and wider, so that at 17 in. from the ends it is W 2 3/10 in. and Th 7/10 in.; and at the ends the size is again diminished to W 9/10 in. and Th 7/10 in. The wood has been bent into shape by steaming, (as in the Esquimaux bow No 733), but, as it is of Pine wood, would be very slightly elastic, this property of the bow being given by a number of very finely plaited lines of animal sinews mixed or plaited in with human hair \and red worsted/ which extend from end to end along the front. The bow is rudely but curiously ornamented with red blue and yellow patches and lines. Pieces of bone and wood are laid along the front underneath the lines of sinews, apparently as strainers. Purchased in 1869. (For a similar weapon see Wood's Nat: Hist: of Man, vol: 2, pp. 725 and 726) (The Indians of California make their

[35] I think it very probable that this spoon belongs to the bowl No. 858 thought it does not state so.

bows in this manner, It may therefore possibly be from there).

861 An arrow from the same locality as the preceding article; made much after the manner of the Esquimaux bird spears which are used with throwing board, (See Esquimaux collection, No 718 719). The shaft is L 2 ft. 4 3/10 in. \D 4/10 in./ of wood, neatly rounded, headed with a piece of bone of the same size, L 6 3/10 in., into a socket in the end of which a pointed harpoon-head L 1 8/10 in., having three barbes cut on one edge, is fastened, but only so that it may be easily detached. This harpoon head is also attached to the shaft by a fine line of plaited sinews, which is single to the extent of 2 ft. 11 in., and then \only about half the size and/ double for nearly the same distance, the ends of which are fastened at some distance apart to the middle portion of the shaft. When used, with the line neatly coiled round the shaft, and the head fixed in its place in the socket, on striking an animal the shaft becomes detached, and being thrown by the double line across the track of the creature it acts as a check to its escape (It could also be used for turtle or fish shooting, the shaft serving the purpose of a drag, float or buoy, and also as a hand grip. It could only have been used for small animals, but I am of the opinion that it was used for catching fish.) In principle it is exactly like to the Esquimaux darts referred to above, except its having been used with a bow instead of a throwing board. The joining of the wood and the bone of the shaft is strengthened with a piece of bark bound round with a fine line of [-plaitea\plaited] \twisted/ sinews. Whole L with harpoon-head in position 36 4/10 in. Purchased in 1869. (For a similar arrow, said to have been used for killing fish, see Wood's Natural History of Man, vol: 2, p. 727).

862 A Tobacco-pipe made by Indians of Lower Canada; the bowl being out of dark grey slate-stone, and having the figure of a Beaver at the back, facing upwards, and the head of a Moose-Deer on the front, facing downwards, both being correctly and neatly cut. The remainder of the ornamentation merely consisting of incised quatrefoil and trefoil figures combined with circles which are made to appear to spring by a stem from the neck of the pipe, and apparently intended to represent flowers. The stem or tube which is L 7 1/10 in. and D 9/20 is \nearly/ quadrangular, (except 1 9/20 for the mouth piece which smaller oval-shaped and smooth) of white wood, ornamented with various carved lines on three in a kind of pattern, and attached to the bow[-e]l, by a loop carved at the bottom, with a bit of pale blue ribbon, the other end of which is tied round a groove near the middle of the stem. Whole L 9 3/10 in., L of bowl only 2 3/10 in. D of top 1 in., the bowl being of the common ordinary shape, excepting the \two/ figures, which are wholly carved out and only rest like against the bowl. Given by Greville J. Chester B.A. London 1870.

863 A pair of Canadian (Micmac ?) Indian's Snow-shoes. They are boat-shaped in outline, and pointed at both ends, but quite flat except a[t] the toe which curves upwards at the point in front about 4 in. The sides are of quadrangular pieces of wood, bent into the proper shape, about 1 3/10 in. in \greatest/ depth, and 8/10 in. \greatest/ thickness, with three light wooden st[r]etchers between them, the two la[r]gest of which are oval-shaped in section, the small front one being quadrangular but flat; the spaces between being filled up with a fine but strongly made net-work of thongs of hide, that in the middle division being much coarser and stronger than that at the front and back, for the feet to rest upon. The square opening called the eye is for the toes to play up and down through. L 4 ft. 9 5/10 in.; greatest W 13 8/10 in. These articles are called snow-shoes, but they might more properly be called snow skates, as they are for sliding more than walking on the snow, the large surface keeping the feet from sinking into it. The use of snow-shoes gives the Indians a peculiar gait, as they must keep the feet far apart, and the toes straight to the front when using them. For figure and description of the way of wearing snow-shoes, see Wood's "Nat: Hist: of Man" vol: 2 p. 663 Given by Lieut: Francis Harding H.M.S. Griper 1824 presented in 1827.
Ashmolean 1836, p. 185 no. 316.

864 A Canadian Indians' Canoe, made of a single piece of bark of the Paper Birch (Betula papyracea). L 20 ft.; greatest W 33 in. It is beautifully shaped, very light, and capable of holding four persons. For the way of making birch bark canoes, and figures of ditto, see Wood's "Nat: Hist: of Man", vol: 2 pp. 690-692. Given by James Parker, Esq. The Turl, Oxford, 1858.
Ashmolean 1836-68, p. 11.[36]

865-866 Two Canadian Indian's Paddles, of pine-wood coloured or stained of a yellow colour; belonging to the Birch bark Canoe No 864. They are neatly made, having flattish long leaf shaped blades L 3 ft. and W 7 in., with a slight ridge along the middle on each side; above which the handle is nearly round for the distance of 15 in. in one and 20 in. in the other, and D about 1 3/10 in. from whence it is wider and flattish to the end, and D from 2 to 2 5/10 in. Whole L 6 ft. 5 in. Given by James Parker, Esq. The Turl, Oxford, 1858 \or 1864?/.

867 One ditto similar but smaller paddle, L 5 ft. 7 \1/2/ in. W of blade 6 5/10 in. Ditto, ditto.

868 A native-made model of a Canadian Indian's Birch-bark Canoe, and \two/ paddles. The model is made of bark, the sides being ornamented with porcupine quill work dyed red, blue, and yellow, edged below with a lozenge shaped border in black. L 15 in.: W 3 8/10 in. L of paddles 6 5/20 in., W 15/20, and 7/10 in. For a similar model see Wood's Nat: Hist: of

[36] ... where it is said to have been given in 1864, which is [-evidently\probably] a mistake

Man, Vol. 2, p. 691. Mrs Birkbeck, Widow of Dr. Birkbeck, originator of Mechanic's Institutes. 1873.

869 A native made model of a Canadian Indian's Birch-bark Canoe, ornamented along the edges, and \the tops of/ stretchers with yellow quill-work. A very old specimen a good deal damaged many of the ribs being loose, and one end broken. L 5 ft. 8 in., W 10 8/10 in. L of two paddles 23 3/10, and 22 1/10 in. History and locality unknown.
Ashmolean 1836, p. 174 no. 14; MacGregor 1983, no. 355.

870 A somewhat \pointed/ oval-shaped piece of birch-bark, ornamented in a kind of diamond-shaped pattern on one side with quill work, dyed blue, green, and yellow, Probably intended for [-an ornamental stand\producing a low humming noise by being whirled round and round by hand by a string tied at each end]. Locality unknown. In bad condition. L 7 7/10 in. W 3 4/10 in. North American Indian. (Ramsden collection No ? Purchased by the University 1878).

871 A woman's cloak made of intestines of the Seal, or Walrus; worn by Females of the Aleutian Islands, Behring Sea. This article, if made of textile material, might very well pass both in shape and ornamentation for the work of an English dressmaker. It is of the usual form, open down the front, gathered in neatly to a narrow collar \2 in. wide/, for the throat, from which hangs a cape 11 5/10 in. in depth, which also is open in front. Whole depth 4 ft. 5 in., measurement around the bottom 11 ft. 9 in. It is entirely made of strips of finely prepared entrails, each strip being about 2 3/10 in. wide, which are arranged horizontally, and sewn together with a neatness which could hardly be surpassed, the seams being scarcely visible. There are four such widths to form the cape, and twenty the body of the cloak not including the [-wider\plain] band which forms the collar; and as each strip is stained white along the middle while the edges or sides are of an almost transparent horn colour, the whole appears in horizontal stripes. The collar and all the edges are ornamented with a \coloured/ border, the workmanship of which is really surprising, [-formed of the same kind of material as that of the cloak], and is made of a black strip 1 2/10 in. wide \of the same material as the cloak/, on which are sewn seven very narrow horizontal bands \some of which differ slightly from the other material/, each about W 1/10 in. and coloured red, blue, and white, each band being of a separate colour. The stitches in these bands are minute, and they appear as truly parallel, as if done with a modern sewing machine. Around the whole of the cloak on the outer edge of this coloured border, is an edging W 5/10 in. of what at first sight loooks like intestines \formed into a kind of lace from being punched up from the back/, but which on closer inspection appears to be the skin of some bird, probably of the duck tribe, from which the down \or feathers/ has been \either/ purposely removed or \else/ accidentally destroyed by

insects, probably the latter, as the whole cloak has been greatly damaged by the moth, [-and has now much the appearance as if intended for lace]. The whole of the \coloured/ bordering is done in a similar manner, but the colours are arranged rather differently on the cape, the front, and round the bottom, and some of the little red bands has been delicately ornamented with a fine [-quill-work?\white] quills after the manner of some of the Canadian Indians' work, in a lozenge pattern which is also sewn on. Of what material the needle \with which it was made/ may have been [-made of] is not stated, but it was probably a fine pointed \fishes/ bone. The thread has been manufactured out of animal sinews. Altogether it is a very beautiful specimen [of] Indian skill, though it is much inferior to what it was originally (Refer to Esquimaux collection No. 654 to 658, and 705[.]) Capt. W. F. Beechey R.N. Given by him 18[].
Ashmolean 1836, p. 183 no. 137.

872 A sheet of leather, made up of four skins or portions of skins, perhaps of the [-Buffalo\Deer], and rudely ornamented with white shells (Marginella margarita) pierced and sewn on with shreds of animal sinews. The pieces of skin are neatly sewn together forming four quarters, but the outer edges are left rough and irregular. From the central seam lengthways both [-animals] sides are ornamented alike. In the middle is the rude figure of a man standing with square shoulders, and very straight arms which hang down by the sides, with a head, but no attempt to represent a face, the whole being formed of close lines of the shell which in the figure only are reduced in size \by grinding away the fore part of the shells/. On each side of this central figure, as if standing upright on its hind legs, and parallel with it, is that of an animal having a long tail tapering to a point, and very Lizard like in shape, except that it has prominent ears[;] these figures also are formed of close lines of the shell; But besides these there have been thirty-four disks (three of which are gone) each formed of a continuous coil of shells, so that each is ten rows deep and D about 7 in. L about 7 ft. 6 in.; W 4 ft. 6 in.

"This article is interesting as being at least of a rare kind, and from all inquiries made with the exception of the following, it has hitherto seemed to be unique. The locality from whence it was procured is uncertain, as it was found some years ago stowed away in a box, all hair from the surface having disappeared." From the rarity of such articles, and other circumstances, it has been suggested that this may have been brought home by the younger Tradescant, who in the early part of the 17th century travelled and collected in Virginia, and the West Indies, where the shell is very common, and that such articles may have been the work of natives who then inhabited the Islands, or the Coast, but whose race have now ceased to exist in those parts."

I presume this article is that entered in the Tradescant catalogue of 1656, page 47, as "Pohatan,

King of Virginia's habit all embroidered with shells or Roanoke" (Edward Evans, 1879).[37]

873 A North American Indian's Apron of coarsely made thin flannel of a reddish-brown colour edged all round with a twisted narrow binding of raw hide to prevent the edges from tearing, and thickly ornamented in a singular pattern with close set rows of small white shells (Marginella margarita), the largest being arranged round the margin, and each shell being ground off flat at the back and sewn on in rows, the thread being of the same substance as the apron and passing along the mouth of each shell. The pattern consists chiefly of lines of shells at different angles, squares and disks. The apron has been a good deal strengthened by darning, the threads \of which/ being very visible at the back. Shape square, size 1 ft. 8 in. by 1 ft. 6 in. Given by Mrs Birkbeck, widow of Dr Birkbeck, originator of Mechanics' Institutes, 1865. Ashmolean 1836-68, p. 4.

874 A belt, or sash, made in twenty longitudinal ridges, of a very coarse woven cotton \like/ thread, or fine string, the thread running transversely. It is ornamented on the front with numerous small perforated disks of white shell D 3/10 in. or rather less, sewn on with the same kind of [-material \thread] as the belt is made of, in lozenge-shaped patterns, between which as well as over the other part of the belt were formerly variously coloured feathers, woven in in the making, in regular rows, but these have been destroyed, leaving only just the stumps visible. The material of the belt is apparently flax, and the disks of shell are [-concave\hollow] on the underside and [-] rounded above. L 5 ft. 8 5/10 in. W 4 4/10 in. Given by Captain \F.W./ Beechey \R.N./ probably 1825-1828. Ashmolean 1836, p. 183 no. 138.

875 Indian's belt, probably from California \or Mexico/ the middle portion apparently forming a pocket. It is made double, of rather stout light brown leather, the two sides at the ends being separated, and cut perhaps to represent a snakes head and neck, which for the length of about 9 5/10 in. are each ornamented with perforated small disks \made/ of \sections of/ white shell, about D 1/10 in., sewn in rows very close together edgeways by a fine double fine twisted thread made of sinews, the leather being slit down longitudinally into shreds for the purpose of their insertion, the edges of the disks shewing equally on each side of the leather, and firmly kept in position by means of the double thread arrangement. Above this singular ornamentation, at one end, is a double row of small white shells, each of which has been ground off

at the ends to allow of a string to pass through for stitching them onto the leather. This is now imperfect, and is at the end forming the bottom of the pocket. L 2 ft. 7 in., measured to the end of the white large beads at the ends, and which may have been used for fastening. History unknown.

876 A Bag, or knapsack, made of very close and curiously woven fine string made of [-flax\fine inner bark of a tree] or some such material. W 12 5/10 in.: depth 6 in.: the upper corners forming bags of net-work, L about 21 in. and of large capacity, the mouths being at the opposite end from the bag, which has a piece of inner bark roughly sewn on one side probably the side which is worn inner most \or next the body for softness/. The edge of the mouth of the bag, and also of the nets are slightly ornamented with some plaited brown thread, apparently made of the same material as the rest of the bag. It may have been used for carrying round the body. Locality and history unknown. Perhaps Mexican \or Californian/.

877 A cylindrical shaped box, or knapsack with lid; each made of a single piece of bark sewn together firmly up the side with split cane or rattan, the ends being of wood tied in with split cane, the outer edges being ornamented round with a thick rounded mass or hoop of fine, coloured wicker work. The box and the lid, (which is rather a deep one, and fits over the lower part) has little hoops round them also of ratten, two round the lower portion, and one round the lid to which are worked strong loops along one side, as if for a strap to pass through to connect the lid with lower part and perhaps for carrying it as well. It may have been carried on horseback. H with lid on 11 in. D of the top and bottom 7 5/10 in. D of the upper edge of the lower part 5 5/10 in., of the lower edge of the lid 6 in. Ramsden collection No (?) Purchased by the University 1878.

878 A large and curiously shaped basket, made of split cane and rushes, covered on the outside with rattan, or fine wickerwork coloured red, black, and brown, done in close zig-zag bands, It has been made to take into three parts. The bottom part which the next above fits on to, is cylindrical in shape is H 11 in. and W 14 5/10: The next part is H 13 in. and of the same width as the preceding for the height of 4 in., and which it fits over like a cover, then sloping to the height of 5 5/10 in. to D 7 3/10 in. which width is continued to the height of 3 8/10 in., and is covered by a somewhat conical-shaped lid H 8 in. and W 8 to the height of 2 4/10 in., sloping off thence to 3 3/10 in. at the top which is convex. In shape it a good deal resembles one of the tea canisters. Whole H 2 ft. 3 5/10 in. [*drawing*] Ashmolean 1836. p. 184 no. 168.

879 A bolas, a kind of lasso (native name somai). Used by the Patagonian Indians for entangling the legs of the Ræa (the American Ostrich), and Guanaco. It consists [of] bags of skin H 2 3/10 in. and D 2 in. and 1 8/10

[37](Pohatan, or Powhattan \as the name is sometimes spelled/, was the father of Pocohantas, who married an English Captain named \John/ Rolfe, and from whose \only/ son some of the principal Families in Virginia have descended and are now living there, namely the Randolp[h]s, etc. Pocohantas was buried at Gravesend; there is a great deal of romance about her life.)

in.; filled with some heavy material, perhaps iron, each weighing about 6 ounces, and united by a line of fine plaited sinews L 6 ft. 8 in. and D 2/10 in. the ends of which form reeving strings and inclose the balls. Given by Captain King R.N. 1831. For figure and way of using the Bolass, see Wood's "Nat: Hist of Man" vol: 2 pp. 528-530 and 533. When used the balls are thrown so as to whirl around the legs of the animal and retard its progress. The Esquimaux use a somewhat similar means for entangling the wings of birds. See Esquimaux Collection No. 656-670
Ashmolean 1836, p. 183 no. 117.

880 A Spear L 15 ft. 3 in. (but formerly longer, as 5 in. have lately been \by accident/ broken off the bottom being so worm eaten. Probably about 16 ft. when perfect). Used by the \Auracanian (Araucanian?)/ Indians of the interior of Chile, when on horseback. The shaft is of male bamboo cane D 1 3/10 in. at the lower end, gradually diminishing to 8/10 in. at the top, which is lashed on to an iron leaf-shaped head L 1 ft. 2 5/10 in. and greatest W 1 3/10, with a strong thong of hide, to one side of the shaft. A spear of the same length is used by Indians of Gran Chaco. See Wood's "Nat: Hist of Man" vol: 2 p. 569. Given by Captain F.W. Beechey R.N. (probably [-1825-1828] \1832/). (The other long spear \given by Beechey/ is entirely of black wood and is now in the South Pacific collection and is said to be from Tahiti.
Ashmolean 1836, p. 183 no. 135.

881 A Bow and seven arrows: used by Indians on the coast of Chili. The bow which is flat on the front and rounded on the other side, is made of hard brown wood covered from end to end on the front with animal sinews, in what appears to be one piece, and bound round the middle for \the length of/ 5 5/10, and at each end for 1 5/10 in. with narrow thongs of thin brown leather. L 3 ft. 6 5/10 in.; W in the middle 1 5/10 in., Th 7/10 in., tapering to W 5/10 in. at the ends. The strength of the bow depending greatly on the elasticity of the sinews, the wood acting chiefly as a fulcrum for the strain (See also No 820). The arrows which range from 3 ft. 8/10 in. to 2 ft. 9 4/10 in. whole length, are made of reed having the knots nicely smoothed down so as to be hardly visible, so that they look more like light brown wood, are headed with pieces of light coloured wood, three of which are coloured red, varying from 8 8/10 to 4 3/10 in., which are smaller and fit into the end of the reed which is strengthened by bindings of thin sinews. These pieces of wood are neatly tipped with small, pointed and serrated pieces of chipped obsidian, (volcanic glass) \and [-white] of flint,/ which as well as the three feathers at the end of each arrow are also bound on neatly with fine pieces of sinews. The obsidian points are let into into a little nick in the top of the wood and are kept firmly fixed by the contraction of the sinews which partly cover the point and partly the top of the wooden heads. The feathered ends are painted with rings in red and black.

Whole L 3 ft. 8/10; 2 ft. 11 6/10; 2 ft. 11 2/10; 2 ft. 11 2/10; 2 ft. 11; 2 ft. 10 8/10; 2 ft. 9 4/10 in. Given by Lieut: Cole R.N. 1828.

882 Fishing harpoon head of bone used by Patagonians and also Fuegians. From Terra del Fuego ? South America. They are fixed on long shafts, as spears or javelins, the bottom of the head being cut to fit into a hole [at] the top of the shaft and attached to it by a strong twisted thong L 2 ft. 6 in. of Seals or some such marine animals hide; this head is easily detached from the shaft when the animal is struck, the latter \(That is the shaft)/ then acting then acting as a drag. L 14 4/10 in.; greatest W 1 in., tapering to a long and sharp point, the edges being somewhat keeled, and one of them deeply barbed by a piece 3 2/10 in. and 4/10 deep being cut from one edge \to/which is also fasten[ed] the end of the line, at 1 6/10 in. from the end fitting it in the top of the shaft. For an account of this Fishing harpoon ‾ See Wood's "Nat: Hist of Man" vol: 2 p. 317 and figure p. 535 Given by Captain King R.N. 1831.

883 A pair of wooden stirrups, used by Indians of South America (probably Patagonia), but presenting a great contrast to those of No []. Each stirrup is made of one piece of [-light\pale brown] tough wood, L about 11 in. running the way of the grain, Th 6 /10 in. and rather more in width at the bottom for the foot to rest upon, the sides being thinner. They are ingeniously made, by the wood being cut partly through and \the sides/ bent together to form a triangular-shaped loop 3 in. high and 4 2/10 in. wide, and securely tied together end to end \at the top/, with narrow thongs of raw hide; similar pieces of the same material, cut into lengths, and plaited together in a square shaped rope, forms the suspending straps, which are about whole L 15 in. and D 4/10 in., each having a roughly made loop at the top. Whole L 17 4/10; and 17 2/10 in. Given by Mr Sherrard Camberwell 1824.
Ashmolean 1836, p. 183 no. 121.

884 Horse's head gear, used by Indians of South America, (probably Patagonia). Made of strips of raw hide, the greater portion of which have been slit into narrow strips or thongs, and very neatly plaited together into straps W 8/10 and 6/10 in., and L 2 ft. 4 in. and 1 ft. 1 5/10 in. The fastenings, being in the form of little buttons, made by plaiting the ends of the thongs together, [-and are buttoned\after having been pushed] through holes in the straps. Given by Mr Sherrard Camberwell 1824.
Ashmolean 1836, p. 183 no. 121.

885 Fishing Bow and Arrow: from Pebas Peru, the hig[h]er parts of the Marañon source of the Amazon. Used for shooting Turtle, or Fish. The bow is well made of hard, [-very] dark brown wood, 6 ft. 9 2/10 in. along the back in shape half round in section, the flat side being inwards or at the back, W 1 5/10 in. and Th 15/20 in the middle, and gradually diminishing but retaining the same form, to W 17/20 in. and Th 4/10 at each end [-which\from which] are narrow projections

above an inch long to receive the ends of the line. It is very smoothly and nicely finished. The shaft of the Arrow is L 3 ft. 5 8/10 in., D 9/20 in. near the head but diminishing \in diameter/ nearly 1/10 at the other end, and made of the grass stem (Gynerium sacchardoides) see No [], headed with hard black wood L 2 7/10 in. cylindrical and of the same diameter as the stem, but deeply hollowed round the sides of the middle part to form a kind of [-reel\fixed winder] on which to wind the line, and socketted at the top, into which a cylindrical \and/detachable [-wooden] head of the same kind of black wood, L 2 4/10 in. and D 4/10, [-having \fits] having a slit or groove cut in one side of the top [-and\which] receives a stout iron point L 1 2/10 in., and D 3/10 by 3/20 in. and which is firmly bound with a fine thread. This detachable head \has/ fastened to it one end of a long fine line of twisted flax like fibre, L 23 ft. 6 in. and Th 1/16 which when used is neatly wound round the [-the reeler\fixed winder] on the top of shaft, and the other end of the line secured to it. Whole L with head fixed in position 3 ft. 11 8/10 in. It has two feathers bound on the end, and is nicked for the bow string. These arrows as described by the donor were for shooting fish, as follows - the head was poisoned and on striking the fish the shaft became detached except by the line, and served as a float; as the fish generally became insensible before the line was run out. Bates describes such arrows as used unpoisoned for shooting Turtles, and says he was astonished at the skill displayed by the Indians. See his "Naturalist on the Amazon" vol: 2 p. 260. Given by Lieut: Maw R.N. 1828.[38]
Ashmolean 1836, p. 183 no. 124.

886 Turtle arrow, probably from Guiana. The shaft is made of a tolerably straight stick, L 4 ft. 9 3/10 in. having a flattish plaited line L 4 ft. 7 in. and W 3/10 in. fastened to it near the top; to the other end of which a detachable head of wood whole L 6 3/10 in., headed with a flat triangular shaped barbed [*drawing*] head \1 8/10 long by 1 in. wide/ of iron is very securely bound. This head has a socket in the lower end which fits on the obtusely pointed top of the shaft. When an animal is [s]truck the line uncoils, and the shaft of the arrow acts as a float or drag to show the position of the animal beneath the surface of the water. Whole L 5 ft. 3 in.; D 4/10 in., near the head, decreasing a little [-and] gradually to the other end which is feathered, and nicked for the string of the bow. Ramsden collection No ? Purchased by the University 1878. (For the figure of a similar arrow see Wood's "Nat: Hist: of Man" vol: 2 p. 594).

887 A Blow-gun or Zarabatana, from Pebas, in the Lower Missions of Peru. Used by the Indians for shooting monkeys, Birds etc with small poisoned arrows; (on the principle of the puff and [d]art system)

It is L 7 ft. 4 2/10 in., and D 17/20 in. at the top, gradually in width increasing to the other end which is D 1 5/10 in., which has a cylindrical thick wooden mouth piece L 4 7/10 in. and D 2 9/10 in. at the ends, from which the sides are hollowed so that it is only D 1 5/10 in. in the middle; this a conical shaped opening W 1 7/10 in., so as to collect the breath for the expulsion of the arrow. The bore is W 4/10 in. and very straight and truly made considering that the article is made of two pieces of wood joined together lengthways half of the bore being along each piece of wood; the whole of the outer side is bound round with with thin wickerwork or something of the kind coated with wax, [-or some kind of sugar]. For the way in which these articles are made \and used/, and also the arrows, see Bates' "Naturalist of the Amazon", vol: 2 p. 236; and Wood's "Nat: Hist: of Man" vol: 2 p.p. 583 and 584, right hand figure. The arrows (see No []) are made from the hard rind of the leaf-stalk of certain Palms, thin strips being cut, the ends rendered as sharp as needles and then tipped with the fatal Urari (Wourali) poison (see No []). They are winged with a little oval mass of Samaüma silk (cotton being too heavy) which should fit to a nicety the bore of the blow pipe. A most graphic account of the Urari, and an Expedition undertaken to search of the tree in Guiana, has been given by Sir Robert Schomburgk in the "Annals and Magazine of Natural History", vol: 7 p. 411. See also Wood's "Nat: Hist: of Man" vol: 2 pp. 589 and 594. Another weapon of this kind is used in some parts of South America, called a Pecuna, and made with a reed, of which although of not more than D 5/10 in., the first 14 or 15 ft. is without a knot, is uniform in diameter; and easily polished within. A tube of this sort would be too weak for use, but this is remedied by passing it up another of a stouter kind. See Wood's "Nat: Hist: of Man" vol: 2 p. 583, left hand figure. The Sumpitan, or blowing tube used by the Dyaks of Borneo, is made by boring into the solid wood, (see No. 136 Asiatic collection) Given by Lieut: Maw R.N. 1828.
Ashmolean 1836, p. 183 no. 123.

888 A Quiver and Poisoned Arrows, used by Indians with the Zarabatana or Blow-gun. From Pebas in the lower missions of Peru. The quiver is ingeniously made of portions of sword like leaves, one side of which is cut away to the mid rib. They are arranged as to fold and slide one over the other so that the mouth can be drawn into any size. L 8 4/10 in.; Greatest D 3 in. The arrows are straight, round and slender bits of wood, L between 7 and 8 in., and Th 1/10 in. in the middle, but decreasing to nearly a point at the ends, one of which is charred. They are arranged parallel, but separated from each other, between a double string at each end, the strings being twisted in opposite directions so as to hold each in its place, but allowing of its being easily withdrawn without disturbing the rest: one hundred and seventy arrows thus forming a band L 16 in. and by which means they can be rolled up into little compass and do not rub the one against the [other] See

[38] The other arrow was given to the Trustees of the Christy collection, in exchange, in 1869.

Wood's Nat: Hist: of Man vol: 2 p. 586. Given by Lieut Maw R.N. 1828.

889 A Pouch for holding the fine silk like material which is bound round the end of the poisoned arrow, to confine the breath in the Zarabatana, or Blow-gun. It is of a pear-shape, closely made of narrow plaited bands of fine [-string\fibre, perhaps flax] in longitudinal rows \or ridges:/ of a dark brown colour on the surface \as if coated with some substance/, and somewhat shiny apparently from wear, and having a small square shaped opening underneath the larger or bottom end, D 8/10 in., and a long loop for carrying it at the small end or top, so that the material (of which it is full) [-are] is protected from rain. L 8 in. D about 3 in. See Wood's Nat: Hist: of Man, Vol: 2. p. 588. Given by Lieut: Maw: R.N. 1828.

890 A small, and somewhat globular-shaped pot, of reddish brown earthenware, of Indian's make; containing Wourali or Urari poison. Used by Indians of the neighbourhood of the Amazon, to poison the points of their little arrows, (see No 888), which are used with the Pucuna, and the Zarabatana, or blow gun; (for the latter of which see No 887). H 2 5/10 in.; greatest D 3 4/10 in. Greatest D of rim, which is not truly circular 2 9/20 in., Th of ditto 3/20 in. It will stand upright by the bottom of the underside being flat, 9/10 in. wide. Given by J. Barnett, Esq. British Consulate, Mexico. \Date (?)/. (See Wood's "Nat: Hist: of Man". Vol: 2. p. 596). Ashmolean 1836-68, p. 4.

891 A Quiver and forty poisoned arrows: from Cameta near the mouth of the river Tocantins, near that of the Amazon, Lat 2° 11' S Lon: 49° 32' W. Used with the Blow-gun. The quiver is cylindrical in shape, and made of neatly and closely woven \brown/ grass, L 18 5/10 in., and D 5 1/10 at the bottom which projects all round about 5/10 in. beyond the other part, and is closed with a piece of skin with the brown hair on it. The arrows made of hard rind of the leaf-stalk of a Palm, are straight, rather roughly rounded, varying from L 21 8/10 to 19 3/10 in. and pointed at the head, which to the extent of about 2 in. or less has been poisoned in most of them. When used the other end of the arrow is wound round with Samaüma silk (or as Wood in his "Nat: Hist: of Man" says, "with wild cotton taken from the Bombax Ceiba, and fastened on the arrow with a fibre of silk grass"), to fill up the tube of the blow- gun. (See also No 888). Experiments are said to have been tried with arrows of this kind after being in England for thirty years, and the poisoned [] was still found to be effective. Given by Sir J. Everard Home, Bart: 1839. See Wood's "Nat: Hist: of Man", Vol: 2. pp. 582 and 588. Ashmolean 1836-68, p. 8.

892 Two flowering stems of Gynerium saccharoides, ("Kew catalogue"), a kind of grass, used by Indians of South America, for making the shafts to their arrows, for which purpose they are peculiarly suitable, being very straight, light, and strong. L 5 ft. 1 in. and 4 ft. 8

5/10 in. Greatest D at bottom 7/10 tapering gradually to the top which is a little smaller. Given by Sir J. Everard Home, Bart, 1839.

893 A Bow and eight arrows, from the Ucayali, Peru, one of the principal sources of the Amazon. The bow is of a singular shape both back and and front being very nearly flat, and the edges square. It is of heavy and very dark brown wood, almost black, quite straight, the line being wanting, L 6 ft. 2 in. W 1 4/10 by Th 6/10 in the middle, and gradually diminishing to W 7/10 in., and Th 3/10 in. at the ends, which project 1 in. and are small, and rounded for the string. All the bow except about 15 in. at the ends, is closely and neatly bound round with cotton threads, stained in bands and patterns of various colours. The shafts of the arrows are made of the flowering stalk of the grass Gynerium saccharoides (see No 892); and as the heads are various in form \and construction/, each arrow seems to require a separate description.

[**-893a** Shaft L 4 ft 2 8/10 in., headed with a straight round piece of hard dark brown, almost black wood, L 18 2/10 in., and D 7/20 at the bottom, gradually tapering to a sharp point at the other end, and bound round with a small tuft of brown fibre with another of small yellow red and green feathers below it, these are at 7 in from the point, which is incised round perhaps as a receptacle for the poison. Whole L 5 ft 9 in.]

[**-893b** Similar in every respect to the preceding, 893a but not having the feathers. Shaft L 4 ft 5/10in. Wooden head 18 5/10 in.]

893a Similar to the two preceding; but the head without the fibre and feathers, and much heavier. Shaft L 3 ft 3 4/10 in. L of head 1 ft 6 9/10 in, D 5/10 in. It is painted black at the other end and has two white feathers bound on on the twist, only portions of which remain.

893b Similar, but with a still heavier head, the point of which is armed with a barb of like wood securely bound on. L of shaft 39 5/10 in. L of head 2 ft 1 9/10 in., D 5/10 in. The junction of \the/ head with the shaft is neatly ornamented with a binding of coloured \cotton/ thread, the upper part of which \is crossed/ and binds on a small tuft of black hair, which only surrounds half the wood, and is directed backwards. The other end is painted black and has two long white feathers bound on on the twist, only one of which is perfect.

893c Similar to the preceding 893d, but the head very much shorter and smaller, and ornamentally bound with coloured cotton only \which is crossed and fringed at the upper part./ L of shaft 4 ft 4 1/10 in., of the head 11 8/10 [-ft.\in.]. The other end painted black, with two black feathers (which are imperfect) bound on the twist.

893d Similar to the preceding, but the head being much longer, of pale brown \wood/, with three painted

black rings round it \at intervals/ and having lost its barb at the point, the slit \[-for which]/ remaining by which it was fixed. L of shaft 3 ft 1 6/10 in, of head 1 ft 10 in. The other end \is painted black and/ has two black feathers bound on on the curve.

893e Similar to the preceding, 893d, but the pale brown wooden \head/ painted brown, black, and yellow in an ornamental pattern, the bone barb being so arranged that it also forms the point of the arrow, and securely bound in. L of shaft 3 ft 1 9/10 in, L of head 24 8/10 in. Painted black at the other end, with two black feathers tipped below with white, one of which is gone.

893f Similar to the preceding, No 893e, except that the head instead of being rounded is quadrangular, (in this respect being different from any of the rest). It is painted with plain, \cross/ black and brown bands, and between them, in \black/ [-with] a pattern in lozenges surrounded by narrow lines. The bone barb is adjusted in the same manner. L of shaft 3 ft 8 in; of head 1 ft 9 5/10 in, D of ditto 9/20 in. The other end has been coloured black and has had black feathers.

[-893 Ditto, the head being of light wood colored red, and the bone barb bound on flat \or sideways/ instead of edgeways. The feathered end has been broken off. Length of shaft 47 5\10 in; length of head 17 4\10 in. (Does not belong to the same set as see original writing on article, and the manner of fixing the feathers.]

893g Ditto, the shaft being of the same material as in all the preceding \L 40 2/10 in./ headed with a round piece of hard dark wood, gradually tapering from where it joins the shaft forwards, L 14 7/10 in. \and 3/10 in. greatest D/, which has a long leaf shaped piece \of poisonous bamboo/ cut to sharp edges and point, L 11 3/10 in, and 1 1/20 in greatest W tied on with crossed coloured cotton threads. The other end is painted black and has had two long white feathers mottled with brown bound on one of which is perfect, but only a fragment of the other is left. Whole L 5 ft 4 in.

893h Similar to the preceding, \893g,/ but the dark wooden head thicker and longer, the bamboo point being leaf-shaped but very much shorter. L of shaft 38 5/10 in; L of wooden head 20 6/10 in; L of bamboo point 5 3/10 in, W 1 2/10 in. Painted black at the other end but feathers gone. The cotton binding at the junction of the shaft and the head has a fringe round the top. Given by Lieut Maw, R.N. 1828. For similar arrows see Wood's "Nat: Hist: of Man", Vol: 2, pp. 597 & 598.

Ashmolean 1836, p. 183 no. 125.

894-894f Seven "Arrows from Tocantins a River that enters the Amazon near its Mouth" "Presented by Lieut. Maw, R.N. 1828", as follows.

894 Arrow the shaft being of the same material as the preceding, the head of light wood coloured red, and having a bone barb, which also forms the point bound on sideways or flat, instead of edgeways as in some. The feathered end has been broken off. Present L of shaft 47 4/10 in., L of head 17 2/10 in.

894a-f Six ditto of the same set the shafts of all except one, \(which is of knotted reed)/, being of the same grass stem as in the preceding, the heads being of pieces of \poisonous/ bamboo, round on one side and deeply hollowed out on the other, and fastened to, or rather into the shafts by short pieces of hard, dark brown wood, the junctions being strengthened with bindings of coloured cotton threads, the feathers being bound in quite a different manner to those on the preceding set of arrows, not being bound on neatly their whole length with very fine bits of fibre or grass, but securely fastened at the top and the bottom \only/ by cotton thread bindings, and the ends \of the arrows/ hollowed out at the sides and also neatly bound with cotton threads, and nicked at the end for the bow string, whereas none of the preceding have nicks for that purpose. The \bamboo/ heads are cut to sharp edges and points.

894a L shaft 4 ft 9/10 in; D 6/10 in. Whole L of head 15 4/10 in, W 1 2/10, the cotton binding of which is ornamentally crossed \or interlaced,/ feathers two, black and not split. Whole L 5 ft 4 2/10 in.

894b Shaft of yellow reed 41 1/10 in: D 5/10 in. L of head 18 3/10 in; W 1 1/20 in, cotton bindings of ditto ornamentally crossed. Feathers black. Whole L 5 ft 11 5/10 in.

894c Shaft of grass stem. L 46 5/10 in; L of head 11 9/10 in, W 19/20 in, feathers black and white. Whole L 4 ft 10 4/10 in.

894d Ditto, L of shaft 48 8/10 in, L of head 7 6/10 in, W 19/20 in. Feathers brown, with a little fringe of green feathers near the nick. Whole L 56 4/10 in.

894e Ditto, L of shaft 45 5/10 in: L [of] head 10 in W 17/20 in. Nearly the whole of the shaft has been stained brown. Feathers two as in the others and tied on [on] the twist, and of a mottled black, brown, and white.

894f Ditto. Shaft L 43 5/10 in; Head L 11 1/10 in, and 15/20 wide; feathers blackish and brown, with a reddish tinge on the undersides. Given by Lieut. Maw R.N. 1828.

895 Five arrows from South America, but exact locality uncertain. Shafts made of the grass stems, (as in the preceding two groups), the heads being \much smaller and of/ long round pieces of dark brown wood (Porcupine palm?), sharply pointed at the ends and poisoned, except in one which has had the point cut off, the other four being perfect, and having tufts of some fibre, apparently flax, tied round at \7/ or 8 in. from the points, the longest \arrow/ having besides

\that/ a little crown of small red green and yellow feathers immediately below it. The other ends have been bound round with [-cotton\the] some \kind of/ fibre, and blackened \or waxed/ over, but they do not appear to have been feathered, or nicked for the bow string. The junction of the heads with the shafts are also slightly bound with twisted fibre. The points [-appear to] have been incised round in several \places,/ either for helping to hold the poison, or to break off in the wound, or perhaps for both. L \of shaft/ 50 8/10 in.: of wooden head or point 18 1/10 in. this has the little tuft of coloured feathers. L of shaft 48 9/10 in.: of head 18 6/10 in. L of shaft 48 9/10 in.; L \of head/ 18 4/10 in. L of shaft 48 8/10 in.; L of head 18 4/10 in., and L of shaft 48 9/10 in.; L of imperfect head 10 9/10. For arrows of this kind see Wood's "Nat: Hist: of Man", Vol: 2. pp. 597 and 598. Donor uncertain; but they were mixed up with the previous two sets No. 893a to 893h, and 894 to 894f, and which were given by Lieut: Maw, R.N., 1828.

896 Fourteen Arrows, from Ucayali, one of the principal sources of the Amazon, in Peru. Shafts of the grass stem, as in the preceding two groups; L from 36 3/10 in. to 34 1/10 in., with heads of hard, dark brown wood, (Porcupine Palm?), L 16 5/10 to 13 2/10 in., rounded in a rough manner next the shaft, but sharply keeled along one side to the distance of 5 to 7 in. from the point, which keeled edge is notched in three, four, or five barbes, which are directed backwards. They do not appear to have been feathered, but the ends as well as the junctions of the heads with the shafts are rather sparingly bound round with cotton thread. Perhaps used for shooting Fish.
Ashmolean 1836, p. 183 no. 126.

897 One ditto, similar to the preceding but the \long round wooden / head \ D 4/10 in./ instead of being barbed, having a round painted knob at the end, D 1 3/10, and L 1 8/10 in. L of shaft 37 8/10 in.; L of wooden head 12 in. (Probably belonging to the previous set No 896). For arrows of this kind see Wood's "Nat: Hist: of Man", Vol: 2. pp. 597 and 598.

898 One ditto, the shaft being of the grass stem as in the preceding, L 40 3/10 in., and D 5/10, spirally bound round the top for the length of 11 in. with narrow strips of some black material, which looks like coloured grass \or thin bark/. The detachable head of very dark brown wood is L 12 6/10 in., and W 7/10, round and pointed at the lower end, but deeply barbed along one edge above for the distance of 8 5/10 in. from the point, the barbes being five, about 2 in. or less from each other, and directed backwards. It may have been used for fishing. South American, but exact locality uncertain. It seems to have been broken off at the end and is not feathered. History unknown.

899 Four long South American arrows, exact locality uncertain. The shafts being made of the grass stem, as in the preceding, and the heads of long and tolerably

straight pieces of round knotted stick. They have each two \black/ feathers, small compared with the arrows and rather rudely bound on in three or four places to the shafts with cotton threads. The side[s] at the ends are hollow as in No 894-894f, and the ends are nicked for the bow string. The junctions of the head with the shaft has also been bound with cotton thread, and one of them in an ornamental cross pattern. The points of the heads, which were probably poisoned, have been cut off. Whole L 6 ft. 1 in., of head only 2 ft. 3/10 in. Whole L 5 ft. 6 in., of head only 18 8/10 in., Whole L 5 ft. 5 in., of head only 20 8/10 in. Whole 5 ft. 1 4/10 in.; of head only 17 5/10 in. (Ramsden collection No (?), Purchased by the University 1878).

900 Two ditto, probably of the same set as No 899, as the feathering is identical; but the heads of pieces of wood apparently stained of an uniform dark colour. These are long somewhat rounded except along the whole length of one edge which has been keeled, and then cut away except leaving eight small barbes, each from two to three in. apart. L of shafts 48 8/10 in:of wooden heads 21 8/10, and 21 3/10 in. Ramsden collection (No ?) Purchased by the University, 1878.

901 A poisoned Lance, or Javelin, from Pebas, in the Lower Missions of Peru. Used apparently for throwing with the hand. It is made of hard black wood (Porcupine Palm ?), L 7 ft. 3 in., D 6/10 in. [-at\near] the head, [-tapering] gradually tapering to the other end where it is D 7/20 in., and \the whole/ rather roughly rounded. It is headed with a pointed spike \which has been/ cut out of one piece with the Shaft, \and/ which is round to L 2 4/10 in., and D 4/10 in., and then nicely quadrangular for L 10 2/10 in. and D 3/10 in., and gradually tapering off to a sharp point but still four-sided, and thickly encrusted with poison. The cover for the point has been lost. Given by Lieut: Maw, R.N. 1828.
Ashmolean 1836, p. 183 no. 122.

902 Ditto, exactly similar except in size. From the same place. L of shaft 6 ft. 2 3/10 in.; D at top 6/10 in., and 7/20 in. D at the other end. Whole L of spike 12 5/10 in.; L of quadrangular poisoned portion only 10 1/10 in., D of ditto 3/10 in. The guard for the point is made of the hollow stem of some plant, or perhaps from which the pith has been extracted. Probably it is a piece of the grass stem the same as the \shafts of the/ previous large arrows are made of \L 13 in./. Whole L of spear 7 ft. 2 9/10 in. Given by Lieut Maw, R.N. 1828.
Ashmolean 1836, p. 183 no 122.

903 Ditto, from the same [-place\locality] as No 901 and 902, the quadrangular spike having been [-cut\broken] off. Whole \present/ L 6 ft. 5 5/10 in. In this case the poisoned spike was bound into the other part. Indeed the \spikes/ appear to be made to break off when the object is struck, as they are partly cut through on each of the four sides. Perhaps this was one so

broken then a new spike added, and afterwards broken again. Given by Lieut: Maw R.N. 1828.
Ashmolean 1836 p. 183 no. 122.

904 A Bow and five Arrows; used by Indians of Guayana ? (Guiana), for shooting when lying on their backs, the bow being bent with both hands and the right leg, the arrow being held in its position against the bow by the toes. The bow is of extraordinary length, 8 ft. 5 in., and is made of hard dark brown wood, is well formed, in shape about three quarter round in section, that is flattened, or rather slightly hollow along the inside or back, W 1 1/10 in. and Th 1 in. in the middle portion, gradually diminishing but keeping the same shape to the ends which are W and Th 5/10 in., with short round projections for the bow-string. The line is of thin cord Th 3/20 in., and well made, and apparently of flax or hemp, with what appears to be a spare line of the same size and make wound closely round the bow at between 26 and 27 in. from one end, probably for provision in case of breakage. The arrows L 5 ft. 2 in. to 4 ft. 10 9/10 in., 3 ft. 6 in. of which is of stout reed D 7/20 in., the remainder \or heads/ being of stiff sticks, having their side shoots trimmed off, coloured brown, and tipped with pieces of bone, which are securely bound on sideways so that it forms the point and a sharp barb on each arrow and are about 2 in. long. The bindings at the junctions of these heads with [which] are done with narrow \spirally twisted/ strips of some thin vegetable substance resembling bark, perhaps the same kind of material that is bound round the blow-gun 887, and of the arrow 898. Each arrow has two feathers mottled of various colours L 5 or 6 in. bound on round the two ends, and very much on the twist to cause them to revolve in their flight, the bindings being partly of the same material as that of the heads \tops of the shafts/ and partly of cotton. The ends are nicked for the bow string. Whole L 5 ft. 2 in.; 5 ft. 1 8/10 in.; 5 ft. 1 in.; [-and] 5 ft.; and 4 ft. 10 9/10 in. Wood \says/ that Foot-bows are used by the Gran Chaco Indians for shooting fiery arrows to set on fire the villages of the white settlers. See Wood's "Nat: Hist: of Man", Vol: 2. p. 570 (Burchell collection) Given by his Sister Miss Burchell 1865.

905 A similar bow in every respect to the preceding No 904, except that it is somewhat smaller, is not so well finished and the inside more hollowed out. Both the lines perfect. L 8 ft. 8/10 in. Size in the middle 1 by 1 in., tapering gradually to the ends, which are about D 4/10 in. (Burchell collection). Given by his sister Miss Burchell 1865.

906 A Bow of similar shape to the two preceding No 904 & 905, and probably from about the same locality, but it is much smaller, and appears to have been used by hand only. It has been broken in the middle and has lost the string. L 5 ft. 5 5/10 in. D in the middle 8/10 in. gradually diminishing to 4/10, at the ends.
Ashmolean 1836, p. 183 no. 136 [?].

Articles of dress of Indians of Guiana made of Feathers (Burchell Collection). Given by his sister Miss Burchell in 1865.
Ashmolean 1836-68, p. 5.

They are as follows:

907 An Indian Chief's Headdress, the framework being made of open work of thin flat strips of what appears to be the outer surface of the flower stems of Gynerium saccharoides, about W 5/10 in. (See No 892). H 7 2/10 in.; and D 8 8/10 by 8 in. at the bottom or rim, which is surrounded on the outside with twelve cotton cords, tied in a knot at the back, but plaited together in the front and forming a narrow band, which supports in an upright position a number of the tail feathers of the scarlet, blue and other Macaws, some of which are ornamented \near their tips/ with little cotton pendants, each of which has three blue and yellow small opaque glass beads threaded on it and a little feather at the end. Whole H 14 in.

908 An Indian Females Headdres[s]. This is a closely knitted skull cap of strong cotton cords, thickly covered on the outside with little bunches of small scarlet, orange, green, and blue feathers, having [-four\six] long white ones stuck in at the back and directed downwards as a plume. From the lower edge of the back half of this are suspended a fringe of longer feathers of the same colours, below which again hang a double row, one lower than the other, \of/ blue tail feathers of the Macaw, forming a fall of L 14 in., \measured inside/ and about W 10 in.; each row being edged with a cross band of small shining black feathers.

909 A pair of Epaulett[e] like ornaments, or Armlets?. These for Savage life are elegant in form, and the colours rich and well arranged. The upper part of each is a band about W 3 in. of thick, dull black, down-like feathers, having much the appearance of rich fur, and edged below with three separate bunches of scarlet orange and blue feathers; from one of the side bunches of which hang four pendants L about 9 in., of scarlet and black feathers, arranged in rings, alternately, the ends of each tipped with little bunches of shining bluish black. And from the centre bunch hang four shorter and more loosely made pendants \about 6 in. long,/ nearly [-all\the whole] of which are black. All the feathers are worked on strong cords of white cotton.

910 Twenty-two cords of white cotton ornamented with small feathers closely bound round them, forming ropes of L about 3 ft. \to 3 ft. 9 in./ and W 2 in. Ten of the ropes are of scarlet, Six of yellow \except between 5 and 6 in. at one end which is black and scarlet/ and six of shining jet black \with a bluish gloss/. The ends of all of them have several small bunches of black \feathers/ and there is a [-short] length of the cord left bare at each end apparently for fastening them. They were possibly worn in festoons round the upper part of the body. The proper lengths as near as they can be

342

measured, and not including the bare lengths of cord at the ends, are The scarlet 45, 40, 39, 38 5/10, 37 5/10 and 36 in. The black 40 and 39 in. The yellow having a patch of black and scarlet at one end, all 38 in.

911 An article somewhat resembling a lady's boa, of a soft black down like feathers, (as in No 909), each tied on separately to a \white/ cotton cord, and so closely and evenly set that it might pass for fur if not closely examined. A short length of the cord is left bare at the ends, each of which has a tassel made of small bunches of the shining bluish black feathers tied on. The feathers appear to be bound on with some twisted material, like flax coated with black wax. Whole L 4 ft. 1 in.; L of portion covered only 2 ft. 6 in.

912 A short and much thicker article of the [same] kind as the preceding No 911, but made of little bunches of black down-like feathers tied closely together and attached to a \flat/ knitted band of white cotton 7 3/10 in. long, and 8/10 in. wide, the ends of which are plaited into a cord for tying. Possibly a wristlet. Whole L 23 in., the band portion being the covered part. W 3 in. (For descriptions and figures of various South American Feather ornaments, see Wood's Nat: Hist: of Man, Vol: 2, pp. 574 & 619.

913 An Indian Females headdress made exactly in the same manner as No 908, but the upper portion or cap being ornamented with tufts of black feathers only, three streamers \each/ L about 8 in., of similar feathers hanging down on each side in front. Whole L 1 ft. 7 in. (Ramsden collection No (?). Purchased by the University 1878.)

914 Ditto of orange and a few black coloured feathers, but without the long fall or tail behind having instead a short fringe of orange coloured feathers, and a double streamer of the same colour, L 9 in. tipped with small bunches of black hung on one side in front, the corresponding streamer from the other side having been lost. The fringe at the back has been much injured by insects. Locality not stated (Ramsden collection No ?) Purchased by the University 1878.

915 A Basket from Guiana, in which the Feather ornaments No 907 to 912 were kept. It is made of widths of palm leaf arranged nearly perpendicular between the top and bottom, the one width overlapping the other right round the sides, and tied on with well made string to a slight framework of split bamboo. It is long oval in shape with flat top and bottom, the sides being perpendicular, and the lid and the lower part \if you may so term them/ are made like each other \that is/ in two equal parts, so as the one to fit into the other. L 2 ft. 1 in., W 11 in., and 9 in. deep. (Burchell collection). Given by Miss Burchell his sister 1865.
Ashmolean 1836-68, p. 5.

916 A band, resembling webbing, made of white cotton very closely knitted, and in one piece having no ends or joining. Length all round 42 in. W 1 5/10 in.

(Burchell Collection). Given by Miss Burchell his sister 1865.
Ashmolean 1836-68, p. 5.

917 A South American Indians Ruff for the neck. It is made of two separate bands, each L 18 in., of woven and rather soft grass, tied together side by side with fourteen little strings of white cotton, with plaited strings of the same material as the ends for tying it. The ends of the grass are left separate and are trimmed off square forming a thick fringe 4 in. deep, round about. (Burchell Collection). Given by his sister Miss Burchell 1865.

918 A necklace (?) L 13 ft. 2 5/10 in., of beads or perforated disks of D 2/20 in. and Th about 1/10 in., apparently made of cross sections of a Gorgonia, or may be of hard wood, or bone coloured dark brown. Being very uniform in size, and neatly made, they form as it were one continuous line. Probably worn by Indians of South America, but locality uncertain. The string on which they are threaded appears to be of dirty cotton.

919 A necklace (?) of similar beads to the preceding No 918 but larger and better finish, being about D 5/20 in. and the same or thereabouts in thickness. They are [-threaded\strung] on about 18 separate cotton threads. Whole L 4 ft. 2 in. (Both of the Burchell Collection) Given by Miss Burchell 1865.

920-55 Model of a Dwelling House, and various Implements, etc, made by Indian natives of the banks of the river Essequibo, British Guiana, S. America. Obtained in 1812, by Lieut: Westwood. Presented by Professor J.O. Westwood, M.A. Magd[alen]: Coll[ege]: Oxford Hopeian Professor of Zoology. 1874

920 Native made model of a Dwelling House, with two compartments, one for the hot, and the other for the cooler weather. It is made of Palm leaf supported with a framework of small round sticks, being entirely open on the two sides and the two ends, the leaves of the roof being kept in their place by their cross pieces of bamboo. It has a model of one of the grass-made hammocks slung to the beams of the roof. H 15 5/10 in. L 20 in. W 12 in. (For a house somewhat similar, see Wood's "Nat: Hist: of Man", Vol: 2. p. 607).

921 Model of an Indian man in full dress, which consists simply of a black linen waist cloth, supporting a rudely made knife at his left side; his hair being apparently human, and wound round and round the head in coils; the ears are set with two small teeth, probably human, and the eyes and teeth are represented by very small beads, and there is a small \coloured glass/ bead necklace round the neck. The whole of the figure is made of a reddish brown wax-like substance, and is complete. Greatest W, which is at the feet 1 8/10 in. H 6 in.

922 Ditto of an Indian woman in full dress, which consists of an Apron made of small and variously

coloured glass beads; and [-rows\rings] of small crimson glass beads around the ankles, knees, and wrists; around the waist is a triple [-cord\coil] of twisted hair similar to that of the head; around the neck is a string of similar beads \to those of the hand and neck/ and below it a little chain of fine brass wire: the eyes and teeth are represented as in the preceding \No 921/ by minute single beads painted white. Ht 5 9/10 in; greatest W which is at the shoulder, 1 5/10 in.

923 Model of a Chief's Headdress made of Parrot's feathers attached to a circular frame of wicker work \having a projecting rim round the top/ the feathers being fastened so as to spread out horizontally round the bottom, and stick upright in a tuft in front. H 5 in. D across the top of wicker work 2 5/10.

924 Model of a Fan, made of some kind of leaf or rush, apparently split, and plaited together, having the margin thickened at the bottom and crossed to form projecting handles. D 5 6/10 by 5 6/10 in. Those in use are 15 in. across. See Wood's "Nat: Hist: of Man, vol: 2. p. 605."

925 Ditto, made of the same material, and in the same manner, but considerably smaller, and rather different in shape, but with the cros[s]ed handles. Size L 3 5/10 in. by W 3 in.

926 Model of a Canoe, and four broad bladed paddles. The boat which is keeled along the bottom, and has flat sloping ends, is cut out of a piece of very soft light wood, and entirely coloured black except at the ends of the outside which are coloured red. L 15 4/10 in.; greatest W 2 7/20 in. Depth 1 6/10 in. The paddles (for which see also No []) are of wood, L 6 in. and W 5/10 or 6/10 in. at the blades, the handles being narrow, but widened at the top, the end being hollowed out to receive the hand. They are stained of a dark brown colour.

927 Portion of a model of a similar canoe to the preceding 926. L 10 8/10 in.

928-929 Models of two seats (headrests?) cut out [-out] of solid soft wood, hollowed out lengthways on the top, which is stained brown with black cross lines, the sides and ends being \coloured/ plain black. L 3 5/10, W 1 2/10 in.; and \of the other/ L 3 1/10, W 1 1/10 in.

930 Model of wickerwork basket (cradle), attached by strips of bamboo: Used by the women for carrying the children, slung on their backs. "The body of the Cradle is made of the ever-useful itirritti reed, which is split into strips about the tenth of an inch in width, and then woven so as to make a kind of basket, open at one end and down the side. The edges are strengthened by a rod of flexible wood lashed firmly to them, and the cradle is brought into shape by means of a framework." See Wood's "Nat: Hist: of Man", Vol: 2. p. 609. Extreme L 4 in.; greatest W 2 in.

931 Small pieces of Cakes made of Cassava flour, made by the Indians. Cassava flour is made of pulp from the root of a Shrub (Jatropha manihot \Linn./), one of the Euphorbiacae. The root in its raw state abounds with a milky juice, which is bitter and poisonous. These deleterious qualities are got rid of by crushing or grinding the root and soaking it in water, after which it is dried for use.

932 Model of the elastic bag, (or Press), of wickerwork; in which when suspended from a rafter of the house; the pulp of the Cassava root (Jatropa manihol Linn) is placed for straining. A heavy weight is passed through the lower loop, which by stretching contracts the bag, causing the fluid and the finer particles of the starch to fall into a sieve, which is placed below. L 7 8/10 in. D of the bag portion 1 in., and of the upper loop 1 5/10 in. (See Wood's "Nat: Hist: of Man", Vol: 2, p. 612; and the way of using it p. 607).

933 Model of square shaped wickerwork sieve, used for catching the finer particles of the Cassava root for bread making after the deleterious liquid has escaped. D 3 4/10 in. or at the corners which project \and cross,/ 4 in. See "Wood's Nat: Hist of Man", Vol: 2. pp. 611 & 612.

934 A Drinking Vessel, made of the one half of an egg-shaped gourd, which has been separated lengthways, stained black on the surface and polished on the outside \only,/ which [-has\is] ornamented with geometrical and vandyke patterns, most of which have been finely scratched with a compass, and \portion of/ the black surface slightly cut away to the lighter colour of the gourd \beneath./ L 6 19/20 in. W 4 8/10 in.

935 Model of a short quadrangular shaped club, of dark brown wood; the lower part having a binding of cotton \with a tassel, and also a strong plaited loop for the wrist, of the same material./ It is called by the Gran Chaco Indians "Macana", and exists throughout a very large portion of Southern America. L 3 1/10 in.: greatest D 7/10 in. See Wood's Nat: Hist: of Man, Vol: 2, p. 569 and for figure p. 570.

936 A small whip made of grass, given by the woman to her husband on marriage. L 17 in., D of handle 5/10 in. A similar article to this is figured in Wood's Nat: Hist: of Man, Vol: 2, p. 615, and called a Maquarri whip, called so from the dance in which it is used, see p. 616.

937 A small pointed club of dark brown wood, which the Indians use as a missile weapon, and throw with great precision. Present L 17 6/10 in., (the point having been broken off). Greatest W of blade 1 7/10 in. D of handle; which is round 6/10 in., the blade being lozenge shape in section and tapering to the point.

938 Indian Female's Apron, or full dress; made of transparent green glass beads, with a design in the middle in red, yellow, violet, white, and black opaque glass beads; and round the edges either a single, or

double row of opaque yellow, of the same colour as those in the [-pattern\design], and a fringe made both of opaque and also transparent white \and green / and \opaque/ violet glass beads, and small cotton tassels, at the bottom. The beads are [-threaded\strung] on double horisontal threads, having stronger double perpendicular threads to work them over, and by which the horizontal rows of beads are divided into rows of pairs lengthways, [-and which are\the upright [-] threads being] tied together at the bottom to form the tassels of the fringe. It has also cotton strings at the top corners for tying it on. W at top 4 8/10 in., W at the bottom 9 in. Depth 5 8/10 in., or including the fringe 6 7/10 in., the \sides being/ sloping but straight; the lower edge somewhat rounded, or having the corners higher than the middle.

939 Fragment of another Indian Female's Apron of beadwork, in lozenge patterns, in green, yellow, red, violet, white, and black glass beads, all opaque. L 10 5/10 in. W 1 5/10 in. See Wood's Nat: Hist: of Man, Vol: 2, p.p. 620 & 622.

940 Model of a circular flat plate of black earthenware, on three short legs: to be placed over the fire, for baking the Cassava cakes. Height 6/10 in. D 3 2/10 in.

941 Model of bowl, of black earthenware, used for washing purposes. H 1 3/10 in. D across the top 3 in.

942 Model in black earthenware, of a shallower vessel than the preceding 941. Used for cooking purposes. H 8/10 in. W across the top 2 9/10 in.

943 Ditto, smaller, [-and] of somewhat deeper shape, and having two little projections on the sides, as if for handles.

944 Ditto, of nearly half globular shape, being a little flattened \at the bottom so as/ to stand upright. No handles at the sides. H 1 3/10 in. D across top 2 3/10 in.

945 Model of a deep, circular, openwork basket or quake, of wickerwork. H 2 7/10 in.; D 2 in. (See Wood's "Nat: Hist: of man" vol: 2 p. 395) for a somewhat similar article.

946 Model of a similar shaped basket to the preceding, but smaller, and of closely plaited wicker work, and strengthened with a rim round the top. H 1 8/10 in. D 1 4/10 in.

947 Model of a rather closely woven wickerwork basket of a circular shape round the top, which is strengthened with a hoop \both/ on the inside and outside, and decreasing in size to the bottom which [is] squarish in shape. It is attached to, and supported off the ground, by four strong wooden legs, which are lashed to the sides at equal distance from each other, and which project above the rim. H to top of legs 2 3/10 in. Greatest W, which is from leg to leg 4 3/10 in.; or of the wicker portion only. H 1 5/10 in.; D 3 8/10 in.

948-949 Models of two drinking cups, made of the two equal halves of a small globular shaped gourd, or perhaps the husk of some fruit, (as in the rattle No 955), of a brown colour, stained both outside and inside with wavy lines in black. W across the top 1 8/10 in.

950 An Indian Chief's headdress, made of black, scarlet and orange coloured \feathers/, arranged upright in the order [-stated\mentioned] here, one above the other, and fastened to an ornamental band of cotton thread, the threads of which are \left separate but/ twisted together at the ends, and form six streamers L about 3 ft., having a bunch of longer orange, or black feathers tied at the lower ends. These must have been for fastening it behind. The band of woven cotton in front, is ornamented with a complete row of 39 pear-shaped brownish-grey seeds ([]). L or W 15 5/10 in., H 5 in.

951 A Cap made of the inner bark of a Tree (Spathe of a Palm-tree?) of a dark brown colour; in appearance very like an irregular net-work of coarse hair. It is of an elongated cone shape, the top ending in a \long/ point, the rim being double for the height of between 4 and 5 in. Whole H 20 in. D of [-of rim\across the bottom] about 8 in. For figure and description of a similar article see Wood's "Nat: Hist: of Man", Vol: 2. p. 623.

952 A Necklace worn by the Indians in full dress. It is made of 45 \flat/ pieces of bone L 1 5/20 in. and rather less, and greatest W 3/10 in., and rather less; the lower parts of which have been cut into something the shape of human front teeth, and are bound together side by side [-by\with] a band of cotton [-cords\threads]; from which are suspended by stronger cotton threads \ten/ tee[t]h of a large species of Carnivora, of different sizes, some of which must be of the Jagua[r], each tooth having been drilled through for the purpose. The threads at the ends of the cotton band are plaited together to form long strings, which [-are] are ornamented at the lower ends \with short plaited cords which support/ [-with] a number of little tassels of the same material, perforated human \?/ teeth, and \a few/ small beads of \(crimson, red, and purple)/ coloured glass L 10 in., or including the strings 3 ft. 6 in. Similar articles are mentioned in "Wood's Nat: Hist: of Man", vol: 2. p. 623.

953 A Basket made of cane, grass, and thin close wickerwork, the latter worked into patterns in black and brown. It is of rather a singular shape and construction; the bottom being oblong L 11 in. by W 5 in., decreasing at the top, \which is the same shape/ to L 7 3/10, and W 3 5/10 in. H 6 8/10 in. The fine coloured wickerwork is made separate from the open frame of cane bound with grass, to the \inside/ of which it is bound, having the appearance of being suspended by it.

954 A Child's Rattle, made of fine wicker-work, coloured in patterns brown and black (as in the preceding article 953), and \partly/ filled with a few coloured glass beads. Whole L 8 3/10 in. D 1 6/10 in.; the strips being left \separate/ at the end, and bound together with grass to form the handle, which is D 6/10 in. (See also No []).

955 Ditto, made of a small gourd, (as in No 948. 949) or the husk of a globular shaped \fruit/ with a wooden handle fixed through it, to the top of which is tied a bunch of yellow and green feathers attached to a string of cotton. It has been stained all over with wavy black lines. L 5 2/10 in. D of gourd 1 4/10 in., of handle 4/10 in. (This is more likely to be a model of the Rattle of the So[r]cerer or piai-mon of Guiana. See Wood's "Nat: Hist: of Man", Vol: 2, p. 629, left hand figure.) (See 948 949) (The term wickerwork is applied to many, but it is probable that nearly all so named are made of the itirritti reed).

956 A wicker-work rattle of the same kind and shape to No 954 but much larger, coloured in somewhat key pattern in brown and black. It is made of neatly plaited strips of itirritti reed, of about W 1/10 in., and stained of the two colours, the pattern being worked in plaiting of it. It is cylindrical for the length of between 7 and 8 in., the top being square, D 2 8/10 in. The handle being made by leaving the ends unplaited and binding them round a piece of the grass stem, (Gynerium saccharoides, Kew cat:) with a fine binding of twisted grass. Whole L 11 6/10 in. From British Guiana; probably from Indians of the banks of the Essequibo. It is partly filled with small fragments of a semi-transparent white stone ([]) Given by Sir Everard Home, Bart: 1839.

957 A nearly triangular shaped Fan, of plaited, shiny pale yellow, almost straw coloured reed, or rush. Made by Indians of British Guiana. W of bottom, (or the edge opposite the handle) 15 in.; W of the handle side 4 5/10 in., the handle projecting 1 in. more on each side. L of the side \edges/ from the handle to the angles of the bottom 9 5/10 in. Each of the three edges is somewhat curved outwards. A similar fan is figured in Wood's "Nat: Hist: of Man", Vol: 2. p. 605 (Given in exchange by the Trustees of the Christy collection, 1869).

958 An elastic bag (or press) of wicker work. Used by Indians on the banks of the Essequibo river, [-in] British Guiana; in preparing the Cassava Flour. (See No 932 for the way of using it). L when fully stretched out 5 ft. 1 5/10 in. D 2 6/10 in. (Ramsden collection No ?) Purchased by the University, 1878 See Wood's "Nat: Hist: of Man", vol: 2 p. 612 and the way of using it p. 607.

959 A broad bladed wooden paddle, from South America, probably from British Guiana, (as see No 926). Of brown wood, ornamented on both sides [of] the blade with horizontal rows of curious curved lines painted on in black, somewhat resembling human leg bones in outline. One side of the blade slightly hollowed out near the end, the opposite side somewhat round, and the ends rounded off. Handle round to within 14 3/10 in. of the end, which part is flat and widening to the end which has a semicircular piece cut out to receive the fingers of the right hand. Whole L 4 ft. 10 in. L of blade only 2 ft. 4 in., W of bottom of ditto 6 in. decreasing to 5 in. near the top and then tapering off to the handle. Whole L of handle 3 ft. 3 in., the bottom of which projects considerably into the blade. D of round part of handle 1 8/10 in., decreasing upwards to 1 in., W across top of ditto 3 in. (Ramsden Collection No ? \34/) Purchased by the University 1878.

960 A short quadrangular shaped club, of dark brown, almost black wood. It has a binding and a kind of network pattern of white cotton around the lower part, together with a strong twisted loop for the wrist, and four long cords of twisted cotton with little tassels at the ends for ornament. Indian, from British Guiana. Wood in his "Nat: Hist: of Man", Vol: 2, p.p. 569 & 570, says that it exists throughout a very large portion of Southern America, and is called by the Gran Chaco Indians "Macana". (See also No. 935). L 12 5/10 in. D of the ends 3 3/10 by 2 2/10, \with the four/ sides hollowed out and reduced to 1 4/10 by 5/10 in. \D/ at the handle. Given by the Trustees of the Christy collection in exchange, 1869.

961 An Apron worn by Female Indians of British Guiana; of small opaque white glass beads, with a [-detached pattern\lozenge ornament] above in red yellow and green opaque glass beads, between two quatrefoils in red yellow, blue, green and black; and below these three of the same sized lozenges in red yellow and blue glass beads, also opaque. Round the edges a double row of black beads having at the bottom edge a double row of red and yellow threaded the reverse way to the black above, and the cotton threads left in a little fringe below. W of bottom 9 5/10 in.; of top 5 3/10 in.; \depth 4 in;/ sides sloping but straight; top edge straight; bottom edge rather rounded the corners somewhat puckered. (For similar Aprons and the way they are made, see Wood's "Nat: Hist: of Man", vol: 2, pp. 620 & 622)
Ashmolean 1836, p. 184 no. 193 [?].

962 Ditto of larger size but made of very much smaller beads than No 961, and opaque or nearly so. The body or ground is red divided into large lozenge shaped compartments by single lines of white, each compartment inclosing a quatrefoil ornament in yellow blue [-and] green and black, with four small lozenges \of white/ in the angles outside, and which form cross-like ornaments at the sections of the single white lines. The bottom edge is fringed with 47 nearly round large \(about 4/10 in. D)/ glass beads, \either/ of dark transparent blue, opaque black, [-and\or] opaque dark green ground colour, enamelled in leaf-like ornaments

\of white/ on the blue, and chiefly in dots, or horizontal lines, in yellow, white, pink, and green on the other two grounds. Above \each of/ these large beads are two s\m/aller, one of red and the other of white, threaded on the same thread, above these again is a thin row of small black beads like those in the body of the Apron. L of bottom edge 14 in.; of the top 7 4/10 in.; sides sloping and slightly curved inwards. Depth 5 5/10 in. (For a similar article see Wood's Nat: Hist: of Man, vol: 2 p. 620)
Ashmolean 1836, p. 184 no. 193 [?].

963 Ditto of a much larger size than either Nos 961, 962, the beads being also much larger, and those near the top only about half the size of the rest. Ground entirely opaque white glass, ornamented near the middle with two broad horizontal stripes, each above 1 in. in W, the upper one of opaque green, and the lower one of opaque blue. The bottom edge is ornamented \with/ a fringe, each thread having three dark blue beads, some of which are transparent, with a large bead \of a shape rather longer than wide,/ of transparent very pale green colour \4/10 in. D/ with parallel longitudinal opaque white stripes, below \them,/ and underneath that a small bead of opaque white glass. Half of this fringe is gone. W of bottom edge 16 in. W of top 10 5/10 in. Depth 8 5/10 in.
Ashmolean 1836, p. 184 no. 193 [?].

964 A pair of Indians' bands from S. America? perhaps British Guiana. Of brown worsted interwoven with numerous black and white opaque glass beads, in square shaped patterns: the threads projecting and plaited together to form a fringe at the ends. One end of one of the bands has a few blue beads. They may have been worn round the legs or the arms. L without the fringe 10 4/10 in., or with the fringe, about 2 ft. W 3 in.
Ashmolean 1836, p. 184 no. 193 [?].

965 An Indian's sash, from South America ? perhaps British Guiana: Made of \woven/ reddish-brown worsted and four longitudinal parallel zig-zag stripes of small opaque white glass along the middle; with a narrower border of lozenges and chevrons \alternately/ along each edge. The threads are left long at the ends, and plaited into ten separate plaits for the distance of 1 5/10 at each end, and afterwards left separate, or but slightly \plaited or loosely/ twisted together, four at each end being ornamented along their whole length with numerous beads of the same kind. All the beads have been woven in in the making. L without the fringe 3 ft. 10 in.; or with the fringe 6 ft. W 4 in.
Ashmolean 1836, p. 184 no. 192.

966 Ditto, of dark blue worsted, more closely woven, and in a different manner to the preceding 965; ornamented along the middle with six parallel vandyke \or zig-zag/ rows of small, opaque, white glass beads; the edges having a narrow brown border between single rows of white beads. The ends have been plaited into a number of pendants \and closely bound with

coloured porcupine quills or gras[s]/, each of which has at the end a little cone-shaped pendant of thin sheet iron, inclosing a tuft of black hair, perhaps that of the Bear; eleven such pendants being at each end. L not reckoning the pendants 34 5/10 in. Whole L 50 in. W 3 8/10 in. It has been greatly damaged probably by moth. Perhaps this and the two preceding 964 and 965 are N. American. (Ramsden Collection No ?). Purchased by the University. 1878.

967 Indians necklace from British Guiana; made of 72 teeth of the Peccary, or Pecari, drilled, and ground into shape, so that the necklace lies half circular when flat, each tooth being threaded on a fine cotton thread and bound on to three cotton cords, which forms a band for the necklace, but are left separate at the ends, forming long strings. L of the portion with teeth attached 20 3/10 in. W in the middle 1 3/10 in. gradually decreasing to the ends to 1 in. L of strings at the ends 39 in. Given by the Trustees of the Christy Collection, in exchange, 1869.

968 Ditto, of similar character and make, but much longer, and made on a band of numerous strong cotton theads, which at \each of/ the ends of the necklace are twisted together into six cords ornamented with numerous small tassels. A great many of the teeth are gone. L of the part to which teeth are attached 3 ft. 10 in. W 1 in. gradually decreasing to the ends to 7/10 in. Whole L 8 ft. 6 in. Probably from British Guiana (Ramsden Collection No ?). Purchased by the University, 1878.

969 A pendant ornament of white, semi-transparent stone, resembling Alabaster. Worn hanging through a hole in the lower lip by Chiefs of the Carajas Indians, Central Brazil. \Whole/ L 3 5/10 in. Cylindrical \in shape,/ D at the upper end 5/10 in., which has a cross bar for the mouth W 1 3/20 in.; gradually tapering to the other end to D near 7/20 in., which is finished off with a conicial button shaped projection W 7/10 in.and 3/10 thick or deep, the apex being below. (Burchell Collection). Given by his sister Miss Burchell, 1865. With it was the following "Ornament given me by the Commandant of S. Joãod Araguaya, (?S. João da Barra Araguay) who says it is made by a neighbouring Tribe of Indians, who wear it in the lower lip. The stone is found in the Country". An ornament of this kind is figured in the Proceedings of the Society of Antiquaries, Vol: 1, second series p.(?) It was exhibited by A.W. Franks Esq and the following is from the description given with it: "They are worn only by Chiefs of the Carajas, a powerful Tribe on the banks of the Araguaya (which joins the Tocantins). Its banks are so unhealthy, and its rapids so formidable, that it is scarcely ever visited by White men; but twice a year the Carajas come down to a little Military Colony that the Brazilian Government has formed at the junction of the two rivers, and barter their hammocks, bows, arrows, etc, for knives and beads."

970 A Hat from Cameta, South America, (Lat: 2° 14' South: Long: 49° 9' West). Made of split and plaited Palm leaf? and coated over the whole of the outer surface coated with Coautchouc when in a fluid state. The crown is of a high conicial shape, but flattish on the top, about H 7 in., with a flat brim rather less than W 4 in. Whole W across brim 4 8/10 in. of hole for the head 7 in. Given by Sir J. Everard Home, Bart: 1839. Ashmolean 1836-68, p. 8.

971 A Whip called a Maquarri whip, from the dance in which they are used. Used by natives of British Guiana. It appears to be made of two very long slender rods, (probably stems of some creeping plant, or perhaps thin cane), plaited together, leaving a large loop at one end, and then neatly bound horizontally all over with split rods of the same kind. L 37 3/10 in. See Wood's Nat: Hist: of Man, Vol: 2. p. 615, left-hand figure. Given by the Trustees of the Christy Collection, in exchange. 1869.

972 Portion of a South American Indian Ornament, probably of a necklace, made of perforated Jaguar's teeth? seven in number, strung on cotton threads. History apparently lost. L of teeth 1 8/10 to 1 4/10 in.

973-976 Four Clubs said to be from British Guiana; of black, hard, very heavy wood. They are flat or very nearly so, [-and] have all the edges square, and \are/ of nearly an uniform thickness, only varying from about 7/10 in. to 1 in., the sides being nearly parallel till within about one fourth of the length from the top, whence they gradually curve outwards to the top. There is an abrupt enlargement in the [-sides\width] at the bottom end the edges of which are curved out lengthways. They are plain and polished on all parts except that from \about/ 9 to 13 in. at the top, where both sides are very neatly carved by the surface being cut away, leaving the design in very low relief; which consists of various scroll-like ornaments combined with lozenges made by turning triangles side to side, these being divided into compartments by transverse parallel borders of zig-zags. A similar club is figured in Wood's "Nat: Hist: of Man", Vol: 2. p. 601 \by/ the third figure from the left. L 55 5/10 in. W at bottom 2 3/10 in. W at top 4 5/10 in., Th at bottom 17/20 in., at top 1 in. L 53 1/10 in. Former W of top and bottom uncertain being injured, Th 17/20 in. L 49 1/10 in., W at bottom 2 8/10 in., at top 4 7/10 in., Th 8/10 in., and L 45 in., W at top 3 9/10 in., there is a small hole in the bottom of the handle of this. ? Used by the Caribs and called Potu.
Ashmolean 1836, p. 184 no. 146-7.

977 An Indians' Club from Para, South America. It is of dark heavy wood, of rude make, and appears to have been burnt and afterwards scraped into form. L 27 9/10 in.; D 1 2/10 in. at the handle end, becoming gradually thicker to the top, which terminates in a rough round knob of D 2 5/10 in. (Burchell collection). Given by his sister Miss Burchell, 1865.

978 South American Indians Club of dark brown heavy wood, L 43 in., D of handle portion 1 5/10 by 1 in., gradually spreading out from the middle of the club into a long, two edged, pointed leaf shaped [-two edged] blade D 3 3/10 in., and Th 1 in. The handle is incased in a closely wrought ornamental binding of cotton work, with long fringes attached. Whole L with the fringe 50 in. Locality uncertain, but Guiana? Ashmolean 1836, p. 184 no. 146 or 147 [?].

979 A Flute, made of the thigh bone of the Jaguar. It has the ends partly stopped up with a dark wax like substance, three small round \holes/ about 1 in. apart, along the top for the fingers, and a long tassel of cotton cords tied round it. Used by Indians of British Guiana. Obtained from Demerara. A similar instrument is figured in Wood's "Nat: Hist: of Man", Vol: 2. p. 630. L 8 2/10 in.; W of one end 1 8/10 in.: of the other end 1 3/10 in., which is the end for the mouth. Given by Greville J. Chester, B.A. 1872.

980 A Trumpet used by Indians in Chili, in their semi religious festivals: it is made of two pieces of hard dark brown wood, each half hollowed out on the inner side to form the tube, and then fastened together with bands of light brown wickerwork, some of which are single and plain, and fifteen nearer the large end separate and plaited; and at the two ends with plain bindings of cotton thread, the small end or that near the mouth hole having in addition small bunches of red feathers, and a fringe of hair, the latter projecting a little beyond the end. L 4 ft. 3 2/10 in., D at the small end 1 4/10 in., with the sides parallel for about half the L from it, from which point it gradually increases to about 5 in. D, at 7 5/10 from the other end, whence it diminishes to 2 6/10 in. at that end. The inside appears to follow pretty well the shape of the outside, the thickness of the wood being about 4/10 in. The hole for the mouth is at one side, L 1 3/10 by W 13/20 in., is oblong in shape and situated 4 in. from the small end, which is left solid. The outside is tolerably well shaped, with some attempts at ornament by the bindings of cotton and of the narrow split cane like material. It seems to require Indians' lips and lungs to bring out the tones, if there is anything melodious in them.

981 A pair of pale brown wooden Stirrups; used by Indians of tropical America. They are somewhat pyramidical in shape the base 5 7/10 in. square, H 7 5/10 in. cut out of the solid wood, and handsomely carved on three of the sides, the fourth being hollowed out to the depth of 4 5/10 in. to receive the fore part of the foot. From the hollows inside which have evidently been worn by the toes, they appear to have been used with naked feet only. Given by Mr Sherrard. Camberwell. 1824. A similar stirrup is figured in Meyricks "Ancient Armour", Vol: 2, Plate CXLV fig 11. 12. See also Wood's "Nat: Hist: of Man", vol: 2 p. 639.
Ashmolean 1836, p. 183 no. 121.

982 A pair of Brazilian Spurs. They are of somewhat ornamented wrought iron, of strong heavy make, with most formidable rowells D 3 in., of seven spikes each. L 9 in., W 3 3/10 in. A spur of this kind used by the Araucanians, is figured in Wood's "Nat Hist: of Man", Vol: 2 p. 551. Given by Mr Sherrard. Camberwell. 1824.
Ashmolean 1836, p. 183 no. 121.

982a A pair of Brazilian Tamankas, or slippers. The uppers or fore part of roughish brown leather having an outer strap W nearly 1 in. across the top. Soles of thickish pale brown wood with the leather part nailed to it round the edge after the manner of a clogg, and a few nails driven in the bottom. They have evidently been a good deal worn as is shewn by the soles. L 11 5/10 in., W of sole 3 1/10 in. (Burchell collection). Given by Miss Burchell his sister in 1865.
Ashmolean 1836-68, p. 5.

983 A South American horse-bit, called the Spanish bit. It is of similar workmanship and character to the preceding No 982. Used by the Patagonians and others of South America. L 11 3/10 in. W about 5 in. A bit of this kind is figured in Wood's "Nat: Hist of Man", Vol: 2. p. 528. Given by Mr Sherrard, Camberwell, 1824.
Ashmolean 1836, p. 183 no. 121.

984 An Iron Horse-bit of somewhat similar character and shape to the preceding No 983, but smaller and of better finish. Attached to it are two long plain strong \brown/ leather reins, L 6 ft. 11 in., and W 1 in., ornamented at 22 5/10 in. from the ends with a ball of plaited cotton, the two separate ends of the reins perhaps forming a whip. It has also two shorther leathern straps L 19 5/10 in., and W 1 in., each ornamented on the outside for about 4 5/10 in. [of] its length with very neat openwork done with narrow strips of the same kind of leather, the pattern on each strap being different. Ring of the bit D 4 4/10 by 4 2/10 in. Locality and history unknown. Perhaps given by Mr Sherrard. Camberwell, 1824.
Ashmolean 1836, p. 183 no. 121 [?].

985 A pair of doubled straps \of stiff brown leather,/ connected \together/ at the top through slits made in the ends, by a strong narrow strip of leather. L as doubled about 19 in., W 1 in. Probably they are the bucklers by which the wooden stirrups No 981 were suspended. (Perhaps given by Mr Sherrard, Camberwell, 1824?).
Ashmolean 1836, p. 183 no. 121 [?].

986 A Lasso made of plaited strips of raw hide. From Guiana. L 35 ft.; D 5/10 in. They are very generally used in Mexico and Central America, for catching wild horses and cattle by swinging the loop over the animal's head. It supersedes the bolas as it proceeds northwards. (Burchell collection) Given by his sister Miss Burchell, 1865. For a similar article used by the Indians of Araucania, see Wood's "Nat: Hist: of Man". vol: 2. p. 553

987 Ditto, made in the same manner as No 986, but much longer, thinner, and the noose in an unfinished state. From South America. L 57 ft., D 4/10 in. Given by Mr Sherrard, Camberwell, 1824.
Ashmolean 1836, p. 183 no. 121.

988 A one-handled Drinking Cup, or Goblet, from Paraquay, South America. It is made of Ox horn, with a double groove round the top on the outside, and fourteen oblique ones below running the whole length of the cup. It is ornamented round the top with two \plain/ stripes and a double row of dots, and round the sides, on the plain surfaces between the grooves, with plain stripes having a dot at each end, and also a border round the bottom partly composed of dots, and diagonal plain bands across the handle; all stained of a brownish red colour. It has a flat loop-shaped handle of the common pattern rivetted onto one side, which is 3/10 wide at the bottom, widening to 6/10 in. at the top, and occupies nearly the whole length of the cup. H 4 7/10 in. Greatest W at top 3 3/10 in. W at bottom 2 5/10 in., with straight sloping sides. L of handle 4 2/10 in. Given in exchange by the Trustees of the Christy Collection, 1869.

989 A Bottle gourd, used in South America for smoking tobacco, and called a "Hubble-bubble". The globular part is D 6 in., with a neck L 10 in. and D 1 8/10 in. to 1 2/10. Whole L 16 3/10 in. When used, the bowl of a pipe made for the purpose, is inserted in a circular hole, on one side of the globular part, a stem being fixed in the [-small] end of the neck of the gourd, which is then partly filled with water, through which the smoke is drawn. These gourds are also used in various ways for holding liquids. Given by \Sir/ J. Everard Home, Bart. 1839.

990 A similar gourd, with the neck or handle L 11 in., and D 1 in.; the globular part D 5 3/10 by 4 5/10 in., one half being cut away, perhaps to form a ladle. Whole L 16 in. Given by Sir J. Everard Home, Bart. 1839.

991 A smaller, and globular shaped gourd, with the long neck (if it had any) cut off. Used as a bottle, having an ingeniously made stopper of plaited grass like substance coloured yellow and surrounding the wooden plug. "It contains a white powder which the natives use for chewing". (It is not at all certain if this article is American as most of the things given by Mr Chamberlein are from the Solomon Islands, and Eastern Archipelago.) H 5 2/10 in., with stopper in, D 5 1/10 in. The powder is very fine, like flour. Given by J. Hugh Chambers, Magd[alen]: Coll[ege]: 1875.

992 A Calabash, or the half of an oval-shaped gourd, separated lengthways. Probably used for drinking purposes. From the Barbadoes. 1829. L 5 8/10 in., D 3 8/10 in. Given by Greville J. Chester, Esq. B.A.

993 A Box made of a Gourd of the same kind as the preceding, the outer surface scraped smooth, making

the gourd very thin, and stained black, the one side being ornamented with numerous thick set semicircular scratched lines drawn in opposite directions, done with a compass before the surface quite hard. A nearly squar[e] piece has been cut out of the side near the stalk end \but connected with a piece of string/ and appears to have been intended for a lid. Possibly not of Indian make. From the Barbadoes. Further history unknown. L 5 7/10 in. D 4 by 3 7/10 in. Probably given by Greville A. Chester Esq. B.A.

994 An Arrow of superior make, from America, probably California. The shaft is of a straight stick most beautifully rounded, (the pith being visible at the end), of a pale brown colour, L 27 6/10 in., D 3/10 near the upper part, but gradually tapering to rather less at the lower end; on the upper end of which is neatly fixed a piece of heavy wood coloured brown, L 5 15/20 in., and D 5/20 in. at its junction with the shaft, which has a fine binding of animal sinews, [-and] nicely rounded and tapering to the top to 2/10 in. \D/ which has a \brown/ flint head. This [-flint] head is remarkable for the skill shown in the chipping of it; it is L 2 6/10 in., W 1 3/20 in. at the base, the sides of which are barbed, tapering gradually to a fine point \the sides being straight;/ the bottom part has two side notches at 7/20 in. from the ends of the barbes, by which the flint head is fixed, but rather loosely, into a shallow groove cut in the end of the wood, by a fine crossed binding of sinew. It has had three feathers attached, \portions of which remain/ by bindings of fine sinews above and below, [-portions of which remain], and it is notched for the bow string. Whole L 35 8/10 in. Locality and history unknown. An arrow of this kind with the head fixed in the same manner is figured in Wood's "Nat: Hist: of Man", Vol: 2, p. 648. See also Evans' "Stone Implements", p. 365, Fig 345.

995 A large and thick piece of the inner bark of some tree, somewhat like the Jamaica Lace-bark in appearance but much coarser, of a pale brown colour. Used by natives of Central America as a bed, when spread out on a few sticks raised about 2 ft. from the ground. L 7 ft. 6 in.; W 3 ft. 2 in. Sides and ends square. Given by Lieut. J. Wood, R.N. of H.M.S. 'Pandora' 1850.

996 A piece of the stem of the Jamaica Lace-bark tree (Lagetta linearia). From part of it, the outer bark has been taken off, and the inner bark layers about fifteen in number turned back. The tree grows to 20 or 30 ft. high, and the inner bark is taken off in layers, and made up into articles of dress. Hab[itat]: West Indian Islands and Tropical America. L 4 5/10 in. D 2 5/10 in. by 2 3/20 at bottom; and 2 3/10 by 2 in. at top.
Ashmolean 1836, p. 185 no. 206.

997 An oval-shaped basin or deep dish with scalloped rim. From Para south of the Amazon. It is of recent make and apparently formed by hand only. The clay has a large admixture of Mica, is light in colour and

weight, very absorbing, and gaudily painted with flower pattern in red, yellow, green, white, and gold on a dull blue ground, and inclosed in compartments by plain and chequered red lines and glazed on the inside only, the outside being a plain unglazed dull white. Greatest H 3 8/10 in. L 14 2/10 in.; W 11 8/10 in. Old French ware (?). Given by Sir J. Everard Home. Bart: 1839.

998 A Jug of like material, make, and decoration. Painted and glazed on the whole of the outside, and on the inner side of the mouth. From Para, South of the Amazon. H 8 5/10 in. D of the middle 4 4/10 in.; of the bottom 4 5/10 in. which is circular. The top has a very deep notch at the sides. Apparently fellow to the above No 997. Given by Sir J. Everard Home, Bart. 1839.

999 A vessel shaped somewhat like a Greek 'Kylex', but deeper in the bowl, of drab coloured clay, having similar properties to the preceding 997 & 998, painted inside with flowers in black, red, and violet on the inside, and also on the outside but in a less degree, and glazed on both sides. It has four perforated ears at about 5 in. from each other around the rim on the outside, as if intended for suspension by four lines, and stands on a circular foot which has been broken. H 4 6/10 in. D across the rim not reckoning ears 6 9/10 in. D of foot 3 7/10 in. Found at Hinton Abbey in the Parish of Charter House Hinton, Somersetshire. Made at Guadalajara, Mexico. It may possibly have been used to hold oil to burn a wick, and have been suspended by the perforated projections. Given about the year 1875, but donor's name forgotten.

1000 A somewhat conical shaped article with two sides coming somewhat to a keel which on the outside as well as along the top are bound with narrow strips of wood about W 6/10 in. The inside is made of regularly interwoven narrow strips of palm-leaf W from 4/10 to 5/10 in., the outside being covered with broad pieces of the same material sewn on, and it is strongly bound round the edge with a piece of similar material, and fine well made string. It could have been used as a hat or a basket. H 9 in. D 13 5/10 by 11 2/10 in. Locality uncertain. (Is it from the Eastern Archipelago?) Given by J. Hugh Chambers. Esq. Mag[dalen]: Coll[ege]: 1875.

1001 A Hammock from British Guiana ?, made of cords of twisted grass of a pale brown colour stained with three longitudinal broad stripes of green edged with brown; the numerous suspending cords at each end being of the unstained pale brown and worked into a strong loop at each end for suspension. Whole L 12 ft. 7 in.; L of the net part only about 6 ft. 2 in. History unknown.

1002 A grass Hammock, made in rather a different way. Probably from British Guiana: now of an uniform dark brown colour, a good deal broken, and apparently very old. L of the network portion only about 5 ft. 8 in.

(Ramsden collection. No. 1425.) Purchased by the University 1878.

1003 A Hammock, probably from South America; made of numerous white cotton cords \arranged/ parallel longitudinally, \and/ woven \together/ in twenty-seven [-cross\transverse] bands about 2 to 3 in. apart \from each other/. It is now of a brownish colour with dirt. L of the netted part 7 ft. 2, the cords being left separated and tied together in a knot at each end. History unknown.
MacGregor 1983, no. 16.

1004 A Hammock, probably from South America; made of closely woven strong white cotton thread, ornamented with nine longitudinal rows of dark and light brown stripes, each of the seven middle rows having six or seven narrow stripes, and the two outside or edge ones only three each. These longitudinal bands are crossed at intervals by sixteen fainter transverse bands of the same colour. The threads are left unwoven at each of the ends and plaited into sixteen pairs of cords about L 1 ft., thirty-two cords at each end intended either for a reeving string, or for a pole to suspend it by. Whole L 10 ft.; L of the woven portion only. W 2 ft. 10 in. History unknown.

1005 A pair of large stirrups perhaps from South America, made of cast bronze, or bell metal, with a strong thong of raw hide, L about 34 in. fastened to each by a long narrow hole in the flat upright tops; the bottoms forming a wide semi-circular bridge for the foot, the sides being nearly triangular in shape. Size of base 6 9/10 by 6 1/10 in. H 8 7/10 in. W of top 2 2/10 in. Th of ditto 3/10 in. (Ramsden collection ?). Purchased by the University 1878.

1006-1035 Thirty seven [*sic*] Articles from Ancient Peruvian graves in the neighbourhood of Arica; obtained on the spot by Lieut: M.J. Harrison, R.N. in 1868, after the great earthquake, when an enormous wave, 50 or 60 ft. in height swept over the coast, and left bare thousands of graves of the Ancient Inhabitants: in which from the effects of nitre in the soil, the bodies were in a mummyfied state; the men with their tools, and instruments they used when alive; the women with their w[h]orls and wool, needles and thread, etc, for use in the next world; and the children with minature articles of the same description. The bodies were all in a sitting position. Given by J. Park Harrison. Esq. M.A. 1876.

1006 A detachable harpoon head of reddish brown wood, tipped with a well chipped barbed white flint (chert?) head, finely serrated along the edges; fixed by a shank into a hole cut into the end of the wood, and bound with red wo[o]llen thread; both ba[r]bes have been somewhat broken. L of wood work 12 8/10 in.; D of bottom which has a projecting shoulder 1 in.; gradually diminishing to the top to 6/10 in.: It is somewhat roughly rounded having one side rather keeled and the other flat, and appears to have lost a

barb from a hole on the flat side, near the top. \Used for fishing./ L of flint head 2 4/10 in., Present W 19/20 in. Whole L 14 8/10 in. L of projecting shoulder at lower end 2 1/0 in. From a Man's grave.

1007 A well chipped, barbed, and slightly serrated arrow or harpoon head, of white flint (chert?). Probably used for fishing. One of the barbes broken off, and also the point. L 1 7/10 in., greatest W 13/20 in. From a man's grave.

1008 A Fish-hook, or artificial bait; made of a straight narrow piece of bone, pointed at each end and having a small barb of hard wood 7/10 in. long bound on at an angle near the smaller end with fine shreds of animal sinews: the other or larger end having remains of a wool[l]en line. L 3 8/10 in. Greatest D 3/10 in. From a Man's grave.

1009 A barbless Fish-hook, L 1 7/20 in.; Th of the metal 1/10 in. From a Man's grave. Another fish-hook was found to be composed as follows. Copper 94.83, Tin 4.76, Iron 0.34, and a trace of Antimony.

1010 A bronze Cutting instrument, or perhaps scraper; with short handle made of grass stem, or reed, and a wide chisel-shaped blade, fixed in the handle at right angles, and having a piece cut off one end, which by analysis has been found to have the following percentage, Copper 94.18. Tin 4.27. Antimony 0.17. Iron 0.36. (The close resemblance of these two articles in their composition affords an interesting indication of the practical knowledge of the production of alloys existing among the Mexicans at the time of manufacture of these instruments). L 3 6/10 in. Present W of blade 2 7/10 in. Greatest depth \of ditto/ from handle 15/20 in. L of handle only 2 9/10 in. W 4/10 in. From a Man's grave.

1011 A somewhat shuttle shaped implement of brown stone, that is rounded on all sides and sloping to a point at each end; securely bound at each end to a well made line of cotton 4 ft. long. The other end appears to have had the somewhat finer lines which have been cut off. Probably a plummet used for fishing, as a sinker for fish-hooks, somewhat after the way of the Esquimaux implements of Walrus ivory (see the Esquimaux collection No []) L 4 3/20 in. Greatest D 17/30 in. From a Man's grave.

1012 Two serrated bones \or spines/ of the sting ray, rounded off at the large end. Use uncertain, but thought to have been charms. L 3 in.; and 3 3/20 in.; greatest D 5/20 in. Bound round with a bit of rush. From a Man's grave.

1013 Implement made out of the shank bone of some animal; rudely pointed at one end by having a piece split off the side. Probably used either as a piercer in sewing, or for smoothing down the seams; or possibly as a pottery marker. L 4 in. Greatest D 8/10 in. (For instruments of a somewhat similar character see Swiss Lake collection). From a Man's grave.

1014 A hollow white shell, very much worm eaten on the outside, containing what appears to be a lump of red colour. Size of shell 2 7/10 by 2 1/10 in., and 1 1/10 in. high. Size of colour 1 2/10 by 8/10 in. From a Man's grave.

1015 A small piece of coarse but well made cloth folded up and tied at one end, and apparently containing red colour. L 3 4/10 in. W 1 4/10 in. From a Man's grave.

1016 A globular-shaped two handled pot (Dri[n]king vessel?); of coarse black earthenware. It appears to have been much burnt on the underside. One handle and two sides of the rim broken off. H 5 2/10 in. D 5 in. D of the mouth 3 6/10 in. Bottom rounded. From a man's grave.

1017 Small model of a Drinking cup, of coarse black pottery, having two small pierced projections or ears on the [-rim] sides just below the rim. Bottom globular shaped. H 2 7/10 in. Greatest D 2 1/10 in. D of mouth 1 5/20 in. From a Man's grave.

1018 Ditto, of Food vessel, of coarse black pottery, of a lower and more globular shape, and with the little pierced handles or ears at the sides broken off. H 1 7/10 in. Greatest D 2 3/10 in. D of mouth 1 7/10 in. From a Man's grave.

(The three preceding objects are of hand made pottery)

1019 An Ear of Maize or Indian corn. L 4 1/10 in. D 1 4/10 in. From a man's grave.

1020 A Bag of \coars[e]ly/ woven pale brown wool, ornamented with a dark brown stripe 7/10 in. wide down the middle of each side. It is made of one piece of stuff sewn together up the sides. L 8 5/10 in. W 7 in. From a Man's grave.

1021 A piece of brown Alpaca wool with the skin attached to it. Size 5 5/10 by 3 5/10 in. From a Man's grave.

1022 A spoon-shaped article of dark brown wood. It is nearly pear-shaped in outline, rounded off on the underside, the upper part being hollowed out to near the edge, and having two very Egyptian like squatting figures carved in a rude manner, sitting side by side, and facing inwards towards the bowl. This end has been perforated between the two figures probably for a string to pass through. It is considered very curious and rare. L 3 7/10 in. Greatest W 2 9/20 in., decreasing to 1 1/10 in. at the small end to the seated figures which are W 1 4/10 in., and H 1 3/10. From a Man's grave.

1023 A Spindle of dark brown wood, with spindle-whorl of the same material fixed on one end, immediately below which is wound a specimen of the wool[l]en thread. L of the spindle, which is cylindrical, 12 in., D 5/20 in., and pointed at the opposite end to that on which the w[h]orl is fixed, apparently for the purpose of twirling it between the thumb and finger.

Whorl nearly circular, greatest D 1 17/20 in., one side convex, the other side flat, and 5/10 in. thick. From a Woman's grave. This is a very interesting object as illustrating how articles No [] and also others in the Danish and Anglo-Saxon collections were used. For a description of such articles see Evans' "Ancient Stone Implements of Great Britain". pp. 390-393.

1024 Article of brown wood of the same size round as the spindle No. 1023; pointed at both ends. Probably used as a shuttle used in weaving. Found in the same woman's grave as the spindle. L 5 13/20 in.

1025 A neatly woven wool[l]en bag in ornamental longitudinal stripes in brown, red, white, and black. It is made of one piece of stuff doubled and sewn up at the sides. L 5 7/10 in. W at top 5 8/10 in. From a Woman's grave.

1026 A small Basket made of sticks and white wool[l]en threads, containing a quantity of brown and light brown wool, each in a separate packet; and also pieces of wool[l]en cords of different sizes and shades of brown. L \of basket/ 10 5/10 in. From a Woman's grave.

1027 Five small specimens of Hair, wool, and Fur. Some of which may have been used for charms. From a Woman's grave.

1028 A round straight needle, very neatly made of hard dark wood, perhaps the spine of a Catcus [*Cactus?*] plant?; having a piece of thick cotton thread in the eye, L 5 3/20 in. D 1/20 in. From a Woman's grave.

1029 Two spines of the Catcus [*Cactus?*] plant; possibly intended for pins or needles. L 5 and 4 2/10 in. From a Woman's grave.

1030 Portion of a Necklace of small black beads, of two kinds; some of them globular D 2/10 in., and the others very small and cylindrical shaped. L 6 5/10 in. From a woman's grave.

1031 Wooden Comb, the teeth of which are made of thin strips of hard brown wood L 2 7/10 in., pointed at each end, arranged close together, and fastened along the middle, on each side, with a split piece of grass stem, or reed, bound with numerous crossed cotton threads. L 2 7/10 in. From a Woman's grave.

1032-1033 Minature Bow and Arrow. The bow having no string, and the arrow which is clumsily made of a piece of pithy stick, having a long triangular shaped barbed head of chipped white flint (chert?). L of bow 14 5/10 in., D 4/10 by 5/20 in., being nearly oval-shaped in section and somewhat pointed at each end. L of arrow shaft 8 3/10 in.; D 3/10 in. L of flint head 1 9/20 in. From a Child's grave.

1034 Small basket of the same kind as No 1026, made of small sticks and brown wool[l]en threads. D uncertain as it is much flattened by the breaking of the sticks. From a Child's grave.

1035 Small coarse wool[l]en bag, sewn up on all sides, so that it resembles a small pincushion. Containing food? Size 1 5/10 by 1 5/10 in., and 6/10 in. thick. From a Child's grave.

1036 Ancient Peruvian Water-bottle of red Earthenware. Shape that of a depressed wine bottle with the base projected cone shape, and having two flat loop shaped handles on the sides near the bottom, and a short solid round projection on one side midway between handles near the bottom of the neck, which is comparatively narrow and has a projecting rim. Found in an ancient Peruvian grave or Huacas? H 7 7/10 in. D of body 5 in.; or across handles 6 5/10 in. D of neck 1 3/10 in.; of mouth 2 4/10 in. Portion of the surface appears to have remains of glaze, and has been painted V shaped stripes. Given by the Trustees of the Christy collection, in exchange, 1869.

1037 Fifteen Ancient \white/ Shell Hatchets; found in the ground, on the Codrington Estate, St John's; at St Luke's; at St George's, at Conset Bay, and Conset Point, Barbados, In 1867-68-69. They appear to have served for similar purposes as the Stone and Flint implements of other countries, and to have been made from shells of the large Strombus. L from 7 6/10 to 3 in. W 2 7/10 to 1 7/10 in. Given by Greville J. Chester, B.A. 1869.

1038 Hatchet-head, of very hard, solid, and heavy \white/ shell \Strombus/; ground down on all sides, and to a cutting edge from one side only. It much resembles one of the stone or flint Celts found in Europe, except its being white, and the edge ground from one side only, in that particular reminding one of the New Zealand and Sandwich Island Adzes of stone. L 3 7/10 in.; greatest W 2 7/10 in.; W of cutting edge 2 6/10 in.; W of top 2 in., which has been ground off somewhat round. From Barbados, on the Codrington Estate, St Johns, 1867. Given by Greville J. Chester, B.A. 1869.

1039 Hatchet-head of white shell, similar in shape to No 1037 but of better finish than some of them. From Barbados. L 4 4/10: D 1 7/10 in. (Given about the year 1875, but donor's name not having been registered was forgotten.)

1040 Two fragments of very coarse brown pottery of a darker colour inside. One of them cylindrical and probably having formed the handle of something; the other flat and probably having formed the rim of some vessel. L of round piece 3 5/10 in.; D about 1 in. Size of flat piece 3 1/10 by 2 6/10 in.; and 7/10 in. thick. From St: Luke's, and Conset Point, Barbados, 1868 Given by Greville J. Chester, B.A. 1869.

1041 An Axe-head, or Celt, of green basalt; from Panuco Mexico. It is well worked, more or less rounded on all sides, ground to a sharp curved cutting edge, and grooved round near the upper end for hold for the handle, which probably was made of a twisted stick, after the manner of hafting a blacksmith's cold chisel. L 6 6/10 in. Greatest W 3 5/20 in. Greatest Th 1 7/10 in. The cutting edge being semicircular, and the top, somewhat rounded also. Given by Captain King, R.N. 1831 (For the way in which such an article could have been halfted [*sic*], see Wood's Nat: Hist: of Man, Vol 2, p. 32, fig 1).
Ashmolean 1836, p. 183 no. 118.

1042-1114 A Collection of small articles taken out of the Pyramid of Cholula, Mexico. Given to the Bodleian Library by C. Lemprière, Esq D.C.L St: John's College, and [-removed\transferred] to the Ashmolean in 1864. The Pyramid is situated close to the town of that name, in the State of Puebla, Mexico. It is built in four Terraces, the upper one forming a platform of 212 ft. square, the base measuring 1440 ft. on each side, the whole H 177 ft. On the top a small church has been built. For what purpose and by whom this and similar pyramids were erected is uncertain. It is stated in "Humbolt's Researches" that the Mexicans (Aztecks) conquered by Cortez assigned them to a high antiquity, and to a People previous to their own possession of the Country. See "Humbolt's Researches". Pt. 13. p. 81. vol: 1.
Ashmolean 1836-68, p. 10.

1042 A Bottle shaped article of shining black clay, the middle portion, forming the neck being cylindrical, L 1 6/10 in. and D 1 in., the base swelling out into a globular shape flat at the bottom, L 1 1/10 D 1 9/10 in.; and the top expanded into a flattish \broad/ lip D 2 1/10 in. and Th 2/10. It appears to have been scraped into form on the outside, the tool marks being very distinct. Whole H 3 in. Nearly the one half of the lip broken away.

1043 A cylindrical shaped Pot of dark, almost black clay, having a slightly overhanging lip, and three short feet arranged triangular ways underneath the flattish bottom. It has apparently been scraped into form, and is ornamented on the outside with [-a few\double] parallel horizontal incised lines round the top and bottom of the sides, with a few diagonal lines between. The glaze is not so bright as in the previous No 1042. H 2 2/10 in. D at top 2 17/20 in. by 2 13/20 in. D of bottom 2 3/10 by 2 2/10 in.

1044 A depressed globular shaped vessel of somewhat similar ware to the two preceding Nos. 1042. 1043 but glazed on the outside only, and mounted on three similar little feet. It is quite plain and the upper part appears to have been broken off. On this also the tool marks are visible. H 2 2/10 in. D 3 6/10 in. The outside is of a mottled brown and black appearance, the inside plain drab, the colour of the clay.

1045 A similar shaped vessel to the preceding No. 1044, but without feet: of light brown ware, of an uniform colour inside and outside, and apparently without glaze, and not broken. H 1 9/10 in. D 3 2/10 in. D of mouth 2 5/10 in. Bottom flattish, so that it will stand.

1046 A Bowl shaped vessel of plain light red ware, with a darker red border the outside of the rim. It has been broken in half and stuck together again, a fragment being gone from one side at the top. H 1 9/10 in. D 4 in. D of mouth 3 7/10 in. It will stand upright.

1047 A cylindrical shaped small \pot/ of similar shape to No 1043, of coarse unglazed black pottery, the bottom having no feet, and flat, the sides widening out near the top a little, but the lip not overhanging. H 1 3/10 in. D of top 2 in.; of bottom 1 6/10 in.

1048-1049 Two small roughly made cup shaped vessels with concave sides and rounded bottoms: of unglazed brown pottery. H 1 4/10 and 1 3/10 in. D of top 1 9/20 in.

1050 A somewhat similar but smaller vessel, of darker pottery and having straight sides. Bottom rounded. H 1 in. D 1 5/20 in.

1051 Ditto of brown pottery, which appears to have had a rim which has been broken off. Present H 1 3/10 in.

1052 An article of dark grey unglazed pottery L 2 9/10 in., [-and] 1 15/20 in. greatest W; and H 1 7/20 in. Flat on the sides top and bottom, but rounded at the ends. In the top are two holes side by side W 7/10 in. and 1 3/10 in. deep, each crossed near the bottom by round holes D about 3/10 in. At one end is rudely represented a pair of prominent lips, or perhaps a nose, two of the small side holes just mentioned forming the eyes, behind which are prominent ears. It is also rudely ornamented with incised lines after the manner of No 1043. The use of this article it is difficult to conceive except it was intended for a double tobacco pipe bowl, and that is hardly probable.

1053 Similar to the preceding No 1052, but without the face, and the incised lines; having a groove round the top. D 2 6/10 by 1 5/10 in., and H 1 6/10 in. (The preceding two articles more resemble two thick, rudely formed tobacco pipes, with bowls joined together side by side, but the holes that would answer for the insertion of the stem go right through the back as well as the front).

1054 A small vessel of red ware, in shape somewhat like a short thick body of a bird, the circular mouth of the vessel occupying the place of the head. It stands on three short legs as in No 1043 and 1044. In general form it much resembles a small Greek Askos. L 2 4/10 in., D 1 5/10 in.; and 2 in. high. The neck has been broken and mended again, a fragment being wanting.

1055-1076 Twenty-two Heads or Masks, some of red and others of brown terra-cotta, nearly all of them representing the human face, but in a few cases very grotesquely. No two of the same size or exactly the same in style. Many are represented with peculiar head dresses, and large circular earrings. Two or three of them appear to be intended for monkeys; and one small

one is a dog's head with his tongue out. Some are very Egyptian like in style. L 2 5/10 to 8/10 in.

1077-1079 Three fragments of figures (the trunk portion) representing the human figure, two of which are wearing some kind of dress. One of grey and the other two of brown terracotta. L 1 5/10 in., 1 6/10, and 1 2/10 in.

1080 A necklace composed of 100 small pebbles of different sizes and colours, from D 1 1/10 to 4/10 in., and irregular in shape, but each perforated by the hole being drilled from each side till it met in the middle. Attached to the back is a long oval grey stone with square ends which have been drilled in a different manner. L 2 6/10, D 7/10 by 5/10 in. Whole L of necklace 2 ft. 8 in.

1081 A Spindle whorl of brown terra-cotta ? or perhaps some kind of stone rather shiny on the surface, and ornamented on the top which is truly hemispherical in shape, with concentric circles and straight and curved lines, all rather deeply incised. The underside is flatly convex and quite plain, and the perforation through the middle is round and rather above D 3/10 in. It appears to have been cut or scraped into shape. D 2 1/10 in., and H or Th 1 in.

1082 Ditto, ditto, a little smaller, and and flatly cone-shaped in form. The ornamentation is more worn than on that of the preceding, but appears to have been of a superior kind, and something of a scroll pattern round the bottom of the sides. Underside flatly convex \and plain./ D 1 9/10 in. H 9/10 in.; and perforation D 4/10 in.

1083 Ditto (?) convex above, and flat on the underside. Quite plain and the perforation D 2/10 in. It may have been used as a button. D 1 3/20 in., and Th or H 3/10 in.

1084 Ditto (?) hemispherical in shape above, and flat on the underside. Quite plain, and perforation small, about D 1/10 in. D 8/10, Th 4/10 in. All these Spindle-whorls have the perforation in the centre perpendicular to the base. They take their name from their having been used on the end of hand spindles, to give weight to, and keep them whirling in the making of thread. This doubtless has been a common occupation of Females at some period in the progress of nearly a[ll] peoples; and articles of similar form, and made of various materials, are found amongst the remains (and may be seen in the Collection) from the Lake habitations of Switzerland; also in the Danish, Ancient British, and Anglo-Saxon graves, etc. They thus afford an illustration of how similar wants led to similar means to supply them. In connection with this subject an interesting article has been added to the museum, from Peru, see No 1023. (For description of such articles see Evans' "Ancient Stone Implements of Great Britain". pp. 390-394).

1085 Ditto ? or perhaps a bead: of brown terra-cotta. One side being somewhat convex, the other side hollow in the middle, the edge round and ornamented with six perpendicular indented lines. Small central perforation. D 1 3/20, and Th 6/10 in.

1086 Ditto, ditto, of nearly the same shape and size, the two sides being concave, the edge round but plain. D 1 3/20 in., and Th 11/20 in. Brown terracotta.

1087 A flattish Disk of reddish-brown terracotta, ornamented on one side with a design something between a cross and a wheel, thus [drawing] indented and occupying the whole surface. D 1 7/10 in., and Th 5/20 in.

1088 Disk of brown terracotta, hollowed out from near the edge to near the centre on one side, and flat on the other side, the edge being hollowed out also. Somewhat resembling a draughtsman, or perhaps may have been used for some game. D 1 5/20 in., and Th 6/10 in. Unperforated.

1089-1090 Two ditto, one of brown and the other of grey terracotta; flat on both sides, the edges being hollowed. Unperforated. Probably pieces for a game. D 15/20 in., and Th 11/20; and D 8/10 in., and Th 9/20.

1091 Circular object of light brown stone round on one side and flat on the opposite, this side having a groove across the middle and over the edge, as if for a string to pass round, and this could have been used as a weight for a Plumb-line. D 17/20 in. and Th 9/20.

1092 Brown terra-cotta Disk with raised figures on the flat side within a raised rim. Perhaps part of a stamp or seal. D 9/10 in.

1093 Small flat disk of [-brown\green] stone. D 6/10 in., and Th 3/20.

1094-1095 Two squarish lumps of semitransparent white stone: one much harder than the other; perhaps the softer of the two is Alabaster. Use uncertain. Size of the softer piece 1 3/10 by 1 3/10 in.: of the other 1 3/10 by 1 1/10 in.

1096 A long and somewhat rounded pebble of a bright brown colour. L 2 15/20 in. Greatest D 9/10 by 11/20 in.

1097 An oblong shaped piece of Pumice-stone. L 1 13/20 in. D 1 by 7/10 in.

1098 Two fragments of the flat rim of what seems to have been a rudely formed marble vase \or vases,/ of a pale green colour. Size L 2 15/20, and 1 5/10 in., unequal in width, and Th 3/10 to 4/10 in.

1099 Cylindrical shaped piece of white, veined, alabaster; chamfered of[f] at one end as in the mouth of a whistle; the other end being flattish and having a faintly scratched cross line thus X, which seems to be original. Perhaps a charm. L 1 1/10 in. D 9/20 in.

1100 A cylinder of brown stone, or fine terra-cotta, neatly made and rounded at each end. It appears to be of very absorbing nature. L 1 9/10 in. D 8/10 in.

1101 A flattish, and somewhat square shaped piece of brown terra-cotta, with what looks like the fragment of the circular bottom of some vessel above. It may have formed one of four feet of a vase, as the ornamented side would then be outwards, the opposite or inner side being roughish and unornamented. H 2 in., W 2 2/10 in.; Th above 8/10 in., and of the foot? below 4/10 in.

1102 Little figure of brown terra-cotta moulded one side into nearly the shape of a bundle of sticks, or a sheaf, bound \together/ round and round the middle. The other side is hollow, and the ends nearly square. L 1 7/20 in. Greatest D 17/20 in.

1103 Ditto, ditto, apparently representing a headdress of feathers, or perhaps some fruit or flower. It has certainly been broken, probably from some larger figure. L 1 5/10 in. Greatest W 1 4/10 in.

1104 Semiglobular shaped object of brown [terra-cotta], having characters or figures in relief on the round side and hollowed out at the back, D 9/10 in.

1105 Small object of brown terra-cotta, perhaps intended to resemble some Fruit. In shape something like the lower portion of a jug, with some irregular knobs stuck on it. H 8/10 in. Greatest D 1 1/10 in.

1106 Small fragment of some ornamental object[.] Grey terra-cotta[.] Size 1 7/20 by 8/10 in.

1107 Small circular stand or handle of some object: brown terra-cotta perhaps part of No 1092. D 6/10 in.

1108 A hollow article of brown terra-cotta, of irregular shape, somewhat resembling the bone of some animals joint. It has a hole in the side, and another but much smaller one at the end, and could have been used as a call or whistle It has been somewhat broken. W 1 11/20, H 1 2/10 in.

1109 Two halves of the same species but different specimens of a white bivalve shell; of the genus Cardium ? or something near it. Greatest L 1 in.

1110 One ditto, of a wider form of bivalve \shell/ of a grey colour outside, and rough like No 1109, L 1 4/10 in. W 8/10 in.

1111 A bone from the joint of some animal's foot? Size 1 9/20 by 19/20 in.

1112 Two fragments of thick, coarse brown, unglazed pottery; containing a great quantity of small particles of Mica. D 2 9/10 by 2 6/10 in., and 1 1/10 by 9/10 in. Th 3/10 to 4/10 in.

1113 A quantity of thin flakes of Mica, now of a lustrous brown colour.

1114 The one half of a cylindrical piece of chalky white shell, perforated at each end as if for a string to pass through. Perhaps worn as a pendant, and possibly

may have belonged to the necklace. No 1080 preceding. L 1 2/10 in. W 13/20 in., and greatest Th. 3/10. Looking at the edge it is crescent shape.

1115-1118 Mexican Implements of black Obsidian (Volcanic Glass). Given to the Bodleian Library by C. Lemprière, Esq. D.C.L. St John's College; and removed to the Ashmolean Museum in 1864.
Ashmolean 1836-68, p.10.

1115 Three knives or razors. These are simply narrow Flakes which have been struck off a core. Each has three facets on one side, the other side being smooth and slightly round, and the edges very sharp. L 3 11/20, D 11/20 in.; L 2 4/10, D 9/20 in.; and L 2 5/10, D 7/10 in.

1116 Two fluted cones of black Obsidian, from which similar narrow flakes to the preceding No 1115 have been struck off. L 3 2/10, D 7/10 in.; and L 2 5/10, D 7/10 in.

1117 A large barbed, and triangular Arrow-head of chipped black obsidian, with a short stem for insertion into a split or groove in the top of the shaft. One of the barbes broken off, and a piece broken out of one edge, and also a bit from the point. L 2 9/10 in. Present greatest W 1 4/10 in.

1118 A leaf-shaped spear-head, or knife blade of chipped black obsidian. The lower end is broken off square, and may have been formerly much longer. L 3 3/10 in. Present greatest W 1 1/10 in.

1119 A conical shaped spindle-whorl of fine brown terra-cotta, or stone; with flat base and top, and polished over the whole surface. Ornamented round the side with parallel horizontal lines round near the top and bottom which inclose four double spirals separated from each other by double parallel upright lines, thus [*drawing*] \all incised/. From an Ancient Mexican grave. H 1 in. D of base 2 in. 2 in.; D of top 8/10 in. A piece has been lost from one side of the base. Given by W. M. Wylie, Esq M.A. F.S.A. Merton College \and/ Blackwater, Hants, 1866.
Ashmolean 1836-68, p. 18.

1120 Ditto, ditto round above, and faintly convex at the bottom. The upper side ornamented with three concentric circles, the two lower of which are the furthest apart and inclose between \them/ on opposite sides [-] \of the whorl/ pairs of transverse bars of a kind of faint network pattern edged at the sides with stronger lines [*drawing*] thus; all incised. D 1 8/10 in., and 7/10 in. high. Given by W.M. Wylie, Esq. M.A. F.S.A. Merton Coll[ege]: and Blackwater, Hants, 1866.
Ashmolean 1836-68, p. 18.

1121 An Ancient Mexican Figure, perhaps an idol; of reddish brown terra-cotta \with a whitish somewhat shiny surface,/ rudely representing what looks like a nude and grotesque Female Figure. Left leg and right arm wanting. Dug up in Panuco, Mexico. H 5 5/10 in. Given by Captain King, R.N. 1831.

Ashmolean 1836, p. 183 no. 119.

1122 The upper half of an Ancient Mexican Idol of [] stone []. It is a rude representation of the head, upper arms, and breasts of a Woman, about 20 in. high and 31 wide, the head of which is surmounted by a sort of mask, somewhat resembling the head of a Crocodile. Whole H 3 feet. It was found by Captain Lyon whilst making a survey of the River Panuco, on the Eastern coast of Mexico, at a town or village of the same name. Its date is doubtless prior to the Conquest of Mexico by the Spaniards. Given by Captain G.F. Lyon, R.N. 1825.
Ashmolean 1836, p. 147 no. 502a.

1123 A Wax Model coloured black, of the Mexican \Zodiac/ Calender Stone, on a reduced scale of one tenth. \D 13 in., in a square black glazed frame 16 5/10 in square. W 2, and Th 2 [ins.], / on a reduced scale of one tenth. [-on a reduced scale of one tenth] \D 13 in., in a square black glazed frame 16 5/10 in. square. 2 wide, and 2 thick, and framed to hang up./ and framed to hang up. Made by the donor. Miss [-S\Sibylla] Bullock, London. 1824 [-4]. The original stone is \porous/ Basalt, and was discovered in 1790, in the Plaza Major, [-in\the great square of] the City of Mexico, on the foundation of the ancient Teocalli or Temple. It is a flat sculptured disk D 11 feet 8 in., and standing in relief 7 1/2 in. from the mass, of which it forms a part; the whole weighing 5 tons. \The block of basalt is calculated to have weighed 24 tones when perfect/ In the centre is represented the figure of the Sun, the rays in the direction of the Cardinal points. Round the head the Seasons are exhibited in Heiroglyphics, and in the next circle the names of eighteen Mexican Months of twenty days, thus making the calculation of time nearly the same as ours; a remarkable coincidence in a people who were ignorant of the existence of the other three quarters of the world. It is supposed to have been buried by the Spaniards on their conquest of Mexico, together with other national monuments, to subdue as far as possible the spirit of the people; and when discovered, not being visibly connected with the Ancient Religious Rites, it was permitted to be placed against the south wall of the Cathedral. \It is now walled into the north-west side of the cathedral/ It is commonly called Montezuma's watch. A full sized cast of it was exhibited in Bullocks Mexican Museum, in the Egyptian Hall, 1824; from which this model was copied. Particulars respecting the stone are given in the following works[.] Humbolt's "Researches concerning the Institutions and Monuments of the Ancient Inhabitants of America", pl 23, p. 276, vol: 1. 8° London. 1814. Humbolt's "Vue des Cordillères" (French), with figure \pl 23,/ and exhaustive description. [-pl: 23] W. Bullock's "Six months in Mexico". pp. 333 & 334. 8° London. 1824. \See also Mr Bollaert in "Intellectual Observer", August 1865, with exhaustive description of the meaning of the various parts of this calendar accompanied by a plate/. Brantz Mayers "Mexico as it

was and is". Figured and described, p. 127. 8°. New York, 1844.
Ashmolean 1836, p. 142 no. 405a.

1123A A very curious article of rudely carved bone, probably of the [-arm or] leg-bone of some animal. Where from uncertain. It [-appears to have \has] the figure of an Armadillo or Anteater carved on top, below which is a very grotesque figure which may be either intended for a beast of some kind, or a bird, the eyes of which have been inlaid with white shell, one of which remains, and they appear to have been stuck in with some black gummy substance: Below this is another rude animal, somewhat \rudely/ resembling an Egyptian Sphynx, the eyes of which had also been inlaid. Underneath this the bone is scored with a number of faintly incised crossed lines, below which it is plain, decreases rapidly in size, and has a narrow slit 2 6/10 \ins. long/ up it. It is made out of a marrow bone, though it is hard to say of what animal, and from the many scratches on the surface it seems to have been carved under considerable difficulties, & \probably/ with rude tools, and by some barbarous people. It does not appear to be human bone. Whole L 7 1/10 in., of which the ornamented portion measures 3 9/10. Greatest D 1 2/10 in. I have been given to understand that articles in brass, sometimes plain, and sometimes jewelled, are used by native ladies of Madura in the South of Hindustan, for parting the hair; some have grotesque heads so arranged as to stand upright on a table, but generally are like this bone one, arranged to be laid down.

Volume II: Catalogue of the Australian, New Zealand, and Polynesian Collections in the Ashmolean Museum

N.B. There are only forty objects from New- Zealand and the South Sea Islands entered \separately/ in the printed catalogue of 1836 \p. 184/ as belonging to Cook's collection given to the Ashmolean Museum by Reinhold Forster Esq the Naturalist during the Second Voyage. Some of these have the peculiar number label thus (No. 40) which is also on many other objects not ascribed to Forster.

1124 A New-Zealand cloak, made by natives of fibres from their indigenous flax plant, Phormium tenax, (Forst:). It belongs to the natural family of the Liliaceae and the tribe Asparangacae. "It has a number of showy yellow flowers arranged on a tall branch-panicle, and a number of straitish leaves all starting from the root, and being five or six feet long, and not more than two in. wide at the broadest part." \Wood's Nat: Hist: of Man, Vol:2. p.121/. This plant "resembles in its appearance and manner of growth, the flag, or iris; the long broad sword-shaped leaves furnishing the fibre so useful in making dresses for the natives, fishing lines, twine, and strong cordage". Ellis' "Polynesian Researches", vol:1, p. 27. For the principle of making the various kinds of New Zealand mats, see Wood's "Nat: Hist: of Man.", vol: 2 pp. 12-124. Size about 3 ft. 4 in. by 3 ft. 2. Captain Cook's collection 1772-1774. \No. 107/. Given by Reinhold Forster, Esq.
Ashmolean 1836, p.185 nos. 236-57.

1125 A New-Zealand Cloak, (called E. Wakaiwa), made from the flax plant, but with peculiar ornamentation. The body or warp of the cloak is of woven fibre, dyed black, while the weft is left white; and interwoven with and suspended on the outside of which is a thick coating of narrow strips of the flower stalk, L about 7 or 8 in., each strip being rolled into a cylindrical form, D 1/4 in., and encircled with narrow black rings, which, on the cane coloured ground give the strips the appearance of stalks of the horse-tail plant (Equisetum fluviatile), so common on swampy ground; in addition to this each alternate inch is stripped of its outer coating or epidermis, leaving the fibre exposed and dyed black. The whole appears like a thick mass of porcupine quills. The collar and the bottom edge are ornamented with various coloured worsted. Given by Miss Amelia Solly, 1867.
Ashmolean 1836-68, p. 15.

1126 A New-Zealand cloak of somewhat similar but ruder make than the preceding one. The body of the cloak is of undyed fibre, and the outside ornamented with pieces of undressed leaves of the flax plant L about 8 in., one half of which are dyed black, so that the whole appears as a rough and shaggy, mat-like mass of crumpled bands of a black and straw colour.[- Probably] Perhaps Captain Cook's collection 1772-1774. (Number label lost). Given by Reinhold Forster. Esq. \or possibly given either Captn. Beechey, Captn. Gambier, or J.T. Bigge Esq. but [-not\apparently not by] Rev: A. Bloxam, M.A. 1826, as all the articles given by him [-came\appears to have come] from the Sandwich Islands.
Ashmolean 1836, p. 185 nos. 236-57.

1127 A New Zealand cloak, or mat, (called the Woman's mat); of finely dressed, but undyed native Flax, with a fringe of threads of the like material along the \top/, bottom, and side edges. There are also a few small pendant cords \of the same material/ of L 8 in.\ some of which are dyed black/, thinly spread over the whole of the outside for ornamentation, and it is further ornamented by short, transverse bands, of red and green wool, woven in, the bands being more numerous down the two sides than over the body of the Cloak. L about 40 in.; W about 48 in. Perhaps Captain Cook's collection, [-1772-1774 \stet/] (number label lost), given by Reinhold Forster, Esq.; or possibly given by Captain Beechey, Captain Gambier, or J.T. Bigge, Esq. But \apparently/ not by the Rev. A. Bloxam, M.A. 1826, as see references given to No. 1126 above.
Ashmolean 1836, p. 185 nos. 236-57.

1128 A New Zealand cloak, of the native flax, finely dressed, and of the natural colour. This cloak is of a neat and somewhat elegant fashion; it is fringed on the edges with pendant curled cords \of the same material/, which appear to have been twisted by hand, and similar cords are thickly spread over the whole of the outside, but not so as to hide the body of the cloak. The colour is a light fawn or drab. L about 38 in. W 48 in. Perhaps Captn. Cook's coll[ectio]n, [-1772-1774 \stet/] (number label \lost/), or possibly belonging to the things given by Captn Beechey, Captn Gambier, or J.T. Bigge, Esq. But \apparently/ not by the Rev: A. Bloxam, M.A. 1826, as all the things given by him \appears/ came from the Sandwich Islands.
Ashmolean 1836. p. 185 nos. 236-57.

1129 A New-Zealand woman's Cloak, of like material, and make to the preceding, but with ornamentation as in No 1125, and a few strings as in No 1127 thinly distributed over the surface. Size about L 3 ft. 7 in. by W 5 ft. 5 in. Given by J.T. Bigge Esq. London 1834.
Ashmolean 1836, p. 185 nos. 236-57.

1130 A New-Zealand Cloak, ornamented all over the outside with pendants of black string like material rather thickly distributed, amongst which are mixed a few pendants like those on No [-1127 \1125] and 1129, but finer. L 4 ft., not including the fringe, which is 6 in. W about 4 ft. 10 in. It has two short cords at the top for tying it. (Ramsden Collection No. ?). Purchased by the University 1878.

1131 A New Zealand Woman's Cloak, or mat, ornamented with loosely twisted grey pendants very thickly distributed over the whole surface, amongst which are mixed pendants like those on 1125, 1127, 1129 and 1130. L 3 ft. 10 in. W 4 ft. 6 in. (Ramsden Collection, No. ?). Purchased by the University 1878).

1132 A New-Zealand cloak, or mat, made of Flax in the usual manner, but entirely without any pendants on the outside. Two of the sides have \narrow/ plaited borders of the same material dyed black and brown; and at two of the corners are suspended several thongs of white skin, perhaps dog skin, from which the hair has disappeared. L 4 ft. 1 in. W 5 ft. Perhaps Captn. Cook's collection, 1772-1774 (number label lost), given by Reinhold Forster, Esq. or possibly either belonging to the things given by Captn Beechey, Captain Gambier, or J.T. Bigge, Esq: but \probably/ not by the Rev. A. Bloxam, M.A. 1826, as all the things given by him [-came\seem to have come] from the Sandwich Islands.
Ashmolean 1836, p.185 nos. 236-57

1133 A New-Zealand cloak or mat, of the native Flax; of much finer manufacture than the preceding, the woof being worked very close together. It has a wide dark brown border along one edge, which probably formed the bottom. L 3 ft. 2 in.: W 4 ft. 8 in. Captain Cook's Collection, [-1772-1774, \stet/] No.106, given by Reinhold Forster, Esq.

Ashmolean 1836, p.185 nos. 236-57.

1134 A New-Zealand cloak or mat, of somewhat similar, but extremely coarse make, with the material left in a fringe at the bottom edge. L 3 ft. 11 in.; W 6 ft. 3 in. This article like the two preceding appears to be in an unfinished state. Captain Cook's Collection, [-1772-1774, \stet/] No.102. Given by Reinhold Forster, Esq.
Ashmolean 1836, p.185 nos. 236-57.

1135 A New-Zealand cloak or mat, extremely well made, the body of the article being of the ordinary flax colour, ornamented with three wide bands each composed of parallel wavy lines alternating with the natural colour. One half of each of the ends is ornamented with a beautiful and closely woven border W 5 5/10 in. of narrow Vandyke bands in black brown and white, arranged diagonally so as to form large half lozenges having wide bands of black between them. These borders are continued along the other half of the ends in W only 1 in. The top has a narrow zig-zag border in black and white. L 4 ft. 1 in.: W 6 ft. 1 in.[-Perhaps\Probably] Captn. Cook's collection [-1772-1774 \stet/]. (number label lost), given by Reinhold Forster, Esq. Or possibly belonging to those given either by Captn. Beechey, R.N. Captn. Gambier, or J.T. Bigge Esq. But probably not by Rev. A. Bloxam, M.A. 1826, as all the things given by him\appear/ were procured at the Sandwich Islands. Such cloaks are particularly described in Cook's Voyages.
Ashmolean 1836 p.185 nos. 236-57.

1136 A New-Zealand Cloak or mat, of the native Flax, of finer make than No 1135, ornamented only with three pairs of narrow, horizontal stripes in brown. L 4 ft. 5 in. W 5 ft. Captain Cook's collection [-1772-1774 \stet/]. No. 105: given by Reinhold Forster, Esq.
Ashmolean 1836, p. 185 nos. 236-57.

1137 A New-Zealand cloak or Mat, of lighter and finer make than the two preceding: of the native Flax plant, With strips of white skin sewn on at each of the four corners, [-perhaps \stet/] Dog's skin denuded of the hair. Size 6 ft., 15/10 in. by 4 ft. 6 in. Captain Cook's collection [-1772-1774 \stet/]. No. 104, given by Reinhold Forster, Esq.
Ashmolean 1836, p. 185 nos. 236-57.

1138 Three specimens of Flax from New-Zealand, (Phormium tenax, (Forst:), of the same kind as that used in making the preceding Cloaks or mats, No 1124 to 1137. Brought home by the ship Westmorland, in May 1823. L about 19, 7, and 6 in. Given by [?].
Ashmolean 1836, p. 185 nos. 258-9.

1139 Two specimens, done up in a different manner to the preceding, and tied by the middle with plaited cocoa-nut fibre (sinnet). L about 19 in. Brown, yellow, and white. [- Probably\Possibly] belonging to the same lot as No 1138 preceding.

1140 A large and strong rope made of twisted Cocoa-nut Fibre, in the ordinary way that English

ropes are made; with a running noose at one end, and finish[ed] off at the other end with a plait which diminishes in size. L about 36 ft. D 1 in. Captain Cook's collection \1772-1774/ No.?, given by Reinhold Forster, Esq.
Ashmolean 1836, p. 185 nos. 304-7.

1141 A long length of fine cord made of twisted strands of fibre, and wound up into a ball; made of two strands twisted together. Now of a dark brown colour. D about 3 in., \D of cord 1/10 in./. The material appears to be the inner bark of some tree. Probably of Captain Cook's collection 1772-1774, and given by Reinhold Forster, Esq.
Ashmolean 1836, p. 185 nos. 304-7.

1142 A long length of similar cord to the preceding No.1141, but thicker, and made of like material. Wound up into an oval shaped bundle about 5 by 3 1/2 in. in size. D of cord about 3/20 in. Locality of this and the previous article uncertain, but probably from New-Zealand, or the South Pacific Islands. Probably of Captain Cook's collection 1772-1774, and given by Reinhold Forster, Esq.
Ashmolean 1836, p. 185 no. 306.

1143 A large roll of flat brown cord, (sinnet); made of many strands of cocoa-nut fibre plaited together. From Polynesia or New-Zealand, but probably the former. L 25 1/2 in. D 4 1/2 in. D of the cord about 2/10 in. Probably of Captain Cook's collection, [-1772-1774, \stet/] and given by Reinhold Forster, Esq. Fiji Islands?.
Ashmolean 1836, p. 185 no. 305.

1144 A smaller piece of exactly the same kind of cord as the preceding No. 1143, done up in a skein by being doubled backwards and forwards and tied round near the two ends. L about 19 in. From the Fiji Islands? Probably of Captn Cook's collection, [-1772-1774 \stet/], and given by Reinhold Forster, Esq.
Ashmolean 1836, p. 185 no. 305[?].

1145 A small specimen of the material from which such cords as No. 1140, 1143 and 1144 are made, [-(but ? if 1141 - 1142)]. Done up in a twisted skein. L about 9 1/2 in. Probably of Captain Cook's collection, [-1772-1774 \stet/] , and given by Reinhold Forster, Esq.
Ashmolean 1836, p. 185 nos. 308-11.

1146 A New-Zealand disk of white bone D 18 5/10 in. by 16 8/10 in., and Th about 5/10 in., made from the flat part of the lower jaw of the Spermaceti (Cachalot) whale. The use for which it was intended is uncertain, but it might have been a shield, a platter for food, or a breast plate. The only apparent means for holding or suspending it are three small holes along the upper edge, which is partially straight, but somewhat curved over to one side, the bottom portion being more curved in the opposite direction, but circular, together with the other parts except the top. From New-Zealand. \Said to be/ Captain Cook's collection, 1772-1774. and given

by Reinhold Forster, Esq. For a similar object see Wood's "Nat: Hist: of Man" vol: 2, p.[].

1147 A [- Patoo-Patoo (Patu-Patu or] Merai) or \Meri/. A New Zealand Chief's war club, \worn in the gird[l]e/, made from the blade bone of the Spermaceti whale. The regularity of form in this implement could hardly be surpassed. L 15 3/10 in., greatest W 5 5/10 in. Captain Cook's Collection, 1772-1774. No.114?, given by Reinhold Forster, Esq. For a similar weapon see Wood's "Nat: Hist: of Man:" vol: 2, pp. 157 and 158. Also Meyrick's "Ancient Armour". vol: 2. Pl: CL. Fig. 8. See also Cook's 1st voyage, vol: III. Pl No. 14 p. 62, lower figure, but made of the dark green volcanic stone, called by some basalt.
Ashmolean 1836, p. 184 nos. 152-4.

1148 A [-Patu-Patu] Meri; or New Zealand Chiefs war club made of the dark dull green Volcanic stone of which the New Zealanders make so many of their implements. This weapon also is most beautifully formed, and it is difficult to conceive how such hard stone could be so worked without the aid of metal. L 13 4/10 in. Greatest W 4 3/20 in.; and greatest Th 1 6/10 in., which is at the end of the handle portion. Given by J.T. Bigge, Esq. London 1834 (For figures and descriptions of such articles see Wood's "Nat: Hist: of Man" vol: 2 p. 157) Also Meyrick's "Ancient Armour" vol: 2 plate CL. Fig. 8. A club almost identical in shape is figured in Cook's 1st voyage Vol: III Pl: No 14 p. 62 lower three figures.
Ashmolean 1836, p. 184 no. 155.

1149 A similar but smaller [-Patu-Patu] \Meri/, to the preceding No. 1148, and made of the same kind of stone. L 13 2/10 in. Greater W 3 9/20 in.; and greatest Th 1 3/20 which is at the end of the handle. Captain Cook's Collection, [-1772-1774. \stet/] No. 112. Given by Reinhold Forster, Esq. \A similar object, but apparently not this, is figured in Cook's 1st Voyage Vol: III p. 62, by the lower figure./
Ashmolean 1836, p. 184 no. 153.

1150 A Meri,[- or Patu-Patu], made of green Jade (Serpentinus nephriticus). This weapon is much less perfectly formed than the three preceding, evidently because the material, (which is of a beautiful dark semitransparent green colour, clouded or mottled with paler green) was not large enough, and was [-therefore] therefore left in its present state to economise the material. The top or wide end is unlike any of the preceding, being nearly straight, with a sharp chisel shaped cutting edge. The perforations through the handle portion has with a great deal of labo[u]r been drilled from each side until the hole met in the middle, which it does not do correctly, but obliquely. L 13 in. \Greatest W 4 in.; and greatest Th 15/20 in., which is near the handle/. Captain Cook's Collection, 1772-1774. No. 115?. Given by Reinhold Forster, Esq. Probably this is one of the two Patoo-Patoo's \of green Talc,/ which appear to have been purchased of the natives at Poverty Bay as well as their clothes, paddles,

etc., as see Cook's 1ˢᵗ voyage. vol: 2. p. 298. Or this or either of the other three may be the Patoo-Patoo mentioned as given by a Chief to Cook at Dusky Bay, in exchange for a cloak of red baise. Cook's 2ⁿᵈ voyage. Vol: I. pp.75 & 76.

Ashmolean 1836, p. 184 nos. 152-4.

1151 A New Zealand \Meri or/ War Club of hard heavy, dark brown wood. It is somewhat ducket or bill-hook shaped, and ornamented with a small carved grotesque figure, of the usual New-Zealand type, i.e. the protruded tongue, etc, see No. 1152. L 19 5/10 in. Greatest W 7 in., and Th 1 2/10 in. This weapon, although of good form, is evidently in an unfinished condition, the sides being rough in comparison with the usual polished surfaces of New-Zealand wood\work/ and the carving at the end of the handle incomplete on one side. Captain Cook's Collection, [-1772-1774. \stet/] No. 113. given by Reinhold Forster, Esq. For figure of a similar weapon see Wood's "Nat: Hist of Man", vol: 2. p. 156. fig. 6, \(or 7?)/, and description p. 158. Also Meyrick's "Ancient Armour", vol: 2. pl. 150, fig. 4. A club of the same description is also figured in Captn. Cook's 1st. Voyage, Voll: III, Pl. No. 14, p. 62, three upper figures.

Ashmolean 1836, p. 184 nos. 152-4.

1152 A [-Patu Patu], \Meri/ or New Zealand war club; made by natives of the Hau Hau tribe in 1867. The wood is not so heavy or hard as that used for such instruments in earlier times, and is of a yellow, instead of the rich reddish brown colour of that formerly used. Figures with the Haliotis shell eyes, and protruded tongue, as noticed in No 1153, are exhibited on this weapon, which is carved in various designs over its whole surface, but the workmanship is, in every respect, inferior to that of the preceding article of wood which is of the period when the natives of the country, had but little, or no intercourse with Europeans, and when they had no knowledge of the use of tools made of metal. L 16 2/10 in.; Greatest W 6 in., and 1 5/10 greatest Th which [is] at the handle Given by the Rev: J.C. Andrew M.A. Lincoln Coll[ege]: 1867.

Ashmolean 1836-68, p. 3.

1153 A New Zealand musical instrument, \(Flute)/ of wood, L 20 3/10 in. D 1 7/10 in. in the middle, 6/10 in. at the lower [-end], and 1 2/10 in. at the upper end. It is well finished and formed of two pieces of wood, hollowed out in accordance with the outer form throughout the whole length, and neatly joined, and lashed together in four places with fine ratten, or a fine binding of Osier work, apparently the root or thin stem of some climbing plant \apparently/ split down the middle, and at the large end with string, the inside diameter at the small end being 3/20 in., only, and that of the other end 8/10 in. In the middle [-and] or largest part, there is an oval shaped opening D 1 2/10 by 9/10 in.The whole surface of the wood is plain and smooth, except the larger end, on one side of which is the very usual New Zealand ornamentation, viz. a grotesque

face with eyes inlaid with oval pieces of Halliot-shell notched round the edges, the large and the tongue protruded [*sic*]. The protrusion of the tongue is with the New Zealanders expressive of defiance, it is exhibited in their war dances, and on many of their implements of war, as see Nos.[- Captain] Cook's Colletion, 1772-1774. No. 116. Given by [-Captain] Reinhold Forster, Esq.

Ashmolean 1836, p. 184 no. 175.

1154 A New Zealand musical instrument of the same kind as the preceding No 1153, but larger and much more ornamented with carved work; the middle being surrounded by a grotesque carved figure the open mouth of which forms the hole at the side, the eyes being inlaid with oval shaped pieces of Halliot shell having notched edges. At each end is carved a grotesque face with large open mouth and long protruded tongue, the head at the largest end being also set with Halliot shell eyes, as in the figure round the middle. It is bound round in eight places with \a kind of rattan or split/ osier work of the same kind as No 1153. L 23 2/10 in. Greatest D of middle 2 3/10 in.; D of large end 1 2/10 in.; of the small end 6/10 in. (Ramsden Collection No. 362. Purchased by the University in 1878).

1155-1156 Two New Zealand paddles, of dark [-reddish\brown] wood. Whole L 3 ft. 6 3/10, and 3 ft. 4 5/10 in. These appear too small for actual use, and probably are only ornamental models. The handle part is L 18 in., rounded to about 1 in. in diameter, and curved to a convenient form for grasping with both hands. The blade is straight, of a long, pointed, leaf shape, L 25 in. long, and 4 5/10 broad at its greatest width, which is at about 1 ft. from the point. One side is convex across the width, and elaborately carved, the other side being slightly concave, and plain. The form of these paddles is very similar to the one figured in Wood's "Nat: Hist: of Man" vol: 2 p. 174. by the two right-hand figures, but differs in style of ornamentation. [-Captain F.W. Beechey R.N. 1825-1828.] A paddle of this form is figured in Meyrick's "Ancient Armour", Vol: 2, Pl: 149, Fig. 7, and said to be from New Caledonia.

Ashmolean 1836, p. 183 no. 133.

1157 A [-war] paddle from New Zealand; of [-dark\yellowish] brown wood, somewhat similar in form to the preceding, having a knot of rude carved work at the junction of the handle with the blade, and another of rather different shape at 14 in. from the end of the handle, which has a plain rudely shaped oblong knob. Whole L 5 ft. 6 in. D of handle, which is rounded, 1 3/10 in. Greatest W of blade 6 1/10 in. (Ramsden ollection No. ?) Purchased by the University 1878. A similar shaped paddle is figured in Meyrick's "Ancient Armour" vol: 2 Pl: CXLIX. Fig: 6. See also Wood's "Nat: Hist: of Man" vol: 2 p. 174 the left-hand figure.

1158 War paddle from New Zealand: very similar in shape to the preceding No 1157; of pale brown, and rather soft wood with rounded handle, and flat and pointed leaf-shaped blade. At the end of the handle as well as at the junction of the handle with the blade it is rudely carved, and near the latter place on the handle are three X's cut in. L 5 ft. 6 in.: D of handle 1 4/10 in.: Greatest W of blade 5 8/10 in. (Ramsden Collection No. ?\32/). Purchased by the University, 1878.

1159 A New Zealand Adze. The head and haft, in one piece, is of dark brown wood, the head part and the end of [the] cylindrical handle \being/ curiously carved into grotesque figures, the most prominent on the former being similar to that noticed in No.1153, except that instead of the tongue being protruded, it is held down or hidden by the right hand, which is placed in the widely capacious mouth. On the opposite side, or that on which the blade rests is another head of rather different form. Both heads are inlaid with eyes of Halliot shell notched round the edges, as usual. The blade is of green Jade, and fastened to the haft partly by a binding of sinews, and partly of string probably made of Flax. A bit of the wood is broken off the top. Extreme whole L 18 in. Greatest D of plain part of handle 1 2/10 in. L of blade 5 8/10 in.; 2 3/10 in. wide at the cutting edge, (which is chiefly ground from the under side, W 1 1/10 in. at the back: and greatest Th 5/10 in., both sides being flat, and the edges square. \Possibly this is the green Talk hatchet given to Cook by a Chief at Dusky Bay, together with a piece of cloth. See 2nd Voyage. Vol: 1 p. 82. See also p. 119./ Captain Cook's Collection, \1772-1774./ No. ?. Given by Reinhold Forster, Esq. Figured in Cook's Second Voyage. \vol:1/. pl.19. Figs. 1 and 2.
Ashmolean 1836, p. 184 no. 156.

1160 A New Zealand adze head of Green Jade, somewhat similar in shape to that of the preceding but wider, thicker, and darker in colour. A considerable portion seems to have been broken off the smaller end. L 4 5/10 in.: W of cutting edge 2 8/10 in.; and Th 7/10 in. One side (the top) nearly flat, the other side more rounded, and the edges slightly rounded. It is not smooth all over the surface as in No 1159, but has several rough hollows owing to the size of the material being too small to grind them out. Found in the earth at Bank's Peninsula, Canterbury, New Zealand. Given by [-Henry \stet/] Rose, Esq., Ship "Mermaid" 1865.(For description of similar articles, see Wood's "Nat: Hist: of Man". vol: 2 pp. 200-202.)
Ashmolean 1836-68, p. 14.

1161 A New Zealand saw? or knife?, of dark brown wood set with Shark's teeth. The part forming the handle is L 4 5/10 in., oval-shaped in section, quite plain and perforated at the end; the head part is L 5 5/10 in., and greatest W 2 5/10, and greatest Th 6/10 in., which is at the lower part at the junction with the handle, elaborately and curiously carved, and

ornamented on each side at the bottom and top, near the back by two small disks or eyes of Haliot shell, one of the four being lost. The cutting edge is formed by a row of six of the serrated teeth of a Shark strongly bound in a groove with string made of flax, and apparently strengthened along the sides \with/ a dark waxy looking substance which appears to be stained with blood. This implement is figured in \Cook's 2nd Voyage. vol: 1. Pl: XIX. Fig. 3/, [-the plate with No 1159] and is called a saw, but is more properly a knife or weapon for cutting or tearing with. Whole L 10 in. Captain Cook's Collection, 1772-1774. No.?. Given by Reinhold Forster, Esq. (For figure of a similar article see Wood's "Nat: Hist of Man", vol: 2. p. 157, and description p. 158, where it is called the model of a wooden Merai or Patoo-Patoo, set with Shark's teeth).
Ashmolean 1836, p. 184 no. 208.

1162 A New Zealand comb, made of bone of the Spermaceti Whale, and worn by the natives as an ornament, \stuck behind the knob at the back of the head upright/. It is nearly flat and smooth on both sides: L 13 8/10 in. Greatest W 4 5/10 in., which is near the top: and 3 5/10 towards the other end at the top of the teeth, the two side ones of which a broken away; and Th about 3/20 in. It has no ornament except that the upper edge and the upper portion of one side are curved, the others being straight. At the narrow end are eighteen teeth, there were twenty; these are 3 2/10 in. long, the whole width of the eighteen at the top being 3 in.; and sloping to 2 4/10 at the bottom or points. The teeth are divided very accurately, the "saw cut" between them being straight, and not more than W 1/40 in. Considering the hardness of the material, it is difficult to imagine how, without the aid of metal, such work could have been done. In Cook's First Voyage round the World, \vol: III/ pl:13, \p.49/, a New Zealand[-er] \man/ is represented wearing a comb of this kind, but apparently not this one as the curved ornament at top differs a little. They are mentioned p. 47 same volume. Captain Cook's Collection, [-1772-1774 \stet/]. No.?. Given by Reinhold Forster, Esq.
Ashmolean 1836, p. 184 no. 183.

1163 A New Zealand? article of softish light coloured wood with remains of red paint. It is L 12 3/10 in., the lower portion for the length of 7 5/10 in. being \round and/ peg-shaped, D 8/10 in.; the upper portion being W 1 9/10 in. and Th 1 3/10, and rudel[y] carved into what appears to be the grotesque figure of a human head with large gaping mouth. The lower \or peg/ portion is bound round in an interlaced manner with a narrow band or cord of plaited flax. The eyes and mouth may formerly have been inlaid with shell. Use unknown. (Ramsden Collection No. ?) Purchased by the University, 1878. A somewhat similar article is figured in Wood's "Nat: Hist: of Man" p. 156 Fig: 4 which is called a dagger.

1164 A Pestle, from Tahite used for pounding Bread-fruit. It is made of black Basalt \(volcanic stone?)/; the shape is singular, the lower portion being somewhat cone-shaped with hollowed out sides, and the bottom very convex: the top being worked into a kind of hollowed-out handle, having projecting upright sides, the hollow apparently being intended to receive the three fore fingers of the hand, the thumb and the fourth finger grasping below the projecting sides; it is exceedingly well worked, and fitted for its purpose. H 6 7/10 in., D of the bottom or face, which is circular or nearly so, 4 9/10 by 4 5/10 in. greatest W of handle portion, 3 3/10 in.; ditto of the reverse way 1 9/10 in. Captain Cook's Collection, [-1772-1774 \stet/]. No. 28. Given by Reinhold Forster, Esq. An implement of similar form, and like material, is figured in Cook's "First Voyage". Pl:9. vol:2. p.212. and described p.198. Ashmolean 1836,p. 85 no. 200.

1165 A similar but altogether narrower Pestle, of black Basalt. From Tahite? H 6 4/10 in. D of the bottom, or face, 3 7/10 in. Greatest W of handle portion 2 4/10 by 2 3/20 in. (Ramsden Collection No. ?) Purchased by the University, 1878.

1166 A dark brown wooden Pestle \said to be/ from Tahite, for pounding the Bread-fruit. This is simply a club-like implement, \greatly/ enlarged and rounded at the lower end, where it is D 4 4/10 in.: the long, straight, and round handle decreasing gradually to 1 3/10 in. at the top, which has an overlapping knob D 1 6/10 in. L 12 5/10 in. (See also No. 1164. 1165.) Captain Cook's collection, 1772-1774. No.80. Given by Captain Reinhold Forster, Esq. Ashmolean 1836, p. 185 no. 201.

1167 A New Zealand ornament called a Tiki \or Heitiki/, worn on the breast suspended by a cord round the neck. They are not idols but are worn only as personal decoration. \Are held very sacred, and passed on as heirlooms from father to son/. It is carved in green Jade, \a mineral of extreme hardness found mostly in the locality in the Middle Island/, and represents in a grotesque manner the back of a human figure, with the head disproportionally large, turned round and looking back over the right shoulder: the mouth hideously large, and the eyes set \with/ flat rings of Haliotis shell. H 3 8/10 in. Greatest W 2 5/10 in. Greatest Th 11/20 in. \The other side flat and plain/. This figure is sometimes of much larger size, but of like material, and \similar in/ form. For figure of a similar object see Wood's "Nat: Hist: of Man." vol:2. pp. 128 and 179. Captain Cook's Collection, 1772-1774. No. 120. Given by Reinhold Forster, Esq. \See description also in Catalogue of the Mayer Museum, Part II Prehistoric and Ethnography . London, 1882./

1168 A piece of Kauri gum from Northern Island, New Zealand. This gum is found in masses varying from a few ounces to many pounds in weight, at 2 or 3 ft. below the surface of the earth, on old forest land. The natives discover it by forcing a stick into the ground, and on meeting with any resisting substance they work the point of the \stick/ upon it, and then know by the smell w\h/ether it be the gum or not. Greatest D 6 1/10 by 4 8/10 in. and greatest Th. 2 in. Given by Mrs \Edwin/ Glanville, New Zealand, 1867.

1169 An oblong-shaped piece of New-Zealand? matting work, woven of grass, [-and] dyed yellowish, and ornamented with six pairs of longitudinal stripes in pale green. It has been made of two equal sized pieces [-sewn] each W 1 ft. 7 in. sewn together up the middle. There are three pairs of green stripes on each piece. L 6 ft. 4 in. W 3 ft. 1 in. \Possibly Cook's Collection, numbering label lost/. \Or possibly given by Captain Gambier, Captain Beechey, J. Bigge, Esq. but I think not by Rev: A. Bloxam as all the things given by him seem to have come from the Sandwich Islands. Ashmolean 1836, p. 185 no. 237.

1170 A large oblong-shaped piece of New Zealand matting, very neatly \made/ of narrow strips, each about W 1/8 in., of what appears to be the inner bark of [-some] \a/ tree, or of some very similar material, of a pale brown colour: the four sides or edges being left unwoven and forming long fringes 7 or 8 in. deep. It is slightly torn on the two longest side Size 6 ft. 2 in. by 4 ft. 3 in. Given by J.T. Bigge Esq. \Park Lane/ London, 1834. Ashmolean 1836, p. 185 no. 236.

1171 A large oblong shaped piece of New Zealand matting, like the preceding No.1170, except that it is somewhat coarser, of a darker shade, and has the fringe round the sides [-] much shorter and finer make. Size 6 ft. 4 by 5 ft. 6 in. Captain Cook's Collection. [-1772-1774 \stet/]. No. 21. Given by Reinhold Forster, Esq. Ashmolean 1836, p. 185 no. 236-57.

1172 A large oblong shaped piece of New-Zealand matting, made in a similar manner to the two preceding but of strips made of the outer skin or epedermis of the native Flax plant (Phormium tenax, Forst.); the two ends being ornamented with fringes of broad pointed pieces of the same material. It is of a pale yellow approaching to straw colour. Size 7 ft. 2 in. by 5 ft. 6 in. Captain Cook's Collection. [-1772-1774 \stet/]. No. 58. Given by Reinhold Forster Esq. Ashmolean 1836, p. 185 nos. 236-57.

1173 Ditto, of double thickness, smaller size, and a good deal worn apparently from use. Size 5 ft. 11 in. by 4 ft. 6 in. Without fringes. Captain Cook's collection. [-1772-1774 \stet/]. No.54. Given by Reinhold Forster, Esq. Ashmolean 1836, p. 185 nos. 236-57.

1174 Ditto, of very fine make, and of double thickness as in the preceding, but in much better preservation: the two ends being left unwoven, forming narrow stiffish fringes. Size 6 ft. by 5 ft. 7 in. Captain Cook's

collection. [-1772-1774 \stet/]. No. 55. Given by Reinhold Forster, Esq.
Ashmolean 1836, p. 185 no. 236-57.

1175 Ditto, \made double/, of coarser make, darker, and altogether rougher \than the preceding,/ perhaps a different material, woven in two shades of pale brown. No fringes, on the sides and \has/ been much eaten in holes by insects. Size 7 ft. 7 5/10 by 5 ft. 10 in. Captain Cook's Collection. [-1772-1774]. No. 57. Given by Reinhold Forster, Esq.
Ashmolean 1836, p. 185 nos. 236-57.

1176 Ditto, of similar make to the last, but ornamented with various diagonal bands, each W 2 5/10 in. in patterns in black and the natural colour, alternating in a curious manner with similar bands entirely of the natural yellow colour: the patterns in the ornamented bands being woven in the making, and consisting of lozenges and zig-zags. It is only somewhat over one half of the article which is ornamented in this curious and probably unique pattern, the remainder of the matting being plain. The same pattern is produced on the opposite side but the colours are reversed. Size 6 ft. 10 in. by 4 ft. 3 in. Captain Cook's Collection. [-1772-1774 \stet/ No. 5]. ([-with] the second number having been eaten away.) Given by Reinhold Forster, Esq.
Ashmolean 1836, p. 185 nos. 236-57.

1177 A oblong shaped piece of New Zealand? matting, made of narrow strips of the inner bark of some tree (somewhat similar to the inner bark of the willow), rather loosely woven together so as to allow of the insertion of numerous short lengths of the thin outer skin of the Flax plant or of some kind of rush, which are fastened in and the ends left in short lengths \or tufts/, projecting on the upper surface in diagonal bands of red and yellow alternately, looking like prolonged and unequal lozenges of each colour, the pale brown g[r]ound colour of the mat itself shewing between them. Size 4 ft. 5 in., by 2 ft.. Captain Cook's Collection. [-1772-1774 \stet/]. No. faded out. Given by Reinhold Forster, Esq.
Ashmolean 1836, p. 185 nos. 236-57.

1178 An ornamental oblong shaped New Zealand mat made of narrow strips of the inner bark of some tree, somewhat similar to that of the preceding article, but finer and darker in colour perhaps from its having been dyed. It is closely woven in such a manner as to leave forty-three parallel rows (counting lengthways) of small square-shaped holes, so that the material looks as if in forty-two longitudinal bands, with narrower very short bands between each. It has an ornamental open work border 3 1/2 in. deep sewn on all round the edges, made in the same style and material. Size 5 ft. 4 5/10 in. by 2 ft. 11 in. Captain Cook's Collection. [-1772-1774 \stet/]. \No.36? [-or]/ [-"No.56",] but the first figure is partly destroyed. Given by Reinhold Forster, Esq.
Ashmolean 1836, p. 185 nos. 236-57.

1179 A New-Zealand? Woman's Apron, or Petticoat; made of narrow long strips, or rather shreds, of the inner bark of some tree, somewhat similar to that of the preceding two numbers; each piece being doubled and looped over a twisted cord made of the same material, the ends of which are left long for tying. The whole has the appearance of a very deep rough fringe. W 30 in.; Depth 2 ft.. Probably Captain Cook's collection. [-1772-1774 \stet/]. Number lost. Given by Reinhold Forster, Esq.
Ashmolean 1836, p. 185 nos. 236-57 [?].

1180 A New Zealand Warrior's belt?, apparently made of narrow strips of the outer skin of the native flax plant, or perhaps some kind of grass, and woven so as to produce an artistic pattern in black and yellow. It is folded together, and on opening it the mode of construction is plainly seen, all the loose ends of the edges being turned inside. Whole L 6 ft. 8 in. W in the middle or broadest part 3 5/10 in., diminishing at the ends which are made of plaited cords of flax. In bad condition. (Ramsden Collection, No. ?) Purchased by the University in 1878. For figure of a similar article see Wood's "Nat: Hist: of Man" vol: 2 p. 118.

1181 A New Zealand flat basket, made double, the outside being woven in narrow strips of what appears to be the outer skin of the native flax plant, in twenty squares or chequers on each side, in white, black, and black and white, alternately: the squares \or pattern/ being the same on each side of the basket. The inside portion or lining is made with strips about W 1 in. not dyed. Each is woven in one piece without a seam and the top is bound with a piece of \brownish/ ribbon half of which is gone. L 17 in.: W 9 5/10 in. Probably Captain Cook's Collection. [-1772-1774 \stet/]. Number label lost. Given by Reinhold Forster, Esq.

1182 A New Zealand [-Chief's\warriors] belt made of woven grass, but entirely of a yellowish white colour: the ends being plaited cords of \native [illeg.]/ flax. L 7 ft. 9 in.; greatest W 3 5/10 in. In its [-make\form] it resembles No.1180 \but woven in a different manner/. Captain Cook's Collection? [-1772-1774 \stet/] No.108. Given by Reinhold Forster, Esq.?
Ashmolean 1836, p. 185 nos. 236-57.

1183 A quiver and two arrows from Tahite. Society Islands. The quiver is L 3 ft. 1 in., and D 1 4/10 in. made of a single joint of bamboo, the knot forming the bottom and slightly ornamented [-near round] round near the upper end with eleven undetermined figures burnt upon it. The mouth of the quiver is stopped by a pear-shaped wooden plug \or stopper/, which is pulled into place by a flat string of plaited cocoa nut fibre \having one end attached,/ the other end of which passes down the inside \of the quiver/ for the distance of 8 in. and out through a hole in the side where [-the end] \it/ is knotted, and by pulling this lower end of the string [-pulls the] the stopper \is pulled/ into place. The arrows are L 32 1/10 and 28 8/10 in., made of pale

yellow reed, headed with short \cylindrical/ bits (L 1 in., and 1 1/2), of hard dark wood rounded \off/ at the ends: but they are neither feathered nor barbed. Ellis states that Bows and Arrows were not used in the Society Islands as instruments of war, but simply for amusement, in which the king and leading men would join; the endeavour being to shoot the arrow to the greatest distance, and not to strike an object with it; and this "was frequently 300 yards". Captain Cook's Collection. 1772-74. Given by Reinhold Forster, Esq. Ashmolean 1836 p. 183 no. 130.

1184-1186 Three arrows from the Island of Tanna, New Hebrides; the shafts made of reed, one of dark brown, one of pale brown, and the third of a yellowish colour, headed with very long and extremely fine pointed pieces of black heavy wood, one of them No. 1184, the end of which is tipped with a bone needle-like point loosely bound on but in a very neat manner [-by\with] a fine single fibre, looking much like very fine wire, arranged in a crossed pattern, appears to be poisoned, is figured in Cook's Second Voyage, \vol. 2/, pl. 18. figs 5 and 6. Neither of the arrows are feathered, but two of them \at the lower ends/ are spirally bound with fine grass [-as] like that at the junction [-at\of] the shafts with the points, and are notched for the bow line, the third appears to have had the \lower/ end broken. L \of 1184/ 40 5/10 in. No. 1185, L 39 in., and No. 1186, L 38 in., a small portion of the latter is wanting. Captain Cook's Collection 1772-1774. No?. Given by Reinhold Forster, Esq.?

1187-1189 Three arrows (two of them [-broken \imperfect]); \said to be/ from the Fiji Islands, \but more likely to be from the Soloman Islands:/ made of stout reed L 25 in., headed with long rounded pieces of nearly black heavy wood, L 23in., 23 5/10in. and 19in. \respectively/, on \each of/ which six finely pointed bone barbs, are, or have been firmly bound, three barbes on each side, [-and] projecting backwards, and the whole apparently poisoned. They are not feathered. These weapons are very skillfully made, and the binding on the bone heads is beautifully neat in lozenge pattern of very fine black and yellow grass in interlaced work like minute basket work; but their effects must be really horrible. It is known that the Fiji Islanders poison their weapons by dipping the points in highly putrid human flesh. Whole L 49in. (perfect):L 45in. and 36 8/10in of the two imperfect. Purchased in 1867. See original list had with them, when many other articles were purchased and entered. "No. 20 to 25" along with six bows.

1190-1191 Two arrows [-(one of them wound round the point with grass like material)], made of slender reed, headed with long, nearly black, heavy wooden heads rounded and pointed, and perhaps poisoned \and one of them bound round the point with grass like material/. The reed shaft portion is 25 in. long, not feathered, but bound round the end with grass, and notched for the bow line. Whole L 34 8/10 in., and 38

in. Locality and history not known. [-Probably \Possibly] Captn. Cook's Collection.

1192 An arrow with shaft like to the preceding, but headed with a narrow and somewhat pointed strip of bone, L 11 in. \and 9/10 in. greatest W/, which is curiously carved into 13 sets of barb-like notches, and \the lower end/ bound [-into\between] two short pieces of wood, the lower portion of which forms a peg which is fixed into the hollow end of the reed. Probably from the same place but locality and history unknown. Whole [L] 36 8/10 in. [-Probably\Possibly] Captn. Cook's Collection.

1193-1196 Four arrows said to be from New Caledonia, shafts made of slender brown read, headed with heavy black wood \measuring/ 18 5/10; 15 5/10; 15; and 14 3/10 in. long respectively, three of them being carved into a series of barbs or other forms, \and the other round and pointed;/ and each end of the reed is bound with a thin wire liking fibre \similar to that on the point of No. 1184/. They are not feathered or notched at the end for the bow string. Lengths (in the order of the lengths of the points given above) \No. 1193/, 46 8/10 in.; No. 1194, 47 3/10 in.; No. 1195, 49 8\10 in.; and No. 1196, 53 in. Captain Cook's collection, 1772-1774, No ?. Given by Reinhold Forster, Esq.

1197 An arrow said to be from New Caledonia, of similar reed, size, and make to the four preceding 1193-1196, except that it is headed with three strips of wood, between 6 and 7 in. long, very roughly rounded and pointed, and which forms a three forked head; one of [-which\the strips] has a small barb near the \point/ tied on \the inner side/ and directed backwards, and it is probably that the points of the other two \also/ had barbs. The [-points\strips] form a three forked head arranged triangular ways standing one [-each] inch apart from each other at the [-points\ends]. Such arrows were used for killing birds, and are described as having "two, three, or four points". The [-par] points are kept apart by a little ball of fibre \inserted between the strips at the lower end/, and the bindings are as in the preceding specimens. Not feathered. L 48 5/10 in. Captain Cook's Collection, 1772-1774, No ?. Given by Reinhold Forster, Esq.

1198-1201 A Bow and three arrows, (one of these having the lower end broken off) from the Sandwich Islands. The bow is [-of] perfectly rounded, \throughout,/ dark brown wood, extremely slender and well made L 69 in.; D in the middle 11/20 in., tapering to 3/10 in. near the ends w\h/ich are enlarged and grooved round the string. It has no line, binding or the slightest ornamentation, \being perfectly smooth throughout, and somewhat polished/. The arrows which are 58 5/10, 56, and the broken one 44 in. long, are made of a strong, slender, and extremely light flower stalk of some kind of grass, perfectly round, without knots, [-and] two of them of a dark brown, [-

and] the other of a lighter colour and headed with round pieces of bone 7 5/10: 6: and 5 8/10 in. long, gradually decreasing in size to the point, formed from the tibia (one of the lower leg bones) of one of their former kings. Captain F.W. Beechey, R.N. 1825-1828. Ashmolean 1836, p. 184 no. 148.

1202-1215 [-Fourteen\Fifteen] specimens mostly of a small size, of coloured \tapa/ cloth, or Masi: made from the inner bark of the malo tree (Morus Papyrifera). From the Sandwich Islands. Presented by Captain F.W. Beechey R.N. 1825-1828. For the manufacture of the Masi see Wood's "Nat: Hist: of Man" vol: 2 p. 251. Ashmolean 1836, p. 185 nos. 267-303.

1202 Is comparatively thin, of a plain brown colour, nearly straight on the two sides but uneven at the ends, pieces having been cut off. Marks of the wooden mallet grooves very distinct. Size about 6 ft. 4 by 5 ft. 9 in.

1203 Has been covered, or soaked in some moist sticky solution, and ornamented with thickly set rows of \stamped/ lozenge pattern in brown and black, all over the surface. Sides and ends straightish. Size 4ft. by 3ft.

1204 Is of plain brown colour and has been soaked in the same sticky solution as No.1203. Sides and ends nearly straight. Size 4ft. by 3ft.

1205 Is of brown colour, and stamped with numerous narrow black lines so as to produce a kind of small chequered pattern all over the surface. It also appears to have been dressed with some solution, but is in a drier state than No. 1203,1204. Size 4ft. by 2ft. 9in.

1206 Is of a dark brown color and plain, not covered with any solution. Irregular in shape. Size 4ft. 3in. by 3ft. 7in.

1207 Is of a plain brown colour, nearly square. Size 21ft. by 18in.

1208 Is of a plain yellow colour, and very thin. Size 17ft. by 14 in. with a faint pattern of little rings.

1209 Ditto, ditto, the pattern more distinct, and consisting of crossed lines, dividing it into lozenges, with a little ring in the centre of each lozenge. Size 17ft. by 14in.

1210 Is of a plain dull black colour. Size 15ft. by 14in.

1211 Is of a plain brownish colour, thin, and has been soaked in some solution of a sticky nature as in No. 1204. Size 17ft. by 16in. with edges square.

1212 Is of a plain brown colour and has been soaked as in No. 1211. Size 13ft. by 12in. with edges straight.

1213 Is of a brown [colour] curiously ornamented chiefly with crossed lines in different directions in black: and has been soaked in the solution. Irregular shape. Size 13ft. by 12in.

1214 Is thin of a white colour ornamented with squares and bands in close-set zig-zag lines in black and yellowish; the squares alternating with squares of white

something in the manner of draught board. Size 16ft. by 15in. Nearly square but edges ragged.

1215 Are two irregular three sided pieces, of white, printed with fern leaves in dark brown. Greater dimensions 28ft. by 17in.

1216-1217 Two small specimens of coloured native Tapa, or Cloth, made of the bark of trees. From the Island of Mauti, (Maitea?), near Parry's Island to the westward of Otaheite, Society Group. No 1216 is oblong in shape with straight edges ornamented in wide longitudinal stripes in white, yellow, brown, and black the latter predominating and being arranged in close set Zig-Zag stripes \as if it had all been done with flat wooden stamps as No []/. Rather thick. Size 1 ft. 4 5/10 by 11 in. No 1217 is curiously painted in ornamental bands, in red, yellow, and shiny black, the latter predominating. Each of these two pieces is only ornamented on one side; and that on No 1216 has been printed. Size of No 1217, 1 ft. 3 by 1 ft. 1 in. Given by Professor [] Given by George Rolleston, Esq. M.D. Linacre, Professor of Physiology, Oxford 1875.

1218 A mat or cloth made of a thick piece of Masi, coloured on the upper surface of a very dark shiny brown almost black; the two ends being left white and cut into rude fringes. Made at the Samoan [-Islands] or Navigators Islands. Size 7 ft. 10 in. by 3 ft. 3 in. Given by H.E. Strickland, Esq 1847.

1219 A piece of white Masi, with other pieces dyed light and dark brown stuck one upon \one/ another, and then on to the white piece; the dark brown being uppermost, in two long and rather wide strips having notched edges. L 4 ft. 8 in W 1 ft. 8 5/10 in. It has the original writing on it ⁻ "Pitcairn Jacket". Donor uncertain. Possibly Captain Cook's Collection [-1772-1774 \stet./], (number lost) \and given by Reinhold Forster, Esq./, or may be Gambier's or Beechey's, etc, \or from Sandwich Islands, Rev: Andrew Bloxham M.A. Worc[ester] Coll[ege] 1826/. Ashmolean 1836, p. 185 no. 267-303.

1220 A large piece of Masi, or Polynesian Cloth, manufactured from the inner bark of the Malo tree (Morus Papyrifera) of the natural colour (that is more or less whitish) before stamping, printing, or colouring. L 18 ft. W 6 ft. 5 in. On it is written "Pitcairn". Donor uncertain but possibly Captain Cook's collection [-1772-1774], number label lost, and given by Reinhold Forster, Esq. Or may be Captain Gambier's or Captain Beecheys, or \Rev. A. Bloxham, from Sandwich Ilds./, etc. Ashmolean 1836, p. 185, nos. 267-303.

1221 Ditto, ditto, of finer make L 12ft. 8in.: W 5ft. 4in. Ashmolean 1836, p. 185, nos. 267-303.

1222 Ditto, ditto, of a white, printed in dark brown patterns, chiefly in more or less circular, and tria[n]gular shaped figures, from impressions of bits of fern leaves and moss, in the middle portion; three of

the straight edges having a narrow zig-zag border of the same pattern. L 7ft. 4in.: W 4ft. 3in.
Ashmolean 1836, p. 185, nos. 267-303.

1223 Ditto, ditto. L 7 ft. 4 in.: W 4 ft. Exactly similar to No. 1222 but narrower. Captain Cook's collection, 1772-1774. Given by Reinhold Forster, Esq.? Or may be Captain Gambiers, Captain Beechey's, or Rev: A Bloxam, 1826, \from Sandwich Islands/ etc.
Ashmolean 1836, p.185 nos. 267-303.

1224 Ditto ornamented all over in black and white; forming large lozenge-shaped designs in complicated patterns separated by wide black lines having a narrow white line down the middle \on each side which is a narrow red line/ [-of each]. It appears to have been printed with flat carved wooden stamps, such as those described under No 1553-1554. From the style of pattern I think probably from the Friendly Islands. L 5 ft. 8 in.: W 2 ft. 9 in. Three sides straight, the other end ornamented with a deep border, having a notched narrow fringe of white, one corner being a good deal torn.

1225 Ditto, One half being divided into thiry-three oblong shaped sections by strong dark brown lines, each oblong being again filled in either with a number of small squares of parallel black and white lines which are arranged in each square horizontally or perpendicularly alternately, and the squares separated from each other by thicker lines; the other oblongs having transverse parallel bands of lines which are arranged at different angles to each other, the bands being divided by thicker lines like those separating the squares. These oblongs of squares, and transverse diagonal bands are also arranged alternately. The other half of the cloth is ornamented in a more simple manner with eighteen diagonal parallel bands of light and dark brown alternately, and arranged so that half of each band is the dark and the other half of the paler brown, the junction of the ends being near the middle of the cloth. The middle portion of the cloth is a band of plain dark brown W 13 in. and at each end there is a band W 3 1/2 in., of the same colour. L 11 ft.: W 3 ft. 9 in. Captain Cook's Collection, [-1772-1774 \stet./], No. 52. Given by Reinhold Forster, Esq.
Ashmolean 1836, p. 185 nos. 267-303.

1226 Ditto, the surface coloured a rather shiny dark brown, one half being ornamented with narrow transverse black parallel lines; the other half having the lines arranged in [-lozenges \squares], each [-lozenge\square] being divided into [-quarters\halves] by the lines being drawn on [-different\opposite] directions, [-and] some [-being\of which are] much wider than others. All the edges straight, with a wide brown \edging round three of them/. I think that it is [-is] probably from the Friendly Islands. L 6 ft. 4 in.: W 4 ft. 9 in. Captain Cook's Collection, [-1772-1774 \stet./], No. 50. Given by Reinhold Forster, Esq.
Ashmolean 1836, p. 185 nos. 267-303.

1227 Ditto, of a thicker make, soft, of a dark yellow colour, printed in patches with various shaped Fern leaves in a dark brown colour, and slightly edged along three sides with a similar pattern, the fou[r]th side having a border of two kinds of undetermined ornaments, repeated alternately, and stamped or painted on. From Tahiti, L 9 ft. 3 in.: W 6 ft 1 1/2 in. All the sides straight. Captain Cook's collection 1772-1774, (Number lost)?, given by Reinhold Forster, Esq? Or may be Captain Gambier's, Captain Beechey's \etc, [-or Rev. A. Bloxam], \but not [-fro\by] A. Bloxam, M.A., as his are from the Sandwich Islands/.
Ashmolean 1836, p. 185 nos. 267-303.

1228 Ditto, of a duller yellow and very thin with a kind of diagonal diaper pattern in red and black: the pattern being in oblique shaped lozenges, each made of three parallel ornaments done with a wooden stamp. Size 3 ft. 1 in. by 2 ft. 10 in. (The same remarks refer to this as are found at the bottom of the previous, No. 1227,) except that it may possibly belong to the collection of the Rev: Andrew Bloxam, M.A. Worc[ester]: Coll[ege]: 1826, from the Sandwich Islands.

1229 Ditto, with very similar pattern, the only difference being that the ornaments are double the length. A good deal worn in holes. Size 3 ft. 4 in. by 2 ft. 11 in. (The same remarks as to No. [-1227\1228]).

1230 Ditto, of a yellowish colour, ornamented with thickly set thin parallel cross lines of a brown colour all over the surface, except at one end which is ornamented with a border of rather pretty design resembling leaves springing from the sides of straight stems, with minute dots between. Size 4 ft. 3 in. by 2 ft. 11 in. (The same remarks apply as those to No. 122[-7\8]-1229).

1231 Ditto, a small piece, very thin of a yellow colour. Ornamented in black with three broad bands, like to each other, and each composed of various narrow zig-zag bands and bands of dots, which have been printed horizontally with a wooden stamp. Over each of the zig-zag bands are drawn three closer set parallel lines in Brown. Size 1 ft. 7 in. by 1 ft. 1 1/2 in. Edges straight. The same remarks refer to this as are found at the bottom of No. 122[-7\8]-1229). Exhibited at the Art Treasures Exhibition 1857.

1232 Ditto, very thin of a yellowish colour, and covered with ornaments of a very prolonged lozenge shape, resembling the outline form of an Australian Heelman or shield, in small chequers and each ornament brown on one half and black on the other, the colours being separated lengthways; and arranged in rows end to end crossways the cloth, having narrow lines of the same colour between each row. Size 1 ft. 6 in. by 1 ft. 1/2 in. The same remarks refer to this as found to those of decriptions of No. 122[-7\8]-1231.

1233 Ditto, of a brown colour, thin, and rather rough, having thick close set parallel black lines arranged crossways the cloth in three separate wide bands, one in the middle and one at each end, by way of ornament. Size 3 ft. 1 5/10 in. by 1 ft. (The same remarks apply to this as to the preceding No. \1228-/1232).

1234 Ditto, of a yellow colour, thick, being made of two pieces hammered together, and ornamented all over, but rather thinly, and in an irregular manner, with numerous small [-red] circles of several sizes in red, some of which are joined five or more together to form star-like ornaments, and apparently printed [-printed] with the end of some hollow reed [-and\or] cane and perhaps \with blood/. Size 5 ft. 4 in. by 4 ft. Captain Cook's Collection, [-1772-1774 \stet/], No.15. Given by Reinhold Forster, Esq.
Ashmolean 1836, p. 185 nos. 267-303.

1235 Ditto, of a paler yellow colour, and thicker quality, the circles being larger, fainter, and somewhat arranged in squares \on one half of it;/ having none of the star-like ornaments, but all circles, or halves of circles, put back to back.[*drawing*] thus L 8 ft. 6 in.: W 6 ft. [-(The same remarks apply to this as to the preceding No. 1233)]. Captain Cook's Collection, [-1772-1774 \stet/], No.15. Given by Reinhold Forster, Esq.
Ashmolean 1836, p. 185 nos. 267-303.

1236 Ditto, of a whitish colour, and of much thinner and stiffer make, ornamented with circles, and portions of circles joined together forming a kind of letter [*drawing*] ornament, thinly distributed over the whole surface, in red, and probably done in the same way as the two preceding. L 18 ft. 3 in.: W 4 ft. 1 in. [-(The same remarks refer to this as to the preceding No. 1235)]. Captain Cook's Collection, [-1772-1774 \stet/], No.5. Given by Reinhold Forster, Esq.
Ashmolean 1836, p. 185 nos. 267-303.

1237 Ditto, of yellow colour, and much thicker than No. 1236, being more like No. 1227, but paler in colour and more sparingly ornamented with impressions from Fern leaves in dark brown. Probably from Tahiti: L 11 ft. 3 1/2 in.: W 5 ft. 7 in. Donor uncertain. [-(The same remarks apply to this as the preceding No. 1236)]. \Possibly Cooks Collection the number label being lost and given by Reinhold Forster, Esq. or may be Captn. Gambier's, Captn. Beechey's etc., or Rev: A. Bloxam's from Sandwich Islands./
Ashmolean 1836, p. 185 nos. 267-303.

1238 Ditto, of very large size, and of a whitish colour but rudely ornamented all over the surface with very close set cross lines giving it a brown appearance, and divided into a number of widths by strong plain lines or lines of dots \alternately,/ the widths being about 8 in., giving it a good deal the appearance of oak wainscoating. A broad border of white is left along each side. L 26 ft. W 7 ft. 4 in. Captain Cook's Collection, [-1772-1774 \stet/], No. 51. Given by Reinhold Forster, Esq.

Ashmolean 1836, p. 185 nos. 267-303.

1239 Ditto, coloured all over one side an uniform dark shiny brown. L 10 ft. 7 in. W 6 ft. 10 in. Captain Cook's Collection, [-1772-1774 \stet./], No. 49. Given by Reinhold Forster, Esq.
Ashmolean 1836, p. 185 nos. 267-303.

1240 Ditto, much thinner of a [-lighter brown colour\dark red colour], [-and] not shiny. and stained through, not on one side only. L 22 ft., W 6 ft. 10 in. Captain Cook's collection, [-1772-1774 \stet./], No. 19. Given by Reinhold Forster, Esq.
Ashmolean 1836, p. 185 nos. 267-303.

1241 Ditto, of a very pale brown colour, not shiny, thin, and sprinkled with red colour, or blood, probably for ornament, irregularly over the whole surface. L 9ft 3in.: W 5 ft. [-Possibly] Captain Cook's Collection, [-1772-1774 \stet./], \No.17/. Given by Reinhold Forster, Esq.
Ashmolean 1836, p. 185 nos. 267-303.

1242 Ditto, of a yellowish colour, plain, thin and rather soft to the touch. L 13 ft.: W 7 ft. 1 in. Captain Cook's Collection, [-1772-1774 \stet./], (number lost).? Given by Reinhold Forster, Esq. or may be Captain Gambier's, Captain Beechey's, or Rev: A. Bloxam's \from Sandwich Islands/ etc.
Ashmolean 1836. p. 185 nos. 267-303.

1243 Ditto, of a darker yellow colour, and thinner. L 7 ft. 3 in.: W 2 ft. 11 in. (The same remarks refer to this as to No. 1242 preceding).

1244 Ditto, of a white colour and somewhat thicker, the two sides cut up into thin fringes. All the sides strai[gh]tish. Size 3 ft. 6 in. by 1 ft. 10 in. [-(The same remarks refer to this as to No. 1242 preceding)].

1245 Ditto, of very large size, of a whitish \yellow/ colour, thin but well made. L 25 ft.; W 11 ft. The same remarks refer to this as to No. 1242 above.

1246 Ditto, of a whitish colour, and large size, of two thicknesses backed by several thinner pieces which have not been hammered. Perhaps intended for a bed. Size 10 ft. by 6 ft. 7 in. Captain Cook's Collection [-1772-1774 \stet./], No. 16. Given by R. Forster, Esq.
Ashmolean 1836, p. 185 nos. 267-303.

1247 Ditto, of a white colour and thin, and of only one thickness. L 15 ft.: W 5 ft. 10 in. Captain Cook's Collection? [-1772-1774 \stet./], No. 145? Given by Reinhold Forster, Esq., or may be Captain Gambier's, Captain Beechey's, or Rev: A. Bloxam, \from the Sandwich Islands/ etc.
Ashmolean 1836, p. 185 nos. 267-303.

1248 Ditto, a very large piece, of a still whiter colour, and thin, but well made. L 47 ft. 7 in.: W 7 ft. 6 in. (A very fine piece of Tapa cloth indeed.) Captain Cook's Collection? [-1772-1774 \stet./], No. 13. Given by Reinhold Forster, Esq.
Ashmolean 1836, p. 185 nos. 267-303.

1249 Ditto, of about the same thickness, but a little darker colour. L 11 ft.: W 6 ft. 8 in. Captain Cook's Collection? [-1772-1774 \stet./], No. 2. Given by Reinhold Forster, Esq.
Ashmolean 1836, p. 185 nos. 267-303.

1250 Ditto, of a whitish colour, made of several thicknesses, one on the other, and very regularly run together or quilted with parallel rows with strings which are neatly made of twisted fibre. Size 4 ft. 5 in. by 3 ft. 8 in. Captain Cook's Collection? [-1772-1774 \stet./], No. 128. Given by Reinhold Forster, Esq.
Ashmolean 1836, p. 185 nos. 267-303.

1251 Ditto, of a yellowish white colour, thick, being made of two or three pieces hammered together, and comparatively soft to the touch. L 10 ft. 2 in.: W 4 ft. 3 in. Captain Cook's Collection [-1772-1774 \stet./], "No. 14". Given by Reinhold Forster.
Ashmolean 1836, p. 185 nos. 267-303.

1252 Ditto, ditto, of one thickness rather thin and rather stiff. L 14 ft. 7 in. W 5 ft. 7 in. Captain Cook's Collection [-1772-1774 \stet./], (number partly destroyed), Given by Reinhold Forster, Esq.
Ashmolean 1836, p. 185 nos. 267-303.

1253 Ditto, ditto, two small pieces, very dirty. Size 3 ft. 5 in. by 3 ft. 1 in. Captain Cook's collection, [-1772-1774 \stet./] ? number lost, given by Reinhold Forster, Esq; or may be Captain Gambier's, Captain Beechey's, or Rev: A. Bloxam's \from the Sandwich Islands/ etc.
Ashmolean 1836, p. 185 nos. 267-303.

1254 Ditto, of several thicknesses, of a pale yellow colour. Size 5 ft. 5 in. by 2 ft. Captain Cook's Collection [-1772-1774 \stet./]. No. 20, Given by Reinhold Forster.
Ashmolean 1836, p. 185 nos. 267-303.

1255 \Two/ Ditto, of a much darker yellow colour, of one thickness, and thin. Size 3 ft. 1 in. by 2 ft. 10 in. and 4 ft. 2 by 2 ft. 9 in. The same remarks refer as are found at the bottom of No. 1253 above).

1256 One Ditto, of three thicknesses, the outer one coloured \black/ and the surface curiously ornamented so as to produce the appearance of Fishes scales or skin; this portion being now a good deal decayed. Size 4 ft. 4 in. by 2 ft. 10 in., with edges except where one or two small pieces have been torn out. Captain Cook's Collection [-1772-1774 \stet./]. No. 18. Given by Reinhold Forster, [-or perhaps belonging to the things given by Captain Gambier, Captain Beechey, Rev: A. Bloxam, 1826 etc.].
Ashmolean 1836 p.185 nos. 267-303.

1257 A white cloth or mat, coarsely though well woven of Flax fibre, or some similar material, the ends left unwoven, forming a fringe about 3 in. in depth all round the cloth. Locality uncertain, but probably from New-Zealand. Size 5 ft. by 3 ft. 7 in. Captain Cook's collection. [-1772-1774 \stet./], No. 22. Given by Reinhold Forster, Esq.

Ashmolean 1836, p. 185 nos. 236-257.

1258-1259 Two small specimens of Tapa or Polynesian cloth. From Otaheite. Belonging to Captain Cook's collection 1st voyage. No. 258 is white and thin, oblong in shape with visible marks of the grooves of the hammer or rather wooden mallet used in the manufacture. Size 12 5/10 by 8 5/10 in. No.1259 is thicker [and] softer, being slightly wooly like, and of a yellowish colour, size 18 by 14 5/10. All the edges straight in both of them. Given by Captain D.E.E. Wolterbuk Muller, Dutch Royal Navy Service (pension) Voorburg, near the Hague, Holland Sep. 23rd 1883. In consequence of having seen the objects belonging to Captain Cook's collection 2nd voyage belonging to the Ashmolean Museum Oxford, exhibited at the International Exhibition at Amsterdam in 1883.

1259a Small bundle of white Polynesian cloth, \and \two of/ flat cord of plaited Cocoa-nut fibre;/ received from Professor Rolleston. Used as packing. From the Samoan Islands. For particulars see the professor's writing on large label stuck on the material. Given by Professor George \Rolleston/ M.D. Linacre Professor of Physiology Date?

1260 A Bow and Arrow from the Friendly Islands. These are both of a singular kind: the bow, (which has a part broken off at one end), appears to have been about 6 ft. 9 in. long when entire; the wood is of an oval form \in section/, 1 in. wide, and 7/10 in. thick in the middle, tapering to 5/10 by 3/10 in. near the ends, which are then slightly enlarged the ends being again diminished into a kind of cylindrical peg 1 5/10 in. long for the bowstring. On the inner side, throughout the whole length, is a groove 4/10 in. wide and deep, in which the arrow was kept when not in use. The arrow (a slender cane-like reed of a brown colour) the \hard wood/ head of which is wanting, is \now/ L 5 ft. 8 5/10 in., and Th about 3/10 in. These implements are figured in Cook's second voyage, \vol: 1/, pl. 21, fig. 1 \and described p. 221/, and in reference to them it is remarked that "Their bows and arrows are but indifferent; the former being very slight, and the latter \only made of/ a slender reed, pointed with \hard/ wood, On the \inside/ [-\of the/] of the bow is a groove, in which [-they\is] put the arrow; from which it [-should\would] seem that they [-had\use] but one." Captain Cook's Collection, 1772-1774, \Sep: Oct: 1773/ No.? Given by Reinhold Forster, Esq.
Ashmolean 1836, p. 183 no. 136.

1261 A well made, massive Fiji war Club, of heavy [-wood, dark\reddish] brown wood. Handle part straight and smoothly rounded, L 2 ft. 6 in., D 1 5/10 in, at the bottom which has a projecting ridge, and the end convex, increasing to D 2 5/10 in. at the top which is bent or curved over, the head which is nearly D 5 in. having the form of a flattened round ball, covered with numerous short and strong points and one longer pointed spike projecting in the front in the middle \of them/, at a right angle with the handle. \Whole L 2 ft. 7

in./. A similar club is represented by the middle figure on p. 277 and described p. 278 of Wood's "Nat: Hist: of Man" vol: 2 and also in the concluding Vignette to \the 2nd volume of/ Meyrick's "Ancient \Armour"/ fig: 6, which is said to be from New Caledonia Purchased in 1868.

1262 An ornamental, processional, or emblematic stone-headed Adze, from the Hervey or Cook's Islands; whence alone articles of this kind were procurable. It is remarkable from the interior of the handle, which is of light coloured but hard wood, being so cut away as to leave a sort of outer skeleton frame which is variously carved. That such articles were only made for ornament, or at least not for use is evident, as the edge of the \black/ stone head or blade is rounded rather than sharp, and the handle so large and cumbersome as to make it useless for working with, or as a weapon. In the London Missionary Museum there are some of much larger dimensions than this; one of them having a round open-work handle, nearly a foot in diameter at the lower end, all the handles having the same skeleton like make, and more or less ornamentally carved. L of handle 45 5/10 in.; 2 4/10 square at the top near the head, and 4 in. at the lower end. The head or blade is of black basalt, and the ornamental but secure manner in which this is lashed on to the wood is worthy of notice, the binding being a narrow and evenly plaited cord of sinnet. Whole L 4 ft. 2 3/10 in. L of blade beyond the binding 4 4/10 in.; greatest W of ditto 2 9/10 in. Purchased in 1863. For figure and description of one of these Adzes see Wood's "Nat: Hist: of Man" vol: 2 pp. 372 and 373.

1263 A smaller article, of the same kind as the preceding No 1262, with round solid haft, carved in twenty seven horizontal rings of rather deep vandyke notches; the bottom of the handle being somewhat square shaped, and carved in similar but smaller pattern. The stone head has been lost, but the plaited fine binding of sinnet is attached. L 32 in. D of handle 1 7/10 in.; and of square portion at bottom 2 5/10 in. by 2 in. (Ramsden Collection, No. ?) Purchased by the University in 1878 \?if the head of this head of this Adze was of green Jade and left at the Natural Science Museum when the Ramsden collection was transferred from there to the Ashmolean./

1264 A baler or scoop of dark brown wood, used by New Zealanders to bale out water from their canoes. This article might readily pass for, or be used as a hand shield and probably has been so used. The general form is oval, 17 3/10 in. long, by 11 in. greatest W. One side is convex or rather flatly keeled like the bottom of a boat, the other side being deeply hollowed out so that it somewhat resembles the bowl of a large spoon, but having the handle brought back, over the centre, instead of being a prolongation at the end. It is well and regularly formed, but the chief carved ornamentation is an enormous mouth, and the eyes of oval plates of Haliot shell corresponding with the

figure described in No. 1153, and this is carved on the plain surface behind the handle. Captain Cook's collection, 1772-1774, No. 117 Given by Reinhold Forster.
Ashmolean 1836, p. 184 nos. 150.

1265 A similar implement to the preceding but of paler reddish [-brown] brown wood; but much smaller, and seemingly in a rough unfinished state. L 10 5/10 in.; W 7 5/10 in. Captain Cook's Collection, 1772-1774, No.? Given by Reinhold Forster.
Ashmolean 1836, p. 184 no. 151.

1266 An ornament for the head, [-or neck] from \St Christiana/ the Marquesas Islands. It is ingeniously made, and entirely of Cocoa-nut fibre; short twisted loops of which form a stiff crescent shaped fringe, the cusps being elongated into plaited strings, to fasten it by. This ornament is represented in "Cook's Second Voyage", \Vol:1/ pl.17. Fig: 2. It is exactly crescent shaped in form. D about 10in. Greater depth 2 8/10in., and about Th 1 in., and more of three thicknesses tied together. The plaited strings at the ends are only partly made of cocoa-nut fibre, the rest being of flax or something of that nature twisted like ordinary string. Captain Cook's collection, 1772-1774. \(March: April. 1874 [recte 1774].)/ No. ?. Given by Reinhold Forster. Esq.
Ashmolean 1836, p. 184. no.185.

1267 An ornament \for the Leg or the Arm/ very similar to the preceding, except that thick tufts or curls of human \black/ hair take the place of the Cocoa-nut fibre or cordage. Each separate tuft being bound round the top with a fine thread made of fibre to form a loop to fasten it to the thicker cord of plaited cocoa nut fibre, except the ends used for tying it, which are twisted cord of some other material. D or W of the hair part only about 8 in.; depth about 5 in. Extreme L of cord 33 in. Captain Cook's collection, 1772-1774, No.? Given by Reinhold Forster, Esq. \Described in Cook's 2nd Voyage, vol:1 p. 310/.
Ashmolean 1836, p. 184 no. 180[?].

1268 An ornament [-probably\Probably from Sta Christiana Island, Marquesas/, for the [-neck\leg or arm], made of Cock's \tail/ feathers fastened to a plaited cord of cocoa-nut fibre, the ends of which are tied together behind. Captain Cook's collection, 1772-1774, No.? Given by Reinhold Forster, Esq. Described in Cook's 2nd Voyage, vol: 1 p. 310.
Ashmolean 1836, p. 184 no. 186[?].

1269 An ornament \from the Island of Sta. Christina, Marquesas/, of a light coloured soft wood, in seventeen pieces neatly joined together and decorated with the scarlet and black [-berry] Indian berries (Abrus precatorius) stuck on or rather embedded in a layer of [-wax\gum] with the scarlet sides uppermost. It is the size and shape of a large horse-shoe W 5/10 in. and Th 1 1/10 in., around the outer edge of which on the upper surface, are thirty-seven rays as it were, L 1 7/10 in. at the ends of the shoe shape and gradually increased to L

3 in. in front or the middle of it, each ray being covered by two rows of the berries. It is figured in plate 17 fig. 1 of Cook's "Second Voyage", \vol: 1/, where it is called a "Gorget ornament with red peas". \it is also described on p. 310/. From plate 36 it appears to have been worn suspended on the breast, and from the brillant colour, and the arrangement of the berries, it must have had a striking appearance. Whole W 9 8/10 in. Whole depth 8 6/10 in. Whole W of wood work 2 1/10 at the ends, increasing to 3 5/10 across the middle. Captain Cook's collection, 1772-1774. \(March & April 1774)/ No. 133. Given by Reinhold Forster, Esq. (For a description and figure of a similar ornament, see Wood's "Nat: Hist: of Man." vol: 2, p. 387; and p. 388 where a Marquesasian chief is represented wearing one).
Ashmolean 1836, p. 184 no. 184.

1270 An ornament, worn suspended from the neck, by Ladies of the Sandwich Islands; formed of 233 lengths or more cor[r]ectly speaking doubles of finely plaited black human hair, with a well formed and finished hook-shaped ornament; cut in Spermaceti Whale's tooth suspended from them by some of the plaits passing through the middle of it. All the plaits are quadrangular the majority of them being about the 1/15 in. square, and these do not pass through the hole in the tooth ornament, but are doubled up and tied with a short string which passes through the hole, and is fastened to the plaits on the other side in like manner. The remainder of the plaits are beautifully fine work, being only about half the size of the others, and are arranged on the two sides, thirty two being on one side, and forty on the other, pass through the hole in the tooth ornament and hides the cord which ties the larger plaits where they are doubled, so that the whole of the plaits appear at first sight to go through the hole. It is difficult to say what are the lengths of the plaits, as they appear to be doubled backwards and forwards so as to hide the joinings, if there are any. The [-plaited] cords at the ends for fastening are made of some plaited fibre. Whole L from end to end, of hair \only/ 19 in., or to end of strings 33 in. L of hook 3 8/10 in., greatest W 1 3/10 in. Captain Beechey's collection, 1825-1828.
Ashmolean 1836, p. 183 no. 141.

1271 A nude Male \human/ figure, carved in dark brown wood, From Easter Island. H 9 5/10 in. W across the arms 2 in. The eyes appear to have been inlaid; probably with some kind of shell. The figure is thought by some to be actually a native representation of Captain Cook, \or/ of some other celebrated European, by the parting of the hair of the head before and behind, as no savage wears his hair that in that fashion. With it is a small oblong piece of the native white tapa cloth, L 4 7/10 in. by W 2 8/10in. Given by [-Mr.] George Griffith, \Esq./ M.A. Jesus College. [-1859\or] 1863?
Ashmolean 1836-68, p. 7.

1272 A \dark brown/ wooden foot-rest, from a walking stilt used by natives of the Marquesas Islands. The rest for the foot is bracketed up, or supported by a grotesque human figure, curiously carved, the surface being cut in a series of narrow fluted parallel lines, either straight, curved, or in squares, perhaps intended to represent the tattoo line. Whole L 14 in. H of figure only 10 in., having a high hat or headdress on: greatest W of ditto 2 9/10 in., being the headdress. A pair of stilts as used, may be seen in the Christy Collection, 103 Victoria Street London, see also Wood's Nat: Hist: of Man; vol: 2 page 389. Given by J. Lechmere, Esq. J.P. \Steeple Aston, Oxon 1828?/

1273 Ditto, from the Marquesas Islands with a similar carved figure, but with longer face, the grooves of the carving being not so well defined, and the arms, if it had any, are gone. The whole thing appears to have been coated with some varnish or paint of a dark brown colour. Whole L 15 3/10 in. Greatest W 3 5/10 in. From the Trustees of the Christy collection in exchange, 1869.

1274 Ditto, of a different type, the figure carved without legs, the arms being represented as thrown upwards and somewhat backward: The face too is different the eyes being much larger, and the ears close against the cheeks, not projecting, as in No 1272. 1273. (The eyes of all these figures look as if wearing spectacles, and there is a peculiarity about the turn of the nostrils which is very characteristic). H 14 in. Greatest W 2 6/10 in. Ramsden Collection No. 900. Purchased by the University in 1878.

1275 Ditto, more like No 1272 and 1273, having the legs represented, and the arms in the same position. H 12 in. Greatest W 1 2/10 in. (Ramsden Collection No. ?) Purchased by the University, 1878.

1276 Ditto nearly like it but smaller. H 10 5/10 in. (Ramsden Collection No. ?) Purchased by the University 1878.

1277 A carved wooden stretcher, from the native made model of a New Zealand War Canoe, No 1431. In the two grotesque human figures here represented, the enormous tongue is protruded, as noticed in No 1153 preceding, etc. The wood appears to have been coloured. L 22 8/10 in. Greatest W, which is the middle 3 6/10 in. Given by W. Bennet Esq Faringdon House, Berks 1827.
Ashmolean 1836, p. 174 no. 12.

1278 A Polynesian Tootoofe, or artificial bait and line attached for catching Cuttle fish. It is made of the back of large sized cowry shells (Cypraea tigris) fastened together, and one overlapping the other and formed into a mass of the size of a large specimen of that genus of shells; and having a thin stick of about a foot long fixed horizontally through the middle of it. When used the Cuttle fish entwines its arms round it and so is

drawn to the surface. Captain Beechey's collection, 1825-1828.

1279 A somewhat similar bait, made of a piece of stalactite, ground into a cone shape, covered with plates of Cowry shell, and in this and other respects resembling the preceding one No 1278. Captain Cook's Collection, 1772-1774, No ? given by Reinhold Forster. The probable cause for thus making up an artificial cowry instead of using one in its natural condition was to obtain a sufficient weight to sink readily amongst the coral rocks, where they were used, and also to give better grasping hold to the creature to be caught. For the manner of using such baits see Ellis's "Polynesian Researches" vol: 2, p. 292.
Ashmolean 1836, p. 185 no. 213.

1280 A piece of rope made [from] black and very coarse Woman's hair, [-of a] twisted together. From Easter Island South Pacific. It is almost as coarse as horse hair, and has many pieces of grey amongst it, L about 4 ft.: D 1 in. Given by J. Park Harrison, Esq M.A. 1880.

1281-1282 Two fish-hooks from New Zealand, or the Polynesian Islands. The shafts are made of thick pieces of Mother of Pearl shell, ground into somewhat of a fish-shaped outline, somewhat curved from end to end, and deeply hollowed out in front ground into shape and polished. The hook part being also formed of pointed pieces of Mother of Pearl shell, without barbes, L 1 8/10 and 1 5/10 in., securely lashed onto the shaft. These hooks serve as artificial baits, a tuft of feathers of a white colour being fastened on the lower end of each to aid in the deception. The lines are strong apparently of twisted cocoa-nut \or some such/ fibre except that portion which crosses the inner side of the shaft, which is spirally twisted with some finer material perhaps flax. L of No. 1281, 5 5/10 in.; greatest diameter 1 in; and L of No. 1282 4 8/10 in.; D 9/10 in. They are especially used for catching dolphins, albicores, bonitos, etc. (Probably either belonging to Captain Cook's collection, [-1772-1774 \-stet./] and given by Reinhold Forster, Esq., or else to Captain Beechey's collection, 1825-1828.
Ashmolean 1836, p. 185 nos. 212-30; p. 187 no. 361.

1283 One fish-hook \of/ very similar \construction/ to the preceding, except that it is smaller, the sides near the top flatter, and the hook part made of a straight and darker \or smoky/ piece of shell; the line being [-apparently\comparatively] fine in comparison with the size of the hook, and made of \twisted/ flax? At the lower end of hook are two little tufts, being the untwisted ends of the string instead of feathers \L 3 7/10, greatest W 15/20 in./. (The same remarks refer to this as are found at the end of description of the preceding, No. 1282).
Ashmolean 1836, p. 185 nos. 212-30; p. 187 no.361.

1284 One ditto, similar in general form, the hook being of lighter coloured \mother of pearl/ shell

cur[v]ed somewhat and neatly barbed. The line of twisted flax fibre?, the tufts at the end of the hook being of light coloured hair. L 3 7/10 in.: W 11/20 in. The same remarks refer as those to the preceding).
Ashmolean 1836, p. 185 nos. 212-30; p.187 no. 361.

1285-1289 Five ditto, more fish-shaped, being less hollowed out in front, the hook portion being made of tortoise shell, cut out on the curve but not barbed. No. 1287 and 1289 have the lines, apparently made of twisted flax \or the inner bark of some tree/ attached, and the others have had lines of like material [-\but have been lost,/] fragments of which are attached. The lower end of the hooks have little tufts of flax? L of \No. 1285/ 3 1/10 in., greatest W 13/20 in. L of No. 1286, 3 6/10 in.: W 5/10 in. L of No. 1287, 3 9/20 in.: W 5/10 in. L of No. 1288, 3 in., W 9/20 in., and L of 1289, 2 17/20 in.: W 5/10 in. (The same remarks apply as at the end of description of the preceding).
Ashmolean 1836, p.185 nos. 212-30; p.187 no. 361.

1290 One ditto, of the same form, the shank being of opaque white shell, but the hook itself of tortoise shell as in the preceding five No. 1285-1289. L 4 4/10in., W 6/10 in. (The same remarks).
Ashmolean 1836, p. 185 nos. 212-30; p. 187 no. 361.

1291 A fish-hook, from the South Pacific Islands, or New-Zealand; made of a single, [-piece] flat, and thick piece of black shell, shiny on one side. L 2 6/10 in.; W 1 7/10, \greatest W of material 8/10/ and Th 2/10. The point is curved back inwards very much but not barbed. If an artifical bait it is probably intended to represent some sea zoophyte, or worm as it is anything but fish-like. The short piece of stout twisted line attached, \L 5 in./, is made of some \twisted/ fibre \or inner bark/, but not cocoa-nut fibre. (Probably either belonging to Captain Cook's collection [-1772-1774 \stet/], and given by Reinhold Forster, Esq.; or else to Captain Beechey's collection 1825-1828).
Ashmolean 1836 p. 185 nos. 212-30; p. 187 no. 361.

1292 Ditto, ditto, of somewhat similar form to the preceding No. 1291, but made of a thick piece of Mother of pearl shell, of a smoky or blackish colour towards the point, particularly on one side. The line \stout/ attached in rather a different way and apparently made of twisted cocoa-nut \or some such/ fibre, and bound to the hook with some finer material probably flax. L of hook 3 4/10 in. Greatest W or spread of hook 2 2/10 in.: Greatest W of material 7/10 in.: and Th 5/10. L of line 9 1/2 in., and Th nearly 2/10. (The same remarks apply to this as to the preceding).
Ashmolean 1836 p. 185 nos. 212-30; p. 187 no. 361.

1292a Ditto, of nearly black shell, with well-made line attached resembling modern string. Point of hook broken off. L 2 1\12 in. W 1 4\10 in.

1293-1299 Seven very slender fish-hooks, of similar shape to the preceding No. 1292, and apparently from the make of the top, \they were/ bound to the line in the same manner. Made of tortoise shell. All very flat on

the sides and without lines. They are probably intended to represent sea-worms. L of No. 1293, 2 3/20 in.; greatest W 1 1/10; L of No. 1294 1 9/10 in., W 1 3/20; L of No. 1295 1 19/20 in., W 15/20 in.; L of No. 1296, 1 9/10 in.; W 1 in. L of No. 1297, 1 17/20, diameter 17/20 in.: L of No. 1298, 1 5/10 in. (broken), and L of No. 129[9], 1 3/10, W 7/10 in. 2/10. (The same remarks apply to these as are found at the bottom of description of the preceding No. 1291 and 1292.)
Ashmolean 1836 p. 185 nos. 212-30; p. 187 no. 361.

1300 A fish-hook from New Zealand, or Polynesia, of tortoise shell; somewhat resembling No. 1293-1299, but more so No. 1291, by the attachment of the line, (which is [-made] of fine well made string) being the same, but the point of the hook not so much bent inwards. L 1 4/10 in.; W 1 in. Greatest W of material 9/20 in., and Th 3/20. 2/10. (The same remarks apply as in the former number). (The tribes in Torres Strait, and at Cape York, N. Australia, make fish-hooks of Turtle-shell).
Ashmolean 1836 p. 185 nos. 212-30; p. 187 no. 361.

1301-1305 Five large Fish-hooks, from New-Zealand?: with heavy shafts, from 5 3/10 to 6 5/10 in. long, somewhat fish-shaped made of \white/ bone \probably of the Spermaceti whale/ smoothly worked into shape, backed with a flat and polished plate of blackish or smoky mother of pearl shell. The hook itself is made of thick flat plates of tortoise-shell, two thicknesses being sometimes united for the purpose. This varies from L about 2 to 3 in., and W from 1 8/10 to 1 2/10 at the barbed point and is very securely lashed on to the shaft, with \fine twisted/ thread apparently made of \the native/ flax, passing through holes drilled through the tortoise shell hooks. A tuft of flax is fastened to the end of each shaft, to render them more efficient as artificial bait. The lines are stout, and of plaited flax and pass down the front of the shaft \where they are bound round with fine twisted thread/, the end being securely fixed to the hook itself. The mother of pearl back plates are not continued quite to the lower end of the bone. L of No. 1301, 6 11/20 in.; greatest W 1 5/20 in., and Th 9/10 in. Extreme L of hook part 3 2/10 in.; spread of point from shaft 1 17/20 in., long line attached. L of No. 1302 6 3/10 in.: greatest W 1 5/20 in., and Th 1 in.: extreme L of hook portion 2 9/10 in. (lower portion only of line remaining). L of No. 1303, 5 13/20 in., greatest W 1 2/10 in., and Th 1 1/20: extreme L of hook 2 in. L of No. 1304, 5 3/10 in., greatest W 1 1/10, and Th 8/10: extreme L of hook part 2 3/10 in., and L of No. 1305, 5 4/10 in.: greatest W 1 1/10, and 9/10 thick. Extreme L of hook part 2 15/20 in. (Probably either belonging to Captain Cook's collection [-1772-1774 \stet/] and given by Reinhold Forster, Esq.; or else to Captain Beechey's collection 1825-1828.)[39]

Ashmolean 1836 p. 185 nos. 212-30; p. 187 no. 361.

1306 A New Zealand fish-hook, the body or shank made of brown wood, \flat/ curved and hollowed out from end to end on the inside, decreasing in size from the middle to the ends, the back part being half round. Lined on the inner side with a glittering curved strip of purple and green (pawa) shell. The hook itself is bone, and is always made from the bone of a slain enemy, so that it is valued as a trophy, as well as a means for catching fish; it is barbed, and fastened to the rest of the hook by a very ingenious lashing of flax fibre; a well made twisted line L 14 in. being attached to the top. Whole L 4 1/10 in.; greatest W 8/10 in. and greatest Th. 5/10. L of bone hook only, 1 5/10 in. Given by Mr W. Gilchrist Whicker, 1836. See Wood's "Nat: Hist: of Man" vol: 2 p. 151 fig 1.

1307 An exactly similar hook to No 1306, and a similar piece of line L 1 ft. 10 in. attached, and the bone hook being somewhat smaller, \from New Zealand/ Whole L 3 7/10 in.; greatest W 7/10 in., and Th 5/10. L of bone hook part only 1 4/10 in. Given by Mr George Hilliard, 1845.

1308 A Shark hook from Egmont Island, South Pacific. It is of brown wood, somewhat of the letter V, and unpolished. To one end of the wood the short line is very securely bound in the same manner as \that of/ the pearl-shell hook No 1292, the line and binding being also of the same materials; and at the other end of it an incurved point of the same kind of wood is bound in a similar manner. Whole L 10 in., spread or W of the hook at the top, 6 in. Greatest Th, which is at the angle or bend, 1 7/10 in., diminishing in size to the two ends. L of line which has a loop at the top 11 in. Captain Beechey's Collection, 1825-1828.
Ashmolean 1836, p. 187 nos. 362-3.

1309 A Shark hook similar to the preceding but much smaller, and having the incurved point made of pearly shell. From Egmont Island. L 6 2/10 in.; W at the top 3 5/10 in. L of line which [h]as a loop at the top 14 5/10 in. Captain Beechey's Collection, 1825-1828.
Ashmolean 1836, p. 187 nos. 362-3.

1310 A similar \hook/ to the two preceding, but intermediate in size, and having an incurved point of pearl shell as in No 1309. L 6 7/10 in.; W at top 4 2/10 in. L of line 14 in. From Egmont Island. Captain Beechey's Collection 1825-1828. For the way these and similar hooks are made and used see Ellis's "Polynesian Researches" vol: 2 p. 293
Ashmolean 1836, p. 187 no. 363.

1311 A shark-hook from the Sandwich Islands. This is of dark brown heavy wood nearly cylindrical, of a regular curve, and of the natural growth, and pointed with a triangular piece of human bone which is not

[39] It is very plain that all these fish-hooks \(No. 1281 to 1305)/ belong to more than one collection, and that [-that] at some previous time they had been carelessly mixed together. There is not one of Captain Cook's original number labels on any of them \and therefore none may belong to his Collection but probably that will never be known now.../ (Ed: Evans Assistant Keeper, 1884).

barbed or \in/curved. Whole L 9 8/10 in.; Greatest D 1 3/10 in. L of bone point 1 4/10 in. The top is somewhat pointed, and has five deep horizontal grooves for binding on the end of the line. Greatest W or spread of hook 5 in. The bone point is ingeniously let in the end of the wood and secured by a fine string binding. Given by the Rev: A\ndrew/ Bloxam, M.A. Worcester College, 1826. See Ellis's "Polynesian Researches" as above referred to.
Ashmolean 1836, p. 185 no 215.

1312-1313 Two \Polynesian/ turtle pegs, or harpoon heads. These are of hard black wood: L between 7 and 8 in., and D or Th about 1/2 in., the lower end cylindrical and tapering for insertion into a hole in the end of a shaft, and from which it may be easily detached; the other end is sharply pointed, and has three rows of three or four short and stiff barbs with some fainter barbs or rather incisions above them; these barbs reach back from between 2 1/2 to 3 in. from the point. At that part between the point portion and that for insertion into the shaft is a prominent ridge or shoulder. When used the peg is attached to a line and forced from the end of a pole or shaft, between the plates of the Turtle's shell. L of No 1312, 7 4/10 in., greatest D 8/10 in. L of No 1313 7 1/10 in.; greatest D 8/10 in. Given by Mrs John Bayzand Oxford 1868. These implements, from the skill shown in the making, are probably from the Solomon or neighbouring Islands, but implements (at least) similar to these appear to be used by natives of the North-Eastern Coast of Australia, as during the repairing of the ship in the Endeavour River station, Captain Cook says "we killed a turtle for the days provision, upon opening which we found a wooden harpoon or turtle peg, about as thick as a man's finger, near fifteen inches long, and bearded at the ends, such as we had seen amongst the natives, sticking through both shoulders; it appeared to have been struck a considerable time, for the wound had perfectly healed up over the weapon".
Ashmolean 1836-68, p. 4.

1314-1315 Two instruments from New-Zealand?, called Flesh pegs, and said to be used for taking the meat out of the pot. They are of hard very dark, almost black wood, L 6 8/10 in., D 5/10 in. at one end, and gradually tapering to a sharp point at the other; the large end being thickly bound with the inner bark like that used in some of the New Zealand matting work over a thick coating of resin or wax. (History and donor unknown at present) A very similar implement is figured in Wood's "Nat: Hist: of Man" vol: 2 p. 50, which is said to be Australian.

1316-1317 Two New-Zealand [-needles\bodkins] of bone, or Whale's tooth \Or seals or Sea Lion's teeth?/; No. 1316 is L 5 8/10 in., and D 5/20; and the other, No. 1317, is L 4 11/20 in., and D 5/20 in. They are well made being a good deal curved from end to end, cylindrical and the \round/ eyes drilled \through close

to the uppper end/. Needles of this kind are stated to have been worn attached to the cord by which the cloak was tied on, and used for fastening the cloak together in front when needed. One such and so used is represented in pl. 13 of Cook's "First Voyage", \vol:III. p. 49 [-probably] and described p. 50 and p. 34/ [-but doubtless they were applied to other purposes also]. Captain Cook's Collection, [-1772-1774 \stet/] \No. ?/, given by Reinhold Forster, Esq.
Ashmolean 1836, p. 184 no. 196.

1318 A New-Zealand Ear pendant?, or [-Needle\or bodkin for fastening the Cloak in front?], of green Jade. This is a somewhat similar shaped implement to the \two/ preceding, No. 1316, 1317, being nearly cylindrical, well formed and polished, and having the upper end somewhat ground flat with a circular eye drilled through close to the end; but it is less curved in the length, and comparatively thicker. It is probable that this may have been used for an ornament, (like the following) [-as well as for other purposes.] L 6 1/20 in.: Greatest D about 7/20 in. Captain Cook's Collection, [-1772-1774, \stet./] \No. ?/ See Cook's "First Voyage", vol: III. Pl: 13 p. 49, where a New Zealand man is figured wearing something of the kind/. given by Reinhold Forster, Esq.
Ashmolean 1836, p. 184 no. 196.

1319 A New Zealand ornament of polished green jade, L 6 11/20 in., and 6/10 in. greatest D, one side of a flattened form nearly the whole length; the other two sided the sides meeting in a kind of keel down the middle, and each sides being somewhat hollowed out. The lower end is obtusely pointed, and the upper end which has the appearance of having been formerly perforated, and the hole afterwards broken out, is firmly bound round with string, [-apparently] made of flax fibre, for suspension. Such an ornament, \perhaps this one/ is figured in Cook's "First Voyage", \vol: III. p. 49 Plate 13/, as worn by a New Zealand man, suspended from \the lower part of/ his ear, and described pp. 52 and 53. Captain Cook's Collection, [-1772-1774 \stet./], \No.?/ given by Reinhold Forster, Esq. (For \pendant/ ornaments made of green jade, see \also/ Wood's "Nat Hist: of Man". vol: 2. pp. 128, 129).
Ashmolean 1836, p. 184 no. 196.

1320 An awl made of a small nail set in a groove on one side of a cylindrical bone handle L 3 2/10 in. and D 6/10 in., and securely fixed with a strong binding of plaited cocoa-nut fibre. This implement is entered in the catalogue of 1836 without a donors name, and decribed ([-doubtless\probably] from an original label) as "an awl made with a nail, an instance of the early use of iron by the natives."). In his description of Tongatabo, Captain Cook says ("second voyage" vol: I, p. 217), "The only piece of iron we saw amongst them, was a broad awl made of a nail," and there can be but little doubt that this is the awl he referred to. Whole L

3 9/10 in. Captain Cook's Collection, 1772-1774 No. 101? or 107?: given by Reinhold Forster, Esq.
Ashmolean 1836, p. 185 no. 210.

1321 An awl, or chisel, \probably from Tahiti/, made of a large tooth of a shark, fastened into the end of a cylindrical handle of brown wood with a strong binding of plaited cocoa-nut fibre. The handle has several holes in it as if it had been bored with \an/ awl \like/ No. 1320, \or shot at with small shot/. Whole L 7 5/10 in. D of handle 1 1/10 in. Captain Cook's Collection, [-1772-1774 \stet./] No. 174: given by Reinhold Forster, Esq. \Something of this kind is figured in Cook's First Voyage, Vol: 2, pl: 9. p. 212, but is a gouge for making holes for sewing the planks of the larger canoes together, see pp. 220-226 same volume/.
Ashmolean 1836, p. 185 no. 209.

1322 A basket from the Friendly Islands?, made of brown and straw coloured matting of interwoven narrow strips of cocoa-nut leaf, worked in zigzag stripes. It is of a flat purse-like shape, one side being wider than the other, & forming a kind of lid to fold \down/ over it. L 3 3/10 in. depth 6 5/10 in. Captain Cook's Collection, 1772-1774 No? Given by Reinhold Forster, Esq.
Ashmolean 1836, p. 185 no. 260.

1323 A Polynesian \flat/ basket \probably Friendly Island/; made of interwoven strips W about 4/10 in. of palm-leaf, or some kind of rush, of a shiny yellowish colour with a narrow cord of plaited cocoa nut fibre for handle. It may formerly have had two such handles. Greatest L 1 ft. 3 1/2 in. Depth 8 in. \It is probable that it is of Captain Cook's Collection./

1324 A New Zealand? flat basket of woven narrow strips of the native flax plant or perhaps of some kind of rush, worked in black and yellow, or black, in transverse parallel stripes alternately. In bad condition, and without handles, L 21 5/10 in. Depth 13 5/10 in. (Ramsden Collection No. ?) Purchased by the University in 1878.

1325 A flat basket from New Zealand? made of the same kind of material as No 1324, and woven in very much the same manner, but the bands bending at right angles, somewhat in the kind of key pattern, in black and black and yellow. Two loop handles made of plaited flax fibre, and ornamented all round the top edge with small loops made with a twisted cord of the same material (Ramsden Collection No. ?) L 19 in. Depth 11 1/2 (Purchased by the University in 1878).

1326 A New Zealand? flat basket, made of narrow strips of the same material as the preceding two, No 1324 and 1325, woven in squares of D about 3 in., in narrow black and yellow bands alternately; the bands running in opposite directions and thus forming the squares; the whole thing looking very much as if it was made of a number of separate squares sewn together like patchwork. Two small loop handles of twisted cord

of [-the same\similar] material. L 2 ft. depth 10 in. Ramsden Collection No. ? Purchased by the University 1878.

1327 A flat oblong shaped basket from Egmont Island, very strongly made of woven cocoa-nut fibre in a kind of knotted pattern: without ornamentation except dark \brown/ stripes across the sides, three on one side, and two on the other. It is strengthened round the top with a stiff cord, and has two tiny loop handles attached to it. It is woven in one piece. L 20 in.; depth 12 in. \Compare the make of this article with that of the cocoa-nut [-armour] fibre armour 1385 1386./ Captain Beechey's collection. 1825-1828.
Ashmolean 1836, p. 187 no. 361.

1328 A long oval-shaped open basket, \open at the top and somewhat rounded off towards the bottom/ from the Friendly Islands, of strong \but fine/ wicker work material rather closely woven, dyed black, and ornamented \on the outside/ with \twelve/ triangles and \twenty-five/ crescents in braid of \plaited/ cocoa-nut fibre. The handle which is broken is also of plaited cocoa-nut fibre. L 21 in.: depth 8 in.; width in the middle about 6 in. Captain Cook's collection, 1772-1774 No. [-87\?]. Given by Reinhold Forster, Esq. \(This beautiful basket had been exposed to the dust for some years which probably may have somewhat injured it.)/

1329 A bucket, or basket, from the Friendly Islands. It is a hollow cylinder open at one end, which forms the top; formed of a hard and solid piece of wood. Covered all over the outside with finely worked cocoa-nut fibre, closely plaited, in wedge-shaped ornaments or pattern, of black and lightish brown, alternately, and divided from each other by lines of small white rings or beads, made from cross section of some shell, probably a dentalium, each bead having been drilled from each side until the hole met in the middle. Handle across the top made of several separate twisted cords of some finer material. H 14 in. D 8 in. This article is represented in Cook's "Second Voyage", p. 21, fig. 6. where it is called a basket. The lid which is there figured is now missing. Captain Cook's Collection, 1772-1774 No. 87. Given by Reinhold Forster.

1330 A flat basket from the Friendly Islands; of like material and very similar in pattern to the covering to the preceeding article, No. 1329, and figured in the same plate by fig. 3. L 17 3/10 in.; Depth 13 in. The pattern appears to be in lozenges, half of each lozenge being brown and the other half black, and the white beads forming the separation across the middle as \well as/ being round the edge of each \lozenge/. A thickish cord of plaited cocoa-nut fibre surrounds the top, and the basket is woven in one piece. Captain Cook's Collection, 1772-1774 No. 89. Given by Reinhold Forster, Esq.

1331 A basket? or bucket?, from the Friendly Islands, similar to No 1319 but of smaller size, and the round

piece which forms the bottom being \of a/ separate \piece of wood/ and tied in. H 13 5/10 in.; D 6 5/10 in. The strings which formed the handles a[re] gone (Ramsden Collection, No. ?). Purchased by the University 1878.

1332 An article, [-probably\certain[ly]] a Woman's Apron. From the Friendly Islands? \Certain/. It is made of thirty-six star-like ornaments, each of which has been made separately of a thin wire-like fibre, perhaps cocoa-nut fibre, woven very neatly in a kind of basket-work pattern, ornamented with small red and green parrots feathers, and small disk shaped white beads, made of cross sections of some shell, with here and there a few black ones introduced. Each ornament is attached or sewn to the edge of the other, and the whole form a square of D 26 in. fastened at the top to a belt W 1 5/10 in., made of the same material. Captain Cook's Collection, [-1772-1774 \stet./] No. 61. Given by Reinhold Forster, Esq. This article is very well described in Cook's 2nd voyage. Vol: 1. p. 219. "They have also a curious apron made of cocoa-nut fibre, composed of a number of small pieces sewed together, so as to form stars, half-moons, little squares, etc. It is studded with beads of shells, and covered with red feathers."
Ashmolean 1836, p. 184 no. 193 or p. 183 no. 138 [?].

1333 A small basket from the Friendly Islands, similar to No. 1330 and of the same make and colour as that, and No.1329. L 11 in.: depth 8 in. Captain Cook's Collection, 1772-1774, No. 90.

1334 A Polynesian (Tahitian) stone-headed hatchet or adze; \with which they fell trees/, wooden handle L 2 ft. long Th 1 8/10, head of black basalt L 12 5/10 in. and W 3 8/10 in. at the cutting edge, greatest Th 2 5/10 in. This was evidently a tool for work, both head and handle are well formed, but rough and without polish or ornament. The head is secured to the handle by a binding of flat, plaited cocoa-nut fibre. A similar implement, \perhaps this one/ is figured in pl. 10 of Cook's First Voyage, \vol: 2/. From Tahiti. Captain Cook's Collection, [-1772-1774 \stet./] No.? Given by Reinhold Forster, Esq.
Ashmolean 1836, p. 184 no. 158.

1335 A similar but smaller Adze to No. 1334, and [-no doubt like it] used for [-hollowing\forming] canoes, [-etc.] From Tahiti. L of handle 19 in.: L of blade 9 in. W of ditto 2 6/10 in., and Th 2 2/10. The blade is fastened to the haft as in the preceding, with a strong binding of plaited cocoa-nut fibre. (Probably \from/ the style of the \hand writing of/ original label \on it, it belongs/ [-belonging] to Captain Beecheys collection, 1825-1828.? but is entered in Ashmolean 1836, p. 184 no. 157, [-and] as given, together with the preceding [-number] article, and 1159 \previously entered in this book/, by Reinhold Forster, and therefore of Captain Cook's Collection. Among all the rest of Cook's articles I remember no label \at all/ like that on this article, but it is much like Beechey's writing, as see on

many of his Esquimaux objects.) (A similar Adze is figured in Wood's "Nat: Hist: of Man", Vol: 2, p. 202.).
Ashmolean 1836, p. 184 no. 157.

1336 A neatly made Polynesian Adze, perhaps from Mangaia, Cook's Islands. Blade of black basalt, nicely finished and attached to the long cylindrical handle of polished brown wood by a fine flat binding of plaited cocoa-nut fibre which is crossed and recrossed in different directions, as in No 1262 and 1263. L of handle 2 ft. 3 8/10 in. D near the head 1 2/10 in., gradually decreasing to the bottom where it is 9/10 in. L of visible portion of blade 4 4/10 in. Width of cutting edge 3 in. decreasing to 2 1/10 towards the back, and greatest Th 9/10; the upper side of which is flatly rounded the underside being much more convex and somewhat three sided. (Ramsden Collection No. 250) Purchased by the University in 1878. (For an exactly similar shaped adze except that it is represented with a carved handle, see Wood's "Nat: Hist: of Man" vol: 2 p. 369).

1337 A black basalt headed Adze from the Fiji Islands: The handle which is very short, is of dark brown wood, and roughly rounded; The blade, somewhat resembling an ancient stone celt in shape, is fastened to the haft at an acute angle, (or having the cutting edge inclining inwards), with a strong binding of plaited cocoa-nut fibre, or sinnet. L of handle 11 in.; D 1 5/10 in. L of blade 9 in. W 2 in., not flat but somewhat rounded on all sides except on the underside towards the cutting edge [-which\where it [-is]] is flat. Given by W. Drewett Esq Oxford 1870. (Now along with the Danish flint and stone weapons to illustrate the savages method of hafting).

1338 A large stone Adze-head from the Sandwich Islands. It is of black basalt, well chipped into form, and the cutting portion smoothly ground, the cutting edge being ground from one side only leaving the lower side straight and flat, and the two side edges square. The back part has been shaped so as to fit at an a[n]gle with the handle, and is left unground. L 13 3/10 in. W of cutting edge 3 in., decreasing to 2 4/10 in. at the back, and greatest Th. 2 in. Given by the Rev: Andrew Bloxam, M.A. Worcester Coll[ege]: 1826.

1339 A shallow semicircular black wooden dish having a square projecting middle portion on the opposite or deepest side, the top of which is ornamented with a double zig-zag carved border. From the Fiji Islands. Used for holding oil for anointing the body with the hand. Originally it had four short legs, which are wanting, portions of which remain. It is ingeniously formed to receive the wrist and the fingers when the hand is stretched out. L 16 3/10 in.: W 9 6/10 in. Given by W. Drewett Esq Oxford 1870.

1339a A shallow dish of very dark wood, probably from the Fiji Islands, and for the same purpose as No 1339. It appears to have been made of two dishes

somewhat pear-shaped in outline, being connected together by a perforated flat oblong piece or handle, and each having under it two short legs. Only one dish \a small fragment of the other/ and the perforated handle remain. \The whole has been cut from one piece of wood/ Present L 10 5/10 in. Greatest W 6 1/10 in. Ramsden Collection No. ? Purchased by the University in 1878.

1340 A [-Marquesian] Chief's head-dress, \from the Island of St. Christina, Marquesas/, which they wear in full dress. This is formed of a fillet or band \1 5/10 in. wide except at the ends which are narrow for tying/, made of \woven/ cocoa-nut fibre, on which are fixed side by side two bright plain \hollow/ disks, made by grinding away the back and edges of mother of pearl shells, the concave side of the shell being frontwards, and each D 5 3/10 or 5 5/10 in., having in the centre a thin disk D 3 8/10 in. of tortoise shell neatly perforated in ornamental patterns, on which \in the middle/ is another plain disk of the pearl shell D 1 5/10 in., and on that another small disk of perforated tortoise shell: each of these \two/ sets of disks being surmounted by a plume of black tail feathers of the domestic cock, each plume being composed of four smaller ones bound on separately to small strips of bamboo, the \lower ends of the/ strips being then fastened to the fillet of cocoa-nut fibre, so that when it is tied round the forehead all the feathers stand upright \or nearly so, above the shells/. This article is represented in Cook's "Second Voyage", \vol:1/, plate 17, \Fig 4 and described pp. 309, 310/ and is mentioned as "a very slight ornament". The style appears to have been unobserved in any but the Marquesas Islands. Captain Cook's Collection. 1772-1774. (March, April ? 1874) No.? Given by Reinhold Forster Esq. (For a similar article and the manner of wearing it see Wood's "Nat: Hist: of Man", Vol: 2. p. 388), also Cook's 2nd voyage. vol: 1, pl: XXXVI. p. 310. \(This article, together with \some/ other objects belonging to Captn. Cook's collection, where lent for Exhibition to the Amsterdam International and Colonial Exhibition in the summer of 1883; they were all returned safe and without injury. See printed catalogue and Diploma given us for the loan of these.)/
Ashmolean 1836, p. 184 no. 179.

1341-1342 Two clubs, [-said\thought] to be from the New Hebrides? They are of hard and heavy wood, 4 ft. 2 or 4 ft. 1 in. long, with the upper part of the \rather/ thin, broad, and curved scythe-like form, the back of which is prolonged into a point. The handles near the lower part are ornamented with a carved grotesque figure somewhat the form of an Ape, immediately above which are fastened to a band round the shaft each by a separate short string a number of apparently portions of hard and horny seed vessels, which make a loud \and peculiar/ rattling noise when the club is shaken. These clubs are said to be especially used in the war dances. The beautiful manner in which a

curved arrow shaped [-ridge\ornament] is carved in relief on one of the blades, is well worthy of notice Purchased in 1867.

1343-1344 Two Clubs from the Solomon Islands, similar to those preceding No 1341 and 1342, but the blades are longer, less curved, and have not the projecting point \or spike/ at the back, [-or\nor] the grotesque carved figures on the handle. L 4 ft. 3 1/2 and 4 ft. 8 in. Purchased in 1867.

1345 Another club similar in shape to the preceding but having the carved grotesque figure on the handle \as in 1341 and 1342/ L 4 ft. 1 3/10 in. (Ramsden Collection No. [-?\1350]) Purchased by the University 1878.

1346 A heavy broad bladed war club of very \dark, almost black/ wood, which it is stated belonged to [-Backthorn\Bakthorn] Bau, a principal Chief or king [-in\of] the Fiji Islands. The handle part is straight, oval-shaped in \cross/ section, rounded and polished; the blade also is straight, that is equally spread on both sides of the central line, \but having the edges hollowed out,/ L 1 ft. 9 in., and W \varying/ from 5 to 11 8/10 in., sharp edged, with a prominent rounded ridge, \or bead/ across the sides \in the widest part,/ and closely, but rather irregularly covered over its whole surface with patches of [-carved\incised parallel] crossed lines, which are here and there \at about two or three in./ separated by bands of Zig-Zag alternating \or separated/ with straight lines, which [-are\pattern is] continued \in bands/ round the handle at intervals of \about/ 3 in. \There being seven double bands on the handle, and six double [-and\or] treble bands on each half of each side of the blade, except one half which has only five. All three bands run horizontally or crossways the blade and handle./ Full L 45 5/10 in. A very similar shaped club is figured in Wood's "Nat: Hist: of Man" vol: 2 p. 276 Purchased in 1867.

1347 A club which appears to have been originally of a similar form to the preceding No 1346, but the blade has been reduced in width (probably as a reparation of an injury to 6 in. and less, in a successions [*sic*] of notches \or steps/ to the top. The whole has been elaborately carved with close set narrow zig-zag lines, arranged alternately between straight lines in a kind of pattern. The handle which is carved \apparently throughout its whole length/ in the same manner, is now minutely and beautifully bound horizontally, with black and yellow braid of cocoa-nut fibre plaited. This club is said to have belonged to the same chief as the preceding No 1346. Whole L 42 8/10 in. Purchased in 1867.

1348 A massive Fiji war club of dark heavy \wood,/ probably intended for use with both hands: of similar type to the two preceding, but larger and quite plain. The edges of the blade have been a little broken, and the lower part of each has a series of notches: on one edge is twenty-one, the other having only ten, but some

of them appear to have been broken out. Whole L 4 ft. 3 4/10 in.; Greatest W 1 ft. 2 4/10 in. D of the handle 2 2/10 in. \which is oval shaped, not cylindrical/ [-No history appears to be known of this article] (Ramsden Collection No. ?) Purchased by the University in 1878.

1349 A Fiji war club in every way similar to the preceding, and quite perfect. L 4 ft. 4 [-] in. Greatest W of blade 16 8/10 in. The notches being similar but smaller, and more numerous. (Ramsden collection No 1348?). Purchased by the University 1878.

1350 A Fiji war club, very similar to the two preceding, of [-lighter\paler reddish] brown wood, slightly polished. On the lower part of each edge of the blade are three pretty large square shaped notches. L 4 ft. 4/10 \in./: Greatest D of blade 17 3/10 in. (Ramsden Collection No. ?) Purchased by the University in 1878.

1351 A massive Fiji ?war club of heavy very dark brown wood, the front outline being a moderate convex curve from end to end. Handle portion D about 1 8/10 in. beautifully formed, polished, and plain, except 8 in. at the bottom which is carved in narrow zig-zag lines running lengthways having plain lines between them as in No 1346 and 1347. The upper part or head is somewhat fan shaped, \about/ 8 in. broad, carved, and reduced considerably in thickness to the extent of 11 in. from the top, the ground work of the design being a kind of network of sunken squares in which the marks of the cutting implement are very visible, a lozenge pattern in faintly incised cross lines, and three ornamented prominent bosses etc; both sides being alike. This club also is said to have belonged to the Chief Bakthorn Bau. Whole L 44 5/10 in. The end of the handle for the distance of 2 in. is neatly bound with fine braid of plaited cocoa-nut fibre, [-very] interlaced in a kind of lozenge pattern. Purchased in 1867.

1352 A Fiji ? war club of similar general form to the preceding No 1351, but \of lighter brown wood and/ having the head part much thicker on one edge than the other, the thicker side, which appears to have been the back having a curious curved projecting piece or spur. The greater portion of the head is ornamented on both sides with deeply incised and closely set \parallel/ crossed lines. L 3 ft. 7 [-] in.: Greatest width 10 8/10 in. D of handle 2 in. Handle plain. (Ramsden Collection No. ?). Purchased by the University in 1878.\ A club, almost identical with this one, \and the following/ is figured in Meyrick's "Ancient Armour" fig 5 in the vignette at the end of vol: 2 and stated to be from New Caledonia/.

1353 A similar club in every respect to the preceding but having the ornamentation of incised lines crossed at different angles, and arranged in bands lengthways by intercepting narrow longitudinal plain bands. L 43 8/10 in. Greatest width of blade 11 5/10 in. D of handle about 2 in. (Ramsden Collection No. ?) Purchased by the University in 1878.

1354 A massive Fiji war club, of similar form to No 1352 & 1353, except that the head part is not so wide. Outline a general curve until near the top, where the club is broader and thicker, forming a kind of wide, curved, projecting beak on one side, the opposite or concave side being keeled. It is carved to about 13 5/10 in. from the top end over one half of both sides of the head, the design being a number of unequal sized and badly formed close-set disks in relief, and on each side divided into three groups by double transverse notched bands, [-each gr] the size of the disks in each group decreasing downwards. The general form and finish of the club is really good work. L 42 in.: greatest W of handle 8 in. W of handle 2 in., plain except a binding of plaited cocoa-nut fibre W 3 5/10 in. in the middle. Purchased in 1868. For figure of a similar shaped club to the three preceding No 1352-1354, see the concluding Vignette in Meyrick's "Ancient Armour" vol: 2 Fig: 5 and said to be from New Caledonia.

1355 A Fiji war club, of the same general form to No 1354, but altogether smaller, with the head part much narrower, being not very much larger than the handle, the concave side much cut away forming a number of prominent roughened transverse ridges; the prominent curved beak or spur on the opposite side being nearer the top and not so long. The bottom of the handle for the length of 8 in. is carved with 15 concentric bands having on the front a kind of [*drawing*] ornament, and the half of two such ornaments on opposite sides below it at the bottom. L 3 ft. 4 5/10 in. Greatest W of head 4 2/10 in. D of handle 1 5/10 in. Given by Mr: W. Drewett Oxford 1870.

1356-1357 Two Fijian war clubs exactly alike, and a good deal resembling No 1355, but the heads more curved, and having the concave side or front not so much roughened: The bottom being semi-globular and projecting somewhat beyond the rest of the handle, which is nicely rounded and the whole closely bound (as in a Cricket bat handle) with a narrow flat string, about 1/10 in. wide, of plaited cocoa-nut fibre coloured in horizontal rings black and brown. L of No 1356, 40 5/10 in., \greatest/ W of head 4 8/10. And L of No 1357, 40 in., W of head 4 8/10, W of handle over the binding 1 9/10 in. Given by Mr. W. Drewett, Oxford, 1870.

1358 War club from the Fiji Islands, apparently made from a young tree, the head which is tapering towards the top, and has many different sized prominent \irregular/ knots, appears to have been the root; the handle being round and ornamented with a fine binding of plaited cocoa-nut fibre, as in No 1356 & 1357. The bottom of the handle is carved for the length of 8 in., with zig-zag, and straight perpendicular lines, alternately. L 3 ft. 10 in. Given by Mr W. Drewett, Oxford, 1870.

1359 Fiji war club. It is quite straight, cylindrical, slightly increasing in size towards the top, the end of

which is rounded; the bottom of the lower end being concave and slightly carved \incised with concentric and radiating lines./ The whole thing well made and \very/ smoothly rounded. L 4 ft. 2 in. D of bottom 2 1/10, and of top 2 4/10 in. Given by Mr W. Drewett, Oxford 1870.

1360 Fiji war club similar in every respect to No 1359, except that it is smaller, the two ends being flatly convex, and has remains of plaited cocoa-nut binding round the lower end. \It is worked beautifully round and smooth/ L 45 8/10in. D of the bottom 1 7/10 in., of the top 2 2/10 in. Given by Mr. W. Drewett Oxford 1870.

1361 A Paddle of moderately light and hard \dark brown/ wood, of a rich brown colour, from Tahiti; "made by natives of Riavia or Livivai (?Oparo) or the High Island of Vancouver". Hervey Group. It is very elaborately carved over the whole surface, including the handle and both sides of the blade. The ornamentation consists chiefly of a number of very small geometrical figures made up into a kind of network pattern, and concentric starlike ornaments or circles, and the accuracy and skill with which they are cut, contrasts strongly with the irregularity and want of finish in the carving of No 1346, 1347, 1351, and 1354, preceding, although in the latter there is a greater freedom in design. Handle straight with an oblong shaped cross piece at the end for the hand, carved round with ten ornaments, which appear to be conventional imitations of the human face. Whole L 51 4/10 in. L of blade only 17 5/10 in, greatest W of ditto 10 8/10 in. D of handle which is not quite cylindrical, but somewhat oval-shaped in cross section 1 3/10 by 1 in. Size of cross piece at the end 4 7/10 by 1 7/10 in. Blade somewhat kite-shaped in outline. Given by Captain F.W. Beechey, R.N.: F.R.S. etc [-1825\1825]-1828. For a description of such paddles see Wood's "Nat: Hist: of Man" vol: 2 pp. 371 and 372 Exhibited at the Art Treasures Exhibition 1857.
Ashmolean 1836, p. 183 no. 132.

1362 A Paddle \of brown wood,/ from the same locality as No 1361, and very similar to it, but more elaborately carved \lighter in colour/ and differing somewhat in the pattern. Round the margin of the outside of the blade are carved in one piece with it 56 flat raised bosses, and 19 similar ones down the middle. And where the handle joins the blade is carved a grotesque figure of a bird with expanded wings, perhaps intended to represent a young bird from the nest. The end of the handle has been carved round with ten grotesque heads similar to those in No 1361, three of which have been broken off. L 54 5/10 in. L of blade only 19 8/10 in.; W of ditto 12 1/10 in. D of bottom of handle 4 in., above that 1 3/10 by 1 1/10 in. Given by Captain F.W. Beechey, R.N. \1825 -/ 1828. Exhibited in the Art Treasures Exhibition, 1857.
Ashmolean 1836, p. 183 no. 132.

1363 A very similar but much smaller paddle to the preceding No 1362, but without the raised bosses round the margin and along the middle of the blade. The end of the handle is large round, and has carved round it eight grotesque looking heads of the same character as on the preceding. Wood a paler brown colour. Probably chiefly used for ornament in dancing. L 3 ft. 3 5/10 in. L of blade only 13 6/10 in., D of ditto 7 in. D of handle 9/10 in., of bottom of ditto 2 8/10 in. Probably from the same place and made by the same people as No 1361 1362. (Ramsden Collection No. ? \35/) Purchased by the University, 1878 A similar paddle is figured in Wood's "Nat: Hist: of Man", vol: 2 p. 371 right-hand figure.

1364 A Paddle from the Hervey or Cook's Islands?, with similar carving to the three preceding, No 1361 1362 & 1363. The handle part is L 3 ft. 1/2 in. nearly flat, W 1 8/10 in.; square edged, and Th about 6/10 in., being enlarged at the bottom in an oblong form of W 5 5/10 in. and L 4 6/10 in. The blade is pear shaped or nearly so in outline L 14 5/10 in. by 8 5/10 broad, slightly concave on one side, and slightly round on the other. This article, like those above referred to, is minutely and elaborately carved over its whole surface, but is much more irregular in the arrangement of the pattern. At the point of junction of the handle and blade the wood is reduced to 8/10 by 5/10 in., and this evidently was done when the implement was made, which therefore probably could only have been intended for ornamental purposes as, if used as a paddle the head would easily break. The upper part of the oblong piece at the end of the handle has four grotesque human figures with uplifted hands standing in a row. These are perforated or carved completely through the wood, There are also four similar figures carved in like manner, but standing one above another at the the top of the narrow portion of the handle, and there is a single such figure but not carved through, at the junction of the handle with the blade. Whole L 4 ft. 7 4/10 in. Purchased in 1869.

1365 An elegantly formed "Staff of Authority". From Tahiti; but probably made by natives of Hervey or Cook's Islands. L 6 ft. 9 in. and rather more than 1 in. in its general diameter, the head being larger and somewhat crown shaped, with eight grotesque heads round the top as in the ends of the handles of No 1362 and 1363. The whole of the surface is carved as in those numbers. Probably it came from the same place as No 1361 & 1362 Given by Captain F.W. Beechey, R.N. 1828. For articles carved in this manner see Wood's "Nat: Hist: of Man" vol: 2 p: 371. Exhibited at the Art Treasures Exhibition, 1857.
Ashmolean 1836, p. 184 no. 144.

1366 A brown wooden, somewhat boat-shaped bowl, L 24 3/10 in., greatest W 10 4/10, and H 4 in. in the middle, from whence it gradually turns up to the ends. The outline is well shaped, and the whole of the outside is carved in the manner of the preceding article No

1365, and 1361, 1362, 1363 & 1364 [-& 1365] the inside is smooth and plain, and the vessel is described as "a bowl in which the meals are served up to the chiefs of Tahiti", but it was probably made by the natives of Livivai or the High Island of Vancouver, and belongs to the same set as No 1361, 1362 & 1365. Given by Captain F.W. Beechey R.N. \1825 - / 1828. Consult Wood's "Nat: Hist: of Man" vol: 2 p. 371 & p. 337. These five articles, although so different in form, are of precisely the same style in their ornamentation, as the same patterns in the carvings run through the whole; and from the general arrangement, the accuracy and clearness, in which the comparatively minute details are carried out, they afford good evidence of Polynesian taste and skill. Exhibited at the Art Treasures Exhibition 1857.
Ashmolean 1836, p. 184 no. 142.

1367 A brown wooden Spatula from Tahiti, for mixing up paste \made/ from the bread-fruit. This is a plain but well made implement D 1 in. at the handle part, spreading out into a broad thin blade varying in W from 7 2/10 to 5 6/10 in. at the other and which is about Th 2/10 in., having a thin curved raised ridge across the widest part, and a prominent oval knob at the end of the oval shaped handle. It has a binding of plaited cocoa-nut fibre round the middle part of the handle. Whole L 28 7/10 in. Captain Cook's Collection, 1772-1774, No. 81. Given by Reinhold Forster. The form of this article is very like the club figured in "Wood's Nat: Hist: of Man", vol: 2, p. 276, the middle figure, but the broad \end/ of our specimen is semicircular. \For the manner of preparing paste see Cook's 1st Voyages vol:2, p.198./
Ashmolean 1836, p. 185 no. 199.

1368 A similar Spatula, \and/ of the same kind of wood to No 1367, but longer in comparison to the width, without the curved ridge across the blade, and the handle being nearly round, thinner, with the knob at the end of the same shape but larger. L 29 6/10 in. Greatest W of blade 5 4/10 in. D of handle 7/10 in. Probably from Tahiti. (Ramsden Collection No. ?). Purchased by the University, in 1878.

1369 A Fly-flap? from [-the] \Tahiti/ Society Islands. The \visible portion of the/ handle L 5 3/10 in. and greatest D 1 1/10 in., is of hard \very dark brown/ wood resembling ebony, very neatly carved in eight perpendicular ridges of equal sized notches, and terminating in two grotesque human figures back to back, or more properly speaking one double figure, somewhat resembling the Ancient Egyptian figures of Bes. The brush part is made in four bunches, each of which is composed of a large number of black and stiff threads made of cocoa-nut fibre, each of which is fastened into a central plait, each thread having the appearance, and almost the hardness of small iron wire, which had been coiled about a very small cylinder, and then pulled nearly straight. Whole L 22 in. The threads or brush part is tied to the handle with

a strong binding of plaited cocoa-nut fibre, uncoloured, for the length of 5 3/10 in. Whole L 10 6/10 in. A similar implement is represented in Captain Cook's "First Voyage", \vol 2/ plate 12. \p. 185:/ and also in Wood's "Nat: Hist: of Man", vol: 2, p.256. Also in Ellis' Polynesian Researches, vol: 2, p. 181where it is called "a native fan used by the chiefs or Priests." (Captain Cook's Collection, 1772-1774. No.?). Given by Reinhold Forster, Esq. \"Fijian Orator's Flapper, which the native holds in his hand while he speaks in council. The tuft at the end is formed of cocoa-nut fibre, which has been soaked in water next rolled round [-round] a small twig, and then dried. When it is unwound from the stalk it has a crisp wrinkled appearance very like that of the Fijians hair, and is probably intended to imitate it". See Wood's "Nat: Hist: of Man" as referred to.

1370 A somewhat similar implement, having a plainly rounded handle \of paler wood/, L 11 in., gradually increasing in size from the bottom to the top; the brush part made of single but stout cocoa-nut fibre, of the natural colour done into three loose plaits. The ends left hanging out to form the brush. Whole L 23 in. D of handle 7/20 gradually increasing to 8/10 in. at the end which is rounded off. Probably from the Society Islands. (Captain Cook's collection, 1772-1774, No.?) Given by Reinhold Forster, Esq.

1371 A spear from the Kingsmill Islands?, \Gilbert Group,/ armed with Shark's teeth. L 6 ft. 2 5/10 in.; D 1 in. The teeth are arranged in four rows of L 2ft. at the upper end of the weapon, the plain part below forming the handle: they are sharp pointed, projecting about 4/10 in., and are about the same distance from point to point in the rows, that is about 5/10 in. Each tooth has a small hole drilled through it, by means of which they are securely bound on \to/ and kept in line by a narrow strip of wood, made from the central rib of the palm leaf, one on each side. The teeth are pointed some in one direction and some in the opposite, and are bound on with a fine cord of twisted cocoa-nut fibre. The effect of such a weapon in battle, amongst a lot of semi-naked wretches must be horrible, as no implement is calculated to give a more painful wound. In three places down the point are bindings of fine twisted human hair. Given by Captain F.W. Beechey, R.N. \1825-/ 1828 This weapon is entered in the catalogue of 1836 as from Tahiti, but see Williams's "Missionary Enterprises" p. 533 where similar weapons are represented as from the Kingsmill Islands, one of them being 18 ft. long. See also Wood's "Nat: Hist: of Man" vol: 2 p. 380.
Ashmolean 1836, p. 184 no. 143.

1372 A spear, [-probably] from the Kingsmill Islands, of hard wood armed with four rows of Sharks' teeth, fixed in the same manner as the preceding, but with a binding made of [-coc] a mixture of cocoa-nut fibre and human hair, and bound round the point [-point\or armed] portion with four separate bindings of twisted

hair [-only]. Whole L 7 ft. 3 in., of the point portion only 41 in. (Ramsden collection No 33?) \or perhaps some other defaced number after the 33/ Purchased by the University in 1878.

1373 A similar weapon but of lighter wood \and without the separate bindings of hair at intervals along the point/ 4 ft. 3 5/10 in. long, with three rows of sharks teeth fixed in the same manner with a binding of half human hair and half of fibre twisted together. Having round the shaft at the back of the teeth a neat binding of interlaced fine cord of twisted hair and some kind of \yellow/ rush \or leaf/, perhaps \palm leaf/ or the New Zealand flax leaf. At the end of the handle is an oval knob. [-\Said to be from /] From New Zealand, \but / ? if not from the Kingsmill Islands. Purchased in 1868. \See Wood's "Nat: Hist: of Man" vol: 2 p. 379./

1374 A \very/ similar weapon in every respect to No 1373, but larger, \with three separate bindings of twisted hair along the point as in No 1771 & 1772/. The binding round the Shaft, immediately at the back of the rows of teeth being very neatly done of \narrow strips of yellow/ leaf, and plaited hair \the plaits being round, and the two interlaced/ L 4 ft. 10 3/10 in. Given by C. Leptwich, Esq London 1868 \Said to be from New-Zealand/.

1375 A very similar but still larger implement, but without the separate bindings of hair round the point portion. L 7 ft. 4 5/10 in. (Ramsden Collection No 111 \40/). Purchased by the University in 1878 This has a somewhat oval knob at the end of the handle and the[re]fore more resembles No 1333 and 1334 in that respect [*over last numbers*] \?7 [ie 1373]/ \?7 [ie 1374]/.

1376 A weapon of a similar make \[-probably] from the Kingsmill Islands/ which may be described as four branched or bladed. The middle branch 27 5/10 in. long, has two rows of teeth; one at the back of this and slightly diverging from it, is 20 in. long, and has three rows of teeth; and in front, inclined at an angle of about 45 degrees from the middle one; there are two side by side which are slightly curved and 10 5/10 in. long, each having a double row of sharks teeth All the teeth are bound on with thread made of cocoa-nut fibre only; and there is a double twisted loop of the same material apparently for the wrist. (Purchased in 1868) A similar weapon is figured in Wood's "Nat: Hist: of Man" vol: 2 p. 379.

1377 A very large Sword-shaped weapon probably from the Kingsmill Islands; of light \rough brown/ wood, armed along each edge with a row of \very/ large shark's teeth, each tooth placed at some distance from the other, and each tied into a separate hole \made/ in the wood, with bindings of \twisted/ Cocoa-nut fibre. The blade portion has a prominent \rounded/ ridge along the middle on each side extending along its whole length; and the handle is covered \round its whole length / with a kind [of] rush or perhaps leaves

of the \palm or/ cocoa-nut tree, bound round neatly \but strongly/ with \a/ small cord made of twisted cocoa-nut fibre, and arranged in pairs as it were round the handle, there being forty-two in all. The number of teeth along each side was originally 57, but a few are now wanting. The blade part gradually tapers towards the point; the handle being about an uniform size and oval shaped. Whole L 10 ft. 5 5/10 in.; L of handle only, 2 ft. 10 5/10 in. Greatest W of blade 2 3/10 in., or including the teeth 3 3/10 in. D of handle about 2 in. Between the blade and the handle are two deep \notches on each edge/ (Ramsden Collection No ? \38/) Purchased by the University in 1878.

1378 A wooden weapon \[-probably] from the Kingsmill Islands/ with sword shaped blade \as in 1379,/ with strong keeled ridge down the middle of each side, and long cylindrical shaped handle. Each edge of the blade is armed with a row of large shark's teeth, set a little way apart from each other, not in a continuous groove as in No 1379, but each tooth having a separate hole \or rather holes/ cut for it and fixed \in its place/ by a binding of \twisted/ cocoa-nut fibre mixed with hair? Most of the teeth appear to have blood stains on them and a few are wanting \so that it appears to have been used/. Whole L 5 ft. 4 in. L of handle part only, 2 ft. 5 3/10 in., D of ditto 1 5/10 in. Greatest W of blade 2 3/10 in., gradually tapering off towards the point. The wood is dark brown & heavy. (Ramsden Collection No ? \30/). Purchased by the University in 1878.

1379 A \straight/ sword-shaped weapon \[-probably] from the Kingsmill group, but said to be from the Sandwich Islands/ of \rough/ brown wood, armed with Shark's teeth. It is straight, broad and rather flat, with a prominent ridge along the middle of the blade on both sides. W at one end exclusive of the teeth, 1 8/10 in., gradually tapering to D 8/10 near the point which is broken off. The teeth are similar to, but rather larger than, those in the preceding article; they are closely inserted into a narrow continuous groove along [-each groove] both edges, each tooth as usual being drilled and separately secured in its place, but touching each other, with a fine binding composed of twisted cocoa-nut \fibre/ and hair? \or cocoa nut fibre coloured black/ There is a binding or rather a ring made of yellow rush or \palm/ leaf by way of guard, below which \inserted through a hole made through the handle/ is a plaited loop of cocoa-nut fibre for the wrist. Whole L 31 5/10 in. None of the teeth wanting. Purchased in 1868.

1380 A weapon of similar type to No 1379, but smaller, of dark brown wood, and somewhat curved, or Sabre shaped. It appears to have been much larger originally as many of the holes remain in the sides of the handle that is now, by which the shark's teeth were fixed. There are also two large perforations through the middle of the handle by which the loop for the wrist was attached. The edges \below the double row of teeth/

have been coloured red, and many of the shark's teeth are either broken, or wanting. The binding is of twisted cocoa-nut fibre, and hair? In the wood it is more like No 1378, but stands alone in having the painted edges. (Ramsden Collection No. ? \?43/) Purchased by the University in 1878. \A similar weapon is figured in Wood's "Nat: Hist: of Man" vol: 2 p. 379 left-hand figure./

1381 A \small/ sabre-shaped weapon, of similar type to No 1380, but narrower and more curved; pointed at each end, one of which appears to have been used for a handle and has a small hole through it. It has two rows of smaller shark's teeth, bound along each edge between thin strips of wood; the binding being of twisted cocoa-nut fibre, except two patches 1 5/10, and 1 3/10 in. long respectively, which are of twisted human \black/ hair? It ther[e]fore more resembles No 1371 - 1376. L 22 in. W exclusive of the teeth 1 1/10 in. (Ramsden Collection No. ? \42/) Purchased by the University in 1878.

1382 A similar weapon to No 1380, except that it is straight, is of lighter brown wood, has the teeth tied on in rather a different way \being set in a [-] continuous groove [-] as in 1379/ and the binding made of twisted cocoa-nut fibre only. There is one hole through the handle for a string for the wrist, which is wanting \as are also six or seven of the sharks teeth on one side/. L 17 5/10 in. Greatest width, not including the teeth, 1 6/10 in. \or including the teeth 2 11/20 in./ Purchased in 1868. For similar weapons see Wood's "Nat: Hist: of Man" vol: 2 p. 379 (There seems to be two or more varieties of these weapons, those which have the teeth bound between narrow strips of wood \palm wood?/ and those which have \either/ separate holes, or continuous grooves cut in the wood itself to receive [-them\the teeth]. It is also noticeable that in some specimens the binding is of human hair and cocoa-nut fibre twisted together, and in others it is entirely of cocoa-nut fibre. There is also a variety in the woods used.

1383 A Weapon of dark brown wood, with the handle portion pointed oval-shaped in section, somewhat curved and pointed at the lower end. The head which is somewhat hatchet-shaped is carved in one piece whith the handle and armed with a large Shark's tooth tied in the front with string made of cocoa-nut fibre. There are two holes 1 in. apart on the inside of the handle, not far from the top, which may have been used to fasten a string to, as perhaps it may have been used as a missile, and the string used for recovering it. L 15 5/10 in. Greatest D of handle 1 9/10 by 1 3/10 in. (Ramsden Collection No 364) Purchased by the University 1878.

1384 A similar shaped but smaller weapon to No 1383, with pointed handle which is lozenge shaped in section. It has attached to the handle a cord about 3 ft. long made of twisted [-cocoa-nut\inner bark] fibre which is kept from slipping off by a ridge below it. The

shark's tooth from the front of the head has been lost. L 9 8/10 in. D of handle 1 5/10 in. (Ramsden Collection, No. ?) Purchased by the University 1878.

1385-1386 Two pieces of a kind of Armour, made of cocoa-nut fibre, very strongly interwoven and knotted. One piece \No 1385/ is made in the shape of a close-fitting pants for the legs, and the other \1386 is/ flat to cover the breast and the back, having an opening in the middle to put the head through. The portion for the protection of the legs has an extra double flap apparently to fall down to cover the belly, and a single large flap at the back. These flaps are made finer \and stronger/ than the \other/ portion which \only/ covers the legs, and similar to the piece \No 1386 / for the protection of the breast and back. \The thread used in sewing the legs of No 1385 is made of plaited human hair, and there is a border of the same material round the edges of the flaps/ L of legs piece 5 ft. Greatest W 2 ft. L of the breast & back 43 in.; Greatest W 23 in. (Ramsden Collection No. ?). Purchased by the University in 1878 (For similar armour see Wood's Nat: Hist: of Man, vol: 2 p. 355).

1387 A long narrow shield, from the Salomon or Solomon Islands?, of light \and rather soft/ wood, of a pale brown colour; ornamented with \wide/ black lines \round the edge and down the centre,/ in which the surface is cut away, showing the light underground in patterns \with numerous notches round the edges/. Front slightly convex; \on the front the/ side edges a little raised above the body of the shield; straight to within 5 in. of the ends, where they curve to an \obtuse/ point \like a Gothic arch in shape/ L 40 5/10 in.; W 9 5/10 in. at one end tapering to 7 5/10 at the other. Purchased in 1867. \see the original list in Ashmolean letter book p. 1/ where it is said to be from the Fiji Islands and "used by the natives to protect their bodies from the spears of their Enemies". (I think it more likely that this shield is from Celebes or somewhat that direction).

1388 A long narrow shield, thought to be from the Salomon Islands; made of peeled rods of a light whitish wood, arranged lengthways side by side, the largest in the middle and gradually decreasing in size to the sides, there being 21 such rods when counted at the wide end, and 17 at the narrow end; and bound on to to 24 cross pieces of the same material at the back, with \narrow strips [-of] of/ what appears to be a tough smooth bark, which shows on the front of the shield like narrow horizontal parallel plaited bands; the sides being strengthened by a wider flattish piece of wood and stronger binding. It is backed with a thick layer of some broad thick leaf, probably some kind of palm, and the loop handle, and another larger loop attached are \[-of] well/ made of cord of twisted bark. The sides and the ends are straight. L 34 5/10 in. W at one end 9 in., tapering to the other end to 7 in. In list said to be Fijian, and "used in war as a defence against \the Arrows/". (Purchased in 1867). See the original list

had with it "No.[-17 or] 18". now in the Ashmolean letter book, \p. 1/ There were two of these shields made of stems of wood, but one, "No. 17" of the list \above mentioned/, was given to A.W. Franks in exchange for things had from Trustees of the Christy Collection in 1869.

1389 Seventeen arrows \probably/ from the [-Salomon Islands ?\New Hebrides] L about 48 in., rather more than half of each is of reed or small cane, the remainder of wood, headed with finely pointed pieces of \wood except four which are of / bone, probably poisoned. The wood part of each arrow is \well/ carved with various patterns, brightly coloured in black, white and red \The bottoms are slightly bound with twisted fibre and notched for the bows strings/. Exact L 49 5/10 to 44 6/10 in., these are the longest and the shortest, all the other 15 [are] between them, but four have the points broken off. Purchased in 1867. \see the original list had with them "No 20 to 25" where they are said to be Fijian, now in the Ashmolean letter book p. 1/.

1390 An Apron, also forming a pocket, which is stated to have belonged to a Fiji Chief. It is made of small pieces of very fine matting of what appears to be very finely split rush or leaf, and coloured in patterns of black and yellow; and ornamented with fine fringes of the same material, w[h]elk shell, and small grey beads made of some seed [-vessel]. Whole L 2 ft. 2 in.: Greatest W 9 in. One shell at least appears to be wanting. Purchased in 1867. \see the original list had with it, "No 36", in Ashmolean letter book, \p. 1/ in which it is said to be from the Fiji Islands and an "Apron belonging to a Chief's Daughter, and worn at their Feasts"./

1391 A long Spear or Javelin of \dark/ brown wood: The point which is painted in patterns in red, white, and brown is armed with four rows of \long slender/ barbes, eight in each row, which are made of thin pointed pieces of hard wood tied on. The junction of the shaft with the point is ornamented with a carved oval-shaped boss, [-on each] above and below which is a flat binding of yellow grass. The barbes gradually diminish in size to the point. L 9 ft. 6 in. Greatest D, which is the oval boss 1 81/0 in., below which it is 1 1/10 in., from whence it gradually tapers off to the end to 3/10 in. From the Solomon Islands. Given by Joseph Hugh Chambers, Esq, Magdalen Coll[ege]: 1875.

1392 A spear, or Javelin, of the same kind of wood, & similar make and ornamentation to No 1391, but armed at the point with three rows of barbs, each row having seven barbs. From the Solomon Islands. L 10 ft. 4 in. D of oval-shaped boss 1 8/10 in. below, which it is D 1 2/10 in. gradually diminishing to 3/10 at the end. The oval boss is not carved. From the Solomon Islands. Given by Joseph Hugh Chambers, Esq Magdalen Coll[ege]: 1875.

1393 A spear or Javelin of black wood, very similar in make to the preceding No 1391 & 1392, but much smaller and without the oval-shaped boss at the junction of the point portion with shaft. It is armed with four rows of barbs, twenty-one barbs in each row, [-decreasing in size to the end] and all made of thin pieces of pointed bone, (many of which have been broken) decreasing gradually in size to the point. L 9 ft. 3 in. D 1 in. tapering to the end to 3/10 in., which is finished by a small knob. From the Solomon Islands. Given by Joseph Hugh Chambers, Esq Magdalen College 1875.

1394 A Spear of dark brown wood of somewhat similar form to the three preceding, of similar wood to No 1393. The point is armed with four rows of barbs, each of eight barbs, apparently made of bits of wood, behind which are two stronger curved barbs, probably the talons of some bird, set opposite each other; behind them the point is plain for the distance of 12 5/10 in., which is very neatly bound with red and yellow coloured grass, this has for the whole of its length on one side a stripe of reddish brown paint edged with white. At the junction of the shaft with head part is a round boss made of grass set end ways cut round and coloured reddish-brown. From the Solomon Islands. L 10 ft. 6 3/10 in. D near the head 1 in., gradually tapering to the other end to 3/10 in. [-From the Solomon Islands] Given by Joseph Hugh Chambers Esq Magdalen Coll[ege]: 1875. These four spears, No 1391-1394, are all painted in the same style, and similar to the arrows No 1389.

1395 A Lance or spear, probably from the Solomon Islands; of the same general form to the four preceding No 1391-1394, but of paler brown wood, armed with six rows of barbes, each row consisting of five barbs made of black wood. At the top of the handle portion, between that and the point, is a curiously carved boss L 4 5/10 in. by D 1 3/10. There are three narrow bands of yellow grass bound round at intervals on the point, and one of yellow and red on the top of the shaft immediately behind the boss L 8 ft. 6 5/10 in. Diameter immediately below the boss 8/10 in. tapering gradually to the other end where it is D 3/10 in. There appears to be no history of this spear.

1396-1397 Two good Bows \probably from the Solomon Islands,/ of somewhat polished brown wood, rounded on the inside or back, and ornamented with a double parallel black coloured line [-the whole] to within 7 to 9 in. of the ends. The outside or front being flat, and coloured \plain/ black. The bow strings are intact. L 6 ft. 8 3/10 in.; and L 6 ft. 5 8/10 in. Greatest W in the middle portion 1 5/10 in., gradually diminishing to the ends. \The middle part of each string, and the ends on the bows are bound round with some yellow grass like substance./ Given by Joseph Hugh Chambers Esq Magdalen Coll[ege]: 1875.

1398 [-Eight\Fourteen] long Arrows, of reed, headed with points of about 12 in. long, made of hard rounded black wood, tipped with a binding about 5/10 in. long of fine yellow grass. Most of the joints in the reed shaft of each arrow are ornamented with incised patterns blackened over, the ornamentation chiefly consisting of close-set perpendicular lines. L 4 ft. 8 in., or very near that. The lower ends are neatly bound round for about L 1 in. with some kind of fibre or root and slightly notched for the bow string. From the Solomon Islands. Given by Joseph Hugh Chambers, Esq, Magdalen Coll[ege]: 1875.

1398a Four Arrows [and] the half of another one. Locality uncertain but probably from some of the South Pacific Islands. Shafts of stout reed with long wood heads, the points of which are curiously carved into a series of concentric ridges as it were, there being twenty such ridges on three of them, beyond which they end in plain sharp points. Whole L [-about] 58 in., of which the wood points measure about 18 in. (Ramsden Collection No. ?) Purchased by the University in 1878.

1399 Eight long Arrows from the Solomon Islands; Shafts of stout reed, as in No 1398, and ornamented in the same manner, with heads of hard wood; to which are very neatly attached numbers of variously shaped barbs of hard black wood, and bone. The tips and other portions of the heads are bound round neatly with narrow bands of yellow grass, and some have been painted red and white. The lower ends are bound and notched as in No 1398. The head of one of the arrows has as many as 52 barbs of bone; and all the arrows the barbs as a rule decrease in size to the point, and are arranged round the head in groups of fours. They are very skillfully and beautifully \made,/ some of the barbs are broken off. L from 4 ft. 10 5/10 to 4 ft. 6 3/10 in. Given by Joseph Hugh Chambers Esq Mag[dalen]: College 1875.

1400 A Cylindrical shaped war Club of hard, dark, nearly black wood, and polished, \or rather varnished,/ L 44 in., D at the lower end which forms the handle 1 5/10 in. for the length upwards of 8 in. where by a sharp shoulder it decreases to D 1 1/10 in., and then gradually increases in size to the top to 1 7/10 in. Both ends rounded off, and has a ring made of a few small tufts of hair bound round the middle. In general shape it much resembles one of the Australian waddies. From the Solomon Islands. Given by Joseph Hugh Chambers, Esq. Magdalen Coll[ege]: 1875.

1400a A long spiral narrow piece of bark, or plant? rolled over at the edges towards the inside which is hollow. There is a deepish longitudinal groove, cut along the middle of its whole length on the outside. L 8 or 9 ft., D 8/10 in. or less. Given by Joseph Hugh Chambers, Esq. Mag[dalen]: Coll[ege]: 1875. (1875, no. 110)

1401 A Fiji Sunshade for the [] made of woven red and brown rush \like/ lea[v]es, \probably of the coconut palm/. Made \in a kind of hoop/ to fit over the top of the head with a kind of wide flat poke [*sic*] in front to protect the eyes. Size 11 5/10 by 9 81/0 in. Purchased in 1867. (... said to be \"Sunshade worn on the head"/ from the Fiji Islands). The [-people] natives of Tahiti [-wear] wear the same kind of thing, which they manufacture in a few minutes, as see Cook's 1st voyage vol: 2 p. 217.

1401a A similar sunshade, except that it is woven entirely of brown rush, or \cocoa-nut/ palm leaf, a kind of long fringe or streamers of narrower strips being left at the sides, three of which have been plaited together width about 10 in. From the Fiji Islands Purchased in 1867.

1402-1403 Two bands of unstained curls of Flax fibre, worn as ornaments or false hair by Fijians in their ceremonies. W at the top 7 1/2, and 9 in. Depth 13 or 14 in. Purchased in 1867.

1404 A long \thick/ plaited band made of twisted cords, (some black, but mostly undyed), of Cocoa-nut fibre, L 11 ft., W 1 5/10 and Th 8/10 in the middle part, but diminishing at both ends to W 5/10 in. Use uncertain, but perhaps worn round the waist, or may it have been a sling, as it is made in the same manner as the sling from New Caledonia No. 1535. Probably Captain Cook's collection, 1772-1774 No.? Given by Reinhold Forster, Esq.
Ashmolean 1836, p. 185 no. 232.

1405 A similar article to No 1404, but of considerably finer and consequently stiffer make, and in more decided patterns of black and brown, in alternate patches. Portion of one end gone. L 12 ft. 4 in.: D in the middle part 1 3/10 in. decreasing at both ends to 3/10 in. (Ramsden Collection No. ?) Purchased by the University 1878.

1406 A Necklace or Chain, of rough fragments of Shells of the genus Chama, worn by women of Egmont Islands, S. Pacific. L 12 ft. weight 5 1/2 lbs. Captain F.W. Beechey, R.N. \1825-/ 1828. (These shells are so utterly devoid of regularity or beauty, that it is doubtful whether there may not be some mistake in the label, as otherwise they present a strange contrast to the taste generally displayed in Polynesian ornamentation).
Ashmolean 1836, p. 187 no. 365.

1407 A small figure from the Sandwich Islands, perhaps an Idol of hard brown wood, representing a human grotesque figure, nude except that it wears an helmeted shaped head piece with a curved crest, resembling the ancient Roman helmet. The legs are very large and clumsy; the arms being small in comparison, the hands joined and elevated towards the chin. The face is frightfully ugly, the nose being broad at the end and turned up, the mouth very prominent, and long deep notches for the eyes. Under the feet is a rough projecting piece probably for fixing it upright.

The front portion of the headdress is broken away. The whole is carved out of one piece of \dark brown/ wood. Whole H 13 3/10 in.; W across the shoulders 4 1/10 in. H of figure only 12 in. Given by the Rev: Andrew Bloxam, M.A. Worcester College, 1826. For figure of similar Headdress or helmet, see the concluding vignette in Vol: 2 of Meyrick's "Ancient Armour", fig: 10.
Ashmolean 1836, p. 185 no. 263.

1408 A Bottle calabash or gourd from the Sandwich Islands, ornamented with yellow lines upon a dark brown coloured ground, being divided in several symmetrical figures, eight of which are filled in with parallel fine waved lines the lines running in the opposite direction in the lower four compartments or figures being perpendicular, whereas in the upper four the lines rund [*sic*: run] horizontal. Underneath is a plain square with yellow corners; the top of the spout part is also left yellow. The stopper if it had any is wanting. H 9 8/10 in. D 8 5/10 in. Given by the Rev: Andrew Bloxam, M.A. Worcester Coll: 1826. The ornamentation of this article is remarkable both as regards the correctness of the outlines, and the regularity of the waved lines, and also as to the manner in which they were made. The surface does not appear to have been disturbed in the slightest degree: nothing has been scraped off to produce them, nor has any substance been added to the surface. The only probable means, appears to be, that the lines were drawn in some resisting liquid, and then that the vessel was dipped in a brown dye.
Ashmolean 1836, p. 185 no. 315.

1409 A pear-shaped Calabash or bottle with suspending strings of plaited Cocoa-nut fibre round it. From the Sandwich Islands. The gourd is entirely unornamented and of an uniform brown colour. H 8 2/10 in. D 4 6/10 in. Captain Cook's collection. 1772-1774. No. \35/ ? Given by Reinhold Forster.
Ashmolean 1836, p. 185 no. 314.

1410 A sun-shade, or ornament for the neck?. From Egmont Island. It is formed of a thin cane L 35 5/10 in., bent in the middle, and united at the two ends to a straight stick 17 in. long forming the front, thus making a kind of pyramidal outline with a rounded apex. The circle of the upper part is made complete by the insertion of another bent stick, leaving room to admit the head, and the large space between the circle and the straight front stick is filled up with rather closely woven cocoa-nut fibre in a kind of knotted pattern, similar to the basket No.1327. L 15 in. W 17 3/10 in. Captain Cook's collection. No.? Given by Reinhold Forster, Esq.
Ashmolean 1836, p. 184 no. 186.

1411 A Fan from \the Island of Sta. Christiana/, the Marquesas, made up of a finely split cane like material, \perhaps cocoa-nut leaf,/ closely and neatly woven in the form of a half oval, with a \wooden/ handle projecting 5 in. from the rounded end, and which runs

nearly the whole width across the fan but gradually tapering off, the fan being woven over it. Round the handle is a binding of plaited cocoa-nut fibre. L 18 3/10 in. W 16 3/10 in. This article \or a very similar one,/ is figured in pl: 17. fig 5 of Cook's "Second Voyage", \vol: 1/. For similar articles see also Wood's "Nat: Hist: of Man", vol: 2, p. 384. Captain Cook's collection \1772-1774,/ No. 170. Given by Reinhold Forster, Esq.
Ashmolean 1836, p. 185 no. 235.

1412 Another Marquesian Fan of exactly the same shape and make to the preceding but a good deal larger. L 21 8/10 in. W 23 in. Captain Cook's collection, 1772-1774, No. 160; Given by Reinhold Forster, Esq.
Ashmolean 1836, p. 185 no. 234.

1413 A similar fan to No 1411 & 1412 .\From the Marquesas Islands,/ but minus the handle. W 18 in. L 13 5/10 in. (Ramsden Collection No. ?) Purchased by the University in 1878.

1414 A Fan from Samoa or Navigators Islands. S. Pacific. The fan part somewhat triangular shape, made of \woven/ narrow strips of split leaves of the Cocoa-nut \of a pale brown colour./ Back edge nearly straight W 10 6/10 in.; the side two having a convex curve meeting in a point in front. The handle is of hard black wood L 11 3/10 in., and D 5/10 in. and rather roughly rounded; the lower half or that nearest the fan part, being bound horizontally with alternate rings of plain Cocoa-nut fibre or grass? \of a yellow colour and narrow braids of plaited black human hair. L 20 3/10 in. Given by the Trustees of the Christy Collection, in 1869, in exchange/.

1414a A Fan thought to be from the Sandwich Islands. The fan portion is oblong shaped \wider than long and/ made of neatly plaited narrow strips of split Cocoa-nut leaf?; the handle portion \being thicker and/ converging from the back of the oblong fan part in a gradual concave curve on each side, and \still more/ thickening out into a short cylindrical handle. This is completely made of interwoven fine cords of twisted human black hair; and Cocoa-nut fibre. L 12 3/4 in.: greatest W 1 ft. Collection No. ?). Purchased by the University in 1878.

1415 A disk D 10 3/10 in. of moderately heavy yellowish brown wood, slightly convex on both sides, Th 8/10 in. in the middle gradually diminishing to a sharp edge at the circumference. One side is plain, and the other which is somewhat smoother, is bordered, in black with twenty-four very rude representations of birds; between each pair of which are from four to six short thick lines springing from a line which surrounds the edge, also in black. In the centre there is a hole of D 3/10 in. Its use and locality are uncertain. It may have been used for some kind of game; and is rather coarsely made, and from the tool-marks and the kind of wood it is probably from New-Zealand, (as see the [-

Patoo-Patoo\Wooden Meri] No. 1152) Captain Cook's collection. 1772-1774. No. 93. Given by Reinhold Forster, Esq. It \is thought that it/ may have been used for suspending on a line above articles which were hung to preserve them from rats.

1416 A small \oblong-quadrangular shaped/ Pillow, from the Sandwich Islands; used by the Natives. Made in interwoven strips of \Palm or/ Cocoa-nut leaf, in cheques [*sic*] in pale and dark brown. L 9 3/10 in. D 4 3/10 in., being oblong in shape. Some of the strips are much wider than others Given by the Rev: Andrew Bloxam, M.A. Worc[ester]: College: 1826.

1417 A Head-rest, or pillow, from the Sandwich Islands: cut from a solid piece of reddish brown wood. It is a kind of four legged stool, the top W 5 2/10 in., flat, L 11 in. and hollowed out 1 1/10 in. deep on a gradual curve from the ends to the middle. Height from the ground at the ends 5 9/10 in., or in the middle 4 6/10 in. Each pair of legs has a kind of cross rail at the bottom. The sides and ends of the top are straight. Given by the Rev: Andrew Bloxam, M.A. Worc[ester] College. 1826.
Ashmolean 1836, p. 185 no. 261.

1418 A wooden headrest or pillow, from Polynesia. This is somewhat similar to the preceding, \but much narrower and longer/ and also cut from a solid piece of wood, but far superior in workmanship. Top L 21 8/10 in., and hollowed out on a gradual curve from end to end to the depth of 1 5/10 in. in the middle; W 3 4/10 in. at the ends which are straight. The sides also curving in to W 2 5/10 in. in the middle, and the upper side rounded, the underside being flatter and having a prominent ridge or bead running along the middle from end to end. The somewhat horse-shoe shaped legs are round and have a kind of flat spreading foot, the thin cross rail between each pair having been broken. Height at the ends 6 5/10 in.; in the middle 5 in. It is entirely devoid of carving, but the regularity and finish of the curved and rounded surfaces is extraordinary. Captain Cook's collection, 1772-1774, "No.94". Given by Reinhold Forster, Esq.
Ashmolean 1836, p. 185 no. 262.

1419 Another Polynesian Head-rest of brown wood, exactly like 1418, but larger and perfect except a bit off one corner of the top. L 2 ft. 4 1/10 in. H at one end 6 6/10 in.: at the other end 7 in. H in the middle 5 4/10 in. W of the ends 3 7/10 in. in the middle 2 5/10 in. Probably belonging to Captain Cook's collection, 1772-1774, No.?, and given by Reinhold Forster, Esq. \(It had been put out of the collection in a very broken state some years before, but has been repaired.)/

1420 A Head-rest from the Fiji Islands. This is made of a round bar, of very dark brown wood, with rounded crescent-shaped legs, fastened on near the ends with a strong binding of plaited cocoa-nut fibre. L 23 1/10 in. D of ends 1 7/10 in., which are slightly thicker than the other portion. Present H 4 3/10 in. at one end, and 4 8/10 at the other; the lower portion of each of the legs being wanting, so that it is impossible to say its original height. The bar is perfectly round, and horizontal Given by William Drewett, Esq Oxford 1870. (For figure of a similar article see Wood's "Nat: Hist: of Man" vol 2 p. 312.)

1421 A similar Head-rest, probably from the Fiji Islands. Of paler brown wood, and much longer. Each of the four legs have been broken off at the bottom. L 2 ft. 6 5/10 in. D of the bar 1 4/10 in. \present/ H 4 in. (Ramsden Collection No. ?) Purchased by the University in 1878.

1422 A circular shallow dish, of hard heavy black wood: \said to have been/ Used by the Fiji Islanders in connection with their human sacrifices. D 15 in.: Th 5/10 in.; Concave on the upper side (except round the edge which is flat), about 1 in. in depth, the lower side being convex. Around the rim, both of the upper and the under side it is ornamented with rudely incised parallel lines arranged in opposite directions so as to form triangles, forming a kind of vandyke border; the border round the top being W 1 in., and that on the underside 1 5/10 in. Around the edge is a deep groove. Purchased in 1867.

1423-1424 Two Idols, one represented male and the other female; of hard, heavy, dark brown wood. From Tahiti. If these figures were intended for gods, there was nothing terrific in their appearance, and they differ considerably in that respect from the other objects intended for that purpose in Polynesia (see No. 1448). They are represented in a nude state, and from the size of the head in comparison with the body, they might pass for models of very young children, made by an unskillful hand. H of No. 1423, the male figure 13 in. Greatest W, which is across the legs 5 1/10 in. H of No. 1424, 12 4/10 in. Greatest W, which is across the hips 5 2/10 in. No. 1423 has lost the right arm, the lip of the right ear, and the clumsy made feet of both figures have been much broken. Two similar figures are represented in Cook's "First Voyage" \vol: 2/, pl. 12. \p. 185/; and one is figured in Williams' "Missionary Enterprises", as the Fisherman's God. Captain Cook's Collection. "No.38", the male No. 1423; the female 1424 being without his number, \but probably it was 37 or 39/. Given by Reinhold Forster, Esq.
Ashmolean 1836, p. 185 nos. 265-6.

1425 A somewhat similar figure but of a lighter and paler brown wood, and ruder workmanship; represented with both hands on the belly. Apparently intended for a Female, and has a large hole on the top of the head which is continued downwards through the body. The top of the head is stained black in an irregular manner, and the whole figure is much worn. On the back it is labelled "An Household God, called Tee-e of Tahiti". H 15 4/10 in. Greatest W, which is from ear to ear, 4 6/10 in. Captain Beechey's Collection, \1825-/ 1828.

Ashmolean 1836, p. 185 no. 264.

1426 A Fishing net from [-Fishing] Polynesia, probably the Friendly Islands. It is made of fine \twisted/ thread, with meshes only 1/2 in. square, and it is difficult to conceive that a net could be better made, although the floats are merely short bits of \pithy/ stick \about L 3 in. and D 3/10/ and the sinking weights bits of \grey & whitish colour/ stone \of very irregular shape D about 1 in./. Cook in his Second Voyage, vol: 1, page 215, states that in the Friendly Islands, the nets were "made of very fine thread, with meshes exactly like ours." The net appears to be a large one. Captain Cook's collection. 1772-1774. No.? Given by Reinhold Forster, Esq.
Ashmolean 1836, p. 185 no. 231a.

1427 An Idol carved out of lava from Riavai, (Oparo?) or High Island of Vancouver. It is a rudely formed and unpolished representation of the human figure, with the hands thrown back on the sides of the shoulders, and standing but without feet upon a square shaped pedestal. H of figure only, 36 in.; Whole H 62 in. Given by G.W. Featherstonhaugh, Esq New York 1827. The following statement was sent with the figure - This Idol was named Aroonoona, and considered the watch-god of the Marae (a place of worship and sacrifice). All offerings at the Marae were first presented to this figure. He was supposed to have great power. This particular Tii; (god) belonged to the Mateaina, or district of Tuhuhuatama, principal chief or king (Arii) of Riavai or High Island, and was given to Mr Samuel Stutchbury by the King; the idol having been deposed and its temple overthrown on the introduction of Christianity amongst the natives. The above description is from a catalogue of sale of curiosities collected in the Polynesian groupe of the South Seas, and brought home by the Pacific Pearl company's ship, Sir Geo: Osborne, 1826, by Mr Sam: Stutchbury. The [-material\stone] of which this figure is formed is lava from the mountain ranges of the island. \For notice of a stone Idol of this description seen at Otahiti, see Cook's 1st voyage vol: 2 p. 165/.
Ashmolean 1836, p. 147 no. 503.

1428-1430 Three lances, or throwing spears, from the Solomon Islands? These are remarkable weapons both for workmanship and style of ornamentation. They are about L 9 ft., of brown coloured but hard and strong wood. At about 3 ft. 7 in. from the points they are D 8/10 in., and from thence are straight, smoothly rounded, and gradually taper to the tail, where they only measure D 3/10 in. The fore portions or heads are in parts round which have numerous \small/ indentations painted white, somewhat flattened, or four angled, the latter forming the point proper, the angles having numerous close-set notches along their whole L and coloured a dull red. The [-very] tips of the points are black and may be poisoned. L of No 1428, 9 ft. 2 in.; of No 1429 9 ft. 1 8/10 in.; and of 1430 8 ft. 10 5/10 in. Purchased in 1867 \see the original list had

with them, No 12, 13, 14 and 15, now in Ashmolean letter book \p.1/ and in which they are said to be Fijian, and "Four hunting Spears thrown by the savages with great dexterity and marvellous precision". There were \formerly/ four of them, but one was sent in exchange for things received from the Trustees of the Christy Collection \in 1869/./

1431 A native made model, L 14 ft. of a New Zealand War Canoe. The lower part of the boat, is formed from the solid body of a tree, the sides are deepened by boards lashed on to edges of it, and the joints overlaid with strips of wood to keep them water-tight, these strips and the head of the boat, being ornamented with tufts of Emu feathers. The piece which forms the stern (which has no rudder) runs up to a considerable elevation and is ornamentally perforated and carved; the prow is ornamented with a carved representation of the New Zealand emb[l]em of defiance, that is a figure with a protruding tongue, which emblem is also several times represented, either in profile or full face, along the sides of the boat and in the stretchers which cross the inside of it; one of which is the article No 1277. See also No 1153 etc. In this model, as in their native boats, no metal is used, the whole being lashed together with cord made of their native flax. Given by W. Bennet, Esq Farringdon House Berks. 1827. For an account of dimensions and construction of a New-Zealand War Canoe see in Captain Cook's First Voyage [-to these regions.] \vol III pp. 58 & 59 and figure of large war canoe Pl No 16 facing ditto/ See also Wood's "Nat: Hist: of Man" vol: 2 pp. 170-175.
Ashmolean 1836, p. 174 no. 12.

1431a Two eyes of flat Haliot shell perforated through the centre, & one having a notched edge, the other being plain. D 1 in. Probably from the grotesque heads carved [on] the model of the New Zealand war canoe No 1431.

1432 A small native-made model of a New Zealand War Canoe, made in the same manner as the above described, No 1431. The sides are coloured light and dark brown. The pieces of wood which form the ends have been ornamentally perforated, and carved with grotesque human figures with protruded tongue, as usual. One of the ends of the model and the stretchers are gone. L 6 ft. 9 in.; Greatest W 11 5/10 in. (Ramsden Collection No. ?) Purchased by the University in 1878.

1433 A war club (perhaps an emblem of authority also); from the Friendly Islands. It is of heavy very dark brown wood, straight, the handle portion somewhat oval approaching to lozenge shape in in section bevelled off into an obtuse point at the end; the upper part of the club gradually widening out into a flat thin, pointed oar-shaped blade 6 in. in greatest width with a central ridge extending along the middle on each side. This part is carved into a series of vandykes of \shallow/ incised lines; the lower or handle portion is

entirely unornamented and smooth. There are two sets of close-set parallel transverse prominent ridges or beads 3 5/10 in. apart across the lower part of the blade, three beads in upper set, and two in the lower which is at the junction of the smooth handle portion with the blade. L 56 in. A similar implement but more elaborately ornamented is figured in Cook's "Second Voyage", plate 21. Captain Cook's collection No ?, 1772-1774. Given by Reinhold Forster, Esq.
Ashmolean 1836, p. 184 no. 146 or 147.

1434 A Club from the Friendly Islands, of similar shape to No. 1433, but quite plain except two double horizontal beads or ridges 3 in. apart which mark the division between the blade and the handle part. Wood rather paler brown. L 59 in. Greatest W of blade 6 5/10 in. Captain Cook's collection No ? 1772-1774. Given by Reinhold Forster.
Ashmolean 1836, p. 184 no. 146.

1435 A Club of softish rich brown wood, thought to be from New Ireland, \but?/ It is very similar in general form to No 1433, 1434 but the handle part is more decidedly lozenge shape in section, the angles on each side gradually diminishing or dying out towards the upper or blade part, which is much thicker than in them. The whole of the surface even including the end of the handle is rather deeply carved in thickly set perpendicular [-lin] zig-zag lines \or bands/ alternating with plain lines, having several diagonal bands of like pattern at intervals on each side of the central line of the club,[- somewhat like Nos [].] At the junction of the handle part with the blade are two prominent horizontal beads. L 3 ft. 8 3/10 in. D of lower part of handle 1 4/10 in., gradually widening till it measures [-] D 5 8/10 in. in widest part of blade (Ramsden Collection No. ?) Purchased by the University, 1878.

1436 A Club? or perhaps a paddle, of somewhat [similar] general form to the No 1433 & 1434, of dark brown wood, covered all over \on more than the upper half/ with a small elaborate pattern chiefly consisting of crossed, and very close-set parallel tranverse lines very faintly incised or etched, and the surface afterwards coated with some blackish material, a good deal of which has worn off. Lower portion of handle somewhat lozenge shaped in section inclining to oval, 1 3/10 in. from where it gradually widens and flattens out into rather a broad and flattish \obtusely/ pointed oar shaped blade 5 in. in \greatest/ width, but the central ridge \or angle/ is very distinct through the blade portion. L 5 ft. 7 in. Probably from the Friendly Islands. Some portion of the pattern reminds one of the wooden patterns for stamping the tapa cloth [*drawing*] thus, and the lozenge pattern is likewise alternately in fine parallel lines. It is the only object of its kind in the collection. Probably Captain Cook's collection [-1772-1774 \stet./] No.?, Given by Reinhold Forster, Esq.
Ashmolean 1836, p. 184 no. 146 or 147.

1437 War Club of dark \reddish/ brown \heavy/ wood, approaching the shape of No 1433 & 1434, but very much shorter and particularly in the blade, which is pointed at the top, has a prominent ridge down the middle of each \side/, from which it decreases in thickness to pretty thin edges. There are also two prominent cross ridges at the junction of the handle part with the blade, which forms a kind of collar. The lower part of the handle is round and swells out a little at the bottom, with a small projecting piece left on the end. \The upper part inclining to lozenge shape in section/ L 40 8/10 in. Greatest W of blade 5 in. D of end of handle 1 9/10 in., above that 1 3/10 in. (Ramsden collection, No 348 & 320?) Purchased by the University 1878. For a similar shaped club see Wood's Nat: Hist: of Man vol: 2, p. 276, fig: 1 said to be Fijian. It may be from the Fiji Islands, but of \probably of/ Friendly Island make.

1438 A Club from the Friendly Islands; of very dark brown heavy wood. It is straight D 1 3/10 in. and round for the hand hold, gradually becoming lozenge shaped or four angled at the upper part, the top measuring 5 2/10 by 1 9/10 in., and square or rather slighty hollow. The upper part to the extent of 14 5/10 in., is variously and shallowly carved in perpendicular close set chevron lines, and a lozenge below them, but the whole in straight lines in different directions. Across this portion are 25 parallel close-set prominent transverse beads or ridges, arranged at intervals in five separate bands, numbering as follows beginning at the top: first 6 beads; second 6 beads; third 5 beads; fourth 5 beads; and fifth 3 beads. L 44 3/10 in. Captain Cook's collection No.?, 1772-1774. Given by Reinhold Forster, Esq. A similar club is figured in [-Wood's Nat: His:] Meyrick's "Ancient Armour", vol: 2, the vignette at the end, fig: 7.
Ashmolean 1836, p. 184 no. 146.

1439-1440 Two Clubs from the Friendly Islands, of similar form to No 1438, but longer, wider, and thinner at the upper part, and much more elaborately ornamented with shallow carving, which consists of numerous straight \incised/ lines arranged in different directions to each other, in a great variety of positions, and many crossed; these are divided into groups by [-by] pairs of rather wide transverse or horizontal [-cross\plain] bands, (not beads), being level with the rest of the club, there being 7 such cross bands on the head of No 1439, and eight on 1440. The carving on the two clubs [-are] is of the same character, but they are not alike, and \also/ that on each side of each club is arranged in a different manner. L of No 1439, 54 in., \present/ W across the top 5 3/10 in., \one corner having been broken off/. L of No 1440, 49 in., \present/ W across the top 5 5/10 in., \one corner having been broken off/. There is a pair of beads in each at the junction of the handle part with the ornamented heads. Captain Cook's collection, No.?, 1772-1774. Given by Reinhold Forster, Esq.

Ashmolean 1836, p. 184 nos. 146, 147.

1441 A club of dark brown heavy wood, \probably/ from the Friendly Islands, very similar in shape to 1438, 1439 & 1440, but shorter, and the head thicker than either of them, but the upper part for the length of 11 in. carved with various combinations of horizontal and diagonal incised \parallel/ lines of the same character of the carving on those three but coarser and not so varied. The top \end/ is a good deal hollowed out the other end rounded \with a hole through it,/ and at the junction of the carved head, and the plain, lozenge or four-angled handle, are two horizontal ridges or beads. L 2 ft. 11 in. D 4 5/10 by 2 in. D of end of handle part 1 2/10 in. (Ramsden Collection No. ?) Purchased by the University 1878.

1442 A Club of very dark brown wood, probably from the Friendly Islands, of similar form to the four preceding Nos 1438-1441, but the head part altogether smaller and plain, except 34 close-set horizontal prominent beads or ridges, arranged into five groups by plain & smooth spaces, each about 1 3/10 in. in width between. Beginning at the top the [-number\number] of ridges in each group are \as follows/ 1st eight; 2nd eight; 3rd seven; 4th six; 5th five. The end of the top is hollowed out: the end of the handle is square, and has a hole through it as if for a cord for the wrist. L 42 5/10 in.; D at to 3 5/10 by 1 3/10 in. D of bottom of handle 1 7/10 in., which rather swells out. (Ramsden Collection No. ?). Purchased by the University in 1878.

1443 A Club of hard reddish wood, of somewhat similar form to No 1442, and probably from the same locality. The upper portion or head is bevelled off from the central line to form sharp side edges, each of which are worked into seven large deep notches as it were, each about 2 in. wide, each of the projecting points between the notches has a flattish ridge or bead straight across it. The top is obtusely pointed. The bottom of the handle swells out and the end, \and/ has a perforated pr[o]jecting piece \as in 1437 etc/ L 3 ft. 9 5/10 in. W of top 4 5/10 in. W of bottom of handle 2 1/10 in., above which it is 1 4/10 in. (Ramsden Collection, No. ?) Purchased by the University in 1878. (A somewhat similar club is figured in Wood's "Nat: Hist: of Man" vol: 2 p. 276 right-hand figure).

1444 A Club of dark brown wood somewhat approaching the form of No 1443, but very roughly made; having each side of the top for the extent of 17 in. cut into twelve deep and wide notches or teeth, which spring from a prominent ridge down the middle of each side; this part gradually widens from 2 8/10 in. to the top where it measures W 5 4/10 in. and Th 1 8/10 in. the end being hollowed out, and having the \end of the/ central rib projecting a little beyond it. Hand[l]e part very roughly rounded, swelling out \or enlarged/ at the bottom with a small perforated projection at the end. The pattern of this club may have been copied from some of the Shark's too[t]h

implements, or from some leaf. It may be in an unfinished state. L 3 ft. 8 in. D of top 5 3/10 by 1 8/10 in. (Ramsden Collection, No 349) Purchased by the University in 1878. For figure of a similar club see Wood's Nat: Hist: of Man vol: 2 p. 276, right hand figure.

1445-1447 Three Friendly Island clubs, with thick lozenge shaped or quadrangular heads, becoming less and less angular towards the handle part which is rounded. They are quite plain and well finished. L of No. 1445, 37 9/10 in., D \of top which is slightly hollowed out/, 3 8/10 by 2 6/10 in. D of the lower end 1 3/10 in., which has a square perforated projection which retains a piece of a plaited loop of cocoa-nut fibre. No. 1446 is 33 9/10 in. long; 3 8/10 by 2 3/10 D at the top \the end of/ which is slightly hollowed out: and 1 4/10 at the other end which is rounded off: and has a prominent ridge or bead round it at 10 in. from the top. No. 1447 is 30 5/10 in. long, 3 by 1 9/10 in. D at the top \the end of which is hollowed out/ and 1 3/10 at the bottom, which is rounded off, and has a bit of plaited cocoa-nut fibre bound round it. Captain Cook's collection, 1772-1774, No.?. Given by Reinhold Forster, Esq.
Ashmolean 1836, p. 184 no. 147.

1448 An Idol, or war god from the Sandwich Islands. This is an ugly and absurd representation of a human [-face\head] and neck, H 21 in. It is formed of wickerwork, [-of\over] which is a netting of fine [-cocoa-nut] thread; this has been interwoven with closely set feathers, the whole of which were of a bright scarlet except on the top and back of the head, and the eyebrows, where they were black. The hair is human black and rather long, the eyes formed of two somewhat oval-shaped pieces of pearl-shell, and the mouth which is of great width, is surrounded with close-set prominent teeth of some animal the ends of which have been ground off. In the British Museum, and the London Missionary Society's Museum, there \are/ articles of this kind, of large size and brilliant in appearance. Given by Lord Byron. \R.N./ 1827.
Ashmolean 1886, p. 147 no. 504.

1449 Raft paddle from the Gambier Islands, of pale brown and moderately heavy wood, with cylindrical handle gradually decreasing in size to the top, and very wide blade much curved lengthways, rounded in front, and hollowed out on the back, and having a projecting rounded peak at the end. Handle L 34 in. and D 1 8/10 in., decreasing to 9/10 in. at the top which has a small projecting knob, and straight. L of blade 33 5/10 in. Greatest W 12 in. Paddles of this kind, in use by the natives on their rafts are represented in Beechey's Voyage, at page 105. Such paddles [-are\were] [-used] used exclusively for rafts, as the Gambier Islanders had no Canoes. Captain F.W. Beechey's Collection, \1825-/ 1828.
Ashmolean 1836, p. 186 no. 345.

1450 A Raft paddle from the Gambier Islands, of pale brown wood as in No 1449. It is straight, the handle part cylindrical, L 37 7/10 in.; D 1 3/10 at the top, diminishing a little gradually to where it joins the blade, which [is] straight in a line with the handle nearly oval, or rather short leaf-shaped slightly hollowed on one side and flatly rounded on the other, 20 in. long, and 12 in. present, a piece having been broken off one side. Whole L 4 ft. 11 in. Captain F.W. Beechey's Collection \1825-/ 1828.
Ashmolean 1836, p.186 no. 345.

1451 A curiously shaped paddle or Oar, of pale brown wood. Locality not [-known\certain but probably from the Savage Islands]. The handle is pointed at the top, and at between 14 & 15 in. from the end has a prominent ridge or collar round it, from whence downwards it is still round for the extent of 2 ft. 4 in., from which point it spreads and becomes four angled for the distance of 2 ft. 10 in., where it is gradually increased to 5 5/10 in. in width, from which point it slopes off by an inward curve sharply to a point. It appears [-appears] to partake equally of the form of a paddle and a spear. Whole L 7 ft. 3 5/10 in. (Ramsden Collection, No. ?) Purchased by the University in 1878.

1452 A very large paddle of dark coloured \nearly black/ softish wood; Locality unknown, \but probably from the Savage Islands or thereabouts/. The handle, which is round, and slightly tapering towards the top, is 4 ft. 3 in. long, and D 2 in. \in its largest part/. The blade has a sharp or square shoulder on each side at the junction with the handle, where it is 4 5/8 in. wide, whence it is gradually increased to 10 5/10, whence it slopes off to a leaf-shaped point in a round and hollow curve [*drawing*] thus; L 3 ft. 2 in. Greatest W 11 5/10 in. The top of the blade is ornamented on each side with a cross band of faintly incised zig-zag lines, and the point has a square-shaped ridge on each side, extending back 4 in., also ornamented with zig-zags. Whole L 7 ft. 6 in. (Ramsden Collection No. ? \33/) Purchased by the University in 1878.

1453 A war club from New Caledonia, of very dark brown heavy wood. L 27 8/10 in. Handle straight, plain and round gradually increasing in size from near the bottom to the top, the head being short, projecting 3 in. on the front, pointed, and capped on the top in a kind of keeled boat shape, which pattern seems to be copied from the beak of some bird. The bottom of the handle has a projecting rim like 3 5/10 in. long having a sharp shoulder. It would seem that the club is intended to be held above this so as to prevent its slipping, or being forced out of the hand. The form is said to be peculiar to New Caledonia. D of bottom of handle 1 7/10 in., at 3 5/10 in. above it is D 1 1/10 in., increasing to 2 in. below head. L of 5 7/10 in., and Th 2 in. \A similar club is/ Figured in Cook's "Second Voyage" \vol. 2/ pl: 20 fig: 6. \and described p. 120/. See Wood Nat: Hist: of Man, vol. 2. pp. 206 & 207. Captain Cook's

collection, [-1772-1774 \stet./]. No.?. Given by Reinhold Forster.
Ashmolean 1836, p. 184 no. 147.

1454 A curiously shaped Club, of dark brown \and reddish brown/ wood, said to be from "Erromunga, Torres Straits", (? Erromango one of the New Hebrides), but query if it is not from New [-Guinea\Caledonia]. The handle part is L 30 in. greatest D 1 8/10, round, and probably originally straight, but has since been warped considerably. The top or head, which is cut apparently to resemble a [-crane's\bittern's] head is L 14 in. and stands at right angles to the handle, the part answering to the bill projecting 11 in. The eyes are formed of flattish round projections cut from the wood itself, not inlaid. The bill is sharply keeled both top and bottom, the opening of the bill is not indicated, but on each side a flattish keel [-runds] runs along it, from the point, passing [-of] over the eyes where it is very prominent, and dropping behind the head, forms a kind of wattle or hanging crest at the back of it. There are several tassels [-on\round] the lower part of handle, from which berries were hung, which rattled when shook, but these have disappeared. Whole L 33 8/10 in. For somew[h]at similar club see Wood's "Nat: Hist: of Man." vol: 2 p. 207. Given by C. Leptwich, Esqr London 1868. The bottom part of the handle has a projecting rim like [] round it, L 4 8/10 in. as in No 1453, but not so prominent. In a note which accompanied this article, it is described as a form "which is rarely met with" and it is doubtful if [-would] wood could often be found for the purpose, unless artificially forced to grow to a suitable shape. See reference to Ellis's Polynesian Researches given to No 1310.

1455 A somewhat similar kind of instrument from New Caledonia, described in Cook's "Second Voyage" \vol: 2/ as \like/ "a pick-axe, used in cultivating the ground", see \and for figure of similar object/ pl: 20, fig 8. The handle is straight and round, L 2 ft., with a broad pointed \plane/ blade L 1 ft. at a right angle to it. The peculiar angular growth of the wood of which this implement is also made, was probably aided by artificial means. The bottom of [the] handle is enlarged for the length of 4 3/10 in. as in No. 1453 & 1454. Whole L 2 ft. Whole L of head 13 in. Greatest W of ditto 2 7/10 in. and Th 1 in. Captain Cook's collection, 1772-1774. No.? Given by Reinhold Forster, Esq. It is the same type of club as that figured in Wood's "Nat: Hist: of Man". vol: 2. p. 207.
Ashmolean 1836, p. 184 no. 147.

1456 A war club from New Caledonia, of dark brown heavy wood. Handle straight and round, and gradually increasing in size from near the bottom to the head, which is formed of a sharp edged, overlapping flattish cone shape \or mushroom-shape/. D 4 3/10 in. which is divided by 9 equidistant deep grooves which converge to the top, and cut through the sharp edge of the head, forming deep notches. The bottom of the handle is

enlarged for the length of 4 6/10 in., after the manner of No. 1453 to 1455. L 29 5/10 in. D of bottom of handle 1 6/10 in., above which it is 1 2/10 in., gradually increasing upwards to the head immediately below which it measures D 2 3/10 in. \A similar club is/ Figured in Cook's "Second Voyage", \vol: 2/ pl: 20 fig. 7. Captain Cook's collection, [-1772-1774 \stet./]. No. 157. Given by Reinhold Forster, Esq.
Ashmolean 1836 p. 184 no. 147.

1457 A New-Zealand Chief's sceptre, or staff of office called E'Hani. It is of the usual form that is flattened, and somewhat oar-shaped at the one end, and the other end carved and \formerly/ ornamented with a pair of [-pearl\Haliot] shell eyes, on both sides. This is more slender than is usual, and rather inferior in finish. L 5 ft. 9 3/10 in. \D of wide end 3 in., of the other end 1 7/10/. Such an implement is represented in Meyrick's "Ancient Armour" plate 149 fig: 4 of vol: 2. See also Wood's "Nat: Hist: of Man" vol: 2 pp. 161 & 162 Given by Mr Wolfe 1836.
Ashmolean 1836, p. 183 no. 131.

1458 A New-Zealand Chief's sceptre or Staff of Office?, of rather an unusual form. It has the flattened form at one end, similar to the preceding, but the other end is \round and/ pointed, at 18 in. from the point is ornamented with a carved band of the New Zealand character, which has [was] formerly inlaid on each side with small round eyes of haliot shell, now lost. A staff of this kind is figured in Meyrick's "Ancient Armour", vol: 2 pl: 149 fig: 5. L 5 ft. 1 in.; W at one end 3 5/10 in., at the other []; D at the other end 1 2/10 in. Purchased in 1866.

1459 A New Zealand weapon called a "Patu", ornamented with a bunch of feathers. The handle portion is rather flat [-and] rounded, & pointed at the bottom, from whence it gradually widens to D 1 8/10 in. at the upper end, where it widens out into a flat curved blade \on one side/ describing rather more than the fourth of a circle & W 4 5/10 in.; the back and the top being [-flat\straight] It has been painted brown all over Whole L 2 ft. 11 in. (Ramsden Collection No. ?) Purchased by the University in 1878. A similar weapon is figured in Meyrick's "Ancient Armour" vol: 2, pl: CL fig 12. For figure of a similar weapon see also Wood's "Nat: Hist: of Man" vol: 2 p. 156. fig: 3 and description p. 161.

1460 A New-Zealand Chief's sceptre, or staff of Office, \called Hani/. Similar to No 1457 but longer and smoother, [-than No 1457], the carving at the small end being rather different. It is covered with a number of little cracks. L 6 ft. 6 in. W at the wide end 2 7/10 in.; of the other end 1 6/10 in. The shell eyes have been lost (Ramsden Collection No. ?) Purchased by the University 1878.

1461 Ditto, ditto, much larger in size, having the four small eyes of purple haliot shell complete at the small carved end, with a mass of \small bunches of/ Eumu's

[*sic*] feathers, \and cloth/ tied round below. L 7 ft. 5/10 in. D of wide end 3 7/10 in.; of the narrow end 2 7/10 in. \It is said to be a very fine one of its kind but the feathers appear to have been greatly injured/ (Ramsden Collection No. ?) Purchased by the University 1878.

1462 A New Zealand Staff of office, called E'Hani, similar to No 1461, but smaller. It is a fine implement of the kind, and has three of the haliot shell eyes remaining in the small end. L 6 ft. 7 in. D of wide end 3 6/10 in.; at the narrow end 2 5/10 in. Given by Mr Wolfe 1836.
Ashmolean 1836, p. 183 no. 131.

1463 A staff, probably from New-Zealand, of hard dark brown wood, straight and round, D nearly 1 in. to within about 16 in. of one end, whence it gradually becomes thinner and widens out to 2 in. at the end which is rounded. The small end is somewhat rounded. It is formed with great regularity, and smooth. Captain Cook's Collection. No.? Given by Reinhold Forster, Esq.
Ashmolean 1836 p. 184 no. 144, 146 or 147 [?]

1464 A New-Zealand Chief's Staff of office, called E'Hani, smaller than any of the preceding, but most resembling No 1457. The whole surface somewhat polished, and retaining two of the four haliot shell eyes in the small \carved/ end. L 5 ft. 1 3/10 in., W of broad end 2 4/10 in.; of the narrow carved end 1 8/10 in. It was formerly the property of the late E.R. Owen, Esq F.R.C.S. and given by Mrs Owen his widow, in 1880.

1465 A New Zealand Chief's Staff of Office, similar to No. 1464 but larger, and retaining two of the four haliot shell eyes, in the narrow carved end, L 6 ft. 3 5/10 in. Captain Cook's collection, [1772-1774 \stet./] No.? Given by Reinhold Forster, Esq. Such staffs are mentioned in Cook's 1st voyage, vol: III. pp. 62 & 63. Where it is stated that the superior kinds are generally made of the rib of a whale, as white as snow, with many ornaments of carved work, dog's hair, and feathers.
Ashmolean 1836, p. 184 no. 144, 146 or 147 [?].

1466 A club from the New Hebrides. It is of hard heavy wood, and straight; handle part L 2 ft., D 1 in. and round. Head flattened, L 6 in., W 3 5/10 in. somewhat fiddle-shaped \rounded off to thin sides, and grooved at the end/ and appears to have been intended to represent a grotesque figure of a helmeted human head, the eyes being marked with circles; The other end has a round knob D 1 6/10 in. ornamented with a few faintly incised lines. The handle is of an uniform size throughout. Whole L 2 ft. 6 in. (Captain Cook's collection, \1772-1774/. No.?) Given by Reinhold Forster, Esq. This article looks more like a sceptre than a war club. \A somewhat similar club is figured in Cook's 2nd voyage, vol: 2, pl: XVIII. Fig. 4., and another at Tanna, held by a man, in pl: LIX. p. 54./
Ashmolean 1836, p. 184 no. 146 or 147 [?].

1467 A club of very heavy dark brown, almost black wood; from the Friendly Islands. The hand-grip end is round and D 1 1/10 in., whence it gradually increases in size and becomes more and more four-angled [-\to the top/] having each of the four sides not flat but somewhat rounded \to the top/ where it measures D 2 5/10 by 1 1/10 in. The top is rounded off on the four sides to the end; and to the extent of 14 5/10 in. downwards from that end the club is carved in patterns, similar in general design to Nos. 1438, 1439, & 1440. L 39 4/10 in. Captain Cook's Collection, 1772-1774. No.? Given by Reinhold Forster, Esq.
Ashmolean 1836, p. 184 no. 146 or 147.

1468 A Club from New Guinea, of very dark nearly all of it black wood, probably ebony; handle part very nearly straight, not round but oval shaped, L 2 ft. 6 in.; D the lower end 1 3/10 by 1 in., gradually increasing to 1 7/10 by 1 2/10 in. below the head. The head is of a flattened oval shape rounded off to an edge all round, and is W 5 5/10 in. by 4 3/10, and Th 1 in. The whole club, smooth and polished. Whole L 35 4/10 in. Captain Cook's Collection, No. ? 1772-1774. Given by Reinhold Forster, Esq.
Ashmolean 1836, p. 184 no. 146 or 147.

1469 A spear, [-or staff \said to be] from Tahiti. It is of black heavy wood, very long, straight, round and smooth. D 1 1/10 in. near the middle, gradually tapering to a point at one end, and to nearly so at the other. At 17 in. from the thicker end there is a projecting bead round it, probably as a check to keep the hand from slipping, this is ornamented with a few diagonal incised lines. L 16 ft. 1 in. Captain F.W. Beechey, R.N. \1825-/ 1828. \For spears 16 ft. in length see Cooks Ist voyage vol: 1 pp. 92 & 95 and vol: 2 p. 277, used at Ohetiora 150° 47' W 22° 27' S and made of Etoa wood./
Ashmolean 1836, p. 183 no. 135.

1470 A Staff of authority? from Tahiti, of heavy black wood; the lower part to the extent of 5 ft. 6 5/10 in. somewhat between lozenge shape and round \in section/, and straight; thence widening out into a pointed spear-head form of 4 in. at its greatest width with sharp edges, and having a prominent ridge running down the middle of each side. At the junction of the head part with the shaft is a double carved \horizontal/ ridge or band round it, and projecting considerably from the plain shaft. Whole L 9 ft. 1 in. D of handle part about 1 2/10 in. A similar object is figured in Meyrick's "Ancient Armour" vol: 2 pl: CL, fig: 22 and is said to be a spear from New Caledonia. Captain F.W. Beechey's collection \1825-/ 1828.
Ashmolean 1836, p. 184 no. 144.

1471 A staff of authority \said to be/ from Tahiti, similar in every respect to No 1470 but larger, and the double \horizontal/ carved ridge at the junction of the handle with the head; of \rather/ a different pattern. L 9 ft. 9 in.; Greatest W of head 4 5/10 in., of handle part

1 2/10 in. (Ramsden collection No \332 or/ 1332) Purchased by the University in 1878.

1472 A staff of authority from Tahiti of very similar shape to No 1470 & 1471 but the head part narrower, \and the whole thing much smaller make/. Whole L 9 ft. 2 in. L of the handle or shaft part \which is round/ only, 5 ft. 10 in., and about D 1 in., between which and the head part is a piece of delicate carved wood of the same character as that on No 1361, 1362, 1363, 1364, 1365 & 1366. Greatest W of head 3 3/10 in., gradually tapering to nearly a point at the top, having a prominent straight ridge along the middle on each \side/ from which it is roundly bevelled off to sharp side edges. The carved work extends for the L of 6 3/10 in. The lower end decreases to nearly a point, and at 20 5/10 in. from it is a very prominent sharpish ridge round the shaft, somewhat after the manner of No 1469. (Ramsden collection No 333. Purchased by the University 1878.

1473 Staff of Authority? locality uncertain, \probably from Tahiti ?/ lower portion rounded, but having a slight ridge or keel down the two sides, D 1 3/10 in., then gradually spreading into a narrow oar shape, greatest W 2 8/10 in., and gradually decreasing again to the top, where it is D 1 5/10 in., Th 8/10 in., the sides being nicely rounded off to the edges, which are sharp. Bottom of handle obtusely pointed. L 8 ft. 1 in. The whole surface smooth, and quite plain. Captain F.W. Beechey's collection, \1825-/ 1828.
Ashmolean 1836, p. 184 no. 144 [?].

1474 Staff of Authority \said in Mr Rowell's list to be/ from the Marquesas Islands; of heavy black wood. The lower part to the extent of 4 ft. 11 in., is rounded on both sides leaving two keeled edges, so that in section it would be \pointed/ oval-shaped, D 1 5/10 by 1 310 in. The upper part becoming gradually thinner, and spreading to W 3 1/10 in. near the top, the edges being raised above the middle portion, and deeply scalloped on both sides opposite each other 25 scallops on each side, so that they meet in a sharp edge. L 7 ft. 5 in. A similar Staff is figured in Meyrick's Ancient Armour vol: 2 pl: CL fig: 21, and is said to be from the Marquesas Isles. The lower end is carved on each side with four raised chevron shaped ribs, below which it is somewhat pointed. Captain F.W. Beechey's Collection \1825-/ 1828?
Ashmolean 1836, p. 184 no. 144.

1474a A processional Staff? or perhaps a long paddle, of dark brown, heavy wood. The handle part, or about two thirds of the whole length cylindrical, the other third gradually widening and thinning out to the end which is semicircular, and having all the edges keeled or sharp after the manner of the Pattoo-pattoo of the New-Zealanders. Where from uncertain \Marquesas/ Ramsden collection No \3/ ? Probably New Zealand or from the South Pacific Islands, L 9 ft. 3 in. Greatest W of the flattened blade-like part 3 9/10 in.: D of rounded

handle portion 1 3/10 in. Swelling out a little at the very end. Purchased by the University in 1878. The whole surface is nicely smoothed.

1475 A curved wooden club or weapon, thought to be from the Solomon Islands; similar to No 1343 and 1344, but rather larger, the blade being 6 5/10 in. in greatest W. The wide blade part has a curved ridge running down the middle of each side which springs from a kind of W shaped ornament Purchased in 1867. \see the original list had with it, No 6-8 where they are called Figian, in Ashmolean letter book p. 1./

1476 A Staff of very dark brown wood, probably from Tahiti; of similar make to No 1474 but larger, very much wider and somewhat long leaf-shaped blade, with the scallops not so deeply cut but wider and with very visible marks of the cutting tool. Top end sharply pointed, bottom more obtusely so, and ornamented with two chevron ridges. L 7 ft. 9 in. L of handle part only 4 ft. 6 8/10 in., D of ditto 1 7/10 by 1 3/10 in. L of blade part only 3 ft. 1 5/10 in., W of ditto at the junction with the handle 2 6/10 in., increasing to 6 8/10 in., but side edges a little broken. (Ramsden collection No [-331\4]?) Purchased by the University 1878. A similar implement said to be "a spear from one of the Marquesas Isles" is figured in Meyrick's "Ancient Armour", vol: 2 Pl: CL Fig: 21).

1477 A heavy processional, or war club from the Marquesas Isles, of hard black wood. The lower or handle part to the extent of 3 ft. 9 in., straight, perfectly round and polished; D 1 3/10 in. The upper part enlarged to a nearly racket head shape, 6 8/10 in. greatest W, and Th 3 9/10 in. on the top, which together with both sides is hollowed out, the latter being ornamentally carved with three grotesque human heads, the two upper ones being smaller than the lower one, and placed side by side each on a rayed disk. Below the heads are some curious curved lines in lower relief, resembling some of the Ancient Mexican sculpture. The carving on the two sides [of] the club is nearly alike. Whole L 4 ft. 10 8/10 in. Given by J. Lechmere, Esq J.P. Steeple Aston [-Oxford\Oxon] 1828. \A club similar to this is represented in Cook's "Second Voyage" p. 17 & appears in an unfinished state. There is also one figured in Meyrick's "Ancient Armour" vol: 2 Pl: CXLIX Fig: 2 said to be from Nukahiva. Also in Wood's "Nat: Hist: of Man" vol: 2 p. 353 which is said to be from Samoa or Navigators Islands.
Ashmolean 1836, p. 183 no. 127.

1478 A Club of black wood, similar to No 1477, but shorter, and the carving underneath the three heads a little varied. There is a loop of plaited cocoa-nut fibre in the end of the handle by which probably it was suspended when not in use. L 4 ft. 4 in. Greatest W of top 7 3/10 in. and Th 4 5/10 in. Captain F.W. Beechey's Collection \1825-/ 1828.
Ashmolean 1836, p. 183 no. 128.

1479 Spear? or portion of a bow, of hard \dark/ wood, probably from New-Zealand. It is \nearly/ round \but slightly inclining to oval shape in section/ D about 8/10 in the middle, and tapers \gradually/ towards each end, \and is quite plain and smooth throughout its whole length and slightly polished/. L 6 ft. 1 5/10 in. It was formerly the property of E.R. Owen, Esq. F.R.C.S. and given by Mrs Owen his widow, together with \the New Zealand Chief's Staff of Office or Hani/ No 1464 which is certainly from New-Zealand.

1480 A curiously shaped club or other implement, of dark wood. Marked in pencil "New Ireland New Brit[ain]?" Probably it is from the former. Each end gradually widens and flattens out into a kind of paddle shaped blade rounded at the end, and each ornamented with a curved double ridge across. The one end \or blade/ is larger than the other. The whole surface bears somewhat of a polish. L 4 ft. 2 in. Greatest W of one end 4 2/10 in.; of the other end 3 7/10 in. (Ramsden Collection, No. ?) Purchased by the University 1878.

1481 A club \said to be/ from the Fiji Islands; of brown heavy wood. L 3 ft. 11 in.; Th about 8/10 in., W at the bottom 1 2/10 in., gradually increasing to 3 3/10 near the top which is rounded off to rather an obtuse point; the bottom end is pointed. The sides are rounded off to the edges, which are rather sharp, & the top portion of the club has a narrow bead in the middle of each side 15 in. long. This implement is altogether plain, beautifully formed and polished. Purchased in 1867.

1482 A war club from the island of Tanna, New Hebrides. This is very similar to the articles No 1341 & 1342, but the blade is much shorter, thicker, and is more curved. The general form and ornamentation is the same, even to the curved arrow-shaped ornament \along the middle of the blade,/ but it is not so beautifully worked off. This and the three following articles [-were\appear to have been] procured from the Islands named, by the Donor himself. L 3 ft. 11 8/10 in. Given by C. Leptwich Esq. London 1868.

1483 A broad bladed war club said to be from [-Errumanga\Erromango] (or Eromango, New Hebrides); of very dark nearly black wood. It is similar in form to No 1346, but is less massive, and also wanting in the beautiful finish of the plain parts of that weapon. The outline and form is good but the carving \of the blade/ (if it deserve the name) is merely a number of ill shaped vandyke patterns formed of rudely incised crossed parallel lines places in various directions. It has a strong central rib or bead down [-the middle] each side \[-of the blade]/ which is connected with another similar one across the widest part of the blade. This implement affords a strange contrast to the general beauty of Polynesian work. A bit is gone from one side of the widest part of blade: L 45 5/10 in. Greatest W of blade 8 3/10 in. Handle oval-shaped in section D about 1 5/10 by 1 3/10 and having a projecting rim round the end. Given by C.

Leptwich, Esq London 1868. A club very like this is figured in Wood's "Nat: Hist: of Man" vol: 2 p. 276, by the middle figure, except the Ashmolean specimen is narrower towards the top.

1484 A war club probably from the Island of Tanna, New Hebrides; of a dark reddish brown wood \resembling Mahogany/. The handle or shaft portion is L 39 in., \beautifully/ round and polished; D 1 in. at the lower end, gradually increasing to 1 7/10 at the upper. The lower end terminating in a hemispherical piece of 2 5/10 in., the flat underside of which has a carved quatrefoil like pattern in relief. The head is formed by a sharp edged ridge at 2 in. from the end, projecting 1 7/10 in. at right angles from the shaft; the end is rounded off from the ridge, and the projecting ridge is deeply notched and formed into 7 short, strong, and sharp spikes. Whole L 41 8/10 in. D of head from point to point 4 9/10 in. It more resembles No 1456 than any other in this collection, but is much longer. The carving at the end of the handle reminds one of the Marquesian style. Given by C. Leptwich, Esq London 1868. A somewhat similar club is figured in Meyrick's "Ancient Armour" in the concluding vignette of vol: 2 \and said to be from one of the Marquesas/.

1485 A Bow \said to be/ from Tahiti. This is rather an unskilfully made weapon, of very light and pale brown wood, L 5 ft. 5 5/10 in., nearly round, \in section/ D 1 3/10 in. in the middle, gradually tapering to D 6/10 in. at the ends, with a flat binding of plaited cocoa-nut fibre or sinnet round the middle, extending for 5 6/10 in. \String wanting/. Captain Cook's collection [-1772-1774 \stet/]. No. 42. Given by Reinhold Forster, Esq.
Ashmolean 1836, p. 183 no. 136.

1486 A Bow said to be from the Fiji Islands, \but?/ of lightish wood of a dark reddish brown colour \somewhat resembling Mahoghany,/ L 6 ft. 4 in. nearly round but somewhat approaching to oval in section. D 1 3/10 by 1 1/10 in. in the middle, tapering to the ends near which the wood is cut away on the back and somewhat flattened leaving a prominent notch as it were, the ends being pointed. The string is intact. It is a powerful and well made weapon, and has [-somewhat of a\a smoothly] polished surface. (If this bow is Fijian it is very [-] unlike the five following). Purchased in 1867

1487 A Bow said to be from the Fiji Islands; of hard brown wood, irregularly rounded on the front, and evenly and slightly rounded on the inside; much thinned on the inside near the ends leaving a prominent notch, the ends being smaller and pointed. The line is well made and apparently of hemp. L 6 ft. 9 5/10 in. D in the middle 1 3/10 in., decreasing to the ends. Purchased in 1867.

1488 Ditto, similar in every respect to No 1487, but the front more knotty, \or lumpy down its whole length/ and the inside flatter, and the lines rather thicker. L 6 ft. 7 in. Greatest D 1 3/10 Purchased in 1867.

1489 Ditto, of the same kind of wood as No 1487 & 1488, and of the same shape, the front being knotty \or lumpy down its whole length / as in No 1488, but the inside rounder \than in that and smooth./ L 6 ft. 8 [or 9] 3/10 in.; Greatest D 1 1/10 in. Purchased in 1867.

1490 Ditto, thought to be from the Solomon Islands?, in every respect like 1487, and one of the same set. L 6 ft. 7 8/10 in. D in the middle 1 1/10 in., decreasing to the ends. All these bows measured along the inside. Purchased in 1867.

1491 Ditto, of similar brown wood, but rounded on all sides being oval-shaped in section with pith mark at the back \running down near one half the length/. The ends are plain, and the bow is bent \much / more one end than at the other. Line complete. L 5 ft. 11 in. D in the middle 1 5/10 by 1 in., gradually decreasing to the ends. Purchased in 1867.

1492 A bow of [-pale] brown wood apparently of the same kind as No 1491, round on one side, [-which probably formed the front] and flat on the other side with a slight groove down part of its length apparently the pith mark. From the way the wood is warped anyone would think the flat side formed the front. L 5 ft. 4 3/10 in. D in the middle 1 3/10 in. gradually diminishing to the ends. Line gone. [-Probably] from the Fiji Islands?
Ashmolean 1836, p. 183 no. 136.

1493 A small bow, of dark brown wood, perhaps from the South Pacific Islands, half circular on the front, and less convex on the back \and nicely smoothed all over/. L 50 5/10 in. D in the middle part 1 in. gradually diminishing to the ends. It has been broken, and mended \by us/ near one end on the front. Old Ashmolean Collection. Line lost.
Ashmolean 1836, p. 183 no. 136; MacGregor 1983, no. 391.

1493a A small bow of dark brown hard wood, semi round on the front and flatly round at the back, L 45 1/2 in. D 7/10 in. in the middle, gradually decreasing to a point at each end, but retaining the same form throughout, and finely smoothed and almost polished. (Ramsden Collection No 359) Purchased by the University in 1878.

1494 A larger bow of the same shape as no. 1493, of hard dark brown wood \but/ bearing a polish. The ends also like that number [-have] are cut away to form short peg-like projections for the bow-string. Perhaps from the S. Pacific Islands. L 6 ft. 1 5/10 in. D in the middle 1 3/10 in., gradually diminishing to 7/10 in. at the ends. (Old Ashmolean Collection).
Ashmolean 1836, p. 183 no. 136; MacGregor 1983, no. 392.

1495 A Bow of dark brown wood, from the S. Pacific Islands? or New Guinea? quite a different shape to any of the preceding, being somewhat wide compared to its length, the back and the front flattish or but slightly

rounded, the two side edges being half circular. L 5 ft. 7 in. W in the middle 1 5/10 in. gradually diminishing to D 5/10 at the ends beyond which they are cut away to form pegs like for hitching on the bow string \which is wanting/. Th in the middle 7/10 in. decreasing to 4/10 in. at the ends. (Old Ashmolean Collection, No. 29).
Ashmolean 1836, p. 183 no. 136.

1496 A Bow of exactly the same shape as No 1495, and made of the same kind of wood, but not so long. It has been cracked at one of the ends. The projections at the ends, for the string, have been cut off. L 5 ft. 2 3/10 in. (Old Ashmolean Collection).
Ashmolean 1836, p. 183 no.136.

1497 A similar bow to Nos 1495 & 1496, except that it is flat on the front and somewhat rounded on the back, and not so smoothly made and polished. Line wanting, and the wood has been broken on the inside near one end. L 5 ft. 8 3/10 in. D in the middle 1 7/10 in., gradually decreasing to the ends which have been notched for the string. (Old Ashmolean Collection).
Ashmolean 1836, p. 183 no. 136.

1498 A similar bow to No 1497, of [-the same\paler and heavier] kind of wood, [-but] longer and the front a little rounded instead of being flat. L 6 ft. 1 in. This and No 1497, are not polished as in No 1495 & 1496. Line wanting. Old Ashmolean Collection.
Ashmolean 1836, p. 183 no. 136.

1499 A Club from Tongatabou, Friendly Isles. It is of rather heavy brown wood, L 4 ft. 3/10 in. and cylindrical in form, D 2 6/10 in. at one end, which is square, gradually increasing to 3 2/10 at the other which is rounded off. To the extent of 29 5/10 in. from the larger end the club is plain, the surface of the remainder being carved into three encircling or horizontal bands, 7 5/10 and 9 5/10 in. apart, the spaces between which are ornamented with close set, narrow, straight and zigzag longitudinal lines arranged alternately, the surface being cut away so as to leave the pattern in relief. It is hardly likely that this club could have been for any but ornamental purposes, and probably not for a war club. Presented by Captain F.W. Beechey's [-Coll[ectio]n] \1825-/ 1828 A club of this kind is figured in Meyrick's "Ancient Armour" vol: 2 Pl: 149 Fig: 26. And in Wood's "Nat: Hist: of Man" vol: 2 p. 277, right hand figure.
Ashmolean 1836 p.184 no.145.

1500 A similar but smaller cylindrical club of darker brown, but apparently the same kind of wood, but carved all over the surface and many of the horizontal extending only partly round the club, the carving smaller and a little more varied. It is about one size from end to end, one of which is inlaid with a star-like ornament of bone or ivory. L 41 8/10 in. D about 2 6/10 in. Both ends square. (Ramsden Collection No. ?). Purchased by the University 1878.

1501 Ditto, very similar to No 1500, but shorter, and slightly increasing in size to the top, which is flatly rounded off, the other end being square. L 3 ft. 2 5/10 in. D of small end 2 in. D of top 2 7/10 in. (Ramsden collection, No 320). Purchased by the University in 1878.

1502 Ditto, but thinner than either of the preceding, and apparently of harder and heavier wood. The carving is all in perpendicular lines separated into eight lengths by eight narrow horizontal bands. It is very neatly and regularly carved, and has a transverse perforation through the small end. L 43 3/10 in. At the small end, which is square D 1 7/10 in., gradually increasing to the top which is D 2 3/10 in. and rounded off (Ramsden collection No 344?). Purchased by the University in 1878.

1503 A Club of hard heavy brown wood; from Tongatabou, Friendly Islands, 39 in. long, straight, round, 2 1/10 in. D at the top, and tapering to a point at the other. Except 9 5/10 in. at the pointed end, (which is smooth), the whole of the surface is very neatly carved in various closely set small patterns \in incised lines./ It may be observed that the whole of the ornamentation on this and the preceding article is in various combinations of straight and zig zag lines, particularly in this latter object. Top end rounded off. Given by Captain F.W. Beechey, R.N. \1825-/ 1828?
Ashmolean 1836, p. 184 no. 145.

1504 A Club from Tongatabou? Friendly Islands, of heavy dark brown wood. It is L 47 3/10 in. straight \perfectly/ cylindrical and polished, D 2 2/10 in. at the top, from whence it gradually diminishes to the other end where it is D 1 7/10 in. The whole surface is perfectly smooth and polished except to the extent of 13 6/10 in. from the lower end upwards, and 5/10 at the top, which is carved in the same style as articles No 1499 to 1502. The two ends are slightly convex, and a hole has been made in one side near the bottom, and which passes out through the end. It is very beautifully made. (Ramsden Collection No. ?) Purchased by the University in 1878.

1505 A short Club of dark brown wood, probably from the Friendly Islands. It is only L 28 in., the handle portion which is cylindrical measuring 14 in., and D 1 5/10 in. The ornamented head part is L 14 in. quadrangular or lozenge shaped in section 4 2/10 by 3 in. greatest D, rounded off to an obtuse point at the top and decreasing in size to D 1 9/10 in. at the junction with the handle; it is elaborately carved the pattern consisting of the usual parallel zig-zag lines as in No 1499 1502, in addition to which are four large geometrical figures, which have certainly been struck with a compass, \before being carved out/ each of the designs being different. Each of the flat sides have also been inlaid with a lozenge shaped \piece of whalebone/ and a star shaped pieces of bone or ivory, two of the latter being lost. The handle is perforated near the

bottom the hole passing out at the end. (Possibly this club may not be of native manufacture but European imitation). (Ramsden collection No 355) Purchased by the University in 1878.

1506 A Javelin from New Caledonia, of very heavy black wood, and without any ornamentation. It is L 9 ft. 7 in. Th 8/10 in. in its largest part, which is at 2 ft. from one end, from whence it gradually tapers to a point at each end. Such spears are thrown (as a weapon) by the aid of a becket or loop of [-cocoa-nut fibre\plaited grass] (called by the natives onnep) such as is now attached to it, but they are chiefly used for catching fish. See Cook's "Second Voyage" plate 21, figs 1 and 5, and also plate 39. See \also/ Wood's "Nat: Hist: of Man" vol: 2 p. 205. Given by Captain F.W. Beechey, R.N. \1825-/ 1828. \Compare the binding on this with the fringe on that round handle of \the Club/ No 1454 which is from New Caledonia/. \They use the same weapon in the New Hebrides, as see Cook's 2nd Voyage vol: 2 pp. 81 & 82 where the manner of throwing it is fully described/.
Ashmolean 1836, p. 183 no. 134.

1507 A similar shaped javelin or lance to No 1506, \and from the same place,/ of dark brown, nearly black wood. It is slightly ornamented with a few punctures near the middle [-and\which] has a small flat piece of bamboo \the face of which is neatly ornamented with some kind of fine fibre neatly woven in a kind of pattern and/ tied to it with a binding of the white inner bark of [-a\some] tree. L 8 ft. 10 in. Greatest D 8/10 in. The becket or loop for throwing it has been lost. (Ramsden Collection No. ?) Purchased by the University 1878. \Compare the work on the strip of bamboo on this article with that on the becket or loop of the preceding, No 1506, they are identical/.

1508 Spear or Javelin, from Tonga or Friendly Islands; of moderately dark and heavy wood [-and heavy wood]. L 10 ft. 1 5/10 in. At about 3 ft. 6 in. from the point, it is Th 1 1/10 in., and thence gradually tapering to 3/10 at the tail end. The head is pointed, and backed by 11 rows, or rather rings, of barbs, which vary in length from 3/10 in. to 6 in., [-in length] each ring consisting of five barbs, extending together with the point for the distance of 36 in., and the barbs \(several of which are broken off)/ gradually increasing in size to the back which spread 2 3/10 in.[-A\The upper] portion of the shaft \for the distance of 43 in./ is ornamentally bound with a narrow plait of cocoa-nut fibre or sinnet. This weapon is figured in Cook's "Second Voyage", \vol: 1/ pl: 21. Figs 8 and 9, \and decribed p. 221/. Captain Cook's collection 1772-1774. \Sep.Oct.: 1773/. No. ?. Given by Reinhold Forster Esq. \A spear of this kind, but having only two sets of barbs, is figured in Meyrick's "Ancient Armour". Vol: 2. plate CL. Fig: 20. It has been suggested that such spears were only used for catching Fish, but?/.

1509 A very similar spear to the preceding No 1508, [-but\shorter, stouter and] having seven sets or rings of six barbs each, some of which have been broken off. There are a few plaits of cocoa-nut fibre bound round below each set of barbes, and a thick mass of the same \7 5/10 in. long/ immediately below the lower or larger set, and which is continued in a single plait from the front sets. This mass appears to be intended for a firm hold for the hand, and is made by crossing and recrossing the plait in rather an irregular manner. Whole L 8 ft. 8 in.; L of head part only 3 ft. 4 3/10 in. Greatest spread of barbes 2 8/10 in. Greatest D of shaft 1 2/10 in., gradually diminishing to the end to D 7/10 in. From the Friendly Islands? or more likely from the Fiji Islands. Given by Mr W. Drewett, Oxford. 1870.

1510 A wooden spear exactly like No 1509 in [-everyt] everything except that it is about 5/10 in. shorter, and has lost more of its barbes \and has eight in each ring or set/. Probably from the Fiji Islands, or the Friendly Islands. Given by W. Drewett Esq Oxford 1870.

1511 A spear of very dark brown, almost black wood, from Tongatabou, Friendly Islands. L 11 ft. 3 in., and D 1 2/10 in. at its greatest thickness, \gradually tapering to D 4/10 in. at the end/. It is barbed to the length of 2 ft. 8 5/10 in. back from the point, somewhat in the same manner of No 1508-1510, but the barbes \not deeply undercut, being/ only detached from the other part of the wood just at their ends, there being 13 rings or sets of barbes, each of which consists of eight barbes, increasing in size \from the point/ to the back. It is altogether a very smoothly round and highly finished weapon, the barbs being also smoothly rounded both on the outside and the ends, and a few broken off. Given by Captain F.W. Beechey, R.N. \1825-/ 1828?
Ashmolean 1836, p. 183 no. 134.

1512 A somewhat similar spear to No 1511, but much shorter, and altogether thicker, the head having five sets of very thick barbes, five in each set. The upper portion of the shaft for the length of 37 3/10 in. is ornamented with a narrow binding of plaited cocoa-nut fibre, that part immediately below the head being ornamentally crossed in a regular manner for the length of 7 in. the remainder being simply closely bound round. Present L 9 ft. (a piece having been broken off the small end). L of head part only 22 in., greatest spread of barbes 2 8/10 in. Greatest D of shaft 1 6/10 in. (measured over binding), decreasing gradually to the small end to 6/10 in. None of the barbes are wanting. (Ramsden Collection No 334). Purchased by the University in 1878.

1513 A kava bowl, from Tonga, or the Friendly Islands. This is a shallow circular dish D 16 9/10 in., and 2 8/10 in. deep in the centre, the hollow sloping gradually from the edge is very regular and smooth. The bowl is rather thin, the outer or underside being cut to follow the line of the inner part, the underside,

and also the four short cylindrical legs on which it stands being left rough from the cutting tool. One one side underneath is a perforated projecting piece with a loop made of cocoa-nut fibre attached, probably for suspending it when not in use. H 4 1/10 in. A bowl similar to this is figured in Wood's "Nat: Hist: of Man". vol: 2. p. 120. These bowls were used for holding a favourite liquor of the South Sea Islanders produced from the Kava pepper (Piper mithysticum), cut and chewed in the mouth, and then rapidly fermented and strained. Captain Cook's collection \1772-1774/ No. ?. Given by Reinhold Forster, Esq.

1514 A kava bowl, of similar brown wood, and make to No 1513, but much larger, and pointed oval in shape. L 27 5/10 in. W 17 5/10 in. Height as it stands on its four short cylindrical legs, 5 3/10 in. It is cut out of one piece of wood (as is also No 1513) and has a large projecting notched piece on one side of the underside, which is perforated with two holes, probably for a cord to suspend it with. It is four in. deep in the centre. (Ramsden Collection, No. ?) Purchased by the University in 1878.

1515 An oblong-shaped tray, or shallow dish, on four short cylindrical legs; cut from a solid piece of hard, heavy, very dark brown wood. L 23 in., W 13 5/10 in.; depth along the middle 1 3/10 in., sloping gradually from the sides downwards, the two ends being left solid and square; the underneath side following the curve of the upper or thereabouts, the ends being chamferred off. It is altogether cleanly and well cut into form, but the surface has not been made quite smooth, and there is no attempt at ornamentation. One side of the underside has a perforated [] projecting as in No 1513 & 1514. This dish is stated to have been "used by the Fijians on occasions of fish offerings to their gods". H 4 in. Purchased in 1867. \Such trays are described in Cook's 1st voyage vol: 2 p. 202 and as from Tahiti./

1516 A long, and oval shaped tubular case, or trunk, probably a musical instrument of the stringed kind: from the Friendly Islands. It is cut from a solid piece of moderately hard brown wood. Whole L 43 5/10 in., D 1 ft. by 7 5/10 in. It is hollowed out to about Th 5/10 in. and a kind of lid or capping piece, having an overlapping edge or rim, is lashed over each of the open ends with strings of plaited cocoa-nut fibre, the outsides of these lid-like ends being carved into a series of zig-zag lines. The body part has no ornamentation, is comparatively smooth, and has on one side, along the middle, an opening 16 in. long, by 3 3/10 in. wide, on each side of which are four low projections of the wood, which may have been used for straining strings across the aperture. Captain Cook's collection, No.?. 1772-1774. Given by Reinhold Forster, Esq. \This is a Drum, and is described in Cook's 2nd Voyage vol: 1. p. 220. and 3rd Voyage. vol: 1. pp. \292 &/ 293. It is probable that this is the very drum given to Cook by a Native of the Friendly Islands for a piece of cloth or some article of dress after he had paddled out some

distance from the shore to the ship which was then about leaving these Islands, as see Cook's Voyages./

1517 A [-Fiji \stet/] war-drum, \or bell/ or Tongituri. It is cut from a solid piece of hard very dark brown, sonorous wood, and has somewhat the form of an elongated beer-barrel with a slice taken off on one side. L 26 in., D in the middle 8 by 6 5/10 in. One side being flattened to a W of 6 5/10 in. in the middle, it is there hollowed out, leaving the sides about 1 4/10 in. thick, and the ends much thicker, and which are overlapped by the sides considerably as in a barrel. On the inside it is left rough from the cutting tool, and on the outside it is almost in that condition. The drum-sticks are two roughish club-like pieces of wood L 8 8/10 and 9 2/10 in. and 1 7/10 greatest D. The sound is produced by vibration of the wood, which when beaten gently on the inner edge is not unmusical. Purchased in 1867.

1518 A Tahitian Drum, cut from a solid piece of brown wood. It [is] cylindrical, H 13 5/10 in., D 11 in., the upper part only being hollowed out. The lower edge forms a stout ring, above which the drum part is slightly elevated, so as to preserve its full vibration; this ring also serves to secure the lines by which the head is stretched, which is made of Shark's skin, the roughness of which has been polished down. The bracing lines are of plaited cocoa-nut fibre. Captain Cook's collection, No.?, 1772-1774. Given by Reinhold Forster, Esq. (One of the objects lent to the International Exhibition of Amsterdam in 1883, for which the Ashmolean received a Diploma of a silver medal, & Catalogue).
Ashmolean 1836, p. 184 no. 159.

1519 A similar made drum to No 1518, but much larger, more elevated at the foot, and with thicker and more numerous bracing lines of plaited cocoa-nut fibre, arranged perpendicularly in fours, and several horizontal bands of the same thickness wound round the top above them, and several much wider \horizontal/ bands also of the same material wound round below them. H 19 in. D 12 5/10 in. (Ramsden Collection No. ?). Purchased by the University in 1878.

1520 A short but heavy club, or mace, of hard very dark brown, almost black wood: which is stated to have been taken from the temple of a Fiji Idol, after hanging there for a time as an offering to the god. The handle is straight, round, and comparatively small, L 12 8/10 in. terminated by depressed globular head D 4 3/10 in., the sides of which are carved very regularly into three sets of longitudinal rounded ridges, the upper and lower rows being small in comparison with those between which occupy nearly the whole of the sides. At the top is a sub-globular projection D 1 8/10 in. The lower part of the handle for the length of 5 7/10 in., is carved in zig-zag lines in relief, similar to No 1347, which have been a good deal worn. This club seems to have been a good deal used. Whole L 16 in. A club very like this is figured in Meyrick's "Ancient Armour", vol: 2 pl:

CXLVIII, Fig. 17. It is called a mace; \and said to be from Central Africa/. And for a notice of such clubs see Wood's "Nat: Hist: of Man" vol: 2 p. 353 Purchased in 1867.

1521 A similar made club or mace to No 1520, and of the same kind of wood, but the head smaller, the ridges on the sides of it more prominent but not so numerous. Lower portion of handle lost. Present L 1 ft.. Greatest D of head 3 8/10 in. History unknown but probably Old Ashmolean Collection.

1522 A somewhat similar shaped short club or mace to No 1520 & 1521 and of about the same length, but of hard, heavy wood of a rich reddish brown colour, like mahogany, but differing in the pattern of the head which is not so depressed above and below and considerably more carved, the perpendicular ridges forming mouldings as it were, and having a star-like ornament \of whale's tooth/ or rather a disk with serrated edges, neatly inlaid in the centre of the top, and in the end of the handle, D 1 in. The handle is much thicker than in either of the previous two, the lower part carved for the extent of 6 4/10 in. from the end upwards in perpendicular zig-zag lines between straight lines, all in relief as it were by the other portion being cut away, but this has been much worn down through use. L of handle 12 5/10 in., D of ditto immediately below head 1 5/10 in., decreasing gradually to 1 1/10 in. near the bottom, but widening to 1 2/10 at the end. D of head 4 3/10 in., L of ditto 3 4/10 in. Round the plain part of the top outside the whale's-tooth ornament a double circle of small indentations. Whole L 15 9/10 in. \For notice of such clubs see Woods Nat: Hist: of Man vol: 2 p. 353/ Purchased in 1867.

1523 A short club, or mace, probably from the Fiji Islands, of hard and heavy brown wood. Head nearly globular-shaped, plain, except some deep natural indentations in the wood. Lower portion of the handle for the distance of 5 in. up from the end being ornamented with twenty horizontal rows or rings of irregular shaped deepish indentations diminishing in size from the end upwards \and probably intended for tightness of grip/. L of handle 12 in. D of ditto 8/10 in. increasing in size to the end where it is 1 2/10 in. and which is marked with four small indentations arranged in a lozenge shape. L of head 3 4/10 in. Greatest D 3 9/10 in. Whole L 15 3/10 in. The history of this club appears uncertain, but it is probable that it belongs is probable that it belongs to the old Ashmolean Collection. [- L 7 in]. For notice of a similar object see Wood's "Nat: Hist: of Man" vol: 2 p. 353.

1524 The head part of a similar Club to No. 1523, but of lighter colour, and the holes, or hollows, of natural growth more numerous in it. A fragment of the handle is attached. Present L 7 in. D of head 4 in.

1525 A short club, or mace, probably from the Fiji Islands \or Friendly Islands/; of hard heavy brown wood, and in shape something like Nos 1523 & 1524, but the upper portion of head more truly globular, and perfectly smooth, The whole of the comparatively thick \round/ handle rather deeply carved with perpendicul[ar] zig-zag lines alternating with plain lines, [-ad] and divided into four sections by horizontal bands of a similar pattern, as in Nos 1499, 1500, 1501, & 1503, which are described as from the Friendly Islands. L of handle 14 2/10 in. D 1 6/10 in. where it joins the head, gradually decreasing to 7/10 in., and then widening out to 1 in. at the end. Whole L of club 17 3/10 in. (Ramsden Collection No []4) Purchased by the University in 1878.

1526 A feather Headdress of a Fiji Chief. It is a su[-g]gar-loaf or conical shaped cap, made of closely woven narrow strips of the inner bark of some tree, thickly covered all over the outside and hidden by little bunches of coloured split macaw's or Parrot's feathers tied on with thin string also made of twisted inner bark. Round the lower half of the headdress there are three bands of feathers, the lowermost being mixed pale yellow and white, above that scarlet, some of which are slightly tipped with black; and the third band all black. The upper half is all of the mixed pale yellow and white except two or three single ones of scarlet. H 14 in. D 9 in. Purchased in 1867. \see the original MS list had with it when purchased "No 31" and now preserved in the Ashmolean museum letter book \p. 1/ and in which it is stated to be "A Chief's Cap made [-from\of] Feathers from Figian Birds, and worn by them at their great Cannibal Feasts, after a victory over their Enemies". (It has been thought by some to be from New Guinea, on account of the \kind of/ feathers). The feathers which have been split up the quill, and otherwise trimmed up are tied in little bunches and fastened to a long string which appears to be wound round and round the outside of the bark work in a spiral manner and tied to it; the crow[n]ing bunch being much larger than any of the rest, made Turks-head shape and fastened through a hole in the top. Round the lower edge is a network of string similar to that which the feathers are fastened with, 2 in. wide, having a reeving string [-] in it, probably for fastening it to the head. The feathers at first sight appear to be of one mass.

1527 A Fiji Wig, or headdress made of human hair. It is a rudely made thin frame of open basket work, of narrow flattish strips, apparently of split reed coloured brown; thickly set over the whole of the outside with tufts of frizzly black, and reddish-brown, hair, (the former much predominating), the colours separated by a distinct line, and the brown apparently artificially coloured. It is stated to be "a wig made [-made] by the Savages of Hair Taken from the scalps of captives Taken in Battle". Purchased in 1867. For description of such articles see Wood's "Nat: Hist: of Man" vol: 2 p. 248/.

1528 A thick headdress or crown in form of a ring; thought to be from the Fiji Islands. It is made of little bunches of split feathers neatly bound up separately and fastened on to a cord made of cocoa-nut fibre, something after the manner of the No. 1526; but the bunches are bound closer together, and the cord is wound round in six rings and fastened together at intervals by small strings forming as it were a flat band for the head, the feathers being all on the outside, and as thick again on one side (probably the front), as they are on the opposite side. Captain Cook's Collection, No. ? Given by Reinhold Forster, Esq. Some persons have thought this to be more likely from New Guinea than from the Fiji Islands, and to be made of Gannett's feathers.
Ashmolean 1836, p. 184 no. 179.

1529 A war helmet, from Tongatabou, Friendly Islands. It has nearly the shape of a straw beehive, but is rather higher, and is strongly and firmly made of plaited cocoa-nut fibre in a kind of close basket work, giving it the appearance of forty-two rings wound spirally over one another and decreasing in size to the top [-\and somewhat resembling a small beehive but higher in comparison/]. H 7 3/10 in., inner D 7 8/10 in. by 7 in., Th 3/10 in. The colour is darkish brown ornamented with \numerous/ lozenge shaped patches of black. Given by Captain F.W. Beechey, R.N. \1825-/ 1828.
Ashmolean 1836, p. 183 no. 140.

1530 A Flute, or musical instrument from Tahiti, which the natives blow with their nostril. It is made of a single joint of \hollow/ bamboo, L 15 3/10 in., and D 1 1/10 One end is open, the other stopped by the natural joint, and close to it is a hole D 3/10 in. which is the one blown upon; at 1 5/10 in. from it is a smaller hole, and at 3 5/10 in. from the open end, one hole only of D 1/10 in. This end is bound round [-round] with two separate \flat narrow/ bands of plaited cocoa-nut fibre, one L 3 and the other L 3 5/10 in., of a brown and pale brown colour, both colours in each band, and the hole between them. A similar instrument is figured in plate 9 of Cook's "First Voyage", \vol: 2. p. 212/. and in plate 7 \p. 264 of the same volume/ a man is represented playing one. Captain Cook's collection [-1772-1774]. No. 26. Given by Reinhold Forster, Esq. \For description of these Tahiti noze flutes, see Cook's 1st voyage vol: 2. pp. 204. 205./
Ashmolean 1836, p. 184 no. 171.

1531 A very similar but rather longer and wider instrument to No. 1530, \from Tahiti/ the plaited binding of cocoa-nut fibre being of the same colours but wider covering more of the instrument and continuous [-except] for the length of 11 in., except a little square opening left at the top for the little hole, which is at 4 7/10 in. from the end. L 17 9/10 in. D measured over the binding 1 2/10 in. \See Cook's 1st Voyage Vol: 2, pp. 204 & 205 for the manner of playing these flutes/. Captain Cook's collection, [-

1772-1774]. No. ? Given by Reinhold Forster, Esq. These two flutes appear to be made of two pieces of bamboo, one inserted within the other and forming a close fitting lining. The holes appear to have been first made by burning them.
Ashmolean 1836, p. 184 no. 172.

1532 A musical instrument or \Nose/ flute, from [-Tahiti\the Friendly Islands] made of a single joint of bamboo, but unlike No.1530 & 1531 [-having\it has] both ends closed by the natural joint of the cane, and [-having] a hole close to each end to blow upon, together with four other holes, which are so placed that no person could stop them at one time with his fingers. It appears therefore as if it was intended for two persons to play upon at one time. It is mentioned by Captain Cook that the flutes at Tahiti had two holes, and those at the Friendly Islands had four, but he does not state that they had double flutes. This instrument is L 21 3/10 in. and D 1 5/20 in., except at the ends, which are a little more, because of the joint. It has no cocoa-nut fibre binding, but is encircled [-of\at intervals with] three narrow vandyke bands, and one plain with short lines springing from the side, burnt in by way of ornament. The original six holes have also been ornamented by black radiating lines, two of which nearest one end have been stopped up, and \two/ others unornamented made near them. Captain Cook's collection, No. 82. 1772-1774. Given by Reinhold Forster, Esq.
Ashmolean 1836, p. 184 no. 173.

1533 A musical instrument or "Native \ Nose/ Flute", \said to be/ from the Fiji Islands somewhat similar to the preceding, that is having both ends stopped, but much larger L 21 5/10 in., and D 1 9/10 in. Ornamented with wide scalloped bands, figures of turtles, frogs, etc trees or branches, and star-like ornaments, perhaps intended for starfishes, all \apparently/ burnt in the surface. There are five holes in a line on the front, and one only on the other side, this being in a line with or opposite to the middle one of the five. But in the previous article No 1532, the holes are not in a line. Purchased in 1867.

1534 A \nose/ flute \probably from the Society Islands/, made of one length of bamboo, L 16 8/10 in., D 1 in.; open at both ends, and having two holes on the side and in a line, at 2 and nearly 4 in. from the end, and apparently a broken out one close to the other end. Nearly the whole surface is covered with a kind [of] rudely executed lozenge pattern of various thin lines, for ornament, apparently burnt in. Captain Cook's collection, 1772-1774. No. 83. Given by Reinhold Forster, Esq.
Ashmolean 1836, p. 184 no. 174.

1535 A sling (Wendat), from New Caledonia; made of plaited cocoa-nut fibre W 5/10 in., and Th 2/10 in., flattened and widened out in the middle W 21 5/10 in. and L 5 5/10 and covered on each side with some finer strong material like canvas, to form a pocket for the

slingstone, and gradually decreasing in size two [sic] the ends which are held in the hand. Whole L 7 ft. 11 in. Also six stones for use with the sling, made of hard grey steatite, of a pointed oval shape, or, as Captain Cook describes them "Something like an egg, supposing both ends to be like the small one." \2nd Voyage, vol: 2. p. 120/. L between 2 2/10 and 1 8/10 in. D about 1 1/10 in. Captain Cook's collection, 1772-1774. No.?. Given by Reinhold Forster, Esq. These stones both in shape and size, are very similar to the sling stones, and bullets used by the Greeks and Romans. See "Wood's Nat: Hist: of Man", Vol: 2. p. 205.
Ashmolean 1836, p. 185 nos. 232-3.

1536 A stone used in playing at a peculiar game called Maita Uru, by natives of the Sandwich Islands. It is of a [] colour perfectly circular D exactly 3 2/10, and Th 1 8/10 in the middle, the two sides being moderately convex, and the edge which is W 1 5/20 in. slightly rounded. It is quite smooth and polished all over. Given by the Rev. A\ndrew/ Bloxam, M.A. Worc[ester]: College 1826. Probably the same game as that mentioned in Wood's "Nat: Hist: of Man" vol: 2 p. 440.
Ashmolean 1836, p. 185 no. 211.

1537-1538 Two spoons? or ladles?, made of parts of the pale yellow shell Melo-indicus. The edges have been ground down smooth, and both have a hole drilled through near the small end; the largest of the spoons having been cracked nearly across, just above the perforation. L of No 1537, 7 4/10 in.; Greatest W 3 8/10 in., and 1 5/10 in. deep, and perfect except the crack mentioned. L of No 1538, 4 8/10 in.; greatest W 1 7/10 in., and 5/10 deep, and perfect. Given by the Trustees of the Christy Collection, London, probably in exchange, in 1869.

1539 A Whales' tooth, reduced in size and polished, \such ornaments are/ used [-as an ornament] by New Zealanders. It is rounded on all sides, and nearly of a crescent shaped outline, except that the concave side is rather flatter. At one of the pointed ends is a small hole through which is passed a short string made of twisted [-fibre\inner bark]; there has also been a corresponding hole at the other end, but this has been broken out. It probably was suspended from the ends by the string across the throat or breast. It was considered of very great value. L 5 4/10 in. D in the middle 1 7/10 by 1 7/20 in. Captain Cook's collection, [-1772-1774 \stet./] No.?. \No 139/. Given by Reinhold Forster, Esq. [-It is a question if this object is from New-Zealand as the string is of twisted inner bark, not flax fibre of which the New-Zealanders usually make their cord.] \In Cook's 1st Voyage vol III. pl. 13. p.49 a New-Zealand man is represented wearing a whale tooth ornament, but not of this shape./ There is an uncertain object of \hollow/ Whales? tooth in the Esquimaux Collection see No. 716, perhaps this is New-Zealand. It looks as if it had been used on the end of a spear shaft, or perhaps

hung round the neck as there are small holes through it at the wide end.

1540 An ornament, probably from Tahiti, \but ?/ of somewhat similar form to No. 1539, but much smaller, made of opaque white shell veined and mottled with brown. Used suspended from one end only, which is perforated and receives a thick cord, apparently made of the same kind of inner bark that the Tappa cloth is made of, neatly twisted together. The ornament is smoothly polished over the whole surface. L 3 4/10 in. Greatest D 1 3/20 by 17/20 in. L of cord 30 in. and Th 3/10, of a whitish colour. Captain Cook's Collection, No 139?. [1772-1774 \stet./]. Given by Reinhold Forster, Esq.
Ashmolean 1836, p. 184 no. 195 [?].

1541 A similar ornament to No. 1540, and of the same kind of shell, but the surface less smoothly finished. The upper end has been perforated, the hole having been drilled from each side until it met in the middle. The line is wanting L 3 7/10 in. Greatest D 1 1/10 by 8/10 in. Captain Cook's collection, No. 140. [-1772-1774 \stet./]. Given by Reinhold Forster, Esq.
Ashmolean 1836, p. 184 no. 195 [?].

1542 A pendant ornament made of an uncut whales' tooth suspended by a fine string to which is fastened a small lock of reddish brown human hair. The tooth is in its natural state the holes for the string being perforated through each end. History and locality unknown, but probably from New Zealand. L 3 5/10 in. D 1 2/10 which end is hollow, decreasing to an obtuse point at the other end. Probably belonging to Captn. Cook's collection.

1543 A flat\tish/ Pendant ornament of black slate, or fine stone like basalt; of nearly coffin-shaped outline, with slightly rounded sides and edges. The top which is perforated, the hole being drilled from each side, has a ribbon of brown silk through it. This end has a few ununiform notches cut in it, the other end being [-strait] square. L 4 7/10 in. W in the middle 1 11/20 in., decreasing to each end to Th 7/10 in. in the middle 4/10 in. decreasing both to the sides and the ends. (Ramsden Collection No. ?) Purchased by the University in 1878 \Both the sides are quite plain and somewhat convex or rounded from edge to edge. It is likely to be from New-Zealand or any almost of the South Pacific Islands/.

1544 A long, oval-shaped, flat, and smooth piece of bone, \perhaps human blade bone/, L exactly 6 in. W 2 1/20 in. in the middle, and Th about 1/10 in.: perforated at one end and [-slung on\wired to] a small round cord of [-plaited\twisted] human hair. Use uncertain, but perhaps a pendant neck ornament. Probably from New-Zealand, \or the Fiji Islands, but ? But query if from the size of the cord whether it ever belonged to the pendant/. (Captain Cook's collection, 1772-1774 No. ?) Given by Reinhold Forster, Esq.

1545 A netting? needle, of hard dark brown wood: from Tahiti. L 16 3/10 in. D 9/20 by 5/20 in. at the eye, gradually decreasing in size to the point, and oval shaped in section. (Captain Cook's Collection, 1772-1774 No. ?). Given by Reinhold Forster, Esq.
Ashmolean, 1836. p. 184. no. 197.

1546 A similar but smaller needle, from New Caledonia of hard black wood, but the sides being flattish, the edges rounded. L 13 in. D at the top 9/20 by 5/20, from whence it gradually decreases to the point. Top rounded, or rather obtusely pointed. The eyes in both of these needles are round. (Captain Cook's collection, 1772-1774. No. 141). Given by Reinhold Forster, Esq. How is it certain that this article No. 1546 is from New Caledonia it is very similar to the preceding, No. 1545, and they are both entered in the 1836 catalogue as from Otaheite.
Ashmolean 1836, p. 184 no. 197.

1547 A small tatooing chisel from Tahiti. It consists of a slender black wood handle, L 5 1/10 in., the larger end flat above, and deeply notched on the underside for the finger; from whence it is round and gradually diminishes to a point at the other end, near which a small bone of a bird L 1 2/10 in., and W 3/20 in. wide is securely bound on at an angle of about 60° with the handle, and directed inwards, the end of the bone being ground to a sharp edge, and cut into four very fine teeth, the four together measuring little over W 1/10 in. When used the points are struck into the skin with a small wooden mallet (see No. 1548), the pattern being already traced or scratched into it as desired: but this instrument must have been for minute work or short curves, as some such tools are more than 1 in. broad, and having as many as thirty teeth. See plate 10 in Cook's "First Voyage". vol: 2. Captain Cook's collection, [-1772-1774 \stet/]. No. ? Given by Reinhold Forster, Esq. (See Wood's Nat: Hist: of Man. vol: 2. p. 115. figs. 2 and 4).
Ashmolean 1836, p. 184 no. 198.

1548 An instrument from Tahiti, of very dark brown and hard wood; also used in the tatooing process. The head is of a paddle, or elongated pear-shaped outline, quite flat on both sides, and with square edges, L 5 2/10 in., greatest D or W 2 1/20, and Th 1/12 in., elongated at the small or lower end into a long slender handle L 13 6/10 in., thin and quadrangular in its upper part and D 2/10 in., and gradually increasing in size, and the quadrangular form changing to a round to within a short distance of the other end where it measures D 5/10 in.: and from thence gradually decreases to the end which is rounded off. The use of such an instrument, as described in Captain Cook's "First Voyage", was to strike the points of the preceding kind into the skin. This might have been performed with the handle which is enlarged towards the end, perhaps the chief use of the flat part was to

mark out the curves of the pattern to be punctured; as the outline could be made to produce any curve, either hollow or round, if not sharper than that of the extreme end of the pricking instruments; and from the general regularity of the curves on tattooed New Zealand heads, it is probable that some such method of marking out must have been followed. An instrument of this kind, \probably this one/ is also figured in plate 10 of Cook's First Voyage. vol: 2. Whole L 18 8/10 in. Captain Cook's collection, No. ? [-1772-1774 \stet/]. Given by Reinhold Forster, Esq. For the tatooing process, see Wood's "Nat: Hist: of Man". vol: 2. pp. 114-117.
Ashmolean 1836, p. 184 no. 198.

1549 A tattooing instrument \said to be/ from the Fiji Islands, somewhat similar to No 1547, but larger, and coarser make. The handle of yellow reed \or the flowering stem of some grass/ is straight & round, L 8 in. and D 5/10, on the end of which a flat piece of white bone 2 in. long, W 5/10 in., and Th 1/16 in., securely and ornamentally bound on at nearly a right angle to the handle, with narrow bands of plaited cocoa-nut fibre. The bone blade gradually diminishes from the top to the bottom to a fine edge which is cut into eight sharp teeth \three of which have unfortunately been broken off/. The binding on the head of this instrument is \a/ good illustration of the regular, ingenious and ornamental manner in which such work [-was\is] generally performed. See No 1262 and 1263 purchased in 1867. In reference to the skill and taste shown by Fijians in tattooing, see Ellis's "Polynesian Researches" vol: ? p. ? And with the New Zealanders, and Marquesas Islanders, see Wood's "Nat: Hist: of Man" vol: 2 pp. 114-117, and pp. 383-386.

1550 A wooden club-shaped mallet, used in making cloth by the natives of Tahiti and other South Pacific Islands. It is of hard, very heavy, and very dark brown wood, L 14 8/10 in., and 2 2/10 in. square hollowed out and rounded at one end for grasping with the hand. Each of the four sides is also slightly rounded and grooved lengthways in straight parallel grooves, one side having coarse and the others, in various degrees, finer grooves; the number of grooves on the four sides being respectively 13, 26, 42, and 56, all cut with great regularity. The square end is flatly and smoothly rounded, the handle end very roughly rounded. Used by the women in beating cloth, which is made of the inner bark of the Paper Mulberry tree. \A very similar implement is figured in Cook's 1st Voyage. vol: 2. plate 9. [-fig.] p. 212/. Captain Cook's collection, [-1772-1774 \stet./]. No ?. Given by Reinhold Forster, Esq. For the way in which these mallets are used, and the manner of preparing the cloth, see Wood's Nat: Hist: of Man. Vol: 2. pp. 308-311, and pp. 349-351,

and Cook's 1st Voyage vol: 2. pp. 210-213, and colouring cloth 213-216.
Ashmolean 1836, p. 185 no. 204.

1551 A similar, but smaller, and more coarsely made mallet, of black wood; from the Sandwich Islands. L 15 9/10 in.; 1 4/10 in. square the sides nearly flat, and the number of grooves on the four side[s] being respectively, 5, 8, 20, and 29. Handle part roughly rounded, and also \the ends/. Given by the Trustees of the Christy Collection London 1869, in exchange.

1552 A Polynesian mallet, probably for the same use as No 1550 & 1551, but cut from a solid piece of whitish bone, probably of the whale. L 11 6/10 in. Greatest D 2 2/10 by 1 8/10 in. The sides are flat, the face which is 6 8/10 in. long is rounded considerably from end to end and also from side to side, and is deeply grooved longitudinally with ten well made, narrow, parallel straight grooves. The handle part is much smaller than the other part, has been cut to nicely fit the hand, and the end cut in shape of the end of a [-whales\Fishes] tail or perhaps that of a Shark or Dolphin. The back is concave from end to end following somewhat the line of the front, and somewhat rounded from side to side, and carved with several ornamental, curved, deeply incised lines, some of which have been intended to represent a human face. Locality unknown. (Ramsden Collection No. ?). Purchased by the University in 1878.

1553-1554 Four patterns for printing on Masi cloth: from the Sandwich Islands, \and one from the Island of Mauti/. They are very neatly cut in long flat and narrow strips of bamboo, L from 17 9/10 to 13 3/10 in., and W 5/10 to 3/10 in.; the patterns being cut in relief at one end, and on side [? one side of] the wood only, and L about 2 to 2 5/10 in. See Introductory remarks, paragraph No 6. Given by the Rev: A. Bloxam, M.A. Worc[ester]: Coll[ege]: 1826. [drawings]
Ashmolean 1836, p. 185 no. 205.

1555 A Priest's Comb from the Friendly Islands: made of 16 narrow, round, straight pointed strips of palish brown wood L 5 in., kept together and in a line by a very neat but strong binding round the upper part of a thin wire like dark brown fibre \probably cocoa-nut fibre/, in a beautiful interlaced or woven manner. The upper ends of the strips being bound together to form a point or short handle a little over L 1 in. which is also very neatly and curiously bound with the same kind of dark brown material \apparently/ interwoven with the fine split ends of the strips or else with a lighter brown fibre. Whole L 6 2/10 in. Spread of the points of the teeth 2 5/10 in., converging to W 1 in. at the top, which is finished by the ornamental point. An article of this kind is figured in Cook's "Second Voyage", \vol: 1/ pl: 21. See also Wood's "Nat: Hist: of Man". Vol: 2 pp. 291 & 292. Captain Cook's collection, 1772-1774. No ?. Given by Reinhold Forster Esq.
Ashmolean 1836, p. 184 nos. 181-3.

1556-1557 Two very similar Combs, except that the strips of wood forming the teeth are not so finely rounded and pointed, and that they are rather wider, and have not the ornamentally bound pointed projection at the top, No. 1556 being straight and apparently broken off there, and No. 1557 cut to a slope or gable shape. L of No. 1556 4 9/10 in.: W at bottom 2 4/10 in., converging to 1 4/10 at top. L of No. 1557 4 17/20 in.; W at the bottom 2 5/10 in., converging to the top to 1 5/10 in. The first has 14 strips or teeth, the other 20. [-Query if these combs are not Fijian] Captain Cook's collection, 1772-1774. No ?. Given by Reinhold Forster, Esq.

1558 A comb from New Caledonia, made of 16 long, thin, rounded strips of hard black wood, (four of which are either entirely wanting or partly wanting): bound together in a loose manner at the top with a brown, [-woolly\thin] woolly lo[o]king binding, but quite moveable. Each strip decreases in size [-from\at] the bottom [-to\and at] the top the latter having a little knob on it to prevent it slipping from the binding. L 10 5/10 in. W at top 1 3/10 in. In reference to these Islanders and the Combs Captain Cook says "Their rough heads most probably want frequent scratching, for which purpose they have a most excellent instrument. This is a kind of comb made of sticks of hard wood, from 7 to 9 or 10 in. long, and about the thickness of knitting needles. A number of these, seldom exceeding 20, but generally fewer, are fastened together at one end, parallel to and near 1/10 in. from each other. The other ends, which are a little pointed will spread and open like a fan, by which means they can beat up extensive quarters at one time. They always wear these "combs, or scratchers" in their hair, on one side of the head". An instrument of this kind is figured in Cook's "Second Voyage" \vol: 2/ pl: 20. \Fig 4 and described pp. 118-119/. Captain Cook's collection, 1772-1774. No ?. Given by Reinhold Forster, Esq.
Ashmolean 1836, p. 184 nos. 181-3.

1559 A similar implement to No. 1558, but smaller, and of brown wood, the strips \or teeth/ being \only/ nine in number, and each decreasing slightly and gradually in size to the top. L 7 9/10 in.; W at top 8/10 in. (Captain Cook's collection, [-1772-1774 \stet./]. No ?) Given by Reinhold Forster, Esq. \Compare the binding on these two articles with that on No. 1454 and 1506 which are also from New Caledonia./
Ashmolean 1836, p. 184 nos. 181-3.

1560 A musical instrument of reeds, on the principle of Pandean Pipes, from the Friendly Islands. They are ten in number about D 3/10 in., varying from L 9 8/10 to 6 8/10 in. and consequently in the sounds that are produced from them, and arranged irregularly as to length \so as to make the tune/. Whole W 3 5/10 in. They are tied together \near the top and bottom at 5 2/10 in. apart/ with a thin binding of some \fine/ tough fibre. This instrument is represented in Cook's

"Second Voyage" \vol: 1/ pl: 21. \p. 221/. Captain Cook's Collection, 1772-1774. No ? Given by Reinhold Forster, Esq. \Unlike the following two articles, the [-red] reeds are cut away or bevelled off at the top on each side to allow for the lips, the others being straight/.
Ashmolean 1836, p. 184 no. 176.

1561 A somewhat similar instrument from the Island of Tanna, New Hebrides: consisting of 8 reeds, L from 2 3/10 to 5 6/10 in., regularly graduated both for size and length. Whole W 3 2/10 in. The binding is thick, single, and apparently of some kind of rush or grass, or perhaps narrow strips of palm leaf with a thin binding of some different substance above it. This instrument is figured in Cook's "Second Voyage", vol: 2 pl: 18. Fig: 3. Captain Cook's collection, 1772-1774. No ?. Given by Reinhold Forster, Esq.
Ashmolean 1836, p. 184 no. 177.

1562 A very similar instrument, and probably from the same place as No. 1561 consisting of seven reeds, one of which is very short and small, and may have been broken off. L 5 3/20 in. W of all the reeds 2 6/10 in. The binding is the same, except that the upper thinner one is twisted like a piece of string. \A similar instrument is figured in Cook's 2nd voyage, vol: 2, pl: XVIII Fig 3/. Captain Cook's collection, 1772-1774. No. 15 or 13?. Given by Reinhold Forster, Esq.
Ashmolean 1836, p. 184 no. 178.

1563 A Bracelet of \Hog's or/ Boar's tusks from the Sandwich Islands. It is composed of twenty-two tusks, very little altered from their natural form, except that they are ground smooth all over and polished, ground flat on the sides, and made somewhat thinner in the middle. They are strung close together side by side, through two holes made through each of them, about 2 in. apart near the middle, the strings being made of some twisted hemp-like substance. The whole, when open, forms a curved band about 8 in. wide and 4 deep. But all the tusks being threaded on the double string, they are with that drawn in a ring round the wrist when worn. A bracelet precisely similar in form is represented in Cook's "Third Voyage" pl: 67 Fig: 5 Given by the Rev: [-A\Andrew] Bloxam M.A.: Worcester College, 1826. See Wood's "Nat. Hist: of Man" Vol 2. p. 799, where a similar article is figured.
Ashmolean 1836, p. 184 no. 191.

1564 A Bracelet from the Sandwich Islands of twenty boars' tusks, the ends of each being cut off so as to reduce them to L 1 8/10 in., ground smooth all over and polished, and threaded as in No 1563 on a double string. All the lengths of tusks have three or more perforations, apparently shewing that they had formerly been strung on three strings instead of two as at present or else that they had been used in some other manner. They form a band and tie in a ring round the wrist as in the preceding. One of the end pieces of tusk is not filed off smooth at [-both] both ends as the rest, but has a piece of the root of the tusk adhering, and

projects beyond them, being L 2 1/10 in. Given by the Rev: [-A\Andrew] Bloxam M.A. Worcester College 1826.
Ashmolean 1836, p. 184 no. 191.

1565 Three unpolished and uncut boar's tusks, used as Bracelets, said to be from Otaheite, but more likely from the Sandwich Islands. L [-] across the hollow from end to end 4 2/10; 4 4/10; and 4 8/10 in. Round one is tied a piece of cord of plaited cocoa-nut fibre. \Probably/ Captain Cook's Collection, 1772-1774. No. ? Given by Reinhold Forster, Esq.
Ashmolean 1836, p. 184 no. 188-190.

1566 Bracelet or Armlet, made out of the middle part of a small cocoa-nut shell, carved in a very rude manner with zig-zag bands filled in with fine but very irregular incised cross lines: the inside is quite plain. A piece broken out of one side. D 3 5/20 in. W of material 1 7/10 in., and Th 2/10. It was broken in two and has been mended. From the Friendly Islands? Captain Cook's Collection. 1772-1774. No. 148. Given by Reinhold Forster, Esq. \Probably from the New Hebrides as see Cook's 2nd Voyage vol: 2. p. 80, "The bracelets are chiefly worn by the men; some made of sea-shells, and others of those of the Cocoa-nut"./

1567 A ring, perhaps a bracelet, curiously woven of fibre, perhaps cocoa-nut fibre, and some other \brown/ material like woolen threads, the fibre forming a kind of [illeg.] wavy pattern along the front. The ends are simply plaited and left ragged. Locality uncertain, but probably from New Caledonia. [-History unknown.\Probably Cook's Coll. No. ?] Compare some of the material of this article with that on No. 1454, 1506, 1507, 1558 & 1559 \and 1454 which are from New Caledonia/.

1568 A string or necklace L 6 ft. 2 5/10 in., composed of sections of small white Dentalium shells L about 3/10 in., alternating with two thin, brown cylindrical things, strung side by side, perhaps also some kind of shell or marine substance, of some horn like material; may be another species of dentalium. It is made on a fine double string of some fibre. ? Captain Cook's Collection, 1772-1774. No. ? Given by Reinhold Forster, Esq.
Ashmolean 1836, p. 184 no. 194.

1569 A string or necklace of small beads, probably from the Friendly Islands. Made of short cross sections of some long, narrow, and cylindrical white shell, strung upon a very finely made string of twisted fibre; the hole in each bead having apparently been drilled from each side until it met in the middle. There is a small patch of black beads \L 1 6/10 in./, of some very similar material, \gorgonia stem/, strung between. The white beads are similar to those used in the ornamentation of the baskets. No. 1329 & 1330. Whole L 44 in. D of beads 2/10 to 3/20 in. ?(Captain Cook's Collection, 1772-1774. No. ?) Given by Reinhold Forster, Esq.

Ashmolean 1836, p. 184 no. 194.

1570 A string or necklace, probably from the Friendly Islands, of somewhat \similar/ material to the preceding No. 1569, but much larger, about half the beads being [-black\dark brown], and half white, the former appears to me made of some hard dark brown wood, or may be of cross sections of the stem of a Gorgonia; and the white, from the ribs on the side are apparently of some kind of cockle shell. The edges of the beads are irregular particularly of the dark ones. L 7 ft. 6 in. D of the beads about 3/10 in., and Th about 1/10. ? Captain Cook's Collection, 1772-1774. No. ? Given by Reinhold Forster.
Ashmolean 1836, p. 184 no. 194.

1571 A string or necklace of similar materials to No. 1570, but the beads much smaller, and the string short; with the figure of a bird, and five other unknown ornaments cut in whale's tooth attached, and which measure from L 9/10 to L 1 17/20 in. L of necklace 21 in.: D of [-disks\beads] from 3/20 to 2/10 in. ?Captain Cook's Collection, 1772-1774. No. ? Given by Reinhold Forster, Esq.
Ashmolean 1836, p. 184 no. 194.

1572 A similar but very short string of black and white beads very variable in size, with two perforated teeth like dog's teeth suspended to it. The thread is made of strips of thin inner bark. L of necklace 10 5/10 in. L of teeth 2 4/10 and 9/10 in. Size of beads D 3/10 to 1/10 in. ?Captain Cook's Collection, 1772-1774. No. ? Given by Reinhold Forster, Esq.
Ashmolean 1836, p. 184 no. 194.

1573 A string or necklace said to be from the Society Islands; but more likely from the Friendly Islands: Consisting of a small cord of twisted brown human hair, on which are very thinly threaded several small white beads D about 1/10 in., and similar to those used in the decoration of No. 1329, 1330, 1331, 1332, and 1333, and also of No. 1569, 1571 and 1572; and three small pointed pale red univalve shells \([])/. Whole L 2 ft. 2 in. ?Captain Cook's Collection, 1772-1774. No. ? Given by Reinhold Forster, Esq.
Ashmolean 1836, p. 184 no. 194.

1574 A Necklace \from New Zealand/ consisting of 21 rows, and each row L about 30 in., of milk white bugle-like shell, of a small smooth species of Dentalium. On one of the strings is threaded alternately with the white, ten similar shaped very thin shells of a dark shining brown colour resembling horn, and like those threaded alternately with the white on No. 1568; apparently another species of dentalium. [-Locality unknown] but no doubt from the same place. The strings which are made of some twisted fine fibre, like flax or hemp, are tied \at/ the ends and then rudely

plaited. ?Captain Cook's Collection, 1772-1774. No. ? Given by Reinhold Forster, Esq.[40]
Ashmolean 1836, p. 184 no. 194.

1575 A Necklace from the [-Friendly Islands\New Zealand? or the Friendly Islands?]; consisting of eleven bundles of small cylindrical bones; each bundle containing 10 or 11 apparently wing bones of some bird; D of about 1/6 in. and cut to about L 2 5/10 to 1 8/10 in., the bones in each bundle being of about one length, and the two longest bunches being the end ones. The [-bunges] bunches of bones alternate with bunches of a small, pointed, univalve shell, of a violet colour, of the genus [], about thirty shells being in each bunch. Rude as these materials are, from the contrast between the white of the bones, and the dark colour of the shells, this ornament, for savage life must have had a striking and not inelegant effect on a dark skin. Whole L 4 ft., a bunch of the Shells forming each end. L of the ornamented or necklace part only 2 ft. 8 in., the threads which are made of some fine twisted fibrous material similar to flax, as in No. 1574 being left bare for some distance at each end for tying. The little shell appears to be the same \(?genus)/ as that used in No. 1573. ?Captain Cook's collection, 1772-1774. No. ? Given by Reinhold Forster, Esq. \Possibly No. 1575 and 1576 are from New-Zealand, as the thread on which they are strung looks as if made of the New-Zealand flax, see Cook's 1st Voyage vol: III p. 53, where the women are said to [-] wear bracelets and armlets of the bones of birds and shells. For reference to the Friendly Islands Necklaces, armlets, etc of the bones [-] and shells, etc see 2nd Voyage vol: I p. 219./
Ashmolean 1836, p. 184 no. 194.

1576 A Necklace of similar materials, but different in construction to No 1575, [-probably from the Friendly Islands\from New-Zealand]. Originally consisting of twelve \separate/ rows (eleven only of which remain perfect), each row L 3 ft. 6 5/10 in., of some bird's bones, similar to but smaller than those in the preceding necklace, [-and] each cut to L about 1 5/10 in. and each bone threaded alternately with a single shell of the same kind as those used in that necklace, (Genus []). The ends of the threads are also left bare for tying, and finished with a little bunch of the same shell. The strings are made of fine twisted flax like fibre. Whole L 5 ft. 5 in. ?Captain Cook's Collection 1772 - 1774 No? Given by Reinhold Forster Esq.
Ashmolean 1836, p. 184 no. 194.

1577 A string or necklace, from Van Dieman's Land, bought off the natives. It consists of one hundred and nineteen small, brilliantly iridescent, pointed, univalve, \all/ of the same species, but varying a little in size, of

[40]This necklace is from New-Zealand, as the thread is made of the native flax plant. See Cook's 1st Voyage vol:3 p. 53, and 3rd Voyage vol: 1 p. 156. The same references apply to No. 1575 and 1576 following.

the genus, \(elenchus?)/ each perforated near the mouth and the whole strung on a thin white thread, the backs or points of the shells being directed outwards, but some of these have been broken off. Whole L 14 5/10 in. L of the shells from 6/10 to 4/10 in. Burchell Collection. Given by Miss Burchell his sister, 1865.

1578 A Necklace on the same principle, and probably from the same country or from some of the South Pacific Islands. Made of one hundred and twenty small thin dirty white shells tinged with brown, of a pointed shape, and apparently land shells of the genus bulimus, perforated near the mouth as in No 1577 and strung in the same manner upon a string of twisted fibre like flax. L 15 in. L of shells from 6/10 to 4/10 in. (Probably Burchell Collection) ?Given by Miss Burchell in 1865.

1579 Portion of a string or necklace? probably from the South Pacific; of ten white shells tinged or blotched with brown, of a genus resembling Strombus, L from 1 1/10 to 7/10 in.; each perforated and clumsily bound on a string composed of narrow strips of inner bark, [-or rush]. Whole L 6 in. History unknown. Possibly of Burchell's Collection. Given by Miss Burchell in 1865.

1580 A Necklace, made of twenty-five thick, white shelly operculums, of some marine shell, perhaps of the genus Natica, each perforated and attached to a cord made of cocoa-nut fibre. Whole L 2 ft. 2 in., D of disks 1 to 2 in., the larger ones arranged in the centre and decreasing regularly in size to each end. \The perforations have been worked from each side until they met in the middle/ Locality unknown, \but may be Marquesan, or any other Polynesian group/ Ramsden Collection No. ? \160/ Purchased by the University, 1878.

1581 A necklace originally made of twenty-seven white somewhat egg-shaped [-white] shells, of the genus Natica, (three of which have been lost), perforated by simply having holes broken through them at the back, and attached to a cord made of twisted cocoa-nut fibre. The shells are arranged decreasing in size from the middle to each end, and most of them have more or less smears of some [-red\brown] colour perhaps blood, but not the cord, which is coarsely and rudely made. Whole L 2 ft. 6 in. Shells varying in L from 1 5/10 to 1 in. \Where from uncertain but may be from the Marquesas Islands/ (Ramsden Collection No. ?) Purchased by the University in 1878.

1582 A collar or necklace. Probably from the South Pacific Islands \or from the Esquimaux/: made of thirty three pieces of bone cut into a \long/ pointed oval shape, \nearly/ flat on each side, each perforated through sideways at one end, so that when threaded they would spread round below the neck in a kind of rayed collar. The pendants vary in size from L 2 8/10 in. by W 13/20, to L 1 2/10 by W 9/20, the largest being in the middle and decreasing in size to the ends. The original string is lost and they are now threaded

on a piece of English copper wire. (Ramsden Collection No. ?) Purchased [-for\by] the University in 1878.

1583 An ornamental band L 9 3/4 in. of the teeth of [] ? drilled and securely bound together side by side. Captain Cooks collection (This is copied from Mr Rowell's late Underkeeper's writing, the article corresponding with length stated cannot be found, perhaps No 1584 may be it).

1584 A band about L 3 1/2 in. of the front teeth of some rodent, each of the twenty teeth having the ends ground off, neatly drilled through near the top and bound together with what looks like well made cotton threads which may once have been white but are now dirty. L of each tooth 1 2/10 in. History unknown, probably [-rather] South American rather than Polynesian.

1585 Ditto of nine human? front teeth, which are drilled through near the top, and bound together in the same manner \with cotton threads/, both ends of each tooth having been ground off. L of each tooth 1 in. History unknown. Possibly South American.

1586 An ornament \probably from New Zealand/ of twenty-one human teeth, incisors and bicuspides, there being nine of the former, and having the sides ground down to a thin wedge like upper end, where they are perforated and strung on a kind of root or twig which is twisted round into a ring, the teeth lying close together side by side and forming a kind of horse-shoe shaped ornament, and appear kept from exactly touching each other by a well made thread wound round. D 2 5/10 in. Captain Cook's collection, [-1772-1774 \stet./]. No. ? Given by Reinhold Forster, Esq. \This ornament is said in the 1836 catalogue to be from Otaheite, but is more likely from New-Zealand as see Cook's 1st Voyage vol: III p. 53, where the native's are said to wear in their ears the Nails and Teeth of their deceased relations./
Ashmolean 1836, p. 184 no. 187.

1586a An ornament? Made of numerous fine plaits of black human hair, very long, doubled in the middle, and formed into a strong loop composed of five others, the five being strongly woven \or bound/ together with fine grass. It is impossible to say what its original length was, but probably 6 or 7 ft., and at present there are upwards of 200 plaits. Each plait being about 1/12 in. wide. From the South Pacific Islands, but locality uncertain. Ramsden Collection No. ? Purchased by the University 1878.

1587 A Australian Tomahawk or Axe-head of stone; very similar in form to some of the stone celts of Europe. Said to have been used for cutting notches to ascend trees. It is of \dark grey/ basalt, L 5 9/10 in., W 3 and 1 4/10 in the thickest part. The back is rough, the other end being very regularly rounded and ground to a semi-circular sharp cutting edge. Found near

Buckland Bridge Ovens, S. Australia Given by Robt Rawlinson, Esq C.B. C.E. 1865 For figure and description of such articles, see Wood's "Nat: Hist: of Man" vol: 2 p. 32 fig 1 and Evans' Stone implements of Great Britain p. 150
Ashmolean 1836-68, p. 13.

1588-1589 Two fishing spears from [-South Australia \New South Wales]. Shafts of \very/ light \pithy/ wood, tolerably straight, and tapering, each shaft having a socket at the larger end or head, in which a pointed piece of harder \darker/ wood, two or three feet long is inserted; one side of the latter is roughened by an irregular ridge of black gum-like, and other substance to hold on to any object pierced by it, but a good deal of this has been broken off. L 10 ft. 8 in. L of head of No 1588 2 ft. 3/10 in.; of No 1589 2 ft. 11 5/10 in., both probably poisoned. Given by the Venerable Archdeacon Scott, 1836. A spear of this form is figured in Meyrick's Ancient Armour, vol: 2 Pl: CL Fig: 15.
Ashmolean 1836, p. 183 no. 129.

1590 A Fishing spear from [-South Australia\New South Wales] shaft of the same kind of brown wood, or rather stick & as No 1588 and 1589, but having four instead of the single piece of heavier wood for the head, L 28 5/10 in., each of them pointed and barbed in a rude manner with small bits of bone. Whole L 9 ft. 6 8/10 in. D near the head 7/10 in., gradually diminishing to 4/10 at the end. Given by the Rev and Venerable Archdeacon Scott, 1836. A similar spear is figured in Meyrick's "Ancient Armour" vol: 2 pl: CL Fig: 16.
Ashmolean 1836, p. 183 no. 129.

1591 A spear from [-South Australia\New South Wales] made of a slender, tapering, crooked and knotted brown stick, of heavyish wood. The head which is in one piece with the shaft is 1 foot long, pointed, and three angled, with a series of barbs along each angle to the distance of 10 in. from the point. Whole L 9 ft. 5 4/10 in. Given by the Revd. Thos. Hobbes Scott M.A. Alban Hall Archdeacon of New South Wales, 1836. A spear of this kind is figured in Meyrick's "Ancient Armour" vol: 2 Pl: CL Fig: 17.
Ashmolean 1836, p. 183 no. 129.

1592 A \throwing/ spear, from New South Wales made of a similar stick to the preceding No 1591, but rather straighter, [-but] and the head merely acutely pointed. Whole L 7 ft. 8 7/10 in., D near head 7/10 in. gradually tapering to 2/10 at the other end. Given by the Venerable Archdeacon Scott 1836. For figures and description of Australian spears, see Wood's "Nat: Hist: of Man" vol: 2 pp. 38-40.
Ashmolean 1836, p. 183 no. 129.

1593-1594 Two Australian Wummerahs or Midlahs; sticks used by the natives in casting their Throw-spears. These are straight taper sticks L 35 8/10 and 35 5/10 in., with a small piece lashed on at the smaller end to form a hook, against the point of which the tail end of the spear is placed when about to be thrown. They are very similar in form to that figured in Wood's "Nat: Hist: of Man" p. 43 No 6 but are apparently much too weak for any club like purpose there alluded to. Given by the Venerable Archdeacon Scott 1836. For figures and description of similar article see Wood's Nat: Hist: of Man vol: 2 pp. 42-45.

1595 An Australian Wummerah, said to be also used as a club; probably from Swan River district. Of quite a different form to No. 1593 & 1594, being wide, and flat on the side for the spear, and slightly rounded on the back, the edges being somewhat sharp. The width is gradually reduced towards each end, on one of which is fastened a bit of bone, the other end having a knob of black-boy gum to serve for a handle. L 23 6/10 in. W 3 1/10 in. No history known at present of this article. Probably Captain Cook's Collection. (For figure of a similar article see Wood's "Nat: Hist: of Man", Vol: 2, p. 43.

1596 An Australian "Waddy", or Club, of sweet scented myal wood. It is tolerably straight and round, L 2 ft. 8 in., Th 1 9/10 in. at 9 in. from the head which is pointed, and gradually decreasing in size to the other end \which is obtusely pointed/. A similar club is figured in Wood's "Nat: Hist: of Man" \vol: 2/ p. 29, by the lower horizontal figure. Given by Mr. C. Wood, Oxford 1858.
Ashmolean 1836-68, p. 18.

1597 A similar, but lighter Club, \and of different kind of wood/ L 29 7/10 in., D 1 3/10 in. where thickest. There is a rude attempt at ornamentation on this article by three deeply incised longitudinal grooves between which are cut a few chevrons. The handle part is roughened by faintly incised cross lines. The grooves seem to be intended as edges whereby a blow may cut through the skin as well as inflict a bruise. This club is figured with the foregoing No 1596, by the upright right-hand figure in Wood's "Nat: Hist of Man" vol: 2 p. 29 Given by Mr. C. Wood Oxford 1858. \See also Meyrick's "Ancient Armour" vol: 2 the concluding vignette. Figure not numbered./

1598 A club shaped weapon, of hard, heavy, dark brown wood, probably from New South Wales. It is nearly straight, flattish, with the sides roughly rounded off to the edges, all of which are sharp. Handle end obtusely pointed where it is W 1 3/10 in., and bored as if for a string to pass through, whence upwards it gradually increases in width and thickness to the distance of 21 in. where it measures 5 3/10 by 1 5/10 in., at this point a rather prominent ridge extends across both sides, from whence it decreases in width and thickness to the distance of 6 in. to the end, which is rounded off. Whole L 2 ft. 3 in. The upper part for the L of 19 in. is thickly covered with incised bands of zig-zag and straight lines. (Ramsden Collection No. ?) Purchased by the University in 1878 A somewhat similar weapon is figured in the vignette at the end of

vol: 2 of Meyrick's "Ancient Armour" except that ours is but little bent over to one side.

1599 A flat, angular \[-or boomerang/] shaped club, approaching the boomerang form; of hard, dark brown wood; probably from New South Wales. It is keeled on all the edges. The handle part is straight and increases gradually in width from 1 5/10 in. at the end, upwards to the distance of 22 5/10 in., where it is 5 5/10 in. across, from whence it bends at an acute angle, and decreases in width for about 11 in. to an obtuse point. The tool marks are very conspicuous all over the surface, and the handle end has a hole through it as if for a string. Extreme L from [-point] end to end across the hollow edge, 28 5/10 in. Greatest W 5 5/10 in. (Ramsden Collection No. ?) Purchased by the University in 1878. A similar weapon, called a wooden scymitar, is figured in Meyrick's "Ancient Armour" vol: 2, the concluding vignette Fig: 3. See also Wood's "Nat Hist: of Man" vol: 2 p. 29 fig 1 & 2 and p. 50 fig 6 & 7.

1600 An Australian Boomerang, used by natives of Sydney and of western Australia, generally for striking an object at a distance. This is a flattish curved piece of hard and heavy dark brown wood, 33 1/10 measuring from end to end across the hollow edge. W a trifle over 2 in., and Th 5/10 in. in the middle, and rounded to a sharp edge on all sides, the end being somewhat obtusely pointed. The natives acquire great dexterity in throwing these weapons, not only in striking an object, but also causing the boomerang to recoil and return towards them. It is essentially an Australian weapon, no such thing being known to be in use in any other portion of the world. Given by J.K. Cleeve, Esq 1859. For figures of similar and description of the way of throwing them see Wood's Nat: Hist: of Man vol: 2 pp. 48-53.
Ashmolean 1836-68, p. 6.

1601 An Australian Boomerang similar in shape to the preceding except more curved, and both sides equally rounded. Used for striking objects at a less distance. With this weapon the greater the curve, the more easily are they made to recoil. L measured from point to point across the hollow edge 31 3/10 in. W 2 in.; and Th 4/10. Given by J.K. Cleeve, Esq. 1859.
Ashmolean, 1836-68, p. 6.

1602 A Heilman or Australian Shield, called "Tamarang" Used by Natives of Southern Australia. Of moderately hard lightish coloured wood L 28 7/10 in., W 2 8/10 in. in the middle and 4 6/10 deep, that is from front to back, and is quadrangular or lozenge shaped in section, largest in the middle, and gradually tapering to a point to each end. The front is more sharply keeled than the back, through which an oblong shaped hole is cut, forming the handle left to grasp by. These implements are used by the natives with great dexterity in turning aside the spears, or, from their being very solid, as a guard from a blow with the "waddie"; and from their being pointed, as weapons

also: The rude carving on this article, consisting of rudely incised lines arranged in different directions, fairly represents the ability and taste of the South Australian in works of ornamentation, and shows the great superiority on these grounds, of the Polynesians and New Zealanders. Given by G.H. Cox, Esq. Victoria Australia 1864. For figure and description of similar article see Wood's "Nat: Hist: of Man" vol: 2 p. 55 fig: 7 and p. 56. See also Meyrick's "Ancient Armour" vol: 2 Pl: CXLIX Fig: 10, \where it is said to be used with flat angular clubs such as that shown in Fig 3 of the concluding vignette of that vol: I should think a wider shield such as that shown figs 1 & 2 \of the same vignette/ must be generally used against spears./
Ashmolean 1836-68, p. 6.

1603-1604 Two Australian waddies, or heavy headed clubs; made of sweet scented myal wood. The handle is a good deal curved (particularly of one of them \No 1603/), rounded, L between 15 and 16 in. and D about 1 3/10 in.; with a large head, angular but somewhat rounded, and obtusely pointed at the top, L 4 9/10 in., W 3 9/10, and Th 2 6/10. The wood is heavy, hard, of a very dark brown with small patches of pale brown in it. Whole L of No 1603, 20 5/10 in.; of No 1604 20 in. Given by G.H. Cox, Esq. Victoria. Australia. 1864.

1605 A short club, or mallet? of hard heavy brown wood. This is a very rudely made article L 17 in. and about 2 3/10 in. greatest D but hollowed out to about 1 in. for the handle. The sides appear to have been originally roughly rounded, but have been partly flattened down in a rough way in four places as if cut with an axe or chisel. Locality not known. Around the handle is tied a piece of string made of twisted bark. The lower end is enlarged into a kind of oval shaped knob D 1 8/10 by 1 4/10 in., and the top somewhat rounded, approximating to an obtuse point. Could it have been for beating tapa cloth. Captain Cook's collection, 1772-1774 No. 173. Given by Reinhold Forster.

1606 A string eighteen yards long, composed of six hundred short pieces \or cross [? sections]/ of reed or small cane, of a light brown colour, each about L 1 in. and D 5/20, strung upon \strong/ string made of twisted vegeatable fibre. Used as a necklace by natives of Australia. Given by the Rev: W. Hayward Cox, B.D. St: Mary Hall, 1837.
Ashmolean 1836-68, p. 6.

1607 A Fishing spear, locality unknown but [-probably] from \some of/ the S. Pacific Islands. It is L 8 ft. 5 5/10 in., D 8/10 in. near the head, and gradually diminishing in size to the lower end, which is pointed. The head is made of two polished, [-and] pointed, and serrated pieces of hard black wood. L 19 in., the notched sides being inwards and directed towards each other, the teeth being cut backwards so as to hold the fish firm between the prongs. The points are fastened on with a binding of finely plaited cocoa-nut fibre W 4

in. (Ramsden Collection No. ? \57/) Purchased by the University in 1878. Similar spears are mentioned in Wood's "Nat: Hist: of Man" vol: 2 p. 280.

1608 A similar spear to No 1608 [? 1607], but longer, the points not polished, and the shaft not so smoothly rounded. The plaited cocoa-nut binding which fastens on the points, has a little fringe of dark feathers round the top. From some of the South Pacific Island. L 9 ft. 1 in. L of the points 20 5/10 in. (Ramsden Collection No. ?). Purchased by the University in 1878. (Compare the above two spears with fishing spears in the Esquimaux collection No 723 and 725).

1609 A Fishing spear having four long rounded points of black wood, each of which is pointed at the lower end and firmly but ornamentally lashed on to the outside of the top of the shaft with a narrow flat binding of plaited cocoa-nut fibre, eighteen narrow bands of like material extending at intervals down the upper portion of the shaft. The tops of the points have been broken off, and spread out forming a square measuring from one to the other of about 3 5/10 in. Whole L 7 ft. 6 in., L of points above the shaft 25 3/10 in. D of lower part of ditto 6/10 in. gradually decreasing upwards towards the points. D of upper part of shaft 1 in., decreasing gradually to the other end to 5/10 in. Probably from the Fiji Islands. (Ramsden Collection No. ?). Purchased by the University in 1878. For figure of a similar spear see Wood's Nat: Hist: of Man vol: 2 p. 279 by the right-hand figure.

1610 Fishing spear of exactly the same form as the preceding No 1609, with four long, plain, round wooden points which are fastened to the shaft with a binding of plaited cocoa-nut fibre W 7 5/10 in., below which are two other bands of the same material one W 5 5/10 and the lowermost 4 3/10 in. Whole L 7 ft. 9 in. The points have considerably warp[-h]ed. (Ramsden Collection No. ?) Purchased by the University in 1878.

1611 Fishing ? spear \of dark brown wood,/ having three long straight round points in a line \like a table fork/, cut out of one piece with the handle. It is very well made. Whole L 8 ft. 1 5/10 in.; of points only 2 ft. 1 in., spread of ditto at the ends 3 in. D of upper part of shaft 1 in., gradually diminishing to \the/ other end where it is 5/10 in. (Ramsden Collection No. [-?\538]) Purchased by the University in 1878.

1612 [-Two\A pair of] points or prongs of a Fishing spear, of similar kind to those of No 1607 and 1608, of hard black wood, keeled along the inner edge and serrated, some of the teeth being cut forwards and others backwards. The points have been broken off, and the other ends are pointed for insertion into the shaft. L 20, and 20 5/10 in. (Ramsden Collection No. ?). Purchased by the University in 1878.

1613 Fishing ?spear of rather pale brown \wood/ which has two long round plain points of black wood fastened to the top of the shaft with a narrow \thin/ binding of plaited cocoa-nut fibre. The tips of the points have been broken off. L 9 ft. 3 in. of shaft only 7 ft. 7 in., D of upper part of ditto 9/10 in., gradually decreasing to 5/10 at the end, and is a good deal warp[-h]ed out of the straight line. (Ramsden Collection No. ?). Purchased by the University in 1878.

1614 Short spear or lance of hard black wood; perhaps used for fishing. The top is pointed, immediately below which the sides are each cut to form thirteen flat and deep barbes [-wich] which regularly and slowly increase in size from the point downwards, the last being directed backwards. Whole L 6 ft. 3 in.; of the head or barbed portion only 19 in.; greatest D of ditto 1 3/10 in., gradually diminishing and rounded to the other end where it is 3/10 in. D (Ramsden Collection No. ? \49/). Purchased by the University in 1878.

1615 Short spear, or lance, of black wood and roughish finish, the file marks being very plain. The point which is \[-of one piece with the shaft is]/ 19 in. long, has three rows of barbes, [-three\ten] in each row, the last being double or directed forwards and backwards, and the barbes gradually increase in size from the front to the back. The whole of one piece of wood. D of shaft portion immediately below the point, 1 3/10 in., gradually tapering to the end to D 8/10 in. (Ramsden Collection No. [-?\328]. Purchased by the University in 1878. \A somewhat similar spear is figured in Wood's Nat: Hist of Man, vol: 2 p. 279, middle figure.

1616 A long spear, or lance, with shaft of brown wood and plainly rounded, with a long head of \hard/ black wood the point part of which is armed on each side for the length of 18 in. with fourteen barbes cut from the wood itself, below which it is smoothly rounded and plain except the lower part near the junction with the shaft which is ornamented with the two prominent zig-zag ridges, and intersecting lines of double rows of small punctures. The head is fixed to the shaft with a narrow flat binding of plaited cocoa-nut fibre over a layer of dark feathers. Whole L 10 ft. 1 5/10 in., of head part only 37 in. D of upper part of shaft 17/20 in., gradually diminishing to the other end to 5/10 in. The barbed part of the head slopes down to the edges from a kind of central ridge. (Ramsden Collection No. ?). Purchased by the University in 1878.

1617 A rather long lance or spear of dark brown wood, with a point made in two pieces and armed with three rows of barbes, nine barbs in each row, and gradually increasing in size from the point backwards. The point, at least the lower part, has been cut out of one piece with the shaft. Whole L 10 ft. 6 5/10 in.; L of point only 17 in. D of upper portion of shaft 1 in., gradually diminishing to the other end to 3/10 in. (Ramsden collection No 336) Purchased by the University in 1878.

1618 The [-point\head] of a spear, of hard, pale brown wood, 27 in. long; the point for the length of 6 8/10 in. has three rows of barbes arranged triangular ways,

nine in each row \and directed backwards/ below which for about 4 in. it is round and plain, afterwards having three sets of larger and sharper barbes, three in each set, and directed [-backwards\forwards] towards the point; below which it has the zig-zag ridge, as in No 1616; the lower end being round and pointed for insertion into the top of the shaft. Two of the larger barbes have been broken off. (Ramsden Collection No. ?) \51A/ Purchased by the University in 1878 \Probably it came from the same place as No 1617.

1618a The point of a spear, of black wood with three rows of barbes cut from the wood itself and all \with the points/ directed backwards; 7 in each row arranged triangular ways.

1619 A flat closely plaited band of some whitish material, somewhat resembling cotton, apparently some kind of fibre resembling the New Zealand flax plant, but whiter. Each of the ends form three short plaits. Worn as a Maro by natives of Egmont Island, South Pacific. Whole L 8 ft. 7 in. W 1 7/10 in., the edges being parallel. Captain F.W. Beechey R.N. \1825-/ 1828.
Ashmolean 1836, p. 187 no. 364.

[-**1620** Portion of a rope made of twisted, coarse, black, woman's hair, resembling horse hair; with here and there a few grey ones amongst it. From Easter Island, South Pacific. L 3 ft. 8 in. D 1 in. Given by J. Park Harrison, Esq M.A. 1880. This article has been entered before as No 1280.]

1621 A cast of white plaster of a wooden tablet having twelve horizontal parallel rows of hieroglyphics, or picture writing on each side; each row of signs being incised, and written in a very shallow groove or channel, perhaps intended to protect them from being defaced. The lines appear to read contrary ways \judging/ by the positions of the figures, so that the tablet has to be turned the reverse way to read every other line. The clue has not been discovered. Sides of tablet nearly flat, the ends being about half circular, and all edges rounded off. It is somewhat crooked or warped from end to end, the larger hollow on one side being the consequence of a burn in the original. The original tablet with some others are from Easter Island, South Pacific, and are now in the Museum at Santiago Chili. L 17 8/10 in. W varying between 4 8/10 and 4 in.; and 1 1/10 in. greatest Th. Deposited by J. Park Harrison, Esq M.A. 1884.

1622 A roll of rough Sharks skin. Used as a rasp or file by natives of the South Pacific Islands. It is tied round one end with a small cord made of twisted inner bark, apparently for the purpose of suspending it when not in use. Locality uncertain. L 13 5/10 in. D 2 in. Captain Cook's Collection, 1772-1774 No. 96. Given by Reinhold Forster, Esq.

1623 The skin of the foot and lower part of leg of an Albatros, stuffed tightly with tow. History unknown.

Perhaps used as a bottle or pouch, or more likely as a kind of charm. L 11 in. W 7 in., and 1 5/10 in. thick. \This is much more likely to be the work of English sailors, probably ultimately intended for a tobacco pouch./

1624 A circular band of small parrot's feathers variously coloured, red, yellow and green being most conspicuous; fastened to a small cord made of twisted bark or grass. It has been a great deal damaged by moth. W about 13 in. Depth of the fringe 3 5/10 in. Probably an ornament for the head. Probably from \New Zealand/, the South Pacific, or New Guinea. Captain Cook's collection, 1772-1774 No. ?. Given by Reinhold Forster, Esq.
Ashmolean 1836, p. 184 no. 179.

1625 A large two-handed sword-shaped weapon, probably from Australia? of very dark brown coloured wood which is hard on one side and apparently somewhat pithy on the other. The handle portion is rudely perforated through in some unknown pattern and ends with a large crescent shaped projection or pommel. There is a rudely incised band of diagonal lines W 5 5/10 in. across the widest part of blade, on the hard or rounded side, the other or flatter side being unornamented except being coloured reddish \with some hard substance/. Whole L 5 ft. 1 5/10 in., Greatest W of blade 4 8/10 in., which is at 3 ft. from the top, and gradually tapering to a point. W of crescent shaped pommel 5 3/10 in. (Ramsden Collection No 1356 & [1]325) Purchased by the University in 1878.

1626 A cylindrical rod of hard black wood, the upper portion for the length of 20 in. ornamented with two long knobs incised with deeply cut diagonal, parallel lines, below which is a thick but very neat binding of crossed threads of plaited cocoa-nut fibre. The lower part for the length of 34 5/10 in. being plain smoothly rounded, and slightly tapering to the bottom. Whole L 4 ft. 7 in: Greatest D 1 5/10 in. Probably from the Fiji Islands, \as the remainder of the objects given by Mr Drewett are from there/ and possibly used as a walking stick or sceptre. \Brought home and/ Given by W. Drewett, Esq Oxford 1870.

1626a A long cylindrical stick of brown wood, of nearly the same diameter throughout its whole length, and rather well rounded. Both ends squared off. Where from uncertain, but perhaps from the South Pacific Islands. ? if a walking Staff.

1627 The \barbed/ head of a spear, of black wood, of the same character as \the spear/ No 1509. L 49 5/10 in. From the Fiji Islands. Brought home by, and given by Mr. W. Drewett Oxford 1870.

1628-1629 Two thick waist belts made of numerous narrow strips of inner bark; resembling \thin/ wood shavings, attached to the outside of twisted ropes of the same material. No 1628 of a black \white/ and pale

brown colour mixed, the latter being apparently the natural colour of the material; the other No 1629 being dark brown and black. Probably from the Fiji Islands. L about 4 ft. 4 in. (Ramsden Collection No. ?). Purchased by the University in 1878.

1630-1631 Two lances of light, brown wood: quite plain and smooth except for the length of 5 or 6 in. at some distance from one end, which is ornamented round with incised lines and indentations, and the figure of a grotesque human face carved in relief on one side. L of No 1630, 7 ft. 1 in. D 8/10 in., gradually tapering nearly to a point at each end, and L of No 1631 6 ft. 5 in., greatest D 1 in., \probably/ formerly decreasing to a point at each end, but these are now broken off. Possibly from New Caledonia, and thrown with a becket or loop, as in No 1506, and 1507. As see Wood's "Nat: Hist: of Man" vol: 2 p. 205 (Ramsden Collection No. ?). Purchased by the University in 1878.

1632 A carved grotesque human figure in pale brown hard wood blackened over on the surface, \From the Friendly Islands?, or Solomon Islands?/. The body is very thin and small in comparison with the head which is very long, ugly, and wears a kind of conical headdress with a long spike projecting from the top armed with five sets of barbes, four in each set. It is rather elaborately carved for Polynesian work, and appears from the thin binding round the pointed lower end to have been fixed to some other wood. The beard and hair are represented by incised perpendicular lines. The eyes nose and mouth by lines in relief. Whole L 19 2/10. Greatest D 1 3/10. (Ramsden Collection No. ?) Purchased by the University 1878.

1633 Fishing or harpoon arrow [-probably] \[-probably for Fishing]/ from the Salomon Islands? Shaft of pale brown reed ornamented at the joints with a kind of key pattern of the natural brown colour of the reed on black; L 30 in. Head of black wood partly coloured with bright brown and bound round in two places with a thin yellow grass. It is detachable from the shaft, and has a long hole morticed through it just behind the point, the latter being neatly and thickly set with small barbs cut from the wood itself: the hole being probably intended for a string to pass through: L 16 4/10 in. Whole L of arrow with head fixed in its place 3 ft. 9 3/10 in. Given by Professor J.O. Westwood, M.A. Magd[alen]: Coll[ege] Hopeian Professor of Zoology, 1874.

1634-1635 The tops of two arrows \probably/ from the Salomon Islands; of hard dark wood. No 1634 black wood bound in two places with bits of yellow grass and the point armed with two sets of four barbs, made of bits of bone neatly bound on, three of which are gone. Whole L 15 6/10 in. No 1635 is of brown wood also bound in two places with grass, and the point armed with seven sets of smaller bone barbs neatly bound on and the binding painted brown \green/ and white, several of the barbes being broken off. Much thicker

than the No 1634. L 15 2/10 in. The ends of the \reed/ shafts remain on both. Given by Professor J.O. Westwood, M.A. Magd[alen]: Coll[ege]: Hope Professor of Zoology, 1874.

1636 A curious article, perhaps a shark hook, and from some of the South Pacific Islands. It is made of the pointed under jaw of some marine animal, probably of the Dolphin, or porpoise kind, having numerous small teeth on the sides. This is strengthened by a flat piece of wood, evidently by the carving on it \having/ formerly been used for some other purpose; at the end of the wood is tied an immense tusk of a boar which curved over on one side apparently for the hook. The bindings appear to be of twisted cocoa-nut fibre. Whole L 21 5/10 in. L of Jaw only 14 7/10 in., greatest D of ditto 7 in. Ramsden Collection, No. ? Purchased by the University in 1878.

1637 A piece of matting work, made of palm leaf, with a very curious kind of pattern in squares on one side \made/ with some kind \of thin/ wire like fine fibre, and pairs of narrow strips of wood, perhaps the leaf stalks of a palm; firmly sewn on with the same kind of fibre. The use and locality, \is unknown/, but it has been said by a well informed person to be a pattern for \tapa/ cloth printing, used by some of the South Pacific Islanders. It is of an uniform pale brown colour. Perhaps from the Friendly Islands. Size 27 5/10 by 16 in. (Ramsden Collection No 324) Purchased by the University in 1878.

1637a A long cylinder of open wickerwork, open at each end; L 50 in. and D about 10; to the one side of which is loosely affixed another piece of wickerwork of a long semicylindrical shield shape with overhanging rounded top; L 35 in., W about 16; the face of which is covered with thin layers of inner bark which is \again/ covered all over with little bunches or rather flat tufts of black feathers except round the edge which seems to have had a border of white feathers, but these, except just the quills, and many of the black tufts have been destroyed by the moth. Around the edge projects a border or fringe of the long brown tail feathers of the Tropic Bird, Phaeton aethercus, Linn. It appears that this article belongs to the figure of the Mourner. Captain Cook's Collection, No. ?. Given by Reinhold Forster, Esq. Probably a similar article to that seen at Ulietea, Society Islands and described in Cook's 1st Voyage vol: 2 p. 264 as "A large cylindrical piece of Wickerwork, about 4 ft. long and 8 in. D, faced with feathers perpendicularly, with the top bending forwards, and edged round with Shark's teeth, and the tail feathers of the Tropic Bird. It is called a Whow." See figure on board one of the war canoes at Tahiti represented wearing a headdress resembling this; Cook's 2nd Voyage. Vol: 1 p. 343. Plate LXI.

The following belong to the dress of the Mourner, Tahiti

1637b Two flat, wide, semicircular shaped pieces of thin wood of a pale brown colour, blackened on the surface and ornamented with several large mother of pearl shells tied on each through holes drilled through the edges of the shell. The most perfect of the two has a deep fringe as it were of innumerable narrow thin strips of the same kind of shell, each piece neatly ground to shape perforated at each end and suspended by fine strings in parallel rows end to end, but this unfortunately has been a good deal broken. The other one of the two boards has a large smoky coloured shell attached surrounded by rays formed of the tail feathers of the Tropic bird, like to those on the preceding article No. 1637a, and therefore they both probably belong to the same thing as that. W about 37 and 33 in. They appear to have been across the back and the \breast of the figure/. Captain Cook's Collection, 1772-1774, No. ?. Given by Reinhold Forster, Esq.

1637c Five pearl shells tied together, three of them bright, and two dark, so as to form an object like a gigantic Lobster's tail, round the semicircular end \of/ one \of the end shells/ are arranged a great number of the tail feathers of the tropic bird spreading out like a fan. L 3 ft. Probably portion of the same thing as the three preceding, and belonging to the figure of the mourner. It appears to have hung at the back between the legs. Captain Cook's Collection 1772-1774, No. [] Given by Reinhold Forster Esq.

1637d A Cloak made out of a coarse network of twisted fibre, to the outside of which is tied a covering made of [-of] numerous little bunches of black feathers. It is now in a very bad condition through the moth, and has been removed to the Museum in the Parks \and placed/ under the charge of Professor Moseley to be fumigated. Captain Cook's Collection 1772-1774, No. [] Given by Reinhold Forster, Esq.

1637e A long narrow piece of Polynesian rough cloth made from the inner bark, of a dirty yellow colour, with a large slit through the middle; the back is lined with a piece of fine \yellow/ matting work of closey woven narrow strips [-apparently of the New Zealand Flax] plant (and appears not to belong to it really, but query). The one end for the length of 32 in. is covered with eight rows of disks cut out of Cocoa-nut shell each D about 1 1/2 in., each perforated at opposite sides and sewn [-on] on, there being at present 129 such disks, a few being wanting. L of cloth 5 ft. 10 in. W about 14 in. It [-appears to] belong[s] to the figure of the mourner. The head of the modern \wooden/ framework was through the slit and the end having the disks on it hung down in [-front behind\front]. Captain Cook's Collection 1772-1774, No. []. Given by Reinhold Forster, Esq.

1637f The headdress of the figure of the Mourner [-?], composed of a cap of matting work of [-g] closely woven narrow strips of palm leaf, surmounted by rolls of white \and yellow/ twisted cord made \of/ tapa cloth, and numerous small plaits of black human hair, and above that with bunches of split black feathers. At the back hangs a broad and long piece of tapa cloth of a whitish colour with broad horizontal pieces of the same material beaten on to the outside, and which are coloured brown, yellow, and black, as well as some of the natural white. Whole L 4 ft. 8 in. W of cloth 4 ft. It was found on the head of the \framework/ figure. Captain Cook's collection [-1772-1774], No? Given by Reinhold Forster, Esq.

1637g A large piece of tapa cloth made of several thicknesses stuck together in an irregular manner, of a whitish colour, but coloured on one side of a reddish brown. It is very roughly made and has a large slit in the middle through which the head of the figure previously mentioned projected. Size 6 ft. by 5 ft. Captain Cook's Collection No 16. Given by Reinhold Forster, Esq.

1637h A smaller piece \of ditto/ of one thickness of an uniform dull brown colour with the mallet marks very plain, a rude slit in the middle through which the head of the figure projected. L about 7 ft. W about 2. It belongs to the dress of the Mourner. Captain Cook's Collection No 9. Given by Reinhold Fo[r]ster, Esq.

1637i A headdress of the same character as No. 1637f, but not nearly so perfect, the feathers being almost entirely eaten from the top. The piece of tapa cloth hanging at the back is not so long, and the whole article is very dirty and appears to be very old. Captain Cook's Collection No ? Given by Reinhold Forster, Esq.

1637j A thick piece of tapa cloth made of several thicknesses beaten together; of a dirty white colour with a hole through the middle for the insertion of the head of the figure. L 9 ft. 6 in., W 5 ft. Captain Cook's Collection. Given by Reinhold Forster.

1637k Two pieces of tapa cloth, twisted together, one dark like No. 1256, the other light or of a yellowish white. I think [it] may have formed a kind of turband round the headdress No. 1637i, or 1637f. Captain Cook's Collection [-1772-1774] Given by Reinhold Forster, Esq.

1637l Seven halves of pearl shells, some of them of a large size and all more or less ground and polished. They seem to have belonged to the figure of the Mourner. Four of them were suspended two in each hand of the figure. These are the four largest, two of which are now tied together. The three smaller ones seem to have been used in some other way. Captain Cook's Collection No. ? Given by Reinhold Forster, Esq.

Miscellaneous, and Fragments. Locality not certain, and a few European

1638 A small very thin cup made of the half of a gourd, coloured black on both inside and outside, and having a kind of cruciform shaped [-pattern] design painted in red and white lines on the inside. Locality uncertain, but perhaps from British Guiana. It has been split nearly through. D 3 1/10 in. H 1 6/10 in. (Ramsden Collection No. ?) Purchased by the University in 1878.

1639 A cup? made from a piece cut off the end of a Cocoa-nut shell, perforated through the rim in two places \on opposite sides/, to one of which is attached a small hoop or ring made of twisted split cane \or some such material/. Locality uncertain D of piece of cocoa-nut shell 3 in., of cane ring 4 5/10 in. (Ramsden Collection No. ?) Purchased by the University in 1878.

1640 A wooden short sword or dagger sheath. The outsides painted of an uniform plain red colour. Locality unknown, but a good deal resembling a Malay kriss case but longer. L 18 in. D of top 2 2/10 by 1 3/10 in., gradually tapering to the bottom [-wich] which is slightly enlarged into a conical knob. It has been a good deal cracked all over (Ramsden Collection No. ?). Purchased by the University in 1878.

1641 A small dagger \or knife/ sheath, rudely made of two \flattish/ pieces of palish wood, tied together by a kind of basket work of interwoven thin strips of a paler material, probably of split palm leaf. The lower end has a fringe of coarse dark brown hair neatly fastened round it with cotton threads, the hairs being placed projecting backwards, and some of them reaching beyond the top \of the sheath/. Locality unknown. L 7 2/10 in. Greatest W 1 6/10 in. (Ramsden Collection No. ?) Purchased by the University in 1878.

1642 A small [-band\fringe] of darkish grey hair, long, but much finer than that on the preceding article, No 1641; but worked on a narrow band of cotton threads much in the same manner, the threads being long and bare at the ends for tying. W 5 in.; L 6 in. Ashmolean Collection, but history apparently lost. I think from the cotton work it may be from S. America

1643 A long flat, and rather wide iron blade, with portion of the curved carved handle of blackish wood resembling horn attached. By remains of dirt upon it it appears to have been buried, or else used for a digging tool. Locality and history unknown. The ornamentation of the handle is cut in and consists of various short lines and stars. L of blade 9 in. Greatest W 2 1/10 in. which is near the handle, gradually decreasing to the point. Ramsden Collection No. ? \79/. Purchased by the University in [-1884] 1878.

1644 A wide two edged blade of some weapon, probably a dagger, gradually decreasing from the middle to the edges in thickness, and having a strong shank for insertion into the [-wood] handle. Whole L 13 2/10 in. L of blade only 10 1/10 in. W next the

shank 3 in., gradually tapering to the point. (Ramsden Collection No. ?). Purchased by the University in 1878.

1645 Two pieces of wood of exactly similar shape to each other, and formerly no doubt formed one article. The one end of each is half round for the length of about 5 3/10 in., the inner sides being quite flat which appear to have been put together to form a round handle, and which from being rather rough on the outside seems to have been bound round with some material. The upper part is much longer flatly rounded on the outsides, and flat on the inside, and spreading from each other gradually from the handle [-part] part upwards like the tines of a common clothes peg, which on the whole it resembles in shape. Near the upper end each is perforated with two holes 2 5/10 in. apart, in one of which is the remains of a bone peg. L of each piece 19 4/10 in. Greatest W 2 in. There is also a round hole 1 5/10 in. deep in the end of the handle. [-Use and locality unknown]

1646 A large cylindrical peg, sharpen[e]d to a point at the bottom [-ford] for driving in the ground, the upper part, for the length of 9 9/10 in., painted with eight horizontal rings of red and green alternately, each two rings, beginning with the top, having one, two, three, or four black disks painted on. Probably used in some game resembling Croquet, and may come from Canada. Whole L 19 in. D 1 8/10. The two end[s] have been coloured brown. (Ramsden Collection No. ?). Purchased by the University in 1878.

1647 Two smaller pegs, of the same shape, painted round with eight rings of different colours in the following order commencing with the top and working downwards; the top dark blue, then white, yellow, red, green, brown, dark red, and lastly black. One of the pegs has lost its pointed end, and the other has been broken through. L 14 7/10 and 9 in. D 1 7/10 in. (Ramsden Collection No. ?). Purchased by the University in 1878.

1648 A small circular wooden pot, bottom rounded the sides straightish and converging to the neck which has an overhanging rim a good deal broken. The outside has been coloured of a brownish yellow. H 2 4/10 in. Greatest D 3 6/10 in., D of top 2 6/10 in. Use and locality uncertain. Ramsden collection No 595 ?\598 [-or 195 ?]/ Purchased by the University in 1878.

1649 A nearly triangular shaped box with flat bottom and thin flat lid fixed to one corner with a nail, so that it slides over. It is made of rather rough brown wood, the bottom being hollowed out of a single piece. It is the shaped outline [*drawing*] L 8 6/10 in.: Greatest W 3 7/10 in. and H 1 5/10. (Ramsden collection no 234) Purchased by the University in 1878.

1650 A long round handle of some implement or weapon, of dark brown hard wood, the lower end larger than the rest, and slightly ornamented with turning for the length of 6 5/10 in., the upper end

tennonted for the length of 1 8/10 in. as if for insertion into an iron head. L 3 ft. 1 in. D at top 1 4/10 in., gradually increasing in size to the other or lower end where it is D 1 8/10 in. Use and locality not known. (Ramsden Collection No. ?). Purchased by the University in 1878.

1651 Fragments of two semi-globular gourds, slightly ornamented on the outside by some of the surface being scratched off in squares. D about 9 5/10 in. H 3 5/10, and 5 in.; and fragments of another of darker colour, plain, and more bottle shaped (Ramsden Collection No. ?) Purchased by the University in 1878.

1652 The blade of a sword, or chopper, of a singular shape; gradually widening from the shank which went through the wooden handle, to the point where it is bevelled off from the back. The back is thick, the edge being much notched. L 34 2/10 in. W of blade next where the handle would be 7/10 in., widening to 1 8/10 at the other end. Probably from Malacca or somewhere near.
MacGregor 1983, no. 31.

1653 A short sword sheath, of wood covered with leather, slightly curved from end to end, the edges and the sides being bound with four longitudinal iron bands, one of the side ones being flat and wavy, the other one plain and rounded; these are crossed by seven cross fluted bands reckoning the chape, firmly rivetted on. There are two iron rings each having a thin short leathern strap near the top. The chape which is squarish at the end with a short projecting piece from the middle is really in one piece with the bands along the edges. L 26 5/10 in. W 1 5/10 in. The top a little broken. Probably Eastern, perhaps Chinese. Old Ashmolean Collection.

1654 A cylindrical piece \of white bone/ rounded off at the larger end and inlaid with a wood socket, perhaps intended for fixing a detachable point. It is uncertain what the other end was like as it is broken off, having remains of two cross cuts in it. It appears to have been the heavy head of some kind of Harpoon. Perhaps \W./ Esquimaux \and resembling 717-720/ Present L 5 6/10 in. D 1 2/10. Ashmolean Collection.

1655 A cylindrical smooth handle of brown wood veined with black. The top end rounded off, the other end having a deep hole in which has been inserted the metal shank of some implement, with [a] shoulder for a ferrule on the outside. It resembles the handle of a trowel, L 5 in., D 1 5/10 in.

1656 A thin ring, perhaps an armlet or bracelet of green glass, spotted along the outside with numerous spots of opaque yellow. D 2 3/10 in.; Th of material 2/10 in. Perhaps Modern Syrian. (Ramsden Collection No. ?). Purchased by the University in 1878.

1657 A groteseque head of some animal, apparently by the shape of the mouth intended for one of the cat tribe, carved in dark brown wood. It appears from \curved/

fragments adhering to the back of it to have formed the ornamental end of some kind of bowl. It is probably N. American Indians work. Whole L 5 7/10 in. W 2 3/10, and depth 3 2/10. (Ramsden Collection No. ?). Purchased by the University in 1878.

1658 A long narrow article of dark brown wood, the wider end being perforated through and ornamentally carved, below which is a kind of rosette shaped carved ornament with a perforation through the edge. Use and locality unknown. L 9 6/10 in. Greatest W 7/10 in. and 4/10 thick. (Ramsden collection No 550 ?). Purchased by the University 1878.

1659 An irregular shaped piece of rough grey stone which has been broken off at one end. L 5 in.; Greatest W 2 7/10 in. History unknown (Ramsden Collection No. ?). Purchased by the University in 1878.

1660 Two very fine pieces of what appears to be window blinds, made of very thin pieces of stick or fine rushes, laid parallel and so close together that they nearly touch each other, and bound in that position by many \fine/ cross threads. One piece is \painted dark/ brown, W 1 ft. and L about 35 in. The other is \painted/ dark green, W 14 in. but uncertain length as it is broken into strips. I believe it is Japanese. (Ramsden Collection No. ?) Purchased by the University in 1878.

1661 A pair of Sandals, the soles made of plaited hemp or some such material, rather thick, and lined on the top with pale brown silk, perhaps originally white: the cap for the toe and the heel piece being of woven pale brown silk like threads, with a quatrefoil worked on each in a thin black line. L of sole 8 4/10 in. W 2 3/10 in. Given by Mrs Anne Rummer, sent to her from Rome, 1739.
Ashmolean 1836, p. 181 no. 80.

1662 A pair of similar sandals, but larger, the toe caps being open in front, and that and the strap for the heel made of knitted thick white cotton threads. L of sole 10 3/10 in.: W of ditto 3 3/10 in. (Ramsden Collection No. ? \159/). Purchased by the University in 1878.

1663 A strong leathern strap with iron buckle attached to fasten round the waist, with large pear-shaped pouch, perhaps intended to contain powder and shot attached by strong iron links to to short straps tacked to the sides. All of dark brown leather. Use and locality unknown, but evidently modern. The small end of the pouch forms the mouth. L of strap 3 ft. 8 in. W 2 in. L of the pouches between 9 and 10 in. W of ditto between 6 and 7 in. (Ramsden Collection No. ?) Purchased by the University in 1878.

1664 A "Capa de Palha" or straw Cloak, worn by the peasantry in the Northern Provinces of Portugal. Waterproof. It is made in the shape of the Inverness Cape, the straw, or some such material of which it is entirely composed [-of] being split into fine shreds over the whole of the outside so that the water would run off

as off thatch. L about 5 ft. 9 in. Given by Le Marchant Gosselin, Esq \Oxford/ 1872.

Models of ships etc

1665 A model of a 64 gun ship, date 1719. L about 3 ft. 8 in.; W across the middle about 11 in. This splendid specimen of naval architecture was made by Wm. Lee, Esq. and exhibits the entire construction and fitting up of the vessel. (With full rigging but no sails). Given by Dr. George Clarke LL.D 1719.
Ashmolean 1836, p. 174 no. 1.

1666 A model of the Royal Yacht, built in 1697, but without rigging or sails. L 27 in. W 6 1/4 in. Given by Dr. George Clarke, 1719.
Ashmolean 1836, p. 174 no. 2.

1667 A model of the Royal Yacht, date 1702, but without sails or rigging. L 27 in. W 5 1/2 in. Given by Dr. George Clarke 1719.
Ashmolean 1836, p. 174 no. 3.

1668 A Model of the foremast of the Victory, given to the Rev. Dr Cyril Jackson, Dean of Christ Church by Robert Seppings, Esq Master Shipwright at Chatham, when the ship was under repair, after the memorable battle of Trafalgar. The model shews the several injuries by shot the mast received during the action. Scale 1/4 in. to 1 ft. Given by the Rev. Dr. C. Jackson. (Date?)
Ashmolean 1836, p. 174 no. 6.

1669 A model of a 64 gun ship with rigging, etc complete. Date 1770. L 4 ft. 1 in. W between 11 and 12 in. Given by Sir Samuel Hellier, Bart (Several other things were given by him in 1797 [-as] such as Queen Elizabeth's watch, and others. Charles the 2nd bellows. Probably the model was given at the same time).
Ashmolean 1836, p. 174 no. 5.

1670 Models of the lower mast and bowsprit of a Man of War. L of the mast []; of the bow sprit []. Given by Lieut. Cole R.N. probably 1828 as other things given by him are of that date.
Ashmolean 1836, p. 174 no. 8.

1671 Model of a Frigate, (named the Crown), made by the French prisoners in England after the battle of Waterloo, Bought by Miss Golightly, and presented by her to her Nephew the Rev. Charles Portales Golightly, late of No 6 Holywell Street, Oxford, by whose legal representative it was deposited temporarily in the Ashmolean Museum. L about 3 ft. H 2 ft. 4 in.

1672 Model of a Venetian Gondola, date about 1700. L 12 6/10 in. W 7 in., with [] figures in it [] Richard [] 1775 Given by [-Dr\Richard] Rawlinson \Esq L.L.D / St John's College [-(date?)\1755]. (For the bequest of this, and the model of Indian Palanquin, see Copy of his printed Will preserved in Ashmolean Old Book.)

1673 A small wooden model of a modern Venetian Gondola, the top taking out like the lid of a box. L []

W []. Given by John Shute Duncan D.C.L Keeper of the Ashmolean 1823-1826.
Ashmolean 1836, p. 174 no.10.

1674 Various fragments of wood, copper plaiting, and cordage, from the wreck of the Royal George. Sunk at Spithead 1782, raised in 1840. Donor uncertain, but see labels on object.

1675a Wooden Jug, used in Corfu for carrying milk to market. H to top of handle 9 3/4 in., D at bottom exclusive of the hoops 4 4/10 in., decreasing to 3 1/10 in. at top. Given by Dr E.L Hussy, Esq 24 Winchester Road, Oxford.

1675b Small splinter from the French ship \of War/ L'Orient which blew up at the victory of the Nile. Donor uncertain.
Ashmolean 1836, p. 174 no. 7.

1676 Globular wooden flask or bottle, perhaps a powder flask somewhat depressed on the two sides with short mouth or spout into which fits a wood stopper covered by a hollow dome-shaped lid. Just below the neck is a kind of collar through which are two perforations [-as if] for a suspending string, a piece of which is attached and runs through the perforated lid and fastened round top of stopper. It has been hollowed by turning done by cutting out a circular piece out of the side which had after been fitted in its place, \again/ the sides being ornamented with concentric faint grooves, and standing on four short feet cut out of one piece with the flask. It has been covered with some varnish like solution both inside and out. Locality uncertain perhaps from near the mouth of the Amazon, but quite uncertain as it belongs to the Old Ashmolean Collection probably Tradescants. H 9 1/4 in. D 5 1/2 and 4 3/4 in.

CONVENTIONS OBSERVED IN THE TRANSCRIPTIONS

The following conventions have been used in transcribing the texts of the catalogues.

Spellings, however deviant, have been preserved, generally without comment; occasionally, where the original texts are in English, missing letters have been added in square brackets in order to clarify meaning.

Contracted forms are common in the Latin texts and are reproduced here as accurately as is possible within the limitations imposed by the typeface. The following forms are encountered:

Either ˜ or ¯ is used, apparently for no other reason than personal taste, usually - but not always - at the end of the word:

ã	am	e.g. quibusdã - quibusdam
ẽ	em	e.g. longitudinẽ - longitudinem
õ	om	e.g. rhõboidali - rhomboidali
ũ	um	e.g. iterũ - iterum
⁹	us	e.g. Ludovic⁹ - Ludovicus
m̃	mm	e.g. cõminus - comminus
ñ	no	e.g. omniñ - omnino
ñ	nn	e.g. Chiñitica - Chinnitica
ã	an	e.g. triãgulo - triangulo
g̃	ger	e.g. armig̃ - armiger
p̲	per	e.g. p̲cussum - percussum
c̃	nc	e.g. Ac̃onilanus - Anconilanus

Dñae	Dominae
Dño	Domino
Dñi nr̃i	Domini nostri
Desid́	Desiderius
Joh/Johis	Johannis
Ar̃	Armiger
Mathemat˜	Mathematica
Phil˜	Philosophia
Reg̃	Regius
Magnitud́	magnitudinis
Gũ/Gum̃	gummus

NB: all 'que's have been expanded

Punctuation and capitalization have been preserved as in the original texts. In transcribing the headings, rendered here in bold type, the use of upper and lower case has, however, been standardized in order to impose some overall coherence on the structure. With the same aim in mind, catalogue numbers have been rendered in bold throughout.

Where the primary text occupies the recto folio (as is commonly the case), additions from facing verso have been included here as footnotes to the primary entries: hence additions on fol. 9v would be recorded as footnotes to the related entries on fol. 10r. However, when independent entries appear on a verso, their transcriptions and translations are included in sequence within the main body of the text.

Additions and deletions to the original texts are shown as follows:

ru[-]is	illegible deletion
[-Imago]	legible deletion
[-ovalis\quadratus]	substitution for a deletion
\\emeraux//	addition from the margin
Mar/m\or	addition from above the line[1]

There are many small markings (+, -, x, etc.) throughout the margins of the catalogues, no doubt added at different times by curators and Visitors during periodic stock-checks of the collection. These have been omitted from the present text, except where they form part of a longer passage in which the reason for their inclusion is made clear. Another annotation, *deest*, often shortened to *d*, indicating that an item has been declared to be missing, is so prevalent that while it is included in the transcriptions it has been omitted from the translations. Underlinings, the dates and significance of which are not always clear, similarly have been omitted.

[1] Due to the complex and irregular layout of the inserts in the Anthropological Catalogue (AMS 25), all inserts, wherever placed on the page, are indicated thus: \Fiji/.

Further common abbreviations relating only to the catalogue of coins and medals (AMS 9) have not been translated in individual entries in that text: their significance is discussed in the introduction to the catalogue, on pp. 67-8.

A small number of contractions, all relating to the recording of dimensions, have been introduced into the extended entries of the Anthropological Catalogue (AMS 25): their use is explained in the introduction to that text, on p. 256.

BIBLIOGRAPHY

Compiled by Arthur MacGregor

1: Works cited in the original catalogues

In support of their ascribed identifications, the authors of the original catalogues reproduced in this volume periodically make reference to published works, usually with citations that are cryptic in the extreme. Wherever possible, these have been expanded and rendered as Harvard-style references in the translations. In many cases, comparison of the page- and illustration-numbers cited allow precise identification of the editions cited. In a very few instances (e.g. references in the text to Gessner) the editions used by the compilers have proved elusive and appropriate page-references to alternative editions have been cited in the translated texts.

Aiton, William, 1789. *Hortus Kewensis; or a Catalogue of the Plants cultivated in the Royal Botanic Garden at Kew* (London).

Aldrovandi, Ulisse, 1599. *Ornithologiae* (Bologna).

_____, 1602. *De Animalibus Insectis libri septem* (Bologna).

_____, 1613. *De Piscibus libri V et de Cetis, lib. unus* (Bologna).

Ashmolean Museum, 1836. *A Catalogue of the Ashmolean Museum, descriptive of the Zoological Specimens, Antiquities, Coins, and Miscellaneous Curiosities* (Oxford).

_____, 1868. *A List of Donations to the Antiquarian and Ethnological Collections in the Ashmolean from the Year 1836 to the End of the Year 1868* (Oxford).

Bates, Henry Walter, 1863. *The Naturalist on the River Amazons* (London).

Bauhin, Johannes, 1651. *Historia Plantarum Universalis Nova* (Yverdon).

Beechey, Captain F.W., 1831. *Narrative of a Voyage to the Pacific and Beering's Strait, to co-operate with the Polar Expeditions, performed in His Majesty's Ship Blossom* (London).

Belon, Pierre, 1553. *De Aquatilibus, libro duo* (Paris).

Bontius, Jacobus [Prosper Alpinus], 1658. *Jacobi Bontii, Historiæ Naturalis & Medicæ Indiæ Orientalis ... Comentarii ... quos auctor, morte in Indiis præventus, indigestus reliquit, a Gulielmo Pisone* (Amsterdam).

Borlase, William, 1758. *The Natural History of Cornwall* (Oxford).

Buffon, Comte de, 1764. *Histoire naturelle, générale et particulière avec la description du Cabinet du Roi* (vols.12, 15) (Paris).

Bullock, William, 1824. *Six Months' Residence and Travels in Mexico* (London).

Buonanni, Philippo, 1684. *Recreatio mentis et oculi in observatione animalium testaceorum* (Rome).

Burchell, William J., 1822-4. *Travels in the Interior of Southern Africa* (London).

Camden, William, 1695. *Camden's Britannia, newly translated into English, with large additions and amendments*, ed. E. Gibson (London).

Catlin, George, 1841. *Letters and Notes on the Manners, Customs, and Condition of the North American Indians* (London).

Clusius, Carolus, 1605. *Exoticorum libri decem* (Leiden).

Colonna, Fabio, 1616. *Fabii Columnæ Lyncei: Purpura* (Rome).

Cook's 1st Voyage, 1778. *An Account of the Voyages undertaken by the Order of his Present Majesty for making Discoveries in the Southern Hemisphere ...* (London).

Cook's 2nd Voyage, 1777. *A Voyage towards the South Pole, and Round the World, Performed in his Majesty's Ships Resolution and Adventure, in the Years 1772, 1773, 1774, and 1775 ...* (London).

Croy, Charles (Duc de), 1654. *Regum et Imperatorum Romanorum Numismata* (Antwerp).

Edwards, George, 1743-51. *A Natural History of Birds*, part III (London).

Ellis, William, 1829. *Polynesian Researches* (London).

Evans, [Sir] John, 1872. *The Ancient Stone Implements, Weapons, and Ornaments, of great Britain* (London).

Gessner, Conrad, 1551-8. *Historiae Animalium* (Zürich).

_____, 1620. *Historiæ Animalium Liber IV, qui est de Piscium & Animalium Animantium Naturæ*, 2nd edn. (Frankfurt).

Goltz, Hubert, 1576. *Sicilia et Magna Graecia sive Historiae Urbium et Populorum Graeciae ex antiques Numismatibus restitute* (Bruges).

Grew, Nehemia, 1681. *Musæum Regalis Societatis, or a Catalogue & Description of the Natural and Artificial Rarities belonging to the Royal Society and Preserved at Gresham College* (London).

Hakluyt, Richard, 1589. *The Principall Navigations, Voiages and Discoveries of the English Nation, made by Sea or over Land* (London).

Herbert, Sir Thomas, 1638. *Some Yeares Travels into Africa & Asia the Great* (London).

Hernandez, Francisco, 1651. *Rerum Medicarum Novæ Hispaniæ Thesaurus, seu Plantarum Animalium Mineralium Mexicanorum Historia* (Rome).

Humboldt, Alexander von, 1810. *Vues des Cordillères, et monumens des peoples de l'Amerique* (Paris).

_____, 1814. *Researches, concerning the Institutions and Monuments of the Ancient Inhabitants of America*, trans. H.M. Williams (London).

Imperato, Ferrante, 1599. *Dell' Historia Naturale libri XXVIII* (Naples).

_____, 1672. *Historia Naturale di Ferrante Imperato ... Seconda Impressione* (Venice).

Jonston [Jonstonus], Joannes, 1650a. *Historiæ Naturalis de exanguibus aquaticis libri IV* (Frankfurt am Main).

_____, 1650b. *Historiæ Naturalis de Piscibus et Cetis libri V* (Frankfurt am Main).

_____, 1653. *Historiæ Naturalis de Insectis Libri III, de Serpentibus et Draconibus Libri II* (Frankfurt am Main).

_____, 1657a. *Historiæ Naturalis de Quadrupetibus libri []* (Amsterdam).

_____, 1657b. *Historiæ Naturalis de Avibus libri VI* (Amsterdam).

_____, 1665. *Historiæ Naturalis de Serpentibus libri II* (Amsterdam).

Kemble, John M. 1863. *Horæ Ferales; or Studies in the Archaeology of the Northern Nations*, ed. R.G. Latham and A.W. Franks (London).

Kew Catalogue: see Aiton 1789.

Linnæus, Carolus, 1788. *Systema Naturæ per regna tria naturæ*, 13th revised edn., ed. J.F. Gmelin (Leipzig).

Ligon, Richard, 1657. *A true and exact History of Barbados* (London).

Lister, Martin, 1678. *Historiæ Animalium Angliæ* (London).

_____, 1685. *Historiæ Animalium Angliæ Appendicis ... altera edition* (London).

Lubbock, Sir John, 1869. *Pre-historic Times, as illustrated by Ancient Remains, and the Manners, and Customs of Modern Savages* (London and Edinburgh).

Lyon, Captain G.F., 1821. *A Narrative of Travels in Northern Africa, in the Years 1818, 19 and 20* (London).

_____, 1824. *The Private Journal of Captain G.F. Lyon, of H.M.S. Hecla, during the recent voyage of discovery under Captain Parry* (London).

Mayer, Brantz, 1844. *Mexico as it was and as it is* (New York, London and Paris).

Mayer Collection, 1882. *Liverpool Free Public Library, Museum, etc.: Catalogue of the Mayer Collection* (Liverpool).

Meyrick, Samuel Rush, 1854. *Engraved Illustrations of Antient Arms and Armour from the collection at Goodrich Court, Herefordshire, after the drawings, and with the descriptions of Sir Samuel Rush Meyrick, by Joseph Skelton* (London).

Moscardo, Lodovico, 1672. *Note overo Memorie del Museo del Conte Lodovico Moscardo ... in tre libri* (Verona).

Nieremberg, Johannes, 1635. *Historia Naturæ, maxime peregrinæ, libri XVI distincta* (Antwerp).

Orsino, Fulvio, 1577. *Familiæ Romanæ quæ reperiuntur in antiquis Numismatibus* (Rome).

Parkinson, John, 1640. *Theatrum Botanicum. The Theater of Plantes* (London).

Parry, Captain William Edward, 1824. *Journal of a Second Voyage for the discovery of a North-West Passage from the Atlantic to the Pacific, performed in the years 1821, 1822, 1823, in His Majesty's Ships Fury and Hecla* (London).

＿＿＿, 1828. *Narrative of an Attempt to reach the North Pole ... in the Year 1827* (London).

Pennant, Thomas, 1771. *Synopsis of Quadrupeds* (Chester).

Perry, Charles, 1743. *A View of the Levant, particularly of Constantinople, Syria, Egypt, and Greece* (London).

Petherick, John, 1861. *Egypt, the Soudan and Central Africa ... being Sketches from Sixteen Years' Travel* (Edinburgh and London).

Petherick, John and Petherick, Kate Harriet, 1869. *Travels in Central Africa, and Explorations of the Western Nile Tributaries* (London).

Piso, Willem, 1658. *De Indiæ Utriusque Re naturali et medica* (Amsterdam).

Piso, Willem, and Markgraf, Georg, 1648. *Historia Naturalis Brasiliae* (Leiden).

Plot, Robert, 1677. *The Natural History of Oxfordshire* (Oxford).

Rhode, C.D., 1728. *Cimbrisch-Holsteinische Antiquitæten-Remarques* (Hamburg).

Rondelet, Guillaume, 1554. *Libri de Piscibus Marinis, in quibus verræ Piscium effigies expressæ sunt* (Lyon).

＿＿＿, 1555. *Universæ aquatilium Historiæ, pars altera* (Lyon).

Ray, John, 1673. *Observations Topographical, Moral & Physiological; made in a Journey through part of the Low-Countries, Germany, Italy, and France* (London).

＿＿＿, 1686. *Historia Plantarum* I (London).

Salviano, Hippolito, 1554. *Aquatilium Animalium Historiæ* (Rome).

Schomburgk, Sir Ronald, 1841. `On the *urari*, the arrow poison of the Indians of Guiana; with a description of the plant from which it is extracted', *Annals and Magazine of Natural History* 7, pp. 407-27.

Serrurier, L., 1883. *Catalogus der Ethnographische Afdeeling van de Internationale Koloniale en Uitvoerhandel Tentoonstelling (van 1 Mei tot ulto. October 1883) te Amsterdam* (Leiden).

Tradescant, John, 1656. *Musæum Tradescantianum: or, a Collection of Rarities, preserved at South-Lambeth, neer London* (London).

Uffenbach, Zacharias Conrad von, 1753-4. *Merkwürdige Reisen durch Niedersachsen, Holland und Engelland* (Ulm).

Williams, John, 1888. *Missionary Enterprises in the South-Sea Islands* (Philadelphia)

Willughby, Francis, 1678. *The Ornithology*, ed. John Ray (London).

＿＿＿, 1686. *De Historia Piscium libri quatuor* (Oxford).

Wood, John George, 1874. *The Natural History of Man* (London)

Worm, Ole, 1655. *Museum Wormianum seu Historia Rerum Rariorum* (Leiden).

2: Works cited in support of the texts

The following works are cited in the introductory remarks which preface the individual catalogues but do not form part of the original entries.

Bierbrier, M.L., 1988. 'The Lethieullier family and the British Museum', in *Pyramid Studies and other Essays presented to I.E.S. Edwards*, ed. J. Baines *et al.*, Egypt Exploration Society, Occasional Publication 7 (London), pp. 220-28.

Black, W.H., 1845. *Catalogue of the Manuscripts Bequeathed to the University of Oxford by Elias Ashmole* (Oxford).

Campbell Smith, W., 1913. 'The mineral collection of Thomas Pennant, 1726-1798', *Mineralogical Magazine* 16 no. 77, pp. 331-42.

Case, Humphrey, 1977. 'An early accession to the Ashmolean Museum', in *Ancient Europe and the Mediterranean. Studies in honour of Hugh Hencken*, ed. V. Markotic (Warminster), pp. 19-34.

Caygill, Marjorie and Cherry, John (eds.), 1997. *A.W. Franks. Nineteenth-Century Collecting and the British Museum* (London).

Coote, J., Gathercole, P. and Meister, N., 2000. '"Curiosities sent to Oxford": the original documentation of the Forster collection at the Pitt Rivers Museum', *Journal of the History of Collections* 12, pp. 177-92.

Culpepper, Nicholas, 1702. *Pharmacopœia Londinensis, or the London Dispensatory* (London).

Evelyn, John, 1955. *The Diary of John Evelyn*, ed. E.S. de Beer (Oxford).

Forster, George 1777. *A Voyage round the World in His Britannic Majesty's Sloop, Resolution, Commanded by Capt. James Cook, during the Years 1772, 3, 4, and 5* (2 vols) (London).

_____ 1958-85. *Werke: Sämtliche Schriften, Tagebücher, Briefe*, 18 vols. (Berlin).

_____ 2000. *A Voyage round the World*, ed. N. Thomas and O. Berghof (Honolulu).

Forster, Johann Reinhold 1778. *Observations Made during a Voyage round the World on Physical Geography, Natural History, and Ethic Philosophy...* (London).

_____ 1982. *The Resolution Journal of Johann Reinhold Forster 1772-1775* (ed. M.E. Hoare) (Hakluyt Society, 2nd ser. vols 152-5) (London).

_____ 1996. *Observations Made during a Voyage round the World* (ed. N. Thomas, H. Guest and M. Dettelbach, with a linguistic appendix by K.H. Rensch) (Honolulu).

Gathercole, Peter, [1970]. *'From the Islands of the South Seas, 1773-4'. An Exhibition of a Collection made on Cap^n Cook's Second Voyage of Discovery by J.R. Forster: a short guide* (Oxford).

Gunther, R.T., 1925. *Early Science in Oxford* III *The Biological Sciences [&] Biological Collections* (Oxford).

_____, 1945. *Early Science in Oxford* XIV *Life and Letters of Edward Lhwyd* (Oxford).

Hauser-Schäublin, Brigitta, and Gundolf Krüger 1998. *James Cook: Gifts and Treasures from the South Seas: The Cook/Forster Collection / Gaben und Schätze aus der Südsee: Die Göttinger Sammlung Cook/Forster* (Munich).

Harle, James, 1983. 'An Indian "Gonga"', *The Ashmolean* no. 2, pp. 6-7.

Hoare, Michael E. 1976. *The Tactless Philosopher: Johann Reinhold Forster (1729-98)* (Melbourne).

_____ 1982. 'Introduction', in vol. I of Forster 1982, pp. 1-122.

Hinton, David, 1974. *A Catalogue of the Anglo-Saxon Ornamental Metalwork 700-1100 in the Department of Antiquities, Ashmolean Museum* (Oxford).

Hubert, Robert, 1664. *A Catalogue of the Many Natural Rarities, with Great Industry, Cost and thirty Years travel in Foraign Countries, Collected by Robert Hubert* (London).

Jahn, M.E., 1966. 'The Old Ashmolean and the Lhwyd collection', *Journal of the Society for the Bibliography of Natural History* 4, pp. 244-8.

Josten, C.H., 1966. *Elias Ashmole, 1617-1692* (Oxford).

Kaeppler, Adrienne L. 1972. 'The use of documents in identifying ethnographic specimens from the voyages of Captain Cook', *Journal of Pacific History* 7, pp. 195-200.

_____ 1978a. *'Artificial Curiosities': being an exposition of native manufactures collected on the three Pacific voyages of Captain James Cook, R.N. at the Bernice Pauahi Bishop Museum January 18, 1978 - August 31, 1978 on the occasion of the bicentennial of the European discovery of the Hawaiian Islands by Captain Cook - January 18, 1778* (Bernice P. Bishop Museum Special Publication 65) (Honolulu).

_____ 1978b. *Cook Voyage Artifacts in Leningrad, Berne and Florence Museums* (Bernice P. Bishop Museum Special Publication 66) (Honolulu).

_____, 1998. 'The Göttingen Collection in an International Context / Die Göttinger Sammlung im internationalen Kontext', in Hauser-Schäublin and Krüger (1998), pp. 86-93.

Kunz, G.F., 1915. *The Magic of Jewels and Charms* (Philadelphia and London).

Levine, J.M., 1977. *Dr Woodward's Shield. History, Science and Satire in Augustan England* (Berkely, Los Angeles and London).

Lhywd, Edward, 1699. *Lithophylacii Britannici Ichnographia* (London).

MacGregor, Arthur (ed.), 1983. *Tradescant's Rarities. Essays on the Foundation of the Ashmolean Museum, 1683, with a catalogue of the surviving early collections* (Oxford).

_____1983a. 'Mary Davis's horn: a vanished curiosity', *The Ashmolean* no. 3, pp. 10-11.

_____ 1997. 'The Ashmolean Museum', in *The History of the University of Oxford* VI *The Nineteenth Century*, ed. M. Brock and L.G. Mitchell (Oxford), pp. 598-610.

_____ 1997a. *Ashmolean Museum: A Summary Catalogue of the Continental Archaeological Collections (Roman Iron Age, Migration Period, Early Medieval)* British Archaeological Reports, International Series 674 (Oxford).

MacGregor, Arthur and Headon, Abigail, 2000. 'Reinventing the Ashmolean. Natural history and natural theology at Oxford in the 1820s to 1850s', *Archives of Natural History* 27, 369-406.

MacGregor, Arthur and Turner, Anthony J., 1986. 'The Ashmolean Museum', in *The History of the University of Oxford* V *The Eighteenth Century*, ed. L.S. Sutherland and L.G. Mitchell (Oxford), pp. 639-58.

Málek, Jaromír, 1983. 'The largest piece of Egyptian writing in Europe', *The Ashmolean* no. 4, pp. 12-13.

Ovenell, R. F., 1986. *The Ashmolean Museum, 1683-1894* (Oxford).

_____ 1992. 'The Tradescant dodo', *Archives of Natural History* 19, pp. 145-52.

Petch, Alison, 1998. '"Man as he was and man as he is": General Pitt Rivers's collections', *Journal of the History of Collections* 10, pp. 75-85.

Pool, P.A.S., 1986. *William Borlase* (Truro).

Simpson, A.D.C., 1984. 'Newton's telescope and the cataloguing of the Royal Society's Repository', *Notes and Records of the Royal Society* 38, pp. 59-91.

Thomas, Ben and Wilson, Timothy (eds.), 1999. *C.D.E. Fortnum and the Collecting and Study of Applied Arts and Sculpture in Victorian England* (Journal of the History of Collections vol. 11 no. 2) (Oxford).

Whitehead, Peter, 1970. 'Museums in the history of zoology', *Museums Journal*, 70, pp. 50-7, 155-60.

INDEXES
Compiled by Arthur MacGregor

Note that two indexes are provided and that they are complementary in nature. The index of English terms includes words in common use at the time the respective catalogues were compiled, whatever their linguistic origins. Many of these are literal or approximate renderings of Latin; the ethnographic sections of the catalogue frequently give phonetic renderings of indigenous terms for objects being described while elsewhere ‾ especially in the natural history sections ‾ pre-Colonial Brazilian vernacular terms remained in use up to (and in some cases beyond) the eighteenth century for species for which a European nomenclature had yet to be developed. In some instances the terminology used in the translations provided by past curators and reproduced in the texts is at variance with that used today: in order to ensure recovery of all the relevant references (particularly those relating to natural history and materia medica), both indexes should be consulted.

1: Index of English terms

The national and county boundaries observed are broadly those in use at the time the catalogues were compiled. An alphabetical list of donors to the collection will be found under Donors.

2: Index of Latin terms

The Index of Latin terms limits itself to descriptors of natural history specimens and materia medica. Since it is drawn from the texts themselves, the index inevitably contains various corrupt or spurious words that made their way into everyday use in the nomenclature of natural history, pharmacy, etc.; in some cases these terms remain in use and in others not. In the case of the zoological specimens, for example, the nomenclature of the earliest catalogues is pre-Linnaean while specimens acquired in the late eighteenth and nineteenth centuries are identified according to the system that remains in current use, although in some instances the names themselves have been refined in more recent years. No attempt is made here to reconcile difficulties of this kind. Note that some specimens are named in the catalogues only in English (or in some other language, as in the case of the pre-Colonial Brazilian terms) and hence do not appear in the following list: the Latin index should, therefore, be used in conjunction with that in English in order to recover complete listings.

Note that the names of classical rulers, deities, etc are listed only in the English index.